ART BOOKS

GARLAND REFERENCE LIBRARY
OF THE HUMANITIES
(VOL. 574)

ART BOOKS
A Basic Bibliography of Monographs on Artists

Wolfgang M. Freitag

GARLAND PUBLISHING, INC. • NEW YORK & LONDON
1985

Library of Congress Cataloging-in-Publication Data

Freitag, Wolfgang M.
 Art Books: A basic bibliography of monographs on artists.

 (Garland reference library of the humanities ;
vol. 574)
 1. Art—Bio-bibliography. 2. Artists—Bibliography.
I. Title. II. Series: Garland reference library of the
humanities ; v. 574.
 Z5938.F73 1985 [N40] 016.7′092′2 [B] 85-15943
 ISBN 0-8240-8763-1 (alk. paper)

Cover design by Jonathan Billing

Printed on acid-free, 250-year-life paper
Manufactured in the United States of America

"There is properly no history; only biography."
Ralph Waldo Emerson
Essays in History

CONTENTS

INTRODUCTION

The most basic kind of publication that art historians produce is probably the monograph on a particular artist. In it, all the artist's works will be sorted out and catalogued, with illustrations to match; and an interpretative essay will usually be provided to go along with this. There, the development of the artist's work will be dealt with from different points of view (style, subject matter, technique, and so on), and the discussion of how the artist developed and of his total achievement may well shade into criticism.[1]

As every librarian knows, artists' monographs form the core and account for the bulk of every art book collection, constituting well over fifty percent of the holdings; they have always been and remain— the importance which periodicals have attained notwithstanding—the principal vessels in which research results are packaged and transmitted, a fact which is corroborated by several empirical studies of the research habits of art historians.[2,3,4]

Lois Swan Jones notes in her study guide, *Art Research Methods and Resources*, that at present "there is no single reference work that lists all of the monographs, catalogues raisonnés, and *oeuvres* catalogues that have been compiled on various artists."[5] Indeed, the best and most useful bibliography of monographs deals with artists from only one field: printmaking.[6] The only work in which a general list has been attempted is E. Louise Lucas' *Art Books: A Basic Bibliography* (Greenwich, CT: New York Graphic Society, 1968), which contains a selected bibliography of monographs on about 550 artists from all fields. As this title is now out of print, a researcher wishing to locate additional books and catalogues on individual artists must turn to the bibliography sections appended to the entries in the great biographical dictionaries such as *Thieme-Becker* or *Bénézit*, to encyclopedias like the *Encyclopedia of World Art* or to the multi-volume handbooks of which the *Pelican History of Art* and the *Propyläen-Kunstgeschichte* are prominent examples. The titles found therein can be supplemented further by searching various national art bibliographies and published library catalogues and—if one wishes to bring one's search up to date—by recourse to national and trade bibliographies or serial abstracting and indexing services of which RILA, the *Répertoire d'Art et d'Archéologie*, and *Art Bibliographies Modern* are the most frequently used.

Many of the monographs listed contain substantial bibliographies that will lead to further study. If one intends to pursue research on an artist in depth, the user of this volume will disregard them at his or her peril. A select list of multi-artist biographical dictionaries and other reference works that contain useful data has been added in order to increase the usefulness of the volume.

Art Books: A Basic Bibiography of Monographs on Artists is designed primarily for the graduate student who needs a tool that is compact and affordable yet fairly comprehensive and that can take its place on the personal reference shelf alongside such standard works as Schlosser's *La Letteratura Artistica,* Chamberlin's *Art Reference Books,* Arntzen and Rainwater's *Guide to the Literature of Art History,* and the bibliographies incorporated in a recent spate of study guides of which those by Jones, Kleinbauer, and Muehsam are three outstanding examples.[7,8,9] In compiling this bibliography, I have also been mindful of the usefulness of such a volume to librarians who are charged with the task of collection building and naturally also to book dealers in acquiring stock and preparing catalogues.

Contained here are monographs and works of a monographic character on 1,870 artists from all historical periods and from all countries. The 10,543 titles represent the following media: painting and drawing (64%), sculpture (11%), architecture (11%), graphic arts (8%), photography (5%), and decorative and applied arts (1%).

Since it was my aim to do justice to artists from every historical epoch and from all parts of the world, my approach had to be severely selective if, in accordance with the publisher's plans, the one-volume format of the bibliography was to be preserved. To achieve this compactness I have thought it best to concentrate on artists who interest the American art student, the collector, and the ever-growing number of passionate art lovers among the general public. Many of the artists included are represented with their works in American or Canadian museums or have been shown in travelling exhibitions that have toured the continent; others are the subject of academic courses and lectures on the graduate and undergraduate level in North American colleges and universities.

The proportion of citations per national schools or geographical regions are as follows—Italy: 20%; Austria, Germany, and Switzerland: 18%; North America: 16%; France: 15%; Great Britain and Ireland: 9%; Belgium and the Netherlands: 7%; Russia: 4%; Scandinavia: 3%; Spain, Portugal, Latin America: 3%; Eastern Europe: 2%; the Middle East, India, and Far East: 2%; and Modern Greece: 1%.

The term "monograph" has been defined broadly to include treatises (and published dissertations), biographies, *catalogues raisonnés* and other works catalogues, personal bibliographies, and artists' writings that are of an autobiographical or theoretical nature and illuminate the artist's creative process. I have selectively included the letters but have excluded the poetry, plays, and fiction produced by visual artists. Articles on single artists appearing in periodicals or collections (e.g., *Festschriften,* yearbooks, and general museum catalogues) are also not listed.

Every bibliography that selects from thousands of titles is in the final analysis always a matter of personal taste and reflects not only the selector's background but also what is in vogue at a given time. The present volume is no exception. No apology is offered for titles omitted that another compiler might have included, but I would certainly like to know why my readers would have selected differently and invite their suggestions, just as I shall be grateful for suggestions on how to improve the quality of the work overall.

I have made a serious effort to include books that reflect the current research interests of graduate students at a major university and have tried to anticipate trends. This is not easy in a field as protean as art history that now includes many

subjects that were not considered germane to it when the first monograph bibliographies were compiled by Miss Lucas for her original *Harvard List of Books on Art* (Cambridge, Mass., Harvard University Press, 1938), its predecessors, and its successors.

In a day when it is possible to program a computer to spin off bibliographies on any subject by printing out relevant and appropriately coded titles from bibliographical data bases that are in themselves the machine-generated products of national and trade bibliographies, the present volume may seem like an anachronism. Before they were found worthy of being included, the books for the present compilation were personally examined in the stacks of a mature and well-stocked art library in order to identify publications that ought to be the backbone of the monographs collection of a much younger art library with a comprehensive scope and provide guidance for its acquisitions program.

The books were chosen for a variety of reasons. Some are acknowledged as definitive standard works, others, although perhaps unfamiliar, have been included because I considered them superior to the better-known standard works; some are the only works available on a given artist. The latter is especially true for artists who have not yet received monographic treatment but have received critical attention through substantial exhibitions and the catalogues accompanying them.

It is my hope that this volume, even if it does not immediately fill the gap that exists in the bibliographical literature on artists' monographs, will have a useful function until the field produces a better one.

I dedicate this book to the memory of Edna Louise Lucas, who as a librarian and a bibliographer has helped innumerable scholars and students of art history and who, by her example, taught me the joys of making personal bibliographies.

Wolfgang M. Freitag
Cambridge, Massachusetts
Spring 1985

NOTES

1. Roskill, Mark W. *What Is Art History?* New York, Harper & Row, 1976, p. 14.

2. Nelson, Diane. "Methods of Citation Analysis in the Fine Arts." *Special Libraries*, 68 (11), Nov. 1977, pp. 390–395.

3. Simonton, Wesley C. *Characteristics of the Research Literature of the Fine Arts during the Period 1948–1957.* Diss. (Ph.D.), Univ. of Illinois (Urbana), 1960.

4. Stam, Deirdre C. *The Information-Seeking Practices of Art Historians in Museums and Colleges in the United States, 1982–83.* Diss., Columbia Univ., School of Library Science, 1984.

5. Jones, Lois S. *Art Research Methods and Resources.* 2 ed., rev. and enlarged. Dubuque, Iowa, Kendall/Hunt, 1984, p. 53.

6. Riggs, Timothy A., compiler. *The Print Council Index to Oeuvre-Catalogues of Prints by European and American Artists.* Millwood, N.Y., Kraus International, 1983.

7. Jones, Lois S. *op. cit.*

8. Kleinbauer, W. Eugene, and Slavens, Thomas P. *Research Guide to the History of Western Art.* Chicago, American Library Association, 1982.

9. Muehsam, Gerd. *Guide to Information Sources in the Visual Arts.* Santa Barbara, Cal./Oxford, England, Jeffrey Norton, 1978; distrib. by ABC-Clio.

ACKNOWLEDGMENTS

For help with the present work I am much indebted to Robert S. Sennett, who assisted me in selecting from the mass of the available literature the principal and most noteworthy titles, who was indefatigable in combing the stacks of the Harvard Fine Arts Library for copies to be inspected, who verified the entries, and who also had a major hand in organizing the material and preparing the manuscript for the press. I am also grateful to William S. Johnson, presently editor of the *International Photography Index*, formerly a lecturer in photography at Harvard and public services librarian in its Fine Arts Library, who is responsible for the selection of the photographers and the monographs devoted to them that are included.

Special thanks go to Martha Older and Caroline Ware Rusten, who typed most of the manuscript, and to Judy Morrison, my secretary, for sundry contributions to the work while it was in progress.

Grateful recognition must also be made to the staff of the Harvard Fine Arts Library for their forbearance—especially during the early stages of the project when our requests for recalls, shelflist and in-process information for books that were not immediately accessible were testing their patience daily.

The list of acknowledgments would be incomplete if it did not mention the assistance I have received from members of the faculty of the Fine Arts Department and from Harvard students who have contributed so much to this work, either indirectly by letting me observe them daily in their research and study habits or directly by their frank criticism of books they have used and by making suggestions for new purchases.

Finally, I would like to express my profound gratitude to the officers of the J. Paul Getty Trust, without whose most generous support I could neither have spared the time nor afforded the bibliographical and technical support necessary to bring the project of the bibliography to fruition.

W.M.F.

SOME NOTES ON STYLE AND USE

The material in this bibliography has been organized in a form convenient for the user. The arrangement is alphabetical by the artists' and authors' full last names. When an artist is known by several names, I have, in general, used the one by which he or she is best known. Cross-references are provided when the preferred form of the name is not clear, as in the case of MAN RAY, or for artists who are known chiefly by their pseudonyms. Medieval and Renaissance artists, especially the early Italians whose real name is joined to that of their father, birthplace, or workshop are listed under their best-known names. Thus, for example, DESIDERIO DA SETTIGNANO is found under DESIDERIO, and ANDREA DEL SARTO, whose family name was D'AGNOLO, is found under SARTO. In the first case, a reference from SETTIGNANO leads the user to look under DESIDERIO; in the second, the cross-reference has been omitted because the artist's real name is practically never used. If the artist is known by several variations of his name, the entry is made under the most common form and as many references are made as needed.

Works whose subjects include more than one artist are found under the artist whose name comes earliest in the alphabet. Thus, a book on TURNER, COLE, and HUNT will be listed under COLE, with cross-references to that entry under TURNER and HUNT. The exception to this occurs when the identifying artist has not been the subject of a separate monograph. In such cases, the item is found under the artist whose name follows in the alphabet. For instance, KENZAN AND HIS TRADITION: KENZAN, KOETSU, KORIN, AND SOTATSU will be found under KOETSU since there is no separate listing for KENZAN. Members of the same family are listed together and the monographs on them entered in one alphabet, so that all the books on the DELLA ROBBIAS, for example, will be found together, without regard to the subject's first name.

Anonymous artists that are known to us only by their initials or marks (monograms) or by artificial catch-names beginning with Master or *Meister* are found in their appropriate place in the alphabet. The idiosyncrasies of certain archaic and foreign spellings such as "J" for "I" have been retained. The Dutch letter "IJ" is customarily transcribed as "Y" in English texts, and that is done here. Thus, VAN DIJCK remains VAN DYCK.

Diacritical marks that alter the sound of a vowel or affect the position of a consonant (as in Slavic vernacular alphabets) have been ignored in the alphabetizing of foreign names. For instance, the German *umlaut* (ü) is considered "U," not "UE," and, consequently, entries for MÜLLER follow those for MUELLER. Transliterations

of the names of artists that do not originally appear in the roman alphabet, i.e., LARIANOV, follow the standard form adopted by the Library of Congress. Foreign names that include prepositions such as VAN, VON, DE, or DELLA are entered under the part of the name which follows the prefix: DYCK, ANTHONY VAN or PORTA, GUGLIELMO DELLA.

These rules for alphabetization apply equally to the entries for artists and to the names of the authors. Institutions such as museums and galleries or associations and corporate bodies that appear as authors of catalogues and congress proceedings are found under the vernacular.form of their official name, and if their location is not part of the name it has been added in parentheses in the accepted English version.

The bibliographical description for each entry follows exactly the information presented on the title page of the book in hand. In some cases, this has meant accepting variations of forms of a name for the same author. In such cases, the "literary units principle" adopted in many library catalogues to bring together all the works of an author under one form of the name, has *not* been upheld, and all the variant spellings found on the title pages appear in the text. An effort has been made, however, to bring such entries together in the author index, and thus an exact correlation between author entries in the index and author entries in the text does not necessarily exist. This applies to both individual authors and to corporate bodies as authors (e.g., museums).

When several forms of entry are possible, preference is given to the personal author or authors, rather than to the sponsoring institution. An exception to this are exhibition catalogues, which are usually found under the name of the sponsoring institution. So-called "museum monographs," i.e., books which accompany an exhibition but are the work of one author, are treated as monographs and not as exhibition catalogues.

When two authors have written a work jointly or a publishing house imprint includes two cities, both are listed. If three or more authors are involved, however, only the first author is listed, and multiple authorship is indicated by *et al.*, and when three or more cities are places of publication, only the first is given without mention of the others.

In the few rare instances when a book is a compilation of several short monographs without the aegis of an institution and without an editor, the work is listed under the name of the contributor whose piece appears first.

Entries are cited in the index by item number not by page.

The abbreviation (CR) is used throughout the text for *catalogue raisonné*.

A SELECTION OF BIOGRAPHICAL DICTIONARIES AND OTHER REFERENCE WORKS CONTAINING INFORMATION ON ARTISTS

The most recent works are still in print, the others are readily found in large public and art libraries.

INTERNATIONAL

Arntz, Wilhelm F. *Verzeichnis der seit 1945 erschienenen Werkkataloge zur Kunst des 20. Jahrhunderts.* Haag/Obb., Verlag Gertrud Arntz—Winter, 1975

Bartsch, Adam von. *Le peintre graveur.* 21 v. Wien, Degen, 1803–1821. Reprints: Leipzig, Barth, 1854–1876; Hildesheim, Olms, 1970.

Browne, Turner and Partnow, Elaine. *Macmillan biographical encyclopedia of photographic artists and innovators.* N.Y., Macmillan, 1983.

Bryan, Michael. *A biographical and critical dictionary of painters and engravers.* 2 v. London, Carpenter, 1816.

Clement, Clara E. *Women in the fine arts.* Boston and N.Y., Houghton Mifflin, 1904.

Colnaghi & Co. (London). *Photography: the first eighty years.* [catalogue of an exhibition] 27 October to 1 December 1976. Text by Valerie Lloyd. London, P. & D. Colnaghi, 1967.

Columbia University Libraries. Avery Architectural Library. *Avery obituary index of architects and artists.* Boston, G.K. Hall, 1980. 2 ed.

Contemporary artists. Edited by Muriel Emanuel et al. London, Macmillan, 1983. 2 ed.

Darmstaedter, Robert. *Reclam's Künstlerlexikon.* Stuttgart, 1979.

Delteil, Loÿs. *Le peintre-graveur illustré.* 31 v. Paris, Delteil, 1906–30.

Dictionary of contemporary artists. Edited by V. Babington Smith. Oxford/Santa Barbara, Calif., ABC-Clio Press, 1981.

Drake, Wilfred J. *A dictionary of glasspainters and "glasyers" of the tenth to eighteenth centuries.* N.Y., Metropolitan Museum of Art, 1955.

Edouard-Joseph, René. *Dictionnaire biographique des artistes contemporains 1910–1930*. 3 v. Paris, Art et Edition, 1931–33. With 1st supplement, 1936.

Enciclopedia dell'arte antica, classica e orientale. Dir. di redazione Ranuccio Bianchi Bandinelli. 7 v., atlas and 1st supplement. Roma, Encyclopedia Italiana, 1959–73.

Fleming, John, and Honour, Hugh. *The Penguin dictionary of decorative arts*. London, Lane, 1977.

Forschungsunternehmen der Fritz Thyssen Stiftung. *Bibliographie zur Kunstgeschichte des 19. Jahrhunderts: Publikationen der Jahre 1940–1966*. Zusammengestellt von Hilda Lietzmann. München, Prestel, 1968 (Studien zur Kunst des neunzehnten Jahrhunderts, Bd. 4).

——————. *Bibliographie zur Kunstgeschichte des 19. Jahrhunderts: Publikationen der Jahre 1967–1979, mit Nachträgen zu den Jahren 1940–1966*. Zusammengestellt von Marianne Prause. München, Prestel, 1984 (Studien zur Kunst des neunzehnten Jahrhunderts, Bd. 31).

Goldstein, Franz. *Monogramm-Lexikon; internationales Verzeichnis der Monogramme bildenden Künstler seit 1850*. Berlin, de Gruyter, 1964. (continues Nagler, G.K., *Die Monogrammisten*.)

Gould, John. *Biographical dictionary of painters, sculptors, engravers and architects*. 2 v. London, Wilson, 1835.

Gowing, Lawrence. *A biographical dictionary of artists*. London, Macmillan, 1983.

Graves, Algernon. *A dictionary of artists who have exhibited works in the principal London exhibitions from 1760–1893*. London, Henry Graves, 1901. 3 ed. Reprint: Bath, Kingsmead, 1969; N.Y., Burt Franklin, 1970.

Havlice, Patricia P. *Index to artistic biography*. Metuchen, N.J., Scarecrow Press, 1973. With 1st supplement, 1981.

Jakovsky, Anatole. *Peintres naïfs: a dictionary of primitive painters*. N.Y., Universe, 1967. (2 ed.: Basel, Basilius, 1976)

Kindler's Malereilexikon. Ed. by Germain Bazin et al. 6 v. Zürich, Kindler, 1964–71.

Macmillan Encyclopedia of architects. Edited by Adolf K. Placzek. 4 v. N.Y., The Free Press, 1982.

Mathews, Oliver. *Early photographs and early photographers; a survey in dictionary form*. London, Reedminster, 1973.

Mayer, Leo A. *Bibliography of Jewish art*. Jerusalem, Magnes, 1967.

Nagler, Georg K. *Die Monogrammisten und diejenigen bekannten und unbekannten Künstler aller Schulen*. 5 v. München, Franz, 1858–79. *General-Index*. . . . , München, Hirth, 1920. Reprint: Nieuwkoop, De Graaf, 1966, (including the *Index*).

——————. *Neues allgemeines Künstler-Lexikon*. 22 v. München, 1835–1852. Reprint: Leipzig, Schwarzenberg & Schumann, 1924 (25 v.).

Naylor, Colin, and P-Orrige, Genesis. *Contemporary artists.* N.Y., St. Martin's Press, 1977.

Newhall, Beaumont, and Newhall, Nancy. *Masters of photography.* N.Y., Braziller, 1958.

Osborne, Harold. *The Oxford companion to art.* Oxford, Clarendon Press, 1970.

_____. *The Oxford companion to the decorative arts.* Oxford, Clarendon Press, 1975.

Pavière, Sydney, H. *A dictionary of flower, fruit, and still life painters.* 4 v. Leigh-on-Sea, Lewis, 1962–64.

Pevsner, Nikolaus, Fleming, John, and Honour, Hugh. *A dictionary of architecture.* Rev. and enlarged. London, Lane, 1975.

Portoghesi, Paolo. *Dizionario enciclopedico di archittetura e urbanistica.* 6 v. Roma, Istituto Editoriale Romano, 1968–69.

Riggs, Timothy A. *The Print Council index to oeuvre-catalogues of prints by European and American artists.* Millwood, N.Y., Kraus, 1983.

Schidlof, Leo. *The miniature in Europe in the 16th, 17th, 18th and 19th centuries.* 4 v. Graz, Akademische Druck– und Verlagsanstalt, 1964.

Smith, Veronica B. *International directory of exhibiting artists.* v. 1– . 1983– . Oxford/Santa Barbara, Calif., ABC-Clio Press, 1983.

Spooner, S. *A biographical history of the fine arts.* N.Y., Putnam, 1852.

Thieme, Ulrich, and Becker, Felix. *Allgemeines Lexikon der bildenden Künstler von der Antike bis zur Gegenwart.* 37 v. Leipzig, Seemann, 1907–50.

Vollmer, Hans. *Allgemeines Lexikon der bildenden Künstler des XX. Jahrhunderts.* 6 v. Leipzig, Seemann, 1953–62.

Meissner, Günter. *Allgemeines Künstlerlexikon. Die bildenden Künstler aller Zeiten und Völker.* Band 1 (Aa–Alexander)– . Leipzig, VEB E.A. Seemann, 1983– .

Tufts, Eleanor. *Our hidden heritage, five centuries of women artists.* London/N.Y., Paddington, 1974.

Wasmuths Lexikon der Baukunst. 5 v. Berlin, 1929–37.

Weilbach, Philip. *Weilbachs Kunstnerleksikon.* 3 v. København, Aschehoug, 1947–52. 3 ed.

Who's Who in architecture: from 1400 to the present day. Gen. ed. J.M. Richards; Adolf K. Placzek, American consultant. N.Y., Holt, Rinehart and Winston, 1977.

AUSTRALIA AND NEW ZEALAND

Germaine, Max. *Artists and galleries of Australia and New Zealand.* Sydney, etc. Landsdowne, 1979.

McCulloch, Alan. *Encyclopedia of Australian art.* London, Hutchinson, 1968.

AUSTRIA

Schmidt, Rudolf. *Österreichisches Künstlerlexikon von den Anfängen bis zur Gegenwart.* v. 1– . Wien, Tusch, 1974– .

CANADA

Harper, J. Russell. *Early painters and engravers in Canada.* Toronto, Univ. of Toronto Press, 1970.

MacDonald, Colin S. *Dictionary of Canadian artists.* Ottawa, Canadian Paperbacks, 1967– .

EASTERN EUROPE AND RUSSIA

Gorina, Tatiana G., and Vol'tsenburg, Oskar E. *Khudozhniki narodov SSSR.* Biobibliograficheskii slovar. Moskva, Iskusstvo, 1970.

Maurin-Bialostocka, Jolanta et al. *Słownik artystów polskich i obcych w Polsce działa jacych: malarze, rzezbiarze, graficy.* v. 1—Wrocław, Zakładł. Narodowy im Ossolinskich, 1971– .

Mazalič, Doko. *Leksikon umjetnika: slikara, vajara, graditelja, zlatara, kaligrafa i drugih koji su radili u Bosni i Hercegovini.* Sarajevo, Veselin Maslěsa, 1967.

Neumann, Wilhelm. *Lexikon baltischer Künster.* Riga, Jonck & Doliewsky, 1908. Reprinted: Hannover-Döhren, Hirschheydt, 1972.

Prut, Constantin. *Dictionar de arta moderna.* Bucuresti, Albatross, 1982.

Rainov, Bogomil N. *Portreti.* Sofia, Bulgarski pisatel, 1975.

Toman, Prokop, and Toman, Prokop H. *Dodatky, Ke slovniku; československych výtvarných umělcu.* Praha, Nakladatelstvi Krásné literatury, hudby a umeni, 1955.

Zador, Anna, and Istvan, Genthon. *Müveszeti lexikon.* 4 v. Budapest, Akademiai Kiado, 1965–68.

FRANCE

Auvray, Louis. *Dictionnaire, général des artistes de l'école française.* 2 v. Paris, Renouard, 1882–1885. (Supplement, 1887. Reprint: N.Y. Garland, 1979)

Baudicour, Prosper de. *Le graveur français continué, ou catalogue raisonné des estampes gravées par les peintres et les dessinateurs de l'école française nés dans le XVIIIe siècle.* 2 v. Paris, Bouchard Huzard, Rapilly [etc.], 1859–1861. Reprint: Paris, de Nobele, 1967.

Bénézit, Emmanuel. *Dictionnaire critique et documentaire des peintres, sculpteurs, dessinateurs et graveurs.* 10 v. Paris, Gründ, 1976. 3 ed.

Bonafons, Louis A., *Known as* Abbé de Fontenai. *Dictionnaire des artistes.* 2 v. Paris, Vincent, 1776. Reprint: Genève, Minkoff, 1972.

GERMANY

Andresen, Andreas. *Der deutsche Peintre-Graveur, oder Die deutschen Maler als Kupferstecher nach ihrem Leben und ihren Werken, von dem letzten Drittel des 16. Jahrhunderts bis zum Schluss des 18. Jahrhunderts, und in Anchluss an Bartsch's Peintre-graveur.* 5 v. Leipzig, Rudolph Weigel, Alexander Danz, 1864–78. Reprints: N.Y., Collectors Editions, 1969; Hildesheim, Olms, 1973.

——————. *Die deutschen Maler-Radirer (Peintres-Graveurs) des neunzehnten Jahrhunderts nach ihren Leben und Werken.* 5 v. Leipzig, Alexander Danz, 1878. Reprints: Hildesheim, Olms, 1971; N.Y., Garland, 1978.

Hollstein, F.W.II. *German engravings, etchings and woodcuts, c. 1400–1700. v. 1– . Amsterdam, Hertzberger, 1954– .*

GREAT BRITAIN

Colvin, Howard. *A biographical dictionary of British architects, 1600–1840.* London, Murray, 1978.

Harvey, John. *English medieval architects; a biographical dictionary down to 1550, incl. master masons, carpenters, carvers, building contractors and others responsible for design . . . with contributions by Arthur Oswald.* London, Batsford, 1954.

Johnson, J., and Greutzner, A. *The dictionary of British artists 1880–1940; an Antique Collectors' Club Research Project listing 41,000 artists.* Woodbridge, Suffolk, Antique Collectors' Club, 1976.

Redgrave, Samuel. *A dictionary of artists of the English school: painters, sculptors, architects, engravers and ornamentists; with notices of their lives and work.* London, Bell, 1878. 2 ed. Reprint: Amsterdam, Hissink, 1970.

Strickland, Walter G. *A dictionary of Irish artists.* 2 v. Dublin, Maunsel, 1913. Reprint: N.Y., Hacker, 1968.

Waters, Grant M. *Dictionary of British artists working 1900–1950.* Eastbourne, Eastbourne Fine Art, 1975.

Who's who in art. Havant, England, Art Trade Press, 1982.

Wood, Christopher. *The dictionary of Victorian painters.* Woodbridge, Suffolk, Christopher Wood Ltd., 1978. 2 ed.

ITALY

Baldinucci, Filippo. *Notizie de' professori del disegno da Cimabue [etc.].* 21 v. Firenze, Stecchi e Pagani, 1767–74. *Index* published in Florence by Allegrini in 1813.

Bellori, Giovanni P. *Le vite de' pittori, scultori et architetti moderni.* A cura di Evelina Borea. Introd. by Giovanni Previtali. Torino, Einaudi, 1976.

Bessone-Aurelj, Antonietta M. *Dizionario degli scultori ed architetti italiani.* Genova, etc., Editrice Dante Alighieri, 1947.

Catalogo nazionale Bolaffi d'arte moderna. Torino, Bolaffi, 1962– .

Commanduci, Agostino M. *Dizionario illustrato dei pittori, disegnatori e incisori italiani moderni e contemporanei.* 4 ed. . . . a cura di una redazione diretta da Luigi Servolini. 5 v. Milano, Patuzzi, 1970–74.

Dizionario Bolaffi degli scultori italiani moderni. Torino, Bolaffi, 1972.

Dizionario enciclopedia Bolaffi dei pittori e degli incisori italiani, dall XI al XX secolo. 11 v. Torino, Bolaffi, 1972–76.

Dominici, Bernardo de'. *Vite dei pittori, scultori ed architetti napoletani.* 3 v. Napoli, Ricciardi, 1742–44.

Lanzi, Luigi. A. *Storia pittorica della Italia dal risorgimento delle belle arti fin presso al fine del XVIII secolo.* 3 v. 3d rev. ed. Bassano, Remondini, 1809. Eng. trans. by Thomas Roscoe, 6 v.: London, Simpkin and Marshall, 1828.

Malvasia, Carol C. *Felsina pittrice vite dei pittori bolognesi.* 2 v. Bologna, Tipografia Guidi all' Ancora, 1841. Reprint: Bologna, Forni, 1967.

Pascoli, Lione. *Vite de' pittori, scultori ed architetti moderni.* 2 v. Roma, de Rossi, 1730–1736. Reprint: Roma, Calzone, 1933.

Temanza, Tommaso. *Vite dei piu celebri architetti e scultore veneziani.* Venezia, Palese, 1778. Reprint: Milan, Labor, 1966.

Vasari, Giorgio. *Le vite de' piu eccellenti pittori, scultori e architettori.* Di nuovo dal medesimo riviste et ampliate. 3 v. Fiorenza, Giunti, 1568. Eng. ed. by Blashfield & Hopkins, 4 v.: New York, Scribner, 1896. New Ital. ed.: A cura di Rosanna Bettarini. Commentato secolare a cura di Paola Barocchi, 7 v. Firenze, Sansoni, 1966–76.

Venturi, Adolfo. *Storia dell' arte italiana.* 11 v. Milano, Hoepli, 1901–40. Reprint: Nendeln, Liechtenstein, Kraus, 1967.

_____ . *Index.* Prepared by Jacqueline D. Sisson. Nendeln, Liechtenstein, Kraus, 1975 [Section 2 = *Artists Index*].

LATIN AMERICA

Findlay, James A. *Modern Latin American art: a bibliography.* Westport, Conn./ London, Greenwood Press, 1983.

Handbook of Latin American art—Manual de arte latino americano. Gen. ed. Joyce W. Bailey. 2 v. Santa Barbara, Calif./Oxford, ABC-Clio Information Services, 1984.

Merlino, Adrian. *Diccionario de artistas plasticos de la Argentina, siglos XVIII-XIX-XX.* Buenos Aires, Instituciones de la Argentina Vinculadas a las Artes Plasticas, 1954.

Ortega Ricaurte, Carmen. *Diccionario de artistas en Colombia.* Bogota, Ediciones Tercer Mundo, 1965.

Pontul, Roberto. *Dicionario das artes plásticas no Brasil.* Rio de Janeiro, Editora Civilização Brasileira, 1969.

SOUTH AFRICA

Berman, Esmé. *Art and artists of South Africa; an illustrated biographical dictionary and historical survey of painters, sculptors and graphic artists since 1875.* New updated and enlarged ed. of work first published 1970. Cape Town/Rotterdam, A.A. Balkema, 1983.

SPAIN AND PORTUGAL

Ceán Bermudez, Juan A. *Diccionario histórico de los mas illustres profesores de las bellas artes en España.* 6 v. Madrid, Ibarra, 1800. Reprint: N.Y., Kraus, 1965.

Ossorio y Bernard, Manuel. *Galeria biográfica de artistas españoles del siglo XIX.* Continuacion del *Diccionario* de Ceán Bermudez hasta el año 1882. Madrid, Moreno y Rojas, 1883–84. Reprint. Madrid, Gaudi, 1975.

Pamplona, Fernando de. *Dicionário de pintores e escultores portugueses ou que trabalharam em Portugal.* 4 v. Lisboa, 1954–59.

Rafols, José F. *Diccionario de artistas de Cataluña, Valencia y Baleares.* 5 v. Barcelona/Bilbao, Edicions Catalanes y La Gran Enciclopedia Vasca, 1980–81.

Tannock, Michael. *Portuguese twentieth century artists; a biographical dictionary.* Shopwyke Hall, Chichester, W. Sussex, England, Phillmore, 1978.

SWITZERLAND

Brun, Carl. *Schweizerisches Künstlerlexikon.* 4 v. Frauenfeld, Huber, 1905–17. Reprint: Nendeln, Liechtenstein, Kraus, 1967.

Plüss, Eduard, and Tavel, Hans C. von. *Künstlerlexikon der Schweiz: XX. Jahrhundert.* 2 v. Frauenfeld, Huber, 1958–67.

UNITED STATES

The Britannica encyclopedia of American art. Chicago, Encyclopedia Britannica; dist. N.Y., Simon & Schuster, 1973.

Cederholm, Theresa D. *Afro-American artists; a bio-bibliographical directory.* Boston, Trustees of the Boston Public Library, 1973.

Collins, Jimmie L. *Women artists in America; eighteenth century to the present.* 2 v. Chattanooga, Univ. of Tennessee Press, 1973–75.

Cummings, Paul. *A dictionary of contemporary American artists.* N.Y., St. Martin's Press, 1977. 3 ed.

Davis, Lenwood G., and Sims, Janet L. *Black artists in the United States; an annotated bibliography of books, articles, and dissertations on black artists, 1779–1979.* Westport, Conn., Greenwood Press, 1980.

Fielding, Mantle. *American engravers upon copper and steel.* Biographical sketches and check lists of engravings; a supplement to David McNeely Stauffer's *American engravers.* Philadelphia, privately printed, 1917.

――――――. *Dictionary of American painters, sculptors, and engravers.* Philadelphia, Printed for the subscribers, 1926. Enlarged and revised edition by Genevieve C. Doran. Green Farms, Conn., 1974.

Groce, George C., and Wallace, David H. *The New-York Historical Society's dictionary of artists in America 1564–1860.* New Haven, Yale Univ. Press, 1957.

Igoe, Lynn M., with James Igoe. *250 years of Afro-American art; an annotated bibliography.* N.Y./London, Bowker, 1981.

Karpel, Bernard. *Arts in America, a bibliography.* 4 v. Washingon, D.C., Smithsonian Institution Press, 1979.

Rosenberg, Bernard. *Olana's guide to American artists; a contribution toward a bibliography.* 2 v. Riverdale, NY, Olana Gallery (printed for private distribution only), 1978.

Samuels, Peggy, and Samuels, Harold. *The illustrated biographical encyclopedia of artists of the American West.* Garden City, NY, Doubleday, 1976.

Stouffer, David McNeely. *American engravers upon copper and steel.* 2 v. N.Y., Grolier Club, 1907.

Who's who in American art. Ed. by the Jaques Cattell Press. N.Y./London, Bowker, 1984. 16 ed.

Withey, Henry F., and Withey, Elsie. *Biographical dictionary of American architects.* Los Angeles, Hennessey & Ingalls, 1970.

Wodehouse, Lawrence. *American architects from the Civil War to the First World War.* Detroit, Gale, 1976.

_____. *American architects from the first World War to the present.* Detroit, Gale, 1977.

THE NEAR EAST

Encyclopedia of Islam. New ed. by H.A.R. Gibb et al. Leiden, Brill/London, Luzac, 1954– .

Israel Museum (Jerusalem). *Here and now: Israeli art.* [catalog of an exhibition] autumn 1982. Jerusalem, Israel Museum, 1982.

The Jewish Museum (New York). *Artists of Israel, 1920–1980* [catalog of an exhibition]. Exhibition curator Susan Tumarkin Goodman. Detroit, Wayne State Univ. Press, 1981.

Martin, Fredrik R. *The miniature painting and painters of Persia, India and Turkey, from the 8th to the 18th century.* London, Quaritch, 1912.

Mayer, Leo A. *Bibliography of Jewish art.* Edited by Otto Kurz. Jerusalem, Magnes Press, 1967.

_____. *Islamic architects and their works.* Geneva, Kundig, 1950.

_____. *Islamic metalworkers and their works.* Geneva, Kundig, 1959.

_____. *Islamic woodcarvers and their works.* Geneva, Kundig, 1958.

THE NETHERLANDS AND BELGIUM

Bernt, Walther. *Die niederländischen Maler und Zeichner des 17. Jahrhunderts.* 5 v. München, Bruckmann, 1979–80.

Friedländer, Max J. *Die altniederländische Malerei.* 14 v. Berlin, Cassirer, 1924–1937. Eng. ed.: *Early Netherlandish painting.* 14 v. Leyden, Sijthoff, 1967–1976.

Hollstein, F.W.H. *Dutch and Flemish etchings, engravings and woodcuts, c. 1450–1700.* v. 1– . Amsterdam, Hertzberger, 1949– . *(Editor, place, and publisher vary).*

Scheen, Pieter A. *Lexicon Nederlandse beeldende Kunstenaars 1750–1950.* 2 v. s' Gravenhage, Pieter A. Scheen, 1969–70.

Hymans, Henri S. *Près de 700 biographies d'artistes belges, parues dans La Biographie nationale, dans L'Art flamand et hollandais, dans Le Dictionnaire des Drs. Thieme et Becker et dans diverses publications du pays et de l'étranger.* Bruxelles, Hayez, 1920.

Mander, Carel van. *Het schilder-boeck.* Haerlem, voor Pachier van Wesbusch, 1604. Eng. ed., trans. by Constant van de Wall: N.Y., McFarlane, 1936. Reprint: N.Y., Arno, 1969.

Seyn, Eugène M.H. de. *Dessinateurs, graveurs et peintres des anciens Pays-Bas; écoles flamande et hollandaise.* Turnhout (Belgique), Brépols (1949?).

Wurzbach, Alfred von. *Niederländisches Künstler Lexikon, auf Grund archivalischer Forschungen.* 3 v. Wien, Halm, 1906–11. Reprint: Amsterdam, Israël, 1968.

THE FAR EAST AND INDIA

Blakemore, Frances. *Who's who in modern Japanese prints.* N.Y./Tokyo, Weatherhill, 1975.

Cahill, James. *An index of early Chinese painters and paintings.* Berkeley, Univ. of California Press, 1980.

Kim, Yŏng-Yun. *Hanguk sŏhwa immyŏng sasŏ.* Seoul, Hangyang munhwasa, 1959.

Lalit Kala Akademi (New Delhi). *Artists directory, covering painters, sculptors, and engravers.* New Delhi, Lalit Kala Akademi, 1966 (?).

Roberts, Laurence P. *A dictionary of Japanese artists. Painting, sculpture, ceramics, prints, lacquer.* With a foreword by John M. Rosenfield. Tokyo/N.Y., Weatherhill, 1976.

Siren, Osvald. *Chinese painting: leading masters and principles.* 7 v. New York, Ronald, 1956–58.

The T.L. Yuan bibliography of Western writings on Chinese art and archaeology. Harrie A. Vanderstappen, editor. London, Mansell, 1975.

Waley, Arthur. *An index of Chinese artists represented in the Sub-department of Oriental Prints and Drawings.* London, British Museum, 1922.

SCANDINAVIA

Gelsteds kunstner-leksikon 1900–1942. [Redigeret av Otto Gelsted]. København, Arthur Jensens Forlag, 1942.

Gran, Henning, and Anker, Peter. *Illustrert norsk kunstnerleksikon: stemmeberettigede, malere, grafikere/tegnere, billedhoggere.* Oslo, Broen, 1956. 2 ed.

Koroma, Kaarlo. *Suomen kuvataiteilijat. Suomen taiteilijaseuran julkaisema elämäkerrasto.* Porvoo, Söderström, 1962.

Lilja, Gösta, et al. *Svenskt konstnärs lexikon; tiotusen svenska konstnärers liv och verk.* 5 v. Malmö, Allhems Förlag, 1952–67.

Munksgaards kunstnerleksikon. Redigeret av Svend P. Jørgenen. København, Munksgaard, [1962].

Norsk kunstnerleksikon: Bildende kunstnere arkitekter—kunsthandverkere. Redigert av nasjonalgalleriet [Leif Østby, editor]. 2v.– . Oslo, Universitetsforlaget, 1982–83.

AALTO, ALVAR, 1898-1976

1. Aalto, Alvar. **Synopsis: painting, architecture, sculpture.** Basel, Birkhauser, 1970. (Geschichte und Theorie der Architektur, 12).

2. Fleig, Karl. **Alvar Aalto, 1922-1962.** Scarsdale, N. Y., Wittenborn, 1963.

3. _____. **Alvar Aalto, 1963-1970.** New York, Praeger, 1971. 2 ed., 1975.

4. _____. **Alvar Aalto.** Zürich, Artemis, 1974. [rev. ed. of Alvar Aalto, 1922-1962 and Alvar Aalto, 1963-1970].

5. _____. **Alvar Aalto: Gesamtwerk. Oeuvres complètes. Complete works.** 3 v., Zürich, Artemis, 1970-1978.

6. Gozaka, A. **Arkhitektura i gumanizm; sbornik statei Alvar Aalto.** Moskva, Progress, 1978.

7. Gutheim, Frederick. **Alvar Aalto.** New York, Braziller, 1960.

8. Miller, William Charles. **Alvar Aalto; a bibliography.** Monticello, Ill., Council of Planning Librarians, 1976.

9. Museum Folkwang (Essen). **Alvar Aalto; das architektonische Werk.** Ausstellung 18. März-22. April 1979. Katalog Redaktion, Zdenek Felix. Essen, Museum Folkwang, 1979.

10. Museum of Modern Art (New York). **Architecture and furniture: Aalto.** New York, Museum of Modern Art, 1938.

11. Neuenschwander, Eduard and Neuenschwander, Claudia. **Alvar Aalto and Finnish architecture.** London, Architectural Press; New York, Praeger, 1954.

12. Palazzo Strozzi (Florence). **L'opera di Alvar Aalto.** Cat. della mostra a cura di Leon Mosso, 14. nov. 1965-9 genn. 1966. Milano, Edizioni de Comunità, 1965.

13. Quantrill, Malcolm. **Alvar Aalto.** London, Secker & Warburg, 1982.

14. Schildt, Göran. **Alvar Aalto sketches.** Ed. by G. Schildt. Trans. from Swedish by Stuart Utrede. Cambridge, Mass., M.I.T. Press, 1978.

15. _____. **The sculptures of Alvar Aalto.** Helsinki, Otava, 1967.

AALTONEN, VAINO WALDEMAR, 1894-1966

16. Okkonen, Onni. **Wäinö Aaltonen.** Helsinki, Söderström, 1951. 2 ed.

ABBATE, NICCOLO DELL', ca. 1512-1571

17. Beguin, Sylvie M. **Mostra di Nicolo dell'Abate.** Catalogo critico a cura di S. M. Beguin. Bologna, Palazzo dell'

Archiginnasio, 1 sett.-20 ott. 1969. Bologna, Ediz. Alfa, 1969.

18. Bellochi, Ugo. **Il Mauriziano.** Gli affreschi di Nicolo dell'Abate nel nido di Ludovico Ariosto. Modena, Muratori, 1974. (Deputazione di storia patria per le antiche provincie Modenesi. Monumenti, 25).

19. Godi, Giovanni. **Nicolo dell'Abate e la presunta attività del Parmigianino a Soragna.** Parma, Luigi Battei, 1976. (Collana di storia, arti figurative e architettura diretta da Gianni Capelli, 11).

20. Zanotti, Giovanni Pietro Cavazzoni. **Le pitture de Pellegrino Tibaldi e di Niccolo Abbati esistente nell'Instituto di Bologna, descritte et illustrate da Giampietro Zanotti.** Venezia, Pasquali, 1756.

ABBEY, EDWIN AUSTIN, 1852-1911

21. Lucas, Edward V. **Edwin Austin Abbey, royal academician; the record of his life and work.** 2 v. London, Methuen/New York, Scribner, 1921.

22. Yale University Art Gallery (New Haven). **Edwin Austin Abbey, 1852-1911.** [Catalog of] an exhibition, Dec. 6, 1973-Feb. 17, 1974. Introd. by Alan Shestak. Essays by Kathleen Foster and Michael Quick. New Haven, Yale University Art Gallery, 1973.

ABBOTT, BERENICE, 1898-

23. Marlborough Gallery (New York). **Berenice Abbott.** Exhibition, Jan. 4-Jan. 24, 1976. New York, Marlborough Gallery, 1976.

24. O'Neal, Hank. **Berenice Abbott, American photographer.** Introd. by John Canaday; commentary by Berenice Abbott. New York, McGraw-Hill, 1982.

25. Vestal, David. **Berenice Abbott: photographs.** Foreword by Muriel Rukeyser. Introduction by David Vestal. New York, Horizon, 1970.

ACKERMANN, MAX, 1887-1975

26. Grohmann, Will. **Max Ackermann.** Stuttgart, Kohlhammer, 1955.

27. Hoffmann, Dieter. **Max Ackermann: Zeichnungen und Bilder.** Frankfurt a.M., Societäts-Verlag, 1965.

28. Langenfeld, Ludwig. **Max Ackermann: Aspekte seines Gesamtwerkes.** Stuttgart, Kohlhammer, 1972.

29. Leonhard, Kurt. **Max Ackermann: Zeichnungen und Bilder aus fünf Jahrzehnten.** Frankfurt a.M., Societäts-Verlag, 1966.

30. Mittelrhein-Museum (Koblenz). **Max Ackermann: Gemälde 1908-1967.** Ausstellung, 2. Sept.-29. Okt. 1967. Katalog Bearbeitung Maria Velte. Koblenz, Mittelrhein Museum, 1967.

31. Württembergischer Kunstverein (Stuttgart). **Max Ackermann: Aspekte des abstrakten Werkes 1919 bis 1973.** Ausstellung, 8. Aug.-30. Sept. 1973. Stuttgart, Württ. Kunstverein, 1973.

ADAM

ADAM, HENRI GEORGES, 1904-1967

32. Waldemar-George [pseud.]. **Adam.** Par W.-George et Ionel
 Jianov. Paris, Arted, 1968.

ADAM, JAMES, 1758-1794

 ROBERT, 1728-1792

33. Adam, Robert. **Ruins of the palace of the emperor Diocletian
 at Spalato in Dalmatia.** London, Printed for the Author,
 1764.

34. _____. **The Works in architecture of Robert and James
 Adam.** Ed. with an introd. by Robert Oresko. London,
 Academy Editions/New York, St. Martin's, 1975. [Rev. and
 enl. version of 1902 ed. publ. in 3 v. by Thecard].

35. Beard, Geoffrey W. **The work of Robert Adam.** New York, Arco,
 1978.

36. Bolton, Arthur T. **The architecture of Robert and James Adam
 (1758-1794).** 2 v. London, Country Life, 1922.

37. Fitzgerald, Percy. **Robert Adam, artist and architect; his
 works and his system.** London, Fisher Unwin, 1904.

38. Fleming, John. **Robert Adam and his circle in Edinburgh and
 Rome.** Cambridge, Mass., Harvard University Press/London,
 Murray, 1962.

39. Harris, Eileen. **The furniture of Robert Adam.** London,
 Tiranti, 1963.

40. Lees-Milne, James. **The age of Adam.** London, Batsford, 1947.

41. Musgrave, Clifford. **Adam and Hepplewhite and other neo-
 classical furniture.** London, Faber, 1966.

42. Spiers, Walter L. **Catalogue of the drawings and designs of
 Robert and James Adam in Sir John Soane's Museum.**
 Cambridge, Chadwyck-Healey/Teaneck, N.J., Somerset House,
 1979.

43. Stillman, Damie. **The decorative work of Robert Adam.**
 London, Tiranti, 1966.

44. Swarbrick, John. **Robert Adam and his brothers; their lives,
 work and influence on English architecture, decoration
 and furniture.** London, Batsford, 1915.

45. Yarwood, Doreen. **Robert Adam.** New York, Scribner, 1970.

ADAMS, ANSEL, 1902-1984

46. Adams, Ansel. **The portfolios of Ansel Adams.** Boston, New
 York Graphic Society, 1977.

47. Newhall, Nancy. **Ansel Adams, the eloquent light. His pho-
 tographs and the classic biography.** Millerton, New York,
 distributed in U.S. by Harper & Row, New York, 1980.

AERTSEN, PIETER, 1508-1575

48. Moxey, Keith P. F. **Pieter Aertsen, Joachim Beuckelaer and
 the rise of secular painting in the context of the
 Reformation.** New York, Garland, 1977.

49. Sievers, Johannes. **Pieter Aertsen; ein Beitrag zur
 Geschichte der niederländischen Kunst im XVI. Jahrhundert.**
 Leipzig, Hiersemann, 1908.

AGAM, YAACOV, 1928-

50. Agam, Yaacov. **Yaacov Agam.** Texts by the artist. Ed. by
 Paul Kanelski. Trans. from the French by Haakon Chevalier.
 Neuchâtel, Editions du Griffon, 1962.

51. Popper, Frank. **Agam.** New York, Abrams, 1976.

52. Reichardt, Jasia. **Yaacov Agam.** London, Methuen, 1966.

AGOSTINO DI DUCCIO, 1418-1481

53. Bacci, Mina. **Agostino di Duccio.** Milano, Fabbri, 1966.

54. Pointer, Andy. **Die Werke des florentinischen Bildhauers
 Agostino d'Antonio di Duccio.** Strassburg, 1909. (Zur
 Kunstgeschichte des Auslandes, 68).

AICHL, JAN SANTIN see SANTINI-AICHL, JAN BLAŽEJ

AIGNER, LUCIEN, 1901-

55. Aigner, John P., ed. **Lucien Aigner.** Introd. by Cornell
 Capa. New York, International Center for Photography, 1979.
 (ICP Library of photographers, 7).

AIVAZOVSKII, IVAN KONSTANTINOVICH, 1817-1900

56. Barsamov, Nikolai Stepanovich. **Ivan Konstantinovich
 Aivazovskii, 1817-1900.** Moskva, Isskustvo, 1962.

ALBANI, FRANCESCO, 1578-1660

57. Bolognini Amorini, Antonio. **Vita del celebre pittore Fran-
 cesco Albani.** Bologna, Tip. della Volpe al Sassi, 1837.

ALBERS, JOSEF, 1888-1976

58. Albers, Josef. **Homage to the square; ten works by J. Albers.**
 New Haven, Yale University Press, 1962.

59. _____. **Interaction of color.** 2 v. New Haven, Yale
 University Press, 1963.

60. _____. **Interaction of color.** Rev. pocket edition.
 New Haven, Yale University Press, 1975.

61. _____. **Search versus research; three lectures by J. Albers
 at Trinity College, April 1965.** Hartford, Conn., Trinity
 College Press, 1969.

62. Gomringer, Eugen. **Josef Albers, his work as contribution to visual articulation in the twentieth century.** With articles by Clara Diament de Sujo [and others]. New York, Wittenborn, 1968.

63. Museum of Modern Art (New York). **Josef Albers: Homage to the square.** An exhibition organized by the Museum of Modern Art under the auspices of its International Council. New York, Museum of Modern Art, 1964. Distributed by Doubleday, Garden City, N.Y.

64. Spies, Werner. **Albers.** Trans. from German by Herma Plummer. New York, Abrams, 1970.

65. Wissmann, Jürgen. **Josef Albers.** Recklinghausen, Bongers, 1971. (Monographien zur rheinisch-westfälischen Kunst der Gegenwart, 27).

66. Yale University Art Gallery (New Haven). **Josef Albers: paintings, prints, projects.** A catalogue prepared by George Heard Hamilton for an exhibition arranged by Sewell Stillman, April 25-June 18, 1956. New York, Clarke and Way, 1956.

ALBERTI, LEON BATTISTA, 1404-1472

67. Alberti, Leon Battista. **De pictura praestantissima, et nunquam satis laudata arte libri tres absolutissimo.** Basileae, 1540.

68. _____. **De re aedificatoria.** Florentiae, Laurentii, 1485.

69. _____. **De statua.** Introd. di O. Morisani. Catania, Università di Catania, Facolta di Lett. e Filosofia, 1961. (Pubblicazioni, 1).

70. _____. **L'architettura (De re aedificatoria).** Testo latino e traduzione a cura di G. Orlandi. Introd. e note di P. Portoghesi. 2 v. Milano, Polifilo, 1966.

71. _____. **Leone Battista Alberti's kleinere kunsttheoretische Schriften.** I, Originaltext hrsg., übersetzt, erläutert, mit e. Einleitung und Excursen versehen von Dr. Hubert Janitschek. Wien, Braumüller, 1877. (Quellenschriften für Kunstgeschichte und Kunsttechnik, 11).

72. _____. **On painting.** Trans. by J. R. Spencer. New Haven, Yale University Press, 1966. [Trans. of **De Pictura,** first publ. Basel, 1540].

73. _____. **On painting and On sculpture.** The Latin texts of De Pictura and De Statua. Ed. with trans., introd. and notes, by Cecil Grayson. London, Phaidon, 1972.

74. _____. **Opera volgari;** a cura di Cecil Grayson. 3 v. Bari, Laterza, 1960-1973. (Scrittore d'Italia, 218, 234, 254).

75. _____. **Ten books on architecture.** Ed. by J. Rykwert. New York, Transatlantic, 1955. [Trans. of **De re aedificatoria,** first publ. Florence, 1485].

76. Borsi, Franco. **Leon Battista Alberti.** Milano, Electa, 1975.

77. _____. **Leon Battista Alberti.** Trans. by R. G. Carpanini. New York, Harper, 1977.

78. Flemming, Willi. **Die Begründung der modernen Aesthetik und Kunstwissenschaft durch Leon Battista Alberti.** Leipzig, Teubner, 1916.

79. Gadol, Joan. **Leon Battista Alberti, universal man of the early Renaissance.** Chicago, Chicago University Press, 1969.

80. Luecke, Hans-Karl. **Alberti Index: Leon Battista Alberti, De re aedificatoria, Florence, 1485, Index verborum.** 4 v. München, Prestel, 1975-1979.

81. Mancini, Girolamo. **Vita di Leone Battista Alberti.** Firenze, Carnesecchi, 1911. 2 ed.

ALBERTINELLI, MARIOTTO, 1474-1515

82. Borgo, Ludovico. **The works of Mariotto Albertinelli.** New York, Garland, 1976.

ALCAMENES, 5th c. B.C.

83. Capuis, Loredana. **Alkamenes. Fonti storiche e archeologiche.** Firenze, Olschki, 1968. (Univ. di Padova. Pubblicaz. della Fac. di Lettere e Filosofia, 44).

84. Langlotz, Ernst. **Alkamenes-Probleme.** Berlin, de Gruyter, 1952. (Winckelmannsprogramm der Archäologischen Gesellschaft zu Berlin, 108).

ALDEGREVER, HEINRICH, 1502-1558

85. Fritz, Rolf. **Heinrich Aldegrever als Maler.** Dortmund, Ardey, 1959.

86. Geisberg, Max. **Heinrich Aldegrever.** Dortmund, Ruhfus, 1939. (Westfälische Kunsthefte, 9).

87. _____. **Die münsterischen Wiedertäufer und Aldegrever.** Strassburg, Heitz, 1907. (Schriften zur deutschen Kunstgeschichte, 76).

88. Zschelletzschky, Herbert. **Das graphische Werk Heinrich Aldegrevers.** Strassburg, Heitz, 1933. (Studien zur deutschen Kunstgeschichte, 292).

ALECHINSKY, PIERRE, 1927-

89. Alechinsky, Pierre. **Paintings and writings.** Eugène Ionesco: three approaches. Paris, Ives Rivière--Arts et Métiers Graphiques, 1977. [Catalogue of an exhibition, Carnegie Instit., Pittsburgh, Oct. 28, 1977-Jan. 8, 1978, and at the Art Gallery of Ontario, Toronto, March 10-April 20, 1978].

90. _____. **Pierre Alechinsky: 20 Jahre Impressionen.** Oeuvre-Katalog, Druckgraphik. Introd. by Yvon Taillandier. München: Galerie van de Loo, 1967.

ALESSI, GALEAZZO, 1512-1572

91. Alessi, Galeazzo. **Galeazzo Alessi: mostra di fotografie, rilievi, disegni.** Genova, Palazzo Bianco, 16 apr.-12 magg. 1974. Genova, Sagep, 1974.

92. _____. **Galeazzo Alessi e l'architettura del cinquecento;** atti del convegno internazionale di studi. Genova, 16-20 apr. 1974. Genova, Sagep, 1974.

93. Negri, Emmina de. **Galeazzo Alessi, architetto a Genova.** Genova, Univ. di Genova, 1957. (Quaderni dell' Ist. di Storia dell'arte dell'Univ. di Genova, 1).

ALEXANDER, FRANCESCA (ESTHER FRANCES), 1837-1917

94. Alexander, Constance Grosvenor. **Francesca Alexander: a hidden secret.** Cambridge, Mass., Harvard University Press, 1927.

ALFIERI, BENEDETTO INNOCENTE, 1700-1767

95. Bellini, Amedeo. **Benedetto Alfieri.** Milano, Electa, 1978.

ALGARDI, ALESSANDRO, 1602-1654

96. Heimburger-Revalli, Minna. **Alessandro Algardi, scultore.** Città di Castello, Ist. di Studi Romani, 1973.

ALLAN, DAVID, 1744-1796

97. Gordon, Thomas Crouther. **David Allan of Alloa, the Scottish Hogarth.** Alva, Printed by Cunningham, 1951.

ALLSTON, WASHINGTON, 1779-1843

98. Allston, Washington. **Lectures on art, and poems.** Ed. by Richard H. Dana. New York, Baker and Scribner, 1850. Reprint: Gainesville, Scholars' Facsimiles, 1967.

99. Flagg, Jared. **The life and letters of Washington Allston.** New York, Scribner, 1892. Reprint: New York, Blom, 1969.

100. Gerdts, William Henry. **"A man of genius": the art of Washington Allston (1779-1843)** by W. H. Gerdts and Theodore E. Stebbins. Boston, Museum of Fine Arts, 1979.

101. Harding's Gallery (Boston). **Exhibition of pictures painted by Washington Allston.** Boston, Eastburn, 1839.

102. Richardson, Edgar P. **Washington Allston, a study of the romantic artist in America.** Chicago, Chicago University Press, 1948.

103. [Sweetser, Moses Foster]. **Allston.** Boston, Osgood, 1879.

104. Ware, William. **Lectures on the works and genius of Washington Allston.** Boston, Phillips, Sampson, 1852.

ALMA-TADEMA, LAWRENCE, 1836-1912

105. Borger, Rykle. **Drei Klassizisten: Alma-Tadema, Ebers, Vosmaer. Mit einer Bibliographie der Werke Alma-Tadema's.** Leiden, Ex Oriente Lux, 1978. (Mededelingen en verhandlingen van het vooraziatisch-egyptisch genootschap "Ex Oriente Lux," 20).

106. City Art Galleries, Sheffield. **Sir Lawrence Alma-Tadema.** Exhibition at the Mappin Art Gallery, Weston Park, Sheffield, Jul. 3-Aug. 8, 1976. Cat. by Anne L. Goodchild. Sheffield, City Art Galleries, 1976.

107. Ebers, Georg. **Lorenz Alma Tadema; his life and works.** Trans. by Mary J. Safford. New York, Gottsberger, 1886. (Trans. of art. orig. publ. in **Westermanns Monatshefte,** Bd. 59, Oct./Nov. 1885).

108. Metropolitan Museum of Art (New York). **Victorians in togas: paintings by Sir Lawrence Alma-Tadema from the collection of Allen Funt.** Exhib. March-April, 1973. Cat. by Christopher Forbes. New York, Metropolitan Museum, 1973.

109. Royal Academy of Arts (London). **Exhibition of works by Sir Lawrence Alma-Tadema, R. A., O. M.** London, Cloves, 1913. (Winter exhibition, 44th Year).

110. Stephens, Frederic George. **Laurence Alma-Tadema, R. A. A sketch of His life and work.** London, 1895.

111. Standing, Percy Cross. **Sir Lawrence Alma-Tadema.** London, 1905.

112. Swanson, Vern G. **Sir Lawrence Alma-Tadema, the painter of the Victorian vision of the Ancient World.** London, Ash and Grant, 1977.

113. Zimmern, Helen. **Sir Lawrence Alma-Tadema, R. A.** London, Bell, 1902.

ALT, RUDOLF VON, 1812-1905

114. Hevesi, Ludwig. **Rudolf von Alt: sein Leben und sein Werk.** Wien, Stülpnagel, 1905.

115. Koschatzky, Walter. **Rudolf von Alt, 1812-1905.** Salzburg, Residenz Verlag, 1975.

116. Rössler, Arthur. **Rudolf von Alt.** Wien, Graeser, 1921.

ALTDORFER, ALBRECHT, 1480-1538

117. Baldass, Ludwig von. **Albrecht Altdorfer.** Wien, Gallus/ Zürich, Scientia, 1941. 2 ed.

118. _____. **Albrecht Altdorfer. Studien über die Entwicklungs-faktoren im Werk des Künstlers.** Wien, Hölzel, 1923. (Kunstgeschichtliche Einzeldarstellungen, 2).

119. Bayerische Staatsgemäldesammlung (Munich). **Albrecht Altdorfer und sein Kreis.** Amtlicher Katalog der Gedächtnisausstellung zum 400. Todesjahr Altdorfers. München, Wolf, 1938.

120. Becker, Hanna L. **Die Handzeichnungen Albrecht Altdorfers.** München, Filser, 1938. (Münchener Beiträge zur Kunstgeschichte, 1).

121. Benesch, Otto. **Der Maler Albrecht Altdorfer.** Wien, Schroll, 1939.

122. Friedländer, Max J. **Albrecht Altdorfer.** Berlin, Cassirer, 1923.

123. Oettinger, Karl. **Altdorfer-Studien.** Nürnberg, Carl, 1959. (Erlanger Beiträge zur Sprach- und Kunstwissenschaft, 3).

124. Ruhmer, Eberhard. **Albrecht Altdorfer.** München, Bruckmann, 1965.

125. Tietze, Hans. **Albrecht Altdorfer.** Leipzig, Insel, 1923.

126. Voss, Hermann G. A. **Albrecht Altdorfer und Wolf Huber.** Leipzig, Klinkhardt und Biermann, 1910.

127. Waldmann, Emil. **Albrecht Altdorfer.** London and Boston, Medici Society, 1923.

128. Winzinger, Franz. **Albrecht Altdorfer: die Gemälde, Tafelbilder, Miniaturen, Wandbilder, Bildhauerarbeiten; Werkstatt und Umkreis. Gesamtausgabe.** München, Hirmer, 1975.

129. _____. **Albrecht Altdorfer: Graphik, Holzschnitte, Kupferstiche, Radierungen.** München, Piper, 1963.

130. _____. **Albrecht Altdorfer: Zeichnungen. Gesamtausgabe.** München, Piper, 1952.

131. Wolf, Georg Jacob. **Altdorfer.** Bielefeld, Velhagen, 1925.

ALTECHIERI, ALTECHIERO see ALTECHIERO DA ZEVIO

ALTECHIERO DA ZEVIO, 1320-1385

132. Bronstein, Leo. **Altechieri, l'artiste et son oeuvre.** Paris, Vrin, 1932.

133. Mellini, Gian Lorenzo. **Altechiero e Jacopo Avanzi.** Milano, Ediz. di Comunità, 1967.

134. Pettenella, Plinia. **Altichiero e la pittura Veronese del Trecento.** Verona, Vita Veronese, 1961. (Collana monografie d'arte, 3).

135. Schubring, Paul. **Altichiero und seine Schule.** Leipzig, Hiersemann, 1898.

ALTHERR, HEINRICH, 1878-1947

136. Überwasser, Walter and Braun, Wilhelm. **Der Maler Heinrich Altherr, sein Weg und Werk.** Zürich, Orell Füssli, 1938.

ALTINK, JAN, 1885-1971

137. Altink, Jan. **Jan Altink, 21 Oct. 1885-6 Dec. 1971.** Texts by D.H. Douvee and W.J. de Gruyter. 2 v. Heemskerk, Jan Altink Stichting, 1978.

ALTOMONTE, BARTOLOMEO, 1702-1779

MARTINO (MARTIN HOHENBERG), 1657-1745

138. Aurenhammer, Hans. **Martino Altomonte.** Mit einem Beitrag: Martino Altomonte als Zeichner und Graphiker, von Gertrude Aurenhammer. Wien, Herold, 1965.

139. Heinzl, Brigitte. **Bartolomeo Altomonte.** Wien, Herold, 1964.

ALUNNO, NICCOLO DI LIBERATORE see NICCOLO DA FOLIGNO

AMADEO, GIOVANNI ANTONIO, 1447-1522

140. Malaguzzi-Valeri, Francesco. **Giovanni Antonio Amadeo, scultore e architetto lombardo (1447-1522).** Bergamo, Ist. Ital. d'Arti Grafiche, 1904.

AMALTEO, POMPONIO, 1505-1588

141. Mantoani, Jacopo. **Elogio di Pomponio Amalteo.** San-Vito, Pascatti, 1838.

AMES, EZRA, 1768-1836

142. Bolton, Theodore. **Ezra Ames of Albany, portrait painter, craftsman, Royal Arch mason, banker, 1768-1836.** Catalogue of his works by Irwin F. Cortelyou. New York, New York Historical Soc., 1955.

AMIET, CUNO, 1868-1961

143. Amiet, Cuno. **Über Kunst und Künstler.** Bern, Bernische Kunstgesellschaft, 1948.

144. Galeries Georges Petit (Paris). **Exposition Cuno Amiet, 1-18 mars 1932.** Paris, Galerie Georges Petit, 1932.

145. Jedlicka, Gotthard. **Cuno Amiet, 1868-1961.** Olten, Kunstverein, 1961.

146. Kunsthalle Bern. **Cuno Amiet. Ausstellung zum neunzigsten Geburtstag, 29. März-4. Mai 1958.** Text von Franz Meyer. Bern, Kunsthalle, 1958.

147. _____. **Jubiläumsausstellung Cuno Amiet, 1868-1961; Giovanni Giacometti, 1868-1933, Werke bis 1920.** 8. März-28. April 1968. Bern, Kunsthalle, 1968.

148. Kunsthaus Zürich. **Cuno Amiet und die Maler der Brücke.** [Ausstellung]. Kunsthaus Zürich, 18. Mai-5. Aug. 1979; Brücke Museum, Berlin, 31. Aug.-4 Nov. 1979. Zürich, Kunsthaus, 1979.

149. Müller, Josef. **Cuno Amiet.** Neuchâtel, Editions du Griffon, 1954.

150. Pennsylvania State University Museum of Art (University Park, Penn.). **Cuno Amiet, Giovanni Giacometti, Augusto Giacometti: Three Swiss painters.** An exhib. organized by the Museum of Art, the Pennsylvania State Univ. Selection and cat. by George Manner. 23 Sept.-4 Nov. 1973. Busch-Reisinger Museum, Harvard Univ., 16 Jan.-16 Feb. 1974. University Park, Penn. State Univ., 1973.

151. Sydow, Eckart von. **Cuno Amiet; eine Einführung in sein malerisches Werk.** Strassburg, Heitz, 1913. (Zur Kunstgeschichte des Auslandes, 106).

152. Tatarinoff-Eggenschwiler, Adele. **Cuno Amiet; ein Malerleben.** Solothurn, Vogt-Schild, 1958.

AMMAN, JOST, 1539-1591

153. Amman, Jost. **Kunst- und Lehrbüchlein für die anfahenden Jungen daraus Reissen und Malen zu lernen.** Frankfurt a.M., Feyerabend, 1578.

5

154. Becker, Carl. **Jost Amann, Zeichner und Formschneider, Kupferätzer und Stecher.** Nebst Zusätzen von R. Weigel. Leipzig, Weigel, 1854. Reprint: Nieuwkoop, De Graaf, 1961.

AMMANATI, BARTOLOMEO, 1511-1592

155. Fossi, Mazzino. **Bartolomeo Ammanati, architetto.** Napoli, Morano, 1966/68. (Univ. di Firenze, Fac. di Magistero, Pubblicazioni, 10).

156. Kinney, Peter. **The early sculpture of Bartolomeo Ammanati.** New York, Garland, 1976.

ANDERSON, ALEXANDER, 1775-1870

157. Burr, Frederick M. **Life and works of Alexander Anderson, M. D., the first American wood engraver.** New York, Burr, 1893.

158. Duyckinck, Evert Augustus. **A brief catalogue of books illustrated with engravings by Dr. Alexander Anderson, with a biographical sketch of the artist.** New York, Thompson and Moreau, 1885.

ANDRIOLLI, MICHAEL ELWIR, 1836-1893

159. Piatkowski, Henryk. **Andriolli w sztuce i zyciu.** Spolecznym przez H. Piatkowskiego i H. Dobrzyckiego. Warzawa, Dobrzyckiego, 1904.

160. Wiercinska, Janina. **Andriolli, swadek swoich czasow: Listy i wspomnienia.** Wroclaw, Zakl. Narod. im Ossolinskich, 1976. [Polska Akad. Nauk, Inst. Sztuki].

ANGELICO, FRA (Giovanni da Fiesole), 1387-1455

161. Angelico, Fra Giovanni da Fiesole. **L'opera completa dell' Angelico.** Presentazione di Elsa Morante. Apparati critici e filologici di Umberto Baldina. Milano, Rizzoli, 1970. (Classici dell'arte, 38).

162. Argan, Giulio C. **Fra Angelico, biographical and critical study.** Trans. by James Emmons. Geneva, Skira, 1955. (The taste of our time, 10).

163. Bazin, Germain. **Fra Angelico.** Trans. by Marc Loge; ed. by André Gloeckner. London, Hyperion, 1949.

164. Becherucci, Luisa. **Le celle di San Marco.** 2 v. Firenze, Alinari, 1955.

165. Berti, Luciano. **Beato Angelico.** Milano, Fabbri, 1964. (I maestri del colore, 19).

166. Boskovits, Miklos. **Un 'Adorazione dei Magi' e gli inizi dell'Angelico.** Bern, Abegg-Stiftung, 1976. (Monographien der Abegg-Stiftung, 2).

167. Cartier, Etienne. **Vie de Fra Angelico de Fiesole de l'ordre des Frères Precheurs.** Paris, Poussielgue-Rusand, 1857.

168. Douglas, Robert Langton. **Fra Angelico.** London, Bell, 1902, 2 ed.

169. Hausenstein, Wilhelm. **Fra Angelico.** Trans. by Agnes Blake. London, Methuen, 1928.

170. Muratov, Pavel Pavlovich. **Fra Angelico.** Trans. by E. Law-Gisiko; with 296 reproductions in collotype. London/New York, Warne, 1930.

171. Musei di San Marco (Florence). **Mostra delle opere del beato Angelico nel quinto centenario della morte, 1455-1955.** Magg.-sett. 1955. Firenze, Mus. di S. Marco, 1955.

172. Orlando, Stefano. **Beato Angelico; monografia storica della vita e delle opere, con un'appendice di nuovi documenti inediti.** Premessa di Mario Salmi. Firenze, Olschki, 1964.

173. Pope-Hennessy, John. **The paintings of Fra Angelico.** London/New York, Phaidon, 1952. 2 ed.: London, Phaidon/Ithaca, Cornell University Press, 1974.

174. Procacci, Ugo. **Beato Angelico al Museo di San Marco a Firenze.** (Parallel texts in Italian, French, English and German). Milano, Silvana, n.d.

175. Rothes, Walter. **Die Darstellungen des Fra Giovanni Angelico aus dem Leben Christi und Mariae. Ein Beitrag zur Ikonographie des Meisters.** Strassburg, Heitz, 1902. (Zur Kunstgeschichte des Auslandes, 12).

176. Schottmüller, Frida. **Fra Angelico da Fiesole.** Stuttgart, Deutsche Verlagsanstalt, 1924. 2 ed. (Klassiker der Kunst, 18).

177. Williamson, George C. **Fra Angelico.** London, Bell, 1901.

178. Wingenroth, Max. **Angelico da Fiesole.** Bielefeld/Leipzig, Velhagen und Klasing, 1906. (Künstler-Monographien, 85).

ANGERMAIR, CHRISTOPH, d. 1633

179. Grünewald, Michael D. **Christoph Angermair. Studien zu Leben und Werk des Elfenbeinschnitzers und Bildhauers.** München, Schnell und Steiner, 1975.

ANGERS, PIERRE JEAN DAVID DE see DAVID D'ANGERS, PIERRE JEAN

ANKER, ALBERT, 1831-1910

180. Gantenbein, Leo. **Der Maler Albert Anker.** Zürich, Rigoletto, 1980.

181. Higgler, Max. **Albert Anker, 1831-1910, der Maler und sein Dorf.** Bern, Wyss, 1977.

182. Kuthy, Sandor. **Albert Anker.** Sandor Kuthy und Hans A. Lüthy: Zwei Autoren über einen Maler. Zürich, Orell-Füssli, 1980.

183. Kunstmuseum Bern. **Albert Anker.** Katalog der Gemälde und Ölstudien. Bern, Kunstmuseum, 1962.

184. Rytz, Daniel Albrecht. **Der Berner Maler Albert Anker: ein Lebensbild.** Bern, Stämpfli, 1911.

ANNIGONI, PIETRO, 1910-

185. Cammell, Charles Richard. **Memoirs of Annigoni.** London, Wingate, 1956.

186. _____. **Pietro Annigoni.** With an introd. by C. R. Cammell, and a foreword by Lord Moran. London, Batsford, 1954.

187. Rasmo, Nicolo. **Pietro Annigoni.** Monograph presented by N. Rasmo. Firenze, Edam, 1961.

ANTELAMI, BENEDETTO (Benedetto di Parma), fl. 1177-1233

188. Forster, Kurt W. **Benedetto Antelami, der grosse romanische Bildhauer Italiens.** Aufnahmen von Leonhard von Matt. München, Hirmer, 1961.

189. Francovich, Géza de. **Benedetto Antelami, architetto e scultore, e l'arte del suo tempo.** 2 v. Milano, Electa, 1952.

ANTES, HORST, 1936-

190. Antes, Horst. **Horst Antes: Lithographien.** Werkverzeichnis von Bernd Lutze mit e. Einleitung von Klaus Gallwitz. Stuttgart, Belser, 1976. (CR).

191. _____. **Horst Antes: Metallplastik.** Werkverzeichnis. Engl. trans. Leslie Owen, Fr. trans. Leopold Jaumonet. München, Bruckmann, 1976.

192. _____. **Horst Antes: Werkverzeichnis der Radierungen** von Günther Gercken. München, Galerie Stangl, 1968.

193. Staatliche Kunsthalle Baden-Baden. **Antes: Bilder 1965-1971.** Ausstellung 30. Juli 1971-26. März 1972. Katalog Klaus Gallwitz. Baden-Baden, Staatl. Kunsthalle und Gesellschaft d. Freunde Junger Kunst, 1971.

ANTHOONS, WILLY, 1911-

194. Seuphor, Michel [pseud., Berckelaers, Ferdinand Louis]. **Willy Anthoons.** Anvers, De Sikkel, 1954.

ANTOKOLSKII, MARK MATVEEVICH, 1843-1902

195. Antokol'skii, Mark Matveevich. **Mark Matveevich Antokol'skii; ego zhizn, tvorenia pisma i stati.** Pod. red. V.V. Stasova. S.-Petersburg, Izd. T-va M.O. Volf, 1905.

196. Lebedev, Andrei Konstantinovich. **Tvorcheskoe sodruzhestvo: M. M. Antokolskii i V. V. Stasov.** [By] A. Lebedev [and] G. Burova. Leningrad, Khudoznik RSFSR, 1968.

ANTOLINEZ, JOSE, 1639-1676

197. Angulo Iniguez, Diego. **José Antolinez.** Madrid, Instituto Diego Velazquez, 1957.

ANTONELLO DA MESSINA, 1430-1479

198. Antonello da Messina. **L'opera completa di Antonello da Messina.** Presentazione di Leonardo Sciascia. Apparati critici e filologici di Gabriele Mandel. Milano, Rizzoli, 1967. (Classici dell'arte, 10).

199. Bottari, Stefano. **Antonello da Messina, con 64 tavole fuori testo.** Messina/Milano, Principato, 1939. (Monumenti hist. ed artisti di Sicilia, 1).

200. _____. **Antonello da Messina.** Messina/Milano, Principato, 1953.

201. _____. **Antonello da Messina.** Greenwich, Conn., New York Graphic Society, 1956.

202. Lauts, Jan. **Antonello da Messina.** Wien, Schroll, 1940.

203. Museo Regionale, Messina. **Antonello da Messina.** [Mostra] ott. 1981-jan. 1982. Catalogo a cura di Alessandro Marabottini e Fiorella Stricchia Santoro. Roma, de Luca, 1981.

204. Palazzo Comunale, Messina. **Antonello da Messina e la pittura del '400 in Sicilia.** Catalogo della mostra, a cura di Giorgio Vigni e Giovanni Caradente. Con introduzione di Giuseppe Fioco. Venezia, Alfieri, 1953.

205. Vigni, Giorgio. **All the paintings of Antonello da Messina.** Trans. by Anthony F. O'Sullivan. New York, Hawthorn Books, 1963. (The complete library of world art, 14).

ANUSZKIEWICZ, RICHARD, 1930-

206. Lunde, Karl. **Anuszkiewicz.** New York, Abrams, 1976.

APELLES, 4th c. B.C.

207. Housseye, Henry. **Histoire d'Apelles.** Paris, Didier, 1867. 2 ed. [3 ed. 1868].

208. Lepik-Kopaczynska, Wilhelmina. **Apelles, der berühmteste Maler der Antike.** Berlin, Akademie-Verlag, 1962. (Lebendiges Altertum, 7).

209. Wustmann, Gustav. **Apelles' Leben und Werke.** Leipzig, Engelmann, 1870.

APOLLONIO DI GIOVANNI, 1415-1465

210. Callman, Ellen. **Apollonio di Giovanni.** Oxford, Clarendon Press, 1974.

APOLLONIO DA RIPATRANSONE see APOLLONIO DI GIOVANNI

APPEL, KAREL, 1921-

211. Appel, Karel. **Karel Appel: works on paper.** Improvisation and essay by Jean-Clarence Lambert. Engl. version by Kenneth White. Foreword by Marshall McLuhan. New York, Abbeville, 1980.

212. Centraal Museum Utrecht. **Appel's oogappels.** [Tentoonstelling] 4. sept.-15. nov. 1970. Utrecht, Centraalmuseum, 1970.

APPEL

213. Centre National d'Art Contemporain (Paris). **Karel Appel reliefs, 1966-1968.** Exposition. Paris, Ministère des Affaires Culturelles, 1968.

214. Claus, Hugo. **Karel Appel, painter.** Trans. by Cornelis de Dood. Amsterdam, Strengholt, 1962.

ARBUS, DIANE, 1923-1971

215. Arbus, Diane. **Diane Arbus.** Ed. and designed by Doon Arbus and Marvin Israel. Millerton, N.Y., Aperture, 1972.

ARCA, NICCOLO DELL' see NICCOLO DELL' ARCA

ARCHIPENKO, ALEXANDER, 1887-1964

216. Archipenko, Alexander. **Archipenko-Album.** Einführung von Theodor Däubler und Ivan Goll. Mit einer Dichtung von Blaise Cendrars. Potsdam, Kiepenheuer, 1921.

217. _____. **Alexander Archipenko.** Berlin, Der Sturm, [1920].

218. _____. **Alexander Archipenko, son oeuvre.** 66 reproductions avec un portrait de l'artiste et une introduction par Hans Hildebrandt. Berlin, Editions "Ukrainske slowo," 1923.

219. _____. **Archipenkpo; content and continuity, 1908-1963.** By Donald H. Karshan. Pref. by Marjorie B. Kovler. Chicago, Kovler Gallery, 1968.

220. _____. **Archipenko: fifty creative years, 1908-1958,** by A. Archipenko and fifty art historians. New York, Tekhne, 1960.

221. _____. **Archipenko, international visionary.** Ed. by Donald H. Karshan. Washington, D.C., Smithsonian Press for The National Collection of Fine Arts, 1969.

222. _____. **Archipenko; the American years, 1923-1963.** [Catalog] Exhibition July 23-Aug. 15, 1970, Bernard Danenberg Galleries, New York. New York, Danenberg Galleries, 1970.

223. _____. **Archipenko: the sculpture and graphic art, including a print catalogue raisonné by Donald Karshan.** Tübingen, Wasmuth, 1974. (CR).

224. Michaelsen, Katherine Janszky. **Archipenko; a study of the early works, 1908-1920.** New York, Garland, 1977.

ARCIMBOLDI, GUISEPPE, 1527-1593

225. Geiger, Benno. **I dipinti ghiribizzosi di Guiseppe Arcimboldi, pittore illusionista del Cinquecento (1527-1593).** Con una nota su l'Arcimboldi musicista di Lionello Levi, ed un epilogo di Oskar Kokoschka. Firenze, Valecchi, 1954.

226. Legrand, Francine Claire and Sluys, Felix. **Arcimboldo et les arcimboldesques.** Aalter, Belg., de Rache, 1955.

227. Pieyre de Mandiargues, André. **Arcimboldo the marvelous** by A. Pieyre de Mandiargues. Concept. by Yasha David; editor Patricia Egan. Trans. I. Mark Paris. New York, Abrams, 1978.

ARMAN (Fernandez, Armand), 1928-

228. Arman [Fernandez, Armand]. **Arman, or: Four and twenty blackbirds baked in a pie; or: Why settle for less when you can settle for more.** Text by Henry Martin. New York, Abrams, 1973.

229. _____. **Selected works, 1958-1974.** An exhibition organized by the La Jolla Museum of Contemporary Art, Sept. 15-Oct. 29, 1974. La Jolla, Calif., Museum of Contemp. Art, 1974.

230. Hahn, Otto. **Arman.** Paris, Hazan, 1972.

ARMITAGE, KENNETH, 1916-

231. Penrose, Roland. **Kenneth Armitage.** Amriswil, Switz., Bodensee-Verlag, 1960. (Künstler unserer Zeit, 7).

ARNOLFO DI CAMBIO, 13th c.

232. Abbate, Francesco. **Arnolfo di Cambio.** Milano, Fabbri, 1966. (I maestri della scultura, 4).

233. Mariani, Valerio. **Arnolfo di Cambio.** Roma, Tumminelli, 1943.

234. _____. **Arnolfo e il gotico italiano.** Napoli, Libreria Scient. Edit., 1967.

235. Romanini, Angiola Maria. **Arnolfo di Cambio e lo "stil novo" del gotico italiano.** Milano, Ceschina, 1969. [2d ed.: Firenze, Sansoni, 1980].

AROSENIUS, IVAR, 1878-1909

236. Sandström, Sven. **Ivar Arosenius, hans konst och liv.** Stockholm, Bonnier, 1959.

ARP, HANS, 1887-1966

237. Arp, Hans. **Arp on Arp: Poems, essays, memories.** Ed. by Marcel Jean. Trans. by Joachim Neugroschel. New York, Viking, 1971.

238. _____. **On my way; poetry and essays, 1912-1947.** New York, Wittenborn, 1948. (The Documents of Modern Art, 6).

239. _____. **Jours éffeuillés: Poèmes, essais, souvenirs, 1920-1965.** Préf. de Marcel Jean. Paris, Gallimard, 1966.

240. Arntz, Wilhelm F. **Hans (Jean) Arp: das graphische Werk--L'oeuvre gravé--The graphic work, 1912-1966.** Haag, Obb., Arntz-Winter, 1980.

241. Art of This Century Gallery (New York). **Arp.** [Cat. of an exhibition held in February 1944] with a note by Max Ernst. New York, Art of This Century, 1944.

242. Beyer, Victor, ed. **Hommage à Jean Arp.** Exposition à l'Ancienne Douane, Strasbourg, du 11 juin au 1er oct. 1967. Strasbourg, Soc. d'Edition de la Basse-Alsace, 1967.

243. Brzekowski, Jean. **Hans Arp.** Lodz, Collection "a.r.," 1936.

8

244. Cathelin, Jean. **Arp.** Paris, Fall, 1959.

245. Galerie Denise René (Paris). **Hommage à Jean Arp.** Paris, Gal. Denise René, 1974.

246. Galerie Surréaliste (Paris). **Arp.** [Exposition] 21. nov.-9 déc. 1927. Paris, Gal. Surréaliste, 1927.

247. Giedion-Welcker, Carola. **Hans Arp.** Dokumentation [von] Marguerite Hagenbach. Stuttgart, Hatje, 1957.

248. _____. **Jean Arp.** English trans. by Norbert Guterman. New York, Abrams, 1957.

249. Jianou, Ionel. **Jean Arp.** Paris, Arted, 1973.

250. Klipstein and Kornfeld (Bern). **Hans Arp Zeichnungen und Collagen--Papiers déchirés und Reliefs.** [Ausstellung] 11. Jan.-24. Feb. 1962. Bern, Klipstein und Kornfeld, 1962.

251. Marchiori, Guiseppe. **Arp.** Avec deux poèmes de Arp. Milano, Alfieri, 1964.

252. Metropolitan Museum of Art (New York). **Jean Arp; from the collection of Mme. Marguerite Arp and Arthur and Madeleine Lejwa.** Exhibition, May 24-Sept. 10. New York, Metropolitan Museum of Art, 1972.

253. Musée National d'Art Moderne (Paris). **Arp.** [Exposition] 21 fév.-21 avril 1962. Paris, Musée Natl. d'Art Moderne, 1962.

254. Öffentliche Kunstsammlung Basel. **Sammlung Marguerite Arp-Hagenbach.** Ausstellung vom 4. Nov. 1967-7 Jan. 1968. Katalog von Carlo Huber und Susanne Meyer. Basel, Kunstmuseum, 1968.

255. Poley, Stefanie. **Hans Arp: Die Formensprache im plastischen Werk. Mit einem Anhang unveröffentlichter Plastiken.** Stuttgart, Hatje, 1978.

256. Rau, Bernd. **Jean Arp: the reliefs. Catalogue of complete works.** Introd. by Michel Seuphor. New York, Rizzoli, 1981.

257. Read, Herbert. **The art of Jean Arp.** New York, Abrams, 1968.

258. Seuphor, Michel [pseud., Berckelaers, Ferdinand Louis]. **Arp; sculptures.** Paris, Hazan, 1964. (Petit encyclopédie de l'art, 61).

259. Soby, James Thrall. **Arp.** Ed. with an introd. by J. T. Soby. Texts by R. Huelsenbeck, R. Melville, C. Giedion-Welcker, with an original article by Arp. New York, Museum of Modern Art, 1958. Distributed by Doubleday, Garden City, N.Y.

260. Trier, Eduard. **Hans Arp Skulpturen, 1957-1966.** Einleitung von E. Trier. Bibliographie von Marguerite Arp-Hagenbach. Skulpturenkatalog von François Arp. Stuttgart, Hatje, 1968.

ARP, SOPHIE HENRIETTE (TAEUBER)

see TAEUBER-ARP, SOPHIE HENRIETTE

ASAM, COSMAS DAMIAN, 1686-1739

EGID QUIRIN, 1692-1750

HANS GEORG, 1649-1711

261. Halm, Philipp Maria. **Die Künstlerfamilie der Asam; ein Beitrag zur Kunstgeschichte Süddeutschlands im 17. und 18. Jahrhundert.** München, Lentner, 1896.

262. Hanfstaengl, Erika. **Die Brüder Cosmas Damian und Egid Quirin Asam.** Aufnahmen von Walter Hege. München, Deutscher Kunst-Verlag, 1955.

263. Rupprecht, Bernhard. **Die Brüder Asam. Sinn und Sinnlichkeit im bayerischen Barock.** Photographische Aufnahmen W.-C. von der Mülbe. Regensburg, Pustet, 1980.

ASSELIJN, JAN, 1610-1652

264. Steland-Stief, Anne Charlotte. **Jan Asselijn nach 1610 bis 1652.** Amsterdam, Van Gendt, 1971.

ATGET, EUGENE, 1857-1927

265. Abbott, Berenice. **Eugène Atget.** [By] Berenice Abbottova. Praha, Statni nakladatelstvi kràsné literatury a umeni, 1963.

266. _____. **The world of Atget.** New York, Horizon, 1964.

267. Atget, Eugène. **Atget, photographe de Paris.** Préf. par Pierre Mac-Orlan. New York, Weyhe, 1930.

268. _____. **A vision of Paris. The photographs of Eugène Atget; the words of Marcel Proust.** Ed. with an introd. by Arthur D. Trottenberg. New York, Macmillan, 1963.

269. _____. **Atget: voyages en ville.** Présentation de Pierre Gassmann, texte de Romeo Martinez et Alain Pougetoux. Paris, Editions du Chêne/Hachette, 1979.

270. Leroy, Jean. **Atget magicien du vieux Paris en son époque.** Paris, Balbo, 1975.

271. Szarkowski, John, and Hambourg, Maria M. **The work of Atget.** 4 v. [Vol. 1: Old France; Vol. 2: The art of old Paris; Vol. 3: The ancien regime; Vol. 4: Modern times]. New York, Museum of Modern Art, 1981- .

ATLAN, JEAN, 1913-1960

272. Dorival, Bernard. **Atlan; essai de biographie artistique.** Paris, Tisné, 1962.

273. Musée National d'Art Moderne (Paris). **Atlan: oeuvres des collections publiques françaises.** Exposition organisée par la Bibliothèque Nationale et le Musée National d'Art Moderne, Centre Georges Pompidou, 23 jan.-17 mars 1980. Paris, Mus. Natl. d'Art Moderne, 1980.

274. Ragon, Michel. **Atlan.** Paris, Fall, 1962.

275. _____. **Jean Atlan.** Textes de M. Ragon et André Verdet, images de Roger Hauert. Genève, Kister, 1960.

276. Verdet, André. **Atlan.** Paris, Fall, 1956.

AUBERJONOIS, RENE VICTOR, 1872-1957

277. Auberjonois, René Victor. **René Auberjonois: dessins, textes, photographies.** Précédé de L'atelier du peintre, par Fernand Auberjonois. Lausanne, Mermod, 1958.

278. Galerie Beyeler (Basel). **René Auberjonois.** Ausstellung Februar-März 1964. Basel, Gal. Beyeler, 1964.

279. Musée Cantonal des Beaux Arts (Lausanne). **Rétrospective René Auberjonois, 1872-1957.** Exposition, 6 sept.-19 oct. 1958. Préfaces de Gustave Roud et de Guido Fischer. Lausanne, Musée Cantonal des Beaux Arts, 1958.

280. Kunsthalle Bern. **René Auberjonois.** [Ausstellung] 4. März-9. April 1961. Bern, 1961.

281. Kunsthalle Bremen. **René Auberjonois, 1872-1957.** [Ausstellung] 3. Juli-21 Aug. 1977. Bremen, Kunsthalle, 1977.

282. Ramuz, Charles Ferdinand. **René Auberjonois.** Lausanne, Mermod, 1943.

AUDUBON, JOHN JAMES, 1785-1851

283. Audubon, John James. **The art of Audubon: the complete birds and mammals,** with an introd. by Roger Tory Peterson. New York Times Books, 1979.

284. _____. **Audubon and his journals.** Ed. by Maria R. Audubon. Freeport, New York, Books for Libraries Press, 1972.

285. _____. **The birds of America.** New York, Macmillan, 1937.

286. _____. **Letters of John James Audubon, 1826-1840.** Ed. by Howard Corning. Boston, Club of Odd Volumes, 1930. Reprint: New York, Kraus Reprint Co., 2 v., 1969.

287. _____ and Bachman, John. **The imperial collection of Audubon animals: the quadrupeds of North America.** Ed. by Victor H. Cahalane. New York, Bonanza, 1967.

288. Adams, Alexander B. **John James Audubon, a biography.** New York, Putnam, 1966.

289. Arthur, Stanley C. **Audubon; an intimate life of the American woodsman.** New Orleans, Harmanson, 1937.

290. Chancellor, John. **Audubon; a biography.** New York, Viking, 1978.

291. Fries, Waldemar H. **The double elephant folio: the story of Audubon's Birds of America.** Chicago, American Library Association, 1973.

292. Herrick, Francis H. **Audubon the naturalist; a history of his life and time.** 2 v. New York, Dover, 1968.

293. Lyman Allyn Museum (New London, Conn.). **John J. Audubon Centennial Exhibition,** Oct. 9-Nov. 11, 1951. New London, Conn., Lyman Allyn Museum, 1951.

294. Munson-Williams-Proctor Institute (Utica, N.Y.). **Audubon** watercolors and drawings. Catalog of an exhibition, 11 Apr.-30 May, 1965, by Edward H. Dwight. Also shown at the Pierpont Morgan Library, 15 June-30 July, 1965. Utica, M.-W.-P. Institute, 1965.

295. Peattie, Donald C., ed. **Audubon's America; the narratives and experiences of John James Audubon.** Boston, Houghton Mifflin, 1940.

296. Rourke, Constance. **Audubon.** New York, Harcourt Brace, 1936.

AVATI, MARIO, 1921-

297. Cailler, Pierre. **Mario Avati, 1921.** Documentation réunie par P. Cailler. Genève, Cailler, 1958. (Les cahiers d'art--Documents, 96).

298. Passeron, Roger. **Mario Avati: l'oeuvre gravé.** Préface de Thomas P. F. Hoving. Paris, Bibliothèque des Arts, 1973.

AVEDON, RICHARD, 1923-

299. Avedon, Richard. **Observations.** Photographs by R. Avedon, comments by Truman Capote. New York, Simon and Schuster, 1959.

300. _____. **Photographs, 1947-1977.** Essay by Harold Brodkey. New York, Farrar, Straus & Giroux, 1978.

301. Lartigue, Jacques Henri. **Diary of a century.** Ed. Richard Avedon. Designed by Bea Feitter. New York, Viking, 1970.

302. Minneapolis Institute of Arts. **Avedon.** [Exhibition] July 2-Aug. 30, 1970. Minneapolis, Minn., Inst. of Arts, 1970.

AVERCAMP, BARENT, 1612-1679

 HENDRICK, 1585-1635

303. Welcker, Clara J. **Hendrick Avercamp, 1585-1634, bijgenaamd "de stomme van Campen," en Barent Avercamp, 1612-1679, "schilders tot Campen."** Zwolle, Tijl, 1933.

AVERLINO, ANTONIO DI PIETRO see FILARETE

AVERY, MILTON, 1893-1965

304. Avery, Milton. **Milton Avery.** Introd. by A.D. Breeskin. Catalog of the exhibition, Dec. 12, 1969-Jan. 25, 1970, at the National Collection of Fine Arts, Smithsonian Institution, Washington, D.C. Washington, D.C. Distributed by New York Graphic Society, Greenwich, Conn., 1969.

305. _____. **Milton Avery: prints and drawings, 1930-1964.** Text by Una E. Johnson. Commemorative essay by Mark Rothko. Brooklyn, N.Y., The Brooklyn Museum, 1966. (American graphic artists of the twentieth century, 4).

306. _____. **Milton Avery.** Text by Bonnie Lee Grad. Foreword by Sally Michel Avery. Royal Oak, Strathcona, 1981.

307. Breeskin, Adelyn. **Milton Avery.** Monograph and catalog of a retrospective exhibition. New York, American Federation of Arts, 1960.

308. Brutvan, Cheryl A. **Milton Avery: his works on paper.** Exhibition, Sterling and Francine Clark Art Institute, May 30-July 13, 1980. Catalogue by C. A. Brutvan. Williamstown, Mass., Clark Institute, 1980.

309. Grace Borgenicht Gallery (New York). **Milton Avery: Oil crayons.** [Exhibition] March 31-April 26, 1973. New York, Borgenicht, 1973.

310. Lunn, Harry H. **Milton Avery: Prints 1933-1955.** Comp. and ed. by H.H. Lunn, Jr. Washington, D.C., Graphics International, 1973.

311. University of California Art Gallery (Irvine). **Milton Avery: late paintings, 1958-1963.** [Exhibition] Feb. 16-March 14, 1971. Irvine, Univ. of Calif., 1971.

312. William Benton Museum of Art, University of Connecticut (Storrs). **Milton Avery and the landscape.** Selection and introd. essay by Stephanie Terenzio. [Exhibition] March 15-April 16, 1976. Storrs, William Benton Museum of Art, 1976.

AVETISIAN, MINAS, 1928-1975

313. Avetisian, Minas. **Minas Avetisian.** [Catalogue of works] compiled and introduced by G. Igitian, designed by L. Yatsenko. Leningrad, Aurora, 1975.

314. Igitian, Genrikh. **Minas Avetisian.** Moskva, Sovietskii Khudozhnik, 1970.

BACHIACCA, IL see UBERTINI, FRANCESCO

BACICCIO, GIOVANNI BATTISTA see GAULLI, GIOVANNI BATTISTA

BACKER, JACOB ADRIANSZOON, 1608-1651

315. Bauch, Kurt. **Jakob Adriaensz. Backer; ein Rembrandtschüler aus Friesland.** Berlin, Grote, 1926.

BACKOFFEN, HANS, d. 1519

316. Kautzsch, Paul. **Die Werkstatt und Schule des Bildhauers Hans Backoffen in Mainz; ein Beitrag zur Geschichte der Mainzer Plastik von 1500 zu 1530.** Halle a.S., Erhardt Karras, 1909.

BACO, JACOMART, d. 1461

317. Tormo y Monzo, Elias. **Jacomart y el arte hispano-flamenco cuatrocentista.** Madrid, Centro de Estudios Historicos, 1913.

BACON, FRANCIS, 1909-

318. Alley, Ronald. **Francis Bacon.** Introd. by John Rothenstein, Catalogue raisonné and documentation by R. Alley. New York, Viking, 1964. (CR).

319. Bacon, Francis. **Francis Bacon.** Paris, Maeght, 1966. (Derrière le miroir, 162).

320. Dückers, Alexander. **Francis Bacon; painting 1946.** Stuttgart, Reclam, 1971.

321. Galeries Nationales du Grand Palais (Paris). **Francis Bacon** [exposition]. Paris, Galeries Nationales du Grand Palais, 26 oct. 1971-10 Jan. 1972; Düsseldorf, Kunsthalle, 7 mars-7 mai 1972. Paris, Centre Natl. d'Art Contemporain, 1971.

322. Galleria Civica d'Arte Moderna (Torino). **Bacon** [mostra] 11 sett.-14 ott. 1962. Torino, Gall. d'Arte Moderna, 1962.

323. Solomon R. Guggenheim Museum (New York). **Francis Bacon** [exhibition] Oct. 1963-Jan. 1964. The Solomon R. Guggenheim Museum, New York in collaboration with The Art Institute of Chicago. Catalog by Lawrence Alloway. New York, Solomon R. Guggenheim Museum, 1963.

324. Leiris, Michel. **Francis Bacon; ou la vérité criante.** Montpellier, Fata Morgana, 1974. (Scholies, 8)

325. Marlborough-Gerson Gallery (New York). **Francis Bacon; recent paintings.** [Exhibition] Nov.-Dec. 1968. New York, Marlborough-Gerson Gallery, 1968.

326. Metropolitan Museum of Art (New York). **Francis Bacon; recent paintings 1968-1974.** [Exhibition] March 20-June 29, 1975. New York, Metropolitan Museum of Art, 1975.

327. Russell, John. **Francis Bacon.** London, Thames and Hudson, 1979. Revised ed. [1st ed., 1971]. (World of Art series).

328. _____. **Francis Bacon.** Greenwich, Conn., New York Graphic Society, 1977.

329. Sylvester, David. **Interviews with Francis Bacon.** London, Thames and Hudson, 1975.

330. Trucchi, Lorenza. **Francis Bacon.** Trans. by John Shepley. New York, Abrams, 1975.

331. Tate Gallery (London). **Francis Bacon.** [Exhibition] May 24-July 1, 1962. London, Tate Galley, 1962.

BAKST, LEON, 1866-1924

332. Borisovskaia, Natal'ia Anatol'evna. **Lev Bakst.** Moskva, "Isskustvo," 1979.

333. Buffalo Fine Arts Academy. **Catalogue of an exhibition of original works by L. Bakst.** With an introduction by Martin Birnbaum, Jan. 4-Feb. 1, 1914. New York, De Vinne Press, 1913.

334. Fine Art Society, London. **Bakst.** [Exhibition] 21 Aug.-11 Sept. 1976, Edinburgh; 16 Sept.-9 Oct. 1976, London. London, The Society, 1976.

335. Levinson, Andrei Iakovlevich. **Bakst; the story of Leon Bakst's Life.** New York, Brentano's, 1922.

336. Pruzhan, Irina Nikolaevna. **Lev Samoilovich Bakst.** Leningrad, "Isskustvo," 1975.

337. Réau, Louis, et al. **Inedited works of Bakst.** Essays on

Bakst by Louis Réau, Denis Roche, V. Svietlov and A. Terrier, New York, Brentano's, 1927.

338. Spencer, Charles. **Leon Bakst**. New York, St. Martin's Press, 1973.

BALDOVINETTI, ALESSO, 1425-1499

339. Londi, Emilio. **Alesso Baldovinetti, pittore fiorentino.** Florence, Alfani, 1907.

340. Kennedy, Ruth W. **Alesso Baldovinetti, a critical and historical study.** New Haven, Yale University Press, 1938.

BALDUNG, HANS, 1480-1545

341. Baumgarten, Fritz. **Der Freiburger Hochaltar, kunst-geschichtlich gewürdigt.** Strassburg, Heitz, 1904. (Studien zur deutschen Kunstgeschichte, 49).

342. Bernhard, Marianne. **Hans Baldung Grien Handzeichnungen, Druckgraphik.** Herausgeg. von M. Bernhard. München, Südwest Verlag, 1978.

343. Bussmann, Georg. **Manierismus im Spätwerk Hans Baldung Griens.** Heidelberg, Winter, 1966.

344. Curjel, Hans. **Hans Baldung Grien.** München, Recht, 1923.

345. Escherich, Mela. **Hans Baldung-Grien; Bibliographie 1509-1915.** Strassburg, Heitz, 1916. (Studien zur deutschen Kunstgeschichte, 189).

346. Fischer, Otto. **Hans Baldung Grien.** München, Bruckmann, 1939.

347. Graphische Sammlung Albertina (Wien). **Hans Baldung Grien.** Ausstellung im 450. Geburtsjahr des Meisters im Frühjahr 1935. Wien, Schroll, 1935.

348. Hartlaub, Gustav Friedrich. **Hans Baldung Griens Hexenbilder.** Stuttgart, Reclam, 1961. (Werkmonographien zur bildenden Kunst, 61).

349. Koch, Carl. **Die Zeichnungen Hans Baldung Griens.** Berlin, Deutscher Verlag für Kunstwissenschaft, 1941.

350. Kunstmuseum Basel. **Hans Baldung Grien im Kunstmuseum Basel.** Texte von Paul H. Boerlin, Tilman Falk, Richard W. Gassen, Dieter Keopplin. Basel, Kunstmuseum, 1978. (Schriften des Vereins der Freunde des Kunstmuseums Basel, 2).

351. Martin, Kurt. **Skizzenbuch des Hans Baldung Grien: "Karlsruher Skizzenbuch."** 2 v. Basel, Holbein, 1950. (Veröff. d. Holbein-Gesellschaft, 2). 2 ed. 1959.

352. Mende, Matthias. **Hans Baldung Grien: das graphische Werk.** Vollst. Bild-Katalog der Einzelholzschnitte, Buch-illustrationen u. Kupferstiche. Hrsg. von den Stadtgeschichtl. Museen Nürnberg u. d. Stadt Schwäbisch Gmünd. Unterschneidheim, Uhl, 1978.

353. Oldenbourg, Maria Consuelo. **Die Buchholzschnitte des Baldung Grien; ein bibliographisches Verzeichnis ihrer Verwendungen.** Baden-Baden, Heitz, 1962. (Studien zur deutschen Kunstgeschichte, 335).

354. Schmitz, Hermann. **Hans Baldung, gen. Grien.** Bielefeld/Leipzig, Velhagen & Klasing, 1922. (Künstler-Monographien, 113).

355. Staatliche Kunsthalle Karlsruhe. **Hans Baldung Grien.** Ausstellung unter dem Protektorat des I.C.O.M., 4 Juli-27 Sept. 1959. Karlsruhe, Staatl. Kunsthalle, 1959.

356. Staatliche Museen (Berlin). **Hans Baldung Grien.** Gedächtnisausstellung zur 450. Wiederkehr seines Geburtsjahres. Berlin, Staatliche Museen, 1934.

357. Terez, Gabriel (Gabor) von. **Die Gemälde des Hans Baldung gen. Grien in Lichtdruck-Nachbildungen nach den Originalen.** 2 v. (of plates). Strassburg, Heitz, 1896-1900.

358. _____. **Die Handzeichnungen des Hans Baldung gen. Grien.** 3 v. Strassburg, Heitz, 1894-1896.

359. Weihrauch, Hans Robert. **Hans Baldung Grien.** Mainz, Kupferberg, 1948.

360. Winkler, Friedrich. **Hans Baldung Grien, ein unbekannter Meister deutscher Zeichnung.** Burg, Hopfer, 1941. 2 ed.

BALLA, GIACOMO, 1871-1958

361. De Machis, Giorgio. **Giacomo Balla: l'aura futurista.** Torino, Einaudi, 1971. (Einaudi letteratura, 51)

362. Dorazio, Virginia Dortch. **Giacoma Balla, an album of his life and work.** Introd. by Giuseppe Ungaretti. New York, Wittenborn, 1969.

363. Fagiolo dell'Arco, Maurizio. **Futur Balla.** Roma, Bulzoni, 1970.

364. Galleria Civica d'Arte Moderna (Torino). **Giacomo Balla.** Catalogo a cura di E. Crispolti. Torino, Museo Civico, 1963.

365. Galleria Fonte d'Abisso (Modena). **Giacomo Balla; opere dal 1912 al 1930.** Tipologia di astrazione. [Mostra] 15 marzo-15 maggio 1980. Catalogo a cura di Sergio Poggianella. Modena, Gall. Fonte d'Asisso, 1980.

366. Galleria Nazionale d'Arte Moderna (Roma). **Giacomo Balla 1871-1958.** [Mostra] 23 dic. 1971-27 febb. 1972. Roma, de Luca, 1971.

367. Lista, Giovanni. **Balla.** Modena, Ediz. Galleria Fonte d'Abisso, 1982.

368. Museo di Castelvecchio (Verona). **Giacomo Balla: studi, ricerchi, oggetti.** [Mostra] febbraio-marzo 1976. Schede e notazioni a cura di Luigi Marcucci. Verona, Grafiche AZ, 1976.

369. Robinson, Susan Barnes. **Giacomo Balla: Divisionism and Futurism 1871-1912.** Ann Arbor, UMI Research Press, 1977. (Studies in Fine Arts: The Avant-garde, 14)

BALTHUS (Count Balthasar Klossowski de Rola), 1908-

370. Balthus. **Balthus.** Testi Jean Leymarie, Federico Fellini. Milano, Ediz. La Biennale di Venezia, 1980.

371. Galerie Claude Bernard, Paris. **Balthus; dessins et aquarelles.** Ouvrage édité à l'occasion d l'exposition en octobre 1971. Préf. de Jean Leymarie. Paris, Edits. Gal. Claude Bernard, 1971.

372. Klossowski de Rola, Stanislaus. **Balthus.** London, Thames and Hudson, 1983.

373. Leymarie, Jean. **Balthus.** New York, Skira/Rizzoli, 1979.

374. Pierre Matisse Gallery (New York). **Balthus: "La chambre turque, Les trois soeurs."** Drawings and water colours 1933-1966. March 28-April 22, 1967. New York, Pierre Matisse, 1967.

375. _____. **Balthus: paintings and drawings 1934 to 1977.** Nov. 15-Dec. 15, 1977. New York, Pierre Matisse, 1977.

376. Soby, James Thrall. **Balthus.** New York, Museum of Modern Art, 1956. (Bulletin 24, no. 3)

377. Tate Gallery (London). **Balthus.** A retrospective exhibition arr. by John Russell for the Arts Council of Great Britain, 4 Oct.-10 Nov. 1968. London, Tate Gallery, 1968.

378. Union Centrale des Arts Décoratifs (Paris). **Balthus** [exposition]. Musée des Arts Décoratifs, 12 mai-27 juin 1966. Préf. par Gaetan Picon. Paris, Musée des Arts, déc., 1966.

BANCO, NANNI DI see NANNI DI BANCO

BARBARI, JACOPO DE', 1440-1515

379. Hevesy, André de. **Jacopo de Barbari, le maître au caducée.** Paris, van Oest, 1925.

380. Sevolini, Luigi. **Jacopo de Barbari.** Padova, Tre Venezie, 1944.

BARBIERI, GIOVANNI FRANCESCO called IL GUERCINO, 1591-1666

381. Barbieri, Giovanni Francesco. **Guercino, disegni.** Scelta e introduzione di Stefano Bottari, note di Renato Roli e Anne Ottani Cavina. Firenze, La Nuova Italia, 1966.

382. Atti, Gaetano. **Intorno alla vita e alle opere di Gian-Francesco Barbieri detto Il Guercino da Cento; commentario.** Roma, Tip. delle Scienze Mat. E Fisiche, 1861.

383. Calvi, Jacopo Alessandro. **Notizie della vita e delle opere del cavaliere Gio. Francesco Barbieri, detto Il Guercino da Cento.** Bologna, Guidi all'Ancora, 1842. 2 ed.

384. Grimaldi, Nefta. **Il Guercino, Gian Francesco Barbieri, 1591-1666.** Bologna, Tamari, 1957.

385. Mahon, Denis. **I disegni del Guercino della collezione Mahon.** Catalogo critico. Bologna, Alfa, 1967.

386. Marangoni, Matteo. **Guercino.** Milano, Martello, 1959.

387. Roli, Renato. **I fregi centesi del Guercino.** Introd. di Stefano Bottari. Préf. di Francesco Arcangeli. Bologna, Patron, 1968.

388. Russell, Archibald G. B. **Drawings by Guercino.** London, Arnold, 1923.

389. VII Mostra Biennale d'Arte Antica, Bologna. **Il Guercino, Giovanni Francesco Barbieri, 1591-1666.** Catal. critico dei dipinti a cura di Denis Mahon. Exposizione, Palazzo dell'Archiginnasio, 1 sett.-18 nov. 1968. Bologna, Alfa, 1969. 2 ed. corretta.

BARENDSZ, DIRCK, 1534-1592

390. Judson, Jay Richard. **Dirck Barendsz, 1534-1592.** Amsterdam, Vangendt, 1970.

BARI, NICCOLO DA see NICCOLO DELL'ARCA

BARLACH, ERNST, 1870-1938

391. Barlach, Ernst. **Die Briefe, 1888-1938.** Hrsg. von Friedrich Dross, 2 v. München, Piper, 1968-1969.

392. _____. **Ein selbsterzähltes Leben.** München, Piper, 1948.

393. _____. **Ernst Barlach. Werk und Wirkung. Berichte, Gespräche, Erinnerungen.** Gesammelt und hrsg. von Elmar Jansen. Frankfurt a.M., Athenäum, 1972.

394. Barlach, Karl. **Mein Vetter Ernst Barlach.** Bremen, Heye, [1960].

395. Bevilacqua, Giuseppe. **Ernst Barlach; letteratura e critica.** Urbino, Argalla, 1963.

396. Carls, Carl Dietrich. **Ernst Barlach; das plastische, graphische und dichterische Werk.** Berlin, Rembrandt-Verlag, 1968. [First publ. 1931].

397. Ernst Barlach Haus, Hamburg-Klein Flottbek. [Katalog der Sammlungen]. Hamburg, Stiftung Hermann F. Reemtsma, 1966. 2 ed.

398. Fechter, Paul. **Ernst Barlach.** Gütersloh, Bertelsmann, 1957.

399. Flemming, Willi. **Ernst Barlach, Wesen und Werk.** Bern, Francke, 1958. (Sammlung Dalp, 88)

400. Franck, Hans. **Ernst Barlach, Leben und Werk.** Stuttgart, Kreuz-Verlag, 1961.

401. Fuehmann, Franz. **Ernst Barlach, das schlimme Jahr; Grafik, Zeichnungen, Plastik, Dokumente.** Rostock, Hinstorff, 1963.

402. Gloede, Gunter. **Barlach, Gestalt und Gleichnis.** Hamburg, Furche, 1966.

403. Gross, Helmut. **Zur Seinserfahrung bei Ernst Barlach; eine ontologische Untersuchung von Barlachs dichterischem und bildnerischem Werk.** Freiburg, Herder, 1967.

404. Kunsthalle Bremen. **Ernst Barlach: das druckgraphische Werk, Dore und Kurt Reutti-Stiftung.** Ausstellung Kunsthalle Bremen, 28. Jan.-24. März, 1968. Bremen, Kunsthalle, 1968. (Sammlungskataloge der Kunsthalle Bremen, 4).

405. Schult, Friedrich. **Ernst Barlach: das plastische Werk.** Hamburg, Hauswedell, 1960 (**Ernst Barlach Werkverzeichnis,** Bd. I). (CR).

406. _____. **Ernst Barlach: das graphische Werk.** Hamburg, Hauswedell, 1958. (**Ernst Barlach Werkverzeichnis,** Bd. II). (CR).

407. _____. **Ernst Barlach: Werkkatalog der Zeichnungen.** Hamburg, Hauswedell, 1971. (**Ernst Barlach Werkverzeichnis,** Bd. III). (CR).

408. Schurek, Paul. **Begegnungen mit Barlach; ein Erlebnis-bericht.** Gütersloh, Rufer-Verlag, 1954, 2 ed.

409. _____. **Barlach; eine Bildbiographie.** München, Kindler, 1961.

410. Starczewski, Hanns Joachim. **Barlach; Interpretationen.** München, Starczewski-Verlag, 1964.

411. Stubbe, Wolf. **Ernst Barlach. Plastik.** München, Piper, 1959.

412. _____. **Ernst Barlach; Zeichnungen.** München, Piper, 1961.

413. Werner, Alfred. **Ernst Barlach, his life and work.** New York, McGraw-Hill, 1966.

BARNARD, GEORGE, 1819-1902

414. Barnard, George N. **Photographic views of Sherman's campaign.** New York, Barnard, 1866. (Reprinted, with a new introduction by Beaumont Newhall: New York, Dover, 1977).

BAROCCI, FEDERIGO, 1528-1612

415. Brigata Urbinate degli Amici dei Monumenti. **Studi e notizie su Federigo Barocci.** Firenze, Ist. Micrografico Italiano, 1913.

416. Krommes, Rudolf H. **Studien zu Federigo Barocci.** Leipzig, Seemann, 1912.

417. Olsen, Harald. **Federico Barocci.** København, Munksgaard, 1962. 2 ed.

418. Pietro, Filippo di. **Disegni sconosciuti e disegni finora non identificati di Federigo Barocci negli Uffizi.** Firenze, Ist. Micrografico Italiano, 1913.

BAROZZIO see VIGNOLA

BARRAUD, MAURICE, 1889-1954

419. Barraud, Maurice. **Réflexions à perte de vue.** Vesenaz-Genève, Cailler, 1944.

420. Bovy, Adrien. **Barraud.** Lausanne, Librairie des beaux-arts F. Roth, 1940.

421. Cailler, Pierre and Darel, Henri. **Catalogue illustré de l'oeuvre gravé et lithographié de Maurice Barraud.** [Par] P. Cailler et H. Darel. Genève, Skira, 1944.

BARRY, CHARLES, 1795-1860

422. Barry, Alfred. **The life and works of Sir Charles Barry.** London, Murray, 1867.

BARRY, JAMES, 1741-1806

423. Barry, James. **Lectures on painting by the royal academicians, Barry, Opie and Fuseli.** Ed. with an introduction and notes critical and illustrative, by Ralph N. Wornum. London, Bohn, 1848.

424. _____. **A letter to the Dilettanti Society, respecting the obtention of certain matters essentially necessary for the improvement of public taste, and for accomplishing the original views of the Royal Academy of Great Britain.** London, J. Walker, 1799.

425. Pressly, William L. **The life and art of James Barry.** New Haven, Yale University Press, 1981.

BARTHOLDI, FREDERIC-AUGUSTE, 1834-1904

426. Betz, Jacques. **Bartholdi.** Paris, Editions de Minuit, 1954.

427. Gschaedler, André. **True light on the Statue of Liberty and its creator.** Narberth, Pa., Livingston, 1966.

BARTNING, OTTO, 1883-1959

428. Bartning, Otto. **Kirchen; Handbuch für den Kirchenbau.** Mithrsg. Willy Weyres (Buch I), Otto Bartning (Buch II). München, Callwey, 1959.

429. Mayer, Hans K. F. **Der Baumeister Otto Bartning und die Wiederentdeckung des Raumes.** Heidelberg, Schneider, 1951.

BARTOLINI, LORENZO, 1777-1850

430. Associazione Turistica Pratese. **L'opera di Lorenzo Bartolini, 1777-1850: sculture, disegni, cimeli.** [Mostra] Palazzo Banci Buonamici, Palazzo Pretorio. Cat. curato da Mario Bellandi e Gaetano Siciliano. Prato, Associazione Turistica Pratese, 1956.

431. Bonaini, Francesco. **Dell'arte secondo la mente di Lorenzo Bartolini; discorso.** Firenze, Le Monnier, 1852.

432. Tinti, Mario. **Lorenzo Bartolini, con prefazione di Romano Romanelli.** Roma, Reale Accademia d'Italia, 1936.

BARTOLOMMEO, FRA, 1472-1517

433. Baxter, Lucy E. **Fra Bartolommeo** [and Mariotto Albertinelli, Andrea del Sarto]. By Leader Scott [pseud.]. London, Low, 1892.

434. Borgo, Ludovico. **The works of Mariotto Albertinelli** [and Fra Bartolommeo]. New York, Garland, 1976.

435. Gabelentz, Hans von der. **Fra Bartolommeo und die Florentiner Renaissance.** 2 v. Leipzig, Hiersemann, 1922.

436. Knapp, Fritz. **Fra Bartolommeo della Porta und die Schule von San Marco.** Halle, Knapp, 1903.

437. Rouches, Gabriel. **Fra Bartolommeo, 1472-1517; quatorze dessins.** Paris, Musées Nationaux, 1942.

BARTOLOZZI, FRANCESCO, 1727-1815

438. Baudi di Vesme, Alessandro. **Francesco Bartolozzi; catalogue des estampes et notice biographique d'après les manuscrits de A. de Vesmé, entièrement réformés et complétés d'une étude critique par A. Calibi.** Milan, G. Modiano, 1928.

439. Hind, Arthur Mayger. **Bartolozzi and other stipple engravers working in England at the end of the eighteenth century.** New York, Stokes, 1912.

440. Tuer, Andrew W. **Bartolozzi and his works.** 2 v. London, Field & Tuer, 1881.

BARYE, ANTOINE LOUIS, 1796-1875

441. Alexandre, Arsène. **A. L. Barye.** Paris, Libr. de l'Art, 1889.

442. DeKay, Charles. **Barye. Life and works of Antoine Louis Barye . . . in memory of an exhibition of his bronzes, paintings and water-colors held in New York in aid of the fund for his monument at Paris.** New York, Barye Monument Association, 1889.

443. Lengyel, Alfonz. **Life and art of Antoine Louis Barye.** Dubuque, Iowa, Brown, 1963.

444. Roger-Ballu. **L'oeuvre de Barye.** Précédé d'une introduction de M. Eugène Guillaume. Paris, Quantin, 1890.

445. Saunier, Charles. **Barye.** Paris, Rieder, 1925.

446. Walters, William Thompson. **Antoine-Louis Barye.** From the French of various critics. Baltimore, n.p. [Press of Isaac Friedenwald], 1885.

447. Zieseniss, Charles Otto. **Les aquarelles de Barye; étude critique et catalogue raisonné.** Paris, Massin, 1955. (CR).

BASCHENIS, EVARISTO, 1617-1677

448. Angelini, Luigi. **I Baschenis.** Bergamo, Ediz. Orobiche, 1946. ? ed. (Collana di monografie su artisti bergamaschi, 2).

449. Baschenis, Evaristo. **Evaristo Baschenis.** Testo di Angelo Geddo. Bergamo, Perolari, 1965.

450. Galleria Lorenzelli (Bergamo). **Evaristo Baschenis (1607-1677).** [Mostra] sett.-ott. 1965. Bergamo, Galleria Lorenzelli, 1965.

451. Rosci, Marco. **Baschenis, Bettera & Co.** Produzione e mercato della natura morta del seicento in Italia. Milano, Görlich, 1971.

BASKIN, LEONARD, 1922-

452. Baskin, Leonard. **Baskin; the graphic work, 1950-1970.** Catalog of an exhibition held at the Far Gallery, New York, Feb. 10-Mar. 1, 1970. Text by Herman J. Wechsler and Dale Roylance. New York, Far Gallery, 1970.

453. _____. **Sculpture, drawings and prints.** New York, Braziller, 1970.

454. _____. **Catalog of the exhibition held June 12-July 26, 1970, at the National Collection of Fine Arts of the Smithsonian Institution.** Essay by Alan Fern, Washington, D.C., Smithsonian Press, 1970.

455. Bowdoin College Museum of Fine Arts (Brunswick, Maine). **Leonard Baskin.** [Catalog of an exhibition]. Brunswick, Maine, Bowdoin College, 1962.

BASSANO, JACOPO, 1510-1592

456. Arslan, Walt. **I Bassano.** 2 v. Milano, Ceschina, 1960.

457. Bassano, Jacopo. **Jacopo Bassano.** Catalogo della mostra a cura di Pietro Zampetti. Venezia, Palazzo Ducale, 29 giugno-27 ottobre 1957. Venezia, Arte Veneta-Alfieri, 1957.

458. Bettini, Sergio. **L'arte di Jacopo Bassano.** Bologna, Apollo, 1933.

459. Zampetti, Pietro. **Jacopo Bassano.** Rome, Ist. Poligrafico, 1958.

460. Zottmann, Ludwig. **Zur Kunst der Bassani.** Strassburg, Heitz, 1908. (Zur Kunstgeschichte des Auslandes, 57).

BASTIEN-LEPAGE, JULES, 1848-1884

461. Ady, Julia Cartwright. **Jules Bastien-Lepage,** by Julia Cartwright (Mrs. Henry Ady). London, Seely/New York, Macmillan, 1894.

462. Fourcaud, Louis de. **Bastien-Lepage, sa vie et ses oeuvres, 1848-1884.** Paris, Galerie des artistes modernes, 1885.

463. Theuriet, André, et al. **Jules Bastien-Lepage and his art. A Memoir,** by A. Theuriet with articles by G. Clausen, Walter Sickert. Includes a study of Marie Bashkirtseff by Mathilde Blind. London, Unwin, 1892.

BATTKE, HEINZ, 1900-1966

464. Cuppers, Joachim. **Heinz Battke; Werkkatalog von J. Cuppers** mit einer Würdigung "Der Zeichner Heinz Battke" von Wieland Schmied. Hamburg, Hauswedell, 1970. (CR).

465. Frankfurter Kunstkabinett Hanna Bekker vom Rath. **Heinz Battke zum Gedächtnis.** [Ausstellung] 12.1.-25.2. 1967. Frankfurt a.M., Frankfurter Kunstkabinett, 1967.

BAUMEISTER, WILLI, 1889-1955

466. Akademie der Künste, Berlin. **Willi Baumeister, 1889-1955.**
Ausstellung in der Akademie der Künste vom 30. Mai bis 4.
Juli 1965. Katalog: Herta Elisabeth Killy, Berlin, 1965.

467. Grohmann, Will. **Willi Baumeister; Leben und Werk.** Köln,
Dumont Schauberg, 1963.

468. _____. **Willi Baumeister; life and works.** Trans. by
Robert Allen. New York, Abrams, 1966.

BAYARD, HIPPOLYTE, 1801-1887

469. Jammes, André. **Hippolyte Bayard, ein verkannter Erfinder
und Meister der Photographie.** Luzern/Frankfurt a.M.,
Bucher, 1975. (Bibiliotek der Photographie, 8).

470. Lo Duca, Joseph-Marie. **Bayard.** Paris, Prisma, 1943.
(Reprint: New York, Arno, 1979).

BAYER, HERBERT, 1900-

471. Bayer, Herbert. **Bauhaus, 1919-1928.** Edited by Herbert
Bayer, Walter Gropius, Ise Gropius. New York, Museum of
Modern Art, 1938. 1st ed.; 3rd printing: Boston,
Branford, 1959. 3. Aufl. Teufen, Switzerland, Niggli and
Verkauf, 1955 (in German).

472. _____. **Herbert Bayer. Painter, designer, architect.** New
York, Reinhold/London, Studio Vista, 1967.

473. Denver Art Museum. **Herbert Bayer; a total concept.**
Exhibition, Nov. 11-Dec. 23, 1973. Denver, Colorado Art
Museum, 1973.

474. Doner, Alexander. **The way beyond 'art'; the work of Herbert
Bayer.** New York, Wittenborn, 1947. Reprint: New York,
New York University, 1958.

475. Neue Galerie der Stadt Linz. **Herbert Bayer: Beispiele aus
dem Gesamtwerk 1919-1974.** [Ausstellung] 12. Mai-12. Juni
1976. Linz, Neue Galerie Wolfgang-Gurlitt-Museum, 1976.

BAYEU Y SUBIAS, FRANCISCO, 1734-1795

476. Sambricio, Valentin de. **Francisco Bayeu.** Madrid,
Instituto Diego Velazquez, 1955.

477. Valenzuela la Rosa, José. **Los tiempos de Bayeu; discurso
de ingreso en la Academia Aragonesa de Nobles y Bellas
Artes . . . celebrada el día 18 de Noviembre de 1934.**
. . . Zaragoza, Heraldo de Aragon, 1934.

BAZILLE, FREDERICK, 1841-1870

478. Daulte, François. **Frederick Bazille et son temps.** Genève,
Cailler, 1952. (Peintres et sculpteurs d'hier et
d'aujourd'hui, 24).

479. Poulain, Gaston. **Bazille et ses amis.** Paris, La
Renaissance du Livre, 1932.

480. _____. **Frédéric Bazille, 1841-1870.** Paris, Assoc. des
Etudiants Protestants, 1935.

481. Wildenstein, Daniel. **Bazille exposition,** organisée [par D.
Wildenstein et Philippe Huisman] au profit du musée de
Montpellier, juin-juillet 1950. Paris, Wildenstein, 1950.

BAZZI, GIOVANNI ANTONIO see SODOMA, IL

BEARDEN, ROMARE, 1914-

482. State University of New York Art Gallery, Albany. **Romare
Bearden: paintings and projections.** November 25 through
December 22, 1968. Introduction by Ralph Ellison.
Albany, SUNY Art Gallery, 1968.

483. Washington, M. Bunch. **The art of Romare Bearden: the
prevalence of ritual.** Introduction by John A. Williams.
New York, Abrams, 1972.

BEARDSLEY, AUBREY, 1872-1898

484. Beardsley, Aubrey. **The best of Aubrey Beardsley.** Compiled
and with text by Kenneth Clark, New York, Doubleday, 1978.

485. _____. **A book of fifty drawings by Aubrey Beardsley.** With
iconography by Agnes Vallance. London, Smithers, 1897.

486. _____. **A second book of fifty drawings.** London, Smithers,
1899.

487. _____. **The early work of Aubrey Beardsley, with a note by
H. C. Marillier.** London/New York, Lane, 1899.

488. _____. **The later work of Aubrey Beardsley.** London/New
York, Lane, 1901.

489. _____. **The early and later work.** 2 v. New York, Da Capo,
1967.

490. _____. **Letters from Aubrey Beardsley to Leonard Smithers.**
Edit. by R. A. Walker. London, First Edition Club, 1937.

491. _____. **The letters of Aubrey Beardsley.** Edited by Henry
Maas, J. L. Duncan and W. G. Good. Rutherford, N.J.,
Fairleigh Dickinson University Press, 1970.

492. Benkovitz, Miriam J. **Aubrey Beardsley, an account of his
life.** London, Hamish Hamilton, 1981.

493. Gallatin, Albert E. **Aubrey Beardsley; catalogue of drawings
and bibliography.** New York, The Grolier Club, 1945. (CR).

494. MacFall, Haldane. **Aubrey Beardsley, the man and his work.**
London, Lane, 1928.

495. _____. **Aubrey Beardsley: the clown, the harlequin, the
Pierrot of his age.** New York, Simon and Schuster, 1927.

496. Reade, Brian. **Aubrey Beardsley.** Introd. by John
Rothenstein. New York, Viking, 1967.

497. Victoria and Albert Museum (London). **Aubrey Beardsley
exhibition held 20th May-18th Sept., 1966.** Catalogue
of the original drawings, letters, manuscripts, paintings,
and books, posters, photographs, documents, etc. by B.
Reade and Frank Dickinson. London, HMSO, 1966.

498. Weintraub, Stanley. **Beardsley, a biography.** New York,
Braziller, 1967.

BEATON, CECIL WALTER HARDY, 1904-1980

499. Danziger, James. **Beaton.** New York, Viking, 1980.

500. Beaton, Cecil. [Diaries (variously titled). 6 v.].
 London, Weidenfeld and Nicolson, 1961-78.

501. _____. **Photobiography.** Garden City, N.Y., Doubleday,
 1951.

BEAUDIN, ANDRE, 1895-

502. Beaudin, André. **André Beaudin, oeuvres 1921-1970.** Edité à
 l'occasion de l'exposition realisée dans les Galeries
 Natl. d'exposition du Grand Palais, 21 oct.-30 nov. 1970.
 [Texte] Reynold Arnould. Paris, Centre Natl. d'Art
 Contemporain, 1970.

503. Galerie Louise Leiris (Paris). **A. Beaudin, peintures
 1927-1957.** [Exposition] 31 mai-22 juin 1957. Paris, Gal.
 Louise Leiris, 1957.

504. _____. **Sculptures 1930-1963.** [Exposition] 14. nov.-14
 déc. 1963. Paris, Gal. Louise Leiris, 1963.

505. International Galleries (Chicago). **Retrospective
 exhibition of André Beaudin, paintings, watercolors,
 drawings, graphic works, sculptures held March, 1967.**
 Chicago, Intl. Galleries, 1967.

506. Limbour, Georges. **André Beaudin.** Paris, Verve, 1961.

BEAUX, CECILIA, 1863-1942

507. Beaux, Cecilia. **Background with figures; autobiography of
 Cecilia Beaux.** Boston/New York, Houghton Mifflin, 1930.

508. Oakley, Thornton. **Cecilia Beaux.** Philadelphia, Biddle,
 1943.

509. Pennsylvania Academy of Fine Arts. **The paintings and
 drawings of Cecilia Beaux.** Philadelphia, 1955.

BECCAFUMI, DOMENICO, 1486-1551

510. Gibellino Krasceninnicova, Maria. **Il Beccafumi.** Con
 prefazione di Adolfo Venturi. Siena, Ist. communale
 d'arte e di storia, 1933.

511. Judey-Barosin, Jacob. **Domenico Beccafumi.** Diss.: Freiburg
 i.Br. Berlin, [printed by] Michel, 1932.

512. Sanminiatelli, Donato. **Domenico Beccafumi.** Milano,
 Bramante, 1967.

BECKER, PAULA MODERSOHN see MODERSOHN-BECKER, PAULA

BECKMANN, MAX, 1884-1950

513. Beckmann, Max. **Briefe im Kriege.** Berlin, Cassirer, 1916.

514. _____. **Max Beckmann: Aquarelle und Zeichnungen, 1903-1950.**

[Ausstellung] i. d. Kunsthalle Bielefeld. Bielefeld,
Kunsthalle, 1977.

515. _____. **Max Beckmann: die Druckgraphik.** Radierungen,
 Lithographien, Holzschnitte. [Ausstellung] Badischer
 Kunstverein Karlsruhe, 27. Aug.-18. Nov. 1962. Karlsruhe,
 Bad. Kunstverein, 1962. 2 ed.

516. _____. **Max Beckmann: das Portrait; Gemälde, Aquarelle,
 Zeichnungen.** [Ausstellung] Badischer Kunstverein
 Karlsruhe, 26. Aug.-17. Nov. 1963. Karlsruhe, Bad.
 Kunstverein, 1963.

517. _____. **Max Beckmann 1948.** Retrospective exhibition
 organized by the City Art Museum of St. Louis. St Louis,
 City Art Museum, 1948.

518. _____. **On my painting.** New York, Buchholz Gallery Curt
 Valentin, 1941.

519. _____. **Tagebücher, 1940-1950.** Zusammengestellt von
 Mathhilde A. Beckmann, hrsg. von Erhard Göpel. München,
 Langen-Müller, 1955. Erweiterte und neu durchgesehene
 Ausgabe, 1973. 2 ed.

520. Beckmann, Peter. **Max Beckmann. Sichtbares und
 Unsichtbares.** Einf. von Peter Selz. Stuttgart, Belser,
 1965.

521. Buchheim, Lothar G. **Max Beckmann.** Feldafing, Buchheim,
 1959.

522. Busch, Günter. **Max Beckmann. Eine Einführung.** München,
 Piper, 1960.

523. Erffa, Hans Martin Frhr. von. **Blick auf Beckmann; Dokumente
 und Vorträge.** München, Piper, 1962. (Schriften der Max
 Beckmann Gesellschaft, 2).

524. Fischer, Friedhelm W. **Der Maler Max Beckmann.** Köln, DuMont
 Schauberg, 1972.

525. _____. **Max Beckmann, Symbol und Weltbild des Gesamtwerkes.**
 München, Fink, 1972.

526. Göpel, Erhard and Göpel, Barbara. **Max Beckmann: Katalog
 der Gemälde.** 2 v. Bern, Kornfeld, 1976. (Schriften der
 Max Beckmann Gesellschaft, 3). (CR).

527. Janasch, Adolf. **Max Beckmann als Illustrator.** Neu-
 Isenburg, Tiessen, 1969. (Monographien und Materialien
 zur Buchkunst, 1).

528. Kessler, Charles S. **Max Beckmann's triptychs.** Cambridge,
 Mass., Belknap Press of Harvard University Press, 1970.

529. Lackner, Stephan. **Ich erinnere mich gut an Max Beckmann.**
 Mainz, Kupferberg, 1967.

530. Reifenberg, Benno and Hausenstein, Wilhelm. **Max Beckmann.**
 München, Piper, 1949.

531. Selz, Peter. **Max Beckmann.** With contributions by Harold
 Joachim and Perry T. Rathbone. The Museum of Modern Art,
 New York, in collaboration with the Museum of Fine Arts,
 Boston, and the Art Institute of Chicago. New York,
 distributed by Doubleday, 1964.

532. Simon, Heinrich. **Max Beckmann.** Berlin/Leipzig, Klinkhardt
 und Biermann, 1930. (Junge Kunst, 56).

533. Wiese, Stephan von. **Max Beckmanns zeichnerisches Werk 1903-1925.** Düsseldorf, Droste, 1978.

BEHAM, BARTHEL, 1502-1540

 HANS SEBALD, 1500-1550

534. Burlington Fine Arts Club (London). **Exhibition of the works of Hans Sebald Beham, born 1500, died 1550, and Barthel Beham, born 1502, died 1540.** London, Burlington Fine Arts Club, 1877.

535. Koetschau, Karl. **Barthel Beham und der Meister von Messkirch; eine kunstgeschichtliche Studie.** Strassburg, Heitz, 1893.

536. Pauli, Gustav. **Barthel Beham; ein kritisches Verzeichnis seiner Kupferstiche, Radierungen, Holzschnitte.** Mit vollständiger Reproduktion in Faksimile. Baden-Baden, Heitz, 1958. First ed. 1911. (Studien zur deutschen Kunstgeschichte, 318). (CR).

537. Rosenberg, Adolf. **Sebald und Barthel Beham, zwei Maler der deutschen Renaissance.** Leipzig, Seemann, 1875.

538. Zschelletzschky, Herbert. **Die "Drei gottlosen Maler" von Nürnberg: Sebald Beham, Barthel Beham und Georg Pencz.** Historische Grundlagen und chronologische Probleme ihrer Graphik zur Reformations- und Bauernkriegszeit. Leipzig, Seemann, 1975.

BEHRENS, PETER, 1868-1940

539. Buddensieg, Tilmann and Rogge, Henning. **Industriekultur. Peter Behrens und die AEG 1907-1914.** Berlin, Mann, 1979.

540. Hoeber, Fritz. **Peter Behrens.** München, Müller and Rentsch, 1913.

541. Kadatz, Hans-Joachim. **Peter Behrens, Architekt, Maler, Grafiker und Formgestalter, 1868-1940.** Leipzig, Seemann, 1977.

542. Windsor, Alan. **Peter Behrens, architect and designer.** London, Architectural Press, 1981.

BELLA, STEFANO DELLA, 1610-1664

543. Massar, Phyllis Dearborn. **Presenting Stefano della Bella, seventeenth century printmaker.** New York, Metropolitan Museum of Art, 1971.

544. Cabinet des Dessins, Musée du Louvre (Paris). **Dessins de Stefano della Bella, 1610-1664.** Françoise Viatte, éditeur. Paris, Editions des Musées Nationaux, 1974. (Inventaire général des dessins italiens, 2).

BELLANGE, HIPPOLYTE, 1800-1860

545. Adeline, Jules. **Hippolyte Bellange et son oeuvre.** Paris, Quantin, 1880.

546. Association des Artistes (Paris). **Exposition des oeuvres d'Hippolyte Bellange à l'Ecole des Beaux Arts.** Etude biographique par Francis Way. Paris, Assoc. des Artistes, 1867.

BELLING, RUDOLF, 1886-1972

547. Akademie der Künste (Berlin). **Rudolf Belling.** Ausstellung vom 6. Mai-17. Juni 1962. Katalog: Herta Elisabeth Killy, mit e. Einleitung von Werner Hofmann. Berlin, Akademie der Künste, 1962.

548. Nationalgalerie Berlin. **Rudolf Belling Skulpturen und Architekturen.** Berlin, National-Galerie, 1924.

549. Schmoll gen. Eisenwerth, Josef Adolf. **Rudolf Belling.** St. Gallen, Erker-Verlag, 1971. (Künstler unserer Zeit, 17).

BELLINI, GENTILE, 1429-1507

 GIOVANNI, 1430-1516

 JACOPO, 1400-1470

550. Bottari, Stefano. **Tutta la pitture di Giovanni Bellini.** 2 v. Milano, Rizzoli, 1963.

551. Dussler, Luitpold. **Giovanni Bellini.** Wien, Schroll, 1949.

552. Fry, Roger E. **Giovanni Bellini.** London, Unicorn, 1899.

553. Gamba, Carlo. **Giovanni Bellini.** Milano, Hoepli, 1937.

554. Goloubew, Victor. **Les dessins de Jacopo Bellini au Louvre et au British Museum.** 2 v. Bruxelles, van Oest, 1908-1912.

555. Gronau, Georg. **Giovanni Bellini.** Stuttgart, Deutsche Verlagsanstalt, 1930; also: New York, E. Weyhe, 1930. (Klassiker der Kunst, 36).

556. _____. **Die Künstlerfamilie Bellini.** Bielefeld, Velhagen & Klasing, 1909. (Künstler-Monographien, 96).

557. _____. **Die Spätwerke des Giovanni Bellini.** Strassburg, Heitz, 1928. (Zur Kunstgeschichte des Auslandes, 125).

558. Heinemann, Fritz. **Giovanni Bellini e i belliniani.** 2 v. Venezia, Neri Pozza, 1962. (Saggi e studi di storia dell'arte, 6).

559. Hendy, Philip and Goldscheider, Ludwig. **Giovanni Bellini.** New York, Phaidon, 1945.

560. Huse, Norbert. **Studien zu Giovanni Bellini.** Berlin/New York, de Gruyter, 1972. (Beiträge zur Kunstgeschichte, 7).

561. Moschini, Vittorio. **Disegni di Jacopo Bellini.** Bergamo, Ist. Ital. d'Arti Grafiche, 1943.

562. _____. **Giambellino.** Bergamo, Ist. Ital. d'Arti Grafiche, 1943.

563. Pallucchini, Rodolfo. **Giovanni Bellini.** Milano, Martello, 1959. English edition: New York, Humanities Press, 1962.

564. _____. **Catalogo illustrato [della] mostra di Giovanni Bellini.** Venezia, Pallazzo Ducale, 12 giugno-5 ott. 1949. Con la collaborazione di Giovanni Mariacher per la raccolta del materiale bibliografico. Venezia, Alfieri, 1949.

565. Pignatti, Terisio. **L'opera completa di Giovanni Bellini.**

Presentazione di Renato Ghiotto. Milano, Rizzoli, 1969. (Classici dell'arte, 28).

566. Ricci, Corrado. **Jacopo Bellini e i suoi libre di disegni.** 2 v. Florence, Alinari, 1908.

567. Robertson, Giles. **Giovanni Bellini.** Oxford, Clarendon Press, 1968.

568. Röthlisberger, Marcel. **Studi su Jacopo Bellini.** Venezia, Pozza, 1960. (Estratto da saggi e memorie de storia dell'arte della Fondazione Giorgio Cini, 2).

BELLMER, HANS, 1902-1975

569. Bellmer, Hans. **L'anatomie de l'image.** Paris, Le Terrain Vague, 1957.

570. _____. **Die Puppe.** Carlsruhe, Oberschlesien, Privately publ., 1934.

571. _____. **La poupée.** Paris, Levis-Mano, 1936.

572. _____. **Les jeux de la poupée.** Paris, Editions Premières-Marcel Zerbib, 1949.

573. Centre National d'Art Contemporain (Paris). **Hans Bellmer.** Publié à l'occasion de l'exposition Bellmer, 30 nov.1971-17 jan.1972. Paris, C.N.A.C., 1971. (CNAC Archives, 1).

574. Jelenski, Constantin. **Les dessins de Hans Bellmer.** Paris, Denoël, 1966.

575. _____. **Hans Bellmer.** Ed. by Alex Grall, with an introduction by Constantin Jelenski. London, Academy Editions/New York, St. Martin's Press, 1972-73. (English trans. of **Les dessins**).

576. Kestner Gesellschaft Hannover. **Hans Bellmer.** [Katalog der Ausstellung] 28. April-4. Juni 1967. Hannover, Kestner Gesellschaft, 1967.

577. Pieyre de Mandiargues, André. **Hans Bellmer, oeuvre gravé.** Paris, Denoël, 1969.

578. William and Noma Copley Foundation. **Hans Bellmer.** Biographical note by Alain Jouffroy. Chicago, Copley Foundation, 1959. (Printed in London by Lund Humphries).

BELLOTTO, BERNARDO, 1720-1780

579. Camesasca, Ettore. **L'opera completa del Bellotto.** Introdotta e coordinata da E. Camesasca. Milano, Rizzoli, 1974. (Classici dell'arte, 78).

580. Fritzsche, Hellmuth A. **Bernardo Bellotto, genannt Canaletto.** Burg b.M., Hopfer, 1936. (Beiträge zur Kunstgeschichte, 3).

581. Gemäldegalerie Alte Meister (Dresden). **Bernardo Bellotto genannt Canaletto in Dresden und Warschau.** Ausstellung vom 8. Dez. 1963-31 Aug. 1964, im Albertinum, Dresden. Dresden, Staatl. Kunstsammlungen, 1963.

582. Kozakiewicz, Stefan. **Bernardo Bellotto genannt Canaletto.** 2 v. Bd. I: Leben und Werk, Bd. II: Katalog. Recklinghausen, Bongers, 1972. (CR).

583. Lippold, Gertraude. **Bernardo Bellotto, genannt Canaletto.** Leipzig, Seemann, 1963.

584. Lorentz, Stanislaw, and Kozakiewicz, Stefan. **Bellotto a Varsavia.** Milano, Alfieri, 1955.

585. Oesterreichische Kulturvereinigung (Vienna). **Bernard Bellotto genannt Canaletto.** Ausstellung [Oesterr. Galerie] Wien, Oberes Belvedere, 29. April-25 Juli 1965, unter der Leitung von: Staatl. Kunstsammlungen Dresden; National-Museum Warschau; Kunsthistorisches Museum Wien. Wien, Oesterr. Kulturvereinigung, 1965.

586. Pallucchini, Rodolfo. **Vedute del Bellotto.** Milano, Martello, 1961.

587. Uzanne, Louis Octave. **Les deux Canaletto.** Biographie critique. Paris, Laurens, 1907.

587a. _____. **Les Canaletto: L'oncle et le neveu, Antonio da Canal, 1697-1768, le maître et le disciple, Bernardo Bellotto, 1723-1780.** Paris, Nilsson, 1925.

588. Valcanover, Francesco. **Bernardo Bellotto.** Milano, Fabbri, 1966. (I maestri del colore, 190).

589. Villa Hügel, Essen. **Europäische Veduten des Bernardo Bellotto genannt Canaletto.** 29. April-31 Juli 1966. Essen-Bredeney, Gemeinnütziger Verein Villa Hügel, 1966.

590. Wallis, Mieczyslaw. **Canaletto the painter of Warsaw.** Warsaw, Panstwowy Instytut Wydawniczy, 1954.

BELLOWS, GEORGE WESLEY, 1882-1925

591. Bellows, George W. **George Bellows: his lithographs.** Comp. by Emma Louise Bellows, with an introd., "George W. Bellows," by Thomas Beer. New York, Knopf, 1928.

592. _____. **The paintings of George Bellows.** Comp. by E. L. Bellows. New York, Knopf, 1929.

593. Boswell, Peyton. **George Bellows.** New York, Crown, 1942.

594. Braider, Donald. **George Bellows and the Ashcan School of painting.** Garden City, N.Y., Doubleday, 1971.

595. Columbus Museum of Art (Columbus, Ohio). **George Wesley Bellows: paintings, drawings, and prints.** [Catalog of the exhibition] April 1-May 8, 1979. Columbus, Ohio, 1979.

596. Eggers, George W. **George Bellows.** New York, Macmillan, 1931.

597. Mason, Lauris. **The lithographs of George Bellows; a catalogue raisonné.** L. Mason assisted by Joan Ludman. Foreword by Charles H. Morgan. Millwood, N.Y., KTO Press, 1977. (CR).

598. Metropolitan Museum of Art (New York). **Memorial exhibition of the work of George Bellows,** Oct. 12-Nov. 22, 1925. New York, Metropolitan Museum of Art, 1925.

599. Morgan, Charles H. **George Bellows, painter of America.** New York, Reynal, 1965.

600. _____. **The drawings of George Bellows.** Alhambra, Calif., Borden, 1973.

601. Nugent, Frances F. **George Bellows, American painter.** Chicago, Rand McNally, 1963.

602. Young, Mahonri S. **The paintings of George Bellows.** New York, Watson-Guptill, 1973.

BENEDETTO DA MAIANO, 1442-1497

603. Cendali, Lorenzo. **Guiliano e Benedetto da Majano, Fiesole.** Firenze, Societa Ed. Toscana, 1926.

604. Dussler, Luitpold. **Benedetto da Majano, ein florentiner Bildhauer des späten Quattrocento.** München, Schmidt, 1924.

BENBRIDGE, HENRY, 1743-1812

605. National Portrait Gallery, Smithsonian Institution (Washington, D.C.). **Henry Benbridge (1743-1812): American portrait painter.** April 2-May 16, 1971; catalogue by Robert G. Stewart. Washington, D.C., Smithsonian Institution Press, 1971.

BENEDETTO DI PARMA see ANTELAMI, BENEDETTO

BENSON, AMBROSIUS, d. 1550

606. Marlier, Georges. **Ambrosius Benson et la peinture à Bruges au temps du Charles-Quint.** Damme, Musée van Maulant, 1957.

BENTON, THOMAS HART, 1889-1975

607. Baigell, Matthew. **Thomas Hart Benton.** New York, Abrams, 1974.

608. Benton, Thomas Hart. **An American in art; a professional and technical autobiography.** Lawrence, Univ. Press of Kansas, 1969.

609. _____. **An artist in America.** New York, McBride, 1937. New and rev. ed., Kansas City, U. of Kansas City Press, 1951. 3d rev. ed., Columbia, University of Missouri Press, 1968.

610. _____. **A Thomas Hart Benton miscellany; selections from his published opinions, 1916-1960.** Ed. by Matthew Baigell. Lawrence, Univ. Press of Kansas, 1971.

611. Burroughs, Polly. **Thomas Hart Benton, a portrait.** Garden City, N.Y., Doubleday, 1981.

612. Fath, Creekmore. **The lithographs of Thomas Hart Benton.** Compiled and edited by C. Fath. Austin, University of Texas Press, 1969. New ed. 1979.

613. Guedon, Mary Scholz. **Regionalist art: Thomas Hart Benton, John Stewart Curry and Grant Wood. A guide to the literature.** Metuchen, N.J., Scarecrow Press, 1982.

BENZIGER, AUGUST, 1867-1955

614. Benziger, Marieli. **August Benziger, portrait painter.** Glendale, Calif., Clark, 1958.

615. Braungart, Richard. **August Benziger; sein Leben und sein Werk.** München, Bruckmann, 1922.

BERAIN, JEAN, 1639-1711

616. Weigert, Roger Armand. **Jean I. Bérain, dessinateur de la chambre et du cabinet du roi (1640-1711).** 2 v. Paris, Editions d'Art et d'Histoire, 1936.

BERETTINI, PIETRO see PIETRO DA CORTONA

BERGH, SVEN RICHARD, 1858-1919

617. Bergh, Richard. **Efterlamnade skrifter om konst och annatomi.** Stockholm, Bonnier, 1921.

618. Osterman, Gunhold. **Richard Bergh och Nationalmuseum; nagra dokument.** Lund, Berlingska Bokts., 1958

619. Rapp, Birgitta. **Richard Bergh; konstnär och kultur-politiker 1890-1915.** Stockholm, Raben and Sjögren, 1978.

BERGHE, FRITS VAN DEN, 1883-1939

620. Hecke, Paul Gustave van. **Frits van den Berghe.** Anvers, De Sikkel, 1950. (Monographies de l'art belge, 2. ser., 9).

621. Langui, Emile. **Frits van den Berghe. De mens en zijn werk: 1883-1939.** Antwerpen, Mercatorfonds, 1968.

622. _____. **Frits van den Berghe, 1883-1939.** Catalogue raisonné de son oeuvre peint. Bruxelles, Laconti, 1966. (Maîtres de la peinture contemporaine en Belgique, 2). (CR).

623. Palais des Beaux-Arts (Brussels). **Frits van den Berghe.** [Exposition] Mai 1962. Bruxelles, Palais des Beaux-Arts, 1962.

BERLAGE, HENDRICK PETRUS, 1856-1934

624. Singelenberg, Pieter. **H. P. Berlage; idea and style. The quest for modern architecture.** Utrecht, Haentjens Dekker en Gumbert, 1972.

625. Berlage, Hendrick Petrus. **H. P. Berlage, 1856-1934, een bouwmeester en zijn tijd.** Red. C.H.A. Broos, P. Singelenberg, E.R.M. Taverne. Bussum, Fibula van Dishoeck, 1975.

BERLIN PAINTER, fl. 500-460 B.C.

626. Kurtz, Donna C. **The Berlin painter.** Drawings by Sir John Beazley. Oxford, Clarendon Press, 1983.

BERMEJO, BARTOLOME, 1430-1498

627. Tormo y Monzo, Elias. **Bartolome Bermejo, el mas recio de los primitivos españoles.** Madrid, p. 1936.

628. Young, Eric. **Bartolomé Bermejo, the great Hispano-Flemish master.** London, Elek, 1975.

BERNARD, EMILE, 1868-1941

629. Bernard, Emile. **Souvenirs sur Paul Cézanne, une conversation avec Cézanne.** Paris, Michel, 1926.

630. Hautecoeur, Louis. **Eloge d'Emile Bernard.** Avec des lithographies en couleurs et des gravures sur bois. Paris, Bruker, 1962.

631. Luthi, Jean-Jacques. **Catalogue raisonné de l'oeuvre d'Emile Bernard.** Paris, 1962. (CR).

632. _____. **Emile Bernard, chef de l'école de Pont-Aven.** Par J. J. Luthi; préf. d'Ambroso Vollard. Paris, Nouvelles Editions Latines, 197?.

633. Mornard, Pierre. **Emile Bernard et ses amis: Van Gogh, Gauguin, Toulouse-Lautrec, Cézanne, Odilon Redon.** Genève, Cailler, 1957.

634. Sainte-Marie, Jean Pierre, ed. **Hommage de la Bourgogne à Emile Bernard (1868-1941) à l'occasion de centenaire de sa naissance.** [Exposition] Musées d'Auxerre, Cellier de l'Abbaye Saint-Germain, 7 juillet-8 septembre, 1968. Auxerre, L'Yonne Republicaine, 1968.

BERNARD, JOSEPH, 1866-1931

635. Cantinelli, Richard. **Joseph Bernard; catalogue de l'oeuvre sculpté.** Paris, van Oest, 1928.

636. Musée Rodin (Paris). **Joseph Bernard.** [Exposition] au Musée Rodin, Paris, 1973. Paris, Musée Rodin, 1973.

BERNATH, AUREL, 1895

637. Bernath, Aurel. **So lebten wir in Pannonien.** Übers. aus dem Ungarischen von Heinrich Weissling. Berlin, Union, 1964. [Trans. of Igy eltünk Pannoniaban].

638. Genthon, Istvan. **Bernath Aurel.** Budapest, Kepzomüveszeti Alap Kiadovallata, 1964. (A Müveszet Kiskönyvtara, 58).

BERNINI, GIOVANNI LORENZO, 1598-1680

639. Baldinucci, Filippo. **The life of Bernini.** Trans. by Catherine Engass. Foreword by Robert Engass. University Park/London, Penn. State University Press, 1966. [Trans. of Vita del cavaliere Lorenzo Bernino, scultore, architetto, epittore. Scritta da F. B. Fiorentino, Florence, 1682].

640. _____. **Vita di Gian Lorenzo Bernini.** Con l'inedita vita del Baldinucci, scritta dal Figlio Francesco Saverio. Studio e note de Sergio Saniek Ludovici, Milano, Edizioni del Milione, 1948.

641. _____. **Vita des Giovanni Lorenzo Bernini.** Mit Übersetzung und Kommentar von Alois Riegl; aus seinem Nachlass herausgegeben von Arthur Burdin und Oskar Pollak. Wien, Schroll, 1912.

642. Bauer, George C., ed. **Bernini in perspective.** Englewood Cliffs, N.J., Prentice-Hall, 1976.

643. Benkard, Ernst. **Giovanni Lorenzo Bernini.** Frankfurt a.M., Iris-Verlag, 1926. (Meister der Plastik, 3).

644. Bernini, Domenico. **Vita del cav. Gio. Lorenzo Bernini, descritta da Domenico Bernini suo figlio.** Roma, a spese di Rocco Bernabo, 1713.

645. Bernini, Giovanni Lorenzo. **Selected drawings of Gian Lorenzo Bernini.** Ed. by Ann Sutherland Harris. New York, Dover, 1977.

646. _____. **Die Zeichnungen des Gianlorenzo Bernini.** Hrsg. von Heinrich Brauer und Rudolf Wittkower. Berlin, Keller, 1931. (Römische Forschungen, 9-10).

647. Birindello, Massimo. **La machina heroica.** Il disegno di Gian Lorenzo Bernini per Piazza San Pietro. Roma, Università. Ist. di Fondamenta dell'Architettura, 1980. (Saggi di storie dell'architettura, 4).

648. Boehn, Max von. **Lorenzo Bernini; seine Zeit, sein Leben, sein Werk.** Bielefeld/Leipzig, Velhagen & Klasing, 1912.

649. Borsi, Franco. **Bernini architetto.** Milano, Electa, 1980.

650. Chantelou, Paul Friart de. **Journal du voyage in France du cavalier Bernini.** Ed. by C. Charensol. Paris, Ateliers, 1930.

651. _____. **Journal du voyage du cavalier Bernini en France.** Manuscrit inédit publié et annoté par Ludovic Lalanne. Paris, Gazette des Beaux-Arts, 1885.

652. Comitato Vaticano per l'Anno Berniniano. **Bernini in Vaticano.** [Mostra] Braccio di Carlo Magno, maggio-luglio 1981. Roma, de Luca, 1981.

653. Fagiolo dell'Arco, Maurizio. **Bernini, una introduzione al gran teatro del barocco** [di] Maurizio e Marcello F. dell'Arco. Roma, Bulzoni, 1967.

654. Fraschetti, Stanislao. **Il Bernini la sua vita, la sua opera, il suo tempo.** Con prefazione di Adolfo Venturi. Milano, Hoepli, 1900.

655. Gould, Cecil Hilton M. **Bernini in France; an episode in seventeenth century history.** London, Weidenfeld and Nicolson, 1982.

656. Grassi, Luigi. **Disegni del Bernini.** Bergamo, Ist. Ital. d'Arti Grafiche, 1944.

657. _____. **Gianlorenzo Bernini.** Roma, Ateneo, 1962.

658. Hibbard, Benjamin H. **Bernini.** London, Penguin, 1966.

659. Kauffmann, Hans. **Giovanni Lorenzo Bernini: die figürlichen Kompositionen.** Berlin, Mann, 1970.

660. Kitao, Timothy K. **Circle and oval in the square of Saint Peter's. Bernini's art of planning.** New York, New York University Press, 1968. (Monographs on archaeology and the fine arts, 29).

661. Lavin, Irving. **Bernini and the crossing of Saint Peter's.** New York, New York University Press, 1968. (Monographs on archaeology and the fine arts, 17).

662. _____. **Bernini and the unity of the visual arts.** 2 v. New York/London, Pierpont Morgan Library and Oxford University Press, 1980.

663. _____. **Drawings by Gianlorenzo Bernini from the Museum der Bildenden Künste, Leipzig, German Democratic Republic.** Exhibition and catalogue prepared in a graduate seminar, Department of Art and Archaeology, Princeton University. Princeton, N.J., Princeton University Art Museum, 1981.

664. Mariani, Valerio. **Gian Lorenzo Bernini.** Napoli, Soc. Editrice Vapoletana, 1974.

665. Martinelli, Valentino. **I ritratti di pontefici di G. L. Bernini.** Roma, Ist. di studi romani, 1956. (Quaderni di storia del'arte, 3).

666. Pane, Roberto. **Bernini architetto.** Venezia, Pozza, 1953.

667. Wittkower, Rudolf. **Gian Lorenzo Bernini, the sculptor of the Roman Baroque.** London, Phaidon, 1955. 2 ed. 1966.

668. _____. **Gian Lorenzo Bernini, the sculptor of the Roman Baroque.** Rev. by Howard Hibbard, Thomas Martin and Margot Wittkower, Oxford, Phaidon, 1981. 3 ed.

BERRUGUETE, ALONSO GONZALEZ, 1480?-1561

PEDRO, 1483?-1503

669. Angulo Iniguez, Diego. **Pedro Berruguete en paredes de nava, estudio critico.** Barcelona, Juventud, 1946. (Obras maestras del arte español, 6).

670. Azcarate, Jose Maria de. **Alonso Berruguete. Quatro ensayos.** Valladolid, Publ. por la Direccion General de Bellas Artes, 1963.

671. Castro, Luis de. **El enigma de Berruguete: la danza y la escultara.** Valladolid, El Ateneo de Valladolid, 1953.

672. Gaya Nuño, Juan Antonio. **Alonso Berruguete en Toledo.** Barcelona, Juventud, 1944. (Obras maestras del arte español, 4).

673. Gomez-Moreno, Manuel. **Las aguilas del renacimiento español: Bartolomé Ordonez, Diego Silóee, Pedro Machuca, Alonso Berruguete.** Madrid, Graficas Uguina, 1941.

674. Lainez Alcala, Rafael. **Pedro Berruguete, pintor de Castilla; ensayo critico biografico.** Madrid, Espasa-Calpe, 1935.

675. Orueta, Ricardo de. **Berruguete y su obra.** Madrid, Callega, 1917.

BERTHOLLE, JEAN, 1909-

676. Ferrier, Jean-Louis. **Bertholle.** Paris, 1959.

BERTOIA, HARRY, 1915-

677. Nelson, Junek. **Harry Bertoia, sculptor.** Detroit, Wayne State University Press, 1970.

BERTOLDO, GIOVANNI DI, 1410-1491

678. Bode, Wilhelm von. **Bertoldo und Lorenzo di Medici: die Kunstpolitik des Lorenzo il Magnifico im Spiegel der Werke seines Lieblingsschülers.** Freiburg i.Br., Pontos, 1925.

BERTRAM, MEISTER VON MINDEN, 1345?-1415

679. Dorner, Alexander. **Meister Bertram von Minden.** Berlin, Rembrandt-Verlag, 1937.

680. Martens, Friedrich A. **Meister Bertram; Herkunft, Werk und Wirken.** Berlin, Deutscher Verein fur Kunstwissenschaft, 1936.

681. Portmas, Paul Ferdinand. **Meister Bertram.** Zürich, Rabe, 1963.

BERTRAND, GASTON, 1910-

682. Selevoy, Robert L. **Gaston Bertrand.** Anvers, De Sikkel, 1954.

BESNARD, ALBERT, 1849-1934

683. Besnard, Albert. **Zeichnungen von Albert Besnard.** Mit einer Einleitung von Hans W. Singer. Leipzig, Schumann, 1913.

684. Coppier, André Charles. **Les eaux-fortes de Besnard.** Paris, Berger-Levrault, 1920.

685. Mauclair, Camille. **Albert Besnard, l'homme et l'oeuvre.** Paris, Delagrave, 1914.

686. Mourcy, Gabriel, et al. **Albert Besnard . . . accompagné de quelques écrits d'Albert Besnard et des opinions de quelques écrivains et artistes sur son oeuvre. . . .** Paris, Davoust, 1906.

BETTI, BERNARDINO see PINTURICCHIO

BEUYS, JOSEPH, 1921-

687. Adriani, Götz, et al. **Joseph Beuys,** [von] Götz Adriani, Winfried Konnertz, Karin Thomas. Köln, DuMont Schauberg, 1973.

688. Beuys, Joseph. **Handzeichnungen.** Ausstellung des Kupferstichkabinetts, 11. Dezember 1970 bis 31 Januar 1971. Braunschweig, Herzog Anton Ulrich Museum, 1971.

689. _____. **Joseph Beuys: multiples.** Catalogue raisonné, multiples and prints 1965-80. Ed. by Jörg Schellmann and Bernd Klüser, trans. by C. Tisdall. New York, New York University Press, 1980. 5 ed.

690. Burgbacher-Krupka, Ingrid. **Prophete rechts, Prophete links: Joseph Beuys.** Stuttgart, Belser, 1977.

691. Celant, Germano. **Beuys tracce in Italia.** Naples, Amelio, 1978.

692. Grinten, Franz Joseph and Grinten, Hans van der. **Joseph Beuys: Bleistiftzeichnungen aus den Jahren 1946-1964.** Berlin, Propyläen: Edition Heiner Bastian, 1973.

693. Harlan, Volker. **Sozial Plastik.** Materialien zu Joseph Beuys/Harlan, Rappmann, Schata. Achberg, Achberger Verlagsanstalt, 1976.

694. Joachimides, Christos M. **Joseph Beuys Richtkräfte.** Berlin, Nationalgalerie, 1977.

695. Romain, Lothar and Wedewer, Rolf. **Über Beuys.** Düsseldorf, Droste, 1972.

696. Tisdall, Caroline. **Joseph Beuys.** Preface by Thomas M. Messer. Introduction by Joseph Beuys. [An exhibition book]. New York, The Solomon R. Guggenheim Museum, 1979.

697. _____. **Joseph Beuys Coyote.** München, Schirmer Mosel, 1976.

BEWICK, JOHN, 1760-1795

THOMAS, 1753-1828

698. Bain, Ian. **The watercolours and drawings of Thomas Bewick and his workshop apprentices.** 2 v. London, Gordon Fraser, 1981.

699. Bewick, Thomas. **Memoir of Thomas Bewick written by himself, 1822-1828.** With an introduction by Selwyn Image. London, Lane, 1924.

700. _____. [Another edition]. With an introduction by Edmund Blunden. London, Centaur, 1961.

701. _____. **Memorial edition of Thomas Bewick's works.** 5 v. London, Quaritel, 1885-1887.

702. Dobson, Austin, i.e., Henry Austin. **Thomas Bewick and his pupils.** Boston, Osgood, 1884.

703. Hugo, Thomas. **The Bewick collector. A descriptive catalogue of the works of Thomas and John Bewick . . . with an appendix of portraits, autographs, works of pupils, etc., etc.** The whole described from the originals contained in the largest and most perfect collection ever formed. . . . London, Reeve, 1866.

704. _____. **The Bewick collector. A supplement.** London, Reeve, 1868.

705. Roscoe, S. **Thomas Bewick, a bibliography raisonné of editions of the General history of quadrupeds, the History of British birds and the Fables of Aesop, issued in his lifetime.** London, Oxford University Press, 1953.

706. Ruzicka, Rudolph. **Thomas Bewick, engraver.** New York, The Typophiles, 1943. (Typophile Chap Book, 8).

707. Thomson, David Croal. **The life and works of Thomas Bewick; being an account of his career and achievements in art, with a notice of the works of John Bewick.** London, The Art Journal Office, 1882.

708. _____. **The water-colour drawings of Thomas Bewick.** London, Barbizon House, 1930.

709. Weekley, Montague. **Thomas Bewick.** London, Oxford University Press, 1953.

BIANCHI, MOSE, 1845-1904

710. Marangoni, Guido. **Mosé Bianchi.** Bergamo, Istit. Italiano d'Arti Grafiche, n.d.

711. Nebbia, Ugo. **Mosé Bianchi.** Busto Arsizio, Bramante Editrice, 1960.

BIBIENA, GALLI DA see GALLI DA BIBIENA

BIDDLE, GEORGE, 1885-1974

712. Biddle, George. **An American artist's story.** Boston, Little Brown, 1939.

713. _____. **Artist at war.** New York, Viking, 1944.

714. _____. **Tahitian journal.** Minneapolis, University of Minnesota Press, 1968.

715. _____. **The yes and no of contemporary art; an artist's evaluation.** Cambridge, Mass., Harvard University Press, 1957.

BIEDERMAN, CHARLES JOSEPH, 1906-

716. Biederman, Charles Joseph. **Art as the evolution of visual knowledge.** Red Wing, Minn., Biederman, 1948.

717. _____. **Charles Biederman; a retrospective exhibition with especial emphasis on structurist works of 1936-69.** London, Arts Council of Great Britain, 1969.

718. _____. **Letters on the new art.** Red Wing, Minn., Biederman, 1957.

BIERSTADT, ALBERT, 1830-1902

719. Baigell, Matthew. **Albert Bierstadt.** New York, Watson Guptill, 1981.

720. Hendricks, Gordon. **Albert Bierstadt, 1830-1902.** [Exhibition] Sept. 15-Oct. 10, 1972. M. Knoedler & Co., New York, Knoedler, 1972.

721. _____. **Albert Bierstadt: painter of the American West.** New York, Abrams, 1973.

722. _____. **Bierstadt.** An essay and catalogue to accompany a retrospective exhibition of the work of Albert Bierstadt. Fort Worth, Amon Carter Museum, 1972.

BILL, MAX, 1908-

723. Centre National d'Art Contemporaine (Paris). **Max Bill; oeuvres 1928-1969.** [Catalogue de] l'exposition, 30 oct.-10 déc. 1969. Paris, Centre National d'Art Contemporaine, 1969.

724. Galerie im Erker, St. Gallen. **Max Bill.** [Ausstellung] 8. April-27. Mai 1967. St. Gallen, Gallerie im Erker, 1967.

725. Gomringer, Eugen, ed. **Max Bill** [von] Max Bense et al. Zum 50. Geburtstag am 22. Dezember 1958. Teufen, Niggli, 1958.

726. Kestner-Gesellschaft, Hannover. **Max Bill.** [Ausstellung] 14. Juni-14. Juli, 1968. Hannover, Kestner-Gesellschaft, 1968.

727. Kunsthaus Zürich. **Max Bill.** [Ausstellung] 23. Nov. 1968-5. Jan. 1969. Zürich, Kunsthaus, 1968.

BINDESBØLL, GOTTLIEB, 1800-1856

728. Millech, Knud. **Bindesbøll Museum.** København, Thorvaldsens Museum, 1960.

729. Wanscher, Vilhelm. **Arkitekten G. Bindesbøll.** København, Køster, 1903.

BINGHAM, GEORGE CALEB, 1811-1879

730. Blad, E. Maurice. **The drawings of George Caleb Bingham with a catalogue raisonné.** Columbia, Mo., University of Missouri Press, 1975. (CR).

731. McDermott, John F. **George Caleb Bingham, river portraitist.** Norman, University of Oklahoma Press, 1959.

BIONDO, GIOVANNI DEL see GIOVANNI DEL BIONDO

BISCHOF, WERNER, 1916-1954

732. Burri, Rosellina Bischof and Bischof, René, eds. **Werner Bischof.** Introd. by Bhupendra Karia and Manuel Gasser. New York, Grossman, 1974. (ICP Library of photography, 2).

733. Flüeler, Niklaus. **Werner Bischof.** Luzern/Frankfurt a.M., Bucher, 1973. (Bibliothek der Photographie, 6).

734. Smithsonian Institution (Washington, D.C.). **The world of Werner Bischof, a photographer's Odyssey.** [Sponsored by the Foundation Pro Helvetia]. Zürich, Die Arche, 1961.

BISHOP, ISABEL, 1902-

735. University of Arizona Museum of Art (Tucson, Ariz.). **Isabel Bishop.** Tucson, Ariz., University of Arizona Museum of Art, 1974.

BISSEN, HERMAN VILHELM, 1789-1868

736. Rostrup, Haavard. **Billedhuggeren H. W. Bissen, 1798-1868.** 2 v. København, Kunstforeningen, 1945.

BISSIER, JULIUS, 1893-1965

737. Bissier, Julius. **Julius Bissier, 1893-1965: a retrospective exhibition.** Essay by Thomas Messer. San Francisco, San Francisco Museum of Art, 1968.

738. _____. **Julius Bissier, 1893-1965: an exhibition from the Kunstsammlung Nordrhein-Westfalen, the National Gallery of Ireland, City Museum and Art Gallery, Birmingham, Graves Art Gallery, Sheffield.** London, Arts Council, 1977.

739. Kunstverein Braunschweig. **Julius Bissier, 1893-1965.** [Ausstellung] 21. Dez. 1980-15. Feb. 1981. Katalog [von] Jürgen Schilling. Braunschweig, Kunstverein, 1980.

740. Schmalenbach, Werner. **Julius Bissier.** Köln, DuMont Schauberg, 1974.

741. _____. **Julius Bissier: Tuschen und Aquarelle--Brush Paintings and Watercolors--Encres de Chine et aquarelles.** Frankfurt a.M., Propyläen, 1978.

BISSIERE, ROGER, 1888-1964

742. Fouchet, Max Pol. **Bissière.** Paris, Fall, 1955.

743. Musée des Beaux-Arts (Bordeaux). **Bissière, Bordeaux, 1965.** [Catalogue of the exhibition]. Bordeaux, Musée des Beaux-Arts, 1965.

744. Musée National d'Art Moderne (Paris). **Bissière** [Exposition] 9 avril-10 mai 1959. Paris, Editions des Musées Nationaux, 1959.

BLAKE, WILLIAM, 1757-1827

745. Blake, William. **The complete writings of William Blake.** Ed. by Geoffrey Keynes. London, etc., Nonesuch, 1957. 1st ed.

746. _____. **Letters.** Ed. by Geoffrey Keynes. London, Hart-Davis, 1956.

747. Bentley, Gerald E. and Nurmi, Martin K. **A Blake bibliography.** Minneapolis, University of Minnesota Press, 1964.

748. Bindman, David. **Blake as an artist.** Oxford, Phaidon/New York, Dutton, 1977.

749. Binyon, Laurence. **The drawings and engravings of William Blake,** by L. Binyon. Ed. by Geoffrey Holme. London, Studio, 1922.

750. Blunt, Anthony. **The art of William Blake.** New York, Columbia University Press, 1969. (Bampton Lectures, 12).

751. Bronowski, Jacob. **William Blake, 1757-1827; a man without a mask.** London, Secker & Warburg, 1944.

752. Butlin, Martin. **The paintings and drawings of William Blake.** 2 v. New Haven, Yale University Press, 1981.

753. _____. **William Blake** [exhibition, 9 March–21 May, 1978]. Catalog by Martin Butlin. London, Tate Gallery, 1978.

754. Cary, Elisabeth Luther. **The art of William Blake: his sketch-book, his water-colours, his painted books.** New York, Moffat, 1907.

755. Chester, Gilbert Keith. **William Blake.** London, Duckworth/New York, Dutton, 1910.

756. Damon, Samuel Foster. **William Blake, his philosophy and symbols.** Boston/New York, Houghton Mifflin, 1924.

757. DeSelincourt, Basil. **William Blake.** London, Duckworth, 1909.

758. Ellis, Edwin John. **The real Blake; a portrait biography.** London, Chatto & Windus, 1907.

759. Erdman, David V. **The illuminated Blake.** All of William Blake's illuminated works with a plate-by-plate commentary. Garden City, N.Y., Doubleday, 1974. (CR).

760. Essick, Robert N., ed. **The visionary hand; essays for the study of William Blake's art and aesthetics.** Edited and with an introd. by Robert N. Essick. Los Angeles, Hennessey & Ingalls, 1973.

761. _____. **William Blake, printmaker.** Princeton, New Jersey, Princeton University Press, 1980.

762. Figgis, Darrell. **The paintings of William Blake.** London, Benn, 1925.

763. Fitzwilliam Museum (Cambridge). **William Blake.** Catalogue of the collection in the Fitzwilliam Museum, Cambridge. Ed. by David Bindman. Cambridge, Heffer, 1970.

764. Gilchrist, Alexander. **Life of William Blake.** "Pictor ignotus." With selections from his poems and other writings . . . Illus. in facsimile by W. J. Linton . . . with a few of Blake's own plates. 2 v. London/Cambridge, Macmillan, 1863. 1st ed.

765. Hamburger Kunsthalle. **William Blake, 1757–1827.** [Ausstellung] 6. März–27. April 1975 in der Hamburger Kunsthalle. München, Prestel, 1975.

766. Henry E. Huntington Library and Art Gallery, San Marino, Calif. **Catalogue of William Blake's drawings and paintings in the Huntington Library.** By C. H. Collins Baker. San Marino, 1938.

767. Keynes, Geoffrey Langdon. **A bibliography of William Blake.** New York, Grolier Club, 1921.

768. _____. **Blake studies: notes on his life and works in seventeen chapters.** London, Hart-Davis, 1949.

769. _____. **William Blake's illuminated books; a census.** Compiled by G. Keynes and Edwin Wolf. New York, Grolier Club, 1953.

770. Langridge, Irene. **William Blake; a study of his life and art work.** London, Bell, 1904.

771. Lindsay, Jack. **William Blake; his life and work.** New York, Braziller, 1979.

772. Lister, Raymond. **Infernal methods; a study of William Blake's art techniques.** London, Bell, 1975.

773. Mitchell, W. J. Thomas. **Blake's composite art; a study of the illuminated poetry.** Princeton, N. J., Princeton University Press, 1978.

774. Philadelphia Museum of Art. **William Blake, 1757–1827;** a descriptive catalogue of an exhibition of the works of William Blake selected from collections in the United States. Catalog [by] Agnes Mongan. Philadelphia, The Philadelphia Museum of Art, 1939.

775. Raine, Kathleen Jessie. **Blake and tradition.** 2 v. Princeton, Princeton University Press, 1968. (The A. W. Mellon lectures in the Fine Arts, 11. Bollingen series, 35).

776. _____. **William Blake.** New York, Praeger, 1971.

777. Swinburne, Algernon Charles. **William Blake.** A critical essay. London, Hotten, 1868.

778. Symons, Arthur. **William Blake.** London, Constable, 1907.

779. Wilson, Mona. **The life of William Blake.** London, Nonesuch, 1927.

780. Tate Gallery (London). **William Blake (1757–1827);** a catalogue of the works of William Blake. Introd. by A. Blunt, with a foreword by John Rothenstein. London, Tate Gallery, 1957.

BLANQUART-EVRARD, LOUIS-DESIRE, 1802–1872

781. Jammes, Isabelle. **Blanquart-Evrard et les origines de l'édition photographique française.** Catalogue raisonné des albums photographiques édités 1851–1855. Genève, Librairie Droz, 1981. (CR).

782. Blanquart-Evrard, [Louis-Désiré]. **On the intervention of art in photography.** Trans. by Alfred Harrad. London, Sampson Low, 1864. (Reprinted in The Collodion Process and the Ferrotype. New York, Arno, 1973.

783. _____. **Photographie; ses origines, ses progrès, ses transformations.** Lille, Daniel, 1870. (Reprint: New York, Arno, 1979).

784. _____. **Traité de photographie sur papier.** Paris, Librairie encyclopédique de Roret, 1851.

BLECHEN, CARL, 1798–1840

785. Blechen, Carl. **Karl Blechen, 1798–1840; Ölskizzen, Aquarelle, Sepiablätter, Zeichnungen, Entwürfe.** Ausstellung Berlin 1973. Berlin, Staatl. Museen-National-galerie, 1973.

786. Heider, Gertrud. **Carl Blechen.** Leipzig, Seemann, 1970.

787. Nationalgalerie (Berlin). **Karl Blechen: Leben, Würdigungen, Werk.** Introd. Paul Ortwin Rave. Berlin, Dt. Verein für Kunstwissenschaft, 1940. (CR).

788. Paul-Pescatore, Anni. **Karl Blechen. Sechzig Bilder.** Hrsg. von A. Paul-Pescatore. Königsberg, Kanter-Verlag, 1944.

BLOEMAERT, ABRAHAM, 1564-1651

789. Delbanco, Gustav. **Der Maler Abraham Bloemaert 1564-1651.** Strassburg, Heitz, 1928. (Studien zur deutschen Kunstgeschichte, 253).

BLONDEEL, LANCELOT, 1496-1561

790. Bautier, Pierre. **Lancelot Blondeel.** Bruxelles, van Oest, 1910.

BLONDEL, JACQUES FRANÇOIS, 1705-1774

791. Blondel, Jacques F. **De la distribution des maisons de plaisance, et de la décoration des édifices en général.** 2 v. Paris, Jombert, 1737/1738. Reprint: Farnsborough, England, Gregg, 1967.

792. _____ et Patte, Pierre. **Cours d'architecture.** 9 v. Paris, Desaint, 1771-1777.

793. Prost, Auguste. **Jean François Blondel et son oeuvre.** Metz, Rousseau-Pallez, 1860.

BLOSSFELDT, KARL, 1865-1932

794. Blossfeldt, Karl. **Art forms in nature.** Second series. London, Zwemmer, 1932.

795. _____. **Karl Blossfeldt, 1865-1932: das fotografische Werk.** [Text by Gert Mattenklott]. München, Schirmer/Mosel, 1981.

796. _____. **Urformen der Kunst.** Berlin, Wasmuth, [1928].

797. Rheinisches Landesmuseum (Bonn). **Karl Blossfeldt, Fotographien 1900-1932.** [May 19-June 20, 1976; text by Klaus Honnef]. Bonn, Rheinisches Landesmuseum, 1976. (Kunst und Altertum am Rhein: Führer des Rheinischen Landesmuseum in Bonn, 65).

BOCCACCINO, BOCCACCIO, 1467-1524

798. Puerari, Alfredo. **Boccaccino.** Milano, Ceschina, 1957.

BOCCIONI, UMBERTO, 1882-1916

799. Argan, Giulio Carlo. **Umberto Boccioni.** Scelta degli scritti regesti, bibliografia e catalogo della opera a cura di Maurizio Calvesi. Roma, de Luca, 1953.

800. Ballo, Guido. **Umberto Boccioni. La vita e l'opere.** Milano, Saggiatore, 1964.

801. Bellini, Paolo. **Catalogo completo dell'opera grafica di Boccioni.** Milano: Salamon e Agustoni, 1972.

802. Boccioni, Umberto. **Gli scritti editi e inediti.** A cura di Zeno Birolli; Prefazione di Mario de Micheli. Milano, Feltrinelli, 1971.

803. _____. **L'opera completa di Boccioni.** Presentazione di Aldo Palazzeschi. Apparati critici e filologici di Gianfranco Bruno. Milano, Rizzoli, 1969. (Classici dell'arte, 34).

804. Calvesi, Maurizio and Coen, Ester. **Boccioni. Catalogo generale.** Milano, Electa, 1983.

805. Grada, Raffaele de. **Boccioni, il mito del moderno.** Milano, Club del Libro, 1962.

806. Marinetti, F. **Umberto Boccioni, con uno scritto di Umberto Boccioni sul dinamismo plastico.** Milano, Bottega di Poesia, 1924.

807. Taylor, Joshua Charles. **The graphic work of Umberto Boccioni.** New York, Museum of Modern Art, 1961.

BOECKL, HERBERT, 1894-1966

808. Boeckl, Herbert. **Boeckl: 17 Zeichnungen, 51 Bilder.** Interpretationen von Otto Benesch et al. Wien, Metten, 1947.

809. _____. **Zeichnungen und Aquarelle.** Ausgewählt und einge-leitet von Werner Hofmann. Wien, Rosenbaum, 1968.

810. Museum des 20. Jahrhunderts (Wien). **Herbert Boeckl.** [Sonderausstellung] 18 Dez. 1964-14. Febr. 1965. Wien, Museum des 20. Jahrhunderts, 1964.

811. Pack, Claus. **Der Maler Herbert Boeckl.** Wien, Schroll, 1964.

BOECKLIN, ARNOLD, 1827-1901

812. Andree, Rolf. **Arnold Böcklin, die Gemälde.** Basel, Reinhardt/München, Prestel, 1977. (Schweizer. Inst. für Kunstwissenschaft. Oeuvrekataloge Schweizer Künstler, 6).

813. Barth, Wilhelm. **Arnold Böcklin.** Frauenfeld, Huber, 1928. (Die Schweiz im deutschen Geistesleben, 11).

814. Berger, Ernst. **Böcklins Technik.** München, Callwey, 1906. (Sammlung maltechnischer Schriften, 1).

815. Boecklin, Angela. **Böcklin Memoiren: Tagebuchblätter von Böcklin's Gattin Angela.** Mit dem gesamten brieflichen Nachlass hrsg. von Ferdinand Runkel. Berlin, Internat. Verlagsanstalt fur Kunst und Literatur, 1910.

816. Boecklin, Arnold. **A. Böcklin 1827-1901.** Ausstellung zum 150. Geburtstag veranstaltet vom Magistrat der Stadt Darmstadt. Mathildenhöhe, 23. Oktober-11. December 1977. 2 v. Darmstadt, 1977.

817. _____. **Neben meiner Kunst: Flugstudien, Briefe und Persönliches.** Hrsg. von Ferd. Runkel und Carlo Böcklin. Berlin, Vita, 1909.

818. Floerke, Gustav. **Zehn Jahre mit Böcklin.** Aufzeichnungen und Entwürfe von Gustav Floerke. München, Bruckmann, 1902. 2 ed. (A 3rd edition ed. by Hanns Floerke has

title: **Arnold Böcklin und seine Kunst.** München, Bruckmann, 1921.)

819. Graborsky, Adolf. **Der Kampf um Böcklin.** Berlin, Cronbach, 1906.

820. Hayward Gallery, London. **Arnold Böcklin, 1827-1901.** 20 May-27 June, 1971. An exhibition organized by the Arts Council of Great Britain and the Pro Helvetia Foundation of Switzerland. London, Arts Council of Great Britain, 1971.

821. Kunstmuseum Basel. **Arnold Böcklin, 1827-1901. Gemälde, Zeichnungen, Plastiken.** Ausstellung zum 150. Geburtstag, veranstaltet vom Kunstmuseum Basel und vom Kunstverein, 11. Juni-11. September 1977. Basel/Stuttgart, Schwabe, 1977.

822. Meier-Graefe, Julius. **Der Fall Böcklin und die Lehre von den Einheiten.** Stuttgart, Hoffmann, 1905.

823. Ostini, Fritz von. **Böcklin.** Bielefeld/Leipzig, Velhagen & Klasing, 1904. (Künstler-Monographien, 70).

824. Ritter, William. **L'art en Suisse: Arnold Böcklin.** Gand, Typ. Siffer, 1895.

825. Schick, Rudolf. **Tagebuch-Aufzeichnungen aus den Jahren 1866, 1868, 1869 über Arnold Böcklin . . .** Hrsg. Hugo von Tschudi; gesichtet von Cäsar Flaischlen. Berlin, Fleischel, 1903.

826. Schmid, Heinrich Alfred. **Arnold Böcklin.** München, Bruckmann, 1919.

827. _____. **Böcklin--Verzeichnis der Werke.** München, Bruckmann, 1903.

828. Schneider, Max Ferdinand. **Arnold Böcklin, ein Maler aus dem Geiste der Musik.** Basel, Holbein-Verlag, 1943.

829. Thode, Henry. **Arnold Böcklin.** Heidelberg, Winter, 1905.

BOILLY, LOUIS LEOPOLD, 1761-1845

830. Harrisse, Henry. **L. L. Boilly, peintre, dessinateur et lithographe; sa vie et son oeuvre.** Paris, Société des Livres d'Art, 1888.

831. Marmottan, Paul. **Le peintre Louis Boilly.** Paris, Gateau, 1913.

BOL, FERDINAND, 1616-1680

832. Blankert, Albert. **Kunst als regeringzaak in Amsterdam in de 17e eeuw: rondom schilderingen van Ferdinand Bol.** Lochem: De Tijdstroom, 1975.

833. _____. **Ferdinand Bol (1616-1680), Rembrandt's pupil.** Trans. from Dutch by Ina Rikel. Doornspijk, Neth., Davaco, 1982. (Aetas aurea: Monographs on Dutch & Flemish painting, 2).

BOLOGNA, GIOVANNI DA see GIOVANNI DA BOLOGNA

BON, BARTOLOMEO see BUON, BARTOLOMEO

BON, GIOVANNI see BUON, GIOVANNI

BONDONE, GIOTTO DI see GIOTTO DI BONDONE

BONHEUR, ROSA, 1822-1899

834. Ashton, Dore. **Rosa Bonheur, a life and a legend.** Text by D. Ashton; illus. and captions by Denise Brown Hare. London, Secker and Warburg/New York, Viking, 1981.

835. Digne, Danielle. **Rosa Bonheur, ou l'insolence: l'histoire d'une vie, 1822-1899.** Paris, Denoël Gonthier, 1980.

836. Galerie Georges Petit (Paris). **Atelier Rosa Bonheur.** Préface et catalogue analytique par L. Roger-Milès. 2 v. Paris, Petit, 1900.

837. Klumpke, Anna. **Rosa Bonheur: sa vie, son oeuvre.** Paris, Flammarion, 1909.

838. Lepelle de Bois Gallais, F. **Memoir of Mademoiselle Rosa Bonheur.** Trans. by James Parry. New York, Williams, 1857.

839. Roger-Milès, Léon. **Rosa Bonheur: sa vie, son oeuvre.** Paris, Société d'édition artistique, 1900.

840. Shriver, Rosalia. **Rosa Bonheur. With a checklist of works in American collections.** Philadelphia, Art Alliance/London, Assoc. University Presses, 1982.

841. Stanton, Theodore. **Reminiscences of Rosa Bonheur.** London, Melrose, 1910.

BONIFAZIO DI'PITATI see BONIFAZIO VERONESE

BONIFAZIO VERONESE, 1487-1531

842. Westphal, Dorothee. **Bonifazio Veronese (Bonifazio dei Pitati).** München, Bruckmann, 1931.

BONINGTON, RICHARD PARKES, 1801-1828

843. Curtis, Atherton. **Catalogue de l'oeuvre lithographié et gravé de R. P. Bonington.** Paris, Prouté, 1939.

844. Dubuisson, A. **Richard Parkes Bonington: his life and work.** By A. Dubuisson; trans. with annotations by C. E. Hughes. London, Lane, 1924.

845. Shirley, Andrew. **Bonington.** London, Kegan, 1940.

BONNARD, PIERRE, 1867-1947

846. Beer, François Joachim. **Pierre Bonnard.** Par F.-J. Beer suivi d'un texte de Louis Gillet. Préface par Raymond Cogniat. Marseille, Editions Françaises d'Art, 1947.

847. Bonnard, Pierre. **Bonnard dans sa lumière.** Préfaces de
Marcel Arland et Jean Leymarie. [Paris], Maeght Editeur,
1978.

848. Bouvet, François. **Bonnard, the complete graphic work.**
Introduction by Antoine Terrasse. Trans. from the French
by Jane Brenton. New York, Rizzoli, 1981. (CR).

849. Courthion, Pierre. **Bonnard, peintre du merveilleux.**
Lausanne, Marguerat, 1945.

850. Dauberville, Jean and Dauberville, Henry. **Bonnard;
catalogue raisonné de l'oeuvre peint.** 4 v. Paris,
Bernheim, 1966-1974. (CR).

851. Fondation Maeght (Saint-Paul). **Bonnard dans son lumière.**
[Exposition] du 12 juillet-28 septembre 1975. Paris,
Adrien Maeght, 1975.

852. Galerie Beyeler Bâle. **Bonnard.** Exposition septembre-15
novembre 1966. Basel, Galerie Beyeler, 1966.

853. Haus der Kunst München. **Pierre Bonnard.** [Ausstellung].
Haus der Kunst München, 8 Okt. 1966-1 Jan. 1967; Musée du
Louvre, Paris, 13. Jan.-15. April 1967. Katalog: M.
Antoine Terrasse. München, Haus der Kunst, 1966.

854. Museum of Modern Art (New York). **Bonnard and his
environment.** Texts by James Thrall Soby, James Elliott,
and Monroe Wheeler. New York, Museum of Modern Art; distri-
buted by Doubleday, Garden City, N.Y., 1964.

855. Natanson, Thadée. **Le Bonnard que je propose, 1867-1947.**
Genève, Cailler, 1951.

856. Rewald, John. **Pierre Bonnard.** New York, Museum of Modern
Art, 1948.

857. Royal Academy of Arts (London). **Pierre Bonnard 1867-1947.**
Winter exhibition 1966; text by Denys Sutton. London,
Royal Academy of Arts, 1966.

858. Terrasse, Antoine. **Bonnard; biographical and critical
study.** Trans. by S. Gilbert. Cleveland, World (Skira),
1964.

859. Vaillant, Annette. **Pierre Bonnard, ou le bonheur de voir.**
Neuchâtel, Ides, 1966.

860. Villa Medici (Rome). **Bonnard 1867-1947.** Mostra
all'Accademia di Francia, Villa Medici, Roma, 18 nov.
1971-23 genn. 1972. Roma, de Luca, 1971.

861. Werth, Léon. **Bonnard.** "Cahiers d'Aujourd'hui." Paris,
Crès, 1923. Nouv. éd.

BONNET, LOUIS MARIN, 1736-1793

862. Herold, Jacques. **Louis-Marin Bonnet, 1736-1793. Catalogue
de l'oeuvre gravé.** Paris, Rousseau, 1935. (CR).

BONVICINO, ALESSANDRO see MORETTO, IL

BONVIN, FRANÇOIS, 1817-1887

LEON, 1834-1866

863. Hôtel Drouot (Paris). **Catalogue de tableaux, aquarelles et
dessins par Bonvin.** Déc. 14, 1893 [auction cat.]. Paris,
Drouot, 1893.

864. Moreau-Nélaton, Etienne. **Bonvin raconté par lui-même.**
Paris, Laurens, 1927.

865. Weisberg, Gabriel P. **The drawings and watercolors of Léon
Bonvin.** Introductory essay by William R. Johnson.
Cleveland, Ohio, Cleveland Museum of Art; distributed by
Indiana University Press, Bloomington, Ind., 1980.

BORDONE, PARIS, ca. 1500-1571

866. Canova, Giordana. **Paris Bordone.** Con prefazioni di Rudolfo
Pallucchini. Venezia, Alfieri, 1964. (Profili e saggi di
Arte Veneta, 2).

867. Schefer, Jean Louis. **Scénographie d'un tableau.** Paris,
Editions du Seuil, 1969.

BORDUAS, PAUL-EMILE, 1905-1960

868. Borduas, Paul Emile. **Refus Global: projections libérantes.**
Nouv. éd. augm. d'une introduction de François-Marc Gagnon
et suivie de Notes biographiques de Borduas et l'automa-
tisme par Marcel Fournier et Robert Laplante et de
Dimensions de Borduas par Claude Gauvreau. Montréal,
Parti Pris, 1977. (Collection Projections Libérantes, 1).

869. Ethie-Blais, J. **Autour de Borduas** Essai d'histoire
intellectuelle. Montréal, Les Presses de l'Université de
Montréal, 1979.

870. Gagnon, François Marc. **Paul-Emile Borduas, 1905-1960.**
Biographie critique et analyse de l'oeuvre. Montréal,
Fides, 1978.

871. Musée d'Art Contemporain Montréal. **La collection Borduas du
Musée d'Art Contemporain.** Montréal, Musée d'Art
Contemporain, 1976.

872. Robert, Guy. **Borduas.** Montréal, Presses de l'Université du
Québec, 1972.

872a. _____. **Borduas: ou le dilemme culturel québecois.**
Montréal, Stanke, 1977.

BORGLUM, JOHN GUTZON DE LA MOTHE, 1867-1941

873. Casey, Robert Joseph. **Give the man room: the story of
Gutzon Borglum.** By R. J. Casey and Mary Borglum.
Indianapolis, Bobbs-Merrill, 1952.

874. Price, Willadene. **Gutzon Borglum, artist and patriot.**
Chicago, Rand McNally, 1961.

BORROMINI, FRANCESCO, 1599-1667

875. Argan, Giulio C. **Borromini.** Milano, Mondadori, 1952.
(Biblioteca moderna Mondadori, 300).

876. Blunt, Anthony. **Borromini**. Cambridge, Mass., Harvard University Press, 1979.

877. Bruschi, Arnaldo. **Borromini, manierismo spaziale oltre il Barocco**. Bari, Dedalo libri, 1978. (Universale di architettura, 8).

878. Convegno di studi Borromino. **Atti del convegno promosso dall'Accademia Nazionale di San Luca**. 2 v. Roma, 1967-1972. (Vol. 2 pub. by de Luca).

879. Del Piazzo, Marcello. **Ragguagli borrominiani; mostra documentaria**. Catalogo a cura di Marcello Del Piazzo. Roma, 1968.

880. Hempel, Eberhard. **Francesco Borromini**. Wien, Schroll, 1924.

881. Munoz, Antonio. **Francesco Borromini**. Roma, Società Ed. d'Arte Illus., 1921.

882. Perrotti, Maria Venturi. **Borromini**. Milano/Firenze, Electa, 1951.

883. Portoghesi, Paolo. **Borromini nella cultura europea**. Roma, Officini Ediz., 1964.

884. _____. **Disegni di Francesco Borromini**. Catalogo a cura di Paolo Portoghesi, Roma, de Luca, 1967.

885. _____. **The Rome of Borromini. Architecture as language**. Trans. by Barbara L. LaPenta. New York, Braziller, 1968.

886. Sedlmayr, Hans. **Die Architektur Borrominis**. Berlin, Frankfurter Verlags-Anstalt, 1930.

887. Thelen, Heinrich. **Francesco Borromini; die Handzeichnungen**. Graz, Akad. Druck und Verlagsanstalt, 1967. (Veröffentlichungen der Albertina, 2).

BOS, CORNELIS, 1506-1556

888. Schele, Sune. **Cornelis Bos; a study of the origins of the Netherlands grotesque**. Stockholm, Almquist, 1965. (Stockholm Studies in the History of Art, 10).

BOSCH, HIERONYMUS VAN AKEN, 1450-1516

889. Baldass, Ludwig von. **Hieronymus Bosch**. New York, Abrams, 1960.

890. Bosch, Hieronymus van Aken. **Hieronimus Bosch**. Bijdragen bij gelegenheid van de herdenkings-tentoonstelling to s'Hertogenbosch. s'Hertogenbosch, Hieronymus Bosch Exhibition Foundation, 1967.

891. Combe, Jacques. **Jérôme Bosch**. Paris, Tisné, 1957.

892. Daniel, Howard. **Hieronymus Bosch**. New York, Hyperion, 1947.

893. Fraenger, Wilhelm. **Hieronymus Bosch**. Von W. Fraenger mit einem Beitrag von Patrik Reuterswärd. Dresden, Verlag der Kunst, 1975.

894. _____. **Hieronymus Bosch: das tausendjährige Reich**. Grundzüge einer Auslegung. Amsterdam, Castrum Peregrini, 1969. 2 ed. 1st ed.: Coburg, Winkler, 1947 as his Hieronymus Bosch, 1. (Castrum Peregrini, 86/88).

895. _____. **The millennium of Hieronymus Bosch**. Trans. by E. Wilkins and E. Kaiser. Chicago, Chicago University Press, 1951.

896. Gauffreteau-Sévy, Marcelle. **Jérôme Bosch**. Paris, Editions du Temps, 1965.

897. Gibson, Walter S. **Hieronymus Bosch**. New York, Praeger, 1973.

898. Lafond, Paul. **Hieronymus Bosch--son art, son influence, ses disciples**. Paris, van Oest, 1914.

899. Leymarie, Jean. **Jérôme Bosch**. Paris, Somogy, 1949.

900. Linfert, Carl. **Hieronymus Bosch**. Trans. from the German by Joan Spencer. London, Phaidon, 1959.

901. Marijnissen, Roger H., et al. **Jérôme Bosch**. Bruxelles, Arcade, 1972.

902. Pfister, Kurt, ed. **Hieronymus Bosch: das Werk**. Potsdam, Kiepenheuer, 1922.

903. Puyvelde, Leo van. **Le peinture flamande au siècle de Bosch et Breughel**. Paris, Elsevier, 1962.

904. Reuterswärd, Patrik. **Hieronymus Bosch**. Stockholm, Almquist & Wiksell, 1970. (Uppsala Studies in the History of Art, N.S. 7).

905. Schuder, Rosemarie. **Hieronymus Bosch**. Wien, Tusch, 1975.

906. Schurmeyer, Walter. **Hieronymus Bosch**. München, Piper, 1923.

907. Tolnay, Charles de. **Hieronymus Bosch**. Trans. by M. Bullock and H. Minns. New York, Reynal, 1966.

908. Unverfehrt, G. **Hieronymus Bosch. Die Rezeption seiner Kunst im frühen 16. Jahrhundert**. Berlin, Mann, 1980.

909. Wertheim-Aymes, Clement A. **Hieronymus Bosch; eine Einführung in seine geheime Symbolik, dargestellt am "Garten der himmlischen Freuden," am Heuwagen-Triptychon, am Lissaboner Altar und an Motiven aus anderen Werken**. Amsterdam, van Ditmar, 1957.

BOSSCHAERT, AMBROSIUS, 1573-1621

910. Bol, Laurens Johannes. **The Bosschaert dynasty, painters of flowers and fruit**. Trans. by A. M. de Bruin-Cousins. Leigh-on-Sea, Lewis, 1960.

BOSSE, ABRAHAM, 1602-1676

911. Blum, André. **L'oeuvre gravé d'Abraham Bosse**. Paris, Morance, 1924.

912. Bosse, Abraham. **Le peintre converty aux précises et universelles règles de son art.** Sentiments sur la distinction des diverses manières de peinture, dessin et gravure. Introduction par Roger-Armand Weigert. Paris, Hermann, 1964. [First published 1649].

912a. _____. **Representations geometrales de plusieurs parties de bastiments faites par le reigle de l'architecture antique** Paris, chez l'autheur, 1659.

913. _____. **Le XVII siècle vu par Abraham Bosse, graveur du roy.** Texte de presentation par Nicole Villa. Paris, Editions Dacosta, 1967.

914. _____. **Traité des manières de dessiner les ordres de l'architecture antique en toutes leurs parties.** Paris, l'auteur, 1664.

915. Duplessis, Georges. **Catalogue de l'oeuvre de Abraham Bosse.** Paris, Revue Universelle des Arts, 1859. (CR).

916. Servolini, Luigi. **Abraham Bosse e il suo trattato della calcografia.** Bologna, Ratta, 1937.

917. Smith College Museum of Art (Northampton, Mass.). **Abraham Bosse, 1602-1676.** [Exhibition] Feb.-March, 1956. Northampton, Smith College, 1956.

918. Valabrègue, Antony. **Abraham Bosse.** Paris, Librairie de l'Art, 1892.

BOTERO, FERNANDO, 1932-

919. Arciniegas, German. **Fernando Botero.** Trans. by Gabriela Arciniegas. New York, Abrams, 1977.

920. Botero, Fernando. **Fernando Botero.** Catalog of an exhibition, comp. by Cynthia Jaffee McCabe. Hirshhorn Museum and Sculpture Garden, Washington, D.C., 20 Dec. 1979-10 Feb. 1980 and Art Museum of South Texas, Corpus Christi, 27 March-10 May, 1980. Washington, U.S. Govt. Print. Office, 1979.

921. _____. **Fernando Botero.** Museum Boymans-Van Beuningen, Rotterdam, 27 maart-19 mei 1975. Rotterdam, Museum Boymans-Van Beuningen, 1975.

922. Ratcliff, Carter. **Botero.** New York, Abbeville Press, 1980.

BOTH, JAN, 1618-1652

923. Burke, James. **Jan Both: paintings, drawings, prints.** New York, Garland, 1976.

BOTTICELLI, SANDRO, 1447-1510

924. Argan, Giulio Carlo. **Botticelli: biographical and critical study.** Trans. from the Italian by James Emmons. New York, Skira, 1957. (The Taste of Our Time, 19).

925. Bertini, Aldo. **Botticelli.** Testo di Aldo Bertini. Milano, Marbello, 1953.

926. Bettini, Sergio. **Botticelli.** Bergamo, Instituto Italiano d'Arti Grafiche, 1947.

927. Binyon, Laurence. **The art of Botticelli; an essay in pictorial criticism.** London, Macmillan, 1913.

928. Bode, Wilhelm von. **Botticelli; des Meisters Werke.** Stuttgart, Deutsche Verlagsanstalt, 1926. 2 ed.

929. Botticelli, Sandro. **L'opera completa del Botticelli.** Presentazione di Carlo Bo. Apparati critici e filologici di Gabriele Mandel. Milano, Rizzoli, 1967. (Classici dell'arte, 5).

930. Chastel, André. **Botticelli.** Greenwich, Conn., New York Graphic Society, 1958.

931. Clark, Kenneth. **The drawings by Sandro Botticelli for Dante's Divine Comedy.** After the originals in the Berlin museums and the Vatican. New York, Harper & Row, 1976.

932. Ettlinger, Leopold David. **Botticelli.** By L.D. and Helen S. Ettlinger. London, Thames and Hudson, 1976.

933. Gamba, Carlo. **Botticelli.** Trans. by Jean Chuzeville. Paris, Gallimard, 1937.

934. Hartt, Frederick. **Sandro Botticelli.** New York, Abrams, 1953.

935. Horne, Herbert P. **Alessandro Filipepi, commonly called Sandro Botticelli, painter of Florence.** London, Bell, 1908.

936. Lightbown, Michael. **Botticelli.** 2 v. I: **Life and work.** II: **Complete catalogue.** Berkeley, Univ. of California Press/London, Paul Elek, 1978. (CR).

937. Mandel, Gabriele. **The complete paintings of Botticelli.** Introduction by Michael Levey. New York, Abrams, 1967.

938. Mesnil, Jacques. **Botticelli.** Paris, Albin Michel, 1938. (Les maîtres du Moyen Age et de la Renaissance, 9).

939. Pucci, Eugenio. **Botticelli nelle opere e nella vita del suo tempo.** Milano, Ceschina, 1955.

940. Salvini, Roberto. **All the paintings of Sandro Botticelli.** Trans. by John Grillenzoni. 4 v. New York, Hawthorn, 1965. (The Complete Library of World Art, vols. 25-28).

941. _____. **Tutta la pittura del Botticelli.** 2 v. Milano, Rizzoli, 1958. (Biblioteca d'arte Rizzoli, 32-35).

942. Steinmann, Ernst. **Botticelli.** Bielefeld/Leipzig, Velhagen & Klasing, 1925. 4 ed. 1st ed. 1897. (Künstler-Monographien, 24).

943. _____. **Botticelli.** Trans. by Campbell Dodgson. New York, Lemcke & Buechner, 1904. (Monographs on Artists, 6).

944. Ulmann, Hermann. **Sandro Botticelli.** München, Verlagsanstalt für Kunst und Wissenschaft F. Bruckmann, 1893.

945. Venturi, Adolfo. **Botticelli.** London, Zwemmer, 1927.

946. Venturi, Lionello. **Botticelli.** New York, Phaidon, 1961.

947. Yashiro, Yukio. **Sandro Botticelli and the Florentine renaissance.** London, Medici Society, 1929. 2 ed.

BOUCHARDON, EDME, 1698-1762

948. Bouchardon, Edmé. **Edmé Bouchardon, sculpteur du roi, 1698-1762.** Exposition du bi-centenaire. Catalogue rédigé par Odile Colin. Chaumont, Musée de Chaumont, 1962.

949. Roserot, Alphonse. **Edmé Bouchardon.** Paris, Librairie Centrale des Beaux-Arts, E. Lévy, 1910.

BOUCHER, FRANÇOIS, 1703-1770

950. Ananoff, Alexandre. **François Boucher.** Par A. Ananoff avec la collaboration de Daniel Wildenstein. 2 v. Lausanne, Bibliothèque des Arts, 1976.

951. _____. **L'oeuvre dessiné de François Boucher (1703-1770), catalogue raisonné.** V. I- . Paris, de Nobele, 1966- . (CR).

952. Boucher, François. **François Boucher in North American Collections: 100 Drawings.** Text by Regina Shoolman Slatkin. Washington, D.C., National Gallery of Art, 1973.

953. Fenaille, Maurice. **François Boucher.** Par M. Fenaille avec une préface de Gustave Geffroy. Paris, Nilsson, 1925.

954. Hind, Arthur Mayger. **Watteau, Boucher, and the French engravers and etchers of the earlier eighteenth century.** New York, Stokes, 1911.

955. Kahn, Gustave. **Boucher; biographie critique.** Paris, Laurens, 1904.

956. Lavallée, Pierre. **François Boucher, 1703-1770; quatorze dessins.** Paris, Musées Nationaux, 1942.

957. Macfall, Haldane. **Boucher; the man, his times, his art, and his significance, 1703-1770.** London, The Connoisseur, 1908.

958. Mantz, Paul. **François Boucher, Lemoyne et Natoire.** Paris, Quantin, 1880.

959. McInnes, Ian. **Painter, King & Pompadour: François Boucher at the court of Louis XV.** London, Muller, 1965.

960. Musée du Louvre (Paris). **François Boucher: gravures et dessins provenant du Cabinet des dessins et de la Collection Edmond de Rothschild.** Exposition organisée à l'occasion au bicentenaire de la mort de l'artiste. Musée du Louvre 12 Mai-Sept. 1971. Catalogue par Pierette Jean-Richard. Paris, Réunion des Musées Nationaux, 1971.

961. _____. **L'oeuvre gravé de François Boucher dans la collection Edmond de Rothschild.** Par Pierette Jean-Richard. Paris, Editions des Musées Nationaux, 1978. (Its inventaire général des gravures: Ecole française, 1).

962. Nolhac, Pierre de. **François Boucher, premier peintre du roi, 1703-1770.** Paris, Goupil, 1907.

BOUDIN, EUGENE, 1824-1898

963. Benjamin, Ruth L. **Eugène Boudin.** New York, Raymond and Raymond, 1937.

964. Cahen, Gustave. **Eugène Boudin, sa vie et son oeuvre.** Paris, Floury, 1900.

965. Cario, Louis. **Eugène Boudin.** Paris, Rieder, 1928.

966. Jean-Aubry, Georges. **Eugène Boudin.** By G. Jean-Aubry with Robert Schmit. Trans. by Caroline Tisdall. Greenwich, Conn., New York Graphic Society, 1968.

967. _____. **La vie et l'oeuvre d'après les lettres et les documents inédits d'Eugène Boudin.** Par G. Jean-Aubry. Avec la cooperation de Robert Schmit. Neuchatel, Editions Ides et Calendes, 1968. 1st ed. 1922: Paris, Bernheim-Jeune.

968. Knyff, Gilbert de. **Eugène Boudin raconté par lui-même: Sa vie, son atelier, son oeuvre.** Paris, Mayer, 1976.

969. Musée National du Louvre (Paris). **Boudin: aquarelles et pastels.** Catalogue établi par Lise Duclaux et Geneviève Monnier. Paris, Réunion des Musées Nationaux, 1965.

970. Schmit, Robert. **Eugène Boudin, 1824-1898.** 3 v. Paris, Imp. Union, 1973.

BOULANGER, LOUIS, 1806-1867

971. Marie, Aristide. **Le peintre poète Louis Boulanger.** Paris, Floury, 1925.

BOULLEE, ETIENNE-LOUIS, 1728-1799

972. Perouse de Montclos, Jean Marie. **Etienne-Louis Boullée, 1728-1799, de l'architecture classique à l'architecture révolutionnaire.** Paris, Arts et Métiers Graphiques, 1969.

BOURDELLE, EMILE-ANTOINE, 1861-1929

973. Auricoste, Emmanuel. **Emile-Antoine Bourdelle, 1861-1929.** Paris, Braun, 1955.

974. Jianou, Ionel. **Bourdelle.** Par Ionel Jianou et Michel Dufet. Paris, Arted, 1965.

975. Lorenz, Paul. **Bourdelle, sculptures et dessins.** Paris, Rombaldi, 1947.

976. Starodubova, Veronika Vasi'evna. **Emil'-Antuan Burdel.** Moskva, Iskusstvo, 1970.

977. Varenne, Gaston. **Bourdelle par lui-même; sa pensée et son art.** Paris, Fasquelle, 1937.

BOURDON, SEBASTIEN, 1616-1671

978. Ponsonailhe, Charles. **Sébastien Bourdon: sa vie et son oeuvre d'après des documents inédits tirés des archives de Montpellier.** Paris, Rouam, 1886.

BOUTS, DIERCK, 1420-1475

979. Denis, Valentin. **Thierry Bouts.** Bruxelles, Elsevier, 1957. (Connaissance des primitifs flamands, 2).

980. Palais des Beaux-Arts (Brussels). **Dieric Bouts, Tentoonstelling, Paleis voor Schone Kunsten Brussel, Prinsenhof Delft, 1957-1958.** Catalogus door Frans Baudouin on K.G. Boon. Brussel, Editions de la Connaissance, 1957.

981. Schöne, Wolfgang. **Dieric Bouts und seine Schule.** Berlin, Verlag fur Kunstwissenschaft, 1938.

982. Wauters, Alphonse. **Thierri Bouts ou de Harlem et ses fils.** Bruxells, Devroye Impr., 1863.

BRACHT, EUGEN, 1842-1921

983. Bracht, Eugen. **Eugen Bracht 1842-1921.** [Ausstellung]. Kunsthalle Darmstadt, 14. Sept.-15. Nov. 1970. Katalogbearbeitung Hans-Günther Sperlich. Darmstadt, Kunstverein, 1970.

984. Osborn, Max. **Eugen Bracht.** Bielefeld/Leipzig, Velhagen & Klasing, 1909. (Künstler-Monographien, 97).

BRADY, MATHEW B., 1823-1896

985. Horan, James D. **Mathew Brady, historian with a camera.** New York, Crown, 1955.

986. Kunhardt, Dorothy M. and Kunhardt, Philip B., Jr. **Mathew Brady and his world.** Alexandria, Va., Time-Life, 1977.

987. Meredith, Roy. **Mr. Lincoln's camera man: Mathew B. Brady.** New York, Dover, 1974. Rev. ed.

988. _____. **The World of Mathew Brady; portraits of the Civil war period.** Los Angeles, Brooke House, 1976.

BRAEKELEER, HENRI DE, 1840-1888

989. Conrady, Charles. **Henri di Braekeleer.** Bruxelles, Elsevier, 1957.

990. Gilliams, Maurice. **Inleiding tot de idee Henri de Braekeleer.** Antwerpen, Nederlandsche Boekhandel, 1945.

991. Vanzype, Gustave. **Henri de Braekeleer.** Bruxelles, van Oest, 1923.

BRAMANTE, DONATO, 1444-1514

992. Baroni, Costantino. **Bramante.** Bergamo, Ist. Ital. d'Arti Grafiche, 1944.

993. Bramante, Donato. **L'opera completa di Bramantino e Bramante pittore.** Presentazione di Gian Alberto dell'Acqua; apparati critici e filologici di Germano Mulazzini. Milano, Rizzoli, 1978. (Classici dell'arte,45).

994. Bruschi, Arnaldo. **Bramante.** Foreword by Peter Murray. London, Thames and Hudson, 1977.

995. _____. **Bramante architetto.** Bari, Laterza, 1969.

996. Comitato Nazionale per le Celebrazzioni Bramantesche. **Bramante fra umanesimo e manierismo.** Mostra storico-critica, sett. 1970. Palazzo reale Milano. Roma, Istit. Grafico Tiberino, 1970.

997. Congresso Internazionale di Studi Bramanteschi. **Studi bramanteschi.** Atti del Congresso internazionale. Milano, Urbino, Roma, 1970. Roma, de Luca, 1974.

998. Forster, Otto Helmut. **Bramante.** Wien, Schroll, 1956.

999. Raymond, Marcel. **Bramante et l'architecture italienne au XVIe siècle.** Paris, Laurens, 1914.

1000. Suida, William Emil. **Bramante pittore e il bramantino.** Milano, Ceschina, 1953.

1001. Wolff-Metternich, Franz. **Bramante und St. Peter.** München, Fink, 1975. (Collectanea artis historiae, 2).

BRANCUSI, CONSTANTIN 1876-1957

1002. Brancusi, Constantin. **Brancusi, photographer.** Pref. by Pontus Hulten. Photos selected by Marielle Tabart and Isabelle Monod-Fontaine. Trans. by Kim Sichel. New York, Agrinde, 1979.

1003. Brezianu, Barbu. **Brancusi in Romania.** Bucuresti, Edit. Acad. Rep. Socialiste România, 1976. (1st ed. 1974 has title **Opera lui Constantin Brancusi in Romania**).

1004. Geist, Sidney. **Brancusi. A study of the sculpture; an oeuvre catalogue.** New York, Grossmann, 1983. 2 ed. 1st ed. 1968. (CR).

1005. _____. **Brancusi; the sculpture and drawings.** New York, Abrams, 1975.

1006. Giedion-Welcker, Carola. **Constantin Brancusi.** Basel, Schwabe, 1958.

1007. Jianou, Ionel. **Brancusi.** Paris, Arted, 1963.

1008. Pandrea, Petre. **Brancusi, amintiri si exegeze.** Bucuresti, Meridiane, 1976. (Biblioteca de arta, 177).

1009. Pogorilovschi, Ion. **Comentarea Capodoperei: ansamblul sculptural Brancusi de la Tirgu-Jiu.** Iasi, Janimea, 1976.

1010. Solomon R. Guggenheim Museum (New York). **Constantin Brancusi, 1876-1957: a retrospective exhibition.** Catalog by Sidney Geist. New York, Solomon R. Guggenheim Foundation, 1969.

1011. Zervos, Christian. **Constantin Brancusi: sculptures, peintures, fresques, dessins.** Paris, Editions "Cahiers d'art," 1957.

BRANDT, BILL, 1904-1984

1012. Brandt, Bill. **Camera in London.** London/New York, Focal Press, 1948.

1013. _____. **Portraits.** Introd. by Alan Ross. London, Fraser, 1982.

1014. _____. **Shadow of light.** New York, Da Capo, 1977.

BRANGWYN, FRANK, 1867-1956

1015. Boyd, James D. **The drawings of Sir Frank Brangwyn, 1867-1956.** By J. D. Boyd. Leigh-on-Sea, Lewis, 1967.

1016. Brangwyn, Frank. **Frank Brangwyn, R. A.** Introd. by G. S. Sandilands. London, The Studio, 1928. (Famous water-colour painters, 1).

1017. Brangwyn, Rodney. **Brangwyn.** London, Kimber, 1978.

1018. Bunt, Cyril G. E. **Sir Frank Brangwyn.** Leigh-on-Sea, Lewis, 1949.

1019. _____. **The water-colours of Sir Frank Brangwyn, 1867-1956.** Leigh-on-Sea, Lewis, 1958.

1020. Furst, Herbert E. A. **The decorative art of Frank Brangwyn.** London, Lane/New York, Dodd Mead, 1924.

1021. Galloway, Vincent. **The oils and murals of Sir Frank Brangwyn 1867-1956.** Leigh-on-Sea, Lewis, 1962.

1022. Gaunt, William. **The etchings of Frank Brangwyn; a catalogue raisonné** by W. Gaunt. London, The Studio, 1926.

1023. Sparrow, Walter Shaw. **Frank Brangwyn and his work.** London, Kegan Paul, etc., 1910.

1024. _____. **Prints and drawings by Frank Brangwyn, with some other phases of his art.** London, Lane, 1919.

BRAQUE, GEORGES, 1881-1963

1025. Braque, Georges. **Georges Braque [Exposition].** Orangerie des Tuileries, 10 oct. 1973-14 jan. 1974. Catalogue rédigé par Michèle Richet et Nadine Pouillon. Paris, Editions des Musées Nationaux, 1973.

1026. Brunet, Christian. **Braque et l'espace.** Paris, Klincksieck, 1971.

1027. Cogniat, Raymond. **Georges Braque.** Trans. by I. M. Paris. New York, Abrams, 1980.

1028. Cooper, Douglas. **Braque: the great years.** Catalogue of an exhibition held at the Art Institute of Chicago, Oct. 7-Dec. 3, 1972. Chicago, Art Institute, 1972.

1029. Einstein, Carl. **Georges Braque.** New York, Weyhe, 1934.

1030. Engelberts, Edwin. **Georges Braque.** Oeuvre graphique original. Hommage de René Char. Genève, Cabinet des Estampes du Musée d'Art ed d'Histoire and Galerie Nicolas Rauch, 1958.

1031. Fondation Maeght (Saint-Paul). **Georges Braque: 5 juillet-30 septembre 1980.** Exposition réalisée par Jean-Louis Prat. St. Paul, La Fondation, 1980.

1032. Fumet, Stanislas. **Sculptures de Braque.** Paris, Damase, 1951.

1033. Gallatin, Albert Eugène. **Georges Braque: essay and bibliography.** New York, Wittenborn, 1943.

1034. Gieure, Maurice. **Braque: Dessins.** Paris, Editions Deux Mondes, 1955.

1035. _____. **Georges Braque.** Paris, Tisné, 1956.

1036. Hofmann, Werner. **Georges Braque: das graphische Werk,** Einleitung W. Hofmann. Stuttgart, Hatje, 1961.

1037. _____. **Georges Braque: his graphic work.** Introd. by W. Hofmann. New York, Abrams, 1961.

1038. Hope, Henry R. **Georges Braque.** The Museum of Modern Art, New York, in collaboration with the Cleveland Museum of Art. New York, Museum of Modern Art; distributed by Simon and Schuster, 1949.

1039. Leymarie, Jean. **Braque.** Trans. by James Emmons. New York, Skira, 1961. (The Taste of Our Time, 35).

1040. Mangin, Nicole S. **Catalogue de l'oeuvre de Georges Braque: Peintures 1916-23, 1924-27, 1928-35, 1936-41, 1942-47, 1948-57.** 6 v. Paris, Maeght Editeur, 1959-1973.

1041. Monod-Fontaine, Isabelle. **Braque, the papiers collés.** By I. Monod-Fontaine with E. A. Carmeau and contrib. by T. Clark et al. Washington, D.C., National Galley of Art, 1982.

1042. Paulhan, Jean. **Braque le patron.** Genève/Paris, Editions des Trois Collines, 1946.

1043. Ponge, Francis, et al. **G. Braque de Draeger.** [Par] F. Ponge, P. Descargues, A. Malraux. Paris, Draeger, 1971.

1044. _____. **Georges Braque lithographe.** Préface de F. Ponge. Notices et catalogue établis par Fernand Mourlot. Monte Carlo, Sauret, 1963.

1045. Richardson, John. **Braque.** New York, New York Graphic Society, 1961. 1st pub. by Penguin Books, Harmondsworth, Eng., 1959. (Penguin Modern Painters, 20).

1046. Russell, John. **G. Braque.** London, Phaidon, 1959.

1047. Worms de Romilly, Nicole and Laude, Jean. **Braque: le cubisme fin 1907-1914.** Paris, Maeght, 1982.

BRASSAÏ (Gyula Halasz), 1899-

1048. Brassaï. **The artists of my life.** Trans. by Richard Muller. New York, Viking, 1982.

1049. _____. **Brassaï présente images du camera.** Paris, Hachette, 1964.

1050. _____. **The secret Paris of the 30's.** Trans. by Richard Muller. New York, Pantheon, 1976.

1051. Durrell, Lawrence. **Brassaï.** New York, Museum of Modern Art, 1968; distributed by New York Graphic Society, Greenwich, Conn.

BREENBERGH, BARTHOLOMEUS, 1599-1659

1052. Roethlisberger, Marcel. **Bartholomeus Breenbergh: Handzeichnungen.** Berlin/New York, de Gruyter, 1969.

1053. _____. Bartholomeus Breenbergh: The paintings. Berlin/
New York, de Gruyter, 1981.

BRESDIN, RODOLPHE, 1825-1885

1054. Bresdin, Rodolphe. Rodolphe Bresdin 1822-1885,
[tentoonstelling] Haags Gemeentemuseum 27 oktober 1978-14
januari 1979. Catalogus Dirk van Gelder and John
Sillevis. s'Gravenhage, Staatsuitgeverij, 1978.

1055. Gelder, Dirk van. Rodolphe Bresdin. Monographie et cata-
logue raisonné de l'oeuvre. 2 v. The Hague, Nijhoff,
1976. (CR).

1056. Museum of Modern Art (New York). Odilon Redon, Gustave
Moreau [and] Rodolphe Bresdin. The Museum of Modern Art,
New York, in collaboration with the Art Institute of
Chicago. Garden City, N.Y.; distributed by Doubleday,
1961.

BREUER, MARCEL, 1902-

1057. Blake, Peter. Marcel Breuer, architect and designer. New
York, Architectural Record in collaboration with the
Museum of Modern Art, 1949.

1058. Breuer, Marcel. Sun and shadow; the philosophy of an
architect. New York, Dodd Mead, 1956.

BREUER, PETER, 1472-1541

1059. Hentschel, Walter. Peter Breuer. Eine spätgotische
Bildschnitzer-Werkstatt. Berlin, Union, 1952. 2 ed.
(Forschungen zur sächsischen Kunstgeschichte, 1).

BRIGMAN, ANNE W., 1869-1950

1060. Brigman, Anne. Songs of a pagan. Caldwell, Id., Caxton
Printers, 1949.

1061. Oakland Museum, Oakes Gallery (Oakland, Calif.). Anne
Brigman; pictorial photographer/pagan/member of the
photosecession. September 17 through November 17, 1974.
[Text by Therese Thau Heyman]. Oakland, Calif., The
Oakland Museum Art Department, 1974.

BRILL, MATTHÄUS, 1550-1584

 PAUL, 1554-1626

1062. Baer, Rudolf. Paul Brill; Studien zur Entwicklungs-
geschichte der Landschaftsmalerei um 1500. München,
Grassi, 1930.

1063. Mayer, Anton. Das Leben und die Werke der Brüder Matthäus
und Paul Brill. Leipzig, Hiersemann, 1910.

BRIOSCO, ANDREA see RICCIO, ANDREA

BRONZINO, AGNOLO, 1503-1572

1064. Bronzino, Agnolo. L'opera completa del Bronzino.
Introdotta da scritti del pittore. Milano, Rizzoli,
1973. (Classici dell'arte, 70).

1065. Emiliani, Andrea. Il Bronzino. Milano, Bramante, 1960.

1066. Goldschmidt, F. Pontorino, Rosso und Bronzino; ein Versuch
zur Geschichte der Raumdarstellung mit einem Index ihrer
Figurenkomposition. Leipzig, Klinkhardt und Biermann,
1911.

1067. McComb, Arthur K. Agnolo Bronzino; his life and works.
Cambridge, Mass., Harvard University Press, 1928.

1068. McCorguodale, Charles. Bronzino. New York, Harper & Row,
1981.

1069. Schulze, Hanns. Die Werke Angelo Bronzinos. Von Hanns
Schulze. Strassburg, Heitz, 1911. (Zur Kunstgeschichte
des Auslandes, 81).

1070. Smyth, Craig H. Bronzino as draughtsman. An introduc-
tion. With notes on his portraiture and tapestries.
Locust Valley, N.Y., Augustin, 1977.

1071. Tinti, Mario. Bronzino. Firenze, Alinari, 1927. (Piccola
collezione d'arte, 10).

BROOKS, ROMAINE, 1874-1970

1072. Breeskins, Adelyn D. Romaine Brooks, thief of souls.
[Published in conjunction with an exhibition at the
National Collection of Fine Arts, Smithsonian Institution,
Washington, D.C., 24 Feb.-4 April, 1971]. Washington,
D.C., Smithsonian Institution Press, 1971.

1073. Gramont, Elizabeth de. Romaine Brooks: portraits,
tableaux, dessins. Paris, Braun, 1952.

1074. Morand, Paul et al. Romaine Brooks. Paris, Pauvert, 1968.

1075. Secrest, Meryle. Between me and life; a biography of
Romaine Brooks. Garden City, N.Y., Doubleday, 1974.

BROSSE, SALOMON DE, 1571-1626

1076. Coope, Rosalys. Salomon de Brosse and the development of
the classical style in French architecture from 1565 to
1630. London, Zwemmer, 1972. (Studies in architecture,
11).

1077. Pannier, Jacques. Un architecte français au commencement
du XVIIe siècle: Salomon de Brosse. Paris, Libr.
Centrale d'Art et d'Archit., 1911.

BROUWER, ADRIAEN, 1606-1638

1078. Bode, Wilhelm von. Adriaen Brouwer, sein Leben und seine
Werke. Berlin, Euphorion, 1924.

1079. Böhmer, Günter. Der Landschafter Adriaen Brouwer.
München, Neuer Filser-Verlag, 1940.

1080. Höhne, Erich. Adriaen Brouwer. Leipzig, Seemann, 1960.

1081. Knuttel, Gerhardus. Adriaen Brouwer; the master and his
work. Trans. by J. G. Talma-Schilthuis and R. Wheaton.
The Hague, Boucher, 1962.

1082. Schmidt-Degener, Frederik. **Adriaen Brouwer et son évolution artistique.** Brussels, van Oest, 1908.

BROWN, FORD MADOX, 1821-1893

1083. Art Gallery, Manchester, England. **Loan exhibition of works by Ford Madox Brown and the Pre-Raphaelites.** Manchester, Autumn, 1911. Manchester, Art Gallery, 1911.

1084. Brown, Ford Madox. **The diary of Ford Madox Brown.** Edited by Virginia Surtees. New Haven, publ. for the Paul Mellon Centre for Studies in British Art by Yale University Press, 1981.

1085. _____. **Ford Madox Brown; a record of his life and work.** London, Longmans, 1896.

1086. Rabin, Lucy Feiden. **Ford Madox Brown and the Pre-Raphaelite history picture.** New York, Garland, 1978.

1087. Walker Art Gallery (Liverpool). **Ford Madox Brown, 1821-1893.** Exhibition organized by the Walker Art Gallery, Liverpool. Liverpool, 1964.

BROWN, LANCELOT "CAPABILITY," 1716-1783

1088. Hyams, Edward. **Capability Brown and Humphry Repton.** New York, Scribner, 1971.

1089. Stroud, Dorothy. **Capability Brown.** With an introduction by Christopher Hussey. London, Faber, 1975. 2 ed.

BROWN, MATHER, 1761-1831

1090. Evans, Dorinda. **Mather Brown: early American artist in England.** New York, Harper & Row, 1983.

BRUEGHEL, JAN, 1568-1625

 PIETER (the elder), 1525-1569

 PIETER (the younger), 1564-1638

1091. Barker, Virgil. **Pieter Brueghel the elder: a study of his paintings.** New York, Arts Publ. Corp., 1926.

1092. Barnouw, Adriaan Jacob. **The fantasy of Pieter Brueghel.** New York, Lear, 1947.

1093. Bastelaer, Rene van. **Peter Bruegel l'ancien, son oeuvre et son temps.** 2 v. Bruxelles, van Oest, 1908.

1094. Baumgart, Fritz Erwin. **Blumen-Brueghel (Jan Brueghel d. Ä.). Leben und Werk.** Köln, DuMont, 1978. (DuMont Kunst-Taschenbucher, 67).

1095. Bianconi, Piero. **Bruegel.** Bologna, Capitol, 1979. (Collana d'arte Paola Malipiero, 2).

1096. Bruegel, Pieter, the elder. **Bruegel, the painter and his world.** Catalogue realised on the occasion of the exhibit. "Bruegel and his world"; commemorating the 400th anniversary of Bruegel's death, at the Royal Museums of Fine Arts of Belgium, Brussels, 20 Aug.-16 Nov. 1969. Brussels, Lacconti, 1969.

1097. _____. **The complete paintings of Bruegel.** Introd. by Robert Hughes; notes and catalogue by Piero Bianconi. New York, Abrams, 1970.

1098. _____. **Opera completa.** Presentazione di Giovanni Arpino. Apparati critici e filologici di Piero Bianconi. Milano, Rizzoli, 1967. (Classici dell'arte, 7).

1099. Bruhns, Leo. **Das Bruegel Buch.** Wien, Schroll, 1941.

1100. Denuce, Jean. **Brieven en documenten betreffend Jan Bruegel I en II.** Antwerp, De Sikkel, 1934.

1101. Dvorak, Max. **Pierre Brueghel l'ancien.** Wien, Oesterr. Staatsdruckerei, 1930.

1102. Ertz, Klaus. **Jan Brueghel der Ältere (1568-1625). Die Gemälde: mit kritischem Oeuvre Katalog.** Köln, DuMont, 1979.

1103. Fierens, Paul. **Pieter Bruegel; sa vie, son oeuvre, son temps.** Paris, Richard-Masse, 1949.

1104. Fraenger, Wilhelm. **Der Bauern-Bruegel und das deutsche Sprichwort.** Erlenbach-Zürich, Rentsch, 1923.

1105. Friedländer, Max J. **Pieter Bruegel.** Berlin, Propyläen, 1921.

1106. Glück, Gustav. **Das grosse Bruegel-Werk.** Wien, Schroll, 1951. (Based on the author's **Bruegels Gemälde** and **Bilder aus Bruegels Bildern**).

1107. _____. **Pieter Brueghel, the elder.** Trans. by E. B. Shaw. London, Commodore, 1936. 1st German ed.: Wien, Schroll, 1932.

1108. Grauls, Jan. **Volkstaal en volksleven in het werk van Pieter Bruegel.** Antwerpen, Standaard-Boekhandel, 1957.

1109. Grossman, Fritz. **Pieter Bruegel: complete edition of the paintings.** New York, Phaidon [distributed by Praeger], 1973. 3 ed. First 2 eds. published under title: **Bruegel, the paintings.** 1955, 1966.

1110. Hausenstein, Wilhelm. **Der Bauern-Bruegel.** Mit einem Vorwort zur neuen Ausgabe über Bruegel den Belgier. München, Piper. (Klassische Illustratoren, 6).

1111. Jedlicka, Gotthard. **Pieter Bruegel der Maler in seiner Zeit.** Erlenbach-Zürich, Rentsch, 1938.

1112. Klein, H. Arthur. **Graphic worlds of Peter Bruegel the elder, reproducing 64 engravings and a woodcut after designs by Peter Bruegel the elder.** Selected, edited and with commentary by H. A. Klein, New York, Dover, 1963.

1113. Kunsthandel P. de Boer Amsterdam. **De helsche en de fluweelen Brueghel en hun invloed op de kunst in de Nederlanden naar aanleiding van de tentoonstelling,** 10 febr.-26 maart, 1934. Amsterdam, DeBoer, 1934.

1114. Lavalleye, Jacques. **Lucas van Leyden, Peter Bruegel l'ancien; gravures. Oeuvre complet.** Paris, Arts et Métiers Graphiques, 1966.

1115. Lebeer, Louis. **Catalogue raisonné des estampes de Bruegel l'ancien.** Publ. in conjunction with the 400th anniversary exhibition at the Bibliothèque Royale Albert Ier, Sept.-Nov. 1969. Bruxelles, 1969.

1116. _____. **Les estampes de Pierre Bruegel l'ancien.** Avant-propos de Herman Libaers. Antwerpen, Fond Mercator, 1976.

1117. Marijnissen, Roger H. **Bruegel.** Text, catalogue and notes by R. H. Marijnissen. Photographs by Max Seidel, 1971.

1118. Marlier, Georges. **Pierre Brueghel le jeune;** édition posthume mise au point et annotée par Jacqueline Fobie. Bruxelles, Vinck, 1969.

1119. Michel, Emile. **Les Brueghel.** Paris, Allison, 1892.

1120. Münz, Ludwig. **Bruegel; the drawings. Complete edition.** London, Phaidon, 1961.

1121. Palais des Beaux-Arts, Bruxelles. **Bruegel, une dynastie de peintres.** [Exposition] 18 Sept.-18 Nov. 1980. Bruxelles, Europalia, 1980.

1122. Stechow, Wolfgang. **Pieter Bruegel, the elder.** New York, Abrams, 1972.

1123. Stridbeck, Carl Gustaf. **Bruegel Studien. Untersuchungen zu den ikonologischen Problemen bei Pieter Bruegel d. Ä. sowie dessen Beziehungen zum niederländischen Romanismus.** Stockholm, Almquist & Wiksell, 1956. (Stockholm Studies in the History of Art, 2).

1124. Tolnay, Charles de. **Pierre Bruegel l'ancien.** 2 v. Bruxelles, Nouv. Soc. d'Edit., 1935.

1125. Winkelmann-Rhein, Gertraude. **The paintings and drawings of Jan 'Flower' Bruegel.** New York, Abrams, 1969.

BRUGUIERE, FRANCIS, 1879-1945

1126. Enyeart, James. **Bruguiere, his photographs and his life.** New York, Knopf, 1977.

BRÜHLMANN, HANS, 1878-1911

1127. Frauenfelder, Rudolf. **Hans Brühlmann.** Zeichnungen, hrsg. und eingeleitet von R. Frauenfelder mit dem Katalog der späten Zeichnungen von Rudolf Hanhart. Zürich, Artemis, 1961.

1128. Kempter, Lothar. **Der Maler Hans Brühlmann 1878-1911.** St. Gallen, Tschudy, 1954. (Der Bogen, 42).

1129. Roessler, Arthur. **Hans Brühlmann, ein Beitrag zur Geschichte der modernen Kunst.** Wien, Lanyi, 1918.

BRUNELLESCHI, FILIPPO, 1377-1446

1130. Argan, Giulio C. **Brunelleschi.** Milano, Mondadori, 1955. (Biblioteca moderna Mondadori, 415).

1131. Baldinucci, Filippo. **Vita di Filippo di Ser Brunellesco, architetto fiorentino . . . ora per la prima volta pubblicata** Firenze, N. Carli, 1812.

1132. Battisti, Eugenio. **Filippo Brunelleschi.** Milano, Electa, 1976.

1133. _____. **Filippo Brunelleschi, the complete work.** Trans. from Italian by R. E. Wolf. New York, Rizzoli, 1981.

1134. Benigni, Paola. **Filippo Brunelleschi, l'uomo e l'artista: ricerche brunelleschiane.** Mostra documentaria. Catalogo a cura di P. Benigni. Firenze, Archivio di Stato di Firenze, 1977. (Pubblicazione degli Archivi di Stato, 94).

1135. Bozzoni, Corrado. **Filippo Brunelleschi: saggio di bibliografia.** Di C. Bozzoni, Giovanni Carbonara. 2 v. Roma, Istituto di Fondamenti dell'architettura dell'Università, 1977-1978.

1136. Brunelleschi, Filippo. **Filippo Brunelleschi, la sua opere e il suo tempo.** 2 v. Papers presented at an international conference held in Florence, Oct. 16-22, 1977, organized by Guglielmo DeAngelis d'Ossat, Franco Borsi, and others. Firenze, Centro Di, 1980.

1137. Carli, Enzo. **Brunelleschi.** Firenze, Electa, 1949.

1138. Fabriczy, Cornelius von. **Filippo Brunelleschi. La vita e le opere.** A cura di Anna Maria Poma. Prefazione di Franco Borse. 2 v. Firenze, Uniedit, 1979. 1st ed.: Stuttgart, Cotta, 1892.

1139. Fanelli, Giovanni. **Brunelleschi.** Firenze, Becocci, 1977.

1140. Folnesics, Hans. **Brunelleschi; ein Beitrag zur Entwicklungsgeschichte der Frührenaissance-Architektur.** Wien, Schroll, 1915.

1141. Hyman, Isabelle. **Brunelleschi in perspective.** Englewood Cliffs, N.J., Prentice-Hall, 1974.

1142. Klotz, Heinrich. **Die Frühwerke Brunelleschis und die mittelalterliche Tradition.** Berlin, Mann, 1970.

1143. Luporini, Eugenio. **Brunelleschi; forma e ragione.** Milano, Ediz. di Comunita, 1964. (Studi e documenti di storia dell'arte, 6).

1144. Manetti, Antonio di Tuccio. **The life of Brunelleschi.** Introduction and critical text edition by Howard Saalman. Engl. trans. of the Italian text by Catherine Engass. University Park, Penn./London, Pennsylvania State University Press, 1970.

1145. Museo Nazionale del Bargello (Florence). **Brunelleschi scultore.** Mostra celebrativa nel sesto centenario della nascita. Magg.-ott. 1977. Catalogo a cura di Emma Micheletti e Antonio Paolucci. Firenze, Museo Nazionale del Bargello, 1977.

1146. Ragghianti, Carlo Ludovico. **Filippo Brunelleschi, un uomo, un universo.** Firenze, Vallecchi, 1977.

1147. Sanpaolesi, Piero. **Brunelleschi.** Milano, Club del Libro, 1962.

BRUYN, BARTHEL, 1493-1555

1148. Firmenich-Richartz, Eduard. **Bartholomaeus Bruyn und seine Schule.** Leipzig, Seemann, 1891. (Beiträge zur Kunstgeschichte, N.F. 14).

1149. Wallraf-Richartz-Museum (Cologne). **Barthel Bruyn, 1493-1555.** Gesamtverzeichnis seiner Bildnisse und Altarwerke. Gedächtnisausstellung auf Anlass seines vierhundertsten Todesjahres. Köln, Wallraf-Richartz-Museum, 1955. (CR).

1150. Westhoff-Krummacher, Hildegard. **Barthel Bruyn der Aeltere als Bildnismaler.** München, Deutscher Kunstverlag, 1965. (Kunstwissenschaftliche Studien, 35).

BRYEN, CAMILLE, 1907-

1151. Bryen, Camille. **Bryen, abhomme.** Textes réunis et introduits par Daniel Abadie. Bruxelles, La Connaissance, 1973.

1152. Musée National d'Art Moderne (Paris). **Bryen.** [Cat. d'une exposition] 14. fév.-30 avril 1973. Paris, Éditions des Musées Nationaux, 1973.

BRZESKA, HENRI GAUDIER see GAUDIER-BRZESKA, HENRI

BUCHSER, FRANK, 1828-1890

1153. Buchser, Frank. **Mein Leben und Streben in Amerika; Begegnungen und Bekenntnisse eines schweizer Malers, 1866-1871.** Eingel. und hrsg. von G. Wälchli. Zürich/Leipzig, Orell Füssli, 1942.

1154. Lüdeke, Henry. **Frank Buchsers amerikanische Sendung 1866-1871, die Chronik seiner Reisen.** Basel, Holbein-Verlag, 1941.

1155. Wälchli, Gottfried. **Frank Buchser, 1828-1890: Leben und Werk.** Zürich/Leipzig, Orell Füssli, 1941. (Monographien zur schweizer Kunst, 9).

BUERKEL, HEINRICH, 1802-1869

1156. Buerkel, Ludwig von. **Heinrich Buerkel, 1803-1869, ein Malerleben der Biedermeierzeit.** Erzählt und mit einem Register der Werke ergänzt von seinem Enkel. München, Bruckmann, 1940.

BUFFET, BERNARD, 1928-

1157. Berge, Pierre. **Bernard Buffet.** Genève, Cailler, 1958. 1st. ed.; 2nd ed., rev. et augm., 1964. (Peintres et sculpteurs d'hier et d'aujourd'hui, 45).

1158. Buffet, Bernard. **Oeuvre gravé.** Préf. par Georges Simenon. Catalogue établi par Fernand Mourlot. Lithographies, 1952-1966. Paris, Mazo, 1967.

1159. Descargues, Pierre. **Bernard Buffet.** Suivi de **Bernard Buffet, peintre ou témoin** par P. de Boisdeffre. Paris, Editions universitaires, 1959. (Témoins du XXe siècle, 15).

1160. Sorlier, Charles. **Bernard Buffet lithographe.** Paris, Draeger/Trinckvel, 1980.

BUHOT, FELIX HILAIRE, 1847-1898

1161. Bourchard, Gustave. **Félix Buhot.** Catalogue descriptif de son oeuvre gravé. New York, Gordon, 1979. Reprint of 1899 ed., Paris, Floury.

1162. Uzanne, Octave. **Félix Buhot, dessinateur et aquafortiste.** Paris, Quantin, 1888.

BULFINCH, CHARLES, 1763-1844

1163. Bulfinch, Charles. **The life and letters of Charles Bulfinch, architect, with other family papers.** Ed. by Ellen S. Bulfinch. Boston, Houghton, 1896.

1164. Kirker, Harold. **Bulfinch's Boston, 1787-1817.** [By] H. and James Kirker. New York, Oxford University Press, 1964.

1165. Place, Charles A. **Charles Bulfinch, architect and citizen.** Boston, Houghton, 1925.

BULLOCK, WYNN, 1902-1975

1166. Bullock, Barbara. **Wynn Bullock.** San Francisco, Scrimshaw Press, 1971.

1167. _____. **Wynn Bullock; photography: a way of life.** Edited by Liliane DeCock. Dobbs Ferry, N.Y., Morgan & Morgan, 1973.

1168. Fuess, David. **Wynn Bullock.** Millerton, N.Y., Aperture, 1976. (The Aperture history of photography, 4).

BUON, BARTOLOMEO, d. 1464

 GIOVANNI, fl. 1382-1443

1169. Schulz, Anne. **The sculpture of Giovanni and Bartolomeo Buon and their workshop.** Philadelphia, American Philosophical Society, 1978. (Transactions of the American Philosophical Society, 68, pt. 3).

BUONARROTI see MICHELANGELO

BUONINSEGNA, DUCCIO see DUCCIO DI BUONINSEGNA

BUONTALENTI, BERNARDO, 1531-1608

1170. Galleria degli Uffizi (Florence). **Mostra di disegni di Bernardo Buontalenti, 1531-1608.** Firenze, Olschki, 1968.

BURCHFIELD, CHARLES, 1893-1967

1171. Baigell, Matthew. **Charles Burchfield.** New York, Watson Guptil, 1976.

1172. Baur, John I. H. **Charles Burchfield.** New York, Macmillan, 1956.

1173. _____. The islander: life and work of Charles Burchfield, 1893-1967. Newark, University of Delaware Press/New York, Cornwall Books, 1982.

1174. Burchfield Center at State University College, Buffalo, N.Y. Works by Charles E. Burchfield: a tribute from Tom Sisti. Catalogue of an exhibition 21 Oct.-9 Dec. 1979, held at the Burchfield Center. Buffalo, State University College, 1979.

1175. Burchfield, Charles. Charles Burchfield. Catalogue of paintings in public and private collections. Utica, N.Y., Munson-Williams-Proctor Institute, 1970.

BURGES, WILLIAM, 1827-1881

1176. Crook, J. Mordaunt. William Burges and the High Victorian Dream. London, Murray, 1981.

1177. Pullan, R. P. The architectural designs of William Burges. London, Batsford, 1887.

BURGKMAIR, HANS, 1475-1531

1178. Burkhard, Arthur. Hans Burgkmair d. Ae. Leipzig, Insel, 1934.

1179. Falk, Tilman. Hans Burgkmair. Studien zu Leben und Werk des Augsburger Malers. München, Bruckmann, 1968.

1180. Feuchtmayr, Karl. Das Malerwerk Hans Burgkmairs von Augsburg. Kritisches Verzeichnis anlässlich der im Sommer 1931 von der Direktion der Bayerischen Staatsgemäldesammlungen in Augsburg und München veranstalteten Burgkmair-Ausstellung, Augsburg, Filser, 1931.

BURNE-JONES, EDWARD, 1833-1898

1181. Bell, Malcolm. Sir Edward Burne-Jones; a record and review. London, Bell, 1903. 4 ed.

1182. Burne-Jones, Georgina M. Memorials of Edward Burne-Jones. 2 v. London, Macmillan, 1909. 2 ed.

1183. Cecil, David. Visionary and dreamer; two poetic painters: Samuel Palmer and Edward Burne-Jones. Princeton, N.J., Princeton University Press, 1969. (Bollingen series, 35).

1184. Grossman, Fritz. Burne-Jones; paintings. London, Phaidon, 1956.

1185. Harrison, Martin. Burne-Jones. [By] Martin Harrison and Bill Waters. New York, Putnam, 1973.

1186. Hayward Gallery, London. Burne-Jones: the paintings, graphic and decorative work of Sir Edward Burne-Jones, 1833-1898. Exhibition, 5 Nov. 1975-4 Jan. 1976. Catalogue ed. by Penelope Marcus. London, Arts Council of Great Britain, 1975.

1187. Wood, T. Martin. Drawings of Sir Edward Burne-Jones. New York, Scribner, 1907.

BURNHAM, DANIEL HUDSON, 1846-1912

1188. Hines, Thomas S. Burnham of Chicago, architect and planner. New York, Oxford University Press, 1974.

1189. Moore, Charles H. Daniel H. Burnham, architect and planner of cities. 2 v. Boston, Houghton, 1921.

BURY, POL, 1922-

1190. Ashton, Dore. Pol Bury. Paris, Maeght, 1970. (Collection monographies, 31).

1191. Bury, Pol. Pol Bury. [Catalog of an exhibition held by the Kestner Gesellschaft Hannover, Nov. 20, 1971-Feb. 20, 1972]. Katalogredaktion André Balthazar and Wieland Schmied. Hannover, Kestner Gesellschaft, 1971.

BUSCH, WILHELM, 1832-1908

1192. Bohne, Friedrich. Wilhelm Busch: Leben, Werk, Schicksal. Zürich, Fretz & Wasmuth, 1958.

1193. Gmelin, Hans Georg. Wilhelm Busch als Maler. Mit einem vollständigen Werkverzeichnis nach Vorarbeiten von Reinhold Behrens. Berlin, Mann, 1980. (CR).

1194. Niedersächsisches Landesmuseum (Hannover). Wilhelm Busch 1832-1908. 3 v. Berlin, Mann, 1982.

1195. Nöldeke, Hermann. Wilhelm Busch, von Hermann, Adolf und Otto Nöldeke. München, Lothar Joachim-Verlag, 1909.

1196. Novotny, Fritz. Wilhelm Busch als Zeichner und Maler. Wien, Schroll, 1949.

BUSON, YOSA, 1716-1784

1197. The University of Michigan Museum of Art (Ann Arbor, Mich.). The poet-painters: Buson and his followers. January 9-February 17, 1974. Ann Arbor, Mich., University of Michigan Museum of Art, 1974.

BUYTEWECH, WILLEM PIETERSZOON, 1591/92-1624

1198. Havercamp-Begemann, Egbert. Willem Buytewech. Amsterdam, Hertzberger, 1959.

1199. Kunstreich, Jan S. Der geistreiche Willem; Studien zu Willem Buytewech 1591-1624. Kiel, Kunsthist. Institut der Universität Kiel, 1959.

1200. Museum Boymans-Van Beuningen (Rotterdam). Willem Buytewech 1591-1624. Text and catalogue by Egbert Havercamp-Begemann. Rotterdam, Museum Boymans-van Beuningen, 1975.

CAFFI, IPPOLITO, 1809-1866

1201. Avon Caffi, Guiseppe. Ippolito Caffi, 1809-1866. Padova, Amicucci, 1967.

1202. Pittaluga, Mary. **Il pittore Ippolito Caffi.** Vincenza, Pozza, 1971.

CAILLEBOTTE, GUSTAVE, 1848-1894

1203. Berhaut, Marie. **Caillebotte: sa vie et son oeuvre: catalogue raisonné des peintures et pastels.** Paris, Bibliothèque des Arts, 1978. (CR).

1204. Caillebotte, Gustave. **Gustave Caillebotte: a retrospective exhibition, 1976-1977.** Museum of Fine Arts, Houston, Oct. 22, 1976-Jan. 2, 1977, The Brooklyn Museum, Feb. 12-Apr. 24. Catalogue by Kirk T. Varnedoe and Thomas P. Lee. Houston, Museum of Fine Arts, 1976.

1205. Wildenstein and Co. Ltd., London. **Gustave Caillebotte, 1848-1894.** A loan exhibition in aid of the Hertford British Hospital in Paris, 15 June-16 July, 1966. London, 1966.

CALAMIS, fl. 460 B.C.

1206. Studniczka, Franz. **Kalamis, ein Beitrag zur griechischen Kunstgeschichte.** Leipzig, Teubner, 1907. (Abhandlungen der philologisch-historischen Klasse der königl. sächsischen Gesellschaft der Wissenschaften, 4).

CALDECOTT, RANDOLPH, 1846-1886

1207. Blackburn, Henry. **Randolph Caldecott: a personal memoir of his early art career.** New York, Routledge, 1886 (issued in large and small paper).

1208. Caldecott, Randolph. **Catalogue of drawings by Randolph Caldecott, the property of C. K. Seaman . . . and from other sources.** London, Christie's [sale], June 15, 1936.

CALDER, ALEXANDER, 1898-1976

ALEXANDER MILNE, 1848-1923

ALEXANDER STIRLING, 1870-1945

1209. Arnason, H. Harvard. **Calder.** Photographs by Pedro E. Guerrero. Princeton, N.J., Van Nostrand, 1966.

1210. Bourdon, David. **Calder: mobilist, ringmaster, innovator.** New York, Macmillan, 1980.

1211. Calder, Alexander. **Calder.** Photos and design by Ugo Mulas. Introd. by H. Harvard Arnason, with comments by Alexander Calder. New York, Viking, 1971.

1212. _____. **Calder.** Text by Maurice Bruzeau. Photos by Jacques Masson. Trans. by I. M. Paris. New York, Abrams, 1979.

1213. _____. **Calder: an autobiography with pictures.** New York, Pantheon, 1966.

1214. _____. **Calder, l'artiste et l'oeuvre.** Paris, Maeght, 1971. (Archives Maeght, 1).

1215. Fondation Maeght (Saint-Paul de Vence). **Calder.** Exposition du 2 avril au mai 1969. St.-Paul, Fondation Maeght, 1969.

1216. Hayes, Margaret Calder. **Three Alexander Calders: a family memoir.** Introd. by Malcolm Cowley. Middlebury, Vt., Eriksson, 1977.

1217. Lipman, Jean. **Calder's universe.** By Jean Lipman and Ruth Wolfe, editorial director. New York, Viking, 1976. (A traveling exhibition based on this book began at the Whitney Museum of American Art in New York, Oct. 14, 1976-Feb. 6, 1977).

1218. Marter, Joan. **Alexander Calder.** New York, Abbeville, Press, 1984.

1219. Sims, Patterson. **Alexander Calder, a concentration of works from the permanent collection of the Whitney Museum of American Art: a 50th anniversary exhibition, Feb. 17-May 3, 1981.** New York, Whitney Museum of American Art, 1981.

1220. Solomon R. Guggenheim Museum (New York). **Alexander Calder: a retrospective exhibition by the Solomon R. Guggenheim Museum and Musée National d'Art Moderne, Paris.** New York, 1964.

1221. Sweeney, James J. **Alexander Calder.** New York, Museum of Modern Art, 1951.

CALDERARA, ANTONIO, 1903-

1222. Mendes, Murillo. **Antonio Calderara, pitture dal 1925 al 1965.** Milano, All'Insegna del Pesce d'Oro, 1965. (Arte moderna italiana, 52).

1223. Saba Sardi, Francesco. **Calderara.** Milano, All'Insegna del Pesce d'Oro, 1965. (Antologia di punto, 2).

CALLAHAN, HARRY, 1912-

1224. Bunnell, Peter C. **Harry Callahan.** New York, American Federation of the Arts, 1978.

1225. Callahan, Harry. **Photographs.** Santa Barbara, Calif., El Mochuelo Gallery, 1964. (Monograph series, 1).

1226. Paul, Sherman. **The photography of Harry Callahan.** New York, Museum of Modern Art, 1967.

1227. Szarkowski, John, ed. **Callahan.** [Published in conjunction with an exhibition at the Museum of Modern Art, New York, December 2, 1976-February 8, 1977]. Millerton, N.Y., Aperture, 1976.

1228. Tow, Robert and Winsor, Ricker, eds. **Harry Callahan: color, 1941-1980.** Foreword by Jonathan Williams; afterword by A. D. Coleman. Providence, R.I., Matrix Publications, 1980.

CALLOT, JACQUES, 1592-1635

1229. Albertina (Vienna). **Jacques Callot und sein Kreis. Werke aus dem Besitz der Albertina und Leihgaben aus den Uffizien.** Wien, Albertina, 1969. (Die Kunst der Graphik, 5).

1230. Bechtel, Edwin de T. **Jacques Callot.** New York, Braziller, 1955.

1231. Bibliothèque Nationale (Paris). **Jacques Callot, étude de son oeuvre gravé.** [Par] J. Cain, R.-A. Weigert [et] P. A. Lemoigne. Paris, Editions des Bibliothèques Nationales, 1935.

1232. Bonchot, Henri. **Jacques Callot, sa vie, son oeuvre et ses continuateurs.** Paris, Hachette, 1889.

1233. Bouchot-Saupique, Jacqueline. **Jacques Callot, 1592-1635; quatorze dessins.** Paris, Musées Nationaux, 1942.

1234. Bruwaert, Edmond. **Jacques Callot, biographie critique.** Paris, Laurens, 1913.

1235. _____. **Vie de Jacques Callot, graveur lorrain, 1592-1635.** Paris, Imprimerie Nationale, 1912.

1236. Callot, Jacques. **Jacques Callot, 1592-1635.** By the Department of Art, Brown University at the Museum of Art, Rhode Island School of Design, March 5-April 11, 1970. Providence, Museum of Art, Rhode Island School of Design, 1970.

1237. Daniel, Howard. **The world of Jacques Callot.** New York, Lear, 1948.

1238. Lieure, J. **Jacques Callot.** 2 pts. in 5 v. Editions de la Gazette des Beaux-Arts, 1924-1929.

1239. Meaume, Edouard. **Recherches sur la vie et les ouvrages de Jacques Callot, suite au Peintre-graveur français de Robert-Dumesnil.** 2 v. Paris, Renouard, 1860.

1240. Nasse, Hermann. **Jacques Callot.** Leipzig, Klinkhardt & Biermann, 1919. 2 ed. (Meister der Graphik, 1).

1241. National Gallery of Art (Washington, D.C.). **Jacques Callot: prints and related drawings.** H. Diane Russell, Jeffrey Blanchard, theater section. John Krill, technical appendix. Washington, D.C., National Gallery of Art, 1975.

1242. Plan, Pierre Paul. **Jacques Callot maître graveur (1593-1635), suivi d'un catalogue raisonné et accompagné de la réproduction de 282 estampes et de deux portraits.** Bruxelles, van Oest, 1911. (CR).

1243. Sadoul, Georges. **Jacques Callot, miroir de son temps.** Paris, Gallimard, 1969.

1244. Schroeder, Thomas. **Jacques Callot. Das gesamte Werk.** 2 v. München, Rogner & Bernhard, 1971.

1245. Ternois, Daniel. **L'art de Jacques Callot.** Paris, de Nobele, 1962.

1246. _____. **Jacques Callot; catalogue complet de son oeuvre dessiné.** Paris, de Nobele, 1962.

1247. Zahn, Leopold. **Die Handzeichnungen des Jacques Callot, unter besonderer Berücksichtigung der Petersburger Sammlung.** München, Recht, 1923.

CAMAINO, TINO DA see TINO DA CAMAINO

CAMBIASO, LUCA, 1527-1585

1248. Cambiaso, Luca. **The Genoese Renaissance, grace and geometry: paintings and drawings by Luca Cambiaso from the Suida-Manning Collection.** By Bertina Suida Manning and Robert L. Manning. Houston, Museum of Fine Arts, 1974.

1249. Ente manifestazioni genovesi. **Luca Cambiaso e la sua fortuna.** [Mostra] Genova, Palazzo dell'Accademia, guigno-ottobre 1956. Genova, Ente manifestazioni genovesi, 1956.

1250. Suida Manning, Bertina. **Luca Cambiaso, la vita e le opere.** A cura di Bertina Suida Manning e William Suida. Milano, Ceschina, 1957.

CAMERON, CHARLES, 1740-1812

1251. Arts Council of Great Britain. **Charles Cameron, ca. 1740-1812; architectural drawings and photographs from the Hermitage collection, Leningrad and Architectural Museum, Moscow.** [Exhibition] English Speaking Union Gallery, Edinburgh, August 19-Sept. 9, 1967. London, Arts Council of Great Britain, 1967.

1252. Cameron, Charles. **The baths of the Romans explained and illustrated: with the restorations of Palladio corrected and improved.** To which is prefixed an introductory preface, pointing out the nature of the work; and a dissertation upon the state of the arts during the different periods of the Roman empire. London, Leacroft, 1775.

1253. Lukomskii, Georgii Kreskentévich. **Charles Cameron (1740-1812): an illustrated monograph on his life and work in Russia.** . . . Adapted into English and edited by Nicholas de Gren, with a foreword by the Princess Romanovsky-Pavlovsky, an introduction by D. Talbot Rice . . . and historical notes and bibliography. London, Nicholson & Watson, 1943.

1254. Rae, Isobel. **Charles Cameron, architect to the court of Russia.** London, Elek, 1971.

CAMERON, DAVID YOUNG, 1865-1945

1255. Cameron, David Young. **Sir D. Y. Cameron, R. A.** Introduction by Malcolm C. Salaman. 2 v. London, The Studio, 1925-1932. (Modern Masters of Etching, 7, 33).

1256. Rinder, Frank. **D. Y. Cameron; an illustrated catalogue of his etched work, with introductory essay and descriptive notes on each plate.** Glasgow, Maclehose, 1912.

CAMERON, JULIA MARGARET, 1815-1879

1257. Gernsheim, Helmut. **Julia Margaret Cameron, her life and photographic work.** Millerton, N.Y., Aperture Press, 1975.

1258. Hill, Brian. **Julia Margaret Cameron; a Victorian family portrait.** London, Owen, 1973.

1259. Ovenden, Graham, ed. **A Victorian album: Julia Margaret Cameron and her circle.** Introductory essay by Lord David Cecil. New York, Da Capo, 1975.

CAMPAGNA, GIROLAMO, ca. 1550-1626

1260. Rossi, Paola. **Girolamo Campagna.** Presentazione di Rodolfo
Palluchini. Verona, Vita Veronese, 1968. (Monografie
d'arte, 8).

1261. Tomofiewitsch, Wladimir. **Girolamo Campagna: Studien zur
venezianischen Plastik um das Jahr 1600.** München, Fink,
1972.

CAMPALANS, JUSEP TORRES see TORRES CAMPALANS, JUSEP

CAMPBELL, COLEN, 1676-1729

1262. Campbell, Colen. **Vitruvius Britannicus, or the British
architect.** 3 v. London, 1715-1725. (Reprint: New York,
Blom, 1967).

1263. Stuchbury, Howard E. **The architecture of Colen Campbell.**
Cambridge, Mass., Harvard University Press, 1967.

CAMPEN, JACOB VAN, 1595-1657

1264. Swillens, P. T. A. **Jacob van Campen, schilder en
bouwmeester, 1595-1657.** Assen, Van Gorcum, 1961. (Van
Gorcum's historische bibliotheek, 63).

CAMPENDONK, HEINRICH, 1889-1957

1265. Engles, Mathias Toni. **Campendonk. Holzschnitte.** Werk-
verzeichnis. Stuttgart, Kohlhammer, 1959. (CR).

1266. _____. **Heinrich Campendonk.** Köln, Seemann, 1957.
(Monografien zur rheinisch-westfälischen Kunst der
Gegenwart, 8).

1267. Wember, Paul. **Heinrich Campendonk; Krefeld 1889-1957.**
Amsterdam. Krefeld, Scherpe, 1960.

CAMPHUYSEN, RAFAEL GOVERTSZ, 1597-1657

1268. Bachmann, Fredo. **Der Landschaftsmaler Rafael Govertsz.
Camphuysen,** München, Delp, 1980.

CAMPIGLI, MASSIMO, 1895-1971

1269. Appolonio, Umbro. **Campigli.** Venezia, Cavallino, 1958.

1270. Campigli, Massimo. **Scrupoli.** Venezia, Cavallino, 1955.

1271. Cardazzo, Carlo. **Campigli.** Venezia, Cavallino, 1958.

1272. Cassou, Jean. **Campigli.** Présenté par J. Cassou avec un
texte de l'artiste. Paris, Ed. "L'Oeuvre gravée," 1957.

1273. Ente manifestazioni milanesi. **Mostra di Massimo Campigli.**
Scritti di M. Campigli et al. Catalogo a cura di
Giuseppe L. Mele. Giugno 1967, Milano, Palazzo reale.
Milano, Moneta, 1967.

1274. Galerie de France (Paris). **Campigli.** Album édité à l'oc-
casion de l'exposition des oeuvres récentes de Campigli,
1 juin-17 juillet 1965. Paris, Galerie de France, 1965.

1275. _____. **Les idoles de Campigli.** . . . Editée à l'oc-
casion de l'exposition des oeuvres de Campigli, mai 1961.
Paris, Galerie de France, 1961.

CANALE, ANTONIO, 1697-1768

1276. Barcham, William L. **The imaginary view scenes of Antonio
Canaletto.** New York/London, Garland, 1977.

1277. Brandi, Cesare. **Canaletto.** Milano, Mondadori, 1960.
(Biblioteca moderna Mondadori, 596).

1278. Bromberg, Ruth. **Canaletto's etchings; a catalogue and
study illustrating and describing the known states,
including those hitherto unrecorded.** London/New York,
Sotheby Park Bernet, 1974.

1279. Constable, William G. **Canaletto.** Catalogue of an exhibi-
tion held at the Art Gallery of Toronto, Oct. 17-Nov. 15,
1964, and subsequently at the National Gallery of Canada,
Ottawa, and the Museum of Fine Arts, Montreal. (n. p.),
1964.

1280. _____. **Canaletto, Giovanni Antonio Canal, 1697-1768.**
2 v. New York, Clarendon Press, 1962; 2 ed., revised by
J. G. Links, 1976.

1281. Ferrari, Giulio. **Les deux Canaletto, Antonio Canal,
Bernardo Bellotto, peintres.** Torino, Celanza, 1914.

1282. Hadeln, Detlev von. **The drawings of Antonio Canal, called
Canaletto.** Trans. by C. Dodgson. London, Duckworth,
1929.

1283. Kainen, Jacob. **The etchings of Canaletto.** Washington,
Smithsonian Press, 1967.

1284. Levey, Michael. **Canaletto paintings in the collection of
her Majesty the Queen.** London, Phaidon, 1964.

1285. Links, J. G. **Canaletto and his patrons.** New York, New
York University Press, 1977.

1286. _____. **Views of Venice by Canaletto.** Engraved by A.
Visentini. New York, Dover, 1971.

1287. Martin, Gregory. **Canaletto: Paintings, drawings and
etchings.** London, Folio Society, 1967.

1288. Meyer, Rudolph. **Die beiden Canaletto, Antonio Canale und
Bernardo Belotto; Versuch einer Monographie der radierten
Werke beider Meister.** Dresden, Verlag des Verfassers,
1878.

1289. Moschini, Vittorio. **Canaletto.** Milano, Martello, 1963.
2 ed. (1st ed. 1954.)

1290. Moureau, Adrien. **Antonio Canal, dit le Canaletto.** Paris,
Librairie de l'Art, 1894.

1291. Pallucchini, Rodolfo. **Le acqueforti del Canaletto.**
Venezia, Guarnati, 1945. (Serie Brunetto Fanelli, 1).

1292. Parker, Karl T. **The drawings of Antonio Canaletto in the

collection of His Majesty the King at Windsor Castle. London, Phaidon, 1948.

1293. Pignatti, Terisio. **Antonio Canal detto Il Canaletto.** Milano, Martello-Giunti, 1976.

1294. _____. **Canaletto disegni.** Scelti e annotati da T. Pignatti. Firenze, Nuova Italia, 1969.

1295. _____. **Canaletto; selected drawings.** Trans. by Stella Rudolph. University Park, Penn., Pennsylvania State University Press, 1970.

1296. _____. **Il quaderno di disegni del Canaletto alle gallerie di Venezia.** Milano, Guarnati, 1958.

1297. _____. **Das venezianische Skizzenbuch von Canaletto.** Trans. Erich Steingräber. 2 v. München, Callwey, n.d.

1298. Potterton, Homan. **Pageant and panorama; the elegant world of Canaletto.** Oxford, Phaidon, 1978.

1299. Puppi, Lionello, and Berto, Giuseppe. **The complete paintings of Canaletto.** Introd. by David Bindman, notes and catalogue by L. Puppi. New York, Abrams, 1968.

1300. _____. **L'opera completa del Canaletto.** Milano, Rizzoli, 1968. (Classici dell'arte, 18).

1301. Salamon, Harry. **Catalogo completo delle incisioni di Giovanni Antonio Canal detto Il Canaletto.** Milano, Salamon e Agustoni, 1971.

1302. Uzanne, L. O. **Les Canaletto: l'oncle et le neveu, le maître et le disciple.** Antonio da Canal, 1697-1768; Bernardo Bellotto, 1723-1780. Paris, Nilsson, 1925.

1303. _____. **Les deux Canaletto: biographie critique.** Paris, Laurens, 1907.

1304. Watson, Francis J. B. **Canaletto.** London, Elek, 1954. 2 ed.

CANALETTO see CANALE, ANTONIO; see also BELLOTTO, BERNARDO

CANINA, LUIGI, 1795-1856

1305. Canina, Luigi. **L'architettura antica descritta e dimonstrata coi monumenti.** 6 v. Roma, Canina, [1830]-1844.

1306. _____. **Gli edifizi di Roma antica.** 6 v. Roma, Canina, 1848-1856.

1307. _____. **Richerche sull'architettura piu propria dei tempi cristiani.** Roma, Canina, 1843.

1308. Raggi, Oreste. **Della vita e delle opere di Luigi Canina, architetto e archeologo di Casal Monferrato.** Casal Monferrato, Nanni, 1857.

CANO, ALONSO, 1601-1667

1309. Bernales Ballestros, Jorge. **Alonso Cano en Sevilla.** Sevilla, Diputacion Provincial, 1976.

1310. Cano, Alonso. **[Tercer] centenario de la muerte de Alonso Cano en Granada.** 2 v. (1) Estudios, (2) Catalogo de la exposición, Hospital real, jun. 28-jul. 31 1968. Granada, Ministerio de Educación y Ciencia, 1968.

1311. Diaz-Jiménez y Molleda, Eloy. **El escultor Alonso Cano, 1601-1667.** Madrid, Suarez, 1943. (Monografias de critica artistica, 1).

1312. Martinez Chumillas, Manuel. **Alonso Cano estudio monografico de la obra del insegne racionero que fue de la Catedral de Granada.** Madrid, Jaime, 1948.

1313. Wethey, Harold E. **Alonso Cano: painter, sculptor, architect.** Princeton, N.J., Princeton University Press, 1955.

CANOVA, ANTONIO, 1757-1822

1314. Albrizzi, Isabella. **Opere di scultura e di plastica di Antonio Canova descritte da Isabella Albrizzi nata Teotochi.** 4 v. Pisa, Capurro, 1826.

1315. _____. **The works of Antonio Canova, in sculpture and modelling.** Engraved in outline by Henry Moses. With description from the Italian of the Countess Albrizzi and a biographical memoir by Count Cicognara. 3 v. London, Bohn, 1849. (2 ed.: London, Rowett, 1824; repr. 1887. 3 ed.: Boston, Osgood, 1876-1878. 2 v.).

1316. Argan, Giulio C. **Antonio Canova.** A cura di Elisa Debenedetti. Roma, Bulzoni, 1969. (Univ. di Roma. Fac. di Lettere e Filosofia, Anno academico 1968-69).

1317. Bassi, Elena. **Canova.** Bergamo, Ist. Ital. d'Arti Grafiche, 1943.

1318. Canova, Antonio. **Pensieri su le belli arti.** Milano, Bettoni, 1824.

1319. _____. **I quaderni di viaggio, 1779-1780.** Ed. e commento a cura di E. Bassi. Venezia, Ist. per la collab. culturale, 1959. (Fonti e documenti per la storia dell'arte veneta, 2).

1320. Cicognara, Leopoldo. **Biografia di Antonio Canova.** Venezia, Missiaglia, 1823.

1321. _____. **Lettere ad Antonio Canova.** A cura di Gianni Venturi. Urbino, Argalia, 1973.

1322. Foratti, Aldo. **Antonio Canova, 1757-1822.** Milano, Caddeo, 1922.

1323. Licht, Fred. **Canova.** Photographs by David Finn. New York, Abbeville Press, 1983.

1324. Malamani, Vittorio. **Canova.** Milano, Hoepli, 1911.

1325. Memes, John Smythe. **Memoirs of Antonio Canova, with a critical analysis of his works, and an historical view of modern sculpture.** Edinburgh, Constable, 1825.

1326. Meyer, Alfred G. **Canova.** Bielefeld/Leipzig, Velhagen & Klasing, 1898. (Künstler-Monographien, 36).

1327. Missirini, Melchiorre. **Della vita di Antonio Canova libri quattro.** 2 v. Milano, Bettoni, 1824-1825.

1328. Muñoz, Antonio. **Antonio Canova: le opere.** Roma, Palombi, 1957.

1329. Pantaleoni, Massimo. **Disegni anatomici di Antonio Canova.** Roma, Istituto Superiore di Sanita--Fondazione Emanuele Paterno, 1949.

1330. Paravia, Pier Alessandro. **Notizie intorno alla vita di Antonio Canova.** Giuntovi il catalogo cronologico di tutte le sue opere. Venezia, Orlandelli, 1822.

1331. Praz, Mario. **L'opera completa del Canova.** Presentazione di Mario Praz. Apparati critici e filologici di Giuseppe Pavanello. Milano, Rizzoli, 1976. (Classici dell'arte, 85).

1332. Quatremère de Quincy. **A. C. Canova, et ses ouvrages, ou Mémoires historiques sur la vie et les travaux de ce célèbre artiste.** Paris, LeClerc, 1836. 2 ed.

CAPA, ROBERT, 1913-1954

1333. Capa, Robert. **Robert Capa.** A cura di Romeo Martinez. Milano, Mondadori, 1979.

1334. _____. **Robert Capa, 1913-1954.** Edited by Cornell Capa and Bhupendra Karia. New York, Grossmann, 1974. (ICP library of photographers, 1).

1335. _____. **Slightly out of focus.** New York, Holt, 1947.

CAPEK, JOSEF, 1887-1945

1336. Pecirka, Jaromir. **Josef Capek.** Praze, Melantrich, 1937. (Prameny, sbirka dobreho umeni, 16).

1337. Thiele, Vladimir. **Josef Capek a kniha; soupis kniszni grafiky.** Vladimir Thiele, Jiri Ketalik. Praha, Nakl. Československých vytvarnych umělců, 1958. (Ceska Kniha, 2).

CAPELLE, JAN VAN DE, 1624/6-1679

1338. Russel, Margarita. **Jan van de Cappelle, 1624/6-1679.** Leigh-on-Sea, Lewis, 1975.

CAPOGROSSI, GUISEPPE, 1900-

1339. Argan, Giulio Carlo. **Capogrossi.** Roma, Editalia, 1967.

1340. Tapié, Michel. **Capogrossi.** Testo di Michel Tapié. Note biografiche a cura di Carlo Cardazzo. Venezia, Edizioni di Cavallino, 1962.

CAPONIGRO, PAUL, 1932-

1341. Caponigro, Paul. **Paul Caponigro, an Aperture monograph.** [Chronology and bibliography compiled by Peter C. Bunnell]. Millerton, N.Y., Aperture, 1972. 2 ed.

1342. Photography Gallery (Philadelphia). **Paul Caponigro; photography: 25 years.** [October 16-November 22, 1981]. Philadelphia, The Photography Gallery, 1981.

CAPUCCINO, IL see STROZZI, BERNARDO

CARAVAGGIO, MICHELANGELO MERISI DA, 1565-1610

1343. Accademia Nazionale dei Lincei. **Colloquio sul tema Caravaggio le i caravaggeschi,** Roma, 12-14 febbraio, 1973. Roma, Accademia Nazionale dei Lincei, 1974. (Accademia Nazionale dei Lincei, Anno CCCLI-1974, Quaderno 205).

1344. Bardon, Françoise. **Caravage ou l'experience de la matière.** Paris, Presses Universitaires de France, 1978. (Publications. Univ. de Poitiers. Lettres et sciences humaines, 19).

1345. Baroni, Costantino. **All the paintings of Caravaggio.** Trans. by Anthony F. O'Sullivan. New York, Hawthorn, 1962.

1346. _____. **Tutta la pittura di Caravaggio.** Milano, Rizzoli, 1956, 4 ed. (Biblioteca d'arte Rizzoli, 2).

1347. Baumgart, Fritz Erwin. **Caravaggio. Kunst und Wirklichkeit.** Berlin, Mann, 1955.

1348. Benkard, Ernst. **Caravaggio-Studien.** Berlin, Keller, 1928.

1349. Berenson, Bernard. **Caravaggio, his incongruity and his fame.** London, Chapman, 1953.

1350. DeLogu, Giuseppe. **Caravaggio.** New York, Abrams, n.d.

1351. Friedländer, Walter F. **Caravaggio studies.** Princeton, N.J., Princeton University Press, 1955.

1352. Hibbard, Howard. **Caravaggio.** London, Thames & Hudson, 1983.

1353. Hinks, Roger P. **Michelangelo Merisi da Caravaggio, his life, his legend.** London, Faber, 1953.

1354. Joffroy, Berne. **Le dossier Caravage.** Paris, Editions de Minuit, 1959.

1355. Kirsta, Georg and Zahn, Leopold. **Caravaggio.** 44 Lichtdrucktafeln und 12 Abb. im Text, mit einem Kapitel über **Caravaggio und die Kunst der Gegenwart.** Berlin, Albertus-Verlag, 1928.

1356. Kitson, Michael. **The complete paintings of Caravaggio.** New York, Abrams, 1967.

1357. Longhi, Roberto. **Il Caravaggio.** Milano, Martello, 1952.

1358. _____. **Caravaggio, Michelangelo Merisi, 1573-1610.** Milano, Martello, 1956.

1359. Marabottini, Alessandro. **Polidora da Caravaggio.** 2 v. Roma, Edizione dell'Elefante, 1969.

1360. Marangoni, Matteo. **Il Caravaggio.** Firenze, Battistelli, 1922.

1361. Marini, Maurizio. **Io Michelangelo da Caravaggio.** Roma, Bestetti, 1974. 2 ed.

CARAVAGGIO

1362. Moir, Alfred. **Caravaggio.** New York, Abrams, 1982.

1363. _____. **Caravaggio and his copyists.** New York, New York University Press, 1976. (Monographs on archaeology and the fine arts, 31).

1364. _____. **The Italian followers of Caravaggio.** 2 v. Cambridge, Harvard University Press, 1967.

1365. Nicholson, Benedict. **The international Caravaggesque movement; lists of pictures by Caravaggio and his followers throughout Europe from 1590 to 1650.** Oxford, Phaidon, 1979.

1366. Ottino della Chiesa, Angela. **Caravaggio.** Bergamo, Istituto Italiano d'Arti Grafiche, 1962.

1367. Palazzo Pitti (Florence). **Caravaggio e caravaggeschi nelle gallerie di Firenze.** Catalogo della mostra a cura di Evelina Borea. Paris, Editions de Minuit, 1959.

1368. Palazzo Reale (Milan). **Mostra del Caravaggio e dei Caravaggeschi.** Aprile-giugno, 1951. [Catalogo a cura di Achille Marazza e Roberto Longhi]. Milano, Palazzo Reale, 1951.

1369. Petrucci, Alfredo. **Il Caravaggio, acquafortista e il mondo calcografico romano.** L'Indovina, Leoni, Borgianni, Maggi, Villamena, Onofri, Mercati, amici del Caravaggio. Roma, Palombi, 1956.

1370. Regione Lombardia. **Immagine del Caravaggio.** Mostra didattica itinerante. . . . Catalogo a cura di Mia Cinotti. Milano, Pizzi, 1973.

1371. Röttgen, Herwarth. **Il Caravaggio.** Ricerche e interpretazionei. Roma, Bulzoni, 1974. (Biblioteca di storia dell'arte, 9).

1372. Samek Ludovici, Sergio. **Vita del Caravaggio dalle testimonazione del suo tempo.** Milano, Edizioni del Milione, 1956. (Vite, lettere, testimonianze di artisti italiani, 2).

1373. Schneider, Arthur von. **Caravaggio und die Niederländer.** Amsterdam, Israel, 1967.

1374. Schudt, Ludwig. **Caravaggio.** Wien, Schroll, 1942.

1375. Spear, Richard E. **Caravaggio and his followers.** Cleveland, Cleveland Museum of Art, 1971.

1376. Venturi, Lionello. **Il Caravaggio.** Con prefazione di Benedetto Croce. Sotto gli auspici del Comitato della Città di Caravaggio. Novara, Ist. Geografico De Agostini, 1963. 2 ed.

1377. Witting, Felix. **Michelangelo da Caravaggio; eine kunsthistorische Studie.** Strassburg, Heitz, 1916. (Zur Kunstgeschichte des Auslandes, 113).

CARDI, LODOVICO see CIGOLI, LODOVICO CARDI DA

CARIANI, GIOVANNI DE' BUSI, 1485-1547

1378. Gallina, Luciano. **Giovanni Cariani; materiale per uno studio.** Bergamo, Ediz. "Documenti Lombardi," 1954.

CARLEVARIJS, LUCA, 1663-1730

1379. Mauroner, Fabio. **Luca Carlevarijs.** Padova, Le Tre Venezie, 1945.

1380. Rizzi, Aldo. **Disegni, incisioni, e bozzetti del Carlevarijs.** Catalogo della mostra a cura di Aldo Rizzi. Udine, Loggia del Lionello, 29 dic. 1963-2 febbr. 1964.

1381. _____. **Luca Carlevarijs.** Con una prefazione di Rodolfo Pallucchini. Venezia, Alfieri, 1967. (Profili e saggi di arte veneta, 5).

CARNOVALI, GIOVANNI, 1806-1873

1382. Caversazzi, Ciro. **Giovanni Carnovali, il piccio.** Bergamo, Ist. Ital. d'Arti Grafiche, 1946.

1383. Palazzo della ragione (Bergamo). **Il Piccio e artisti bergamaschi del suo tempo.** 14 settembre-10 novembre, 1974. Bergamo, Palazzo della ragione, 1974.

CARO, ANTHONY, 1924-

1384. Kunstverein Braunschweig. **Anthony Caro, table and related sculptures, 1966-1978.** 18. Mai 1979 bis 1. Juli 1979. [Text in English and German]. Braunschweig, Kunstverein Braunschweig, 1979.

1385. Rubin, William Stanley. **Anthony Caro.** New York, Museum of Modern Art/Boston, New York Graphic Society, 1975.

1386. Waldman, Diane. **Anthony Caro.** New York, Abbeville Press, 1982.

1387. Whelan, Richard. **Anthony Caro** [by] Richard Whelan. With additional texts by Clement Greenberg. Harmondsworth/Baltimore, Penguin Books, 1974.

CARON, ANTOINE, 1521-1599

1388. Ehrmann, Jean. **Antoine Caron, peintre à la cour des Valois, 1521-1599.** Introd. P.-A. Lemoigne. Genève/Lille, Droz/Giard, 1955. (Travaux d'humanisme et renaissance, 18).

CARPACCIO, VITTORE, 1455-1525

1389. Fiocco, Giuseppe. **Carpaccio.** Trans. by Jean Chuzeville. Paris, Crès, 1931.

1390. _____. **Carpaccio.** Novara, Ist. Geografico De Agostini, 1958.

1391. Hausenstein, Wilhelm. **Das Werk des Vittore Carpaccio.** Stuttgart, Deutsche Verlagsanstalt, 1925.

1392. Lauts, Jan. **Carpaccio; paintings and drawings.** New York, Phaidon, 1962.

1393. Ludwig, Gustave and Molmenti, Pompeo G. **Vittore Carpaccio. La vita e le opere.** Milano, Hoepli, 1906.

1394. Molmenti, Pompeo G. **The life and works of Vittore Carpaccio.** Trans. by R. H. H. Cust. London, Murray, 1907.

1395. Murray, Michelangelo. **Carpaccio.** Firenze, Il Fiorino, 1966. (Il più eccelenti. Collano di monografie di artisti, 2).

1396. Palazzo Ducale (Venice). **Vittore Carpaccio.** Guignio-ottobre 1963. [Catalogo a cura di Pietro Zampetti]. Venezia, Palazzo Ducale, 1963.

1397. Pallucchini, Anna. **Carpaccio.** Milano, Martello, 1963.

1398. Perocco, Guido. **L'opera completa del Carpaccio.** Presentazione di Manlio Cancogni. Milano, Rizzoli, 1967. (Classici dell'arte, 13).

1399. Zampetti, Pietro. **Vittore Carpaccio.** Venezia, Alfieri, 1966.

CARPEAUX, JEAN BAPTISTE, 1827-1875

1400. Clément-Carpeaux, Louise. **La vérité sur l'oeuvre et la vie de J.-B. Carpeaux (1827-1875).** 2 v. Paris, Dousset, 1934-1935.

1401. Laran, Jean and LeBas, Georges. **Carpeaux.** Paris, Libr. Centrale des Beaux-Arts, 1912.

1402. Lecomte, Georges C. **La vie héroïque et glorieuse de Carpeaux.** Paris, Plon, 1928.

1403. Musée des Beaux-Arts, Valenciennes. **Catalogue des peintres et sculptures de Jean-Baptiste Carpeaux.** Catalogue [par] André Hardy and Anny Braunwald. Valenciennes, Musée des Beaux-Arts, 1978.

1404. Sarradin, Edouard. **Carpeaux.** Paris, Rieder, 1927.

CARPI, GIROLAMO DA, 1501-1556

1405. Mezzetti, Amalia. **Girolamo da Ferrara detto da Carpi: l'opera pittorica.** Milano, Silvana, 1977.

CARPIONI, GIULIO, 1613-1679

1406. Pilo, Giuseppe Maria. **Giulio Carponi. Tutta la pittura.** Venezia, Alfieri, 1961.

CARR, EMILY, 1871-1945

1407. Carr, Emily. **Growing pains; the autobiography of Emily Carr.** With a foreword by Ira Dilworth. Toronto, Oxford University Press, 1946.

1408. _____. **Hundreds and thousands; the journals of Emily Carr.** Toronto, Clarke-Irwin, 1966.

1409. Shadbolt, Doris. **The art of Emily Carr.** Seattle, University of Washington Press, 1979.

1410. Tippett, Maria. **Emily Carr, a biography.** Toronto/New York, Oxford University Press, 1979.

CARRA, CARLO, 1881-1966

1411. Carrà, Carlo. **La mia vita.** Presentazione di Vittorio Fagone. Milano, Feltrinelli, 1981.

1412. Carrà, Massimo. **L'opera completa di Carrà, dal futurismo alla metafisica e al realismo mitico, 1910-1930.** Presentazione di Piero Bigongiari. Apparati critici e filologici di Massimo Carrà. Milano, Rizzoli, 1970. (Classici dell'arte, 44).

1413. _____. **Carlo Carrà; opera grafica (1922-1964).** A cura di M. Carrà, con un saggio di Marco Valsecchi. Vicenza, Pozza, 1976. (Grafica, 2).

1414. _____. **Carrà; tutta l'opera pittorica.** 3 v. Milano, Ediz. dell'Annunciata, 1967-68.

1415. Galleria civica d'arte moderna (Ferrara). **Carlo Carrà con il patrocinio della regione Emilia-Romagna.** 2 luglio-9 ottobre 1977. [Ferrara, Galleria civica d'arte moderna, 1977].

1416. Pacchioni, Guglielmo. **Carlo Carrà pittore.** Milano, Milione, 1959. 2 ed.

CARRACCI, AGOSTINO, 1557-1602

 ANNIBALE, 1560-1609

 LUDOVICO, 1555-1619

1417. Bellori, Giovanni Pietro. **The lives of Annibale and Agostino Carracci.** Trans. from the Italian by Catherine Enggass. Foreword by Robert Enggass. University Park, Penn., Pennsylvania State University Press, 1968.

1418. Biennali d'Arte Antica, Bologna. **Mostra dei Carracci, sett.-ott. 1956.** Catalogo critico a cura di Gian Carlo Cavalli, Francesco Arcangeli, Andrea Emiliani, Maurizio Calvesi. Con una nota di Denis Mahon. Saggio introduttivo di Cesare Gnudi. Bologna, Alfa, 1956. 2 ed.

1419. _____. **Mostra dei Carracci, sett.-ott. 1956.** Catalogo critico dei disegni, a cura di Denis Mahon. Trad. di Maurizio Calvesi. Bologna, Alfa, 1963. 2 ed. corr. e augmenta.

1420. Bodmer, Heinrich. **Lodovico Carracci.** Burg, Hopfer, 1939. (Beiträge zur Kunstgeschichte, 6).

1421. Bohlin, Diane DeGrazia. **Prints and related drawings by the Carracci family.** A catalogue raisonné. Published in conjunction with the exhibition at the National Gallery, March-May, 1979. Bloomington, Indiana University Press/Washington, D.C., National Gallery of Art. (CR).

1422. Foratti, Aldo. **I Carracci nella teoria e nella practica.** Castello, Lapi, 1913.

1423. Posner, Donald. **Annibale Carracci. A study in the reform of Italian painting around 1590.** London, Phaidon, 1971.

1424. Rouchès, Gabriel. **La peinture bolonaise à la fin du XVI siècle (1575-1619): les Carrache.** Paris, Alcan, 1913.

1425. Wittkower, Rudolf. **The drawings of the Carracci in the collection of Her Majesty the Queen at Windsor Castle.** London, Phaidon, 1952.

CARRIERA, ROSALBA, 1675-1757

1426. Carriera, Rosalba. **Journal de Rosalba Carriera pendant son séjour à Paris en 1720 et 1721.** Trad., annoté et augmenté d'une biographie et de documents inédits sur les artistes et les amateurs du temps par Alfred Sensier. Paris, Techener, 1865.

1427. Malamani, Vittorio. **Rosalba Carreira.** Bergamo, Ist. Ital. d'Arti Grafiche, 1910. (Collezione di monografie illustrate; pittori, scultori, architetti, 8).

CARRIERE, EUGENE, 1849-1906

1428. Bantens, Robert James. **Eugène Carrière: his work and his influence.** Ann Arbor, Mich., UMI Research Press, 1982.

1429. Dubray, Jean Paul. **Eugène Carrière; essai critique.** Paris, Seheur, 1931.

1430. Faure, Elie. **Eugène Carrière, peintre et lithographe.** Paris, Floury, 1908.

1431. Morice, Charles. **Eugène Carrière; l'homme et sa pensée, l'artiste et son oeuvre, essai de nomenclature des oeuvres principales.** Paris, Mercure de France, 1906.

1432. Musée de l'Orangerie (Paris). **Eugène Carrière et le symbolisme.** Exposition en l'honneur du centenaire de la naissance d'Eugène Carrière, déc. 1949-jan. 1950. Introd. et cat. par Michel Florisoone, notices par Jean Leymarie. Paris, Editions des Musées Nationaux, 1950.

1433. Séailles, Gabriel. **Eugène Carrière; essai de biographie psychologique.** Paris, Colin, 1917. 2 ed.

CARRUCI, JACOPO see PONTORMO, JACOPO

CARSTENS, ASMUS JAKOB, 1754-1798

1434. Fernow, Carl Ludwig. **Carstens Leben und Werke.** Hrsg. und ergänzt von Herman Riegel. Hannover, Rumpler, 1867.

1435. Heine, Albrecht-Friedrich. **Asmus Jakob Carstens und die Entwicklung des Figurenbildes.** Strassburg, Heitz, 1928. (Studien zur deutschen Kunstgeschichte, 264).

1436. Kamphausen, Alfred. **Asmus Jakob Carstens.** Neumünster, Wachholtz, 1941. (Studien zur schleswig-holsteinischen Kunstgeschichte, 5).

1437. Sach, August. **Asmus Jakob Carstens' Jugend- und Lehrjahre nach urkundlichen Quellen.** Halle, Verlag der Buchhandlung des Waisenhauses, 1881.

CARTIER-BRESSON, HENRI, 1908-

1438. Cartier-Bresson, Henri. **Henri Cartier-Bresson: photographer.** Text translated from the French by Frances Frenage. Boston, New York Graphic Society, 1979.

1439. _____. **The photographs of Henri Cartier-Bresson.** Texts by Lincoln Kirstein and Beaumont Newhall. New York, Museum of Modern Art, 1947.

1440. Scottish Arts Council (Edinburgh). **Henri Cartier-Bresson: his archive of 390 photographs from the Victoria and Albert Museum.** A Scottish Arts Council exhibition arranged in association with the V. and A. Museum. [First shown at] Fruit Market Gallery, Edinburgh, 19 Aug.-10 Sept. 1978. Catalogue with an essay by Ernst Gombrich. Edinburgh, Scottish Arts Council, 1978.

CARUS, KARL GUSTAV, 1789-1869

1441. Carus, Karl Gustav. **Briefe über Landschaftsmalerei. Zuvor ein Brief von Goethe als Einleitung.** Nach der 2., vermehrten Ausg. von 1835 mit einem Nachwort hrsg. von Dorothea Kuhn. Heidelberg, Schneider, 1972.

1442. _____. **Die Proportionslehre der menschlichen Gestalt.** Zum ersten Male morphologisch und physiologisch begründet von C. G. Carus. Leipzig, Brockhaus, 1854.

1443. _____. **Symbolik der menschlichen Gestalt.** Neu bearbeitet und erweitert von Theodor Lessing. Celle, Kampmann, 1925. 3 ed.

1444. Kaiser, Konrad. **Carl Gustav Carus und die zeitgenössische Dresdner Landschaftsmalerei.** Gemälde aus der Sammlung Georg Schäfer, Schweinfurt. Ausstellung im Alten Rathaus Schweinfurt vom 14. bis 25. Oktober 1970. Schweinfurt, 1970.

1445. Prause, Marianne. **Carl Gustav Carus: Leben und Werk.** Berlin, Deutscher Verlag für Kunstwissenschaft, 1968.

CARZOU, JEAN MARIE, 1907-

1446. Cailler, Pierre. **Catalogue raisonné de l'oeuvre gravé et lithographié de Carzon.** Avec une préface de Jean Bouret. Genève, Cailler, 1962. (Catalogues d'oeuvres gravés et lithographiés, 4). (CR).

1447. Fels, Florent. **Carzou.** Avec une biographie, une bibliographie et une documentation complète sur le peintre et son oeuvre. Genève, Cailler, 1955. (Peintres et sculpteurs d'hier et d'aujourdhui, 34).

1448. Lambertin, Pierre. **Carzou.** Paris, Julliard, 1961.

1449. Verdet, André. **Carzou: Provence.** Introd. de Pierre Cabanne. Monte Carlo, Sauret, 1966.

CASSATT, MARY, 1844-1926

1450. Breeskin, Adelyn D. **The graphic art of Mary Cassatt.** Introd. by A. D. Breeskin. Foreword by Donald H. Karshan. New York, Museum of Graphic Art, 1967.

1451. _____. **Mary Cassatt: a catalogue raisonné of the graphic work.** 2 ed., rev. Washington, Smithsonian Institution Press, 1979. (CR).

1452. _____. **Mary Cassatt: a catalogue raisonné of the oils, pastels, watercolors, and drawings.** Washington, Smithsonian Institution Press, 1970. (CR).

1453. Breuning, Mary. **Mary Cassatt.** New York, publ. by Hyperion Press, distributed by Duell, Sloan and Pearce, 1944.

1454. Bullard, E. John. **Mary Cassatt, oils and pastels.** New York, Watson-Guptill, 1972.

1455. Carson, Julia M. **Mary Cassatt.** New York, McKay, 1966.

1456. Cassatt, Mary. **Cassatt and her circle; selected letters.** Ed. by Nancy Mowil Mathews. New York, Abbeville Press, 1984.

1457. Getlein, Frank. **Mary Cassatt: paintings and prints.** New York, Abbeville, 1980.

1458. Hale, Nancy. **Mary Cassatt.** New York, Doubleday, 1975.

1459. Love, Richard H. **Cassatt, the independent.** Chicago, Love, 1980.

1460. Segard, Achille. **Mary Cassatt. Un peintre des enfants et des mères.** Paris, Ollendorff, 1913. 2 ed.

1461. Sweet, Frederick A. **Miss Mary Cassatt, impressionist from Pennsylvania.** Norman, University of Oklahoma Press, 1966.

1462. Watson, Forbes. **Mary Cassatt.** New York, Macmillan, 1932.

CASTAGNO, ANDREA DEL, 1423-1457

1463. Berti, Luciano. **Andrea del Castagno.** Firenze, Sadea/Sansoni, 1966.

1464. Fortuna, Alberto M. **Andrea del Castagno.** Firenze, Olschki, 1957. (Pocket library of "studies" in art, 9).

1465. Horster, Marita. **Andrea del Castagno.** Complete edition with a critical catalogue. Oxford, Phaidon, 1980.

1466. Richter, George M. **Andrea del Castagno.** Chicago, University of Chicago Press, 1943.

1467. Salmi, Mario. **Andrea del Castagno.** Novara, Agostini, 1961.

1468. Zanoli, Anna. **Andrea del Castagno.** Milano, Fabbri, 1965. (I maestri del colore, 48).

CASTELLANI, ENRICO, 1930-

1469. Agnetti, Vincenzo. **Enrico Castellani pittore.** Milano, Mauri, 1969.

1470. Castellani, Enrico. **Enrico Castellani.** Saggi di Achille Bonito Oliva, Arturo Carlo Quintavalle; inoltre testi di Vincenzo Agnetti. Parma, Univ. di Parma, 1976. (Quaderni, 32).

CASTIGLIONE, GIOVANNI BENEDETTO, called Il Grechetto, 1610?-1670?

1471. Blunt, Anthony. **The drawings of G. B. Castiglione and Stefano della Bella in the collection of Her Majesty the Queen at Windsor Castle.** London, Phaidon, 1954.

1472. Delogu, Giuseppe. **G. B. Castiglione detto Il Grechetto.** Bologna, Apollo, 1928.

1473. Percy, Ann. **Giovanni Benedetto Castiglione, master draughtsman of the Italian Baroque.** [Catalogue of an exhibition held at the Philadelphia Museum of Art, Sept. 17-Nov. 28, 1971]. Foreword by A. Blunt. Philadelphia Museum of Art, 1971.

CASTIGLIONE, GIUSEPPE, 1688-1766

1474. Beurdeley, Cécile. **Giuseppe Castiglione, a Jesuit painter at the court of the Chinese emperors.** By Cécile and Michel Beurdeley. Trans. by Michael Bullock. Rutland, Vt., Tuttle, 1971.

CASTILLO, JORGE, 1933-

1475. Haftmann, Werner. **Jorge Castillo: Gemälde, Aquarelle, Zeichnungen.** Text von Werner Haftmann; Bildbeschreibung, Jean-Luc Daval. Frankfurt a.M., Propyläen, 1975.

CASTLEDEN, GEORGE FREDERICK, 1861-1945

1476. Castleden, Louise Decatur. **George Frederick Castleden, etcher-painter; a brief biography.** With a foreword by Elihu Root, Jr. New York, Exposition Press, 1954.

CATENA, VINCENZO, ca. 1470-ca. 1531

1477. Robertson, Giles. **Vincenzo Catena.** Edinburgh, Edinburgh University Press, 1954.

CATESBY, MARK, ca. 1679-1749

1478. Frick, George F. and Stearns, Raymond P. **Mark Catesby, the colonial Audubon.** Urbana, Ill., University of Illinois Press, 1961.

CATLIN, GEORGE, 1796-1872

1479. Catlin, George. **Letters and notes on the North American Indian.** Ed. and introd. by Michael M. Mooney. New York, Potter, 1975 (Reprint of 1841 ed.).

1480. _____. **The letters of George Catlin and his family.** Ed. by Marjorie Catlin Roehm. Berkeley/Los Angeles, University of California Press, 1966.

1481. Haberly, Lloyd. **Pursuit of the horizon. A life of George Catlin, painter recorder of the American Indian.** New York, Macmillan, 1948.

1482. McCracken, Harold. **George Catlin and the Old Frontier.** New York, Crown, 1959.

1483. Plate, Robert. **Palette and tomahawk: the story of George Catlin.** New York, McKay, 1962.

1484. Truettner, William H. **The natural man observed: a study of George Catlin's Indian Gallery.** Washington, D.C., Smithsonian Institution Press, 1979.

CAVALLI, VITALE see VITALE DA BOLOGNA, fl. 1320-1359

CAVALLINI, PIETRO, ca. 1250-ca. 1330

1485. Matthaie, Guglielmo. **Pietro Cavallini.** Milano, Ist. Italiane Editoriale, 1972.

1486. Lavagnino, Emilio. **Pietro Cavallini.** Roma, Palombi, 1953.

1487. Sindona, Enio. **Pietro Cavallini.** Milano, Istituto Editorial Italiano, 1958. (Arte e pensiero, 2).

1488. Toesca, Pietro. **Pietro Cavallini.** Trans. by Elizabeth Andrews. New York, McGraw-Hill, 1960. (Collezione silvana, 19).

CAVE, MARIE ELISABETH BOULANGER see BOULANGER, MARIE-ELISABETH

CELLINI, BENVENUTO, 1500-1571

1489. Calamandrei, Piero. **Scritti e inediti celliniani.** A cura di Carlo Cordie. Firenze, La Nuova Italia, 1971. (Documenti di storia italiana, ser. 3, pt. 3, v. 4).

1490. Cellini, Benvenuto. **Autobiography.** Ed. by John Pope-Hennessy. New York, Phaidon, 1960.

1491. _____. **The autobiography of Benvenuto Cellini.** Trans. by George Bull. London, Folio Society, 1966.

1492. _____. **Due trattati di Benvenuto Cellini, . . . uno dell'oreficeria, l'altro della scultura.** Firenze, Tartini e Franchi, 1731. 2 ed.

1493. _____. **The life of Benvenuto Cellini, a Florentine artist. Written by himself.** Trans by Thomas Nugent. 2 v. London, Davies, 1771.

1494. _____. **L'opera completa del Cellini.** Presentazione di Charles Avery. Apparati critici e filologici di Susanna Barbaglia. Milano, Rizzoli, 1981. (Classici dell'arte, 104).

1495. _____. **Tutta l'opera del Cellini.** A cura di Ettore Camesasca. Milano, Rizzoli, 1955. (Biblioteca d'arte Rizzoli, 21).

1496. _____. **La vita scritta da lui medesimo.** [A cura] di A. Cocci. Napoli, 1728.

1497. _____. **La Vita.** A cura di Bruno Maier. Novara, Ist. Geografico de Agostini, 1962. (I classici di tutti i tempi, 2. Serie memorialisti e viaggiatori, 1).

1498. Cervigni, Dino S. **The Vita of Benvenuto Cellini: literary tradition and genre.** Ravenna, Longo, 1979. (L'intreprete, 13).

1499. Cust, Robert H. H. **Life of Benvenuto Cellini.** 2 v. London, Methuen, 1910.

1500. Goethe, Johann Wolfgang von. **Benvenuto Cellini.** Mit Steinzeichnungen von Max Slevogt. Stuttgart, Cotta, 1802.

1501. Plon, Eugène. **Benvenuto Cellini, orfevre, médailleur, sculpteur; recherches sur sa vie, sur son oeuvre et sur les pièces qui lui sont attribuées.** 2 v. Paris, Plon, 1883-1884.

1502. Supino, Igino B. **L'art di Benvenuto Cellini, con nuovi documenti sull'oreficeria fiorentina del secolo XVI.** Firenze, Alinari, 1901.

CERDÁ, ILDEFONSO, 1815-1876

1503. Cerdá, Ildefonso. **Teoría general de la urbanizatión.** 2 v. Madrid, Imprenta Española, 1867. (Reprint: 3 v. Madrid, Instituto de Estudios Fiscales, 1968).

CERMÁK, JAROSLAV, 1830-1878

1504. Cerny, Vratislav. **Zivot, a dílo Jaroslava Cermáka.** Sepsali Vratislav Cerny, F.V. Mokry, V. Naprstek. Praha, Vytvarny odbor Umeleké besedý, 1930.

1505. Siblik, Emmanuel. **Le peintre Jaroslav Cermák, 1830-1878.** Prague, Umelecká beseda, 1930.

CEZANNE, PAUL, 1839-1906

1506. Adriani, Götz. **Paul Cézanne: Zeichnungen.** [Katalog] der Ausstellung in der Kunsthalle Tübingen, 21 Okt.-31 Dezember 1978. Köln, DuMont, 1978.

1507. Anderson, Wayne. **Cézanne's portrait drawings.** Cambridge, M.I.T. Press, 1970.

1508. Badt, Kurt. **The art of Cézanne.** Trans. by S. A. Ogilvie. Berkeley, University of California Press, 1965.

1509. Barnes, Albert C. and De Mazia, Violette. **The art of Cézanne.** New York, Harcourt, Brace & Co., 1939.

1510. Bernard, Emile. **Souvenirs sur Paul Cézanne, une conversation avec Cézanne, la méthode de Cézanne.** Paris, Michel, 1926. 3 ed.

1511. Berthold, Gertrude. **Cézanne und die alten Meister. Die Bedeutung der Zeichnungen Cézannes nach Werken anderer Künstler.** Stuttgart, Kohlhammer, 1958.

1512. Biederman, Charles. **The new Cézanne.** Red Wing, Minnesota, Art History, 1958.

1513. Boisdeffre, Pierre de, et al. **Cézanne.** Paris, Hachette et Société d'Etudes et de Publications Economiques, 1966. (Génies et réalités, 26).

1514. Brion-Guerry, Liliane. **Cézanne et l'expression de l'espace.** Paris, Michel, 1966.

1515. Cézanne, Paul. **Album de Paul Cézanne.** [Par] Adrien Chappuis. Préface de Roseline Bacori. 2 v. Paris, Berggman, 1966.

1516. _____. **Paul Cézanne, correspondance.** Recueillie, annotée et préfacée par John Rewald. Nouv. éd. rev. et augm. Paris, Grasset, 1978. 2 ed.

1517. _____. **Paul Cézanne sketchbook, 1875-1885.** Introd. by John Rewald; trans. by Olivier Bernier. New York, Johnson Reprint Corp., 1982.

1518. Chappuis, Adrien. **Les dessins de Paul Cézanne au Cabinet des Estampes du Musée des Beaux-Arts, Bâle.** 2 v. Oeten/Lausanne, Graf, 1962.

1519. _____. **The drawings of Paul Cézanne: a catalogue raisonné.** 2 v. Greenwich, Conn., New York Graphic Society, 1973. (CR).

1520. Cherpin, Jean. **L'oeuvre gravé de Cézanne.** Préf. par Paul Gachet. Lettres de Paul Gachet à propos de Cézanne. Marseilles, Arts et Livres de Provence, 1972.

1521. Dorival, Bernard. **Cézanne.** Paris, Tisné, 1948.

1522. Faure, Elie. **Cézanne.** Trans. by Walter Pach. New York, Assoc. of American Painters and Sculptors, 1913.

1523. _____. **Les constructeurs.** Paris, Editions Crès, 1921.

1524. Fry, Roger E. **Cézanne, a study of his development.** New York, Farrar, 1958. 3 ed. First publ.: London, L. & V. Woolf, 1927.

1525. Gasquet, Joachim. **Cézanne.** Paris, Bernheim-Jeune, 1921.

1526. Gatto, Alfonso. **L'opera completa di Cézanne.** Presentazione di A. Gatto; apparati critici e filologici di Sandra Orienti. Milano, Rizzoli, 1970. (Classici dell'arte, 39).

1527. Glaser, Curt. **Paul Cézanne.** Leipzig, Seemann, 1922. (Bibliothek der Kunstgeschichte, 50).

1528. Guerry, Liliane. **Cézanne et l'expression de l'espace.** Paris, Michel, 1966. 2 ed.

1529. Huyghe, René. **Cézanne.** Paris, Somogy, 1961.

1530. Lindsay, Jack. **Cézanne; his life and art.** Greenwich, Conn., New York Graphic Society, 1969.

1531. Loran, Erle. **Cézanne's composition; analysis of his form with diagrams and photographs of his motifs.** Berkeley, University of California Press, 1963. 3 ed.

1532. Mack, Gerstle. **Paul Cézanne.** Trans. by J. Holroyd-Reece. New York, Knopf, 1942. 2 ed.

1533. McLeave, Hugh. **A man and his mountain: the life of Paul Cézanne.** New York, Macmillan, 1977.

1534. Meier-Graefe, Julius. **Cézanne.** Trans. by J. Holroyd-Reece. London, Benn, 1927.

1535. _____. **Paul Cézanne.** München, Piper, 1923. 5 ed. First publ. 1910.

1536. Murphy, Richard W. **The world of Cézanne, 1839-1906.** New York, Time-Life Books, 1968.

1537. Museum of Modern Art (New York). **Cézanne: the late work.** Essays by Theodore Reff et al. Edited by William Rubin. Published on the occasion of the exhibition "Cezanne: The Late Work." New York, Museum of Modern Art, 1977; distributed by New York Graphic Society, Boston.

1538. Neumeyer, Alfred. **Cézanne drawings.** New York, Yoseloff, 1958.

1539. Novotny, Fritz. **Cézanne.** New York, Phaidon, 1961.

1540. _____. **Cézanne und das Ende der wissenschaftlichen Perspektive.** Wien/München, Schroll, 1970. (Reprint of 1938 ed.).

1541. Orangerie des Tuileries (Paris). **Cézanne dans les musées nationaux.** 19 juillet-14 octobre 1974. Paris, Editions des Musées Nationaux, 1974.

1542. Perruchot, Henri. **La vie de Cézanne.** Paris, Hachette, 1956.

1543. Phillips Collection (Washington, D.C.). **Cézanne; an exhibition in honor of the fiftieth anniversary of the Phillips Collection.** Feb. 27-March 28, 1971. Introd. by John Rewald; catalogue entries by Anne d'Harnoncourt. Washington, D.C., The Phillips Collection, 1971.

1544. Ponente, Nello. **Cézanne.** Bologna, Capitol, 1980. (Collana d'arte Paola Malipiero, 9).

1545. Reynal, Maurice. **Cézanne; biographical and critical studies.** Trans. by James Emmons. Geneva, Skira, 1954. (The Taste of Our Time, 8).

1546. Rewald, John. **Cézanne et Zola.** Paris, Sedrowski, 1936.

1547. _____. **Paul Cézanne, a biography.** New York, Schocken, 1968.

1548. _____. **Paul Cézanne, carnet des dessins.** Préface et catalogue raisonné. 2 v. Paris, Quatre Chemins-Editart, 1957. (CR).

1549. Rubin, William. **Cézanne, the late work.** London, Thames and Hudson, 1978.

1550. Schapiro, Meyer. **Paul Cézanne.** New York, Abrams, 1965. 3 ed.

1551. Venturi, Lionello. **Cézanne; son art, son oeuvre.** 2 v. Paris, Rosenberg, 1936.

1552. Vollard, Ambroise. **Paul Cézanne; his life and art.** Trans. by H. L. Van Doren. New York, Brown, 1923.

1553. Wechsler, Judith. **Cézanne in perspective.** Englewood Cliffs, Prentice-Hall, 1975.

1554. _____. **The interpretation of Cézanne.** Ann Arbor, Mich., UMI Research Press, 1981. (Studies in the fine arts. Art Theory, 8).

CHADWICK, LYNN, 1914-

1555. Musée National d'Art Moderne (Paris). **Lynn Chadwick.** Exposition organisée par le British Council et des musées

49

de France, 7 fev.-10 mars 1957. Paris, Editions des Musées Nationaux, 1957.

1556. Read, Herbert. **Lynn Chadwick.** Amriswil, Switzerland, Bodensee-Verlag, 1958.

CHADWICK, WILLIAM, 1879-1962

1557. Love, Richard H. **William Chadwick, 1879-1962: an American impressionist.** Chicago, R. H. Love Galleries, 1978.

CHAGALL, MARC, 1887-1985

1558. Aronson, Boris. **Mark Shagal.** Petropolis [i.e. Berlin], Petropolis-Verlag, 1923.

1559. Bibliothèque Nationale (Paris). **Chagall, l'oeuvre gravé.** [Catalogue de l'exposition] par Françoise Voimant, 1970.

1560. Bidermanis, Izis. **The world of Marc Chagall.** Photographed by I. Bidermanis. Text by Roy McMullen. Garden City, N.Y., Doubleday, 1968.

1561. Cain, Julien. **Chagall lithographe.** Avant-propos de Marc Chagall. Notices de Fernand Mourlot. 4 v. Monte-Carlo, Sauret, 1960-1974.

1562. Cassou, Jean. **Chagall.** Trans. by Alice Jaffa. New York, Praeger, 1965.

1563. Chagall, Marc. **Chagall by Chagall.** Ed. by Charles Sorlier, trans. by John Shepley. New York, Abrams, 1979.

1564. _____. **Marc Chagall.** Berlin, Verlag Der Sturm, 1920. (Sturm Bilderbücher, 1).

1565. _____. **My life.** Trans. by E. Abbott. New York, Grossman, 1960.

1566. Crespelle, Jean-Paul. **Chagall, l'amour, le rêve et la vie.** Paris, Presses de la Cité, 1969.

1567. Däubler, Theodor. **Marc Chagall.** Roma, Edit. de Valori Plastici, 1922.

1568. Debenedetti, Elisa. **I miti di Chagall.** Milano, Longanesi, 1962.

1569. Efros, Abram M. **Die Kunst Marc Chagalls.** Von A. Efros und J. Tugenhold. Autorisierte Übersetzung aus dem Russischen von F. Ichak-Rubiner. Potsdam, Kiepenheuer, 1921.

1570. Erben, Walter. **Marc Chagall.** Trans. by Michael Bullock. Rev. ed., New York, Praeger, 1966.

1571. Haftmann, Werner. **Marc Chagall.** Köln, DuMont, 1972.

1572. Kornfeld, Eberhard. **Marc Chagall: das graphische Werk.** Bern, Kornfeld und Klipstein, 1970.

1573. Lassaigne, Jacques. **Chagall.** Paris, Maeght, 1957.

1574. _____. **Chagall: unpublished drawings.** Genève, Skira, 1968.

1575. Leymarie, Jean. **Marc Chagall: monotypes.** Catalogue établie par Gerald Cramer. 2 v. Genève, Cramer, 1966-1977.

1576. Mathey, François. **Chagall.** 2 v. Paris, Hazan, 1959. (Petite encyclopédie de l'art, 27-28).

1577. Meyer, Franz. **Marc Chagall; his graphic work.** Documentation: Hans Bolliger. New York, Abrams, 1957.

1578. _____. **Marc Chagall; life and work.** Trans. by Robert Allen. New York, Abrams, 1964.

1579. Musée des Arts Décoratifs (Paris). **Marc Chagall.** Juin-octobre 1959, Palais du Louvre, Pavillon de Marsan. Catalogue par François Mathey. Paris, 1959.

1580. Salmon, André. **Chagall.** Paris, Editions des Chroniques du Jour, 1928.

1581. Sidney, Alexander. **Marc Chagall; a biography.** New York, Putnam, 1978.

1582. Sorlier, Charles. **Les affiches de Marc Chagall.** Préf. de Léopold Senghor; introd. de Jean Adhémar. Paris, Draeger-Vilo, 1975. (CR).

1583. _____. **Les céramiques et sculptures de Chagall.** Catalogue raisonné. Préf. de André Malraux. Monaco, Editions Sauret, 1972. (CR).

1584. _____. **Marc Chagall et Ambrose Vollard.** Catalogue complet des gravures exécutés par Marc Chagall à la demande de Ambrose Vollard. Textes de Marc Chagall, André Malraux, Robert Marteneau. Paris, Editions Galerie Matignon, 1981.

1585. Sweeney, James Johnson. **Marc Chagall.** The Museum of Modern Art in New York in collaboration with the Art Institute of Chicago. New York, Museum of Modern Art, 1946.

1586. Venturi, Lionello. **Chagall; a biographical and critical study.** Trans. by S. J. C. Harrison and James Emmons. New York, Skira, 1956. (The Taste of Our Time, 18).

1587. With, Karl. **Marc Chagall.** Leipzig, Klinkhardt & Biermann, 1923. (Junge Kunst, 35).

CHAMBERS, WILLIAM, 1723-1796

1588. Chambers, William. **A treatise on civil architecture in which the principles of that art are laid down, and illustrated by a great number of plates, accurately designed, and elegantly engraved by the best hands.** London, Printed for the author by J. Haberkorn, 1759.

1589. _____. **A treatise on the decorative part of civil architecture.** Illustrated by fifty original, and three additional plates, engraved by old Rooker, old Foudrinier, Charles Grignion, and other eminent hands. London, Smeeton, 1791. 3 ed.

1590. Harris, John. **Sir William Chambers, Knight of the Polar Star.** With contributions by J. Mordaunt Crook and Eileen Harris. London, Zwemmer, 1970. (Studies in Architecture, 9).

CHAMPAIGNE, JEAN BAPTISTE DE, 1631-1681

PHILIPPE DE, 1602-1674

1591. Gazier, A. L. **Philippe et Jean Baptiste de Champaigne.** Paris, Librairie de l'Art, 1923.

1592. Orangerie des Tuileries (Paris). **Philippe de Champaigne.** Exposition [fév.-mars 1952] en l'honneur du trois cent cinquantième anniversaire de sa naissance. Avant-propos de Mauricheau-Beaupré. Catalogue par Bernard Dorival. Paris, Editions des Musées Nationaux, 1952.

CHARDIN, JEAN-BAPTISTE SIMEON, 1699-1779

1593. Consibee, Philip. **Chardin.** Oxford, Oxford University Press, 1983.

1594. Dayot, Armand P. M. **J.-B. Siméon Chardin, avec un catalogue complet de l'oeuvre du maître par Jean Guiffrey.** Paris, Piazza, 1907.

1595. De La Mare, Walter. **Chardin (1699-1779).** London, Faber and Faber, 1948.

1596. Denvir, Bernard. **Chardin.** New York, Harper, 1950.

1597. Florisoone, Michel. **Chardin.** Paris, Skira, 1938. (Les trésors de la peinture française; XVIIIe siècle, 2).

1598. Fourcaud, Louis de. **J. B. Siméon Chardin.** Paris, Ollendorff, 1900.

1599. Furst, Herbert E. A. **Chardin.** London, Methuen, 1911.

1600. Konody, Paul George. **Chardin.** London, Jack/New York, Stokes, 1909.

1601. Lazarev, Viktor N. **Jean-Baptiste Siméon Chardin.** Dresden, Verlag der Kunst, 1966.

1602. Leclère, Tristan. **Chardin.** Paris, Nilsson, 1924.

1603. Mittelstädt, Kuno. **Jean-Baptiste Siméon Chardin.** Berlin, Henschel, 1963.

1604. Normand, Charles. **J.-B. Siméon Chardin.** Paris, Librairie de l'Art/E. Moreau, 1901.

1605. Ridder, André de. **J.-B. S. Chardin.** Paris, Floury, 1932.

1606. Rosenberg, Pierre. **Chardin, biographical and critical study.** Trans. by Helga Harrison. Lausanne, Skira, 1963. (The Taste of Our Time, 40).

1607. _____. **Chardin, 1699-1779.** A special exhibition organized by the Réunion des Musées Nationaux, Paris, the Cleveland Museum of Art, and Museum of Fine Arts, Boston. Cleveland, Cleveland Museum of Art in cooperation with Indiana University Press, 1979.

1608. Rothschild, Henri de. **Documents sur la vie et l'oeuvre de Chardin.** Réunies et annotés par André Pascal [pseud.] et Roger Gaucheron. Paris, Editions de la Galerie Pigalle, 1931.

1609. Schéfer, Gaston. **Chardin, biographie critique.** Paris, Laurens, 1907.

1610. Wildenstein, Georges. **Chardin.** Zurich, Manesse, 1963. Rev. and enl. ed. by Daniel Wildenstein. Trans. by Stuart Gilbert. Oxford, Cassirer, 1969. (CR).

1611. _____. **Chardin: biographie et catalogue critique.** Paris, Les Beaux-arts, 1933. (CR).

1612. Zolotov, Iurii K. **Jean-Baptiste Siméon Chardin.** Moscow, Iskusstvo, 1956.

CHARLET, NICOLAS-TOUSSAINT, 1792-1845

1613. Dayot, Armand P. M. **Charlet et son oeuvre. . . . 118 compositions, lithographiques, peintures à l'huile, aquarelles, sépias et dessins inédits.** Paris, Librairies-Imprimeries Réunies, 1892.

1614. _____. **Les peintres militaires: Charlet et Raffet.** Paris, Librairies-Imprimeries Réunies, n.d.

1615. LaCombe, Joseph F. L. de. **Charlet, sa vie, ses lettres, suivie d'une description raisonné de son oeuvre lithographique.** Paris, Paulin et Le Chevalier, 1856.

1616. Lhomme, François. **Charlet.** Paris, Librairie de l'Art, 1892.

CHASSERIAU, THEODORE, 1819-1856

1617. Bénédite, Léonce. **Théodore Chasseriau, sa vie et son oeuvre;** manuscrit inédit publié par André Dezarrois, 2 v. Paris, Braun, 1932.

1618. Chevillard, Valbert. **Un peintre romantique: Théodore Chasseriau.** Avec une eau-forte de Bracquemond. Paris, Lemerre, 1893.

1619. Fogg Art Museum, Harvard University (Cambridge, Mass.). **Between the empires; Géricault, Delacroix, Chasseriau, painters of the Romantic movement,** April 30-June 1, 1946. Cambridge, Mass. Fogg Art Museum, Harvard University, 1946.

1620. Laran, Jean. **Chasseriau . . .** Par J. Laran . . . précédée d'une introduction biographique et critique par Henry Marcel. Paris, La Renaissance du Livre, J. Gulleguin, 1911. (L'art de notre temps, 1).

1621. Musée de l'Orangerie (Paris). **Exposition Chasseriau, 1819-1856.** Préf. de Jean-Louis Vaudoyer. Paris, Musée de l'Orangerie, 1933.

1622. Sandoz, Marc. **Théodore Chasseriau, 1819-1856.** Catalogue raisonné des peintures et estampes. Paris, Arts et Métiers Graphiques, 1974. (CR).

CHERET, JULES, 1836-1932

1623. Maindron, Ernest. **Les affiches illustrées; ouvrage orné de** 20 chromalithographies par Jules Chéret et de nombreuses reproductions en noir et en couleur d'après les documents originaux. Paris, Launette, 1886.

1624. Mauclair, Camille. **Jules Chéret.** Paris, Le Carrec, 1930.

CHIPPENDALE, THOMAS, 1718-1779

1625. Brackett, Oliver. **Thomas Chippendale; a study of his life, work and influence.** Boston, Houghton Mifflin, 1925.

1626. Chippendale, Thomas. **The gentleman & cabinet-maker's director, being a large collection of the most elegant and useful designs of household furniture in the most fashionable taste.** London, Chippendale, 1762. 3 ed. (Reprint: New York, Dover, 1966).

1627. Hayden, Arthur. **The furniture designs of Thomas Chippendale.** London, Gibbings, 1910.

1628. Layton, Edwin J. **Thomas Chippendale; a review of his life and origin.** London, Murray, 1928.

1629. Lowe, John. **Möbel von Thomas Chippendale.** Darmstadt, Schneekluth, n.d. (Wohnkunst und Hausrat einst und jetzt, 15).

CHIRICO, GIORGIO DE, 1888-1978

1630. Chirico, Giorgio de. **Catalogo generale Giorgio de Chirico.** Coordin. Claudio Bruni con collab. di Giorgio de Chirico e Isabella Far, e con la consulenza speciale di Giuliana Briganti. 7 v. Milano, Electa, [1971-1983]. (CR).

1631. _____. **The memoirs of Giorgio de Chirico.** Trans. from Italian and with introd. by Margaret Crosland. London, Owen, 1971.

1632. _____. **Memorie della vita mia.** Milano, Rizzoli, 1962. 2 ed.

1633. Ciranna, Alfonso. **Giorgio de Chirico.** Catalogo delle opere grafiche: incisioni e litografie, 1921-1969. A cura di Alfonso Ciranna con introd. critica di Cesare Vivaldi. Milano, Ciranna, 1969.

1634. Costantini, Constanzo. **Il pittore glorioso.** Milano, Sugar Co., 1978.

1635. Far, Isabella. **De Chirico.** Trans. from French by Joseph M. Bernstein. New York, Abrams, 1968.

1636. Ragghianti, Carlo Ludovico. **Il caso de Chirico: saggi e studi 1934-1978.** Firenze, Critica d'Arte, 1979.

1637. Soby, James Thrall. **The early Chirico.** New York, Dodd, Mead, 1941; rev. ed.: Giorgio de Chirico, New York, Museum of Modern Art, 1955.

1638. Spaguoli, Luisa. **Lunga vita di Giorgio de Chirico.** Milano, Longanesi, 1971.

1639. Waldemar-George [pseud.]. **Chirico.** Avec des fragments littéraires de l'artiste. Paris, Editions des Chroniques du Jour, 1928. (Les maîtres nouveaux, 15).

CHODOWIECKI, DANIEL NIKOLAUS, 1726-1801

1640. Bauer, J. **Daniel Nikolaus Chodowiecki, 1726-1801. Das druckgraphische Werk.** Hannover, Galerie Bauer, 1982.

1641. Bredt, E. W. **Chodowiecki. Zwischen Rokoko und Romantik.** München, Hugo Schmidt, n.d.

1642. Brinitzer, Carl. **Die Geschichte des Daniel Chodowicki; ein Sittenbild des 18. Jahrhunderts.** Stuttgart, Deutsche Verlagsanstalt, 1973.

1643. Chodowiecki, Daniel. **Briefe an Anton Graff.** Hrsg. von Charlotte Steinbrucker. Berlin/Leipzig, de Gruyter, 1921.

1644. _____. **Briefe an die Gräfin von Solms-Laubach.** Hrsg. von Charlotte Steinbrucker. Strassburg, Heitz, 1928. (Studien zur deutschen Kunstgeschichte, 250).

1645. _____. **Briefwechsel zwischen Daniel Chodowicki und seinen Zeitgenossen.** Hrsg. von Charlotte Steinbrucker. Berlin, Duncker, 1919.

1646. _____. **Journal gehalten auf einer Lustreise von Berlin nach Dresden im Jahre 1789.** Mit einer Einleitung von Adam Wiecek. Berlin, Akademie-Verlag, 1961. (Schriften zur Kunstgeschichte, 6).

1647. _____. **Unveröffentlichte Handzeichnungen zu dem Elementarwerk von Johann Bernhard Basedow.** Mit einem Vorworte von Max von Boehn. Frankfurt, Voigtländer-Tetzner, 1922. (Veröffentlichung der Prestel-Gesellschaft, 10).

1648. _____. **Unveröffentlichte Handzeichnungen zu dem moralischen Elementarbuche von Christian Gotthelf Salzman.** Mit einem Vorworte von Max von Boehn. Frankfurt, Voigtländer-Tetzner, 1922. (Veröffentlichung der Prestel-Gesellschaft, 11).

1649. _____. **Von Berlin nach Danzig. Eine Künstlerfahrt im Jahre 1773 von Daniel Chodowiecki.** 108 Lichtdrucke nach Originalen in der Königl. Akademie der Künste in Berlin. Mit erläuterndem Text und einer Einführung von Wolfgang von Oettingen. Leipzig, Insel, 1923.

1650. Denkert, Paul. **Daniel Chodowiecki.** Berlin, Rembrandt-Verlag, 1977.

1651. Engelmann, Wilhelm. **Daniel Chodowiecki's sämmtliche Kupferstiche.** Beschrieben, mit historischen, literarischen und bibliographischen Nachweisungen, der Lebensbeschreibung des Künstlers und Registern versehen von Wilhelm Engelmann. Mit drei Kupfertafeln Copien der seltensten Blätter des Meisters enthaltend. Leipzig, Engelmann, 1857. (Reprint: Hildesheim, Olms, 1969).

1652. _____. **Nachträge und Berichtigungen.** Leipzig, Engelmann, 1860. (Reprint: see above).

1653. Jahn, Johannes. **Daniel Chodowiecki und die künstlerische Entdeckung des Berliner bürgerlichen Alltags.** Berlin, Henschelverlag, 1954. (Berlin in der Kunst. Veröff. der Deutschen Akademie der Künste, 1).

1654. Kaemmerer, Ludwig J. K. **Chodowiecki.** Bielefeld/Leipzig, Velhagen & Klasing, 1897. (Künstler-Monographien, 21).

1655. Laundau, Paul. **Chodowieckis Illustrationen zu den deutschen Klassikern.** Berlin, Bard, 1920.

1656. Meyer, Ferdinand. **Daniel Chodowiecki der peintre-graveur.** Im Lichte seiner und unsere Zeit dargestellt. Berlin, Mückenberger, 1888.

1657. Oettingen, Wolfgang von. **Daniel Chodowiecki; ein Berliner Künstlerleben im achtzehnten Jahrhundert.** Berlin, Grote, 1895.

1658. Redslob, Edwin. **Daniel Chodowiecki.** Berlin, Berlin-Museum, 1965. (Veröffentlichungen des Berlin-Museums, 2).

1659. Rümann, Arthur. **Daniel Chodowiecki (Bibliographie).** Berlin. (Das Werk, Sammlung praktischer Bibliographien, 1: Das graphische Werk).

1660. Städelsches Kunstinstitut (Frankfurt a.M.). **Bürgerliches Leben im 18. Jahrhundert: Daniel Chodowiecki, 1726-1801. Zeichnungen und Druckgraphik.** Katalog der Ausstellung vom 8. Juni-20 August, 1978. Katalogbearbeitung Peter Märker. Frankfurt a.M., Städel, 1978.

1661. Turnau, Irena. **Kultura materialna oswiecenia w rycinach Daniela Chodowieckiego.** Wrocław, etc. Zaktad Narodowy Imienia Ossolinskich Wydawnictwo Polskiej Akademii Nauk, 1968.

CHRISTO (Christo Javacheff), 1935-

1662. Christo. **Christo.** Text by David Bourdon. New York, Abrams, 1972.

1663. _____. **Running Fence, Sonoma and Marin Counties, California, 1972-76.** Photos by Gianfranco Gorgoni; chronicle by Calvin Tomkins; text by David Bourdon. New York, Abrams, 1978.

1664. _____. **Valley Curtain, Rifle, Colorado, 1970-72.** Photos: Harry Shunk. New York, Abrams, 1973.

1665. Houdenakk, Pei and Schellmann, Jorg. **Christo: The complete editions, 1964-1982.** New York University Press, 1982.

1666. Institute of Contemporary Art (Boston). **Urban projects; a survey [by Christo].** May 9-July 1, 1979. Boston, Institute of Contemporary Art, 1979.

1667. Princeton University Art Museum. **Christo: Oceanfront.** Text by Sally Yard; photos by Gianfranco Gorgoni. Princeton, N.J., University Art Museum; distributed by Princeton University Press, 1975.

CHRISTUS, PETRUS see CRISTUS, PETRUS

CHU TA, c. 1630-c. 1705

1668. Chang, Wan-li and Hu Jen-mou. **The selected paintings and calligraphy of Pa-Ta-Shan-Jeh [Chu Ta].** 2 v. Hong Kong, Cafa, 1969.

1669. Vassar College Art Gallery. **Chu Ta, selected paintings and calligraphy.** December 2, 1972-January 28, 1973. New York, New York Cultural Center, 1973.

CHURCH, FREDERIC EDWIN, 1826-1900

1670. Huntington, David C. **The landscape of Frederic Edwin Church; vision of an American era.** New York, Braziller, 1966.

1671. Metropolitan Museum of Art (New York). **Paintings by Frederic E. Church; special exhibition, May 28 to Oct. 15, 1900.** New York, Metropolitan Museum of Art, 1900.

1672. National Collection of Fine Arts (Washington, D.C.). **Frederic Edwin Church; an exhibition, Feb. 12-Mar. 13, 1966.** Preface by Richard Wunder. Washington, D.C., Smithsonian Institution-N.C.F.A., 1966.

CIGNANI, CARLO, 1628-1719

1673. Vitelli Buscaroli, Syra. **Carlo Cignani, 1628-1719.** Bologna, Arti Grafiche, 1953.

CIGOLI, LODOVICO CARDI DA, 1559-1613

1674. Battelli, Guido. **Lodovico Cardi, detto il Cigoli.** Firenze, Alinari, 1922. (Piccola collezione d'arte, 38).

CIMA DA CONEGLIANO, GIOVANNI BATTISTA, 1460-1517

1675. Botteon, Vincenzo. **Ricerche intorno alla vita e alle opere di Giambattista Cima.** Conegliano, Cagnani, 1893.

1676. Burckhardt, Rudolf F. **Cima da Conegliano; ein venezianischer Maler des Übergangs vom Quattrocento zum Cinquecento.** Leipzig, Hiersemann, 1905. (Kunstgeschichtliche Monographien, 2).

1677. Coletti, Luigi. **Cima da Conegliano.** Venezia, Pozza, 1959.

1678. Humfrey, Peter. **Cima.** Cambridge, Cambridge University Press, 1983.

1679. Palazzo de Trecento (Venice). **Cima da Conegliano.** 26 agosto-11 novembre 1962. Venezia, Pozza, 1962.

CIMABUE, GIOVANNI, 1240-1302

1680. Battisti, Eugenio. **Cimabue.** Milano, Istituto Editoriale Italiano, 1963. (Arte e pensiero, 5). (English ed.: University Park, Penn., Pennsylvania State University Press, 1966).

1681. Nicholson, Alfred. **Cimabue; a critical study.** Princeton, N.J., Princeton University Press, 1932. (Princeton Monographs in Art and Archaeology, 16).

1682. Salvini, Roberto. **Cimabue.** Roma, Tuminelli, 1946.

CINGRIA, ALEXANDRE, 1879-1945

1683. Bouvier, Jean Bernard. **Alexandre Cingria, peintre, mosaïste et verrier.** Genève-Annemasse, Editions du Mont Blanc, 1944.

1684. Fosca, François. **Portrait d'Alexandre Cingria.** Lausanne, Payot, 1930. (Les Cahiers romands, 11).

1685. Musée Rath (Geneva). **Alexandre Cingria (1879-1945).** 14 mai-27 juin 1965. Genève, 1965.

CIVITALI, MATTEO, 1436-1501

1686. Meli, Filippo. **L'arte di Matteo Civitali.** Lucca, Baroni, 1934.

1687. Yriarte, Charles E. **Sculpture italienne, XV. siècle; Matteo Civitali, sa vie et son oeuvre.** Paris, Rothschild, 1886.

CLARK, ROBERT see INDIANA, ROBERT

CLAUDE LORRAIN (Claude Gellée), 1600-1682

1688. Blum, André. **Les eaux-fortes de Claude Gellée.** Paris, Documents d'Art, 1923.

1689. Bouyer, Raymond. **Claude Lorrain.** Paris, Laurens, 1905.

1690. Christoffel, Ulrich. **Poussin und Claude Lorrain.** Einleitung von U. Christoffel. Die Auswahl der Bilder besorgte Bernhard Dörries. München, Bruckmann, 1942.

1691. Claude Lorrain. **Liber veritatis; or, a collection of prints, after the original designs of Claude Lorrain, in the collection of His Grace, the Duke of Devonshire.** 3 v. London, Boydell, 1777-1819.

1692. Cotté, Sabine. **Claude Lorrain.** Trans. by Helen Sebba. New York, Braziller, 1971.

1693. Courthion, Pierre. **Claude Gellée dit Le Lorrain.** Paris, Floury, 1932.

1694. Demonts, Louis. **Les dessins de Claude Gellée dit Le Lorrain.** Paris, Morancé, 1923.

1695. Dulles, Owen J. **Claude Gellée Le Lorrain.** London, Sampson Low, 1887.

1696. Friedländer, Walter. **Claude Lorrain.** Berlin, Cassirer, 1921.

1697. Grahame, George. **Claude Lorrain, painter and etcher.** London, Seeley/New York, Macmillan, 1895. (Portfolio Artistic Monographs, 15).

1698. Graphische Sammlung Albertina (Vienna). **Claude Lorrain und die Meister der römischen Landschaft im XVII. Jahrhundert.** 16. Nov.-15. Feb. 1965. Wien, Albertina, 1964.

1699. Hetzer, Theodor. **Claude Lorrain.** Frankfurt a.M., Klostermann, 1947.

1700. Hind, Arthur M. **Catalogue of the drawings of Claude Lorrain in the Print Dept. of the British Museum.** London, British Museum, 1926.

1701. _____. **The drawings of Claude Lorrain.** London, Halton/New York, Minton, 1925.

1702. Kitson, Michael. **Claude Lorrain, Liber veritatis.** London, British Museum Publications, 1978.

1703. Manwaring, Elizabeth W. **Italian landscape in eighteenth century England; a study chiefly of the influence of Claude Lorrain and Salvator Rosa on English taste, 1700-1800.** New York, Oxford University Press, 1925.

1704. Marotte, Léon. **Claude Gellée dit Le Lorrain.** Cinquante-deux reproductions de L. Marotte avec un catalogue et une vie du peintre par J. de Sandrart, nouvellement traduit de l'allemand par Charles Martine. Paris, Helleu, 1922. (Dessins de maîtres français, 2).

1705. Pattison, Emily F. **Claude Lorrain, sa vie et ses oeuvres, d'après des documents inédits.** Par Mme. Mark Pattison. Suivi d'un catalogue des oeuvres de Claude Lorrain, conservées dans les musées et dans les collections particulières de l'Europe. Paris, Rouam, 1884.

1706. Röthlisberger, Marcel. **Claude Lorrain: the drawings.** 2 v. Berkeley, University of California Press, 1968. (California Studies in the History of Art, 8).

1707. _____. **Claude Lorrain: The Paintings.** New Haven, Yale University Press, 1961. (Yale publications in the history of art, 13).

1708. _____. **L'opera completa di Claude Lorrain.** Presentazione di M. Röthlisberger, apparati critici e filologici a cura di Doretta Cecchi. Milano, Rizzoli, 1975. (Classici dell'arte, 83).

1709. Russell, H. Diane. **Claude Lorrain, 1600-1682.** Washington, D.C., National Gallery of Art, 1982.

1710. Sweetser, Moses F. **Claude Lorrain.** Boston, Houghton Mifflin, 1878. (Artist-biographies, 6).

CLERICI, FABRIZIO, 1913-

1711. Brion, Marcel. **Fabrizio Clerici.** Milano, Electa, 1955.

1712. Carrieri, Raffaele. **Fabrizio Clerici.** Milano, Electa, 1955.

1713. Museo Civico (Bologna). **Fabrizio Clerici: I disegni per L'Orlando Furioso.** 28 marzo-3 maggio 1981. Bologna, Grafis industrie, 1981.

CLEVE, JOOS VAN, ca. 1485-ca. 1540

1714. Baldass, Ludwig von. **Joos van Cleve der Meister des Todes Mariä.** Wein, Krystall-Verlag, 1925.

CLOUET, FRANÇOIS, 1505-1572

JEAN, 1475-1541

1715. Bibliothèque Nationale, Paris. **Les Clouet et la cour des rois de France.** [Exposition] catalogue: Jean Adhémar. Paris, Bibliothèque Nationale, 1970.

1716. Clouet, François. **Three hundred French portraits representing personages of the courts of Francis I, Henry II, and Francis II.** Autolithographed from the originals at Castle Howard, Yorkshire, by Lord Ronald Gower. London, Low/Paris, Hachette, 1875.

1717. Fourreau, Armand. **Les Clouet.** Paris, Rieder, 1929.

1718. Germain, Alphonse. **Les Clouet; biographie critique.** Paris, Laurens, 1907.

1719. Jolly, Alphonse. **Les crayons de Jean Clouet.** Paris, Marceau, 1952.

1720. Malo, Henri. **Les Clouet de Chantilly.** Paris, Laurens, 1932.

1721. Mellen, Peter. **Jean Clouet: complete edition of drawings, miniatures and paintings.** London, Phaidon, 1971.

1722. Moreau-Nélaton, Etienne. **Les Clouet et leurs émules.** 3 v. Paris, Laurens, 1924.

1723. _____. **Les Clouet, peintres officiels des rois de France.** Paris, Levy, 1908.

CLOVIO, GIULIO (Macedo), 1498-1578

1724. Bradley, John W. **The life and works of Giorgio Giulio Clovio, miniaturist, with notices of his contemporaries and of the art of book decoration in the sixteenth century.** London, Quaritch, 1891.

1725. Gamulin, Grego and Cionini-Visani, Maria. **Giulio Clovio.** A catalogue raisonné. New York, Alpine, 1980. (CR).

COBURN, ALVIN LANGDON, 1882-1966

1726. Coburn, Alvin Langdon. **Alvin Langdon Coburn, photographer; an autobiography.** Ed. by Helmut and A. Gernsheim. New York, Praeger, 1966.

1727. George Eastman House (Rochester, New York). **Alvin Langdon Coburn: an exhibition of photographs from the International Museum of Photography.** Rochester, New York, George Eastman House/London, Arts Council of Great Britain, 1978.

CODUCCI, MAURO, c. 1440-1504

1728. Angelini, Luigi. **Le opere in Venezia di Mauro Codussi.** Milano, Bestetti, 1945.

1729. Puppi, Lionello [and] Loredana O. **Mauro Codussi.** Fotografie di Paolo Monti. Milano, Electa, 1977.

COECKE, PIETER, 1502-1550

1730. Corbet, August. **Pieter Coecke van Aelst.** Antwerpen, De Sikkel, 1950. (Maerlantbibliotheek, 21).

1731. Friedländer, Max J. **Jan van Scorel and Pieter Coeck van Aelst.** Comments and notes by H. Pauwels and G. Lemmen. Assisted by Monique Gierts and Anne-Marie Hess. Trans. by Heinz Norden. Leyden, Sijthoff/Brussels, La Connaissance, 1975. (Early Netherlandish Painting, 12).

1732. Marlier, Georges. **Pierre Coeck d'Alost, 1502-1550; la renaissance flamande.** Bruxelles, Finck, 1966.

COELLO, ALONSO SANCHEZ see SANCHEZ COELLO, ALONSO

COLE, THOMAS, 1801-1848

1733. Baigell, Matthew. **Thomas Cole.** New York, Watson-Guptill, 1981.

1734. Baltimore Museum of Art. **Studies on Thomas Cole, an American romanticist.** Essays by Howard S. Merritt and William H. Gerdts, Jr. Baltimore Museum of Art, 1967.

1735. Noble, Louis L. **The Course of Empire, Voyage of Life, and other pictures of Thomas Cole, N.A., with selections from his letters and miscellaneous writings.** New York, Cornish, Lamport, 1853. (New ed.: The life and works of Thomas Cole. Edited by Eliot S. Vesell. Cambridge, Mass., Harvard University Press, 1964).

1736. Wadsworth Atheneum (Hartford). **Thomas Cole, 1801-1848; one hundred years later, a loan exhibition, Nov. 12, 1948-Jan. 2, 1949.** Hartford, Wadsworth Atheneum, 1948.

COLOMBE, MICHEL, 1430-1512

1737. Fillon, Benjamin. **Documents relatifs aux oeuvres de Michel Colombe, exécutées pour le Poitou, l'Aunis et le Pays Natais.** Fontenay-le-Comte, Robuchon, 1865.

1738. Pradel, Pierre. **Michel Colombe, le dernier imagier gothique.** Paris, Plon, 1953.

1739. Vitra, Paul. **Michel Colombe et la sculpture française de son temps.** Paris, Librairie Centrale des Beaux-Arts, 1901.

CONEGLIANO, GIOVANNI BATTISTA CIMA DA

see CIMA DA CONEGLIANO, GIOVANNI BATTISTA

CONSTABLE, JOHN, 1776-1837

1740. Bunt, Cyril G. E. **John Constable, the father of modern landscape.** Leigh-on-Sea, Lewis, 1948. (The Lewis "Introduction to painters" series, 1).

1741. Constable, John. **Correspondence, edited by R. B. Bechet with an introduction and notes.** 6 v. London, HMSO, 1962-1968.

1742. Fraser, John Lloyd. **John Constable, 1776-1837: the man and his mistress.** London, Hutchinson, 1976.

1743. Gadney, Reg. **Constable and his world.** London, Thames and Hudson, 1976.

1744. Holmes, Charles J. **Constable and his influence on landscape painting.** Westminster, Constable, 1902.

1745. Leslie, Charles R. **Memoirs of the life of John Constable, Esq., R. A.; composed chiefly of his letters.** With an introduction by Benedict Nicolson. London, Phaidon, 1951. 2 ed. (The Chiltern library, 29).

1746. Peacock, Carlos. **John Constable, the man and his work.** Greenwich, Conn., New York Graphic Society, 1956.

1747. Reynolds, Graham. **Constable, the natural painter.** New York, McGraw-Hill, 1965.

1748. _____, ed. **Constable with his friends in 1806; sketchbooks in facsimile.** 5 v. London, Trianon Press/Genesis, 1983.

1749. Rosenthal, Michael. **Constable; the painter and his landscape.** New Haven, Yale University Press, 1982.

1750. Shirley, Andrew. **John Constable.** London, Medici Society, 1948.

1751. Smart, Alastair. **Constable and his country.** By A. Smart and Attfield Brooks. London, Elek, 1976.

1752. Tate Gallery (London). **Constable: paintings, watercolours and drawings.** 18 Feb.-25 Apr. 1976. [Catalogue by Leslie Parris et al.]. London, Tate Gallery, 1976. 2 rev. ed.

1753. Taylor, Basil. **Constable; paintings, drawings and watercolours.** London, Phaidon, 1975. 2 ed.

1753a. Victoria and Albert Museum (London). **Catalogue of the Constable collection.** By Graham Reynolds. London, HMSO, 1960.

1754. Walker, John. **John Constable.** New York, Abrams, 1978.

1755. Windsor, J. **John Constable.** London, Walker Scott/New York, Scribner, 1903.

COOPER, SAMUEL, 1609-1672

1756. Foskett, Daphne. **Samuel Cooper, 1609-1672.** London, Faber, 1974.

1757. Foster, Joshua J. **Samuel Cooper and the English miniature painters of the XVII century.** London, Dickinsons, 1914-16.

1758. National Portrait Gallery (London). **Samuel Cooper and his contemporaries.** [Text by Daphne Foskett et al.]. London, HMSO, 1974.

COPLEY, JOHN SINGLETON, 1738-1815

1759. Bayley, Frank W. **The life and works of John Singleton Copley,** founded on the work of Augustus Thorndike Perkins. Boston, Taylor, 1915.

1760. Copley, John Singleton. **Letters and papers of John Singleton Copley and Henry Pelham, 1739-1776.** New York, Kennedy Graphics, 1970. (Republication of 1st ed., 1914, which appeared as vol. 71 of the "Collections of the Massachusetts Historical Society").

1761. Flexner, James T. **The double adventure of John Singleton Copley, first major painter of the new world.** Boston, Little Brown, 1969.

1762. _____. **John Singleton Copley.** Boston, Houghton-Mifflin, 1948.

1763. Frankenstein, Alfred Victor. **The world of Copley, 1738-1815.** New York, Time-Life Books, 1970.

1764. Morgan, John H. **John Singleton Copley, 1737/8-1815.** Windham, Conn., The Walpole Society, 1939.

1765. National Gallery of Art (Washington, D.C.). **John Singleton Copley, 1738-1815.** Catalog of an exhibition at the National Gallery of Art, Washington; the Metropolitan Museum of Art, New York, and the Museum of Fine Arts, Boston. Text by Jules D. Brown. New York, October House, 1965.

1766. Parker, Barbara N. and Wheeler, Anne B. **John Singleton Copley; American portraits in oil, pastel, and miniature.** Boston, Museum of Fine Arts, 1938.

1767. Perkins, Augustus T. **A sketch of the life and a list of some of the works of John Singleton Copley.** Boston, Osgood, 1873.

1768. Prown, Jules D. **John Singleton Copley.** 2 v. Publ. for the National Gallery of Art. Cambridge, Mass., Harvard University Press, 1966.

CORINTH, LOVIS, 1858-1925

1769. Badischer Kunstverein, Karlsruhe. **Lovis Corinth: das Portrait, Gemälde, Aquarelle, Zeichnungen.** 4. Juni-3. Sept. 1967. Katalogredaktion: Klaus Gallwitz. Karlsruhe, Badischer Kunstverein, 1967.

1770. Biermann, Georg. **Lovis Corinth.** Bielefeld/Leipzig, Velhagen & Klasing, 1913. (Künstler-Monographien, 107).

1771. _____. **Der Zeichner Lovis Corinth.** Dresden, Arnold, 1924.

1772. Corinth, Charlotte Berend. **Die Gemälde von Lovis Corinth: Werkkatalog.** Mit einer Einführung von H. K. Röthel. München, Bruckmann, 1958.

1773. _____. **Lovis.** München, Langen, 1958.

1774. _____. **Mein Leben mit Lovis Corinth.** München, List, 1947.

1775. Corinth, Lovis. **Das Erlernen der Malerei.** Berlin, Cassirer, 1920. 3 ed. (Reprint: Hildesheim, Gerstenberg, 1979).

1776. _____. **Gesammelte Schriften.** Berlin, Gurlitt, 1920. (Maler-Bücher, 1).

1777. _____. **Lovis Corinth; eine Dokumentation.** Zusammengestellt und erläutert von Thomas Corinth. Tübingen, Wasmuth, 1979.

1778. _____. **Selbstbiographie.** Leipzig, Hirzel, 1926.

1779. Klein, Rudolf. **Lovis Corinth.** Paris, Librairie Artistique et Littéraire, 1909.

1780. Kuhn, Alfred. **Lovis Corinth.** Berlin, Propyläen-Verlag, 1925.

1781. Kunsthalle Köln. **Lovis Corinth: Gemälde, Aquarelle, Zeichnungen und druckgraphische Zyklen.** Ausstellung des Wallraf-Richartz-Museums in der Kunsthalle, 10. Januar-21. März 1976. Vorwort von Horst Keller, Katalogbearbeitung Siegfried Gohr. Köln, Museum der Stadt Köln, 1976.

1782. Müller, Heinrich. **Die späte Graphik von Lovis Corinth.** Hamburg, Lichtwarkstiftung; distributed by W. Gurlitt, München, 1960.

1783. Nationalgalerie (Berlin). **Lovis Corinth.** Ausstellung von Gemälden und Aquarellen zu seinem Gedächtnis. Einführung von Ludwig Justi. Berlin, Nationalgalerie, 1926. 4 ed.

1784. Osten, Gert von der. **Lovis Corinth.** München, Bruckmann, 1955. 2 ed.

1785. Rhode, Alfred. **Der junge Corinth.** Berlin, Rembrandt-Verlag, 1941.

1786. Röthel, Hans K. **Lovis Corinth.** Zur Feier seines hundertsten Geburtstages. Ausstellung, 7. Juli–17. August 1958. Gemälde: Städtische Galerie; Aquarelle, Zeichnung, Druckgraphik: Staatl. Graphische Sammlung. 50 graph. Selbstbildnisse: Galerie Gurlitt. München, 1958.

1787. Schwarz, Karl. **Das graphische Werk von Lovis Corinth.** Berlin, Gurlitt, 1922. 2 ed.

1788. Singer, Hans W. **Zeichnungen von Lovis Corinth.** Leipzig, A. Schumann's Verlag, 1921. (Meister der Zeichnung, 8).

1789. Städtische Galerie im Lenbachhaus München. **Lovis Corinth 1858–1925.** Gemälde und Druckgraphik. München, Prestel, 1975.

CORNELISZ, JAKOB, VAN OOSTSANEN, ca. 1470–1533

1790. Steinbart, Kurt. **Das Holzschnittwerk des Jakob Cornelisz von Amsterdam.** Burg, Hopfer, 1937.

1791. _____. **Die Tafelgemälde des Jakob Cornelisz von Amsterdam.** Strassburg, Heitz, 1922. (Studien zur deutschen Kunstgeschichte, 221).

CORNELIUS, PETER, 1783–1867

1792. Eckert, Christian L. M. **Peter Cornelius.** Bielefeld/Leipzig, Velhagen & Klasing, 1906. (Künstler-Monographien, 82).

1793. Kuhn, Alfred. **Peter Cornelius und die geistigen Strömungen seiner Zeit.** Mit den Briefen des Meisters an Ludwig I von Bayern und an Goethe. Berlin, Reimer, 1921.

1794. Riegel, Herman. **Cornelius der Meister der deutschen Malerei.** Hannover, Rümpler, 1870. 2 ed.

1795. _____. **Peter Cornelius.** Festschrift zu des grossen Künstlers hundertstem Geburtstage. Berlin, Decker, 1883.

1796. Simon, Karl. **Die Frühzeit des Peter Cornelius.** Düsseldorf, Schwann, 1925. (Pempelfort; Sammlung kleiner Düsseldorfer Kunstschriften, 4).

COROT, JEAN-BAPTISTE CAMILLE, 1796–1875

1797. Art Institute of Chicago. **Corot 1796–1875.** An exhibition of his paintings and graphic works, Oct. 6–Nov. 13, 1960. Introduction by S. Lane Faison. Notes by James Merrill. Chicago, 1960.

1798. Baud-Bovy, Daniel. **Corot.** Genève, Jullien, 1957.

1799. Bazin, Germain. **Corot.** Paris, Tisné, 1942.

1800. Bibliothèque Nationale (Paris). **Estampes et dessins de Corot.** Exposition organisée avec le concours de Musée du Louvre. Paris, Editions des Bibliothèques Nationales, 1931.

1801. Coquis, André. **Corot et la critique contemporaine.** Paris, Dervy, 1959.

1802. Cornu, Paul. **Corot.** Paris, Michaud, 1889.

1803. Corot, Jean-Baptiste C. **Corot, raconté par lui-même et par ses amis.** Ed. by Etienne Moreau-Nélaton. 2 v. Genève, Cailler, 1946.

1804. Faure, Elie. **Corot.** Paris, Crès, 1931.

1805. Gaillot, Edouard. **La vie secrète de Jean-Baptiste-Camille Corot, peintre, graveur et sculpteur; d'après des documents nouveaux et quelques anciens nouvellement élucidés.** Paris, Guitard, 1934.

1806. Gensel, Walther. **Corot und Troyon.** Bielefeld/Leipzig, Velhagen & Klasing, 1906. (Künstler-Monographien, 83).

1807. Leymarie, Jean. **Corot.** Trans. by S. Gilbert. A biographical and critical study. Lausanne, Skira/Cleveland, World, 1966. (The Taste of Our Time, 44).

1808. Mauclair, Camille. **Corot, peintre-poète de la France.** Paris, Michel, 1962.

1809. Meier-Graefe, Julius. **Corot.** Berlin, Cassirer/Klinkhardt und Biermann, 1930.

1810. _____. **Corot und Courbet.** München, Piper, 1912. 2 ed.

1811. Meynell, Everard. **Corot and his friends.** London, Methuen, 1908.

1812. Michel, Emile. **Corot.** Paris, Librairie de l'Art, 1905.

1813. Musée de l'Orangerie (Paris). **Hommage à Corot: peintures et dessins des collections françaises, 6 juin–29 sept. 1975.** Catalogue par Hélène Toussaint, Geneviève Monnier et Martine Servot. Paris, Editions des Musées Nationaux, 1975.

1814. Musée Nationale du Louvre (Paris). **Dessins de Corot, 1796–1875.** Catalogue établi par Martine Servot. Paris, 1962. (Cabinet des Dessins du Louvre).

1815. _____. **Figures de Corot.** Juin-septembre 1962. Paris, Ministère d'Etat pour Affaires Culturelles, 1962.

1816. Palais Galliera (Paris). **Exposition organisée au profit du monument du centenaire de Corot.** Catalogue des chefs-d'oeuvre prêtés par les musées de l'état et les grandes collections de France et de l'étranger. Paris, Georges Petit, 1895.

1817. Philadelphia Museum of Art. **Corot 1796–1875.** [Catalog of the exhibition]. Foreword by Henri Marceau. Introduction by Lionello Venturi. Philadelphia, 1946.

1818. Robaut, Alfred and Moreau-Nélaton, Etienne. **L'oeuvre de Corot.** 5 v. Paris, Floury, 1905. (Reprint: Paris, Laget, 1965, 1966). (CR).

1819. Schoeller, André and Dieterle, Jean. **Corot**. Premier supplément à L'oeuvre de Corot par A. Robaut et Moreau-Nélaton. Paris, Arts et Métiers Graphiques, 1948. (CR).

1820. _____. **Corot**. Deuxième supplément à L'oeuvre de Corot par A. Robaut et Moreau-Nélaton. Paris, Quatre Chemins-Editart, 1974. (CR).

1821. _____. **Corot**. Troisième supplément à L'oeuvre de Corot par A. Robaut et Moreau-Nélaton. Paris, Quatre Chemins-Editart, 1974. (CR).

1822. Sérullaz, Maurice. **Corot**. Paris, Hazan, 1951.

1823. Traz, Georges de. **Corot, sa vie et son oeuvre**. Par François Fosca [pseud.]. Bruxelles, Elsevier, 1958. (Les grands maîtres de l'art français, 2).

CORREGGIO, ANTONIO ALLEGRI, 1489-1534

1824. Bigi, Quirino. **Della vita e delle opere certe ed incerte di Antonio Allegri detto il Correggio; opere posthuma**. Modena, Vicenzi, 1880.

1825. Bodmer, Heinrich. **Correggio und die Malerei der Emilia**. Wien, Denticke, 1942.

1826. Bottari, Stefano. **Correggio**. Milano Edizioni per Il Club del Libro, 1961. (Collana d'arte del Club del Libro, 1).

1827. Correggio, Antonio Allegri. **L'opera completa del Correggio**. Presentazione di Alberto Bevilacqua. Apparati critici e filologici di A. C. Quintavalle. Milano, Rizzoli, 1970. (Classici dell'arte, 41).

1828. De Vito Battaglia, Silvia. **Correggio bibliografia**. Con prefazione de Corrado Ricci. Roma, Palombi, 1934. (R. Istituto di Archeologia e Storia dell'Arte. Bibliografie e cataloghi, 3).

1829. Ghidiglia Quintavalle, Augusta. **Gli affreschi del Correggio in San Giovanni Evangelista a Parma**. Presentazione di Roberto Longhi. Milano, Silvana, 1962.

1830. Gould, Cecil H. P. **The paintings of Correggio**. London, Faber/Ithaca, N.Y., Cornell University Press, 1976.

1831. _____. **The School of Love and Correggio's mythologies**. London, National Gallery, 1970.

1832. Gronau, Georg. **Correggio; des Meisters Gemälde**. Stuttgart, Deutsche Verlagsanstalt, 1907.

1833. _____. **The work of Correggio**. Abridged from G. Gronau. New York, Brentano's, 1908. (Classics in art series, 8).

1834. Hagen, Oskar F. L. **Correggio Apokryphen; eine kritische Studie über die sogenannten Jugendwerke des Correggio**. Berlin, Hyperion, 1915.

1835. Longhi, Roberto. **Il Correggio e la Camera di San Paolo a Parma**. A cura di A. Ghidiglia, Quintavalle. Milano, Silvana, 1973.

1836. Martini, Pietro. **Il Correggio**. Studi. Parma, Grazioli, 1871.

1837. Mecklenburg, Carl Gregor, Herzog zu. **Correggio in der deutschen Kunstanschauung in der Zeit von 1750 bis 1850; mit besonderer Berücksichtigung der Frühromantik**. Baden-Baden, Heitz, 1970. (Studien zur deutschen Kunstgeschichte, 347).

1838. Meyer, Julius. **Antonio Allegri da Correggio**. Trans. with an introduction by Mrs. Charles Heaton. London, Macmillan, 1876.

1839. _____. **Correggio**. Leipzig, Engelmann, 1871.

1840. Moore, Thomas S. **Correggio**. London, Duckworth/New York, Scribner, 1911.

1841. Mottini, Guido E. **Il Correggio**. Bergamo, Ist. italiano d'arte grafiche, 1935.

1842. Musée du Louvre (Paris). **Dessins de l'école de Parme: Corrège, Parmesan, XXXIIIe exposition du Cabinet des Dessins**. Paris, 1964.

1843. Musée de l'Orangerie (Paris). **Hommage à Corrège**. Catalogue des dessins du maître et de ses élèves et des artistes qui ont subi son influence, exposés à l'occasion du quatrième centenaire de sa mort (1534); catalogue rédigé par Jean Vernet-Ruiz. Paris, 1934.

1844. Panofsky, Erwin. **The iconography of Correggio's Camera di San Paolo**. London, Warburg Institute of the University of London, 1961. (Warburg Institute Studies, 26).

1845. Popham, Arthur E. **Correggio's drawings**. New York, Oxford University Press, 1957.

1846. Pungileoni, Luigi. **Memorie istoriche di Antonio Allegri, detto il Correggio**. 3 v. Parma, Stamperia ducale, 1817-21.

1847. Ricci, Corrado. **Antonio Allegri de Corregio, his life, his friends, and his time**. Trans. by Florence Simmonds. London, Heinemann, 1896.

1848. _____. **Correggio**. London/New York, Warne, 1930.

1849. Roi, Pia. **Il Correggio**. Firenze, Alinari, 1921.

1850. Thode, Henry. **Correggio**. Bielefeld/Leipzig, Velhagen & Klasing, 1898. (Künstler-Monographien, 30).

1851. Toscano, Giuseppe M. **Nuovi studi sul Correggio**. Parma, Libreria Aurea, 1974.

1852. Venturi, Adolfo. **Correggio**. Roma, Stock, 1926.

1853. Venturi, Adolfo, et al. **Manifestazioni parmensi nel IV. centenario della morte del Correggio**. 21 Aprile-28 ottobre XIII (1936). A cura della Federazione dei Fasci di Combattimento di Parma. Parma, Federazione dei Fasci di Combattimento di Parma, 1936.

1854. _____. **Mostra nazionale del Correggio, organizzata per gli auspici della R. Accademia d'Italia dalla Federazione dei Fasci di Combattimento di Parma. . . . maggio-ottobre 1935**. Parma, Crispoli, 1935.

CORTONA, PIETRO DA, 1596-1669

1855. Briganti, Giuliano. **Pietro da Cortona o della pittura barocca.** Firenze, Sansoni, 1962.

1856. Campbell, Malcolm. **Pietro da Cortona at the Pitti Palace, a study of the planetary rooms and related projects.** Princeton, N.J., Princeton University Press, 1977. (Princeton Monographs in Art and Archaeology, 41).

1857. Noehles, Karl. **La chiesa dei SS. Luca e Martina nell'opera di Pietro da Cortona, con contributi di G. Incisa della Rocchetta e Carlo Pietrangeli, presentazione di Mino Maccari.** Roma, Bozzi, 1970. (Saggi e studi di storia dell'arte, 3).

CORTONA, URBANO DA see URBANO DA CORTONA

COSINDAS, MARIE, 1925-

1858. Cosindas, Marie. **Marie Cosindas, color photographs.** With an essay by Tom Wolfe. Boston, New York Graphic Society, 1978.

1859. Museum of Modern Art (New York). **Marie Cosindas, Polaroid color photographs.** [April 12-July 4, 1966]. New York, [Museum of Modern Art], 1966.

COSSA, FRANCESCO DEL, 1435-1477

1860. Ortolani, Sergio. **Cosmè Tura, Francesco del Cossa, Ercole de'Roberti.** Milano, Hoepli, [1941].

1861. Ruhmer, Eberhard. **Francesco del Cossa.** Mit vollständigem Werkverzeichnis. München, Bruckmann, 1959. (CR).

1862. Scassellati-Riccardi, Vincenza. **Francesco del Cossa.** Milano, Fabbri, 1957. (I maestri del colore, 110).

COSWAY, RICHARD, 1742-1821

1863. Danniell, Frederick B. **A catalogue raisonné of the engraved works by Richard Cosway, R. A., with a memoir of Cosway by Sir Philip Currie.** London, Daniell, 1890. (CR).

1864. Williamson, George C. **Richard Cosway, R. A., and his wife and pupils.** London, Bell, 1897.

COTES, FRANCIS, 1726-1770

1865. Johnson, Edward M. **Francis Cotes: complete edition with a critical essay and a catalogue.** Oxford, Phaidon, 1976.

COTMAN, JOHN JOSEPH, 1814-1878

JOHN SELL, 1782-1842

MILES EDMUND, 1811-1858

1866. Binyon, Laurence. **John Crome and John Sell Cotman.** London, Seely/New York, Macmillan, 1897. (The Portfolio Artistic Monographs, 32).

1867. Holcomb, Adele M. **John Sell Cotman.** London, British Museum Publications, 1978.

1868. Kitson, Sydney D. **The life of John Sell Cotman.** London, Faber & Faber, 1937.

1869. Rajnai, Miklos. **John Sell Cotman: drawings of Normandy in Norwich Castle Museum,** by M. Rajnai; assisted by Marjorie Allthorpe-Guyton. Norwich, Norfolk Museums Service, 1975.

1870. _____. **John Sell Cotman, 1782-1842: early drawings (1798-1812) in Norwich Castle Museum.** By M. Rajnai assisted by Marjorie Allthorpe-Guyton. Norwich, Norfolk Museums Service, 1979.

1871. Rienaecker, Victor G. R. **John Sell Cotman, 1782-1842.** Leigh-on-Sea, Lewis, 1953.

1872. Tate Gallery (London). **Exhibition of works by John Sell Cotman, and some related painters of the Norwich School: Miles Edmund Cotman, John Joseph Cotman, John Thirtle.** April 7-July 3, 1922. London, National Gallery, 1922.

1873. Turner, Dawson. **Architectural antiquities of Normandy,** by John Sell Cotman; accompanied by historical and descriptive notices by Dawson Turner. 2 v. London, Arel, 1822.

COURBET, GUSTAVE, 1819-1877

1874. Aragon, Louis. **L'exemple de Courbet.** Paris, Editions Cercle d'art, 1952.

1875. Bénédite, Léonce. **Gustave Courbet,** with notes by J. Laran and Ph. Baston-Dreyfus. Philadelphia, Lippincott, 1913.

1876. Boas, George. **Courbet and the naturalistic movement.** New York, Russell, 1938.

1877. Bonniot, Roger. **Gustave Courbet en Saintonge, 1862-1863.** Préf. de Yves Brayer. Paris, Klincksieck, 1973.

1878. Borel, Pierre. **Le roman de Gustave Courbet d'après une correspondance originale du grand peintre.** Préf. de C. Mauclair. Paris, Chiberre, 1922.

1879. Boudaille, Georges. **Gustave Courbet, painter in protest.** Trans. by Michael Bullock. Greenwich, Conn., New York Graphic Society, 1969.

1880. Bowness, Alan. **Courbet's L'Atelier du Peintre.** Newcastle upon Tyne, University of Newcastle, 1972. (Charlton Lectures on Art, 50).

1881. Castagnary, Jules A. **Gustave Courbet et la colonne Vendome; plaidoyer pour un ami mort.** Paris, Dentu, 1883.

1882. Clark, Timothy J. **Image of the people; Gustave Courbet and the second French Republic, 1848-1851.** Greenwich, Conn., New York Graphic Society, 1973.

1883. Courbet, Gustave. **Courbet in perspective.** Edited by Petra ten-Doesschate-Chu. Englewood Cliffs, N.J., Prentice-Hall, 1977.

1884. _____. **Courbet, raconté par lui-même et par ses amis; sa vie et ses oeuvres.** Genève, Cailler, 1948. (Collection les grands artistes vus par eux-mêmes et par leurs amis, 7).

1885. _____. **Lettres de Gustave Courbet à Alfred Bruyas.** Publiées par P. Borel. Genève, Cailler, 1951. (Collection écrits et documents de peintres, 8).

1886. Courthion, Pierre. **Courbet.** Paris, Floury, 1931.

1887. Duret, Théodore. **Courbet.** Paris, Bernheim, 1918.

1888. Estignard, Alexandre. **Courbet: sa vie, ses oeuvres.** Besançon, Delagrange-Louys, 1896.

1889. Fermigier, André. **Courbet; étude biographique et critique.** Genève, Skira, 1971.

1890. Fernier, Robert. **Gustave Courbet, peintre de l'art vivant.** Préface de René Huyghe. Paris, Bibliothèque des arts, 1969.

1891. _____. **La vie et l'oeuvre de Gustave Courbet: catalogue raisonné.** 2 v. Lausanne, Bibliothèque des Arts, 1977-1978. (CR).

1892. Foucart, Bruno. **G. Courbet.** Trans. by Alice Sachs. New York, Crown, 1977.

1893. Galerie Claude Aubry (Paris). **Courbet dans les collections privées françaises.** Exposition organisée au profit du Musée Courbet, 5 mai-25 juin 1966. Paris, Galerie C. Aubry, 1966.

1894. Grand Palais (Paris). **Gustave Courbet: 1819-1877.** 30 sept. 1977-6 jan. 1978. Catalogue par Hélène Toussaint. Paris, Ministère de la culture et de l'environment, Editions des Musées Nationaux, 1977.

1895. Hamburger Kunsthalle. **Courbet und Deutschland.** 19. Oktober-17 Dezember 1978. [Edited by Werner Hoffman and Klaus Herding]. Köln, DuMont, 1978.

1896. Léger, Charles. **Courbet.** Paris, Crès, 1929.

1897. _____. **Courbet et son temps; lettres et documents inédits.** Paris, Editions universelles, 1948.

1898. Lindsay, Jack. **Gustave Courbet; his life and art.** Bath, Adams and Dart. Distributed by Jupiter Books, London, 1973.

1899. Mack, Gerstle. **Gustave Courbet.** New York, Knopf, 1951.

1900. Meier-Graefe, Julius. **Corot und Courbet.** München, Piper, 1912.

1901. _____. **Courbet.** München, Piper, 1921.

1902. Musée Gustave Courbet (Ornans). **Hommage à Courbet: catalogue de l'exposition organisée à l'occasion du centenaire de la mort du maître-peintre.** 2 juillet-16 octobre 1977. Paris, Les amis de Gustave Courbet, 1977.

1903. Nochlin, Linda. **Gustave Courbet: a study of style and society.** New York, Garland, 1976.

1904. Philadelphia Museum of Art. **Gustave Courbet, 1819-1877.** Philadelphia Museum of Art, Dec. 17, 1959-Feb. 14, 1960; Museum of Fine Arts, Boston, Feb. 26-Apr. 14, 1960. Boston, Museum of Fine Arts, 1960.

1905. Riat, Georges. **Gustave Courbet, peintre.** Paris, Floury, 1906.

1906. Zahar, Marcel. **Courbet.** Genève, Cailler, 1952. (Collection Les problèmes de l'art, 2).

COUSIN, JEAN (the elder), ca. 1490-1560/61

JEAN (the younger), ca. 1522-ca. 1594

1907. Cousin, Jean (the elder). **Livre de perspective de Iehan Cousin senonois, maistre painctre à Paris.** Paris, Le Royer, 1560.

1908. Cousin, Jean (the younger). **The book of fortune; two hundred unpublished drawings.** With introduction and notes by Ludovic Lalanne. Trans. by H. Mainwaring Dunstan. Paris, Librairie de l'art, 1883.

1909. Didot, Ambroise F. **Recueil des oeuvres choisies de Jean Cousin reproduites en facsimile.** Paris, Didot, 1873.

1910. Lobet, Jean. **Quelques preuves sur Jean Cousin, peintre, sculpteur, géomètre et graveur.** Paris, Renouard, 1881.

COUSINS, SAMUEL, 1801-1887

1911. Whitman, Alfred. **Samuel Cousins.** London, Bell, 1904.

COYSEVOX, ANTOINE, 1640-1720

1912. Jouin, Henry. **Antoine Coyzevox, sa vie, son oeuvre et ses contemporains.** Paris, Didier, 1883.

1913. Keller-Dorian, Georges. **Antoine Coysevox (1640-1720); catalogue raisonné de son oeuvre.** Précédé d'une introd. par Paul Vitry. 2 v. Paris, Keller-Dorian, 1920. (CR).

COZENS, ALEXANDER, 1717-1786

JOHN ROBERT, 1752-1797

1914. Bell, C. F. and Girtin, Thomas. **The drawings and sketches of John Robert Cozens; a catalogue with an historical introduction.** Oxford, Johnson, 1935. (Walpole Society, London annual volume, 23 [1934-35]).

1915. Burlington Fine Arts Club. **Exhibition of the Herbert Horne collection of drawings, with special reference to the works of Alexander Cozens, with some decorative furniture and other objects of art.** London, Burlington Fine Arts Club, 1916.

1916. Oppé, Adolf P. **Alexander and John Robert Cozens.** With a reprint of Alexander Cozen's A new method of assisting the invention in drawing original compositions of landscape. London, Black, 1952.

CRAIG, EDWARD GORDON, 1872-1966

1917. Craig, Edward Gordon. **Woodcuts, and some words, by E. G. Craig;** with an introduction by Campbell Dodgson. London/Toronto, Dent, 1924.

1918. Nash, George. **Edward Gordon Craig, 1872-1966.** London, HMSO, 1967. (Victoria and Albert Museum. Large picture book, 35).

CRAM, RALPH ADAMS, 1863-1942

1919. Muccigrosso, Robert. **American Gothic: the mind and art of Ralph Adams Cram.** Washington, D.C., University Press of America, 1980.

1920. Tucci, Douglas S. **Ralph Adams Cram, American medievalist.** Catalogue of an exhibition. Boston, Boston Public Library, 1975.

CRANACH, LUCAS (the elder), 1472-1553

LUCAS (the younger), 1515-1586

1921. Coburger Landesstiftung. **Lucas Cranach d. Ae. 1472-1553.** Aus dem Kupferstichkabinett der Kunstsammlungen der Veste Coburg. [Ausstellung] anlässlich der 500. Wiederkehr des Geburtstages von Lucas Cranach d. Ae. 16. Juli-30 Sept. 1972. Coburg, Kunstsammlungen der Veste Coburg, 1972.

1922. Friedländer, Max J. and Rosenberg, Jakob. **The paintings of Lucas Cranach.** Catalogue trans. by Heinz Norden; introd. trans. by Ronald Taylor. Ithaca, N.Y., Cornell University Press, 1978. Rev. and enlarged ed. (Original publ.: Berlin, Deutscher Verein für Kunstwissenschaft, 1932).

1923. Glaser, Curt. **Lukas Cranach.** Leipzig, Insel, 1923.

1924. Grote, Ludwig. **Lucas Cranach, der Maler der Reformation; eine biographische Skizze.** Dresden, Naumann, 1883.

1925. Heyck, Eduard. **Lukas Cranach.** Bielefeld/Leipzig, Velhagen & Klasing, 1927. 2 ed. (Künstler-Monographien, 95).

1926. Jahn, Johannes. **Lucas Cranach als Graphiker.** Leipzig, Seemann, 1955.

1927. Koepplin, Dieter and Falk, Tilman. **Lukas Cranach.** Ausstellung in Kunstmuseum, Basel, 15. Juni-8 September 1974. 2 v. Basel, Birkhäuser, 1974-1976.

1928. Kunsthistorisches Museum (Wien). **Lucas Cranach der Ältere und seine Werkstatt.** Jubiläumsausstellung museumseigener Werke, 1472-1972. Wien, Kunsthistorisches Museum, 1972.

1929. Lilienfein, Heinrich. **Lukas Cranach und seine Zeit.** Bielefeld/Leipzig, Velhagen & Klasing, 1942.

1930. Lüdecke, Heinz. **Lucas Cranach der Ältere; der Künstler und seine Zeit.** Berlin, Henschel, 1953.

1931. _____. **Lucas Cranach der Ältere im Spiegel seiner Zeit, aus Urkunden, Chroniken, Briefen, Reden und Gedichten.** Berlin, Rütten & Loening, 1953.

1932. Posse, Hans. **Lucas Cranach.** Wien, Schroll, 1942.

1933. Schade, Werner. **Cranach, a family of painters.** Trans. by Helen Sebba. New York, Putnam, 1980.

1934. Schlossmuseum Weimar. **Lucas Cranach, 1472-1553; ein grosser Maler in bewegter Zeit.** Ausstellung zu seinem 500. Geburtstag, 22. Juni-15. Oktober 1972. Redaktion: Gerhard Pommeranz-Liedke. Weimar, Kunstsammlungen, 1972.

1935. Schuchardt, Christian. **Lucas Cranach des Aelteren: Leben und Werke.** 3 v. Leipzig, Brockhaus, 1851-71.

1936. Schwarz, Herbert. **Lucas Cranach der Ältere: Führer durch Leben und Werk.** Kronach, Link, 1972.

1937. Thöne, Friedrich. **Lukas Cranach des Älteren Meisterzeichnungen.** Burg, Hopfer, 1939.

1938. Thulin, Oskar. **Cranach-Altäre der Reformation.** Berlin, Evangelische Verlagsanstalt, 1955.

CRANE, WALTER, 1845-1915

1939. Konody, Paul G. **The art of Walter Crane.** London, Bell, 1902.

1940. Massé, Gertrude C. E. **A bibliography of first editions of books illustrated by Walter Crane.** With a preface by Heyward Sumner. London, Chelsea Publ. Co., 1923.

1941. Schleinitz, Otto J. W. von. **Walter Crane.** Bielefeld/Leipzig, Velhagen & Klasing, 1902. (Künstler-Monographien, 62).

1942. Spencer, Isobel. **Walter Crane.** New York, Macmillan, 1975.

CRAYER, GASPAR DE, 1584-1669

1943. Vlieghe, Hans. **Gaspar de Crayer, sa vie et ses oeuvres.** 2 v. Bruxelles, Arcade, 1972.

CREDI, LORENZO DI see LORENZO DI CREDI

CRIPPA, ROBERTO, 1921-1972

1944. Crippa, Roberto. **Crippa.** Prefazione di Giampiero Giani. Venezia, Edizioni del Cavallino, 1954.

1945. Giani, Giampiero. **Crippa.** Venezia, Edizioni del Cavallino, 1956.

1946. Jouffroy, Alain. **Crippa.** Milano, Schwarz Galleria d'Arte, 1962.

1947. Palazzo Reale (Milan). **Roberto Crippa.** Novembre-dicembre 1971. Milano, Arti Grafiche Fiorin, 1971.

CRISTUS (Christus), PETRUS, 1420-1472/73

1948. Panhans Bühler, Ursula. **Eklektizismus und Originalität im Werk des Petrus Christus.** Wien, Holzhausens Nfg., 1978.

1949. Schabracker, Peter H. **Petrus Christus.** Utrecht, Dekker & Gumbert, 1974.

CRIVELLI, CARLO, 1430-1493

 TADDEO, fl. 1452-1476

 VITTORE, 1440-1502

1950. Bertoni, Giulio. **Il maggior miniatore della bibbia di Borso d'Este, Taddeo Crivelli.** Modena, Oriandini, 1925.

1951. Crivelli, Carlo. **L'opera completa del Crivelli,** introdotta e coordinata de Anna Bovero. Milano, Rizzoli, 1975. (Classici dell'arte, 80).

1952. _____. **Tutta la pittura del Crivelli.** A cura d'Anna Bovero. Milano, Rizzoli, 1961. (Biblioteca d'arte Rizzoli, 44-45).

1953. Davies, Martin. **Carlo Crivelli.** London, National Gallery, 1972. (Themes and painters in the National Gallery, 4).

1954. Di Provvido, Sandra. **La pittura di Vittore Crivelli.** L'Aquila, Japadre, 1972.

1955. Drey, Franz. **Carlo Crivelli und seine Schule.** München, Bruckmann, 1927.

1956. Palazzo Ducale (Venice). **Carlo Crivelli e i Crivelleschi.** Catalogo della mostra a cura di Pietro Zampetti, 10 giugno-10 ottobre 1961. Venezia, Alfieri, 1961.

1957. Rushforth, Gordon M. **Carlo Crivelli.** London, Bell, 1900.

1958. Zampetti, Pietro. **Carlo Crivelli.** Milano, Martello, 1961.

CROME, JOHN, 1768-1821

1959. Baker, Charles H. **Crome.** With an introduction by C. J. Holmes. London, Methuen, 1921.

1960. Binyon, Laurence. **John Crome and John Sell Cotman.** London, Seeley/New York, Macmillan, 1897. (The Portfolio Artistic Monographs, 32).

1961. Clifford, Derek P. and Clifford, Timothy. **John Crome.** London, Faber, 1968.

1962. Mallalieu, Huon. **The Norwich school: Crome, Cotman and Their Followers.** London, Academy Eds./New York, St. Martin's, 1974.

1963. Mottram, Ralph H. **John Crome of Norwich.** London, Lane, 1931.

1964. Norwich Castle Museum. **John Crome, 1768-1821; an exhibition of paintings and drawings organized by the Arts Council to mark the bicentenary of the artist's birth.** 3 August-29 September, 1968. London, Arts Council, 1968.

1965. Smith, Solomon C. K. **Crome, with a note on the Norwich school.** With an introduction by C. H. Collins Baker. London, Allan, 1923.

CROSS, HENRI EDMOND, 1856-1910

1966. Compin, Isabelle. **H. E. Cross.** Préf. de Bernard Dorival. Paris, Quatre Chemins-Editart, 1964.

1967. Rewald, John. **Henri-Edmond Cross; carnet de dessins.** 2 v. Paris, Berggruen, 1959.

CRUIKSHANK, GEORGE, 1792-1878

1968. Buchanan-Brown, John. **The book illustrations of George Cruikshank.** North Pomfret, Vt., David & Charles, 1980.

1969. Chesson, Wilfrid H. **George Cruikshank.** London, Duckworth/New York, Dutton, 1908.

1970. Cohn, Albert Mayer. **A biographical catalogue of the printed works illustrated by George Cruikshank.** London/New York, Longmans, Green, 1914.

1971. Evans, Hilary and Evans, Mary. **The life and art of George Cruikshank, 1792-1878; the man who drew the Drunkard's Daughter.** Chatham, N.Y., Phillips, 1978.

1972. Gough, John B. **The works of George Cruikshank in oil, watercolors, original drawings, etchings, woodcuts, lithographs, and glypographs, collected by J. Gough.** Boston, The Club of Odd Volumes, 1890.

1973. Hamilton, Walter. **A memoir of George Cruikshank, artist and humorist.** London, Stock, 1878.

1974. Jerrold, Blanchard. **The life of George Cruikshank in two epochs.** London, Chatto and Windus, 1898. 2 ed.

1975. McLean, Ruari. **George Cruikshank, his life and work as a book illustrator.** New York, Pellegrini & Cudahy, 1948.

1976. Rosenbach, A. S. W. **A catalogue of the works illustrated by George Cruikshank and Isaac and Robert Cruikshank in the Library of Harry Elkins Widener.** Philadelphia, Rosenbach, 1918.

1977. Speed Art Museum (Louisville, Ky.). **The inimitable George Cruikshank: an exhibition of illustrated books, prints, drawings and manuscripts from the collection of David Borowitz.** Oct. 12-Nov. 15, 1968. Louisville, Ky., Univ. of Louisville Libraries, 1968.

1978. Stephens, Frederick G. **A memoir of George Cruikshank by F. G. Stephens; and an essay on the genius of George Cruikshank by William Makepeace Thackeray.** London, Sampson Low, 1891.

1979. Wardroper, John. **The caricatures of George Cruikshank.** London, Gordon Fraser Gallery, 1977.

1980. Wynn Jones, Michael. **George Cruikshank: his life and London.** London, Macmillan, 1978.

CUNNINGHAM, IMOGEN, 1883-1976

1981. Cunningham, Imogen. **After Ninety.** Introd. by Margaretta Mitchell. Seattle/London, University of Washington Press, 1977.

1982. _____. **Photographs.** Introd. by Margery Mann. Seattle, University of Washington Press, 1971.

1983. Dater, Judy. **Imogen Cunningham, a portrait.** Boston, New York Graphic Society, 1979.

1984. Henry Art Gallery (Seattle). **Imogen! Imogen Cunningham; photographs, 1910-1973.** Introd. by Margery Mann. [March 23-April 21, 1974]. Seattle, Henry Art Gallery, 1974.

CURRY, JOHN STEUART, 1897-1946

1985. Cole, Sylvan. **The lithographs of John Steuart Curry: a catalogue raisonné.** Compiled and edited by S. Cole; introd. by Laurence Schmeckebier. New York, Associated American Artists, 1976. (CR).

1986. Curry, John Steuart. **John Steuart Curry.** New York, American Artists Group, 1945. (American Artists Group Monograph, 14).

1987. Czestochowski, Joseph H. **John Steuart Curry and Grant Wood: a portrait of rural America.** Columbia, Mo./ London, University of Missouri Press, 1981.

1988. Schmeckebier, Laurence E. **John Steuart Curry's pageant of America.** New York, American Artists Group, 1943.

CUVILLIES, FRANÇOIS, 1695-1768

1989. Wolf, Friedrich. **François de Cuvilliés (1695-1768), der Architekt und Dekorschöpfer.** München, Histor. Verein von Oberbayern, 1967. (Oberbayerisches Archiv, 89).

CUYP, AELBERT, 1620-1691

1990. Dordrechts Museum (Dordrecht, Netherlands). **Aelbert Cuyp en zijn familie.** 12 Nov. 1977-8 Jan. 1978. Dordrecht, Dordrechts Museum, 1977.

1991. Reiss, Stephen. **Aelbert Cuyp.** Boston, New York Graphic Society, 1975.

1992. _____. **Albert Cuyp in British Collections.** Catalog of an exhibition held at the National Gallery, London, 3 Jan.-11 Feb. 1973. Colchester, Benham, 1972.

DADD, RICHARD, 1817-1886

1993. Allderidge, Patricia. **The late Richard Dadd, 1817-1886.** London, Tate Gallery, 1974.

DADDI, BERNARDO, 1280-1350

1994. Bacci, Pèleo. **Dipinti inediti e sconosciuti di Pietro Lorenzetti, Bernardo Daddi, etc., in Siena e nel contado.** Con documenti, commenti critici e 70 illustrazioni. Siena, Accademia per le arti e per le lettere, 1939.

1995. Vitzthum von Eckstädt, Georg. **Bernardo Daddi.** Leipzig, Hiersemann, 1903.

DAGOTY, PIERRE EDOUARD, 1775-1871

1996. Du Pasquier, Jacqueline. **Pierre-Edouard Dagoty, 1775-1871 et la miniature bordelaise au XIXe siècle; biographie critique et catalogue raisonné de l'oeuvre.** Préf. de F. G. Pariset. Chartres, Laget, 1974. (CR).

DAGUERRE, LOUIS JACQUES MANDE, 1787-1851

1997. Daguerre, [Louis J. M.]. **Histoire et description des procédés du daguerreotype et du diorama.** Paris, Giroux, 1839. (Reprinted, with an introduction by Beaumont Newhall and with a facsimile of the first English edition published in London by McLean & Nutt in 1839, by Winter House, New York, 1971).

1998. Gernsheim, Helmut and Gernsheim, Alison. **L. J. M. Daguerre, the world's first photographer.** Cleveland, World, 1956.

1999. Hôtel de Malestroit à Bry-sur-Marne. **Hommage à Daguerre, magicien de l'image.** 23 octobre-7 novembre 1976. Bry-sur-Marne, Office culturel de Bry-sur-Marne, 1976.

2000. Mentienne, Adrien. **La découverte de la photographie en 1839.** Paris, Dupont, 1892. (Reprint: New York, Arno, 1979).

DAHL, JOHAN CHRISTIAN CLAUSEN, 1788-1857

2001. Nasjonal galleriet (Oslo). **Dahl's Dresden: utstilling.** [11 October-7 December 1980]. Kat. Pontus Grate redaksjon Magne Malmanger. Oslo, Nasjonalgalleriet, 1980.

2002. _____. **Johan Christian Dahl, tegninger og akvareller.** Innledning av Leif Østby. Oslo, Nasjonalgalleriet og Bergens billedgalleri, 1957.

2003. Venturi, Lionello. **Johan Christian Dahl.** Oslo, Gyldendal, 1957.

DALI, SALVADOR, 1904-

2004. Ades, Dawn. **Dali.** London, Thames and Hudson, 1983.

2005. Bosquet, Alain. **Entretiens avec Salvador Dali.** Paris, Belfond, 1966.

2006. Centre Georges Pompidou (Paris). **Salvador Dali: rétrospective 1920-1980, 18 décembre 1979-14 avril 1980.** Centre Georges Pompidou, Musée national d'art moderne. Catalogue conçu et réalisé par Daniel Abadie. Paris, Centre Georges Pompidou, 1979.

2007. _____. **La vie publique de Salvador Dali.** [Catalogue d'une exposition] publié à l'occasion de la rétrospective Salvador Dali. Catalogue par Daniel Abadie. Documentation par Evelyne Pomey. Paris, Centre Georges Pompidou, 1979.

2008. Dali, Ana Maria. **Salvador Dali vue par sa soeur.** Introd., traduction et notes de Jean Martin. Paris, Arthaud, 1960.

2009. Dali, Salvador. **Diary of a genius.** Trans. by Richard Howard. New York, Doubleday, 1965.

2010. _____. On modern art; the cuckolds of antiquated modern art. Trans. by Haakon M. Chevalier. New York, Dial, 1957.

2011. _____. Oui; méthode paranoïaque-critique, et autres textes. Paris, Denoël-Gonthier, 1971. (Bibliothèque médiations, 88).

2012. _____. The unspeakable confessions of Salvador Dali. Trans. by Harold J. Salemson. New York, Morrow, 1976.

2013. Descharnes, Robert. Salvador Dali. Trans. by Eleanor R. Morse. New York, Abrams, 1976.

2014. _____. The world of Salvador Dali. Trans. by Albert Field. New York, Harper & Row, 1962.

2015. Gaya Nuño, Juan Antonio. Salvador Dali. Barcelona, Omega, 1950.

2016. Gomez de la Serna, Ramón. Dali. Paris, Flammarion, 1979.

2017. Lake, Carlton. In quest of Dali. New York, Putnam, 1969.

2018. Maddox, Conroy. Dali. New York, Crown, 1979.

2019. Morse, Albert Reynolds. Dali: a study of his life and work. Text by A. Reynolds Morse and a special appreciation by Michel Tapié. Greenwich, Conn., New York Graphic Society, 1958.

2020. _____. Salvador Dali; a panorama of his art: ninety-three oils 1917-1970. Written and edited by A. Reynolds Morse. Cleveland, Ohio, Salvador Dali Museum, 1974.

2021. Museum Boymans-Van Beuningen (Rotterdam). Dali, 21 november 1970-10 januari 1971. Exposition Dali, avec la collection de Edward F. W. James. [Samengesteld] door R. Hammacher-Van der Brande en L. Brandt Corstius. Rotterdam, Museum Boymans-Van Beuningen, 1970.

2022. Rey, Henri François. Dali dans son labyrinthe. Paris, Grasset, 1974.

2023. Salvador Dali Museum (Cleveland). Salvador Dali: catalog of a collection; ninety-three oils, 1917-1970. Cleveland, Ohio, 1972.

2024. _____. Salvador Dali, Spanish (1904-). A guide to his works in public museums. Cleveland, The Dali Museum, published for the Reynolds Morse Foundation, 1973.

2025. Soby, James Thrall. Salvador Dali. New York Museum of Modern Art, 1946. Reprinted by Arno Press, New York, 1969.

2026. Staatliche Kunsthalle Baden-Baden. Dali: Gemälde, Zeichnungen, Objekte, Schmuck. Ausstellung Salvador Dali unter Einschluss der Sammlung Edward F. W. James, 29. Jan.-18. April 1971. Baden-Baden, Staatl. Kunsthalle, 1971.

DALOU, AIME JULES, 1838-1902

2027. Caillaux, Henriette. Aimé-Jules Dalou (1838-1902). Paris, Delagrave, 1935.

2028. Delestre, François. Jules Dalou, 1838-1902. Exposition, 9 nov.-18 déc. 1976, Galerie Delestre, Paris. Catalogue rédigé par F. Delestre et Robert Stoppenbach. Paris, Delestre, 1976.

2029. Dreyfous, Maurice. Dalou, sa vie et son oeuvre. Paris, Laurens, 1903.

DANBY, FRANCIS, 1793-1861

2030. Adams, Eric. Francis Danby: varieties of poetic landscape. New Haven, Yale University Press, 1973.

2031. City Art Gallery (Bristol). The Bristol school of artists; Francis Danby and painting in Bristol, 1810-1840. Exhibition, 4 Sept.-10 Nov. 1973. Catalogue by Francis Greenacre. Bristol, City Art Gallery, 1973.

2032. Malins, Edward G. James Smetham and Francis Danby: two 19th century Romantic painters. By E. G. Malins and Morchard Bishop. London, Stevens, 1974.

DANIELL, SAMUEL, 1775-1811

THOMAS, 1749-1840

WILLIAM, 1769-1837

2033. Shellim, Maurice. Oil paintings of India and the East by Thomas Daniell, 1749-1840, and William Daniell, 1769-1837. Foreword by Mildred Archer. London, Inchcape, 1979.

2034. Sutton, Thomas. The Daniells; artists and travellers. London, Bodley Head, 1954.

2035. Victoria Memorial (Calcutta). A descriptive catalogue of Daniells work in the Victoria Memorial (Museum). Calcutta, Victoria Memorial, 1976.

DANNECKER, JOHANN HEINRICH VON, 1758-1841

2036. Spemann, Adolf. Dannecker. Berlin/Stuttgart, Spemann, 1909.

2037. _____. Johann Heinrich Dannecker: das Leben, das Werk, der Mensch. München, Bruckmann, 1958.

DANTAN, JEAN PIERRE, 1800-1869

2038. Hale, Richard W. Dantan, jeune, 1800-1869, and his satirical and other sculpture, especially his Portraits chargés. With Christmas greetings from Richard Walden Hale. Meriden, Conn., Meriden Gravure Co., 1940.

2039. Seligman, Janet. Figures of fun; the caricature-statuettes of Jean-Pierre Dantan. London/New York, Oxford University Press, 1957.

DARLEY, FELIX OCTAVIUS CARR, 1822-1888

2040. Bolton, Theodore. The book illustrations of Felix Octavius Carr Darley. Worcester, Mass., American Antiquarian Society, 1952.

2041. Delaware Art Museum (Wilmington). ". . . . illustrated by Darley," an exhibition of original drawings by the American book illustrator Felix Octavius Carr Darley (1822-1888). May 4-June 18, 1978. Wilmington, Delaware Art Museum, 1978.

2042. King, Ethel M. Darley, the most popular illustrator of his time. Brooklyn, Gaus, 1964.

DA SILVA, MARIE HELENA VIERA see VIERA DA SILVA, MARIE HELENA

DAUBIGNY, CHARLES FRANÇOIS, 1817-1878

 KARL CHARLES PIERRE, 1846-1856

2043. Fidell-Beaufort, Madeleine. Daubigny. [By] M. Fidell-Beaufort [and] Janine Bailly-Herzberg. Textes anglais de Judith Schub. Paris, Geoffroy-Dechaume, 1975.

2044. Hellebranth, Robert. Charles-François Daubigny, 1817-1878. Morges, Matute, 1976.

2045. Henriet, Frédéric. C. Daubigny et son oeuvre gravé, eaux fortes et bois inédits par C. Daubigny, Karl Daubigny, Léon Lhermitte. Paris, Lévy, 1875.

2046. Moreau-Nélaton, Etienne. Daubigny, raconté par lui-même. Paris, Laurens, 1925.

DAUMIER, HONORE VICTORIN, 1788-1856

2047. Adhémar, Jean. Honoré Daumier. London, Zwemmer, 1954.

2048. Alexandre, Arsène. Honoré Daumier, l'homme et l'oeuvre. Paris, Laurens, 1888.

2049. Balzer, Wolfgang. Der junge Daumier und seine Kampfgefährten; politische Karikatur in Frankreich, 1830-1835. Dresden, Verlag der Kunst, 1965.

2050. Baudelaire, Charles. Les dessins de Daumier. Paris, Crès, n.d. (Ars graphica, 2).

2051. Bertels, Kurt. Honoré Daumier als Lithograph. München/Leipzig, Piper, 1908. (Klassische Illustratoren, 4).

2052. Bibliothèque Nationale (Paris). Daumier: lithographies, gravures sur bois, sculptures. Paris, Editions des Bibliothèques Nationales de France, 1934.

2053. _____. Daumier: le peintre graveur. Préface par Julien Cain. Texte par George Duhamel, Claude Roger-Marx et Jean Vallery-Radot. Paris, 1958.

2054. Bouvy, Eugène. Daumier, l'oeuvre gravé du maître. 2 v. Paris, Le Garrec, 1933.

2055. Cary, Elisabeth. Honoré Daumier. New York, Putnam, 1907.

2056. Cassou, Jean. Daumier. Lausanne, Marguerat, 1950.

2057. Champfleury, Jules F. Honoré Daumier. Catalogue de l'oeuvre lithographié et gravé. Paris, Librairie Parisienne, 1878.

2058. Château de Blois (Blois, France). Hommage à Honoré Daumier. Exhibition presented by La Ville de Blois and organized by Roger Passeron. Paris, Presses de A. Lahure, 1968.

2059. Courthion, Pierre. Daumier, raconté par lui-même et par ses amis. Genève, Cailler, 1945.

2060. Daumier, Honoré Victorin. La chasse et la pêche. Préface de Paul Vialac; catalogue et notices de Jacqueline Armingeat. Paris, Editions Vilo, 1975.

2061. _____. Commerces et commerçants. Préface de Jean Fernicot; notices de Jacqueline Perrot. Paris, Editions Vilo, 1979.

2062. _____. Les gens d'affaires (Robert Macaire) par Daumier. Préface, catalogue et notices de Jean Adhémar. Paris, Editions Vilo, 1968.

2063. _____. Les gens de médecine dans l'oeuvre de Daumier. [Texte de Henri] Mondor; catalogue raisonné de Jean Adhémar. Paris, Impr. nationale, A. Sauret, 1960.

2064. _____. Intellectuelles (bas bleus) et femmes socialistes. Préface de Françoise Parturier. Catalogue et notices de Jacqueline Armingeat. Paris, Editions Vilo, 1974.

2065. _____. Locataires et propriétaires. Préface de Paul Guth; catalogue et notices de Jacqueline Armingeat. Paris, Vilo, 1977.

2066. _____. Moeurs conjugales. Préface, catalogue et notices de Philippe Roberts-Jones. Paris, Editions Vilo/Monte Carlo, Sauret, 1967.

2067. _____. Les tracas de Paris. Préface de Pierre Mazars, catalogue et notices de Jacqueline Armingeat. Paris, Editions Vilo, 1978.

2068. _____. Les transports en commun. Préface de Max Gallo. Catalogue et notices de Jacqueline Armingeat. Paris, Editions Vilo, 1976.

2069. Escholier, Raymond. Daumier et son monde. Nancy, Berger-Levrault, 1965.

2070. _____. Daumier, peintre et lithographe. Paris, Floury, 1923.

2071. Fontainas, André. La peinture de Daumier. Paris, Crès, n.d. (Ars graphica, 1).

2072. Fuchs, Eduard. Honoré Daumier; Holzschnitte, 1833-1870. München, Langen, 1918.

2073. _____. Honoré Daumier; Lithographien. 3 v. München, Langen, 1920-1922.

2074. _____. Der Maler Daumier; Nachtrag. München, Langen, 1930.

2075. Galeries Durand-Ruel (Paris). Exposition des peintures et dessins de Honoré Daumier. Paris, 1878.

2076. Gobin, Maurice. Daumier sculpteur, 1808-1879, avec un catalogue raisonné et illustré de l'oeuvre sculpté. Genève, Cailler, 1952. (CR). (Peintures et sculpteurs d'hier et d'aujourd'hui, 27).

2077. Hausenstein, Wilhelm. **Daumier; Zeichnungen.** München, Piper, 1918.

2078. Hazard, Nicolas A. **Catalogue raisonné de l'oeuvre lithographie de Honoré Daumier.** Par N. A. Hazard et Loys Delteil. Orrouy (Oise), Hazard, 1904. (CR).

2079. Kalitina, Nina N. **Onore Dom'e.** Moskva, Iskusstvo, 1955.

2080. Klossowski, Erich. **Honoré Daumier.** München, Piper, 1923. 2 ed.

2081. Larkin, Oliver W. **Daumier, man of his time.** New York, McGraw-Hill, 1966.

2082. Lejeune, Robert. **Honoré Daumier.** Köln, Kiepenheuer & Witsch, 1953.

2083. Los Angeles County Museum of Art. **Daumier in retrospect, 1808-1879.** March 20-June 3, 1979. [Text by Elizabeth Mongan]. Los Angeles, Armand Hammer Foundation, 1979.

2084. Maison, Karl E. **Honoré Daumier; catalogue raisonné of the paintings, watercolours and drawings.** 2 v. Greenwich, Conn., New York Graphic Society, 1968. (CR).

2085. Mandel, Gabriele. **L'opera pittorica completa di Daumier.** Presentazione di Luigi Barzini, apparati critici e filologici di G. Mandel. Milano, Rizzoli, 1971. (Classici dell'arte, 47).

2086. Mondor, Henri. **Doctors and medicine in the works of Daumier.** Notes and catalogue by Jean Adhémar. Pref. by Arthur W. Heintzelman. Trans. by C. de Chabanne. Boston, Boston Book and Art Shop, 1960.

2087. Musée de l'Orangerie (Paris). **Daumier: peintures, aquarelles, dessins.** Préface de Anatole de Monzie, introduction de Claude Roger-Marx. Paris, Musée de l'Orangerie, 1934.

2088. Neue Gesellschaft für Bildende Kunst, Berlin. **Honoré Daumier und die ungelösten Probleme der bürgerlichen Gesellschaft.** Hrsg. zur Ausstellung im Schloss Charlottenburg, Mai-Juni 1974. Berlin, NGBK, 1974.

2089. Passeron, Roger. **Daumier, témoin de son temps.** Paris, Bibliothèque des Arts, 1979.

2090. Rey, Robert. **Honoré Daumier.** Trans. by Norbert Guterman. New York, Abrams, 1966.

2091. Roger-Marx, Claude. **Daumier.** Paris, Plon, 1938.

2092. Rossel, André. **H. Daumier; oeuvres politiques et sociales: lithographies, bois, peintures, sculptures.** Paris, Editions de la Courtille, 1971.

2093. Roy, Claude. **Daumier; étude biographique et critique.** Genève, Skira, 1971. (Le goût de notre temps, 50).

2094. Rümann, Arthur. **Honoré Daumier, sein Holzschnittwerk.** München, Delphin, 1914.

2095. Saint-Guilhelm, F. et Schrenk, Klaus. **Honoré Daumier: l'oeuvre lithographique.** Présentation de F. Saint-Guilhelm et Klaus Schrenk; suivi d'un texte contemporain de l'artiste par Charles Baudelaire. Paris, Hubschmid, 1978.

2096. Vincent, Howard P. **Daumier and his world.** Evanston, Ill., Northwestern University Press, 1968.

2097. Wassermann, Jeanne L. **Daumier sculpture; a critical and comparative study.** By Jeanne L. Wasserman, assisted by Joan M. Lukach and Arthur Beale. Catalog of an exhibition Fogg Art Museum, Harvard University, May 1-June 23, 1969. Greenwich, Conn., distributed by New York Graphic Society, 1969.

DAUZATS, ADRIEN, 1808-1868

2098. Guinard, Paul. **Dauzats et Blanchard, peintres de L'Espagne romantique.** Paris, Presses Universitaires de France, 1967.

DAVID, GERARD, 1460-1523

2099. Bodenhauser-Degener, Eberhard von. **Gerard David und seine Schule.** München, Bruckmann, 1905.

2100. Boon, Karel G. **Gerard David.** Amsterdam, Becht, 1948. (Palet serie, 20).

2101. Musée Communal des Beaux Arts (Bruges). **Gerard David.** 18 June-21 August 1949. Bruxelles, Editions de la Connaissance, 1949.

2102. Weale, William H. J. **Gerard David, painter and illuminator.** London, Seeley/New York, Macmillan, 1895. (The Portfolio Artistic Monographs, 24).

DAVID, JACQUES-LOUIS, 1748-1825

2103. Cantinelli, Richard. **Jacques-Louis David, 1748-1825.** Paris, van Oest, 1930.

2104. David, Jacques Louis Jules. **Le peintre Louis David.** 2 v. Paris, Havard, 1880-82.

2105. Delécluze, Etienne J. **Louis David, son école et son temps.** Souvenirs par M. E. J. Delécluze. Paris, Didier, 1855.

2106. Dowd, David. **Pageant master of the republic: J. L. David and the French revolution.** Lincoln, University of Nebraska Press, 1948. Reprint: Freeport, N.Y., Books for Libraries, 1969.

2107. Herbert, Robert L. **David, Voltaire, Brutus and the French Revolution; an essay in art and politics.** New York, Viking, 1973.

2108. Kuznetsova, Irina A. **Lui David; monograficheskii ocherk.** Moskva, Iskusstvo, 1965.

2109. Maret, Jacques. **David.** Monaco, Documents d'Art, 1943.

2110. Maurois, André. **J.-L. David.** Paris, Dimanche, 1948.

2111. Miette de Villars. **Memoires de David, peintre et deputé à la Convention.** Paris, Chez tous les librairies, 1850.

2112. Musée de l'Orangerie (Paris). **David, exposition en l'honneur du deuxième centenaire de sa naissance.** Exposition, juin-septembre 1948. Préface de René Huyghe. . . . catalogue par Michel Florisoone. Paris, Editions des Musées Nationaux, 1948.

2113. Serullaz, Maurice. **J.-L. David, 1748-1825; quatorze dessins.** Paris, Musées Nationaux, 1939.

2114. Schnapper, Antoine. **David.** New York, Alpine Fine Arts Ltd., 1983.

2115. Thome, Antoine. **Vie de David.** Paris, Marchands de nouveautés, 1826.

2116. Valentiner, Wilhelm R. **Jacques Louis David and the French revolution.** New York, Sherman, 1929.

2117. Verbraeken, René. **Jacques-Louis David jugé par ses contemporains et par la posterité.** Suivi de la liste des tableaux dont l'authenticité est garantie. Avec une bibliographie chronologique. Préface par Louis Hautecoeur. Paris, Laget, 1973. (CR).

2118. Wildenstein, Daniel. **Documents complémentaires au catalogue de l'oeuvre de Louis David par Daniel et Guy Wildenstein.** Paris, Wildenstein, 1973. (CR).

DAVID D'ANGERS, PIERRE-JEAN, 1788-1856

2119. David d'Angers, Pierre-Jean. **Les carnets de David d'Angers.** Publiés pour la première fois intégralement, avec une introduction par André Bruel. 2 v. Paris, Plon, 1958.

2120. _____. **David d'Angers et ses relations littéraires.** Correspondance du maître avec Victor Hugo, Lamartine, Chateaubriand [etc.]. Publiée par Henry Jouin. Paris, Plon, 1890.

2121. _____. Oeuvres complètes de P. J. David d'Angers, statuaire, membre de l'Institut de France, lithographiées par Eugène Marc. 3 v. Paris, 1856.

2122. David d'Angers, Robert. **David d'Angers, un grand statuaire, sa vie, ses oeuvres, par son fils.** Paris, Charavay, Mantons, Martin, 1891.

2123. Jouin, Henri A. **David d'Angers, sa vie, son oeuvre, ses écrits et ses contemporains.** 2 v. Paris, Plon, 1878.

2124. Schazmann, Paul E. **David d'Angers, profils de l'Europe.** Genève, Editions de Bonvent, 1973.

2125. Valotaire, Marcel. **David d'Angers; étude critique.** Paris, Laurens, 1932.

DAVIES, ARTHUR BOWEN, 1862-1928

2126. Ackerman, Martin S. and Ackerman, Diane L., eds. **Arthur B. Davies: essays on his art, with illustrations.** Essays by Dwight Williams and others. New York, Arco, 1974. (Arco collectors' series, 2).

2127. Cortissoz, Royal. **Arthur B. Davies.** New York, Whitney Museum of American Art, 1931.

2128. Metropolitan Museum of Art (New York). **Catalogue of a memorial exhibition of the works of Arthur B. Davies, Feb. 17-March 30, 1930.** New York, Metropolitan Museum of Art, 1930.

2129. Pennsylvania State University, Museum of Art (University Park, Penn.). **Works by Arthur B. Davies from the** collection of Mr. and Mrs. Herbert Brill. Exhibition June 24-Sept. 9, 1979. Catalogue compiled and annotated by John P. Driscoll. University Park, Penn., Pennsylvania State University Museum of Art, 1979.

2130. Phillips Memorial Art Gallery (Washington, D.C.). **Arthur B. Davies; essays on the man and his art.** A symposium. Cambridge, Mass., The Riverside Press, 1924. (The Phillips Publications, 3).

2131. Price, Frederic N. **The etchings and lithographs of Arthur B. Davies.** New York, Kennerley, 1929.

DAVIS, ALEXANDER JACKSON, 1803-1892

2132. Davis, Alexander J., et al. **Rural residences.** New York, New York University, 1837. (Reprint, with an introduction by Jane B. Davies: New York, Da Capo, 1980).

2133. Newton, Roger H. **Town & Davis, architects: pioneers in American revivalist architecture, 1812-1870.** New York, Columbia University Press, 1942.

DAVIS, STUART, 1894-1964

2134. Blesh, Rudi. **Stuart Davis.** New York, Grove Press, 1960. (Evergreen gallery book, 11).

2135. Goossen, E. C. **Stuart Davis.** New York, Braziller, 1959.

2136. Kelder, Diane. **Stuart Davis.** New York, Praeger, 1971.

2137. Lane, John R. **Stuart Davis: art and art theory.** Brooklyn, N.Y., Brooklyn Museum, 1978.

2138. National Collection of Fine Arts (Washington, D.C.). **Stuart Davis memorial exhibition, 1894-1964.** Washington, D.C. Smithsonian Institution Press, 1965. (Smithsonian Publication, 4614).

2139. Sweeney, James J. **Stuart Davis.** New York, Metropolitan Museum of Art, 1945.

DAY, FREDERICK HOLLAND, 1864-1933

2140. Jussim, Estelle. **Slave to beauty: the eccentric life and controversial career of F. Holland Day, photographer, publisher, aesthete.** Boston, Godine, 1981.

2141. Wellesley College Museum (Wellesley, Mass.). **The photographic work of F. Holland Day.** February 21-March 24, 1975. [Introduction and catalogue by Ellen Fritz Clattenberg]. Wellesley, Mass., Wellesley College Museum, 1975.

DAYEZ, GEORGES, 1907-

2142. Duchateau, Jacques. **Dayez.** Paris, Musée de Poche, 1967. (Eng. ed. by George Schwab).

DECAMPS, ALEXANDRE GABRIEL, 1803-1860

2143. Chaumelin, Marius. **Decamps, sa vie, son oeuvre, ses imitateurs.** Marseille, Camoin, 1861.

2144. Clément, Charles. **Decamps.** Paris, Librairie de l'Art, 1887.

2145. Du Colombier, Pierre. **Decamps.** Paris, Rieder, 1928.

2146. Moreau, Adolphe. **Decamps et son oeuvre, avec des gravures en facsimile, des planches originales les plus rares.** Paris, Jouaust, 1869.

2147. Mosby, Dewey F. **Alexandre-Gabriel Decamps, 1803-1860.** 2 v. New York, Garland, 1977.

DEFREGGER, FRANZ VON, 1835-1921

2148. Defregger, Hans P. **Defregger.** Rosenheim, Rosenheimer Verlagshaus, 1983.

2149. Kunstverein München. **Franz von Defregger 1835-1921.** Ehrenausstellung anlässlich seines 100. Geburtstages. München, Kunstverein, 1935.

2150. Rosenberg, Adolf. **Defregger.** Bielefeld/Leipzig, Velhagen & Klasing, 1897. (Künstler-Monographien, 18).

DEGAS, HILAIRE GERMAIN EDGAR, 1834-1917

2151. Adhémar, Jean [and] Cachin, Françoise. **Degas, gravures et monotypes.** Paris, Arts et Métiers Graphiques, 1973.

2152. Boggs, Jean S. **Drawings by Degas.** New York, Abrams, 1967.

2153. _____. **Portraits by Degas.** Berkeley, University of California Press, 1962.

2154. Browse, Lillian. **Degas dancers.** New York, Studio Publications, n.d.

2155. City Art Museum of St. Louis. **Drawings by Degas.** Essay and catalogue of the exhibition, Jan. 20-Feb. 26, 1967, by Jean S. Boggs. St. Louis, City Art Museum, 1967.

2156. Coquiot, Gustave. **Degas.** Paris, Ollendorff, 1924. 2 ed.

2157. Degas, Edgar. **Letters.** Ed. by Marcel Guérin. Oxford, Cassirer, 1947.

2158. Dunlop, Ian. **Degas.** New York, Harper & Row, 1979.

2159. Galerie Georges Petit, Paris. **Ventes atelier Degas.** Catalogue des tableaux, pastels et dessins par Edgar Degas et provenant de son atelier. Ventes I-IV. 4 v. Paris, Petit, 1918-1919.

2160. Hertz, Henri. **Degas; art et esthétique.** Paris, Alcan, 1920.

2161. Jamot, Paul. **Degas.** Paris, Gazette des Beaux-arts, 1931.

2162. Janis, Eugenia P. **Degas monotypes.** Essay, catalogue and checklist [of the exhibition held at the] Fogg Art Museum, Harvard University, April 25-June 14, 1968. Cambridge, Mass., Fogg Art Museum, 1968. (CR).

2163. Lafond, Paul. **Degas.** 2 v. Paris, Floury, 1918-1919.

2164. Lefevre Gallery (London). **The complete sculptures of Degas.** With an introduction by John Rewald. 18 Nov.-21 Dec., 1976. London, Lefevre, 1976.

2165. Lemoisne, Paul A. **Degas et son oeuvre.** 4 v. Paris, Brame, 1947. Supplement. New York, Garland, 1984.

2166. Lévêque, Jean-J. **Edgar Degas.** Paris, Editions Siloé, 1978.

2167. Leymarie, Jean. **Les Degas du Louvre.** Paris, Librairie des Arts Décoratifs, 1947.

2168. Liebermann, Max. **Degas.** Berlin, Cassirer, 1902. 7 ed.

2169. Los Angeles County Museum of Art. **An exhibition of works by Edgar Hilaire Germain Degas, 1834-1917.** March 1958. Los Angeles, Los Angeles County Museum of Art, 1958.

2170. Mauclair, Camille. **Degas.** Paris, Hyperion Press, 1937.

2171. Meier-Graefe, Julius. **Degas; ein Beitrag zur Entwicklungsgeschichte der modernen Malerei.** München, Piper, 1920.

2172. _____. **Degas.** Trans. by J. Holroyd-Reece. London, Benn, 1923.

2173. Millard, Charles W. **The sculpture of Edgar Degas.** Princeton, N.J., Princeton University Press, 1976.

2174. Pečirka, Jaromir. **Edgar Degas: drawings.** London, Nevill, 1963.

2175. Reff, Theodore F. **Degas: the artist's mind.** New York, Metropolitan Museum of Art, 1976.

2176. _____. **The notebooks of Edgar Degas: a catalogue of the thirty-eight notebooks in the Bibliotheque Nationale and other collections.** 2 v. Oxford, Clarendon Press, 1976.

2177. Rewald, John. **Degas: sculpture, the complete works.** Photographed by Leonard von Matt. Trans. from the French by John Coleman and Noel Moneton. London, Thames and Hudson, 1957. (CR).

2178. Rich, Daniel C. **Degas.** New York, Abrams, 1951.

2179. Rivière, Henri. **Les dessins de Degas.** 2 v. Ser. I-II. Paris, Demotte, 1922-1923.

2180. Rouart, Denis. **Degas à la recherche de sa technique.** Paris, Floury, 1945.

2181. _____. **Degas: Collection palettes.** Paris, Braun, 1949.

2182. _____. **Degas dessins.** Paris, Braun, 1949.

2183. Russoli, Franco, e Minervino, Fiorella. **L'opera completa di Degas.** Presentazione di Franco Russoli. Apparati critici e filologici di Fiorella Minervino. Milano, Rizzoli, 1970. (Classici dell'arte, 45). (CR).

2184. Traz, Georges de. **Degas.** Trans. by James Emmons. Geneva, Skira, 1954. (The Taste of Our Time, 5).

2185. Valéry, Paul. **Degas. Danse, dessin.** Paris, Gallimard, 1928.

2186. Vollard, Ambroise. **Degas, an intimate portrait.** Trans. by R. T. Weaver. New York, Greenberg, 1927.

DE KOONING, WILLEM, 1904-

2187. Gaugh, Harry F. **Willem de Kooning.** New York, Abbeville Press, 1983.

2188. Hess, Th. B. **Willem de Kooning.** New York, Braziller, 1959.

2189. _____. **Willem de Kooning.** New York, Museum of Modern Art; distributed by New York Graphic Society, Greenwich, Conn., 1968.

2190. _____. **Willem de Kooning drawings.** London, Secker and Warburg, 1972.

2191. Rosenberg, Harold. **De Kooning.** New York, Abrams, 1974.

2192. Stedelijk Museum (Amsterdam). **Willem de Kooning.** 19. Sept. to 17. Nov. 1968. Amsterdam, Dienst der Gemeentemusea, 1968.

2193. Walker Art Center (Minneapolis). **De Kooning: drawings, sculptures.** An exhibition organized by the Walker Art Center, March 10-April 21, 1974. Text by Philip Larson and Peter Schjeldahl. New York, Dutton, 1974.

DELACROIX, EUGENE, 1798-1863

2194. Badt, Kurt. **Eugène Delacroix drawings.** Oxford, Cassirer, 1946.

2195. Baudelaire, Charles. **Eugène Delacroix, his life and work.** Trans. by J. M. Bernstein. New York, Lear, 1947.

2196. Cassou, Jean. **Delacroix.** Paris, Dimanche, 1947.

2197. Courthion, Pierre. **La vie de Delacroix.** Paris, Gallimard, 1927. 6 ed.

2198. Delacroix, Eugène. **Album de croquis.** Préface et catalogue raisonné par Maurice Sérullaz. 2 v. Paris, Quatre Chemins-Editart, 1961. (CR).

2199. _____. **Correspondance générale d'Eugène Delacroix.** Publiée par André Joubin. 5 v. Paris, Plon, 1936-1938.

2200. _____. **Journal de Eugène Delacroix.** Avec notes par André Joubin. 3 v. Paris, Plon, 1932. (English ed., trans. by Lucy Norton: London, Phaidon, 1952).

2201. _____. **Oeuvres littéraires.** 2 pt. in 1 v. Paris, Crès, 1923. 3 ed.

2202. Escholier, Raymond. **Delacroix, peintre, graveur, écrivain.** 3 v. Paris, Floury, 1926-1929.

2203. Huyghe, René. **Delacroix.** Trans. by Jonathan Griffin. New York, Abrams, 1963.

2204. Johnson, Lee. **Delacroix.** New York, Norton, 1963.

2205. _____. **The paintings of Eugène Delacroix; a critical catalogue, 1816-1831.** 2 v. Oxford, Clarendon Press, 1981. (CR).

2206. Kunstmuseum Bern. **Eugène Delacroix.** 16. Nov. 1963-19. Jan. 1964. Katalog bearbeitet von Felix Baumann und Hugo Wagner. Bern, Kunstmuseum, 1963.

2207. Lavallée, Pierre. **Eugène Delacroix, quatorze dessins.** Paris, Musées Nationaux, 1938.

2208. Moreau-Nélaton, Etienne. **Delacroix, raconté par lui-même; étude biographique d'après ses lettres, son journal.** 2 v. Paris, Laurens, 1916.

2209. Moss, Armand. **Baudelaire et Delacroix.** Paris, Nizet, 1973.

2210. Mras, George P. **Eugène Delacroix's theory of art.** Princeton, N.J., Princeton University Press, 1966.

2211. Musée du Louvre (Paris). **Centenaire d'Eugène Delacroix, 1798-1863.** Exposition, mai-septembre 1963. Paris, Ministère d'Etat Affaires Culturelles, 1963.

2212. Planet, Louis de. **Souvenirs de travaux de peinture avec M. Eugène Delacroix.** Pub. avec une introd. et des notes par André Joubin. Paris, Colin, 1929.

2213. Robaut, Alfred. **L'oeuvre complet de Eugène Delacroix: peintures, dessins, gravures, lithographies.** Paris, Charavay, 1885.

2214. Rossi Bortolatto, Luigina. **L'opera pittorica completa di Delacroix.** Milano, Rizzoli, 1972. (Classici dell'arte, 57).

2215. Rudrauf, Lucien. **Eugène Delacroix et le problème du romantisme artistique.** Paris, Laurens, 1942.

2216. Sérullaz, Maurice. **Eugène Delacroix.** New York, Abrams, 1971.

2217. _____. **Les peintures murales de Delacroix.** Paris, Les Editions du Temps, 1963.

2218. Signac, Paul. **D'Eugène Delacroix au néo-impressionisme.** Paris, Floury, 1939. 4 ed.

2219. Tourneux, Maurice. **Eugène Delacroix; biographie critique.** Paris, Renouard, 1904.

2220. _____. **Eugène Delacroix devant ses contemporains, ses écrits, ses biographies, ses critiques.** Paris, Librairie de l'Art/Jules Rouam, 1886.

2221. Trapp, Frank A. **The attainment of Delacroix.** Baltimore, Johns Hopkins Press, 1970.

DELACROIX, HENRI-EDMOND see CROSS, HENRI-EDMOND

DELAUNAY, ROBERT, 1885-1941

SONIA, 1885-1979

2222. Albright-Knox Art Gallery (Buffalo, New York). **Sonia Delaunay; a retrospective,** Feb. 2-March 16, 1980. Foreword by Robert T. Buck, essays by Sherry A.

Buckberrough; chronology by Susan Krane. Buffalo, New York. Albright-Knox Art Gallery, 1980.

2223. Cohen, Arthur A. **Sonia Delaunay.** New York, Abrams, 1975.

2224. Delaunay, Robert and Delaunay, Sonia. **The new art of color. The writings of Robert and Sonia Delaunay.** Ed. with introd. by Arthur A. Cohen. Trans. by David Shapiro and A. A. Cohen. New York, Viking, 1978.

2225. Delaunay, Sonia. **Nous irons jusqu'au soleil.** Avec la collaboration de Jacques Damase et de Patrick Raynaud. Paris, Laffont, 1978.

2226. Dorival, Bernard. **Robert Delaunay 1885-1941.** Paris/ Bruxelles, Jacques Damase Gallery, 1975.

2227. _____. **Sonia Delaunay, sa vie, son oeuvre 1885-1979. Notes biographiques.** Paris, Jacques Damase Editeur, 1980.

2228. Gilles de la Tourette, F. **Robert Delaunay.** Préf. par Yvon Bizardel. Paris, Massin, 1950.

2229. Hoog, Michel. **Robert Delaunay.** Paris, Flammarion, 1976.

2230. _____. **Robert et Sonia Delaunay: Paris, Musée National d'Art Moderne.** Paris, Editions des Musées Nationaux, 1967. (Inventaire des collections publiques françaises, 15).

2231. Orangerie des Tuileries (Paris). **Robert Delaunay (1885-1941).** 25 mai-30 août 1976. Préf. de Jean Cassou; introduction de Michel Hoog. Paris, Editions des Musées Nationaux, 1976.

DELORME, PHILIBERT, 1512-1570

2232. Blunt, Anthony. **Philibert de l'Orme.** London, Zwemmer, 1958. (Studies in architecture, 1).

2233. Clouzot, Henri. **Philibert de l'Orme.** Paris, Plon-Nourrit, 1910.

2234. Delorme, Philibert. **L'oeuvre de Philibert Delorme, comprenant le premier tome de l'architecture et les nouvelles inventions pour bien bastir et a petitz frais.** Paris, Morel, 1567. (Reprint: Paris, Librairies imprimeries réunies, 1894).

2235. Prévost, Jean. **Philibert Delorme.** Paris, Gallimard, 1948.

2236. Vachon, Marius. **Philibert de l'Orme.** Paris, Librairie de l'Art, 1887.

DELVAUX, LAURENT, 1698-1778

2237. Devigne, Marguerite. **Laurent Delvaux et ses élèves.** Bruxelles/Paris, van Oest, 1928.

2238. Musées Royaux des Beaux-Arts de Belgique (Brussels). **Laurent Delvaux—Jacob de Wit.** Dec. 5, 1968-Jan. 1, 1969. Préf. Ph. Roberts-Jones, introd. H. Pauwels; textes F. Popelier et F. De Wilde. Bruxelles, Musées Royaux des Beaux-Arts de Belgique, 1968.

2239. Willame, Georges. **Laurent Delvaux, 1696-1778.** Bruxelles et Paris, van Oest, 1914.

DELVAUX, PAUL, 1897-

2240. Bock, Paul A. de. **Paul Delvaux: l'homme, le peintre, psychologie d'un art.** Paris, Pauvert/Bruxelles, Laconti, 1967.

2241. Butor, Michel, et al. **Delvaux.** [By] M. Butor, Jean Clair, Suzanne Houbart-Wilkin. Bruxelles, Cosmos, 1975.

2242. Musées Royaux des Beaux-Arts de Belgique (Brussels). **Hommage à Paul Delvaux.** 13 juillet-25 septembre 1977. Bruxelles, Musées Royaux des Beaux Arts, 1977.

2243. Museum Boymans-van Beuningen (Rotterdam). **Paul Delvaux.** 13 apr.-17 juni 1973. Rotterdam, Mus. Boymans-van Beuningen, 1973.

2244. Nadeau, Maurice. **Les dessins de Paul Delvaux.** Paris, Denoël, 1967.

2245. Spaak, Claude. **Paul Delvaux.** Antwerp, De Sikkel, 1948.

2246. Terrasse, Antoine. **Paul Delvaux: la septième face du dé.** Paris, Filipaichi, 1972.

DEMACHY, ROBERT, 1859-1936

2247. Demachy, Robert [and] Puyo, C. **Les procédés d'art en photographie.** Paris, Photo-Club de Paris, 1906. (Reprint: New York, Arno, 1979).

2248. Jay, Bill. **Robert Demachy, 1859-1936; photographs and essays.** London, Academy Editions/New York, St. Martin's, 1974.

DEMARNE, JEAN-LOUIS, 1752-1829

2249. Watelin, Jacques. **Le peintre J.-L. de Marne, 1752-1829.** Paris, Bibliothèque des arts, 1962). (La Bibliothèque des arts, 10).

DEMUTH, CHARLES HENRY, 1883-1935

2250. Eiseman, Alvord L. **Charles Demuth.** New York, Watson-Guptill, 1982.

2251. Farnham, Emily. **Charles Demuth: behind a laughing mask.** Norman, University of Oklahoma Press, 1971.

2252. Gallatin, Albert E. **Charles Demuth.** New York, Rudge, 1927.

2253. Murrell, William. **Charles Demuth.** New York, Macmillan, 1931.

2254. Norton, Thomas E., ed. **Homage to Charles Demuth, still life painter of Lancaster.** Ed. and with an introd. by Thomas E. Norton. Essays by Alvord L. Eiseman, Sherman E. Lee, and Gerald S. Lestz. Valedictory by Marsden Hartley. Ephrata, Penn., Science Press, 1978.

2255. Ritchie, Andrew C. **Charles Demuth.** New York, Metropolitan Museum of Modern Art, 1950.

DENIS, MAURICE, 1870-1943

2256. Denis, Maurice. **Journal.** 3 v. Paris, La Colombe, 1957-1959.

2257. _____. **Théories, 1890-1910. Du symbolisme et de Gauguin; vers un nouvel ordre classique.** Paris, Rouart et Watelin, 1920.

2258. _____. **Nouvelles théories; sur l'art moderne, sur l'art sacré, 1914-1921.** Paris, Rouart et Watelin, 1922.

2259. Fosca, François [pseud., Georges de Traz]. **Maurice Denis.** Paris, Nouvelle Revue Français, 1924. (Les peintres français nouveaux, 17).

2260. Jamot, Paul. **Maurice Denis.** Paris, Plon, 1945.

DERAIN, ANDRE, 1880-1954

2261. Arts Council of Great Britain. **Derain, an exhibition of paintings, drawings, sculpture, and theatre designs** [at The Royal Academy, London]. 30 Sept.-5 Nov., 1967. London, Arts Council, 1967.

2262. Basler, Adolphe. **André Derain.** Paris, Librairie de France, 1929. (Albums d'art Druet, 21).

2263. _____. **Derain.** Paris, Crès, 1931.

2264. Cailler, Pierre. **Catalogue raisonné de l'oeuvre sculpté de André Derain; première partie: l'oeuvre édité.** Aigle, Imprimerie de la Plaine du Rhone, 1965. (CR).

2265. Carra, Carlo. **André Derain.** Roma, Valori Plastici, 1924.

2266. Derain, André. **Lettres à Vlaminck.** Paris, Flammarion, 1955.

2267. Diel, Gaston. **Derain.** Paris, Flammarion, 1964.

2268. Dunoyer de Segonzac, André. **Album André Derain.** Paris, Editions d'Art du Lion, 1961.

2269. Faure, Elie. **A. Derain.** Paris, Crès, 1926.

2270. Grand Palais (Paris). **André Derain.** 15 février-11 avril 1977. Paris, Editions des Musées Nationaux, 1977.

2271. Henry, Daniel [pseud., Daniel H. Kahnweiler]. **André Derain.** Leipzig, Klinkhardt und Biermann, 1920. (Junge Kunst, 15).

2272. Hilaire, Georges. **Derain.** Genève, Cailler, 1959.

2273. Kalitina, Nina N. **André Derain.** Leningrad, Aurora, 1976.

2274. Leymarie, Jean. **André Derain ou le retour à l'ontologie.** Genève, Skira, 1948.

2275. Papazoff, George. **Derain, mon copain.** Paris, SNEV, 1960.

2276. Salmon, André. **André Derain.** Paris, Editions des Chroniques du Jour, 1928.

2277. Sutton, Denys. **André Derain.** London, Phaidon, 1959.

2278. Vaughan, Malcolm. **Derain.** New York, Hyperion Press/ Harper, 1941.

DERUET, CLAUDE, 1588-1660

2279. Fessenden, De Witt H. **The life and works of Claude Deruet, court painter, 1588-1660.** Brooklyn, N.Y., Fessenden, 1952.

DESIDERIO DA SETTIGNANO, 1428-1464

2280. Cardellini, Ida. **Desiderio da Settignano.** Milano, Edizioni di Communità, 1962. (Studi e documenti di storia dell'arte, 3).

2281. Planiscig, Leo. **Desiderio da Settignano.** Wien, Schroll, 1943.

DESMAREES, GEORGE see MAREES, GEORGE DES

DESNOYER, FRANÇOIS, 1894-1972

2282. Bouret, Jean. **Desnoyer: dessins.** Paris, Galerie Guiot, 1944.

2283. Dorival, Bernard. **Desnoyer.** Paris, Braun, 1943.

2284. Galerie Marcel Guiot (Paris). **Desnoyer: Venise.** Oct. 1963. Paris, Guiot, 1963.

2285. Gay, Paul. **Desnoyer.** Saint Jeoire en Faucigny (Hte. Savoie), La Peinture pour Tous, 1951.

2286. Musée Ingres (Montauban). **F. Desnoyer, cinquante ans de peinture.** 26 juin-15 sept. 1968. Catalogue par Duchein et Mathieu Méras. Montauban, Musée Ingres, 1968.

DESPIAU, CHARLES, 1874-1946

2287. Basler, Adolphe. **Despiau.** Paris, Druet, 1927. (Les albums d'art Druet, 9).

2288. Deshairs, Léon. **C. Despiau.** Paris, Crès, 1930.

2289. George, Waldemar. **Despiau.** Amsterdam, De Lange, 1954.

2290. _____. **Despiau vivant, l'homme et l'oeuvre.** London, Dupont, 1947.

2291. Musée Rodin (Paris). **Charles Despiau, sculptures et dessins.** [Catalogue by Claude Roger-Marx]. Paris, Musée Rodin, 1974.

2292. Roger-Marx, Claude. **Charles Despiau.** Paris, Gallimard, 1922. (Les sculpteurs français nouveaux, 1).

DETAILLE, EDOUARD, 1848-1912

2293. Chanlaine, Pierre. **Edouard Detaille.** Paris, Bonne, 1962.

2294. Detaille, Edouard. **Types et uniformes: L'armée française,** par Edouard Detaille; texte par Jules Richard. 2 v. Paris, Boussod, Valadon, 1885-1889.

2295. Humbert, Jean. **Edouard Detaille; l'heroïsme d'un siècle.** Paris, Editions Copernic, 1979.

2296. Vachon, Marius. **Detaille.** Paris, Lahure, 1898.

DEUTSCH, NIKLAUS MANUEL see MANUEL-DEUTSCH, NIKLAUS

DEVERIA, ACHILLE, 1800-1857

EUGENE, 1805-1865

2297. Gauthier, Maximilien. **Achille et Eugène Devéria.** Paris, Floury, 1925.

2298. Musée des Beaux-Arts, Pau (France). **Eugène Devéria (Paris 1805-Pau 1865).** 29 oct.-31 déc. 1965. Pau, Musée des Beaux-Arts, 1965.

DIAZ, DANIEL VAZQUEZ see VAZQUEZ-DIAZ, DANIEL

DIENTZENHOFER, CHRISTOPH, 1655-1722

KILIAN IGNAZ, 1689-1751

WOLFGANG, 1648-1706

2299. Franz, Heinrich G. **Die Kirchenbauten des Christoph Dientzenhofer.** Brünn, Rohrer, 1942. (Beiträge zur Geschichte der Kunst im Sudeten- und Karpathenraum, 5).

2300. Gürth, Alcuin H. **Über Wolfgang Dientzenhofer; Materialen zur Geschichte der oberpfälzischen Barockarchitektur.** Kallmünz, Lassleben, 1959.

2301. Norberg-Schulz, Christian. **Kilian Ignaz Dientzenhofer e il barocco boemo.** Roma, Officina, 1968.

2302. Weigmann, Otto A. **Eine Bamberger Baumeister-Familie um die Wende des 17. Jahrhunderts.** Ein Beitrag zur Geschichte der Dientzenhofer. Strassburg, Heitz, 1902. (Studien zur deutschen Kunstgeschichte, 34).

DIETTERLIN, WENDEL, 1550-1599

2303. Dietterlin, Wendel. **Architectura von Austheilungs Symetria und Proportion der fünff Seulen, und aller daraufs volgender Kunst Arbeit, von Fenstern, Caminen, Thürgerichten, Portalen, Bronnen, und Epitaphien.** Nürnberg, Caymox, 1598. (Repr.: Darmstadt, Wissenschaftliche Buchgesellschaft, 1954; Einführung von

Hans Gerhard Evers; also: New York, Dover, 1968; introd. by Adolf K. Placzek).

2304. Ohnesorge, Karl. **Wendel Dietterlin, Maler von Strassburg; ein Beitrag zur Geschichte der deutschen Kunst in der zweiten Hälfte des sechszehnten Jahrhunderts.** Leipzig, Seemann, 1893. (Beiträge zur Kunstgeschichte, N.F. 21).

DILLIS, CANTIUS, 1779-1856

JOHANN GEORG, 1759-1841

2305. Bayerische Staatsgemäldesammlungen (Munich). **Johann Georg von Dillis, 26. Dezember 1759-28. September 1841: Ausstellung, 15 Dez. 1959-14. Feb. 1960.** München, Prestel, 1959.

2306. Galerie Arnoldi-Livie (Munich). **Johann Georg von Dillis, 1759-1841; Cantius Dillis, 1779-1856.** 40 Aquarelle und Zeichnungen aus e. Privatsammlung. Herbst 1979. München, Galerie Arnoldi-Livie, 1979.

2307. Lessing, Waldemar. **Johann Georg von Dillis als Künstler und Museumsmann, 1759-1841.** München, Bruckmann, 1951.

2308. Messerer, Richard. **Georg von Dillis; Leben und Werk.** München, 1961. (Oberbayerisches Archiv, 84).

DINE, JIM, 1935-

2309. Beal, Graham W., et al. **Jim Dine: five themes.** New York, Abbeville Press, 1984.

2310. Dine, Jim. **Jim Dine designs for A Midsummer Night's Dream.** Selected from the drawings and prints collection of the Museum of Modern Art. Introd. by Virginia Allen. General editor S. Lieberman. New York, Museum of Modern Art, 1968.

2311. Shapiro, David. **Jim Dine. Painting what one is.** New York, Abrams, 1981.

2312. Whitney Museum of American Art (New York). **Jim Dine.** Feb. 27-April 19, 1970. [Text by John Gordon]. New York, Whitney Museum of American Art, 1970.

DINGLINGER, JOHANN MELCHIOR, 1664-1731

2313. Watzdorf, Erna von. **Johann Melchior Dinglinger der Goldschmied des deutschen Barock.** 2 v. Berlin, Mann, 1962.

DIX, OTTO, 1891-1969

2314. Akademie der Künste Berlin. **Otto Dix; Gemälde und Graphik von 1912-1957.** 12. April-31. Mai 1957. Redaktion und Gestaltung [von] Gerhard Pommeranz-Liedke. Berlin, Akademie der Künste, 1957.

2315. Barton, Brigid S. **Otto Dix und die Neue Sachlichkeit, 1918-1925.** Ann Arbor, UMI Research Press, 1981. (Studies in the fine arts. The avant-garde, 11).

2316. Dix, Otto. **Otto Dix im Selbstbildnis.** Mit 126 Abbildungen, 43 Farbreproduktionen und einer Sammlung von Schriften, Briefen und Gesprächen von Dieter Schmidt. Berlin, Henschel, 1978.

2317. Fischer, Lothar. **Otto Dix; ein Malerleben in Deutschland.** Berlin, Nicolai, 1981.

2318. Galerie der Stadt Stuttgart. **Otto Dix, Menschenbilder.** Gemälde, Aquarelle, Gouachen und Zeichnungen. 3 Dez. 1981-31 Jan. 1982. Katalog Eugen Keuerleber; wiss. Mitarbeit Brigitte Reinhardt. Stuttgart, Die Galerie, 1981.

2319. _____. **Otto Dix zum 80. Geburtstag: Gemälde, Aquarelle, Gouachen, Zeichnungen und Radierfolge Der Krieg.** 2. Okt.-28. Nov. 1971. Stuttgart, Die Galerie, 1971.

2320. Kunsthalle zu Kiel. **Otto Dix: Zeichnungen aus dem Nachlass 1911-1942.** 30. März-21. Mai 1980. Katalog von Jens Christian Jensen. Kiel, Kunsthalle und Schleswig-Holsteinischer Kunstverein, 1980.

2321. Löffler, Fritz. **Otto Dix: Leben und Werk.** Dresden, Verlag der Kunst, 1977. 4 ed.

2322. _____. **Otto Dix, 1891-1969: Oeuvre der Gemälde.** Recklinghausen, Bongers, 1981.

2323. McGreevy, Linda F. **The life and works of Otto Dix, a German critical realist.** Ann Arbor, UMI Research Press, 1981. (Studies in the fine arts. The avant-garde, 12).

2324. Schubert, Dietrich. **Otto Dix in Selbstzeugnissen und Bilddokumenten.** Reinbeck, Rowohlt, 1980. (Rowohlts Monographien, 287).

DOBSON, FRANK, 1886-1963

2325. Arts Council of Great Britain. **Frank Dobson, 1886-1963; memorial exhibition [of] sculpture, drawings and designs.** Arts Council Gallery, 22 June-23 July 1966. London, Arts Council, 1966.

2326. Earp, Thomas W. **Frank Dobson, sculptor.** London, Tiranti, 1945.

DOESBURG, THEO VAN, 1883-1931

2327. Baljeu, Joost. **Theo van Doesburg.** New York, Macmillan, 1974.

2328. Doesburg, Theo van. **Grundbegriffe der neuen gestaltenden Kunst.** München, Langen, 1925. (Bauhausbücher, 6).

2329. _____. **Principles of neo-plastic art.** With an introd. by Hans M. Wingler and a postscript by H. L. C. Jaffé. Trans. by Janet Seligman. Greenwich, Conn., New York Graphic Society, 1968.

2330. _____. **Klassiek--barok--modern; lezing.** Antwerpen, De Sikkel, 1920.

2331. _____. **De nieuwe beweging in de schilderkunst.** Delft, Waltman, 1917.

2332. _____. **Scritti di arte e di architettura.** A cura di Sergio Polano. Roma, Officina Edizioni, 1979. (Collana di architettura, 19).

2333. Hedrick, Hannah L. **Theo van Doesburg, propagandist and practitioner of the avant-garde, 1909-1923.** Ann Arbor, UMI Research Press, 1980. (Studies in the fine arts. The avant-garde, 5).

2334. Mansbach, Steven A. **Visions of totality: Laszlo Moholy-Nagy, Theo van Doesburg, and El Lissitzky.** Ann Arbor, UMI Research Press, 1980. (Studies in the fine arts. The avant-garde, 6).

2335. Musée National d'Art Moderne (Paris). **Théo van Doesburg: projets pour l'Aubette.** Centre national d'art et de culture Georges Pompidou, 12 oct.-12 déc. 1979. Paris, Centre Georges Pompidou, 1977.

2336. Stedelijk van Abbemuseum Eindhoven. **Theo van Doesburg 1883-1931.** Eindhoven, van Abbemuseum, 1968.

2337. Weyergraf, Clara. **Piet Mondrian und Theo van Doesburg: Deutung von Werk und Theorie.** München, Fink, 1979.

DOMELA, CESAR, 1900-

2338. Clairet, Alain. **Domela: un catalogue raisonné de l'oeuvre de César Domela-Nieuwenhuis; peintures, reliefs, sculptures.** Traduction anglaise de Madeleine Hage. Paris, Carmen Martinez, 1978. (CR).

2339. Kunsthalle Düsseldorf. **César Domela, Werke 1922-1972.** 12. Okt.-3 Dez. 1972. Bearb. und Gestaltung: Karl-Heinz Hering. Düsseldorf, Kunstverein für die Rheinlande und Westfalen, 1972.

DOMENICHINO (Domenico Zampieri), 1581-1641

2340. Borea, Evelina. **Dominichino.** Milano, Club del libro, 1965. (Collana d'arte del Club del libro, 12).

2341. Pope-Hennessy, John. **The drawings of Domenichino in the collection of His Majesty the King at Windsor Castle.** London, Phaidon, 1948.

2342. Serra, Luigi. **Domenico Zampieri, detto il Domenichino.** Rome, Calzone, 1909.

2343. Spear, Richard E. **Domenichino.** 2 v. New Haven, Yale University Press, 1982.

DONATELLO (Donato di Niccolo di Betto Bardi), 1386-1466

2344. Cecci, Emilio. **Donatello.** Rome, Tumminelli, 1942.

2345. Colasanti, Arduino. **Donatello.** Roma, Valori Plastici, n.d.

2346. _____. **Donatello.** Trans. de Jean Chuzeville. Paris, Crès, 1931.

2347. Convegno Internazionale di Studi sul Rinascimento VIII. **Donatello e il suo tempo.** Atti del convegno 25 sett.-1 ott. 1966, Firenze-Padova. Firenze, Istituto Nazionale di Studi sul Rinascimento, 1968.

2348. Crawford, David A. E. L. (Lord Balcarres). **Donatello.** New York, Scribner, 1903.

2349. Fechheimer, Samuel S. **Donatello und die Reliefkunst; eine kunstwissenschaftliche Studie.** Strassburg, Heitz, 1904. (Zur Kunstgeschichte des Auslandes, 17).

2350. Goldscheider, Ludwig. **Donatello.** London, Phaidon, 1944.

2351. Grassi, Luigi. **All the sculpture of Donatello.** Trans. by Paul Colacicchi. New York, Hawthorn Books, 1964. (The Complete Library of World Art, 23-24).

2352. Hartt, Frederick. **Donatello, prophet of modern vision.** Photographs by David Finn. New York, Abrams, 1973.

2353. Janson, Horst W. **The sculpture of Donatello.** 2 v. Princeton, N.J., Princeton University Press, 1957. (Rev. ed., incorporating the notes of Jenö Lányi, 1963).

2354. Kauffmann, Hans. **Donatello. Eine Einführung in sein Bilden und Denken.** Berlin, Grote, 1935.

2355. Lightbown, Ronald W. **Donatello and Michelozzo: an artistic partnership and its patrons in the early Renaissance.** 2 v. London, Miller, 1980.

2356. Meyer, Alfred G. **Donatello.** Trans. by P. G. Konody. Bielefeld/Leipzig, Velhagen & Klasing, 1904. (Monographs on artists, 8). (Rev., 3 ed., in German, 1926).

2357. Milanesi, Gaetano. **Catalogo delle opere di Donatello e bibliografia degli autori che ne hanno scritto.** Firenze, Tipi dell'arte della stampa, 1887.

2358. Morisani, Ottavio. **Studi su Donatello.** Venezia, Pozza, 1952.

2359. Parronchi, Alessandro. **Donatello e il potere.** Bologna, Cappelli/Firenze, Il Portolano, 1980.

2360. Planiscig, Leo. **Donatello.** Wien, Schroll, 1939. 3 ed.

2361. Poeschke, Joachim. **Donatello, Figur und Quadro.** München, Fink, 1980.

2362. Rosenauer, Artur. **Studien zum frühen Donatello; Skulptur im projektiven Raum der Neuzeit.** Wien, Holzhausen, 1975. (Wiener kunstgeschichtliche Forschungen, 3).

2363. Schottmüller, F. **Donatello: ein Beiträg zum Verständnis seiner künstlerischen Tat.** München, Bruckmann, 1904.

2364. Schubring, Paul. **Donatello; des Meisters Werke.** Stuttgart, Deutsche Verlagsanstalt, 1922. 2 ed.

2365. Semper, Hans. **Donatello. Seine Zeit und Schule; eine Reihenfolge von Abhandlungen. Im Anhange: Das Leben des Donatello von Vasari. Der Tractat des Francesco Bocchi über den S. Georg des Donatello.** Wien, Braumüller, 1875.

2366. _____. **Donatellos Leben und Werke.** Eine Festschrift zum fünfhundertjährigen Jubiläum seiner Geburt in Florenz. Innsbruck, Wagner, 1887.

2367. Wundram, Manfred. **Donatello und Nanni di Banco.** Berlin, de Gruyter, 1969. (Beiträge zur Kunstgeschichte, 3).

DONATO DI NICCOLO DI BETTO BARDI see DONATELLO

DONGEN, KEES VAN, 1877-1968

2368. Chaumeil, Louis. **Van Dongen, l'homme et l'artiste: la vie et l'oeuvre.** Genève, Cailler, 1967.

2369. Courières, Eduard des. **Van Dongen.** Paris, Floury, 1925.

2370. Dongen, Kees van. **La Hollande, les femmes et l'art.** Paris, Flammarion, 1927.

2371. Fierens, Paul. **Van Dongen, l'homme et l'oeuvre.** Paris, Les Ecrivains Réunis, 1929.

2372. Museum Boymans-van Beuningen (Rotterdam). **Tentoonstelling Kees van Dongen, Werken van 1894 tot 1949.** 28 mei-10 juli 1949. Rotterdam, Museum Boymans-van Beuningen, 1949.

2373. _____. **Van Dongen.** 8 dec. 1967-28 jan. 1968. Museum Boymans-van Beuningen, Rotterdam. Rotterdam, Museum Boymans-van Beuningen, 1967.

2374. Musée Cantini (Marseille). **Hommage à van Dongen.** Juin-septembre 1969. Catalogue par Daniele Giraudy, avec le concours de Frédérique Cuchet. Marseille, Presses Municipales, 1969.

2375. Musée de Lyon. **Van Dongen.** Introduction par René Déroudille. Lyon, Musée de Lyon, 1967.

2376. Stedelijk Museum (Amsterdam). **Kees van Dongen tentoonstelling 9 april-8 mei 1927.** Georganiseerd door weekblad Het Leven. Amsterdam, Stedelijk Museum, 1927.

2377. _____. **Van Dongen 1877-1937.** Dec. 1937-jan. 1938. Amsterdam, Stedelijk Museum, 1937.

DONNER, GEORG RAPHAEL, 1693-1741

2378. Blauensteiner, Kurt. **Georg Raphael Donner.** Mit 96 Bildern nach Aufnahmen von Helga Glassner. Wien, Schroll, 1944.

2379. Pigler, Andor. **Georg Raphael Donner.** Leipzig, Epstein, 1929.

2380. Schlager, J. E. **Georg Rafael Donner; ein Beitrag zur österreichischen Kunstgeschichte.** Wien, Kaulfuss-Prandel, 1853.

2381. Schwarz, Michael. **Georg Raphael Donner: Kategorien der Plastik.** München, Fink, 1968.

DORE, GUSTAVE, 1832-1883

2382. Cercle de la Librairie (Paris). **Catalogue de l'exposition de Gustave Doré: catalogue des dessins, aquarelles et estampes exposés dans les salons du Cercle de la Librairie (mars 1885), avec une notice biographique par M. G. Duplessis.** Paris, Cercle de la Librairie, 1885. (Reprint: New York, Garland, 1981.)

2383. Delormé, René. **Gustave Doré; peintre, sculpteur, dessinateur et graveur.** Paris, Librairie d'Art Baschet, 1879.

2384. Doré Gallery (London). **Descriptive catalogue of pictures by Gustave Doré.** London, 1869.

2385. Farner, Konrad. **Gustave Doré, der industrialisierte Romantiker.** 2 v. Dresden, Verlag der Kunst, 1963.

2386. Forberg, Gabriele. **Gustave Doré; das graphische Werk.** Ausgewählt von G. Forberg; nachwort von Günter Metken. 2 v. München, Rogner & Bernhard, 1975.

2387. Gosling, Nigel. **Gustave Doré.** New York, Praeger, 1974.

2388. Hartlaub, Gustav F. **Gustave Doré.** Leipzig, Klinkhardt & Biermann, 1923. (Meister der Graphik, 12).

2389. Jerrold, Blanchard. **Life of Gustave Doré.** London, Allen, 1891. (Reprint: Detroit, Singing Tree Press, 1969).

2390. _____. **London; a pilgrimage.** By Gustave Doré and B. Jerrold. London, Allen, 1872. (Reprint: New York, Blom, 1968).

2391. Leblanc, Henri. **Catalogue de l'oeuvre complet de Gustave Doré; illustrations, peintures, dessins, sculptures, eaux fortes, lithographies.** Paris, Bosse, 1931.

2392. Lehmann-Haupt, Hellmut. **The terrible Gustave Doré.** New York, Marchbanks Press, 1943. (Reprint: Westport, Conn., Greenwood, 1976).

2393. Richardson, Joanna. **Gustave Doré: a biography.** London, Cassell, 1980.

2394. Roosevelt, Blanche [pseud.]. **Life and reminiscences of Gustave Doré; compiled from material supplied by Doré's relations and friends and from personal recollection.** New York, Cassell, 1885.

2395. Rose, Millicent. **Gustave Doré.** London, Pleiades Books, 1946.

2396. Valmy-Baysse, Jean. **Gustave Doré.** Bibliographie et catalogue complet de l'oeuvre par Louis Dézé. Paris, Seheur, 1930.

DOSSI, BATTISTA (Battista de Lutero), d. 1548

DOSSO (Giovanni de Lutero), 1479-1542

2397. Gibbons, Felton L. **Dosso and Battista Dossi, court painters at Ferrara.** Princeton, N.J., Princeton University Press, 1968. (Princeton Monographs in Art and Archaeology, 39).

2398. Mendelsohn, Henriette. **Das Werk der Dossi.** München, Müller & Rentsch, 1914.

2399. Mezzetti, Amalia. **Il Dosso e Battista, Ferranesi.** Milano, Silvana, 1965.

2400. Zwanziger, Walter C. **Dosso Dossi, mit besonderer Berücksichtigung seines künstlerischen Verhältnisses zu seinem Bruder Battista.** Leipzig, Klinkhardt und Biermann, 1911.

DOU, GERARD, 1613-1675

2401. Martin, Wilhelm. **Gerard Dou; des Meisters Gemälde in 247 Abbildungen.** Stuttgart/Berlin, Deutsche Verlagsanstalt, 1913. (Klassiker der Kunst in Gesamtausgaben, 24).

2402. _____. **Gerard Dou.** Trans. by Clara Bell. London, Bell, 1902.

2403. _____. **Het leven en de werken van Gerrit Dou, beschouwd in Verband met het schildersleven van zijn tijd.** Leiden, van Doesburgh, 1901.

DOVE, ARTHUR GARFIELD, 1880-1946

2404. Newman, Sasha M. **Arthur Dove and Duncan Phillips, artist and patron.** Foreword by Laughlin Phillips; exhibition history and reviews [by] Jan Lancaster. Washington, D.C., Phillips Collection/New York, Braziller, 1981.

2405. Wight, Frederick S. **Arthur G. Dove.** Berkeley, University of California Press, 1958.

2406. Worcester Art Museum (Worcester, Mass.). **Paintings and water colors by Arthur G. Dove lent by the William H. Lane Foundation.** 17 July-17 Sept. 1961. Text by Daniel C. Rich. Worcester, Mass., Worcester Art Museum, 1961.

DUBUFFET, JEAN, 1901-

2407. Akademie der Künste (Berlin). **Dubuffet Retrospektive.** 7. Sept.-26. Okt. 1980. Berlin, Akademie der Kunst, 1980. (Akademie-Katalog, 130).

2408. Barilli, Renato. **Dubuffet, le cycle de l'Hourloupe.** Paris, Éditions du Chêne, 1976.

2409. Cordier, Daniel. **The drawings of Jean Dubuffet.** Trans. by Cecily Mackworth. New York, Braziller, 1980.

2410. Fitzsimmons, James. **Jean Dubuffet, brève introduction à son oeuvre.** Bruxelles, Éditions de la Connaissance, 1958.

2411. Franzke, Andreas. **Dubuffet.** Trans. by Robert E. Wolf. New York, Abrams, 1981.

2412. _____. **Dubuffet Zeichnungen.** München, Rogner und Bernhard, 1980.

2413. Gagnon, François. **Jean Dubuffet: aux sources de la figuration humaine.** Montréal, Les Presses de l'Université de Montreal, 1972.

2414. Loreau, Max. **Dubuffet et le voyage au centre de la perception.** Paris, La Jeune Parque, 1966.

2415. _____. **Dubuffet. Catalogue des travaux.** V. 1-(33). Paris, Pauvert, 1964- . (CR).

2416. _____. **Jean Dubuffet; délits, déportements, lieux de haut jeu.** Paris, Weber, 1971.

2417. _____. **Jean Dubuffet: stratégie de la création.** Paris, Gallimard, 1973.

2418. Musée des Arts Décoratifs (Paris). **Jean Dubuffet, 1942-1960.** [16 déc. 1960-25 fév. 1961]. Palais du Louvre, Pavillon de Marsan. Catalogue rédigé par François Mathey. Paris, Musée des Arts Décoratifs, 1960.

2419. Picon, Gaëtan. **Le travail de Jean Buffet.** Genève, Skira, 1973.

2420. Selz, Peter. **The work of Jean Dubuffet.** New York, Museum of Modern Art, 1962; distributed by Doubleday, New York.

2421. Trucchi, Lorenza. **Jean Dubuffet.** Roma, de Luca, 1965.

DUCCIO, AGOSTINO DI see AGOSTINO DI DUCCIO

DU CERCEAU, JACQUES ANDROUET, c. 1515-1585

2422. Chevalley, Denis A. **Der grosse Tuilerienentwurf in der Überlieferung du Cerceaus.** Bern, Lang, 1973. (Kieler kunsthistoriche Studien, 3).

2423. Du Cerceau, Jacques A. **Les plus excellents bastiments de France.** Paris, Du Cerceau, 1576-79. (New ed., revised: Paris, Levy, 1868-70. 2 v.).

2424. Geymüller, Henry de. **Les du Cerceau; leur vie et leur oeuvre.** Paris, Rouam/London, Wood, 1887.

2425. Ward, W. H. **French chateaux and gardens in the XVIth century; a series of reproductions of contemporary drawings hitherto unpublished by Jacques Androuet du Cerceau, selected and described with an account of the artist and his works.** London, Batsford, 1909.

DUCCIO DI BUONINSEGNA, ca. 1255-1319

2426. Baccheschi, Edi. **L'opera completa di Duccio.** Presentazione di Giulio Cataneo. Milano, Rizzoli, 1972.

2427. Brandi, Cesare. **Duccio.** Firenze, Vallecchi, 1951.

2428. Carli, Enzo. **Duccio di Buoninsegna.** Milano, Electa, 1959.

2429. Stubblebine, James H. **Duccio di Buoninsegna and his school.** Princeton, N.J., Princeton University Press, 1979.

2430. Weigelt, Curt H. **Duccio di Buoninsegna; Studien zur Geschichte der frühsienesischen Tafelmalerei.** Leipzig, Hiersemann, 1911. (Kunstgeschichtliche Monographien, 15).

2431. White, John. **Duccio: Tuscan art and the medieval workshop.** London, Thames and Hudson, 1979.

DUCHAMP, GASTON see VILLON, JACQUES

DUCHAMP, MARCEL, 1887-1968

 SUZANNE, 1889-1963

DUCHAMP-VILLON, RAYMOND, 1876-1918

2432. Agee, William C. **Raymond Duchamp-Villon, 1876-1918.** Introd. by George Heard Hamilton. New York, Walker, 1967.

2433. Cabanne, Pierre. **The brothers Duchamp: Jacques Villon, Raymond Duchamp-Villon, Marcel Duchamp.** Boston, New York Graphic Society, 1976.

2434. _____. **Dialogues with Marcel Duchamp.** Trans. by Ron Padgett. New York, Viking, 1971.

2435. _____. **Ingénieur du temps perdu: entretiens avec Pierre Cabanne.** Paris, Belfond, 1977.

2436. Clair, Jean. **Duchamp et la photographie: essai d'analyse d'un primat technique sur le développement d'une oeuvre.** Paris, Chêne, 1977.

2437. _____. **Marcel Duchamp: abécédaire; approches critiques.** Réalisé sous la direction de Jean Clair avec la collaboration de Ulf Linde. Paris, Musée National d'Art Moderne, Centre National d'Art et de Culture Georges Pompidou, 1977. (Série des catalogues, No. 8, t. 3).

2438. _____. **Marcel Duchamp: catalogue raisonné.** Paris, Centre National d'Art et de Culture Georges Pompidou, Musée d'Art Moderne, 1977. (Série des catalogues, No. 8, t. 2). (CR).

2439. _____. **Marcel Duchamp ou le grand fictif. Essai de mythanalyse du grand verre.** Paris, Editions Galilée, 1975.

2440. Duchamp, Marcel. **The bride stripped bare by her bachelors, even; a typographic version by Richard Hamilton of Marcel Duchamp's Green box.** Trans. by George Heard Hamilton. New York, Wittenborn, 1960. (The Documents of Modern Art, 14).

2441. _____. **From the green box.** Trans. and with a pref. by George Heard Hamilton. New Haven, Readymade Press, 1957.

2442. _____. **Notes and projects for the Large Glass.** Selected, ordered and with an introduction by Arturo Schwarz. New York, Abrams, 1969.

2443. _____. **Salt seller; the writings of Marcel Duchamp.** Ed. by Michel Sanouillet and Elmer Peterson. New York, Oxford University Press, 1973.

2444. Duchamp-Villon, Raymond. **Raymond Duchamp-Villon: sculpteur (1876-1918).** Paris, Povolozky, 1924.

2445. Galerie Louis Carré, Paris. **Duchamp-Villon: le cheval majeur.** [Exposition] sous la direction de Marcel Duchamp, réalisée avec l'aide de Gilioli. Paris, Galerie Louis Carré, 1966.

2446. _____. **Sculptures de Duchamp-Villon.** 17 juin-30 juillet 1963. Paris, Galerie Louis Carré, 1963.

2447. Golding, John. **Marcel Duchamp: The bride stripped bare by her bachelors, even.** New York, Viking Press, 1973.

2448. Gough-Cooper, Jennifer [and] Caumont, Jacques. **Plan pour écrire une vie de Marcel Duchamp.** Paris, Centre National d'Art et de Culture Georges Pompidou, Musée d'Art Moderne, 1977. (Série des catalogues, No. 8, pt. 1).

2449. Harnoncourt, Anne d' and McShine, Kynaston, eds. **Marcel Duchamp.** Published on occasion of the exhibition organized by the Philadelphia Museum of Art and the Museum of Modern Art. Greenwich, Conn., New York Graphic Society, 1973.

2450. Lebel, Robert. **Marcel Duchamp.** With chapters by Marcel Duchamp, André Breton and H. P. Roché. Trans. by George Heard Hamilton. New York, Grove, 1959.

2451. Lyotard, Jean F. **Les transformateurs Duchamp.** Paris, Editions Galilée, 1977.

2452. Mashek, Joseph. **Marcel Duchamp in perspective.** Englewood Cliffs, N.J., Prentice-Hall, 1975.

2453. Musée des Beaux-Arts (Rouen). **Les Duchamps: Jacques Villon, Raymond Duchamp-Villon, Marcel Duchamp, Suzanne Duchamp.** 15 avril-1 juin 1967. Rouen, Musée des Beaux-Arts, 1967.

2454. Musée National d'Art Moderne (Paris). **Raymond Duchamp-Villon, 1876-1918, Marcel Duchamp, 1887- .** 7 juin-2 juillet 1967. Paris, Musée National d'Art Moderne, 1967.

2455. Paz, Octavio. **Marcel Duchamp, appearance stripped bare.** Trans. by Rachel Phillips and Donald Gardner. New York, Viking Press, 1978.

2456. Schwarz, Arturo. **The complete works of Marcel Duchamp.** New York, Abrams, 1969.

2457. _____. **Marcel Duchamp: 66 creative years.** From the first painting to the last drawing, over 260 items. [Cat. of an exhibition, 12 Dec. 1972-28 Feb. 1973]. Milano, Gallery Schwarz, 1972.

2458. Tomkins, Calvin. **The bride and the bachelors; the heretical courtship in modern art.** New York, Viking, 1965.

2459. _____. **The world of Marcel Duchamp.** New York, Time-Life, 1966.

DUFRESNE, CHARLES, 1876-1938

2460. Fosca, François. **Charles Dufresne.** Paris, La Bibliothèque des Arts, 1958.

2461. Hirschl and Adler Galleries (New York). **Charles Dufresne, 1876-1936.** A retrospective exhibition April 27-May 21, 1971. New York, Hirschl and Adler Galleries, 1971.

DUFY, RAOUL, 1877-1953

2462. Berr de Turique, Marcelle. **Raoul Dufy.** Paris, Floury, 1930.

2463. Brion, Marcel. **Raoul Dufy; paintings and watercolours** selected by René ben Sussan with an introduction by M. Brion. Trans. by Lucy Norton. London, Phaidon, 1959.

2464. Cassou, Jean. **Raoul Dufy, poète et artisan.** Genève, Skira, 1946.

2465. Cogniat, Raymond. **Dufy, décorateur.** Genève, Cailler, 1957. (Les maîtres de l'art décoratif contemporain, 3).

2466. _____. **Raoul Dufy.** Paris, Flammarion, 1962.

2467. Courthion, Pierre. **Raoul Dufy.** Paris, Editions des Chroniques du Jour, 1929.

2468. _____. **Raoul Dufy.** Genève, Cailler, 1951. (Peintres et sculpteurs d'hier et d'aujourd'hui, 19. Les Grandes monographies, 1).

2469. Galerie Louis Carré (Paris). **Tapisseries de Raoul Dufy.** Paris, Galerie Louis Carré, 1963.

2470. Gieure, Maurice. **Dufy, dessins.** Paris, Editions de Deux Mondes, 1952. (Dessins des grands peintres, 4).

2471. Guillon-Laffaille, H. **Dufy, catalogue raisonné des aquarelles, gouaches et pastels.** 2 v. Paris, Carré, 1981. (CR).

2472. Haus der Kunst, München. **Raoul Dufy, 1877-1953.** 30. Juni-30 Sept. 1973. Katalog-Redaktion: Maurice Lafaille und Fanny Guillon. München, Haus der Kunst, 1973.

2473. Hunter, Sam. **Raoul Dufy.** New York, Abrams, 1954.

2474. Kunsthalle Bern. **Raoul Dufy.** 12. Juni-11. Juli 1954. Bern, Kunsthalle, 1954.

2475. Lafaille, Maurice. **Raoul Dufy; catalogue raisonné de l'oeuvre peint.** Avant-propos de Maurice Lafaille. Préf. de Marcelle Berr de Turique. Biographie de Bernard Dorival. 4 v. Genève, Motte, 1972-1977. (CR).

2476. Lassaigne, Jacques. **Dufy: biographical and critical studies.** Trans. by James Emmons. Genève, Skira, 1954. (The Taste of Our Time, 9).

2477. Musée Jules Chéret (Nice). **Raoul Dufy à Nice: collection du Musée des beaux-arts Jules Chéret.** Nice, Direction des Musées de Nice, 1977.

2478. Musée National d'Art Moderne (Paris). **Raoul Dufy, 1877-1953.** Catalogue par Bernard Dorival. Paris, Editions des Musées Nationaux, 1953.

2479. Museum Folkwang (Essen). **Raoul Dufy: Gemälde, Aquarelle, Gouachen, Zeichnungen.** 18. Feb.-14. April 1968. Hrsg. vom Kunstverein in Hamburg. Hamburg, Kunstverein, 1968.

2480. San Francisco Museum of Art. **Raoul Dufy, 1877-1953.** May 12-July 4, 1954. San Francisco, San Francisco Museum of Art, 1954.

2481. Tate Gallery (London). **Raoul Dufy; an exhibition of paintings and drawings organized by the Arts Council of Great Britain and the Assoc. Française d'Action Artistique.** 9 Jan.-7 Feb., 1954. London, Tate Gallery, 1954.

2482. Werner, Alfred. **Raoul Dufy (1877-1953).** New York, Abrams (in assoc. with Pocket Books), 1953. (The Pocket Library of Great Art, A5).

2483. Zervos, Christian. **Raoul Dufy.** Paris, Editions Cahiers d'Art, 1928.

DUNLAP, WILLIAM, 1766-1839

2484. Coad, Oral S. **William Dunlap: a study of his life and works and of his place in contemporary culture.** New York, Dunlap Society, 1917.

2485. Dunlap, William. **The diary of William Dunlap (1766-1839).** 3 v. New York, New York Historical Society, 1930.

2486. _____. **History of the rise and progress of the arts of design in the United States.** 2 v. New York, Scott, 1834. (New ed., illustrated, edited, and with additions by Frank W. Bayley and Charles E. Goodspeed, in 3 v.: Boston, Goodspeed, 1918).

DUNOYER DE SEGONZAC, ANDRE see SEGONZAC, ANDRE DUNOYER DE

DUPRE, GIOVANNI, 1817-1882

2487. Dupré, Giovanni. **Giovanni Dupré scultore.** Torino, 1919.
2 ed. (I maestri dell'arte; monografie d'artisti italiani
moderni, 2).

2488. _____. **Pensieri sull'arte e ricordi autobiografici.**
Firenze, Le Monnier, 1880.

2489. _____. **Scritti minori e lettere.** Con un'appendice ai
suoi **Ricordi autobiografici** per Luigi Venturi. Firenze,
Le Monnier, 1882.

2490. _____. **Thoughts on art and autobiographical memories.**
Trans. by E. M. Peruzzi. Edinburgh, Blackwood, 1884.

2491. _____. **Vocazione d'artista, da Pensieri sull'arte e
Ricordi autobiografici.** A cura di Enzo Petrini.
Firenze, Marzocco, 1958.

2492. Frieze, Henry Simmons. **Giovanni Dupré.** With two dialogues
on art from the Italian of Augusto Conti. London, Low,
Marston, Searle & Rivington, 1888.

DUPRE, JULES, 1811-1889

2493. Aubrun, Marie M. **Jules Dupré, 1811-1889: catalogue
raisonné et l'oeuvre peint, dessiné et gravé.** Préf. de
M. Jacques Thuillier. Paris, Laget, 1974. Supplement:
Nantes, Chiffoleau, 1982. (CR).

2494. Dixon Gallery and Gardens (Memphis, Tenn.). **Jules Dupré,
1811-1889; a loan exhibition.** Sept. 9-Oct. 21, 1979.
[Text by Michael Milkovich]. Memphis, Tenn., Dixon
Gallery, 1979.

2495. Galerie du Fleuve (Paris). **Jules Dupré, 1811-1889.** 21
novembre au 22 décembre 1973. Paris, Galerie du Fleuve,
1973.

DURAND, ASHER BROWN, 1796-1886

2496. Durand, John. **The life and times of A. B. Durand.** New
York, Scribner's, 1894. Reprint: New York, Kennedy
Graphics and DaCapo Press, 1970.

2497. Lawall, David B. **Asher B. Durand: a documentary catalogue
of the narrative and landscape paintings.** New York,
Garland, 1978. (Garland Reference Library of the
Humanities, 74).

2498. _____. **Asher Brown Durand, his art and art theory in
relation to his times.** New York, Garland, 1977.

2499. Montclair Art Museum (Montclair, New Jersey). **A. B.
Durand, 1796-1886.** Oct. 24-Nov. 28, 1971. Essay by
David Lawall. Montclair, New Jersey, Montclair Art
Museum, 1971.

DÜRER, ALBRECHT, 1471-1528

2500. Albertina (Vienna). **Die Dürerzeichnungen der Albertina,
von Walter Koschatzky und Alice Strobl.** Salzburg,
Residenz-Verlag, 1971.

2501. Anzelewsky, Fedja. **Albrecht Dürer: das malerische Werk.**
Berlin, Deutscher Verlag für Kunstwissenschaft, 1971.

2502. _____. **Dürer: Werk und Wirkung.** Stuttgart, Electa/
Klett-Cotta, 1980.

2503. Arend, Henrich C. **Das Gedechtniss der Ehren. . . .
Albrecht Dürers.** Goslar, König, 1728.

2504. Bohatta, Hanns. **Versuch einer Bibliographie der
kunsttheoretischen Werke Albrecht Dürers.** Wien, Gilhofer
& Ranschburg, 1928.

2505. Brion, Marcel. **Dürer, his life and work.** Trans. by James
Cleugh. New York, Tudor, 1960.

2506. Conway, William Martin. **Literary remains of Albrecht
Dürer.** With transcripts from the British Museum
manuscripts, and notes upon them by Lina Eckenstein.
Cambridge, Cambridge University Press, 1889. (New ed.:
The writings of Albrecht Dürer. New York, Philosophical
Library, 1958).

2507. Dodgson, Campbell. **Albrecht Dürer.** London/Boston, Medici
Society, 1926.

2508. Dürer, Albrecht. **Reliquien von Albrecht Dürer, seinen
Verehrern geweiht.** Nürnberg, Campe, 1828.

2509. _____. **Schriftlicher Nachlass.** Hrsg. von Hans Rupprich.
3 v. Berlin, Deutscher Verein für Kunstwissenschaft,
1956-1969.

2510. _____. **Writings.** Trans. by W. M. Conway. Ed. by Alfred
Werner. New York, Philosophical Library, 1958.

2511. Eye, August von. **Leben und Wirken Albrecht Dürers.**
Nördlingen, Beck, 1860.

2512. Flechsig, Eduard. **Albrecht Dürer; sein Leben und seine
künstlerische Entwicklung.** 2 v. Berlin, Grote,
1928-1931.

2513. Friedländer, Max J. **Albrecht Dürer.** Leipzig, Insel
Verlag, 1921.

2514. Germanisches Nationalmuseum (Nuremberg). **Albrecht Dürer
Ausstellung im Germanischen Museum.** Nürnberg,
Germanisches Nationalmuseum, 1928.

2515. _____. **Albrecht Dürer, 1471-1971.** 21. Mai-1. Aug. 1971.
München, Prestel-Verlag, 1971.

2516. _____. **Vorbild Dürer: Kupferstiche und Holzschnitte
Albrecht Dürers im Spiegel der europäischen Druckgraphik
des 16. Jahrhunderts.** Katalog der Ausstellung 8. Juli-
10. Sept. 1978. München, Prestel, 1978.

2517. Grote, Ludwig. **Dürer; biographical and critical study.**
Trans. by Helga Harrison. Geneva, Skira; distributed by
World Pub. Co., Cleveland, 1965. (The Taste of Our Time,
43).

2518. Haendcke, Berthold. **Die Chronologie der Landschaften
Albrecht Dürers.** Strassburg, Heitz, 1899. (Studien zur
deutschen Kunstgeschichte, 19).

2519. Heidrich, Ernst. **Dürer und die Reformation.** Leipzig,
Klinkhardt & Biermann, 1909.

2520. _____. Geschichte des Dürer'schen Marienbildes. Leipzig, Hiersemann, 1906. (Kunstgeschichtliche Monographien, 3).

2521. Hind, Arthur M. **Albrecht Dürer, his engravings and woodcuts.** New York, Stokes, 1911.

2522. Hofmann, Walter J. **Über Dürers Farbe.** Nürnberg, Carl, 1971. (Erlanger Beiträge zur Sprach- und Kunstwissenschaft, 42).

2523. Hollstein, Friedrich W. H. **German engravings, etchings and woodcuts, ca. 1400-1700: Albrecht and Hans Dürer.** Ed. by K. G. Boon and R. W. Scheller. Amsterdam, Hertzberger, 1962. (German engravings, etchings and woodcuts, 7).

2524. Hütt, Wolfgang. **Albrecht Dürer, 1471 bis 1528; das gesamte graphische Werk.** 2 v. München, Rogner & Bernhard, 1971.

2525. Jahn, Johannes. **Entwicklungsstufen der Dürerforschung.** Berlin, Akademie-Verlag, 1971. (Sitzungsberichte der Sächs. Akademie der Wissenschaften zu Leipzig. Philol. Hist. Klasse, Bd. 115, Heft 1).

2526. Kauffmann, Hans. **Albrecht Dürers rhythmische Kunst.** Leipzig, Seemann, 1924.

2527. Kehrer, Hugo. **Dürers Selbstbildnisse und die Dürer-Bildnisse.** Berlin, Mann, 1934.

2528. Knappe, Karl Adolf. **Dürer; complete engravings, etchings and woodcuts.** New York, Abrams, 1965.

2529. Knorr, Georg W. **Historische Künstler-Belustigung oder Gespräche in dem Reiche der Todten, zwischen denen beeden weltbekannten Künstlern Albrecht Dürer und Raphael de Urbino.** Nürnberg, Knorr, 1738.

2530. Koehler, Sylvester R. **A chronological catalogue of the engravings, drypoints and etchings of Albert Dürer.** New York, Grolier Club, 1897. (CR).

2531. Koschatzky, Walter. **Albrecht Dürer: die Landschafts-aquarelle.** Wien/München, Jugend und Volk, 1971.

2532. Kurth, Willi. **The complete woodcuts of Albrecht Dürer.** Trans. by S. M. Welsh. New York, Crown, 1946. (Reprint: Magnolia, Mass., Peter Smith, 1963).

2533. Levey, Michael. **Dürer.** New York, Norton, 1964.

2534. Lippmann, Friedrich. **Drawings by Albrecht Dürer.** 7 v. Berlin, Grote, 1883-1929. (CR).

2535. Lorenz, Ludwig. **Die Marien-Darstellungen Albrecht Dürers.** Strassburg, Heitz, 1904. (Studien zur deutschen Kunstgeschichte, 55).

2536. Lüdecke, Heinz and Heiland, Susanne. **Dürer und die Nachwelt.** Urkunden, Briefe, Dichtungen und wissenschaftliche Betrachtungen aus vier Jahrhunderten, gesammelt und erläutert von Heinz Lüdecke und Susanne Heiland. Berlin, Rütten & Loening, 1955.

2537. Meder, Joseph. **Dürer Katalog: ein Handbuch über Albrecht Dürers Stiche, Radierungen, Holzschnitte, deren Zustände, Ausgaben und Wasserzeichen.** Wien, Gilhofer & Ranschburg, 1932.

2538. Mende, Matthias. **Dürer Bibliographie.** Wiesbaden, Harrassowitz, 1971.

2539. Müller, Franz L. **Die Ästhetik Albrecht Dürers.** Strassburg, Heitz, 1910. (Studien zur deutschen Kunstgeschichte, 123).

2540. Museum of Fine Arts (Boston). **Albrecht Dürer: master printmaker.** Nov. 17, 1970-Jan. 16, 1971. Boston, Museum of Fine Arts, 1971.

2541. Musper, Theodor. **Albrecht Dürer.** Trans. by Robert E. Wolf. New York, Abrams, 1966.

2542. _____. **Albrecht Dürer.** Köln, DuMont Schauberg, 1971.

2543. _____. **Albrecht Dürer; der gegenwärtige Stand der Forschung.** Stuttgart, Kohlhammer, 1952.

2544. _____. **Dürers Kaiserbildnisse.** Köln, DuMont Schauberg, 1969.

2545. National Gallery of Art (Washington, D.C.). **Dürer in America, his graphic work.** Charles W. Talbot, ed. Notes by Gaillard F. Ravenel and Jay A. Levenson. April 25-June 6, 1971. Washington, D.C., National Gallery of Art, 1971.

2546. Panofsky, Erwin. **Albrecht Dürer.** 2 v. Princeton, N.J., Princeton University, 1943. (This is the original edition with the catalogue. A 2d rev. ed. in 2 vols. was published in 1945 and reprinted as a 3d ed. The 4th ed. of 1955 is in 1 vol. and lacks the critical catalogue.)

2547. _____. **Dürers Kunsttheorie.** Berlin, Reimer, 1915.

2548. _____. **Dürers Stellung zur Antike.** Wien, Hölzel, 1922.

2549. Retberg, Ralf Leopold von. **Dürers Kupferstiche und Holzschnitte. Ein kritisches Verzeichnis.** München, Ackermann, 1871.

2550. Rupprich, Hans, ed. **Albrecht Dürer, schriftlicher Nachlass.** Berlin, Deutscher Verein für Kunstwissenschaft, 1956.

2551. Scherer, Valentin. **Dürer; des Meisters Gemälde, Kupferstiche und Holzschnitte.** Stuttgart, Deutsche Verlaganstalt, 1928. 4 ed. (Klassiker der Kunst in Gesamtausgaben, 4).

2552. _____. **Die Ornamentik bei Albrecht Dürer.** Strassburg, Heitz, 1902. (Studien zur deutschen Kunstgeschichte, 38).

2553. Schöber, David G. **Albrecht Dürers . . . Leben, Schriften und Kunstwerke.** Leipzig/Schleiz, Mauke, 1769.

2554. Singer, Hans W. **Versuch einer Dürer Bibliographie.** Strassburg, Heitz, 1928. 2 ed.

2555. Stechow, Wolfgang. **Dürer and America.** Washington, D.C., National Gallery of Art, 1971.

2556. Strauss, Walter L., ed. **Albrecht Dürer: woodcuts and wood blocks.** New York, Abaris, 1975.

2557. _____. **All of Dürer's engravings, etchings, and drypoints.** New York, Abaris, 1981. 3 ed.

2558. _____. The complete drawings of Albrecht Dürer. 6 v. New York, Abaris, 1974. Supplements: New York, Abaris, 1977- . (CR).

2559. _____. The intaglio prints of Albrecht Dürer: engravings, etchings & drypoints. Expanded ed. New York, Kennedy Galleries, 1977.

2560. Strieder, Peter. Albrecht Dürer: paintings, prints, drawings. Trans. by Nancy M. Gordon and Walter L. Strauss. New York, Abaris, 1982.

2561. _____. The hidden Dürer. Trans. by Vivienne Menkes. Oxford, Phaidon, 1978.

2562. Suida, Wilhelm. Die Genredarstellung Albrecht Dürers. Strassburg, Heitz, 1900. (Studien zur deutschen Kunstgeschichte, 27).

2563. Thausing, Moritz. Dürer; Geschichte seines Lebens und seiner Kunst. 2 v. Leipzig, Seemann, 1884. 2 ed.

2564. Tietze, Hans and Tietze-Conrat, Erika. Kritisches Verzeichnis der Werke Albrecht Dürers. 2 v. (in 3). Augsburg, Filser, 1928-1938. (CR).

2565. Waetzoldt, Wilhelm. Dürer and his times. Trans. by R. H. Boothroyd. London, Phaidon, 1950.

2566. Waldmann, Emil. Albrecht Dürer. Leipzig, Insel-Verlag, 1923.

2567. _____. Albrecht Dürers Handzeichnungen. Leipzig, Insel-Verlag, 1920.

2568. _____. Albrecht Dürers Stiche und Holzschnitte. Leipzig, Insel, 1920.

2569. Weise, Adam. Albrecht Dürer und sein Zeitalter; ein Versuch. Leipzig, Gleditsch, 1819.

2570. Weise, Georg. Dürer und die Ideale der Humanisten. Tübingen, Kunsthist. Institut der Universität, 1953. (Tübinger Forschungen zur Kunstgeschichte, 6).

2571. White, Christopher. Dürer: the artist and his drawings. London, Phaidon, 1971.

2572. Winkler, Friedrich. Albrecht Dürer, Leben und Werk. Berlin, Mann, 1957.

2573. _____. Die Zeichnungen Albrecht Dürers. 4 v. Berlin, Deutscher Verein für Kunstwissenschaft, 1936-1939.

2574. Winzinger, Franz. Albrecht Dürer in Selbstzeugnissen und Bilddokumenten. Reinbeck bei Hamburg, Rowohlt, 1971. (Rowohlts Monografien, 177).

2575. Wölfflin, Heinrich. The art of Albrecht Dürer. Trans. by Alastair and Heide Grieve. London, Phaidon, 1971.

2576. _____. Die Kunst Albrecht Dürers. München, Bruckmann, 1905.

2577. Zahn, Albert von. Dürers Kunstlehre und sein Verhältnis zur Renaissance. Leipzig, Weigel, 1866.

DURIS, fl. 500 B.C.

2578. Pottier, Edmond. Douris and the painters of Greek vases. Trans. by Bettina Kahlweiler, with a preface by Jane Ellen Harrison. London, Murray, 1909.

DU RY, CHARLES LOUIS, 1692-1757

PAUL, 1640-1714

SIMON LOUIS, 1726-1799

2579. Boehlke, Hans-Kurt. Simon Louis Du Ry, ein Wegbereiter klassizistischer Architektur in Deutschland. Kassel, Stauda, 1980.

2580. Gerland, Otto. Paul, Charles, und Simon Louis du Ry; eine Künstlerfamilie der Barockzeit. Stuttgart, Neff, 1895.

DYCE, WILLIAM, 1806-1864

2581. Art Gallery and Industrial Museum (Aberdeen, Scotland). Centenary exhibition of the work of William Dyce, R. A. (1806-1864), Aug. 7-Sept. 13, 1964. Aberdeen, Art Gallery, 1964.

2582. Pointon, Marcia R. William Dyce, 1806-1864: a critical biography. Foreword by Quentin Bell. Oxford, Clarendon Press, 1979.

DYCK, ANTHONY VAN, 1599-1641

2583. Carpenter, William H. Pictorial notices consisting of a memoir of Sir Anthonis van Dyck, with a descriptive catalogue of the etchings. London, J. Carpenter, 1844.

2584. Cust, Lionel H. Anthony van Dyck, an historical study of his life and works. London, Bell, 1900.

2585. _____. Anthony van Dyck. A further study by L. Cust, with twenty-five illustrations in colour executed under the supervision of the Medici Society. New York/London, Hodder and Stoughton, 1911.

2586. Delacre, Maurice. Le dessin dans l'oeuvre de van Dyck. Brussels, Hayez, 1934.

2587. Didière, Pierre. Antoine van Dyck. Suivi d'un portrait d'Antoine Van Dyck par Eugène Fromentin. Bruxelles, Meddens, 1969.

2588. Dyck, Anthony van. Antwerp sketchbook. Ed. by Michael Jaffé. 2 v. London, Macdonald, 1966.

2589. _____. Italienisches Skizzenbuch. Hrsg. von Gert Adriani. Wien, Schroll, 1940.

2590. Fierens-Gevaert, Hippolyte. Van Dyck; biographie critique. Paris, Laurens, 1903.

2591. Glück, Gustav. Van Dyck; des Meisters Gemälde in 571 Abbildungen. Stuttgart, Deutsche Verlagsanstalt, 1931; distributed by F. Kleinberger, New York. 2 ed. of the work edited by E. Schaeffer. (Klassiker der Kunst in Gesamtausgaben, 13). (See also 2610).

2592. Guiffrey, Jules M. J. **Antoine van Dyck, sa vie et son oeuvre.** Paris, Quantin, 1882.

2593. Head, Percy R. **Van Dyck.** New York, Scribner and Welford, 1879.

2594. Hind, Arthur M. **Van Dyck and portrait engraving and etching in the seventeenth century.** New York, Stokes, 1911.

2595. _____. **Van Dyck, his original etchings and his iconography.** New York, Houghton Mifflin, 1915.

2596. Knackfuss, Hermann. **A. van Dyck.** Bielefeld/Leipzig, Velhagen & Klasing, 1896. (Künstler-Monographien, 13).

2597. _____. **Van Dyck.** Trans. by Campbell Dodgson. Bielefeld/Leipzig, Velhagen & Klasing/New York, Lemcke & Buechner, 1899. (Monographs on Artists, 4).

2598. Knoedler & Company, New York. **The portrait etchings of Anthony van Dyck.** Catalogue of an exhibition. New York, Knoedler, 1934.

2599. Koninklijk Muzeum voor Schoone Kunsten (Antwerp). **Album der Van Dyck-tentoonstelling, uitgegeven onder de Bescherming der Commissie van de tentoonstelling.** Bruxelles, Editions Lyon-Claesen, 1899.

2600. _____. **Van Dyck tentoonstelling juli-august 1949.** Antwerpen, Nederlandsche Boekhandel, 1949.

2601. _____. **Van Dijk tentoonstelling ter gelegenheid der 300e verjaring der geboorte van den meester, 12 aug.-15 oct., 1899.** Antwerpen, 1899.

2602. Larsen, Erik. **L'opera completa di Van Dyck, 1626-1641.** Milano, Rizzoli, 1980. (Classici dell'arte, 103).

2603. Mayer, August L. **Anthonis van Dyck.** München, Recht, 1923.

2604. Michiels, Alfred. **Van Dyck et ses élèves.** Paris, Renouard, 1882. 2 ed.

2605. National Gallery of Canada (Ottawa). **The young van Dyck/ le jeune van Dyck.** Sept. 19-Nov. 9, 1980. [Text by Alan McNairn]. Ottawa, National Museums of Canada, 1980.

2606. Newbolt, Francis G. **Etchings of Van Dyck.** London, Newnes/ New York, Scribner, 1906.

2607. Palazzo dell'Accademia (Genoa). **Cento opere di Van Dyck.** Catalogo della mostra, guigno-agosto 1955. Genova, 1955.

2608. Royal Academy of Arts (London). **Exhibition of works by Van Dyck, 1599-1641.** London, Clowes, 1900.

2609. Rubenshuis (Antwerp). **Antoon Van Dyck: tekeningen en olieverfschetsen.** 1 juli-31 aug. 1960. [Text by Roger-A. d'Hulst and Horst Vey]. Antwerpen, Rubenshuis, 1960.

2610. Schaeffer, Emil. **Van Dyck; des Meisters Gemälde in 537 Abbildungen.** Stuttgart/Leipzig, Deutsche Verlagsanstalt, 1909. (Klassiker der Kunst in Gesamtausgaben, 13). (See also 2591).

2611. Sweetser, Moses F. **Van Dyck.** Boston, Houghton, Osgood, 1878. (Artist-biographies, 10).

2612. Szwykowski, Ignaz von. **Anton van Dyck's Bildnisse bekannter Personen. . . .** Leipzig, Weigel, 1859.

2613. Vey, Horst. **Die Zeichnung Anton van Dycks.** 2 v. Brüssel, Arcade, 1962. (Natl. Centrum voor de Plastiche Kunsten van de XVIde en XVIIde eeuw. Monographien, 1).

2614. Wibiral, Franz. **L'Iconographie d'Antoine van Dyck d'après les recherches de H. Weber.** Leipzig, Danz, 1877.

2615. Wijngaert, Frank van den. **Antoon van Dyck.** Antwerpen, Nederlandsche Boekhandel, 1943.

EAKINS, THOMAS, 1844-1916

2616. Carnegie Institute (Pittsburgh). **Thomas Eakins centennial exhibition, 1844-1944.** Pittsburgh, Carnegie Institute, Dept. of Fine Arts, 1945.

2617. Coe Kerr Gallery (New York). **A family album, photographs by Thomas Eakins, 1880-1890.** New York, Coe Kerr Gallery, 1976.

2618. Corcoran Gallery of Art (Washington, D.C.). **The sculpture of Thomas Eakins.** Washington, D.C., Corcoran Gallery of Art, 1960.

2619. Goodrich, Lloyd. **Thomas Eakins, his life and work.** New York, Macmillan, 1933.

2620. _____. **Thomas Eakins.** 2 v. Cambridge, Harvard University Press, 1982 (revision of earlier work). (CR).

2621. Hendricks, Gordon. **The life and work of Thomas Eakins.** New York, Grossman, 1974.

2622. _____. **The photographs of Thomas Eakins.** New York, Grossman, 1972.

2623. Hoopes, Donelson F. **Eakins watercolours.** New York, Watson-Guptill, 1971.

2624. McKinney, Roland J. **Thomas Eakins.** New York, Crown, 1942.

2625. Metropolitan Museum of Art (New York). **Loan exhibition of the works of Thomas Eakins.** [Nov. 5, 1917-Dec. 3, 1917]. New York, Metropolitan Museum of Art, 1917.

2626. National Gallery of Art (Washington, D.C.). **Thomas Eakins, a retrospective exhibition.** [Oct. 8, 1961-Nov. 12, 1961]. Washington, D.C., National Gallery of Art, 1961.

2627. Pennsylvania Academy of the Fine Arts (Philadelphia). **Memorial exhibition of the works of the late Thomas Eakins.** [Dec. 23, 1917-Jan. 13, 1918]. Philadelphia, Penn., Academy of Fine Arts, 1918.

2628. _____. **Thomas Eakins, his photographic works.** Philadelphia, Penn., Academy of Fine Arts, 1969.

2629. Porter, Fairfield. **Thomas Eakins.** New York, Braziller, 1959.

2630. Rosenzweig, Phyllis D. **The Thomas Eakins Collection of the Hirshhorn Museum and Sculpture Garden.** Washington, D.C., Smithsonian Institution, 1977.

2631. Schendler, Sylvan. **Eakins.** Boston, Little, Brown, 1967.

2632. Sewell, Darrel. **Thomas Eakins, artist of Philadelphia.** [Catalog of an exhibition, Philadelphia Museum of Art, May 19, 1982-Aug. 1, 1982]. Philadelphia, Penn., Philadelphia Museum of Art, 1982.

2633. Siegl, Theodor. **The Thomas Eakins Collection.** [Philadelphia Museum of Art]. Philadelphia, Philadelphia Museum of Art, 1978. (Handbooks in American Art, No. 1).

2634. Soyer, Raphael. **Hommage to Thomas Eakins, etc.** South Brunswick, N.J., Thomas Yoseloff, 1966.

2635. Whitney Museum of American Art (New York). **Thomas Eakins, a retrospective exhibition.** By Lloyd Goodrich. [Sept. 22, 1970-Nov. 21, 1970]. New York, Whitney Museum, 1970.

EARL, RALPH, 1751-1801

2636. Gallery of Fine Arts, Yale University (New Haven). **Connecticut portraits by Ralph Earl, 1751-1801.** [Published in conjunction with Connecticut Tercentenary, 1635-1935]. New Haven, Gallery of Fine Arts, 1935.

2637. Goodrich, Laurence B. **Ralph Earl, recorder for an era.** Albany, State Univ. of New York, 1967.

2638. Sawitzky, William. **Ralph Earl, 1751-1801.** [Catalog of an exhibition, Oct. 16, 1945-Nov. 21, 1945]. New York, Whitney Museum of American Art, 1946.

2639. William Benton Museum of Art (Storrs, Conn.). **The American Earls: Ralph Earl, James Earl, R. E. W. Earl.** [Pub. in conjunction with an exhibition, Oct. 14-Nov. 12, 1972]. Storrs, University of Connecticut, 1972.

EASTLAKE, CHARLES LOCK, 1793-1865

2640. Eastlake, Sir Charles Lock. **Contributions to the literature of the fine arts.** London, John Murray, 1848.

2641. _____. **Materials for a history of oil painting.** 2 v. London, Longman Brown, 1847-1869. (Reprint: New York, Dover, 1960).

2642. Robertson, David. **Sir Charles Eastlake and the Victorian art world.** Princeton, N.J., Princeton University Press, 1978.

ECKERSBERG, CHRISTOFFER WILHELM, 1783-1853

2643. Christensen, Laura J. **Graenselandets Maler, Christoffer Wilhelm Eckersberg.** Sonderborg, Clausens, 1962.

2644. Hannover, Emil. **Maleren C. W. Eckersberg, en studie i dansk kunsthistorie.** København, Thiele, 1898.

2645. Johansen, Peter. **Den danske Malerkunsts Fader, Christoffer Wilhelm Eckersberg, 1783-1853.** København, Slesvigsk, 1925.

2646. Weilback, Philip. **Eckersbergs leved og värker.** København, Lind, 1872.

2647. Zahle, Eric. **C. W. Eckersberg.** Odense, Flensteds, 1945.

ECKMANN, OTTO, 1865-1902

2648. Eckmann, Otto. **Neue Formen, dekorative Entwürfe für die Praxis.** Berlin, Max Spielmeyer, 1897.

2649. Kaiser-Wilhelm-Museum (Krefeld, W. Germany). **Otto Eckmann (1865-1902), ein Hauptmeister des Jugendstils.** (Nov. 6, 1977-Jan. 8, 1978). Krefeld, Kaiser Wilhelm Museum, 1978.

EDELFELT, ALBERT GUSTAF ARISTIDES, 1854-1905

2650. Hintze, Bertel. **Albert Edelfelt.** 3 v. Helsingfors, Söderström, 1942-44.

EDELINCK, GERARD, 1640-1707

2651. Delaborde, Henri. **Gerard Edelinck.** Paris, Librairie de l'art, 1886. (Les artistes célèbres).

EDGERTON, HAROLD E., 1903-

2652. Edgerton, Harold E. and Killian, James R., Jr. **Flash! Seeing the unseen by ultra high-speed photography.** Boston, Branford, 1954. 2 ed.

2653. _____. **Moments of vision; the stroboscopic revolution in photography.** Cambridge, Mass., MIT Press, 1979.

EGGER-LIENZ, ALBIN, 1868-1926

2654. Hammer, Heinrich. **Albin Egger-Lienz, ein Buch für das deutsche Volk.** Innsbruck, Deutscher Alpenverlag, 1938.

2655. _____ and Kollreider, Franz. **Albin Egger-Lienz, ein Bildwerk.** Innsbruck, Tyrolia, 1963.

2656. Soyka, Josef. **A. Egger-Lienz, Leben und Werke.** Wien, Carl Konegen, 1925.

2657. Tiroler Landesmuseum Ferdinandeum (Innsbruck). **Albin Egger-Lienz, 1868-1926.** [May 25, 1976-July 15, 1976]. Innsbruck, Tiroler Landesmuseum Ferdinandeum, 1976.

2658. Weigelt, Curt H. **Albin Egger-Lienz, eine Studie.** Berlin, Weise, 1914.

EICHENBERG, FRITZ, 1902-

2659. Eichenberg, Fritz. **The art of the print; masterpieces, history, techniques.** New York, Abrams, 1976.

2660. _____. **The wood and the graver; the work of Fritz Eichenberg.** New York, Clarkson Potter, 1976.

2661. New York Public Library (New York). **Fritz Eichenberg,
illustrator and printmaker.** [Exhibition, Feb.-Mar.
1949]. New York, AIGA, 1949.

EIFFEL, ALEXANDRE GUSTAVE, 1832-1923

2662. Besset, Maurice. **Gustave Eiffel, 1832-1923.** Milano,
Electa Editrice, 1957. (Astra-Arengarum collana di
monografie d'arte, Serie architetti).

2663. Eiffel, Gustave. **La tour de trois cents mètres.** 2 v.
Paris, Société des Imprimeries Lemercier, 1900.

2664. Keim, Jean A. **La tour Eiffel.** [Text in French and
English]. Paris, Editions Tel, 1950.

2665. Prévost, Jean. **Eiffel.** Paris, Rieder, 1929. (Maîtres de
l'art moderne).

EISENSTAEDT, ALFRED, 1898-

2666. Eisenstaedt, Alfred. **The eye of Eisenstaedt,** as told to
Arthur Goldsmith. New York, Viking, 1969.

2667. _____. **People.** New York, Viking, 1973.

2668. _____. **Witness to our time.** Foreword by Henry R. Luce.
Harmondsworth, England, Penguin, 1980. 2 ed.

EISHI, HOSODA, 1756-1829

2669. Brandt, Klaus J. **Hosoda Eishi, 1756-1829; der japanische
Maler und Holzschnittmeister und seine Schüler.**
Stuttgart, Brandt, 1977.

ELSHEIMER, ADAM, 1578-1610

2670. Andrews, Keith. **Adam Elsheimer; paintings, drawings,
prints.** New York, Rizzoli, 1977.

2671. Bode, Wilhelm von. **Adam Elsheimer, der römische Maler
deutscher Nation.** München, Schmidt, 1920.

2672. Drost, Willi. **Adam Elsheimer als Zeichner.** Stuttgart,
Kohlhammer, 1957.

2673. _____. **Adam Elsheimer und sein Kreis.** Potsdam,
Athenaion, 1933. (Die Grossen Deutschen Maler).

2674. Möhle, Hans. **Die Zeichnungen Adam Elsheimers.** Berlin,
Deutscher Verlag für Kunstwissenschaft, 1966.

2675. Städelsches Kunstinstitut (Frankfurt a.M.). **Adam
Elsheimer; Werk, künstlerische Herkunft und Nachfolge.**
[Katalog der Ausstellung, Dec. 2, 1966-Jan. 31, 1967.]
Frankfurt, Städelsches Kunstinstitut, 1967.

2676. Weizsäcker, Heinrich. **Adam Elsheimer, der Maler von
Frankfurt.** 2 v. [V. 2: **Des Künstlers Leben und Werke,**
ed. H. Möhle]. Berlin, Deutscher Verein f.
Kunstwissenschaft, 1936-1952.

2677. _____. **Die Zeichnungen Adam Elsheimers.** Frankfurt
a.M., Baer, 1923.

EMERSON, PETER HENRY, 1856-1936

2678. Emerson, Peter H. **Naturalistic photography for students
of the art.** New York, Scovil & Adams, 1899. 3 ed.
(Reprint: New York, Arno, 1973).

2679. Newhall, Nancy W. **P. H. Emerson: the fight for
photography as a fine art.** Millerton, N.Y.,
Aperture, 1975. (Aperture, 19: 2-3).

2680. Turner, Peter and Wood, Richard. **P. H. Emerson,
photographer of Norfolk.** London, Fraser, 1974.

ENGEL, JOHANN CARL LUDWIG, 1778-1840

2681. Hein, Birgit. **Carl Ludwig Engel, Baukunst in Helsinki.**
Köln, Universität Köln, 1966.

2682. Meissner, Carl. **Carl Ludwig Engel, deutscher Baumeister
in Finnland.** Berlin, Deutscher Verein für
Kunstwissenschaft, 1937. (Forschungen zur deutschen
Kunstgeschichte, v. 20).

ENSOR, JAMES, 1860-1949

2683. Arts Council of Great Britain. **The works of James Ensor.**
[Catalogue of an exhibition]. London, Arts Council of
Great Britain, 1946.

2684. Colin, Paul. **James Ensor.** Berlin, Klinkhardt & Biermann,
1931. (Junge Kunst, 59).

2685. Cuypers, Firmin. **Aspects & propos de James Ensor.**
Bruges, A. G. Stainforth, 1946.

2686. Damase, Jacques. **L'oeuvre gravé de James Ensor.** Genève,
Editions Motte, 1967.

2687. [Electa]. **Ensor; dipinti, disegni, incisioni.** Milano,
Electa Editrice, 1981.

2688. Elsevier (publishers). **James Ensor; portraitiste, peintre
de squelettes et de sujets grotesques, peintre de
masques, peintre "réaliste" et "fantaisiste."** 4 v.
Bruxelles, Elsevier, 1959. (CR).

2689. Ensor, James. **Ecrits.** [Ed. by H. Vandeputte].
Bruxelles, Lumière, 1944.

2690. Fierens, Paul. **James Ensor.** Paris, Editions Hypérion,
1946.

2691. Haesaerts, Paul. **James Ensor.** New York, Abrams, 1959.

2692. Janssens, Jacques. **Ensor.** New York, Crown, 1978.

2693. Legrand, Francine-Claire. **Ensor cet inconnu.** Bruxelles,
Collection Renaissance Art, 1971.

2694. LeRoy, Grégoire. **James Ensor.** Bruxelles, van Oest, 1922.
(Librairie Nationale d'Art et d'Histoire).

2695. Marlborough Fine Art, Ltd. (London). **James Ensor, 1860-1949; a retrospective centenary exhibition.** London, Marlborough Fine Art, Ltd., 1960.

2696. Ollinger-Zinque, Gisèlde. **Ensor by himself.** Bruxelles, Laconti, 1976.

2697. Ridder, André de. **James Ensor.** Paris, Rieder, 1930. (Maîtres de l'art moderne).

2698. Rousseau, Blanche, et al. **James Ensor, peintre & graveur.** Paris, Librairie de la Société Anonyme "La Plume," 1899.

2699. Taevernier, Aug. **James Ensor; illustrated catalogue of his engravings, their critical description, and inventory of the plates.** Ghent, Ledeberg, 1973.

2700. _____. **Le drame Ensorien, les auréoles du Christ ou les sensibilités de la lumière.** Ghent, Ledeberg, 1976.

2701. Tannenbaum, Libby. **James Ensor.** New York, Museum of Modern Art, 1951; distributed by Simon & Schuster, New York.

2702. Verhaeren, Emile. **James Ensor.** Bruxelles, van Oest, 1908.

EPSTEIN, JACOB, 1880-1959

2703. Arts Council of Great Britain. **Epstein** [memorial exhibition]. London, Arts Council of Great Britain, 1961.

2704. Black, Robert. **The art of Jacob Epstein.** Cleveland, World, 1942.

2705. Buckle, Richard. **Jacob Epstein, sculptor.** Cleveland, World, 1963.

2706. Dieran, Bernard van. **Epstein.** London, Lane, 1920.

2707. Epstein, Jacob. **Let there be sculpture, an autobiography.** London, Joseph, 1940.

2708. _____. **An autobiography.** [Revised ed. of earlier work]. New York, Dutton, 1955.

2709. _____. **The sculptor speaks, a series of conversations on art.** [Edited by Arnold L. Haskell]. London, Heinemann, 1931.

2710. Epstein, Kathleen. **Epstein drawings.** With notes by Lady Epstein. London, Faber, 1962.

2711. Powell, L. B. **Jacob Epstein.** London, Chapman & Hall, 1932.

2712. Schinman, Edward P. and Schinman, Barbara Ann. **Jacob Epstein, a catalogue of the collection of Edward P. Schinman.** Rutherford, N.J., Fairleigh Dickinson University Press, 1970.

2713. Wellington, Hubert. **Jacob Epstein.** London, Benn, 1925. (Contemporary British Artists).

ERFURTH, HUGO, 1874-1948

2714. Lohse, Bernd, ed. **Hugo Erfurth, 1874-1948; der Fotograf der goldenen zwanziger Jahre.** Seebruck a. Chiemsee, Heering, 1977.

ERNI, HANS, 1909-

2715. Burckhardt, Carl J. **Hans Erni.** Zürich, Scheidegger, 1964.

2716. Cailler, Pierre. **Catalogue raisonné de l'oeuvre lithographié et gravé de Hans Erni.** 2 v. Genève, Cailler, 1969-1971. (CR).

2717. Erns, Hans. **Skizzenbuch.** Zürich, Scheidegger, 1963.

2718. _____. **Skizzenbuch 2: Afrika.** Vorwort von Leopold Sédar Senghor. Zürich, Scheidegger, 1966.

2719. _____. **Wo steht der Maler in der Gegenwart?** Zürich, Büchergilde Gutenberg, 1947.

2720. Farner, Konrad. **Weg und Zielsetzung des Künstlers.** Zürich, Amstutz Herdeg, 1943.

2721. _____. **Hans Erni, ein Maler unserer Zeit.** Zürich, Kultur und Volk, 1945.

2722. Gabus, Jean. **Les fresques de Hans Enri, ou la part du peintre en ethnographie.** Neuchâtel, La Baconnière, 1955.

2723. Roy, Claude. **Hans Erni.** Genève, Cailler, 1955.

2724. Rüegg, Walter. **Hans Erni, das malerische Werk.** Bern, Erpf, 1980.

ERNST, MAX, 1891-1976

2725. Bibliothèque Nationale (Paris). **Max Ernst, estampes et livres illustrés.** [Catalogue de l'exposition]. Paris, Bibliothèque Nationale, 1975.

2726. Bosquet, Joe and Tapié, Michel. **Max Ernst.** Paris, Drouin, 1950.

2727. Cahiers d'Art. **Max Ernst, oeuvres de 1919 à 1936.** Paris, Cahiers d'Art, 1937.

2728. Diehl, Gaston. **Max Ernst.** New York, Crown, 1973.

2729. Ernst, Max. **Beyond Painting and other writings by the artist and his friends.** New York, Wittenborn, 1948. (The Documents of Modern Art).

2730. _____. **Ecritures.** Paris, Gallimard, 1970.

2731. Gatt, Giuseppe. **Max Ernst.** London, Hamlyn, 1970. (Twentieth-Century Masters).

2732. Herzogenrath, Wulf. **Max Ernst in Köln, die rheinische Kunstszene bis 1922.** Köln, Rheinland, 1980.

2733. Konnertz, Winfried. **Max Ernst.** Köln, DuMont, 1980.

2734. Kunstmuseum Hannover. **Max Ernst: Gemälde, Skulpturen, Collagen, Frottagen, Zeichnungen, Druckgraphik und Bücher.** [Verzeichnis der Bestände]. Hannover, Kunstmuseum, 1981. (CR).

2735. Le Point Cardinal (Paris). **Max Ernst; oeuvre sculpté, 1913-1961.** [15 novembre-fin décembre 1961]. Paris, Le Point Cardinal, 1962.

2736. Museum of Modern Art (New York). **Max Ernst.** [March 1, 1961-May 7, 1961]. New York, Museum of Modern Art, 1961.

2737. Musée d'Art et d'Histoire (Geneva). **Max Ernst, oeuvre gravé.** [Cabinet des estampes, 30 mai-9 août, 1970]. Genève, Musée d'Art et d'Histoire, 1970.

2738. O'Hara, J. Philip. **Max Ernst.** Chicago, O'Hara, 1972.

2739. Quinn, Edward. **Max Ernst.** Zürich, Atlantis, 1977.

2740. Russell, John. **Max Ernst, life and work.** New York, Abrams, 1967.

2741. Sala, Carlo. **Max Ernst et la démarche onirique.** Paris, Klincksieck, 1970.

2742. Schneede, Uwe M. **Max Ernst.** New York, Praeger, 1973.

2743. Solomon R. Guggenheim Museum (New York). **Max Ernst, a retrospective.** [Catalogue of an exhibition]. New York, Guggenheim Museum, 1975.

2744. Spies, Werner. **Max Ernst, Collagen; Inventar und Widerspruch.** Köln, DuMont, 1974.

2745. ———. **Max Ernst, Frottages.** London, Thames and Hudson, 1969.

2746. ———. **Max Ernst, Loplop: the artist's other self.** London, Thames and Hudson, 1983.

2747. ———. **Max Ernst, Oeuvre-Katalog.** 5 v. Köln, DuMont, 1974-76. (Menil Foundation). (CR).

2748. ———. **The return of la belle jardinière; Max Ernst, 1950-1970.** New York, Abrams, 1971.

2749. Trier, Eduard. **Max Ernst.** Recklinghausen, Bongers, 1959. (Monographien zur rheinisch-westfälischen Kunst der Gegenwart).

2750. Waldberg, Patrick. **Max Ernst.** Paris, Pauvert, 1958.

E. S., MASTER see MASTER. . .

ESCHER, MAURITS CORNELIS, 1898-1971

2751. Ernst, Bruno. **The magic mirror of M. C. Escher.** New York, Random House, 1976.

2752. Escher, M. C. **The world of M. C. Escher.** New York, Abrams, 1971.

2753. ———. **Grafiek in tekeningen.** Zwolle, Tijl, 1962.

2754. Macgillavry, Caroline H. **Fantasy & symmetry, the periodic drawings of M. C. Escher.** New York, Abrams, 1976.

ESTEVE, MAURICE, 1904-

2755. Francastel, Pierre. **Estève.** Paris, Galanis, 1956.

2756. Lesbats, Roger. **Cinq peintres d'aujourd'hui; oeuvres de Beaudin, Borès, Estève, Gischia, Pignon.** Paris, Les Editions du Chêne, 1943.

2757. Muller, Joseph-Emile. **Maurice Estève.** Paris, Hazan, 1962. (Peintres d'aujourd'hui).

2758. Ulmer Museum (Ulm, Germany). **Maurice Estève.** 27. Mai-8. Juli 1973. Ulm, Ulmer Museum, 1973.

ETTY, WILLIAM, 1787-1849

2759. Arts Council of Great Britain. **An exhibition of paintings by William Etty.** London, Arts Council of Great Britain, 1955.

2760. Farr, Dennis. **William Etty.** London, Routledge, 1958. (English Master Painters).

2761. Gaunt, William and Roe, F. Gordon. **Etty and the nude; the art and life of William Etty, R. A., 1787-1849.** Leigh-on-Sea, Tithe House, 1943.

2762. Gilchrist, Alexander. **Life of William Etty, R. A.** 2 v. London, Bogue, 1855.

2763. Musée des Beaux-Arts de Dijon. **William Etty (1787-1849); oeuvres de l'Art Gallery d'York.** Dijon, Musée des Beaux-Arts, 1979.

EUPHRONIOS, fl. 510-490 B.C.

2764. Klein, Wilhelm. **Euphronios, eine Studie zur Geschichte der griechischen Malerei.** Wien, Gerold, 1886. 2 ed.

EUTHYMIDES, fl. 520-500 B.C.

2765. Hoppin, Joseph C. **Euthymides and his fellows.** Cambridge, Mass., Harvard University Press, 1917.

EVANS, FREDERICK, 1853-1943

2766. Newhall, Beaumont. **Frederick H. Evans: photographer of the majesty, light, and space of the medieval cathedrals of England and France.** Millerton, N.Y., Aperture, 1978.

2767. University of Kansas Museum of Art (Lawrence, Kansas). **The Romantic chateau: architectural photographs by Frederick Evans.** [Summer, 1972]. Lawrence, Kansas, University of Kansas, 1972. (The Register of the Museum of Art, v. 4, no. 8).

EVANS, WALKER, 1903-1975

2768. Evans, Walker. **American photographs.** With an essay by
Lincoln Kirstein. New York, Museum of Modern Art, 1938.
(Reprint: New York, East River Press, 1975).

2769. _____. **First and last.** New York, Harper & Row, 1978.

2770. _____. **Walker Evans at work: 745 photographs together
with documents selected from letters, memoranda,
interviews, notes.** With an essay by Jerry L. Thompson.
New York, Harper & Row, 1982.

2771. _____. **Walker Evans: photographs for the Farm Security
Administration, 1935-1938.** A catalog of photographic
prints available from the Farm Security Administration
Collection in the Library of Congress. Introduction by
Jerald C. Maddox. New York, Da Capo, 1973.

2772. Evans, Walker and Agee, James. **Let us now praise famous
men: three tenant families.** Boston, Houghton Mifflin,
1960. 2 ed.

2773. [Fonvielle, Lloyd]. **Walker Evans.** Millerton, N.Y.,
Aperture, 1979. (History of photography, 14).

2774. Museum of Modern Art (New York). **Walker Evans.** Introd. by
John Szarkowski. New York, Museum of Modern Art, 1980;
distributed by New York Graphic Society, Boston, Mass.
2 ed.

EVENEPOEL, HENRY JACQUES EDOUARD, 1872-1899

2775. Evenepoel, Henri. **Henri Evenepoel à Paris; lettres
choisies 1892-1899.** Editées avec une introduction et
des notes par Francis E. Hyslop. Bruxelles, La
Renaissance du Livre, 1972.

2776. Hellens, Franz. **Henri Evenepoel.** Anvers, De Sikkel,
1947. (Monographies de l'art belge).

2777. Hyslop, Francis E. **Henri Evenepoel, Belgian painter in
Paris, 1892-1899.** University Park, Penn. State
University Press, 1975.

2778. Lambotte, Paul. **Henri Evenepoel.** Bruxelles, van Oest,
1908. (Collection des artistes belges contemporains).

2779. Musée Royaux des Beaux-Arts de Belgique, Bruxelles.
**Hommage à Henri Evenepoel, 1872-1899; oeuvres des
collections publiques de Belgique.** 2 ed. Bruxelles,
Musée Royaux des Beaux-Arts de Belgique, 1973.

EXEKIAS, 6th c. B.C.

2780. Technau, Werner. **Exekias.** Leipzig, Keller, 1936.
(Bilder griechischer Vasen, 9).

EYCK, HUBERT VAN, 1366-1426

JAN VAN, 1390-1440

2781. Baldass, Ludwig. **Jan van Eyck.** New York, Phaidon, 1952.

2782. Beenken, Hermann. **Hubert und Jan van Eyck.** München,
Bruckmann, 1943. 2 ed.

2783. Brignetti, Raffaello. **L'opera completa dei van Eyck.**
Milano, Rizzoli, 1968. (Classici dell'arte, 17).

2784. Brockwell, Maurice W. **The van Eyck Problem.** London,
Chatto & Windus, 1954.

2785. Bruyn, Josua. **Van Eyck problemen.** Utrecht,
Kunsthistorisches Institut, 1957.

2786. Conway, Martin. **The van Eycks and their followers.**
London, Murray, 1921.

2787. Coremans, Paul. **L'agneau mystique au laboratoire, examen
et traitement.** Anvers, De Sikkel, 1953. (Les Primitifs
Flamands, III: Contributions à l'étude des Primitifs
Flamands, 2).

2788. _____ and Bisthoven, A. Jannssens de. **Van Eyck, the
adoration of the mystic lamb.** Antwerp, Nederlandsche
Boekhandel, 1948.

2789. Cornette, A. H. **De protretten van Jan van Eyck.**
Antwerpen, De Sikkel, 1947. (Maerlantbibliotheek, 20).

2790. Devigne, Marguerite. **Van Eyck.** Bruxelles, Kryn, 1926.

2791. Dhanens, Elisabeth. **Van Eyck, the Ghent altarpiece.** New
York, Viking, 1973.

2792. Durand-Greville, E. **Hubert et Jean van Eyck.** Bruxelles,
van Oest, 1910.

2793. Dvorak, Max. **Das Rätsel der Kunst der Brüder van Eyck.**
München, Piper, 1925.

2794. Faggin, Giorgio T. **The complete paintings of the van
Eycks.** New York, Abrams, 1968.

2795. Friedländer, Max J. **Die van Eyck, Petrus Christus.**
Berlin, Cassirer, 1924. (Die Altniederländische
Malerei, 1).

2796. Hotho, H. G. **Die Malerschule Huberts van Eyck, nebst
deutschen Vorgängern und Zeitgenossen.** 2 v. Berlin,
Veit, 1858.

2797. Hymans, Henri. **Les van Eyck.** Paris, H. Laurens, 1908.

2798. Kaemmerer, Ludwig. **Hubert und Jan van Eyck.** Leipzig,
Velhagen & Klasing, 1898. (Künstler-Monographien, 35).

2799. Kerbert, Ottmar. **Hubert van Eyck, die Verwandlung der
mittelalterlichen in die neuzeitliche Gestaltung.**
Frankfurt a.M., Klostermann, 1937.

2800. Knuttel, G. **Hubert en Jan van Eyck.** Amsterdam, Becht,
1949. (Palet serie, 1).

2801. Konody, P. G. **The brothers van Eyck.** London, Bell, 1907.

2802. Lejeune, Jean. **Les van Eyck, peintres de Liège et de sa
cathédrale.** Liège, Thone, 1956.

2803. Pfister, Kurt. **Van Eyck.** München, Delphin, 1922.

2804. Philip, Lotte Brand. The Ghent altarpiece and the art of Jan van Eyck. Princeton, N.J., Princeton University Press, 1971.

2805. Philippe, Joseph. Van Eyck et la genèse mosane de la peinture des anciens pays-bas. Liège, Bénard et Centrale, 1960.

2806. Puyvelde, Leo van. Van Eyck, the holy lamb. Paris, Marion Press, 1947.

2807. Renders, Emile. Hubert van Eyck, personnage de légende. Paris, van Oest, 1933.

2808. _____. Jean van Eyck et le polyptyque, deux problèmes résolus. Bruxelles, Librairie Générale, 1950.

2809. _____. Jean van Eyck, son oeuvre, son style, son évolution et la légende d'un frère peintre. Bruges, Beyaert, 1935.

2810. Scheewe, L. Hubert und Jan van Eyck, ihre literarische Würdigung bis ins 18. Jahrhundert. Haag, Nijhoff, 1933.

2811. Schmarsow, August. Hubert und Jan van Eyck. Leipzig, Hiersemann, 1924. (Kunstgeschichtliche Monographien, 19).

2812. Schopenhauer, Johanna. Johann van Eyck und seine Nachfolger. Frankfurt a.M., Wilmans, 1822.

2813. Waagen, Gustav Friedrich. Ueber Hubert und Johann van Eyck. Breslau, Max, 1822.

2814. Weale, W. H. James. Hubert and John van Eyck, their life and work. London, Lane, 1908.

2815. _____ and Brockwell, Maurice W. The van Eycks and their art. London, Lane, 1912.

2816. Ziloty, Alexandre. La découverte de Jean van Eyck et l'évolution du procédé de la peinture à l'huile du moyen age à nos jours. Paris, Librairie Floury, 1941.

FABRIANO, GENTILE DA see GENTILE DA FABRIANO

FABRITIUS, BARENT, 1624-1673

2817. Miomandre, Francis de. Trois chefs-d'oeuvre de Barent Fabritius. Paris, Brunner, 1914.

2818. Point, Daniël. Barent Fabritius, 1624-1673. Utrecht, Drukkerij Trio, 1958.

FABRITIUS, CAREL, 1622?-1654

2819. Brown, Christopher. Carel Fabritius, complete edition with a catalogue raisonné. Oxford, Phaidon, 1981. (CR).

2820. Hofstede de Groot, Cornelis. Jan Vermeer of Delft and Carel Fabritius; photogravures of all their known paintings. With biographical and descriptive text by C. Hofstede de Groot. Amsterdam, Scheltema, 1909.

2821. Schuurman, K. E. Carel Fabritius. Amsterdam, Becht, 1947.

2822. Tietze-Conrat, E. Die delfter Malerschule; Carel Fabritius, Pieter de Hooch, Jan Vermeer. Leipzig, Seemann, 1922.

FADRUSZ, JÁNOS, 1858-1903

2823. Béla, Lázár. Fadrusz János élete és müveszete. Budapest, Athenaeum, 1923.

FAED, THOMAS, 1826-1900

2824. [James R. Osgood and Company]. The Faed gallery; a series of the most renowned works of Thomas Faed, reproduced in heliotype. Boston, Osgood, 1878.

FAICHTMAYER, JOSEPH ANTON see FAICHTMAYR, JOSEPH ANTON

FAICHTMAYR, JOSEPH ANTON, 1696-1770

2825. Boeck, Wilhelm. Feuchtmayer Meisterwerke. Tübingen, Wasmuth, 1963.

2826. _____. Joseph Anton Feuchtmayer. Tübingen, Wasmuth, 1948.

2827. Sauer, Horst. Herkunft und Anfänge des Bildhauers Joseph Anton Faichtmeyer. Leipzig, Gerhardt, 1932.

FALCONET, ETIENNE MAURICE, 1716-1791

2828. [Falconet, Etienne]. Oeuvres d'Etienne Falconet, statuaire; contenant plusieurs écrits relatifs aux beaux arts. 6 v. Lausanne, Société Typographique, 1781. (CR).

2829. _____. Oeuvres diverses concernant les arts. 3 v. Paris, Didot, 1787. Nouvelle édition.

2830. Hildebrandt, Edmund. Leben, Werke und Schriften des Bildhauers E.-M. Falconet, 1716-1791. Strassburg, Heitz, 1908. (Zur Kunstgeschichte des Auslandes, 63).

2831. Levitine, George. The Sculpture of Falconet. Greenwich, Conn., New York Graphic Society, 1972.

2832. Réau, Louis. Etienne-Maurice Falconet. 2 v. Paris, Demotte, 1922.

2833. Vallon, Fernand. Falconet; Falconet et Diderot, Falconet et Catherine II. Senlis, Imprimeries réunies, 1927.

2834. Weinshenker, Anne B. Falconet, his writings and his friend Diderot. Genève, Droz, 1966.

FANSAGA, COSIMO see FANZAGO, COSIMO

FANZAGO, COSIMO, 1593-1678

2835. Fogaccia, Piero. **Cosimo Fanzago.** Bergamo, Istituto italiano d'arti grafiche, 1945.

2836. Winther, Annemarie. **Cosimo Fanzago und die Neapler Ornamentik des 17. und 18. Jahrhunderts.** Bremen, Hauschild, 1973.

FANTIN-LATOUR, IGNACE HENRI JEAN THEODORE, 1836-1904

2837. Bénédite, Léonce. **Catalogue des lithographies originales de Henri Fantin-Latour.** Paris, Motteroz, 1899.

2838. _____. **Fantin-Latour.** Paris, Librairie de L'Art Ancien et Moderne, 1903. (Les artists de tous les temps; Série D--le XXe siècle).

2839. _____. **L'oeuvre de Fantin-Latour, recueil de cinquante reproductions.** Paris, Librairie Centrale des Beaux-Arts, 1906.

2840. [Fantin-Latour]. **L'oeuvre lithographique de Fantin-Latour; collection complète de ses lithographies reproduites et réduites en fac-similé par le procédé héliographique boyet.** Paris, Delteil, 1907.

2841. Fantin-Latour, Victoria D. **Catalogue de l'oeuvre complet (1849-1904) de Fantin-Latour.** Paris, Floury, 1911. Reprint: New York, Da Capo, 1969. (CR).

2842. Gibson, Frank W. **The art of Henri Fantin-Latour.** London, Drane, 1924.

2843. Hédiard, Germain. **Fantin-Latour, catalogue de l'oeuvre lithographique du maître.** Paris, Librairie de L'Art Ancien et Moderne, 1906. (Les maîtres de la lithographie).

2844. Jullien, Adolphe. **Fantin-Latour, sa vie et ses amitiés; lettres inédites et souvenirs personnels.** Paris, Laveur, 1909.

2845. Kahn, Gustave. **Fantin-Latour.** New York, Dodd, Mead, 1927.

2846. Lucie-Smith, Edward. **Henri Fantin-Latour.** New York, Rizzoli, 1977.

2847. Musée d'Art et d'Histoire (Geneva). **Fantin-Latour lithographies.** [19 décembre-11 février 1981]. Genève, Editions du Tricorne, 1981.

2848. Palais de L'Ecole National des Beaux-Arts (Paris). **Exposition de l'oeuvre de Fantin-Latour, mai-juin 1906.** 2 ed. Paris, Librairie Centrale des Beaux-Arts, 1906.

2849. Smith College Museum of Art (Northampton, Mass.). **Henri Fantin-Latour.** [April 28-June 6, 1966]. Northampton, Mass., Smith College Museum of Art, 1966.

FARINATI, PAOLO, 1524-1606

2850. Farinati, Paolo. **Giornale (1573-1606).** A cura di Lionello Puppi. Firenze, Olschki, 1968. (Civiltà Veneziana fonti e testi, VIII; Serie prima, 5).

2851. Forno, Federico dal. **Paolo Farinati, 1524-1606.** Verona, Vita Veronese, 1965. (Collana monografie d'arte, 6).

FAUCONNIER, HENRI VICTOR GABRIEL

see LE FAUCONNIER, HENRI VICTOR GABRIEL

FATTORI, GIOVANNI, 1825-1908

2852. Bianciardi, Luciano. **L'opera completa di Fattori.** Milano, Rizzoli, 1970. (Classici dell'arte, 42).

2853. Centro d'Arte Dolomiti (Cortina d'Ampezzo). **Omaggio a Giovanni Fattori.** Cortina d'Ampezzo, Centro d'Arte Dolomiti, 1972.

2854. Cisternino del Poccianti (Livorno). **La giovinezza di Fattori, catalogo della mostra, ottobre-dicembre 1980.** Roma, de Luca, 1980. (Archivio dei Macchiaioli, 2).

2855. Di Micheli, Mario. **Giovanni Fattori.** Busto Arsizio, Bramante, 1961. (I grandi pittori italiani dell'ottocento, 4).

2856. Franchi, Anna. **Giovanni Fattori, studio biografico.** Firenze, Alinari, 1910.

2857. _____. **Giovanni Fattori, Silvestro Lega, Telemaco Signorini; conferenze e saggi.** Milano, Ceschina, 1953.

2858. Francini Ciaranfi, Anna M. **Incisioni del Fattori.** Bergamo, Istituto italiano d'arti grafiche, 1944.

2859. Galleria Nazionale d'Arte Moderna (Roma). **Disegni di Giovanni Fattori del Museo Civico di Livorno.** 19 dicembre 1970-31 gennaio 1971. Rome, de Luca, 1970.

2860. Ghiglia, Oscar. **L'opera di Giovanni Fattori.** Firenze, Edizioni Self, 1913.

2861. Malesci, Giovanni. **Catalogazione illustra della pittura ad olio di Giovanni Fattori.** Novara, de Agostini, 1961.

2862. La Meridiana di Palazzo Pitti (Florence). **Le acqueforti di Fattori della collezione Rosselli.** 12 guigno-31 dicembre 1976. Firenze, La Meridiano di Palazzo Pitti, 1976. (Galleria d'arte moderna di Palazzo Pitti, Firenze, 1).

2863. Paolieri, Ferdinando. **Giovanni Fattori, il maestro Toscano del secolo XIX.** Firenze, Benaglia, 1925.

FAUTRIER, JEAN, 1898-1964

2864. Argan, Gian-Carlo. **Fautrier, matière et mémoire; testo: italiano, francese, inglese, tedesco.** Milano, Apollonaire, 1960.

2865. Bucarelli, Palma. **Jean Fautrier, pittura e materia.** Milano, Il Saggiatore, 1960. (La Cultura, Vol. XX).

2866. Galerie Engleberts (Geneva). **Jean Fautrier; oeuvre gravé, oeuvre sculpté; essai d'un catalogue raisonné.** Genève, Galerie Engleberts, 1969. (CR).

2867. Josef-Haubrich-Kunsthalle (Cologne). **Jean Fautrier; Gemälde, Skulpturen und Handzeichnungen.** 23. Februar bis 7. April 1980. Köln, Josef-Haubrich-Kunsthalle, 1980.

2868. Kunstverein Hamburg. **Jean Fautrier.** 19. Mai-17. Juni 1973. Hamburg, Kunstverein, 1973.

2869. Musée d'Art Moderne de la Ville de Paris. **Jean Fautrier, rétrospective, avril-mai 1964.** Paris, Les Presses Artistiques, 1964.

2870. Paulhan, Jean. **Fautrier l'enragé.** Paris, Gallimard, 1962.

2871. _____. **Fautrier, oeuvres (1915-1943).** Paris, Drouin, 1943.

2872. Ragon, Michel. **Fautrier.** Paris, Fall, 1957. (Le Musée de Poche).

FEICHTMAYR, JOSEPH ANTON see FAICHTMAYR, JOSEPH ANTON

FEININGER, LYONEL, 1871-1956

2873. Dorfles, Gillo. **Lyonel Feininger.** Milano, Scheiwiller, 1958. (All'Insegna de Pesce d'Oro, Serie illustrata, 62).

2874. Feininger, T. Lux. **Lyonel Feininger, city at the edge of the world.** New York, Praeger, 1965.

2875. Haus der Kunst (Munich). **Lyonel Feininger, 1871-1956.** 24. März bis 13. Mai 1973. München, Haus der Kunst, 1973.

2876. Hess, Hans. **Lyonel Feininger.** New York, Abrams, 1961.

2877. Museum für Kunst und Gewerbe (Hamburg). **Lyonel Feininger; Karikaturen, Comic strips, Illustrationen, 1888-1915.** [9. Januar-22. Februar 1981]. Hamburg, Museum für Kunst und Gewerbe, 1981.

2878. Museum of Modern Art (New York). **Lyonel Feininger; Marsden Hartley.** New York, Museum of Modern Art, 1944.

2879. Ness, June L., ed. **Lyonel Feininger [letters].** New York, Praeger, 1974. (Documentary Monographs in Modern Art).

2880. Prasse, Leona E. **Lyonel Feininger; a descriptive catalogue of his graphic work: etchings, lithographs, woodcuts.** Cleveland, Cleveland Museum of Art, 1972. (CR).

2881. Ruhmer, Eberhard. **Lyonel Feininger; Zeichnungen, Aquarelle, Graphik.** München, Bruckmann, 1961.

2882. Scheyer, Ernst. **Lyonel Feininger, caricature & fantasy.** Detroit, Wayne State University Press, 1964.

2883. Wolfradt, Willi. **Lyonel Feininger.** Leipzig, Klinkhardt & Biermann, 1924. (Junge Kunst, 47).

FEKE, ROBERT, 1705?-1750

2884. Bayley, Frank W. **Five colonial artists of New England: Joseph Badger, Joseph Blackburn, John Singleton Copley, Robert Feke, John Smibert.** Boston, [Privately printed], 1929.

2885. Foote, Henry W. **Robert Feke, colonial portrait painter.** Cambridge, Harvard University Press, 1930.

2886. Poland, William C. **Robert Feke, the early Newport portrait painter and the beginnings of colonial painting.** Providence, Rhode Island Historical Society, 1907.

2887. Smith, Albert D. **Robert Feke, native colonial painter.** [Exhibition, Nov. 2-Nov. 10, 1946]. Huntington, N.Y., Heckscher Art Museum, 1946.

2888. Whitney Museum of American Art (New York). **Robert Feke.** October 8-30, 1946. [Text by Lloyd Goodrich]. New York, Whitney Museum, 1946.

FELIXMUELLER, CONRAD, 1897-1977

2889. Germanisches Nationalmuseum (Nuremberg). **Conrad Felixmüller, Werke und Documente.** [Dec. 3, 1981-Jan. 31, 1982]. Nürnberg, Germanisches Nationalmuseum, 1982.

2890. Heinz, Hellmuth. **Conrad Felixmüller, gezeichnetes Menschenbild.** Dresden, Verlag der Kunst, 1958.

2891. Söhn, Gerhart. **Conrad Felixmüller, das graphische Werk, 1912-1974.** Düsseldorf, Graphik-Salon, 1975.

2892. _____. **Conrad Felixmüller, von ihm--über ihn.** Düsseldorf, Graphik-Salon, 1977.

2893. Verein Berliner Künstler. **Conrad Felixmüller: Ausstellungen seiner Malereien von 1913 bis 1973. Gemälde,** 12. Okt.-11. Nov. 1973 in den Räumen der ehemaligen Nationalgalerie; Aquarelle, 13. Okt.-11. Nov. 1973 in der Galerie des Vereins. Berlin, Verein Berliner Künstler, 1973.

2894. Wächter, Bernhard. **Das kleine Holzschnittbuch von Conrad Felixmüller.** Rudolstadt, Greifenverlag, 1958.

FENTON, ROGER, 1819-1869

2895. Gernsheim, Helmut and Gernsheim, Alison. **Roger Fenton, photographer of the Crimean War; his photographs and his letters from the Crimea.** London, Secker & Warburg, 1954. Reprint: New York, Arno, 1973.

2896. Hannavy, John. **Roger Fenton of Crimble Hall.** London, Fraser, 1975. (The Gordon Fraser Photographic Monographs, 3).

FERENCZY, KÁROLY, 1862-1917

2897. Genthon, István. **Ferenczy Károly.** Budapest, Képzömuvészeti Alap Kiadóvállata, 1963.

2898. Magyar Nemzeti Gelerija (Budapest). **Die Familie Ferenczy.** Budapest, Magyar Nemzeti Galeria, 1968.

2899. Petrovics, Elek. **Ferenczy.** Budapest, Athenaeum, 1943.

FERNANDEZ, ARMAN D. see ARMAN

FERRARI, GAUDENZIO, 1480-1546

2900. Bordiga, Gaudenzio. **Notizie intorno alle opere di Gaudenzio Ferrari, pittore e plasticatore.** Milano, Pirotta, 1821.

2901. _____, et al. **Le opere del pittori e plasticatore Gaudenzio Ferrari.** Milano, Molina, 1835-1846.

2902. Colombo, Giuseppe. **Vita ed opera di Gaudenzio Ferrari pittore con documenti inediti.** Torino, Bocca, 1881.

2903. Halsey, Ethel. **Gaudenzio Ferrari.** London, Bell, 1904.

2904. Mallé, Luigi. **Incontri con Gaudenzio, raccolta di studi e note su problemi gaudenziani.** Torino, Tipografia Impronta, 1969.

2905. Museo Borgogna (Vercelli). **Mostra da Gaudenzio Ferrari.** Aprile-guigno 1956. Milano, Molina, 1956.

2906. Perpenti, A. **Elogio di Gaudenzio Ferrari, pittore e plastificatore.** Milano, Molina, 1843.

2907. Regaldi, Giuseppe. **Nella solenne inaugurazione del monumento a Gaudenzio Ferrari in Varallo-Sesai, 6 settembre 1874.** Firenze, Cellini, 1875.

2908. Testori, Giovanni. **Il gran teatro montano, saggi su Gaudenzio Ferrari.** Milano, Feltrinelli, 1965.

2909. Viale, Vittorio. **Gaudenzio Ferrari.** Torino, Edizioni RAI, 1969.

2910. Weber, Siegfried. **Gaudenzio Ferrari und seine Schule.** Strassburg, Heitz, 1927.

FERRER BASSA, 1290-1348

2911. Trens, Manuel. **Ferrer Bassa i les pintures de pedrables.** Barcelona, Institut d'Estudis Catalans, 1936. (Memòries de la Seccio Històrico-Arqueològica, 6).

FEUCHTMAYR, JOSEPH ANTON see FAICHTMAYR, JOSEPH ANTON

FEUERBACH, ANSELM, 1829-1880

2912. Allgeyer, Julius. **Anselm Feuerbach.** 2 v. Berlin, Spemann, 1904.

2913. _____. **Anselm Feuerbach, sein Leben und seine Kunst.** Bamberg, Buchner, 1894.

2914. Christoffel, Ulrich. **Anselm Feuerbach.** München, Bruckmann, 1944.

2915. Feuerbach, Anselm. **Briefe an seine Mutter.** Berlin, Meyer & Jessen, 1911.

2916. _____. **Ein Vermächtnis.** Wien, Gerald'ssohn, 1890. 3 ed.

2917. Gerstenberg, Kurt. **Anselm Feuerbach, aus unbekannten Skizzenbüchern der Jugend.** München, Piper, 1925.

2918. Heyck, Eduard. **Anselm Feuerbach.** Bielefeld/Leipzig, Velhagen & Klasing, 1905. (Künstler-Monographien, 76).

2919. Oechelhaeuser, Adolf von. **Aus Anselm Feuerbachs Jugendjahren.** Leipzig, Seemann, 1905.

2920. Staatliche Kunsthalle Karlsruhe. **Anselm Feuerbach, 1829-1880, Gemälde und Zeichnungen.** 5. Juni-15. August, 1976. Karlsruhe, Staatliche Kunsthalle, 1976.

2921. Uhde-Bernays, Hermann. **Feuerbach; des Meisters Gemälde.** Stuttgart, Deutsche Verlags-Anstalt, 1913. (Klassiker der Kunst, 23).

2922. _____. **Feuerbach; beschreibender Katalog seiner sämtlichen Gemälde.** München, Bruckmann, 1929.

2923. Waldmann, Emil. **Anselm Feuerbach.** Berlin, Rembrandt, 1942. (Die Kunstbücher des Volkes, 41).

FIELD, ROBERT, ca. 1769-1819

2924. Art Gallery of Nova Scotia (Halifax). **Robert Field, 1769-1819.** Oct. 5 to Nov. 27, 1978. [Text in English and French]. Halifax, Art Gallery of Nova Scotia, 1978.

2925. Piers, Harry. **Robert Field, portrait painter in oils, miniatures, and water-colours, and engraver.** New York, Sherman, 1927.

FIESOLE, MINO DA see MINO DA FIESOLE

FILARETE, 1400-1469

2926. Filarete. **Treatise on architecture, being the treatise by Antonio di Piero Averlino, known as Filarete.** 2 v. New Haven, Yale University Press, 1965. (Yale publications in the history of art, 16).

2927. Lazzaroni, Michele and Muñoz, Antonio. **Filarete, scultore e architetto del secolo XV.** Roma, Modes, 1908.

2928. Moos, Stanislaus von. **Die Kastelltyp-Variationen des Filarete.** Zürich, Atlantis, 1971.

2929. Oettingen, Wolfgang von. **Über das Leben und die Werke des Antonio Averlino gennant Filarete, eine Studie.** Leipzig, Seemann, 1888. (Beiträge zur Kunstgeschichte, N.F., 6).

2930. Tigler, Peter. **Die Architekturtheorie des Filarete.** Berlin, de Gruyter, 1963. (Neue Münchner Beiträge zur Kunstgeschichte, 5).

FINI, TOMMASO DI CRISTOFERO see MASOLINO DA PANICALE

FINIGUERRA, TOMMASO, 1426-1464

2931. Colvin, Sidney. **A Florentine picture-chronicle, being a**

series of ninety-nine drawings representing scenes and personages of ancient history sacred and profane, by **Masso Finiguerra.** [With] a critical and descriptive text by Sidney Colvin. London, Quaritch, 1898. Reprint: New York, Bloom, 1970.

FIORENZO DI LORENZO, 1445-1525

2932. Graham, Jean C. **The problem of Fiorenzo di Lorenzo of Perugia, a critical and historical study.** Perugia, Domenico Terese, 1903.

2933. Weber, Siegfried. **Fiorenzo di Lorenzo, eine kunst-historische Studie.** Strassburg, Heitz, 1904. (Zur Kunstgeschichte des Auslandes, 27).

FIRENZE, AGOSTINO DA see ACOSTINO DI DUCCIO

FISCHER, JOHANN MICHAEL, 1692-1766

2934. Hagen-Dempf, Felicitas. **Der Zentralbaugedanke bei Johann Michael Fischer.** München, Schnell & Steiner, 1954.

2935. Heilbronner, Paul. **Studien über Johann Michael Fischer.** München, Heller, 1933.

2936. Lieb, Norbert. **Johann Michael Fischer: Baumeister und Raum-schöpfer im späten Barock Süddeutschlands.** Regensburg, Pustet, 1982.

FISCHER VON ERLACH, JOHANN BERNHARD, 1656-1723
JOSEPH EMANUEL, 1693-1742

2937. Aurenhammer, Hans. **J. B. Fischer von Erlach.** Cambridge, Mass., Harvard University Press, 1973.

2938. _____. **Johann Bernhard Fischer von Erlach, 1656-1723. Katalog der Ausstellung: Graz, Wien, Salzburg, 1956-57.** Wien/München, Schroll, 1956.

2939. _____. **Johann Bernhard Fischer von Erlach.** Wien, Bergland, 1957. (Österreich-Reihe, 35/37).

2940. Fischer von Erlach, Johann Bernhard. **Entwurff einer historischen Architectur.** Leipzig, 1725. (Reprint: Boston, Gregg, 1964; English trans.: 1737).

2941. Frey, Dagobert. **Johann Bernhard Fischer von Erlach, eine Studie über seine Stellung in der Entwicklung der Wiener Palastfassade.** Wien, Hölzel, 1923. (Kunstgeschichtliche Einzeldarstellungen, 6).

2942. Ilg, Albert. **Die Fischer von Erlach.** Wien, Konegen, 1895.

2943. Kunoth, George. **Die historische Architektur Fischers von Erlach.** Düsseldorf, Schwann, 1956. (Bonner Beiträge zur Kunstwissenschaft, 5).

2944. Lanchester, Henry V. **Fischer von Erlach.** London, Benn, 1924.

2945. Schmidt, Justus. **Fischer von Erlach der Jüngere.** Wien, Verein für Geschichte der Stadt Wien, 1933.

2946. Sedlmayr, Hans. **Johann Bernhard Fischer von Erlach.** Wien, Herold, 1976. 2 ed.

2947. Zacharias, Thomas. **Joseph Emanuel Fischer von Erlach.** Wien/München, Herold, 1960.

FLAXMAN, JOHN, 1755-1826

2948. Bentley, G. A., Jr. **The early engravings of Flaxman's classical designs, a bibliographical study.** New York, New York Public Library, 1964.

2949. Colvin, Sidney. **The drawings of Flaxman in the gallery of University College, London.** London, University College, 1876.

2950. Constable, William G. **John Flaxman, 1755-1826.** London, University of London, 1927.

2951. Essick, Robert and LaBelle, Jenijoy. **Flaxman's illustrations to Homer; drawn by John Flaxman, engraved by William Blake and others.** Edited with an introduction and commentary. New York, Dover, 1977.

2952. Flaxman, John. **Anatomical studies of the bones and muscles for the use of artists.** London, Nattali, 1833.

2953. _____. **Lectures on sculpture.** London, Murray, 1829.

2954. Hamburger Kunsthalle. **John Flaxman, Mythologie und Industrie.** 20. April bis 3. Juni 1979. Hamburg, Hamburger Kunsthalle, 1979.

2955. Irwin, David. **John Flaxman, 1755-1826; sculptor, illustrator, designer.** New York, Rizzoli, 1979.

2956. Sparkes, John C. L. **Flaxman's classical outlines; notes on their leading characteristics, with a brief memoir of the artist.** London, Seeley, Jackson and Halliday, 1879.

2957. Wark, Robert R. **Drawings by John Flaxman in the Huntington Collection.** San Marino, Calif., Huntington Library, 1970.

2958. Whinney, Margaret and Gunnis, Rupert. **The collection of models by John Flaxman, R. A., at University College, London; a catalogue and introduction.** London, Athlone Press, 1967.

FLEGEL, GEORG, 1563-1638

2959. Müller, Wolfgang J. **Der Maler Georg Flegel und die Anfänge des Stillebens.** Frankfurt a.M., Kramer, 1956. (Schriften des Historischen Museums, 8).

2960. Winkler, Friedrich. **Georg Flegel, sechs Aquarelle.** Berlin, Deutscher Verein fur Kunstwissenschaft, 1954.

FLEISCHMANN, ADOLF, 1892-1968

2961. Galerie der Stadt Esslingen, Villa Merkel. **Adolf Fleischmann.** 18. April bis 1. Juni 1975. Esslingen, Kulturamt der Stadt Esslingen, 1975.

2962. Wedewer, Rolf. **Adolf Fleischmann.** Stuttgart, Hatje, 1977.

FLETTNER, PETER, ca. 1485-1546

2963. Bange, E. F. **Peter Flötner.** Leipzig, Klinkhardt & Biermann, 1926. (Meister der Graphik, 14).

2964. Germanisches Nationalmuseum (Nuremberg). **Peter Flötner und die Renaissance in Deutschland.** 14. Dezember 1946-28. Februar 1947. Nürnberg, Die Egge, 1947.

2965. Haupt, Albrecht. **Peter Flettner, der erste Meister des Ott-Heinrichsbaus zu Heidelberg.** Leipzig, Hiersemann, 1904. (Kunstgeschichtliche Monographien, 1).

2966. Lange, Konrad. **Peter Flötner, ein Bahnbrecher der deutschen Renaissance.** Berlin, Grote, 1897.

2967. Leitschuh, Franz F. **Flötner-Studien, 1: das Plakettenwerk Peter Flötners in dem Verzeichnis des Nürnberger Patriziers Paulus Behaim.** Strassburg, Beust, 1904.

2968. Reimers, J. **Peter Flötner nach seinen Handzeichnungen und Holzschnitten.** München/Leipzig, Hirth, 1890.

2969. Röttinger, Heinrich. **Peter Flettners Holzschnitte.** Strassburg, Heitz, 1916. (Studien zur deutschen Kunstgeschichte, 186).

FLÖTNER, PETER see FLETTNER, PETER

FLORIS, CORNELIS, 1514-1575

 FRANS, 1517-1570

2970. Corbet, August. **Cornelis Floris en de bouw van het stadhuis van Antwerpen.** Antwerpen, De Sikkel, 1937.

2971. Hedicke, Robert. **Cornelis Floris und die Florisdekoration.** 2 v. Berlin, Bard, 1913.

2972. Velde, Carl van de. **Frans Floris (1519/20-1570), leven en werken.** 2 v. Brussel, Academie voor Wetenschapen, 1975.

2973. Zuntz, Dora. **Frans Floris, ein Beitrag zur Geschichte der niederländischen Kunst im XVI. Jahrhundert.** Strassburg, Heitz, 1929. (Zur Kunstgeschichte des Auslands, 130).

FOHR, CARL PHILIPP, 1795-1818

2974. Dieffenbach, Philipp. **Das Leben des Malers Karl Fohr.** Erstmalig gedruckt 1823. Frankfurt a.M., Voigtländer-Tetzner, 1918.

2975. Hardenberg, Kuno F. Graf von [and] Schilling, Edmund. **Karl Philipp Fohr, Leben und Werk eines deutschen Malers der Romantik.** Freiburg i.Br., Urban Verlag, 1925.

2976. Jensen, Jens. **Carl Philipp Fohr in Heidelberg und im Neckartal, Landschaften und Bildnisse.** Karlsruhe, Braun, 1968.

2977. Poensgen, Georg. **Carl Philipp Fohr und das Café Greco. Die Künstlerbildnisse des Heidelberger Romantikers im geschichtlichen Rahmen der berühmten Gaststätte an der Via Condotti zu Rom.** Heidelberg, Kerle, 1957.

2978. Schneider, Arthur von. **Carl Philipp Fohr, Skizzenbuch.**

Bildniszeichnungen deutscher Künstler in Rom. Berlin, Mann, 1952.

2979. Städelsches Kunstinstitut (Frankfurt a.M.). **Karl Philipp Fohr, 1795-1818.** 21. Juni-11. August 1968. Frankfurt a.M., Städelsches Kunstinstitut, 1968.

FOLGORE DA SAN GIMIGNANO, fl. 1309-1317

2980. Caravaggi, Giovanni. **Folgore da S. Gimignano.** Milano, Ceschina, 1960. (Pubblicazioni della Facoltà di Filosofia e Lettere dell'Università di Pavia, 10).

FONTANA, CARLO, 1634-1714

2981. Braham, Allan and Hager, Hellmut. **Carlo Fontana, the drawings at Windsor Castle.** London, Zwemmer, 1977. (Studies in Architecture, 18).

2982. Coudenhove-Erthal, Eduard. **Carlo Fontana und die Architektur des römischen Spätbarocks.** Wien, Schroll, 1930.

2983. Fontana, Carolo. **Templum Vaticanum et ipsius origo, cum aedificiis maxime conspicuis antiquitus & recens ibidem constitutis.** Romae, Jo. Francisci Buagni, 1694.

FONTANA, DOMENICO, 1543-1607

2984. Fontana, Domenico. **Della trasportatione dell'obelisco Vaticano et delle fabriche di Nostro Signore Papa Sisto V.** Roma, Domenico Basa, 1590. Reprint: Milano, Edizioni il Profilo, 1978.

2985. Muñoz, Antonio. **Dominico Fontana, architetto, 1543-1607.** Roma, Cremonese, 1944. (Quaderni Italo-Svizzeri, 3).

FONTANA, LAVINIA, 1552-1614

2986. Galli, Romeo. **Lavinia Fontana, pittrice, 1552-1614.** Imola, Galeati, 1940.

FONTANA, LUCIO, 1899-1968

2987. Ballo, Guido. **Lucio Fontana.** New York, Praeger, 1971.

2988. Castello Sforzesco (Milan). **Fontana, disegni; opere donate alle collezioni civiche de Milano.** 19 maggio-31 luglio, 1977. Milano, Electa, 1977.

2989. Crispolti, Enrico. **Carriera "barocca" di Fontana, un saggio e alcune note.** Milano, all'Insegna del Pesce d'Oro, 1963. (Fascicoli del verri, 10).

2990. Istituto Italo-Latino Americano (Rome). **L. Fontana.** 1972, 2 marzo-15 aprile. Roma, Istituto Italo-Latino Americano, 1972.

2991. Marck, Jan van der, and Crispolti, Enrico. **Lucio Fontana.** 2 v. Bruxelles, La Connaissance, 1974. (CR).

2992. Palazzo Pitti (Florence). **Fontana.** Aprile-giugno 1980. Firenze, Vallecchi, 1980.

2993. Palazzo Reale (Milan). **La donazione Lucio Fontana.** Proposta per una sistemazione museografica. 28 novembre 1978-31 gennaio 1979. Milano, Multipla Edizioni, 1978.

2994. Persico, Eduardo. **Lucio Fontana.** Milano, Campo Grafico, 1936.

2995. Pica, Agnoldomenico. **Fontana.** Venezia, Cavallino, 1953.

2996. Solomon R. Guggenheim Museum (New York). **Lucio Fontana, 1899-1968; a retrospective.** New York, Guggenheim Foundation, 1977.

2997. Tapié, Michel. **Devenir de Fontana.** Torino, Pozzo, 1961.

2998. Zocchi, Juan. **Lucio Fontana.** Buenos Aires, Poseidon, 1946.

FONTANESI, ANTONIO, 1818-1882

2999. Bernardi, Marziano. **Antonio Fontanesi.** Milano, Mondadori, 1933.

3000. _____. **Fontanesi.** Torino, RAI, 1968.

3001. Calderini, Marco. **Antonio Fontanesi, pittore-paesista, 1818-1882.** Torino, Paravia, 1901.

3002. Carrà, Carlo. **Antonio Fontanesi.** Rome, Valori Plastici, 1924.

3003. Carrà, Massimo. **Antonio Fontanesi.** Milano, Fabbri, 1966.

3004. Museo Nazionale d'Arte Moderna, Tokyo. **Fontanesi, ragusa e l'arte giapponese nel primo periodo Meiji.** 7 ott.-27 nov. 1977. Tokyo, Museo Nazionale d'Arte Moderna, 1977.

FOPPA, VINCENZO, 1428-1516

3005. Cipriani, Renata, et al. **La Cappella Portinari in Sant'eustorgio a Milano.** Milano, Electa, 1963.

3006. Ffoulkes, Constance J. **Vincenzo Foppa of Brescia, founder of the Lombard school; his life and work.** London, Lane, 1909.

3007. Matalon, Stella. **Vincenzo Foppa.** Milano, Fabbri, 1965. (I maestri del colore, 58).

3008. Rotondi, Pasquale. **Vincenzo Foppa in S. Maria di Castello a Savona.** Genova [privately printed], 1958. (Quaderni della soprintendenza alle gallerie et opere d'arte della Liguria, 8).

3009. Wittgens, Fernanda. **Vincenzo Foppa.** Milano, Pizzi, [1948].

FORAIN, JEAN LOUIS, 1852-1931

3010. Bibliothèque Nationale (Paris). **J.-L. Forain, peintre, dessinateur et graveur; exposition organisée pour le centenaire de sa naissance.** Juin-septembre 1952. Paris, Bibliothèque Nationale, 1952.

3011. Bory, Jean-François. **Forain [les dessin satiriques].** Paris, Veyrier, 1979.

3012. Browse, Lillian. **Forain, the painter; 1852-1931.** London, Elek, 1978.

3013. D. Caz-Delbo Galleries (New York). **Exhibition Forain; paintings, drawings, prints.** [Nov. 25-Dec. 25, 1931]. New York, Caz-Delbo Galleries, 1931.

3014. Danforth Museum (Framingham, Mass.). **Jean-Louis Forain, 1852-1931; works from New England Collections.** 14 Oct.-31 Nov., 1979. Framingham, Danforth Museum, 1979.

3015. Daudet, Alphonse. **Album de Forain.** Paris, Empis, 1893.

3016. Dodgson, Campbell. **Forain; draughtsman, lithographer, etcher.** New York, Knoedler, 1936.

3017. Faxon, Alicia Craig. **Jean-Louis Forain, a catalogue raisonné of the prints.** New York, Garland, 1982. (CR).

3018. Guérin, Marcel. **J.-L. Forain, aquafortiste; catalogue raisonné de l'oeuvre gravé de l'artiste.** 2 v. Paris, Floury, 1912. (CR).

3019. _____. **J.-L. Forain, lithographe; catalogue raisonné de l'oeuvre lithographié de l'artiste.** Paris, Floury, 1910. (CR).

3020. Museum of Fine Arts (Springfield, Mass.). **Jean-Louis Forain, 1852-1931.** April 15-May 20, 1956. Springfield, Museum of Fine Arts, 1956.

3021. Salaman, Malcolm C. **J. L. Forain.** London, The Studio, 1925. (Modern Masters of Etching, 4).

FORLI, MELOZZO DA see MELOZZO DA FORLI

FORTUNY, MARIANO

see FORTUNY Y CARBO, MARIANO JOSÉ MARIA BERNARDO

FORTUNY Y CARBO, MARIANO JOSÉ MARIA BERNARDO, 1838-1874

3022. Ciervo, Joaquin. **El arte y el vivir de Fortuny.** Barcelona, Bayes, n.d.

3023. Davillier, Jean C. **Fortuny, sa vie, son oeuvre, sa correspondance.** Paris, Aubry, 1875. (CR).

3024. Gil Fillol, Luis. **Mariano Fortuny: su vida, su obra, su arte.** Barcelona, Iberia, 1952.

3025. Pompey Salgueiro, Francisco. **Fortuny.** Madrid, Publicaciones Españolas, 1958. (Temas españoles, 72).

3026. Yriarte, Charles E. **Fortuny.** Librairie d'Art, 1886. (Les artistes célèbres).

3027. Yxart y Morgas, José. **Fortuny; noticia biografica critica.** Barcelona, Arte y Letras, 1881.

FOUJITA, TSUGOHARU, 1886-1974

3028. Bauer, Gerard. **Foujita, l'homme et le peintre.** Paris, Les Presses Artistiques, 1958.

3029. George Walter Vincent Smith Art Gallery (Springfield, Mass.). **Modern French paintings and prints, also drawings and prints by M. Foujita Tsugoharu.** Springfield, Mass., George Walter Vincent Smith Art Gallery, 1931.

3030. Morand, Paul. **Foujita, avec des souvenirs d'enfance de l'artiste et un commentaire par Charles-Albert Cingria.** Paris, Chroniques du Jour, 1928.

3031. Vaucaire, Michel-Gabriel. **Foujita.** Paris, Crès, 1924.

FOUQUET, JEAN, 1415-1480

3032. Bazin, Germain. **Fouquet.** Genève, Skira, 1942. (Les trésors de la peinture française, Tome I, 4).

3033. Castelnuovo, E. **Jean Fouquet.** Milano, Fabbri, 1966. (I maestri del colore, 168).

3034. Cox, Trenchard. **Jehan Foucquet, native of Tours.** London, Faber, 1931.

3035. Durrieu, Paul. **Les antiquités judaïques et le peintre Jean Fouquet.** Paris, Plon, 1908.

3036. _____. **Livre d'heures peint par Jean Foucquet pour maître Etienne Chevalier.** Paris, La Société Française, 1923.

3037. Fouquet, Jehan. **Oeuvre.** 2 v. Paris, Curmer, 1866-1867.

3038. Gruyer, François Anatole. **Chantilly, les quarante Fouquet.** Paris, Plon, 1897.

3039. Heywood, Florence. **The Life of Christ and his Mother according to Jean Fouquet.** London, Methuen, 1927.

3040. Lafenestre, Georges. **Jehan Fouquet.** Paris, Baranger, 1905.

3041. Melet-Sanson, J. **Fouquet.** Paris, Scrépel, 1977.

3042. Perls, Klaus G. **Jean Fouquet.** London/Paris/New York, Hyperion, 1940.

3043. Sterling, Charles and Schaefer, Claude. **The hours of Etienne Chevalier [by] Jean Fouquet.** New York, Braziller, 1971.

3044. Thompson, Henry Y. **Facsimiles of two "Histoires" by Jean Foucquet from Vols. I and II of the Anciennetés des Juifs . . . to which is added a notice with two photographs and four three-colour photographs.** [Notes by Henry Yates Thompson]. London, Chiswick Press, 1903.

3045. Wescher, Paul. **Jean Fouquet and his time.** Trans. E. Winkworth. [London], Pleiades, 1947.

FRA ANGELICO see ANGELICO, FRA

FRAGONARD, JEAN HONORE, 1732-1806

3046. Ananoff, Alexandre. **L'oeuvre dessiné de Jean-Honoré Fragonard (1732-1806).** 4 v. Paris, de Nobele, 1961-70. (CR).

3047. Feuillet, Maurice. **Les dessins d'Honoré Fragonard et de Hubert Robert des Bibliothèque et Musée de Besançon.** Paris, Delteil, 1926. (Les plus beaux dessins des musées de France, 1).

3048. Grappe, Georges. **H. Fragonard, peintre de l'amour au XVIII^e siècle.** 2 v. Paris, Piazza, 1913.

3049. _____. **La vie et l'oeuvre de J.-H. Fragonard.** Paris, Les Editions Pittoresques, 1929.

3050. Guimbaud, Louis. **Fragonard.** Paris, Plon, 1947.

3051. _____. **Saint-Non et Fragonard, d'après des documents inédits.** Paris, Goupy, 1928.

3052. Josz, Virgile. **Fragonard.** Paris, Société du Mercure de France, 1901.

3053. Kahn, Gustave. **Jean Honoré Fragonard.** Paris, Librairie Internationale, 1907.

3054. Mandel, Gabriele. **L'opera completa di Fragonard.** Milano, Rizzoli, 1972. (Classici dell'arte, 62).

3055. Mauclair, Camille. **Fragonard, biographie critique.** Paris, Laurens, 1904.

3056. Mongan, Elizabeth, et al. **Fragonard, drawings for Ariosto.** Published for the National Gallery of Art, Washington, D.C. [and] the Harvard College Library, Cambridge, Mass., New York, Pantheon, 1945.

3057. Musée des Arts Décoratifs (Paris). **Exposition d'oeuvres de J.-H. Fragonard.** 7 juin-10 juillet 1921. Paris, Musée des Arts Décoratifs, 1921.

3058. Naquet, Félix. **Fragonard.** Paris, Librairie de l'Art, 1890.

3059. National Museum of Western Art (Tokyo). **Fragonard.** 18 March-11 May 1980. Tokyo, National Museum of Western Art, 1980.

3060. Noldac, Pierre de. **J.-H. Fragonard, 1732-1806.** Paris, Goupil, 1906.

3061. Portalis, Roger. **Honoré Fragonard, sa vie et son oeuvre.** 2 v. Paris, Rothschild, 1889.

3062. Réau, Louis. **Fragonard.** Paris, Skira, 1938. (Les trésors de la peinture française).

3063. _____. **Fragonard, sa vie et son oeuvre.** Bruxelles, Elsevier, 1956.

3064. Thuillier, Jacques. **Fragonard.** Geneva, Skira, 1967; dist. by Cleveland, World. (The Taste of Our Time, 46).

3065. Traz, Georges de. **Les dessins de Fragonard.** Paris, Perret, 1954.

3066. Wakefield, David. **Fragonard.** London, Oresko, 1976.

3067. Wildenstein, Georges. **The paintings of Fragonard, complete edition.** London, Phaidon, 1960.

3068. Williams, Eunice. **Drawings by Fragonard in North American**

collections. [National Gallery of Art, Washington; Nov. 19, 1978-Jan. 21, 1979]. Washington, D.C., National Gallery of Art, 1978.

FRANCESCA, PIERO DELLA, 1416-1492

3069. Alazard, Jean. **Piero della Francesca.** Paris, Plon, 1948.

3070. Battisti, Eugenio. **Piero della Francesca.** 2 v. Milano, Istituto Editoriale Italiano, 1971.

3071. Berenson, Bernard. **Piero della Francesca or the ineloquent in art.** London, Chapman & Hall, 1954.

3072. Bianconi, Piero. **All the paintings of Piero della Francesca.** New York, Hawthorne, 1962. (Complete Library of World Art, 5).

3073. Borra, Pompeo. **Piero della Francesca.** Milano, Istituto Editoriale Italiano, 1950.

3074. Buono, O. del and Vecchi, P. de. **L'opera completa di Piero della Francesca.** Milano, Rizzoli, 1967. (Classici dell'arte, 9).

3075. Chiasserini, Vera. **La pittura a Sansepolcro e nell'alta valle Tiberina, primo di Piero della Francesca.** Firenze, Olschki, 1951. (Collana di monografie storiche e artistiche Altotiberine, 1).

3076. Clark, Kenneth. **Piero della Francesca, complete edition.** London/New York, Phaidon, 1969.

3077. Davis, Margaret D. **Piero della Francesca's mathematical treatises, the Trattato d'abaco and Libellus de quinque corporibus regularibus.** Ravenna, Longo, 1977.

3078. Focillon, Henri. **Piero della Francesca.** Paris, Colin, 1952.

3079. Formaggio, Dino. **Piero della Francesca.** Milano, Mondadori, 1957. (Biblioteca moderna Mondadori, 492).

3080. Francesco, Piero della. **De prospectiva pingendi.** A cura di Nico Fasola. 2 v. Firenze, Sansoni, 1942. (Raccolta di fonti per la storia dell'arte, 5).

3081. _____. **Trattato d'abaco.** Pisa, Domus Galilaeana, 1970. (Testimonianze di storia della cienza, 6).

3082. Gilbert, Creighton. **Change in Piero della Francesca.** Locust Valley, N.Y., Augustin, 1968.

3083. Graber, Hans. **Piero della Francesca, achtundsechzig Tafeln mit einführendem Text.** Basel, Schwabe, 1922.

3084. Hendy, Philip. **Piero della Francesca and the early Renaissance.** New York, Macmillan, 1968.

3085. Longhi, Roberto. **Piero della Francesca, 1927, con aggiunte fino al 1962.** Firenze, Sansoni, 1963. (English ed.: New York/London, Warne, 1930).

3086. Pichi, Giovanni F. **La vita e le opere di Piero della Francesca.** Sansepolcro, Becamorti, 1892.

3087. Previtali, Giovanni. **Piero della Francesca.** Milano,

Fabbri, 1965. (I maestri del colore, 89).

3088. Ricci, Corrado. **Piero della Francesca.** Roma, Anderson, 1910. (L'opera dei grande artisti italiani, 1).

3089. Salmi, Mario. **La pittura di Piero della Francesca.** Novara, Istituto Geografico de Agostini, 1979.

3090. Venturi, Adolfo. **Piero della Francesca.** Firenze, Alinari, 1922.

3091. Venturi, Lionello. **Piero della Francesca.** Geneva, Skira, 1954. (The Taste of Our Time, 6).

3092. Vita, Alessandro del. **Piero della Francesca.** Firenze, Alinari, 1921. (Piccola collezione d'arte, 20).

3093. Waters, William George. **Piero della Francesca.** London, Bell, 1901.

3094. Witting, Felix. **Piero dei Franceschi, eine kunst-historische Studie.** Strassburg, Heitz, 1898.

FRANCESCHI, PIERO DEI see FRANCESCA, PIERO DELLA

FRANCESCO DI GIORGIO MARTINI, 1439-1502

3095. Brinton, Selwyn. **Francesco di Giorgio Martini of Siena, painter, sculptor, engineer, civil and military architect (1439-1502).** London, Besant, 1934.

3096. Ericsson, Christoffer H. **Roman architecture expressed in sketches by Francesco di Giorgio Martini.** Helsinki, Societas Scientiarum Fennica, 1980. (Commentationes Humanorum Litterarum, 66).

3097. Fiore, F. Paolo. **Città e macchine del '400 nei disegni di Francesco di Giorgio Martini.** Firenze, Olschki, 1978.

3098. Francesco di Giorgio Martini. **La praticha di gieometria dal Codice Ashburnham 361 della Biblioteca Medicea Laurenziana di Firenze.** Firenze, Giunti, 1970. (Istituto Italiano per la storia della tecnica, Sez. 1, Vol. 1).

3099. _____. **Trattati di architettura ingegneria e arte militare.** 2 v. Milano, Il Polifilo, 1967.

3100. Pantanelli, Antonio. **Di Francesco di Giorgio Martini, pittore, scultore e architetto Senese del secolo XV e dell'arte de' suoi tempi in Siena.** Siena, Gati, 1870.

3101. Papini, Roberto. **Francesco di Giorgio, architetto.** 3 v. Firenze, Electa, 1946.

3102. Promis, Carlo. **Vita di Francesco di Giorgio Martini.** Torino, Chirio e Mina, 1841.

3103. Salmi, Mario. **Disegni di Francesco di Giorgio nella collezione Chigi Saracini.** Siena, Ticci, 1947. (Quaderni dell'accademia Chigiana, 11).

3104. Weller, Allen S. **Francesco di Giorgio, 1439-1501.** Chicago, University of Chicago Press, 1943.

FRANCESCO DI STEFANO see PESELLINO

FRANCIA

FRANCIA, 1450-1518

3105. Calvi, Jacopo A. **Memorie della vita, e delle opere di Francesco Raibolini detto Il Francia, pittore Bolognese.** Bologna, Lucchesini, 1812.

3106. Cartwright, Julia. **Mantegna and Francia.** New York, Scribner and Welford, 1881.

3107. Lipparini, Giuseppe. **Francesco Francia.** Bergamo, Istituto italiano d'arti grafiche, 1913. (Collezione di monografie illustrate, Serie: Pittori, scultori, architetti, 9).

3108. Malaguzzi-Valeri, Francesco. **Il Francia.** Firenze, Alinari, 1921. (Piccola collezione d'arte, 23).

3109. Williamson, George C. **Francesco Raibolino, called Francia.** London, Bell, 1901.

FRANCIS, SAM, 1923-

3110. Albright-Knox Art Gallery (Buffalo, N.Y.). **Sam Francis, paintings, 1947-1972.** Buffalo, Buffalo Fine Arts Academy, 1972.

3111. Klipstein & Kornfeld (Berne). **Sam Francis Ausstellung.** 25. September bis 5. November 1957. Bern, Klipstein & Kornfeld, 1957.

3112. Los Angeles County Museum of Art. **Sam Francis.** March 13-May 11, 1980. Los Angeles, Los Angeles County Museum of Art, 1980.

3113. Selz, Peter. **Sam Francis.** New York, Abrams, 1975; rev. ed., 1982.

FRANCKE, MEISTER, 15th c.

3114. Kunsthalle Hamburg. **Meister Francke und die Kunst um 1400.** 30. Aug.-19. Okt. 1969. Hamburg, Kunsthalle, 1969.

3115. Lichtwark, Alfred. **Meister Francke, 1424.** Hamburg, Kunsthalle zu Hamburg, 1899.

3116. Martens, Bella. **Meister Francke.** 2 v. Hamburg, Friederichsen, 1929.

FRANK, ROBERT, 1924-

3117. Frank, Robert. **The Americans.** Introd. by Jack Kerouac. New York, Grossman, 1969. 2 ed.

3118. _____. **The lines of my hand.** Los Angeles, Lustrum, 1972.

3119. _____. **Robert Frank.** Millerton, N.Y., Aperture, 1976. (History of Photography, 2).

FRANKENTHALER, HELEN, 1928-

3120. Corcoran Gallery of Art (Washington, D.C.). **Helen Frankenthaler: paintings, 1969-1974.** April 20-June 1, 1975. Washington, D.C., Corcoran Gallery of Art, 1975.

3121. Krens, Thomas. **Helen Frankenthaler, prints, 1961-1979.** [Catalogue of an exhibition, Sterling and Francine Clark Art Institute, Williamstown, Mass., April 11-May 11, 1980]. New York, Harper & Row, 1980.

3122. Rose, Barbara. **Frankenthaler.** New York, Abrams, 1972.

3123. Rose Art Museum, Brandeis University (Waltham, Mass.). **Frankenthaler: the 1950'S.** May 10-June 28, 1981. Waltham, Mass., Rose Art Museum, 1981.

3124. Whitney Museum of American Art (New York). **Helen Frankenthaler.** February 20-April 6, 1969. New York, Whitney Museum of American Art, 1969.

FRENCH, DANIEL CHESTER, 1850-1931

3125. Adams, Adeline. **Daniel Chester French, sculptor.** Boston, Houghton Mifflin, 1932.

3126. Cresson, Margaret French. **Daniel Chester French.** New York, Norton, 1947. (American Sculptor Series, 4).

3127. _____. **Journey into fame, the life of Daniel Chester French.** Cambridge, Mass., Harvard University Press, 1947.

3128. French, Mrs. Daniel Chester. **Memories of a sculptor's wife.** Boston, Houghton Mifflin, 1928.

3129. Richman, Michael. **Daniel Chester French, an American sculptor.** [Catalogue of an exhibition, Nov. 4, 1976-Jan. 10, 1977]. New York, Metropolitan Museum of Art, 1976.

FRIEDLANDER, LEE, 1934-

3130. Friedlander, Lee. **The American monument.** New York, Eakins, 1976.

3131. _____. **Photographs.** New City, N.Y., Haywire, 1978.

3132. _____. **Self-portrait.** New City, N.Y., Haywire, 1970.

FRIEDRICH, CASPAR DAVID, 1774-1840

3133. Aubert, Andreas. **Caspar David Friedrich: Gott, Freiheit, Vaterland.** Berlin, Cassirer, 1915.

3134. Bauer, Franz. **Caspar David Friedrich, ein Maler der Romantik.** Stuttgart, Schuler, 1961.

3135. Börsch-Supan, Helmut. **Caspar David Friedrich.** München, Prestel, 1973. (English ed.: New York, Braziller, 1974).

3136. _____. **Caspar David Friedrich; Gemälde, Druckgraphik und bildmässige Zeichnungen.** München, Prestel, 1973.

3137. _____. **L'opera completa di Friedrich.** Milano, Rizzoli, 1976. (Classici dell'arte, 84).

3138. Eimer, Gerhard. **Caspar David Friedrich und die Gotik.** Hamburg, von der Ropp, 1963.

3139. Einem, Herbert von. **Caspar David Friedrich.** Berlin, Rembrandt, 1938.

3140. Emmrich, Irma. **Caspar David Friedrich.** Weimar, Böhlau, 1964.

3141. Fiege, Gertrud. **Caspar David Friedrich in Selbstzeugnissen und Bilddokumenten.** Hamburg, Rowohlt, 1977. (Rowohlts Monographien, 252).

3142. Gärtner, Hannelore, ed. **Caspar David Friedrich; Leben, Werk, Diskussion.** Berlin, Union, 1977.

3143. Geismeier, Willi. **Caspar David Friedrich.** Wien/München, Schroll, 1975.

3144. Grote, Ludwig. **Caspar David Friedrich, Skizzenbuch aus den Jahren 1806 und 1818.** Berlin, Mann, 1942.

3145. Hamburger Kunsthalle. **Caspar David Friedrich, 1774-1840.** 14. September bis 3. November 1974. München, Prestel, 1974.

3146. Hinz, Berthold, et al. **Bürgerliche Revolution und Romantik; Natur und Gesellschaft bei Caspar David Friedrich.** Giessen, Anabas, 1976. (Kunstwissenschaftliche Untersuchungen des Ulmer Vereins, Verband für Kunst und Kulturwissenschaften, 6).

3147. Hofmann, Werner, ed. **Caspar David Friedrich und die deutsche Nachwelt.** Frankfurt a.M., Suhrkamp, 1974.

3148. Hofstätter, Hans H. **Caspar David Friedrich, das gesamte graphische Werk.** Herrsching, Pawlak, 1982. 2 ed. (CR).

3149. Leonhardi, Klaus. **Die romantische Landschaftsmalerei: Caspar David Friedrich.** Würzburg, Mayr, 1936.

3150. National Museum for Modern Art (Tokyo). **Caspar David Friedrich and his circle.** February 11-April 2, 1978. Tokyo, National Museum for Modern Art, 1978.

3151. Nemitz, Fritz. **Caspar David Friedrich. Die unendliche Landschaft.** München, Bruckmann, 1938.

3152. Prybram-Gladona, Charlotte Margarethe de. **Caspar David Friedrich.** Paris, Les Editions d'Art et d'Histoire, 1942.

3153. Rautmann, Peter. **Caspar David Friedrich, Landschaft als Sinnbild entfalteter bürgerlicher Wirklichkeitsaneignung.** Frankfurt a.M./Bern/Las Vegas, Lang, 1979. (Kunstwissenschaftliche Studien, 7).

3154. Richter, Gottfried. **Caspar David Friedrich, der Maler der Erdenfrömmigkeit.** Stuttgart, Urachhaus, 1953.

3155. Schmied, Wieland. **Caspar David Friedrich.** Köln, DuMont Schauberg, 1975.

3156. Sigismund, Ernst. **Caspar David Friedrich: eine Umrisszeichnung.** Dresden, Jess, 1943.

3157. Sumowski, Werner. **Caspar David Friedrich-Studien.** Weisbaden, Steiner, 1970.

3158. Tassi, Roberto. **Caspar David Friedrich.** Milano, Fabbri, 1966. (I maestri del colore, 195).

3159. Tate Gallery (London). **Caspar David Friedrich, 1774-1840. Romantic landscape painting in Dresden.** [6 September-16 October, 1972]. London, Tate Gallery, 1972.

3160. Wolfradt, Willi. **Caspar David Friedrich und die Landschaft der Romantik.** Berlin, Mauritius, 1924.

FRIES, HANS, 1465-1523?

3161. Kelterborn-Haemmerli, Anna. **Die Kunst des Hans Fries.** Strassburg, Heitz, 1927. (Studien zur deutschen Kunstgeschichte, 245).

FRITH, WILLIAM POWELL, 1819-1903

3162. Frith, William P. **My autobiography and reminiscences.** 2 v. New York, Harper, 1888.

3163. Noakes, Aubrey. **William Frith, extraordinary Victorian painter; a biography & critical essay.** London, Jupiter, 1978.

FRIESZ, OTHON, 1879-1949

3164. Fleuret, Fernand, et al. **Friesz, oeuvres (1901-1927).** Paris, Editions des Chroniques du Jour, 1928. (Les maîtres nouveaux, 1).

3165. Galerie Charpentier (Paris). **Rétrospective Othon Friesz.** Paris, Galerie Charpentier, 1950.

3166. Gauthier, Maximilien. **Othon Friesz.** Genève, Cailler, 1957.

3167. Salmon, André and Aubert, Georges. **Emile-Othon Friesz.** Paris, La Nouvelle Revue Française, 1920. (Les peintres français nouveaux, 5).

FROMENT, NICOLAS, ca. 1435-ca. 1484

3168. Chamson, Lucie. **Nicolas Froment et l'école Avignonaise au XVe siècle.** Paris, Rieder, 1931. (Maîtres de l'art ancien, 18).

3169. Marignane, M. **Nicolas Froment.** Paris, Morancé, 1955.

FROMENTIN, EUGENE, 1820-1876

3170. Association des Artistes, Peintres, Sculpteurs, Architectes, Graveurs et Dessinateurs. **Exposition des oeuvres de Eugène Fromentin à l'Ecole National des Beaux Arts.** Paris, Claye, 1877.

3171. Beaume, Georges. **Fromentin.** Paris, Louis-Michaud, 1911.

3172. Bibliothèque Municipale (La Rochelle). **Fromentin, le peintre et l'écrivain, 1820-1876.** La Rochelle, Bibliothèque Municipale, 1970.

3173. Dorbec, Prosper. **Eugène Fromentin, biographie critique.** Paris, Laurens, 1926.

3174. Fromentin, Eugène. **Correspondance et fragments inédits.** Paris, Plon, 1912.

3175. _____. **Lettres de jeunesse.** Paris, Plon, 1909.

3176. _____. The masters of past time; Dutch & Flemish painting from van Eyck to Rembrandt. London, Phaidon, 1960.

3177. Gonse, M. Louis. Eugène Fromentin, painter and writer. Boston, Osgood, 1883.

3178. Lagrange, Andrée. L'art de Fromentin. Paris, Dervy, 1952.

3179. Marcos, Fouad. Fromentin et l'Afrique. Sherbrooke, Québec, Editions Cosmos, 1973.

FUCHS, ERNST, 1930-

3180. Fuchs, Ernst. Architectura Caelestis, die Bilder des verschollenen Stils. Salzburg, Residenz, 1966.

3181. _____ and Brion, Marcel. Ernst Fuchs. New York, Abrams, 1979.

3182. _____ and Hartmann, Richard P. Ernst Fuchs, das graphische Werk, 1967-1980. München/Zürich, Piper, 1980. (Klassiker der Neuzeit, 4). (CR).

3183. Weis, Helmut. Ernst Fuchs, das graphische Werk. Wien/ München, Verlag für Jugend und Volk, 1967. (CR).

FUESSLI, JOHANN HEINRICH see FUSELI, HENRY

FUGA, FERDINANDO, 1699-1781

3184. Bianchi, Lidia. Disegni di Ferdinando Fuga e di altri architetti del settecento. Roma, Gabinetto Nazionale delle Stampe, 1955.

3185. Matthiae, Guglielmo. Ferdinando Fuga e la sua opera Romana. Roma, Palombi, 1952.

3186. Pane, Roberto. Ferdinando Fuga. Napoli, Scientifiche Italiane, 1956.

FULLER, RICHARD BUCKMINSTER, 1895-1983

3187. Fuller, R. Buckminster. Ideas & integrities, a spontaneous autobiographical disclosure. Englewood Cliffs, N.J., Prentice-Hall, 1963.

3188. Hatch, Alden. Buckminster Fuller at home in the universe. New York, Crown, 1974.

3189. Kenner, Hugh. Bucky, a guided tour of Buckminster Fuller. New York, Morrow, 1973.

3190. Marks, Robert W. The Dymaxion world of Buckminster Fuller. New York, Reinhold, 1960.

3191. McHale, John. R. Buckminster Fuller. New York, Braziller, 1962.

3192. Robertson, Donald W. Mind's eye of Richard Buckminster Fuller. New York, Vantage, 1974.

3193. Rose Art Museum, Brandeis University (Waltham, Mass.). Two urbanists; the engineering-architecture of R. Buckminster Fuller and Paolo Soleri. December 21, 1964-January 17, 1965. Waltham, Mass., Rose Art Museum, 1964.

FUNGAI, BERNARDINO, 1460-1516

3194. Bacci, Pèleo. Bernardino Fungai, pittore Senese (1460-1516). Siena, Lazzeri, 1947.

FURINI, FRANCESCO, 1604-1646

3195. Cantelli, Giuseppe. Disegni di Francesco Furini e del suo ambiente. Firenze, Olschki, 1972. (Gabinetto disegni e stampe degli Uffizi, 36).

3196. Toesca, Elena. Francesco Furini. Roma, Tumminelli, 1950. (Quaderni d'arte, 11).

FUSELI, HENRY (Heinrich Fuessli), 1741-1825

See also BARRY, JAMES

3197. Antal, Frederick. Fuseli studies. London, Routledge & Kegan Paul, 1956.

3198. Federmann, Arnold. Johann Heinrich Füssli, Dichter und Maler, 1741-1825. Zürich/Leipzig, Orell Füssli, 1927.

3199. Füssli, Heinrich. Aphorismen über die Kunst. Klosterberg/ Basel, Schwabe, 1944.

3200. _____. Briefe. Klosterberg/Basel, Schwabe, 1942.

3201. _____. Lectures on painting delivered at the Royal Academy. London, Colburn and Bentley, 1830.

3202. Ganz, Paul. Die Zeichungen Hans Heinrich Füsslis (Henry Fuseli). Bern, Urs, 1947. (English ed.: London, Parrish, 1949).

3203. Hamburger Kunsthalle. Johann Heinrich Füssli, 1741-1825. 4. Dez. 1974 bis 19. Jan. 1975. München, Prestel, 1974.

3204. Jaloux, Edmond. Johann-Heinrich Füssli. Genève, Cailler, 1942.

3205. Knowles, John. The life and writings of Henry Fuseli. 3 v. London, Colburn and Bentley, 1831.

3206. Kunsthaus Zürich. Johann Heinrich Füssli, 1741-1825; Gemälde und Zeichnungen. 17. Mai bis 6 Juli 1969. Zürich, Kunsthaus Zürich, 1969

3207. Mason, Eudo C. The mind of Henry Fuseli; selections from his writings with an introductory study. London, Routledge & Kegan Paul, 1951.

3208. Powell, Nicolas. Fuseli--The Nightmare. New York, Viking, 1973.

3209. Pressly, Nancy L. The Fuseli circle in Rome; early romantic art of the 1770's. New Haven, Yale Center for British Art, 1979.

3210. Schiff, Gert. Johann Heinrich Füssli, 1741-1825. 2 v. Zürich, Berichthaus/München, Prestel, 1973. (CR). (Oeuvrekataloge schweizer Künstler, 1).

3211. _____ and Viotto, Paola. L'opera completa di Füssli. Milano, Rizzoli, 1977. (Classici dell'arte, 94).

3212. Tate Gallery (London). **Henry Fuseli, 1741-1825.**
[19 February-31 March, 1975]. London, Tate Gallery, 1975.

3213. Tomory, Peter. **The life and art of Henry Fuseli.** New
York/Washington, Praeger, 1972.

GABO, NAUM, 1890-1977

3214. Gabo, Naum. **Gabo: constructions, sculpture, paintings,
drawings, engravings.** Introd. by Herbert Read and Leslie
Martin. Cambridge, Mass., Harvard University Press, 1957.

3215. _____. **Of divers arts.** New York, Pantheon, 1962.
(Bollingen series, 35. The A. W. Mellon lectures in the
fine arts, 8).

3216. Galerie Percier (Paris). **Constructivistes russes: Gabo et
Pevsner: peintures, constructions.** Exposition du 19
juin au 5 juillet 1924. Paris, Galerie Percier, 1924.

3217. Musée de Peinture et de Sculpture (Grenoble). **Naum Gabo.**
Exposition, Grenoble sept.-oct. 1971; Paris, Musée
National d'Art Moderne nov.-déc. 1971. Catalogue rédigé
par Marie-Claude Beaud. Paris, Réunion des Musées
Nationaux, 1971.

3218. Museum of Modern Art (New York). **Naum Gabo [and] Antoine
Pevsner.** Introd. by Herbert Read; text by Ruth Olson and
Abraham Chanin. New York, Museum of Modern Art, 1948.

3219. Pevsner, Alexei. **A biographical sketch of my brothers Naum
Gabo and Antoine Pevsner.** Amsterdam, Augustin &
Schoonman, 1964.

GABRIEL, JACQUES ANGE, 1698-1782

3220. Bottineau, Yves. **L'art d'Ange-Jacques Gabriel à
Fontainebleau, 1735-1774.** Paris, De Boccard, 1962.

3221. Despierres, Gérasième (Bonnaire). **Les Gabriel; recherches
sur les origines provinciales de ces architects.** Paris,
Plon, 1895.

3222. Fels, Edmond, Comte de. **Ange-Jacques Gabriel premier
architecte du roi, d'après des documents inédits.** Paris,
Laurens, 1924. 2 ed. 1 ed.: Paris, Emile-Paul, 1912.

3223. Tadgell, Christopher. **Ange-Jacques Gabriel.** London,
Zwemmer, 1978. (Studies in architecture, 19).

GADDI, AGNOLO, 1350-1396

 GADDO, d. 1312

 TADDEO, 1300-1366

3224. Cole, Bruce. **Agnolo Gaddi.** Oxford/New York, Clarendon
Press, 1977. (Oxford Studies in the History of Art and
Architecture).

3225. Donati, Pier P. **Taddeo Gaddi.** Firenze, Sadea/Sansoni,
1966.

3226. Ladis, Andrew. **Taddeo Gaddi: a critical reappraisal and
catalogue raisonné.** Columbia, University of Missouri
Press, 1982. (CR).

3227. Mather, Frank J. **The Isaac Master; a reconstruction of the
work of Gaddo Gaddi.** Princeton, N.J., Princeton
University Press/London, Oxford University Press, 1932.
(Princeton Monographs in Art and Archaeology, 17).

3228. Salvini, Roberto. **L'arte di Agnolo Gaddi.** Firenze,
Sansoni, 1936. (Monographie e studi. Istituto di storia
dell'arte della Università di Firenze, 1).

GAERTNER, EDUARD, 1801-1877

3229. Berlin Museum. **Eduard Gaertner.** Architekturmaler in
Berlin. Ausstellung, 6. Sept.-4 Okt. 1968. Katalog:
Irmgard Wirth. Berlin, Berlin Museum, 1968.

3230. Wirth, Irmgard. **Eduard Gaertner, der Berliner
Architekturmaler.** Frankfurt a.M., Propyläen, 1979.

GAERTNER, FRIEDRICH VON, 1792-1847

3231. Eggert, Klaus. **Friedrich von Gärtner, der Baumeister
König Ludwigs I.** München, Stadtarchiv München, 1963.
(Neue Schriftenreihe d. Stadtarchivs München, 15).

3232. Hederer, Oswald. **Friedrich von Gärtner, 1792-1847: Leben,
Werk, Schüler.** München, Prestel, 1976. (Studien zur
Kunst des neunzehnten Jahrhunderts, 30).

GAINSBOROUGH, THOMAS, 1727-1788

3233. Armstrong, Walter. **Gainsborough and his place in English
art.** London, Heinemann, 1898. New ed.: New York,
Dutton, 1906.

3234. _____. **Thomas Gainsborough.** London, Seeley/New York,
Macmillan, 1894. (The Portfolio Artistic Monographs, 9).

3235. Boulton, William B. **Thomas Gainsborough, his life, work,
friends and sitters.** London, Methuen, 1905.

3236. Brock-Arnold, George M. **Gainsborough.** London, Low,
Marston, 1901. (Illustrated Biographies of the Great
Artists).

3237. Chamberlain, Arthur B. **Thomas Gainsborough.** London,
Duckworth/New York, Dutton, n.d.

3238. Dibdin, Edward R. **Thomas Gainsborough, 1727-1788.** New
York, Funk & Wagnalls, 1923.

3239. Fulcher, George W. **Life of Thomas Gainsborough.** London,
Longman, 1856.

3240. Gainsborough, Thomas. **Letters.** Ed. by Mary Woodall.
Greenwich, Conn., New York Graphic Society, 1963.

3241. Galeries Nationales du Grand Palais (Paris). **Gainsborough,
1727-1788:** [exposition], Grand Palais, 6 février-27
avril 1981. Organisée par le British Council et la
Réunion des musées nationaux, avec la collaboration de la
Tate Gallery. Paris, Ministère de la Culture et de la
Communication, Editions de la Réunion des Musées
Nationaux, 1981.

3242. Gower, Ronald S. **Thomas Gainsborough.** London, Bell, 1903.
(The British Artists series).

3243. Hayes, John T. **Thomas Gainsborough.** Catalog of an exhibition held at the Tate Gallery, Oct. 8, 1980-Jan. 4, 1981. London, Tate Gallery, 1980.

3244. _____. **Gainsborough: paintings and drawings.** London, Phaidon, 1975.

3245. _____. **Gainsborough as printmaker.** London, Zwemmer, 1971.

3246. _____. **The drawings of Thomas Gainsborough.** 2 v. New Haven, Yale University Press, for the Paul Mellon Centre for Studies in British Art, 1971.

3247. Leonard, Jonathan N. **The world of Gainsborough.** New York, Time-Life, 1969.

3248. Lindsay, Jack. **Thomas Gainsborough, his life and art.** New York, Universe, 1981.

3249. Millar, Oliver. **Thomas Gainsborough.** New York, Harper, 1949.

3250. Mourey, Gabriel. **Gainsborough, biographie critique.** Paris, Librairie Renouard, Henri Laurens, 1905. (Les grands artistes).

3251. Pauli, Gustav. **Gainsborough.** Bielefeld/Leipzig, Velhagen & Klasing, 1904.

3252. Tate Gallery (London). **Thomas Gainsborough, 1727-1788: an exhibition of paintings arranged by the Arts Council of Great Britain and the Tate Gallery.** London, Tate Gallery, 1953.

3253. Waterhouse, Ellis K. **Gainsbourough.** London, Hulton, 1958.

3254. Whitley, William T. **Thomas Gainsborough.** London, Murray, 1915.

3255. Williamson, Geoffrey. **The ingenious Mr. Gainsborough; Thomas Gainsborough, a biographical study.** New York, St. Martin's, 1972.

3256. Woodall, Mary. **Gainsborough's landscape drawings.** London, Faber, 1939.

3257. _____. **Thomas Gainsborough, his life and work.** London, Phoenix, 1949.

GALLE, EMILE, 1846-1904

3258. Charpentier, Françoise-Thérèse. **Emile Gallé.** Nancy, Université de Nancy II, 1978.

3259. Gallé, Emile. **Ecrits pour l'art; floriculture, art décoratif, notices d'exposition (1884-1889).** Paris, Renouard, 1908. (Repr.: Marseille, Laffitte, 1980).

3260. Garner, Philippe. **Emile Gallé.** New York, Rizzoli, 1976.

3261. Münchner Stadtmuseum. **Nancy 1900; Jugendstil in Lothringen, zwischen Historismus und Art Déco.** 28. August bis 23. November 1980. Mainz/Murnau, von Zabern, 1980.

3262. Museum Bellerive (Zurich). **Emile Gallé: Keramik, Glas und Möbel des Art Nouveau.** 28. Mai-17. August 1980. Zürich, Museum Bellerive, 1980. (Wegleitung des Kunstgewerbe-museums Zürich, 329).

GALLEGO, FERNANDO, ca. 1440-ca. 1507

3263. Gaya Nuño, Juan A. **Fernando Gallego.** Madrid, Istituto Diego Velazquez, 1958.

3264. Quinn, R. M. **Fernando Gallego and the retablo of Ciudad Rodrigo.** Tucson, University of Arizona, 1961.

GALLEN-KALLELA, AKSELI, 1865-1931

3265. Gallen-Kallena, Kirsti. **Isäni, Akseli Gallen-Kallena.** 2 v. Helsinki, Söderström, 1964-5.

3266. Knuuttilla, Seppo. **Akseli Gallen-Kallelan Väinämöiset.** Helsinki, Suomalaisen Kirjallisuuden Seura, 1978.

3267. Okkonen, Onni. **A. Gallen-Kallela, elämä ja taide.** Helsinki, Söderström, 1949. (Suomen tiedettä, 6).

GALLI DA BIBIENA, FERDINANDO, 1657-1743

GIUSEPPE, 1696-1756

3268. Casa del Mantegan (Mantua). **I Bibiena: disegni e incisioni nelle collezioni del Museo teatrale alla Scala.** 7 sett.-4 nov. 1975. Catalogo a cura di Mario Monteverdi; con un contributo di Ercolano Marani. Milano, Electa, 1975.

3269. Galli da Bibiena, Fernando. **Direzioni a' giovani studenti nel disegno dell'architettura civile, nell'Accademia Clementina dell'Istituto delle Scienze unite da F. G. Bibiena.** 2 v. Venezia, 1796.

3270. Galli da Bibiena, Giuseppe. **Architectural and perspective designs dedicated to His Majesty Charles VI, Holy Roman Emperor.** Introd. by A. Hyatt Mayor. New York, Dover, 1964. (Repr. of 1740 edition).

3271. Hadamowsky, Franz. **Die Familie Galli-Bibiena in Wien; Leben und Werk für das Theater.** Wien, Prachner, 1962. (Museion; Reihe 1, Bd. 2).

3272. Mayor, Alpheus Hyatt. **The Bibiena family.** New York, Bittner, 1945.

3273. Muraro, Maria T. and Povoledo, Elena. **Disegni teatrali dei Bibiena.** Catalogo della mostra a cura di M. T. Muraro e Elena Povoledo. Presentazione di Gianfranco Folena. Venezia, Pozza, 1970. (Fondazione Giorgio Cini. Cataloghi di mostre, 31).

3274. Ricci, Corrado. **I Bibiena, architetti teatrali . . . opere esposte alla mostra scenografica nel Museo teatrale alla Scala in Milano, primavera, 1915.** Milano, Alfieri, 1915.

GARDELLA, IGNAZIO, 1905-

3275. Argan, Giulio Carlo. **Ignazio Gardella.** Milano, Comunità, 1959.

GAUDI, ANTONIO, 1852-1926

3276. Bassegoda Nonell, Juan. **Obras completas de Gaudi.** 2 v. Tokyo, Rikuyosha, 1979.

3277. Bergós, Joan. **Gaudí, l'home i l'obra.** Barcelona, Ariel, 1954.

3278. Casanelles, Enric. **Nueva vision de Gaudí.** Barcelona, Poligrafa, 1965. (English ed.: Greenwich, Conn., New York Graphic Society, 1965).

3279. Cirlot, Juan-Eduardo. **Introduccion a la arquitectura de Gaudi.** Barcelona, Editorial RM, 1966.

3280. Collins, George R. **Antonio Gaudí.** New York, Braziller, 1960.

3281. _____ and Bassegoda Nonell, Juan. **The designs and drawings of Antonio Gaudi.** Princeton, N.J., Princeton University Press, 1981.

3282. Dalisi, Riccardo. **Gaudi furniture.** London, Academy Editions, 1980.

3283. Flores, Carlos. **Gaudí, Jujol y el Modernismo Catalan.** 2 v. Madrid, Aguilar, 1982.

3284. Hitchcock, Henry-Russell. **Gaudí.** New York, Museum of Modern Art, 1957.

3285. Martinell, Cèsar. **Antonio Gaudí.** Milano, Electa, 1955. (Astra-Arengarium collana di monografie d'arte, serie architetti, 39).

3286. Martinell i Brunet, Cèsar. **Gaudí; su vida, su teoria, su obra.** Barcelona, Colegio de Arquitectos de Cataluña y Baleares, Comision de Cultura, 1967. (English ed.: Cambridge, Mass., MIT Press, 1975).

3287. O'Neal, William B., ed. **Antonio Gaudí and the Catalan Movement, 1870-1930.** Charlottesville, Virginia, University Press of Virginia, 1973. (American Association of Architectural Bibliographers, Papers v. 10).

3288. Palazzo Vecchio (Florence). **Antoni Gaudí.** Luglio-settembre, 1979. Firenze, Vallecchi, 1979.

3289. Pane, Roberto. **Antoni Gaudí.** Milano, Edizioni di Comunità, 1964. (Studi e documenti di storia dell' arte, 5).

3290. Perucho, Juan. **Gaudí, una arquitectura de anticipacion.** Barcelona, Poligrafa, 1967.

3291. Prévost, Clovis and Descharnes, Robert. **La vision artistica y religiosa de Gaudí.** Barcelona, Aymá, 1971.

3292. Pujols, Francesc. **La visio' artística; religiosa d'En Gaudí.** Barcelona, Llibereria Catalònia, 1927.

3293. Ràfols, Josep F. **Antoni Gaudí.** Barcelona, Canosa, 1928.

3294. _____. **Gaudí, 1852-1926.** Barcelona, Aedos, 1952.

3295. Sugranes, Jose M.ª Guix. **Defensa de Gaudi.** Reus, Monterols, 1960.

3296. Sweeney, James Johnson and Sert, Josep Lluís. **Antoni Gaudí.** New York, Praeger, 1960.

GAUDIER-BRZESKA, HENRI, 1891-1915

3297. Brodzky, Harold. **Henri Gaudier-Brzeska.** London, Faber, 1933.

3298. Cole, Roger. **Burning to speak, the life and art of Henri Gaudier Brzeska.** Oxford, Phaidon, 1978.

3299. Ede, H. S. **A life of Gaudier-Brzeska.** London, Heinemann, 1930.

3300. _____. **Savage Messiah.** New York, Knopf, 1931.

3301. Kunsthalle der Stadt Bielefeld. **Henri Gaudier-Brzeska, 1891-1915, Skulpturen, Zeichnungen, Briefe, programmatische Schriften.** Bielefeld, Kunsthalle der Stadt, 1969.

3302. Levy, Mervyn. **Gaudier-Brzeska, drawings and sculpture.** New York, October House, 1965.

3303. Pound, Ezra. **Gaudier-Brzeska, a memoir.** New York, New Directions, 1970.

3304. Secrétain, Roger. **Un sculpteur 'maudit'; Gaudier-Brzeska, 1891-1915.** Paris, Le Temps, 1979.

GAUERMANN, FRIEDRICH, 1807-1862

3305. Feuchtmüller, Rupert. **Friedrich Gauermann, 1897-1862; der Tier- und Landschaftsmaler des österreichischen Biedermeier.** Wien, Österreichische Staatsdruckerei, 1962.

3306. Niederösterreichischer Ausstellungsverein (Vienna). **Biedermeier Ausstellung; Friedrich Gauermann und seine Zeit.** 19. Mai bis 18. Oktober 1962. Wien, Niederösterreichisches Landesmuseum, 1962.

GAUGUIN, PAUL, 1848-1903

3307. Alexandre, Arsène. **Paul Gauguin, sa vie et le sens de son oeuvre.** Paris, Bernheim-Jeune, 1930.

3308. Andersen, Wayne. **Gauguin's paradise lost.** New York, Viking, 1971.

3309. Art Institute of Chicago. **Gaugin; paintings, drawings, prints, sculpture.** [February 12-March 19, 1959]. Chicago, Art Institute of Chicago, 1959.

3310. Becker, Beril. **Paul Gaugin, the calm madman.** New York, Boni, 1931.

3311. Bodelsen, Merete. **Gauguin's ceramics, a study in the development of his art.** London, Faber, 1964.

3312. Boudaille, Georges. **Gauguin.** Paris, Somogy, 1963.

3313. Burnett, Robert. **The life of Paul Gauguin.** London, Cobden-Sanderson, 1936; New York, Oxford University Press, 1937.

3314. Chassé, Charles. **Gauguin et le groupe de Pont-Aven, documents inédits.** Paris, Floury, 1921.

3315. _____. **Gauguin et son temps.** Paris, La Bibliothèque des Arts, 1955.

3316. Cogniat, Raymond. **Gauguin.** Paris, Tisné, 1947.

3317. _____. **Paul Gauguin, a sketchbook.** 3 v. New York, Hammer Galleries, 1962.

3318. Danielsson, Bengt. **Gauguin in the South Seas.** Trans. by Reginald Spink. London, Allen and Unwin, 1965.

3319. _____ and O'Reilly, Patrick. **Gauguin, journaliste à Tahiti & ses articles des Guêpes.** Paris, Société des Océanistes, 1966.

3320. Estienne, Charles. **Gauguin.** Geneva, Skira, 1953. (The Taste of Our Time, 1).

3321. Fletcher, John E. **Paul Gauguin, his life and art.** New York, Brown, 1921.

3322. Gauguin, Paul. **The letters of Paul Gauguin to Georges Daniel de Monfried.** Trans. by Ruth Pielkovo. London, Heinemann, 1923.

3323. _____. **Letters to his wife and friends.** Ed. by M. Malingue. Cleveland, World, 1949.

3324. _____. **Noa-Noa, première édition du texte authentique de Gauguin, établi sur le manuscript initial retrouvé.** Paris, Ballard, 1966.

3325. _____. **Paul Gauguin's intimate journals.** Trans. by Van Wyck Brooks. New York, Crown, 1936.

3326. Gauguin, Pola. **My father, Paul Gauguin.** New York, Knopf, 1937.

3327. Goldwater, Robert. **Gauguin.** New York, Abrams, 1957.

3328. Graber, Hans. **Paul Gauguin, nach eigenen und fremden Zeugnissen.** Basel, Schwabe, 1946.

3329. Gray, Christopher. **Sculpture and ceramics of Paul Gauguin.** Baltimore, Johns Hopkins, 1963.

3330. Guérin, Daniel. **The writings of a savage, Paul Gauguin.** Trans. by Eleanor Levieux. New York, Viking, 1978.

3331. Guérin, Marcel. **L'oeuvre gravé de Gauguin.** 2 v. Paris, Floury, 1927.

3332. Hanson, Lawrence and Hanson, Elisabeth. **The noble savage; a life of Paul Gauguin.** London, Chatto & Windus, 1954.

3333. Huyge, René. **Les carnets de Paul Gauguin.** 2 v. Paris, Quatre Chemins-Editart, 1952.

3334. _____. **Gauguin.** New York, Crown, 1959.

3335. _____, et al. **Gauguin.** Paris, Hachette, 1960. (Collection génies et réalités).

3336. Jaworska, Wladyslawa. **Paul Gauguin et l'école de Pont-Aven.** Neuchâtel, Editions Ides et Calandes, 1971.

3337. Kunstler, Charles. **Gauguin.** Paris, Floury, 1934.

3338. Leprohon, Pierre. **Paul Gauguin.** Paris, Gründ, 1975.

3339. Leymarie, Jean. **Paul Gauguin; water-colours, pastels and drawings in colour.** London, Faber, 1961.

3340. Malingue, Maurice. **Gauguin, le peintre et son oeuvre.** Avant-propos de Pola Gauguin. Paris, Presses de la Cité, 1948.

3341. Morice, Charles. **Paul Gauguin.** Paris, Floury, 1919.

3342. Museum of Modern Art (New York). **First loan exhibition, New York, November 1929: Cézanne, Gauguin, Seurat, van Gogh.** New York, Museum of Modern Art, 1929.

3343. O'Reilly, Patrick. **Catalogue du Musée Gauguin, Papeari, Tahiti.** Paris, Foundation Singer-Polignac, 1965.

3344. Perruchot, Henri. **Gauguin.** Trans. by Humphrey Hare. Cleveland/New York, World, 1963.

3345. Pickvance, Ronald. **The drawings of Gauguin.** London, Hamlyn, 1970.

3346. Read, Herbert. **Gauguin (1848-1903).** London, Faber, 1954.

3347. Rewald, John. **Gauguin.** Paris, Hyperion, 1938.

3348. _____. **Gaugin drawings.** New York/London, Yoseloff, 1958.

3349. _____. **Paul Gauguin.** New York, Abrams, 1952.

3350. Rey, Robert. **Gauguin.** Trans. by F. C. de Sumichrast. New York, Dodd, Mead, 1924.

3351. Rotonchamp, Jean de. **Paul Gauguin, 1848-1903.** Paris, Drouet, 1906.

3352. Schneeberger, Pierre-Francis. **Gauguin à Tahiti.** Lausanne, International Art Book, 1961.

3353. Sugana, G. M. **L'opera completa di Gauguin.** Milano, Rizzoli, 1972. (Classici dell'arte, 61).

3354. Sýkorová, Libuše. **Gauguin woodcuts.** London, Hamlyn, 1963.

3355. Tate Gallery (London). **Gauguin and the Pont-Aven group.** 7 January-13 February [1966]. London, Arts Council, 1966.

3356. Wildenstein, Georges. **Gauguin.** Paris, Les Beaux Arts, 1964. (CR).

GAUL, AUGUST, 1869-1921

3357. Rosenhagen, Hans. **Bildwerke von August Gaul.** Berlin, Cassirer, 1905.

3358. Waldmann, Emil. **August Gaul.** Berlin, Cassirer, 1919.

3359. Walther, Angelo. **August Gaul.** Leipzig, Seemann, 1973.

GAULLI, GIOVANNI BATTISTA (Baciccio), 1639-1709

3360. Allen Memorial Art Museum (Oberlin, Ohio). **An exhibition of paintings, bozzetti, and drawings made by Baciccio, January 16 to February 13, 1967.** (Allen Memorial Art Museum Bulletin, v. 24, 2).

3361. Brugnoli, Maria Vittoria. **Il Baciccio.** Milano, Fabbri, 1966. (I maestri del colore, 214).

3362. Enggass, Robert. **The paintings of Baciccio, Giovanni Battista Gaulli, 1639-1709.** University Park, Penn., Pennsylvania State University Press, 1964. (CR).

3363. Kunstmuseum Düsseldorf. **Die Handzeichnungen von Guglielmo Cortese und Giovanni Battista Gaulli.** Düsseldorf, Kunstmuseum Düsseldorf, 1976. (Kataloge des Kunstmuseums Düsseldorf III, 2/1).

GEBHARDT, EDUARD VON, 1838-1925

3364. Burckhardt, Rudolf F. **Zum Schauen bestellt: Eduard von Gebhardt, der Düsseldorfer Meister der biblischen Historie.** Stuttgart, Quell-Verlag, 1928. (Aus klaren Quellen, 19).

3365. Rosenberg, Adolf. **E. von Gebhardt.** Bielefeld/Leipzig, Velhagen & Klasing, 1899. (Künstler-Monographien, 38).

GEERTGEN TOT SINT JANS, 1465-1495

3366. Balet, Leo. **Der Frühholländer Geertgen tot Sint Jans.** Haag, Nijhoff, 1910.

3367. Friedländer, Max J. **Geertgen tot Sint Jans and Jerome Bosch.** Leyden, Sijthoff/Brussels, La Connaissance, 1969. (Early Netherlandish Painting, 5).

3368. Kessler, Johann H. H. **Geertgen tot Sint Jans, zijn herkomst en invloed in Holland.** Utrecht, Oosthoek, 1930.

3369. Vogelsang, W. **Geertgen tot Sint Jans.** Amsterdam, Becht, [n.d.]. (Palet serie, 21).

GEILER, HANS, fl. 1513-1534

3370. Strub, Marcel. **Deux maîtres de la sculpture Suisse du XVIe siècle: Hans Geiler et Hans Gieng.** Fribourg, Editions Universitaires, 1962.

GELDER, ARENT DE, 1645-1727

3371. Lilienfeld, Karl. **Arent de Gelder, sein Leben und seine Kunst.** Haag, Nijhoff, 1914. (Quellenstudien zur holländischen Kunstgeschichte, 4).

GELLEE, CLAUDE see CLAUDE LORRAIN

GENELLI, BONAVENTURA, 1798-1868

3372. Christoffel, Ulrich. **Buonaventura Genelli, aus dem Leben eines Künstlers.** Berlin, Propyläen, 1922.

3373. Ebert, Hans. **Buonaventura Genelli, Leben und Werk.** Weimar, Hermann Böhlaus Nachfolger, 1971.

3374. Marshall, Hans. **Buonaventura Genelli.** Leipzig, Xenien-Verlag, 1912. (Der Künstler und seine Werke, 2).

GENERALIC, IVAN, 1914-

3375. Bašičević, Dimitrije. **Ivan Generalić.** Zagreb, Društvo Historicara Umjetnostri NRH, 1962.

3376. Tomasević, Nebojša. **Magični svet Ivana Generalića.** Beograd, Jugoslovenska Revija, 1976. (English ed.: New York, Rizzoli, 1976).

3377. Zdunić, Drago, et al. **Ivan Generalić.** Zagreb, Spektar, 1973.

GENNAI, HIRAGA, 1729-1780

3378. Mäes, Hubert. **Hiraga Gennai et son temps.** Paris, Ecole Française d'Extrême-Orient, 1970. (Publications, 72).

GENSLER, GÜNTHER, 1803-1884

JAKOB, 1808-1845

MARTIN, 1811-1881

3379. Bürger, Fritz. **Die Gensler, drei Hamburger Malerbrüder des 19. Jahrhunderts.** Strassburg, Heitz, 1916. (Studien zur deutschen Kunstgeschichte, 190).

GENTILE DA FABRIANO, 1370-1427

3380. Bellosi, Luciano. **Gentile da Fabriano.** Milano, Fabbri, 1966. (I maestri del colore, 159).

3381. Christiansen, Keith. **Gentile da Fabriano.** Ithaca, N.Y., Cornell University Press, 1982.

3382. Colasanti, Arduino. **Gentile da Fabriano.** Bergamo, Ist. Ital. d'Arti Grafiche, 1909. (Collezione di monografie illustrate; Pittori, scultori, architetti, 6).

3383. Grassi, Luigi. **Tutta la pittura di Gentile da Fabriano.** Milano, Rizzoli, 1953. (Biblioteca d'arte Rizzoli, 13).

3384. Micheletti, Emma. **L'opera completa di Gentile da Fabriano.** Milano, Rizzoli, 1976. (Classici dell'arte, 86). (CR).

3385. Molajoli, Bruno. **Gentile da Fabriano.** Fabrino, Edizioni Gentile, 1927. (2 ed., 1934).

GENTILESCHI, ORAZIO, 1563-1640?

3386. Bissell, Raymond Ward. **The baroque painter Orazio**

Gentileschi; his career in Italy. 2 v. Ann Arbor, Mich., University Microfilms, 1975.

3387. _____. Orazio Gentileschi and the poetic tradition in Caravaggesque painting. University Park, Penn., Pennsylvania State University Press, 1982.

3388. Rosci, Marco. Orazio Gentileschi. Milano, Fabbri, 1965. (I maestri del colore, 83).

GERARD, FRANÇOIS, 1770-1837

3389. Gérard, Henri. Lettres adressées au Baron François Gérard, peintre d'histoire, par les artistes et les personnages célèbres de son temps. 2 v. Paris, Quantin, 1888. 3 ed.

3390. _____. Oeuvres du Baron François Gérard, 1789-1836. 3 v. Paris, Vignières, 1852-57.

3391. Lenormant, Charles. François Gérard, peintre d'histoire. Paris, René, 1847.

GERARD, JEAN IGNACE ISIDORE see GRANDVILLE

GERHAERT, NICOLAUS VAN LEYDEN, 1420/30-1473

3392. Fischel, L. Nicolaus Gerhaert und die Bildhauer der deutschen Spätgotik. München, Bruckmann, 1944.

3393. Maier, August R. Niclaus Gerhaert von Leiden, ein niederländer Plastiker des 15. Jahrhunderts. Strassburg, Heitz, 1910. (Studien zur deutschen Kunstgeschichte, 131).

3394. Wertheimer, Otto. Nicolaus Gerhaert, seine Kunst und seine Wirkung. Berlin, Deutscher Verein für Kunstwissenschaft, 1929.

GERICAULT, THEODORE, 1791-1824

3395. Aimé-Azam, Denise. La passion de Géricault. Paris, Fayard, 1970.

3396. _____. Mazeppa; Géricault et son temps. Paris, Plon, 1956.

3397. Berger, Klaus. Géricault: drawings & watercolors. New York, Bittner, 1946.

3398. _____. Géricault und sein Werk. Wien, Schroll, 1952. (English ed., Lawrence, Kansas, University of Kansas, 1955).

3399. Clement, Charles. Géricault, étude biographique et critique. Paris, Didier, 1879. 3 ed., illustrée. Reprint: Paris, Laget, 1973; English ed.: New York, Da Capo, 1974. (CR).

3400. Courthier, Pierre, ed. Géricault, raconté par lui-même et par ses amis. Vésenaz-Genève, Cailler, 1947.

3401. Eitner, Lorenz. Géricault, an album of drawings in the Art Institute of Chicago. Chicago, University of Chicago Press, 1960.

3402. _____. Géricault, his life and work. Ithaca, New York, Cornell University Press, 1982.

3403. Gauthier, Maximilien. Géricault. Paris, Braun, 1935.

3404. Guercio, Antonio del. Géricault. Milano, Club del Libro, 1963. (Collana d'arte del Club del Libro, 4).

3405. _____. Théodore Géricault. Milano, Fabbri, 1965. (I maestri del colore, 46).

3406. Hôtel Jean Charpentier (Paris). Exposition de l'oeuvres de Géricault. 24 avril au 16 mai 1924. Paris, La Sauvegarde de l'Art Français, 1924. (CR).

3407. Musée des Beaux-Arts de Rouen. Géricault; tout l'oeuvre gravé et pièces en rapport. 28 novembre 1981-28 février 1982. Rouen, Musée des Beaux-Arts, 1981.

3408. Oprescu, Georges. Géricault. Paris, La Renaissance du Livre, 1927.

3409. Régamey, Raymond. Géricault. Paris, Rieder, 1926.

3410. Rosenthal, Léon. Géricault. Paris, Librairie de l'Art Ancien et Moderne, 1905.

3411. Thuillier, Jacques. L'opera completa di Géricault. Milano, Rizzoli, 1978. (Classici dell'arte, 92).

3412. Villa Medici (Rome). Géricault. Novembre 1979-gennaio 1980. Roma, Edizioni dell'Elefante, 1979.

GEROME, JEAN LEON, 1824-1904

3413. Dayton Art Institute (Dayton, Ohio). Jean-Léon Gérôme (1824-1904). November 10-December 30, 1972. Dayton, Dayton Art Institute, 1972.

3414. Hering, Fanny F. Gérôme; the life and works of Jean Léon Gérôme. New York, Cassell, 1892.

3415. Moreau-Vauthier, Charles. Gérôme, peintre et sculpteur, l'homme et l'artiste. Paris, Hachette, 1906.

3416. Musée de Vesoul. Gérôme: Jean-Léon Gérôme, 1824-1904; peintre, sculpteur et graveur. Vesoul, Ville de Vesoul, 1981.

GHIBERTI, LORENZO, 1378-1455

3417. Goldscheider, Ludwig. Ghiberti. London, Phaidon, 1949.

3418. Gollob, Hedwig. Lorenzo Ghibertis künstlerischer Werdegang. Strassburg, Heitz, 1929. (Zur Kunstgeschichte des Auslandes, 126).

3419. Gonelli, Guiseppe. Elogio di Lorenzo Ghiberti. Firenze, Piatti, 1822.

3420. Krautheimer, Richard. Lorenzo Ghiberti. Princeton, N.J., Princeton University Press, 1956. (Rev. ed.: 2 v., 1970).

3421. ———, et al. **Lorenzo Ghiberti nel suo tempo, atti del convegno internazionale di studi (Firenze, 18-21 ottobre 1978).** 2 v. Firenze, Olschki, 1980.

3422. Marchini, Giuseppe. **Ghiberti architetto.** Firenze, La Nuova Italia, 1978.

3423. Museo dell'Accademia e Museo di San Marco (Florence). **Lorenzo Ghiberti, materia e ragionamenti.** 18 ottobre 1978/31 gennaio 1979. Firenze, Centro Di, 1978. (CR).

3424. Perkins, Charles. **Ghiberti et son école.** Paris, Librairie de l'Art, 1886.

3425. Planiscig, Leo. **Lorenzo Ghiberti.** Wien, Schroll, 1940.

3426. Rosito, Massimiliano, ed. **Ghiberti e la sua arte nella Firenze del '3-'400.** Firenze, Città di Vita, 1979.

3427. Schlosser, Julius, von. **Leben und Meinungen des florentinischen Bildners Lorenzo Ghiberti.** Basel, Holbein, 1941.

3428. ———. **Lorenzo Ghibertis Denkwürdigkeiten (I commentarii).** 2 v. Berlin, Bard, 1912.

GHIRLANDAIO, DOMENICO, 1449-1494

3429. Bargellini, Piero. **Il Ghirlandaio del bel mondo fiorentino.** Firenze, Arnaud, 1946.

3430. Biagi, Luigi. **Domenico Ghirlandaio.** Firenze, Alinari, 1928. (Piccola collezione d'arte, 42).

3431. Chiarini, Marco. **Domenico Ghirlandaio.** Milano, Fabbri, 1966. (I maestri del colore, 156).

3432. Davies, Gerald S. **Ghirlandaio.** London, Methuen, 1908.

3433. Hauvette, Henri. **Ghirlandaio.** Paris, Plon, 1908.

3434. Küppers, Paul E. **Die Tafelbilder des Domenico Ghirlandajo.** Strassburg, Heitz, 1916. (Zur Kunstgeschichte des Auslandes, 111).

3435. Lauts, Jan. **Domenico Ghirlandajo.** Wien, Schroll, 1943.

3436. Sabatini, Attilio. **Domenico Ghirlandaio.** Firenze, Illustrazione Toscana, 1944.

3437. Steinmann, Ernst. **Ghirlandajo.** Bielefeld/Leipzig, Velhagen & Klasing, 1897. (Künstler-Monographien, 25).

3438. Weiser von Inffeld, Josepha. **Das Buch um Ghirlandaio, eine Florentiner Chronik.** Zürich/Stuttgart, Rascher, 1957.

GIACOMETTI, ALBERTO, 1901-1966

AUGUSTO, 1877-1947

GIOVANNI, 1868-1933

3439. Bucarelli, Palma. **Giacometti.** Roma, Editalia, 1962.

3440. Carluccio, Luigi. **Giacometti, a sketchbook of interpretive drawings.** Trans. by Barbara Luigia La Penta. New York, Abrams, 1968.

3441. du Bouchet, André. **Alberto Giacometti, dessins, 1914-1965.** Paris, Maeght, 1969.

3442. du Carrois, Norbert R. **Giovanni Giacometti; Katalog des graphischen Werkes, 1888-1933.** Zürich, P & P Galerie, 1977.

3443. Dupin, Jacques. **Alberto Giacometti.** Paris, Maeght, 1963.

3444. Fondation Maeght (Paris). **Alberto Giacometti.** 8 juillet-30 septembre 1978. Paris, Fondation Maeght, 1978. (CR).

3445. Genêt, Jean. **L'atelier d'Alberto Giacometti.** Décines (Isère), Barbezat, 1963.

3446. Giacometti, Augusto. **Von Florenz bis Zürich, Blätter der Erinnerung.** Zürich, Rascher, 1948.

3447. ———. **Von Stampa bis Florenz, Blätter der Erinnerung.** Zürich, Rascher, 1943.

3448. Hohl, Reinhold. **Alberto Giacometti.** Trans. by Gerd Hatje. New York, Abrams, 1972.

3449. Huber, Carla. **Alberto Giacometti.** Zürich, Ex Libris, 1970.

3450. Hugelshofer, Walter. **Giovanni Giacometti, 1868-1933.** Zürich/Leipzig, Füssli, 1936.

3451. Köhler, Elisabeth E. **Giovanni Giacometti, 1868-1933; Leben und Werk.** Zürich, Fischer, 1969.

3452. Lord, James. **Alberto Giacometti, drawings.** Greenwich, Conn., New York Graphic Society, 1971.

3453. ———. **A Giacometti portrait.** New York, Farrar, Straus & Giroux, 1980.

3454. Lust, Herbert C. and Taylor, John L. **Giacometti, the complete graphics and fifteen drawings.** New York, Tudor, 1970.

3455. Martini, Alberto. **Giacometti.** Milano, Fabbri, 1967. (I maestri del colore, 79).

3456. Meyer, Franz. **Alberto Giacometti; eine Kunst existentieller Wirklichkeit.** Frauenfeld/Stuttgart, Huber, 1968.

3457. Moulin, Raoul-Jean. **Giacometti, sculptures.** Trans. by Bettina Wadia. New York, Tudor, 1964.

3458. Museum of Modern Art (New York). **Alberto Giacometti.** New York, Museum of Modern Art, 1965; distributed by Doubleday, Garden City, N.Y.

3459. Negri, Mario. **Giacometti.** Milano, Fabbri, 1969. (I maestri della scultura, 57).

3460. Pierre Matisse Gallery (New York). **Exhibition of sculptures, paintings, drawings [by Alberto Giacometti].**

Introduction by Jean-Paul Sartre and a letter from
Alberto Giacometti. January 19 to February 14, 1948.
New York, Pierre Matisse Gallery, 1948.

3461. Poeschel, Erwin. **Augusto Giacometti.** Zürich/Leipzig,
Füssli, 1928. (Monographien zur Schweizer Kunst, 3).

3462. Solomon R. Guggenheim Museum (New York). **Alberto
Giacometti, a retrospective exhibition.** New York,
Guggenheim Foundation, 1974.

3463. Zendralli, A. M. **Augusto Giacometti.** Zurigo/Lipsia,
Füssli, 1936.

GIBBONS, GRINLING, 1648-1721

3464. Bullock, Albert E., ed. **Grinling Gibbons and his compeers.**
London, Tiranti, 1914.

3465. Green, David. **Grinling Gibbons, his work as carver and
statuary.** London, Country Life, 1964.

3466. Tipping, H. Avray. **Grinling Gibbons and the woodwork of
his age (1648-1720).** London, Country Life, 1914.

3467. Whinney, Margaret D. **Grinling Gibbons in Cambridge.**
Cambridge, Cambridge University Press, 1948.

GIBBS, JAMES, 1682-1754

3468. Gibbs, James. **Designs of buildings and ornaments; a
collection of the best plates from this work.**
Washington, D.C., The Reprint Co., 1909.

3469. _____. **The rules for drawing the several parts of
architecture.** The first edition reduced. London, Hodder
and Stoughton, 1924.

3470. Little, Bryan. **The life and work of James Gibbs,
1682-1754.** London, Batsford, 1955.

GIBSON, JOHN, 1790-1866

3471. Eastlake, Elizabeth R. **Life of John Gibson, R. A.,
sculptor.** London, Longmans, Green, 1870.

3472. Matthews, T. **The biography of John Gibson, R. A.,
sculptor, Rome.** London, Heinemann, 1911.

GILBERT, ALFRED, 1854-1934

3473. Bury, Adrian. **Shadow of Eros, a biographical and critical
study of the life and works of Sir Alfred Gilbert, R. A.,
M.V.O., D.C.L.** London, The Dropmore Press, 1952.

3474. Cox, E. M. **Commemorative catalogue of an exhibition of
models and designs by the late Sir Alfred Gilbert, R. A.,
held at the Victoria and Albert Museum, autumn 1936.**
Oxford, Oxford University Press, 1936.

3475. Hatton, Joseph. **The life and work of Alfred Gilbert.**
London, The Art Journal, 1903.

3476. McAllister, I. G. **Alfred Gilbert.** London, Black, 1929.

3477. Minneapolis Institute of Arts. **Victorian High Renaissance:
George Frederick Watts, 1817-1904; Frederic Leighton,
1830-1939; Albert Moore, 1841-93; Alfred Gilbert, 1854-
1939.** 19 November-7 January, 1979. Minneapolis,
Minneapolis Institute of Arts, 1978.

GILL, ERIC, 1882-1940

3478. Brady, Elizabeth A. **Eric Gill, twentieth-century book
designer.** Metuchen, New Jersey, Scarecrow Press, 1974.

3479. Brewer, Roy. **Eric Gill, the man who loved letters.**
London, Muller, 1973.

3480. Gill, Eric. **Art.** London, Bodley Head, 1934.

3481. _____. **Autobiography.** London, Cape, 1940.

3482. _____. **Beauty looks after herself.** London/New York,
Sheed & Ward, 1933. (Reprint: Freeport, New York, Books
for Libraries, 1956).

3483. _____. **The engravings of Eric Gill.** Wellingborough,
Eng., Skelton's Press, 1983.

3484. _____. **It all goes together; selected essays.** New York,
Devin, 1944.

3485. _____. **Letters.** Ed. by Walter Shewring. New York,
Devin, 1948.

3486. Gill, Evan R. **Bibliography of Eric Gill.** London, Cassell,
1953. (CR).

3487. _____. **The inscriptional work of Eric Gill, an
inventory.** London, Cassell, 1964. (CR).

3488. Physick, J. F. **The engraved work of Eric Gill.** London,
Her Majesty's Stationery Office, 1963. (CR).

3489. _____. **The engraved work of Eric Gill.** [A photographic
supplement of works in the Victoria and Albert Museum].
London, Her Majesty's Stationery Office, 1963.

3490. Speaight, Robert. **The life of Eric Gill.** London, Methuen,
1966.

3491. Thorp, Joseph and Marriott, Charles. **Eric Gill.** London,
Cape, 1929.

3492. Yorke, Malcolm. **Eric Gill, man of flesh and spirit.** New
York, Universe, 1982.

GILLES, WERNER, 1894-1961

3493. Akademie der Künste (Berlin). **Werner Gilles, 1894-1961.**
Berlin, Akademie der Künste, [1962?]. (Kunst und
Altertum am Rhein, 43).

3494. Hentzen, Alfred. **Werner Gilles.** Köln, DuMont Schauberg,
1960.

3495. Rheinisches Landesmuseum (Bonn). **Werner Gilles, 1894-1961; ein Rückblick.** [January 17-February 25, 1973]. Köln, Rheinisches Landesmuseum, 1973.

GILLRAY, JAMES, 1757-1815

3496. Arts Council of Great Britain. **James Gillray, 1756-1815; drawings and caricatures.** [Arts Council Gallery, January 6-February 4, 1967]. London, The Arts Council, 1967.

3497. Gillray, James. **Fashionable contrasts; caricatures.** Introduced and annotated by Draper Hill. London, Phaidon, 1966.

3498. _____. **The works of James Gillray, from the original plates, with the addition of many subjects not before collected.** 2 v. London, Bohn, 1851.

3499. Hill, Draper. **Mr. Gillray, the caricaturist; a biography.** London, Phaidon, 1965. (U.S. distributors: Greenwich, Conn., New York Graphic Society).

3500. Wright, Thomas and Evans, R. H. **Historical and descriptive account of the caricatures of James Gillray, comprising a political and humorous history of the latter part of the reign of George the third.** [As an accompaniment to his collected works published . . . by H. G. Bohn]. London, Bohn, 1851. (CR).

GILLY, FRIEDRICH, 1772-1800

3501. Oncken, Alste. **Friedrich Gilly, 1772-1800.** Berlin, Deutscher Verein für Kunstwissenschaft, 1935. (CR). (Forschungen zur deutschen Kunstgeschichte, 5).

3502. Rietdorf, Alfred. **Gilly, Wiedergeburt der Architektur.** Berlin, Hugo, 1940.

GILPIN, WILLIAM, 1724-1804

3503. Barbier, Carl P. **William Gilpin; his drawings, teachings, and theory of the picturesque.** Oxford, Oxford University Press, 1963.

3504. Templeman, William D. **The life and work of William Gilpin.** Urbana, Ill., University of Illinois Press, 1939.

GIMMI, WILHELM, 1886-1965

3505. Cailler, Pierre. **Catalogue raisonné de l'oeuvre lithographié de Wilhelm Gimmi.** Genève, Cailler, 1956. (CR). (Catalogue d'oeuvres gravés et lithographiés, 1).

3506. Jacometti, Nesto. **Wilhelm Gimmi.** Genève, Skira, 1943. (Peintres d'hier et d'aujourd'hui, 1).

3507. Jedlicka, Gotthard. **Begegnung mit Wilhelm Gimmi.** Zürich, Füssli, 1961.

3508. Peillex, Georges. **Wilhelm Gimmi, catalogue raisonné des peintures.** Zürich, Füssli, 1978. (CR).

3509. _____ [and] Scheidegger, Alfred. **Wilhelm Gimmi.** Zürich, Füssli, 1972.

GIOCONDO, FRA GIOVANNI, 1435-1515

3510. Brenzoni, Raffaello. **Fra Giovanni Giocondo Veronese, Verona 1435-Roma 1515.** Firenze, Olschki, 1960.

3511. Geymüller, Heinrich. **Cento disegni di architettura d'ornato e di figure di Frà Giovanni Giocondo.** Firenze, Bocca, 1882.

GIORDANO, LUCA, 1635-1705

3512. Benesch, Otto. **Luca Giordano.** Wien, Hölzel, 1923.

3513. Brooks Memorial Art Gallery (Memphis, Tenn.). **Luca Giordano in America; a loan exhibition, April 1964.** [Catalogue by Michael Milkovich]. Memphis, Tenn., Brooks Memorial Art Gallery, 1964.

3514. Ferrari, Oreste [and] Scavizzi, Giuseppe. **Luca Giordano.** 3 v. Napoli, Edizioni Scientifiche Italiane, 1966.

3515. Petraccone, Enzo. **Luca Giordano, opera postuma.** Napoli, Ricciardi, 1919.

3516. Rinaldis, Aldo de. **Luca Giordano.** Firenze, Alinari, 1922. (Piccola collezione d'arte, 40).

GIORGIO, FRANCESCO DI see FRANCESCO DI GIORGIO MARTINI

GIORGIONE DA CASTELFRANCO, 1477-1510

3517. Baldass, Ludwig von. **Giorgione.** Trans. by J. M. Brownjohn. New York, Abrams, 1965.

3518. Calvesi, Maurizio, ed. **Giorgione e la cultura veneta tra '400 e '500; mito, allegoria, analisi iconologica.** Roma, de Luca, 1981.

3519. Castelfranco Veneto (Venice). **Giorgione, guida alla mostra: i tempi di Giorgione.** Firenze, Alinari, 1978.

3520. Coletti, Luigi. **All the paintings of Giorgione.** New York, Hawthorn, 1961. (Complete Library of World Art, 3).

3521. Conti, Angelo. **Giorgione, studio.** Firenzi, Alinari, 1984.

3522. Conway, William M. **Giorgione, a new study of his art as a landscape painter.** London, Benn, 1929.

3523. Cook, Herbert F. **Giorgione.** London, Bell, 1904. 2 ed.

3524. Dreyfous, Georges. **Giorgione.** Paris, Alcan, 1914.

3525. Ferriguto, Arnaldo. **Attraverso i 'misteri' di Giorgione.** Castelfranco Veneto, Arti Grafiche Trevisan, 1933.

3526. Fiocco, Giuseppe. **Giorgione.** Bergamo, Ist. Ital. d'Arti Grafiche, 1948. 2 ed.

3527. Fossi, Piero. **Di Giorgione e della critica d'arte.** Firenze, Olschki, 1957. (Pocket Library of Studies in Art, 7).

3528. Hartlaub, G. F. **Giorgiones Geheimnis; ein kunstgeschicht-
licher Beitrag zur Mystik der Renaissance.** München,
Allgemeine Verlagsanstalt, 1925.

3529. Hermanin, Federico. **Il mito di Giorgione.** Spoleto,
Argentieri, 1933.

3530. Hourticq, Louis. **Le problème de Giorgione; sa légende, son
oeuvre, ses élèves.** Paris, Hachette, 1930.

3531. Justi, Ludwig. **Giorgione.** 2 v. Berlin, Reimer, 1936.
3 ed.

3532. Laudau, Paul. **Giorgione.** Berlin, Bard, 1903. (Die Kunst,
20).

3533. Magugliani, Lodovico. **Introduzione a Giorgione ed alla
pittura veneziana del Rinascimento.** Milano, Ceschina,
1970.

3534. Morassi, Antonio. **Giorgione.** Milano, Hoepli, 1942.

3535. Palazzo Ducale (Venice). **Giorgione e i Giorgioneschi,
catalogo della mostra.** 11 giugno-23 ottobre 1955.
Venezia, Casa Editrice Arte Veneta, 1955.

3536. Pallucchini, Rodolfo, ed. **Giorgione e l'umanesimo
veneziano.** 2 v. Firenze, Olschki, 1981. (Civiltà
veneziana saggi, 27).

3537. Pergola, Paolo della. **Giorgione.** Milano, Martello, 1955.

3538. Phillips, Duncan. **The leadership of Giorgione.**
Washington, D.C., The American Federation of the Arts,
1937.

3539. Pignatti, Terisio. **Giorgione, complete edition.** Trans. by
Clovis Whitfield. London, Phaidon, 1971. (Rev. ed.:
Milano, Alfieri, 1978).

3540. Richter, George M. **Giorgio da Castelfranco, called
Giorgione.** Chicago, University of Chicago Press, 1937.

3541. Schaukal, Richard von. **Giorgione; oder, Gespräche über die
Kunst.** München, Müller, 1907.

3542. Trevisan, Luca L. **Giorgione.** Venezia, Emiliana, 1951.

3543. Tschmelitsch, Günther. **Zorzo, genannt Giorgione; der
Genius und sein Bannkreis.** Wien, Braumüller, 1975.

3544. Venturi, Lionello. **Giorgione e il Giorgionismo.** Milano,
Hoepli, 1913.

3545. Villard, Ugo Monneret de. **Giorgione da Castelfranco;
studio critico.** Bergamo, Istituto Italiano d'Arti
Grafiche, 1904.

3546. Zampetti, Pietro. **L'opera completa de Giorgione.** Milano,
Rizzoli, 1968. (I classici dell'arte, 16). (CR).
(English ed.: New York, Abrams, 1968).

GIOTTO DI BONDONE, 1266-1337

3547. Alazard, Jean. **Giotto, biographie critique.** Paris,
Librairie Renouard, 1918.

3548. Baccheschi, Edi. **The complete paintings of Giotto.**
New York, Abrams, 1966.

3549. Battisti, Eugenio. **Giotto, biographical and critical
study.** Trans. by James Emmons. Lausanne, Skira, 1960;
U.S. distribution: World, Cleveland.

3550. Baxandall, Michael. **Giotto and the orators; humanist
observers of painting in Italy and the discovery of
pictorial composition, 1350-1450.** Oxford, Oxford
University Press, 1971.

3551. Bayet, Charles. **Giotto.** Paris, Librairie de l'art ancien
et moderne, 1907.

3552. Bellinati, Claudio. **La cappella di Giotto all'Arena
(1300-1306).** Padova, Tipografia del Seminario di Padova,
1967.

3553. Bologna, Ferdinando. **Novità su Giotto; Giotto al tempo
della cappella Peruzzi.** Torino, Einaudi, 1969.

3554. Carli, Enzo. **Giotto.** Firenze, Electa, 1951.
(Astra-Arengarium collana di monografie d'arte, pittori,
19).

3555. Carrà, Carlo. **Giotto.** London, Zwemmer, 1925.

3556. Cecci, Emilio. **Giotto.** Milano, Hoepli, 1937.

3557. _____. **Giotto.** Trans. by Elizabeth Andrews. New York,
McGraw-Hill, 1961. (Not the same title as above).

3558. Cole, Bruce. **Giotto and Florentine painting, 1280-1375.**
New York, Harper & Row, 1976.

3559. de Selincourt, Basil. **Giotto.** London, Duckworth, 1905.
(U.S. ed.: New York, Scribner, 1911).

3560. Gioseffi, Decio. **Giotto architetto.** Milano, Edizioni di
Comunità, 1963.

3561. Gnudi, Cesare. **Giotto.** Milano, Martelli, 1959.

3562. Gosebruch, Martin. **Giotto und die Entwicklung des
neuzeitlichen Kunstbewusstseins.** Köln, DuMont Schauberg,
1962.

3563. _____, et al. **Giotto di Bondone.** Konstanz,
Leonhardt, 1970. (Persönlichkeit und Werk, 3).

3564. Hausenstein, Wilhelm. **Giotto.** Berlin, Propyläen, 1923.

3565. Hetzer, Theodor. **Giotto, Grundlegung der neuzeitlichen
Kunst.** Mittenwald, Mäander/Stuttgart, Urachhaus, 1981.
(Schriften Theodor Hetzers, 1).

3566. Mariani, Valerio. **Giotto.** Napoli, Libreria Scientifica,
1966.

3567. _____. **Giotto, 1337-1937.** Roma, Palombi, 1937.

3568. Luzzatto, Guido L. **L'arte di Giotto.** Bologna, Zanichelli,
1927.

3569. Marle, Raimond van. **Recherches sur l'iconographie de
Giotto et de Duccio.** Strassburg, Heitz, 1920.

3570. Perkins, F. Mason. **Giotto.** London, Bell, 1902.

3571. Previtali, Giovanni. **Giotto.** 2 v. Milano, Fabbri, 1964. (I maestri del colore, 26-27).

3572. _____. **Giotto e la suo bottega.** Milano, Fabbri, 1974.

3573. Quilter, Harry. **Giotto.** London, Sampson Low, 1880.

3574. Rintelin, Friedrich. **Giotto und die Giotto-Apokryphen.** München/Leipzig, Müller, 1912. (Rev. ed.: Basel, Schwabe, 1923).

3575. Rosenthal, Erwin. **Giotto in der mittelalterlichen Geistesentwicklung.** Augsburg, Filser, 1924.

3576. Ruskin, John. **Giotto and his works in Padua, being an explanatory notice of the series of woodcuts executed for the Arundel Society after the frescoes in the Arena Chapel.** [London], Arundel Society, 1854. (Reprint: London, Allen, 1905).

3577. Salvini, Roberto. **All the paintings of Giotto.** Trans. by Paul Colacicchi. 2 v. New York, Hawthorn, 1964. (Complete Library of World Art, 18-19).

3578. _____ and Benedictis, Cristina de. **Giotto bibliografia.** 2 v. Roma, Palombi, 1938/Roma, Istituto Nazionale d'Archeologia e Storia dell'Arte, 1973. (Istituto nazionale d'archeologia e storia dell'arte, bibliografie e cataloghi, 4).

3579. Schneider, Laurie, ed. **Giotto in perspective.** Englewood Cliffs, N.J., Prentice-Hall, 1974.

3580. Sirén, Osvald. **Giotto and some of his followers.** Trans. by Frederick Schenck. 2 v. Cambridge, Mass., Harvard University Press, 1917. (Reprint: New York, Hacker, 1975).

3581. Smart, Alastair. **The Assisi problem and the art of Giotto.** Oxford, Oxford University Press, 1971.

3582. Supino, Igino B. **Giotto.** 2 v. Firenze, Ist. di Ediz. Artistiche, 1920.

3583. Thode, Henry. **Giotto.** Bielefeld/Leipzig, Velhagen & Klasing, 1899. (Künstler-Monographien, 43).

3584. Vigorelli, Giancarlo. **L'opera completa di Giotto.** Milano, Rizzoli, 1966. (CR). (Classici dell'arte, 3).

3585. Weigelt, Curt H. **Giotto; des Meisters Gemälde.** Stuttgart, Deutsche Verlagsanstalt, 1925. (Klassiker der Kunst in Gesamtausgaben, 19).

GIOVANNI DA BOLOGNA, 1529-1608

3586. Desjardins, Abel. **La vie et l'oeuvre de Jean Bologne.** Paris, Quantin, 1883.

3587. Dhanens, Elisabeth. **Jean Boulogne, Giovanni Bologna Fiammingo; Douai 1529-Florence 1608.** Brussels, Paleis der Academiën, 1956. (Vlaamsche Academie voor Wetenschappen, Lettern en Schoone Kunsten van Belgie, Brussels; Klasse der Schoone Kunsten; Verhandelingen, 11).

GIOVANNI DA MILANO, 1300-1370

3588. Boscovits, Miklos. **Giovanni da Milano.** Firenze, Sadea/Sansoni, 1966. (I diamanti dell'arte, 13).

3589. Castelfranchi-Vegas, Liana. **Giovanni da Milano.** Milano, Fabbri, 1965. (I maestri del colore, 111).

3590. Cavadini, Luigi. **Giovanni da Milano.** Valmorea, Comune di Valmorea, 1980.

3591. Marabottini, Alessandro. **Giovanni da Milano.** Firenze, Sansoni, 1950. (Monografie e studi a cura dell'Istituto di Storia dell'Arte dell'Università di Firenze, 5).

GIOVANNI DA FIESOLE see ANGELICO, FRA

GIOVANNI DA VERONA, 1457-1525

3592. Lugano, Placido. **Di Fra Giovanni da Verona, maestro d'intaglio e di tarsia e della sua scuola.** Siena, Lazzeri, 1905.

GIOVANNI DI PAOLO, 1403-1482

3593. Brandi, Cesare. **Giovanni di Paolo.** Firenze, Le Monnier, 1947.

3594. Pope-Hennessy, John. **Giovanni di Paolo, 1403-1483.** London, Chatto, 1937.

GIOVANNI DI PIETRO see SPAGNA, LO

GIRARDON, FRANCOIS, 1628-1715

3595. Corrard de Breban. **Notice sur la vie et les oeuvres de François Girardon de Troyes.** Troyes, Fèvre, 1850. 2 ed.

3596. Francastel, Pierre. **Girardon; biographie et catalogue critiques; l'oeuvre complète de l'artiste.** Paris, Beaux-Arts, 1928. (CR).

3597. Musée des Beaux-Arts (Troyes). **Mignard et Girardon.** 25 juin au 2 octobre 1955. Troyes, Musée des Beaux-Arts, 1955.

GIRODET-TRIOSON, ANNE LOUIS, 1767-1824

3598. Bernier, Georges. **Anne-Louis Girodet, 1764-1824, prix de Rome 1789.** Paris, Damase, 1975.

3599. Coupin, P. A. **Oeuvres posthumes de Girodet-Trioson, peintre d'histoire.** 2 v. Paris, Renouard, 1829.

3600. Grasset, August. **Girodet-Trioson, tableau inédit de ce célèbre peintre.** Paris, Loones, 1872.

3601. Leroy, Paul Auguste. **Girodet-Trioson, peintre d'histoire.** Orléans, Herluison, 1892.

3602. Musée de Montargis. **Girodet, 1767-1824; exposition du deuxième centenaire.** Montargis, Musée de Montargis, 1967.

3603. Souesme, Etienne. **Girodet.** Paris, Delauney, 1825.

GIRTIN, THOMAS, 1775-1802

3604. Binyon, Laurence. **Thomas Girtin, his life and works; an essay.** London, Seeley, 1900.

3605. Burlington Fine Arts Club (London). **Exhibition on the works of Thomas Girtin, born 1773, died 1802.** London, Spottiswoode, 1875.

3606. Davies, Randall. **Thomas Girtin's water-colours.** London, Studio, 1924.

3607. Girtin, Thomas and Loshak, David. **The art of Thomas Girtin.** London, Black, 1954. (CR).

3608. Mayne, Jonathan. **Thomas Girtin.** Leigh-on-Sea, Lewis, 1949.

3609. Whitworth Art Gallery, University of Manchester (Manchester, England)/Victoria and Albert Museum (London). **Watercolours by Thomas Girtin.** January-February, 1975/March-April, 1975. London, Victoria and Albert Museum, 1975.

GISLEBERTUS, fl. 1125-1150

3610. Grivot, Denis and Zarnecki, George. **Gislebertus, sculptor of Autun.** New York, Orion, 1961.

GIULIO ROMANO, 1499-1546

3611. Carpeggiani, Paolo, et al. **Studi su Giulio Romano; omaggio all'artista nel 450 della venuta a Mantova (1524-1974).** San Benedetto Po, Accademia Polironiana, 1975. (Biblioteca Polironiana di Fonti e Studi, 2).

3612. Carpi, Piera. **Giulio Romano ai servigi di Federico II Gonzaga.** Mantova, Mondovi, 1920.

3613. D'Arco, Carlo. **Istoria della vita e delle opere di Giulio Pippi Romano.** Mantua, Negretti, 1842. 2 ed.

3614. Grand Palais (Paris). **Jules Romain: l'Histoire de Scipion; tapisseries et dessins.** 26 mai-2 octobre 1978. Paris, Editions de la réunion des musées nationaux, 1978.

3615. Hartt, Frederick. **Drawings by Giulio Romano in the National Museum in Stockholm.** [Stockholm], Nationalmusei Arsbok, 1939.

3616. ———. **Giulio Romano.** 2 v. New Haven, Yale University Press, 1958.

GLACKENS, WILLIAM JAMES, 1870-1938

3617. DuBois, Guy P. **William J. Glackens.** New York, Whitney Museum of American Art, 1931.

3618. Glackens, Ira. **William Glackens and the Ashcan Group; the emergence of the realism in American art.** New York, Crown, 1957.

3619. Watson, Forbes. **William Glackens.** New York, Duffield, 1923.

3620. Whitney Museum of American Art (New York). **William Glackens, memorial exhibition.** December 14, 1938, to January 15, 1939. New York, Whitney Museum of American Art, 1938.

GLEIZES, ALBERT, 1881-1953

3621. Cassou, Jean, ed. **Albert Gleizes [hommage].** [Lyon], Atelier de la Rose, 1954.

3622. Chevalier, Jean, ed. **Albert Gleizes et le Cubisme.** [Text in French, German, and English]. Basel, Basilius Presse, 1962.

3623. Gleizes, Albert and Metzinger, Jean. **Du Cubisme.** Paris, Figuière, 1912. (English ed.: London, Unwin, 1913).

3624. Solomon R. Guggenheim Museum (New York). **Albert Gleizes, 1881-1953; a retrospective exhibition.** New York, Guggenheim Foundation, 1964. (CR).

GLEYRE, MARC CHARLES GABRIEL, 1806-1874

3625. Clément, Charles. **Gleyre; étude biographique et critique, avec le catalogue raisonné de l'oeuvre du maître.** Paris, Didier, 1878. (CR).

3626. Grey Art Gallery and Study Center, New York University (New York). **Charles Gleyre, 1806-1874.** February 6-March 22, 1980. New York, Grey Art Gallery and Study Center, 1980.

3627. Kunstmuseum (Winterthur, Switzerland). **Charles Gleyre ou les illusions perdues.** [Includes reprint of Clément's catalogue raisonné]. Zürich, Schweizerisches Institut für Kunstwissenschaft, 1974. (CR).

3628. Lugeon, Raphael. **Charles Gleyre, le peintre et l'homme.** Lausanne, Imprimérie centrale, 1939.

GLOEDEN, WILHELM VON, 1856-1931

3629. Barthes, Roland. **Wilhelm von Gloeden; interventi di Joseph Beuys, Michelangelo Pistoletta, Andy Warhol.** Napoli Amelio, 1978.

3630. Falzone del Barbaró, Michele, et al. **Le fotografie di von Gloeden.** Milano, Longanesi, 1980.

3631. Gloeden, Wilhelm von. **Photographs of the classic male nude.** Preface by Jean-Claude Lemagny. New York, Camera/Graphic, 1977.

3632. Kunsthalle Basel. **Wilhelm von Gloeden (1856-1931).** 15. Juli bis 9. September 1979. [Text by Ekkehard Hieronimus]. Basel, Kunsthalle, 1979.

GOES, HUGO VAN DER, 1435-1482

3633. Denis, Valentin. **Hugo van der Goes.** Bruxelles, Elsevier, 1956. (Connaissance des primitifs Flamands, 1).

3634. Destrée, Joseph. **Hugo van der Goes.** Bruxelles/Paris, Librairie d'art et d'histoire/van Oest, 1914.

3635. Friedländer, Max J. **Hugo van der Goes.** Trans. by Heinz Norden. Leyden, Sijthoff/Brussels, La Connaissance, 1969. (Early Netherlandish Painting, 4).

3636. Knipping, John B. **Hugo van der Goes.** Amsterdam, Becht, 1940. (Palet serie, 3).

3637. Pfister, Kurt. **Hugo van der Goes.** Basel, Schwabe, 1923.

3638. Rey, Robert. **Hugo van der Goes.** Bruxelles, Cercle d'Art, 1945.

3639. Wauters, Alphonse. **Hugues van der Goes, sa vie et ses oeuvres.** Bruxelles, Hayez, 1872.

3640. Winkler, Friedrich. **Das Werk des Hugo van der Goes.** Berlin, de Gruyter, 1964.

GOGH, VINCENT VAN, 1853-1890

3641. Andriesse, Emmy. **De Wereld van van Gogh.** [Photographs; text in Dutch/English/French]. Haag, Daamen, 1953.

3642. Artaud, Antonin. **Van Gogh, le suicidé de la société.** Paris, K éditeur, 1947.

3643. Arts Council of Great Britain. **Vincent van Gogh, 1853-1890; an exhibition of paintings and drawings.** London, Arts Council of Great Britain, 1947.

3644. Badt, Kurt. **Die Farbenlehre van Goghs.** New ed. Köln, DuMont Schauberg, 1981.

3645. Bauer, Walter. **Die Sonne von Arles; das Leben von Vincent van Gogh.** Hattingen (Ruhr), Hundt, 1956. 2 ed.

3646. Beucken, Jean de. **Un portrait de Vincent van Gogh.** Liège, Editions du Balancier, 1938.

3647. Bourniquel, Camille, et al. **Van Gogh.** [Paris], Hachette, 1968.

3648. Braunfels, Wolfgang, ed. **Vincent van Gogh: ein Leben in Einsamkeit und Leidenschaft.** Berlin, Safari, 1962.

3649. Bremmer, Henricus P. **Vincent van Gogh, inleidende beschouwingen.** Amsterdam, Versluys, 1911.

3650. Brooks, Charles M. **Vincent van Gogh; a bibliography comprising a catalogue of the literature published from 1890 through 1940.** New York, Museum of Modern Art, 1942.

3651. Buchmann, Mark. **Die Farbe bei Vincent van Gogh.** Zürich, Bibliander, 1948.

3652. Cabanne, Pierre. **Van Gogh.** Paris, Somogy, 1961.

3653. Chetham, Charles S. **The role of Vincent van Gogh's copies in the development of his art.** New York, Garland, 1976.

3654. Cogniat, Raymond. **Van Gogh.** Paris, Somogy, 1958. (U.S. ed.: New York, Abrams, 1959).

3655. Colin, Paul E. **Van Gogh.** Trans. by Beatrice Moggridge. New York, Dodd, Mead, 1926.

3656. Cooper, Douglas [and] Hofmannsthal, Hugo von. **Drawings and watercolors by Vincent van Gogh.** New York, Macmillan, 1955.

3657. Courthion, Pierre, ed. **Van Gogh, raconté par lui-même et par ses amis.** Vésenaz-Genève, Cailler, 1947.

3658. Dantzig, Maurits M. van. **Vincent? A new method of identifying the artist and his work and of unmasking the forger and his products.** Amsterdam, Keesing, 1953.

3659. Doiteau, Victor et Leroy, Edgard. **La folie de Vincent van Gogh.** Paris, Editions Aesculape, 1928.

3660. Duret, Théodore. **Van Gogh, édition définitive.** Paris, Bernheim-Jeune, 1919.

3661. Elgar, Frank. **Van Gogh.** Trans. by James Cleugh. New York, Praeger, 1966.

3662. Erpel, Fritz. **Van Gogh, self-portraits.** Oxford, Cassirer, 1964.

3663. Estienne, Charles. **Van Gogh.** Trans. by S. J. C. Harrison. Genève, Skira, 1953.

3664. Faille, Jacob B. de la. **L'époque française de van Gogh.** Paris, Bernheim-Jeune, 1927.

3665. ————. **Les faux van Gogh.** Paris et Bruxelles, van Oest, 1930.

3666. ————. **L'oeuvre de Vincent van Gogh; catalogue raisonné.** 4 v. Paris/Bruxelles, van Oest, 1928. (Rev., English ed.: Amsterdam, Meulenhoff International, 1970). (CR).

3667. ————. **Vincent van Gogh.** Paris, Hyperion, 1939.

3668. Fels, Florent. **Vincent van Gogh.** Paris, Floury, 1928.

3669. Fierens, Paul. **Van Gogh.** Paris, Braun, 1949.

3670. Florisoone, Michel. **Van Gogh.** Paris, Plon, 1937.

3671. Formaggio, Dino. **Van Gogh.** Milano, Mondadori, 1952. (Biblioteca moderna Mondadori, 275).

3672. Forrester, Viviane. **Van Gogh, ou l'enterrement dans les blés.** Paris, Seuil, 1983.

3673. Galerie H. O. Miethke (Vienna). **Vincent van Gogh, Kollektiv Ausstellung.** Jänner 1906. Wien, Ohwala, [1906].

3674. Gemeentemuseum (The Hague). **Vincent van Gogh, herdenkingstentoonstelling.** 30 Maart-17 Mei 1953. 's Gravenhage, [Gemeentemuseum], 1953.

3675. Gogh, Elizabeth du Quesne van. **Personal recollections of Vincent van Gogh.** Trans. by Katherine S. Dreier. Boston/New York, Houghton Mifflin, 1913.

3676. Gogh, Vincent van. **The complete letters.** Trans. by Mrs. J. van Gogh-Bonger and C. de Dood. 3 v. Greenwich, Conn., New York Graphic Society, 1959. 2 ed.

3677. ———. **Letters, 1886-1890; a facsimile edition.** 2 v. London, The Scolar Press, 1977.

3678. Goldscheider, Ludwig. **Vincent van Gogh.** London, Phaidon, 1947.

3679. Graetz, H. R. **The symbolic language of Vincent van Gogh.** New York, McGraw-Hill, 1963.

3680. Grappe, Georges. **Van Gogh.** Genève, Skira, 1943. (Les trésors de la peinture française, 18).

3681. Hammacher, Abraham M. **Genius and disaster; the ten creative years of Vincent van Gogh.** New York, Abrams, 1968.

3682. ———. **Van Gogh, a documentary biography.** New York, Macmillan, 1982.

3683. Hanson, Lawrence and Hanson, Elisabeth. **Portrait of Vincent, a Van Gogh biography.** London, Chatto & Windus, 1955.

3684. Hautecoeur, Louis. **Van Gogh.** Monaco, Documents d'Art, 1946.

3685. Huisman, Philippe. **Van Gogh, portraits.** Lausanne, International Art Book, 1960. (Rhythmes et couleurs, 5).

3686. Hulsker, Jan. **The complete Van Gogh: paintings, drawings, sketches.** New York, Abrams, 1980.

3687. Huyge, René. **Van Gogh.** New York, Crown, 1958.

3688. Keller, Horst. **Vincent van Gogh; die Jahre der Vollendung.** Köln, DuMont Schauberg, 1969. (U.S. ed.: New York, Abrams, 1970).

3689. Knapp, Fritz. **Vincent van Gogh.** Bielefeld/Leipzig, Velhagen & Klasing, 1930. (Künstler-Monographien, 118).

3690. Krauss, André. **Vincent van Gogh: studies in the social aspects of his work.** Göteborg, Acta Universitatis Göthoburgensis, 1983. (Gothenburg Studies in Art and Architecture, 2).

3691. Kuhn-Foelix, August. **Vincent van Gogh, eine Psychographie.** Bergen, Müller & Kiepenheuer, 1958.

3692. Lecaldano, Paolo. **L'opera pittorica completa di Van Gogh e i suoi nessi grafici.** 2 v. Milano, Rizzoli, 1971. (CR). (Classici dell'arte, 51-52).

3693. Leprohon, Pierre. **Vincent van Gogh.** Paris, Bonne, 1972.

3694. Leymarie, Jean. **Van Gogh.** [Paris], Tisné, [1951].

3695. ———. **Who was Van Gogh?** Trans. by James Emmons. Genève, Skira, 1968; U.S. distributors: World, Cleveland.

3696. Lubin, Albert J. **Stranger on earth, a psychological biography of Vincent van Gogh.** New York, Holt, Rinehart, 1972.

3697. Mauron, Charles. **Van Gogh, études psychocritiques.** Paris, Librairie José Corti, 1976.

3698. Meier-Graefe, Julius. **Vincent van Gogh, a biographical study.** Trans. by John Holroyd Reece. 2 v. London/Boston, The Medici Society, 1926. 2 ed.

3699. ———. **Vincent van Gogh, der Zeichner.** Berlin, Wacker, 1928.

3700. Metropolitan Museum of Art (New York). **Van Gogh, paintings and drawings; a special loan exhibition.** New York, Metropolitan Museum of Art, 1949.

3701. Museum of Modern Art (New York). **First loan exhibition, November 1929: Cézanne, Gaugin, Seurat, Van Gogh.** New York, Museum of Modern Art, 1929.

3702. ———. **Vincent van Gogh.** [Nov. 4, 1935-Jan. 5, 1936]. New York, Museum of Modern Art, 1935. (Reprint: New York, Arno, 1966).

3703. Nagera, Humberto. **Vincent van Gogh, a psychological study.** New York, International Universities Press, 1967.

3704. Nordenfalk, Carl. **The life and work of Van Gogh.** New York, Philosophical Library, 1953.

3705. Orangerie des Tuileries (Paris). **Vincent van Gogh; collection du Musée National Vincent van Gogh à Amsterdam.** 21 décembre 1971-10 avril 1972. Paris, Réunion des Musées Nationaux, 1971.

3706. Pach, Walter. **Vincent van Gogh, 1853-1890; a study of the artist and his work in relation to his times.** New York, Artbook Museum, 1936.

3707. Perruchot, Henri. **La vie de van Gogh.** Paris, Hachette, 1955.

3708. Pfister, Kurt. **Vincent van Gogh.** Berlin, Kiepenheuer, 1929.

3709. Piérard, Louis. **The tragic life of Vincent van Gogh.** Trans. by Herbert Garland. Boston/New York, Houghton Mifflin, 1925.

3710. Pollock, Griselda and Orton, Fred. **Vincent van Gogh, artist of his time.** Oxford, Phaidon, 1978.

3711. Robin, Michel. **Van Gogh, ou la remontée vers la lumière.** Paris, Plon, 1964.

3712. Schapiro, Meyer. **Vincent van Gogh.** New York, Abrams, 1950.

3713. Scherjon, W. and Gruyter, Jos. de. **Vincent van Gogh's great period; Arles, St. Rémy and Auvers-sur-Oise.** 2 v. Amsterdam, de Spieghel, 1937. (CR).

3714. Stedelijk Museum (Amsterdam). **Vincent van Gogh; paintings, watercolours and drawings.** Amsterdam, Stedelijk Museum, 1966.

3715. Stone, Irving, ed. **Dear Theo: the autobiography of Vincent van Gogh.** Boston, Houghton Mifflin, 1937.

3716. Terrasse, Charles. **Van Gogh.** Paris, Floury, 1935.

3717. Tralbaut, Marc Edo. **Vincent van Gogh.** New York, Viking, 1969.

3718. _____. **Vincent van Gogh.** New York, Alpine Fine Arts, 1981.

3719. _____. **Van Gogh, eine Bildbiographie.** München, Kindler, 1958.

3720. Uhde, Wilhelm. **Vincent van Gogh in full colour.** [London], Phaidon, 1951.

3721. Uitert, Evert van. **Van Gogh drawings.** Trans. by Elizabeth Willems-Treeman. Woodstock, New York, Overlook Press, 1978.

3722. _____. **Vincent van Gogh, Leben und Werk.** Köln, DuMont Schauberg, 1976.

3723. Valsecchi, Marco. **Van Gogh.** Milano, Electa, 1952. (Astra-Arengarium collana di monografie d'arte, pittori, 35).

3724. Vanbeselaere, Walther. **De Hollandsche periode (1880-1885) in het werk van Vincent Van Gogh (1863-1890).** Antwerpen, De Sikkel, 1937. (CR).

3725. Wadley, Nicholas. **The drawings of van Gogh.** London, Hamlyn, 1969.

3726. Weisbach, Werner. **Vincent van Gogh, Kunst und Schicksal.** 2 v. Basel, Amerbach, 1949.

3727. Zemel, Carol M. **The formation of a legend: Van Gogh criticism, 1890-1920.** Ann Arbor, Mich., UMI Research Press, 1980.

GOLTZIUS, HENDRIK, 1558-1617

3728. Hirschmann, Otto. **Hendrick Goltzius.** Haag, Nijhoff, 1916.

3729. _____. **Verzeichnis des graphischen Werks von Hendrick Goltzius, 1558-1617.** Leipzig, Klinkhardt & Biermann, 1921. (Reprint: Braunschweig, Klinkhardt & Biermann, 1976).

3730. Museum Boymans (Rotterdam). **H. Goltzius als Tekenaar.** Van 23 mei tot 13 juli 1958. Rotterdam, Museum Boymans, 1958.

3731. Museum of Art, University of Connecticut (Storrs, Conn.). **Hendrik Goltzius & the printmakers of Haarlem.** April 22-May 21, 1972. Storrs, Conn., University of Connecticut, 1972.

3732. Reznicek, Emil K. J. **Die Zeichnungen von Henrik Goltzius, mit einem beschreibenden Katalog.** 2 v. Utrecht, Haentjens Dekker & Gumbert, 1961. (Utrechtse kunsthistorische Studien, 6). (CR).

3733. Strauss, Walter L., ed. **Hendrick Goltzius, 1558-1617; the complete engravings and woodcuts.** 2 v. New York, Abaris, 1977. (CR).

GONÇALVES, NUÑO, fl. 1450-1471

3734. Figueiredo, José de. **O pintor Nuño Conçalves.** Lisboa, Typ. do Annuario Commercial, 1910. (Arte portugueza primitiva, 1).

3735. Francis, Anne F. **Voyage of re-discovery; the veneration of Saint Vincent.** Hicksville, New York, Exposition Press, 1979.

3736. Gusmão, Adriano de. **Nuño Gonçalves.** Lisboa, Europa-America, 1957.

3737. _____. **Nuño Gonçalves.** [Lisbon], Artis, 1958. (Nova colecçao de arte Portuguesa, 11).

3738. Lapa, Albino. **Historia dos painéis de Nuño Gonçalves.** Lisboa, [Beleza], 1935.

3739. Santos, Reynaldo dos. **Nuño Gonçalves, the great Portuguese painter of the fifteenth century and his altar-piece for the Convent of St. Vincent.** Trans. by Lucy Norton. London, Phaidon, 1955.

GONCHAROVA, NATHALIA, 1881-1962 see LARIANOV, MIKHAIL

GONZALES, JOAN, 1868-1908

JULIO, 1876-1942

ROBERTA, 1909-

3740. Cerni, Vicente Aguilera. **Julio Gonzalez.** Roma, Edizioni dell'Ateneo, 1962. (Contributi alla storia dell'arte, 1).

3741. _____. **Julio, Joan, Roberta Gonzalez, itinerario de una dinastia.** [Text in Spanish/English/French/German]. Barcelona, Polígrafa, 1973. (CR).

3742. Galerie Chalette (New York). **Julio Gonzalez.** October-November 1961. [Text by Hilton Kramer]. New York, Galerie Chalette, 1961.

3743. Galerie de France (Paris). **Joan Gonzalez, 1868-1908; Julio Gonzalez, 1876-1942; Roberta Gonzalez; peintures et dessins inédits.** 9 avril-30 mai 1965. Paris, Galerie de France, 1965.

3744. Gilbert, Josette. **Julio Gonzalez, dessins.** 9 v. Paris, Martinez, 1975. (CR).

3745. Museum of Modern Art (New York). **Julio Gonzalez.** New York, Museum of Modern Art, 1956.

3746. Pradel de Grandry, Marie. **Julio Gonzalez.** Milano, Fabbri, 1966. (I maestri della sculture, 25).

3747. Withers, Josephine. **Julio Gonzales, les materiaux de son expression.** 2 v. [Text in French/English/Spanish/German]. Paris, Galerie de France, 1970.

GORKY, ARSHILE, 1905-1948

3748. Jordan, Jim M. and Goldwater, Robert. **The paintings of Arshile Gorky, a critical catalogue.** New York/London, New York University Press, 1982. (CR).

3749. Levy, Julien. Arshile Gorky. New York, Abrams, 1966.

3750. Mooradian, Karlen. Arshile Gorky Adoian. Chicago, Gilgamesh, 1978. (Rev. ed.: The many worlds of Arshile Gorky, 1980).

3751. Rand, Harry. Arshile Gorky; the implications of symbols. Montclair, N.J./London, Allanheld & Schram/Prior, 1980.

3752. Rosenberg, Harold. Arshile Gorky; the man, the time, the idea. New York, Horizon, 1962.

3753. Schwabacher, Ethel. Arshile Gorky. New York, Macmillan, 1957.

3754. Seitz, William C. Arshile Gorky; paintings, drawings; studies. [Exhibition catalogue, Museum of Modern Art, New York]. New York, Museum of Modern Art, 1962; distributed by Doubleday, Garden City, N.Y.

3755. Waldman, Diane. Arshile Gorky, 1904-1948; a retrospective. [at the Solomon R. Guggenheim Museum, New York, April 24-July 19, 1981]. New York, Abrams, 1981. (CR).

3756. Whitney Museum of American Art (New York). Arshile Gorky, memorial exhibition. January 5-February 18, 1951. New York [Whitney Museum], 1951.

GOSSAERT, JAN, 1478-1532

3757. Gossart, Maurice. Un des peintres peu connus de l'école flamande de transition: Jean Gossart de Maubeuge, sa vie & son oeuvre. Lille, Editions du Beffroi, [1902].

3758. Museum Boymans-van Beuningen (Rotterdam). Jan Gossaert genaamd Mabuse. 15 mei-27 juni 1965. [Rotterdam, Museum Boysmans-van Beuningen, 1965]. (CR).

3759. Segard, Achille. Jean Gossaert, dit Mabuse. Bruxelles et Paris, van Oest, 1923.

3760. Weisz, Ernst. Jan Gossart gennant Mabuse, sein Leben und seine Werke. Parchim i.M., Freises, 1913.

GOUJON, JEAN, 1510-1565

3761. Du Colombier, Pierre. Jean Goujon. Paris, Michel, 1949. (Les maîtres du Moyen Age et de la Renaissance, 11).

3762. Gailhabaud, Jules. Quelques notes sur Jean Goujon. Paris, Pillet, 1863.

3763. Jouin, Henry. Jean Goujon. Paris, Librairie de l'Art [1906].

3764. Lister, Reginald. Jean Goujon, his life and work. London, Duckworth, 1903.

3765. Vitry, Paul. Jean Goujon, biographie critique. Paris, Laurens, 1908.

GOUTHIERE, PIERRE, 1732-1813

3766. Robiquet, Jacques. Gouthière; sa vie, son oeuvre. Paris, Laurens, 1912.

GOYA Y LUCIENTES, FRANCISCO JOSÉ DE, 1746-1828

3767. Adhémar, Jean. Goya. Trans. by Denys Sutton and David Weston. Paris, Tisné, 1948; distributed by Continental Book Center, New York.

3768. Almoisna, José. La pósthuma peripecia de Goya. [Mexico City], Imprenta Universitaria, 1949.

3769. Art Institute of Chicago. The art of Goya; paintings, drawings, and prints. January 30 to March 2, 1941. Chicago, Art Institute of Chicago, 1941.

3770. Beruete y Moret, Aureliano de. Goya as portrait painter. Trans. by Selwyn Brinton. Boston and New York, Houghton Mifflin, 1922.

3771. Brunet, Gustave. Etude sur Francisco Goya; sa vie et ses travaux; notice biographique et artistique. Paris, Aubry, 1865.

3772. Calvert, Albert F. Goya, an account of his life and works. London, Lane, 1908.

3773. Camon Aznar, José. Francisco de Goya. [3 v., ongoing]. [Zaragoza], Caja de Ahorros de Zaragoza, Aragón y Rioja, [1980-]. (CR).

3774. Chabrun, Jean-François. Goya. Trans. by J. Maxwell Brownjohn. London, Thames and Hudson, 1965.

3775. Chastenet, Jacques, et al. Goya, collection génies et réalités. [Paris], Hachette, 1964.

3776. Cruzada Villaamil, D. G. Los tapices de Goya. Madrid, Rivadeneyra, 1870. (Biblioteca de el arte en Espana, 8).

3777. De Angelis, Rita. L'opera pittorica completa di Goya. Milano, Rizzoli, 1974. (Classici dell'arte, 74).

3778. Delteil, Loys. Francisco Goya. 2 v. Paris, [Delteil], 1922. (Le peintre graveur illustré, 14-15).

3779. Desparmet Fitz-gerald, Xavière. L'oeuvre peint de Goya, catalogue raisonné. 4 v. Paris, de Nobele, 1928-1950. (CR).

3780. Encina, Juan de la [pseud., Gutierrez Abascal, Ricardo]. El mundo historico y poetico de Goya. México, D.F., La Casa de España, 1939.

3781. _____. Goya en zig-zag; bosquejo de interpretacion biográfica. Madrid, Espasa-Calpe, [1928].

3782. Estarico, Leonard. Francisco de Goya, el hombre y el artista. Buenos Aires, El Ateneo, [1942].

3783. Esteve Botey, Francisco. Francisco de Goya y Lucientes, intérprete genial de su época. Barcelona, Amaltea, 1944.

3784. Estrada, Genaro. Bibliografia de Goya. [Mexico City], La Casa de Espana, 1940.

3785. Ezquerra del Bayo, Joaquin. La duquesa de Alba y Goya, estudio biografico y artistico. Madrid, Hermanos, 1928.

3786. Formaggio, Dino, ed. Goya. [Milano], Mondadori, 1951. (Biblioteca moderna Mondadori, 166).

3787. Gantner, Joseph. **Goya, der Künstler und seine Welt.** Berlin, Mann, 1974.

3788. Gassier, Pierre. **The drawings of Goya: the sketches, studies, and individual drawings.** New York, Harper & Row, 1975.

3789. _____. **Goya, biographical and critical study.** Trans. by James Emmons. New York, Skira, 1955. (The Taste of Our Time, 13).

3790. Gassier, Pierre and Wilson, Juliet. **Goya, his life and work, with a catalogue raisonné of the paintings, drawings and engravings.** London, Thames and Hudson, 1971. (CR).

3791. Glendinning, Nigel. **Goya and his critics.** New Haven/London, Yale University Press, 1977.

3792. Gudiol, José. **Goya.** New York, Hyperion Press, 1941.

3793. _____. **Goya, 1746-1828; biography, analytical study and catalogue of his paintings.** Trans. by Kenneth Lyons. 4 v. New York, Tudor, 1971. (CR).

3794. Guerlin, Henri. **Goya, biographie critique.** Paris, Laurens, 1923.

3795. Harris, Tomás. **Goya, engravings and lithographs.** 2 v. Oxford, Cassirer, 1964. (CR).

3796. Hamburger Kunsthalle. **Goya; das Zeitalter der Revolutionen, 1789-1830.** 17. Oktober bis 4. Januar 1981. Hamburg, Hamburger Kunsthalle/Prestel, 1980.

3797. Held, Jutta. **Farbe und Licht in Goyas Malerei.** Berlin, de Gruyter, 1964.

3798. Helman, Edith. **Trasmundo de Goya.** Madrid, Revista de Occidente, 1963.

3799. Hofmann, Julius. **Francisco de Goya, Katalog seines graphischen Werkes.** Wien, Gesellschaft für Vervielfältigende Kunst, 1907. (CR).

3800. Huxley, Aldous L. **The complete etchings of Goya.** New York, Crown, 1943.

3801. Lafond, Paul. **Goya.** Paris, Baranger, [1901].

3802. Lefort, Paul. **Francisco Goya, étude biographique et critique, suivie de l'essai d'un catalogue raisonné de son oeuvre gravé et lithographié.** Paris, Renouard, 1877. (CR).

3803. Lewis, D. B. Wyndham. **The world of Goya.** New York, Clarkson Potter, 1968.

3804. Licht, Fred, ed. **Goya in perspective.** Englewood Cliffs, N.J., Prentice-Hall, 1973.

3805. _____. **Goya, the origins of the modern temper in art.** New York, Universe Books, 1979.

3806. Lopez-Rey, José. **A cycle of Goya's drawings; the expression of Truth and Liberty.** New York, Macmillan, 1956.

3807. _____. **Goya y el mundo a su alrededor.** Buenos Aires, Editorial Sudamericana, 1947.

3808. Malraux, André. **Dessins de Goya au Musée du Prado.** [Genève], Skira, 1947.

3809. _____. **Saturn, an essay on Goya.** Trans. by C. W. Chilton. London, Phaidon, 1957; distributed by Garden City Books, N.Y. (New ed.: Saturne; le destin, l'art et Goya, Paris, Gallimard, 1978).

3810. Matheron, Laurent. **Goya.** Paris, Schulz et Thuillie, 1858.

3811. Mayer, August L. **Francisco de Goya.** Trans. by Robert West. London, Dent, 1924.

3812. Museo del Prado (Madrid). **Catálogo ilustrado de la exposition de pinturas de Goya, celebrada para commemorar el primer centenario de la muerte del artista.** Abril-mayo 1928. Madrid, [Museo del Prado], 1928.

3813. Muther, Richard. **Francisco de Goya.** New York, Scribner, 1905.

3814. Nordström, Folke. **Goya, Saturn and Melancholy; studies in the art of Goya.** Stockholm, Almquist & Wicksell, 1962. (Uppsala Studies in the History of Art, New Series, 3).

3815. Oertel, Richard. **Goya.** Bielefeld/Leipzig, Velhagen & Klasing, 1929. 2 ed. (Künstler-Monographien, 89).

3816. Onieva, Antonio J. **Goya, estudio biografico y critico.** Madrid, Offo, 1962.

3817. Ortega y Gasset, José. **Goya.** Madrid, Revista de Occidente, 1958.

3818. Paris, Pierre. **Goya.** Paris, Plon, 1928.

3819. Pompey, Francisco. **Goya, su vida y sus obras.** Madrid, Aguado, 1945.

3820. Poore, Charles. **Goya.** New York/London, Scribner, 1938.

3821. Rothe, Hans. **Francisco Goya; Handzeichnungen.** München, Piper, 1943.

3822. Rothenstein, William. **Goya.** New York, Longmans/London, Unicorn Press, 1901.

3823. Roy, Claude. **Goya.** Paris, Cercle d'Art, 1952.

3824. Ruiz Cabraida, Agustin. **Aportación a una bibliografía de Goya.** Madrid, Junta Técnica de Archivos, 1946.

3825. Saint-Paulien [pseud., Sicard, Maurice I.]. **Goya; son temps, ses personnages.** Paris, Plon, 1965.

3826. Salas, Xavier de. **Goya.** Trans. by G. T. Culverwell. London, Cassell, 1979.

3827. Sambricio, Valentin de. **Tapices de Goya.** Madrid, Patrimonio Nacional, 1946. (CR).

3828. Sanchez-Canton, Francisco J. **Como vivia Goya; I. El inventorio de sus bienes; II. Leyanda e historia de la Quinta del Sordo.** Madrid, Instituto Diego Velazquez, 1946.

3829. _____. **Goya.** Trans. by Georges Pillement. New York, Reynal, 1964.

3830. _____. **Los dibujos de Goya.** 2 v. Madrid, Museo del Prado, 1954. (CR).

3831. _____. **Vida y obras de Goya.** Madrid, Editorial Peninsular, 1951.

3832. Sayre, Eleanore A. **The changing image; prints by Francisco Goya.** [Catalogue of an exhibition at the Museum of Fine Arts, Boston, October 24-December 29, 1974]. Boston, Museum of Fine Arts, 1974; distributed by New York Graphic Society, Boston.

3833. Schlosser, Julius. **Francisco Goya.** Leipzig, Seemann, 1922. (Bibliothek der Kunstgeschichte, 26).

3834. Sociedad Española de Amigos del Arte. **Antecedentes, coincidencias e influencias del arte de Goya.** Catalogo ilustrado de la exposicion celebrada en 1932, ahora publicado con un estudio preliminar sobre la situacion y la estela del arte de Goya por Enrique Lafuente Ferrari. Madrid, Sociedad Española de Amigos del Arte, 1947.

3835. Städtische Galerie im Städtischen Kunstinstitut, Frankfurt am Main. **Goya, Zeichnungen und Druckgraphik.** 13. Februar bis 5. April 1981. Frankfurt a.M., Städtische Galerie, 1981.

3836. Starkweather, William E. B. **Paintings and drawings by Francisco Goya in the collection of the Hispanic Society of America.** New York, Hispanic Society of America, 1916.

3837. Stokes, Hugh. **Francisco Goya, a study of the work and personality of the eighteenth century Spanish painter and satirist.** London, Jenkins, 1914.

3838. Terrasse, Charles. **Goya y Lucientes, 1746-1828.** Paris, Floury, 1931.

3839. Vallentin, Antonina. **This I saw; the life and times of Goya.** Trans. by Katherine Woods. New York, Random House, 1949.

3840. Viñaza, Cipriano Muñoz y Manzano. **Goya; su tiempo, su vida, sus obras.** Madrid, Hernández, 1887.

3841. Williams, Gwyn A. **Goya and the impossible revolution.** New York, Pantheon, 1976.

3842. Yriarte, Charles. **Goya; sa biographie, les fresques, les toiles, les tapisseries, les eaux-fortes et le catalogue de l'oeuvre.** Paris, Plon, 1867.

GOYEN, JAN VAN, 1596-1656

3843. Beck, Hans-Ulrich. **Jan van Goyen, 1596-1656; ein Oeuvreverzeichnis in zwei Bänden.** 2 v. Amsterdam, van Gendt, 1972. (CR).

3844. Dobryzcka, Anna. **Jan van Goyen, 1596-1959.** [Text in French]. Poznán, Pánstwowe Wydawn, 1966.

3845. Volhard, Hans. **Die Grundtypen der Landschaftsbilder Jan van Goyens und ihre Entwicklung.** Frankfurt, Hemp, 1927.

3846. Waal, Henri van de. **Jan van Goyen.** Amsterdam, Becht, [1954]. (Palet serie, 12).

3847. Waterman Gallery (Amsterdam). **Jan van Goyen, 1596-1656: Conquest of space; paintings from museums and private collections.** Amsterdam, Waterman Gallery, 1981.

GOZZOLI, BENOZZO, 1420-1497

3848. Bargellini, Piero. **La fiaba pittorica de Benozzo Gozzoli.** Firenze, Arnaud, 1946.

3849. Contaldi, Elena. **Benozzo Gozzoli, la vita, le opere.** Milano, Hoepli, 1928.

3850. Hoogewerff, Goffredo J. **Benozzo Gozzoli.** Paris, Alcan, 1930.

3851. Lagaisse, Marcelle. **Benozzo Gozzoli, les traditions trecentistes et les tendances nouvelles chez un peintre florentin du quattorcento.** Paris, Laurens, 1934.

3852. Mengin, Urbain. **Benozzo Gozzoli.** Paris, Plon, 1909.

3853. Padoa Rizzo, Anna. **Benozzo Gozzoli, pittore fiorentino.** Firenze, Edam, 1972.

3854. Scarpellini, Pietro. **Benozzo Gozzoli.** Milano, Fabbri, [1966]. (I maestri del colore, 188).

3855. Wingenroth, Max. **Die Jugendwerke des Benozzo Gozzoli; eine kunstgeschichtliche Studie.** Heidelberg, Winter, 1897.

GRAF, URS, ca. 1485-ca. 1528

3856. Amiet, Jacob. **Urs Graf, ein Künstlerleben aus alter Zeit.** Basel/Genf, Georg, 1873.

3857. Koegler, Hans. **Beschreibendes Verzeichnis der Basler Handzeichnungen des Urs Graf.** Nebst einem Katalog der Basler Urs Graf-Ausstellung, 1 Juli. bis 15 September 1926. [Oeffentliche Kunstsammlung]. Basel, Schwabe, 1926.

3858. Lüthi, Walter. **Urs Graf und die Kunst der alten Schweizer.** Zürich unde Leipzig, Füssli, 1928. (Monographien zur schweizer Kunst, 4).

3859. Major, Emil. **Urs Graf; ein Beitrag zur Geschichte der Goldschmiedekunst im 16. Jahrhundert.** Strassburg, Heitz, 1907.

3860. _____ and Gradmann, Erwin. **Urs Graf.** London, Home & van Thal, 1947.

GRAFF, ANTON, 1736-1813

3861. Berckenhagen, Eckhart. **Anton Graff, Leben und Werk.** Berlin, Deutscher Verlag für Kunstwissenschaft, 1967.

3862. Muther, Richard. **Anton Graff, sein Leben und seine Werke.** Leipzig, Seemann, 1881. (Beiträge zur Kunstgeschichte, 4).

3863. Staatliche Museen zu Berlin, Nationalgalerie. **Anton Graff, 1736-1813.** Berlin, Staatliche Museen zu Berlin, 1963.

3864. Vogel, Julius. **Anton Graff, Bildnisse von Zeitgenossen des Meisters in Nachbildungen der Originale.** Leipzig, Breitkopf & Härtel, 1898. (K. Sächsische Kommission für Geschichte. Schriften, 1).

3865. Waser, Otto. **Anton Graff, 1736-1813.** Frauenfeld und Leipzig, Huber, 1926.

GRAN, DANIEL, 1695-1757

3866. Albertina (Vienna). **Daniel Gran, 1694-1757.** Gedächtnis-ausstellung, Sommer 1957. Wien, Albertina, 1957.

3867. Knab, Eckhart. **Daniel Gran.** Wien/München, Herold, 1977. (CR).

GRANDVILLE (Jean Ignace Isidore Gérard), 1803-1847

3868. Applebaum, Stanley. **Bizarreries and fantasies of Grandville; 266 illustrations from Un Autre Monde and Les Animaux.** New York, Dover, 1974.

3869. Blanc, Charles. **Grandville.** Paris, Audois, 1855. (Reprint: Paris, Garnier, 1979; introd. by Roland Topor).

3870. Garcin, Laure. **J. J. Grandville, revolutionnaire et précurseur de l'art du mouvement.** Paris, Losfeld, 1970.

3871. Nollet, Jules. **Eloge historique de J. J. Grandville.** Anvers, Kornicker, 1853.

3872. Sello, Gottfried. **Grandville; das gesamte Werk.** 2 v. München, Rogner & Bernhard, 1969. (CR).

GRASSER, ERASMUS, 1450-1518

3873. Halm, Philipp M. **Erasmus Grasser.** Augsburg, Filser, 1928. (Jahresgabe des deutschen Vereins für Kunstwissenschaft, 1927.

GRECO, EL, 1541-1614

3874. Ballo, Guido. **El Greco.** [Milano], Mondadori, 1952. (Biblioteca moderna Mondadori, 297).

3875. Barres, Maurice et Lafond, Paul. **Le Greco.** Paris, Floury, [1911].

3876. Béritens, Germán. **Aberraciones del Greco, científicamente consideradas.** Madrid, Fé, 1913.

3877. Bronstein, Leo. **El Greco (Domenicos Theotocopoulos).** New York, Abrams, [1950].

3878. Brown, Jonathan, et al. **El Greco of Toledo.** Boston, New York Graphic Society, 1982.

3879. Calvert, Albert F. and Hartley, C. Gasquoine. **El Greco, an account of his life and works.** London, Lane, 1909.

3880. Camón Aznar, José. **Dominico Greco.** 2 v. Madrid, Espasa-Calpe, 1970. 2 ed. (CR).

3881. Cassou, Jean. **Le Greco.** Paris, Rieder, 1931.

3882. Cocteau, Jean. **Le Greco.** [Paris], Au Divan, [1943].

3883. Cossio, Manuel B. **El Greco.** 2 v. Madrid, Suarez, 1908. (Edicion definitiva al cuidado de Natalia Cossio de Jiminez. Barcelona, Editorial R.M., 1972). (CR).

3884. Crastre, Victor. **Le mythe Greco.** Genève, Cailler, 1961. (Les problèmes de l'art, 9).

3885. Escholier, Raymond. **Greco.** Paris, Floury, 1937.

3886. Esclasans, Agustín. **El Greco y su tiempo.** Barcelona, Juventud, 1953.

3887. Encina, Juan de la. **Domenico Greco.** [Mexico City], Leyenda, 1944.

3888. Gallart y Folch, José. **El espíritu y 1 técnica de "El Greco."** Barcelona, Porter, 1946.

3889. Goldscheider, Ludwig. **El Greco; paintings, drawings and sculptures.** New York, Phaidon, 1954. 3 ed.; distributed by Garden City Books, N.Y.

3890. Gomez de la Serna, Ramón. **El Greco, el visionario de la pintura.** Santiago de Chile, Ercilla, 1941.

3891. Gudiol y Ricart, Josep. **Domenikos Theotokopoulos; El Greco, 1541-1614.** Trans. by Kenneth Lyons. New York, Viking, 1973.

3892. Guinard, Paul. **El Greco, biographical and critical study.** Trans. by James Emmons. [Lausanne], Skira, 1956. (The Taste of Our Time, 15).

3893. Ipser, Karl. **El Greco, der Maler des christlichen Weltbildes.** Berlin/Braunschweig, Klinkhardt & Biermann, 1960.

3894. Jorge, Ricardo. **El Greco; nova contríbuiçao biográfica, crítica e médica ao estudo do pintor Doménico Theotocópuli.** Coimbra, Imprensa da Universidade, 1913.

3895. Kehrer Hugo. **Die Kunst des Greco.** München, Schmidt, 1914. 3 ed.

3896. _____. **Greco als Gestalt des Manierismus.** München, Filser, 1939.

3897. _____. **Greco in Toledo; Höhe und Vollendung, 1577-1614.** Stuttgart, Kohlhammer, 1960.

3898. Keleman, Pál. **El Greco revisited: Candia, Venice, Toledo.** New York, Macmillan, 1961.

3899. Lafond, Paul. Le Greco; essai sur sa vie et sur son oeuvre, suivi d'un catalogue et d'une bibliographie illustré de nombreuses reproductions. Paris, Sansot, [1913].

3900. Lafuente Ferrari, Enrique. **El Greco, the expressionism of his final years.** Trans. by Robert Erich Wolf. New York, Abrams, 1969.

3901. Lassaigne, Jacques. **El Greco.** Trans. by Jane Brenton. London, Thames & Hudson, 1974.

3902. Legendre, Maurice. **El Greco (Domenico Theotocopuli).** New York, Hyperion Press/Duel, Sloan and Pearce, 1947.

3903. _____ and Hartmann, A. **Domenikos Thetokopoulos, called El Greco.** London, Commodore, Press, 1937.

3904. Manzini, Gianna. **L'opera completa del Greco.** Milano, Rizzoli, 1969. (Classici dell'arte, 35). (CR).

3905. Marañón, Gregorio. **El Greco y Toledo.** Madrid, Espasa-Calpe, 1958. 2 ed.

3906. Marias, Fernando [and] Bustamante Garcia, Agustín. **Las ideas artísticas de El Greco; comentarios a un texto inédito.** Madrid, Ediciones Cátedra, 1981.

3907. Martini, Pietro. **Del pittore Domenico Theotocopulo e di suo dipinto.** Torino, Botta, 1862.

3908. Mayer, August L. **Dominico Theotocopuli, El Greco; kritisches und illustriertes Verzeichnis des Gesamtwerkes.** München, Hanfstaengl, 1926. (CR).

3909. _____. **El Greco.** Berlin, Klinkhardt & Biermann, 1931.

3910. _____. **El Greco; eine Einführung in das Leben und Wirken des Dominico Theotocopuli gennant El Greco.** München, Delphin, 1916.

3911. Merediz, José A. **La transformación espanola de El Greco.** Madrid, Plutarco, 1930.

3912. Pallucchini, Anna. **El Greco.** Milano, Fabbri, 1964. (I maestri del colore, 42).

3913. Reimann, Georg J. **El Greco.** Wien/München, Schroll, 1966.

3914. Rutter, Frank. **El Greco (1541-1614).** N.Y., Weyhe, [1930].

3915. San Román y Fernández, Francisco de Borja de. **El Greco en Toledo; nuevas investigaciones acerca de la vida y obra de Dominico Theotocópuli.** Madrid, Suárez, 1910.

3916. Sanchez de Palacios, Mariano. **El Greco, estudio biografico y critico.** Madrid, Offo, 1961.

3917. Trapier, Elizabeth du Gué. **El Greco.** New York, Hispanic Society of America, 1925.

3918. _____. **El Greco; early years at Toledo, 1576-1586.** New York, Hispanic Society of America, 1958.

3919. Vallentin, Antonina. **El Greco.** Trans. by Andrew Révai and Robin Chancellor. Garden City, N.Y., Doubleday, 1955.

3920. Vázquez Campo, Antonio. **El divino Greco, puntualizaciones en torno a su vida y obra.** Madrid, Prensa Española, 1974.

3921. Villegas López, Manuel, ed. **El Greco, antologia de textos en torno a su vida y obra.** Madrid, Taurus, 1960. (Ser y tiempo, temas de España, 10).

3922. Wethey, Harold E. **El Greco and his school.** 2 v. Princeton, N.J., Princeton University Press, 1962.

3923. Willumsen, Jens F. **La jeunesse du peintre El Greco; essai sur la transformation de l'artiste byzantin en peintre européen.** 2 v. Paris, Crès, 1927.

3924. Zervos, Christian. **Les oeuvres du Greco en Espagne.** Paris, Cahiers d'Art, 1939.

GREENAWAY, KATE, 1846-1901

3925. Greenaway, Kate. **The complete Kate Greenaway, featuring The Language of Flowers and listing all her illustrated books with value guide.** Watkins Glen, N.Y., Century House, 1967.

3926. Spielmann, M. H. and Layard, G. S. **Kate Greenaway.** London, Black, 1905.

GREENOUGH, HORATIO, 1805-1852

3927. Greenough, Horatio. **Form and function; remarks on art, design, and architecture.** Ed. by Harold A. Small. Berkeley, University of California Press, 1969.

3928. _____. **Letters of Horatio Greenough, American sculptor.** Ed. by Nathalia Wright. Madison, Wis., University of Wisconsin Press, 1972.

3929. _____. **Letters of Horatio Greenough to his brother, Henry Greenough.** Ed. by Frances Boott Greenough. Boston, Ticknor, 1887.

3930. _____. **The travels, observations, and experience of a Yankee stonecutter.** By Horace Bender [pseud.]. New York, Putnam, 1852. (Reprint: Scholars' Facsimiles & Reprints, Gainesville, Fla., 1958. Introd. by Nathalia Wright).

3931. Tuckerman, Henry T. **A memorial of Horatio Greenough, consisting of a memoir, selections from his writings, and tributes to his genius.** New York, Putnam, 1853.

3932. Wright, Nathalia. **Horatio Greenough, the first American sculptor.** Philadelphia, University of Pennsylvania Press, 1963.

GREUZE, JEAN BAPTISTE, 1725-1805

3933. Brookner, Anita. **Greuze, the rise and fall of an eighteenth century phenomenon.** Greenwich, Conn., New York Graphic Society, [1972].

3934. Hautecoeur, Louis. **Greuze.** Paris, Alcan, 1913.

3935. Houssaye, Arsène, et al. **Greuze, sa vie et son oeuvre; sa statue, le Musée Greuze.** Paris, Plon, [1868]. (L'artiste, revue du XIX^e siècle, 37).

3936. Martin, Jean. Catalogue raisonné de l'oeuvre peint et dessiné de Jean-Baptiste Greuze, suivi de la liste des gravures executées d'après ses ouvrages. Paris, Kadar, [1908]. (CR).

3937. Mauclair, Camille. **Greuze et son temps.** Paris, Michel, 1926.

3938. _____. **Jean-Baptiste Greuze.** Paris, Piazza, [1905]. (CR).

3939. Normand, Charles. **J. B. Greuze.** Paris, Allison, [1892].

3940. Pilon, Edmund. **J.-B. Greuze, peintre de la femme et la jeune fille du XVIII. siècle.** Paris, Piazza, [1912].

3941. Rivers, John. **Greuze and his models.** London, Hutchinson, 1912.

3942. Wadsworth Atheneum (Hartford, Conn.). **Jean-Baptiste Greuze/1725-1805.** 1 December 1976-23 January 1977. Hartford, Conn., Wadsworth Atheneum, 1976.

GRIEN, HANS BALDUNG see BALDUNG, HANS

GRIESHABER, HAP (i.e., Helmut Andreas Paul), 1909-1981

3943. Boeck, Wilhelm. **Hap Grieshaber, Holzschnitte.** Pfullingen, Neske, 1959.

3944. Eingangshalle des Rathauses, Stadt Reutlingen. **Grieshaber in Reutlingen.** 25. März 1979 bis 6. Mai 1979. Reutlingen, Stadt Reutlingen, 1979.

3945. Fuerst, Margot, ed. **Grieshaber; Malbriefe.** Stuttgart, Hatje, 1967.

3946. Museum für Kunst und Gewerbe (Hamburg). **Grieshaber, der Drucker und Holzschneider.** [September 8-October 6, 1965]. Stuttgart, Hatje, 1965.

3947. Pfäfflin, Friedrich [and] Fuerst, Margot. **Grieshaber; die Plakate, 1934-1979.** Stuttgart, Hatje, 1979.

3948. Studentenstudio für Moderne Kunst (Tübingen). **H. A. P. Grieshaber; eine Ausstellung des graphischen Werkes.** Stuttgart, Verlag KG, 1949.

3949. Universitätsbibliothek (Tübingen). **Grieshaber und das Buch.** 25. Mai bis 14. Juli 1979. Tübingen, Universitätsbibliothek, 1979.

GRIS, JUAN, 1887-1927

3950. Cooper, Douglas. **Juan Gris, catalogue raisonné de l'oeuvre peint** établi avec le collaboration de Margaret Potter. 2 v. Paris, Berggruen, 1977. (CR).

3951. _____. **Juan Gris, ou le goût du solennel.** Paris, Skira, [1949]. (Les trésors de la peinture française, 11).

3952. Gaya-Nuño, Juan Antonio. **Juan Gris.** Trans. by Kenneth Lyons. Boston, New York Graphic Society, 1975.

3953. Gris, Juan. **Letters of Juan Gris [1913-1927].** Collected by Daniel-Henry Kahnweiler; translated and edited by Douglas Cooper. London, [Douglas Cooper], 1956.

3954. _____. **Posibilidades de la pintura y otros escritas.** Córdoba, Argentina, Assandri, 1957.

3955. Kahnweiler, Daniel H. **Juan Gris.** Milano, Fabbri, [1967]. (I maestri del colore, 177).

3956. _____. **Juan Gris, his life and work.** Trans. by Douglas Cooper. New York, Valentin, 1947; rev. ed.: Abrams, New York, 1969.

3957. _____. **Juan Gris** von Daniel Henry [pseud.]. Leipzig/Berlin, Klinkhardt & Biermann, 1929. (Junge Kunst, 55).

3958. Kunsthalle Baden-Baden. **Juan Gris.** [July 20-September 29, 1974]. Baden-Baden, Staatliche Kunsthalle, 1974.

3959. Museum of Modern Art (New York). **Juan Gris.** April 9-June 1, 1958. [Text by James Thrall Soby]. New York, Museum of Modern Art, 1958.

3960. Raynal, Maurice. **Juan Gris, vingt tableaux.** Paris, Editions de l'effort Moderne, 1920.

3961. Rosenthal, Mark. **Juan Gris.** New York, Abbeville, 1983.

GROPIUS, WALTER, 1883-1969

3962. Cook, Ruth V. **A bibliography: Walter Gropius, 1919 to 1950.** Chicago, American Institute of Architects, 1951.

3963. Fitch, James M. **Walter Gropius.** New York, Braziller, 1960.

3964. _____ [and] Gropius, Ise. **Walter Gropius; buildings, plans, projects, 1906-1969.** Lincoln, Mass., International Exhibitions Foundation, 1972.

3965. Franciscono, Marcel. **Walter Gropius and the creation of the Bauhaus in Weimar: the ideals and artistic theories of its founding years.** Urbana, Ill., University of Illinois Press, 1971.

3966. Giedion, Sigfried. **Walter Gropius.** Paris, Crès, 1931.

3967. _____. **Walter Gropius, l'homme et l'oeuvre.** Paris, Morancé, 1954. (U.S. ed.: **Walter Gropius, work and teamwork.** New York, Reinhold, 1954.)

3968. Gropius, Walter. **Bauhausbauten Dessau.** München, Langen, 1930. (Bauhausbücher, 12). (Reprint: Mainz, Kupferberg, 1974).

3969. _____. **Idee und Aufbau des staatlichen Bauhauses.** Weimar/München, Bauhausverlag, 1923.

3970. _____. **Internationale Architektur.** München, Langen, 1925. (Bauhausbücher, 1). (Reprint: Mainz, Kupferberg, 1981).

3971. ———. **The new architecture and the Bauhaus.** Trans. by P. Morton Shand. New York, Museum of Modern Art/London, Faber, [1937].

3972. ———. **Scope of total architecture.** New York, Harper, 1955. (World Perspectives, 3).

3973. Museum of Modern Art (New York). **Bauhaus, 1919-1928.** Edited by Herbert Bayer, Walter Gropius, Ise Gropius. New York, Museum of Modern Art, 1938.

3974. Rudolph, Paul and Gropius, Walter. **Walter Gropius et son école** [being the entire contents of the February, 1950, issue of L'Architecture d'aujourd'hui]. Paris, L'Architecture d'aujourd'hui, 1950.

3975. Wingler, Hans M. **The Bauhaus: Weimar, Dessau, Berlin, Chicago.** Cambridge, Mass., MIT Press, 1969.

GROS, ANTOINE JEAN, 1771-1835

3976. Dargenty, G. [pseud., Arthur Auguste Mallebay du Cluseau d'Echêrac]. **Le Baron Gros.** Paris, Librairie de l'Art, [1887]. (Les artistes célèbres, 18).

3977. Delestre, Jean-Baptiste. **Gros et ses ouvrages, ou mémoires historiques sur la vie et les travaux de ce célèbre artiste.** Paris, Labitte, [1845]; 2 ed.: Paris, Renouard, 1867.

3978. Escholier, Raymond. **Gros, ses amis et ses élèves.** Paris, Floury, 1936.

3979. Lemonnier, Henry. **Gros; biographie critique.** Paris, Laurens, 1905.

3980. Petit Palais (Paris). **Gros; ses amis, ses élèves.** [Mai-juillet, 1936]. [Paris, Petit Palais, 1936]. (CR).

3981. Tripier le Franc, J. **Histoire de la vie et de la mort du Baron Gros, le grand peintre.** Paris, Martin et Baur, 1880.

GROSSMANN, RUDOLF, 1882-1941

3982. Hausenstein, Wilhelm. **Rudolf Grossmann.** Leipzig, Klinkhardt & Biermann, 1919. (Junge Kunst, 7).

3983. Kunstgalerie Esslingen. **Rudolf Grossmann, 1882-1941.** Juni/Juli 1974. Esslingen, Kunstgalerie Esslingen, 1974.

3984. Staatsgalerie Stuttgart. **Rudolf Grossmann, Zeichnungen und Druckgraphik.** September bis Oktober 1963. Karlsruhe, Staatliche Kunsthalle, 1963.

GROSZ, GEORGE, 1893-1959

3985. Ballo, Ferdinando, ed. **Grosz.** Milano, Rosa e Ballo, 1946. (Documenti d'arte contemporanea, 3).

3986. Baur, John I. H. **George Grosz.** Exhibition and catalogue by the Whitney Museum of Modern Art. January 14-March 7, 1954. New York, Whitney Museum of American Art, 1954.

3987. Bazalgette, Léon. **George Grosz, l'homme & l'oeuvre.** Paris, Escrivains Réunis, 1926.

3988. Dückers, Alexander. **George Grosz, das druckgraphische Werk.** Frankfurt a.M., Propyläen, 1979. (CR).

3989. Grosz, George. **Briefe, 1913-1959.** Herausgegeben von Herbert Knust. Reinbek bei Hamburg, Rowohlt, 1979.

3990. ———. **Drawings, with an introduction by the artist.** New York, Bittner, 1944.

3991. ———. **A little yes and a big no; the autobiography of George Grosz.** New York, Dial, 1946.

3992. Hess, Hans. **George Grosz.** New York, Macmillan, 1974.

3993. Lewis, Beth I. **George Grosz; art and politics in the Weimar Republic.** Madison, Wis., University of Wisconsin Press, 1971.

3994. Mynona [pseud., Salomon Friedländer]. **George Grosz.** Dresden, Kaemmerer, 1922. (Kunstler der Gegenwart, 3).

3995. Ray, Marcel. **George Grosz.** Paris, Crès, 1927.

3996. Schneede, Uwe M. **George Grosz, his life and work.** Trans. by Susanne Flatauer. London, Fraser, 1979.

GROTTGER, ARTUR, 1837-1867

3997. Antoniewicz, Jan B. **Grottger.** Lwów, Altenberga, 1910.

3998. Kanteckiego, Klemensa. **Artur Grottger, szkic biograficzny.** Lwów, Przewodnika naukowego i literackiego, 1879.

3999. Potocki, Antoni. **Grottger.** Lwów, Altenberga, 1907.

4000. Rogosz, Józef. **Artur Grottger, Jan Matejko: studja o sztuce w Polsce.** Lwów, Redakcji Tygodnia, 1876.

4001. Táborský, Frantisek. **Arthur Grottger, jeho láska a dílo.** Praze, Orbis, 1933. (Práce Slovanského Ústavu v Praza, 10).

4002. Wolska, Maryla i Pawlikowski, Michal. **Arthur i Wanda; dzieje miłości Arthura Grottgera i Wandy Monné.** 2 v. Medyka/Lwów, Biblioteki Medyckiej, 1928.

GROUX, HENRY DE, 1867-1930

4003. Baumann, Emile. **La vie terrible d'Henry de Groux.** Paris, Grasset, 1936.

4004. Souguenet, Léon, et al. **L'oeuvre de Henry Groux.** Paris, La Plume, 1899.

GRUNDIG, HANS, 1901-1958

LEA LANGER, 1906-1977

4005. Feist, Günther. **Hans Grundig.** Dresden, Verlag der Kunst, 1979.

4006. Frommhold, Erhard. **Hans und Lea Grundig, Einführung.** Dresden, Verlag der Kunst, 1958.

4007. Grundig, Hans. **Künstlerbriefe aus den Jahren 1926 bis 1957.** Mit einem Vorwort herausgegeben von Bernhard Wächter. Rudolstadt, Greifenverlag, 1966.

4008. _____. **Zwischen Karneval und Aschermittwoch, Erinnerungen eines Malers.** Berlin, Dietz, 1957.

4009. Grundig, Lea. **Gesichte und Geschichte.** Berlin, Dietz, 1958.

4010. Hütt, Wolfgang. **Lea Grundig.** Dresden, Verlag der Kunst, 1969.

4011. Ladengalerie (West Berlin). **Lea Grundig, Werkverzeichnis der Radierungen.** Westberlin, Ladengalerie, 1973.

4012. Staatliche Museen zu Berlin, National-Galerie. **Hans Grundig; Malerei, Zeichnungen; Druckgraphik.** Juli bis August 1962. Berlin, Staatliche Museen, 1962.

GRÜNEWALD, MATTHIAS, 1470-1528

4013. Behling, Lottlisa. **Die Handzeichnungen des Mathis Gothart Nithart genannt Grünewald.** Weimar, Böhlaus, 1955.

4014. Bianconi, Piero. **L'opera completa di Grünewald.** Milano, Rizzoli, 1972. (Classici dell'arte, 58). (CR).

4015. Bock, Franz. **Die Werke des Mathias Grünewald.** Strassburg, Heitz, 1904. (Studien zur deutschen Kunstgeschichte, 54).

4016. Brion, Marcel. **Grünewald.** Paris, Plon, 1939.

4017. Burkhard, Arthur. **Matthias Grünewald, personality and accomplishment.** Cambridge, Mass., Harvard University Press, 1936. (Reprint: New York, Hacker, 1976).

4018. Dittman, Lorenz. **Die Farbe bei Grünewald.** München, Wolf & Sohn, 1955.

4019. Escherich, Mela. **Grünewald-Bibliographie (1489-Juni 1914).** Strassburg, Heitz, 1914. (Studien zur deutschen Kunstgeschichte, 177).

4020. Feurstein, Heinrich. **Matthias Grünewald.** Bonn am Rhein, Verlag der Buchgemeinde, 1930. (Buchgemeinde Bonn, Religiöse Schriftenreihe, 6).

4021. Fraenger, Wilhelm. **Matthias Grünewald in seinen Werken, ein physiognomischer Versuch.** Berlin, Rembrandt, 1936.

4022. Gasser, Helmi. **Das Gewand in der Formensprache Grünewalds.** Bern, Francke, 1962. (Basler Studien zur Kunstgeschichte, N.F., 3).

4023. Hagen, Oskar F. L. **Matthias Grünewald.** München, Piper, 1923. 4 ed.

4024. Hausenberg, Margarethe. **Matthias Grünewald im Wandel der deutschen Kunstanschauung.** Leipzig, Weber, 1927.

4025. Hotz, Walter. **Meister Mathis der Bildschnitzer; die Plastik Grünewalds und seines Kreises.** Aschaffenburg, Pattloch, 1961. (Veröffentlichungen des Geschichts- und Kunstvereins Aschaffenburg e.V., 5).

4026. Hürlimann, Martin. **Grünewald, das Werk des Meisters Mathis Gothardt Neithardt.** Berlin, Atlantis, 1939.

4027. Huysmans, Joris K. **Mathias Grünewald.** München, Recht, 1923.

4028. Josten, Hanns H. **Matthias Grünewald.** Bielefeld/Leipzig, Velhagen & Klasing, 1921. (Künstler-Monographien, 108).

4029. Kehl, Anton. **Grünewald-Forschungen.** Neustadt a.d. Aisch, Schmidt, 1964.

4030. Kromer, Joachim. **Matthias Grünewald; die Schlüssel-kompositionen seiner Tafeln.** Baden-Baden, Koerner, 1978. (Studien zur deutschen Kunstgeschichte, 356).

4031. Lanckoronska, Maria. **Matthäus Gotthart Neithart, Sinngehalt und historischer Untergrund der Gemälde.** Darmstadt, Roether, 1963.

4032. _____. **Matthäus Neithart Sculptor, der Meister des Blaubeurer Altars und seine Werke.** München, Frühmorgen, 1965.

4033. _____. **Neithart in Italien, ein Versuch.** München, Frühmorgen, 1967.

4034. Mayer, August L. **Matthias Grünewald.** München, Delphin, 1920.

4035. Naumann, Hans H. **Das Grünewald-Problem und das neuentdeckte Selbstbildnis des 20 jährigen Mathis Nithart aus dem Jahre 1475.** Jena, Diederichs, 1930.

4036. Pevsner, Nikolaus and Meier, Michael. **Grünewald.** New York, Abrams, 1958.

4037. Réau, Louis. **Mathias Grünewald et le Retable de Colmar.** Nancy, Berger-Levrault, 1920.

4038. Rolfs, Wilhelm. **Die Grünewald-Legende, kritische Beiträge zur Grünewald-Forschung.** Leipzig, Hiersemann, 1923.

4039. Ruhmer, Eberhard. **Grünewald drawings, complete edition.** Trans. by Anna R. Cooper. London, Phaidon, 1970.

4040. Saran, Bernhard. **Matthias Grünewald, Mensch und Weltbild.** München, Goldmann, 1972.

4041. Schmidt, Heinrich A. **Die Gemälde und Zeichnungen von Matthias Grünewald.** 2 v. Strassburg, Heinrich, 1907/1911. (CR).

4042. Schoenberger, Guido. **The drawings of Mathis Gothart Nithart, called Grünewald.** New York, Bittner, 1948.

4043. Société pour la conservation des monuments historiques d'Alsace/Société Schongauer. **Grünewald et son oeuvre.** Acts de la Table Ronde organisée par le Centre National de la Recherche Scientifique à Strasbourg et Colmar du 18 au 21 octobre 1974. Strasbourg, Imprimerie des Dernières Nouvelles, [1974].

4044. Vogt, Adolf M. **Grünewald: Mathis Gothart Nithart, Meister gegenklassischer Malerei.** Zürich/Stuttgart, Artemis, 1957.

4045. Weixlgärtner, Arpad. **Grünewald.** Wien/München, Schroll, 1962. (Neue Sammlung Schroll, 3).

4046. Zülch, Walter K. **Der historische Grünewald, Mathis Gothardt-Neithardt.** München, Bruckmann, 1938.

GRUPELLO, GABRIEL, 1644-1730

4047. Berghe, Gustaaf van den. **Gabriel Grupello; Opperbelt-snyder van Syne Majesteit.** Geraardsbergen, G. van den Berghe-Steenhoudt, 1958.

4048. Kultermann, Udo. **Gabriel Grupello.** Berlin, Deutscher Verlag für Kunstwissenschaft, 1968.

4049. Kunstmuseum Düsseldorf. **Europäische Barockplastik am Niederrhein; Grupello und seine Zeit.** 4. April bis 20. Juni 1971. Düsseldorf, Kunstmuseum Düsseldorf, 1971.

GUARDI, FRANCESCO, 1712-1793

 GIACOMO, 1764-1835

 GIOVANNI ANTONIO, 1699-1760

4050. Bortolatto, Luigina R. **L'opera completa di Francesco Guardi.** Milano, Rizzoli, 1974. (Classici dell'arte, 71).

4051. Binion, Alice. **Antonio and Francesco Guardi; their life and milieu, with a catalogue of their figure drawings.** New York/London, Garland, 1976. (CR).

4052. Damerini, Gino. **L'arte di Francesco Guardi.** Venezia, Istituto Veneto di Arti Grafiche, 1912.

4053. Fiocco, Giuseppe. **Francesco Guardi.** Firenze, Battistelli, 1923.

4054. Goering, Max. **Francesco Guardi.** Wien, Schroll, 1944.

4055. Morassi, Antonio. **Guardi: Antonio e Francesco Guardi.** 2 v. Venezia, Alfieri, [1973]. (CR). (Profili e saggi di arte veneta, 11).

4056. _____. **Guardi: tutti i disegni di Antonio, Francesco e Giacomo Guardi.** Venezia, Alfieri, 1975. (Profile e saggi di arte veneta, 13).

4057. Maffei, Fernanda de. **Gian Antonio Guardi, pittore di figura.** Verona, Libreria Dante, 1948.

4058. Moschini, Vittorio. **Francesco Guardi.** Milano, Martello, 1952.

4059. Pallucchini, Rodolfo. **Francesco Guardi.** Milano, Fabbri, 1965. (I maestri del colore, 104).

4060. _____. **I desegni del Guardi al Museo Correr di Venezia.** Venezia, Guarnati, 1943.

4061. Pignatti, Terisio. **Disegni dei Guardi.** Firenze, La Nuova Italia, 1967.

4062. Shaw, J. Byam. **The drawings of Francesco Guardi.** London, Faber, 1951.

4063. Simonson, George A. **Francesco Guardi, 1712-1793.** London, Methuen, 1904.

4064. Zampetti, Pietro. **Mostra dei Guardi.** Palazzo Grassi, Venezia, 5 giugno-10 ottobre 1965. Venezia, Alfieri, 1965.

GUARINI, GUARINO, 1624-1683

4065. Accademia delle Scienze di Torino. **Guarino Guarini e l'internazionalità del Barocco; atti del convegno internazionale.** 2 v. 30 settembre-5 ottobre 1968. Torino, Accademia delle Scienze, 1970.

4066. Anderegg-Tille, Maria. **Die Schule Guarinis.** Winterthur, Keller, 1962.

4067. Bernardi Ferrero, Daria de. **I Disegni d'architettura civile et ecclesiastica di Guarino Guarini e l'arte del maestro.** Torino, Albra, 1966.

4068. Guarini, Guarino. **Architettura civile.** Torino, Mairesse, 1737. (Reprint: London, Gregg, 1964. 2 v.).

4069. _____. **Architettura civile.** Introduzione di Nino Carboneri; note e appendice a cura di Bianci Tavassi La Greca. Milano, Polifilo, 1968. (Trattati di architettura, 8).

4070. Passanti, Mario. **Nel mondo magico di Guarino Guarini.** Torino, Toso, 1963.

4071. Portoghesi, Paolo. **Guarino Guarini, 1624-1683.** Milano, Electa, 1956. (Astra-Arengarium collana di monografie d'arte, serie architetti, 40).

GÜNTHER, IGNAZ, 1725-1775

4072. Feulner, Adolf. **Ignaz Günther, der grosse Bildhauer des bayerischen Rokoko.** München, Münchner Verlag, 1947.

4073. _____. **Ignaz Günther, kurfürstlich bayrischer Hofbildhauer.** Wien, Österreichische Staatsdruckerei, 1920. (Jahresgabe des deutschen Vereins für Kunstwissenschaft, 1921).

4074. Heikamp, Detlef. **Ignaz Günther.** Milano, Fabbri, 1966. (I maestri della scultura, 18).

4075. Schoenberger, Arno. **Ignaz Günther.** München, Hirmer, 1954.

4076. Woeckel, Gerhard P. **Franz Ignaz Günther, der grosse Bildhauer des bayerischen Rokoko.** Regensburg, Pustet, 1977.

4077. _____. **Ignaz Günther, die Handzeichnungen des kurfürstlich bayerischen Hofbildhauers Franz Ignaz Günther (1725-1775).** Weissenhorn, Konrad, 1975.

GUERCINO, IL see BARBIERI, GIOVANNI FRANCESCO called IL GUERCINO

GUETERSLOH, ALBERT PARIS [pseud.], 1887-1973

4078. Doderer, Heimito. Der Fall Gütersloh, ein Schicksal und seine Deutung. Wien, Haybach, 1930.

4079. _____, et al., eds. Albert Paris Gütersloh, Autor und Werk. München, Piper, 1962.

4080. Gütersloh, Albert Paris [pseud.]. Bekenntnisse eines modernen Malers. Wien/Leipzig, Zahn und Diamond, 1926.

4081. _____. Zur Situation der modernen Kunst; Aufsätze und Reden. Wien, Forum, 1963.,

4082. Hutter, Heribert, ed. A. P. Gütersloh, Beispiele; Schriften zur Kunst, Bilder, Werkverzeichnis. Wien/München, Jugend und Volk, 1977. (CR).

GUIDI, TOMMASO see MASACCIO

GUIDO DA SIENA, 13th cent.

4083. Stubblebine, James H. Guido da Siena. Princeton, N.J., Princeton University Press, 1964. (CR).

GUILLAUMIN, JEAN BAPTISTE ARMAND, 1841-1927

4084. Courières, Edouard des. Armand Guillaumin. Paris, Floury, 1924.

4085. Gray, Christopher. Armand Guillaumin. Chester, Conn., Pequot Press, 1972.

4086. Lecomte, Georges. Guillaumin. Paris, Bernheim, 1926.

4087. Serret, Georges [and] Fabiani, Dominique. Armand Guillaumin, 1841-1921; catalogue raisonné de l'oeuvre peint. Paris, Mayer, 1971. (CR).

GUTTUSO, RENATO, 1912-

4088. Assemblea regionale siciliana. Catalogo della mostra ontologica dell'opera di Renato Guttuso. Palermo, Palazzo dei Normanni, 13 febbraio 14 marzo 1971. Palermo, Banco di Sicilia, 1971.

4089. De Micheli, Mario. Guttuso. Milano, [Edizioni il Torchietto], 1966.

4090. Guttuso, Renato. Mestiere di pittore; scritti sull'arte e la società. Bari, de Donato, 1972.

4091. Guttuso, Renato, et al. Renato Guttuso, negli scritti. Milano, Fabbri, 1976.

4092. Marchiori, Giuseppe. Renato Guttuso. Milano, Edizione d'Arte Moneta, 1952. (Collezione monografie artisti contemporanei, 1).

4093. Moravia, Alberto [pseud.]. Renato Guttuso. [Including] La vita e l'opera di Guttuso [by] Franco Grasso. Palermo, Edizioni Il Punto, 1962.

4094. Morosini, Duilio. Renato Guttuso. Roma, Cusmano, [1960].

4095. Vittorini, Elio. Storia de Renato Guttuso e nota congiunta sulla pittura contemporanea. Milano, Edizioni del Milione, 1960. (Pittori italiani contemporanei, seconda serie, 1).

GUYS, CONSTANTIN, 1805-1892

4096. Baudelaire, Charles. Le peintre de la vie moderne, Constantin Guys. Paris, Kieffer, 1923.

4097. Dubray, Jean-Paul. Constantin Guys. Paris, Rieder, 1930.

4098. Galeries Barbazanges (Paris). Exposition des oeuvres de Constantin Guys. Préface par Armand Dayot. 18 mai au 1 juin [1904]. Paris, Galeries Barbazanges, 1904.

4099. Geffroy, Gustave. Constantin Guys, l'historien du Second Empire. Paris, Gallimard, 1904.

4100. Grappe, Georges. Constantin Guys. Paris, Librairie Artistique et Littéraire, [1910]. (L'art et le beau, quatrième année, 1).

4101. Konody, P. G. The painter of Victorian life, a study of Constantin Guys with an introduction and a translation of Baudelaire's Peintre de la vie moderne. Edited by C. Geoffrey Holme. New York, Rudge/London, Studio, 1930.

4102. Palazzo Braschi (Rome). Constantin Guys; il pittore della vita moderna. 10 settembre-5 ottobre 1980. Milano, Savelli, 1980.

HACKERT, JACOB PHILIPP, 1737-1807

4103. Goethe, Johann Wolfgang von. Philipp Hackert. Biographische Skizze, meist nach dessen eigenen Aufsätzen entworfen. Tübingen, Cotta, 1811.

4104. Lohse, Bruno. Jakob Philipp Hackert, Leben und Anfänge seiner Kunst. Emsdetten, Lechte, 1936.

HAGENAU, NIKLAUS VON (called Niclas Hagnower), 1445-1538

4105. Vöge, Wilhelm. Niclas Hagnower, der Meister des Isenheimer Hochaltars und seine Frühwerke. Freiburg im Breisgau, Urban-Verlag, 1931.

HAGNOWER, NICLAS see HAGENAU, NIKLAUS VON

HALÁSZ, GYULA see BRASSAÏ

HALS, FRANS, 1584-1666

4106. Baard, Henricus Petrus. Frans Hals. Trans. by George Stuck. New York, Abrams, 1981.

4107. Bode, Wilhelm von. Frans Hals und seine Schule. Leipzig, Seemann, 1871.

4108. _____, ed. **Frans Hals, his life and work.** With an essay by M. J. Binder. Trans. by Maurice W. Brockwell. 2 v. Berlin, Photographische Gesellschaft, 1914; London agents: The Berlin Photographic Company.

4109. Dantzig, Maurits Michel van. **Frans Hals, echt of onecht.** Amsterdam, Paris, 1937.

4110. Davies, Gerald S. **Frans Hals.** London, Bell, 1902.

4111. Descargues, Pierre. **Hals, biographical and critical study.** Lausanne, Skira, 1968. (The Taste of Our Time, 48).

4112. Dülberg, Franz. **Frans Hals, ein Leben und ein Werk.** Stuttgart, Neff, 1930.

4113. Fontainas, André. **Frans Hals.** Paris, Laurens, 1908.

4114. Gratama, Gerrit David. **Frans Hals.** Haag, Oceanus, 1943.

4115. Grimm, Claus. **Frans Hals; Entwicklung, Werkanalyse, Gesamtkatalog.** Berlin, Mann, 1972. (CR).

4116. _____. **L'opera completa di Frans Hals.** Milano, Rizzoli, 1974. (I classici dell'arte, 76).

4117. Knackfuss, Hermann. **Franz Hals.** Bielefeld/Leipzig, Velhagen & Klasing, 1897. 3 ed. (Künstler-Monographien, 12).

4118. Luns, Theo M. **Frans Hals.** Amsterdam, Becht, [1948]. (Palet serie, [27]).

4119. Martin, Wilhelm. **Frans Hals in zijn tijd.** Amsterdam, Meulenhoff, 1935. (De Hollandsche Schilderkunst in de zeventiende Eeuw, 1).

4120. Moes, Ernst W. **Frans Hals, sa vie et son oeuvre.** Trans. by Jean de Bosschère. Brussels, van Oest, 1909.

4121. Peladan, Joséphin. **Frans Hals, 1580(?)-1666.** Paris, Goupil, 1912.

4122. Slive, Seymour. **Frans Hals.** 3 v. London, Phaidon, 1970. (National Gallery of Art, Kress Foundation Studies in the History of European Art, 4). (CR).

4123. Trivas, Numa S. **The paintings of Frans Hals, complete edition.** London, Phaidon, 1949. 2 ed.; distributed by Oxford University Press, New York.

4124. Valentiner, Wilhelm R. **Frans Hals, des Meisters Gemälde.** Stuttgart, Deutsche Verlags-Anstalt, 1923. 2 ed. (Klassiker der Kunst in Gesamtausgaben, 28).

HALSMAN, PHILIPPE, 1906-1979

4125. Halsman, Philippe. **The jump book.** New York, Simon & Schuster, 1959.

4126. _____. **Portraits.** Selected and edited by Yvonne Halsman. New York, McGraw-Hill, 1983.

4127. _____. **Sight and insight.** Garden City, N.Y., Doubleday, 1972.

4128. International Center for Photography (New York). **Halsman** © 79. June 9-July 22, 1979. New York, International Center for Photography, 1979.

HAMMERSHØJ, VILHELM, 1864-1916

4129. Hammershøi, Wilhelm. **60 Autotypier i Sorttryk efter Fotografier af Originalerne.** [København], Gad, 1916. (Smaa kunstbøger, 13).

4130. Michaëlis, Sophus [and] Bramsen, Alfred. **Vilhelm Hammershøi, Kunstneren og hans Vaerk.** København, Gyldendal, 1918.

4131. Vad, Poul. **Vilhelm Hammershøi.** [København], Gyldendal, 1957.

HANS VON TÜBINGEN, ca. 1400-1462

4132. Oettinger, Karl. **Hans von Tübingen und seine Schule.** Berlin, Deutscher Verein für Kunstwissenschaft, 1938.

HANSEN, CHRISTIAN FREDERIK, 1756-1845

4133. Altonaer Museum in Hamburg. **Architekt Christian Frederik Hansen, 1756-1845.** 26. Juni bis 1. September 1968. Hamburg, [Altonaer Museum, 1968].

4134. Jakstein, Werner. **Landesbaumeister Christian Friedrich Hansen, der nordische Klassizist.** Neumünster in Holstein, Wachholtz, 1937. (Studien zür schleswig-holsteinischen Kunstgeschichte, 2).

4135. Rubow, Jorn. **C. F. Hansens Arkitektur.** København, Gad, 1936.

4136. Smidt, Carl Martin. **Arkitekten C. F. Hansen og hans Bygninger.** København, Gad, 1911.

4137. Wietek, Gerhard, ed. **C. F. Hansen, 1756-1845, und seine Bauten in Schleswig-Holstein.** Neumünster, Wachholtz, 1982. (Kunst in Schleswig-Holstein, 23).

HARNETT, WILLIAM MICHAEL, 1848-1892

4138. Frankenstein, Alfred. **After the hunt; William Harnett and other American still life painters, 1870-1900.** Berkeley/Los Angeles, University of California, 1953. (Rev. ed., University of California, Berkeley/Los Angeles, 1969; California Studies in the History of Art, 12). (CR).

HARRISON, PETER, 1716-1775

4139. Bridenbaugh, Carl. **Peter Harrison, first American architect.** Chapel Hill, University of North Carolina Press, 1949.

HARTLEY, MARSDEN, 1877-1943

see also LYONEL FEININGER

4140. Hartley, Marsden. **Adventures in the arts; informal
 chapters on painters, vaudeville, and poets.** New York,
 Boni and Liveright, 1921.

4141. McCausland, Elizabeth. **Marsden Hartley.** Minneapolis,
 University of Minnesota Press, 1952.

4142. Whitney Museum of American Art (New York). **Marsden
 Hartley.** March 4-May 25, 1980. New York, Whitney Museum
 of Modern Art/New York University Press, 1980.

HARTUNG, HANS, 1904-

4143. Apollonio, Umbro. **Hans Hartung.** Trans. by John Shepley.
 New York, Abrams, [1972].

4144. Aubier, Dominique. **Hartung.** Paris, Le Musée de Poche,
 1961.

4145. Descargues, Pierre. **Hartung.** Paris, Cercle d'Art, 1977.

4146. Gindertael, Roger van. **Hans Hartung.** [Paris], Tisné,
 1960.

4147. Hartung, Hans. **Autoportrait.** Paris, Grasset, 1976.

4148. Rousseau, Madeleine. **Hans Hartung.** [Text in English,
 French, German]. Stuttgart, Domnick, [1949].

4149. Schmücking, Rolf. **Hans Hartung, Werkverzeichnis der
 Graphik, 1921-1965.** Braunschweig, Galerie Schmücking,
 1965. (CR).

4150. Städtische Kunsthalle Düsseldorf. **Hans Hartung; Malerei,
 Zeichnung, Photographie.** 12. September bis 11. Oktober
 1981. Berlin, Kunstbuch Berlin, 1981.

HARUNOBU, SUZUKI, 1725-1770

4151. Hájek, Lubor. **Harunobu.** Trans. by Hedda Veselá Stránská.
 London, Spring, [1958].

4152. Kondō, Ichitarō. **Suzuki Harunobu.** Trans. and adapted by
 Kaoru Ogimi. Tokyo/Rutland, Vermont, Tuttle, [1956].
 (Kodansha Library of Japanese Art, 7).

4153. Kurth, Julius. **Suzuki Harunobu.** München/Leipzig, Piper,
 1923. 2 ed.

4154. Noguchi, Yone. **Harunobu.** London, Kegan Paul/Yokohama,
 Yoshikawa, 1940. (CR).

4155. Philadelphia Museum of Art. **Suzuki Harunobu, an exhibition
 of his colour-prints and illustrated books on the
 occasion of the bicentenary of his death in 1770.**
 18 September to 22 November 1970. Philadelphia,
 Philadelphia Museum of Art, 1970.

4156. Smidt, Hermann. **Harunobu, Technik und Fälschungen seiner
 Holzschnitte.** Wien, Gesellschaft für Vervielfältigende
 Kunst, 1911.

4157. Takahashi, Seiichirō. **Harunobu.** English adaptation by
 John Bester. Tokyo/Palo Alto, Calif., Kodansha, 1968.
 (Masterworks of Ukiyo-e, 6).

4158. Waterhouse, David B. **Harunobu and his age; the development
 of colour printing in Japan.** London, Trustees of the
 British Museum, 1964.

HASENCLEVER, JOHANN PETER, 1810-1853

4159. Bestvater-Hasenclever, Hanna. **J. P. Hasenclever, ein
 wacher Zeitgenosse des Biedermeier.** Recklinghausen,
 Bongers, 1979.

4160. Hasenclever, Hermann, ed. **Das Geschlecht Hasenclever im
 ehemaligen Herzogtum Berg in der Provinz Westfalen und
 zeitweise in Schlesien.** 2 v. Leipzig, Gohlis, 1922/4.

HASSAM, CHILDE, 1859-1935

4161. Adams, Adeline. **Childe Hassam.** New York, American Academy
 of Arts and Letters, 1938.

4162. Cortissoz, Royal. **Catalogue of the etchings and dry-points
 of Childe Hassam.** New York/London, Scribner, 1925.

4163. Eliasoph, Paula. **Handbook of the complete set of etchings
 and drypoints . . . of Child Hassam . . . from 1883 till
 October 1933.** New York, The Leonard Clayton Gallery,
 1933. (CR).

4164. Griffith, Fuller. **The lithographs of Childe Hassam, a
 catalog.** Washington, D.C., Smithsonian Institution,
 1962. (Smithsonian Institution Bulletin, 232). (CR).

4165. Hoopes, Donelson F. **Childe Hassam.** New York,
 Watson-Guptill, 1979.

4166. University of Arizona Museum of Art (Tucson). **Childe
 Hassam, 1859-1935.** February 5 to March 5, 1972. Tucson,
 Arizona, University of Arizona Museum of Art, [1972].

4167. Weir, J. Alden and Zigrosser, Carl. **Childe Hassam.** New
 York, Keppel, 1916.

HAUSMANN, RAOUL, 1886-1971

4168. Giroud, Michel, ed. **Raoul Hausmann: je ne suis pas un
 photographe.** Paris, Chêne, 1975.

4169. Haus, Andreas. **Raoul Hausmann, Kamerafotografien
 1927-1957.** München, Schirmer/Mosel, 1979.

4170. Hausmann, Raoul. **Courrier Dada.** Suivi d'une
 bio-bibliographie de l'auteur par Poupard-Lieussou.
 Paris, Le Terrain Vague, 1958.

4171. Kestner-Gesellschaft Hannover. **Raoul Hausmann,
 Retrospektive.** 12. Juni bis 9. August 1981. Hannover,
 Kestner-Gesellschaft, 1981. (Katalog 4/1981).

HAUSSMANN, GEORGES-EUGENE, 1809-1891

4172. Cars, Jean des. **Haussmann: la gloire du Second Empire.**
 Paris, Perrin, 1978.

4173. Chapman, Joan M. and Chapman, Brian. **The life and times of Baron Haussmann: Paris in the Second Empire.** London, Weidenfeld, 1957.

4174. Gaillard, Jeanne. **Paris, la ville, 1852-1870: l'urbanisme parisien à l'heure d'Haussmann.** Paris, Champion, 1977.

4175. Haussmann, Georges-Eugène. **Mémoires.** 3 v. Paris, Havard, 1890-1893. (Reprint: Paris, Durier, 1979).

4176. Laronze, Georges. **Le Baron Haussmann.** Paris, Alcan, 1932.

4177. Londei, Enrico F. **La Parigi di Haussmann: la transformazione urbanistica di Parigi durante il seconda impero.** Roma, Kappa, 1982.

4178. Saalman, Howard. **Haussmann: Paris transformed.** New York, Braziller, 1971.

4179. Touttain, Pierre-André. **Haussmann: artisan du Second Empire, créateur du Paris moderne.** Paris, Grund, 1971.

HAWES, JOSIAH J. see SOUTHWORTH, ALFRED S.

HAWKSMOOR, NICHOLAS, 1661-1736

4180. Downes, Kerry. **Hawksmoor.** London, Zwemmer, 1979. 2 ed.

4181. Goodhart-Rendel, H. S. **Nicholas Hawksmoor.** New York, Scribner, 1924.

HAYDON, BENJAMIN ROBERT, 1786-1846

4182. George, Eric. **The life and death of Benjamin Robert Haydon, 1786-1846.** London, Oxford University Press, 1948.

4183. Haydon, Benjamin Robert. **Correspondence and table-talk.** With a memoir by his son Frederic Wordsworth Haydon. 2 v. London, Chatto and Windus, 1876.

4184. _____. **The diary of Benjamin Robert Haydon.** 5 v. Ed. by Willard Bissell Pope. Cambridge, Mass., Harvard University Press, 1960-63.

4185. _____. **Lectures on painting and design.** 2 v. London, Longman, Brown, Green, 1844-46.

4186. Olney, Clarke. **Benjamin Robert Haydon, historical painter.** Athens, Ga., University of Georgia Press, 1952.

4187. Paston, George [pseud., Emily Morse Symonds]. **B. R. Haydon and his friends.** London, Nisbet, 1905.

4188. Taylor, Tom, ed. **Life of Benjamin Robert Haydon, historical painter, from his autobiography and journals.** 3 v. London, Longman, Brown, Green, 1853. (New ed. with an introduction by Aldous Huxley, 2 v. New York, Harcourt, Brace, [1926]).

HAYEZ, FRANCESCO, 1791-1882

4189. Castellaneta, Carlo. **L'opera completa di Hayez.** Milano, Rizzoli, 1971. (Classici dell'arte, 54).

4190. Hayez, Francesco. **Le mie memorie.** Milano, Reale Accademia de Belle Arti in Milano, 1890.

4191. Nicodemi, Giorgio. **Francesco Hayez.** 2 v. Milano, Ceschina, 1962. (CR).

HEBERT, ERNEST, 1817-1908

4192. Peladan, Joséphin. **Ernest Hébert, son oeuvre et son temps.** Paris, Delagrave, 1910.

HECKEL, ERICH, 1883-1970

4193. Dube, Annemarie und Dube, Wolf-Dieter. **Erich Heckel, das graphische Werk.** 3 v. New York, Rathenau, 1974; distributed by Hauswedell, Hamburg. (CR).

4194. Köhn, Heinz. **Erich Heckel, Aquarelle und Zeichnungen.** München, Bruckmann, 1959.

4195. Schleswig-Holsteinisches Landesmuseum (Schleswig, W. Germany). **Erich Heckel.** [Ausstellung]. 2. November 1980-4. Januar 1981. Schleswig, Schleswig-Holsteinisches Landesmuseum, 1980.

4196. Thormaehlen, Ludwig. **Erich Heckel.** Berlin, Klinkhardt & Biermann, 1931. (Junge Kunst, 58).

4197. Vogt, Paul. **Erich Heckel.** Recklinghausen, Bongers, 1965. (CR).

HEEMSKERCK, MARTIN VAN, 1498-1574

4198. Garff, Jan. **Tegninger af Maerten van Heemskerck, illustreret katalog.** København, Statens Museum vor Kunst, 1971. (CR).

4199. Huelsen, Christian and Egger, Hermann. **Die römischen Skizzenbücher von Marten van Heemskerk im königlichen Kupferstichkabinett zu Berlin.** 2 v. Berlin, Bard, 1913-1916.

4200. Kerrich, Thomas. **A catalogue of the prints which have been engraved after Martin Heemskerck; or rather, an essay towards such a catalogue.** London, Rodwell, 1829.

4201. Preibisz, Leon. **Martin van Heemskerck, ein Beitrag zur Geschichte des Romanismus in der niederländischen Malerei des XVI. Jahrhunderts.** Leipzig, Klinkhardt & Biermann, 1911.

4202. Veldman, Ilja M. **Maarten van Heemskerck and Dutch humanism in the sixteenth century.** Trans. by Michael Hoyle. Maarssen, Schwartz, 1977.

HEGENBARTH, JOSEF, 1884-1962

4203. Hegenbarth, Josef. **Aufzeichnungen über seine Illustrationsarbeit.** Hamburg, Christians, 1964.

4204. Löffler, Fritz. **Josef Hegenbarth.** Dresden, Verlag der Kunst, 1980. 2 ed.

4205. Reichelt, Johannes. **Josef Hegenbarth.** Essen, Baedeker, 1925. (Charakterbilder der neuen kunst, 5).

HEGI, FRANZ, 1774-1850

4206. Appenzeller, Heinrich. **Der Kupferstecher Franz Hegi von Zürich, 1774-1850; sein Leben und seine Werke, beschreibendes Verzeichnis seiner sämtlichen Kupferstiche.** Zürich, Appenzeller, 1906. (CR).

4207. Dönz-Breimaier, Maria Gertrud. **Franz Hegi und sein Kreis.** Chur, Ebner, 1944.

HEILIGER, BERNHARD, 1915-

4208. Flemming, Hanns Theodor. **Bernhard Heiliger.** Berlin, Rembrandt, 1962.

4209. Hammacher, Abraham M. **Bernhard Heiliger.** Trans. by Guy Atkins. St. Gallen, Erker-Verlag, 1978. (Künstler unserer Zeit, 20).

4210. Neuer Berliner Kunstverein und Akademie der Künste. **Bernhard Heiliger, Skulpturen und Zeichnungen, 1960-1975.** 13. April bis 25. Mai 1975. Berlin, Neuer Berliner Kunstverein und Akademie der Künste, 1975.

HELDT, WERNER, 1904-1954

4211. Kestner-Gesellschaft (Hannover). **Werner Heldt.** 8. März bis 7. April 1968. Hannover, Kestner-Gesellschaft, 1968.

4212. Schmied, Wieland. **Werner Heldt.** Mit einem Werkkatalog von Eberhard Seel. Köln, DuMont, 1976. (CR).

HELLEU, PAUL CESAR, 1859-1927

4213. Adhémar, Jean. **Helleu.** Paris, Bibliothèque Nationale, 1957.

4214. Montesquiou-Fezensac, Robert. **Paul Helleu, peintre et graveur.** Paris, Floury, 1913.

HELST, BARTOLOMEUS VAN DER, 1613-1670

4215. Gelder, Jan J. **Bartholomeus van der Helst.** Rotterdam, Brusse, 1921. (CR).

HENNER, JEAN JACQUES, 1829-1905

4216. Crastre, François. **Henner.** Trans. by Frederic Taber-Cooper. New York, Stokes, 1913.

4217. Muenier, Pierre-Alexis. **La vie et l'art de Jean-Jacques Henner, peintures et dessins.** [Paris], Flammarion, 1927.

4218. Soubies, Albert. **J.-J. Henner (1829-1905); notes biographiques.** Paris, Flammarion, 1905.

HENRI, ROBERT, 1865-1929

4219. Henri, Robert. **The art spirit.** Compiled by Margery Ryerson. Philadelphia, Lippincott, 1960. 4 ed.

4220. Homer, William Innes and Organ, Violet. **Robert Henri and his circle.** Ithaca, N.Y., Cornell University Press, 1969.

4221. Metropolitan Museum of Art (New York). **Catalogue of a memorial exhibition of the work of Robert Henri.** [March 9-April 19, 1931]. New York, Metropolitan Museum of Art, 1931.

4222. Read, Helen A. **Robert Henri.** New York, Whitney Museum of American Art, 1931.

4223. Yarrow, William and Bouche, Louis. **Robert Henri, his life and works.** New York, Boni & Liveright, 1921.

HEPPLEWHITE, GEORGE, d. 1786

see also ADAM, ROBERT

4224. Hepplewhite, A[lice], and Co. **The cabinet-maker and upholsterer's guide.** London, Taylor, 1788.

HEPWORTH, BARBARA, 1903-1975

4225. Bowness, Alan. **The sculpture of Barbara Hepworth, 1960-1969.** New York/Washington [D.C.], Praeger, 1971.

4226. Gibson, William. **Barbara Hepworth, sculptress.** London, Faber, 1946.

4227. Hammacher, Abraham M. **Barbara Hepworth.** Trans. by James Brockway. London, Thames and Hudson, 1968.

4228. Hepworth, Barbara. **Carvings and drawings.** Introduction by Herbert Read. London, Humphries, 1952.

4229. _____. **A pictorial autobiography, new and extended edition.** Bradford-on-Avon, Moonraker Press, 1978.

4230. Hodin, Josef Paul. **Barbara Hepworth.** Catalogue by Alan Bowness. New York, McKay, 1961.

4231. Shepherd, Michael. **Barbara Hepworth.** London, Methuen, 1963.

HERKOMER, HUBERT VON, 1849-1914

4232. Baldry, Alfred Lys. **Hubert von Herkomer, R. A., a study and a biography.** London, Bell, 1901.

4233. Courtney, William Leonard. **Professor Hubert Herkomer, his life and work.** London, Art Journal, 1892. (Art Annual, 9).

4234. Herkomer, Sir Hubert von. **Etching and mezzotint engraving; lectures delivered at Oxford.** London/New York, Macmillan, 1892.

4235. _____. **The Herkomers.** 2 v. London, Macmillan, 1910.

4236. _____. **My school and my gospel.** London, Constable, 1908.

4237. Pietsch, Ludwig. **Herkomer.** Bielefeld/Leipzig, Velhagen & Klasing, 1901. (Künstler-Monographien, 54).

HEYDEN, JAN VAN DER, 1637-1712

4238. Wagner, Helga. **Jan van der Heyden, 1637-1712.** Amsterdam/ Haarlem, Scheltema & Holkema, 1971. (CR).

HILDEBRAND, ADOLF VON, 1847-1921

4239. Hausenstein, Wilhelm. **Adolf von Hildebrand.** München, Filser, 1947. (Meisterwerke der Kunst, 5).

4240. Heilmeyer, Alexander. **Adolf Hildebrand.** Bielefeld/ Leipzig, Velhagen & Klasing, 1902. (Künstler-Monographien, 60).

4241. _____. **Adolf von Hildebrand.** München, Langen, 1922. (CR).

4242. Hildebrand, Adolf von. **Gesammelte Schriften zur Kunst.** Bearbeitet von Henning Bok. Köln/Opladen, Westdeutscher Verlag, 1969. (Wissenschaftliche Abhandlungen der Arbeitsgemeinschaft für Forschung des Landes Nordrhein-Westfalen, 39).

4243. _____. **The problem of form in painting and sculpture.** Trans. by Max Meyer and Robert Morris Ogden. New York, Stechert, 1932. 2 ed. (Reprint: New York/London, Garland, 1978; Connoisseurship, Criticism and Art History in the Nineteenth Century, 11).

4244. Sattler, Bernhard, ed. **Adolf von Hildebrand und seine Welt; Briefe und Erinnerungen.** München, Callwey, 1962.

HILDEBRANDT, JOHANN LUKAS VON, 1668-1745

4245. Grimschitz, Bruno. **Johann Lucas von Hildebrandt.** Wien/München, Herold, 1959.

4246. _____. **Johann Lucas von Hildebrandt. Künstlerische Entwicklung bis zum Jahre 1725.** Wien, Hölzel, 1922 (Kunstgeschichtliche Einzeldarstellungen, 1).

HILDER, ROWLAND, 1905-

4247. Lewis, John. **Rowland Hilder, painter and illustrator.** London, Barrie & Jenkins, 1978.

HILER, HILAIRE, 1898-

4248. George, Waldemar. **Hilaire Hiler and structuralism, new conception of form-color.** New York, Wittenborn, [1958].

4249. Hiler, Hilaire. **Notes on the technique of painting.** London, Faber, 1934.

4250. _____. **The painter's pocket-book of methods and materials.** New York, Harcourt, Brace, 1938.

4251. _____. **Why abstract?** [With a note on Hilaire Hiler by William Saroyan and a letter from Henry Miller]. New York, New Directions, 1945.

HILL, CARL FREDERIK, 1849-1911

4252. Anderberg, Adolf. **Carl Hill, hans liv och hans konst.** Malmö, Allhems, 1951.

4253. Blomberg, Erik. **Carl Fredrick Hill, hans friska och sjuka konst.** Stockholm, Natur och Kultur, 1949.

4254. Ekelöf, Gunnar. **C. F. Hill.** Göteborg, Förlagsaktiebolaget Bokkonst, 1946.

4255. Lindhagen, Nils. **C. F. Hill, sjukdomsarens konst.** Malmö, Bernce, 1976.

4256. Polfeldt, Ingegerd. **Möte med Carl Fredrik Hill.** Stockholm, Liber, 1979.

HILL, DAVID OCTAVIUS, 1802-1870

4257. Bruce, David. **Sun pictures; the Hill-Adamson calotypes.** Greenwich, Conn., New York Graphic Society, 1973.

4258. Elliot, Andrew. **Calotypes by D. O. Hill and R. Adamson, illustrating an early stage in the development of photography.** Edinburgh, [privately printed], 1928.

4259. Ford, Colin and Strong, Roy. **An early Victorian album; the Hill/Adamson collection.** London, Cape, 1974.

4260. Nickel, Heinrich. **David Octavius Hill, Wurzeln und Wirkungen seiner Lichtbildkunst.** Saale, Fotokinoverlag, 1960.

4261. Schwarz, Heinrich. **David Octavius Hill, master of photography.** Trans. by Helene E. Fraenkel. New York, Viking, 1931.

4262. Scottish Arts Council Gallery (Edinburgh). **A centenary exhibition of the work of David Octavius Hill, 1802-1848.** May 2-31 1970. Edinburgh, Scottish Arts Council, 1970.

4263. Stevenson, Sara. **David Octavius Hill and Robert Adamson, catalogue of their calotypes taken between 1843 and 1847 in the collection of the Scottish National Portrait Gallery.** Edinburgh, National Galleries of Scotland, 1981. (CR).

HILLIARD, NICHOLAS, ca. 1537-1619

4264. Auerbach, Erna. **Nicholas Hilliard.** London, Routledge & Kegan Paul, 1961. (CR).

4265. Pope-Hennessy, John. **A lecture on Nicholas Hilliard.** London, Home and Van Thal, 1949.

4266. Reynolds, Graham. **Nicholas Hilliard & Isaac Oliver.** London, HMSO, 1971. 2 ed.

4267. Strong, Roy. **Nicholas Hilliard.** London, Joseph, 1975.

HINE, LEWIS WICKES, 1874-1940

4268. Gutman, Judith Mara. **Lewis W. Hine, 1874-1940; two perspectives.** New York, Grossman, 1974.

4269. ⎯⎯⎯. **Lewis W. Hine and the American social conscience.**
New York, Walker, 1967.

4270. Hine, Lewis W. **Men at work; photographic studies of modern men and machines.** New York, Macmillan, 1932. (Reprinted, with a supplement: New York, Dover, 1977).

4271. Trachtenberg, Alan, et al. **America & Lewis Hine, photographs 1904-1940.** Millerton, N.Y., Aperture, 1977.

HIROSHIGE, 1797-1858

4272. Addiss, Stephen, ed. **Tōkaidō, adventures on the road in old Japan.** Lawrence, Kansas, The Helen Foresman Spencer Museum of Art, 1980.

4273. Amsden, Dora [and] Happer, John Stewart. **The heritage of Hiroshige; a glimpse at Japanese landscape art.** San Francisco, Elder, 1912.

4274. Exner, Walter. **Hiroshige.** Trans. by Marguerite Kay. New York, Crown, 1960.

4275. Fenollosa, Mary McNeil. **Hiroshige, the artist of mist, snow, and rain.** San Francisco, Vickery, Atkins & Torrey, 1901.

4276. Narazaki, Muneshige. **Hiroshige, famous views.** English adaptation by Richard L. Gage. Tokyo/Palo Alto, Calif., Kodansha, 1968. (Masterpieces of Ukiyo-e, 5).

4277. Noguchi, Yone. **Hiroshige.** New York, Orientalia, 1921.

4278. ⎯⎯⎯. **Hiroshige.** London, Kegan Paul, 1934.

4279. Oka, Isaburō. **Hiroshige.** Trans. by Stanleigh H. Jones. Tokyo, Kodansha, 1982.

4280. Strange, Edward F. **The colour-prints of Hiroshige.** London, Cassell, 1925.

4281. Takahashi, Sei-ichiro. **Andō Hiroshige (1797-1858).** English adaptation by Charles E. Perry. Rutland, Vermont/Tokyo, Tuttle, 1956. (Kodansha Library of Japanese Art, 3).

HIRSCHVOGEL, AUGUSTIN, 1503-1553

4282. Friedrich, Carl. **Augustin Hirschvogel als Töpfer, seine Gefässentwürfe, Öfen und Glasgemälde.** Nürnberg, Schrag, 1885.

4283. Schwarz, Karl. **Augustin Hirschvogel, ein deutscher Meister der Renaissance.** Berlin, Bard, 1917.

HITCHENS, SYDNEY IVON, 1893-

4284. Bowness, Alan [and] Rosenthal, T. G. **Ivon Hitchens.** London, Humphries, 1973.

4285. Tate Gallery (London). **Ivon Hitchens, a retrospective exhibition.** 11 July-18 August, 1963. London, Arts Council of Great Britain, 1963.

HOBBEMA, MEINDERT, 1638-1709

4286. Broulhiet, Georges. **Meindert Hobbema (1638-1709).** Paris, Firmin-Didot, 1938.

4287. Héris, Henri Joseph. **Notice raisonnée sur la vie et les ouvrages de Mindert Hobbema.** Paris, Febvre, 1854.

4288. Michel, Emile. **Hobbema et les paysagistes de son temps en Hollande.** Paris, Librairie de l'Art, 1890.

HODLER, FERDINAND, 1853-1918

4289. Bender, Ewald. **Das Leben Ferdinand Hodlers.** Zürich, Rascher, 1922.

4290. ⎯⎯⎯ and Müller, Werner Y. **Die Kunst Ferdinand Hodlers.** 2 v. Zürich, Rascher, 1923/1941.

4291. Brüschweiler, Jura. **Eine unbekannte Hodler-Sammlung aus Sarajewo.** Bern, Benteli, 1978. (Hodler-Publikation, 1).

4292. ⎯⎯⎯. **Ferdinand Hodler, Selbstbildnisse als Selbstbiographie.** Bern, Benteli, 1979. (Hodler-Publikation, 2).

4293. Dietschi, Peter. **Der Parallelismus Ferdinand Hodlers; ein Beitrag zur Stilpsychologie der neueren Kunst.** Basel, Birkhäuser, 1957. (Basler Studien zur Kunstgeschichte, 16).

4294. Frey, Adolf. **Ferdinand Hodler.** Leipzig, Haessel, 1922.

4295. Guerzoni, Stéphanie. **Ferdinand Hodler; sa vie, son oeuvre, son enseignement, souvenirs personnels.** Genève, Cailler, 1957. (Les grands artistes racontés par eux-mêmes et par leurs amis, 13).

4296. Hirsh, Sharon L. **Ferdinand Hodler.** New York, Braziller, 1982.

4297. Hugelshofer, Walter. **Ferdinand Hodler, eine Monographie.** Zürich, Rascher, 1952.

4298. Kesser, Herman. **Zeichnungen Ferdinand Hodlers.** Basel, Rhein-Verlag, 1921.

4299. Klein, Rudolf. **Ferdinand Hodler & the Swiss.** Washington, D.C., Brentano, 1910.

4300. Loosli, Carl A. **Ferdinand Hodler; Leben, Werk und Nachlass.** 4 v. Bern, Sluter, 1921-1924. (CR).

4301. Maeder, Alphonse. **F. Hodler, eine Skizze seiner seelischen Entwicklung und Bedeutung für die schweizerisch-nationale Kultur.** Zürich, Rascher, 1916.

4302. Mühlestein, Hans. **Ferdinand Hodler, ein Deutungsversuch.** Weimar, Kiepenheuer, 1914.

4303. ⎯⎯⎯ und Schmidt, Georg. **Ferdinand Hodler, 1853-1918; sein Leben und sein Werk.** Erlenbach/Zürich, Rentsch, 1942.

4304. Museum für Kunst und Geschichte (Freiburg i.Ue.). **Hodler, die Mission des Künstlers.** 11. Juni-20. September 1981.

[Text in German and French]. Bern, Benteli, 1981.
(Hodler-Publikation, 4).

4305. Roffler, Thomas. **Ferdinand Hodler.** Frauenfeld/Leipzig,
Huber, [1926].

4306. Schweizerisches Institut für Kunstwissenschaft (Zurich).
Der frühe Hodler, das Werk 1870-1890. 11. April bis
14. Juni 1981. Bern, Benteli, 1981. (Hodler-
Publikation, 3).

4307. Selz, Peter. **Ferdinand Hodler.** [Published in conjunction
with an exhibition, University Art Museum, Berkeley,
Calif., November 22, 1972-January 7, 1973; with contribu-
tions by Jura Brüschweiler, Phyllis Hattis, and Eva
Wyler]. Berkeley, Calif., University Art Museum, 1972.

4308. Steinberg, Solomon David. **Ferdinand Hodler, ein Platoniker
der Kunst.** Zürich, Rascher, 1947.

4309. Ueberwasser, Walter and Spreng, Robert. **Hodler, Köpfe und
Gestalten.** Zürich, Rascher, 1947.

4310. Weese, Artur. **Ferdinand Hodler.** Bern, Francke, 1910.

HOFFMAN, MALVINA CORNELL, 1887-1966

4311. Alexandre, Arsène. **Malvina Hoffman.** Paris, Pouterman,
1930.

4312. Hoffman, Malvina. **Heads and tales.** New York, Scribner,
1936.

4313. _____. **Sculpture inside and out.** New York, Norton, 1939.

4314. _____. **Yesterday is tomorrow, a personal history.** New
York, Crown, 1965.

HOFER, KARL, 1878-1955

4315. Akademie der Künste (Berlin). **Karl Hofer, 1878-1955.**
7. November 1965-2. Januar 1966. Berlin, Akademie der
Künste, [1965].

4316. Feist, Ursula. **Karl Hofer.** Berlin, Henschel, 1977.

4317. Hofer, Karl. **Aus Leben und Kunst.** Berlin, Rembrandt,
1952.

4318. _____. **Erinnerungen eines Malers.** Berlin/Grunewald,
Herbig, 1953.

4319. _____. **Über das Gesetzliche in der bildenden Kunst.**
Berlin, Akademie der Künste, 1956. (Monographien und
Biographien, 1).

4320. Reifenberg, Benno. **Karl Hofer.** Leipzig, Klinkhardt &
Biermann, 1924. (Junge Kunst, 48).

4321. Staatliche Kunsthalle (Berlin). **Karl Hofer, 1878-1955.**
16. April bis 14. Juni 1978. Berlin, Staatliche
Kunsthalle, 1978. (CR).

HOFFMANN, JOSEF, 1870-1956

4322. Baroni, Daniele e D'Aruia, Antonio. **Josef Hoffman e la
Wiener Werkstätte.** Milano, Electa, 1981.

4323. Fagiolo, Maurizio. **Hoffmann, i mobili semplici; Vienna
1900-1910.** [Rome], Galleria dell'Emporio Floreale,
[1977].

4324. Kleiner, Leopold. **Josef Hoffmann.** Berlin, Hübsch, 1927.

4325. Sekler, Eduard. **Josef Hoffmann.** Trans. by the author.
Catalogue raisonné trans. by John Maass. Princeton,
N.J., Princeton University Press, 1984. (CR).

4326. Veronesi, Giulia. **Josef Hoffmann.** Milano, Il Balcone,
1956. (Architetti del movimento moderno, 17).

4327. Weiser, Armand. **Josef Hoffmann.** Genf, Meister der
Baukunst, 1930.

HOFMANN, HANS, 1880-1966

4328. Greenberg, Clement. **Hofmann.** Paris, Fall, 1961. (Musée
de poche, 1).

4329. Hofmann, Hans. **Search for the real and other essays.**
Andover, Mass., Addison Gallery of American Art, 1948.

4330. Hunter, Sam. **Hans Hofmann.** New York, Abrams, 1963.

4331. Museum of Modern Art (New York). **Hans Hofmann.** September
11-November 28, 1963. Text by William C. Seitz. New
York, Museum of Modern Art, 1963; distributed by
Doubleday, Garden City, N.Y. (Reprint: New York, Arno,
1972).

4332. Wight, Frederick S. **Hans Hofmann.** Los Angeles, University
of California Press, 1957.

HOGARTH, WILLIAM, 1697-1764

4333. Antal, Frederick. **Hogarth and his place in European art.**
New York, Basic Books, 1962.

4334. Beckett, Ronald B. **Hogarth.** London, Routledge, 1949.

4335. Benoit, François. **Hogarth.** Paris, Laurens, [1904].

4336. Berry, Erick [pseud., Allena Best]. **The four Londons of
William Hogarth.** New York, McKay, 1964.

4337. Bindman, David. **Hogarth.** London, Thames and Hudson, 1981.

4338. Blum, André. **Hogarth.** Paris, Alcan, 1922.

4339. Bowen, Marjorie. **William Hogarth, the Cockney's mirror.**
New York/London, Appleton-Century, 1936.

4340. Brown, Gerard B. **William Hogarth.** New York, Scribner,
1905.

4341. Burke, Joseph and Caldwell, Colin. **Hogarth, the complete
engravings.** London, Thames and Hudson, 1968.

4342. Cook, Thomas. **Hogarth restored; the whole works of the celebrated William Hogarth as originally published, now re-engraved, accompanied by anecdotes of Mr. Hogarth.** 2 v. London, [Cook] and Robinson, 1802.

4343. Dobson, Austin. **William Hogarth.** London, Heinemann/New York, McClure, Phillips, 1902.

4344. Garnett, Edward. **Hogarth.** London, Duckworth/New York, Dutton, [1911].

4345. Gaunt, William. **The world of William Hogarth.** London, Cape, 1978.

4346. Gowing, Lawrence. **Hogarth.** [Catalogue of an exhibition, The Tate Gallery, 2 December 1971-6 February 1972]. London, The Tate Gallery, 1971.

4347. Hogarth, William. **The analysis of beauty, written with a view of fixing the fluctuating ideas of taste.** London, Reeves, 1753. (New edition: Oxford, Clarendon Press, 1955).

4348. _____. **The works of William Hogarth . . . with a sketch of Hogarth's life and career by William Makepeace Thackeray and an essay on the genius and character of Hogarth by Charles Lamb.** Boston, Osgood, 1876.

4349. Ireland, John. **Hogarth illustrated.** 3 v. London, Boydell, 1793. 2 ed.

4350. Lichtenberg, Georg Christoph. **W. Hogarth's Zeichnungen, nach den Originalen in Stahl gestochen.** 2 v. Stuttgart, Literatur-Comptoir, 1840.

4351. _____. **Witzige und launige Sittengemälde nach Hogarth.** Wien, Commission der Gassler'schen Buchhandlung, 1811.

4352. _____. **The world of Hogarth, Lichtenberg's commentaries on Hogarth's engravings.** Trans. by Innes and Gustav Herdan. Boston, Houghton Mifflin, 1966.

4353. Lindsay, Jack. **Hogarth; his art and his world.** New York, Taplinger, 1979.

4354. Mandel, Gabriele. **L'opera completa di Hogarth pittore.** Milano, Rizzoli, 1967. (Classici dell'arte, 15).

4355. Meier-Graefe, Julius. **William Hogarth.** München/Leipzig, Piper, 1907.

4356. Moore, Robert E. **Hogarth's literary relationships.** Minneapolis, University of Minnesota Press, 1948.

4357. [Nichols, John, ed.]. **Anecdotes of William Hogarth written by himself, with essays on his life and genius, and criticisms on his works selected from Walpole, Gilpin, J. Ireland, Lamb, Phillips, and others.** London, Nichols, 1833. (Reprint: London, Cornmarket Press, 1970).

4358. Nichols, John and Steevens, George. **The geniune work of William Hogarth, illustrated with biographical anecdotes, a chronological catalogue and commentary.** 2 v. London, Longman, Hurst, Rees, and Orme, 1808/1810 [with a supplementary volume containing **Clavis Hogarthiana** purported to be by Edmund Ferres and other illustrative essays, with fifty additional plates, London, Nichols, Son, and Bentley, 1817].

4359. Oppé, Adolf P. **The drawings of William Hogarth.** New York, Phaidon, 1948.

4360. Quennell, Peter. **Hogarth's progress.** London, Collins, 1955.

4361. Paulson, Ronald. **Hogarth: his life, art, and times.** 2 v. New Haven/London, Yale University Press, 1971.

4362. _____. **Hogarth's graphic work, revised edition.** 2 v. New Haven/London, Yale University Press, 1970. (CR).

4363. Sala, George Augustus. **William Hogarth, painter, engraver and philosopher; essays on the man, the work and the time.** London, Smith, Elder, 1866.

4364. Trusler, John. **Hogarth moralized, being a complete edition of Hogarth's works . . . with an explanation . . . and a comment on their moral tendency.** London, Hooper [and] Jane Hogarth, 1768.

4365. Webster, Mary. **Hogarth.** London, Studio Vista, 1979.

4366. Weitenkampf, Frank. **A bibliography of William Hogarth.** Cambridge, Mass., The Library of Harvard University, 1890. (Library of Harvard University, Bibliographic Contributions, 37).

4367. Wheatley, Henry B. **Hogarth's London; pictures of the manners of the eighteenth century.** New York, Dutton, 1909.

HOHENBERG, MARTIN see ALTOMONTE, MARTINO, 1657-1745

HOKUSAI, 1760-1849

4368. Bowie, Theodore. **The drawings of Hokusai.** Bloomington, Ind., Indiana University Press, 1964.

4369. Dickins, Frederick V. **Fugaku Hiyaku-kei, or a hundred views of Fuji.** London, Batsford, 1880.

4370. [Fenellosa, Ernest F.]. **Catalogue of the exhibition of paintings of Hokusai held at the Japan Fine Art Association, Uyeno Park, Tokio, from 13th to 30th January, 1900.** Tokio, Bunshichi Kobayashi, 1901.

4371. Focillon, Henri. **Hokousaï.** Paris, Alcan, 1914.

4372. Forrer, Matthi. **Hokusai, a guide to the aerial graphics.** Philadelphia/London, Heron Press, 1974.

4373. Goncourt, Edmond de. **Hokousaï.** Paris, Bibliothèque Charpentier, 1896.

4374. Hillier, Jack R. **The art of Hokusai in book illustration.** London, Sotheby Parke Bernet/Berkeley and Los Angeles, University of California, 1980.

4375. _____. **Hokusai; paintings, drawings, and woodcuts.** New York, Phaidon, 1955; distributed by Garden City Books, Garden City, N.Y.

4376. Holmes, Charles J. **Hokusai.** London, At the Sign of the Unicorn, 1900. (Artist's Library, 1).

4377. Michener, James A. **The Hokusai sketchbooks; selections from the Manga.** Rutland, Vermont/Tokyo, Tuttle, 1958.

4378. Nagasse, Takeshiro. **Le paysage dans l'art de Hokouçai.** Paris, Les Editions d'Art et d'Histoire, 1937.

4379. Narazaki, Muneshige. **Hokusai, sketches and paintings.** English adaptation by John Bester. Tokyo/Palo Alto, Calif., Kodansha, 1969.

4380. _____. **Hokusai, the thirty-six views of Mt. Fuji.** English adaptation by John Bester. Tokyo/Palo Alto, Calif., Kodansha, 1968.

4381. Noguchi, Yone. **Hokusai.** London, Elkin Mathews, 1925.

4382. Perzynski, Friedrich. **Hokusai.** Bielefeld/Leipzig, Velhagen & Klasing, 1904. (Künstler-Monographien, 68).

4383. Revon, Michel. **Etude sur Hoksaï.** Paris, Lecène, Oudin, 1896.

4384. Strange, Edward F. **Hokusai, the old man mad with painting.** London, Siegle, Hill, 1906. (Langham Series of Art Monographs, 17).

HOLBEIN, HANS (the elder), 1460-1524

HANS (the younger), 1497-1543

4385. Benoit, François. **Holbein.** Paris, Librairie de l'Art Ancien et Moderne, [1905].

4386. Beutler, Christian and Thiem, Günther. **Hans Holbein d. Ä., die spätgotische Altar- und Glasmalerei.** Augsburg, Rösler, 1960. (Abhandlungen zur Geschichte der Stadt Augsburg, Schriftenreihe des Stadtarchivs Augsburg, 13).

4387. Chamberlain, Arthur B. **Hans Holbein the younger.** 2 v. London, Allen, 1913.

4388. Chamberlaine, John. **Imitations of original drawings by Hans Holbein in the collection of His Majesty for the portraits of illustrious persons of the Court of Henry VIII, with biographical tracts** [by Edmund Lodge]. London, Bulmer, 1792.

4389. Christoffel, Ulrich. **Hans Holbein d. J.** Berlin, Verlag des Druckhauses Tempelhof, 1950.

4390. Cohn, Werner. **Der Wandel der Architekturgestaltung in den Werken Hans Holbein d. J., ein Beitrag zur Holbein-Chronologie.** Strassburg, Heitz, 1930. (Studien zur deutschen Kunstgeschichte, 278).

4391. Davies, Gerald S. **Hans Holbein the younger.** London, Bell, 1903.

4392. Fougerat, Emmanuel. **Holbein.** Paris, Alcan, 1914.

Ford, Ford M. see Hueffer, Ford Madox

4393. Frölicher, Elsa. **Die Porträtkunst Hans Holbein des Jüngeren und ihr Einfluss auf die schweizerische Bildnismalerei im XVII. Jahrhundert.** Strassburg, Heitz, 1909. (Studien zur deutschen Kunstgeschichte, 117).

4394. Ganz, Paul. **Les dessins de Hans Holbein le jeune.** 9 v. Genève, Boissonas, [1911-1939]. (CR).

4395. _____. **Die Handzeichnungen Hans Holbein d.J., kritischer Katalog.** Berlin, Bard, 1937.

4396. _____. **Hans Holbein d.J., des Meisters Gemälde.** Stuttgart/Leipzig, Deutsche Verlags-Anstalt, 1912. (Klassiker der Kunst, 20).

4397. _____. **The paintings of Hans Holbein, first complete edition.** Trans. by R. H. Boothroyd and Marguerite Kay. London, Phaidon, 1950.

4398. Gauthiez, Pierre. **Holbein, biographie critique.** Paris, Laurens, [1907].

4399. Glaser, Curt. **Hans Holbein d. J., Zeichnungen.** New York, Weyhe, [1924].

4400. _____. **Hans Holbein der Ältere.** Leipzig, Hiersemann, 1908. (Kunstgeschichtliche Monographien, 11).

4401. Hegner, Ulrich. **Hans Holbein der Jüngere.** Berlin, Reimer, 1827.

4402. Holbein, Hans. **Todtentanz.** Lyon, Trechfelz fratres, 1538. (Reprint: München, Hirth, 1884).

4403. _____. **The dance of death.** With an introduction and notes by James M. Clark. London, Phaidon, 1947.

4404. _____. **Icones historiarvm Veteris Testamenti.** Lvdgvni [Lyons], Apud I. Frellonium, 1547. (Reprint: Manchester [England], Holbein Society, 1869).

4405. Hueffer, Ford Madox. **Hans Holbein, the younger; a critical monograph.** London, Duckworth/New York, Dutton, 1905.

4406. Knackfuss, Hermann. **Holbein.** Trans. by Campbell Dodgson. Bielefeld/Leipzig, Velhagen & Klasing/London, Grevel, 1899. (Monographs on Artists, 2).

4407. Koegler, Hans. **Hans Holbein d. J.; die Bilder zum Gebetbuch Hortulus animae.** 2 v. Basel, Schwabe, 1943.

4408. Kunstmuseum Basel zur Fünfhundertjahrfeier der Universität Basel. **Die Malerfamilie Holbein in Basel.** 4. Juni-25. September 1960. Basel, Kunstmuseum Basel, 1960.

4409. Landolt, Hanspeter. **Das Skizzenbuch Hans Holbein des Älteren im Kupferstichkabinett Basel.** 2 v. Olten, Urs Graf-Verlag, 1960.

4410. Leroy, Alfred. **Hans Holbein et son temps.** Paris, Michel, 1943.

4411. Lieb, Norbert and Strange, Alfred. **Hans Holbein der Ältere.** [München], Deutscher Kunstverlag, [1960].

4412. Mantz, Paul. **Hans Holbein.** Paris, Quantin, 1879.

4413. Parker, Karl T. **The drawings of Hans Holbein in the collection of His Majesty the King at Windsor Castle.** London, Phaidon, 1945.

4414. Pinder, Wilhelm. **Holbein der Jüngere und das Ende der altdeutschen Kunst.** Köln, Seemann, 1951.

4415. Richter, Julius Wilhelm. **Hans Holbein der Jüngere; eine altdeutsche Künstlergeschichte.** Berlin, Schall, 1901.

4416. Rousseau, Jean. **Hans Holbein.** Paris, Rouam, 1885.

4417. Rumohr, Karl Friedrich von. **Hans Holbein der Jüngere in seinem Verhältniss zum deutschen Formschnittwesen.** Leipzig, Weigel, 1836.

4418. Schmid, Heinrich A. **Hans Holbein der Jüngere, sein Aufstieg zur Meisterschaft und sein englischer Stil.** 3 v. Basel, Holbein-Verlag, 1948/1955.

4419. Stein, Wilhelm. **Holbein.** Berlin, Bard, 1929.

4420. Strong, Roy. **Holbein and Henry VIII.** London, Routledge & Kegan Paul, 1967.

4421. Waetzoldt, Wilhelm. **Hans Holbein der Jüngere; Werk und Welt.** Berlin, Grote, 1938.

4422. Wornum, Ralph N. **Some account of the life and works of Hans Holbein, painter of Augsburg.** London, Chapman and Hall, 1867.

4423. Woltmann, Alfred. **Holbein and his time.** Trans. by F. E. Bunnett. London, Bentley, 1872.

4424. _____. **Holbein und seine Zeit.** 2 v. Leipzig, Seemann, 1874/1876. 2 ed.

4425. Zoege von Manteuffel, Kurt. **Hans Holbein der Maler.** München, Schmidt, 1920.

4426. _____. **Hans Holbein der Zeichner für Holzschnitt und Kunstgewerbe.** München, Schmidt, 1920.

HOLL, ELIAS, 1573-1646

4427. Baum, Julius. **Die Bauwerke des Elias Holl.** Strassburg, Heitz, 1908. (Studien zur deutschen Kunstgeschichte, 93).

4428. Dirr, Pius. **Handschriften und Zeichnungen Elias Holls.** Augsburg, [Schlosser], 1907.

4429. Hieber, Hermann. **Elias Holl, der Meister der deutschen Renaissance.** München, Piper, 1923.

4430. Vogt, Wilhelm. **Elias Holl, der Reichsstadt Augsburg bestellter Werkmeister.** Bamberg, Buchnersche Verlagsbuchhandlung, 1890. (Bayerische Bibliothek, 7).

4431. Wagenseil, Christian Jakob. **Elias Holl, Baumeister zu Augsburg, biographische Skizze.** Augsburg, Braun, 1818.

HOLLAR, WENCESLAUS, 1607-1677

4432. Borovský, František. **Wenzel Hollar. Ergänzungen zu G. Parthey's beschreibendem Verzeichniss seiner Kupferstiche.** Prag, [Rivnác], 1898.

4433. Denkstein, Vladimír. **Václav Hollar, Kresby.** [Praha], Odeon, 1977.

4434. Dolenský, Antonin. **Václav Hollar, cesky rytec.** Praha, Veraikon, 1919.

4435. Dostál, Eugène. **Venceslas Hollar.** Prague, Stenc, 1924.

4436. Eerde, Katherine S. van. **Wenceslaus Hollar, delineator of his time.** Charlottesville, Va., Folger Shakespeare Library/University Press of Virginia, 1970.

4437. Hind, Arthur M. **Wenceslaus Hollar and his views of London and Windsor in the seventeenth century.** London, Lane, 1922.

4438. Institut Néerlandais (Paris). **Wenzel Hollar, 1607-1677; dessins, gravures, cuivres.** 11 janvier-25 février 1979. Paris, Institut Néerlandais, 1979.

4439. Parry, Graham. **Hollar's England, a mid-seventeenth century view.** Salisbury, Russell, 1980.

4440. Parthey, Gustav. **Wenzel Hollar, beschreibendes Verzeichniss seiner Kupferstiche.** Berlin, Verlag der Nicolaischen Buchhandlung, 1853. (CR).

4441. _____. **Nachträge und Verbesserungen zum Verzeichnisse der Hollar'schen Kupferstiche.** Berlin, Verlag der Nicolaischen Buchhandlung, 1858. (CR).

4442. Richter, Stanislav. **Václav Hollar, umelec a jeho doba 1607-1677.** Praha, Vysehrad, 1977.

4443. Sprinzels, Franz. **Hollar, Handzeichnungen.** Wien, Passer, 1938.

4444. Urzidil, Johannes. **Hollar, a Czech emigré in England.** London, The Czechoslovak, 1942.

4445. _____. **Wenceslaus Hollar, der Kupferstecher des Barock.** Leipzig, Passer, 1936.

4446. Vertue, George. **A description of the works of the ingenious delineator and engraver Wencelas Hollar.** London, William Bathoe, 1759. 2 ed.

HOMER, WINSLOW, 1836-1910

4447. Beam, Philip C. **Winslow Homer at Prout's Neck.** Boston/Toronto, Little, Brown, 1966.

4448. _____. **Winslow Homer's magazine engravings.** New York, Harper & Row, 1979.

4449. Cox, Kenyon. **Winslow Homer.** New York, [Frederick Fairchild Sherman], 1914.

4450. Davis, Melinda D. **Winslow Homer, an annotated bibliography of periodical literature.** Metuchen, N.J., Scarecrow Press, 1975.

4451. Downes, William Howe. **The life and works of Winslow Homer.** Boston/New York, Houghton Mifflin, 1911.

4452. Flexner, James Thomas. **The world of Winslow Homer, 1836-1910.** New York, Time, Inc., 1966.

4453. Foster, Allen E. **A check list of illustrations by Winslow Homer in Harper's Weekly and other periodicials.** New York, New York Public Library, 1936.

4454. Gardner, Albert Ten Eyck. **Winslow Homer, American artist; his world and his work.** New York, Clarkson Potter, 1961.

4455. Gelman, Barbara. **The wood engravings of Winslow Homer.** New York, Bounty, 1970.

4456. Goodrich, Lloyd. **American watercolor and Winslow Homer.** Minneapolis, Walker Art Center, 1945.

4457. _____. **The graphic art of Winslow Homer.** [Washington, D.C.], Smithsonian Institution Press, 1968. (CR).

4458. _____. **Winslow Homer.** New York, Whitney Museum of American Art/Macmillan, 1944.

4459. _____. **Winslow Homer.** New York, Braziller, 1959.

4460. _____. **Winslow Homer's America.** New York, Tudor, 1969.

4461. Gould, Jean. **Winslow Homer, a portrait.** New York, Dodd, Mead, 1962.

4462. Grossman, Julian. **Echo of a distant drum; Winslow Homer and the Civil War.** New York, Abrams, 1974.

4463. Hannaway, Patti. **Winslow Homer in the tropics.** Richmond, Virginia, Westover, 1973.

4464. Hendricks, Gordon. **The life and work of Winslow Homer.** New York, Abrams, 1979. (CR).

4465. Hoopes, Donelson F. **Winslow Homer, watercolors.** New York, Watson-Guptill, 1969.

4466. Hyman, Linda. **Winslow Homer, America's old master.** New York, Doubleday, 1973.

4467. Metropolitan Museum of Art (New York). **Winslow Homer, memorial exhibition.** February 6-March 19, [1911]. New York, Metropolitan Museum of Art, 1911.

4468. National Gallery of Art (Washington, D.C.). **Winslow Homer, a retrospective exhibiton.** November 23, 1958-January 4, 1959. [Text by Albert Ten Eyck Gardner]. Washington, D.C., National Gallery of Art, 1958.

4469. Ripley, Elizabeth. **Winslow Homer, a biography.** Philadelphia, Lippincott, 1963.

4470. Watson, Forbes. **Winslow Homer.** New York, Crown, 1942.

4471. Whitney Museum of American Art (New York). **Winslow Homer, centenary exhibition.** December 15, 1936 to January 15, 1937. [Text by Lloyd Goodrich]. New York, Whitney Museum of American Art, 1936.

4472. Wilmerding, John. **Winslow Homer.** New York, Praeger, 1972.

HONNECOURT, VILLARD DE see VILLARD DE HONNECOURT

HONTHORST, GERRIT VAN, 1590-1656

4473. Hoogewerff, Godefritus J. **Gerrit van Honthorst.** The Hague, Naeff, 1924.

4474. Judson, J. Richard. **Gerrit van Honthorst, a discussion of his position in Dutch art.** The Hague, Nijhoff, 1959. (CR). (Utrechtse Bijdragen tot de Kunstgeschiedenis, 6).

HOOCH, PIETER DE, 1629-1684

see also FABRITIUS, CAREL

4475. Rudder, Arthur de. **Pieter de Hooch et son oeuvre.** Bruxelles, van Oest, 1914.

4476. Sutton, Peter C. **Pieter de Hooch, complete edition.** Oxford, Phaidon, 1980. (CR).

4477. Thienen, Frithjof Willem Sophi van. **Pieter de Hooch.** Amsterdam, Becht, [1945].

4478. Valentiner, Wilhelm R. **Pieter de Hooch, the master's paintings.** New York, Weyhe, [1930].

HOPPER, EDWARD, 1882-1967

4479. DuBois, Guy P. **Edward Hopper.** New York, Whitney Museum of American Art, 1931.

4480. Goodrich, Lloyd. **Edward Hopper.** New York, Abrams, [1971].

4481. Levin, Gail. **Edward Hopper as illustrator.** New York, Norton/Whitney Museum of American Art, 1979. (CR).

4482. _____. **Edward Hopper, the art and the artist.** New York, Norton/Whitney Museum of American Art, 1980.

4483. _____. **Edward Hopper, the complete prints.** New York, Norton/Whitney Museum of American Art, 1979. (CR).

4484. Museum of Modern Art (New York). **Edward Hopper, retrospective exhibition.** November 1-December 7, 1933. [Text by Alfred H. Barr, Jr., Charles Burchfield, and Edward Hopper]. New York, Museum of Modern Art, 1933.

4485. Whitney Museum of American Art (New York). **Edward Hopper, retrospective exhibition.** February 11-March 26, 1950. [Text by Lloyd Goodrich]. New York, Whitney Museum of American Art, 1950.

HOPPNER, JOHN, 1758-1810

4486. McKay, William and Roberts, William. **John Hoppner, R. A.** London, Colnaghi/Bell, 1909. (CR).

HORTA, VICTOR, 1861-1947

4487. Borsi, Franco [and] Portoghesi, Paolo. **Victor Horta.** Roma, Edizioni del Tritone, 1969.

4488. Delevoy, Robert L. **Victor Horta.** Bruxelles, Elsevier, 1958.

4489. Oostens-Wittamer, Yolande. **Victor Horta; l'Hôtel Solvay/the Solvay House.** Trans. by John A. Gray, Jr. 2 v. [Text in French and English]. Louvain-la-neuve, Institut supérieur d'archéologie et d'histoire de l'art, 1980. (Publications d'histoire de l'art et d'archéologie de l'Université Catholique de Louvain, 20).

HOUDON, JEAN ANTOINE, 1741-1828

4490. Arnason, H. H. **The sculptures of Houdon.** London, Phaidon, 1975.

4491. Chinard, Gilbert, ed. **Houdon in America, a collection of documents in the Jefferson papers in the Library of Congress.** Baltimore, Johns Hopkins/London, Oxford University Press, 1930. (Historical Documents, Institut Français de Washington, 4).

4492. Dierks, Hermann. **Houdons Leben und Werke; eine kunsthistorische Studie.** Gotha, Thienemanns, 1887.

4493. Délerot, Emile et Legrelle, Arsène. **Notice sur J. A. Houdon de l'Institut (1741-1828).** Versailles, Montalant-Bongleux, 1856.

4494. Gandouin, Ernest. **Quelques notes sur J.-A. Houdon, statuaire, 1741-1828.** Paris, Nouvelle Imprimerie, [1900].

4495. Giacometti, Georges. **La vie et l'oeuvre de Houdon.** 2 v. Paris, Camoin, [1921]. (CR).

4496. Hart, Charles Henry and Biddle, Edward. **Memoirs of the life and works of Jean Antoine Houdon, the sculptor of Voltaire and of Washington.** Philadelphia, printed for the authors, 1911.

4497. Maillard, Elisa. **Houdon.** Paris, Rieder, 1931.

4498. Réau, Louis. **Houdon, biographie critique.** Paris, Laurens, 1930.

4499. _____. **Houdon, sa vie et son oeuvre; ouvrage posthume suivi d'un catalogue systématique.** 2 v. Paris, de Nobele, 1964. (CR).

HOUËL, JEAN PIERRE, 1735-1813

4500. Bloberg, Maurice. **Jean Houel, peintre et graveur.** Paris, Naert, 1930.

HUANG KUNG-WANG, 1269-1354

4501. Hay, John. **Huang Kung-Wang's Dwelling in the Fu-ch'un Mountains: the dimensions of landscape.** Ann Arbor, Michigan, University Microfilms, 1978.

HUBER, WOLF, 1485-1553

4502. Heinzle, Erwin. **Wolf Huber, um 1485-1553.** Innsbruck, Wagner, [1953].

4503. Riggenbach, Rudolf. **Der Maler und Zeichner Wolfgang Huber (ca. 1490-nach 1542).** Basel, Gasser, 1907.

4504. Weinberger, Martin. **Wolfgang Huber.** Leipzig, Insel-Verlag, 1930.

4505. Winzinger, Franz. **Wolf Huber, das Gesamtwerk.** 2 v. München, Hirmer/München [und] Zürich, Piper, 1979. (CR).

HUET, PAUL, 1803-1869

4506. Burty, Philippe. **Paul Huet, notice biographique et critique, suivie du catalogue de ses oeuvres exposées en partie dans les salons de l'Union artistique.** Paris, Claye, 1869.

4507. Huet, René Paul. **Paul Huet (1803-1869) d'après ses notes, sa correspondance, ses contemporains, documents recueillis et précédés d'une notice biographique par son fils.** Paris, Renouard, 1911.

4508. Miquel, Pierre. **Paul Huet de l'aube romantique à l'aube impressionniste.** Sceaux, Editions de la Martinelle, 1962.

4509. Musée des Beaux-Arts (Rouen). **Paul Huet (1803-1869).** 28 mai-15 septembre 1965. Rouen, Musée des Beaux-Arts, 1965.

HUGUET, JAIME, 1448-1487

4510. Gudiol Ricart, José [and] Ainaud de Lasarte, Juan. **Huguet.** Barcelona, Instituto Amateller de Arte Hispánico, 1948.

4511. Rowland, Benjamin, Jr. **Jaume Huguet, a study of late Gothic painting in Catalonia.** Cambridge, Mass., Harvard University Press, 1932.

HUNDERTWASSER, FRIEDENSREICH, 1928-

4512. Bockelmann, Manfred. **Hundertwasser: Regentag, Rainy Day, Jour de pluie; Idee, Fotografie und Gestaltung.** [By] Manfred Bockelmann. [Text in German, English, and French]. München, Bruckmann, [1972].

4513. Chipp, Herschel B. and Richardson, Brenda. **Hundertwasser.** [Catalogue of an exhibition, October 8-November 10, 1968]. Berkeley, Calif., University Art Museum, University of California, 1968. Distributed by New York Graphic Society, Greenwich, Conn.

4514. Haus der Kunst (Munich). **Hundertwasser, Friedensreich: Regentag.** München, Gruener Janura, 1975.

4515. Kestner-Gesellschaft Hannover. **Hundertwasser.** 25. März bis 3. Mai 1964. Hannover, Kestner-Gesellschaft, 1964. (Katalog 5, Ausstellungsjahr 1963/64).

HUNT, WILLIAM HENRY, 1790-1864

4516. Witt, John. **William Henry Hunt (1790-1864); life and work, with a catalogue.** London, Barrie & Jenkins, 1982. (CR).

HUNT, WILLIAM HOLMAN, 1827-1910

4517. Farrar, Frederick William and Meynell, Mrs. [Alice]. **William Holman Hunt, his life and work.** London, Art Journal, 1893.

4518. Gissing, Alfred C. **William Holman Hunt, a biography.** London, Duckworth, 1936.

4519. Holman-Hunt, Diana. **My grandfather, his wives and loves.** London, Hamish Hamilton, 1969.

4520. Hunt, William H. **Pre-Raphaelitism and the pre-Raphaelite brotherhood.** 2 v. New York, Dutton, 1914. 2 ed.

4521. Landow, George P. **William Holman Hunt and typological symbolism.** New Haven/London, Yale University Press, 1979.

4522. Schleinitz, Otto von. **William Holman Hunt.** Bielefeld/ Leipzig, Velhagen & Klasing, 1907. (Künstler- Monographien, 88).

4523. [Stephens, Frederic George]. **William Holman Hunt and his works; a memoir of the artist's life with description of his pictures.** London, Nisbet, 1860.

4524. Walker Art Gallery (Liverpool). **William Holman Hunt.** March-April 1969. Liverpool, Walker Art Gallery, 1969. (CR).

4525. Williamson, George C. **Holman Hunt.** London, Bell, 1902.

HUNT, WILLIAM MORRIS, 1824-1879

4526. Angell, Henry C. **Records of William M. Hunt.** Boston, Osgood, 1881.

4527. Hunt, William Morris. **Talks on art.** [Extracts edited by Helen M. Knowlton]. Boston, Houghton, Mifflin, 1875.

4528. Knowlton, Helen M. **Art-life of William Morris Hunt.** Boston, Little, Brown, 1899.

4529. Museum of Fine Arts (Boston). **William Morris Hunt, a memorial exhibition.** [June 27-August 19, 1979; text by Martha J. Hoppin and Henry Adams]. Boston, Museum of Fine Arts, 1979.

4530. Shannon, Martha A. S. **Boston days of William Morris Hunt.** Boston, Marshall Jones, 1923.

IBBETSON, JULIUS CAESAR, 1759-1817

see also MORLAND, GEORGE

4531. Clay, Rotha M. **Julius Caesar Ibbetson, 1759-1817.** London, Country Life, 1948.

INDIANA, ROBERT, 1928-

4532. McCoubrey, John W. **Robert Indiana, an introduction, with statements by the artist.** [Catalogue of an exhibition, Institute of Contemporary Art of the University of Pennsylvania, April 17 to May 17, 1968]. [University Park, Penn.], Institute of Contemporary Art, 1968.

4533. University Art Museum (Austin, Texas). **Robert Indiana.** September 25-November 6, 1977. Austin, Texas, University of Texas Press, 1977.

INGRES, JEAN-AUGUSTE DOMINIQUE, 1780-1867

4534. Alazard, Jean. **Ingres et l'ingrisme.** Paris, Michel, 1950.

4535. Amaury-Duval, Eugène E. **L'Atelier d'Ingres.** Paris, Charpentier, 1878.

4536. Angrand, Pierre. **Monsieur Ingres et son époque.** Lausanne/Paris, La Bibliothèque des Arts, 1967.

4537. Blanc, Charles. **Ingres, sa vie et ses ouvrages.** Paris, Renouard, 1870.

4538. Cassou, Jean. **Ingres.** Bruxelles, Editions de la Connaissance, 1947.

4539. Courthion, Pierre, ed. **Ingres raconté par lui-même et par ses amis.** 2 v. Vésenaz-Genève, Cailler, 1947/1948. (Les grands artistes racontés par eux-mêmes et par leur amis, 5).

4540. D'Agen, Boyer. **Ingres d'après une correspondance inédite.** Paris, Daragon, 1909.

4541. Delaborde, Henri. **Ingres; sa vie, ses travaux, sa doctrine.** Paris, Plon, 1870. (CR).

4542. L'Ecole Impériale des Beaux-Arts (Paris). **Catalogue des tableaux, études peintes, dessins, et croquis de J.-A.-D. Ingres . . . exposés dans les galeries du palais de l'école.** Paris, Lainé et Havard, 1867.

4543. Fouquet, Jacques. **La vie d'Ingres.** Paris, Gallimard, 1930. 3 ed. (Vie des hommes illustres, 62).

4544. Fröhlich-Bum, Lili. **Ingres, his life & art.** Trans. by Maude V. White. London, Heinemann, 1926.

4545. Gatti, Lelio. **Ingres, l'idealista della forma.** Milano, Bietti, 1946.

4546. Ingres, Jean-Auguste Dominique. **Ecrits sur l'art; textes recueillis dans les carnets et dans la correspondance de Ingres.** Paris, La Jeune Parque, 1947.

4547. Lapauze, Henry. **Les dessins de J.-A.-D. Ingres du Musée de Montauban.** Paris, Bulloz, 1901.

4548. ———. **Ingres, sa vie et son oeuvre (1780-1867) d'après des documents inédits.** Paris, Petit, 1911.

4549. Merson, Olivier. **Ingres, sa vie et ses oeuvres.** Paris, Hetzel, [1867].

4550. Mirecourt, Eugène de. **Ingres.** Paris, Havard, 1855.

4551. Momméja, Jules. **Ingres, biographie critique.** Paris, Laurens, [1903].

4552. Mongan, Agnes and Naef, Hans. **Ingres; centennial exhibition, 1867-1967.** Fogg Art Museum, Harvard University (Cambridge, Mass.). February 12-April 9, 1967. Cambridge, Mass., Harvard College, 1967.

4553. Montrond, Maxime de. **Ingres, étude biographique et historique.** Lille, Lefort, [1868].

4554. Naef, Hans. **Die Bildniszeichnungen von J.-A.-D. Ingres.** 5 v. Bern, Benteli, 1977-1980. (CR).

4555. Pach, Walter. **Ingres.** New York, Harper, 1939.

4556. Picon, Gaëtan. **Jean-Auguste-Dominique Ingres.** Trans. by Stuart Gilbert. New York, Rizzoli, 1980.

4557. Radius, Emilio [and] Camesasca, Ettore. **L'opera completa di Ingres.** Milano, Rizzoli, 1968. (CR). (Classici dell'arte, 19).

4558. Rosenblum, Robert. **Jean-Auguste-Dominique Ingres.** New York, Abrams, 1967.

4559. Schlenoff, Norman. **Ingres, ses sources littéraires.** Paris, Presses Universitaires de France, 1956.

4560. Ternois, Daniel. **Ingres.** [Paris?], Nathan, 1980; distributed by Mondadori, Milano.

4561. Wildenstein, Georges. **Ingres.** London, Phaidon, 1954; distributed by Garden City Books, Garden City, N.Y.

INNESS, GEORGE, 1825-1894

4562. Cikovsky, Nicolai, Jr. **George Inness.** New York, Praeger, 1971.

4563. _____. **The life and work of George Inness.** New York, Garland, 1977.

4564. Daingerfield, Elliott. **George Inness, the man and his art.** New York, [Frederic Fairchild Sherman], 1911.

4565. Inness, George, Jr. **Life, art and letters of George Inness.** New York, Century, 1917.

4566. Ireland, Le Roy. **The works of George Inness, an illustrated catalogue raisonné.** Austin, Texas/London, University of Texas, 1965. (CR).

4567. McCausland, Elizabeth. **George Inness, an American landscape painter, 1825-1894.** [Catalogue of an exhibition, George Walter Vincent Smith Art Museum, February 25 to March 24, 1946]. Springfield, Mass., Smith Art Museum, 1946.

4568. Trumble, Alfred. **George Inness, N. A.; a memorial of the student, the artist, and the man.** New York, The Collector, 1895.

4569. Werner, Alfred. **Inness landscapes.** New York, Watson-Guptill, 1973.

ISABEY, EUGENE, 1803-1886

JEAN-BAPTISTE, 1767-1855

4570. Basily-Callimaki, Mme. E. de. **J.-B. Isabey; sa vie, son temps, 1767-1855, suivi du catalogue de l'oeuvre gravée par et d'après Isabey.** 2 v. Paris, Frazier-Soye, 1909. (CR).

4571. Curtis, Atherton. **Catalogue de l'oeuvre lithographié de Eugène Isabey.** Paris, Prouté, [1939].

4572. Hediard, Germain. **Eugène Isabey, étude suivie du catalogue de son oeuvre.** Paris, Delteil, 1906. (CR).

4572a. _____. **J.-B. Isabey.** Chateaudun, Société Typographique, 1896.

4573. Miquel, Pierre. **Eugène Isabey, 1803-1886; la marine au XIXe siècle.** 2 v. Maurs-la-Jolie, Editions de la Martinelle, 1980. (CR).

4574. Osmond, Marion W. **Jean-Baptiste Isabey, the fortunate painter, 1767-1855.** London, Nicholson & Watson, 1947.

4575. Taigny, Edmond. **J.-B. Isabey, sa vie et ses oeuvres.** Paris, Panckoucke, 1859.

ISRAËLS, JOZEF, 1824-1911

4576. Dake, Carel L. **Jozef Israëls.** Berlin, Internationale Verlagsanstalt für Kunst und Literatur, [1909].

4577. Eisler, Max. **Josef Israëls.** London, The Studio, 1924.

4578. Gelder, Hendrik E. van. **Jozef Israëls.** Amsterdam, Becht, 1947. (Palet serie, [32]).

4579. Liebermann, Max. **Jozef Israels, kritische Studie.** Berlin, Cassirer, 1902. 2 ed.

4580. Netscher, Frans et Zilcken, Philippe. **Jozef Israëls, l'homme et l'artiste.** Amsterdam, Schalekamp, 1890.

4581. Phythian, J. Ernest. **Jozef Israëls.** London, Allen, 1912.

4582. Veth, Jan P. **Jozef Israëls en zijn kunst.** Arnhem en Nijmegen, Cohen, 1904.

ITTEN, JOHANNES, 1882-1967

4583. Itten, Johannes. **The art of color.** Trans. by Ernst van Haagen. New York, Reinhold, 1961.

4584. _____. **Design and form, revised edition; the basic course at the Bauhaus and later.** New York, Van Nostrand Reinhold, 1975.

4585. Rotzler, Willy. **Johannes Itten, Werke und Schriften.** Werkverzeichnis von Anneliese Itten. Zürich, Füssli, 1972. (CR).

4586. Westfälisches Landesmuseum für Kunst und Kulturgeschichte, Münster. **Johannes Itten; Gemälde, Gouachen, Aquarelle, Tuschen, Zeichnungen.** 24. August bis 5. Oktober 1980. Münster, Landschaftsverband Westfalen-Lippe/Landesmuseum, 1980.

IVANOV, ALEKSANDR ANDREEVICH, 1806-1858

4587. Alpatov, Mikhail V. **Aleksandr Ivanov.** Moskva, Molodaia gvardiia, 1959.

4588. Botkin, Tzdal M. **Aleksandr Andreevich Ivanov; ego zhizn' i perepiska, 1806-1858.** Sanktpeterburg, Stasiulevicha, 1880. (German ed.: **Alexander Andejewitsch Iwanoff, 1806-1858; biographische Skizze.** Berlin, Asher, 1880).

4589. Gosudarstvennaia Tret'iakovskaia galleria (Moscow). **Aleksandr Andreevich Ivanov; 150 let so dnia rozhdenia, 1806-1956.** Moskva, Iskusstvo, 1956. (CR).

JACKSON, WILLIAM HENRY, 1843-1942

4590. Forsee, Aylesa. **William Henry Jackson, pioneer photorapher of the West.** Illustrated with drawings by Douglas Gorsline and with photographs by William Henry Jackson. New York, Viking, 1964.

4591. Jackson, Clarence S. **Picture maker of the old West: William H. Jackson.** New York, Scribner, 1971. 2 ed.

4592. Jackson, William H. **Time exposure: the autobiography of William Henry Jackson.** New York, Cooper Square, 1940.

4593. _____. **William Henry Jackson's Colorado.** Compiled by William C. Jones and Elizabeth B. Jones. Foreword by Marshall Sprague. Boulder, Col., Pruett, 1975.

4594. _____ and Driggs, Howard R. **The pioneer photographer; Rocky Mountain adventures with a camera.** Yonkers-on-Hudson, N.Y., World, 1929.

4595. Newhall, Beaumont and Edkins, Diane E. **William H. Jackson.** With a critical essay by William L. Broecker. Dobbs Ferry, N.Y., Morgan & Morgan/Fort Worth, Texas, Amon Carter Museum of Western Art, 1974.

JACOB, GEORGES, 1739-1814

JACOB-DESMALTER, FRANÇOIS-HONORE-GEORGES, 1770-1841

4596. Dumanthier, Ernest. **Les sièges de Georges Jacob.** Paris, Morancé, 1922.

4597. Lefuel, Hector. **François-Honoré Jacob-Desmalter, ébéniste de Napoléon I^{er} et de Louis XVIII.** Paris, Morancé, 1925.

4598. _____. **Georges Jacob, ébéniste du XVIII^e siècle.** Paris, Morancé, 1923.

JACOBI, LOTTE, 1896-

4599. Wise, Kelley, ed. **Lotte Jacobi.** Dunbury, N.H., Addison House, 1978.

JACOMART, JAIME BACÓ see BACÓ, JACOMART

JACQUE, CHARLES EMILE, 1813-1894

4600. Galerie Georges Petit (Paris). **Catalogue des tableaux, études peintes, aquarelles, dessins, gravures, objets d'art . . . composant l'atelier Charles Jacque.** [Catalogue de la vente, 10 novembre 1894-15 novembre 1894]. Paris, Petit, 1894.

4601. Guiffrey, Jules. **L'oeuvre de Ch. Jacque; catalogue de ses eaux-fortes et pointes sèches.** Paris, Lemaire, 1866. (CR).

4602. Wickenden, Robert J. **Charles Jacque.** [Boston], Museum of Fine Arts/Houghton Mifflin, 1914.

JAMNITZER, WENZEL, 1508-1585

4603. Frankenburger, Max. **Beiträge zur Geschichte Wenzel Jamnitzers und seiner Familie.** Strassburg, Heitz, 1901. (Studien zur deutschen Kunstgeschichte, 30).

4604. Rosenberg, Marc. **Jamnitzer; alle erhaltenen Goldschmiede-Arbeiten, verlorene Werke, Handzeichnungen.** Frankfurt a.M., Baer, 1920.

JANSSEN, HORST, 1929-

4605. Albertina (Vienna). **Horst Janssen, Zeichnungen.** 1. April bis 2. Mai 1982. [Text by Walter Koschatzky and Wolfgang Hildesheimer]. München, Prestel, 1982.

4606. Kestner-Gesellschaft Hannover. **Horst Janssen.** 23. März bis 6. Mai 1973. Hannover, Kestner-Gesellschaft, 1973. (Katalog 3/1973).

4607. Schack, Gerhard. **Horst Janssen, die Kopie.** Hamburg, Christians, 1977.

JAVACHEFF, CHRISTO see CHRISTO

JAWLENSKY, ALEXEJ, 1864-1941

4608. Galerie im Ganserhaus (Wasserburg). **Alexej Jawlensky.** 15. September bis 28. Oktober 1979. Wasserburg, Künstlergemeinschaft Wasserburg, 1979.

4609. Pasadena Art Museum. **Alexei Jawlensky, a centennial exhibition.** April 14-May 19, 1964. [Text by James T. Demetrion]. Pasadena, Pasadena Art Museum, 1964.

4610. Rathke, Ewald. **Alexej Jawlensky.** Hanau, Peters, 1968.

4611. Schultze, Jürgen. **Alexej Jawlensky.** Köln, DuMont Schauberg, 1970.

4612. Weiler, Clemens. **Alexej Jawlensky.** Köln, DuMont Schauberg, 1959. (CR).

JEANNERET-GRIS, CHARLES EDOUARD see LE CORBUSIER

JEFFERSON, THOMAS, 1745-1826

4613. Adams, William Howard, ed. **Jefferson and the arts: an extended view.** Washington, D.C., National Gallery of Art, 1976.

4614. Frary, Ihna T. **Thomas Jefferson, architect and builder.** Richmond, Va., Garret & Massie, 1931.

4615. Guinness, Desmond and Sadler, Julius T., Jr. **Mr. Jefferson, architect.** New York, Viking, 1973.

4616. Kimball, Fiske. **Thomas Jefferson, architect.** Boston, Riverside Press, 1916. (Reprint, with a new introduction by Frederick Doveton Nichols: New York, DaCapo, 1968. Da Capo Press Series in Architecture and Decorative Art, 5).

4617. Lambeth, William A. and Manning, Warren H. **Thomas Jefferson as an architect and a designer of landscapes.** Boston/New York, Houghton Mifflin, 1913.

4618. Nichols, Frederick D. **Thomas Jefferson's architectural drawings compiled and with commentary and a check list.** Boston, Massachusetts Historical Society/Charlottesville, Va., Jefferson Memorial Foundation and University of Virginia Press, 1961. 2 ed., revised and enlarged.

4619. _____ and Griswold, Ralph E. **Thomas Jefferson, landscape architect.** Charlottesville, Va., University Press of Virginia, 1978.

4620. O'Neal, William B. **A checklist of writings on Thomas Jefferson as an architect.** [Charlottesville, Va., American Association of Architectural Bibliographers], 1959. (American Association of Architectural Bibliographers, 15).

JOHN, AUGUSTUS, 1878-1961

4621. Dodgson, Campbell. **A catalogue of etchings by Augustus John, 1901-1914.** London, Chenil, 1920.

4622. Earp, Thomas W. **Augustus John.** London/Edinburgh, Nelson/Jack, [1904].

4623. Easton, Malcolm and Holroyd, Michael. **The art of Augustus John.** London, Secker & Warburg, 1974.

4624. Holroyd, Michael. **Augustus John, a biography.** New York, Holt, Rinehart and Winston, 1975.

4625. John, Augustus. **Chiaroscuro; fragments of autobiography.** London, Cape, 1952.

4626. _____. **Finishing touches.** London, Cape, 1964.

4627. Rothenstein, John. **Augustus John.** Oxford/London, Phaidon, 1945. 2 ed.

JOHNS, JASPER, 1930-

4628. Crichton, Michael. **Jasper Johns.** [Catalogue of an exhibition at the Whitney Museum of American Art, New York, Oct. 17, 1977-Jan. 22, 1978]. New York, Abrams, 1977.

4629. Kozloff, Max. **Jasper Johns.** New York, Abrams, [1968].

4630. Steinberg, Leo. **Jasper Johns.** New York, Wittenborn, 1963.

JOHNSON, PHILIP CORTELYOU, 1906-

4631. Hitchcock, Henry R. **Philip Johnson; architecture, 1949-1965.** New York, Holt, Rinehart and Winston, 1966.

4632. Jacobus, John M., Jr. **Philip Johnson.** New York, Braziller, 1962.

4633. Johnson, Philip. **Writings.** New York, Oxford University Press, 1979.

4634. Noble, Charles. **Philip Johnson.** New York, Simon & Schuster, 1972.

JOHNSTON, FRANCES BENJAMIN, 1864-1952

4635. Art Museum and Galleries and the Center for Southern California Studies in the Visual Arts, California State University, Long Beach. **Frances Benjamin Johnston: women of class and station.** February 12-March 11, 1979. [Text by Constance W. Glenn and Leland Rice]. Long Beach, Calif., Art Museum and Galleries, California State University, 1979.

4636. Daniel, Pete and Smock, Raymond. **A talent for detail; the photographs of Miss Frances Benjamin Johnston, 1889-1910.** New York, Harmony, 1974.

4637. Johnston, Frances B. **The early architecture of North Carolina; a pictorial survey.** With an architectural history by Thomas Tileston Waterman. Chapel Hill, North Carolina, University of North Carolina Press, 1941.

JOHNSTON, JOSHUA, 1765-1830

4638. Pleasants, J. Hall. **Joshua Johnston: an early Baltimore Negro portrait painter.** [Windham, Conn.], The Walpole Society, 1940.

JONES, INIGO, 1573-1652

4639. Cunningham, Peter. **Inigo Jones, a life of the architect** [with] remarks on some of his sketches for masques and dramas by J. R. Planché, Esq., and five court masques edited from the original mss. . . . by J. Payne Collier, Esq. London, Shakespeare Society, 1848. (Shakespeare Society Publications, 39).

4640. Gotch, John A. **Inigo Jones.** London, Methuen, 1928.

4641. [Jones, Inigo]. **The designs of Inigo Jones, consisting of plans and elevations for publick and private buildings,** published by William Kent with some additional designs. London, [Kent], 1727. (Reprint: [Ridgewood, N.J.], Gregg, 1967).

4642. [_____]. **Inigo Jones on Palladio, being the notes** by Inigo Jones in the copy of I Quattro Libri dell'Architettura di Andrea Palladio, 1601 in the Library of Worcester College, Oxford. 2 v. Edited by Bruce Allsopp. Oxford, Oriel Press, 1970.

4643. Lees-Milne, James. **The age of Inigo Jones.** London, Batsford, 1953.

4644. Orgel, Stephen and Strong, Roy. **Inigo Jones; the theatre of the Stuart court, including the complete designs for productions at court.** 2 v. London, Sotheby Parke Bernet/Berkeley and Los Angeles, University of California Press, 1973. (CR).

4645. Ramsey, Stanley C. **Inigo Jones.** London, Benn, 1924.

4646. Simpson, Percy and Bell, Charles F. **Designs by Inigo Jones for masques & plays at court, a descriptive catalogue of drawings for scenery and costumes.** Oxford, Walpole Society, 1924. (The Walpole Society, 12).

4647. Summerson, John. **Inigo Jones.** Harmondsworth, Eng., Penguin, 1966.

JONES, LOIS MAILOU, 1905-

4648. Museum of Fine Arts (Boston). **Reflective moments; Lois Mailou Jones; retrospective, 1930-1972.** March 11-April 15, 1973. Boston, Museum of Fine Arts, 1973.

4649. Porter, James A. **Lois Mailou Jones; peintures, 1935-1951.** Tourcoing (France), Frère, 1952.

JONGKIND, JOHAN BARTHOLD, 1819-1891

4650. Colin, Paul. **J. B. Jongkind.** Paris, Rieder, 1931.

4651. Hefting, Victorine. **Jongkind d'après sa correspondance.** Utrecht, Haentjens Dekker & Gumbert, 1969.

4652. _____. **Jongkind; sa vie, son oeuvre, son époque.** Paris, Arts et Métiers Graphiques, 1975. (CR).

4653. Moreau-Nélaton, Etienne, ed. **Jongkind raconté par lui-même.** Paris, Laurens, 1918.

4654. Roger-Marx, Claude. **Jongkind.** Paris, Crès, 1932.

4655. Signac, Paul. **Jongkind.** Paris, Crès, 1927.

JORDAENS, JAKOB, 1593-1678

4656. Buschmann, Paul, Jr. **Jacob Jordaens, eene studie.** Amsterdam, Veen, 1905.

4657. Coopman, Henrik. **Jordaens.** Bruxelles, Kryn, 1926.

4658. Fierens-Gevaert, Hippolyte. **Jordaens; biographie critique.** Paris, Laurens, 1905.

4659. Hulst, Roger Adolf d'. **Jacob Jordaens.** Trans. by P. S. Falla. Ithaca, N.Y., Cornell University Press, 1982.

4660. _____. **Jordaens drawings.** 4 v. Brussels, Arcade, 1974. (CR). (Monographs of the National Centrum voor de Plastiche Kunsten van de XVIde en XVIIde Eeuw, 5).

4661. _____. **De Tekeningen van Jakob Jordaens.** Brussel, Paleis der Academiën, 1956. (Verhandelingen van de Koninklijke Vlaamse Academie voor Wetenschappen, Letteren en Schone Kunsten van België, Klasse der Schone Kunsten, 10).

4662. National Gallery of Canada (Ottawa). **Jacob Jordaens, 1593-1678.** [29 November 1968-5 January 1969; selection and catalogue by Michael Jaffé]. Ottawa, National Gallery of Canada, 1968.

4663. Puyvelde, Leo van. **Jordaens.** Paris/Bruxelles, Elsevier, 1953.

4664. Rooses, Max. **Jacob Jordaens, his life and work.** Trans. by Elisabeth C. Broers. London, Dent/New York, Dutton, 1908.

JORN, ASGER, 1914-1973

4665. Atkins, Guy. **Asger Jorn, the crucial years: 1954-1964.** London, Humphries, 1977. (CR).

4666. _____. **Asger Jorn, the final years: 1965-1973.** London, Humphries, 1980. (CR).

4667. _____. **A bibliography of Asger Jorn's writings to 1963 (Bibliografi over Asger Jorns skrifter til 1963).** With Erik Schmidt. København, Permild & Rosengreen, 1964.

4668. _____. **Jorn in Scandinavia, 1930-1953.** London, Humphries, 1968. (CR).

4669. Kestner-Gesellschaft Hannover. **Asger Jorn.** 16. Februar-18. März 1973. Hannover, Kestner-Gesellschaft, 1973. (Kestner-Gesellschaft Katalog 2/1973).

4670. Schade, Virtus. **Asger Jorn.** København, Venderkaers, 1968. 2 ed.

4671. Schmied, Wieland, ed. **Jorn.** St. Gallen, Erker-Verlag, 1973.

JOSEPHSON, ERNST ABRAHAM, 1851-1906

4672. Blomberg, Erik. **Ernst Josephson, hans liv.** Stockholm, Wahlstrom & Widstrand, 1951.

4673. _____. **Ernst Josephsons konst; från näcken till gåslisa.** Stockholm, Norstedt, 1959.

4674. _____. **Ernst Josephsons konst: historie-, porträtt- och genremåleren.** Stockholm, Norstedt, 1956.

4675. Millner, Simon L. **Ernst Josephson.** New York, Machmadim Art Editions, 1948.

4676. Pauli, Georg. **Ernst Josephson.** Stockholm, Norstedt, 1914. 2 ed.

4677. Städtisches Kunstmuseum (Bonn). **Ernst Josephson, 1851-1906; Bilder und Zeichnungen.** 22. März bis 6. Mai 1979. Bonn, Städtisches Kunstmuseum, [1979].

4678. Wåhlin, Karl. **Ernst Josephson, 1851-1906; en minnesteckning.** 2 v. Stockholm, Svenges Allmänna Konstforenings, 1911/1912. (Svenges allmänna konstforenings publikations, 19/20).

4679. Zennström, Per-Olav. **Ernst Josephson, en studie.** Stockholm, Norstedt, 1946.

JOUVENET, JEAN, 1644-1717

4680. Leroy, François N. **Histoire de Jouvenet.** Paris, Didron, 1860.

4681. Schnapper, Antoine. **Jean Jouvenet, 1644-1717, et la peinture d'histoire à Paris.** Paris, Laget, 1974. (CR).

JUNGSTEDT, KURT, 1894-

4682. Strömberg, Martin. **Kurt Jungstedt.** Stockholm, Bonniers, 1945.

JUNI, JUAN DE, ca. 1507-1577

4683. García Chico, Esteban. **Juan de Juni.** Valladolid [Spain], Escuela de Artes y Oficios Artísticos de Valladolid, 1949.

4684. Griseri, Andreina. **Juan de Juni.** Milano, Fabbri, 1966. (I maestri della scultura, 72).

4685. Martín Gonzales, Juan José. **Juan de Juni, vida y obra.** Madrid, Dirección General de Bellas Artes, Ministerio de Educación y Ciencia, 1974.

4686. Museo National de Escultura (Valladolid, Spain). **Juan de Juni y su epoca; exposicion commorative del IV centenario de la muerte de Juan de Juni.** Abril-Mayo 1977. Valladolid, Museo Nacional de Escultura, 1977.

JUVARRA, FILIPPO, 1678-1736

4687. Boscarino, Salvatore. **Juvarra architetto.** Roma, Officina Edizioni, 1973.

4688. Rovere, Lorenzo, et al. [Comitato per le onoranze a Filippo Juvarra]. **Filippo Juvarra.** Milano, Oberdan Zucci, 1937.

4689. Telluccini, Augusto. **L'arte dell'architetto Filippo Juvara in Piemonte.** Torino, Crudo, 1926.

4690. Viale Ferrero, Mercedes. **Filippo Juvarra, scenografo e architetto teatrale.** Torino, Pozzo, [1970].

KAENDLER, JOHANN JOACHIM, 1706-1775

4691. Gröger, Helmuth. **Johann Joachim Kaendler, der Meister des Porzellans.** Dresden, Jess, 1956. (Dresdener Beiträge zur Kunstgeschichte, 2).

4692. Handt, Ingelore. **Johann Joachim Kändler und die Meissner Porzellanplastik des 18. Jahrhunderts.** Dresden, Verlag der Kunst, 1954. (Das kleine Kunstheft, 7).

4693. Sponsel, Jean Louis. **Kabinettstücke der Meissner Porzellan-Manufaktur von Johann Joachim Kändler.** Leipzig, Seemann, 1900.

KAHN, LOUIS I., 1901-1974

4694. [American Association of Architectural Bibliographers]. **Louis Kahn and Paul Zucker, two bibliographies.** [Kahn bibliography compiled by Jack Perry Brown]. New York/London, Garland, 1978. (Papers of the American Association of Architectural Bibliographers, 12).

4695. Giurgola, Romaldo and Mehta, Jaimini. **Louis I. Kahn.** Boulder, Colo., Westview Press, 1975.

4696. Komendant, August E. **18 years with architect Louis I. Kahn.** Englewood, N.J., Aloray, 1975.

4697. Lobell, John. **Between silence and light; spirit in the architecture of Louis I. Kahn.** Boulder, Colo., Shambhala, 1979; distributed by Random House, New York.

4698. Norberg-Schultz, Christian. **Louis I. Kahn, idea e immagine.** Roma, Officina Edizioni, 1980.

4699. Ronner, Heinz, et al. **Louis I. Kahn; complete works, 1935-74.** Boulder, Colo., Westview Press/Zürich, Institute for the History and Theory of Architecture, 1977. (CR).

4700. Scully, Vincent, Jr. **Louis I. Kahn.** New York, Braziller, 1962.

4701. Wurman, Richard S. and Feldman, Eugene. **The notebooks and drawings of Louis I. Kahn.** Cambridge, Mass./London, MIT Press, 1973. 2 ed.

KANDINSKY, WASSILY, 1866-1944

4702. Barnett, Vivian E. **Kandinsky at the Guggenheim.** New York, Abbeville Press, 1983.

4703. Bill, Max. **Wassily Kandinsky.** Boston, Institute of Contemporary Art/Paris, Maeght, 1951.

4704. Brion, Marcel. **Kandinsky.** Paris, Somogy, 1961.

4705. Eichner, Johannes. **Kandinsky und Gabriele Münter; von den Ursprüngen moderner Kunst.** München, Bruckmann, 1957.

4706. Geddo, Angelo. **Commento a Kandinsky.** Bergamo, San Marco, 1960.

4707. Grohmann, Will. **Wassily Kandinsky.** Leipzig, Klinkhardt & Biermann, 1924. (Junge Kunst, 42).

4708. _____. **Wassily Kandinsky, life and work.** Trans. by Norbert Guterman. New York, Abrams, 1958.

4709. Hanfstaengl, Erika. **Wassily Kandinsky, Zeichnungen und Aquarelle; Katalog der Sammlung in der Städtischen Galerie im Lenbachhaus München.** München, Prestel, 1974 (Materialien zur Kunst des 19. Jahrhunderts, 13).

4710. Haus der Kunst München. **Wassily Kandinsky, 1866-1944.** 13. November 1976-30. Januar 1977. München, Haus der Kunst, 1976.

4711. Kandinsky, Nina. **Kandinsky und ich.** München, Kindler, 1976.

4712. Kandinsky, Wassily. **Concerning the spiritual in art.** Trans. by Michael Sadleir [et al.]. New York, Wittenborn, 1972. 3 ed.

4713. _____. **Ecrits complets.** 3 v. Paris, Denoël Gonthier, 1970-1975. (Vol. 1 in preparation.)

4714. _____. **Point and line to plane.** Trans. by Howard Dearstyne and Hilla Rebay. New York, Solomon Guggenheim Foundation, 1947. (Reprint: New York, Dover, 1979).

4715. _____ and Marc, Franz. **The Blaue Reiter Almanac.** New documentary edition. New York, Viking, 1974.

4716. _____ [and] Schönberg, Arnold. **Arnold Schönberg, Wassily Kandinsky; Briefe, Bilder und Dokumente einer aussergewöhnlichen Begegnung.** Herausgegeben von Jelena Hahl-Koch. Salzburg und Wien, Residenz, 1980.

4717. Korn, Rudolf. **Kandinsky und die Theorie der abstrakten Malerei.** Berlin, Henschel, 1960.

4718. Lassaigne, Jacques. **Kandinsky, biographical and critical study.** Trans. by H. S. B. Harrison. Genève, Skira, 1969; distributed by World, Cleveland.

4719. Long, Rose-Carol. **Kandinsky, the development of an abstract style.** Oxford, Clarendon Press, 1980.

4720. Overy, Paul. **Kandinsky, the language of the eye.** New York, Praeger, 1969.

4721. Ringbom, Sixten. **The sounding cosmos; a study in the spiritualism of Kandinsky and the genesis of abstract painting.** Åbo [Finland], Åbo Akademi, 1970.

4722. Roethel, Hans K. und Benjamin, Jean K. **Kandinsky: Werkverzeichnis der Ölgemälde.** 2 v. München, Beck, 1982/1984. (CR).

4723. Société Internationale d'Art XXᵉ Siècle. **Hommage à Wassily Kandinsky.** [Numéro spécial de XXᵉ Siècle]. Paris, XXᵉ Siècle, 1974.

4724. Solomon R. Guggenheim Museum (New York). **Vasily Kandinsky, 1866-1944; a retrospective exhibition.** [January-April 1963]. New York, Guggenheim Foundation, 1962.

4725. Zehder, Hugo. **Wassily Kandinsky.** Dresden, Kaemmerer, 1920. (Künstler der Gegenwart, 1).

KANŌ EITOKU, 1543-1590

4726. Takeda, Tsuneo. **Kanō Eitoku.** Trans. and adapted by H. Mack Horton and Catherine Kaputa. Tokyo, Kodansha, 1977.

KANOLDT, ALEXANDER, 1881-1939

4727. Ammann, Edith, ed. **Das graphische Werk von Alexander Kanoldt.** Karlsruhe, Staatliche Kunsthalle, 1963. (Schriften der Staatlichen Kunsthalle Karlsruhe, 7).

KAPROW, ALLAN JOSEPH, 1927-

4728. Kaprow, Allan. **Assemblage, environments & happenings.** New York, Abrams, [1966].

4729. Pasadena Art Museum (Pasadena, Calif.). **Allan Kaprow.** September 15 through October 22, 1967. Pasadena, Calif., Pasadena Art Museum, 1967.

KARS, GEORGES, 1880-1945

4730. Fels, Florent. **Georges Kars.** Paris, Le Triangle, [1933].

4731. Jolinon, Joseph. **La vie et l'oeuvre de Georges Kars.** Lyon, Imprimerie Générale du Sud-Est, 1958.

KARSH, YOUSUF, 1908-

4732. Karsh, Yousuf. **Faces of destiny.** Chicago/New York, Ziff-Davis/London, Harrap, 1946.

4733. _____. **In search of greatness; reflections of Yousuf Karsh.** New York, Knopf, 1962.

4734. _____. **Karsh Canadians.** Toronto, University of Toronto Press, 1978.

4735. _____. **Karsh portraits.** Toronto, University of Toronto Press, 1976.

KÄSEBIER, GERTRUDE, 1852-1934

4736. Delaware Art Museum (Wilmington, Del.). **A pictorial heritage: the photographs of Gertrude Käsebier.** March 2-April 22, 1979. [Text by William Innes Homer et al.]. Wilmington, Del., Delaware Art Museum, 1979.

KASIIAN, VASYL' ILLICH, 1896-

4737. Kostiuk, S. P. **Vasyl' Kasiian, bibliohrafichnyi pokazhchyk.** L'viv, Akademiia Nauk Ukrains'koi RSR, 1976.

4738. Vladych, Leonid V. **Vasyl' Kasiian, p'iat' etiudiv pro khudozhnyka.** Kÿiv, Mystetsvko, 1978.

KASPAR, ADOLF, 1877-1934

4739. Beneš Buchlovan, Bedřich. **Knizní ilustrace Adolfa Kašpara.** Praha, Šmidt, 1942.

4740. Scheybal, Josef V. **Adolf Kašpar, život a dílo.** Praha, Hudby a Umení, 1957.

4741. Táborský, František. **A. Kašpar, ilustrátor, malíř, grafik.** Olomouc, Promberger, 1935.

KATZ, ALEX, 1927-

4742. Sandler, Irving. **Alex Katz.** New York, Abrams, 1979.

4743. [_____ and Berkson, William, eds.]. **Alex Katz.** New York, Praeger, 1971.

KAUFFMANN, ANGELICA, 1741-1807

4744. C. G. Boerner (Düsseldorf). **Angelika Kauffmann und ihre Zeit; Graphik und Zeichnungen von 1760-1810.** [Einladung zur Herbst-Ausstellung, 1.-22. September 1979]. Düsseldorf, Boerner, 1979. (Neue Lagerliste, 70).

4745. Gerard, Frances A. Angelica Kauffman, a biography; new edition. New York, Macmillan, 1893.

4746. Hartcup, Adeline. Angelica, the portrait of an eighteenth-century artist. Melbourne, Heinemann, 1954.

4747. Helbok, Claudia. Miss Angel; Angelika Kauffmann, eine Biographie. Wien, Rosenbaum, 1968.

4748. Manners, Victoria and Williamson, George C. Angelica Kauffmann, R.A.; her life and her works. London, Lane, 1924.

4749. Mayer, Dorothy M. Angelica Kauffman, R.A., 1741-1807. Gerrards Cross, Buckinghamshire, Smythe, 1972.

4750. Rossi, Giovanni G. de. Vita di Angelica Kauffman, pittrice. Firenze, Landi, 1810.

4751. Schram, Wilhelm. Die Malerin Angelica Kauffmann. Brünn, Rohrer, 1890.

4752. Thurnher, Eugen, ed. Angelika Kauffmann und die deutsche Dichtung. Bregenz, Russ, [1966]. (Vorarlberger Schrifttum, 10).

4753. Vorarlberger Landesmuseum (Bregenz). Angelika Kauffmann und ihre Zeitgenossen. 23. Juli bis 13. Oktober 1968. Bregenz, Vorarlberger Landesmuseum, 1968.

KAULBACH, WILHELM VON, 1805-1874

 FRIEDRICH AUGUST VON, 1850-1920

 HERMANN, 1846-1909

4754. Dürck-Kaulbach, Josefa. Erinnerungen an Wilhelm von Kaulbach und sein Haus. München, Delphin, 1917. 3 ed.

4755. Kaulbach, Isidore. Friedrich Kaulbach; Erinnerungen an mein Vaterhaus. Berlin, Mittler, 1931.

4756. Lehmann, Evelyn [and] Riemer, Elke. Die Kaulbachs, eine Künstlerfamilie aus Arolsen. Arolsen, Waldeckischer Geschichtsverein, 1978.

4757. Müller, Hans. Wilhelm Kaulbach. Berlin, Fontane, 1893.

4758. [Ostini, Fritz von]. Fritz August von Kaulbach, Gesamtwerk. München, Hanfstaengl, [1911].

4759. _____. Wilhelm von Kaulbach. Bielefeld/Leipzig, Velhagen & Klasing, 1906. (Künstler-Monographien, 84).

4760. Rosenberg, Adolf. Friedrich August von Kaulbach. Bielefeld/Leipzig, Velhagen & Klasing, 1910. 2 ed. (Künstler-Monographien, 48).

4761. Schasler, Max. Die Wandgemälde Wilhelm von Kaulbachs im Treppenhause des Neuen Museums zu Berlin. Berlin, Wolff, 1854.

4762. Zimmermanns, Klaus. Friedrich August von Kaulbach, 1850-1920; Monographie und Werkverzeichnis. München, Prestel, 1980. (CR). (Materialien zur Kunst des 19. Jahrhunderts, 26).

KAVÁN, FRANTIŠEK, 1866-1941

4763. Kovárna, František. František Kaván. Praha, Jednota umelců výtvarných, 1942.

4764. Vancl, Karel. František Kaván. Liberci, Severočeské Krajské, 1962.

KAWAI, GYOKUDŌ, 1873-1957

4765. Takahaski, Seiichiro. Gyokudō Kawai. [Text in Japanese and English]. Tokyo, Bijutsu Shippansha, 1958.

KAZAKOV, MATVEĬ FEDOROVICH, 1738-1813

4766. [Beletskoĭ, E. A.]. Arkhitekturnye al'bomy M. F. Kazakova. Moskva, Gosizdat lit-ry po stroitel'stvu i arkhitekture, 1956.

4767. Bondarenko, Ilia Evgrafovich. Arkhitekor Matvyeĭ Fedorovich Kazakov. Moskva, Institut Moskovskogo arkhitekturnogo obshchestva, 1912.

KEENE, CHARLES SAMUEL, 1823-1891

4768. Hudson, Derek. Charles Keene. London, Pleiades, 1947.

4769. Layard, George S. The life and letters of Charles Samuel Keene. London, Sampson Low, 1892.

4770. Pennell, Joseph. The work of Charles Keene. London, Unwin, 1897.

KEITH, WILLIAM, 1838-1911

4771. Art Institute of Chicago. Exhibition of paintings by the late William Keith. April 22 to May 6, 1913. Chicago, Art Institute of Chicago, 1913.

4772. Cornelius, Fidelis. Keith, old master of California. [Vol. 1] New York, Putnam's, 1942. [Vol. 2] Fresno, California, Academy Library Guild, 1956.

4773. Hay, Emily. William Keith as prophet painter. San Francisco, Elder, 1916. (Reprint: San Francisco, Kenneth Starosciak, [1981]).

4774. Oakland Art Museum (Oakland, Calif.). An introduction to the art of William Keith. [Text by Paul Mills; published upon the opening of the William Keith Memorial Gallery]. Oakland, Calif., Oakland Art Museum, 1956.

KELLER, FERDINAND, 1842-1922

4775. Gaertner, Friedrich W. Ferdinand Keller. Karlsruhe, Müller, 1912.

4776. Koch, Michael. Ferdinand Keller (1842-1922), Leben und Werk. Karlsruhe, Müller, 1978. (CR).

KELLY, ELLSWORTH, 1923–

4777. Coplans, John. **Ellsworth Kelly.** New York, Abrams, 1973. (CR).

4778. Goossen, Eugene C. **Ellsworth Kelly.** [Catalogue of an exhibition, Museum of Modern Art, Sept. 12–Nov. 4, 1973]. New York, Museum of Modern Art, 1973; distributed by New York Graphic Society, Greenwich, Conn.

4779. Metropolitan Museum of Art (New York). **Ellsworth Kelly, recent paintings and sculptures.** April 26–June 24, 1979. New York, Metropolitan Museum of Art, 1979.

4780. Sims, Patterson. **Ellsworth Kelly, sculpture.** [Catalogue of an exhibition, Whitney Museum of American Art; Dec. 17, 1982–Feb. 21, 1983]. New York, Whitney Museum of American Art, 1982.

4781. Waldman, Diane. **Ellsworth Kelly; drawings, collages, prints.** Greenwich, Conn., New York Graphic Society, 1971.

KEMENY, ZOLTAN, 1907–1965

4782. Fondation Maeght (Paris). **Kemeny.** 23 mars–31 mai 1974. [Text by Michel Ragon]. Paris, Fondation Maeght, 1974.

4783. Giedion-Welcker, Carola. **Zoltan Kemeny.** [Text in German, French and English]. St. Gallen, Erker, 1968. (Artists of Our Time, 15).

4784. Kunstmuseum Bern. **Zoltan Kemeny.** [March 9–May 9, 1982]. [Text in German and French]. Bern, Kunstmuseum Bern, 1982.

4785. Ragon, Michel. **Zoltan Kemeny.** [Text in French, English, and German]. Neuchâtel, Editions du Griffon, 1960.

KEMP-WELCH, LUCY ELIZABETH, 1869–1958

4786. Messum, David. **The life and work of Lucy Kemp-Welch.** [n.p.], Antique Collectors' Club, 1976.

KENT, ROCKWELL, 1882–1971

4787. Armitage, Merle. **Rockwell Kent.** New York, Knopf, 1932.

4788. Chegodaev, Andrei. **Rokuell Kent, zhivopis', grafika.** Moskva, Akad. khudozhestv SSSR, 1962.

4789. Kent, Rockwell. **It's me, O Lord; the autobiography of Rockwell Kent.** New York, Dodd, Mead, 1955.

4790. _____. **Later bookplates & marks of Rockwell Kent.** With a preface by the artist. New York, Pynson Printers, 1937.

4791. [_____ and Zigrosser, Carl]. **Rockwellkentiana; few words and many pictures by R. K. and, by Carl Zigrosser, a bibliography and a list of prints.** New York, Harcourt, Brace, 1933.

4792. Johnson, Fridolf. **The illustrations of Rockwell Kent; 231 examples from books, magazines and advertising art.** New York, Dover, 1976.

4793. _____. **Rockwell Kent, an anthology of his works.** New York, Knopf, 1982.

4794. Jones, Dan B. **The prints of Rockwell Kent, a catalogue raisonné.** Chicago/London, University of Chicago Press, 1975. (CR).

4795. Traxel, David. **An American saga; the life and times of Rockwell Kent.** New York, Harper & Row, 1980.

KENT, WILLIAM, 1685–1748

4796. Jourdain, Margaret. **The work of William Kent; artist, painter, designer, and landscape gardener.** Introduction by Christopher Hussey. London, Country Life, 1948.

KENZAN, ca. 1662–1743 see KOETSU

KERKOVIUS, IDA, 1879–1970

4797. Galerie der Stadt Stuttgart. **Ida Kerkovius, 1879–1970; Gesichter.** 19. Juli bis 16. September 1979. Stuttgart, Galerie der Stadt, 1979.

4798. Leonhard, Kurt. **Ida Kerkovius, Leben und Werk.** Köln, DuMont Schauberg, 1967.

4799. _____. **Die Malerin Ida Kerkovius.** Stuttgart, Kohlhammer, 1954.

4800. Roditi, Eduard. **Ida Kerkovius.** Konstanz, Simon und Koch, 1961.

KERTESZ, ANDRE, 1894–

4801. Gaillard, Agathe. **André Kertész.** Paris, Belfond, 1980.

4802. Kertész, André. **Hungarian memories.** Introduction by Hilton Kramer. Boston, New York Graphic Society, 1982.

4803. _____. **J'aime Paris; photographs since the twenties.** Ed. by Nicolas Ducrot. New York, Grossman, 1974.

4804. _____. **A lifetime of perception.** Introduction by Ben Lifson. Ed. by Jane Corkin. New York, Abrams, 1982.

4805. _____. **Sixty years of photography, 1912–1972.** Ed. by Nicolas Ducrot. New York, Grossman, 1972.

4806. Museum of Modern Art (New York). **A. Kertész, photographer.** Introductory essay by John Szarkowski. New York, Museum of Modern Art, 1964.

KEYSER, HENDRICK CORNELIS DE, 1565–1621

4807. [Bray, Salomon de]. **Archetectura moderna ofte Bouwinge van onsen tyt.** [With descriptions of Hendrick de Keyser's buildings]. Amsterdam, Dankerts, 1633. (Reprint: Soest, Holland, Davaco, 1971).

4808. Nuerdenburg, Elisabeth. **Hendrick de Keyser, beeldhouwer en bouwmeester van Amsterdam.** Amsterdam, Scheltema & Holkema, 1930.

KHNOPFF, FERNAND, 1858-1921

4809. Delevoy, Robert L. **Fernand Khnopff.** [Catalogue de l'oeuvre et bibliographie: Catherine De Croës et Giselle Ollinger-Zinque]. Bruxelles, Cosmos Monographies [Editions Lebeer-Hossmann], 1979. (CR).

4810. Dumont-Wilden, Louis. **Fernand Khnopff.** Bruxelles, van Oest, 1907.

4811. Howe, Jeffery W. **The symbolist art of Fernand Khnopff.** [Ann Arbor, Mich.], University of Michigan Press, 1982. (Studies in Fine Arts: the Avant-Garde, 28).

4812. Musée des Arts Décoratifs (Paris). **Fernand Khnopff, 1858-1921.** 10 octobre-31 décembre, 1979. [Brussels], Ministère de la Communauté française de Belgique, 1979.

4813. Verhaeren, Emile. **Quelques notes sur l'oeuvre de Fernand Khnopff, 1881-1887.** Bruxelles, Veuve Monnom, 1887.

KIRCHNER, ERNST LUDWIG, 1880-1938

4814. Crispolti, Enrico. **Ernst Kirchner.** Milano, Fabbri, 1966. (I maestri del colore, 137).

4815. Dube, Annemarie and Dube, Wolf-Dieter. **E. L. Kirchner, das graphische Werk.** 2 v. München, Prestel, 1980. 2 ed. (CR).

4816. Dube-Heynig, Annemarie. **Kirchner; his graphic art.** Greenwich, Conn., New York Graphic Society, 1961.

4817. Gordon, Donald E. **Ernst Ludwig Kirchner.** Cambridge, Mass., Harvard University Press, 1968. (CR).

4818. Grisebach, Lothar. **E. L. Kirchners Davoser Tagebuch; eine Darstellung des Malers und eine Sammlung seiner Schriften.** Köln, DuMont Schauberg, 1968.

4819. Grohmann, Will. **Das Werk Ernst Ludwig Kirchners.** München, Wolff, 1926.

4820. _____. **E. L. Kirchner.** New York, Arts, 1961.

4821. _____. **Zeichnungen von Ernst Ludwig Kirchner.** Dresden, Arnold, 1925.

4822. Ketterer, Roman N., et al. **Ernst Ludwig Kirchner; Zeichnungen und Pastelle.** Stuttgart/Zürich, Belser, 1979.

4823. Kirchner, Ernst L. **Briefe an Nele und Henry van de Velde.** München, Piper, 1961.

4824. Kornfeld, Eberhard W. **Ernst Ludwig Kirchner, Nachzeichnung seines Lebens.** Katalog der Sammlung von Werken von Ernst Ludwig Kirchner im Kirchner-Haus Davos. Bern, Kornfeld und Ketterer, 1979.

4825. Museum der Stadt Aschaffenburg. **E. L. Kirchner; Zeichnungen, Pastelle, Aquarelle. Dokumente: Fotos, Schriften, Briefe.** 2 v. [Text and compilation by Karlheinz Gabler]. 19. April bis 26. Mai 1980. Aschaffenburg, Museum der Stadt, 1980.

4826. Museum of Fine Arts (Boston). **Ernst Ludwig Kirchner, a retrospective exhibition.** [Text by Donald E. Gordon].

March 20-April 27, 1969. Boston, Museum of Fine Arts, 1968.

4827. Schiefler, Gustav. **Die Graphik Ernst Ludwig Kirchners.** 2 v. Berlin, Euphorion, 1924/1931.

KISLING, MOÏSE, 1891-1953

4828. Charensol, Georges. **Moïse Kisling.** Paris, Editions de Clermont, 1948. (Art-Présent, 2).

4829. Einstein, Carl. **M. Kisling.** Leipzig, Klinkhardt & Biermann, 1922. (Junge Kunst, 31).

4830. Kesel, Joseph. **Kisling.** New York, Abrams, 1971. (CR).

4831. Troyat, Henri and Kisling, Jean. **Moïse Kisling: catalogue raisonné de l'oeuvre peint.** Paris, Kisling, 1982. 2 ed. (CR).

KITAGAWA, UTAMARO see UTAMARO KITAGAWA

KIYONAGA, TORII see TORII, KIYONAGA

KLAPHECK, KONRAD, 1935-

4832. Museum Boymans-van Beuningen (Rotterdam). **Konrad Klapheck.** [September 14-November 3, 1974]. Rotterdam, Museum Boymans-van Beuningen, 1974.

4833. Pierre, José. **Konrad Klapheck.** Köln, DuMont Schauberg, 1970.

KLEE, PAUL, 1879-1940

4834. [Armitage, Merle, ed.]. **5 essays on Klee.** New York, [designed by Merle Armitage and distributed by] Duell, Sloan & Pearce, 1950.

4835. Cherchi, Placido. **Paul Klee teorico.** Bari, De Donato, 1978.

4836. Geist, Hans Friedrich. **Paul Klee.** Hamburg, Ernst Hauswedell, 1948.

4837. Giedion-Welcker, Carola. **Paul Klee.** Trans. by Alexander Gode. New York, Viking, 1952. (2 ed.: Stuttgart, Hatje, 1954).

4838. _____. **Paul Klee in Selbstzeugnissen und Bilddokumenten.** [Reinbeck bei Hamburg], Rowohlt, 1961. (Rowohlt Monographien, 52).

4839. Glaesemer, Jürgen. **Paul Klee; die farbigen Werke im Kunstmuseum Bern.** Bern, Kornfeld, 1976. (Sammlungskataloge des Berner Kunstmuseums: Paul Klee, 1).

4840. _____. **Paul Klee; Handzeichnungen.** 3 v. Bern, Kunstmuseum Bern, 1973-1979. (CR). (Sammlungskataloge des Berner Kunstmuseums: Paul Klee, 2-4).

4841. Grohmann, Will. **Paul Klee.** Paris, Cahiers d'art, 1929.

4842. _____. **Paul Klee.** New York, Abrams, [1954].

4843. _____. **Paul Klee: Handzeichnungen.** Köln, DuMont Schauberg, 1959.

4844. Grote, Ludwig. **Erinnerungen an Paul Klee.** München, Prestel, 1959.

4845. Haftmann, Werner. **The mind and work of Paul Klee.** New York, Praeger, 1954.

4846. Haxthausen, Charles W. **Paul Klee, the formative years.** New York, Garland, 1981.

4847. Huggler, Max. **Paul Klee, die Malerei als Blick in den Kosmos.** Frauenfeld/Stuttgart, Huber, 1969. (Wirkung und Gestalt, 7).

4848. Kagan, Andrew. **Paul Klee, art & music.** Ithaca/London, Cornell University Press, 1983.

4849. Kahnweiler, Daniel-Henry. **Klee.** [Text in French, English, and German]. Paris, Braun/New York, Herrmann, 1950.

4850. Klee, Felix. **Paul Klee, his life and works in documents.** New York, Braziller, 1962.

4851. Klee, Paul. **Beiträge zur bildnerischen Formlehre.** Faksimilierte Ausgabe des Originalmanuskripts. Herausgegeben von Jürgen Glaesemer. Basel/Stuttgart, Schwabe, 1979.

4852. _____. **Briefe an die Familie, 1893-1940.** [Edited by Felix Klee]. Köln, DuMont Schauberg, 1979.

4853. _____. **The diaries of Paul Klee, 1898-1918.** Edited, with an introduction, by Felix Klee. Berkeley and Los Angeles, University of California Press, 1964.

4854. _____. **Journal.** Trans. by Pierre Klossowski. Paris, Grasset, 1959.

4855. _____. **The nature of nature. The notebooks of Paul Klee** [vol. 2]. Edited by Jürgen Spiller; trans. by Heinz Norden. New York, Wittenborn, 1973. (Documents of Modern Art, 17).

4856. _____. **On modern art.** Trans. by Paul Findlay. London, Faber, 1948.

4857. _____. **Pedagogical sketchbook.** Trans. by Sibyl Moholy-Nagy. New York, Praeger, 1953.

4858. _____. **Schriften; Rezensionen und Aufsätze.** [Edited by Christian Geelhaar]. Köln, DuMont Schauberg, 1976.

4859. _____. **The thinking eye; the notebooks of Paul Klee** [vol. 1]. Edited by Jürgen Spiller; trans. by Ralph Manheim. New York, Wittenborn, 1961. (Documents of Modern Art, 15).

4860. _____, et al. **The inward vision; watercolors, drawings, writings.** Trans. by Norbert Guterman. [Text by Paul Klee with Werner Haftman, Carola Giedion-Welcker, et al.]. New York, Abrams, 1959.

4861. Miller, Margaret. **Paul Klee.** New York, Museum of Modern Art, 1945.

4862. Mösser, Andeheinz. **Das Problem der Bewegung bei Paul Klee.** Heidelberg, Winter, 1976. (Heidelberger Kunstgeschichtliche Abhandlungen, Neue Folge, 12).

4863. National Gallery of Canada (Ottawa). **A tribute to Paul Klee, 1879-1940.** 2 March-15 April 1979. [Text by David Burnett]. Ottawa, National Gallery of Canada, 1979.

4864. Naubert-Riser, Constance. **La création chez Paul Klee; étude de la relation théoriepraxis de 1900 à 1924.** Paris, Klincksieck/Ottawa, Editions de l'Université d'Ottawa, 1978.

4865. Osterwold, Tilman. **Paul Klee, ein Kind träumt sich.** Stuttgart, Hatje, [1979].

4866. Pfeiffer-Belli, Erich. **Klee, eine Bildbiographie.** München, Kindler, 1964.

4867. Plant, Margaret. **Paul Klee, figures and faces.** London, Thames and Hudson, 1978.

4868. Ponente, Nello. **Klee, biographical and critical study.** Trans. by James Emmons. Lausanne, Skira, 1960; distributed by World, Cleveland.

4869. San Lazzaro, Gualtieri di. **Klee, a study of his life and work.** Trans. by Stuart Hood. New York, Praeger, 1957.

4870. Soby, James T. **The prints of Paul Klee.** New York, Valentin, 1945. 2 ed.

4871. Solomon R. Guggenheim Museum (New York). **Paul Klee, 1879-1940.** New York, Guggenheim Foundation, 1977.

4872. Wedderkop, Hermann von. **Paul Klee.** Leipzig, Klinkhardt & Biermann, 1920. (Junge Kunst, 13).

4873. Werckmeister, Otto K. **Versuch über Paul Klee.** Frankfurt a.M., Syndikat, 1981.

4874. Zahn, Leopold. **Paul Klee; Leben/Werk/Geist.** Potsdam, Kiepenheuer, 1920.

KLEIN, CESAR, 1876-1954

4875. Däubler, Theodor. **César Klein.** Leipzig, Klinkhardt & Biermann, 1923. 2 ed.

4876. Pfefferkorn, Rudolph. **César Klein.** Berlin, Rembrandt, 1962. (Die Kunst unserer Zeit, 14).

KLEIN, JOHANN ADAM, 1792-1875

4877. Jahn, Carl. **Das Werk von Johann Adam Klein.** München, Montmorillon'sche Kunsthandlung, 1863.

4878. Schwemmer, Wilhelm. **Johann Adam Klein, ein Nürnberger Meister des 19. Jahrhunderts.** Nürnberg, Carl, 1966.

4879. Stadtgeschichtliche Museen (Nuremberg). **Johann Adam Klein, 1792-1875; Zeichnungen und Aquarelle.** Nürnberg, Stadtgeschichtliche Museen, 1975. (Bestandskatalog, 1).

KLEIN, YVES, 1928-1962

4880. [Klein, Yves]. **Yves Klein, 1928-1962; selected writings.**
Trans. by Barbara Wright. [Edited by Jacques Caumont and
Jennifer Gough-Cooper]. London, Tate Gallery, 1974.

4881. Kunsthalle Bern. **Yves Klein.** 4.-29. August 1971.
[Hannover, Kunstverein Hannover, 1971].

4882. Martano, Giuliano. **Yves Klein, il mistero ostentato.**
Torino, Martano, 1970. (Nadar, ricerche sull'arte
contemporanea, 6).

4883. McEveilley, Thomas, et al. **Yves Klein, 1928-1962; a
retrospective.** Houston, Tex., Institute for the Arts,
Rice University, 1983.

4884. Restany, Pierre. **Yves Klein.** Trans. by John Shepley. New
York, Abrams, 1982.

4885. Wember, Paul. **Yves Klein.** Köln, DuMont Schauberg, 1969.
(CR).

KLENZE, LEO VON, 1784-1864

4886. Hederer, Oswald. **Leo von Klenze. Persönlichkeit und Werk.**
München, Callwey, 1964.

4887. Klenze, Leo von. **Sammlung architektonischer Entwürfe für
die Ausführung bestimmt oder wirklich ausgeführt.** 5 v.
München, Cotta, 1847-50. 2 ed.

4888. Lieb, Norbert [and] Hufnagl, Florian. **Leo von Klenze,
Gemälde und Zeichnungen.** München, Callwey, 1979.

4889. Wiegmann, Rudolf. **Der Ritter Leo von Klenze und unsere
Kunst.** Leipzig, Fleischer, 1839.

KLEOPHRADES PAINTER, fl. 430-410 B.C.

4890. Beazley, John D. **The Kleophrades painter.** Mainz, von
Zabern, 1974. 4 ed. (Bilder griechischer Vasen, 6).

KLIMT, GUSTAV, 1861-1918

4891. Breicha, Otto. **Gustav Klimt, die goldene Pforte;
Werk-Wesen-Wirkung; Bilder und Schriften zu Leben und
Werk.** Salzburg, Galerie Welz, 1978.

4892. Comini, Alessandra. **Gustav Klimt.** New York, Braziller,
1975.

4893. Dobai, Johannes. **L'opera completa di Klimt.** Milano,
Rizzoli, 1978. (CR). (Classici dell'arte, [94]).

4894. Eisler, Max, ed. **Gustav Klimt, eine Nachlese.** Wien,
Oesterreichische Staatsdruckerei, 1920. (English ed.:
Gustav Klimt, an aftermath. Vienna, 1931).

4895. Hofmann, Werner. **Gustav Klimt.** Trans. by Inge Goodwin.
Boston, New York Graphic Society, 1971.

4896. Hofstätter, Hans H. **Gustav Klimt, erotische Zeichnungen.**
Köln, DuMont, 1979.

4897. Nebehay, Christian M., ed. **Gustav Klimt, Dokumentation.**
Wien, Galerie Christian M. Nebehay, 1969.

4898. Novotny, Fritz and Dobai, Johannes. **Gustav Klimt.**
Salzburg, Galerie Welz, 1967. (CR).

4899. Pirchan, Emil. **Gustav Klimt.** Wien, Bergland, 1956.

4900. Salten, Felix. **Gustav Klimt, gelegentliche Anmerkungen.**
Wien, Wiener Verlag, 1903.

4901. Strobl, Alice. **Gustav Klimt; die Zeichnungen.** 3 v.
Salzburg, Galerie Welz, 1980-83. (CR). (Veröffentlich-
ungen der Albertina, 15: 1-3).

KLINE, FRANZ JOSEF, 1910-1962

4902. Dawson, Fielding. **An emotional memoir of Franz Kline.** New
York, Pantheon, 1967.

4903. Whitney Museum of American Art (New York). **Franz Kline,
1910-1962.** October 1-November 24, 1968. [Text by John
Gordon]. New York, Whitney Museum of American Art, 1968.

KLINGER, MAX, 1857-1920

4904. Avenarius, Ferdinand. **Max Klinger als Poet.** München,
Callwey, [1919]. 3 ed.

4905. Brieger-Wasservogel, Lothar. **Max Klinger.** Leipzig,
Seemann, 1902. (Männer der Zeit, 12).

4906. Dückers, Alexander. **Max Klinger.** Berlin, Rembrandt, 1976.

4907. Heyne, Hildegard. **Max Klinger, im Rahmen der modernen
Weltanschauung und Kunst.** Leipzig, Wigand, 1907.

4908. Klinger, Max. **Briefe . . . aus den Jahren 1874 bis 1919.**
Herausgegeben von Hans Wolfgang Singer. Leipzig,
Seemann, 1924.

4909. ———. **Gedanken und Bilder aus der Werkstatt des
werdenden Meisters.** Herausgegeben von Dr. [Hildegard]
Heyne. Leipzig, Koehler & Amelang, 1925.

4910. ———. **Malerei und Zeichnungen.** Leipzig, Insel, 1885.
(Insel-Bücherei, 263).

4911. Kühn, Paul. **Max Klinger.** Leipzig, Breitkopf, 1907.

4912. Kunsthalle Bielefeld. **Max Klinger.** [October 10-November
11, 1976]. Bielefeld, Kunsthalle Bielefeld, 1976.

4913. Mathieu, Stella W., ed. **Max Klinger, Leben und Werk in
Daten und Bildern.** Frankfurt a.M., Insel, 1976. (Insel
Taschenbuch, 204).

4914. Meissner, Franz H. **Max Klinger.** Berlin/Leipzig,
Schuster & Loeffler, 1899. (Das Künstlerbuch, 2).

4915. ———. **Max Klinger: Radierungen, Zeichnungen, Bilder und
Sculpturen des Künstlers.** München, Hanfstaengl, 1896.

4916. Museum Boymans-van Beuningen (Rotterdam). **Max Klinger,
1857-1920; Beeldhouwwerken, Schilderijen, Tekeningen,**

Grafiek. 30 September-12 November 1978. Rotterdam, Museum Boymans-van Beuningen, 1978.

4917. National Gallery of Victoria (Melbourne). **Max Klinger; love, death, and the beyond.** 26 February-12 April 1981. Melbourne, National Gallery of Victoria, 1981.

4918. Pastor, Willy. **Max Klinger.** Berlin, Amsler, 1919. 2 ed.

4919. Schmid, Max. **Klinger.** Bielefeld/Leipzig, Velhagen & Klasing, 1901. 2 ed. (Künstler-Monographien, 41).

4920. Servaes, Franz. **Max Klinger.** [Berlin], Bard, [1904].

4921. Singer, Hans W. **Max Klingers Radierungen, Stiche und Steindrucke; wissenschaftliches Verzeichnis.** Berlin, Amsler und Ruthardt, 1909. (CR).

4922. _____. **Zeichnungen von Max Klinger.** Leipzig, Schumann, 1912. (Meister der Zeichnung, 1).

4923. Treu, Georg. **Max Klinger als Bildhauer.** Leipzig/Berlin, Seemann, 1900.

4924. Varnedoe, J. Kirk T. and Streicher, Elizabeth. **The graphic work of Max Klinger.** New York, Dover, 1977.

4925. Vogel, Julius. **Max Klinger und seine Vaterstadt Leipzig.** Leipzig, Scholl, 1923.

4926. _____. **Max Klingers Leipziger Skulpturen.** Leipzig, Seemann, 1902. 2 ed.

KNELLER, GODFREY, 1646-1723

4927. Ackermann, Wilhelm A. **Der Portraitmaler Sir Godfrey Kneller.** Leipzig, Weigel, 1845.

4928. Killanin, Michael M. **Sir Godfrey Kneller and his times, 1646-1723, being a review of English portraiture of the period.** London, Batsford, 1948.

4929. Stewart, J. Douglas. **Sir Godfrey Kneller.** London, Bell, 1971. (New ed.: Oxford, Clarendon Press, 1983).

KNOBELSDORFF, GEORG WENCESLAUS VON, 1699-1753

4930. Eggeling, Tilo. **Studien zum friderizianischen Rokoko; Georg Wenceslaus von Knobelsdorff als Entwerfer von Innendekorationen.** Berlin, Mann, 1980.

4931. Streichhan, Annelise. **Knobelsdorff und das friderizianische Rokoko.** Burg, Hopfer, 1932.

4932. Westarp, Franz G. von. **Knobelsdorffs Rheinsberger Werk.** Würzburg, Verlagsdruckerei Würzburg, 1929.

KOBELL, FERDINAND, 1740-1799

WILHELM ALEXANDER WOLFGANG VON, 1766-1855

4933. Beringer, Joseph A. **Ferdinand Kobell, eine Studie über sein Leben und Schaffen.** Mannheim, Nemnich, 1909.

4934. Biedermann, Margret. **Ferdinand Kobell, 1740-1799; das malerische und zeichnerische Werk.** München, Galerie Margret Biedermann, 1973.

4935. Goedl-Roth, Monika. **Wilhelm von Kobell, Druckgraphik; Studien zur Radierung und Aquatinta mit kritischem Verzeichnis.** München, Bruckmann, 1974. (CR).

4936. Kugler, Franz. **Radirungen von Ferdinand Kobell.** Stuttgart, Goepel, [1842].

4937. Lessing, Waldemar. **Wilhelm von Kobell.** München, Bruckmann, 1923. (2 ed., rev. by Ludwig Grote, 1966).

4938. Stengel, Etienne. **Catalogue raisonné des estampes de Ferdinand Kobell.** Nürnberg, Riegel et Wiesner, 1822. (CR).

4939. Wichmann, Siegfried. **Wilhelm von Kobell, Monographie und kritisches Verzeichnis der Werke.** München, Prestel, 1970. (CR).

KOCH, JOSEPH ANTON, 1768-1839

4940. Jaffé, Ernst. **Joseph Anton Koch, sein Leben und sein Schaffen.** Innsbruck, Wagner, 1905.

4941. Lutterotti, Otto R. von. **Joseph Anton Koch, 1768-1839.** Berlin, Deutscher Verein für Kunstwissenschaft, 1940.

4942. Mark, Hans. **Der Maler Joseph Anton Koch und seine Tiroler Heimat.** Innsbruck, Wagner, 1939.

KOCH, RUDOLF, 1876-1934

4943. Haupt, Georg. **Rudolf Koch der Schreiber.** Leipzig, Insel, 1936.

4944. Koch, Rudolph. **The book of signs, which contains all manner of symbols used from the earliest times to the middle ages by primitive peoples and early Christians.** Trans. by Vyvyan Holland. New York, Dover, [1957].

KOENIG, LEO VON, 1871-1944

4945. Kroll, Bruno. **Leo von König.** Berlin, Rembrandt, 1941.

4946. Nemitz, Fritz. **Leo von König.** Berlin-Frohnau, Ottens, 1930.

4947. Schneider, Reinhold. **Gestalt und Seele, das Werk des Malers Leo von König.** Leipzig, Insel, 1936.

KOETSU, HOMANI, 1558-1637

4948. Leach, Bernard H. **Kenzan and his tradition; the lives and times of Koetsu, Sotatsu, Korin, and Kenzan.** London, Faber, 1966.

4949. Ushikubo, D. J. R. **Life of Kōyetsu.** [Text in English]. Kyoto, Igyoku-do, 1926.

KOKEI, KOBAYASHI, 1883-1957

4950. Kawakita, Michiaki. **Kobayashi Kokei (1883-1957).** English
adaptation by Ray Andrew Miller. Rutland, Vt./Tokyo,
Tuttle, 1957. (Kodansha Library of Japanese Art, 11).

KOKOSCHKA, OSKAR, 1886-1980

4951. Biermann, Georg. **Oskar Kokoschka.** Leipzig/Berlin,
Klinkhardt & Biermann, 1929. (Junge Kunst, 52).

4952. Bultmann, Bernhard. **Oskar Kokoschka.** Salzburg, Galerie
Welz, 1959.

4953. Gatt, Giuseppe. **Oskar Kokoschka.** Firenze, Sansoni, 1970.
(I maestri del novecento, 15).

4954. Goldscheider, Ludwig. **Kokoschka.** London, Phaidon, 1963;
distributed by New York Graphic Society, Greenwich,
Conn., 1966.

4955. Hodin, Josef P. **Kokoschka, the artist and his time.**
Greenwich, Conn., New York Graphic Society, 1966.

4956. _____. **Oskar Kokoschka, eine Psychographie.** Wien,
Europa, 1971.

4957. _____, ed. **Bekenntnis zu Kokoschka, Erinnerungen und
Deutungen.** Berlin/Mainz, Kupferberg, 1963.

4958. Hoffmann, Edith. **Kokoschka, his life and work.** London,
Faber, 1947.

4959. Kokoschka, Oskar. **Das schriftliche Werk.** Ed. by Heinz
Spielmann. 4 v. Hamburg, Christians, 1973-76.

4960. _____. **My life.** Trans. by David Britt. New York,
Macmillan, 1974.

4961. Institute of Contemporary Art (Boston). **Oskar Kokoschka, a
retrospective exhibition, with an introduction by James
S. Plaut.** New York, Chanticleer Press, 1948.

4962. Rathenau, Ernst, ed. **Oskar Kokoschka, Handzeichnungen.**
5 v. New York, Rathenau/Berlin, Euphorion, 1936-1977.
(CR).

4963. Salzburger Residenzgalerie (Salzburg). **Oskar Kokoschka vom
Erlebnis im Leben.** März/April 1976. Salzburg, Galerie
Welz, 1976.

4964. Schvey, Henry I. **Oskar Kokoschka, the painter as
playwright.** Detroit, Wayne State University Press, 1982.

4965. Westheim, Paul. **Oskar Kokoschka.** Berlin, Cassirer, 1925.
2 ed.

4966. Wingler, Hans M. **Oskar Kokoschka, the work of the artist.**
Salzburg, Galerie Welz, 1956.

4967. _____, ed. **Oskar Kokoschka, ein Lebensbild in
zeitgenössischen Dokumenten.** München, Langen/Müller,
1956. (Langen-Müller's kleine Geschenkbücher, 56).

4968. _____ [and] Welz, Friedrich. **Oskar Kokoschka, das
druckgraphische Werk.** Salzburg, Galerie Welz, 1975.
(CR).

KOLBE, GEORG, 1877-1947

4969. Binding, Rudolf G. **Vom Leben der Plastik; Inhalt und
Schönheit des Werkes von Georg Kolbe.** Berlin, Rembrandt,
1933.

4970. Justi, Ludwig. **Georg Kolbe.** Berlin, Klinkhardt &
Biermann, 1931. (Junge Kunst, 60).

4971. Kolbe, Georg. **Auf Wegen der Kunst; Schriften, Skizzen,
Plastiken.** Berlin-Zehlendorf, Lemmer, 1949.

4972. Pinder, Wilhelm. **Georg Kolbe, Zeichnungen.** Berlin,
Rembrandt, 1942.

4973. Scheibe, Richard. **Georg Kolbe, 100 Lichtdrucktafeln.**
Marburg/Lahn, Verlag des Kunstgeschichtlichen Seminars,
1931.

4974. Valentiner, Wilhelm R. **Georg Kolbe, Plastik und
Zeichnungen.** München, Wolff, 1922.

KOLLWITZ, KÄTHE SCHMIDT, 1867-1945

4975. Akademie der Künste (Berlin). **Käthe Kollwitz, 1867-1945.**
10. Dezember 1967 bis zum 7. Januar 1968. Berlin,
Akademie der Kunst, 1967.

4976. Art Museum and Galleries, California State University (Long
Beach, Calif.). **Käthe Kollwitz/Jake Zeitlin Bookshop and
Gallery: 1937.** November 26-December 19, 1979. Long
Beach, Calif., Art Museum and Galleries, 1979.

4977. Bauer, Arnold. **Käthe Kollwitz.** Berlin, Colloquium, 1967.
(Köpfe des XX. Jahrhunderts, 19).

4978. Bittner, Herbert. **Käthe Kollwitz drawings.** New York,
Yoseloff, 1959.

4979. Bonus, Arthur. **Das Kaethe Kollwitz-Werk.** Dresden,
Reissner, 1914.

4980. Bonus-Jeep, Beate. **Sechzig Jahre Freundschaft mit Käthe
Kollwitz.** Boppard, Rauch, 1948. (Reprint: Bremen,
Schünemann, 1963).

4981. Diel, Louise. **Käthe Kollwitz, ein Ruf ertönt: eine
Einführung in das Lebenswerk der Künstlerin.** Berlin,
Furche, 1927.

4982. Fanning, Robert J. **Kaethe Kollwitz.** Karlsruhe, Müller,
1956; distributed by Wittenborn, New York.

4983. Heilborn, Adolf. **Käthe Kollwitz.** Berlin, Lemmer, 1949.
2 ed.

4984. Hinz, Renate. **Käthe Kollwitz: Druckgrafik, Plakate,
Zeichnungen.** Berlin, Elefanten Press, 1981. 2 ed.

4985. Kaemmerer, Ludwig. **Kaethe Kollwitz, Griffelkunst und
Weltanschauung.** Dresden, Richter, 1923.

4986. Kearns, Martha. **Käthe Kollwitz: woman and artist.** Old
Westbury, N.Y., Feminist Press, 1976.

4987. Klein, Mina C. [and] Klein, H. Arthur. **Käthe Kollwitz;
life in art.** New York, Holt, Rinehart, 1972.

4988. Klipstein, August. Käthe Kollwitz; Verzeichnis des graphischen Werkes. Bern, Klipstein, 1955. (CR).

4989. Koerber, Lenka von. Erlebtes mit Käthe Kollwitz. Berlin, Rütten & Loening, 1957.

4990. Kollwitz, Hans, ed. Käthe Kollwitz, das plastische Werk. Hamburg, Wegner, 1967.

4991. Kollwitz, Käthe. Aus meinem Leben. München, List, 1957. (List-Bücher, 92).

4992. _____. The diary and letters of Käthe Kollwitz. Ed. by Hans Kollwitz. Trans. by Richard and Clara Winston. Chicago, Regnery, 1955.

4993. _____. Ich sah die Welt mit liebevollen Blicken; ein Leben in Selbstzeugnissen. Ed. by Hans Kollwitz. Hannover, Fackelträger, 1968.

4994. _____. Ich will wirken in dieser Zeit. Berlin, Mann, 1952.

4995. _____. Tagebuchblätter und Briefe. Ed. by Hans Kollwitz. Berlin, Mann, 1948.

4996. Nagel, Otto. The drawings of Käthe Kollwitz. New York, Crown, 1972. (CR).

4997. _____. Käthe Kollwitz. Trans. by Stella Humphries. Greenwich, Conn., New York Graphic Society, 1971.

4998. Schneede, Uwe M. Käthe Kollwitz, das zeichnerische Werk. München, Schirmer-Mosel, 1981.

4999. Sievers, Johannes. Die Radierungen und Steindrucke von Käthe Kollwitz innerhalt der Jahre 1890 bis 1912; ein beschreibendes Verzeichnis. Dresden, Holst, 1913. (CR).

5000. Singer, Hans W. Käthe Kollwitz. Esslingen, Neff, 1908. (Führer zur Kunst, 15).

5001. Strauss, Gerhard. Käthe Kollwitz. Dresden, Sachsenverlag, 1950.

5002. Wagner, A. Die Radierungen, Holzschnitte, und Lithographien von Käthe Kollwitz; eine Zusammenstellung der seit 1912 entstandenen graphischen Arbeiten in chronologischer Folge. Dresden, Richter, 1927. (CR).

5003. Zigrosser, Carl. Kaethe Kollwitz. New York, Bittner, 1946.

KONINCK, PHILIPS, 1619-1688

5004. Gerson, Horst. Philips Koninck, ein Beitrag zur Erforschung der holländischen Malerei des XVII. Jahrhunderts. Berlin, Mann, 1980. 2 ed. (CR).

KOONING, WILLEM DE see DE KOONING, WILLEM

KONRAD VON SOEST see SOEST, CONRAD VON

KORIN, OGATA, 1658-1716

see also KOETSU, HONAMI

5005. Mizuo, Hiroshi. Edo painting: Sotatsu and Korin. Trans. by John M. Shields. New York, Weatherhill, 1972. (Heibonsha Survey of Japanese Art, 18).

5006. Noguchi, Yone. Korin. London, Matthews, 1922.

5007. Perzyński, Friedrich. Korin und seine Zeit. Berlin, Marquart, [1907].

KRAFFT, ADAM, ca. 1455-ca. 1509

5008. Daun, Berthold. Adam Krafft und die Künstler seiner Zeit. Berlin, Hertz, 1897.

5009. Schwemmer, Wilhelm. Adam Kraft. Nürnberg, Carl, 1958.

5010. Stern, Dorothea. Der Nürnberger Bildhauer Adam Kraft, Stilentwicklung und Chronologie seiner Werke. Strassburg, Heitz, 1916. (Studien zur deutschen Kunstgeschichte, 191).

5011. Wanderer, Friedrich. Adam Krafft und seine Schule, 1490-1507. [Text in German, French and English]. Nürnberg, Schrag, 1868.

KRAFT, ADAM see KRAFFT, ADAM

KRAMSKOI, IVAN NIKOLAEVICH, 1837-1887

5012. Davydova, Alla S. Kramskoi. Moskva, Iskusstvo, 1962.

5013. Goldshtein, Sofia N. Ivan Nikolaevich Kramskoi, zhizn' i tvorchestvo. Moskva, Iskusstvo, 1965.

5014. Kramskoi, Ivan N. Pis'ma. 2 v. [Moskva], Gosudarstvennoe izdatel'stvo izobrazitel'nykh iskusstvo, 1937.

5015. Kurochkina, Tatiana I. Ivan Nikolaevich Kramskoi. Moskva, Izobrazitel'noe iskusstvo, 1980.

5016. Lapunova, Nina F. Ivan Nikolaevich Kramskoi, monograficheskii ocherk. Moskva, Iskusstvo, 1964.

5017. Stasiv, V., ed. Ivan Nikolaevich Kramskoi; ego zhizn', perepiska, i khudozhestvennoe kriticheskie stat'i, 1837-1887. S. Petersburg, Suvorin, 1888.

KRICKE, NORBERT, 1922-

5018. Morschel, Jürgen. Norbert Kricke. Stuttgart, Hatje, 1976.

5019. Museum of Modern Art (New York). Norbert Kricke. [March 2-April 2, 1961]. New York, Museum of Modern Art, 1961.

5020. Thwaites, John A. Kricke. New York, Abrams, 1964.

5021. Trier, Eduard. Norbert Kricke. Recklinghausen, Bongers, 1963. (Monographien zur rheinisch-westfälischen Kunst der Gegenwart, 28).

KUNIYOSHI

5022. Wilhelm-Lehmbruck-Museum der Stadt Duisberg/Städtische Kunsthalle Düsseldorf. **Norbert Kricke.** [June 28-August 31, 1975]. Duisberg/Düsseldorf, Museum/Kunsthalle, 1975.

KU K'AI-CHIH, c. 345-405

5023. Chen, Shih-Hsiang. **Biography of Ku K'ai-chih.** Trans. and annotated by Chen Shih-Hsiang. Berkeley and Los Angeles, University of California Press, 1953. (University of California Institute of East Asiatic Studies, Chinese Dynastic Histories Translations, 2).

KUBIN, ALFRED, 1877-1959

5024. Bayerische Akademie der Schönen Künste (Munich). **Alfred Kubin, 1877-1959.** 26. Juni bis 9. Oktober 1964. München, Bayerische Akademie der Schönen Künste, 1964.

5025. Bisanz, Hans. **Alfred Kubin; Zeichner, Schriftsteller und Philosoph.** München, Spangenberg, 1977.

5026. Bredt, Ernst W. **Alfred Kubin.** München, Schmidt, 1922.

5027. Breicha, Otto, ed. **Alfred Kubin Weltgeflecht, ein Kubin-Kompendium; Schriften und Bilder zu Leben und Werk.** München, Spangenberg, 1978.

5028. Esswein, Hermann. **Alfred Kubin, der Künstler und sein Werk.** München, Müller, [1911].

5029. Horodisch, Abraham. **Alfred Kubin Taschenbibliographie.** Amsterdam, Erasmus, 1962.

5030. _____, ed. **Alfred Kubin, book illustrator.** New York, Aldus, 1950.

5031. Kubin, Alfred. **Aus meinem Leben.** Ed. by Ulrich Riemerschmidt. München, Spangenberg, 1974.

5032. _____. **Aus meiner Werkstatt.** Ed. by Ulrich Riemerschmidt. München, Nymphenburger, 1973.

5033. _____. **Die wilde Rast; Alfred Kubin in Waldhäuser.** Briefe an Reinhold und Hanne Koeppel. Ed. by Walter Boll. München, Nymphenburger, 1972.

5034. Kunstgeschichtliches Institut der Johannes Gutenberg-Universität Mainz. **Handzeichnungen, Aquarelle und Druckgraphik von Alfred Kubin, 1877-1959.** [Text by Friedrich Gerke]. 2. Dezember 1964-10. Januar 1965. Mainz, Kunstgeschichtliches Institut, 1964. (Kleine Schriften der Gesellschaft für Bildende Kunst in Mainz, 24).

5035. Kunstsammlung der Universität Göttingen. **Alfred Kubin; Mappenwerke, Bücher, Einzelblätter aus der Sammlung Hedwig und Helmut Goedeckemeyer.** [January 20-March 30, 1980]. Göttingen, Kunstgeschichtliches Seminar der Universität Göttingen, 1980.

5036. Marks, Alfred. **Der Illustrator Alfred Kubin, Gesamtkatalog seiner Illustrationen und buchkünstlerischen Arbeiten.** München, Spangenberg, 1977. (CR).

5037. Mitsch, Erwin. **Alfred Kubin, Zeichnungen.** Salzburg, Galerie Welz, 1967.

5038. Müller-Thalheim, Wolfgang K. **Erotik und Dämonie im Werk Alfred Kubins, eine psychopathologische Studie.** München, Nymphenburger, 1970.

5039. Raabe, Paul, ed. **Alfred Kubin; Leben, Werk, Wirkung.** Hamburg, Rowohlt, 1957.

5040. Rosenberger, Ludwig. **Wanderungen zu Alfred Kubin, aus dem Briefwechsel.** München, Heimeran, 1969.

5041. Schmidt, Paul F. **Alfred Kubin.** Leipzig, Klinkhardt & Biermann, 1924. (Junge Kunst, 44).

5042. Schmied, Wieland. **Der Zeichner Alfred Kubin.** Salzburg, Residenz, 1967.

5043. Schneditz, Wolfgang. **Alfred Kubin.** Wien, Rosenbaum, 1956.

5044. Staatliche Kunsthalle Baden-Baden. **Alfred Kubin, das zeichnerische Frühwerk bis 1904.** 1. April bis 30. Mai 1977. Baden-Baden, Staatliche Kunsthalle, 1977.

KUEPPER, CHRISTIAN E. M. see DOESBURG, THEO VAN

KUHN, WALT, 1877-1949

5045. Adams, Philip R. **Walt Kuhn, painter; his life and work.** Columbus, Ohio, Ohio State University Press, 1978. (CR).

5046. Bird, Paul. **Fifty paintings by Walt Kuhn.** New York, Studio, 1940.

5047. Kuhn, Walt. **The story of the Armory show.** New York, Kuhn, 1938.

5048. University of Arizona Art Gallery (Tucson, Ariz.). **Painter of vision, a retrospective exhibition of oils, watercolors, and drawings by Walt Kuhn, 1877-1949.** Feb. 6-March 31, [1966]. Tucson, Ariz., Board of Regents of the Universities and State College of Arizona, 1966.

KULMBACH, HANS SUESS VON, 1480-1522

5049. Koelitz, Karl. **Hans Suess von Kulmbach und seine Werke.** Leipzig, Seemann, 1891. (Beiträge zur Kunstgeschichte, neue Folge, 12).

5050. Stadler, Franz. **Hans von Kulmbach.** Wien, Schroll, 1936.

5051. Winkler, Friedrich. **Hans von Kulmbach, Leben und Werk eines fränkischen Künstlers der Dürerzeit.** [Kulmbach], Staatsarchiv Kulmbach, 1959. (Die Plassenburg, Schriften für Heimatforschung und Kulturpflege in Ostfranken, 14).

5052. _____. **Die Zeichnungen Hans Süss von Kulmbachs und Hans Leonhard Schäufeleins.** Berlin, Deutscher Verein für Kunstwissenschaft, 1942.

KUNIYOSHI, UTAGAWA, 1798-1861

5053. Robinson, Basil W. **Kuniyoshi.** London, HMSO, 1961.

5054. _____. **Kuniyoshi, the warrior prints.** Ithaca, N.Y., Cornell University Press/London, Phaidon, 1983.

151

5055. Speiser, Werner. **Kuniyoshi.** Bad Wildungen, Siebenberg, 1969.

5056. Springfield Museum of Fine Arts (Springfield, Mass.). **Utagawa Kuniyoshi.** Springfield, Mass., Springfield Library and Museums Association, 1980.

KUNIYOSHI, YASUO, 1893-1953

5057. Goodrich, Lloyd. **Yasuo Kuniyoshi.** New York, Whitney Museum of American Art/Macmillan, 1948.

KUPECKY, JAN, 1667-1740

5058. Dvořák, František. **Kupecký, the great baroque portrait painter.** Trans. by. Hedda Stránská. Prague, Artia, [1956].

5059. Nyári, Alexander. **Der Porträtmaler Johann Kupetzky, sein Leben und seine Werke.** Wien, Hartleben, 1889.

5060. Šafařík, Eduard. **Joannes Kupezky, 1667-1740.** Prague, Orbis, 1928.

KUPELWIESER, LEOPOLD, 1796-1862

5061. Feuchtmüller, Rupert. **Leopold Kupelwieser und die Kunst der österreichischen Spätromantik.** Wien, Österreichischer Bundesverlag für Unterricht, Wissenschaft und Kunst, 1970.

KUPEZKY, JOHANN see KUPECKY, JAN

KUPKA, FRANK see KUPKA, FRANTIŠEK

KUPKA, FRANTIŠEK, 1871-1957

5062. Arnold-Grémilly, Louis. **Frank Kupka.** Paris, Povolozky, 1922.

5063. Cassou, Jean et Fédit, Denise. **Kupka.** Paris, Tisné, 1964.

5064. Galerie Gmurzynska (Cologne). **Frank Kupka.** Februar-April 1981. [Text in German and English]. Köln, Galerie Gmurzynska, 1981.

5065. Solomon R. Guggenheim Museum (New York). **Frantisek Kupka, 1871-1957; a retrospective.** [May 1975]. New York, Guggenheim Foundation, 1975.

5066. Vachtová, Ludmila. **Frank Kupka, pioneer of modern art.** Trans. by Zdenek Lederer. New York, McGraw-Hill, 1968. (CR).

LABILLE-GUIARD, ADÉLAÏDE, 1749-1803

5067. Passez, Anne M. **Adélaïde Labille-Guiard, 1749-1803; biographie et catalogue raisonné de son oeuvre.** Paris, Arts et Métiers Graphiques, 1973. (CR).

5068. Portalis, Roger. **Adélaïde Labille-Guiard.** Paris, Petit, 1902.

LACHAISE, GASTON, 1882-1935

5069. Gallatin, Albert E. **Gaston Lachaise.** New York, Dutton, 1924.

5070. Kramer, Hilton, et al. **The sculpture of Gaston Lachaise.** New York, Eakins Press, 1967.

5071. Museum of Modern Art (New York). **Gaston Lachaise, retrospective exhibition.** January 30-March 7, 1935. [Text by Lincoln Kirstein]. New York, Museum of Modern Art, 1935.

5072. Nordland, Gerald. **Gaston Lachaise, the man and his work.** New York, Braziller, 1974.

5073. Whitney Museum of American Art (New York). **Gaston Lachaise, a concentration of works from the permanent collection.** March 5-April 27, 1980. New York, Whitney Museum of American Art, 1980.

LA FARGE, JOHN, 1835-1910

5074. Cortissoz, Royal. **John La Farge, a memoir and a study.** Boston/New York, Houghton Mifflin, 1911. (Reprint: New York, Da Capo, 1971).

5075. La Farge, John. **An artist's letter from Japan.** New York, Century, 1897.

5076. _____. **Considerations on painting; lectures given in the year 1893 at the Metropolitan Museum of New York.** New York, Macmillan, 1895.

5077. Metropolitan Museum of Art (New York). **An exhibition of the work of John La Farge.** March 23 to April 26, 1936. New York, Metropolitan Museum of Art, 1936.

5078. Waern, Cecilia. **John La Farge, artist and writer.** London, Seeley/New York, Macmillan, 1896. (Portfolio Monographs, 26).

LAFRENSEN, NICOLAS, 1737-1807

5079. Bibliothèque Nationale (Paris). **Lavreince; Nicolas Lafrensen, peintre suédois, 1737-1807.** Mai-juin, 1949. Paris, Bibliothèque Nationale, 1949.

5080. Bocher, Emmanuel. **Nicholas Lavreince, catalogue raisonné des estampes.** Paris, Librairie des Bibliophiles, 1874. (Les gravures françaises du XVIIIe siècle, 2). (CR).

5081. Levertin, Oscar I. **Nicolas Lafrensen d. y. och forbindelserna mellan svensk och fransk målarkonst på 1700 -- talet, konsthistorisk studie.** Stockholm, Bonnier, 1910. 2 ed.

5082. Wennberg, Bo G. **Niclas Lafrensen, den yngre.** Malmö, Allhem, 1947.

LA FRESNAYE, ROGER de, 1885-1925

5083. Allard, Roger. **R. de La Fresnaye.** Paris, Editions de la Nouvelle Revue Française, 1922.

5084. Cogniat, Raymond [and] George, Waldemar. **Oeuvre complète de Roger de la Fresnaye.** Paris, Rivarol, 1950.

5085. Gaffé, René. **Roger de La Fresnaye.** Bruxelles, Editions des Artistes, 1956.

5086. Nebelthau, Eberhard. **Roger de La Fresnaye.** Paris, Montaignac, 1935.

5087. Seligman, Germain. **Roger de La Fresnaye.** Greenwich, Conn., New York Graphic Society, 1969. (CR).

LALIQUE, RENE, 1860-1945

5088. Barten, Sigrid. **René Lalique; Schmuck und Objets d'art, 1890-1910. Monographie und Werkkatalog.** München, Prestel, 1977. (CR). (Materialen zur Kunst des 19. Jahrhunderts, 22).

5089. Geffroy, Gustave. **René Lalique.** Paris, Mary, 1922.

5090. McClinton, Katharine M. **Lalique for collectors.** New York, Scribner, 1975.

5091. Percy, Christopher V. **The glass of Lalique, a collector's guide.** London, Studio Vista, 1977.

LAMBERTI, NICCOLO, d. 1451

PIERO, fl. 1393-1437

5092. Goldner, George R. **Niccolò and Piero Lamberti.** New York and London, Garland, 1978.

5093. Salmi, Mario. **La vita di Niccolò di Piero, scultore e architetto aretino.** Arezzo, Presso gli Amici dei Monumenti, 1910.

LAMI, EUGENE LOUIS, 1800-1890

5094. Lemoisne, Paul-André. **Eugène Lami, 1800-1890.** Paris, Goupil, 1912.

5095. _____. **L'oeuvre d'Eugène Lami (1800-1890); lithographies, dessins, aquarelles, peintures.** Essai d'un catalogue raisonné. Paris, Champion, 1914. (CR).

LANCRET, NICOLAS, 1690-1743

5096. Ballot de Sovot. **Eloge de Lancret, peintre du roi [1743].** Accompagné de diverses notes sur Lancret, de pièces inédites et du catalogue de ses tableaux et de ses estampes. Réunis et publiés par J. J. Guiffrey. Paris, Baur, [1874]. (Collection de travaux sur l'art français, 5).

5097. Bocher, Emmanuel. **Nicolas Lancret.** Paris, Librairie des Bibliophiles, 1877. (CR). (Les gravures françaises du XVIIIe siècle, 4).

5098. Wildenstein, Georges. **Lancret, biographie et catalogue critique.** Paris, Servant, 1924.

LANDSEER, EDWIN HENRY, 1802-1873

5099. Dafforne, James. **Pictures by Sir Edwin Landseer, Royal Academician; with descriptions and a biographical sketch of the painter.** London, Virtue, [1874].

5100. Hurll, Estelle M. **Landseer, a collection of pictures with introduction and interpretation.** Boston, Houghton Mifflin, 1901. (Riverside Art Series, 9).

5101. Lennie, Campbell. **Landseer, the Victorian paragon.** London, Hamilton, 1976.

5102. Manson, James A. **Sir Edwin Landseer, R. A.** London, Scott/New York, Scribner, 1902.

5103. Monkhouse, William C. **The works of Sir Edwin Landseer, R. A., with a history of his art-life.** London, Virtue, 1879.

5104. Philadelphia Museum of Art. **Sir Edwin Landseer.** October 25, 1981-January 3, 1982. [Text by Richard Ormond and Joseph Rishel]. Philadelphia, Philadelphia Museum of Art, 1981.

5105. Scott, McDougall. **Sir Edwin Landseer, R. A.** London, Bell, 1903.

5106. Stephens, Frederick. **Sir Edwin Landseer.** London, Sampson Low, 1881. 3 ed.

5107. [Sweetser, Moses F.]. **Landseer.** Boston, Houghton, Osgood, 1879.

LANE, FITZ HUGH, 1804-1865

5108. Cape Ann Historical Association (Gloucester, Mass.). **Paintings and drawings by Fitz Hugh Lane.** Gloucester, Mass., Cape Ann Historical Association, 1974.

5109. Wilmerding, John. **Fitz Hugh Lane.** New York, Praeger, 1971.

LANGE, DOROTHEA, 1895-1965

5110. Heyman, Therese T., et al. **Celebrating a collection: the work of Dorothea Lange.** Oakland, Calif., The Oakland Museum, 1978.

5111. Lange, Dorothea. **Dorothea Lange looks at the American country woman; a photographic essay with a commentary by Beaumont Newhall.** Fort Worth, Tex., Amon Carter Museum of Western Art, 1967.

5112. _____. **Dorothea Lange; photographs of a lifetime.** With an essay by Robert Coles. Millerton, N.Y., Aperture, 1982.

5113. _____ [and] Mitchell, Margaretta K. **To a cabin.** New York, Grossman, 1973.

5114. _____ and Taylor, Paul S. **An American exodus; a record of human erosion.** New York, Reynal & Hitchcock, 1939. (Reprint: New York, Arno Press, 1975).

5115. Levin, Howard M. and Northrup, Katherine, eds. **Dorothea Lange: Farm Security Administration photographs [from the Library of Congress], 1935-1939.** With writings by Paul S. Taylor. 2 v. Glencoe, Ill., Text-Fiche Press, 1980.

5116. Meltzer, Milton. **Dorothea Lange, a photographer's life.** New York, Farrar, Straus & Giroux, 1978.

5117. Museum of Modern Art (New York). **Dorothea Lange.** [Text by George P. Elliott]. New York, Museum of Modern Art, 1966; distributed by Doubleday, Garden City, N.Y.

5118. Ohrn, Karin B. **Dorothea Lange and the documentary tradition.** Baton Rouge, La., Louisiana State University Press, 1980.

LANGHANS, CARL GOTTHARD, 1732-1808

5119. Hinrichs, Walther T. **Carl Gotthard Langhans, ein schlesischer Baumeister, 1733-1808.** Strassburg, Heitz, 1909. (Studien zur deutschen Kunstgeschichte, 116).

LANSERE, EVGENII EVGENEVICH, 1875-1946

5120. Borovskii, Aleksandr Davydovich. **Evgenii Evgen'evich Lansere.** Leningrad, Khudozhnik RSFSR, 1975.

5121. Podobedova, O. I. **Evgenii Evgen'evich Lansere, 1875-1946.** Moskva, Sovetskii Khudozhnik, 1961.

LAPICQUE, CHARLES RENE, 1898-

5122. Balanci, Bernard [and] Auger, Elmina. **Charles Lapicque, catalogue raisonné de l'oeuvre peint et de la sculpture.** Paris, Mayer, 1972. (CR).

5123. _____ et Blache, Gérard. **Catalogue raisonné de l'oeuvre gravé de Charles Lapicque.** Paris, Amateur, 1982. (CR).

5124. Centre National d'Art et de Culture Georges Pompidou, Musée National d'Art Moderne (Paris). **Les dessins de Lapicque au Musée National d'Art Moderne.** 1 mars-23 avril 1978. [Paris], Centre National d'Art et de Culture Georges Pompidou, 1978.

5125. Lapicque, Charles. **Dessins de Lapicque.** 3 v. [Vol. 1: La figure. Texte de Charles Estienne. Vol. 2: Les chevaux. Texte de Jean Guichard-Meili. Vol. 3: La mer. Texte de Jean Lescure]. Paris, Galanis, 1959-1964.

5126. _____. **Essais sur l'espace, l'art et la destinée.** Paris, Grasset, 1958.

5127. Lescure, Jean. **Lapicque.** Paris, Galanis, 1956.

LARDERA, BERTO, 1911-

5128. Jianou, Ionel. **Lardera.** Paris, Arted, 1968. (CR).

5129. Kunstverein Hannover. **Berto Lardera.** 24. April bis 6. Juni 1971. Hannover, Kunstverein Hannover, 1971.

5130. Seuphor, Michel. **Berto Lardera.** [Text in French, English and German]. Neuchâtel, Editions du Griffon, 1960.

5131. Wilhelm-Lehmbruck-Museum der Stadt Duisburg. **Berto Lardera; Plastiken, Collagen, Graphiken.** 9. Mai bis 20. Juni 1976. Duisburg, Wilhelm-Lehmbruck Museum, 1976.

LARGILLIERRE, NICOLAS de, 1656-1746

5132. Pascal, Georges. **Largillierre.** Paris, Les Beaux-Arts, 1928.

5133. Rosenfeld, Myra N. **Largillierre and the eighteenth-century portrait.** [Catalogue of an exhibition, Montreal Museum of Fine Arts, September 19 to November 15, 1981]. Montreal, Montreal Museum of Fine Arts, 1982.

LARIONOV, MIKHAIL, 1881-1964

5134. Arts Council of Great Britain. **A retrospective exhibition of paintings and designs for the theatre; Larionov and Goncharova.** [Leeds, City Art Gallery, 9-30 September, 1961, et al.]. London, Arts Council, 1961.

5135. Chamot, Mary. **Goncharova.** Paris, Bibliothèque des Arts, 1972.

5136. Eganbiuri, Eli. **Natalia Goncharova, Mikhail Larionov.** Moskva, Münster, 1913.

5137. George, Waldemar. **Larionov.** Paris, Bibliothèque des Arts, 1966.

5138. Musée d'Ixelles (Bruxelles). **Retrospective Larionov, Gontcharova.** 29 avril au 6 juin 1976. [Bruxelles, Musée d'Ixelles, 1976].

5139. Musée Toulouse-Lautrec (Albi). **Michel Larionov et son temps.** Juin-septembre 1973. [Albi, Musée Toulouse-Lautrec, 1973].

5140. Parnakh, Valentin. **Gontcharova [et] Larionov; l'art décoratif théâtral moderne.** Paris, Edition La Cible, 1919.

LARSEN, JOHANNES, 1867-1961

5141. Jensen, Johannes V. **Johannes Larsen og hans billeder; med et kapitel af hans erindringer.** København, Gyldendal, 1947. 2 ed.

5142. La Cour, Tage. **Johannes Larsen, tegninger og grafik.** [København], Selskabet Bogvennerne, [1963].

5143. _____ and Madsen, Herman. **Johannes Larsen tegninger.** København, Gyldendal, 1938.

5144. _____ and Marcus, Aage, eds. **En hilsen til Johannes Larsen på 80 årsdagen.** København, Glydendal, 1947.

5145. Madsen, Herman. **Johannes Larsen.** København, Jensen, 1937.

5146. Marcus, Aage. **Maleren Johannes Larsen, en mindebog.** København, Gyldendal, 1962.

5147. Mentze, Ernst. Johannes Larsen, kunstnerens erindringer; med biografiske oplysninger, noter og kommentarer. København, Berlingske Forlag, 1955.

5148. Rasmussen, Holger M. Johannes Larsens grafiske arbejder, en illustreret fortegnelse. København, Fischer, 1938.

5149. Vinding, Ole. Med Johannes Larsen i naturen; illustreret af kunstneren. [København], Munksgaard, [1957].

LARSSON, CARL OLAF, 1853-1919

5150. Alfons, Harriet, [and] Alfons, Sven, eds. Carl Larsson skildrad av honom själv i text och bilder. Stockholm, Bonniers, 1952.

5151. Frieberg, Axel. Karin, en bok om Carl Larssons hustru. Stockholm, Bonniers, 1967.

5152. Kruse, John. Carl Larsson. Wien, Gesellschaft für Vervielfältigende Kunst, 1905.

5153. Larson, Carl O. Das Haus in der Sonne. Königstein im Taunus, Langewiesche, 1909. (Die Blauen Bücher).

5154. _____. Jag. Stockholm, Bonniers, 1953.

5155. Lindwall, Bo. Carl Larsson och Nationalmuseum. Stockholm, Rabén & Sjögren, 1969. (Årsbok för Svenska statens konstsamlingar, 16).

5156. Nordensvan, Georg. Carl Larsson. 2 v. Stockholm, Norstedt, 1920-1. (Sveriges allmänna konstförenings publikation, 29-30).

5157. Zweigbergk, Eva von. Hemma hos Carl Larssons. Stockholm, Bonniers, 1968.

LASTMAN, PIETER, 1583-1633

5158. Freise, Kurt. Pieter Lastman, sein Leben und sein Kunst. Leipzig, Klinkhardt & Biermann, 1911. (Kunstwissenschaftliche Studien, 5).

LA TOUR, GEORGES DUMESNIL DE, 1593-1652

5159. Arland, Marcel [and] Marsan, Anna. Georges de La Tour. Paris, Editions du Dimanche, 1953.

5160. Bloch, Vitale. Georges de La Tour, een beschouwing over zijn werk voorafgegaan door een catalogus van zijn oeuvre. Amsterdam, de Bussy, 1950.

5161. Bourgier, Annette M. La mystique de Georges de La Tour. Bruges, Desclée de Brouwer, 1963.

5162. Furness, S. M. Georges de La Tour of Lorraine, 1593-1652. London, Routledge & Kegan Paul, 1949.

5163. Jamot, Paul. Georges de La Tour. Paris, Floury, 1942.

5164. Musée de l'Orangerie (Paris). Georges de la Tour. 10 mai-25 septembre 1972. Paris, Editions des Musées Nationaux, 1972.

5165. Nicholson, Benedict and Wright, Christopher. Georges de La Tour. London, Phaidon, 1974. (CR).

5166. Ottani Cavina, Anna. La Tour. Milano, Fabbri, 1966. (I maestri del colore, 140).

5167. Pariset, François-Georges. Georges de La Tour. Paris, Laurens, 1948.

5168. Rosenberg, Pierre [and] Macé de l'Epinay, François. Georges de La Tour, vie et oeuvre. Fribourg, Office du Livre, 1973. (CR).

5169. Solesmes, François. Georges de La Tour. Lausanne, Clairefontaine, 1973.

5170. Thuillier, Jacques. L'opera completa di Georges de La Tour. Milano, Rizzoli, 1973. (Classici dell'arte, 65).

5171. Zolotov, Iurii K. Zhorzh de La Tur. Moskva, Iskusstvo, 1979.

LATOUR, IGNACE HENRI JEAN THEODORE, FANTIN
see FANTIN-LATOUR, IGNACE HENRI JEAN THEODORE

LA TOUR, MAURICE-QUENTIN DE, 1704-1788

5172. Besnard, Albert. La Tour, la vie et l'oeuvre de l'artiste. [With a] catalogue critique par Georges Wildenstein. Paris, Les Beaux-Arts, 1928. (CR).

5173. Bury, Adrian. Maurice-Quentin de La Tour, the greatest pastel portraitist. London, Skilton, 1971.

5174. Champfleury [pseud., Jules Fleury]. De La Tour. Paris, Didron/Dumoulin, 1855.

5175. Desmaze, Charles. Maurice-Quentin de La Tour, peintre du roi Louis XV. Paris, Levy, 1854.

5176. _____. Le reliquaire de La Tour; sa correspondance et son oeuvre. Paris, Leroux, 1874.

5177. Dréolle de Nodon, Ernest. Eloge biographique de M. Q. de La Tour. Paris, Amyot, 1856.

5178. Duplaquet, Charles-Vincent. Eloge historique de M. Q. de La Tour, peintre du roi. Saint-Quentin et Paris, Hautoy, 1788.

5179. Erhard, Hermann. La Tour, der Pastellmaler Ludwigs XV. München, Piper, 1917. (Französische Kunst, 1).

5180. Goncourt, Edmond et Goncourt, Jules de. La Tour, étude. Paris, Dentu, 1867.

5181. Lapauze, Henry. La Tour et son oeuvre au Musée de Saint-Quentin. 2 v. Paris, Goupil, 1905.

5182. Leroy, Alfred. Maurice-Quentin de La Tour et la société française du XVIII siècle. Paris, Michel, 1953.

5183. Nolhac, Pierre de. La vie et oeuvre de Maurice-Quentin de La Tour. Paris, Piazza, 1930.

5184. Patoux, Abel. Les dernières années de M.-Q. de La Tour. Saint-Quentin, Poëtte, 1880.

5185. Tourneux, Maurice. La Tour, biographie critique. Paris, Laurens, 1904.

LATROBE, BENJAMIN, 764-1820

5186. Carter, Edward C., II, ed. The Virginia journals of Benjamin Henry Latrobe, 1795-1798. 2 v. New Haven, Yale University Press, 1977.

5187. _____, et al., eds. The journals of Benjamin Henry Latrobe, 1799-1820: from Philadelphia to New Orleans. New Haven, Yale University Press, 1980.

5188. Hamlin, Talbot F. Benjamin Henry Latrobe. New York, Oxford, 1955.

5189. Latrobe, Benjamin H. Impressions respecting New Orleans; diary and sketches, 1818-1820. Edited, with an introduction and notes, by Samuel Wilson, Jr. New York, Columbia University Press, 1951.

5190. Norton, Paul F. Latrobe, Jefferson and the National Capital. New York/London, Garland, 1977.

5191. Stapleton, Darwin H., ed. The engineering drawings of Benjamin Henry Latrobe. New Haven, Yale University Press, 1980.

LAURANA, FRANCESCO, 1430-1502

5192. Burger, Fritz. Francesco Laurana, eine Studie zur italienischen Quattrocentoskulptur. Strassburg, Heitz, 1907. (Kunstgeschichte des Auslandes, 50).

5193. Chiarini, Marco. Francesco Laurana. Milano, Fabbri, 1966. (I maestri della scultura, 47).

5194. Rolfs, Wilhelm. Franz Laurana. 2 v. Berlin, Bong, 1907.

LAURENCIN, MARIE, 1885-1956

5195. Allard, Roger. Marie Laurencin. Paris, Editions de la Nouvelle Revue Française, 1921. (Les peintres français nouveaux, 10).

5196. Day, George [pseud.]. Marie Laurencin. Paris, Editions du Dauphin, 1947.

5197. Gere, Charlotte. Marie Laurencin. New York, Rizzoli, 1977.

5198. Laurencin, Marie. Le carnet des nuits. Genève, Cailler, 1956. (Ecrits et documents de peintres, 12).

5199. Wedderkop, H. von. Marie Laurencin. Leipzig, Klinkhardt & Biermann, 1921. (Junge Kunst, 22).

LAURENS, HENRI, 1885-1954

5200. Arts Council of Great Britain. Henri Laurens, 1895 [i.e., 1885]-1954. [The Hayward Gallery, London, 19 May-27 June 1971]. London, Arts Council, 1971.

5201. Falcidia, Giorgio. Henri Laurens. Milano, Fabbri, 1966. (I maestri della scultura, 41).

5202. Grand Palais (Paris). Henri Laurens. Exposition de la donation aux Musées Nationaux. Mai-août 1967. Paris, Réunion des Musées Nationaux, 1967.

5203. Hofmann, Werner. The sculpture of Henri Laurens. With recollections of Henri Laurens by Daniel-Henry Kahnweiler. New York, Abrams, 1970.

5204. Laurens, Marthe, ed. Henri Laurens, sculpteur, 1885-1954. [Années 1915 à 1924]. Paris, [Bérès], 1955.

5205. Waldberg, Patrick. Henri Laurens ou la femme placée en abîme. Paris, Le Sphinx-Veyrier, 1980.

LAVERY, SIR JOHN, 1856-1941

5206. Lavery, John. The life of a painter. Boston, Little, Brown, 1940.

5207. Shaw-Sparrow, Walter. John Lavery and his work. London, Kegan Paul, [1911].

LAVREINCE, NICOLAS see LAFRENSEN, NICOLAS

LAWRENCE, JACOB ARMSTEAD, 1917-

5208. Brown, Milton W. Jacob Lawrence. New York, Dodd, Mead, 1974.

5209. Detroit Institute of Arts. Jacob Lawrence: John Brown series. October 14-November 26, 1978. Detroit, Detroit Institute of Arts, 1978.

LAWRENCE, SIR THOMAS, 1769-1830

5210. Armstrong, Walter. Lawrence. New York, Scribner, 1913.

5211. Garlick, Kenneth. A catalogue of the paintings, drawings, and pastels of Sir Thomas Lawrence. London, Walpole Society, 1964. (Walpole Society, 39).

5212. _____. Sir Thomas Lawrence. London, Routledge & Kegan Paul, 1954.

5213. Goldring, Douglas. Regency portrait painter; the life of Sir Thomas Lawrence, P. R. A. London, Macdonald, 1951.

5214. Gower, Ronald S. Sir Thomas Lawrence. London, Goupil, 1900.

5215. Knapp, Oswald G. An artist's love story, told in the letters of Sir Thomas Lawrence, Mrs. Siddons, and her daughter. London, Allen, 1905.

5216. Layard, George S., ed. **Sir Thomas Lawrence's letter-bag, with recollections of the artist by Miss Elizabeth Croft.** London, Allen, 1906.

5217. Williams, D. E. **The life and correspondence of Sir Thomas Lawrence.** 2 v. London, Colburn & Bentley, 1831.

LAWSON, ERNEST, 1873-1939

5218. Berry-Hill, Henry and Berry-Hill, Sidney. **Ernest Lawson, American impressionist, 1873-1939.** With a foreword by Ira Glackens. Leigh-on-Sea, Lewis, 1968.

5219. Du Bois, Guy Pène. **Ernest Lawson.** New York, Whitney Museum of American Art, 1932.

5220. Price, Frederic N. **Ernest Lawson, Canadian-American.** New York, Ferargil, 1930.

5221. University of Arizona Museum of Art (Tucson, Ariz.). **Ernest Lawson, 1873-1939.** February 11-March 8, 1979. [Tucson, Ariz.], Arizona Board of Regents, 1979.

LEAL, JUAN DE VALDES
see VALDES LEAL, JUAN DE

LEAR, EDWARD, 1812-1888

5222. Arts Council of Great Britain. **Edward Lear, 1812-1888.** An exhibition of oil paintings, water-colours and drawings, books and prints, manuscripts, photographs and records. [Arts Council Gallery, London, 5 July-26 July, 1958]. London, Arts Council, 1958.

5223. Davidson, Angus. **Edward Lear, landscape painter and nonsense poet (1812-1888).** London, Murray, 1938. (Reprint: Port Washington, N.Y., Kennikat Press, 1968).

5224. Field, William B. **Edward Lear on my shelves.** München, privately printed [for William B. Field], 1933.

5225. Hofer, Philip. **Edward Lear.** New York, Oxford University Press, 1962.

5226. _____. **Edward Lear as a landscape draughtsman.** Cambridge, Mass., Belknap Press, 1967.

5227. Hyman, Susan. **Edward Lear's birds.** Introduction by Philip Hofer. New York, Morrow, 1980.

5228. Lear, Edward. **Journals of a landscape painter in Corsica.** London, Bush, 1870. (Reprint: London, Kimber, 1966).

5229. _____. **Journals of a landscape painter in Greece and Albania.** London, Bentley, 1851. (Reprint: London, Kimber, 1965).

5230. _____. **Journals of a landscape painter in Southern Calabria, &c.** London, Bentley, 1852. (Reprint: London, Kimber, 1964).

5231. Lehmann, John. **Edward Lear and his world.** [London], Thames and Hudson, 1977.

5232. Noakes, Vivien. **Edward Lear: the life of a wanderer.** London, Collins, 1968.

5233. Strachey, Constance, ed. **Later letters of Edward Lear.** London, Unwin, 1911.

5234. _____. **Letters of Edward Lear.** London, Unwin, 1907.

LE BRUN, CHARLES, 1619-1690

5235. Château de Versailles. **Charles Le Brun, 1619-1690; peintre et dessinatuer.** Juillet-octobre 1963. Paris, Ministère d'Etat Chargé des Affaires Culturelles, 1963.

5236. Fontaine, André. **Quid senserit Carolus Le Brun, de arte sua; thesim proponebat.** [Paris], Apud Fontemoing Bibliopolam, [1903].

5237. Genevay, Antoine. **Le style Louis XIV: Charles Le Brun, décorateur; ses oeuvres, son influence, ses collaborateurs et son temps.** Paris, Rouam, 1886.

5238. Jouin, Henri A. **Charles Le Brun et les arts sous Louis XIV, le premier peintre, sa vie, son oeuvre, ses écrits, ses contemporains, son influence, d'après le manuscrit de Nivelon et de nombreuses pièces inédits.** Paris, Imp. Nat., 1889.

5239. Le Brun, Charles. **Conférence . . . sur l'expression générale et particulière.** Paris, Picard, 1698. (English ed.: London, Smith, 1701).

5240. _____. **A series of lithographic drawings illustrative of the relation between the human physiognomy and that of the brute creation, with remarks on the system.** London, Carpenter, 1827.

5241. Marcel, Pierre. **Charles Le Brun.** Paris, Plon-Nourrit, [1909].

5242. Mignard, Paul. **Ode à M. Le Brun, premier peintre du roy.** Paris, Le Petit, 1683.

LE BRUN, MARIE LOUISE ELISABETH VIGEE
see VIGEE-LE BRUN, ELISABETH LOUISE

LECHTER, MELCHIOR, 1865-1937

5243. Hoffmann, Marguerite. **Mein Weg mit Melchior Lechter.** Amsterdam, Castrum Peregrini Presse, [1966]. (Castrum Peregrini, 72-74).

5244. Rapsilber, Maximilian. **Melchior Lechter.** Berlin, Wasmuth, 1904. (Berliner Kunst, 3).

5245. Raub, Wolfhard. **Melchior Lechter als Buchkünstler; Darstellung, Werkverzeichnis, Bibliographie.** Köln, Greven, 1969. (CR).

5246. Wissman, Jürgen. **Melchior Lechter.** Recklinghausen, Bongers, 1966. (Monographien zur rheinisch-westfälischen Kunst der Gegenwart, 19).

5247. Wolters, Friedrich. **Melchior Lechter.** München, Hanfstaengl, 1911.

LE CLERC, SÉBASTIEN, 1637-1714

5248. Jombert, Charles-Antoine. **Catalogue raisonné de l'oeuvre de Sébastian Le Clerc, chevalier romain, dessinateur & gravure du cabinet du Roi.** 2 v. Paris, [Jombert], 1774. (CR).

5249. LeClerc, Sébastien. **Pratique de la géométrie sur le papier et sur le terrain, avec un nouvel ordre et une méthode particulière.** Paris, [Quay des Augustins, à l'image Nostre-Dame], 1682. 2 ed.

5250. _____. **Traité d'architecture avec des remarques et des observations très-utiles pour les jeunes gens qui veulent s'appliquer à ce bel art.** Paris, Giffart, 1714. (English ed., trans. by Mr. Chambers: London, Bateman and Taylor, 1724).

5251. _____. **Traité de géométrie.** Paris, Gaubert, 1690.

5252. Meaume, Edouard. **Sébastien Le Clerc et son oeuvre.** Paris, Baur/Rapilly, 1877.

5253. Musée de Metz. **Sébastien Le Clerc (1637-1714); guide et catalogue de l'exposition organisée à l'occasion du III centenaire de sa naissance.** Nancy, Edition du Pays Lorrain, 1937.

LE CORBUSIER, 1887-1965

5254. Alazard, Jean. **Le Corbusier.** New York, Universe, 1960.

5255. Besset, Maurice. **Who was Le Corbusier?** Trans. by Robin Kemball. Genève, Skira, 1968; distributed by World, Cleveland.

5256. Blake, Peter. **Le Corbusier, architecture and form.** Baltimore, Penguin, 1960.

5257. Brooks, H. Allen, ed. **The Le Corbusier archives.** 32 v. [Titled variously]. New York/London, Garland [and] Paris, Fondation Le Corbusier, 1982-83.

5258. Choay, Françoise. **Le Corbusier.** New York, Braziller, 1960.

5259. Le Corbusier. **Almanach d'architecture moderne.** Paris, Crès, [1925].

5260. _____. **L'art décoratif d'aujord'hui.** Paris, Crès, [1925].

5261. _____. **Croisade ou le créspuscule des académies.** Paris, Crès, 1932.

5262. _____. **Un maison-un palais.** Paris, Crès, 1928.

5263. _____. **Last works.** Ed. by Willy Boesiger. Trans. by Henry A. Frey. [Text in French, English, and German]. New York/Washington, D.C., Praeger, 1970.

5264. _____. **Le Corbusier: textes et planches.** Préface de Maurice Jardot. Paris, Vincent, Fréal, 1960.

5265. _____. **Manière de penser l'urbanisme.** Paris, Denoël/Gonthier, [1977]. 2 ed. (English trans. of 1st ed. by Eleanor Levieux: New York, Grossman, 1971).

5266. _____. **The modulor: a harmonious measure to the human scale universally applicable to architecture and mechanics.** Trans. by Peter de Francia and Anna Bostock. Cambridge, Mass., Harvard University Press, 1954. 2 ed.

5267. _____. **Modulor 2: 1955 (Let the user speak next).** Continuation of The modulor, 1948. Trans. by Peter de Francia and Anna Bostock. Cambridge, Mass., Harvard University Press, 1956.

5268. _____. **My work.** Trans. by James Palmes. London, Architectural Press, 1960.

5269. _____. **The new world of space.** New York, Reynal & Hitchcock/Boston, Institute of Contemporary Art, 1948.

5270. _____. **Oeuvre complète.** 7 v. Ed. by Willy Boesiger et al. Zürich, Les Editions d'Architecture, 1930-71. (CR).

5271. _____. **Le poème électronique.** [Paris], Edition de Minuit, 1958.

5272. _____. **Précisions sur un état présent de l'architecture et de l'urbanisme.** Paris, Crès, 1930.

5273. _____. **Propose d'urbanisme.** Paris, Bourrelier, 1946. (English ed.: London, Architectural Press, 1947).

5274. _____. **Selected drawings.** Introduction by Michael Graves. London, Academy, 1981.

5275. _____. **Sketchbooks [1914-1964].** 4 v. Preface by André Wogenscky. Introduction by Maurice Besset. Notes by Françoise Franclieu. New York, Architectural History Foundation/Cambridge, Mass., MIT Press in collaboration with the Fondation Le Corbusier, Paris, 1981-82.

5276. _____. **Urbanisme.** Paris, Crès, [1925]. (Reprint: Paris, Arthaud, 1980; English ed. trans. by Frederick Etchells: **The city of tomorrow and its planning.** London, Rodka, 1929; new ed.: Cambridge, Mass., MIT Press, 1971.)

5277. _____. **Vers une architecture.** Paris, Crès, 1923. (English ed., trans. by Frederick Etchells: London, Architectural Press, 1927; new ed.: New York, Praeger, 1946).

5278. _____. **When the cathedrals were white; a journey to the country of timid people.** Trans. by Francis E. Hyslop, Jr. New York, Reynal & Hitchcock, 1947.

5279. [_____]. **Le Corbusier et P. Janneret.** 7 v. Paris, Morancé, [1927-1936].

5280. Cresti, Carlo. **Le Corbusier.** London, Hamlyn, 1970.

5281. Daria, Sophie. **Le Corbusier, sociologue de l'urbanisme.** Paris, Seghers, 1964.

5282. [L'Esprit Nouveau]. **L'Esprit Nouveau, Nos. 1-28.** 8 v. New York, Da Capo, 1968-69.

5283. Evenson, Norma. **Le Corbusier: the machine and the grand design.** New York, Braziller, 1969.

5284. Fusco, Renato De. **Le Corbusier, designer: furniture, 1929.** Woodbury, N.Y., Barron's, 1977.

5285. Gabetti, Roberto e Olmo, Carlo. **Le Corbusier e L'Esprit Nouveau.** Torino, Einaudi, 1975.

5286. Gardiner, Stephen. **Le Corbusier.** New York, Viking, 1974.

5287. Gauthier, Maximilien. **Le Corbusier ou l'architecture au service de l'homme.** Paris, Denoël, 1944.

5288. Gerosa, Pier G. **Le Corbusier--urbanisme et mobilité.** Basel/Stuttgart, Birkhäuser, 1978. (Studien aus dem Institut für Geschichte und Theorie der Architektur, 3).

5289. Girsberger, Hans. **Im Umgang mit Le Corbusier--mes contacts avec Le Corbusier.** [Text in German and French]. Zürich, Editions d'Architecture Artemis, 1981.

5290. Gresleri, Giuliano, et al. **L'esprit nouveau: Parigi-Bologna; costruzione e ricostruzione di un prototipo dell'architettura moderna.** Milano, Electa, 1979.

5291. Guiton, Jacques, ed. **The ideas of Le Corbusier on architecture and urban planning.** Trans. by Margaret Guiton. New York, Braziller, 1981.

5292. Hervé, Lucien. **Le Corbusier, as artist, as writer.** Introduction by Marcel Joray. Trans. by Haakon Chevalier. Neuchâtel, Editions du Griffon, 1970.

5293. Jeanneret, Charles-Edouard [Le Corbusier]. **Etude sur le mouvement d'art décoratif en Allemagne.** La Chaux-de-Fonds, Haefel, 1912.

5294. Jencks, Charles. **Le Corbusier and the tragic view of architecture.** Cambridge, Mass., Harvard University Press, 1973.

5295. Jordan, Robert F. **Le Corbusier.** London, Dent, 1972.

5296. Kunsthaus Zürich. **Le Corbusier: Architektur, Malerei, Plastik, Wandteppiche.** 5. Juni-31. August 1957. Zürich, Kunsthaus, 1957.

5297. Moos, Stanislaus von. **Le Corbusier; elements of a synthesis.** Cambridge, Mass., MIT Press, 1979.

5298. Musée National d'Art Moderne (Paris). **Le Corbusier.** Novembre 1962-janvier 1963. Paris, Ministère d'Etat Chargé d'Affaires Culturelles, 1962.

5299. Papadaki, Stamo. **Le Corbusier, architect, painter, writer.** New York, Macmillan, 1948.

5300. Pawley, Martin. **Le Corbusier.** New York, Simon and Schuster, 1970.

5301. Perruchot, Henri. **Le Corbusier.** Paris, Editions Universitaires, 1958. (Témoins du XXᵉ siècle, 10).

5302. Petit, Jean. **Le Corbusier lui-même.** Genève, Rousseau, 1970.

5303. Sekler, Mary P. **The early drawings of Charles-Edouard Jeanneret (Le Corbusier), 1902-1908.** New York/London, Garland, 1977.

5304. Serenyi, Peter, ed. **Le Corbusier in perspective.** Englewood Cliffs, N.J., Prentice-Hall, 1975.

5305. Turner, Paul V. **The education of Le Corbusier.** New York/London, Garland, 1977.

5306. Walden, Russell, ed. **The open hand: essays on Le Corbusier.** Cambridge, Mass./London, MIT Press, 1977.

LEDOUX, CLAUDE NICOLAS, 1736-1806

5307. Christ, Yvan. **Projets et divagations de Claude-Nicolas Ledoux, architecte du Roi.** Paris, Editions du Minotaure, 1961.

5308. Gallet, Michel. **Claude-Nicolas Ledoux, 1736-1806.** Paris, Picard, 1980.

5309. Ledoux, Claude-Nicolas. **L'architecture considérée sous le rapport de l'art, des moeurs et de la législation.** Paris, [Ledoux], 1804. (Plates published in Paris by Daniel Ramée, 1847; both vols. reprinted by Fernand de Nobele, Paris, 1962).

5310. Levallée-Haug, Géneviève. **Claude-Nicolas Ledoux.** Paris/Strasbourg, Istra, 1934.

5311. Raval, Marcel H. **Claude-Nicolas Ledoux, 1736-1806.** Paris, Arts et Métiers Graphiques, 1946.

5312. Stoloff, Bernard. **L'affaire Claude-Nicolas Ledoux; autopsie d'un mythe.** Bruxelles/Liège, Mardaga, 1977. (Architecture + recherches, 7).

LEE, RUSSELL, 1903-

5313. Hurley, F. Jack. **Russell Lee, photographer.** Introduction by Robert Coles. Dobbs Ferry, N.Y., Morgan & Morgan, 1978.

LEECH, JOHN, 1817-1864

5314. Brown, John. **John Leech and other papers.** Edinburgh, Douglas, 1882.

5315. Chambers, Charles E. S. **A list of works containing illustrations by John Leech; a bibliography.** Edinburgh, Brown, 1892.

5316. Field, William B. **John Leech on my shelves.** München, privately printed [for William B. Field], 1930. (CR).

5317. Frith, William P. **John Leech, his life and work.** 2 v. London, Bentley, 1891.

5318. Grolier Club (New York). **Catalogue of an exhibition of the works of John Leech (1817-1864) held at the Grolier Club from January 22 until March 8, 1914.** New York, The Grolier Club, 1914.

5319. Kitton, Fred G. **John Leech, artist and humorist; a biographical sketch.** New edition, revised. London, Redway, 1884.

5320. Leech, John. Pictures of life & character from the collection of Mr. Punch. 5 v. London, Bradbury and Evans, 1854-1869.

5321. Tidy, Gordon. A little about Leech. London, Constable, 1931.

LE FAUCONNIER, HENRI VICTOR GABRIEL, 1881-1946

5322. Ridder, André de. Le Fauconnier. Bruxelles, Editions de l'Art Libre, 1919.

5323. Romains, Jules. Le Fauconnier. Paris, Seheur, 1927. (L'art et la vie, 3).

LEGER, FERNAND, 1881-1955

5324. Cassou, Jean et Leymarie, Jean. Fernand Léger; dessins et gouaches. Paris, Chêne, 1972.

5325. Cooper, Douglas. Fernand Léger et le nouvel espace. London, Lund Humphries/Genève-Paris, Editions des Trois Collines, 1949.

5326. Couturie, Marie A., et al. Fernand Léger; la forme humaine dans l'espace. Montréal, Les Editions de l'Arbre, 1945.

5327. de Francia, Peter. Fernand Léger. New Haven, Yale University Press, 1983.

5328. Delevoy, Robert L. Léger, biographical and critical study. Trans. by Stuart Gilbert. Genève, Skira, 1962; distributed by World, Cleveland. (The Taste of Our Time, 38).

5329. Descargues, Pierre. Fernand Léger. Paris, Cercle d'Art, 1955.

5330. Garaudy, Roger. Pour un réalisme du XXe siècle; dialogue posthume avec Fernand Léger. Paris, Grasset, 1968.

5331. George, Waldemar. Fernand Léger. Paris, Gallimard, 1929.

5332. Green, Christopher. Léger and the avant-garde. New Haven/London, Yale University Press, 1976.

5333. Jardot, Maurice. Léger. Paris, Hazan, 1956.

5334. Kuh, Katharine. Léger. Urbana, Ill., University of Illinois, 1953.

5335. Kunsthalle Köln. Fernand Léger, das figürliche Werk. 12. April bis 4. Juni 1978. Köln, Museen der Stadt Köln, 1978.

5336. Laugier, Claude et Richet, Michèle. Léger; oeuvres de Fernand Léger (1881-1955). Paris, Centre Georges Pompidou, Musée National d'Art Moderne, 1981. (CR).

5337. Léger, Fernand. Functions of painting. Trans. by Alexandra Anderson. Ed. and introd. by Edward F. Fry. New York, Viking, 1973.

5338. _____, et al. Entretien de Fernand Léger avec Blaise Cendrars et Louis Carré sur le paysage dans l'oeuvre de Léger. Paris, Carré, 1956.

5339. Le Noci, Guido. Fernand Léger: sa vie, son oeuvre, son rêve. Milano, Apollinaire, 1971. (Inchiostri dell'Apollinaire, 5).

5340. Musée des Arts Décoratifs, Palais du Louvre, Pavillon de Marsan (Paris). Fernand Léger, 1881-1955. Juin-octobre 1956. Paris, Musée des Arts Décoratifs, 1956.

5341. Raynal, Maurice. Fernand Léger, vingt tableaux. Paris, L'Effort Moderne, 1920.

5342. Saphire, Lawrence. Fernand Léger, the complete graphic work. New York, Blue Moon Press, 1978. (CR)

5343. Staatliche Kunsthalle Berlin. Fernand Léger, 1881-1965. 24. Oktober 1980 bis 7. Januar 1981. Berlin, Staatliche Kunsthalle, 1980.

5344. Tate Gallery (London). Léger and purist Paris. 18 November 1970-24 January 1971. London, Tate Gallery, 1970.

5345. Tériade, E. Fernand Léger. Paris, Cahiers d'Art, 1928.

5346. Verdet, André. Fernand Léger. Images de Robert Doisneau et Gilles Ehrmann. Genève, Kister, 1956.

5347. _____. Fernand Léger; le dynamisme pictural. Genève, Cailler, 1955.

LEGROS, ALPHONSE, 1837-1911

5348. Bénédite, Léonce. Alphonse Legros. Paris, Ollendorff, 1900.

5349. [Bliss, Frank E.]. A catalogue of the etchings, drypoints and lithographs by Professor Alphonse Legros (1837-1911) in the collection of Frank E. Bliss. With a preface by Campbell Dodgson. London, [printed for private circulation], 1923.

5350. Poulet-Malassis, Auguste [and] Thibaudeau, A. Catalogue raisonné de l'oeuvre gravé et lithographié de M. Alphonse Legros, 1855-1877. Paris, Baur, 1877. (CR).

LEHMBRUCK, WILHELM, 1881-1919

5351. Hoff, August. Wilhelm Lehmbruck. Berlin, Klinkhardt & Biermann, 1933. (Junge Kunst, 61/62).

5352. _____. Wilhelm Lehmbruck, Leben und Werk. Berlin, Rembrandt, 1961 (Die Kunst unserer Zeit, 13). (CR).

5353. National Gallery of Art (Washington, D.C.). The art of Wilhelm Lehmbruck. May 20-August 13, 1972. [Text by Reinhold Heller]. Washington, D.C., National Gallery of Art, 1972.

5354. Petermann, Erwin. Die Druckgraphik von Wilhelm Lehmbruck, Verzeichnis. Stuttgart, Hatje, 1964. (CR).

5355. Schubert, Dietrich. Die Kunst Lehmbrucks. Worms, Werner, 1981.

5356. Westheim, Paul. Wilhelm Lehmbruck. Berlin, Kiepenheuer, 1922. 2 ed.

5357. Wilhelm-Lehmbruck-Museum der Stadt Duisburg. **Hommage à Lehmbruck/Lehmbruck in seiner Zeit.** 25. Oktober-3. Januar 1982. Duisburg, Wilhelm-Lehmbruck-Museum, 1981.

LEIBL, WILHELM, 1844-1900

5358. Gronau, Georg. **Leibl.** Bielefeld/Leipzig, Velhagen & Klasing, 1901. (Künstler-Monographien, 50).

5359. Langer, Alfred. **Wilhelm Leibl.** Leipzig, Rosenheimer Verlagshaus, 1961. 2 ed.

5360. Mayr, Julius. **Wilhelm Leibl, sein Leben und sein Schaffen.** Berlin, Cassirer, 1919. 3 ed.

5361. Nasse, Hermann. **Wilhelm Leibl.** München, Schmidt, 1923.

5362. Römpler, Karl. **Wilhelm Leibl.** Dresden, Verlag der Kunst, 1955.

5363. Städtische Galerie im Lenbachhaus München. **Wilhelm Leibl und sein Kreis.** 25. Juli bis 29. September 1974. [Text ed. by Michael Petzet]. München, Prestel, 1974.

5364. Waldmann, Emil. **Wilhelm Leibl als Zeichner.** München, Prestel, 1943.

5365. _____. **Wilhelm Leibl: eine Darstellung seiner Kunst; Gesamtverzeichnis seiner Gemälde.** Berlin, Cassirer, 1914. (CR).

5366. Wallraf-Richartz-Museum (Köln). **Wilhelm Leibl; Gemälde, Zeichnungen, Radierungen.** 10.-31. März 1929. Berlin, Cassirer, 1929.

5367. Wolf, Georg J. **Leibl und sein Kreis.** München, Bruckmann, 1923.

LEIGHTON, FREDERICK (LORD STRETTON), 1830-1896

5368. Baldry, A. Lys. **Leighton.** London, Jack/New York, Stokes, [1908].

5369. Barrington, Mrs. Russell. **The life, letters and work of Frederic Leighton.** 2 v. New York, Macmillan, 1906.

5370. Gaunt, William. **Victorian Olympus.** London, Cape, 1975. Rev. ed.

5371. Lang, Leonora B. **Sir F. Leighton, president of the Royal Academy; his life and work.** London, Virtue/New York, International News Company, 1884. (The Art Annual, 1884).

5372. Ormond, Leonée and Ormond, Richard. **Lord Leighton.** New Haven/London, Yale University Press, 1975.

5373. Rhys, Ernest. **Frederic Lord Leighton, an illustrated record of his life and work.** London, Bell, 1900.

5374. Staley, Edgcumbe. **Lord Leighton of Stretton.** London, Scott/New York, Scribner's, 1906.

LEINBERGER, HANS, fl. 1511-1522

5375. Liedke, Volker. **Hans Leinberger; Marginalien zur künstlerischen und genealogischen Herkunft des grossen Landshuter Bildschnitzers.** München, Weber, 1979.

5376. Lill, Georg. **Hans Leinberger der Bildschnitzer von Landshut.** München, Bruckmann, 1942.

5377. Lossnitzer, Max. **Hans Leinberger: Nachbildungen seiner Kupferstiche und Holzschnitte.** Berlin, Cassirer, 1913. (Graphische Gesellschaft, 18).

5378. Thoma, Hans. **Hans Leinberger: seine Stadt, seine Zeit, sein Werk.** Regensburg, Pustet, 1979.

LELY, PETER, 1618-1680

5379. Baker, Charles H. **Lely and the Stuart portrait painters; a study of English portraiture before and after Van Dyck.** 2 v. London, Warner, 1912.

5380. Beckett, Ronald B. **Lely.** London, Routledge, 1951.

5381. Carlton House Terrace (London). **Sir Peter Lely, 1618-80.** 17 November 1978-18 March 1979. [Text by Sir Oliver Millar]. London, National Portrait Gallery, 1978.

LE MOYNE, JACQUES see LE MOYNE DE MORGUES, JACQUES

LEMOYNE, JEAN-BAPTISTE, 1704-1778

see also BOUCHER, FRANÇOIS

5382. Le Breton, Gaston. **Le sculpteur Jean-Baptiste Lemoyne et L'Académie de Rouen.** Paris, Plon, 1882.

5383. Réau, Louis. **Les Lemoyne; une dynastie de sculpteurs au XVIIIe siècle.** Paris, Les Beaux-Arts, 1927.

LE MOYNE DE MORGUES, JACQUES, d. 1588

5384. Hulton, Paul. **The work of Jacques Le Moyne de Morgues, a Huguenot artist in France, Florida and England.** 2 v. London, The Trustees of the British Museum, 1977.

5385. Le Moyne de Morgues, Jacques. **Narrative of Le Moyne, an artist who accompanied the French expedition to Florida under Laudonnière, 1564.** Trans. from the Latin of De Bry by Frederick B. Perkins. Boston, Osgood, 1875.

5386. Lorant, Stefan, ed. **The New World; the first pictures of America, made by John White and Jacques Le Moyne and engraved by Theodore De Bry.** New York, Duell, Sloan & Pearce, 1946.

LE NAIN, ANTOINE, 1588-1648

LOUIS, 1593-1648

MATHIEU, 1607-1677

5387. Champfleury [pseud., Jules Fleury]. **Les frères Le Nain.** Paris, Renouard, 1862.

LE NAIN

5388. Fierens, Paul. **Les Le Nain.** Paris, Floury, 1933.

5389. Grand Palais (Paris). **Les frères Le Nain.** 3 octobre 1978-
8 janvier 1979. [Text by Jacques Thuillier]. Paris,
Editions de la Réunion des Musées Nationaux, 1978.

5390. Jamot, Paul. **Les Le Nain; biographie critique.** Paris,
Laurens, 1929.

5391. Valabrègue, Antony. **Les frères Le Nain.** Paris, Baranger,
1904.

LENBACH, FRANZ VON, 1836-1904

5392. Mehl, Sonia. **Franz von Lenbach in der Städtischen Galerie
im Lenbachhaus München.** München, Prestel, 1980. (CR).
(Materialien zur Kunst des neunzehnten Jahrhunderts, 25).

5393. Reischl, Georg A. **Lenbach und seine Heimat.**
Schrobenhausen [Oberbayern], [Reischl], 1954.

5394. Rosenberg, Adolf. **Lenbach.** Bielefeld/Leipzig,
Velhagen & Klasing, 1898. (Künstler-Monographien, 34).

5395. Wichmann, Siegfried. **Franz von Lenbach und seine Zeit.**
Köln, DuMont Schauberg, 1973.

5396. Wyl, Wilhelm [pseud., Wilhelm Ritter von Wymetal]. **Franz
von Lenbach, Gespräche und Erinnerungen.** Stuttgart/
Leipzig, Deutsche Verlags-Anstalt, 1904.

L'ENFANT, PIERRE CHARLES, 1754-1825

5397. Caemmerer, H. Paul. **The life of Pierre Charles L'Enfant.**
Washington, D.C., National Republic Publishing Co., 1950.
(Reprint: New York, Da Capo, 1970).

5398. Kite, Elizabeth S. **L'Enfant and Washington.** Baltimore,
Johns Hopkins Press, 1929.

LE NÔTRE, ANDRÉ, 1613-1700

5399. Fox, Helen M. **André Le Nôtre, garden architect to kings.**
London, Batsford, 1963.

5400. Ganay, Ernest de. **André Le Nostre, 1613-1700.** Paris,
Vincent, Fréal, 1962.

5401. Guiffrey, Jules. **André LeNostre.** Paris, Laurens, 1912.

5402. Hazlehurst, F. Hamilton. **Gardens of illusion; the genius
of André Le Nostre.** Nashville, Tenn., Vanderbilt
University Press, 1980.

LEONARDO DA VINCI, 1452-1519

5403. Amoretti, Carlo. **Memorie storiche su la vita gli studi e
le opere di Lionardo da Vinci.** Milano, Giusti, Ferrario,
1804.

5404. Argan, Giulio C., et al. **Leonardo: la pittura.** Firenze,
Martello-Giunti, 1977.

5405. [Arte Lombarda, eds.]. **Leonardo; il Cenacolo.** Milano,
Arte Lombarda, 1982. (Arte Lombarda, nuova serie, 62).

5406. Baratta, Mario. **Curiosità Vinciane.** Torino, Bocca, 1905.
(Piccola biblioteca di scienze moderne, 103).

5407. _____. **Leonardo da Vinci ed i problemi della terra.**
Torino, Bocca, 1903.

5408. Beck, James. **Leonardo's rules of painting; an
unconventional approach to modern art.** New York, Viking,
1979.

5409. Belt, Elmer. **Manuscripts of Leonardo da Vinci; their
history, with a description of the manuscript editions in
facsimile.** Catalogue by Kate T. Steinitz with the
assistance of Margot Archer. Los Angeles, Elmer Belt
Library of Vinciana, 1948.

5410. Beltrami, Luca. **Documenti e memorie riguardanti la vita e
le opere di Leonardo da Vinci in ordine cronologico.**
Milano, Treves, 1919.

5411. Bérence, Fred. **Léonard de Vinci.** Paris, Somogy, 1965.
(Les plus grands, 10).

5412. Bode, Wilhelm von. **Studien über Leonardo da Vinci.**
Berlin, Grote, 1921.

5413. Bossi, Giuseppe. **Del Cenacolo di Leonardo da Vinci.**
Milano, Stamperia Reale, 1810.

5414. Bovi, Arturo. **Leonardo; filosofo, artista, uomo.** Milano,
Hoepli, 1952.

5415. Brasil, Jaime. **Leonardo da Vinci e o seu tempo.** Lisboa,
Portugália, 1959.

5416. Braunfels-Esche, Sigrid. **Leonardo da Vinci, das
anatomische Werk.** Stuttgart, Schattauer, 1961. 2 ed.

5417. Brion, Marcel. **Léonard de Vinci, génie et destinée.**
Paris, Michel, 1952.

5418. Brown, John W. **The life of Leonardo da Vinci with a
critical account of his works.** London, Pickering, 1828.

5419. Calder, Ritchie. **Leonardo and the age of the eye.** New
York, Simon & Schuster, 1970.

5420. Calvi, Gerolamo. **I manoscritti di Leonardo da Vinci dal
punto di vista cronologico storico e biografico.**
Bologna, Zanichelli, 1925. (Studi e testi vinciani, 6).

5421. Calvi, Ignazio. **L'architettura militare di Leonardo da
Vinci.** Milano, Libreria Lombarda, 1943.

5422. Campana, Adelemo. **Leonardo; la vita, il pensiero, i testi
esemplari.** Milano, Edizioni Accademia, 1973.

5423. Carotti, Giulio. **Leonardo da Vinci; pittore, scultore,
architetto.** Studio biografico-critico. Torino, Celanza,
1921.

5424. Carpiceci, Alberto C. **L'architettura di Leonardo: indagine
e ipotesi su tutta l'opera di Leonardo architetto.**
Firenze, Bonechi, 1978.

5425. Castelfranco, Giorgio. **Studi vinciana.** Roma, de Luca, 1966.

5426. Ceccarelli, Anna. **L'idea pedagogica di Leonardo da Vinci.** Roma, Loescher, 1914.

5427. Chastel, André, ed. **Léonard de Vinci par lui-même.** Textes choisis, traduits et présentés par André Chastel, précédés de la vie de Léonard par Vasari. Paris, Nagel, 1952. (English ed.: **The genius of Leonardo da Vinci.** Trans. by Ellen Callmann. New York, Orion Press, 1961).

5428. Clark, Kenneth. **The drawings of Leonardo da Vinci in the collection of Her Majesty the Queen at Windsor Castle,** revised with the assistance of Carlo Pedretti. 3 v. London, Phaidon, 1968. 2 ed. (CR).

5429. _____. **Leonardo da Vinci, an account of his development as an artist.** Cambridge, Cambridge University Press, 1939.

5430. Coleman, Marguerite. **Amboise et Léonard de Vinci à Amboise.** Préf. de Pierre Nolhac. Tours, Arrault, 1932.

5431. Colombo, Alfredo. **Ecco Leonardo.** Novara, Istituto Geografico de Agostini, 1952.

5432. [Comitato Nazionale per le Onoranze a Leonardo da Vinci nel Quinto Centenario della Nascita (1452-1952)]. **Leonardo, saggi e ricerche.** Roma, Istituto Poligrafico dello Stato, 1954.

5433. [Convegno di Studi Vinciani]. **Atti del convegno di studi vinciani, indetto dalla Unione Regionale delle province Toscane e dalle Università di Firenze, Pisa e Siena.** [Firenze/Pisa/Siena, 15-18 gennaio 1953]. Firenze, Olschki, 1953.

5434. Cook, Theodore A. **Leonardo da Vinci, sculptor.** London, Humphreys, 1923.

5435. D'adda, Gerolamo. **Leonardo da Vinci e la sua libreria; note di un bibliofilo.** Milano, Bernardini, 1873.

5436. Duhem, Pierre. **Etudes sur Léonard de Vinci.** [3 v., published separately]. Paris, Hermann, 1906-1913. (Reprint: Paris, de Nobele, 1955).

5437. Einem, Herbert von. **Das Abendmahl des Leonardo da Vinci.** Köln, Westdeutscher-Verlag, 1961.

5438. Eissler, Kurt R. **Leonardo da Vinci, psychoanalytic notes on the enigma.** London, Hogarth Press, 1962. (The International Psycho-analytical Library, 58).

5439. Feddersen, Hans. **Leonardo da Vincis Abendmahl.** Stuttgart, Urachhaus, 1975.

5440. Feldhaus, Franz M. **Leonardo der Techniker und Erfinder.** Jena, Diederichs, 1922.

5441. Firpo, Luigi. **Leonardo, architetto e urbanista.** Torino, Unione Tipografico-Editrice Torinese, 1963.

5442. Flora, Francesco. **Leonardo.** Milano, Mondadori, 1952. (Biblioteca moderna Mondadori, 279).

5443. [Fratelli Treves, editori]. **Leonardo da Vinci, conferenze fiorentine.** [Text by Edmondo Solmi, Luca Beltrami, Benedetto Croce, et al.] Milano, Treves, 1910.

5444. Freud, Sigmund. **Leonardo da Vinci; a psychosexual study of an infantile reminiscence.** Trans. by A. Brill. New York, Moffat, Yard, 1916.

5445. Friedenthal, Richard. **Leonardo, eine Bildbiographie.** München, Kindler, 1959.

5446. Fumagalli, Giuseppina. **Eros di Leonardo.** Milano, Garzanti, 1952.

5447. _____. **Leonardo iere e oggi.** Pisa, Nistri-Lischi, 1959. (Saggi di varia umanità, 28).

5448. Galbiati, Giovanni. **Dizionario Leonardesco; repertorio generale delle voci e cose contenute nel Codice Atlantico.** Milano, Hoepli, 1939.

5449. Gallenberg, Hugo G. von. **Leonardo da Vinci.** Leipzig, Fleischer, 1834.

5450. Gantner, Joseph. **Leonardos Visionen von der Sintflut und vom Untergang der Welt; Geschichte einer künstlerischen Idee.** Bern, Francke, 1958.

5451. Gault de Saint-Germain, Pierre M. **Vie de Leonard de Vinci,** suivie du catalogue de ses ouvrages dans les beaux-arts. Paris, Perlet, 1803.

5452. Giacomelli, Raffaele. **Gli scritti di Leonardo da Vinci sul volo.** Roma, Bardi, 1936.

5453. Giglioli, Odoardo H. **Leonardo; iniziazione alla conoscenza de lui e delle questioni vinciane.** Firenze, Arnaud, 1944.

5454. Gilles de la Tourette, François. **Léonard de Vinci.** Paris, Michel, 1932. (Les maîtres du Moyen Age et de la Renaissance, 8).

5455. Goldscheider, Ludwig, ed. **Leonardo da Vinci.** London, Phaidon/New York, Oxford University Press, 1964. 7 ed.

5456. Gould, Cecil H. **Leonardo: the artist and the non-artist.** Boston, New York Graphic Society, 1975.

5457. Gronau, Georg. **Leonardo da Vinci.** Trans. by Frederic Pledge. London, Duckworth/New York, Dutton, [1903].

5458. Grothe, Hermann. **Leonardo da Vinci als Ingenieur und Philosoph;** ein Beitrag zur Geschichte der Technik und der induktiven Wissenschaften. Berlin, Nicolaische Verlags-Buchhandlung, 1874.

5459. Guillerm, Jean-Pierre. **Tombeau de Léonard de Vinci; le peintre et ses tableaux dans l'écriture symboliste et décadente.** Lille, Presses Universitaires de Lille, 1981.

5460. Guillion, Aimé. **Le Cénacle de Léonard de Vinci, rendu aux amis des beaux-arts, dans le tableau qu'on voit aujourd'hui chez un citoyen de Milan, et qui étoit ci-devant dans le réfectoire de l'insigne chartreuse de Pavie.** Essai historique et psychologique. Milano, Dumolard, Artaria/Lyon, Maire, 1811.

5461. _____. **Sur l'ancien copie de la Cène de Léonard de Vinci** qu'on voit maintenant au Musée Royal; comparée à la plus célèbre de toutes, celle des Chartreux de Pavie; et à la copie récente d'après laquelle s'exécute à Milan, une mosaïque égale en dimentions à l'original. Paris, Normant, 1817.

5462. Heaton, Mrs. Charles W. [and] Black, Charles C. **Leonardo da Vinci and his works, consisting of a life of Leonardo da Vinci** [by Mrs. Heaton], **an essay on his scientific and literary works** [by Mr. Black] **and an account of his most important paintings.** London/New York, Macmillan, 1874.

5463. Heesvelde, François van. **Les signatures de Léonard de Vinci dans ses oeuvres.** Anvers, Blondé, 1962.

5464. Herzfeld, Marie. **Leonardo da Vinci; der Denker, Forscher und Poet.** Leipzig, Diederichs, 1904.

5465. Hevesy, André de. **Pèlerinage avec Léonard de Vinci.** Paris, Fermin-Didot, 1939.

5466. Heydenreich, Ludwig H. **Leonardo da Vinci.** 2 v. New York, Macmillan/Basel, Holbein, 1954.

5467. ———. **Leonardo: the Last Supper.** New York, Viking, 1974.

5468. ———. **Die Sakralbau-Studien Leonardo da Vincis.** München, Fink, 1971. 2 ed.

5469. Hildebrandt, Edmund. **Leonardo da Vinci, der Künstler und sein Werk.** Berlin, Grote, 1927.

5470. Hoerth, Otto. **Das Abendmahl des Leonardo da Vinci, ein Beitrag zur Frage seiner künstlerischen Rekonstruktion.** Leipzig, Hiersemann, 1907. (Kunstgeschichtliche Monographien, 8).

5471. Houssaye, Arsène. **Histoire de Léonard de Vinci.** Paris, Didier, 1876. 2 ed.

5472. Istituto di Studi Vinciani di Roma. **Per il IV° centenario della morte di Leonardo da Vinci, [2] maggio [1919].** [Edited by Mario Cermenati]. Bergamo, Istituto Italiano d'Arti Grafiche, 1919.

5473. Jordan, Max. **Das Malerbuch des Lionardo da Vinci; Untersuchung der Ausgaben und Handschriften.** Leipzig, Seemann, 1873.

5474. Kemp, Martin. **Leonardo da Vinci; the marvelous works of nature and man.** Cambridge, Mass., Harvard University Press, 1981.

5475. Klaiber, Hans. **Leonardostudien.** Strassburg, Heitz, 1907. (Zur Kunstgeschichte des Auslandes, 56).

5476. Knapp, Fritz. **Leonardo da Vinci.** Bielefeld/Leipzig, Velhagen & Klasing, 1938. (Künstler-Monographien, 33).

5477. Koenig, Frédéric [pseud., Just J. E. Roy]. **Léonard de Vinci.** Tours, Mame, 1869. 2 ed.

5478. Léonard de Vinci. [Feuillets inédits, variously titled]. 23 v. Paris, Rouveyre, 1901.

5479. ———. **Les manuscrits de Léonard de Vinci.** Avec transcription littérale, traduction française, préface et table méthodique par Charles Ravaisson-Mollien. 6 v. Paris, Quantin, 1881-91.

5480. ———. **Problèmes de géométrie et d'hydraulique.** Manuscrits inédits, reproduits d'après les originaux conservés à la Forster Library, South Kensington Museum, London. 3 v. Paris, Rouveyre, 1901.

5481. ———. **Sciences physico-mathématiques.** Manuscrits inédits, reproduits d'après les originaux conservés au British Museum, London. 4 v. Paris, Rouveyre, 1901.

5482. Leonardo da Vinci. **Il Codice Atlantico della Biblioteca Ambrosiana di Milano.** Transcrizione diplomatica e critica di Augusto Marinoni. 12 v. Firenze, Giunti/Barbèra, 1975-1980.

5483. ———. **Il codice di Leonardo da Vinci della biblioteca del principe Trivulzio in Milano.** Transcritto ed annotato di Luca Beltrami. Milano, Hoepli, 1891.

5484. ———. **Leonardo da Vinci on the human body; the anatomical, physiological, and embryological drawings.** With transcription, emendations, and a biographical introduction by Charles D. O'Malley and J. B. Saunders. New York, Schuman, 1952.

5485. ———. **I libri di meccanica, nella ricostruzione ordinata di Arturo Uccelli, preceduti da un'introduzione critica e da un esame della fonti.** Milano, Hoepli, 1940.

5486. ———. **The literary works of Leonardo da Vinci, compiled and edited from the original manuscripts by Jean Paul Richter.** Commentary by Carlo Pedretti. 2 v. Berkeley, Calif., University of California Press, 1977.

5487. ———. **The Madrid codices.** [Tratato de estatica y mechanica en italiano; transcription and translation by Ladislao Reti]. New York, McGraw-Hill, 1974.

5488. ———. **I manoscritti e i disegni di Leonardo da Vinci pubblicati dalla Reale Commissione Vinciana.** A cura di Adolfo Venturi. 7 v. Roma, Danesi/La Libreria dello Stato, 1928-1952.

5489. ———. **The notebooks of Leonardo da Vinci.** Arranged, rendered into English, and introduced by Edward MacCurdy. Garden City, N.Y., Garden City Publishing Co., 1941-42.

5490. ———. **I pensieri.** A cura di Bruno Nardini. Firenze, Giunti, 1977.

5491. ———. **Quaderni d'anatomia; tredici fogli della Royal Library di Windsor.** Pubblicati da Ove C. L. Vangensten, A. Fonahn, [and] H. Hopstock. 6 v. [Text in English and Norwegian]. Christiania [Oslo], Dybwad, 1911-1916.

5492. ———. **Scritti scelti.** [Ed. by Anna Maria Brizio]. Torino, Unione Tipografico-Editrice Torinese, 1952. (Classici italiani, 40).

5493. ———. **Thoughts on art and life.** Trans. by Maurice Baring. Boston, Merrymount Press, 1906. (The Humanist's Library, 1).

5494. ———. **Treatise on painting (Codex Urbinas Latinus 1270).** Translated and annotated by A. Philip McMahon, with an introduction by Ludwig H. Heydenreich. 2 v. (Vol. II: **Facsimile of the Codex**). Princeton, N.J., Princeton University Press, 1956.

5495. ———. **A treatise on painting.** [First English edition]. Translated from the original Italian [by John Senex] **and adorn'd with a great number of cuts.** London, Senex/Taylor, 1721.

5496. Lionardo da Vinci. **Trattato della pittura; nuovamente data in luce, colla vita dell'istesso autore scritta da Rafaelle du Fresne.** Paris, Langois, 1651.

5497. Lüdecke, Heinz. **Leonardo da Vinci im Spiegel seiner Zeit.** Berlin, Rütten und Loening, 1953. 2 ed.

5498. Luporini, Cesare. **La mente di Leonardo.** Firenze, Sansoni, 1953. (Biblioteca storica del Rinascimento, nuova serie, 2).

5499. McCurdy, Edward. **The mind of Leonardo da Vinci.** London, Cape, 1952.

5500. Malaguzzi Valeri, Francesco. **Leonardo da Vinci e la scultura.** Bologna, Zanichelli, 1922. (Studi e testi vinciani, 5).

5501. Marcolongo, Roberto. **Leonardo da Vinci; artista, scienzato.** Milano, Hoepli, 1939.

5502. Marcus, Aage. **Leonardo da Vinci.** Stockholm, Bonniers, 1944.

5503. Marinoni, Augusto, et al. **Leonardo da Vinci, letto e commentato.** [Letture vinciane, 1-12]. Firenze, Barbara, 1974.

5504. _____. **I rebus di Leonardo da Vinci, raccolti e interpretati.** Firenze, Olschki, 1954.

5505. Mazenta, Giovanni A. **Le memorie su Leonardo da Vinci.** Ripubblicate e illustrate a cura di Luigi Gramatica. Milano, Alfieri e Lacroix, 1919.

5506. Mazzucconi, Ridolfo. **Leonardo da Vinci.** Firenze, Vallecchi, 1943. (Biblioteca Vallecchi, 38).

5507. McMullen, Roy. **Mona Lisa; the picture and the myth.** Boston, Houghton Mifflin, 1975.

5508. Moeller, Emil. **Das Abendmahl des Lionardo da Vinci.** Baden-Baden, Verlag für Kunst und Wissenschaft, 1952.

5509. Müller-Walde, Paul. **Leonardo da Vinci; Lebensskizze und Forschungen über sein Verhältniss zur florentiner Kunst und zu Rafael.** München, Hirth, 1889-1890.

5510. Müntz, Eugène. **Leonardo da Vinci; artist, thinker, man of science.** 2 v. London, Heinemann/New York, Scribner's, 1898.

5511. Oberdorfer, Aldo. **Leonardo da Vinci.** Torino, Paravia, 1928.

5512. Ost, Hans. **Leonardo-Studien.** Berlin/New York, de Gruyter, 1975. (Beiträge zur Kunstgeschichte, 11).

5513. Ottino della Chiesa, Angela. **The complete paintings of Leonardo da Vinci.** Trans. by Madeline Jay. New York, Abrams, 1967.

5514. Panofsky, Erwin. **The Codex Huygens and Leonardo da Vinci's art theory.** London, Warburg Institute, 1940. (Studies of the Warburg Institute, 13). (Reprint: New York, Kraus, 1968).

5515. Payne, Robert. **Leonardo.** Garden City, N.Y., Doubleday, 1978.

5516. Pedretti, Carlo. **A chronology of Leonardo da Vinci's architectural studies after 1500.** Genève, Droz, 1962. (Travaux d'Humanisme et Renaissance, 54).

5517. _____. **Documenti e memorie rigvardanti Leonardo da Vinci a Bologna e in Emilia.** Bologna, Fiammenghi, 1953.

5518. _____. **Leonardo architetto.** [Milano], Electa, 1978.

5519. _____. **Leonardo da Vinci on painting; a lost book (Libro A), reassembled from the Codex Vaticanus Urbinas 1270 and from the Codex Leicester.** Foreword by Sir Kenneth Clark. Berkeley/Los Angeles, University of California Press, 1964. (California Studies in the History of Art, 3).

5520. _____. **Leonardo da Vinci: the Royal Palace at Romorantin.** Cambridge, Mass., Belknap Press, 1972.

5521. _____. **Leonardo, a study in chronology and style.** Berkeley/Los Angeles, University of California Press, 1973.

5522. _____. **Studi vinciani; documenti, analisi e inediti leonardeschi.** Genève, Droz, 1957. (Travaux d'Humanisme et Renaissance, 27).

5523. Péladan, Joséphin. **La philosophie de Léonard de Vinci d'après ses manuscrits.** Paris, Alcan, 1910.

5524. Philipson, Morris, ed. **Leonardo da Vinci; aspects of the renaissance genius.** New York, Braziller, 1966.

5525. Piantanida, Sandro [and] Baroni, Constantino. **Leonardo da Vinci.** [Published in conjunction with the exhibition at the Palazzo dell'Arte, Milan, May 9-September 30, 1939]. Novaro, Istituto Geografico de Agostini, 1939. (English ed.: 1956).

5526. Pierantoni, Amalia C. **Studi sul libro della pittura di Leonardo da Vinci.** Roma, Scotti, 1921.

5527. Pino, Domenico. **Storia genuina del Cenacolo insigne dipinto da Leonardo da Vinci nel refettorio de' Padri Domenicani de Santa Maria delle Grazie de Milano.** Milano, Malatesta, 1796.

5528. Polifolo [pseud., Luca Beltrami]. **Leonardo e i disfattisti suoi** [with] **Leonardo architetto di Luca Beltrami.** Milano, Treves, 1919.

5529. Pomilio, Mario. **L'opera completa di Leonardo pittore.** Milano, Rizzoli, 1967. (Classici dell'arte, 12).

5530. Popham, Arthur E. **The drawings of Leonardo da Vinci.** New York, Reynal, 1945.

5531. Reti, Ladislao, ed. **The unknown Leonardo.** New York, McGraw-Hill, 1974.

5532. Richter, Jean Paul. **Leonardo.** Trans. by Percy E. Pinkerton. London, Sampson Low, 1880.

5533. Rigollot, Marcel J. **Catalogue de l'oeuvre de Léonard de Vinci.** Paris, Dumoulin, 1849.

5534. Rinaldis, Aldo de. **Storia dell'opera pittorica de Leonardo da Vinci.** Bologna, Zanichelli, 1926. (Studi e testi vinciani, 7).

5535. Rio, Alexis F. Léonard de Vinci et son école. Paris, Bray, 1855.

5536. Roger-Milès, Léon. Léonard de Vinci et les jocondes. Paris, Floury, 1923.

5537. Rosci, Marco. The hidden Leonardo. Trans. by John Gilbert. Milano, Mondadori, 1977.

5538. Rosenberg, Adolf. Leonardo da Vinci. Bielefeld/Leipzig, Velhagen & Klasing, 1898. (Künstler-Monographien, 33).

5539. Sartoris, Alberto. Léonard, architecte. Paris, La Maison de Mansart, 1952.

5540. Schiaparelli, Attilio. Leonardo ritrattista. Milano, Treves, 1921.

5541. Schumacher, Joachim. Leonardo da Vinci, Maler und Forscher in anarchischer Gesellschaft. Berlin, Wagenbach, 1974.

5542. Séailles, Gabriel. Léonard de Vinci, l'artist & le savant; essai de biographie psychologique. Paris, Perrin, 1892.

5543. Seidlitz, Woldemar von. Leonardo da Vinci, der Wendepunkt der Renaissance. Wien, Phaidon, 1935. 2 ed.

5544. Sirén, Osvald. Leonardo da Vinci. 3 v. Paris, van Oest, 1928. 2 ed.

5545. Solmi, Edmondo. Scritti vinciani. Raccolta a cura di Arrigo Solmi. Firenze, La Voce, 1924.

5546. Steinitz, Kate T. Leonardo da Vinci's Trattato della Pittura; a bibliography of the printed editions, 1651-1956, based on the complete collection in the Elmer Belt Library of Vinciana, preceded by a study of its sources and illustrations. København, Munksgaard, 1958. (Library Research Monographs, 5).

5547. _____. Pierre-Jean Mariette & le Comte de Caylus and their concept of Leonardo da Vinci in the eighteenth century. Los Angeles, Zeitlin & Ver Brugge, 1974.

5548. Stites, Raymond S. The sublimations of Leonardo da Vinci, with a translation of the Codex Trivulzianus. Washington, D.C., Smithsonian Institution, 1970.

5549. Suida, Wilhelm. Leonardo und sein Kreis. München, Bruckmann, 1929.

5550. Sweetser, Moses F. Leonardo da Vinci. Boston, Houghton, Osgood, 1879.

5551. Thiis, Jens. Leonardo da Vinci: the Florentine years of Leonardo & Verrocchio. Trans. by Jessie Muir. Boston, Small, Maynard, [1913].

5552. Toni, Giambattista de. Le piante e gli animali in Leonardo da Vinci. Bologna, Zanichelli, 1922. (Studi e testi vinciani, 4).

5553. Ullmann, Ernst. Leonardo da Vinci. Leipzig, Seemann, 1980.

5554. Uzielli, Gustavo. Ricerche intorno a Leonardo da Vinci, serie prima. Torino, Loescher, 1896. 2 ed.

5555. _____. Ricerche intorno a Leonardo da Vinci, serie seconda. Roma, Salviucci, 1884.

5556. Valéry, Paul. Les divers essais sur Léonard de Vinci de Paul Valéry, commentés et annotés par lui-même. Paris, Editions du Sagittaire, 1931.

5557. Venturi, Adolfo. Leonardo da Vinci, pittore. Bologna, Zanichelli, 1920. (Studi e testi vinciani, 2)

5558. Venturi, Lionello. La critica e l'arte de Leonardo da Vinci. Bologna, Zanichelli, 1919. (Studi e testi vinciani, 1).

5559. Verga, Ettore. Bibliografica Vinciana, 1493-1930. 2 v. Bologna, Zanichelli, 1931. (Reprint: New York, Franklin, 1970.)

5560. _____. Gli studi intorno a Leonardo da Vinci nell'ultimo cinquantennio (1872-1922). Roma, Casa Libreria Editrice Italiana, 1923.

5561. Vuilliaud, Paul. La pensée ésotérique de Léonard de Vinci. Paris, Lieutier, 1945. 2 ed.

5562. Wasserman, Jack. Leonardo da Vinci. New York, Abrams, 1975.

5563. Wilhelm-Lehmbruck-Museum der Stadt Duisberg. Mona Lisa im 20. Jahrhundert. [September 24-December 3, 1978]. Duisburg, Wilhelm-Lehmbruck-Museum, 1978.

5564. Zubov, Vasilii P. Leonardo da Vinci. Trans. by David H. Kraus. Cambridge, Mass., Harvard University Press, 1968.

LEPAUTRE, ANTOINE, 1621-1679

JEAN, 1618-1682

5565. Berger, Robert W. Antoine Lepautre, a French architect of the era of Louis XIV. New York, Published for the College Art Association of America by New York University Press, 1969.

5566. [D'Aviler, Augustin C.]. Les oeuvres d'architecture d'Anthoine Le Pautre, architecte ordinaire du Roy. Paris, Jombert, 1652. (Reprint: Farnsborough, Eng., Gregg, 1966).

5567. [Lepautre, Jean]. Collection des plus belles compositions de [Jean] Lepautre, gravée par Decloux, architecte, & Doury, peintre. Paris, Caudrilier et Morel, [1854].

5568. _____. Oeuvres d'architecture de Jean Le Pautre, architecte, dessinateur et graveur du Roi. 3 v. Paris, Jombert, 1751.

LE PRINCE, JEAN-BAPTISTE, 1734-1781

5569. Hedou, Jules P. Jean Le Prince et son oeuvre. Paris, Baur, 1879.

5570. [Le Prince, Jean-Baptiste]. Oeuvres de Jean-Baptiste le Prince. Paris, Basan & Poignant, 1782.

LERMONTOV, MIKHAIL IUR'EVICH, 1814-1841

5571. Kovalevskaia, E. **Mikhail Iur'evich Lermontov i kartiny i risunki poeta; illustratsii k ego proizvedeniiam.** Moskva, Sovetskii Khudozhnik, 1964.

5572. Suzdalev, Petr K. **Vrubel' i Lermontov.** Moskva, Izobradzitel'noe Iskusstvo, 1980.

LESCAZE, WILLIAM, 1896-1969

5573. Lescaze, William H. **On being an architect.** New York, Putnam, 1942.

LE SUEUR, EUSTACHE, 1617-1655

5574. Dussieux, Louis E., ed. **Nouvelles recherches sur la vie et les ouvrages d'Eustache LeSueur.** Paris, Dumoulin, 1852.

5575. Landon, Charles P. **Vie et oeuvre d'Eustache LeSueur.** Paris, Treuttel et Würtz, 1811. (Vie et oeuvres des peintres les plus célèbres, 8).

5576. Rouchès, Gabriel. **Eustache Le Sueur.** Paris, Alcan, 1923.

5577. Vitet, Ludovic. **Eustache Le Sueur, sa vie et ses oeuvres.** Paris, Challamel, 1849.

LEVITAN, ISAAK IL'ICH, 1860-1900

5578. Fedora-Davydova, Aleksei A., ed. **Isaak Il'ich Levitan; dokumenty, materialy, bibliografiia.** Moskva, Iskusstvo, 1966.

5579. _____. **Isaak Il'ich Levitan i zhizn' i tvorchestvo, 1860-1900.** Moskva, Iskusstvo, 1976.

5580. Prytkov, Vladimir A. **Levitan.** Moskva, Akademii Khudozhestv SSR, 1960.

5581. Razdobreyeva, Irina V. **Levitan.** [Text in Russian, French, German, and English]. Leningrad, Aurora Art Publishers, 1971.

5582. Turkov, Andrei M. **Isaak Il'ich Levitan.** Moskva, Iskusstvo, 1974.

LEVITSKII, DMITRII GRIGOR'EVICH, 1735-1822

5583. Gershenzon-Chegodaeva, Natalia M. **Dmitrii Grigor'evich Levitskii.** Moskva, Iskusstvo, 1964.

5584. Maleva, Nina M. **Dmitrii Grigor'evich Levitskii.** Moskva, Iskusstvo, 1980.

5585. Roche, Denis. **D. M. Lévitski, un portraitiste petit-russien.** Paris, Gazette des Beaux-Arts, 1904.

LEWIS, WYNDHAM, 1882-1957

5586. Handley-Read, Charles, ed. **The art of Wyndham Lewis.** With a critical evaluation by Eric Newton. London, Faber, 1951.

5587. Lewis, Wyndham. **Blasting and bombardiering.** London, Calder & Boyars, 1967. 2 ed.

5588. _____. **The letters of Wyndham Lewis.** Ed. by W. K. Rose. London, Methuen, 1963.

5589. _____. **Wyndham Lewis on art; collected writings, 1913-1956.** Introduction and notes by Walter Michel and C. J. Fox. New York, Funk & Wagnalls, 1969.

5590. Manchester City Art Gallery (England). **Wyndham Lewis.** 1 October to 15 November 1980. Manchester, England, City of Manchester Cultural Services, 1980.

5591. Marrow, Bradford and Lafourcade, Bernard. **A bibliography of the writings of Wyndham Lewis.** Santa Barbara, Calif., Black Sparrow Press, 1978.

5592. Meyers, Jeffrey. **The enemy: a biography of Wyndham Lewis.** London/Henley, Routledge & Kegan Paul, 1980.

5593. Michel, Walter. **Wyndham Lewis, paintings and drawings.** Introductory essay by Hugh Kenner. Berkeley and Los Angeles, University of California Press, 1971. (CR).

5594. Porteus, Hugh G. **Wyndham Lewis, a discursive exposition.** London, Harmsworth, 1932.

5595. Wagner, Geoffrey. **Wyndham Lewis: a portrait of the artist as the enemy.** London, Routledge & Kegan Paul, 1957.

LEWITT, SOL, 1928-

5596. Kunsthalle Basel. **Sol LeWitt, Graphik 1970-1975.** Bern, Kornfeld/Basel, Kunsthalle, [1976].

5597. Museum of Modern Art (New York). **Sol Lewitt.** [Text and catalogue edited and introduced by Alicia Legg]. New York, Museum of Modern Art, 1978.

LEYDEN, GERHAERT NICOLAUS VAN see GERHAERT, NICOLAUS VAN LEYDEN

LEYDEN, LUCAS VAN see LUCAS VAN LEYDEN

LEYSTER, JUDITH, 1609-1660

5598. Harms, Juliane. **Judith Leyster, ihr Leben und ihr Werk.** Amsterdam, Oud-Holland, 1929. (Oud-Holland, 44).

LHOTE, ANDRE, 1885-1962

5599. Artcurial (Centre d'Art Plastique Contemporain, Paris). **André Lhote; retrospective 1907-1962: peintures, aquarelles, dessins.** Octobre-novembre 1981. Paris, Artcurial, 1981.

5600. Brielle, Roger. **André Lhote.** Paris, Librairie de France, 1931.

5601. Courthion, Pierre. **André Lhote.** Paris, Gallimard, 1926. (Les peintres français nouveaux, 26).

5602. Jakovsky, Anatole. **André Lhote, étude.** Paris, Floury, 1947.

5603. Lhote, André. **Figure painting.** Trans. by W. J. Strachan. London, Zwemmer, 1953.

5604. ———. **La peinture: le coeur et l'esprit, suivi de Parlons peinture; essais.** Paris, Denoël, 1950. 2 ed.

5605. Mercereau, Alexandre. **André Lhote.** Paris, Povolzky, 1921.

LI LUNG-MIEN, fl. 1070-1106

5606. Meyer, A. E. **Chinese painting as reflected in the thought and art of Li Lung-mien, 1070-1106.** New York, Duffield, 1923. 2 ed.

LIBERALE DA VERONA, ca. 1445-1529

5607. Brenzoni, Raffaello. **Liberale da Verona (1445-1526).** Milano, Lucini, 1930.

5608. Carli, Enzo. **Miniature di Liberale da Verona dai Corali per il Duomo di Siena.** Milano, Martello, 1953. (Il fiore della miniatura italiana, 1).

5609. **Del Bravo, Carlo. Liberale da Verona.** Firenze, Edizioni d'Arte il Fiorino, 1967. (I più eccelenti, collana di monografie di artisti, 3).

5610. Museo di Castelvecchio (Verona). **Liberale ritrovato nell'Esopo Veronese del 1479.** [Inaugurata il 22 dicembre 1973; testo di Giovanni Mardersteig con una nota introduttiva di Licisco Magagnato]. Verona, Museo di Castelvecchio, 1973.

LIBERATORE, NICCOLO DI see NICCOLO DA FOLIGNO

LIBERMAN, ALEXANDER, 1912-

5611. Rose, Barbara. **Alexander Liberman.** New York, Abbeville, 1981.

LICHTENSTEIN, ROY, 1923-

5612. Alloway, Lawrence. **Roy Lichtenstein.** New York, Abbeville Press, 1983.

5613. Coplans, John. **Roy Lichtenstein.** New York, Praeger, 1972.

5614. Saint Louis Art Museum. **Roy Lichtenstein, 1970-1980.** May 8-June 28, 1981. [Text by Jack Cowart]. St. Louis, Saint Louis Art Museum, 1981.

5615. Waldman, Diane. **Roy Lichtenstein.** New York, Abrams, 1971.

5616. ———. **Roy Lichtenstein, drawings and prints.** New York, Chelsea House, 1969.

LIEBERMANN, MAX, 1847-1935

5617. Elias, Julius. **Max Liebermann, eine Bibliographie.** Berlin, Cassirer, 1917.

5618. Friedländer, Max J., ed. **Max Liebermanns graphische Kunst.** Dresden, Arnold, 1922. 2 ed. (Arnolds graphische Bücher, erste Folge, 1).

5619. Hancke, Erich. **Max Liebermann, sein Leben und sein Werk.** Berlin, Cassirer, 1914.

5620. Klein, Rudolf. **Max Liebermann.** Berlin, Bard, Marquardt, 1906. (Die Kunst, 55/56).

5621. Lichtwark, Alfred. **Briefe an Max Liebermann.** Im Auftrage der Lichtwark-Stiftung herausgegeben von Carl Schellenberg. Hamburg, Trautmann, 1947.

5622. Liebermann, Max. **Die Phantasie in der Malerei; Schriften und Reden.** Herausgegeben und eingeleitet von Günter Busch. Frankfurt a.M., Fischer, 1978.

5623. ———. **Siebzig Briefe.** Herausgegeben von Franz Landsberger. Berlin, Schocken, 1937.

5624. Meissner, Günter. **Max Liebermann.** Wien/München, Schroll, 1974.

5625. Nationalgalerie Berlin. **Max Liebermann in seiner Zeit.** 6. September bis 4. November 1979. Berlin, Nationalgalerie Berlin, 1979. (CR).

5626. Pauli, Gustav. **Max Liebermann.** Stuttgart, Deutsche Verlags-Anstalt, 1911.

5627. Rosenhagen, Hans. **Liebermann.** Beilefeld/Leipzig, Velhagen & Klasing, 1900. (Künstler-Monographien, 45).

5628. Scheffler, Karl. **Max Liebermann.** München, Piper, 1906. (New ed.: Wiesbaden, Insel, 1953).

5629. Schiefler, Gustav. **Das graphische Werk von Max Liebermann.** Berlin, Cassirer, 1914. 2 ed.

5630. Stuttmann, Ferdinand. **Max Liebermann.** Hannover, Fackelträger, 1961.

5631. Wolff, Hans. **Zeichnungen von Max Liebermann.** Dresden, Arnold, 1922. (Arnolds graphische Bücher, zweite Folge, 4).

LIENZ, ALBIN EGGER see EGGER-LIENZ, ALBIN

LIEVENS, JAN, 1607-1674

5632. Herzog Anton Ulrich-Museum (Braunschweig). **Jan Lievens, ein Maler im Schatten Rembrandts.** 6. September bis 11. November 1979. Braunschweig, Herzog Anton Ulrich-Museum, 1979.

5633. Schneider, Hans. **Jan Lievens, sein Leben und sein Werk.** Haarlem, Bohn, 1932. (Reprinted, with a supplement by R. E. O. Ekkart: Amsterdam, Israël, 1973).

LILIEN, EPHRAIM MOSE, 1874-1925

5634. Brieger, Lothar. **E. M. Lilien, eine künstlerische Entwicklung um die Jahrhundertwende.** Berlin/Wien, Harz, 1922.

5635. Levussove, Moses S. **The new art of an ancient people; the work of Ephraim Mose Lilien.** New York, Huebsch, 1906.

5636. Lilien, Ephraim M. **Jerusalem.** Introd. by Joseph Gutman. New York, Ktav, 1976.

5637. Regener, Edgar. **E. M. Lilien, ein Beitrag zur Geschichte der zeichnenden Künste.** Berlin/Leipzig, Lattmann, 1905.

5638. Stadt Museum Braunschweig. **Der Grafiker E. M. Lilien (1874-1925).** 21. Mai-16. Juni 1974. [Catalogue by Ekkehard Hieronimus]. Braunschweig, Stadt Museum, 1974.

5639. Zweig, Stefan. **E. M. Lilien, sein Werk.** Berlin, Schuster & Loeffler, 1903.

LINDNER, RICHARD, 1901-1978

5640. Ashton, Dore. **Richard Lindner.** New York, Abrams, 1969.

5641. Dienst, Rolf-Gunter. **Lindner.** Trans. by Christopher Cortis. New York, Abrams, 1970.

5642. Fondation Maeght (Paris). **Richard Lindner.** 12 mai-30 juin 1979. [Text by Werner Spies; trans. by Eliane Kaufholz]. [Paris], Fondation Maeght, 1979.

5643. Kramer, Hilton. **Richard Lindner.** London, Thames and Hudson, 1975.

5644. Tillim, Sidney. **Lindner.** Chicago, William and Noma Copley Foundation, 1960.

LINDSAY, NORMAN, 1879-1969

5645. Bloomfield, Lin, ed. **The world of Norman Lindsay.** South Melbourne, Macmillan, 1979.

5646. Chaplin, Harry F. **Norman Lindsay; his books, manuscripts and autograph letters in the library of and annotated by the author.** Sydney, Wentworth Press, 1969.

5647. Hetherington, John. **Norman Lindsay, the embattled Olympian.** Melbourne, Oxford University Press, 1973.

5648. Lindsay, Norman. **Letters of Norman Lindsay.** Edited by R. G. Howarth and A. W. Barker. Sydney, Angus & Robertson, 1979.

5649. _____. **My mask, for what little I know of the man behind it: an autobiography.** Sydney, Angus & Richardson, 1970.

5650. _____. **Norman Lindsay watercolours.** With an appreciation of the medium by Norman Lindsay and a survey of the artist's life and work by Geofrey Blunden. Sydney/London, Smith, 1969.

5651. Lindsay, Rose. **Model wife; my life with Norman Lindsay.** Sydney, Smith, 1967.

5652. Stewart, Douglas A. **Norman Lindsay, a personal memoir.** Melbourne, Nelson, 1975.

LINNELL, JOHN, 1792-1882

5653. Colnaghi & Co., Ltd. (London). **A loan exhibition of drawings, watercolours, and paintings by John Linnell and his circle.** 10 January to 2 February 1973. London, Colnaghi, 1973.

5654. Fitzwilliam Museum (Cambridge, Eng.). **John Linnell, a centennial exhibition.** Oct. 5-Dec. 12, 1981. [Selected and catalogued by Katherine Crouan]. Cambridge, Fitzwilliam Museum, 1982.

5655. Story, Alfred T. **The life of John Linnell.** 2 v. London, Bentley, 1892.

LIOTARD, JEAN ETIENNE, 1702-1789

5656. Fosca, François [pseud., Georges de Traz]. **La vie, les voyages et les oeuvres de Jean-Etienne Liotard, citoyen de Genève, dit le peintre turc.** Lausanne/Paris, Bibliothèque des Arts, 1956.

5657. Humbert, Edouard, et al. **La vie et les oeuvres de Jean Etienne Liotard (1702-1789); étude biographique et iconographique.** Amsterdam, van Gogh, 1897.

5658. Liotard, Jean-Etienne. **Traité des principes et des règles de la peinture.** Pref. de Pierre Courthion. Vésenaz/Genève, Cailler, 1945.

5659. Loche, Renée e Roethlisberger, Marcel. **L'opera completa di Liotard.** Milano, Rizzoli, 1978. (CR). (Classici dell'arte).

5660. Previtali, Giovanni. **Jean-Etienne Liotard.** Milano, Fabbri, 1966. (I maestri del colore, 240).

LIPCHITZ, JACQUES, 1891-1973

5661. Arnason, H. Harvard. **Jacques Lipchitz: sketches in bronze.** New York, Praeger, 1969.

5662. Hammacher, Abraham M. **Jacques Lipchitz, his sculpture.** New York, Abrams, 1975. 2 ed.

5663. Lipchitz, Jacques. **My life in sculpture.** With H. H. Arnason. New York, Viking, 1972.

5664. Musée National d'Art Moderne, Centre Georges Pompidou (Paris). **Oeuvres de Jacques Lipchitz (1891-1973).** Catalogue établi par Nicole Barbier. Paris, Musée National d'Art Moderne, 1978.

5665. Museum of Modern Art (New York). **The sculpture of Jacques Lipchitz.** [May 18-August 1, 1954; text by Henry R. Hope]. New York, Museum of Modern Art, 1954.

5666. Patai, Irene. **Encounters; the life of Jacques Lipchitz.** New York, Funk & Wagnalls, 1961.

5667. Raynal, Maurice. **Lipchitz.** Paris, Action, 1920. (L'art d'aujourd'hui, 1).

5668. Van Bork, Bert. **Jacques Lipchitz; the artist at work.** With a critical evaluation by Dr. Alfred Werner. New York, Crown, 1966.

5669. Vitrac, Roger. **Jacques Lipchitz, une étude critique.** Paris, Gallimard, 1929. (Les sculpteurs français nouveaux, 7).

LIPPI, FILIPPINO, 1457-1504

FILIPPO, ca. 1406-1469

see also MASACCIO

5670. Associazione Turistica Pratese, ed. **Saggi su Filippino Lippi** di Cesare Brandi, Roberto Salvini, Valerio Mariani [and] Giuseppe Fiocco. Firenze, Arnaud, 1957.

5671. [Baldanzi, Ferdinando]. **Delle pitture di Fra Filippo Lippi nel coro della cattedrale di Prato e de' loro restauri.** Prato, Giachetti, 1835.

5672. Baldini, Umberto. **Filippo Lippi.** Milano, Fabbri, 1965. (I maestri del colore, 61).

5673. Berti, Luciano [and] Baldini, Umberto. **Filippino Lippi.** Firenze, Arnaud, 1957.

5674. Gamba, Fiammetta. **Filippino Lippi nella storia della critica.** Firenze, Arnaud, 1958.

5675. Marchini, Giuseppe. **Filippo Lippi.** Milano, Electa, 1975.

5676. Mendelsohn, Henriette. **Fra Filippo Lippi.** Berlin, Bard, 1909.

5677. Mengin, Urbain. **Les deux Lippi.** Paris, Plon, 1932.

5678. Neilson, Katherine B. **Filippino Lippi; a critical study.** Cambridge, Mass., Harvard University Press, 1938.

5679. Oertel, Robert. **Fra Filippo Lippi.** Wien, Schroll, 1942.

5680. Pittaluga, Mary. **Filippo Lippi.** Firenze, Del Turco, 1949.

5681. Sacher, Helen. **Die Ausdruckskraft der Farbe bei Filippino Lippi.** Strassburg, Heitz, 1929. (Zur Kunstgeschichte des Auslandes, 128).

5682. Scharf, Alfred. **Filippino Lippi.** Wien, Schroll, 1950.

5683. Strutt, Edward C. **Fra Filippo Lippi.** London, Bell, 1901.

5684. Supino, Igino B. **Les deux Lippi.** Trans. by J. de Crozals. Firenze, Alinari, 1904.

5685. _____. **Fra Filippo Lippi.** Firenze, Alinari, 1902.

LIPPI, LORENZO, 1606-1664

5686. Alterocca, Arnaldo. **La vita e l'opera poetica e pittorica di Lorenzo Lippi.** Catania, Battiato, 1914.

LIPTON, SEYMOUR, 1903-

5687. Elsen, Albert. **Seymour Lipton.** New York, Abrams, 1971.

5688. Rand, Harry. **Seymour Lipton: aspects of sculpture.** (Published in conjunction with an exhibition at the National Collection of Fine Arts, Smithsonian Institution, March 16-May 6, 1979). Washington, D.C., National Collection of Fine Arts, 1979.

LISBÕA, ANTONIO FRANCISCO, called O Aleijadinho, 1730-1814

5689. Alves Guimarães, Renato. **Antonio Francisco Lisboa (O Aleijadinho); monumentos e tradições de Minas Gerais.** São Paulo, Ferraz, 1931.

5690. Bazin, Germain. **Aleijadinho et la sculpture baroque au Brésil.** Paris, Le Temps, 1963.

5691. Feu de Carvalho, Theophilo. **O Aleijadinho (Antonio Francisco Lisboa).** Bello Horizonte, Edições Históricas, 1934.

5692. Jorge, Fernando. **O Aleijadinho; sua vida, suo obra, seu gênio.** Rio de Janeiro, Buccini/São Paulo, Leia, 1961. 2 ed.

5693. Lima, Augusto de, Jr. **O Aleijadinho e a arte colonial.** Rio de Janeiro, [Lima], 1942.

5694. Marianno Filho, José. **Antonio Francisco Lisbõa.** Rio de Janeiro, [Mendes], 1945.

5695. Pires, Heliodoro. **Mestre Aleijadinho; vida e obra de Antônio Francisco Lisboa, gigante da arte no Brasil.** Rio de Janeiro, Livraria São José, 1961. 2 ed.

LISS, JOHANN, 1576-1629

5696. Cleveland Museum of Art. **Johann Liss.** December 17, 1975-March 7, 1976. Cleveland, Cleveland Museum of Art, 1975. (CR).

5697. Steinbart, Kurt. **Johann Liss, der Maler aus Holstein.** Berlin, Deutscher Verein für Kunstwissenschaft, 1940.

LISSITZKY, EL, 1890-1941

5698. Birnholz, Alan C. **El Lissitsky.** 2 v. Ann Arbor, Mich., University Microfilms, 1974.

5699. Galerie Gmurzynska (Cologne). **El Lissitsky.** (9. April bis Ende Juni 1976). [Text in German and English]. Köln, Galerie Gmurzynska, 1976.

5700. Lissitsky, El. **Russland, die Rekonstruktion der Architektur in der Sowjetunion.** Wien, Schroll, 1930. (English ed.: Russia, an architecture for world

revolution. Trans. by Eric Dluhosch. Cambridge, Mass., MIT Press, 1970).

5701. Lissitzky, E. and Arp, Hans. **Die Kunstismen.** [Text in German, French, and English]. Zürich, Rentsch, 1925.

5702. Lissitzky-Küppers, Sophie. **El Lissitsky; life, letters, texts.** Introd. by Herbert Read. Trans. by Helene Aldwinckle and Mary Whittall. London, Thames and Hudson, 1968.

5703. Richter, Horst. **El Lissitzky: Sieg über die Sonne; zur Kunst des Konstruktivismus.** Köln, Galerie Christop Czwiklitzer, 1958.

5704. Stedelijk van Abbemuseum, Eindhoven (Holland). **El Lissitzky.** 3. Dezember 1965 bis 16. Januar 1966. Eindhoven, Stedelijk van Abbemuseum/Hannover, Kestner-Gesellschaft, 1965. (Kestner-Gesellschaft Hannover, Katalog 4, Ausstellungsjahr 1965/66).

LOCHNER, STEFAN, 1410-1451

5705. Förster, Otto H. **Stefan Lochner, ein Maler zu Köln.** Bonn, Auer, 1952. 3 ed.

5706. Kerber, Bernard. **Stephan Lochner.** Milano, Fabbri, 1965. (I maestri del colore, 99).

5707. May, Helmut. **Stefan Lochner und sein Jahrhundert.** Köln, Seemann, 1955.

5708. Schrade, Hubert. **Stephan Lochner.** München, Verlag der Wissenschaften, 1923. (Kompendien zur deutschen Kunst, 2).

LOMBARD, LAMBERT, ca. 1505-1566

5709. Helbig, Jules. **Lambert Lombard, peintre et architecte.** Bruxelles, Baertsoen, 1893.

5710. Lampsonius, Dominicus. **Lamberti Lombardi apud Eburones pictoris celeberrimi vita, pictoribus, sculptoribus architectis, aliisque id artificibus utilis et necessaria.** Brugis, Goltzii, 1565.

5711. Musée de l'Art Wallon (Liège). **Dessins de Lambert Lombard ex-collection d'Arenberg.** 26 janvier-24 mars 1963. Liège, Musée de l'Art Wallon, 1963.

5712. _____. **Lambert Lombard et son temps.** 30 septembre-31 octobre 1966. Liège, Musée de l'Art Wallon, 1963.

LOMBARDO, ANTONIO, ca. 1458 1516

PIETRO, ca. 1435-1515

TULLIO, ca. 1455-1532

5713. Wilk, Sarah. **The sculpture of Tullio Lombardo; studies in sources and meaning.** New York/London, Garland, 1978.

5714. Zandomeneghi, Luigi. **Elogio di Tullio ed Antonio fratelli Lombardo.** Venezia, Picotti, 1828.

5715. Zava Boccazzi, Franca. **I Lombardo.** Milano, Fabbri, 1968. (I maestri della scultura, 73),

LONGHENA, BALDASSARE, 1596?-1682

5716. Cristinelli, Giuseppe. **Baldassare Longhena, architetto del '600 a Venezia.** Fotografie di Francesco Possani. Padua, Marsilio, 1978. 2 ed. (Le grande opere dell' architettura, 4).

5717. Semenzato, Camillo. **L'architettura di Baldassare Longhena.** Padova, CEDAM, 1954. (Università di Padova, pubblicazioni della Facoltà di Lettere e Filosofia, 29).

LONGHI, PIETRO, 1702-1795

5718. Moschini, Vittorio. **Pietro Longhi.** Milano, Martelli, 1956.

5719. Pignatti, Terisio. **L'opera completa di Pietro Longhi.** Milano, Rizzoli, 1974. (Classici dell'arte, 75).

5720. _____. **Pietro Longhi dal disegno alla pittura.** Venezia, Alfieri, 1975.

5721. _____. **Pietro Longhi, paintings and drawings; complete edition.** Trans. by Pamela Wiley. London, Phaidon, 1969. (CR).

5722. Ravà, Aldo. **Pietro Longhi.** Firenzi, Alinari, 1923. 2 ed. (Collezione d'arte, 3).

5723. Valcanover, Francesco. **Pietro Longhi.** Milano, Fabbri, 1964. (I maestri del colore, 21).

LOOS, ADOLF, 1870-1933

5724. Altenberg, Peter, et al. **Adolf Loos zum 60. Geburtstag am 10. Dezember 1930.** Wien, Lanyi, 1930.

5725. Glück, Franz. **Adolf Loos.** Paris, Crès, 1931.

5726. Gravagnuolo, Benedetto. **Adolf Loos, theory and works.** New York, Rizzoli, 1982.

5727. Kubinsky, Mihály. **Adolf Loos.** Berlin, Henschel, 1970.

5728. Loos, Adolf. **Sämtliche Schriften in zwei Bänden.** Herausgegeben von Franz Glück. 2 v. Wien/München, Herold, 1962.

5729. _____. **Spoken into the void: collected essays 1897-1900.** Introd. by Aldo Rossi. Trans. by Jane O. Newman and John H. Smith. Cambridge, Mass., MIT Press, 1982.

5730. _____. **Das Werk des Architekten.** Herausgegeben von Heinrich Kulka. Wien, Schroll, 1931. (Reprint: Wien, Locker, 1979).

5731. Marilaun, Karl. **Adolf Loos.** Wien/Leipzig, Wiener Literarische Anstalt, 1922. (Die Wiedergabe, 1. Reihe, 5. Band).

5732. Münz, Ludwig and Künstler, Gustav. **Adolf Loos; pioneer of modern architecture.** With an introduction by Nikolaus Pevsner and an appreciation by Oskar Kokoschka. London, Thames and Hudson, 1966.

LOOS

5733. Rukschcio, Burkhardt [and] Schachel, Roland. **Adolf Loos, Leben und Werk.** Salzburg und Wien, Residenz, 1982. (CR). (Veröffentlichungen der Albertina, 17).

5734. Volkmann, Barbara [and] Raddatz, Rose-France. **Adolf Loos, 1870-1933: Raumplan-Wohnungsbau: Ausstellung der Akademie der Künste, 4 Dezember 1983 bis 15 Januar 1984.** Berlin, Akademie der Künste, 1983.

LOPEZ MEZQUITA, JOSÉ MARÍA, 1883-1954

5735. Francés, José. **José María Lopez Mezquita.** [Madrid], Estrella, 1919.

5736. Nogales y Marquez de Prado, Antonio. **Lopez Mezquita, su personalidad en la pintura española.** Madrid, Aguirre Torre, 1954.

LORENZETTI, AMBROGIO, ca. 1324-1345

PIETRO, 1305-1348

5737. Boorsook, Eve. **Ambrogio Lorenzetti.** Firenze, Sadea, 1966. (I diamanti dell'arte, 6).

5738. Carli, Enzo. **Pietro e Ambrogio Lorenzetti.** Milano, Silvana, 1971.

5739. Cecci, Emilio. **Pietro Lorenzetti.** Milano, Treves, 1930.

5740. Dewald, Ernest T. **Pietro Lorenzetti.** Cambridge, Mass., Harvard University Press, 1930.

5741. Meyenburg, Ernst von. **Ambrogio Lorenzetti. Ein Beitrag zur Geschichte der sienesischen Malerei im vierzehnten Jahrhundert.** Zürich, Frey, 1903.

5742. Rowley, George. **Ambrogio Lorenzetti.** 2 v. Princeton, N.J., Princeton University Press, 1958. (Princeton Monographs in Art and Archeology, 32).

5743. Sinibaldi, Giulia. **I Lorenzetti.** Siena, Istituto Comunale d'Arte e di Storia, 1933.

LORENZO DA BOLOGNA, 15th c.

5744. Lorenzoni, Giovanni. **Lorenzo da Bologna.** Venezia, Pozza, 1963. (Profili, 3).

LORENZO DI CREDI, 1456-1557

5745. Brewer, Robert. **A study of Lorenzo di Credi.** Firenze, Giuntina, 1970.

5746. Dalli Regoli, Gigetta. **Lorenzo di Credi.** Milano, Edizioni di Comunità, 1966. (Raccolta Pisana di saggi e studi, 19).

LORENZO, FIORENZO DI see FIORENZO DI LORENZO

LORENZO, MONACO, 1370-1425

5747. Bellosi, Luciano. **Lorenzo Monaco.** Milano, Fabbri, 1965. (I maestri del colore, 73).

5748. Golzio, Vincenzo. **Lorenzo Monaco; l'unification della tradizione senese con la fiorentina e il gotico.** Roma, Biblioteca d'Arte Editrice, 1931.

5749. Sirén, Osvald. **Don Lorenzo Monaco.** Strassburg, Heitz, 1905. (Zur Kunstgeschichte des Auslandes, 33).

LORRAIN, CLAUDE see CLAUDE LORRAIN

LORY, GABRIEL, 1763-1840

GABRIEL, 1784-1846

5750. Mandach, Conrad de. **Deux peintres suisses: Gabriel Lory le père (1763-1840) et Gabriel Lory le fils (1784-1846).** Lausanne, Haeschel, 1920. (Reprint, Genève, Slatkine, 1978).

LOSENKO, ANTON PAVLOVICH, 1737-1773

5751. Gavrilova, Evgeniia I. **Anton Pavlovich Losenko.** Leningrad, Khudozhnik RSFSR, 1977.

5752. Kaganovich, A. L. **Anton Losenko i russkoe iskusstvo serediny XVIII stoletiia.** Moskva, Izd-vo Akademiia Khudozhestv SSR, 1963.

LOTTO, LORENZO, 1480-1556

5753. Accademia Carrara (Bergamo). **Bergamo per Lorenzo Lotto.** [Dec. 15, 1980-March 31, 1981]. Bergamo, Bolis, 1980.

5754. Angelini, Luigi. **Gli affreschi di Lorenzo Lotto in Bergamo.** Bergamo, Istituto Italiano d'Arti Grafiche, 1953.

5755. Banti, Anna and Boschetto, Antonio. **Lorenzo Lotto.** Firenze, Sansoni, 1953.

5756. Berenson, Bernhard. **Lorenzo Lotto, an essay in constructive art criticism.** New York/London, Putnam, 1895. (Rev. ed.: Lorenzo Lotto, complete edition. London, Phaidon, 1956; distributed by Garden City Books, Garden City, N.Y.).

5757. Biagi, Luigi. **Lorenzo Lotto.** Roma, Tumminelli, 1942.

5758. Bianconi, Piero. **Lorenzo Lotto.** Trans. by Paul Colacicchi. 2 v. New York, Hawthorn, 1963. (Complete Library of World Art, 16-17).

5759. Caroli, Flavio. **Lorenzo Lotto.** Firenze, Edizioni d'Arte il Fiorino, 1975. (I più eccellenti; collana di monografie di artisti, 6; new ed.: **Lorenzo Lotto e la nascita della psicologia moderna.** Milano, Fabbri, 1980).

5760. Chiesa del Gesù, et al. (Ancona, Italy). **Lorenzo Lotto nelle Marche; il suo tempo, il suo influsso.** 4 luglio-11 ottobre 1981. Catalogo a cura di Paolo Dal Poggetto e Pietro Zampetti. Firenze, Centro Di, 1981.

5761. Chiodi, Luigi, ed. **Lettere inedite di Lorenzo Lotto su le tarsie di S. Maria Maggiore in Bergamo.** Bergamo, Edizioni Monumenta Bergomensia, 1962. (Monumenta bergomensia, 8).

5762. Cortesi Bosco, Francesca. **Gli affreschi dell'Oratorio Suardi: Lorenzo Lotto nella crisi della Riforma.** Bergamo, Bolis, 1980.

5763. Dillon, Gianvittorio, ed. **Lorenzo Lotto a Treviso, ricerche e restauri.** Treviso, Canova, 1980.

5764. Galis, Diana W. **Lorenzo Lotto: a study of his career and character with particular emphasis on his emblematic and hieroglyphic works.** Ann Arbor, Mich., University Microfilms, 1980.

5765. Lotto, Lorenzo. **Il libro di spese diverse.** A cura di Pietro Zampetti. Venezia/Roma, Istituto per la Collaborazione Culturale, 1969.

5766. Mascherpa, Giorgio. **Invito a Lorenzo Lotto.** Milano, Rusconi, 1980.

5767. _____. **Lorenzo Lotto a Bergamo.** Milano, Cassa di Risparmio della Provincie Lombarde, 1971.

5768. Palazzo Ducale (Venice). **Mostra di Lorenzo Lotto.** 14 giugno-18 ottobre 1953. Catalogo ufficiale a cura di Pietro Zampetti. Venezia, Casa Editrice Arte Veneta, 1953.

5769. Pallucchini, Rodolfo [and] Mariani Canova, Giordana. **L'opera completa di Lotto.** Milano, Rizzoli, 1975. (CR). (Classici dell'arte, 79).

5770. Siedenberg, Margot. **Die Bildnisse des Lorenzo Lotto.** Lörrach, Schahl, 1964.

5771. Zampetti, Pietro. **Lorenzo Lotto.** Milano, Fabbri, 1965. (I maestri del colore, 115).

5772. _____. **Lorenzo Lotto nelle Marche.** Urbino, Istituto Statale d'Arte, 1953. (Collana di studi archeologici ed artistici marchigiani, 3).

5773. _____, ed. **Lorenzo Lotto nel suo e nel nostro tempo.** Urbino, Argalia, 1980. (Notizie da Palazzo Albani, anno IX, 1-2).

LOUDON, JOHN CLAUDIUS, 1783-1843

5774. Gloag, John. **Mr. Loudon's England: the life and work of John Claudius Loudon and his influence on architecture and furniture design.** Newcastle-upon-Tyne, Oriel, 1970.

5775. Loudon, John C. **An encyclopaedia of cottage, farm, and villa architecture.** London, Longman, 1833. (New ed., edited by Jane Loudon: London, Warne, 1844).

5776. _____. **An encyclopaedia of gardening.** 2 v. London, Longman, 1822. (New ed., edited by Jane Loudon: London, Longman, 1850; reprint of 1835 ed.: New York, Garland, 1982).

5777. _____. **Observations on the formation and management of useful and ornamental plantations, on the theory and practice of landscape gardening, and on gaining and embanking land from rivers or the sea.** Edinburgh, Constable/London, Longman, 1804.

5778. _____. **The suburban gardener and villa companion.** London, Printed for the author, 1838. (Reprint: New York, Garland, 1982).

5779. MacDougall, Elisabeth B., ed. **John Claudius Loudon and the early nineteenth century in Great Britain: papers.** Washington, D.C., Dumbarton Oaks Trustees for Harvard University, 1980. (Dumbarton Oaks Colloquium on the History of Landscape Architecture, 6).

LOUTHERBOURG, PHILIP JAMES DE, 1740-1812

5780. Joppien, Rüdiger. **Philippe Jacques de Loutherbourg, R.A., 1740-1812.** [Catalogue of an exhibition held at the Iveagh Bequest, Kenwood, Hampstead, England]. London, Greater London Council, 1973.

LUCAS VAN LEYDEN, 1494-1533

5781. Baldass, Ludwig von. **Die Gemälde des Lucas van Leyden.** Wien, Hölzel, 1923.

5782. Bartsch, Adam von. **Catalogue raisonné de toutes les estampes qui forment l'oeuvre de Lucas de Leyde.** Wien, Degen, 1798. (CR).

5783. Beets, Nicholas. **Lucas de Leyde.** Bruxelles, van Oest, 1913.

5784. Evrard, W. **Lucas de Leyde et Albert Dürer: la vie et l'oeuvre de Lucas de Leyde; son école, ses gravures, ses peintures, ses dessins; catalogue et prix de cinq cents de ses ouvrages.** Bruxelles, van Trigt, 1884.

5785. Friedländer, Max J. **Lucas van Leyden.** Berlin, de Gruyter, 1963.

5786. Hollstein, F. W. **The graphic art of Lucas van Leyden (1494-1533).** Amsterdam, Hertzberger, [1968]. (CR).

5787. Jacobowitz, Ellen. **The prints of Lucas van Leyden and his contemporaries.** Washington, D.C., National Gallery of Art, 1983.

5788. Kahn, Rosy. **Die frühen Stiche des Lucas van Leyden.** Strassburg, Heitz, 1917. (Zur Kunstgeschichte des Auslandes, 118).

5789. Volbehr, Theodor. **Lucas van Leyden; Verzeichniss seiner Kupferstiche, Radierungen und Holzschnitte.** Hamburg, Haendcke & Lehmkuhl, 1888.

5790. Vos, Rik. **Lucas van Leyden.** Bentveld, Landshoff/Maarssen, Schwartz, 1978. (CR).

LUCHETTO DA GENOVA see CAMBIASO, LUCA

LUINI, BERNARDINO, 1475-1533

5791. Beltrami, Luca. **Luini, 1512-1532; materiale di studio raccolto.** Milano, Allegretti, 1911.

5792. Civico Istituto di Cultura Popolare (Luino). **Sacro e profano nella pittura di Bernardino Luini.** [August 9-October 8, 1975]. Luino, Civico Istituto di Cultura Popolare, 1975.

5793. Della Chiesa, Angela O. **Bernardino Luini.** Novara, Istituto Geografico de Agostini, 1956.

5794. Gauthiez, Pierre. **Luini, biographie critique.** Paris, Laurens, [1905].

5795. Mason, James. **Bernardino Luini.** London, Jack/New York, Stokes, [1908].

5796. Reggiori, Giovanni B. **Bernardino Luini, cenni biografici preceduti da una introduzione sui magistri comacini.** Milano, Mohr, [1911].

5797. Williamson, George C. **Bernardino Luini.** London, Bell, 1907.

LURÇAT, JEAN, 1892-1966

5798. Cingria, Charles A. **Lurçat ou la peinture avec des phares.** Amsterdam, Bladzvranckx, 1927.

5799. Lurçat, Jean. **Designing tapestry.** Trans. by Barbara Crocker. London, Rockliff, 1950.

5800. _____. **Le travail dans la tapisserie du Moyen Age.** Préface de Louis Giller. Genève/Paris, Cailler, 1947.

5801. Marcenac, Jean. **L'exemple de Jean Lurçat.** Zurich, Hurliman, 1952.

5802. Roy, Claude. **Jean Lurçat.** Genève, Cailler, 1956. 2 ed.

5803. Vercors [pseud., Jean Bruller]. **Tapisseries de Jean Lurçat, 1939-1957.** Belvès (Dordogne, France), Vorms, 1958.

LUTERO, GIOVANNI DE see DOSSI, DOSSO

LUTYENS, EDWIN LANDSEER, 1869-1944

5804. Butler, Arthur S. **The architecture of Sir Edwin Lutyens.** 3 v. London, Country Life, 1950. (CR).

5805. Gradidge, Roderick. **Edwin Lutyens, architect laureate.** London, Allen & Unwin, 1981.

5806. Hayward Gallery (London). **Lutyens: the work of the English architect Sir Edwin Lutyens (1869-1944).** 18 November 1981-31 January 1982. London, Arts Council of Great Britain, 1981.

5807. Hussey, Christopher. **The life of Sir Edwin Lutyens.** London, Country Life, 1950.

5808. Irving, Robert G. **Indian summer: Lutyens, Baker, and imperial Delhi.** New Haven/London, Yale University Press, 1981.

5809. Inskip, Peter. **Edwin Lutyens.** New York, Rizzoli, 1979. (Architectural Monographs, 6).

5810. Lutyens, Mary. **Edwin Lutyens.** London, Murray, 1980.

5811. O'Neill, Daniel. **Sir Edwin Lutyens, country houses.** With a preface by Sir Hugh Casson. London, Lund Humphries, 1980.

5812. Weaver, Lawrence. **Houses and gardens by E. L. Lutyens, described and criticized.** London, Country Life, 1913. (Reprint: London, Antique Collectors' Club, 1981).

LYS, JAN, called PAN
see LISS, JOHANN

LYSIPPUS, sculptor, 4th c. B.C.

5813. Collignon, Maxime. **Lysippe, étude critique.** Paris, Librairie Renouard, [1904].

5814. Johnson, Franklin P. **Lysippos.** Durham, N.C., Duke University Press, 1927.

5815. Lange, Konrad. **Das Motiv des aufgestützten Fusses in der antiken Kunst und dessen statuarische Verwendung durch Lysippos.** Leipzig, Seemann, 1879. (Beiträge zur Kunstgeschichte, 3).

5816. Löwy, Emanuel. **Lysipp und seine Stellung in der griechischen Plastik.** Hamburg, Richter, 1891.

5817. Maviglia, Ada. **L'attività artistica di Lisippo ricostruita su nuova base.** Roma, Loescher, 1914.

5818. Moreno, Paolo, ed. **Testimonianze per la teoria artistica di Lisippo.** Treviso, Canova, 1973.

MABUSE see GOSSAERT, JAN

MACEDO see CLOVIO, GIULIO

MACKE, AUGUST, 1887-1914

5819. Bartmann, Domenik. **August Macke, Kunsthandwerk: Glasbilder, Stickerien, Keramiken, Holzarbeiten und Entwürfe.** Berlin, Mann, 1979.

5820. Cohen, Walter. **August Macke.** Leipzig, Klinkhardt & Biermann, 1922. (Junge Kunst, 32).

5821. Erdmann-Macke, Elisabeth. **Erinnerung an August Macke.** Stuttgart, Kohlhammer, 1962.

5822. Macke, August, et al. **Tunisian watercolors and drawings.** Trans. by Norbert Guterman. New York, Abrams, 1969.

5823. [Macke, Wolfgang, ed.]. **August Macke; Franz Marc: Briefwechsel.** Köln, DuMont Schauberg, 1964.

5824. Städtisches Kunstmuseum (Bonn). **Die rheinischen Expressionisten: August Macke und seine Malerfreunde.** 30. Mai-29. Juli 1979. Recklinghausen, Bongers, 1979.

5825. Vriesen, Gustav. **August Macke.** Stuttgart, Kohlhammer, 1957. 2 ed. (CR).

5826. Westfälischer Kunstverein (Westfalen). **August Macke, Gedenkausstellung zum 70. Geburtstag.** 27. Januar-24. März 1957. Westfalen, Westfälischer Kunstverein, 1957.

MACKINTOSH, CHARLES RENNIE, 1868-1928

5827. Alison, Filippo. **Charles Rennie Mackintosh as a designer of chairs.** Trans. by Bruno and Christina del Piore. Milan/London, Warehouse, 1974.

5828. [Barnes, H. Jefferson, introd.]. **Some examples of furniture by Charles Rennie Mackintosh in the Glasgow School of Art Collection.** Glasgow, Glasgow School of Art, [1968].

5829. _____. **Some examples of iron work and metalwork by Charles Rennie Mackintosh at Glasgow School of Art.** Glasgow, Glasgow School of Art, [1968].

5830. Billcliffe, Roger. **Charles Rennie Macintosh; the complete furniture, furniture drawings, and interior designs.** New York, Taplinger, 1979. (CR).

5831. _____. **Mackintosh, textile designs.** London, Murray, 1982.

5832. _____. **Mackintosh watercolours.** London, Murray, 1978. (CR).

5833. Howarth, Thomas. **Charles Rennie Mackintosh and the modern movement.** London, Routledge & Kegan Paul, 1977. 2 ed.

5834. Mackintosh, Charles R. **Architectural sketches & flower drawings.** Ed. by Roger Billcliffe. London, Academy, 1977.

5835. Macleod, Robert. **Charles Rennie Mackintosh.** Feltham, Eng., Country Life, 1968.

5836. Pevsner, Nikolaus. **Charles R. Mackintosh.** Milano, Il Balcone, 1950. (Reprinted in translation in: Pevsner, Nikolaus. **Studies in art, architecture and design.** 2 v. London, Thames and Hudson, 1968).

5837. Victoria and Albert Museum (London). **Charles Rennie Mackintosh (1868-1928), a centenary exhibition. Architecture, design and painting.** [30 October-29 December 1968; introduction, notes, and catalogue by Andrew McLaren Young]. Edinburgh, Scottish Arts Council, 1968.

McINTIRE, SAMUEL, 1757-1811

5838. Cousins, Frank and Riley, Phil M. **The wood-carver of Salem; Samuel McIntire, his life and work.** Boston, Little, Brown, 1916. (Reprint: New York, AMS, 1970).

5839. Hipkiss, Edwin J. **Three McIntire rooms from Peabody, Massachusetts.** Boston, Museum of Fine Arts, 1931.

5840. Labaree, Benjamin W., ed. **Samuel McIntire; a bicentennial symposium, 1757-1957.**

5841. Kimball, Fiske. **Mr. Samuel McIntire, carver; the architect of Salem.** Portland, Me., Southworth-Anthoensen Press, 1940. (Reprint: Gloucester, Mass., Peter Smith, 1966).

McKIM, CHARLES FOLLEN, 1847-1911

5842. Granger, Alfred H. **Charles Follen McKim, a study of his life and work.** Boston/New York, Houghton Mifflin, 1913. (Reprint: New York, Arno, 1972).

5843. Hill, Frederick P. **Charles F. McKim, the man.** Francestown, N.H., Jones, 1950.

5844. [McKim, Charles F., et al.]. **A monograph of the work of McKim, Mead & White, 1879-1915.** 4 v. New York, Architectural Book Publishing Co., 1915-1920. (New ed., with an essay and notes on the plates by Leland M. Roth; New York, Blom, 1973; student's edition, with an introduction by Alan Greenberg and notes by Michael George: New York, Architectural Book Publishing Co., 1981). (CR).

5845. Moore, Charles. **The life and times of Charles Follen McKim.** Boston/New York, Houghton Mifflin, 1929. (Reprint: New York, Da Capo, 1969).

5846. Reilly, C. H. **McKim, Mead & White.** London, Benn, 1924. (Reprint: New York, Blom, 1973).

5847. Roth, Leland M. **The architecture of McKim, Mead & White, 1870-1920: a building list.** New York, Garland, 1978. (Garland Reference Library of the Humanities, 114).

MADERNO, CARLO, 1556-1629

5848. Caflisch, Nina. **Carlo Maderno, ein Beitrag zur Geschichte der römischen Barockarchitektur.** München, Bruckmann, 1934.

5849. Donati, Ugo. **Carlo Maderno, architetto ticinese a Roma.** Lugano, A cura del Banco di Roma per la Svizzera, 1957.

5850. Hibbard, Howard. **Carlo Maderno and Roman architecture, 1580-1630.** London, Zwemmer, 1971. (Studies in Architecture, 10).

5851. Muñoz, Antonio. **Carla Maderno.** Roma, Società editrice della biblioteca d'arte illustrata, 1921.

MADERNO, STEFANO, 1576-1636

5852. Muñoz, Antonio. **Stefano Maderno: contributo allo studio della scultura barocca primi del Bernini.** Roma, Tipografia Editrice Romana, 1915.

5853. Nava Cellini, Antonia. **Stefano Maderno.** Milano, Fabbri, 1966. (I maestri della scultura, 60).

MADRAZO, FEDERICO DE, 1815-1894

JOSE, 1781-1859

5854. [Ceán Bermúdez and Musso y Valiente]. **Coleccion lithographica de cuadros del Rey de España, el señor, don Fernando VII.** Obra lithographica por hábiles artistas bajo le direccion de Jose de Madrazo. Madrid, Real Establecimienta Lithographico, 1826-32.

5855. Madrazo, Mariano de. **Federico de Madrazo.** 2 v. Madrid, Estrella, 1921.

MAES, NICOLAES, 1632-1693

5856. Valentiner, Wilhelm R. **Nicolaes Maes.** Stuttgart, Deutsche Verlags-Anstalt, 1924.

MAFFEI, FRANCESCO, 1620-1660

5857. Basilica Palladiana di Vicenza. **Mostra di Francesco Maffei.** Giugno-ottobre 1956. [Catalogue by Nicola Ivanoff]. Venezia, Pozza, 1956.

5858. Ivanoff, Nicola. **Francesco Maffei.** Padova, Le Tre Venezie, 1947. (Collection d'art, deuxième série, 6). (CR).

MAGNASCO, ALESSANDRO, 1667-1749

5859. Beltrami, Giuseppe. **Alessandro Magnasco, detto il Lissandrino.** Milano, Allegretti, 1913.

5860. Bonzi, Mario. **Saggi sul Magnasco.** Genova, Liguria, 1971. 3 ed.

5861. Dürst, Hans. **Alessandro Magnasco.** Teufen, Niggli, 1966.

5862. Franchini Guelfi, Fausta. **Alessandro Magnasco.** Genova, Pagano, 1977.

5863. Geiger, Benno. **Magnasco.** Bergamo, Istituto Italiano d'Arte Grafiche, 1949.

5864. _____. **Magnasco, i disegni.** Padova, Le Tre Venezie, 1945.

5865. Magnoni, Valentina. **Alessandro Magnasco.** Roma, Edizioni Mediterranee, [1965].

5866. Pospisil, Maria. **Magnasco.** Firenze, Alinari, 1944.

5867. Syamken, Georg G. **Die Bildinhalte des Alessandro Magnasco, 1667-1749.** Hamburg, Hintze & Sachse, 1963.

MAGNELLI, ALBERTO, 1888-1971

5868. Degand, Léon. **Magnelli.** Venezia, Edizioni del Cavallino, [1952].

5869. Lochard, Anne. **Magnelli, opere 1907-1939.** Roma, Il Collezionista, 1972.

5870. Maisonnier, Anne. **Alberto Magnelli, l'oeuvre peint: catalogue raisonné.** Paris, Société Internationale d'Art XXe siècle, 1975. (CR).

5871. Mendes, Murillo, ed. **Alberto Magnelli.** [Texts in Italian, French and English]. Roma, Ateneo, 1964. (Contributi alla storia dell'arte, 2).

MAGRITTE, RENE, 1898-1967

5872. Foucault, Michel. **This is not a pipe.** With illustrations and letters by René Magritte. Trans. and ed. by James Harkness. Berkeley, Calif., University of California Press, 1983.

5873. Gablik, Suzi. **Magritte.** Greenwich, Conn., New York Graphic Society, 1970.

5874. Hammacher, Abraham M. **René Magritte.** Trans. by James Brockway. New York, Abrams, 1973.

5875. Kunstverein und Kunsthaus Hamburg. **René Magritte und der Surrealismus in Belgien.** 23. Januar bis 28. März 1982. Brüssel, Lebeer Hossmann, 1982.

5876. Lebel, Robert. **Magritte, peintures.** Paris, Hazan, 1969.

5877. Magritte, René. **La destination: lettres à Marcel Mariën, 1937-1962.** Bruxelles, Lèvres, 1977.

5878. _____. **Ecrits complets.** Ed. par André Blavier. Paris, Flammarion, 1979.

5879. _____. **Quatre vingt deux lettres de René Magritte à Mirabelle Dors et Maurice Rapin avec des lettres de Noël Arnaud et Georgette Magritte** [in facsimile]. Paris, [Georgette Magritte et al.], 1976.

5880. Museum Boymans-von Beuningen (Rotterdam). **René Magritte: het mysterie van de werkelijkheid.** 4 augustus-24 september 1967. [Text in Dutch and French]. Rotterdam, Museum Boymans-van Beuningen, 1967.

5881. Museum of Modern Art (New York). **René Magritte.** [Dec. 15, 1965-Feb. 27, 1966; text by James T. Soby]. New York, Museum of Modern Art, 1965; distributed by Doubleday, Garden City, N.Y.

5882. Noël, Bernard. **Magritte.** Paris, Flammarion, 1976.

5883. Nougé, Paul. **René Magritte ou les images défendues.** Bruxelles, Les Augeurs Associés, 1943.

5884. Palais des Beaux-Arts (Brussels). **Rétrospective Magritte.** 27 ottobre-31 décembre 1978. Bruxelles, Département de la Culture Française de Belgique/Paris, Musée d'Art Modern, Centre Georges Pompidou, 1978.

5885. Passeron, René and Saucet, Jean. **René Magritte.** Trans. by Elisabeth Abbott. Chicago, O'Hara, 1972.

5886. Roberts-Jones, Philippe. **Magritte, poète visible.** Bruxelles, Laconti, 1972.

5887. Schliebler, Ralf. **Die Kunsttheorie René Magrittes.** München/Wien, Hanser, 1981.

5888. Schneede, Uwe M. **René Magritte: Leben und Werk.** Köln, DuMont Schauberg, 1973.

5889. Scutenaire, Louis. **Avec Magritte.** Bruxelles, Lebeer Hossmann, 1977.

5890. Sylvester, David. **Magritte.** New York, Praeger, 1969.

5891. Torczyner, Harry. **Magritte: ideas and images.** Trans. by Richard Miller. New York, Abrams, 1977.

5892. _____. **Magritte: the true art of painting.** With the collaboration of Bella Bessard. Trans. by Richard Miller. New York, Abrams, 1979.

5893. Waldberg, Patrick. **René Magritte.** Trans. by Austryn Wainhouse. Bruxelles, de Roche, 1965.

MAILLOL, ARISTIDE JOSEPH BONAVENTURE, 1861-1944

5894. Albright Art Gallery (Buffalo, N.Y.). **Aristide Maillol**
[commemorative exhibition]. Buffalo, N.Y., Buffalo Fine
Arts Academy, 1945.

5895. Bouvier, Marguette. **Aristide Maillol.** Lausanne, Editions
Margeurat, 1945.

5896. Chevalier, Denys. **Maillol.** Trans. by Eileen B. Hennessy.
New York, Crown, 1970.

5897. Cladel, Judith. **Maillol; sa vie, son oeuvres, ses idées.**
Paris, Grasset, 1937.

5898. Denis, Maurice. **A. Maillol.** Paris, Crès, 1925.

5899. _____ et Colombier, Pierre du. **Maillol, dessins
et pastels.** Paris, Carré, 1942.

5900. Frère, Henri. **Conversations de Maillol.** Genève, Cailler,
1956. (Les grands artistes racontés par eux-mêmes et par
leurs amis, 12).

5901. George, Waldemar. **Aristide Maillol et l'âme de la
sculpture.** Paris, La Bibliothèque des Arts/Neuchâtel,
Editions Ides et Calendes, 1977.

5902. Guérin, Marcel. **Catalogue raisonné de l'oeuvre gravé et
lithographié de Aristide Maillol.** 2 v. Genève, Cailler,
1965-1967. (CR).

5903. Kuhn, Alfred. **Aristide Maillol: Landschaft, Werke,
Gespräche.** Leipzig, Seemann, 1925.

5904. Linnenkamp, Rolf. **Aristide Maillol, die grossen Plastiken.**
München, Bruckmann, 1960.

5905. Mirbeau, Octave. **Aristide Maillol.** Paris, Crès, 1921.

5906. Rewald, John. **Maillol.** London, Hyperion, 1939.

5907. _____. **The woodcuts of Aristide Maillol, a complete
catalogue.** New York, Pantheon, 1951. 2 ed. (CR).

5908. Sentenac, Paul. **Aristide Maillol.** Paris, Peyre, [1936].

5909. Solomon R. Guggenheim Museum (New York). **Aristide Maillol,
1861-1944.** [Text by John Rewald]. New York, Guggenheim
Foundation, 1965.

5910. Staatliche Kunsthalle Baden-Baden. **Maillol.** 17. Juni bis
3. September 1978. Herausgegeben von Hans Albert Peters.
Baden-Baden, Staatliche Kunsthalle, 1978.

MAKART, HANS, 1840-1884

5911. Bachelin, Léopold. **Hans Makart et les cinq sens.** Paris,
Sandoz & Thullier, 1883.

5912. Frodel, Gerbert. **Hans Makart; Monographie und
Werkverzeichnis.** Salzburg, Residenz, 1974. (CR).

5913. Pirchan, Emil. **Hans Makart.** Wien, Bergland, 1954. 2 ed.

5914. Staatliche Kunsthalle Baden-Baden. **Makart.** 23. Juni bis
17. September 1972. Baden-Baden, Staatliche Kunsthalle,
1972. 2 ed.

MALBONE, EDWARD GREENE, 1777-1807

5915. Tolman, Ruel P. **The life and works of Edward Greene
Malbone.** Foreword by John Davis, Jr. Introd. by
Theodore Bolton. New York, New York Historical Society,
1958. (CR).

MALEVICH, KAZIMIR SEVERINOVICH, 1878-1935

5916. Andersen, Troels. **Malevich: catalogue raisonné of the
Berlin exhibition, 1927, including the collection of the
Stedelijk Museum, Amsterdam.** Amsterdam, Stedelijk
Museum, 1970. (CR).

5917. Douglas, Charlotte. **Swans of other worlds; Kazimir
Malevich and the origins of abstraction in Russia.** Ann
Arbor, Mich., UMI Research Press, 1976. (Studies in the
Fine Arts: the Avant-garde, 2).

5918. Galerie Gmurzynska (Cologne). **Kasimir Malewitsch zum 100.
Geburtstag.** June-July 1978. [Text in English and
German]. Köln, Galerie Gmurzynska, 1978.

5919. Karshan, Donald. **Malevich: the graphic work, 1913-1930.**
A print catalogue raisonné. [Published in conjunction
with an exhibition, November 1975-January 1976].
Jerusalem, Israel Museum, 1975. (CR).

5920. [Malevich, Kazimir S.]. **Ecrits.** Traduits par Jean-Claude
et Valentine Marcadé et al. 4 v. Lausanne, L'Age
d'Homme, 1974-1981.

5921. _____. [Essays on art]. Edited by Troels Andersen.
Trans. by Xenia Glowacki-Prus [Hoffman], et al. 4 v.
Copenhagen, Borgen, 1968-1978.

5922. Marcadé, Jean-Claude. **Malévitch, 1878-1978; actes du
colloque international tenu au Centre Pompidou, Musée
National d'Art Moderne, les 4 et 5 mai 1978.** Lausanne,
L'Age d'Homme, 1979.

5923. Martineau, Emmanuel. **Malévitch et la philosophie: la
question de la peinture abstraite.** Lausanne, L'Age
d'Homme, 1976.

5924. Musée National d'Art Moderne (Paris). **Malévitch: oeuvres
de Casimir Severinovitch Malévitch (1878-1935).**
Catalogue établi par Jean-Hubert Martin. Paris, Musée
National d'Art Modern/Centre Georges Pompidou, 1980.

5925. Zhadova, Larisa. **Malevich: Suprematism and revolution in
Russian art, 1910-1930.** Trans. by Alexander Lieven.
New York, Thames & Hudson, 1982.

MAN, FELIX H., 1893-

5926. Man, Felix H. **60 Jahre Fotografie.** Bielefeld, Kunsthalle
Bielefeld, 1978.

MAN RAY see RAY, MAN

MANDER, KAREL VAN, 1548-1606

5927. Greve, H. E. **De Bronnen van Carel van Mander.** Haag, Nijhoff, 1903. (Quellenstudien zur holländischen Kunstgeschichte, 2).

5928. Hoecker, Rudolf, ed. **Das Lehrgedicht des Karl van Mander; Text, Uebersetzung, und Kommentar.** Haag, Nijhoff, 1916. (Quellenstudien zur holländischen Kunstgeschichte, 8).

5929. Jacobsen, R. **Carel van Mander (1548-1606), dichter en prozaschrijver.** Rotterdam, Brusse, 1906.

5930. Mander, Carel van. **Het Schilder-Boeck.** Haarlem, Paschier von Wesbusch, 1604. (Reprint: Utrecht, Davaco, 1969; English trans. by Constant van de Wall: New York, McFarlane, 1936. 2 v. Reprint: New York, Arno, 1969.

5931. Noë, Helen. **Carel van Mander en Italië.** Haag, Nijhoff, 1954.

5932. Plettinck, Leopold. **Studien over het leven en de werken van Karel van Mander, dichter, schilder en kunstgeschiedschrijver, 1598-1606.** Gent, Siffer, 1896. 2 v.

5933. Valentiner, Elisabeth. **Karel van Mander als Maler.** Strassburg, Heitz, 1930. (Zur Kunstgeschichte des Auslandes, 132).

MANÉS, JOSEF, 1820-1871

5934. Chytil, Karel. **Josef Mánes a jeho rod.** Praha, Nákladem Kruhu pro pěstování dějin umení, 1934. (Knihova Kruhu pro pěstování dějin umeni, 2).

5935. Kühndel, Jan, ed. **Dopisy Josefa Mánesa.** Praha, Odeon, 1968.

5936. Lamač, Miroslav. **Josef Mánes.** Praha, Nakladatelstvi československých výtvarných umělců, 1956. 2 ed. (Umeni lidu svazek, 2).

5937. Loriš, Jan. **Mánesovy podobizny.** Praha, Státí nakladatelství krásné literatury, hudby a umeni, 1954.

5938. Máal, Karel B. **Josef Mánes, jeho život a díla.** Praze, Topič, 1905.

5939. Macková, Olga. **Josef Mánes.** Praha, Odeon, 1970.

5940. Matějček, Antonin. **Dílo Josefa Mánesa.** 4 v. Praha, Štenc, 1923-1940. (CR).

5941. Paur, Jaroslav. **Josef Mánes; výbor obrazů a kreseb z jehodíla.** Praha, Dědictví Komenského, 1949. 2 ed.

5942. Pěcírka, Jaromír. **Josef Mánes, živy pramen národní tradice.** Praze, Melantrich, 1941.

5943. Štencuv graficky kabinet (Prague). **Josefa Mánesa.** Praze, Štenc, 1920.

5944. Volavková, Hana. **Josef Mánes, malíř vzorkůa ornamentu.** Praha, Odeon, 1981.

MANESSIER, ALFRED, 1911-

5945. Cayrol, Jean. **Manessier.** Paris, Fall, 1966. 2 ed.

5946. Hodin, Josef Paul. **Manessier.** Bath (Eng.), Adams & Dart, 1972.

MANET, EDOUARD, 1832-1883

5947. Bataille, Georges. **Manet, biographical and critical study.** Trans. by Austryn Wainhouse and James Emmons. New York, Skira, 1955. (The Taste of Our Time, 14; new ed.: Paris, Flammarion, 1980).

5948. Bazire, Edmond. **Manet: illustrations d'après les originaux et gravures de Guérard.** Paris, Quantin, 1884.

5949. Biez, Jacques de, ed. **Edouard Manet, conférence faite à la Salle des Capucines, le mardi 22 janvier, 1884.** Paris, Baschet, 1884.

5950. Blanche, Jacques-Emile. **Manet.** Paris, Rieder, 1924.

5951. Colin, Paul. **Edouard Manet.** Paris, Floury, 1932.

5952. Courthion, Pierre. **Edouard Manet.** New York, Abrams, 1962.

5953. _____ and Cailler, Pierre, eds. **Portrait of Manet by himself and his contemporaries.** Trans. by Michael Ross. New York, Roy, 1960.

5954. Duret, Théodore. **Histoire d'Edouard Manet et de son oeuvre.** Paris, Floury, 1902; new ed.: Paris, Bernheim-Jeune, 1926. (English ed., trans. by J. E. Crawford Flitch: New York, Crown, 1927).

5955. _____. **Manet and the French Impressionists.** Trans. by J. E. Crawford Flitch. London, Richards/Philadelphia, Lippincott, 1910.

5956. Ecole Nationale des Beaux-Arts. **Exposition des oeuvres d'Edouard Manet.** Préface de Emile Zola. [June 5-28, 1884]. Paris, Quantin, 1884.

5957. Farwell, Beatrice. **Manet and the nude: a study in iconography in the Second Empire.** New York/London, Garland, 1981.

5958. Florisoone, Michel. **Manet.** Monaco, Documents d'Art, 1947.

5959. Galeries nationales du Grand Palais (Paris). **Manet, 1832-1883.** 22 avril-1er août 1983. Paris, Editions de la Réunion des Musées Nationaux, 1983.

5960. Graber, Hans. **Edouard Manet nach eigenen und fremden Zeugnissen.** Basel, Schwabe, 1941.

5961. Gramantieri, Tullo. **Il caso Manet.** Roma, Palombi, 1944.

5962. Guérin, Marcel. **L'oeuvre gravé de Manet.** Paris, Floury, 1944.

5963. Hamilton, George H. **Manet and his critics.** New Haven, Yale University Press, 1954. (Yale Historical Publications: History of Art, 7; reprint: New York, Norton, 1969).

5964. Hanson, Anne C. **Manet and the modern tradition.** New Haven/London, Yale University Press, 1977.

5965. Harris, Jean C. **Edouard Manet, graphic work.** A definitive catalogue raisonné. New York, Collectors Editions, 1970. (CR).

5966. Hopp, Gisela. **Edouard Manet, Farbe und Bildgestalt.** Berlin, de Gruyter, 1968. (Beiträge zur Kunstgeschichte, 1).

5967. Jamot, Paul et Wildenstein, Georges. **Manet.** 2 v. Paris, Les Beaux-Arts, 1932. (CR).

5968. Jedlicka, Gotthard. **Edouard Manet.** Erlenbach/Zürich, Rentsch, 1941.

5969. Leiris, Alain de. **The drawings of Edouard Manet.** Berkeley/Los Angeles, University of California Press, 1969. (California Studies in the History of Art, 10).

5970. Leveque, Jacques. **Manet.** Paris, Quatre Chemins, 1983.

5971. Manet, Edouard. **Lettres de jeunesse, 1848-1849: voyage à Rio.** Paris, Rouart, 1928.

5972. _____. **Lettres illustrées.** Introduction de Jean Guiffrey. Paris, Legarrec, 1929.

5973. Mathey, Jacques. **Graphisme de Manet.** 3 v. Paris, de Nobele, 1961-66. (CR).

5974. Mauner, George. **Manet, peintre-philosophe: a study of the painter's themes.** University Park, Penn./London, Pennsylvania State University Press, 1975.

5975. Meier-Graefe, Julius. **Manet und sein Kreis.** Berlin, Bard, Marquardt, [1904]. 2 ed. (Die Kunst, 7).

5976. Moreau-Nélaton, Etienne. **Manet, raconté par lui-même.** 2 v. Paris, Laurens, 1926.

5977. Musée de l'Orangerie (Paris). **Exposition Manet, 1832-1883.** [June 16-October 9, 1932]. Préface de Paul Valéry; introd. de Paul Jamot. Ed. by Charles Sterling. Paris, [Musée de l'Orangerie], 1932.

5978. National Gallery of Art (Washington, D.C.). **Manet and modern Paris.** [Dec. 5, 1982-March 6, 1983; text by Theodore Reff]. Washington, D.C., National Gallery of Art, 1982.

5979. Perruchot, Henri. **La vie de Manet.** Paris, Hachette, 1959.

5980. Philadelphia Museum of Art. **Edouard Manet, 1832-1883.** Nov. 3-Dec. 11, 1966. [Catalogue by Anne C. Hanson]. Philadelphia, Philadelphia Museum of Art, 1966.

5981. Piérard, Louis. **Manet l'incompris.** Paris, Sagittaire, 1945.

5982. Proust, Antonin. **Edouard Manet: souvenirs.** Paris, Laurens, 1913.

5983. Reff, Theodore. **Manet: Olympia.** New York, Viking, 1976.

5984. Rewald, John. **Edouard Manet pastels.** Oxford, Cassirer, 1947.

5985. Rosenthal, Léon. **Manet, aquafortiste et lithographe.** Paris, Le Goupy, 1925.

5986. Rouart, Denis et Wildenstein, Daniel. **Edouard Manet, catalogue raisonné.** 2 v. Lausanne/Paris, La Bibliothèque des Arts, 1975. (CR).

5987. Sandblad, Nils G. **Manet: three studies in artistic conception.** Trans. by Walter Nash. Lund (Sweden), Gleerup, 1954. (Publications of the New Society of Letters at Lund, 46).

5988. Tabarant, Adolphe. **Manet et ses oeuvres.** Paris, Gallimard, 1947.

5989. _____. **Manet: histoire catalographique.** Paris, Editions Montaigne, 1931.

5990. Tschudi, Hugo V. **Edouard Manet.** Berlin, Cassirer, 1909. 2 ed.

5991. Venturi, Marcello [and] Orienti, Sandra. **L'opera pittorica di Edouard Manet.** Milano, Rizzoli, 1967. (Classici dell'arte, 14).

5992. Waldmann, Emil. **Edouard Manet.** Berlin, Cassirer, 1923.

5993. Zola, Emile. **Edouard Manet, étude biographique et critique.** Paris, Dentu, 1867.

MANSART, FRANÇOIS, 1598-1666

5994. Blunt, Anthony. **François Mansart and the origins of French classical architecture.** London, Warburg Inst., 1941. (Studies of the Warburg Institute, 14).

5995. Braham, Allan and Smith, Peter. **François Mansart.** 2 v. London, Zwemmer, 1973. (CR). (Studies in Architecture, 13).

5996. Marie, Alfred et Marie, Jeanne. **Mansart à Versailles.** 2 v. Paris, Fréal, 1972. (Versailles, son histoire, 2).

5997. _____. **Mansart et Robert de Cotte.** Paris, Imprimerie nationale, 1976. (Versailles, son histoire, 3).

MANSART, JULES HARDOUIN, 1646-1708

5998. Bibliothèque National (Paris). **Hardouin-Mansart et son école, exposition organisée à l'occasion du troisième centenaire de sa naissance.** 16 octobre-6 novembre 1946. Paris, Bibliothèque nationale, 1946.

5999. Bourget, Pierre et Cattaui, Georges. **Jules Hardouin Mansart.** Paris, Vincent, Fréal, 1956.

MANSHIP, PAUL, 1885-1966

6000. Gallatin, Albert E. **Paul Manship, a critical essay on his sculpture and an iconography.** New York, Lane, 1917.

6001. Murtha, Edwin. **Paul Manship.** New York, Macmillan, 1957.

6002. Permanent Collection Galleries, Minnesota Museum of Art [and] Bush Memorial Library, Hamline University (St.

Paul, Minn.). **Paul Howard Manship, an intimate view.** [Museum exhibit: Dec. 7, 1972-March 31, 1973; Library exhibit: Dec. 7, 1972-Jan. 31, 1973; text by Frederick D. Leach]. St. Paul, Minnesota Museum of Art, 1972.

6003. Vitry, Paul. **Paul Manship, sculpteur américain.** Paris, Editions de la Gazette de Beaux-Arts, 1927.

MANTEGNA, ANDREA, 1431-1506

see also FRANCIA

6004. Bell, Mrs. Arthur [Nancy]. **Mantegna.** London, Jack/New York, Stokes, [1911].

6005. Bellonci, Maria and Garavaglia, Niny. **L'opera completa del Mantegna.** Milano, Rizzoli, 1967. (Classici dell'arte, 8).

6006. Beyen, Hendrik G. **Andrea Mantegna en de verovering der ruinote on der schilderkunst.** Haag, Nijhoff, 1931.

6007. Blum, André. **Mantegna; biographie critique.** Paris, Laurens, 1912.

6008. Blum, Ilse. **Andrea Mantegna und die Antike.** Strassburg, Heitz, 1936. (Sammlung Heitz, III. Reihe, 8).

6009. Camesasca, Ettore. **Mantegna.** Milano, Club del Libro, 1964. (Collana d'arte del Club del Libro, 8).

6010. Cipriani, Renata. **All the paintings of Mantegna.** Trans. by Paul Colacicchi. 2 v. New York, Hawthorn, 1963. (Complete Library of World Art, 20/21).

6011. Cruttwell, Maud. **Andrea Mantegna.** London, Bell, 1901.

6012. Fiocco, Giuseppe. **L'arte di Andrea Mantegna.** Venezia, Pozza, 1959. 2 ed.

6013. ———. **Mantegna.** Milano, Hoepli, 1937.

6014. ———. **Mantegna, la Cappella Ovetori nella Chiesa degli Eremitani.** Milano, Pizzi, 1947. (New ed., in English, with an introduction by Teresio Pignatti: London, Phaidon, 1978.)

6015. Knapp, Fritz. **Andrea Mantegna; des Meisters Gemälde und Kupferstiche.** Stuttgart/Leipzig, Deutsche Verlags-Anstalt, 1910. (Klassiker der Kunst, 16).

6016. Kristeller, Paul. **Andrea Mantegna.** Trans. by S. Arthur Strong. London, Longmans, 1901.

6017. Martindale, Andrew. **The Triumphs of Caesar by Andrea Mantegna in the collection of Her Majesty the Queen at Hampton Court.** London, Miller, 1979.

6018. Meiss, Millard. **Andrea Mantegna as illuminator; an episode in Renaissance art, humanism, and diplomacy.** New York, Columbia University Press, 1957.

6019. Palazzo Ducale (Venice). **Andrea Mantegna.** Settembre-ottobre 1961. Catalogo della mostra a cura di Giovanni Paccagnini. Venezia, Pozza, 1961.

6020. Thode, Henry. **Mantegna.** Bielefeld/Leipzig, Velhagen & Klasing, 1897. (Künstler-Monographien, 27).

6021. Tietze-Conrat, Erica. **Mantegna.** London, Phaidon, 1955; distributed by Garden City Books, N.Y.

6022. Yriarte, Charles. **Mantegna; sa vie, sa maison, son tombeau, ses oeuvres dans les musées et les collections.** Paris, Rothschild, 1901.

MANUEL-DEUTSCH, NIKLAUS, 1484-1530

6023. Beerli, Conrad A. **Le peintre poète Nicolas Manuel et l'évolution sociale de son temps.** Genève, Droz, 1953. (Travaux d'Humanisme et Renaissance, 4).

6024. Ganz, Paul. **Zwei Schreibbüchlein des Niklaus Manuel Deutsch von Bern.** Berlin, Bard; Im Auftrag des Deutschen Vereins für Kunstwissenschaft, 1909.

6025. Grüneisen, Karl van. **Niclaus Manuel; Leben und Werke eines Malers und Dichters, Kriegers, Staatsmannes und Reformators im sechzehnten Jahrhundert.** Stuttgart/Tübingen, Cotta, 1837.

6026. Haendcke, Berthold. **Nikolaus Manuel Deutsch als Künstler.** Frauenfeld, Huber, 1889.

6027. Koegler, Hans. **Beschreibendes Verzeichnis der Basler Handzeichnungen des Niklaus Manuel Deutsch.** Basel, Schwabe, 1930.

6028. Kunstmuseum Bern. **Niklaus Manuel Deutsch: Maler, Dichter, Staatsmann.** 22. September bis 2. Dezember 1979. Bern, Kunstmuseum Bern, 1979. (CR).

6029. Mandach, Conrad de. **Niklaus Manuel Deutsch.** Basel, Urs Graf, [1956]. 2 ed. (Basler Kunstbücher, 2).

6030. Stumm, Lucie. **Niklaus Manuel Deutsch von Bern als bildender Künstler.** Bern, Stämpfli, 1925.

6031. Tavel, Hans C. von. **Niklaus Manuel. Zur Kunst eines Eidgenossen der Dürerzeit.** Bern, Wyss Erben, 1979.

6032. Zinsli, Paul. **Der Berner Totentanz des Niklaus Manuel.** Bern, Haupt, 1953. (Berner Heimatbücher, 54/55).

MANZÙ, GIACOMO, 1908-

6033. Accademia delle Arti del Disegno. **Giacomo Manzù: esposizione per le celebrazioni del suo settantesimo anno.** [Text by Cesare Brandi et al.]. Firenze, Barbèra, 1979.

6034. Ciranna, Alfonso. **Giacomo Manzù, catalogo delle opere grafiche, 1929-1968.** Milano, Ciranna, 1968. (CR).

6035. Micheli, Mario de. **Giacomo Manzù.** New York, Abrams, 1974.

6036. Pacchioni, Anna. **Giacomo Manzù.** Prefazione di Lionello Venturi. Milano, Edizioni del Milione, 1948. (New ed., text by Carlo L. Ragghianti: 1957).

6037. Rewald, John. **Giacomo Manzù.** Greenwich, Conn., New York Graphic Society, 1967.

MARC, FRANZ, 1880-1916

see also MACKE, AUGUST and KANDINSKY, WASSILY

6038. Bünemann, Hermann, ed. **Franz Marc: Zeichnungen, Aquarelle.**
München, Bruckmann, 1952.

6039. Lankheit, Klaus. **Franz Marc im Urteil seiner Zeit.** Köln,
DuMont Schauberg, 1960.

6040. _____. **Franz Marc, sein Leben und seine Kunst.** Köln,
DuMont, 1976. (CR).

6041. _____. **Franz Marc: watercolors, drawings, writings.**
Trans. by Norbert Guterman. New York, Abrams, 1960.

6042. Levine, Frederick S. **The apocalyptic vision: the art of
Franz Marc as German expressionism.** New York, Harper &
Row, 1979.

6043. Marc, Franz. **Briefe aus dem Felde, 1914-1916.** Berlin,
Rembrandt, 1959. 5 ed.

6044. _____. **Briefe, Aufzeichnungen und Aphorismen.** 2 v.
Berlin, Cassirer, 1920.

6045. _____. **Schriften.** Herausgegeben von Klaus Lankheit.
Köln, DuMont, 1978.

6046. Schardt, Alois J. **Franz Marc.** Berlin, Rembrandt, 1936.

6047. Städtische Galerie im Lenbachhaus (Munich). **Franz Marc,
1880-1916.** [Aug. 27-Oct. 26, 1980]. München, Prestel,
1980.

6048. University Art Museum, Berkeley. **Franz Marc; pioneer of
spiritual abstraction.** Dec. 5, 1979-Feb. 3, 1980. [Text
by Marc Rosenthal et al.]. Berkeley, Calif., University
Art Museum, 1979.

MARCANTONIO see RAIMONDI, MARCANTONIO

MARCKS, GERHARD, 1889-1981

6049. Georg-Kolbe-Museum (Berlin). **Gerhard Marcks.** [April 11,
1979-June 1, 1980]. Berlin, Georg-Kolbe-Museum, 1979.

6050. Rieth, Adolf. **Gerhard Marcks.** Recklinghausen, Bongers,
1959. (Monographien zur Rheinisch-Westfälischen Kunst
der Gegenwart, 16).

6051. U.C.L.A. Art Gallery (Los Angeles). **Gerhard Marcks.** [Text
by Werner Haftman et al.]. Los Angeles, Regents of the
University of California, 1969.

MAREES, GEORGES DES, 1697-1776

6052. Heenmarck, Carl. **Georg Desmarées; Studien über die
Rokoko-Malerei in Schweden und Deutschland.** Uppsala,
Almquist & Wiksells, 1933.

MAREES, HANS VON, 1837-1887

6053. Degenhart, Bernhard. **Marées Zeichnungen.** Berlin, Mann,
1963. 2 ed.

6054. Fiedler, Conrad. **Bilder und Zeichnungen von Hans von
Marées, seinem Andenken gewidmet.** München, [Bruckmann],
1889. (New ed.: Frankfurt a.M., Heiderhoff, 1969).

6055. Gebäude der Secession (Berlin). **Ausstellung Hans von
Marées.** 28. Februar bis Anfang April 1909. Berlin,
Cassirer, [1909].

6056. Gerlach-Laxner, Uta. **Hans von Marées, Katalog seiner
Gemälde.** München, Prestel, 1980. (CR).

6057. Kutter, Erich. **Hans von Marées; die Tragödie des deutschen
Idealismus.** Dresden, Verlag der Kunst, 1958. 2 ed.

6058. Liebmann, Kurt. **Hans von Marées.** Dresden, Verlag der
Kunst, 1972.

6059. Marées, Hans von. **Briefe.** München, Piper, 1920.

6060. Meier-Graefe, Julius. **Hans von Marées, sein Leben und sein
Werk.** 3 v. München/Leipzig, Piper, 1910.

6061. _____. **Der Zeichner Hans von Marées.** München, Piper,
1925.

MARIN, JOHN, 1870-1953

6062. Benson, Emanuel M. **John Marin, the man and his work.**
Washington, D.C., American Federation of Arts, 1935.

6063. Gray, Cleve, ed. **John Marin by John Marin.** New York,
Holt, Rinehart & Winston, [1970].

6064. Helm, Mackinley. **John Marin.** New York, Pellegrini &
Cuhady/Boston, Institute of Contemporary Art, 1948.
(Reprint: New York, Kennedy Graphics/Da Capo, 1970).

6065. Marin, John. **Letters.** Edited, with an introduction by
Herbert J. Seligmann. New York, [An American Place],
1931.

6066. _____. **The selected writings of John Marin.** Edited, with
an introduction by Dorothy Norman. New York, Pellegrini
& Cuhady, 1949.

6067. Museum of Modern Art (New York). **John Marin; watercolors,
oil paintings, etchings.** New York, Museum of Modern Art,
1936.

6068. Philadelphia Museum of Art. **John Marin: etchings and
related works.** 2 v. January 17-March 17, 1969. [Vol.
I: The complete etchings of John Marin; a catalogue
raisonné by Carl Zigrosser; Vol. II: Oils, watercolors,
and drawings which relate to his etchings by Sheldon
Reich]. Philadelphia, Philadelphia Museum of Art, 1969.
(CR).

6069. Reich, Sheldon. **John Marin, a stylistic analysis and
catalogue raisonné.** 2 v. Tucson, Ariz., University of
Arizona Press, 1970. (CR).

MARIS, JACOB, 1837-1899

MATTHIJS, 1835-1917

WILLEM, 1844-1910

6070. Arondéus, Willem. **Matthijs Maris, de tragick van den droom.** Amsterdam, Querido, 1939.

6071. Bock, Theophile E. A. **Jacob Maris.** Amsterdam, Scheltema & Holkema, 1902-3. (English ed.: London, Moring, 1904).

6072. Boer, H. de. **Willem Maris.** Haag, Zürcher, [n.d.].

6073. Fridlander, Ernest D. **Matthew Maris.** London/Boston, Warner, 1921.

6074. Gemeentemuseum (The Hague). **Maris tentoonstelling.** 22 December 1935 tot 2 Februari 1936. [Haag], Gemeentemuseum, [1935].

6075. Thomson, D. Croal. **The brothers Maris (James-Matthew-William).** Edited by Charles Holme. London/Paris, The Studio, 1907.

MARNE, JEAN-LOUIS DE see DEMARNE, JEAN-LOUIS

MARSY, BALTHAZARD, 1629-1674

GASPARD, 1624-1681

6076. Hedin, Thomas. **The sculpture of Gaspard and Balthazard Marsy: art and patronage in the early reign of Louis XIV.** With a catalogue raisonné. New York, Harper and Row, 1984. (CR).

MARTIN, HOMER DODGE, 1836-1897

6077. Martin, Elizabeth G. **Homer Martin, a reminiscence.** New York, Macbeth, 1904.

6078. Mather, Frank J., Jr. **Homer Martin, poet in landscape.** New York, [Frederick F. Sherman], 1912.

MARTIN, JOHN, 1789-1854

6079. Balston, Thomas. **John Martin, 1789-1854; his life and works.** London, Duckworth, 1947.

6080. Feaver, William. **The art of John Martin.** Oxford, Clarendon Press, 1975.

6081. Johnstone, Christopher. **John Martin.** London, Academy/New York, St. Martin's, 1974.

6082. Pendered, Mary L. **John Martin, painter; his life and times.** London, Hurst & Blackett, 1923.

MARTIN, PAUL, 1864-1944

6083. Flukinger, Roy, et al. **Paul Martin: Victorian photographer.** Austin, University of Texas Press, 1977.

6084. Jay, Bill. **Victorian candid camera: Paul Martin, 1864-1944.** Introd. by Cecil Beaton. Newton Abbot, David & Charles, 1973.

6085. Martin, Paul. **Victorian snapshots.** With an introduction by Charles Harvard. London, Country Life/New York, Scribner, 1939. (Reprint: New York, Arno, 1973).

MARTINI, SIMONE, 1285-1344

6086. Bologna, Ferdinando. **Simone Martini.** Milano, Fabbri, 1966. (I maestri del colore, 119).

6087. Contini, Gianfranco [and] Gozzoli, Maria C. **L'opera completa di Simone Martini.** Milano, Rizzoli, 1970. (CR). (Classici dell'arte, 43).

6088. Gosche, Agnes. **Simone Martini, ein Beitrag zur Geschichte der sienesischen Malerei im XIV. Jahrhundert.** Leipzig, Seemann, 1899. (Beiträge zur Kunstgeschichte, Neue Folge, 26).

6089. Mariani, Valerio. **Simone Martini e il suo tempo.** Napoli, Libreria Scientifica, 1968.

6090. Marle, Raimond van. **Simone Martini et les peintres de son école.** Strassbourg, Heitz, 1920.

6091. Paccagnini, Giovanni. **Simone Martini.** Milano, Martello, 1955.

6092. Rinaldis, Aldo de. **Simone Martini.** Roma, Palombi, [1936].

MARTINS, NABUR see MASTER OF FLEMALLE

MASACCIO, 1401-1428

6093. Berti, Luciano. **Masaccio.** University Park, Penn., Penn. State University Press, 1967.

6094. Cole, Bruce. **Masaccio and the art of early Renaissance Florence.** Bloomington, Ind., Indiana University Press, 1980.

6095. Creutz, Max. **Masaccio; ein Versuch zur stilistischen und chronologischen Einordnung seiner Werke.** Berlin, Ebering, 1901.

6096. Hendy, Philip. **Masaccio; frescoes in Florence.** [Greenwich, Conn.], New York Graphic Society/Paris, UNESCO, 1956.

6097. Hertlein, Edgar. **Masaccios Trinität: Kunst, Geschichte und Politik der Frührenaissance in Florenz.** Firenze, Olschki, 1979. (Pocket Library of Studies in Art, 24).

6098. Knudtzon, Fried G. **Masaccio og den florentiniske Malerkunst.** København, Lund, 1875.

6099. Lindberg, Henrik. **To the problem of Masolino and Masaccio.** 2 v. Stockholm, Norstedt, 1931.

6100. Magherini-Graziani, Giovanni, ed. **Masaccio: ricordo delle rese in San Giovanni di Valdarno nel di XXV ottobre MCMIII in occasione del V centenario della sua nascita.** Firenze, Seeber, 1904.

6101. Mesnil, Jacques. **Masaccio et les débuts de la renaissance.** La Haye, Nijhoff, 1927.

6102. Missirini, Melchior. **Masaccio, orazione.** Firenze, Piatti, 1846.

6103. Pittaluga, Mary. **Masaccio.** Firenze, LeMonnier, 1935.

6104. Procacci, Ugo. **All the paintings of Masaccio.** Trans. by Paul Colacicchi. New York, Hawthorn, 1962. (Complete Library of World Art, 6).

6105. Schmarsow, August. **Masaccio Studien.** [Issued in 3 v.] Kassel, Fisher, 1895-1899.

6106. _____. **Masolino und Masaccio.** Leipzig, [Schmarsow], 1928.

6107. Salmi, Mario. **La Cappella Brancacci a Firenze.** 2 v. [Vol. I: Masaccio; Vol. II: Masaccio-Masolino-Filippino Lippi]. Milano, Pizzi, [1948]. (Collezione Silvana, 8/10).

6108. _____. **Masaccio.** Roma, Valori Plastici, [1932].

6109. Somaré, Enrico. **Masaccio.** Milano, Bottega di Poesia, [1924].

6110. Steinbart, Kurt. **Masaccio.** Wien, Schroll, 1948.

6111. Volponi, Paolo [and] Berti, Luciano. **L'opera completa di Masaccio.** Milano, Rizzoli, 1968. (CR). (Classici dell'arte, 24).

6112. Wasserman, Gertrud. **Masaccio und Masolino; Probleme einer Zeitenwende und ihre schöpferische Gestaltung.** Strassburg, Heitz, 1935. (Zur Kunstgeschichte des Auslandes, 134).

MASEREEL, FRANS, 1889-1972

6113. Avermaete, Roger. **Frans Masereel.** Bibliography and catalogue by Pierre Vorms and Hanns-Conon von der Gabelentz. New York, Rizzoli, 1977. (CR).

6114. Durtain, Luc. **Frans Masereel.** Paris, Vorms, 1931.

6115. Hagelstange, Rudolf. **Gesang des Lebens; das Werk Frans Masereels.** Hannover, Fackelträger, 1957.

6116. Havelaar, Just. **Het werk van Frans Masereel.** Haag, De Baanbreker, 1930.

6117. Holitscher, Arthur [and] Zweig, Stefan. **Frans Masereel.** Berlin, Juncker, 1923. (Graphiker Unserer Zeit, 1).

6118. Pommeranz-Liedtke, Gerhard. **Der Maler Frans Masereel.** Dresden, Verlag der Kunst, 1961. 2 ed.

6119. Vorms, Pierre. **Gespräche mit Frans Masereel.** Dresden, Verlag der Kunst, 1967.

6120. Ziller, Gerhart. **Frans Masereel, Einführung und Auswahl.** Dresden, Sachsenverlag, 1949.

6121. Zweig, Stefan, et al. **Frans Masereel, mit Beiträgen von Stefan Zweig et al.** Dresden, Verlag der Kunst, 1961. 2 ed.

MASOLINO DA PANICALE, 1383-1440

see also MASACCIO

6122. Martini, Alberto. **Masolino a Castiglione Olona.** Milano, Fabbri/Ginevra, Skira, 1965. (L'arte racconta, 3).

6123. Micheletti, Emma. **Masolino da Panicale.** Milano, Istituto Editoriale Italiano, 1959. (Arte e pensiero, 3).

6124. Toesca, Pietro. **Masolino da Panicale.** Bergamo, Istituto Italiano d'Arti Grafiche, 1908. (Collezione di monografie illustrate; pittore, scultori, architetti, 4).

MASSON, ANDRE, 1896-

6125. Barrault, Jean-Louis, et al. **André Masson.** Rouen, Wolf, 1940.

6126. Clébert, Jean-Paul. **Mythologie d'André Masson.** Genève, Cailler, 1971. (Les grandes monographies, 14).

6127. Hahn, Otto. **Masson.** London, Thames & Hudson, 1965.

6128. Juin, Hubert. **André Masson.** Paris, Fall, 1963.

6129. Leiris, Michel et Limbour, Georges. **André Masson et son univers.** Genève/Paris, Editions des Trois Collines, 1947.

6130. Masson, André. **Métamorphose de l'artiste.** 2 v. Genève, Cailler, 1956.

6131. _____. **Le rebelle du surréalisme; écrits.** Edition établie par Françoise Will-Levaillant. Paris, Hermann, 1976.

6132. Museum of Modern Art (New York). **André Masson.** [Text and catalogue by William Rubin and Carolyn Lancher]. New York, Museum of Modern Art, 1976.

6133. Passeron, Roger. **André Masson et les puissances du signe.** [Paris], Denoël, 1975.

6134. _____. **André Masson: gravures, 1924-1972.** Fribourg, Weber, 1973.

6135. Pia, Pascal. **André Masson.** Paris, Gallimard, 1930.

MASSYS, QUENTIN, 1466-1530

6136. Boon, Karel G. **Quinten Massys.** Amsterdam, Becht, [1948]. (Palet serie, 22).

6137. Bosque, Andrée de. **Quentin Metsys.** Bruxelles, Arcade, 1975. (CR).

6138. Bosschère, Jean de. **Quinten Metsys.** Bruxelles, van Oest, 1907.

6139. Brising, Harald. **Quinten Metsys und der Ursprung des Italianismus in der Kunst der Niederlande.** 2 v. Leipzig, Schumann, 1908. 2 ed.

6140. Cohen, Walter. **Studien zu Quinten Metsys.** München, Bruckmann, 1904.

6141. Friedländer, Max J. **Quentin Massys.** Comments and notes by H. Paulwels. Trans. by Heinz Norden. Leyden, Sijthoff/Brussels, La Connaissance, 1971. (Early Netherlandish Painting, 7).

6142. Génard, Pierre. **Nasporingen over de geboorteplatts en de familie van Quinten Massys.** Antwerpen, Fontaine, 1870.

6143. Roosen-Runge, Heinz. **Die Gestaltung der Farbe bei Quentin Metsys.** München, Filser, 1940. (Münchener Beiträge zur Kunstgeschichte, 6).

MASTER . . .

[Here are grouped all monographs on those anonymous artists called MASTER or MEISTER.]

[Collective biography]

6144. Lehrs, Max. **Geschichte und kritischer Katalog des deutschen, niederländischen und französischen Kupferstichs im XV. Jahrhundert.** 9 v. Wien, Gesellschaft für Vervielfältigende Kunst, 1908-1934.

MASTER OF THE AMSTERDAM CABINET, 15th c.

6145. Hutchison, Jane C. **The master of the housebook.** New York, Collectors Editions, 1972.

6146. Lanckoronska, Maria. **Das mittelalterliche Hausbuch der fürstlich waldburgschen Sammlung; Auftraggeber, Entstehungsgrund und Zeichner.** Darmstadt, Roether, 1975.

6147. Naumann, Hans. **Die Holzschnitte des Meisters vom Amsterdamer Kabinett zum Spiegel Menschlicher Behaltnis.** Strassburg, Heitz, 1910. (Studien zur deutschen Kunstgeschichte, 126).

6148. Stange, Alfred. **Der Hausbuchmeister; Gesamtdarstellung und Katalog seiner Gemälde, Kupferstiche und Zeichnungen.** Strasbourg/Baden-Baden, Heitz, 1958. (Studien zur deutschen Kunstgeschichte, 316).

MASTER BERTRAM OF MINDEN, 1345?-1415

6149. Dorner, Alexander. **Meister Bertram von Minden.** Berlin, Rembrandt, 1937. (Kunstbücher des Volkes, 17).

6150. Lichtwark, Alfred. **Meister Bertram, tätig in Hamburg, 1367-1415.** Hamburg, Lütcke & Wulff, 1905.

6151. Portmann, Paul. **Meister Bertram.** Zürich, Rabe, 1963.

MASTER OF THE BOUCICAUT HOURS, 15th c.

6152. Champeaux, Alfred de [and] Gauchery, Paul. **Les travaux d'art exécutés pour Jean de France, duc de Berry, avec une etude biographique sur les artistes employés par ce prince.** Paris, Champion, 1894.

6153. Meiss, Millard. **French painting in the time of Jean de Berry: the Boucicaut Master.** With the assistance of Kathleen Morand and Edith W. Kirsch. London, Phaidon, 1968.

MASTER DS, fl. 1503-1515

6154. Bock, Elfried. **Holzschnitte des Meisters DS.** Berlin, Deutscher Verein für Kunstwissenschaft, 1924.

MASTER OF 1515

6155. Kristeller, Paul. **Der Meister von 1515; Nachbildungen seiner Kupferstiche.** Berlin, Cassirer, 1916. (Graphische Gesellschaft, 22).

MASTER OF FLEMALLE

see also WEYDEN, ROGER VAN DER

6156. Beyaert-Carlier, Louis. **Le problème van der Weyden, Flémalle, Campin.** Bruxelles, Notre Temps, 1937.

6157. Frinta, Mojmír S. **The genius of Robert Campin.** The Hague, Mouton, 1966. (Studies in Art, 1).

6158. Hasse, Carl. **Roger van Brügge, der Meister von Flémalle.** Strassburg, Heitz, 1904. (Zur Kunstgeschichte des Auslandes, 21).

6159. Maeterlinck, Louis. **Nabur Martins ou Le Maître de Flémalle.** Bruxelles/Paris, van Oest, 1913.

6160. Renders, Emile. **La solution du problème van der Weyden, Flémalle, Campin.** 2 v. Bruges, Beyaert, 1931.

6161. Winkler, Friedrich. **Der Meister von Flémalle und Rogier van der Weyden.** Strassburg, Heitz, 1913.

MASTER FRANCKE, 15th c.

6162. Lichtwark, Alfred. **Meister Francke, 1424.** Hamburg, Kunsthalle zu Hamburg, 1899.

6163. Martens, Bella. **Meister Francke.** 2 v. Hamburg, Friederichsen, de Gruyter, 1929.

MASTER OF THE GARDENS OF LOVE, 15th c.

6164. Lehrs, Max. **Der Meister der Liebesgärten; ein Beitrag zur Geschichte des ältesten Kupferstichs in den Niederlanden.** Leipzig, Hiersemann, 1893.

6165. Schüler, Irmgard. **Der Meister der Liebesgärten; ein Beitrag zur frühholländischen Malerei.** Amsterdam, van Munster, 1932.

MASTER OF MOULINS, fl. 1480-1503

6166. Huillet d'Istria, Madeleine. **Le Maître de Moulins.** Paris, Presses Universitaires du France, 1961. (Le peinture française de la fin du Moyen Age, 1).

MASTER OF NAUMBURG, 13th c.

6167. Beenken, Hermann. **Der Meister von Naumburg.** Berlin, Rembrandt, 1939.

6168. Hinz, Paulus. **Der Naumburger Meister.** Berlin, Evangelische Verlags-Anstalt, 1954.

MASTER OF PETRARCH, 16th c.

see also WEIDITZ, HANS

6169. Musper, Theodor. **Die Holzschnitte des Petrakameisters; ein kritisches Verzeichnis mit Einleitung.** München, Verlag der Münchner Drucke, 1927.

MASTER OF THE PLAYING CARDS, fl. 1445

6170. Geisberg, Max. **Das älteste gestochene deutsche Kartenspiel vom Meister der Spielkarten.** Strassburg, Heitz, 1905. (Studien zur deutschen Kunstgeschichte, 66).

6171. Lehmann-Haupt, Hellmut. **Gutenberg and the Master of the Playing Cards.** New Haven/London, Yale University Press, 1966.

MASTER OF THE VYSSÍ BROD CYCLE, fl. 1350

6172. Friedl, Antonín. **Pasionál Mistrů Vyšebrodských.** Praha, Borový, 1934.

MASTER OF THE WILTON DIPTYCH, 14th c.

6173. Bodkin, Thomas. **The Wilton diptych in the National Gallery, London.** London, Humphries, [1947]. (The Gallery Books, 16).

6174. Scharf, George. **Description of the Wilton House diptych, containing a contemporary portrait of King Richard the Second.** [London], Arundel Society, 1882.

MEISTER E. S., 15th c.

6175. Albert, Peter P. **Der Meister E. S.; sein Name, seine Heimat und sein Ende: Funde und Vermutungen.** Strassburg, Heitz, 1911. (Studien zur deutschen Kunstgeschichte, 137).

6176. Geisberg, Max. **Die Anfänge des deutschen Kupferstiches & der Meister E. S.** Leipzig, Klinkhardt & Biermann, 1910. (Meister der Graphik, 2).

6177. _____. **Die Kupferstiche des Meisters E. S.** Berlin, Cassirer, 1924.

6178. Hessig, Edith. **Die Kunst des Meisters E. S. und die Plastik der Spätgotik.** Berlin, Deutscher Verein für Kunst-wissenschaft, 1935. (Forschungen zur deutschen Kunstgeschichte, 1).

MEISTER DES MARIENLEBENS, fl. 1463-1480

6179. Schmidt, Hans M. **Der Meister des Marienlebens und sein Kreis; studien zur spätgotischen Malerei in Köln.** Düsseldorf, Schwann, 1978. (Beiträge zu den Bau- und Kunstdenkmälern im Rheinland, 22).

MASTROIANNI, UMBERTO, 1910-

6180. Argan, Giulio C. **Umberto Mastroianni.** Venezia, Edizioni del Cavallino, 1958.

6181. Galleria Nazionale d'Arte Moderna (Rome). **Umberto Mastroianni.** 12 giugno-20 settembre 1974; presentazioni di Palma Bucarelli. Roma, de Luca, 1974.

6182. Ponente, Nello. **Mastroianni.** Rome, Modern Art Editions, 1963. (Album of Contemporary Art, 2).

MATARE, EWALD, 1887-1965

6183. Flemming, Hanns F. **Ewald Mataré.** München, Prestel, 1955.

6184. Kestner-Gesellschaft Hannover. **Mataré und seine Schüler: Beuys, Haese, Heerich, Meistermann.** 2. März bis 15. April 1979. Hannover, Kestner-Gesellschaft, 1979. (Kestner-Gesellschaft Katalog 1/1979).

6185. Mataré, Ewald. **Tagebücher.** Ausgewählt und Herausgegeben von Hanna Mataré und Franz Müller. Köln, Hegner, 1973.

6186. Peters, Heinz. **Ewald Mataré, das graphische Werk.** 2 v. Köln, Czwiklitzer, 1957. (CR).

MATEJKO, JAN, 1838-1893

see also GROTTGER, ARTUR

6187. Bogucki, Janusz. **Matejko.** Warszawa, Wiedna Powszechna, 1955.

6188. Gintel, Jan. **Jan Matejko, biografia w wypisach.** Kraków, Literackie, 1966. 2 ed.

6189. Kunsthalle Nürnberg. **Jan Matejko, 1838-1893: Gemälde, Aquarelle, Zeichnungen.** [March 26-April 25, 1982]. Nürnburg, Kunsthalle Nürnberg, 1982.

6190. Matejko, Jan. **Ubiory w Polsce, 1200-1795.** Kraków, [n.p.], 1860. (New ed.: Kraków, Literackie, 1967).

6191. Ostrovs'kyi, Hryhorii S. **Ian Matejko; monograficheskii ocherk.** Moskva, Iskusstvo, 1965.

6192. Państwowy Instytut Sztuki (Warsaw). **Jan Matejko; materialy z sesji naukowej pôswięconej twôrczości artysty.** [Nov. 23-27, 1953]. Warszawa, Arkady, 1957.

6193. Serafińska, Stanislawa, ed. **Jan Matejko: wspomnienia rodzinne.** Kraków, Literackie, 1955.

6194. Starzyński, Juliusz. **Jan Matejko.** Warszawa, Arkady, 1979. 2 ed.

6195. Tarnowski, Stanislaw. **Matejko.** Kraków, Spółki wydawnictwo, 1897.

6196. Treter, Mieczyslaw. **Matejko; osobowość artysty, twórczość, forma i styl.** Lwów/Warszawa, Książnisa-Atlas, 1939.

6197. Witkiewicz, Stanislaw. **Matejko.** Lwów, Gubrynowicza, 1912. (Nauka i sztuka, 9).

MATISSE, HENRI, 1869-1954

6198. Alpetov, Mikhail V. **Henri Matisse.** [Translated from the Russian]. Dresden, Verlag der Kunst, 1973.

6199. Aragon, [Louis]. **Henri Matisse, roman.** 2 v. Paris, Gallimard, 1971.

6200. Baltimore Museum of Art. **Matisse as a draughtsman.** 12 January-21 February 1971. Introduction and commentary by Victor I. Carlson. Baltimore, Md., Baltimore Museum of Art, 1971; distributed by New York Graphic Society, Greenwich, Conn.

6201. Barnes, Albert C. and de Mazia, Violette. **The art of Henri Matisse.** New York/London, Scribner, 1933.

6202. Barr, Alfred H., Jr. **Matisse, his art and his public.** New York, Museum of Modern Art, 1951. (Reprint: New York, Arno, 1966).

6203. Basler, Adolphe. **Henri Matisse.** Leipzig, Klinkhardt & Biermann, 1924. (Junge Kunst, 46).

6204. Bock, Catherine C. **Henri Matisse and neo-impressionism, 1898-1908.** Ann Arbor, Mich., University Microfilms, 1981. (Studies in the Fine Arts; the Avant-garde, 13).

6205. Courthion, Pierre. **Henri Matisse.** Paris, Rieder, 1934.

6206. ———. **Le visage de Matisse.** Lausanne, Marguerat, 1942.

6207. Diehl, Gaston. **Henri Matisse.** Paris, Nouvelles Editions Françaises, 1970.

6208. Escholier, Raymond. **Matisse from the life.** Trans. by Geraldine and H. M. Colville. London, Faber, 1960.

6209. Faure, Elie, et al. **Henri Matisse.** Paris, Cahiers d'Aujourd'hui, [1920].

6210. Flam, Jack D., ed. **Matisse on art.** London, Phaidon, 1973.

6211. Fry, Roger. **Henri Matisse.** Paris, Chroniques du Jour, [1930].

6212. Elsen, Albert E. **The sculpture of Henri Matisse.** New York, Abrams, 1972.

6213. Gowing, Lawrence. **Matisse.** New York, Oxford University Press, 1979.

6214. Grand Palais (Paris). **Henri Matisse, exposition du centenaire.** Avril-septembre 1970. [Text by Pierre Schneider]. Paris, Ministère d'Etat Affaires Culturelles/Réunion des Musées Nationaux, 1970.

6215. Grünewald, Isaac. **Matisse och expressionismen.** Stockholm, Wahlström & Widstrand, 1944.

6216. Guichard-Meili, Jean. **Matisse.** Trans. by Caroline Moorehead. New York, Praeger, 1967.

6217. Jacobus, John. **Henri Matisse.** New York, Abrams, 1973.

6218. Kunsthaus Zürich. **Henri Matisse.** 15. Oktober 1982 bis 16. Januar 1983. [Text by Felix Baumann et al.]. Zürich, Kunsthaus Zürich, 1982.

6219. Lassaigne, Jacques. **Matisse, biographical and critical study.** Trans. by Stuart Gilbert. Geneva, Skira, 1959. (The Taste of Our Time, 30).

6220. Lieberman, William S. **Matisse, [fifty] years of his graphic art.** New York, Braziller, 1956.

6221. Luzi, Mario [and] Carrà, Massimo. **L'opera di Matisse dalla rivolta fauve all'intimismo, 1904-1928.** Milano, Rizzoli, 1971. (Classici dell'arte, 49).

6222. Marchiori, Giuseppe. **Matisse.** [Milano], Pizzi, [1967].

6223. McBride, Henry. **Matisse.** New York, Knopf, 1930.

6224. Musée National d'Art Moderne (Paris). **Henri Matisse, dessins et sculpture.** 29 mai-7 septembre 1975. Paris, Centre National d'Art et de Culture Georges Pompidou/Musée National d'Art Moderne, 1975.

6225. ———. **Oeuvres de Henri Matisse (1869-1954).** Catalogue établi par Isabelle Monod-Fontaine. Paris, Centre Georges Pompidous, Musée National d'Art Moderne, 1979.

6226. Museum of Modern Art (New York). **Henri Matisse, retrospective exhibition.** November 3-December 6, 1931. New York, Museum of Modern Art, 1931.

6227. ———. **The last works of Henri Matisse: large cut gouaches.** October 17-December 3, 1961. [Text by Monroe Wheeler]. New York, Museum of Modern Art, 1961. Distributed by Doubleday, Garden City, N.Y.

6228. ———. **Matisse in the collection of the Museum of Modern Art, including remainder interest and promised gifts.** [Text by John Elderfield et al.]. New York, Museum of Modern Art, 1978.

6229. Orienti, Sandra. **Henri Matisse.** Firenze, Sansoni, 1971. (I maestri del novecento, 18).

6230. Philadelphia Museum of Art. **Henri Matisse, retrospective exhibition of paintings, drawings and sculpture.** Philadelphia, Philadelphia Museum of Art, 1948.

6231. Reverdy, Pierre and Duthuit, Georges. **The last works of Henri Matisse, 1950-1954.** New York, Harcourt, Brace, 1958.

6232. St. Louis Art Museum. **Henri Matisse paper cut-outs.** January 29-March 12, 1978. [Catalogue by Jack Cowart et al.]. St. Louis, Mo., St. Louis Art Museum, 1977.

6233. Schacht, Roland. **Henri Matisse.** Dresden, Kaemmerer, 1922. (Künstler der Gegenwart, 4).

6234. Selz, Jean. **Henri Matisse.** Trans. by A. P. H. Hamilton. New York, Crown, 1964.

6235. Sembat, Marcel. **Matisse et son oeuvre.** Paris, Gallimard, 1920. (Les peintres français nouveaux, 1).

6236. Swane, Leo. **Henri Matisse.** Stockholm, Nordstedt, 1944.

6237. U.C.L.A. Art Galleries (Los Angeles). **Henri Matisse.** Jan. 5-Feb. 27, 1966. [Text by Jean Leymarie et al.]. Berkeley, University of California Press, 1966.

6238. Verdet, André. **Prestiges de Matisse.** Paris, Emile-Paul, 1952.

6239. Zervos, Christian, et al. **Henri Matisse.** Paris, Cahiers d'Art/New York, Weyhe, 1931.

6240. Zubova, Mariia V. **Grafika Matissa.** Moskva, Iskusstvo, 1977.

MATTA ECHAURREN, ROBERTO SEBASTIÁN, 1911-

6241. Kestner-Gesellschaft Hannover. **Matta.** 12. Juli bis 29. September 1974. Hannover, Kestner-Gesellschaft, 1974. (Katalog 4/1974).

6242. Museum of Modern Art (New York). **Matta.** September 10-October 20, 1957. [Text by William Rubin]. New York, Museum of Modern Art, 1957.

6243. Rose Art Museum, Brandeis University (Waltham, Mass.). **Matta, the first decade.** May 9-June 20, 1982. Waltham, Mass., Rose Art Museum, 1982.

6244. Schuster, Jean. **Developpements sur l'infra-réalisme de Matta.** Paris, Losfeld, 1970.

MATTEO DI GIOVANNI, 1435-1495

6245. Hartlaub, Gustav. F. **Matteo da Siena und seine Zeit.** Strassburg, Heitz, 1910. (Zur Kunstgeschichte des Auslandes, 78).

MAUFRA, MAXIME, 1861-1918

6246. Alexandre, Arsène. **Maxime Maufra, peintre marin et rustique (1861-1918).** Paris, Petit, 1926.

6247. Michelet, Victor-Emile. **Maufra, peintre et graveur.** Paris, Floury, 1908.

MAY, ERNST, 1886-1970

6248. Buekschmitt, Justus. **Ernst May.** Stuttgart, Koch, 1963.

6249. May, Ernst, et al. **Das neue Mainz.** Mainz, Margraf und Fischer, 1961.

MAYER, CONSTANCE, 1775?-1821

6250. Pilon, Edmond. **Constance Mayer.** Paris, Delpleuch, 1927.

MAZZOLINO, LUDOVICO, 1480-1528/30

6251. Zamboni, Silla. **Ludovico Mazzolino.** Milano, Silvana, 1968.

MEAD, WILLIAM RUTHERFORD see McKIM, CHARLES FOLLEN

MECKENEM, ISRAHEL VAN, ca. 1440-1503

6252. Geisberg, Max. **Der Meister der Berliner Passion und Israhel van Meckenem; Studien zur Geschichte der westfälischen Kupferstecher im fünfzehnten Jahrhundert.** Strassburg, Heitz, 1903. (Studien zur deutschen Kunstgeschichte, 42).

6253. _____. **Verzeichnis der Kupferstiche Israhels van Meckenem.** Strassburg, Heitz, 1905. (CR). (Studien zur deutschen Kunstgeschichte, 58).

6254. Schnack, Jutta. **Der Passionszyklus in der Graphik Israhel van Meckenems und Martin Schongauers.** Münster, Aschendorff, 1979. (Bocholter Quellen und Beiträge, 2).

6255. [Stadt Bocholt]. **Israhel van Meckenem, Goldschmied und Kupferstecher.** Zur 450. Wiederkehr seines Todestages. [Text by Paul Pieper et al.]. Bocholt [Germany], Stadt Bocholt, 1953.

6256. Warburg, Anni. **Israhel van Meckenem; sein Leben, sein Werk une seine Bedeutung für die Kunst des ausgehenden 15. Jahrhunderts.** Bonn, Schroeder, 1930. (Forschungen zur Kunstgeschichte Westeuropas, 7).

MEER, JAN VAN DER see VERMEER, JAN

MEID, HANS, 1883-1957

6257. Brieger, Lothar. **Hans Meid.** Berlin, Verlag Neue Kunsthandlung, 1921. (Graphiker der Gegenwart, 7).

6258. Friedländer, Max J. **Der Radierer Hans Meid.** Leipzig, Thyrsos, 1923.

6259. Jentsch, Ralph. **Hans Meid, das graphische Werk.** Esslingen, Kunstgalerie Esslingen, 1978.

MEIDIAS, 5th c. B.C.

6260. Becatti, Giovanni. **Meidia, un manierista antico.** Firenze, Sansoni, 1947.

6261. Ducati, Pericle. **I vasi dipinti nello stile del ceramista Midia; contributo alla storia della ceramica attica.** Roma, Accademia dei Lincei, 1909.

6262. Nicole, Georges. **Meidias et le style fleuri dans la céramique attique.** Genève, Kündig, 1908.

MEIDNER, LUDWIG, 1884-1966

6263. Grochowiak, Thomas. **Ludwig Meidner.** Recklinghausen, Bongers, 1966.

6264. Hodin, Joseph. **Ludwig Meidner; seine Kunst, seine Persönlichkeit, seine Zeit.** Darmstadt, von Liebig, 1975.

6265. Kunz, Ludwig, ed. **Ludwig Meidner; Dichter, Maler und Cafés.** Zürich, Arche, 1973.

6266. Meidner, Ludwig. **Eine autobiographische Plauderei.** Leipzig, Klinkhardt & Biermann, 1919. (Junge Kunst, 4).

6267. University of Michigan Museum of Art (Ann Arbor, Mich.). **Ludwig Meidner, an expressionist master.** October 20-November 19, 1978. Ann Arbor, Mich., University of Michigan Museum of Art, 1978.

MEISSONIER, JEAN LOUIS ERNEST, 1815-1891

6268. Bénédite, Léonce. **Meissonier, biographie critique.** Paris, Laurens, 1910.

6269. Galerie Georges Petit (Paris). **Exposition Meissonier.** Mars 1893. [Text by Alexandre Dumas]. Paris, Galerie Georges Petit, 1893.

6270. Gréard, Vallery C. O. **Meissonier, his life and his art.** Trans. by Mary Loyd and Florence Simmonds. New York, Armstrong, 1897.

6271. Larroumet, Gustave. **Meissonier.** Étude suivie d'une biographie par Philippe Burty. Paris, Baschet, [1893].

6272. Mollett, John W. **Meissonier.** New York, Scribner and Welford/London, Sampson Low, 1882.

MEISTER . . . see MASTER . . .

MEISTERMANN, GEORG, 1911-

6273. Germanisches Nationalmuseum (Nuremberg). **Georg Meistermann.** 16. Juni bis 23. August 1981. Nürnberg, Archiv für Bildende Kunst am Germanischen Nationalmuseum, 1981. (Werke und Dokumente, Neue Folge, 3).

6274. Linfert, Carl. **Georg Meistermann.** Recklinghausen, Bongers, 1958. (Monographien zur Rheinisch-Westfälischen Kunst der Gegenwart, 6).

MEIT, KONRAD, 1475-1550

6275. Duverger, Jozef. **Conrat Meijt (ca. 1480-1551).** Bruxelles, Academie Royale de Belgique, 1934.

6276. Troescher, Georg. **Conrat Meit von Worms; ein rheinischer Bildhauer der Renaissance.** Freiburg i.Br., Urban-Verlag, 1927.

MELCHIOR, JOHANN PETER, 1742-1825

6277. Hofmann, Friedrich H. **Johann Peter Melchior, 1742-1825.** München, Schmidt, 1921. (Einzeldarstellungen zur süddeutschen Kunst, 2).

MELLAN, CLAUDE, 1598-1688

6278. Montaiglon, Anatole de. **Catalogue raisonné de l'oeuvre de Claude Mellan d'Abbeville, précédé d'une notice sur la vie et les ouvrages de Mellan par [Pierre J.] Mariette.** Abbeville, Briez, 1856. (CR).

6279. Sgard, Jean. **La Sainte Face de Claude Mellan; étude des bases géométriques du dessin.** Abbeville, Société d'Emulation Historique et Littéraire, 1957. (Etudes Picardes, 1).

MELOZZO DA FORLI, 1438-1494

6280. Buscaroli, Rezio. **Melozzo da Forlì, nei documenti nelle testimonianze dei contemporanei e nella bibliografia.** Roma, Reale Accademia d'Italia, 1938. (Reale Accademia d'Italia; architettura, pittura, scultura, 3).

6281. _____. **Melozzo e il Melozzismo.** Bologna, Athena, 1955.

6282. Okkonen, Onni. **Melozzo da Forli und seine Schule; eine kunsthistorische Studie.** Helsinki, Suomalaisen Teideakatemian Toimituksia, 1910.

6283. Palazzo dei Musei (Forli). **Mostra di Melozzo e del quattrocentro Romagnolo.** 2 v. Guigno-ottobre, 1938. Forlì, Città di Forlì, 1938.

6284. Ricci, Corrado. **Melozzo da Forlì.** Roma, Anderson, 1911.

6285. Schmarsow, August. **Melozzo da Forli; ein Beitrag zur kunst- und kulturgeschichte Italiens im XV. Jahrhundert.** Berlin/Stuttgart, Spemann, 1886.

MEMLING, HANS, 1433-1494

6286. Baldass, Ludwig von. **Hans Memling.** Wien, Schroll, 1942.

6287. Bazin, Germain. **Memling.** Paris, Tisné, 1939.

6288. Corti, Maria and Faggin, Giorgio T. **L'opera completa di Memling.** Milano, Rizzoli, 1969. (CR). (Classici dell'arte, 27).

6289. Delepierre, Joseph O. et Voisin, Auguste. **La châsse de Saint Ursule.** Bruges, Société des Beaux-Arts, 1841.

6290. Eemans, Marc. **Hans Memling.** Bruxelles, Meddens, 1970.

6291. Huisman, Georges. **Memlinc.** Paris, Alcan, 1923.

6292. Kaemmerer, Ludwig. **Memling.** Bielefeld/Leipzig, Velhagen & Klasing, 1899. (Künstler-Monographien, 39).

6293. Marlier, Georges. **Memlinc.** Bruxelles, Nouvelle Société d'Editions, 1934.

6294. McFarlane, Kenneth B. **Hans Memling.** Edited by Edgar Wind
with the assistance of G. L. Harris. Oxford, Clarendon
Press, 1971.

6295. Muls, Jozef. **Memling.** Naarden, In den Toren, [1939].
(New ed.: Hasselt, Heideland, 1960).

6296. Musée Communal (Bruges). **Exposition Memling.** 22 juin-
1 octobre 1939. [Text by Paul Lambotte]. Bruges,
Desclée, de Brouwer, 1939.

6297. Nuyens, Alvarus J. **Het mysterie van leven en werk van Hans
Memlinc.** Antwerpen, Nederlandsche Boekhandel, 1944.

6298. Voll, Karl. **Memling, des Meisters Gemälde.** Stuttgart/
Leipzig, Deutsche Verlags-Anstalt, 1909. (Klassiker der
Kunst, 14).

6299. Wauters, Alphonse J. **Sept études pour servir à l'histoire
de Hans Memling.** Bruxelles, Dietrich, 1893.

6300. Weale, W. H. James. **Hans Memlinc, a notice of his life and
works.** [London], Arundel Society, 1865. (New ed.:
London, Bell, 1901).

MENDELSOHN, ERICH, 1887-1953

6301. Beyer, Oskar, ed. **Eric Mendelsohn: letters of an
architect.** Trans. by Geoffrey Strachan, with an intro-
duction by Nikolaus Pevsner. London, Abelard-Schuman,
1967.

6302. Mendelsohn, Erich. **Amerika; Bilderbuch eines Architekten.**
Berlin, Mosse, 1926. (Reprint: New York, Da Capo,
1976).

6303. _____. **Das Gesamtschaffen des Architekten: Skizzen,
Entwürfe, Bauten.** Berlin, Mosse, 1930.

6304. _____. **Russland, Europa, Amerika: ein architektonischer
Querschnitt.** Berlin, Mosse, 1929.

6305. _____. **Structures and sketches.** Trans. by Herman G.
Scheffauer. London, Benn, 1924.

6306. _____. **Three lectures on architecture.** Berkeley,
University of California Press, 1944.

6307. Roggero, Mario F. **Il contributo di Mendelsohn alla
evoluzione dell'architettura moderna.** Milano, Tamburini,
1952.

6308. University Art Museum, University of California (Berkeley).
The drawings of Eric Mendelsohn. [March 1969; text by
Susan King and Gerald McCue]. Berkeley, Regents of
the University of California, 1969.

6309. Von Eckhardt, Wolf. **Eric Mendelsohn.** London, Mayflower/
New York, Braziller, 1960.

6310. Whittick, Arnold. **Eric Mendelsohn.** London, Faber, 1940.
(New ed.: London, Hill, 1956.)

6311. Zevi, Bruno. **Erich Mendelsohn: opera completa; con note
biografiche di Luise Mendelsohn.** Milano, Kompass, 1970.
(CR).

MENGS, ANTON RAPHAEL, 1728-1779

6312. Azara, Nicolas de. **Obras de D. Antonio Rafael Mengs,
primer Pintor de Camera del Rey.** Madrid, Imprenta Real,
1780. (English ed.: 2 v. London, Faulder, 1796).

6313. Biancomi, Giovanni L. **Elogio storico del Cavaliere Anton
Raffaele Mengs, con un catalogo delle opere da esso
fatte.** Milano, Imperial Monistero di S. Ambrogio
Maggiore, 1780. (Reprint: Ann Arbor, Mich., University
Microfilms, 1974).

6314. Hanisch, Dieter. **Anton Raphael Mengs und die Bildform des
Frühklassizismus.** Recklinghausen, Bongers, 1965.
(Münstersche Studien zur Kunstgeschichte, 1).

6315. Martinelli, Rossa C. **La ragione dell'arte; teoria e
critica in Anton Raphael Mengs e Johann Joachim
Winckelmann.** Napoli, Liguori, 1981.

6316. Menegazzi, Luigi. **Anton Raphael Mengs.** Milano, Fabbri,
1966. (I maestri del colore, 221).

6317. Mengs, Anton R. **Briefe an Raimondo Ghelli und Anton Maron.**
Herausgegeben und kommentiert von Herbert von Einem.
Göttingen, Vandenhoeck und Ruprecht, 1973.

6318. Museo del Prado (Madrid). **Antonio Rafael Mengs, 1728-1779.**
Junio-Julio 1980. Madrid, Ministerio de Cultura, 1980.

6319. Prange, Christian F., ed. **Anton Raphael Mengs;
hinterlassene Werke.** 3 v. Halle, Hendel, 1786.

6320. Ratti, Carlo G. **Epilogo della vita del fu Cavalier Antonio
Raffaello Mengs.** Genova, Casamara dalle Cinque Lampardi,
1779.

MENZEL, ADOLPH VON, 1815-1905

6321. Becker, Robert. **Adolph Menzel und seine schlesische
Verwandtschaft.** Strassburg, Heitz, 1922. (Studien zur
deutschen Kunstgeschichte, 222).

6322. Biberfeld, Arthur, ed. **Adolph von Menzel: Architekturen.**
4 v. Berlin, Wasmuth, 1906.

6323. Erbertshäuser, Heidi. **Adolph von Menzel, das graphische
Werk.** Mit einem Vorwort von Jens Christian Jensen und
einem Essay von Max Liebermann. 2 v. München, Rogner &
Bernhard, 1976. (CR).

6324. Hamburger Kunsthalle. **Menzel--der Beobachter.** [22. Mai-
25. Juli 1981]. München, Prestel/Hamburg, Kunsthalle,
1982.

6325. Hütt, Wolfgang. **Adolph Menzel.** Leipzig, Seemann, 1981.

6326. Jensen, Jens C. **Adolph Menzel.** Köln, DuMont, 1982.

6327. Jordan, Max und Dohme, Robert. **Das Werk Adolph Menzels.**
2 v. München, Bruckmann, 1890.

6328. Kaiser, Konrad. **Adolph Menzel, der Maler.** Stuttgart,
Schuler, 1965.

6329. _____. **Adolph Menzels Eisenwalzwerk.** Berlin, Henschel,
1953.

6330. Kirstein, Gustav. **Das Leben Adolph Menzels.** Leipzig, Seemann, 1919.

6331. Knackfuss, Hermann. **Menzel.** Bielefeld/Leipzig, Velhagen & Klasing, 1895. (Künstler-Monographien, 7).

6332. Meier-Graefe, Julius. **Der junge Menzel; ein Problem der Kunstökonomie Deutschlands.** Leipzig, Insel-Verlag, 1906.

6333. Meissner, Franz H. **Adolph von Menzel.** Berlin, Schuster & Loeffler, 1902.

6334. Menzel, Adolph von. **Briefe.** Herausgegeben von Hans Wolff. Berlin, Bard, 1914.

6335. Meyerheim, Paul. **Adolf von Menzel, Erinnerungen.** Berlin, Paetel, 1906.

6336. Nationalgalerie (Berlin). **Adolph Menzel; Gemälde, Zeichnungen.** Ausstellung 1980. [Text by Peter H. Feist et al.]. Berlin, Staatliche Museen zu Berlin, 1980.

6337. Scheffler, Karl. **Menzel; der Mensch, das Werk.** Neu herausgegeben von Carl Georg Heise. München, Bruckmann, 1955.

6338. Sondermann, Fritz. **Adolph Menzel.** Magdeburg, Rathke, 1895.

6339. Tschudi, Hugo von. **Adolph von Menzel; Abbildungen seiner Gemälde und Studien.** München, Bruckmann, 1906. (CR).

6340. Waldmann, Emil. **Der Maler Adolph Menzel.** Wien, Schroll, 1941. 3 ed.

6341. Weinhold, Renate. **Menzel Bibliographie.** Leipzig, Seemann, 1959.

6342. Wirth, Irmgard. **Mit Adolph Menzel in Berlin.** München, Prestel, 1965.

6343. _____. **Mit Menzel in Bayern und Österreich.** München, Prestel, 1974.

6344. Wolf, Georg J. **Adolf von Menzel, der Maler deutschen Wesens.** München, Bruckmann, [1915].

6345. Wolff, Hans, ed. **Zeichnungen von Adolph Menzel.** Dresden, Arnold, 1920. (Arnolds graphische Bücher, zweite Folge, 1).

MERIAN, MARIA SIBYLLA, 1647-1717

6346. Lendorff, Gertrud. **Maria Sibylla Merian, 1647-1717; ihr Leben und ihr Werk.** Basel, Gute Schriften, 1955.

6347. Pfister-Burkhalter, Margarete. **Maria Sibylla Merian, Leben und Werk, 1647-1717.** Basel, GS-Verlag, 1980.

6348. Rücker, Elizabeth. **Maria Sibylla Merian, 1647-1717.** [Published in conjunction with an exhibition at the Germanisches Nationalmuseum, Nuremberg, April 12-June 4, 1967]. Nürnberg, Germanisches Nationalmuseum, 1967.

MERRILL, JOHN O., 1896-1975 see SKIDMORE, LOUIS

MERYON, CHARLES, 1821-1868

6349. Bouvenne, Aglaus. **Notes et souveniers sur Charles Meryon.** Paris, Charavay, 1883.

6350. Burty, Philip. **Charles Meryon; sailor, engraver, and etcher.** A memoir and complete descriptive catalogue of his works. Trans. by Marcus B. Huish. London, Fine Art Society, 1879.

6351. Delteil, Loys. **Catalogue raisonné of the etchings of Charles Meryon, with the addition of many newly discovered states.** Edited by Harold J. L. Wright. New York, Truesdell, 1924. (CR).

6352. Ecke, Goesta. **Charles Meryon.** Leipzig, Klinkhardt & Biermann, 1923. (Meister der Graphik, 11).

6353. Geffroy, Gustave. **Charles Meryon.** Paris, Floury, 1926.

6354. Städelsches Kunstinstitut und Städtische Galerie (Frankfurt). **Charles Meryon: Paris um 1850; Zeichnungen, Radierungen, Photographien.** [Oct. 23, 1975-Jan. 4, 1976]. Frankfurt a.M., Städelsches Kunstinstitut und Städtische Galerie, 1975.

6355. Wedmore, Frederick. **Meryon and Meryon's Paris, with a descriptive catalogue of the artist's work.** London, Thibaudeau, 1879.

MESSEL, ALFRED, 1853-1909

6356. Rapsilber, Maximilian. **Das Werk Alfred Messels.** Berlin, Wasmuth, [1905]. (Sonderheft der **Berliner Architekturwelt,** 5).

6357. Stahl, Fritz. **Alfred Messel.** Berlin, Wasmuth, [1910]. (Sonderheft der **Berliner Architekturwelt,** 9).

MESSINA, FRANCESCO, 1900-

6358. Bernasconi, Ugo. **Francesco Messina.** Milano, Hoepli, 1937. (Arte moderna italiana, 28).

6359. Cavallo, Luigi, ed. **Messina.** Firenze, Galleria Michaud, [1971].

6360. Cocteau, Jean. **Francesco Messina.** [Text in French, English, and German]. Milano, Pizzi, 1959.

6361. Salmon, André. **Francesco Messina.** Paris, Chroniques du Jour, 1936.

MEŠTROVIĆ, IVAN, 1883-1962

6362. Ćurcin, Milan, et al. **Ivan Meštrović, a monograph.** London, Williams and Norgate, 1919.

6363. Grum, Željko. **Ivan Meštrović.** [Text in English]. Zagreb, Matica, 1962. (New ed., in Croatian: 1969).

6364. Kečkemet, Dusko. **Ivan Meštrović: the only way to be an artist is to work.** Zagreb, Spektar, 1970.

6365. Meštrović, Ivan. **Dennoch will ich hoffen . . . : ein**

Weihnachtsgespräch. [Aus dem noch unveröffentlichen Manuskript vom Kroatischen ins Deutsche übertragen durch Dr. A. Licht]. Zürich, Rascher, 1945.

6366. _____. Uspomene na političke ljude i dogadiaje. Zagreb, Matica, 1969.

6367. Rice, Norman L. **The sculpture of Ivan Meštrović.** Syracuse, Syracuse University Press, 1948.

6368. Schmeckebier, Lawrence. **Ivan Meštrović, sculptor and patriot.** Syracuse, Syracuse University Press, 1959.

6369. Strajnić, Kosta. **Ivan Meštrović.** Beograd, Ćelap i Popovac, 1919.

6370. Vidović, Žarko. **Meštrović i savremeni sukob skulptora s arhitektom.** Sarajevo, Veselin Masleša, 1961.

6371. Yusuf Ali, Abd Allah. **Meštrović and Serbian sculpture.** London, Mathews, 1916. (Vigo Cabinet Series, second century, 38).

METSU, GABRIEL, 1629-1667

6372. Robinson, Franklin W. **Gabriel Metsu (1629-1667); a study of his place in Dutch genre painting of the Golden Age.** New York, Schram, 1974.

METSYS, QUENTIN see MASSYS, QUENTIN

METZINGER, JEAN, 1883-1956 see GLEIZES, ALBERT

MEUNIER, CONSTANTIN EMILE, 1831-1905

6373. Bazalgette, Léon, et al. **Constantin Meunier et son oeuvre.** Paris, La Plume, 1905.

6374. Behets, Armand. **Constantin Meunier; l'homme, l'artiste et l'oeuvre.** Avec d'abondants extraits des lettres du maître et une lettre-préface de Mme. Jacques-Meunier, sa fille. Bruxelles, Lebègue, 1942.

6375. Demolder, Eugène. **Constantin Meunier, étude.** Bruxelles, Deman, 1901.

6376. Fontaine, André. **Constantin Meunier.** Paris, Alcan, 1923.

6377. Gensel, Walter. **Constantin Meunier.** Bielefeld/ Leipzig, Velhagen und Klasing, 1905. (Künstler-Monographien, 79).

6378. Lemonnier, Camille. **Constantin Meunier, sculpteur et peintre.** Paris, Floury 1904.

6379. Nikitiuk, Olga D. **Konstantin Men'e, 1831-1905.** Moskva, Iskusstvo, 1974.

6380. Scheffler, Karl. **Constantin Meunier.** Berlin, Bard, 1908. 2 ed.

6381. Theiry, A. [and] Dievoet, E. van. **Catalogue complet des oeuvres dessinées, peintes et sculptées de Constantin Meunier.** Louvain, Nova & Vetera, [1909].

6382. Treu, Georg. **Constantin Meunier.** Dresden, Richter, 1898.

MI FEI, 1051-1107

6383. Vandier-Nicolas, Nicole. **Art et sagesse en chine: Mi Fou (1051-1107), peintre et connaisseur d'art dans la perspective de l'esthétique des lettres.** Paris, Presses Universitaires de France, 1963.

6384. _____. **Le houa-che di Mi Fou (1051-1107), ou le carnet d'un connaisseur a l'époque des Song du Nord.** Paris, Imprimerie Nationale, 1964.

MICHEL, GEORGES, 1763-1843

6385. Larguier, Léo. **Georges Michel.** Paris, Delpeuch, 1927.

6386. Sensier, Alfred. **Etude sur Georges Michel.** Paris, Lemerre, 1873.

MICHELANGELO BUONARROTI, 1475-1564

6387. Ackerman, James S. **The architecture of Michelangelo.** Baltimore, Penguin, 1971. 2 ed.

6388. Alker, Hermann R. **Michelangelo und seine Kuppel von St. Peter in Rom.** Karlsruhe, Braun, 1968.

6389. Ancona, Paolo d', et al. **Michelangelo: architettura, pittura, scultura.** Milano, Bramante, 1964.

6390. Arbour, Renée. **Michel-Ange.** Paris, Somogy, 1962.

6391. Baldini, Umberto. **Michelangelo scultore.** Fotografie di Liberto Perugi. Firenze, Sansoni, 1981.

6392. Bardeschi Ciulich, Lucilla e Barocchi, Paola, eds. **I ricordi di Michelangelo.** Firenze, Sansoni, 1970.

6393. Barocchi, Paola. **Giorgio Vasari: la vita di Michelangelo nelle redazioni del 1550 e del 1568.** Curata e commentata de Paola Barocchi. 5 v. Milano/Napoli, Ricciardi, 1962.

6394. _____. **Michelangelo e la sua scuola.** 2 v. Firenze, Olschki, 1962. (Accademia toscana di scienze e lettere, 8).

6395. Beck, James. **Michelangelo: a lesson in anatomy.** New York, Viking, 1975.

6396. Bérence, Fred. **La vie de Michel-Ange.** Paris, Editions du Sud, 1965. 2 ed.

6397. Blanc, Charles, et al. **L'oeuvre et la vie de Michel-Ange, dessinateur-sculpteur-peintre-architecte et poète.** Paris, Gazette des Beaux-Arts, 1876.

6398. Borinski, Karl. **Die Rätsel Michelangelos; Michelangelo und Dante.** München, Muller, 1908.

6399. Brandes, Georg. **Michelangelo Buonarroti.** 2 v. København, Gyldendal, 1921. (English ed., trans. by Heinz Norden: New York, Ungar, 1963).

6400. Brion, Marcel. **Michelangelo.** Trans. by James Whitall. New York, Crown, 1940.

6401. Buscaroli, Rezio. **Michelangelo; la vita, la teorica sull'arte, le opere.** Bologna, Tamari, 1959.

6402. Calì, Maria. **Da Michelangelo all'Escorial: momenti del dibattito religioso nell'arte del Cinquecento.** Torino, Einaudi, 1980.

6403. Carli, Enzo. **Michelangelo.** Bergamo, Istituto Italiano d'Arti Grafiche, 1942.

6404. Clements, Robert J. **Michelangelo's theory of art.** New York, New York University Press, 1961.

6405. _____, ed. **Michelangelo, a self-portrait.** Edited with commentaries and new translations by Robert John Clements. Englewood Cliffs, N.J., Prentice-Hall, 1963.

6406. Colombier, Pierre du, et al. **Michel-Ange.** Paris, Hachette, 1961. (Collection génies et réalitiés).

6407. Condivi, Ascanio. **Vita di Michelagnolo Buonarroti.** Roma, Blado, 1553. (English ed., trans. by Alice S. Wohl; ed. by Hellmut Wohl: Baton Rouge, La., Louisiana State University Press, 1976).

6408. Dal Poggetto, Paolo. **I disegni murali di Michelangelo e della sua scuola nella Sagrestia Nuova di San Lorenzo.** Firenze, Centro Di, 1978.

6409. Davray, Jean. **Michel-Ange, essai.** Paris, Michel, 1937.

6410. Delacre, Maurice. **Le dessin de Michel-Ange.** Bruxelles, Palais des Académies, 1938.

6411. Dening-Brylow, B. **Michel-Ange et la psychologie du Barocco.** Lausanne, Frankfurter, 1913.

6412. Duppa, Richard. **The life of Michel Angelo Buonarroti, with his poetry and letters.** London, Murray, 1806.

6413. Dussler, Luitpold. **Michelangelo-Bibliographie, 1927-1970.** Wiesbaden, Harrassowitz, 1974.

6414. _____. **Die Zeichnungen des Michelangelo; kritischer Katalog.** Berlin, Mann, 1959. (CR).

6415. Einem, Herbert von. **Michelangelo.** Trans. by Ronald Taylor. London, Methuen, 1973.

6416. Fagan, Louis. **The art of Michel-Angelo Buonarroti as illustrated by the various collections in the British Museum.** London, Dulau, 1883.

6417. Frey, Dagobert. **Michelangelo-Studien.** Wien, Schroll, 1920.

6418. Frey, Karl. **Die Handzeichnungen Michelagniolos Buonarroti.** [3 v., with supplement by Fritz Knapp]. Berlin, Bard, 1909-11. (CR).

6419. _____. **Michelagniolos Jugendjahre.** Berlin, Curtius, 1907.

6420. Frommel, Christoph L. **Michelangelo und Tomasso dei Cavalieri.** Amsterdam, Peregrini, 1979. 2 ed.

6421. Geymüller, Heinrich F. von. **Michelagnolo Buonarroti als Architekt.** München, Bruckmann, 1904.

6422. Giunti, Jacopo. **Esequie del divino Michelagnolo Buonarroti, celebrate in Firenze dall'Accademia de Pittori, Scultori, & Architettori nella chiesa di S. Lorenzo il di 14 Luglio, MDLXIIII.** Firenze, Giunti, 1564. (New ed., introduced, translated, and annotated by Rudolf & Margot Wittkower: London, Phaidon, 1964).

6423. Goldscheider, Ludwig. **Michelangelo: paintings, sculptures, architecture.** London, Phaidon, 1962. 4 ed.

6424. _____. **A survey of Michelangelo's models in wax and clay.** London, Phaidon, 1962.

6425. Gotti, Aurelio. **Vita di Michelangelo Buonarotti.** 2 v. Firenze, Gazzetta d'Italia, 1875.

6426. Granchi, Giovanni, et al. **Atti del Convegno di Studi Michelangelo, Firenze-Roma 1964.** Roma, Ateneo, 1966.

6427. Grimm, Hermann. **Life of Michelangelo.** Trans. by Fanny E. Bunnett. 2 v. London, Smith, Elder, 1865. (New ed.: Boston, Little, Brown, 1896).

6428. Harford, John S. **The life of Michael Angelo Buonarroti, with translations of many of his poems and letters.** 2 v. London, Longman, 1857.

6429. Hartt, Frederick. **Michelangelo.** New York, Abrams, 1965.

6430. _____. **Michelangelo drawings.** New York, Abrams, 1970. (CR).

6431. _____. **Michelangelo; the complete sculpture.** New York, Abrams, 1968.

6432. _____. **Michelangelo's three pietàs: a photographic study by David Finn.** Text by Frederick Hartt. New York, Abrams, 1976.

6433. Hauchecorne, l'Abbé. **Vie de Michel-Ange Buonarotti, peintre, sculpteur et architecte de Florence.** Paris, Cellot, 1783.

6434. Heusinger, Lutz. **Michelangelo: life and works in chronological order.** Trans. by Lisa Clark. London, Constable, 1978.

6435. Hibbard, Howard. **Michelangelo.** New York, Harper & Row, 1974.

6436. Holroyd, Charles. **Michael Angelo Buonarroti.** London, Duckworth, 1911. 2 ed.

6437. Ipser, Karl. **Michelangelo, der Künstler-Prophet der Kirche.** Augsburg, Kraft, 1963.

6438. Jahn, Johannes. **Michelangelo.** Leipzig, Seemann, 1963.

6439. Justi, Carl. **Michelangelo; Beiträge zur Erklärung der Werke und des Menschen.** Berlin, Grote, 1922. 2 ed.

6440. Knackfuss, Hermann. **Michelangelo.** Bielefeld/Leipzig, Velhagen & Klasing, 1895; new ed.: 1914. (Künstler-Monographien, 4).

6441. Knapp, Fritz. **Michelangelo.** Stuttgart, Deutsche Verlags-Anstalt, 1906. (Klassiker der Kunst, 7).

6442. Kriegbaum, Friedrich. **Michelangelo Buonarroti, die Bildwerke.** Berlin, Rembrandt, 1940.

6443. Liebert, Robert S. **Michelangelo: a psychoanalytic study of his life and images.** New Haven, Yale University Press, 1983.

6444. Ludwig, Emil. **Michelangelo.** Berlin, Rowohlt, 1930.

6445. Mackowsky, Hans. **Michelagniolo.** Berlin, Marquardt, 1908. (New ed.: **Michelangelo.** Stuttgart, Metzler, 1939).

6446. Magherini, Giovanni. **Michelangiolo Buonarrati.** Firenze, Barbèra, 1875.

6447. Maio, Romeo de. **Michelangelo e la Controriforma.** Roma, Laterza, 1978.

6448. Mariani, Valerio. **Michelangelo, the painter.** Milano, Ricordi, 1964.

6449. Michelangelo Buonarroti. **Il carteggio di Michelangelo.** Edizione posthuma di Giovanni Poggi, a cura di Paola Barocchi e Renzo Ristori. 4 v. Firenze, Sansoni, 1965-79.

6450. _____. **The letters of Michelangelo, translated from the original Tuscan.** Edited and annotated by E. H. Ramsden. 2 v. London, Owen, 1963.

6451. Morgan, Charles H. **The life of Michelangelo.** New York, Reynal, 1960.

6452. Murray, Linda. **Michelangelo.** New York, Oxford University Press, 1980.

6453. Ollivier, Emile. **Michel-Ange.** Paris, Garnier, 1892.

6454. Papini, Giovanni. **Dante e Michelangiolo.** Milano, Mondadori, 1961.

6455. _____, ed. **Michelangiolo Buonarroti nel IV centenario del Giudizio Universale (1541-1941).** Firenze, Sansoni, 1942.

6456. Parronchi, Alessandro. **Opere giovanili di Michelangelo.** 3 v. Firenze, Olschki, 1968-81.

6457. Passerini, Luigi. **La bibliografia di Michelangelo Buonarroti e gli incisori delle sue opere.** Firenze, Cellini, 1875.

6458. Perrig, Alexander. **Michelangelo Studien.** 4 v. Frankfurt a.M., Peter Lang/Bern, Herbert Lang, 1976-7. (Kunstwissenschaftliche Studien, 1-4).

6459. Popp, Anny E. **Die Medici-Kapelle Michelangelos.** München, Recht, 1922.

6460. Powers, Harry M. **The art of Michelangelo.** New York, Macmillan, 1935.

6461. Quasimodo, Salvatore [and] Camesasca, Ettore. **L'opera completa di Michelangelo, pittore.** Milano, Rizzoli, 1966. (CR). (Classici dell'arte, 1; English ed. with an introduction by L. D. Ettinger: New York, Abrams, 1959).

6462. Quatremère de Quincy, Antoine C. **Histoire de la vie et des ouvrages de Michel-Ange Bonarroti.** Paris, Didot, 1835.

6463. Redig de Campos, Deoclezio [and] Biagetti, Biagio. **Il Giudizio Universale di Michelangelo.** Prefazione di Bartolomeo Nogara. 2 v. Roma, Faccioli, 1944.

6464. Ricci, Corrado. **Michelangelo.** Firenze, Barbèra, 1900.

6465. Romdahl, Axel. **Michelangelo.** Stockholm, Norstedt, 1943.

6466. Rossi, Giuseppe I. **La libreria Medicea-Laurenziana, architettura di Michelagnolo Buonarroti.** Firenze, Stamperia Granducale, 1739.

6467. Salmi, Mario, et al. **The complete work of Michelangelo.** New York, Reynal, 1965.

6468. Salviati, Lionardo. **Orazione di Lionardo Salviati nella morte di Michelagnolo Buonarroti.** Firenze, Stamperia Ducale, 1564.

6469. Salvini, Roberto. **The hidden Michelangelo.** Oxford, Phaidon, 1978.

6470. _____. **The Sistine Chapel.** Appendix by Ettore Camesasca. With an essay by C. L. Ragghianti. 2 v. New York, Abrams, 1971.

6471. Schiavo, Armando. **La vita e le opere architettoniche di Michelangelo.** Roma, La Libreria dello Stato, 1953. 2 ed.

6472. Schmidt, Heinrich [and] Schadewaldt, Hans. **Michelangelo und die Medizin seiner Zeit.** Stuttgart, Schattauer, 1965.

6473. Schott, Rudolf. **Michelangelo.** Translated and adapted by Constance McNab. New York, Tudor, 1963.

6474. Seymour, Charles, Jr. **Michelangelo: the Sistine Chapel ceiling.** New York, Norton, 1972.

6475. _____. **Michelangelo's David: a search for identity.** Pittsburgh, University of Pittsburgh Press, 1967.

6476. Spahn, Martin. **Michelangelo und die Sixtinische Kapelle; eine psychologisch-historische Studie über die Anfänge der abendländischen Religions- und Kulturspaltung.** Berlin, Grote, 1907.

6477. Steinmann, Ernst. **Das Geheimnis der Medicigräber Michel Angelos.** Leipzig, Hiersemann, 1907.

6478. _____. **Michelangelo im Spiegel seiner Zeit.** Leipzig, [Privatdruck], 1930. (Römische Forschungen der Bibliotheca Herziana, 8).

6479. _____. **Die sixtinische Kapelle.** 2 v. München, Bruckmann, 1901/1905.

6480. _____ und Wittkower, Rudolf. **Michelangelo Bibliographie, 1510-1926.** Leipzig, Klinkhardt & Biermann, 1927. (Römische Forschungen der Bibliotheca Herziana, 1).

6481. Summers, David. **Michelangelo and the language of art.** Princeton, N.J., Princeton University Press, 1981.

6482. Symonds, John A. **The life of Michelangelo Buonarroti,** based on studies in the archives of the Buonarroti family at Florence. 2 v. London, Nimmo, 1893.

6483. Thode, Henry. **Michelangelo; kritische Untersuchungen über seine Werke.** 3 v. Berlin, Grote, 1908-1913.

6484. _____. **Michelangelo und das Ende der Renaissance.** 3 v. Berlin, Grote, 1902-1913.

6485. Tolnay, Charles de. **The art and thought of Michelangelo.** Trans. by Nan Buranelli. New York, Pantheon, 1964.

6486. _____. **Corpus dei disegni di Michelangelo.** Presentazione di Mario Salmi. 4 v. Novara, De Agostino, 1975-80. (CR).

6487. _____. **Michelangelo.** 5 v. Princeton, N.J., Princeton University Press, 1947-1960. (Reprint: 1969-70).

6488. _____. **Michelangelo: sculptor, painter, architect.** Trans. by Gaynor Woodhouse. Princeton, N.J., Princeton University Press, 1975.

6489. Torti, Luigi. **La concezione estetica di Michelangelo.** Pavia, Marelli, 1974.

6490. Varchi, Benedetto. **Orazione funerale . . . fatta e recitata da lui pubblicamente nell'essequie di Michelagnolo Buonarroti in Firenze, nella chiesa di San Lorenzo.** Firenze, Giunti, 1564.

6491. Venturi, Adolfo. **Michelangelo.** Trans. by Joan Redfern. London/New York, Warne, 1928.

6492. Weinberger, Martin. **Michelangelo, the sculptor.** 2 v. London, Routledge/New York, Columbia University Press, 1967.

6493. Wilde, Johannes. **Michelangelo and his studio.** Introduction by A. E. Popham. London, Trustees of the British Museum, 1953.

6494. _____. **Michelangelo: six lectures.** Oxford, Clarendon Press, 1978.

6495. Wilson, Charles H. **The life and works of Michelangelo Buonarroti.** London, Murray, 1876.

6496. Wölfflin, Heinrich. **Die Jugendwerke des Michelangelo.** München, Ackermann, 1891.

6497. Zevi, Bruno e Portoghesi, Paolo. **Michelangelo architetto.** Saggi di Giulio C. Argan et al. Catalogo delle opere a cura di Franco Barbieri e Lionello Puppi. Torino, Einaudi, 1964. (CR).

MICHELOZZO DI BARTOLOMMEO, 1396-1472

see also BRUNELLESCHI, FILIPPO and DONATELLO

6498. Caplow, Harriet M. **Michelozzo.** 2 v. New York, Garland, 1977.

6499. Morisani, Ottavio. **Michelozzo architetto.** Torino, Einaudi, 1951. (Collana storica di architettura, 1).

6500. Wolff, Fritz. **Michelozzo di Bartolommeo, ein Beitrag zur Geschichte der Architektur und Plastik im Quattrocento.** Strassburg, Heitz, 1900. (Zur Kunstgeschichte des Auslandes, 2).

MIERIS, FRANS VAN, 1635-1681

6501. Naumann, Otto. **Frans von Mieris.** 2 v. Doornspijk, Davaco, 1981. (CR).

MIES VAN DER ROHE, LUDWIG, 1886-1969

6502. Art Institute of Chicago. **Mies van der Rohe.** April 27-June 30, 1968. Text by A. James Speyer. Chicago, Art Institute, 1968.

6503. Bill, Max. **Ludwig Mies van der Rohe.** Traduzione autorizzata di Cornelia Tamborini. Milano, Il Balcone, 1955.

6504. Blake, Peter. **Mies van der Rohe, architecture and structure.** Baltimore, Penguin, 1964.

6505. Blaser, Werner. **After Mies: Mies van der Rohe--teaching and principles.** New York, Van Nostrand Reinhold, 1977.

6506. _____. **Mies van der Rohe.** Trans. by D. Q. Stephenson. New York, Praeger, 1972. 2 ed.

6507. Carter, Peter. **Mies van der Rohe at work.** New York, Praeger, 1974.

6508. Drexler, Arthur. **Ludwig Mies van der Rohe.** New York, Braziller, 1960.

6509. Glaeser, Ludwig. **Ludwig Mies van der Rohe: furniture and furniture designs from the Design Collection and the Mies van der Rohe Archive** [of the Museum of Modern Art]. New York, Museum of Modern Art, 1977.

6510. Hilberseimer, Ludwig. **Mies van der Rohe.** Chicago, Theobald, 1956.

6511. Johnson, Philip C. **Mies van der Rohe.** New York, Museum of Modern Art, 1978; distributed by New York Graphic Society, Boston. 3 ed.

6512. Machulskii, Gennadii K. **Mis van der Roe.** Moskva, Izd-vo litry po stroitel'stvu, 1969.

6513. Pawley, Martin. **Mies van der Rohe.** With photographs by Yukio Futagawa. New York, Simon & Schuster, 1970.

6514. Spaeth, David A. **Ludwig Mies van der Rohe; an annotated bibliography and chronology.** With a foreword by George E. Danforth. New York/London, Garland, 1979. (Papers of the American Association of Architectural Bibliographers, 13).

MILANO, GIOVANNI DA see GIOVANNI DA MILANO

MILLAIS, JOHN EVERETT, 1829-1896

6515. Baldry, Alfred L. **Sir John Everett Millais, his art and influence.** London, Bell, 1899.

6516. Fish, Arthur. **John Everett Millais, 1829-1896.** London, Cassell, 1923.

6517. Lutyens, Mary. **Millais and the Ruskins.** London, Murray, 1967.

6518. Millais, Geoffroy. **Sir John Everett Millais.** London, Academy, 1979.

6519. Millais, John G. **The life and letters of Sir John Everett Millais.** 2 v. London, Methuen, 1899.

6520. Pythian, John E. **Millais.** London, Allen, 1911.

6521. Ruskin, John. **Notes on some of the principal pictures of Sir John Everett Millais, exhibited at the Grosvenor Gallery, 1886, with a preface and original selected criticisms.** London, Reeves, 1886.

6522. Spielmann, Marion H. **Millais and his works, with a chapter Thoughts on our art of to-day by Sir J. E. Millais.** Edinburgh/London, Blackwood, 1898.

MILLER, KENNETH HAYES, 1876-1952

6523. Burroughs, Alan. **Kenneth Hayes Miller.** New York, Whitney Museum of American Art, 1931.

6524. Goodrich, Lloyd. **Kenneth Hayes Miller.** New York, The Arts, 1930.

6525. Rothschild, Lincoln. **To keep art alive: the effort of Kenneth Hayes Miller, American painter (1876-1952).** Philadelphia, Art Alliance Press, 1974.

MILLES, CARL, 1875-1955

6526. Ångström, Astrid S. **Carl Milles.** Stockholm, Forum, 1956.

6527. Arvidsson, Karl A. **Carl Milles and Millesgården.** With photographs by Anna Riwkin-Brick. Trans. by Eric Dancy and P. E. Burke. Stockholm, Rabén & Sjögren, 1960.

6528. Cornell, Henrik. **Carl Milles and the Milles Gardens.** Photographers: Sune Sundahl and others. Stockholm, Bonnier, 1957.

6529. Köper, Conrad. **Carl Milles.** Stockholm, Norstedt, 1913.

6530. Rogers, Meyric R. **Carl Milles; an interpretation of his work.** New Haven, Yale University Press, 1940.

6531. Verneuil, Maurice P. **Carl Milles, sculpteur suédois; suivi de deux études.** 2 v. Paris, Van Oest, 1929.

6532. Westholm, Alfred. **Milles, en bok om Carl Milles konst.** Stockholm, Norstedt, 1949.

MILLET, JEAN FRANÇOIS, 1814-1875

6533. [Anonymous]. **Le livre d'or de J.-F. Millet par un ancien ami, illustré de dix-sept eaux-fortes originales par Frédéric Jacques.** Paris, Ferroud, [1891].

6534. Bacou, Roseline. **Millet dessins.** Paris, Bibliothèque des Arts, 1975.

6535. Bénédite, Léonce. **The drawings of Jean-François Millet.** Philadelphia, Lippincott, 1906.

6536. Cartwright, Julia. **Jean François Millet, his life and letters.** London, Sonnenschein/New York, Macmillan, 1896.

6537. Dali, Salvador. **Le mythe tragique de l'Angelus de Millet.** Paris, Pauvert, 1963. (New ed.: 1978).

6538. Fermigier, André. **Jean-François Millet.** New York, Rizzoli, 1977.

6539. Gensel, Walther. **Millet and Rousseau.** Bielefeld/Leipzig, Velhagen & Klasing, 1902. (Künstler-Monographien, 57).

6540. Hayward Gallery (London). **Jean-François Millet.** 22 January-7 March 1976. [Text by Robert L. Herbert et al.]. London, Arts Council of Great Britain, 1976.

6541. Lepoittevin, Lucien. **Jean-François Millet.** 2 v. [Vol. I: Portraitiste, essai et catalogue; préf. par René Jullian. Vol. II: L'ambiguïté de l'image, essai; préf. par Frédéric Mégret]. Paris, Laget, 1971/1973.

6542. _____. **Jean-François Millet, bibliographie générale.** Préf. par Pierre Leberruyer. [Cherbourg], La Fenêtre Ouverte, 1980.

6543. Marcel, Henry. **J.-F. Millet, biographie critique.** Paris, Laurens, [1904].

6544. Moreau-Nélaton, Etienne. **Millet raconté par lui-même.** 3 v. Paris, Laurens, 1921.

6545. Muther, Richard. **J. F. Millet.** Berlin, Bard, [1904]. (Die Kunst, 17).

6546. Naegely, Henry. **J. F. Millet and rustic art.** London, Stock, 1898.

6547. Sensier, Alfred. **Jean-François Millet, peasant and painter.** Trans. by Helena de Kay. Boston, Osgood, 1881.

6548. Soullié, Louis. **Peintures, aquarelles, pastels, dessins de Jean-François Millet relevés dans les catalogues de ventes de 1849 à 1900, précédé d'une notice biographique par Paul Mantz.** Paris, Souillé, 1900. (Les grands peintres aux ventes publiques, 2).

6549. Tomson, Arthur. **Jean-François Millet and the Barbizon school.** London, Bell, 1903.

6550. Yriarte, Charles. **J. F. Millet.** Paris, Rouam, 1885.

MILLS, ROBERT, 1781-1855

6551. Bryan, John M. **Robert Mills, architect, 1781-1855.** [Published in conjunction with an exhibition at the Columbia Museum of Art, Columbia, S.C., October 1-31, 1976, and other places]. Columbia, S.C., Columbia Museum of Art, 1976.

6552. Gallagher, Helen M. **Robert Mills, architect of the Washington Monument, 1781-1855.** New York, Columbia University Press, 1935.

6553. Marsh, Blanche. **Robert Mills, architect in South Carolina.** Columbia, S.C., Bryan, 1970.

MINNE, GEORG, 1866-1941

6554. Museum voor Schone Kunsten (Ghent). **George Minne en de kunst rond 1900.** 18 september 1982 tot 5 december 1982. Gent, Gemeentekrediet, 1982.

6555. Puyvelde, Leo van. **George Minne.** Bruxelles, Cahiers de Belgique, 1930.

6556. Ridder, André de. **George Minne.** Anvers, De Sikkel, 1947. (Monographies de l'art belge, 3).

MINO DA FIESOLE, 1429-1484

6557. Angeli, Diego. **Mino da Fiesole.** Florence, Alinari, 1905.

6558. Cionini Visani, Maria. **Mino da Fiesole.** Milano, Fabbri, 1966. (I maestri della scultura, 62).

6559. Lange, Hildegard. **Mino da Fiesole; ein Beitrag zur Geschichte der florentinischen und römischen Plastik des Quattrocentos.** Greifswald, Abel, 1928.

6560. Sciolla, Gianni C. **La scultura di Mino da Fiesole.** Torino, Giappichelli, 1970.

MIRÓ, JOAN, 1893-1983

6561. Bonnefoy, Yves. **Miró.** New York, Viking, 1967.

6562. Cirici Pellicer, Alejandro. **Miró y la imaginación.** Barcelona, Omega, 1949.

6563. Cirlot, Juan E. **Joan Miró.** Barcelona, Cobalto, 1949.

6564. Corredor-Matheos, José. **Los carteles de Miró.** Catálogo de los carteles por Gloria Picazo. Barcelona, Polígrafa, 1980. (CR).

6565. Dupin, Jacques. **Joan Miró, life and work.** Trans. by Norbert Guterman. New York, Abrams, 1962. (CR).

6566. Erben, Walter. **Joan Miró.** München, Prestel, 1959.

6567. Fondation Maeght. **Joan Miró; peintures, sculptures, dessins, céramiques, 1956-1979.** 7 juillet-30 septembre 1979. Saint-Paul, Fondation Maeght, 1979.

6568. Gimferrer, Pere. **Miró: colpir sense nafrar.** Barcelona, Polígrafa, 1978.

6569. Grand Palais (Paris). **Joan Miró.** 17 mai-13 octobre 1974. Paris, Editions des Musées Nationaux, 1974.

6570. Greenberg, Clement. **Joan Miró.** New York, Quadrangle, 1948.

6571. Hunter, Sam. **Joan Miró, his graphic work.** New York, Abrams, 1958.

6572. Lassaigne, Jacques. **Miró, biographical and critical study.** Trans. by Stuart Gilbert. Lausanne, Skira, 1963. (The Taste of Our Time, 39).

6573. Leiris, Michel. **Joan Miró, lithographe.** Catalogue et notices [by] Fernand Mourlot. 4 v. Paris, Mazo, 1972-81. (CR). (English ed., vol. I only: trans. by P. Niemark, New York, Tudor, 1972).

6574. Melià, Josep. **Joan Miró, vida y testimonio.** Barcelona, Dopesa, 1975.

6575. Museo Español de Arte Contemporáneo (Madrid). **Joan Miró, pintura.** 4 mayo-23 julio 1978. [Text by Julián Gállego et al.]. Barcelona, Polígrafa, 1978.

6576. Penrose, Roland. **Miró.** New York, Abrams, 1969.

6577. Perucho, Juan. **Joan Miró y Cataluña.** [Text in Spanish, English, French, and German]. Barcelona, Polígrafa, [1968].

6578. Picon, Gaëtan, ed. **Joan Miró, carnets catalans: dessins et texte inédits.** 2 v. Genève, Skira, 1976.

6579. Rose, Barbara. **Miró in America.** With essays by Judith McCandless and Duncan Hamilton. Houston, Museum of Fine Arts, 1982.

6580. Rowell, Margit. **Miró.** New York, Abrams, 1970.

6581. Rubin, William. **Miro in the collection of the Museum of Modern Art.** New York, Museum of Modern Art, 1973; distributed by New York Graphic Society, Greenwich, Conn.

6582. Salas de la Dirección General del Patrimonio Artístico, Archivos y Museos (Madrid). **Joan Miró, obra gráfica.** 4 mayo-23 julio 1978. [Text by Joan Teixidor]. Barcelona, Polígrafa, 1978.

6583. Soby, James T. **Joan Miró.** New York, Museum of Modern Art, 1959; distributed by Doubleday, Garden City, N.Y.

6584. Stich, Sidra. **Joan Miró: the development of a sign language.** [Published in conjunction with an exhibition at the Washington University Gallery of Art, St. Louis, Mo., March 19-April 27, 1980]. St. Louis, Washington University, 1980.

6585. Sweeney, James J. **Joan Miró.** [Published in conjunction with an exhibition at the Museum of Modern Art, New York, 1941]. New York, Museum of Modern Art, 1941.

6586. Taillandier, Ivon. **Mirógrafías: dibujos, grabados sobre cobre, lithografías, grabados sobre madera, libros, carteles.** Barcelona, Gili, 1972.

MODENA, TOMASO DA see TOMASO DA MODENA

MODERSOHN-BECKER, PAULA, 1876-1907

6587. Busch, Günter. **Paula Modersohn-Becker: Malerin, Zeichnerin.** Frankfurt a.M., Fischer, 1981. (CR).

6588. Hetsch, Rolf, ed. **Paula Modersohn-Becker, ein Buch der Freundschaft.** Berlin, Rembrandt, 1932.

6589. Kunsthalle Bremen. **Paula Modersohn-Becker zum hundertsten Geburtstag.** 8. Februar bis 4. April 1976. Bremen, Kunsthalle Bremen, 1976.

6590. Kunstverein in Hamburg. **Paula Modersohn-Becker: Zeichnungen, Pastelle, Bildentwürfe.** 25. September bis 21. November 1976. Hamburg, Kunstverein in Hamburg, 1976.

6591. Modersohn-Becker, Paula. **The letters and journals of Paula Modersohn-Becker.** Translated and annotated by J. Diane Radycki. Metuchen, N.J./London, Scarecrow Press, 1980.

6592. _____. **Paula Modersohn-Becker in Briefen und Tagebüchern.** Herausgegeben von Günter Busch und Liselotte von Reinken. Frankfurt a.M., Fischer, 1979.

6593. Murken-Altrogge, Christa. **Paula Modersohn-Becker: Leben und Werk.** Köln, DuMont, 1980.

6594. Pauli, Gustav. **Paula Moderson-Becker.** München, Wolff, 1919. (Das neue Bild, 1).

6595. Perry, Gillian. **Paula Modersohn-Becker, her life and work.** New York, Harper & Row, 1979.

6596. Stelzer, Otto. **Paula Modersohn-Becker.** Berlin, Rembrandt, 1958. (Die Kunst unserer Zeit, 12).

6597. Uphoff, Carl E. **Paula Modersohn.** Leipzig, Klinkhardt & Biermann, 1919. (Junge Kunst, 2).

MODIGLIANI, AMEDEO, 1884 1920

6598. Carli, Enzo. **Amedeo Modigliani, con una testimonianza di Jean Cassou.** Roma, de Luca, 1952.

6599. Ceroni, Ambrogio. **Amedeo Modigliani, dessins et sculptures.** Milano, Edizioni del Milione, 1965. (Monographes des artistes italiens modernes, 8).

6600. _____. **Amedeo Modigliani, peintre.** Milano, Edizioni del Milione, 1958. (Monographie des artistes italiens modernes, 6).

6601. Fifield, William. **Modigliani.** New York, Morrow, 1976.

6602. Gindertael, Roger V. **Modigliani e Montparnasse.** Milano, Fabbri, 1969.

6603. Jedlicka, Gotthard. **Modigliani, 1884-1920.** Erlenbach/ Zürich, Rentsch, 1953.

6604. Lanthemann, Jacques. **Modigliani, 1884-1920; catalogue raisonné; sa vie, son oeuvre complet, son art.** Barcelona, Gráficas Condal, 1970. (CR).

6605. Mann, Carol. **Modigliani.** New York/Toronto, Oxford University Press, 1980.

6606. Modigliani, Jeanne. **Modigliani: man and myth.** Trans. by Esther R. Clifford. New York, Orion, 1958; distributed by Crown, New York.

6607. Musée d'Art Moderne de la Ville de Paris. **Amedeo Modigliani.** 26 mars-28 juin 1981. Paris, Musée d'Art Moderne de la Ville de Paris, 1981.

6608. Pfannstiel, Arthur. **Dessins de Modigliani.** Lausanne, Mermod, 1958.

6609. _____. **Modigliani.** Préface de Louis Latourrettes. Paris, Seheur, 1929.

6610. _____. **Modigliani et son oeuvre; étude critique et catalogue raisonné.** Paris, Bibliothèque des Arts, 1956. (CR).

6611. Piccioni, Leone [and] Ceroni, Ambrogio. **I dipinti di Modigliani.** Milano, Rizzoli, 1970. (Classici dell'arte, 40).

6612. Russoli, Franco. **Modigliani, drawings and sketches.** Trans. by John Shepley. New York, Abrams, 1969. (CR).

6613. Salmon, André. **Modigliani, a memoir.** Trans. by Dorothy and Randolph Weaver. New York, Putnam, 1961.

6614. _____. **Modigliani, sa vie et son oeuvre.** Paris, Editions des Quatre Chemins, 1926.

6615. Scheiwiller, Giovanni. **Modigliani.** Milano, Hoepli, 1927.

6616. [_____, ed.]. **Omaggio a Modigliani, 1884-1920.** Milano, Società Anonima Tipografica Editoriale, 1930.

6617. Sichel, Pierre. **Modigliani; a biography.** New York, Dutton, 1967.

6618. Soby, James T. **Modigliani; paintings, drawings, sculpture.** New York, Museum of Modern Art, 1951.

6619. Werner, Alfred. **Amedeo Modigliani.** New York, Abrams, 1966.

MOHOLY-NAGY, LÁSZLÓ, 1895-1946

6620. Centre de Création Industrielle, Centre Georges Pompidou (Paris). **Laszlo Moholy-Nagy.** [18 novembre 1976 au 31 janvier 1977]. Paris, Centre National d'Art et de Culture Georges Pompidou, 1976.

6621. Haus, Andreas. **Moholy-Nagy; Fotos und Fotogramme.** München, Schirmer/Mosel, 1978.

6622. Kostelanetz, Richard, ed. **Moholy-Nagy.** New York/ Washington, D.C., Praeger, 1970.

6623. Lusk, Irene-Charlotte. **Montagen ins Blaue: Laszlo Moholy-Nagy; Fotomontagen und -collagen, 1922-1943.** Berlin, Anabas, 1980.

6624. Moholy, Lucia. **Moholy-Nagy, marginal notes.** Krefeld, Scherpe, 1972.

6625. Moholy-Nagy, László. **Malerei, photographie, film.** München, Langen, 1925. (English ed., trans. by Janet Seligman: Cambridge, Mass., MIT Press, 1969).

6626. _____. The new vision, from material to architecture. Trans. by Daphne M. Hoffmann. New York, Brewer, Warren, 1932.

6627. _____. 60 Fotos. Herausgegeben von Franz Roh. Berlin, Klinkhardt & Biermann, 1930.

6628. _____. Vision in motion. Chicago, Theobald, 1947.

6629. Moholy-Nagy, Sibyl. Moholy-Nagy, experiment in totality. With an introduction by Walter Gropius. New York, Harper, 1950. (New ed.: Cambridge, Mass., MIT Press, 1969).

6630. Rondolino, Gianni. Laszlo Moholy-Nagy; pittura, fotografia, film. Con prefazione di Giulio C. Argan. Torino, Martano, 1975.

MOLL, OSKAR, 1875-1947

6631. Krickau, Heinz B. Oskar Moll. Leipzig, Klinkhardt & Biermann, 1921. (Junge Kunst, 19).

6632. Salzmann, Siegfried und Salzmann, Dorothea. Oskar Moll, Leben und Werk. München, Bruckmann, 1975. (CR).

6633. Scheyer, Ernst. Die Kunstakademie Breslau und Oskar Moll. Würzburg, Holzner, 1961.

MÖLLER, ANTON, 1563-1611

6634. Gyssling, Walter. Anton Möller und seine Schule; ein Beitrag zur Geschichte der Niederdeutschen Renaissance-Malerei. Strassburg, Heitz, 1917. (Studien zur deutschen Kunstgeschichte, 197).

6635. Möller, Antonius. Der Danziger Frauen und Jungfrauen gebreuchliche Zierheit und Tracht. Danzig, Rhodo, 1601. (Reprint: Danzig, Bertling, 1886).

MOLLER, GEORG, 1784-1852

6636. Frölich, Marie [and] Sperlich, Hans-Günther. Georg Moller, Baumeister der Romantik. Darmstadt, Roether, 1959.

6637. Magistrat der Stadt Darmstadt. Darmstadt in der Zeit des Klassizismus und der Romantik. 19. November 1978 bis 14. Januar 1979. [Konzeption und Katalogbearbeitung zu Georg Moller: Eva Huber]. Darmstadt, Magistrat der Stadt Darmstadt, 1978.

6638. Moller, Georg. Beiträge zu der Lehre von den Constructionen. 7 v. Darmstadt, Leske, 1833-44.

6639. _____. Denkmäler der deutschen Baukunst. 3 v. [Vol. 3 ed. by Ernst Gladbach]. Leipzig/Darmstadt, Leske, [1844]. 2 ed.

MONDRIAAN, PIETER CORNELIS, 1872-1944

6640. Art Gallery of Toronto. Piet Mondrian, 1872-1944. February 12-March 10, 1966. Catalogue by Robert P. Welsh. Toronto, Art Gallery of Toronto, 1966.

6641. Blok, Cor. Piet Mondriaan, een catalogus van zijn werk in Nederlands openbaarbezit. Amsterdam, Meulenhoff, 1974.

6642. Elgar, Frank. Mondrian. Trans. by Thomas Walton. New York, Praeger, 1968.

6643. Jaffé, Hans L. Mondrian und De Stijl. Köln, Schauberg, 1967.

6644. _____. Piet Mondrian. New York, Abrams, 1970.

6645. Menna, Filiberto. Mondrian, cultura e poesia. Prefazione di Giulio C. Argan. Roma, Ateneo, 1962. (Nuovi saggi, 36).

6646. Mondrian, Piet. Le néo-plasticisme. Paris, Editions de l'Effort Moderne, 1920.

6647. _____. Plastic art and pure plastic art, 1937, and other essays, 1941-1943. New York, Wittenborn, 1945.

6648. Morisani, Ottavio. L'astrattismo di Piet Mondrian. Venezia, Pozza, 1956. (Collezione di varia critica, 13).

6649. Ottolenghi, Maria G. L'opera completa di Mondrian. Milano, Rizzoli, 1974. (CR). (Classici dell'arte, 77).

6650. Ragghianti, Carlo L. Mondrian e l'arte de XX secolo. Milano, Edizioni di Comunità, 1962.

6651. Seuphor, Michel [pseud., Ferdinand L. Berckelaers]. Piet Mondrian, life and work. New York, Abrams, 1956.

6652. Solomon R. Guggenheim Museum. Piet Mondrian, 1872-1944; centennial exhibition. [Oct. 8-Dec. 12, 1971]. New York, Guggenheim Foundation, 1971.

6653. Wijsenbeek, Louis J. F. Piet Mondrian. Trans. by Irene R. Gibbons. Greenwich, Conn., New York Graphic Society, 1969.

MONET, CLAUDE, 1840-1926

6654. Alexandre, Arsène. Claude Monet. Paris, Bernheim, 1921.

6655. Clemenceau, Georges. Claude Monet: the Water Lilies. Trans. by George Boas. Garden City, N.Y., Doubleday, 1930.

6656. Cogniat, Raymond. Monet and his world. Trans. by Wayne Dynes. New York, Viking, 1966.

6657. Elder, Marc [pseud., Marcel Tendron]. À Giverny chez Claude Monet. Paris, Blenheim, 1924.

6658. Fels, Marthe de. La vie de Claude Monet. Paris, Gallimard, 1929. (Vies des hommes illustres, 33).

6659. Geffroy, Gustave. Claude Monet, sa vie, son oeuvre. Paris, Crès, 1922.

6660. Grand Palais (Paris). Hommage à Claude Monet (1840-1926). 8 février-5 mai 1980. Paris, Editions de la Réunion des Musée Nationaux/Ministère de la Culture et de la Communication, 1980.

6661. Grappe, Georges. **Claude Monet.** Paris, Librairie Artistique Internationale, [1911].

6662. Gwynn, Stephen. **Claude Monet and his garden; the story of an artist's paradise.** New York, Macmillan, 1934.

6663. Hoschedé, Jean-Pierre. **Claude Monet, ce mal connu; intimité familiale d'un demi-siècle à Giverny de 1883 à 1926.** 2 v. Genève, Cailler, 1960.

6664. Isaacson, Joel. **Claude Monet: observation and reflection.** Oxford, Phaidon, 1978.

6665. _____. **Monet: Le Déjeuner sur l'Herbe.** New York, Viking, 1972.

6666. Joyes, Claire. **Monet at Giverny.** Photographic and editorial research by Robert Gordon and Jean-Marie Toulgouat. With a commentary on the paintings at Giverny by Andrew Forge. London, Mathews Miller Dunbar, 1975.

6667. Keller, Horst. **Ein Garten wird Malerei: Monets Jahre in Giverny.** Köln, DuMont, 1982.

6668. Lathom, Xenia. **Claude Monet.** London, Allan, 1931.

6669. Levine, Steven Z. **Monet and his critics.** New York, Garland, 1976.

6670. Leymarie, Jean. **Monet.** 2 v. Paris, Hazan, 1964. (Petite encyclopédie de l'art, 59-60).

6671. Martini, Alberto. **Monet.** Milano, Fabbri, 1964. (I maestri del colore, 30).

6672. Mauclair, Camille. **Claude Monet.** Trans. by J. Louis May. New York, Dodd, 1924.

6673. Metropolitan Museum of Art (New York). **Monet's years at Giverny: beyond Impressionism.** [April 22-July 9, 1978; text by Daniel Wildenstein et al.]. New York, Metropolitan Museum, 1978; distributed by Abrams, New York.

6674. Morisani, Ottavio. **Il linguaggio di Monet e la crisi dell'impressionismo.** Napoli, Libreria Scientifica Editrice, 1971.

6675. Mount, Charles M. **Monet, a biography.** New York, Simon & Schuster, 1966.

6676. Musée de l'Orangerie (Paris). **Claude Monet, exposition rétrospective.** [Text by Paul Jamot]. Paris, Les Musées Nationaux, 1931.

6677. Petrie, Brian. **Claude Monet, the first of the Impressionists.** Oxford, Phaidon/New York, Dutton, 1979.

6678. Proietti, Maria L. **Lettere di Claude Monet.** Assisi/Roma, Carucci, 1974.

6679. Reuterswärd, Oscar. **Monet, en konstnärhistorik.** Stockholm, Bonniers, 1948.

6680. Rossi Bortolatto, Luigina. **L'opera completa di Claude Monet, 1870-1889.** Milano, Rizzoli, 1972. (Classici dell'arte, 63).

6681. Rouart, Denis. **Claude Monet.** Introduction and conclusion by Léon Degand. Trans. by James Emmons. [New York], Skira, 1958. (The Taste of Our Time, 25).

6682. _____ et Rey, Jean-Dominique. **Monet: Nymphéas, ou les miroirs du temps.** Suivi d'un catalogue raisonné par Robert Maillard. Paris, Hazan, 1972. (CR).

6683. Seitz, William. **Claude Monet.** New York, Abrams, 1960. (New ed.: 1971).

6684. Taillandier, Yvon. **Monet.** Paris, Flammarion, [1963].

6685. Tucker, Paul H. **Monet at Argenteuil.** New Haven, Yale University Press, 1982.

6686. Weekes, C. P. **Camille, a study of Claude Monet.** London, Sidgwick and Jackson, 1962. 2 ed.

6687. Wildenstein, Daniel. **Claude Monet, biographie et catalogue raisonné [1840-1898].** 3 v. Lausanne/Paris, La Bibliothèque des Arts, 1974-1979. (CR).

MONTAGNA, BARTOLOMEO, ca. 1450-1523

6688. Foratti, Aldo. **Bartolomeo Montagna.** Padova, Drucker, 1908.

6689. Puppi, Lionello. **Bartolomeo Montagna.** Venezia, Pozza, 1962.

MONTICELLI, ADOLPHE, 1824-1886

6690. Alauzen, André M. et Ripert, Pierre. **Monticelli, sa vie et son oeuvre.** Paris, Bibliothèque des Arts, 1969. (CR).

6691. Arnaud d'Agnel, G. et Isnard, Emile. **Monticelli, sa vie et son oeuvre (1824-1886).** Paris, Occitania, 1926.

6692. Coquiot, Gustave. **Monticelli.** Paris, Michel, 1925.

6693. Guinand, Louis. **La vie et les oeuvres de Monticelli.** Marseilles, Aubertin, 1894.

6694. Isnard, Guy. **Monticelli sans sa légende.** Genève, Cailler, 1967.

6695. Museum of Art, Carnegie Institute (Pittsburgh). **Monticelli; his contemporaries, his influence.** October 27, 1978 to January 7, 1979. Text by Aaron Sheon. Pittsburgh, Museum of Art, Carnegie Institute, 1978.

6696. Négis, André. **Adolphe Monticelli, chatelain des nues.** Paris, Grasset, 1929. (La vie de Bohème, 7).

MOORE, HENRY SPENCER, 1898-

6697. Argan, Giulio C. **Henry Moore.** Trans. by Daniel Dichter. New York, Abrams, 1973.

6698. Clark, Kenneth. **Henry Moore, drawings.** London, Thames and Hudson, 1974.

6699. Cramer, Gérard, et al. **Henry Moore: catalogue of graphic works.** 2 v. [Vol. I: 1931-1972; Vol. II: 1973-1975]. Genève, Cramer, 1972-[1976]. (CR).

6700. Finn, David. **Henry Moore: sculpture and environment.** Foreword by Kenneth Clark. Commentaries by Henry Moore. New York, Abrams, 1977.

6701. Forte di Belvedere (Florence). **Mostra di Henry Moore.** 20 maggio-30 settembre 1972. A cura di Giovanni Carandente. Firenze, Il Bisonte, 1972.

6702. Grigson, Geoffrey. **Henry Moore.** Harmondsworth [Eng.], Penguin, 1943.

6703. Grohmann, Will. **Henry Moore.** New York, Abrams, 1960.

6704. Hall, Donald. **Henry Moore, the life and work of a great sculptor.** New York, Harper, 1966.

6705. Hedgecoe, John [and] Moore, Henry. **Henry Moore.** Photographed and edited by John Hedgecoe; words by Henry Moore. New York, Simon & Schuster, 1968.

6706. Jianou, Ionel. **Henry Moore.** Trans. by Geoffrey Skelding. Paris, Arted, 1968.

6707. Levine, Gemma. **With Henry Moore: the artist at work.** Photographed by Gemma Levine. Preface by David Mitchinson. London, Sidgwick & Jackson, 1978

6708. Melville, Robert. **Henry Moore: sculpture and drawings, 1921-1969.** New York, Abrams, 1970.

6709. Mitchinson, David. **Henry Moore, unpublished drawings.** New York, Abrams, 1972.

6710. Moore, Henry. **Henry Moore on sculpture.** Edited with an introduction by Philip James. New York, Viking, 1971. 2 ed.

6711. _____. **Shelter sketch book.** London, Poetry London, 1940.

6712. Neumann, Erich. **The archetypal world of Henry Moore.** Trans. by R. F. C. Hull. New York, Pantheon, 1959.

6713. Read, Herbert. **Henry Moore, a study of his life and work.** New York, Praeger, 1966.

6714. _____ [and] Bowness, Alan. **Henry Moore, sculpture and drawings.** 5 v. London, Lund Humphries/Zwemmer, 1944-1983. (CR).

6715. Russell, John. **Henry Moore.** Baltimore, Penguin, 1973. 2 ed.

6716. Seldis, Henry J. **Henry Moore in America.** New York, Praeger, in association with the Los Angeles County Museum of Art, 1973.

6717. Spender, Stephen. **Henry Moore, sculptures in landscape.** Photographs and foreword by Geoffrey Shakerley. Introduction by Henry Moore. New York, Clarkson Potter, [1980]; distributed by Crown, New York.

6718. Sweeney, James J. **Henry Moore.** New York, Museum of Modern Art, 1946.

6719. Tate Gallery (London). **Henry Moore.** 17 July to 22 September 1968. [Text by David Sylvester]. London, Arts Council of Great Britain, 1968.

6720. Teague, Edward H. **Henry Moore, bibliography and reproductions index.** Jefferson, N.C., McFarland, 1981.

6721. Wilkinson, Alan G. **The Moore collection in the Art Gallery of Ontario.** [Toronto], Art Gallery of Ontario, 1979.

MOR, ANTHONIS see MORO, ANTONIO

MORALES, LUIS DE, 1509?-1580

6722. Baecksbacka, Ingjal. **Luis de Morales.** [Text in English]. Helsinki, Paava Heinon Kirjapaino, 1962. (Societas Scientiarum Fennica, Commentationes Humanorum Litterarum, 31).

6723. Berjano Escobar, Daniel. **El pintor Luis de Morales (El Divino).** Madrid, Matev, [1918?].

6724. Gaya Nuno, Juna Antonio. **Luis de Morales.** Madrid, Instituto Diego Velazquez, 1961.

6725. Tormo, Elías. **El Divino Morales.** Barcelona, Thomas, 1917.

6726. Trapier, Elizabeth du Gué. **Luis de Morales and Leonardesque influences in Spain.** New York, Trustees of the Hispanic Society of America, 1953.

MORANDI, GIORGIO, 1890-1964

6727. Arcangeli, Francesco. **Giorgio Morandi.** Milano, Edizioni del Milione, 1964. (Vite, lettere, testimonianze di artisti italiani, 4).

6728. Beccaria, Arnaldo. **Giorgio Morandi.** Milano, Hoepli, 1939.

6729. Brandi, Cesare. **Morandi.** Firenze, Le Monnier, 1952

6730. Des Moines Art Center (Des Moines, Ia.). **Giorgio Morandi.** February 1-March 14, 1982. [Exhibition opened at the San Francisco Museum of Modern Art, September 24-November 1, 1981]. Des Moines, Des Moines Art Center, 1981.

6731. Galleria d'Arte Moderna (Bologna). **Giorgio Morandi.** 1 maggio-2 giugno 1975; a cura di Lamberto Vitali. Bologna, Grafis, 1975.

6732. Pozza, Neri. **Morandi, dessins/drawings.** [Text in French and English]. Milano/Paris, Idea e, 1976.

6733. Valsecchi, Marco [and] Ruggeri, Giorgio. **Morandi disegni.** A cura di Efrem Tavoni. [Work in progress]. Bologna, Marconi, 1981- (CR).

6734. Vitali, Lamberto. **Giorgio Morandi, pittore.** Milano, Edizioni del Milione, 1964.

6735. _____. **Morandi, catalogo generale.** 2 v. Milano, Electa, 1977. (CR).

6736. _____. **L'opera grafica di Giorgio Morandi.** 2 v. Torino, Einaudi, 1964/1968.

MORAZZONE, PIER FRANCESCO, 1573-1626

6737. Musei Civici e Centro di Studi Preistorici e Archeologici Varese, Villa Mirabello (Varese). **Il Morazzone.** 14. luglio-14 ottobre 1962. Catalogo della mostra a cura di Mina Gregori. Milano, Bramante, 1962.

6738. Nicodemi, Giorgio. **Pier Francesco Mazzucchelli, detto Il Morazzone.** Varese, Cronica Prealpina, 1927.

MOREAU, GUSTAVE, 1826-1898

6739. Alexandrian, Sarane. **L'univers de Gustave Moreau.** Paris, Scrépel, 1975.

6740. Flat, Paul. **Le Musée Gustave Moreau; l'artiste, son oeuvre, son influence.** Paris, Société d'Edition Artistique, [1899].

6741. Geffroy, Gustave. **L'oeuvre de Gustave Moreau.** Paris, L'Oeuvre d'Art, [1900].

6742. Hahlbrock, Peter. **Gustave Moreau oder das Unbehagen in der Natur.** Berlin, Rembrandt, 1976.

6743. Hofstätter, Hans H. **Gustave Moreau, Leben und Werk.** Köln, DuMont, 1978.

6744. Holten, Ragnar von. **L'art fantastique de Gustave Moreau.** Paris, Pauvert 1961.

6745. Leprieur, Paul. **Gustave Moreau et son oeuvre.** Paris, L'Artiste, 1889.

6746. Los Angeles County Museum of Art. **Gustave Moreau.** July 23-September 1, 1974. [Text by Julius Kaplan]. Los Angeles, Los Angeles County Museum of Art, 1974; distributed by New York Graphic Society, [Greenwich, Conn.].

6747. Mathieu, Pierre-Louis. **Gustave Moreau.** With a catalogue of the finished paintings, watercolors, and drawings. Trans. by James Emmons. Boston, New York Graphic Society, 1976. (CR).

6748. Paladilhe, Jean and Pierre, José. **Gustave Moreau.** Trans. by Bettina Wadia. New York, Praeger, 1972.

6749. Renan, Ary. **Gustave Moreau (1826-1898).** Paris, Gazette des Beaux-Arts, 1900.

6750. Selz, Jean. **Gustave Moreau.** Trans. by Alice Sachs. New York, Crown, 1979.

6751. Thévenin, Léon. **L'esthétique de Gustave Moreau.** Paris, Vanier, 1897.

MOREAU, JEAN MICHEL, 1741-1815

LOUIS GABRIEL, 1740-1805

6752. Boucher, Emmanuel. **Jean-Michel Moreau le jeune.** Paris, Morgand et Fatout, 1882. (CR). (Catalogue raisonné des estampes, vignettes, eaux-fortes, pièces en couleur au bistre et au lavis de 1700 à 1800, 6).

6753. Draibel, Henri [pseud., Henri Beraldi]. **L'oeuvre de Moreau le jeune, notice & catalogue.** Paris, Rouquette, 1874.

6754. Mahérault, Marie J. F. **L'oeuvre de Moreau le jeune; catalogue raisonné et descriptif avec notes iconographiques et bibliographiques, et précédé d'une notice biographique par Emile de Najac.** Paris, Labitte, 1880. (CR).

6755. Marcel, Pierre. **Carnet de croquis par Moreau le jeune; fac-similé de l'album du Musée du Louvre.** Introduction et description par Pierre Marcel. Paris, Terquem, 1914.

6756. Moreau, Adrien. **Les Moreau.** Paris, Pierson, [1893].

6757. Schéfer, Gaston. **Moreau le jeune, 1741-1814.** Paris, Goupil, 1915.

6758. Wildenstein, Georges. **Un peintre de paysage au XVIII siècle: Louis Moreau.** Paris, Beaux-Arts, 1923.

MOREELSE, PAULUS, 1571-1638

6759. Jonge, Caroline H. de. **Paulus Moreelse, portret en genreschilder te Utrecht, 1571-1638.** Assen, van Gorcum, 1938.

MORETTO, IL, 1498-1554

6760. Boselli, Camillo. **Il Moretto, 1498-1554.** Brescia, Ateneo di Brescia, 1954.

6761. Cassa Salvi, Elvira. **Moretto.** Milano, Fabbri, 1966. (I maestri del colore, 145).

6762. Gombosi, György. **Moretto da Brescia.** Basel, Holbein, 1943.

6763. Molmenti, Pompeo. **Il Moretto da Brescia.** Firenze, Bemporad, 1898.

6764. Ponte, Pietro da. **L'opera del Moretto.** Brescia, Canosi, 1898.

MORISOT, BERTHE, 1841-1895

6765. Angoulvent, Monique. **Berthe Morisot.** Preface de Robert Rey. Paris, Morancé, [1933].

6766. Bataille, Maria-Louis et Wildenstein, Georges. **Berthe Morisot; catalogue des peintures, pastels et aquarelles.** Paris, Les Beaux-Arts, 1961. (CR).

6767. Charles E. Slatkin Galleries (New York). **Berthe Morisot: drawings, pastels, watercolors, paintings.** November 12 to December 10, 1960. [Text by Elizabeth Mongan et al.]. New York, Shorewood, 1960; in collaboration with Charles E. Slatkin Galleries, New York.

6768. Fourreau, Armand. **Berthe Morisot.** Trans. by H. Wellington. New York, Dodd, Mead, 1925.

6769. Galerie Durand-Ruel (Paris). **Berthe Morisot (Madame Eugène Manet).** 5 au 24 Mars 1896. Préface de Stéphane Mallarmé. Paris, Galerie Durand-Ruel, 1896.

6770. Rey, Jean D. **Berthe Morisot.** Trans. by Shirley Jennings. Naefels, Switzerland, Bonfini, 1982.

6771. Rouart, Denis, ed. **The correspondence of Berthe Morisot with her family and friends.** Trans. by Betty W. Hubbard. New York, Wittenborn, 1957.

6772. Rouart, Louis. **Berthe Morisot.** Paris, Plon, 1941.

MORLAND, GEORGE, 1763-1804

6773. Baily, J. T. Herbert. **George Morland, a biographical essay.** London, Otto, 1906.

6774. Collins, William. **Memoirs of a picture . . . including a genuine biographical sketch of the late Mr. George Morland, to which is added a copious appendix, etc.** London, Symonds, 1805. 3 v.

6775. Dawe, George. **The life of George Morland, with remarks on his works.** London, Vernor, Hood, 1807. (New ed.: London, Laurie, 1904).

6776. Gilbey, Walter and Cuming, Edward D. **George Morland, his life and works.** London, Black, 1907.

6777. Hassell, John. **Memoirs of the life of the late G. Morland.** London, Cundee, 1806.

6778. Henderson, Bernard L. **Morland and Ibbetson.** London, Allan, 1923.

6779. Nettleship, John T. **George Morland and the evolution from him of some later painters.** London, Seeley, 1898. (The Portfolio, 39).

6780. Richardson, Ralph. **George Morland, painter, London (1763-1804).** London, Stock, 1895.

6781. Williamson, George C. **George Morland, his life and works.** London, Bell, 1907.

6782. Wilson, David H. **George Morland.** London, Scott/New York, Scribner, 1907.

MORO, ANTONIO, 1519-1576

6783. Hymans, Henri S. **Antonio Moro, son oeuvre et son temps.** Bruxelles, van Oest, 1910.

6784. Frerichs, L. C. **Antonio Moro.** Amsterdam, Becht, [1947]. (Palet serie, 23).

6785. Friedländer, Max J. **Anthonis Mor and his contemporaries.** Comments and notes by H. Pauwels and G. Lemmens; assisted by M. Gierts. Trans. by Heinz Norden. Leyden, Sijthoff/Brussels, La Connaissance, 1975. (Early Netherlandish Painting, 13).

6786. Marlier, Georges. **Anthonis Mor van Dashorst (Antonio Moro).** Bruxelles, Nouvelle Société d'Editions, 1934.

MORONE, DOMENICO, 1442-1518

6787. Brenzoni, Raffaello. **Domenico Morone, 1458-9 c.-1517 c.; vita ed opere.** Firenze, Olschki, 1956.

6788. Dal-Gal, Niccolò. **Un pittore veronese del quattrocento: Domenico Morone e i suoi affreschi nel chiostro francescano di San Bernardino in Verona.** Roma, Tipografia Editrice Industriale, 1909.

MORONI, GIOVANNI BATTISTA, 1520-1578

6789. Cugini, Davide. **Moroni, pittore.** Bergamo, Orobiche, 1939.

6790. Lendorff, Gertrud. **Giovanni Battista Moroni, der Porträtmaler von Bergamo.** Winterthur, Schönenberger & Gall, 1933.

6791. Palazzo dell Ragione (Bergamo). **Giovan Battista Moroni (1520-1578).** [Direttore della mostra: Francesco Rossi; coordinamento scientifica: Mina Gregori]. Bergamo, Azienda Autonoma di Turismo, 1979.

6792. Spina, Emma. **Giovan Battista Moroni.** Milano, Fabbri, 1966. (I maestri del colore, 139).

MORRIS, ROBERT, 1931-

6793. Contemporary Arts Museum (Houston). **Robert Morris; selected works, 1970-1980.** December 12, 1981-February 14, 1982. [Essay by Marti Mayo]. Houston, Tex., Contemporary Arts Museum, 1981.

6794. Corcoran Gallery of Art (Washington, D.C.). **Robert Morris.** November 24-December 28, 1969. [Essay by Annette Michelson]. Washington, D.C., Corcoran Gallery of Art, 1969.

6795. Tate Galley (London). **Robert Morris.** 28 April-6 June 1971. [Text by Michael Compton and David Sylvester]. London, Tate Gallery, 1971.

6796. Whitney Museum of American Art (New York). **Robert Morris.** April 9-May 31, 1970. [Text by Marcia Tucker]. New York, Whitney Museum of American Art, 1970.

MORRIS, WILLIAM, 1834-1896

6797. Bradley, Ian. **William Morris and his world.** London, Thames and Hudson, 1978.

6798. Cary, Elisabeth L. **William Morris, poet, craftsman, socialist.** New York, Putnam, 1902.

6799. Clark, Fiona. **William Morris, wallpaper and chintzes.** With a biographical note by Andrew Malvin. New York, St. Martin's, 1973.

6800. Clutton-Brock, Arthur. **William Morris: his work and influence.** London, Williams and Norgate, 1914.

6801. Crow, Gerald H. **William Morris, designer.** London, The Studio, 1934.

6802. Eshleman, Lloyd W. **A Victorian rebel; the life of William Morris.** New York, Scribner, 1940.

6803. Fairclough, Oliver and Leary, Emmeline. **Textiles by William Morris and Morris & Co., 1861-1940.** Introduction by Barbara Morris. London, Thames and Hudson, 1981.

6804. Faulkner, Peter. **Against the age: an introduction to William Morris.** London, Allen & Unwin, 1980.

6805. Forman, Harry B. **The books of William Morris described, with some account of his doings in literature and the allied crafts.** London, Hollings, 1897.

6806. Henderson, Philip. **William Morris: his life, work and friends.** London, Thames and Hudson, 1967.

6807. Jackson, Holbrook. **William Morris.** London, Cape, 1926. 2 ed.

6808. Lindsay, Jack. **William Morris, his life and work.** London, Constable, 1975.

6809. Mackail, John W. **The life of William Morris.** London, Longmans, 1899. 2 v.

6810. Meynell, Esther H. **Portrait of William Morris.** London, Chapman & Hall, 1947.

6811. Morris, May. **William Morris; artist, writer, socialist.** Oxford, Blackwell, 1936. 2 v.

6812. Morris, William. **Architecture, industry & wealth: collected papers.** London, Longmans, 1902.

6813. _____. **Gothic architecture: a lecture for the Arts and Crafts Exhibition Society.** London, Kelmscott Press, 1893.

6814. _____. **Hopes and fears for art.** Boston, Roberts, 1882.

6815. _____. **The letters of William Morris to his family and friends.** Edited by Philip Henderson. New York, Longmans, 1950.

6816. _____. **A note by William Morris on his aims in founding the Kelmscott Press.** Together with a short description of the press by S. J. Cockerell, & an annotated list of the books printed thereat. London, Kelmscott Press, 1898.

6817. _____. **On art and socialism; essays and lectures.** Selected with an introduction by Holbrook Jackson. London, Lehmann, 1947.

6818. Parry, Linda. **William Morris textiles.** New York, Viking, 1983.

6819. Schleinitz, Otto. **William Morris, sein Leben und Wirken.** 4 v. Bielefeld/Leipzig, Velhagen & Klasing, 1907-8.

6820. Schmidt-Künsemüller, Friedrich A. **William Morris und die neuere Buchkunst.** Wiesbaden, Harrassowitz, 1955.

6821. Scott, Temple. **A bibliography of the works of William Morris.** London, Bell, 1897.

6822. Sewter, A. Charles. **The stained glass of William Morris and his circle.** 2 v. New Haven/London, Yale University Press, 1974. (CR).

6823. Sparling Henry H. **The Kelmscott Press and William Morris, master-craftsman.** London, Macmillan, 1924.

6824. Stoppani, Leonard, et al. **William Morris & Kelmscott.** London, Design Council, 1981.

6825. Thompson, Paul R. **The work of William Morris.** London, Heinemann, 1967.

6826. Vallance, Aymer. **William Morris; his art, his writings and his public life.** London, Bell, 1897.

6827. Vidalenc, Georges. **William Morris.** Paris, Alcan, 1920.

6828. Walsdorf, John J. **William Morris in private press and limited editions: a descriptive bibliography of books by and about William Morris, 1891-1981.** Foreword by Sir Basil Blackwell. Phoenix, Ariz., Oryx Press, 1983.

6829. Watkinson, Ray. **William Morris as designer.** New York, Reinhold, 1967.

MORRIS, WRIGHT, 1910-

6830. Morris, Wright. **Photographs and words.** Edited with an introduction by James Alinder. Carmel, Calif., Friends of Photography, 1982. (Untitled: Quarterly of the Friends of Photography, 29).

6831. Sheldon Memorial Art Gallery, University of Nebraska (Lincoln, Nebr.). **Wright Morris: structures and artifacts; photographs 1933-1954.** October 21-November 16, 1975. Lincoln, Neb., Sheldon Memorial Art Gallery, 1975.

MORSE, SAMUEL FINLEY BREESE. 1791-1872

6832. Larkin, Oliver W. **Samuel F. B. Morse and American democratic art.** Boston, Little, Brown, 1954.

6833. Mabee, Carleton. **The American Leonardo; a life of Samuel F. B. Morse.** With an introduction by Allan Nevins. New York, Knopf, 1943. (Reprint: New York, Octagon, 1967).

6834. Morse, Samuel F. B. **Lectures on the affinity of painting with the other fine arts.** Edited with an introduction by Nicolai Cikovsky, Jr. Columbia, Mo./London, University of Missouri Press, 1983.

6835. _____. **Samuel F. B. Morse, his letters and journals.** Edited and supplemented by his son. 2 v. Boston/New York, Houghton Mifflin, 1914. (Reprint: New York, Da Capo, 1973).

6836. Prime, Samuel F. **The life of Samuel F. B. Morse, the inventor of the electro-magnetic telegraph.** New York, Appleton, 1875.

6837. Wehle, Harry B. **Samuel F. B. Morse, American painter.** A study occasioned by an exhibition of his paintings [at the Metropolitan Museum of Art, New York] February 16 through March 27, 1932. New York, Metropolitan Museum of Art, 1932.

MOSER, LUKAS, ca. 1400-ca. 1450

6838. May, Helmut. **Lucas Moser.** Stuttgart, Fink, 1961.

6839. Piccard, Gerhard. **Der Magdalenenaltar des Lukas Moser in Tiefenbronn; ein Beitrag zur europäischen Kunstgeschichte.** Wiesbaden, Harrassowitz, 1969.

MOSTAERT, JAN, ca. 1475-1556

6840. Pierron, Sander. **Les Mostaert: Jean Mostaert, dit le maître d'Oultremont; Gilles et François Mostaert; Michel Mostaert.** Bruxelles/Paris, van Oest, 1912.

MOTHERWELL, ROBERT, 1915-

6841. Arnason, H. Harvard. **Robert Motherwell.** Introduction by Dore Ashton. New York, Abrams, 1982. 2 ed.

6842. Museum of Modern Art (New York). **Robert Motherwell.** Sept. 30-Nov. 28, 1965. New York, Museum of Modern Art, 1965; distributed by Doubleday, Garden City, N.Y.

6843. Städtische Kunsthalle Düsseldorf. **Robert Motherwell.** [Text by Robert C. Hobbs et al., in English and German]. Düsseldorf, Städtische Kunsthalle, 1976.

6844. Terenzio, Stephanie. **The painter and the printer: Robert Motherwell's graphics, 1943-1980.** Catalogue raisonné by Dorothy C. Belknap. New York, American Federation of Arts, 1980. (CR).

MOUNT, WILLIAM SIDNEY, 1807-1868

6845. Cowdrey, Bartlett and Williams, Hermann W., Jr. **William Sidney Mount, 1807-1868; an American painter.** With a foreword by Harry B. Wehle. New York, published for the Metropolitan Museum of Art by Columbia University Press, 1944.

6846. Frankenstein, Alfred. **William Sidney Mount.** New York, Abrams, 1975.

MUCHA, ALPHONSE MARIE, 1860-1939

6847. Bridges, Ann, ed. **Alphonse Mucha, the complete graphic work.** Foreword by Jiří Mucha. Contributions by Marina Henderson and Anna Dvořák. New York, Harmony, 1980. (CR).

6848. Mathildenhöhe Darmstadt. **Alfons Mucha, 1860-1939.** 8. Juni bis 3. August 1980. Darmstadt, Mathildenhöhe Darmstadt/München, Prestel, 1980. (CR).

6849. Mucha, Alphonse. **Lectures on art.** New York, St. Martin's/London, Academy, 1975.

6850. Mucha, Jiří. **Alphonse Mucha; his life and art, by his son.** London, Heinemann, 1966. (New ed.: Praha, Miadá Fronta, 1982).

6851. _____, et al. **Alphonse Mucha, revised, enlarged edition.** New York, St. Martin's/London, Academy, 1974.

6852. Ovenden, Graham. **Alphonse Mucha, photographs.** New York, St. Martin's/London, Academy, 1974.

MUCHE, GEORG, 1895-

6853. Muche, Georg. **Blickpunkt: Sturm, Dada, Bauhaus, Gegenwart.** München, Langen/Müller, 1961.

6854. Richter, Horst. **George Muche.** Recklinghausen, Bongers, 1960. (Monographien zur Rheinisch-Westfälischen Kunst der Gegenwart, 18).

6855. Schiller, Peter H. **George Muche: das druckgraphische Werk. Kritisches Verzeichnis.** Darmstadt/Berlin, Bauhaus-Archiv, 1970. (CR).

6856. Städtische Galerie Schwarzes Kloster, Freiburg im Breisgau. **Muche, Zeichnungen und Druckgraphik aus den Jahren 1912-73.** 27. Oktober bis 25. November 1973. Freiburg i.Br., Städtische Galerie Schwarzes Kloster, 1973.

MUELICH, HANS, 1516-1573

6857. Röttger, Bernhard H. **Der Maler Hans Mielich.** München, Schmidt, 1925.

MÜLLER, FRIEDRICH, 1749-1825

6858. Unverricht, Konrad. **Die Radierungen des Maler Müller; ein Beitrag zur Geschichte der deutschen Kunst im späten achtzehnten Jahrhundert.** Speyer am Rhein, Jaeger, 1930.

MÜLLER, OTTO, 1874-1930

6859. Buchheim, Lothar-Günther. **Otto Mueller, Leben und Werk.** Mit einem Werkverzeichnis der Graphik Otto Muellers von Florian Karsch. Feldafing, Buchheim, 1963. (CR).

6860. Galerie Nierendorf (Berlin). **Otto Mueller zum hundertsten Geburtstag: das graphische Gesamtwerk.** [November 25, 1974-March 18, 1975]. Berlin, Galerie Nierendorf, 1974. (CR).

6861. Troeger, Eberhard. **Otto Mueller.** Freiburg im Breisgau, Crone, 1949.

MÜNTER, GABRIELE, 1877-1962

see also KANDINSKY, WASSILY

6862. Lahnstein, Peter. **Münter.** Ettal, Buch-Kunstverlag Ettal, 1971.

6863. Mochan, Anne. **Gabriele Münter: between Munich and Murnau.** [Published in conjunction with an exhibition at the Busch-Reisenger Museum, Cambridge, Mass., Sept. 25-Nov. 8, 1980]. Cambridge, Mass., President and Fellows of Harvard College, 1980.

6864. Pfeiffer-Belli, Erich. **Gabriele Münter, Zeichnungen und Aquarelle.** Mit einem Katalog von Sabine Helms. Berlin, Mann, 1979.

6865. Städtische Galerie im Lenbachhaus (Munich). **Gabriele Münter, 1877-1962; Gemälde, Zeichnungen, Hinterglasbilder und Volkskunst aus ihrem Besitz.** 22. April-3. Juli 1977. München, Städtische Galerie im Lenbachhaus, 1977.

MULREADY, WILLIAM, 1786-1863

6866. Dafforne, James. **Pictures of William Mulready, R. A., with descriptions and a biographical sketch of the painter.** London, Virtue, [1872].

6867. Heleniak, Kathryn M. **William Mulready.** New Haven/London, published for the Paul Mellon Centre for Studies in British Art by Yale University Press, 1980.

6868. Stephens, Frederick. **Memorials of William Mulready, R. A.** London, Sampson Low, 1890. 2 ed.

MULTSCHER, HANS, 1400-1467

6869. Gerstenberg, Kurt. **Hans Multscher.** Leipzig, Insel-Verlag, 1928.

6870. Rasmo, Nicolò. **L'altare di Hans Multscher a Vipiteno.** Bolzano, Ferrari-Auer, 1963.

6871. Stadler, Fran J. **Hans Multscher und seine Werkstatt; ihre Stellung in der Geschichte der schwäbischen Kunst.** Strassburg, Heitz, 1907. (Studien zur deutschen Kunstgeschichte, 82).

6872. Tripps, Manfred. **Hans Multscher, seine Ulmer Schaffenszeit, 1427-1467.** Weissenhorn, Konrad, 1969.

MUNCH, EDVARD, 1863-1944

6873. Benesch, Otto. **Edvard Munch.** Trans. by Joan Spencer. Phaidon, 1943.

6874. Bock, Henning und Busch, Günter, eds. **Edvard Munch: Probleme, Forschungen, Thesen.** München, Prestel, 1973. (Studien zur Kunst des neunzehnten Jahrhunderts, 21).

6875. Deknatel, Frederick B. **Edvard Munch.** With an introduction by Johan H. Langaard. Boston, Institute of Contemporary Art/New York, Chanticleer Press, 1950.

6876. Gauguin, Pola. **Edvard Munch.** Oslo, Aschehoug, 1946.

6877. _____. **Grafikeren Edvard Munch.** 2 v. Trondheim, Bruns, 1946.

6878. Gerlach, Hans E. **Edvard Munch, sein Leben und sein Werk.** Hamburg, Wagner, 1955.

6879. Gierloff, Christian. **Edvard Munch selv.** Oslo, Gyldendal, 1953.

6880. Glaser, Curt. **Edvard Munch.** Berlin, Cassirer, 1917.

6881. Greve, Eli. **Edvard Munch, liv og werk i lys av tresnittene.** Oslo, Cappelens, 1963.

6882. Heller, Reinhold. **Edvard Munch: The scream.** New York, Viking, 1973.

6883. Hodin, Josef P. **Edvard Munch, der Genius des Nordens.** Stockholm, Neuer Verlag, 1948.

6884. Hougen, Pål, ed. **Edvard Munch, Handzeichnungen.** New York, Rathenau/Berlin, Euphorion, 1976. (CR).

6885. Krieger, Peter. **Edvard Munch: der Lebensfries für Max Reinhardts Kammerspiele.** Berlin, Mann, 1978.

6886. Langaard, Ingrid. **Edvard Munch, modningsår; en studie i tidlig ekspresjonisme og symbolisme.** Oslo, Gyldendal, 1960.

6887. Langaard, Johan H. [and] Revold, Reidar. **Edvard Munch, masterpieces from the artist's collections in the Munch Museum in Oslo.** Trans. by Michael Bullock. New York/Toronto, McGraw-Hill, 1964.

6888. Linde, Max. **Edvard Munch. Neue Ausgabe.** Berlin-Charlottenburg, Gottheiner, 1905.

6889. Moen, Arve. **Edvard Munch.** 3 v. Oslo, Forlaget Norsk Kunstreproduksjon, 1956-58.

6890. Munch, Edvard. **Edvard Munchs brev familien: et utvalg ved Inger Munch.** Oslo, Tanum, 1949.

6891. National Gallery of Art (Washington, D.C.). **Edvard Munch: symbols & images.** Nov. 11, 1978-Feb. 19, 1979. Introd. by Robert Rosenblum; essays by Arne Eggum et al. Washington, D.C., National Gallery of Art, 1978.

6892. Prelinger, Elizabeth. **Edvard Munch, master printmaker: an examination of the artist's works and techniques based on the Philip and Lynn Straus Collection.** New York, Norton, in association with the Busch-Reisinger Museum, Harvard University, Cambridge, Mass., 1983.

6893. Przybyszewski, Stanislaw, et al. **Das Werk des Edvard Munch.** Berlin, Fischer, 1896.

6894. Sarvig, Ole. **The graphic work of Edvard Munch.** Trans. by Helen Sarvig in collaboration with Alberta Feynman and the author. Ed. by Elizabeth Pollet. Lyngby, Hamlet, 1980.

6895. Schiefler, Gustav. **Edvard Munch, das graphische Werk, 1906-1926.** Berlin, Euphorion, 1928.

6896. _____. **Verzeichnis des graphischen Werks Edvard Munchs bis 1906.** Berlin, Cassirer, 1907. (CR).

6897. Selz, Jean. **E. Munch.** Trans. by Eileen B. Hennessy. New York, Crown, 1974.

6898. Stang, Ragna T. **Edvard Munch: the man and his art.** Trans. by Geoffrey Culverwell. New York, Abbeville Press, 1979.

6899. Stenersen, Rolf. **Edvard Munch, close-up of a genius.** Trans. and edited by Reidar Dittman. Oslo, Gyldendal, 1969.

6900. Stenerud, Karl, et al. **Edvard Munch, mennesket og kunstneren.** Oslo, Gyldendal, 1946. (Kunst og kulturs serie).

6901. Svenaeus, Gösta. **Edvard Munch im männlichen Gehirn.** 2 v. Lund, Vetenskaps-Societeten i Lund, 1973. (Publications of the New Society of Letters at Lund, 66-67).

6902. _____. **Edvard Munch: das Universum der Melancholie.** Lund, Vetenskaps-Societen i Lund, 1968. (Publications of the New Society of Letters at Lund, 58).

6903. Thiis, Jens. **Edvard Munch.** Berlin, Rembrandt, 1934.

6904. Timm, Werner. **The graphic art of Edvard Munch.** Trans. by Ruth Michaelis-Jena with the collaboration of Patrick Murray. Greenwich, Conn., New York Graphic Society, 1973.

6905. Weisner, Ulrich, ed. **Edvard Munch: Liebe, Angst, Tod. Themen und Variationen; Zeichnungen und Graphiken aus dem Munch-Museum, Oslo.** Bielefeld, Kunsthalle Bielefeld, 1980.

MUNKACSY, MIHALY VON, 1844-1900

6906. Aleshina, Liliia S. **Mikhai Munkachi, 1844-1900.** Moskva, Iskusstvo, 1960.

6907. Ilges, Franz W. **M. von Munkacsy.** Bielefeld/Leipzig, Velhagen & Klasing, 1899. (Künstler-Monographien, 40).

6908. Malonyay, Dezsö. **Munkácsy Mihály.** 2 v. Budapest, Lampel, 1907. 2 ed.

6909. Sedelmeyer, Charles. **M. von Monkácsy, sein Leben und seine künstlerische Entwicklung.** Paris, Sedelmeyer, 1914.

6910. Végvári, Lajos. **Katalog der Gemälde und Zeichnungen Mihály Munkacsys.** Budapest, Akadémiai Kiado, 1958. (CR).

6911. _____. **Munkácsy Mihály élete és müvei.** Budapest, Akadémiai Kiado, 1958.

MUNTHE, GERHARD PETER, 1849-1929

6912. Bakken, Hilmar. **Gerhard Munthes dekorative Kunst.** Oslo, Gyldendal, 1946.

6913. _____. **Gerhard Munthe, en biografisk studie.** With a summary in English. Oslo, Gyldendal, 1952.

MURILLO, BARTOLOME ESTEBAN, 1617-1682

6914. Alfonso, Luis. **Murillo; el hombre, el artista, las obras.** Barcelona, Maucci, 1883.

6915. Angulo Iñiguez, Diego. **Murillo.** 3 v. Madrid, Espasa-Calpe, 1981. (CR).

6916. Brown, Jonathan. **Murillo and his drawings.** (Published in conjunction with an exhibition of drawings by Murillo held at the Art Museum, Princeton University, Princeton, N.J., Dec. 12, 1976-Jan. 30, 1977). Princeton, N.J., Art Museum, Princeton University, 1976; distributed by Princeton University Press, Princeton, N.J. (CR).

6917. Calvert, Albert F. **Murillo, a biography and appreciation.** New York, Lane, 1907.

6918. Causa, Raffaello. **Murillo.** Milano, Fabbri, 1964. (I maestri del colore, 51).

6919. Curtis, Charles B. **Velázquez and Murillo; a descriptive and historical catalogue of the works.** London, Sampson Low/New York, Bouton, 1883. (Reprint: Ann Arbor, Mich., University Microfilms, 1973).

6920. Davies, Edward. **The life of Bartolomé E. Murillo, compiled from the writings of various authors.** London, Bensley, 1819.

6921. Elizalde, Ignacio. **En torno a las inmaculadas de Murillo.** Prologo del Marques de Lozoya. Madrid, Sapientia, 1955.

6922. Gaya Nuño, Juan A. **L'opera completa di Murillo.** Milano, Rizzoli, 1978. (CR). (Classici dell'arte, 93).

6923. Justi, Carl. **Murillo.** Leipzig, Seemann, 1892.

6924. Lafond, Paul. **Murillo; biographie critique.** Paris, Laurens, 1908.

6925. Lefort, Paul. **Murillo et ses élèves.** Paris, Rouam, 1892.

6926. Knackfuss, Hermann. **Murillo.** Bielefeld/Leipzig, Velhagen & Klasing, 1896. (Künstler-Monographien, 10).

6927. Mayer, August L. **Murillo.** Stuttgart, Deutsche Verlags-Anstalt, 1923. (Klassiker der Kunst, 22).

6928. Minor, Ellen E. **Murillo.** London, Sampson Low, 1881.

6929. Montoto de Sedas, Santiago. **Murillo.** Barcelona, Hymsa, 1932.

6930. Muñoz, Antonio. **Murillo.** Novara, Ist. Geog. de Agostini, 1942.

6931. Royal Academy of Arts (London). **Bartolomé Esteban Murillo, 1617-1682.** London, Royal Academy of Arts, in association with Weidenfeld and Nicolson, 1983.

6932. Sanchez de Palacios, Mariano. **Murillo.** Madrid, Offo, 1965.

6933. Tubino, Francisco M. **Murillo; su época, su vida, sus cuadros.** Sevilla, La Andalucia, 1864.

MUYBRIDGE, EADWEARD, 1830-1904

6934. Haas, Robert B. **Muybridge, man in motion.** Berkeley/Los Angeles, University of California Press, 1976.

6935. Hendricks, Gordon. **Eadweard Muybridge, the father of the motion picture.** New York, Grossman, 1975.

6936. MacDonnell, Kevin. **Eadweard Muybridge: the man who invented the moving picture.** Boston, Little, Brown, 1972.

6937. Muybridge, Eadweard. **Animal locomotion, an electrophoto-graphic investigation of consecutive phases of animal movements.** Philadelphia, University of Pennsylvania, 1881. 11 v. (Reprint: New York, Dover, 1979).

6938. Württembergischer Kunstverein Stuttgart. **Eadweard Muybridge.** [Oct. 21-Nov. 28, 1976]. Stuttgart, Württembergischer Kunstverein, 1976.

MYRON, 5th c. B.C.

6939. Klöter, Hermann. **Myron im Licht neuerer Forschungen.** Würzburg, Triltsch, 1933.

6940. Mirone, Salvatore. **Mirone d'eleutere.** Catania, Tropea, 1921.

6941. Schröder, Bruno. **Zum Diskobol des Myron, eine Untersuchung.** Strassburg, Heitz, 1913. (Zur Kunstgeschichte des Auslandes, 105).

NADAR see TOURNACHON, FELIX

NADELMAN, ELIE, 1882-1946

6942. Kirstein, Lincoln. **Elie Nadelman.** New York, Eakins Press, [1973]. (CR).

6943. Museum of Modern Art (New York). **The sculpture of Elie Nadelman.** [Text by Lincoln Kirstein]. New York, Museum of Modern Art, 1948.

6944. Whitney Museum of American Art (New York). **The sculpture and drawings of Elie Nadelman.** September 23-November 30, 1975. [Text by John I. H. Baur]. New York, Whitney Museum of American Art, 1975.

NAGY, LÁSZLÓ MOHOLY see MOHOLY NAGY, LÁSZLÓ

NANNI DI BANCO, 1373-1421

see also DONATELLO

6945. Bellosi, Luciano. **Nanni di Banco.** Milano, Fabbri, 1966. (I maestri della scultura, 64).

6946. Planiscig, Leo. **Nanni di Banco.** Firenze, Arnaud, 1946.

6947. Vaccarino, Paolo. **Nanni.** Firenze, Sansoni, 1950.

NANTEUIL, CELESTIN, 1813-1873

6948. Burty, Philippe. **Célestin Nanteuil, graveur et peintre.** 2 v. Paris, Monnier, 1887. (L'âge du romantisme, 1-2).

6949. Marie, Aristide. **Un imagier romantique: Célestin Nanteuil, peintre, aquafortiste et lithographe.** Paris, Carteret, 1910.

NANTEUIL, ROBERT, 1623-1678

6950. Bouvy, Eugène. **Nanteuil.** Paris, Le Goupy, 1924.

6951. Loriquet, Charles. **Robert Nanteuil, sa vie & son oeuvre.** Reims, Michaud, 1886.

6952. Petitjean, Charles. **Catalogue de l'oeuvre gravé de Robert Nanteuil.** Notice biographique de François Courbon. Paris, Delteil et Le Garrec, 1925.

NASH, JOHN, 1752-1835

6953. Davis, Terence. **The architecture of John Nash.** Introduced with a critical essay by Sir John Summerson. London, Studio, 1960.

6954. _____. **John Nash, the Prince Regent's architect.** Newton Abbot (England), David & Charles, 1973. 2 ed.

6955. Summerson, John. **The life and work of John Nash, architect.** Cambridge, Mass., MIT Press, 1980.

6956. Temple, Nigel. **John Nash & the village picturesque.** Gloucester (England), Sutton, 1979.

NASH, PAUL, 1889-1946

6957. Bertram, Anthony. **Paul Nash, the portrait of an artist.** London, Faber, 1955.

6958. Causey, Andrew. **Paul Nash.** Oxford, Clarendon Press, 1980. (CR).

6959. _____. **Paul Nash's photographs: document and image.** London, Tate Gallery, 1973.

6960. Eates, Margot. **Paul Nash, the master of the image, 1889-1946.** London, Murray, 1973.

6961. _____, ed. **Paul Nash: paintings, drawings and illustrations.** [Memorial volume; text by Herbert Read, John Rothenstein, et al.]. London, Humphries, 1948.

6962. Nash, Paul. **Outline; an autobiography, and other writings.** With a preface by Herbert Read. London, Faber, 1949.

6963. _____ and Bottomley, Gordon. **Poet and painter; being the correspondence between Gordon Bottomley and Paul Nash, 1910-1946.** Edited by C. C. Abbott and A. Bertram. London, Oxford University Press, 1955.

6964. Postan, Alexander. **The complete graphic work of Paul Nash.** London, Secker & Warburg, 1973. (CR).

6965. Read, Herbert. **Paul Nash.** Harmondsworth (England), Penguin, 1944.

6966. Tate Gallery. **Paul Nash, paintings and watercolours.** 12 November-28 December 1975. London, Tate Gallery, 1975.

NATOIRE, CHARLES JOSEPH, 1700-1777

see also BOUCHER, FRANÇOIS

6967. Boyer, Ferdinand. **Catalogue raisonné de l'oeuvre de Charles Natoire.** Paris, Colin, 1949. (CR). (Archives de l'art français, nouvelle période, 21).

6968. Musée des Beaux-Arts, Troyes, et al. **Charles-Joseph Natoire (Nîmes, 1700-Castel Gandolfo, 1777): peintures, dessins, estampes et tapisseries des collections publiques françaises.** Mars-juin 1977. [Nantes, Chiffoleau], 1977.

6969. Musée National du Château de Compiègne. **Don Quichotte vu par un peintre du XVIIIe siècle: Natoire.** 14 mai-

10 juillet 1977. Paris, Editions des Musées Nationaux, 1977.

NATTIER, JEAN-MARC, 1685-1766

6970. Nolhac, Pierre de. **Nattier, peintre de la cour de Louis XV.** Paris, Floury, 1925. 3 ed.

NAY, ERNST WILHELM, 1902-1968

6971. Germanisches Nationalmuseum Nürnberg. **E. W. Nay, 1902-1968; Bilder und Dokumente.** 29 März bis 1. Juni 1980. München, Prestel, 1980. (Werke und Dokumente, neue Folge, 1).

6972. Haftmann, Werner. **E. W. Nay.** Köln, DuMont Schauberg, 1960.

6973. Heise, Carl G. [and] Gabler, Karlheinz. **Ernst Wilhelm Nay, die Druckgraphik 1923-1968.** Vorwort von Carl Georg Heise . . . Werkkatalog von Karlheinz Gabler. Zürich/ Stuttgart, Belser, 1975. (CR).

6974. Usinger, Fritz. **Ernst Wilhelm Nay.** Recklinghausen, Bongers, 1961. (Monographien zur rheinisch-westfälischen Kunst der Gegenwart, 21).

NEGRE, CHARLES, 1820-1880

6975. Borcoman, James. **Charles Nègre, 1820-1880.** [Text in English and French]. Ottawa, National Gallery of Canada, 1976.

6976. Jammes, André. **Charles Nègre, photographe, 1820-1880.** Préface de Jean Adhémar. Paris, Jammes, 1963.

6977. Musée Réattu (Arles). **Charles Nègre, photographe, 1820-1880.** 5 juillet-17 août 1980. [Catalogue rédigé par François Heilbrun et Philippe Neagu]. Paris, Editions des Musées Nationaux, 1980.

6978. Nègre, Charles. **De la gravure héliographique, son utilité, son origine, son application à l'étude de l'histoire des arts et des sciences naturelles.** Nice, Gauther, 1866.

NEITHARDT, MATHIS see GRUENEWALD, MATTHIAS

NEIZVESTNYĬ, ERNST, 1926-

6979. Berger, John. **Art and revolution: Ernest Neizvestny and the role of the artist in the U.S.S.R.** London, Weidenfeld and Nicolson, 1969.

6980. Städtisches Museum Leverkusen. **Ernst Neizvestny; Plastiken, Grafiken, Zeichnungen.** [Oct. 28-Dec. 18, 1977]. Leverkusen, Städtisches Museum Leverkusen, 1977.

NEROCCIO DE'LANDI, 1447-1500

6981. Coor, Gertrude. **Neroccio de'Landi, 1447-1500.** Princeton, N.J., Princeton University Press, 1961.

NERVI, PIER LUIGI, 1893-1979

6982. Argan, Giulio C. **Pier Luigi Nervi.** Milano, Il Balcone, 1955. (Architetti del movimento moderne, 11).

6983. Desideri, Paolo [and] Nervi, Pier Luigi, Jr. **Pier Luigi Nervi.** Bologna, Zanchelli, 1979. (Serie di architettura, 5).

6984. Huxtable, Ada L. **Pier Luigi Nervi.** New York, Braziller, 1960.

6985. Nervi, Pier L. **Aesthetics and technology in building.** Trans. by Robert Einaudi. Cambridge, Mass., Harvard University Press, 1965.

6986. _____. **Architettura d'oggi.** Firenze, Vallecchi, 1955.

6987. _____. **New structures.** London, Architectural Press, 1963.

6988. _____. **Scienza o arte del construire?** Caratteristiche e possibilità del cemento armato. Roma, Bussola, 1945. (Panorama di cultura contemporanea, 3).

6989. _____. **Structures.** Trans. by Giuseppina and Mario Salvadori. New York, McGraw-Hill, 1956.

6990. Rogers, Ernesto N. **The works of Pier Luigi Nervi.** Introduction by Ernesto N. Rogers. Explanatory notes to the illustrations by Jürgen Joedicke, trans. by Ernst Priefert. London, Architectural Press, 1957.

NESCH, ROLF, 1893-1975

6991. Detroit Institute of Arts. **The graphic art of Rolf Nesch.** March 18-April 27, 1969. Detroit, Detroit Institute of Arts, 1969.

6992. Hentzen, Alfred. **Rolf Nesch; Graphik, Materialbilder, Plastik.** Stuttgart, Belser, 1960. (English ed.: New York, Atlantis, 1964).

6993. _____ und Stubbe, Wolf. **Rolf Nesch, Drucke.** Frankfurt a.M., Propyläen, 1973.

NEUHUIJS, ALBERT, 1844-1914

6994. Martin, Wilhelm. **Albert Neuhuys, zijn leven en zijn kunst.** Amsterdam, van Kampen & Zoon, [1915].

NEUMANN, BALTHASAR, 1687-1754

6995. Eckert, Georg. **Balthasar Neumann und die Würzburger Residenzpläne; ein Beitrag zur Entwicklungsgeschichte des Würzburger Residenzbaues.** Strassburg, Heitz, 1917. (Studien zur deutschen Kunstgeschichte, 203).

6996. Eckstein, Hans. **Vierzehnheiligen.** Berlin, Rembrandt, 1939.

6997. Freeden, Max H. von. **Balthasar Neumann als Stadtbaumeister.** Berlin, Deutscher Kunstverlag, 1937. (Kunstwissenschaftliche Studien, 20). Reprint: Würzburg, Freunde Mainfränkischer Kunst und Geschichte, 1978.

6998. _____. **Balthasar Neumann, Leben und Werk.** Aufnahmen von Walter Hege. [München], Deutscher Kunstverlag, [1953].

6999. Hirsch, Fritz. **Das sogenannte Skizzenbuch Balthasar Neumanns: ein Beitrag zur Charakteristik des Meisters und zur Philosophie der Baukunst.** Heidelberg, Winter, 1912. (Zeitschrift für Geschichte der Architektur, 8; reprint: Nendeln [Liechtenstein], Kraus, 1978).

7000. Hotz, Joachim. **Das Skizzenbuch Balthasar Neumanns; Studien zur Arbeitsweise des Würzburger Meisters und zur Dekorationskunst im 18. Jahrhundert.** 2 v. Wiesbaden, Reichert, 1981.

7001. Keller, Joseph. **Balthasar Neumann, Artillerie- und Ingenieur-Obrist, fürstlich Bambergischer und Würzburger Oberarchitekt und Baudirektor; eine Studie zur Kunstgeschichte des 18. Jahrhunderts.** Würzburg, Bauer, 1896.

7002. Knapp, Fritz. **Balthasar Neumann, der grosse Architekt seiner Zeit.** Bielefeld/Leipzig, Velhagen & Klasing, 1937. (Künstler-Monographien, 120).

7003. Lohmeyer, Karl, ed. **Die Briefe Balthasar Neumanns an Friedrich Karl von Schönborn, Fürstbischof von Würzburg und Bamberg, und Dokumente aus den ersten Baujahren der Würzburger Residenz.** Saarbrücken, Hofer, 1921. (Das rheinisch-fränkische Barock, 1).

7004. Neumann, Günther. **Neresheim.** Herausgegeben von Hans Jantzen. München, Filser, 1947. (Münchener Beiträge zur Kunstgeschichte, 9).

7005. Otto, Christian F. **Space into light; the churches of Balthasar Neumann.** New York, Architectural History Foundation/Cambridge, Mass. and London, MIT Press, 1979.

7006. Reuther, Hans. **Die Kirchenbauen Balthasar Neumann.** Berlin, Hessling, 1960.

7007. _____. **Die Zeichnungen aus dem Nachlass Balthasar Neumanns: der Bestand in der Kunstbibliothek Berlin.** Berlin, Mann, 1979. (Veröffentlichung der Kunstbibliothek Berlin, 82).

7008. Schmorl, Theodor A. **Balthasar Neumann; Räume und Symbole des Spätbarock.** Hamburg, Claassen & Goverts, 1946.

7009. Sedlmaier, Richard und Pfister, Rudolf. **Die fürstbischofliche Residenz zu Würzburg.** 2 v. München, Müller, 1923.

7010. Staatsgalerie Stuttgart. **Balthasar Neumann in Baden-Württemberg: Bruchsal-Karlsruhe-Stuttgart-Neresheim.** 28. September bis 30. November 1975. Stuttgart, Staatsgalerie Stuttgart, 1975.

7011. Teufel, Richard. **Balthasar Neumann, sein Werk in Oberfranken.** Lichtenfels, Schulze, 1953.

7012. _____. **Vierzehnheiligen.** Lichtenfels, Schulze, 1957. 2 ed.

NEUTRA, RICHARD JOSEPH, 1892-1970

7013. Boesiger, Willy. **Richard Neutra, buildings and projects.** 3 v. [Text in English, French, and German]. Zürich, Girsberger [Vols. 1-2]/New York, Praeger [Vol. 3],

7014. Hines, Thomas S. **Richard Neutra and the search for modern architecture, a biography and history.** New York, Oxford University Press, 1982.

7015. McCoy, Esther. **Richard Neutra.** New York, Braziller, 1960.

7016. Museum of Modern Art (New York). **The architecture of Richard Neutra: from international style to California modern.** [Text by Arthur Drexler and Thomas S. Hines]. New York, Museum of Modern Art, 1982.

7017. Neutra, Richard J. **Amerika; die Stilbildung des neuen Bauens in den Vereinigten Staaten.** Wien, Schroll, 1930. (Neues Bauen in der Welt, 2).

7018. _____. **Building with nature.** New York, Universe, 1971.

7019. _____. **Life and human habitat.** [Text in English and German]. Stuttgart, Koch, 1956.

7020. _____. **Life and shape.** New York, Appleton, 1962.

7021. _____. **Survival through design.** New York, Oxford University Press, 1954.

7022. _____. **Wie baut Amerika?** Stuttgart, Hoffman, 1927.

7023. _____. **World and dwelling.** London, Tiranti, 1962.

7024. Spade, Rupert. **Richard Neutra.** Photographs by Yukio Futagawa. London, Thames and Hudson, 1971.

7025. Zevi, Bruno. **Richard Neutra.** Milano, Il Balcone, 1954.

NEVELSON, LOUISE (BERLIAWSKI), 1900-

7026. Glimcher, Arnold B. **Louise Nelson.** New York, Dutton, 1976. 2 ed.

7027. Gordon, John. **Louise Nevelson.** [Published in conjunction with an exhibition at the Whitney Museum of American Art, New York, March 8-April 30, 1967]. New York, Whitney Museum of American Art, 1967.

7028. Nevelson, Louise. **Dawns and dusks: taped conversations with Diana MacKown.** New York, Scribner, 1976.

7029. Roberts, Colette. **Nevelson.** Paris, Fall, 1964.

7030. Whitney Museum of American Art (New York). **Louise Nevelson, atmospheres and environments.** May 27-September 14, 1980. [Introduction by Edward Albee]. New York, Potter, in association with the Whitney Museum of American Art, 1980; distributed by Crown, New York.

NEWMAN, BARNETT, 1905-1970

7031. Baltimore Museum of Art. **Barnett Newman: the complete drawings, 1944-1969.** April 29-June 17, 1979. [Text and catalogue by Brenda Richardson]. Baltimore, Museum of Art, 1979. (CR).

7032. Hess, Thomas B. **Barnett Newman.** [Published in conjunction with an exhibition at the Museum of Modern Art, New York, Oct. 21, 1971-Jan. 10, 1972]. New York, Museum of Modern Art, 1971; distributed by New York Graphic Society, Greenwich, Conn.

7033. Heynen, Julian. **Barnett Newmans Texte zur Kunst.** New York/Hildesheim, Olms, 1979. (Studien zur Kunstgeschichte, 10).

7034. Rosenberg, Harold. **Barnett Newman.** New York, Abrams, 1978.

NICCOLÒ DA FOLIGNO, 1430-1502

7035. Ergas, Rudolf. **Niccolò da Liberatore, gennant Alunno; eine kunsthistorische Studie.** München, Wolf, 1912.

7036. Frenfanelli Cibo, Serafino. **Niccolò Alunno e la scuola Umbra.** Roma, Barbèra, 1872. (Reprint: Bologna, Forni, 1975).

7037. Passavant, Johann D. **Niccolò Alunno da Foligno, saggio critico.** Roma, Barbèra, 1872.

NICCOLÒ DELL'ABBATE see ABBATE, NICCOLÒ DELL'

NICCOLÒ DELL'ARCA, d. 1494

7038. Gnudi, Cesare. **Niccolò dell'Arca.** Torino, Einaudi, 1942. (Biblioteca d'arte, 2).

7039. _____. **Nuove ricerche su Niccolò dell'Arca.** Roma, de Luca, [1973]. (Quaderni di commentari, 3).

7040. Novelli, Mariangela. **Niccolò dell'Arca.** Milano, Fabbri, 1966. (I maestri della scultura, 15).

7041. Silvestri Baffi, Rosetta. **Lo scultore dell'Arca, Nicolò di Puglia.** Galantina (Italy), Congedo, 1971.

NICCOLÒ DI GIOVANNI FIORENTINO, d. 1505

7042. Schulz, Anne M. **Niccolò di Giovanni Fiorentino and Venetian sculpture of the early Renaissance.** New York, New York University Press for the College Art Association of America, 1978. (Monographs on Archeology and Fine Arts, 33).

NICCOLÒ DI LIBERATORE see NICCOLÒ DA FOLIGNO

NICHOLSON, BEN, 1894-

WILLIAM, 1872-1949

7043. Albright-Knox Art Gallery (Buffalo, N.Y.). **Ben Nicholson, fifty years of his art.** October 21-November 26, 1978. [Text by Steven A. Nash]. Buffalo, N.Y., Buffalo Fine Arts Academy, 1978.

7044. Baxandall, David. **Ben Nicholson: art in progress.** London, Methuen, 1962.

7045. Browse, Lillian. **William Nicholson.** London, Hart-Davis, 1956. (CR).

7046. Hodin, Joseph P. **Ben Nicholson: the meaning of his art.** London, Tiranti, 1957.

7047. Read, Herbert. **Ben Nicholson.** 2 v. [Vol. 1: **Paintings, reliefs, drawings**; Vol. 2: **Work since 1947**]. London, Humphries, 1948/1956.

7048. Russell, John. **Ben Nicholson: drawings, paintings and reliefs, 1911-1968.** London, Thames and Hudson, 1969.

7049. Steen, Marguerite. **William Nicholson.** London, Collins, 1943.

7050. Tate Gallery (London). **Ben Nicholson.** 19 June-27 July 1969. London, Tate Gallery, 1969; distributed by Arno Press, New York.

NIEMEYER, OSCAR, 1907-

7051. Khait, Vladimir L. [and] Ianitskii, O. **Oskar Nimeir.** Moskva, Gosstroiizdat, 1963.

7052. Niemeyer, Oscar. **Quase memórias viagens: tempos de entusiasmo e revolta, 1961-1966.** Rio de Janeiro, Civilização Brasileira, 1968.

7053. Papadaki, Stamo. **Oscar Niemeyer.** New York, Braziller, 1960.

7054. _____. **Oscar Niemeyer: works in progress.** New York, Reinhold, 1956.

7055. _____. **The work of Oscar Niemeyer.** With a foreword by Lucio Costa. New York, Reinhold, 1954. 2 ed.

7056. Sodré, Nelson W. **Oscar Niemeyer.** Rio de Janeiro, Graal, 1978.

7057. Spade, Rupert. **Oscar Niemeyer.** Photographs by Yukio Futagawa. New York, Simon & Schuster, 1971.

NIEPCE, JOSEPH NICEPHORE, 1765-1833

7058. Art Institute of Chicago. **Niépce to Atget: the first century of photography from the collection of André Jammes.** November 16, 1977-January 15, 1978. Essay and catalogue by Marie-Thérèse and André Jammes, and an introduction by David Travis. Chicago, Art Institute of Chicago, 1977.

7059. Fouque, Victor. **The truth concerning the invention of photography: Nicéphore Niépce; his life, letters and works.** Trans. by Edward Epstean. New York, Tennant and Ward, 1935. (Reprint: New York, Arno, 1973).

7060. Niépce, Joseph N. **Correspondances, 1825-1829.** Avec une nomenclature des sources manuscrites par Pierre G. Harmant. Rouen, Pavillon de la Photographie, 1974. (Histoire de la photographie, 2).

7061. _____. **Lettres, 1816-1817.** Correspondance conservée à Châlon-sur-Saône. Rouen, Pavillon de la Photographie, 1973. (Histoire de la photographie, 1).

7062. Société Française de Photographie et de Cinématographie. **Commémoration du centenaire de la mort de Joseph Nicéphore Niépce, inventeur de la photographie.** Manifestations organisées à Châlon-sur-Saone en Juin 1933. Paris, Société Française de Photographie et de Cinématographie, 1933.

NITTIS, GIUSEPPE DE, 1846-1884

7063. Nittis, Giuseppe de. **Notes et souvenirs.** Paris, May et Motteroz, 1895. (Italian ed.: Taccuino, 1870/1884. Prefazione di Emilio Cecchi. Bari, Leonardo da Vinci, 1964).

7064. Pica, Vittorio. **Giuseppe de Nittis, l'uomo e l'artista.** Milano, Alfieri & Lacroix, 1914.

7065. Piceni, Enrico. **De Nittis, l'uomo e l'opera.** Milano, Bramante, 1979.

7066. Pittaluga, Mary [and] Piceni, Enrico. **De Nittis.** Milano, Bramante, 1963. (CR).

NOAKOWSKI, STANISLAW, 1867-1928

7067. Bieganskiego, Piotra. **O Stanislawie Noakowskim.** Warszawa, Pánstwowe Wydawnictwo Naukowe, 1959.

7068. Noakowski, Stanislaw. **Pisma.** Materialy zestawil i wstepem opatrzyl Mieczyslaw Wallis. Warszawa, Wydawnictwo Budownictwo i Architektura, 1957.

7069. Wallis, Mieczyslaw. **Kraj lat dziecinnych Stanislawa Noakowskiego.** Warszawa, Czytelnik, 1960.

7070. _____. **Lata nauki i mistrzostwa Stanislawa Noakowskiego.** Warszawa, Czytelnik, 1971.

7071. _____. **Noakowski.** Warszawie/Auriga, Oficyna Wydawnicza, 1965.

7072. Zachwatowicz, Jan. **Stanislaw Noakowski, rysunki katalog.** Warszawa, Pánstwowe Wydawnictwo Naukowe, 1966. (CR).

NOGUCHI, ISAMU, 1904-

7073. Cordon, John. **Isamu Noguchi.** [Published in conjunction with an exhibition at the Whitney Museum of American Art, New York, April 17-June 16, 1969]. New York, Whitney Museum of American Art, 1968.

7074. Grove, Nancy and Botnick, Diane. **The sculpture of Isamu Noguchi, 1924-1979; a catalogue.** Foreword by Isamu Noguchi. New York/London, Garland, 1980. (CR). (Garland Reference Library of the Humanities, 207).

7075. Hunter, Sam. **Isamu Noguchi.** New York, Abbeville Press, 1978.

7076. Noguchi, Isamu. **A sculptor's world.** Foreword by R. Buckminster Fuller. New York, Harper & Row, 1968.

7077. Tobias, Tobi. **Isamu Noguchi, the life of a sculptor.** New York, Crowell, 1974.

7078. Whitney Museum of American Art (New York). **Isamu Noguchi: the sculpture of space.** February 5-April 6, 1980. New York, Whitney Museum of American Art, 1980.

NOLAN, SIDNEY ROBERT, 1917-

7079. Lynn, Elwyn. **Sidney Nolan: myth and imagery.** London/Melbourne, Macmillan, 1967.

7080. MacInnes, Colin and Robertson, Bryan. **Sidney Nolan.** Introduction by Kenneth Clark. London, Thames and Hudson, 1961.

NOLAND, KENNETH, 1924-

7081. Moffett, Kenworth. **Kenneth Noland.** New York, Abrams, 1977.

7082. Waldman, Diane. **Kenneth Noland, a retrospective.** [Published in conjunction with an exhibition at the Solomon R. Guggenheim Museum, New York]. New York, Guggenheim Foundation in collaboration with Abrams, 1977.

NOLDE, EMIL, 1867-1956

7083. Fehr, Hans. **Emil Nolde, ein Buch der Freundschaft.** Köln, DuMont Schauberg, 1957.

7084. Haftmann, Werner. **Emil Nolde.** Trans. by Norbert Guterman. New York, Abrams, 1959.

7085. Kunstmuseum Hannover und Sammlung Sprengel (Hannover). **Emil Nolde: Gemälde, Aquarelle und Druckgraphik, Verzeichnis der Bestände.** Hannover, Kunstmuseum Hannover und Sammlung Sprengel, 1980. (CR).

7086. Nolde, Emil. **Briefe aus den Jahren 1894-1926.** Herausgegeben und mit einem Vorwort versehen von Max Sauerlandt. Berlin, Furche-Kunstverlag, [1927].

7087. _____. **Das eigene Leben; die Zeit der Jugend, 1867-1902.** Herausgegeben von der Stiftung Seebüll Ada und Emil Nolde. Köln, DuMont Schauberg, 1967. 3 ed.

7088. _____. **Jahre der Kämpfe, 1902-1914.** Herausgegeben von der Stiftung Seebüll Ada und Emil Nolde. Flensburg, Wolff, [1957]. 2 ed.

7089. _____. **Reisen, Achtung, Befreiung: 1919-1946.** Herausgegeben von der Stiftung Seebüll Ada und Emil Nolde. Köln, DuMont Schauberg, 1967.

7090. _____. **Welt und Heimat; die Südseereise, 1913-1918 (geschrieben 1936).** Herausgegeben von der Stiftung Seebüll Ada und Emile Nolde. Köln, DuMont Schauberg, 1965.

7091. Pois, Robert. **Emil Nolde.** Washington, D.C., University Press of America, 1982.

7092. Sauerlandt, Max. **Emil Nolde.** München, Wolff, 1921.

7093. Schiefler, Gustav. **Emil Nolde: das graphische Werk.** Neu bearbeitet, ergänzt und mit Abbildungen versehen von Christel Mosel. 2 v. Köln, DuMont Schauberg, 1966-1967. (CR).

7094. Schleswig-Holsteinischer Kunstverein (Kiel). **Emil Nolde: Graphik aus der Sammlung der Stiftung Seebüll Ada und Emil Nolde.** [October 19-November 30, 1975; text by Martin Urban et al.]. Neukirchen über Niebüll, Stiftung Seebüll Ada und Emil Nolde, 1975.

7095. Schmidt, Paul F. **Emil Nolde.** Leipzig/Berlin, Klinkhardt & Biermann, 1929. (Junge Kunst, 53).

7096. Selz, Peter H. **Emil Nolde.** [Published in conjunction with an exhibition at the Museum of Modern Art, New York, March 4-April 30, 1963]. New York, Museum of Modern Art, 1963; distributed by Doubleday, Garden City, N.Y.

7097. Urban, Martin. **Emil Nolde: landscapes; watercolors and drawings.** Trans. by Paul Stevenson. New York, Praeger, 1970.

NOLLEKENS, JOSEPH, 1737-1823

7098. Smith, John T. **Nollekens and his times, comprehending a life of that celebrated sculptor; and the memoirs of several contemporary artists from the time of Roubiliac, Hogarth, and Reynolds to that of Fuseli, Flaxman, and Blake.** 2 v. London, Colburn, 1829. (New ed., minus the parts on other contemporary artists: London, Turnstile Press, 1949).

NOTKE, BERNT, 1440-1509

7099. Hasse, Max. **Das Triumphkreuz des Bernt Notke im Lübecker Dom.** Hamburg, Ellermann, 1952.

7100. Heise, Carl G. **Die Gregorsmesse des Bernt Notke.** Hamburg, Ellermann, 1941.

7101. Paatz, Walter. **Bernt Notke und sein Kreis.** 2 v. Berlin, Deutscher Verein für Kunstwissenschaft, 1939.

7102. Stoll, Karlheinz, et al. **Triumphkreuz im Dom zu Lübeck: ein Meisterwerk Bernt Notkes.** Wiesbaden, Reichert, 1977.

NUZI, ALLEGRETTO, 1346-1373

7103. Romagnoli, Fernanda. **Allegretto Nuzi, pittore fabrianese.** Fabriano, Tipografia Gentile, 1927.

OELZE, RICHARD, 1900-

7104. Schmied, Wieland. **Richard Oelze.** Göttingen, Musterschmidt, 1965. (Niedersächsische Künstler der Gegenwart, 7).

7105. Württembergischer Kunstverein Stuttgart. **Richard Oelze: Oeuvre-Katalog, 1925-1964.** 15. Januar bis 15. Februar 1965. Hannover, Kestner-Gesellschaft Hannover 1964.

OESER, ADAM FRIEDRICH, 1717-1799

7106. Benyovszky, Karl. **Adam Friedrich Oeser, der Zeichenlehrer Goethes.** Leipzig, Thomas, 1930.

7107. Dürr, Alphons. **Adam Friedrich Oeser, ein Beitrag zur Kunstgeschichte des 18. Jahrhunderts.** Leipzig, Dürr, 1879.

7108. Schulze, Friedrich. **Adam Friedrich Oeser, der Vorläufer des Klassizismus.** Leipzig, Koehler & Amelung, [1944].

O'KEEFFE, GEORGIA, 1887-

7109. Goodrich, Lloyd and Bry, Doris. **Georgia O'Keeffe.** New York, published for the Whitney Museum of American Art by Praeger, 1970.

7110. Lisle, Laurie. **Portrait of an artist: a biography of Georgia O'Keeffe.** New York, Seaview Books, 1980.

7111. O'Keeffe, Georgia. **Georgia O'Keeffe.** New York, Viking, 1976.

7112. Rich, Daniel C. **Georgia O'Keeffe.** Chicago, Art Institute, 1943.

OKYO, MARUYAMA, 1733-1795

7113. Saint Louis Art Museum. **Okyo and the Maruyama-Shijo school of Japanese painting.** [Winter, 1980]. St. Louis, St. Louis Art Museum, 1980.

OLBRICH, JOSEF MARIA, 1867-1908

7114. Creutz, Max. **Joseph Maria Olbrich, das Warenhaus Tietz in Düsseldorf.** Berlin, Wasmuth, 1909.

7115. Hessischen Landesmuseum in Darmstadt. **Joseph M. Olbrich, 1867-1908; das Werk des Architekten.** Ausstellung anlässlich der 100. Wiederkehr des Geburtstages. Darmstadt, Hessisches Landesmuseum, 1967.

7116. Latham, Ian. **Olbrich.** London, Academy, 1980.

7117. Lux, Joseph A. **Joseph Maria Olbrich, eine Monographie.** Berlin, Wasmuth, 1919.

7118. Mathildenhöhe Darmstadt. **Joseph M. Olbrich, 1867-1908.** [Sept. 18-Nov. 27, 1983]. Darmstadt, Mathildenhöhe Darmstadt, 1983.

7119. Olbrich, Joseph M. **Architektur von Olbrich.** Berlin, Wasmuth, 1904.

7120. Schreyl, Karl Heinz [and] Neumeister, Dorothea. **Joseph Maria Olbrich: die Zeichnungen in der Kunstbibliothek Berlin; kritischer Katalog.** Berlin, Mann, 1972. (CR).

7121. Veronesi, Giulia. **Joseph Maria Olbrich.** Milano, Il Balcone, 1948. (Architetti del movimento moderno, 7).

OLDENBURG, CLAES, 1929-

7122. Baro, Gene. **Claes Oldenburg: drawings and prints.** London/New York, Chelsea House, 1969. (CR).

7123. Johnson, Ellen H. **Claes Oldenburg.** Harmondsworth (Eng.), Penguin, 1971.

7124. Kunsthalle Tübingen. **Zeichnungen von Claes Oldenburg.** Mit Textbeiträgen von Götz Adriani, Dieter Koepplin, Barbara Rose. [March 1-April 20, 1975]. Tübingen, Kunsthalle Tübingen, 1975.

7125. Oldenburg, Claes. **Proposals for monuments and buildings, 1965-1969.** Chicago, Big Table Publishing Co., 1969.

7126. _____. **Raw notes; documents and scripts of the performances: Stars, Moveyhouse, Massage, The Typewriter.** With annotations by the author. Halifax (Nova Scotia), The Press of the Nova Scotia College of Art and Design, 1973.

7127. _____ and Van Bruggen, Coosje. **Claes Oldenburg: large-scale projects, 1977-1980; a chronicle.** New York, Rizzoli, 1980.

7128. _____ and Williams, Emmett. **Store days: documents from The Store (1961) and Ray Gun Theater (1962).** Photographs by Robert R. McElroy. New York, Something Else Press, 1967.

7129. Rose, Barbara. **Claes Oldenburg.** [Published in conjunction with an exhibition at the Museum of Modern Art, New York, Sept. 25-Nov. 23, 1969]. New York, Museum of Modern Art, 1969; distributed by New York Graphic Society, Greenwich, Conn.

7130. Tate Gallery (London). **Claes Oldenburg.** 24 June-16 August 1970. London, Arts Council of Great Britain, 1970.

OLITSKI, JULES, 1922

7131. Fenton, Terry. **Jules Olitski and the tradition of oil painting.** [Published in conjunction with an exhibition at the Edmonton Art Gallery, Edmonton, Alberta, Sept. 12-Oct. 28, 1979]. Edmonton, Edmonton Art Gallery, 1979.

7132. Moffett, Kenworth. **Jules Olitski.** New York, Abrams, 1981.

7133. Museum of Fine Arts (Boston). **Jules Olitski.** April 6-May 13, 1973. Boston, Museum of Fine Arts, 1973.

OLIVER, ISAAC, 1556-1617 see HILLIARD, NICHOLAS

OMODEO, GIOVANNI ANTONIO see AMADEO, GIOVANNI ANTONIO

ONATAS, 5th c. B.C.

7134. Dörig, José. **Onatas of Aegina.** Leiden, Brill, 1977. (Monumenta graeca et romana, 1).

OPIE, JOHN, 1761-1807

see also BARRY, JAMES

7135. Earland, Ada. **John Opie and his circle.** London, Hutchinson, 1911.

7136. Opie, John. **Lectures on painting delivered at the Royal Academy of Arts, to which are prefixed a memoir by Mrs. Opie and other accounts of Mr. Opie's talents and character.** London, Longman, 1809.

7137. Rogers, John J. **Opie and his works; being a catalogue of 760 pictures by John Opie, R. A., preceded by a biographical sketch.** London, Colnaghi, 1878. (CR).

ORCAGNA, ANDREA DI CIONE, 1308-1368

7138. Gronau, Hans D. **Andrea Orcagna und Nardo di Cione, eine stilgeschichtliche Untersuchung.** Berlin, Deutscher Kunstverlag, 1937. (Kunstwissenschaftliche Studien, 23).

7139. Niccolini, Giovanni B. **Elogio d'Andrea Orcagna.** Firenze, Carli, 1816.

7140. Steinweg, Klara. **Andrea Orcagna; quellengeschichtliche und stilkritische Untersuchung.** Strassburg, Heitz, 1929.

ORDOÑEZ, BARTOLOME, ca. 1480-1520

see also BERRUGUETE, ALONSO GONZALEZ

7141. Gómez-Moreno, María E. **Bartolomé Ordoñez.** Madrid, Instituto Diego Velázquez, 1956.

ORLEY, BERNAERT VAN, 1485-1542

7142. Musée de l'Ain (Bourg-en-Bresse, France). **Van Orley et les artistes de la cour de Marguerite d'Autriche.** 19 juin-13 septembre 1981. Bourge-en-Bresse, Musée de l'Ain, 1981.

7143. Terlinden, Charles, et al. **Bernard van Orley, 1488-1541.** [Papers edited by the Société Royale d'Archéologie de Belgique], Bruxelles, Dessart, 1943.

7144. Wauters, Alphonse J. **Bernard van Orley.** Paris, Librairie de l'Art, [1893].

ORLIK, EMIL, 1870-1932

7145. Orlik, Emil. **Malergrüsse an Max Lehrs, 1898-1930.** Herausgegeben vom Adalbert Stifter Verein. München, Prestel, 1981.

7146. Osborn, Max. **Emil Orlik.** Berlin, Verlag Neue Kunsthandlung, 1920. (Graphiker der Gegenwart, 2).

7147. Pauli, Friedrich W. **Emil Orlik; Wege eines Zeichners und Graphikers.** Mit einem Beitrag von Walter R. Habicht. Darmstadt, Bläschke, 1972.

7148. Singer, Hans W. **Zeichnungen von Emil Orlik.** Leipzig, Schumann, 1912. (Meister der Zeichnung, 7).

ORLOFF, CHANA, 1888-1968

7149. Courières, Edouard des. **Chana Orloff: trente reproductions de sculptures et dessins précédées d'une étude critique.** Paris, Nouvelle Revue Française, 1927. (Les sculpteurs français nouveaux, 6).

7150. Musée Rodin (Paris). **Chana Orloff, sculptures et dessins.** Paris, Musée Rodin, 1971.

7151. Werth, Leon. **Chana Orloff.** Paris, Crès, 1927.

ORLOVSKII, ALEKSANDR OSIPOVICH, 1777-1832

7152. Atsarkina, Esfir N. **Aleksandr Osipovich Orlovskii, 1777-1832.** Moskva, Iskusstvo, 1971.

7153. Cękalska-Zborowska, Halina. **Aleksander Orlowski.** Warszawa, Wiedza Powszechna, 1962.

7154. Muzeum Narodowe (Warsaw). **Aleksander Orlowski, 1777-1832.** [December 1957-February 1958]. Warszawa, Arkady, 1957.

7155. Tatarkiewicz, Wladyslaw. **Aleksander Orlowski.** Warszawa, Gebethnera i Wolffa, 1926. (Monografje artystyczne, 7).

ORME, PHILIBERT DE L' see DELORME, PHILIBERT

OROZCO, JOSE CLEMENTE, 1883-1949

7156. Cardoza y Aragón, Luis. **Orozco.** [Mexico City], Universidad Nacional Autónoma de México, 1959.

7157. Fernández, Justino. **José Clemente Orozco, forma e idea.** [Mexico City], Porrua, 1956. 2 ed.

7158. Guerico, Antonio del. **José Clemente Orozco.** Milano, Fabbri, 1966 (I maestri del colore, 200).

7159. Helm, MacKinley. **Man of fire, J. C. Orozco; an interpretive memoir.** Boston, Institute of Contemporary Art/New York, Harcourt Brace, 1953. (Reprint: Westport, Conn., Greenwood, 1971).

7160. Hopkins, Jon H. **Orozco: a catalogue of his graphic work.** Flagstaff, Ariz., Northern Arizona University Publications, 1967. (CR).

7161. Merida, Carlos. **Orozco's frescos in Guadalajara.** Photographs by Juan Arauz Lomeli. Edited by Frances Toor. [Mexico City], Toor Studios, 1940.

7162. Museum of Modern Art (Oxford, Eng.). **Orozco!: 1883-1949.** 9 November 1980-4 January 1981. Oxford, Eng., Museum of Modern Art, 1980.

7163. Orangerie Schloss Charlottenburg (Berlin). **José Clemente Orozco, 1883-1949.** Herausgegeben von Egbert Baqué und Heinz Spreitz. 24. Januar bis 1. März 1981. Berlin, Leibniz-Gesellschaft für kulturellen Austausch, 1981.

7164. Orozco, José C. **The artist in New York: letters to Jean Charlot and unpublished writings, 1925-1929.** Foreword and notes by Jean Charlot. Letters and writings trans. by Ruth L. C. Sims. Austin, Tex., University of Texas Press, 1974.

7165. _____. **An autobiography.** Trans. by Robert C. Stephenson. Introduction by John Palmer Leeper. Austin, Tex., University of Texas Press, 1962.

7166. Reed, Alma. **Orozco.** New York, Oxford University Press, 1956.

7167. Zuno, José G. **Orozco y la ironía plástica.** [Mexico City], Cuadernos Americanos, 1953.

ORPEN, WILLIAM, 1878-1931

7168. Arnold, Bruce. **Orpen, mirror to an age.** London, Cape, 1981.

7169. Konody, Paul G. and Dark, Sidney. **Sir William Orpen, artist and man.** London, Seeley, 1932.

7170. National Gallery of Ireland (Dublin). **William Orpen, 1878-1931; a centenary exhibition.** 1 Nov.-15 Dec. 1978. Dublin, National Gallery of Ireland, 1978.

7171. Pickle, R. **Sir William Orpen.** London, Benn, 1923.

OSTADE, ADRIAEN VAN, 1610-1685

ISAAC VAN, 1621-1649

7172. Gaedertz, Theodor. **Adrian van Ostade, sein Leben und seine Kunst.** Lübeck, Rohden, 1869.

7173. Rosenberg, Adolf. **Adriaen und Isack van Ostade.** Bielefeld/Leipzig, Velhagen & Klasing, 1900. (Künstler-Monographien, 44).

7174. Rovinski, Dmitri et Tchétchouline, Nicolas. **L'oeuvre gravé d'Adrien van Ostade.** [Text in Russian and French]. Leipzig, Hiersemann/Saint-Pétersbourg, Kotov, 1912. (CR).

7175. Schnackenburg, Bernhard. **Adriaen von Ostade, Isack von Ostade: Zeichnungen und Aquarelle.** 2 v. Hamburg, Hauswedell, 1981. (CR).

7176. Wessely, Joseph E. **Adriaen van Ostade.** Hamburg, Haendcke & Lehmkuhl, 1888. (Kritische Verzeichnisse von Werken hervorragender Kupferstecher, 5).

7177. Wiele, Marguerite van de. **Les frères van Ostade.** Paris, Librairie de l'Art, 1893.

O'SULLIVAN, TIMOTHY H., 1839-1882

7178. Horan, James D. **Timothy O'Sullivan, America's forgotten photographer.** Garden City, N.Y., Doubleday, 1966.

7179. Newhall, Beaumont and Newhall, Nancy. **T. H. O'Sullivan, photographer.** With an appreciation by Ansel Adams. Rochester, N.Y., George Eastman House/Fort Worth, Tex., Amon Carter Museum of Western Art, 1966.

7180. Snyder, Joel. **American frontiers: the photographs of Timothy H. O'Sullivan, 1867-1874.** Millerton, N.Y., Aperture, 1981.

OUD, JACOBUS JOHANNES PIETER, 1890-1963

7181. Florida State University Art Gallery (Tallahassee, Fla.). **The architecture of J. J. P. Oud, 1906-1963: an exhibition of drawings, plans, and photographs from the archives of Mrs. J. M. A. Oud-Dianux, Wassenaar, Holland.** May 4-28, 1978. Tallahassee, Fla., University Presses of Florida, 1978.

7182. Oud, Jacobus J. P. **Holländische Architektur.** Eschwege, Poeschel & Schulz-Schamburgk, 1926. (Neue Bauhausbücher, 10; reprint: Mainz/Berlin, Kupferberg, 1976).

7183. _____. **Mein weg in De Stijl.** 's Gravenhage, Nijgh en van Ditmar, 1961.

7184. Veronesi, Giulia. **J. J. Pieter Oud.** Milano, Il Balcone, 1953.

OUDRY, JEAN BAPTISTE, 1686-1755

7185. Cordey, Jean. **Esquisses de portraits peints par J.-B. Oudrey avec une étude sur Oudry portraitiste.** Paris, Société des Bibliophiles Français, 1929.

7186. Grand Palais (Paris). **J. B. Oudry, 1686-1755.** 1 octobre 1982-3 janvier 1983. [Catalogue by Hal Opperman]. Paris, Editions de la Réunion des Musées Nationaux, 1982.

7187. Hennique, Nicolette. **Jean-Baptiste Oudry, 1686-1755.** Paris, Nilsson, 1926.

7188. Locquin, Jean. **Catalogue raisonné de l'oeuvre de J. B. Oudry, peintre du roi, 1686-1755.** Paris, Schemit, 1912. (CR).

7189. Opperman, Hal. **J. B. Oudry, 1686-1755.** [Published in conjunction with an exhibition at the Kimball Art Museum, Fort Worth, Tex., February 26-June 5, 1983]. Fort Worth, Tex., Kimball Art Museum, 1983.

7190. _____. **Jean-Baptiste Oudry.** 2 v. New York/London, Garland, 1977.

OUTERBRIDGE, PAUL, 1896-1958

7191. Dines, Elaine and Howe, Graham. **Paul Outerbridge, a singular aesthetic: photographs and drawings, 1921-1941.** A catalogue raisonné. Introductory essay by Bernard Barryte. [Published in conjunction with an exhibition at the Laguna Beach Museum of Art, Laguna Beach, Calif., Nov. 21, 1981-Jan. 10, 1982]. Santa Barbara, Calif., Arabesque Books, 1981. (CR).

7192. Howe, Graham and Hawkins, G. Ray, eds. **Paul Outerbridge, Jr.: photographs.** [Additional material by Jacqueline Markham]. New York, Rizzoli, 1980.

7193. Outerbridge, Paul. **Photographing in color.** New York, Random House, 1940.

OVENS, JÜRGEN, 1623-1678

7194. Schlüter-Göttsche, Gertrud. **Jürgen Ovens, ein schleswig-holsteinischer Barockmaler.** Heine in Holstein, Boyens, 1978.

7195. Schmidt, Harry. **Jürgen Ovens, sein Leben und seine Werke; ein Beitrag zur Geschichte der niederländischen Malerei im XVII. Jahrhundert.** Kiel, Schmidt, [1922].

OVERBECK, JOHANN FRIEDRICH, 1789-1869

7196. Atkinson, J. Beavington. **Overbeck.** New York, Scribner and Welford/London, Sampson Low, 1882.

7197. Heise, Karl G. **Overbeck und sein Kreis.** München, Wolff, 1928.

7198. Howitt, Margaret. **Friedrich Overbeck, sein Leben und Schaffen.** 2 v. Freiburg im Breisgau, Herder, 1886.

7199. Jensen, Jens C. **Friedrich Overbeck, die Werke im Behnhaus.** Lübeck, [Museum für Kunst und Kulturgeschichte, 1963]. (Lübecker Museumshefte, 4).

7200. _____. **Die Zeichnungen Overbecks in der Lübecker Graphiksammlung.** Lübeck, [Museum für Kunst und Kulturgeschichte, n.d.]. (Lübecker Museumshefte, 8).

7201. Laderchi, Camillo. **Sulla vita e sulle opere di Federico Overbeck.** Roma, Menicanti, 1848.

OWINGS, NATHANIEL A., 1903- see SKIDMORE, LOUIS

PACHER, MICHAEL, 1435-1498

FRIEDRICH, ca. 1435-1510

7202. Allesch, Johannes von. **Michael Pacher.** Leipzig, Insel-Verlag, 1931.

7203. Doering, Oscar. **Michael Pacher und die Seinen; eine Tiroler Künstlergruppe am Ende des Mittelalters.** München Gladbach, Kühlen, 1913.

7204. Hempel, Eberhard. **Michael Pacher.** Wien, Schroll, 1931.

7205. Mannowsky, Walter. **Die Gemälde des Michael Pacher.** München, Müller, 1910.

7206. Rasmo, Nicolò. **Michele Pacher.** Milano, Electa, 1969.

7207. Schürer, Oskar. **Michael Pacher.** Bielefeld/Leipzig, Velhagen & Klasing, 1940. (Künstler-Monographien, 121).

7208. Schwabik, Aurel. **Michael Pacher.** Milano, Fabbri, 1966. (I maestri del colore, 191).

7209. _____. **Michael Pachers Grieser Altar.** München, Bruckmann, 1933.

7210. Semper, Hans. **Michael und Friedrich Pacher; ihr Kreis und ihre Nachfolger.** Esslingen, Neff, 1911.

PALLADIO, ANDREA, 1508-1580

7211. Ackerman, James. **Palladio.** Harmondsworth, Eng./New York, Penguin, 1977. 2 ed.

7212. _____. **Palladio's villas.** Locust Valley, N.Y., Augustin, 1967.

7213. Azzi Visentini, Margherita. **Il Palladianesimo in America e l'architettura della villa.** Milano, Polifilo, 1976.

7214. Barbieri, Franco. **The Basilica of Andrea Palladio.** University Park, Penn./London, Pennsylvania State University Press, 1970. (Corpus Palladianum, 2).

7215. Barichella, Vittorio. **Andrea Palladio e la sua scuola.** Lonigo (Italy), Gaspari, 1880.

7216. Basilica Palladiana (Vicenza). **Mostra del Palladio.** Direttore della mostra: Renato Cevese. Milano, Electa, [1974]. 2 ed.

7217. Bassi, Elena. **The Convento della Carità.** Trans. by C. W. Westfall. University Park, Penn./London, Pennsylvania State University Press, 1973. (Corpus Palladianum, 6).

7218. Bertotti Scamozzi, Ottavio. **Le fabbriche e i disegni di Andrea Palladio, raccolti ed illustrati.** 4 v. Vicenza, Rossi, 1786. (Reprinted, with an introduction by Quentin Hughes: New York, Architectural Book Publishing Co., 1968).

7219. Bordignon Favero, Giampaolo. **The Villa Emo at Fanzolo.** Trans. by Douglas Lewis. University Park, Penn./London, Pennsylvania State University Press, 1972. (Corpus Palladianum, 5).

7220. Burger, Fritz. **Die Villen des Andrea Palladio; ein Beitrag zur Entwicklungsgeschichte der Renaissance-Architektur.** Leipzig, Klinkhardt & Biermann, [1909].

7221. Burlington, Richard. **Fabbriche antiche disegnate da Andrea Palladio, vicentino.** Londra, [Burlington], 1730. (Reprint: Farnborough, Eng., Gregg, 1969).

7222. Burns, Howard, et al. **Andrea Palladio, 1508-1580; the portico and the farmyard.** Catalogue by Howard Burns in collaboration with Lynda Fairburn and Bruce Boucher. [Catalogue of an exhibition]. London, Arts Council of Great Britain, 1975.

7223. Cevese, Renato. **Invito a Palladio.** Milano, Rusconi Immagini, 1980.

7224. Fancelli, Paolo. **Palladio e Praeneste: archeologia, modelli, progettazione.** Roma, Bulzoni, 1974. (Studi di storia dell'arte, 2).

7225. Ferrari, Luigi. **Palladio e Venezia.** Venezia, Cordella, 1880.

7226. Fletcher, Banister F. **Andrea Palladio, his life and works.** London, Bell, 1902.

7227. Forssman, Erik. **The Palazzo da Porta Festa in Vicenza.** Trans. by Catherine Enggass. University Park, Penn./ London, Pennsylvania State University Press, 1973. (Corpus Palladianum, 8).

7228. _____. **Palladios Lehrgebäude: Studien über den Zusammenhang von Architektur und Architektur-Theorie bei Andrea Palladio.** Stockholm, Almquist & Wiksell, 1965. (Acta Universitatis Stockholmiensis, 9).

7229. _____, et al. **Palladio: la sua eredità nel mondo.** Milano, Electa, 1980.

7230. Guinness, Desmond and Sadler, Julius T., Jr. **Palladio: a western progress.** New York, Viking, 1976.

7231. Gurlitt, Cornelius. **Andrea Palladio.** Berlin, Der Zirkel, 1914. (Bibliothek alter Meister der Baukunst, 1).

7232. Harris, John. **The Palladians.** New York, Rizzoli, 1982.

7233. Hofer, Paul. **Palladios Erstling: die Villa Godi Valmarana in Lonedo bei Vicenza; Palladio-Studien, 1.** Basel und Stuttgart, Birkhäuser, 1969. (Geschichte und Theorie der Architektur, 5).

7234. Ivanoff, Nicola. **Palladio.** Milano, Edizioni per il Club del Libro, 1967. (Collana d'arte del Club del Libro, 14).

7235. Lewis, Douglas. **The drawings of Andrea Palladio.** [Catalogue of a traveling exhibition commencing at the National Gallery of Art, Washington, D.C.]. Washington, D.C., International Exhibitions Foundation, 1981.

7236. Magrini, Antonio. **Memorie intorno la vita e le opere di Andrea Palladio.** Padova, Tipi del Seminario, 1845.

7237. Mazzotti, Giuseppe. **Palladian and other Venetian villas.** Roma, Bestetti, 1966.

7238. Montenari, Giovanni. **Del Teatro Olimpico di Andrea Palladio in Vicenza.** Padova, Conzatti, 1733.

7239. Oosting, J. Thomas. **Andrea Palladio's Teatro Olimpico.** Ann Arbor, Mich., UMI Research Press, 1981. (Theatre and Dramatic Studies, 8).

7240. Palazzo della Gran Guardia (Verona). **Palladio e Verona.** 3 agosto al 5 novembre 1980. Catalogo della mostra a cura di Paola Martini. Verona, Pozza, 1980.

7241. Palladio, Andrea. **I quattro libri dell'architettura.** Venezia, Franceschi, 1570. (English ed.: London, Ware, 1738; reprinted, with an introduction by Adolf K. Placzek: New York, Dover, 1965).

7242. [_____ and Jones, Inigo]. **Inigo Jones on Palladio; being the notes by Inigo Jones in the copy of I Quattro Libri dell'Architettura di Andrea Palladio, 1601, in the Library of Worcester College, Oxford.** 2 v. Newcastle-upon-Tyne, Oriel Press, 1970.

7243. Pane, Roberto. **Andrea Palladio.** Torino, Einaudi, 1961. (Collana storica di architettura, 5).

7244. Pée, Herbert. **Die Palastbauten des Andrea Palladio.** Würzburg-Aumühle, Triltsch, 1941. 2 ed.

7245. Pozza, Antonio M. dalla. **Palladio.** Vicenza, Edizioni del Pellicano, 1943.

7246. Puppi, Lionello. **Andrea Palladio.** Boston, New York Graphic Society, 1975.

7247. _____. **The Villa Badoer at Fratta Polesine.** Trans. by Catherine Enggass. University Park, Penn./London, Pennsylvania State University Press, 1975. (Corpus Palladianum, 7).

7248. _____, ed. **Palladio e Venezia.** Firenze, Sansoni, 1982.

7249. Reed, Henry H. **Palladio's architecture and its influence: a photographic guide.** Photographs by Joseph C. Farber. New York, Dover, 1980.

7250. Reynolds, James. **Andrea Palladio and the winged device.** New York, Creative Age, 1948.

7251. Rigon, Fernando. **Palladio.** Bologna, Capitol, 1980.

7252. Roop, Guy. **Villas & palaces of Andrea Palladio, 1508-1580.** Color photographs by Franca Parisi Baslini and Anna Pressi. [Text in English, French, Italian, Dutch and Spanish]. Milano, Ghezzi, 1968.

7253. Sale del Palazzo Leoni-Montanari (Vicenza). **Andrea Palladio; il testo, l'immagine, la città.** 30 agosto al 9 novembre 1980. Catalogo della mostra a cura di Lionello Puppi. Milano, Electa, 1980.

7254. Semenzato, Camillo. **The Rotunda of Andrea Palladio.** Trans. by Ann Percy. University Park, Penn./London, Pennsylvania State University Press, 1968. (Corpus Palladianum, 1).

7255. Spielmann, Heinz. **Andrea Palladio und die Antike; Untersuchung und Katalog der Zeichnungen aus seinem Nachlass.** München, Deutscher Kunstverlag, 1966. (Kunstwissenschaftliche Studien, 37).

7256. Streitz, Robert. **Palladio: la Rotonde et sa géométrie.** Lausanne/Paris, Bibliothèque des Arts, 1973.

7257. Temanza, Tommaso. **Vita di Andrea Palladio, Vicentino.** Venezia, Pasquali, 1762.

7258. Timofiewitsch, Wladimir. **The Chiesa del Redentore.** University Park, Penn./London, Pennsylvania State University Press, 1971. (Corpus Palladianum, 3).

7259. _____. **Die sakrale Architektur Palladios.** München, Fink, 1968.

7260. Venditti, Arnaldo. **The Loggia del Capitaniato.** With a note on the pictorial decoration by Franco Barbieri. University Park, Penn./London, Pennsylvania State University Press, 1971. (Corpus Palladianum, 4).

7261. Whitehill, Walter M. **Palladio in America: the work of Andrea Palladio as represented in an exhibition sent to the United States in 1976 by the Centro Internazionale di Studi di Architettura Andrea Palladio of Vicenza.** With an essay on Palladio's influence on American architecture by Frederick Doveton Nichols. Milano, Electa, 1976; distributed by Rizzoli, New York.

7262. Wittkower, Rudolf. **Palladio and Palladianism.** New York, Braziller, 1974.

7263. Zorzi, Giangiorgio. **Le chiese e i ponti di Andrea Palladio.** Venezia, Pozza, 1967.

7264. _____. **I disegni delle antichità di Andrea Palladio.** Pref. di Giuseppe Fiocco. Venezia, Pozza, 1959.

7265. _____. **Le opere pubbliche e i palazzi privati di Andrea Palladio.** Venezia, Pozza, 1965.

7266. _____. **Le ville e i teatri di Andrea Palladio.** Venezia, Pozza, 1968.

PALMA, GIACOMO see PALMA VECCHIO

PALMA VECCHIO, 1480-1528

7267. Ballarin, Alessandro. **Palma il Vecchio.** Milano, Fabbri, 1965. (I maestri del colore, 64).

7268. Gombosi, György. **Palma Vecchio, des Meisters Gemälde und Zeichnungen.** Stuttgart/Berlin, Deutsche Verlags-Anstalt, 1937. (Klassiker der Kunst, 38).

7269. Locatelli, Pasino. **Notizie intorno a Giacomo Palma il Vecchio ed alle sue pitture.** Bergamo, Cattaneo, 1890.

7270. Mariacher, Giovanni. **Palma il Vecchio.** Milano, Bramante, 1968.

7271. Spahn, Annemarie. **Palma Vecchio.** Leipzig, Hiersemann, 1932. (Kunstgeschichtliche Monographien, 20).

PALMER, SAMUEL, 1805-1881

see also BURNE-JONES, EDWARD

7272. Alexander, Russell G. **A catalogue of the etchings of Samuel Palmer.** London, Print Collector's Club, 1937. (Print Collector's Club Publications, 16).

7273. Butlin, Martin. **Samuel Palmer's sketch-book, 1824 [with] an introduction and commentary.** Preface by Geoffrey Keynes. 2 v. Paris, Trianon Press, 1962; distributed by Quaritch, London.

7274. Grigson, Geoffrey. **Samuel Palmer, the visionary years.** London, Kegan Paul, 1947.

7275. Lister, Raymond. **Samuel Palmer, a biography.** London, Faber, 1974.

7276. _____. **Samuel Palmer and his etchings.** London, Faber, 1969.

7277. Malins, Edward. **Samuel Palmer's Italian honeymoon.** London, Oxford University Press, 1968.

7278. Palmer, Alfred H. **The life and letters of Samuel Palmer, painter and etcher.** London, Seeley, 1892.

7279. Palmer, Samuel. **The letters of Samuel Palmer.** Edited by Raymond Lister. 2 v. Oxford, Clarendon Press, 1974.

7280. Peacock, Carlos. **Samuel Palmer: Shoreham and after.** Greenwich, Conn., New York Graphic Society, 1968.

7281. Sellars, James. **Samuel Palmer.** London, Academy, 1974.

PALMEZZANO, MARCO, 1460-1539

7282. Grigioni, Carlo. **Marco Palmezzano, pittore forlivese; nella vita, nelle opere, nell'arte.** Faenza, Lega, 1956.

PAN PAINTER, 5th c. B.C.

7283. Beazley, John D. **The Pan painter.** Mainz, von Zabern, 1974. 4 ed. (Bilder griechischer Vasen, 4).

7284. Follmann, Anna-Barbara. **Der Pan-Maler.** Bonn, Bouvier, 1968. (Abhandlungen zur Kunst-, Musik- und Literaturwissenschaft, 52).

PANKOK, OTTO, 1893-1966

7285. Greither, Aloys. **Der junge Otto Pankok: das Frühwerk des Malers.** Düsseldorf, Droste, 1977.

7286. Schifner, Kurt. **Otto Pankok.** Dresden, Verlag der Kunst, 1963.

7287. Zimmermann, Rainer. **Otto Pankok: das Werk des Malers, Holzschneiders und Bildhauers.** Berlin, Rembrandt, 1964.

PANNINI, GIOVANNI PAOLO, 1691-1765

7288. Arisi, Ferdinando. **Gian Paolo Panini.** Piacenza, Cassa de Risparmio, 1961.

7289. Ozzòla, Leandro. **Gian Paolo Pannini, pittore.** Torino, Celanza, 1921.

PAOLO, GIOVANNI DI see GIOVANNI DI PAOLO

PARIS, MATTHEW, 1200-1259

7290. James, Montague R. **Illustrations to the life of St. Alban in Trinity College, Dublin Manuscript E.i.40** [purported to be by Matthew Paris]. With a description of the illustrations. Oxford, Clarendon Press, 1924.

PARLER, PETER, 1330-1399

7291. Kletzl, Otto. **Peter Parler, der Dombaumeister von Prag.** Leipzig, Seemann, 1940.

7292. Neuwirth, Josef. **Peter Parler von Gmünd und seine Familie.** Prag, Calve, 1891.

7293. Reinhold, Hans. **Der Chor des Münsters zu Freiburg i. Br. und die Baukunst der Parlerfamilie.** Strassburg, Heitz, 1929. (Studien zur deutschen Kunstgeschichte, 263).

7294. Schnütgen-Museum, Kunsthalle Köln. **Die Parler und der Schöne Stil, 1350-1400; europäische Kunst unter den Luxemburgern.** 6 v. Herausgegeben von Anton Legner. Köln, Museen der Stadt Köln, 1978-80.

7295. Swoboda, Karl M. **Peter Parler, der Baukünstler und Bildhauer.** Wien, Schroll, 1940.

PARMA, BENEDETTO DI see ANTELAMI, BENEDETTO

PARMIGIANINO, IL, 1503-1540

7296. Affo, Ireneo. **Vita del graziosissimo pittore Francesco Mazzola detto Il Parmigianino.** Parma, Carmignani, 1784.

7297. Copertini, Giovanni. **Il Parmigianino.** 2 v. Parma, Fresching, 1932.

7298. Faelli, Emilio. **Bibliografia Mazzoliana.** Parma, Battei, 1884.

7299. Fagiolo dell'Arco, Maurizio. **Il Parmigianino; un saggio sull'ermetismo nel cinquecento.** Roma, Bulzoni, 1970.

7300. Freedberg, Sydney J. **Parmigianino; his works in painting.** Cambridge, Mass., Harvard University Press, 1950. (CR).

7301. Fröhlich-Bum, Lili. **Parmigianino und der Manierismus.** Wien, Schroll, 1921.

7302. Mortara, Antonio E. **Della vita e dei lavori di Francesco Mazzola detto Il Parmigianino.** Casalmaggiore, Bizzarri, 1846.

7303. Popham, Arthur E. **Catalogue of the drawings of Parmigianino.** 3 v. New Haven/London, Yale University Press, 1971. (CR).

7304. Quintavalle, Armando O. **Il Parmigianino.** Milano, Istituto Editoriale Italiano, [1948].

7305. Quintavalle, Augusta G. **Gli affreschi giovanili del Parmigianino.** Milano, Silvana, 1968.

7306. _____. **Gli ultimo affreschi del Parmigianino.** Milano, Silvana, 1971.

7307. Rossi, Paola. **L'opera completa del Parmigianino.** Milano, Rizzoli, 1980. (CR). (Classici dell'arte, 101).

PASCIN, JULES, 1885-1930

7308. Brodzky, Horace. **Pascin.** With a preface by James Laver. London, Nicholson & Watson, 1946.

7309. Fels, Florent. **Dessins de Pascin: choix de dessins, maquette et mise en pages d'Arielli.** Paris, Editions du Colombier, 1966.

7310. Freudenheim, Tom L. **Pascin.** [Published in conjunction wih an exhibition at the University Art Museum, University of California, Berkeley, Nov. 15-Dec. 18, 1966]. Berkeley, Regents of the University of California, 1966.

7311. Leeper, John P. **Jules Pascin's Caribbean sketchbook.** Austin, Tex., University of Texas Press, 1964.

7312. Roger-Marx, Claude. **Pascin: carnet de dessins, Berlin-Tunis 1908.** 2 v. Paris, Berggruen, 1968.

7313. Warnod, André. **Pascin.** Préface de Pierre Mac Orlan. Monte Carlo, Sauret, 1954.

7314. Werner, Alfred. **Pascin.** New York, Abrams, [1959].

PASITELES, 1st c.

7315. Borda, Maurizio. **La scuola di Pasiteles.** Bari, Adriatica Editrice, 1953.

PASMORE, VICTOR, 1908-

7316. Bell, Clive. **Victor Pasmore.** Harmondsworth, Eng.,
Penguin, 1945.

7317. Bowness, Alan and Lambertini, Luigi. **Victor Pasmore, a
catalogue raisonné of the paintings, constructions and
graphics, 1926-1979.** New York, Rizzoli, 1980. (CR).

PATER, JEAN-BAPTISTE-JOSEPH, 1695-1736

7318. Ingersoll-Smouse, Florence. **Pater; biographie et catalogue
critiques, l'oeuvre complète de l'artiste.** Paris,
Beaux-Arts, 1928. (CR).

PEALE, CHARLES WILLSON, 1741-1827

JAMES, 1749-1831

RAPHAELLE, 1774-1825

REMBRANDT, 1778-1860

7319. Briggs, Berta N. **Charles Willson Peale, artist & patriot.**
New York, McGraw-Hill, 1952.

7320. Detroit Institute of Arts. **The Peale family: three
generations of American artists.** [Catalogue of an
exhibition]. Detroit, Detroit Institute of Arts, 1967.

7321. Maryland Historical Society (Baltimore). **Four generations
of commissions: the Peale Collection of the Maryland
Historical Society.** March 3-June 29, 1975. Baltimore,
Maryland Historical Society, 1975.

7322. Pennsylvania Academy of Fine Arts (Philadelphia).
**Catalogue of an exhibition of portraits by Charles
Willson Peale and James Peale and Rembrandt Peale.**
[April 11-May 9, 1923]. Philadelphia, Pennsylvania
Academy of Fine Arts, 1923.

7323. Richardson, Edgar P., et al. **Charles Willson Peale and his
world.** [Published in conjunction with an exhibition at
the National Portrait Gallery, Washington, D.C.]. New
York, Abrams, 1983.

7324. Sellers, Charles C. **Charles Willson Peale.** 2 v.
Philadelphia, American Philosophical Society, 1947.
(Memories of the American Philosophical Society, vol. 23,
parts 1-2; new ed.: New York, Scribner, 1969).

7325. _____. **Portraits and miniatures by Charles Willson Peale.**
Philadelphia, American Philosophical Society, 1952.
(CR). (Transactions of the American Philosophical
Society, vol. 42, part 1).

PECHSTEIN, MAX, 1881-1955

7326. Biermann, Georg. **Max Pechstein.** Leipzig, Klinkhardt &
Biermann, 1920. 2 ed. (Junge Kunst, 1).

7327. Heymann, Walther. **Max Pechstein.** München, Piper, 1916.

7328. Kunstverein Braunschweig. **Max Pechstein.** 18. April-
27. Juni 1982. Braunschweig, Kunstverein Braunschweig,
1982.

7329. Osborn, Max. **Max Pechstein.** Berlin, Propyläen, 1922.

7330. Pechstein, Max. **Erinnerungen.** Herausgegeben von L.
Reidemeister. Wiesbaden, Limes, 1960.

PELLEGRINI, PELLEGRINO see TIBALDI, PELLEGRINO

PENNELL, JOSEPH, 1860-1926

7331. Pennell, Elizabeth R. **The life and letters of Joseph
Pennell.** 2 v. Boston, Little, Brown, 1929.

7332. Pennell, Joseph. **The adventures of an illustrator.**
Boston, Little, Brown, 1925.

7333. _____. **Joseph Pennell's Liberty Loan poster; a text book
for artists and amateurs.** Philadelphia/London,
Lippincott, 1918.

7334. _____. **Joseph Pennell's pictures in the land of temples.**
Philadelphia, Lippincott/London, Heinemann, 1915.

7335. _____. **Joseph Pennell's pictures of war work in America.**
Philadelphia, Lippincott, 1918.

7336. _____. **Joseph Pennell's pictures of war work in England.**
Philadelphia, Lippincott/London, Heinemann, 1917.

7337. _____. **Joseph Pennell's pictures of the wonder of work.**
Philadelphia, Lippincott, 1916.

7338. Wuerth, Louis A. **Catalogue of the etchings of Joseph
Pennell.** With an introduction by Elizabeth Robins
Pennell. Boston, Little, Brown, 1928. (CR).

PERMEKE, CONSTANT, 1886-1952

7339. Avermaete, Roger. **Permeke, 1886-1952.** Bruxelles,
Elsevier, 1958.

7340. Fierens, Paul. **Permeke.** Paris, Crès, 1930.

7341. Langui, Emile. **Constant Permeke.** Anvers, De Sikkel, 1952.

7342. Ridder, André de. **Constant Permeke, 1887[sic]-1952.**
Brussel, Paleis der Academiën, 1953.

PERMOSER, BALTHASAR, 1651-1732

7343. Asche, Sigfried. **Balthasar Permoser, Leben und Werk.**
Berlin, Deutscher Verlag für Kunstwissenschaft, 1978.

7344. _____. **Balthasar Permoser und die Barockskulptur des
Dresdener Zwingers.** Frankfurt a.M., Weidlich, 1966.

7345. Beschorner, Hans. **Permoser-Studien.** Dresden, Baensch
Stiftung, 1913.

7346. Michalski, Ernst. **Balthasar Permoser.** Frankfurt a.M.,
Iris, 1927.

PEROV, VASILII GRIGOR'EVICH, 1833-1882

7347. Liaskovskaia, Olga A. **V. G. Perov.** Moskva, Iskusstvo,
1979.

7348. Sobko, N. P. **Vasilii Grigor'evich Perov; ego zhizn' i proizvedeniia.** S. Peterburg, Stasiulevicha, 1892.

PERRAULT, CLAUDE, 1613-1688

7349. Hallays, André. **Les Perrault.** Paris, Perrin, 1926.

7350. Herrmann, Wolfgang. **The theory of Claude Perrault.** London, Zwemmer, 1973. (Studies in Architecture, 12).

7351. Kambartel, Walter. **Symmetrie und Schönheit; über mögliche Voraussetzungen des neueren Kunstbewusstseins in der Architekturtheorie Claude Perraults.** München, Fink, 1972. (Theorie und Geschichte der Literatur und der Schönen Künste, 20).

7352. Perrault, Claude. **Ordonnance des cinq espèces de collones, selon la méthode des anciens.** Paris, Coignard, 1683. (English ed., trans. by John James: London, Motte/Sturt, 1708).

PERREAL, JEAN, ca. 1455-1530

7353. Bancel, E. M. **Jehan Perréal dit Jehan de Paris, peintre et valet de chambre des rois Charles VIII, Louis XII et François I.** Paris, Launette, 1885. (Reprint: Genève, Slatkine, 1970).

7354. Charvet, Léon. **Jehan Perréal, Clément Trie, et Edouard Grand.** Lyon, Glairon Mondet, 1874.

7355. Dufay, Charles J. **Essai biographique sur Jehan Perréal dit Jehan de Paris, peintre et architecte Lyonnais.** Lyon, Brun, 1864.

7356. Maulde de Clavière, René. **Jean Perréal dit Jean de Paris.** Paris, Leroux, 1896.

7357. Renouvier, Jules. **Iehan de Paris, varlet de chambre et peintre ordinaire des rois Charles VIII et Louis XII, précédé d'une notice biographique sur la vie et les ouvrages par Georges Duplessis.** Paris, Aubry, 1861.

PERUGINO, 1446-1524

7358. Alazard, Jean. **Pérugin, biographie critique.** Paris, Laurens, 1927.

7359. Bombe, Walter. **Perugino, des Meisters Gemälde.** Stuttgart/Berlin, Deutsche Verlags-Anstalt, 1914. (Klassiker der Kunst, 25).

7360. Broussole, Abbé. **La jeunesse du Pérugin et les origins de l'école ombrienne.** Paris, Oudin, 1901.

7361. Camesasca, Ettore. **Tutta la pittura del Perugino.** Milano, Rizzoli, 1959. (Biblioteca d'arte Rizzoli, 36/37).

7362. Canuti, Fiorenzo. **Il Perugino.** 2 v. Siena, La Diana, 1931.

7363. Castellaneta, Carlo [and] Camesasca, Ettore. **L'opera completa del Perugino.** Milano, Rizzoli, 1969. (CR). (Classici dell'arte, 30).

7364. Gnoli, Umberto. **Pietro Perugino.** Spoleto, Argentieri, 1923.

7365. Hutton, Edward. **Perugino.** London, Duckworth/New York, Dutton, [1907].

7366. Knapp, Fritz. **Perugino.** Bielefeld/Leipzig, Velhagen & Klasing, 1926. 2 ed. (Künstler-Monographien, 87).

7367. Mezzanotte, Antonio. **Della vita e delle opere di Pietro Vanucci da Castello della Pieve cognominato Il Perugino; commentario istorico.** Perugia, Baduel/Bartelli, 1836.

7368. Negri Arnoldi, Francesco. **Perugino.** Milano, Fabbri, 1965. (I maestri del colore, 68).

7369. [Orsini, Baldassare]. **Vita elogio e memorie dell'egregio pittore Pietro Perugino e degli scolari di esso.** Perugia, Stamperia Badueliana, 1804.

7370. Williamson, George C. **Pietro Vannucci, called Perugino.** London, Bell, 1903.

PERUZZI, BALDASSARE, 1481-1536

7371. Archivio Italiano dell'Arte dei Giardini (San Quirico d'Orcia, Italy). **Baldassare Peruzzi e le ville senesi del Cinquecento.** San Quirico, Archivo Italiano dell'Arte dei Giardini, 1977.

7372. Cataldo, Noella de. **Baldassare Peruzzi, pittore.** Roma, Palombi, [1930].

7373. Comune di Sovicille, Assessorato alla Cultura (Sovicille, Italy). **Baldassare Peruzzi, architetto: V centenario della nascità di Baldassare Peruzzi.** [July 20-August 20, 1981]. Sovicille, Comune di Sovicille, 1981.

7374. Frommel, Christoph L. **Baldassare Peruzzi als Maler und Zeichner.** Wien/München, Schroll, 1967. (Beiheft zum Römischen Jahrbuch für Kunstgeschichte, 11).

7375. _____. **Die Farnesina und Peruzzis architektonisches Frühwerk.** Berlin, de Gruyter, 1961. (Neue Münchner Beiträge zur Kunstgeschichte, 1).

7376. Kent, William W. **The life and works of Baldassare Peruzzi.** New York, Architectural Book Publishing Co., 1925.

PESELLINO, 1422-1457

7377. Weisbach, Werner. **Francesco Pesellino und die Romantik der Renaissance.** Berlin, Cassirer, 1901.

PESNE, ANTOINE, 1683-1757

7378. Galerie Goldschmidt-Wallerstein (Berlin). **Antoine Pesne, 1683-1757. 21. November-19. Dezember [1926].** [Text by Charles F. Foerster]. Berlin, Galerie Goldschmidt-Wallerstein, 1926.

7379. Poensgen, Georg, et al. **Antoine Pesne.** Berlin, Deutscher Verein für Kunstwissenschaft, 1958. (CR).

PETRARCA-MEISTER see WEIDITZ, HANS

PEVSNER, ANTOINE, 1886-1962

see also GABO, NAUM

7380. Peissi, Pierre [and] Giedion-Welcker, Carola. **Antoine Pevsner.** Trans. by Haakon Chevalier. Neuchâtel (Switzerland), Editions du Griffon, 1961.

PHIDIAS, ca. 500-430 B.C.

7381. Buschor, Ernst. **Phidias der Mensch.** München, Bruckmann, 1948.

7382. Caro-Delvaille, Henry. **Phidias, ou le génie grec.** Paris, Alcan, 1922.

7383. Collignon, Maxime. **Phidias.** Paris, Rouam, [1886].

7384. Diehl, August. **Die Reiterschöpfungen der phidiasischen Kunst.** Berlin, de Gruyter, 1921.

7385. Johansen, Peter. **Phidias and the Parthenon sculptures.** Trans. by Ingeborg Andersen. Kjøbenhavn, Gyldendal, 1925.

7386. Langlotz, Ernst. **Phidiasprobleme.** Frankfurt a.M., Klostermann, 1947.

7387. Lechat, Henri. **Phidias et la sculpture grecque au Ve siècle.** Paris, Librairie de l'Art Ancien et Moderne, 1906.

7388. Liegle, Josef. **Der Zeus des Phidias.** Berlin, Weidmann, 1952.

7389. Mueller, Karl O. **De Phidiae vita et operibus.** Gottingae, Dieterich, 1827.

7390. Petersen, Eugen. **Die Kunst des Pheidias am Parthenon und zu Olympia.** Berlin, Weidmann, 1873.

7391. Ronchaud, Louis de. **Phidias, sa vie et ses ouvrages.** Paris, Gide, 1861.

7392. Semler, Christian. **Die Tempelsculpturen aus der Schule des Phidias im Britischen Museum.** Hamburg, Meissner, 1858.

7393. Settis, Salvatore. **Saggio sull'Afrodite Urania di Fidia.** Pisa, Nistri-Lischi, 1966. (Studi di lettere, storia e filosofia, 30).

7394. Ubell, Hermann. **Phidias.** Berlin, Bard, Marquardt, [1904]. (Die Kunst, 31).

7395. Waldstein, Charles. **Essays on the art of Pheidias.** Cambridge, Cambridge University Press, 1885.

PIAZZETTA, GIOVANNI BATTISTA, 1682-1754

7396. Pallucchini, Rodolfo. **L'arte di Giovanni Battista Piazzetta.** Bologna, Maylender, 1934.

7397. _____ [and] Mariuz, Adriano. **L'opera completa del Piazzetta.** Milano, Rizzoli, 1982. (CR). (Classici dell'arte).

7398. Ravà, Aldo. **G. B. Piazzetta.** Firenze, Alinari, 1921.

7399. Ruggeri, Ugo. **Disegni piazzetteschi; disegni inediti di raccolte bergamasche.** Bergamo, Istituto Italiano d'Arte Grafiche, 1967. (Monumenta bergomensia, 17).

7400. White, D. Maxwell e Sewter, A. C. **I disegni di G. B. Piazzetta nella Biblioteca Reale di Torino.** Testo italiano in collaborazione con Maria Pia Nazzari di Calabiana. Roma, Istituto Poligrafico dello Stato, 1969. (CR).

PICABIA, FRANCIS, 1878-1953

7401. André, Edouard. **Picabia, le peintre & l'aqua-fortiste.** Paris, Rey, 1908.

7402. Camfield, William A. **Francis Picabia: his life, art and times.** Princeton, N.J., Princeton University Press, 1979.

7403. Fagiolo Dell'Arco, Maurizio. **Francis Picabia.** Milano, Fabbri, 1976.

7404. Galerie Haussmann (Paris). **Picabia.** 10 février au 25 février 1905. [Text by L. Roger-Milès]. Paris, Galerie Haussmann, 1905.

7405. Grand Palais (Paris). **Francis Picabia.** 23 janvier-29 mars 1976. Paris, Centre National d'Art et de Culture Georges Pompidou, 1976.

7406. La Hire, Marie de. **Francis Picabia.** Paris, Galerie La Cible, 1920.

7407. Le Bot, Marc. **Francis Picabia et la crise des valeurs figuratives, 1900-1925.** Paris, Klincksieck, 1968.

7408. Picabia, Francis. **Écrits.** Textes réunis et présentés par Olivier Revault d'Allones. 2 v. Paris, Belfond, 1975/1978.

7409. Sanouillet, Michel. **Picabia.** Paris, L'Oeil du Temps, 1964.

PICASSO, PABLO, 1881-1973

7410. Alberti, Rafael. **Picasso, el rayo que no cesa.** Barcelona, Poligrafa, 1975.

7411. Arnheim, Rudolf. **Picasso's Guernica: the genesis of a painting.** Berkeley/Los Angeles, University of California Press, 1962.

7412. Ashton, Dore, ed. **Picasso on art: a selection of views.** New York, Viking, 1972.

7413. Badisches Landesmuseum (Karlsruhe). **Picasso und die Antike.** Zusammengestellt und bearbeitet von Jürgen Thimme. [September 6-November 17, 1974]. Karlsruhe, Badisches Landesmuseum, 1974.

7414. Barr, Alfred H., Jr. **Picasso: fifty years of his art.** New York, Museum of Modern Art, 1946; distributed by Simon & Schuster, New York.

7415. Berger, John. **The success and failure of Picasso.**
Harmondsworth, Eng., Penguin, 1965.

7416. Bloch, Georges. **Pablo Picasso.** 4 v. [Text in French,
English, and German]. Berne, Kornfeld et Klipstein,
1968-1979. (CR).

7417. Blunt, Anthony and Pool, Phoebe. **Picasso, the formative
years; a study of his sources.** Greenwich, Conn., New
York Graphic Society, 1962.

7418. Boeck, Wilhelm and Sabartes, Jaime. **Picasso.** New York,
Abrams, 1955.

7419. Bollinger, Hans. **Picasso for Vollard.** Trans. by Norbert
Guterman. New York, Abrams, 1956.

7420. Bonet Correa, Antonio, et al. **Picasso, 1881-1981.** Madrid,
Taurus, 1981.

7421. Brassaï. **Picasso and company.** Trans. by Francis Price.
Preface by Henry Miller. Introd. by Roland Penrose.
Garden City, N.Y., Doubleday, 1966.

7422. Cabanne, Pierre. **Pablo Picasso, his life and times.**
Trans. by Harold J. Salemson. New York, Morrow, 1977.

7423. Camón Aznar, José. **Picasso y el cubismo.** Madrid,
Espasa-Calpe, 1956.

7424. Cassou, Jean. **Picasso.** Trans. by Mary Chamot. New York,
Hyperion Press, 1940.

7425. Champris, Pierre de. **Picasso, ombre et soleil.** Paris,
Gallimard, 1960.

7426. Cirici-Pellicer, Alejandro. **Picasso avant Picasso.**
Traduit de l'espagnol par Marguerite de Flores et Ventura
Gasol. Genève, Cailler, 1950. 2 ed. (Peintres et
sculpteurs d'hier et d'aujourd'hui, 6).

7427. Cirlot, Juan-Edouardo. **Picasso, birth of a genius.** Trans.
by Paul Elek. New York, Praeger, 1972.

7428. Cocteau, Jean. **Picasso.** Paris, Stock, 1923.

7429. Cooper, Douglas. **Picasso theatre.** New York, Abrams, 1968.

7430. Czwiklitzer, Christopher. **Picasso's posters.** New York,
Random House, 1971. (CR).

7431. Daix, Pierre. **La vie de peintre de Pablo Picasso.** Paris,
Editions du Seuil, 1977.

7432. _____ and Boudaille, Georges. **Picasso: the blue and
rose periods; a catalogue raisonné of the paintings,
1900-1906.** Trans. by P. Pool. Greenwich, Conn., New
York Graphic Society, 1967. (CR).

7433. _____ and Rosselet, Joan. **Picasso, the cubist years,
1907-1916; a catalogue raisonné of the paintings and
related works.** Trans. by Dorothy S. Blair. Boston,
New York Graphic Society, 1979. (CR).

7434. Descargues, Pierre. **Picasso.** Trans. by Roland Balay.
Introd. by John Russell. Photographs by Edward Quinn.
New York, Felicie, 1974.

7435. Dufour, Pierre. **Picasso, 1950-1968; biographical and
critical study.** Trans. by Robert Allen. Geneva, Skira,
1969. Distributed by World, Cleveland. (The Taste of
Our Time, 49).

7436. Duncan, David D. **Goodbye, Picasso.** New York, Grosset &
Dunlap, 1974.

7437. _____. **Picasso's Picassos.** New York, Harper, 1961.

7438. Elgar, Frank. **Picasso, a study of his work.** [With] a
biographical study by Robert Maillard. Trans. by Francis
Scarfe. New York, Praeger, 1956.

7439. Eluard, Paul. **Pablo Picasso.** Trans. by Joseph T. Shipley.
New York, Philosophical Library, 1947.

7440. Fogg Art Museum (Cambridge, Mass.). **Master drawings by
Picasso.** [Catalogue by Gary Tinterow]. Cambridge,
Mass., President and Fellows of Harvard College, 1981.

7441. Gallwitz, Klaus. **Picasso at 90: the late work.** New York,
Putnam, 1971.

7442. Gayo Nuño, Juan A. **Bibliografia critica y antologica de
Picasso.** San Juan, Puerto Rico, Ediciones de la Torre,
Universidad de Puerto Rico, 1966.

7443. Gedo, Mary M. **Picasso: art as autobiography.** Chicago/
London, University of Chicago Press, 1980.

7444. Geiser, Bernhard. **Picasso, peintre-graveur.** 2 v. Berne,
Geiser, 1933/1968. (CR).

7445. _____ and Bollinger, Hans. **Picasso, fifty-five
years of his graphic work.** Trans. by Lisbeth Gombrich.
New York, Abrams, 1955. (CR).

7446. Gieure, Maurice. **Initiation à l'oeuvre de Picasso.** Paris,
Editions des Deux Mondes, 1951.

7447. Giraudy, Danièle, et al. **L'oeuvre de Picasso à Antibes.**
2 v. [Exhibition and catalogue organized by Danièle
Giraudy, assisted by Michèle Pinguet and Gilbert
Gianangelli]. Antibes, Musée Picasso/Château Grimaldi,
1981.

7448. Hayward Gallery (London). **Picasso's Picassos.** An exhibi-
tion from the Musée Picasso, Paris. 17 July-11 October
1981. London, Arts Council of Great Britain, 1981.

7449. Hilton, Timothy. **Picasso.** London, Thames and Hudson,
1975.

7450. Horodisch, Abraham. **Picasso as a book artist.** Trans. by
I. Grafe. Cleveland/New York, World, 1962.

7451. Huelin y Ruiz-Blasco, Ricardo. **Pablo Ruiz Picasso; su
infancia, su adolescencia, y primeros años de juventud,
todo ello precedido de datos historicos, anecdotas,
curiosidades y recuerdos de la familia Ruiz-Blasco.**
Prólogo de Enrique Lafuente Ferrari. Madrid, Revista de
Occidente, 1975.

7452. Jaffé, Hans L. C. **Pablo Picasso.** Trans. by Norbert
Guterman. New York, Abrams, 1964.

7453. Jardot, Maurice. **Pablo Picasso: drawings.** New York,
Abrams, 1959.

7454. Jouffroy, Jean P. et Ruiz, Edouard. **Picasso de l'image à la lettre.** Paris, Temps Actuels, 1981.

7455. Kahnweiler, Daniel H. **Les sculptures de Picasso.** Paris, du Chêne, 1948.

7456. _____, et al. **Picasso, 1881-1973.** London, Elek, 1973.

7457. Kibbey, Ray A. **Picasso: a comprehensive bibliography.** New York/London, Garland, 1977.

7458. Larrea, Juan. **Guernica, Pablo Picasso.** Trans. by Alexander H. Krappe. Edited by Walter Pach. Introd. by Alfred H. Barr, Jr. New York, Valentin, 1947. (Reprint: New York, Arno, 1969).

7459. Leonhard, Kurt [and] Bollinger, Hans. **Picasso: recent etchings, lithographs, and linoleum cuts.** Trans. by Norbert Guterman. New York, Abrams, 1967. (CR).

7460. Level, André. **Picasso.** Paris, Crès, 1928.

7461. Leymarie, Jean. **Picasso drawings.** Trans. by Stuart Gilbert. Geneva, Skira, 1957; distributed by World, Cleveland. (The Taste of Our Time).

7462. _____. **Picasso: the artist of the century.** Trans. by James Emmons. New York, Viking, 1972.

7463. Lipton, Eunice. **Picasso criticism, 1901-1939; the making of an artist hero.** New York/London, Garland, 1976. (Outstanding Dissertations in the Fine Arts).

7464. Marrero, Vincente. **Picasso and the bull.** Trans. by Anthony Kerrigan. Chicago, Regnery, 1956.

7465. McCully, Marilyn, ed. **A Picasso anthology: documents, criticism, reminiscences.** Princeton, N.J., Princeton University Press, 1982.

7466. Merli, Joan. **Picasso, el artista y la obra de nuestro tiempo.** Buenos Aires, El Ateneo, 1942.

7467. Ministerio de Cultura, Direccion General de Bellas Artes, Archivos y Bibliotecas (Madrid). **Una sociedad a fines del siglo XIX: Malaga/Estudios Picassianos/Picasso y Malaga.** 3 v. [Issued in commemoration of the 100th anniversary of Picasso's birth]. Madrid, Ministerio de Cultura, 1981.

7468. Moravia, Alberto [and] Lecaldano, Paolo. **L'opera completa di Picasso, blu e rosa.** Milano, Rizzoli, 1968. (CR). (Classici dell'arte, 22).

7469. Mourlot, Fernand. **Picasso lithographe.** Préface de Jaime Sabartés. 4 v. Monte Carlo, Sauret, 1949-1964. (CR). (English ed., in a reduced format and with additional entries, trans. by Jean Didry: Boston, Boston Book and Art Co., 1970).

7470. Mujica Gallo, Manuel. **La minitauromaquia de Picasso.** Madrid, Prensa Española, 1971.

7471. Museum of Modern Art (New York). **Pablo Picasso, a retrospective.** Edited by William Rubin; chronology by Jane Fluegel. [May 22-September 16, 1980]. New York, Museum of Modern Art, 1980; distributed by New York Graphic Society, Boston.

7472. _____. **The sculpture of Picasso.** [Essay by Roland Penrose; chronology by Alicia Legg]. New York, Museum of Modern Art, 1967.

7473. O'Brian, Patrick. **Pablo Ruiz Picasso.** New York, Putnam, 1976.

7474. Olivier, Fernande. **Picasso et ses amis.** Préface de Paul Léautaud. Paris, Stock, 1933. (English ed., trans. by Jane Miller: New York, Appleton-Century, 1965).

7475. Oriol Anguera, A. **Guernica al desnudo.** Barcelona, Polígrafa, 1979.

7476. Ors y Rovira, Eugenio d'. **Pablo Picasso.** Trans. by Warren B. Wells. New York, Weyhe, 1930.

7477. Palau i Fabre, Josep. **Picasso en Cataluña.** [Text in English, French, Spanish, and German]. Barcelona, Polígrafa, 1966.

7478. _____. **Picasso i els seus amics catalans.** Barcelona, Aedos, 1971.

7479. _____. **Picasso: the early years, 1881-1907.** Trans. by Kenneth Lyons. New York, Rizzoli, 1981.

7480. _____. **El secret de les Menines de Picasso.** Barcelona, Polígrafa, 1981.

7481. Parmelin, Hélène. **Intimate secrets of a studio-- Picasso: women, Cannes and Mougins; Picasso, the artist and his model; Picasso at Notre Dame de Vie.** 3 v. New York, Abrams, 1965-1967.

7482. _____. **Picasso plain: an intimate portrait.** Trans. by Humphrey Hare. New York, St. Martin's, 1963.

7483. Penrose, Roland. **Picasso, his life and work.** Berkeley/Los Angeles, University of California Press, 1981. 3 ed.

7484. Picasso, Pablo. **Carnet Catalan.** [Preface and notes by Douglas Cooper]. Paris, Berggruen, 1958.

7485. _____. **Carnet Picasso: La Coruna, 1894-1895.** 2 v. [Introduction by Juan Ainaud de Lasarte]. Barcelona, Gili, 1971.

7486. _____. **Carnet Picasso: Paris, 1900.** 2 v. [Introduction by Rosa Maria Subirana]. Barcelona, Gili. 1972.

7487. Quintanilla, Felix M. **Proceso a Picasso.** Barcelona, Acervo, 1972.

7488. Ramié, Georges. **Picasso's ceramics.** Trans. by Kenneth Lyons. New York, Viking, 1976. (CR).

7489. Raynal, Maurice. **Picasso, biographical and critical study.** Trans. by James Emmons. Geneva, Skira, 1953. (The Taste of Our Time, 4).

7490. Rodriguez-Aguilera, Cesareo. **Picassos de Barcelona.** Barcelona, Polígrafa, 1974. (CR).

7491. Russell, Frank D. **Picasso's Guernica: the labyrinth of narrative and vision.** London, Thames and Hudson, 1980.

7492. Russoli, Franco [and] Minervino, Fiorella. **L'opera completa di Picasso, cubista.** Milano, Rizzoli, 1972. (CR). (Classici dell'arte, 64).

7493. Sabartés, Jaime. **Picasso: an intimate portrait.** Trans. by Angel Flores. New York, Prentice-Hall, 1948.

7494. _____. **Picasso: documents iconographiques.** Avec une préface et des notes. Traduction de Félia Leal et Alfred Rosset. Genève, Cailler, 1954.

7495. _____. **Picasso: toreros.** With four original lithographs. Trans. by Patrick Gregory. New York, Braziller/Monte-Carlo, Sauret, 1961.

7496. Salas de Exposiciones de la Subdirección General de Artes Plásticas, Ministerio de Cultura (Madrid). **Picasso; obra gráfica original, 1904-1971.** 2 v. Mayo-Julio, 1981. Madrid, Ministerio de Cultura, 1981.

7497. Salinero Portero, José. **Libros sobre Picasso en el Museo de Malaga.** Madrid, Ministerio de Cultura, 1981.

7498. Schiff, Gert, ed. **Picasso in perspective.** Englewood Cliffs, N.J., Prentice-Hall, 1976.

7499. Schürer, Oskar. **Pablo Picasso.** Berlin/Leipzig, Klinkhardt & Biermann, 1927. (Junge Kunst, 49/50).

7500. Sopeña Ibañez, Federico. **Picasso y la musica.** Madrid, Ministerio de Cultura, 1982.

7501. Spies, Werner. **Sculpture by Picasso, with a catalogue of the works.** Trans. by Maxwell Brownjohn. New York, Abrams, 1971. (CR).

7502. Stein, Gertrude. **On Picasso.** Edited by Edward Burns. Afterword by Leon Katz and Edward Burns. New York, Liveright, 1970.

7503. Uhde, Wilhelm. **Picasso and the French tradition.** Trans. by F. M. Loving. New York, Weyhe, 1929.

7504. Vallentin, Antonina. **Pablo Picasso.** Paris, Michel, 1957. (English ed.: Garden City, N.Y., Doubleday, 1963).

7505. Zervos, Christian. **Pablo Picasso.** 33 v. Paris, Cahiers d'Art, 1932-1978. (CR).

PIERO DELLA FRANCESCA see FRANCESCA, PIERO DELLA

PIERO DI COSIMO, 1462-1521

7506. Bacci, Mina. **L'opera completa di Piero di Cosimo.** Milano, Rizzoli, 1976. (CR). (Classici dell'arte, 88).

7507. _____. **Piero di Cosimo.** Milano, Bramante, 1966. (Antichi pittori italiani, 4).

7508. Douglas, Robert L. **Piero di Cosimo.** Chicago, University of Chicago Press, 1946.

7509. Knapp, Fritz. **Piero di Cosimo: ein Übergangsmeister vom florentiner Quattrocento zum Cinquecento.** Halle, Knapp, 1899.

PIETRO DA CORTONA, 1596-1669

7510. Abbate, Francesco. **Pietro da Cortona.** Milano, Fabbri, 1965. (I maestri del colore, 109).

7511. Briganti, Giuliano. **Pietro da Cortona, o della pittura barocca.** Firenze, Sansoni, 1962. (CR).

7512. Campbell, Malcolm. **Pietro da Cortona at the Pitti Palace; a study of the Planetary Rooms and related projects.** Princeton, N.J., Princeton University Press, 1977. (Princeton Monographs in Art and Archeology, 41).

7513. Noehles, Karl. **La chiesa dei SS. Luca e Martina nell' opera di Pietro da Cortona.** Con contributi di Giovanni Incisa della Rocchetta e Carlo Pietrangeli. Presentazione di Mino Maccari. Roma, Bozzi, 1970. (Saggi e studi di storia dell'arte, 3).

PIETRO, SANO DI see SANO DI PIETRO

PIGALLE, JEAN-BAPTISTE, 1714-1785

7514. Réau, Louis. **J.-B. Pigalle.** Paris, Tisné, 1950.

7515. Rocheblave, Samuel. **Jean-Baptiste Pigalle.** Paris, Lévy, 1919.

7516. Tarbé, Prosper. **La vie et les oeuvres de Jean-Baptiste Pigalle.** Paris, Renouard, 1859.

PIKOV, MIKHAIL IVANOVICH, 1903-

7517. Miamlin, Igor G. **Mikhail Ivanovich Pikov.** Leningrad, Khudozhnik RSFSR, 1968.

PILO, CARL GUSTAF, 1711-1793

7518. Jungmarker, Gunnar. **Carl Gustaf Pilo, son tecknare.** Stockholm, Allmänna, 1973.

7519. Sirén, Osvald. **Carl Gustav Pilo och hans förhållande till den samtida porträttkonsten i Sverige och Danmark.** Stockholm, Tullberg, 1902. (Sveriges Allmänna Konstförenings Publikation, 11).

PILON, GERMAIN, 1536-1590

7520. Babelon, Jean. **Germain Pilon; biographie et catalogue critiques, l'oeuvre complète de l'artiste.** Paris, Beaux-Arts, 1927. (CR).

7521. Terrasse, Charles. **Germain Pilon, biographie critique.** Paris, Laurens, 1930.

PIMENOV, STEPAN STEPANOVICH, 1784-1833

7522. Petrova, E. N. **Stepan Stepanovich Pimenov.** Moskva, Izogiz, 1961.

PINEAU, DOMINIQUE, 1718-1786

FRANÇOIS NICOLAS, 1746-1823

JEAN BAPTISTE, 1652-1715

NICOLAS, 1684-1754

PIERRE DOMINIQUE, 1842-1886

7523. Blais, Emile. Les Pineau, sculpteurs, dessinateurs des
bâtiments du roy, graveurs, architects (1652-1886).
Paris, Société des Bibliophiles Français, 1892.

7524. Deshairs, Léon. Dessins originaux des maîtres
décorateurs; les dessins du Musée et de la Bibliothèque
des arts décoratifs: Nicolas et Dominique Pineau.
Paris, Longuet, 1914.

PINELLI, BARTOLOMEO, 1781-1835

7525. Mariani, Valerio. Bartolomeo Pinelli. Roma, Olympus,
1948.

7526. Pacini, Renato. Bartolomeo Pinelli e la Roma del tempo
suo. Milano, Treves, 1935.

7527. Palazzo Braschi (Rome). Bartolomeo Pinelli. A cura di
Giovanni Incisa della Rocchetta. Prefazione di Valerio
Mariani. Maggio-luglio, 1956. Roma, Amici dei Musei di
Roma, 1956.

7528. Raggi, Oreste. Cenni intorno alla vita ed alle opere
principale di Bartolomeo Pinelli. Roma, Salviucci, 1835.

PINTURICCHIO, 1454-1513

7529. Carli, Enzo. Il Pinturicchio. Milano, Electa, 1960.

7530. Ehrle, Francesco e Stevenson, Enrico. Gli affreschi del
Pinturicchio nell'appartamento Borgia del Palazzo
Apostolica Vaticano. Roma, Danesi, 1897.

7531. Goffin, Arnold. Pinturicchio, biographie critique. Paris,
Laurens, 1908.

7532. Phillips, Evelyn M. Pintoricchio. London, Bell, 1901.

7533. Ricci, Corrado. Pintoricchio (Bernardino di Betto of
Perugia): his life, work and time. Trans. by Florence
Simmonds. Philadelphia, Lippincott, 1902.

7534. Schmarsow, August. Pinturicchio in Rom, eine kritische
Studie. Stuttgart, Spemann, 1882.

7535. Steinmann, Ernst. Pinturicchio. Bielefeld/Leipzig,
Velhagen & Klasing, 1898. (Künstler-Monographien, 37).

7536. Vermiglioli, Giovanni B. Di Bernardino Pinturicchio,
pittore Perugino de' secoli XV. XVI; memorie raccolte e
pubblicate. Perugia, Baduel, 1837.

PINWELL, GEORGE JOHN, 1842-1875

7537. Williamson, George C. George J. Pinwell and his works.
London, Bell, 1900.

PIOMBO, SEBASTIANO LUCIANI, 1485-1547

7538. Archiardi, Pietro d'. Sebastiano del Piombo, monografia
storico-artistica. Roma, Casa Editrice de l'Arte, 1908.

7539. Bernardini, Giorgio. Sebastiano del Piombo. Bergamo,
Istituto Italiano d'Arti Grafiche, 1908.

7540. Biagi, Pietro. Memorie storico-critiche intorno alla vita
ed alle opere di F. Sebastiano Luciani soprannominato del
Piombo. Venezia, Picotti, 1826.

7541. Dussler, Luitpold. Sebastiano del Piombo. Basel, Holbein,
1942.

7542. Hirst, Michael. Sebastiano del Piombo. Oxford, Clarendon
Press, 1981. (Oxford Studies in the History of Art and
Architecture).

7543. Pallucchini, Rodolfo. Sebastian Viniziano (Fra Sebastiano
del Piombo). Milano, Mondadori, 1944.

7544. Volpe, Carlo [and] Lucco, Mauro. L'opera completa di
Sebastiano del Piombo. Milano, Rizzoli, 1980. (CR).
(Classici dell'arte).

PIPER, JOHN, 1903-

7545. Betjeman, John. John Piper. Harmondsworth, Eng.,
Penguin, 1944. (Penguin Modern Painters).

7546. West, Anthony. John Piper. London, Secker & Warburg,
1979.

7547. Woods, Sydney J. John Piper: paintings, drawings &
theatre designs, 1932-1954. Arranged and with an intro-
duction by S. John Woods. London, Faber, 1955.

PIPPIN, HORACE, 1888-1946

7548. Rodman, Selden. Horace Pippin: a Negro painter in
America. New York, Quadrangle, 1947.

7549. _____ and Cleaver, Carole. Horace Pippin: the artist as
a Black American. Garden City, N.Y., Doubleday, 1972.

PIRANESI, FRANCESCO, 1750-1810

GIOVANNI BATTISTA, 1720-1778

7550. Bacou, Roseline. Piranesi, etchings and drawings.
Selected and with an introduction by Roseline Bacou.
Boston, New York Graphic Society, 1975.

7551. Bettagno, Alessandro, ed. Piranesi; incisioni, rami,
legature, architetture. Presentazione di Bruno
Visentini. Venezia, Pozza, 1978. (Grafica veneta, 2).

7552. Castel Sant'angelo (Rome) et al. Piranesi nei luoghi di
Piranesi. [Catalogue of an exhibition]. Roma,
Multigrafica Editrice/Palombi, 1979.

7553. Focillon, Henri. G. B. Piranesi/Giovanni Battista
Piranesi, essai de catalogue raisonné de son oeuvre.
2 v. [issued separately]. Paris, Laurens, 1918. (CR).

(New ed., ed. by Maurizio Calvesi and Augusta Monferini. Trans. by Giuseppe Guglielmi. Bologna, Alfa, 1967).

7554. Giesecke, Albert. **Giovanni Battista Piranesi.** Leipzig, Klinkhardt & Biermann, [1911]. (Meister der Graphik, 6).

7555. Hermanin, Federico. **Giambattista Piranesi.** Roma, Sansaini, 1922. 2 ed.

7556. Hind, Arthur M. **Giovanni Battista Piranesi; a critical study, with a list of his published works and detailed catalogues of the prisons and views of Rome.** London, Cotswold Gallery, 1922.

7557. Keller, Luzius. **Piranèse et les romantiques français.** Paris, Corti, 1966.

7558. Mayor, A. Hyatt. **Giovanni Battista Piranesi.** New York, Bittner, 1952.

7559. Miller, Norbert. **Archäologie des Traums; Versuch über Giovanni Battista Piranesi.** München/Wien, Hanser, 1978.

7560. Morazzoni, Giuseppe. **G. B. Piranesi, notizie biografiche.** Milano, Alfieri & Lacroix, [1921].

7561. Murray, Peter. **Piranesi and the grandeur of ancient Rome.** London, Thames and Hudson, 1971.

7562. Pane, Roberto. **Paestum nelle acqueforti di Piranesi.** Milano, Edizioni di Comunità, 1980.

7563. Piranesi, Giovanni B. **Le carceri: the prisons.** The complete first and second states. With a new introduction by Philip Hofer. New York, Dover, 1973.

7564. _____. **Opere [Views of Rome].** 27 v. Paris, Firmin-Didot, 1835-1839.

7565. [Placzek, Adolf K., et al.] **The Arthur M. Sackler Collection: Piranesi; drawings and etchings at the Avery Architectural Library, Columbia University, New York.** New York, Arthur M. Sackler Foundation, 1975. (CR).

7566. Reudenbach, Bruno. **G. B. Piranesi, Architektur als Bild; der Wandel in der Architekturauffassung des achtzehnten Jahrhunderts.** München, Prestel, 1979.

7567. Samuel, Arthur. **Piranesi.** London, Batsford, 1910.

7568. Scott, Jonathan. **Piranesi.** London, Academy/New York, St. Martin's, 1975.

7569. Stampfle, Felice. **Giovanni Battista Piranesi: drawings in the Pierpont Morgan Library.** With a foreword by Charles Ryskamp. New York, Dover, in association with the Pierpont Morgan Library, 1978.

7570. Thomas, Hylton. **The drawings of Giovanni Battista Piranesi.** London, Faber, 1954.

7571. Villa Medici (Rome), et al. **Piranèse et les français, 1740-1790.** [Catalogue of a traveling exhibition, May-November 1976]. Roma, Edizioni dell'Elefante, 1976.

7572. Volkmann, Hans. **Giovanni Battista Piranesi, Architekt und Graphiker.** Berlin, Hessling, 1965.

7573. Wilton-Ely, John. **The mind and art of Giovanni Battista Piranesi.** London, Thames and Hudson, 1978.

PISANELLO, 1393-1455

7574. Acqua, Gian A. dell' [and] Chiarelli, Renzo. **L'opera completa del Pisanello.** Milano, Rizzoli, 1972. (CR). (Classici dell'arte, 56).

7575. Bernasconi, Cesare. **Il Pisano, grand' artefice Veronese della prima metà del secolo decimoquinto, considerato primieramento come pittore e di poi come scultore in bronzo.** Verona, Civelli, 1862.

7576. Brenzoni, Raffaello. **Pisanello, pittore.** Firenze, Olschki, 1952.

7577. Calabi, Augusto [and] Cornaggia, G. **Pisanello; l'opera medaglistica paragonata a quella pittorica.** Studio critico italiano e inglese, e catalogo ragionato. Milano, Modiano, 1927. (CR).

7578. Degenhart, Bernhard. **Antonio Pisanello.** Wien, Schroll, 1940.

7579. Fossi Todorow, Maria. **I disegni del Pisanello e della sua cerchia.** Firenze, Olschki, 1966. (CR).

7580. Foville, Jean de. **Pisanello et les médailleurs italiens, étude critique.** Paris, Laurens, 1908.

7581. Hill, George F. **Dessins de Pisanello, choisis et reproduits avec introduction et notices.** Paris/Bruxelles, van Oest, 1929.

7582. _____. **Pisanello.** London, Duckworth/New York, Scribner, 1905.

7583. Nocq, Henry. **Les médailles d'Antonio Pisano, dit le Pisanello.** Série complète moulée et décrite. Paris, Marotte, 1912.

7584. Paccagnini, Giovanni. **Pisanello.** Trans. by Jane Carroll. London, Phaidon, 1973.

7585. Sindona, Enio. **Pisanello.** Trans. by John Ross. New York, Abrams, 1963.

7586. Société de Reproductions des Dessins de Maîtres. **Les dessins de Pisanello & de son école conservés au Musée du Louvre.** 4 v. [Text by Jean Guiffrey]. Paris, [Société de Reproductions], 1911-1920.

7587. Venturi, Adolfo. **Pisanello.** Roma, Palombi, 1939.

7588. Zanoli, Anna. **Pisanello.** Milano, Fabbri, 1964. (I maestri del colore, 47).

PISANO, ANDREA, 1270-1348/9

NINO, fl. 1358-1368

7589. Castelnuovo, Enrico. **Andrea Pisano.** Milano, Fabbri, 1966. (I maestri della scultura, 48).

7590. Falk, Ilse. **Studien zu Andrea Pisano.** Hamburg, Niemann & Moschinski, 1940.

7591. Toesca, Ilaria. **Andrea e Nino Pisano.** Firenze, Sansoni, 1950.

PISANO, GIOVANNI, 1240-1320

NICOLA, 1206-1280

7592. Ayrton, Michael. **Giovanni Pisano, sculptor.** Introduction by Henry Moore. Photographs by Ilario Bessi. New York, Weybright and Talley, 1969. (CR).

7593. Bacci, Pèleo. **La ricostruzione del pergamo di Giovanni Pisano nel Duomo di Pisa.** Milano/Roma, Bestetti e Tumminelli, [1926].

7594. Bottari, Stefano. **Saggi su Nicola Pisano.** Bologna, Pàtron, 1969.

7595. Brach, Albert. **Nicola und Giovanni Pisano und die Plastik des XIV. Jahrhunderts in Siena.** Strassburg, Heitz, 1904. (Zur Kunstgeschichte des Auslandes, 16).

7596. Carli, Enzo. **Giovanni Pisano.** Pisa, Pacini, 1977.

7597. Crichton, George H. and Crichton, E. R. **Nicola Pisano and the revival of sculpture in Italy.** Cambridge, Cambridge University Press, 1938.

7598. Fassola, Giusta N. **Nicola Pisano, orientamenti sulla formazione del gusto italiano.** Roma, Palombi, 1941.

7599. Graber, Hans. **Beiträge zu Nicola Pisano.** Strassburg, Heitz, 1911. (Zur Kunstgeschichte des Auslandes, 90).

7600. Keller, Harald. **Giovanni Pisano.** Wien, Schroll, 1942.

7601. Mellini, Gian L. **Il pulpito di Giovanni Pisano a Pistoia.** Fotografia di Aurelio Amendola. Milano, Electa, 1970.

7602. Swarzenski, Georg. **Nicolo Pisano.** Frankfurt am Main, Iris, 1926.

7603. Venturi, Adolfo. **Giovanni Pisano, his life and work.** Paris, Pegasus, 1928.

7604. Wallace, Robert D. **L'influence de la France gothique sur deux des précurseurs de la Renaissance italienne: Nicola et Giovanni Pisano.** Genève, Droz, 1953.

PISIS, FILIPPO DE, 1896-1956

7605. Ballo, Guido. **De Pisis.** Torino, Industria Libraria Tipografica Editrice, 1968.

7606. Malabotta, Manlio. **L'opera grafica di Filippo de Pisis.** Milano, Edizioni di Communità, 1969. (CR). (Studi e documenti di storia dell'arte, 9).

7607. Pisis, Filippo de. **Prose e articoli.** Milano, Il Balcone, 1947. (Testi e documenti d'arte moderna, 6).

7608. Raimondi, Guiseppe. **Filippo de Pisis.** Firenze, Vallecchi, 1952.

7609. Solmi, Sergio. **Filippo de Pisis.** Milano, Hoepli, 1931. (Arte moderna italiana, 19).

PISSARRO, CAMILLE JACOB, 1830-1903

LUCIEN, 1863-1944

7610. Adler, Kathleen. **Camille Pissarro, a biography.** New York, St. Martin's, 1977.

7611. Brettell, Richard and Lloyd, Christopher. **A catalogue of the drawings by Camille Pissarro in the Ashmolean Museum, Oxford.** Oxford, Clarendon Press, 1980. (CR).

7612. Hayward Gallery (London). **Camille Pissarro, 1830-1903.** 30 October 1980-11 January 1981. London, Arts Council of Great Britain, 1980.

7613. Holl, J.-C. **Camille Pissarro et son oeuvre.** Paris, Daragon, 1904.

7614. Lecomte, Georges. **Camille Pissarro.** Paris, Bernheim-Jeune, 1922.

7615. Lloyd, Christopher. **Pissarro.** Geneva, Skira/New York, Rizzoli, 1981.

7616. Malvano, Laura. **Camille Pissarro.** Milano, Fabbri, 1965. (I maestri del colore, 70).

7617. Meadmore, William S. **Lucien Pissarro, un coeur simple.** London, Constable, 1962.

7618. Pissarro, Camille. **Correspondance, 1865-1885.** [Edited by Janine Bailly-Herzberg]. Préface de Bernard Dorival. [In progress]. Paris, Presses Universitaires de France, 1980-.

7619. _____. **Letters to his son, Lucien.** Edited with the assistance of Lucien Pissarro by John Rewald. Trans. by Lionel Abel. New York, Pantheon, 1943. 2 ed.

7620. Pissarro, Ludovic R. et Venturi, Lionello. **Camille Pissarro; son art, son oeuvre.** 2 v. Paris, Rosenberg, 1939. (CR).

7621. Rewald, John. **Camille Pissarro.** London, Thames and Hudson, 1963.

7622. Shikes, Ralph and Harper, Paula. **Pissarro, his life and work.** New York, Horizon, 1980.

7623. Tabarant, Adolphe. **Pissarro.** Paris, Rieder, 1924.

7624. Thorold, Ann. **A catalogue of the paintings of Lucien Pissarro.** London, Athelney, 1983. (CR).

PITTONI, GIOVANNI BATTISTA, 1687-1767

7625. Binion, Alice. **I disegni di Giovanni Pittoni.** Firenze, Nuova Italia, 1983. (Corpus graphicum, 4).

7626. Coggiola Pittoni, Laura. **G. B. Pittoni.** Firenze, Alinari, 1921. (Piccola collezione d'arte, 26).

7627. Pallucchini, Rodolfo. **I disegni di Giambattista Pittoni.** Padova, Le Tre Venezie, 1945. (Collana d'arte, II series, 5).

7628. Zava Boccazzi, Franca. **Pittoni.** Venezia, Alfieri, 1979. (CR).

PLIMER, ANDREW, 1763-1837

 NATHANIEL, 1757-1822

7629. Williamson, George C. **Andrew & Nathaniel Plimer, miniature painters; their lives and works.** London, Bell, 1903.

POELZIG, HANS, 1869-1936

7630. Heuss, Theodor. **Hans Poelzig, Bauten und Entwürfe; das Lebensbild eines deutschen Baumeisters.** Berlin, Wasmuth, 1939.

7631. Poelzig, Hans. **Gesammelte Schriften und Werke.** Herausgegeben von Julius Posener. Berlin, Mann, 1970. (Schriftenreihe der Akademie der Kunst, 6).

POEPPELMANN, MATTHES DANIEL, 1662-1736

7632. Döring, Bruno A. **Matthes Daniel Pöppelmann, der Meister des Dresdener Zwingers.** Ergänzt und herausgegeben von Hubert Georg Ermisch mit einem Vorwort von Cornelius Gurlitt. Dresden, Limpert, 1930.

7633. Heckmann, Hermann. **M. D. Pöppelmann als Zeichner.** Dresden, Verlag der Kunst, 1954.

7634. _____ und Pape, Johannes. **Matthes Daniel Pöppelmann.** Herford/Bonn, Maximilian, 1962.

POLENOV, VASILII DMITRIEVICH, 1844-1927

7635. Gosudarstvennyi Muzei--usad'ba V. D. Polenova (Polenova, USSR). **Gosudarstvennyi muzei--usad'ba V. D. Polenova: zhivopis i grafika.** Leningrad, RSFSR, 1979.

7636. Iurova, Tamara V. **Vasilii Dmitrievich Polenov.** Moskva, Iskusstvo, 1961.

7637. Sakharova, Ekaterina V. **Vasilii Dmitrievich Polenova i Elena Dmitrievna Polenova; khronika sem'i khudozhnikov.** Moskva, Iskusstvo, 1964.

POLIAKOFF, SERGE, 1900-1969

7638. Galerie Melki (Paris). **Poliakoff.** 29 mai-15 juillet 1975. Paris, Galerie Melki, 1975.

7639. Poliakoff, Alexis. **Serge Poliakoff: les estampes.** Paris, Editions Arts et Métiers Graphiques/Yves Rivière, 1974.

7640. Ragon, Michel. **Poliakoff.** Paris, Fall, 1956. (Le musée de poche).

7641. Vallier, Dora. **Serge Poliakoff.** Paris, Cahiers d'Art, 1959.

POLLAIUOLO, ANTONIO DEL, 1432?-1498

 PIERO DEL, 1441-1496

7642. Bovi, Arturo. **Pollaiolo.** Milano, Fabbri, 1965. (I maestri del colore, 85).

7643. Busignani, Alberto. **Pollaiolo.** Firenzi, Edizioni d'Arte il Fiorino, 1970.

7644. Colacicchi, Giovanni. **Antonio del Pollaiuolo.** Florence, Chessa, 1945. (Collection Astarte, 1).

7645. Cruttwell, Maud. **Antonio Pollaiuolo.** London, Duckworth/ New York, Scribner, 1907.

7646. Ettlinger, Leopold D. **Antonio and Piero Pollaiuolo, complete edition with a critical catalogue.** London, Phaidon, 1978. (CR).

7647. Ortolani, Sergio. **Il Pollaiuolo.** Milano, Hoepli, 1948.

7648. Sabatini, Attilio. **Antonio e Piero del Pollaiolo.** Firenze, Sansoni, 1944.

7649. Schwabacher, Sascha. **Die Stickerein nach Entwürfen des Antonio Pallaiuolo in der opera di S. Maria del Fiore zu Florenz.** Strassburg, Heitz, 1911. (Zur Kunstgeschichte des Auslandes, 83).

POLLARD, JAMES, 1792-1867

7650. Selway, Neville C. **The Regency Road: the coaching prints of James Pollard.** Introd. by James Laver. London, Faber, 1957.

POLLOCK, JACKSON, 1912-1956

7651. Frank, Elizabeth. **Jackson Pollock.** New York, Abbeville Press, 1983.

7652. Friedman, Bernard H. **Jackson Pollock: energy made visible.** New York, McGraw-Hill, 1972.

7653. Museum of Modern Art (New York). **Jackson Pollock.** [Chronology by Francis V. O'Connor]. New York, Museum of Modern Art, 1967.

7654. O'Connor, Francis V. and Thaw, Eugene V. **Jackson Pollock; a catalogue raisonné of paintings, drawings, and other works.** 4 v. New Haven/London, Yale University Press, 1978. (CR).

7655. O'Hara, Frank. **Jackson Pollock.** New York, Braziller, 1959.

7656. Putz, Ekkehard. **Jackson Pollock: Theorie und Bild.** Hildesheim/New York, Olms, 1975. (Studien zur Kunstgeschichte, 4).

7657. Robertson, Bryan. **Jackson Pollock.** New York, Abrams, 1960.

7658. Rose, Bernice. **Jackson Pollock: works on paper.** New York, Museum of Modern Art in association with the Drawing Society, Inc., 1969; distributed by New York Graphic Society, Greenwich, Conn.

7659. Wysuph, C. L. **Jackson Pollock: psychoanalytic drawings.** New York, Horizon, 1970.

POLYCLITUS, 5th c. B.C.

7660. Arias, Paolo E. **Policleto.** Milano, Edizioni per Il Club del Libro, 1964. (Collana d'arte del Club del Libro, 7).

7661. Lorenz, Thuri. **Polyklet.** Wiesbaden, Steiner, 1972.

7662. Mahler, Arthur. **Polyklet und seine Schule; ein Beitrag zur Geschichte der griechischen Plastik.** Athen/Leipzig, Barth, 1902.

7663. Paris, Pierre. **Polyclète.** Paris, Librairie de l'Art, [1895].

POLYGNOTUS, 5th c. B.C.

7664. Feihl, Eugen. **Die ficoronische Cista und Polygnot.** Tübingen, Laupp, 1913.

7665. Löwy, Emanuel. **Polygnot, ein Buch von griechischer Malerei.** 2 v. Wien, Schroll, 1929.

7666. Schreiber, Theodor. **Die Wandbilder des Polygnotos in der Halle der Knidier zu Delphi.** Leipzig, Hirzel, 1897. (Abhandlungen der philologisch-historischen Classe der königl. sächsischen Gesellschaft der Wissenschaft, 6).

7667. Weizsäcker, Paul. **Polygnots Gemälde in der Lesche der Knidier in Delphi.** Stuttgart, Neff, 1895.

PONTORMO, JACOPO DA, 1494-1557

7668. Becherucci, Luisa. **Disegni del Pontormo.** Bergamo, Istituto Italiano d'Arti Grafiche, 1943.

7669. Berti, Luciano. **L'opera completa di Pontormo.** Milano, Rizzoli, 1973. (Classici dell'arte, 66).

7670. _____. **Pontormo.** Firenze, Edizioni d'Arte Il Fiorino, 1966. (I più eccellenti, collana di monografie de artisti, 1).

7671. Clapp, Frederick M. **Les dessins de Pontormo; catalogue raisonné.** Paris, Champion, 1914. (CR).

7672. _____. **Jacopo Carucci da Pontormo, his life and work.** New Haven, Yale University Press, 1916.

7673. Forster, Kurt W. **Pontormo; Monographie mit kritischem Katalog.** München, Bruckmann, 1966. (CR).

7674. Palazzo Strozzi (Florence). **Mostra del Pontormo e del primo manierismo fiorentino.** 24 marzo-15 luglio 1956. Firenze, Palazzo Strozzi, 1956.

7675. Pontormo, Jacopo da. **Diario; fatto nel tempo che dipingeva il coro di San Lorenzo, 1554-1556.** A cura di Emilio Cecchi. Firenze, Le Monnier, 1956.

7676. Rearick, Janet C. **The drawings of Pontormo.** 2 v. Cambridge, Mass., Harvard University Press, 1964. (CR).

7677. Toesca, Elena. **Il Pontormo.** Roma, Tumminelli, 1943.

PORDENONE, GIOVANNI ANTONIO, 1484-1539

7678. Cohen, Charles. **The drawings of Giovanni Antonio da Pordenone.** Firenze, Nuova Italia, 1980. (CR).

7679. Fiocco, Giuseppe. **Giovanni Antonio Pordenone.** 2 v. Pordenone, Cosarini, 1969. 3 ed.

POST, FRANS JANSZOON, 1612?-1680

7680. Larsen, Erik. **Frans Post, interprète du Brésil.** Avec une préface par Jacques Lavalleye. Amsterdam/Rio de Janeiro, Colibris, 1962.

7681. Museu Nacional de Bellas Artes (Rio de Janeiro). **Exposição, Frans Post.** Rio de Janeiro, Ministério da Educação e Saúde, 1942.

7682. Sousa-Leão, Joaquim de. **Frans Post, 1612-1680.** [Text in English]. Amsterdam, van Gendt, 1973. (CR). (Painters of the Past).

POUGNY, JEAN, 1892-1956

7683. Berninger, Herman [and] Cartier, Jean-Albert. **Jean Pougny (Iwan Puni), 1892-1956; catalogue de l'oeuvre. Tome 1: Les années d'avant-garde, Russie-Berlin, 1910-1923.** [No further volumes published to date]. Tübingen, Wasmuth, 1972. (CR).

7684. Gindertael, Roger V. **Pougny.** Genève, Cailler, 1957.

7685. Haus am Waldsee (Berlin). **Iwan Puni (Jean Pougny), 1892-1956; Gemälde, Zeichnungen, Reliefs.** 15. Mai bis 22. Juni 1975. Berlin, Haus am Waldsee, 1975.

POUSSIN, NICOLAS, 1594-1665

7686. Advielle, Victor. **Recherches sur Nicolas Poussin et sur sa famille.** Paris, Rapilly, 1902.

7687. Andresen, Andreas. **Nicolas Poussin: Verzeichniss der nach seinen Gemälden Gefertigten . . . Kupferstiche.** Leipzig, Weigel, 1863.

7688. Badt, Kurt. **Die Kunst des Nicolas Poussin.** 2 v. Köln, DuMont Schauberg, 1969.

7689. Bellori, Giovanni P. **Vie de Nicolas Poussin.** [Trans. by Georges Rémond and extracted from his Vies des peintres, 1672]. Vésanez-Genève, Cailler, 1947. (Collection écrits de peintres).

7690. Blunt, Anthony. **The drawings of Poussin.** New Haven/London, Yale University Press, 1979.

7691. _____. **Nicolas Poussin.** 2 v. Washington, D.C., National Gallery of Art, 1967; distributed by Pantheon, New York. (Bollingen Series, 35; Mellon Lectures in the Fine Arts, 7).

7692. _____. **The paintings of Nicolas Poussin; a critical catalogue.** London, Phaidon, 1966. (CR).

7693. Bouchitté, Hervé. Le Poussin, sa vie et son oeuvre. Paris, Didier, 1858.

7694. Cambry, Jacques. Essai sur la vie et sur les tableaux du Poussin. Rome/Paris, Le Jay, 1783.

7695. Chastel, André, ed. Nicolas Poussin [Symposium held Sept. 19-21, 1958]. 2 v. Paris, Editions du Centre National de la Recherche Scientifique, 1960.

7696. Courthion, Pierre. Nicolas Poussin. Paris, Plon, 1929.

7697. Delacroix, Eugène. Essai sur Poussin. Préface et notes de Pierre Jaquillard. Genève, Cailler, 1965.

7698. Denio, Elizabeth H. Nicolas Poussin, his life and work. London, Sampson Low/New York, Scribner, 1899.

7699. Desjardins, Paul. Poussin, biographie critique. Paris, Laurens, [1906].

7700. Félibien, André. Entretiens sur la vie et les ouvrages de Nicolas Poussin. [Extracted from his Entretiens sur les vies et sur les ouvrages de plus excellents peintres, 1705, and his Conférences de l'Académie Royale, 1705]. Vésanez-Genève, Caille, 1947. (Collection écrits et documents de peintres).

7701. Friedlaender, Walter. The drawings of Nicolas Poussin; catalogue raisonné. 5 v. [Vol. 5 prepared with the assistance of Anthony Blunt]. London, Warburg Institute/University of London, 1939-1974. (CR). (Studies of the Warburg Institute, 5).

7702. _____. Nicolas Poussin; a new approach. New York, Abrams, 1965.

7703. _____. Nicolas Poussin; die Entwicklung seiner Kunst. München, Piper, 1914.

7704. Gandar, Eugène. Les Andelys et Nicolas Poussin. Paris, Renouard, 1860.

7705. Gault de Saint-Germain, Pierre M. Vie de Nicolas Poussin. Paris, Didot/Renouard, 1806.

7706. Graham, Maria. Memoirs of the life of Nicholas Poussin. London, Longman, 1820.

7707. Grautoff, Otto. Nicolas Poussin, sein Werk und sein Leben. 2 v. München, Müller, 1914.

7708. Guibal, Nicolas. Eloge de Nicolas Poussin, peintre ordinaire du roi. Paris, Imprimerie Royale, 1783.

7709. Hourticq, Louis. La jeunesse de Poussin. Paris, Hachette, 1937.

7710. Jamot, Paul. Connaissance de Poussin. Paris, Floury, 1948.

7711. Kauffmann, Georg. Poussin-Studien. Berlin, de Gruyter, 1960.

7712. Licht, Fred S. Die Entwicklung der Landschaft in den Werken von Nicolas Poussin. Basel/Stuttgart, Birkhäuser, 1954. (Basler Studien zur Kunstgeschichte, 11).

7713. Magne, Emile. Nicolas Poussin, premier peintre du roi, 1594-1665. Bruxelles/Paris, van Oest, 1914.

7714. Mahon, Denis. Poussiniana: afterthoughts arising from the exhibition [i.e., at the Musée du Louvre, 1960]. Paris/New York, Gazette des Beaux Arts, 1962.

7715. Musée du Louvre (Paris). Exposition Nicolas Poussin. Mai-juillet 1960. Paris, Edition des Musées Nationaux, 1960.

7716. Poillon, Louis. Nicolas Poussin, étude biographique. Lille/Paris, Lefort, 1868.

7717. Poussin, Nicolas. Correspondance. Publiée d'après les originaux par Charles Jouanny. Paris, Champion, 1911.

7718. _____. Oeuvres complètes. 2 v. [Engravings after the paintings]. Paris, Didot, 1845.

7719. Rouchès, Gabriel. Nicolas Poussin; quatorze dessins. Paris, Musées Nationaux, 1938.

7720. Thuillier, Jacques. L'opera completa di Poussin. Milano, Rizzoli, 1974. (CR). (Classici dell'arte, 72).

7721. Villa Medici (Rome). Nicolas Poussin, 1594-1665. Novembre 1977-gennaio 1978. [Organisée par l'Académie de France à Rome]. Roma, Edizioni dell'Elefante, 1977.

7722. Wild, Doris. Nicolas Poussin. 2 v. Zürich, Füssli, 1980. (CR).

POZZO, ANDREA, 1642-1709

7723. Carboneri, Nino. Andrea Pozzo, architetto (1642-1709). Prefazione di Giuseppe Fiocco. Trenti, Collana Artisti Trentini, 1961.

7724. Kerber, Bernhard. Andrea Pozzo. Berlin/New York, de Gruyter, 1971. (Beiträge zur Kunstgeschichte, 6).

7725. Marini, Remigio. Andrea Pozzo, pittore (1642-1709). Trento, Collana di Artisti Trentini, 1959.

7726. Pozzo, Andrea. Rules and examples of perspective proper for painters and architects, in English and Latin. Trans. by John James. London, Senex, [1707].

PRANDTAUER, JAKOB, 1660-1726

7727. Hantsch, Hugo. Jakob Prandtauer, der Klosterarchitekt des österreichischen Barock. Wien, Krystall, 1926.

7728. Stift Melk (Austria). Jakob Prandtauer und sein Kunstkreis. Ausstellung zum 300. Geburtstag des grossen österreichischen Baumeisters. 14. Mai bis 31. Oktober 1960. Wien, Österreichische Staatsdruckerei, 1960.

PRAXITELES, 4th c. B.C.

7729. Collignon, Maxime. Scopas et Praxitèle; la sculpture grecque au IV siècle jusqu'au temps d'Alexandre. Paris, Plon, 1907.

7730. Ducati, Pericle. Prassitele. Firenze, Le Monnier, 1927.

7731. Friedrichs, Karl. **Praxiteles und die Niobegruppe, nebst Erklärung einiger Vasenbilder.** Leipzig, Teubner, 1855.

7732. Gebhart, Emile. **Praxitèle; essai sur l'histoire de l'art et du génie grecs.** Paris, Tandou, 1864.

7733. Klein, Wilhelm. **Praxiteles.** Leipzig, Veit, 1898.

7734. Perrot, Georges. **Praxitèle, étude critique.** Paris, Laurens, [1904].

7735. Rizzo, Giulio E. **Prassitele.** Milano/Roma, Treves, 1932.

PREETORIUS, EMIL, 1883-1973

7736. Adolf, Rudolf. **Emil Preetorius.** Aschaffenburg, Pattloch, 1960.

7737. Hölscher, Eberhard. **Emil Preetorius, das Gesamtwerk.** Berlin, Heintze & Blanckertz, 1943. (Monographien künstlerischer Schrift, 10).

7738. Preetorius, Emil. **Geheimnis des Sichtbaren: gesammelte Aufsätze zur Kunst.** München, Piper, 1963.

7739. Stuck-Villa (Munich). **Emil Preetorius; Illustrationen, Graphik, Plakate.** 21. September bis 2. Dezember 1973. München, Rossipaul, 1973.

PREGELJ, MARIJ, 1913-1967

7740. Bihalji-Merin, Oto. **Marij Pregelj.** [Text in Slovak, German, and French]. Maribor (Yugoslavia), Založba Obzorja, 1971. (Likovna obzorja, 11).

7741. Moderna Galerija (Ljubljani, Yugoslavia). **Marij Pregelj; retrospektivna razstava, 1937-1967.** 4. februar-9. marec 1969. [Text in Slovak and French]. Ljubljani, Moderna Galerija, 1969.

PREISLER, JAN, 1872-1918

7742. Kotalík, Jiří. **Jan Preisler.** Praha, Odeon, 1968.

7743. Matějček, Antonín. **Jan Preisler.** Praza, Melantrich, 1950.

7744. Žáhavec, František. **Jan Preisler.** Praha, Štenc, 1921.

PRENDERGAST, MAURICE BRAZIL, 1859-1924

7745. Breuning, Margaret. **Maurice Prendergast.** New York, Macmillan, 1931.

7746. Rhys, Hedley H. **Maurice Prendergast, 1859-1924.** [Published in conjunction with an exhibition at the Museum of Fine Arts, Boston, October 26-December 4, 1960]. Cambridge, Mass., Harvard University Press, 1960.

7747. University of Maryland Art Gallery (College Park, Md.). **Maurice Prendergast: art of impulse and color.** 1 September-6 October 1976. College Park, Md., University of Maryland, 1976.

7748. Whitney Museum of American Art (New York). **Maurice B. Prendergast, a concentration of works from the permanent collecton.** January 9-March 2, 1980. New York, Whitney Museum of American Art, 1979.

PRETI, MATTIA, 1613-1699

7749. Chimirri, Bruno [and] Frangipane, Alfonso. **Mattia Preti, detto il Cavalier Calabrese.** Milano, Alfieri & Lacroix, 1914.

7750. Frangipane, Alfonso. **Mattia Preti, il Cavalier Calabrese.** Milano, Alpes, 1929.

7751. Mariani, Valerio. **Mattia Preti a Malta.** Roma, Biblioteca d'Arte, 1929.

7752. Pelaggi, Antonio. **Mattia Preti ed il seicento italiano, col catalogo delle opere.** Catanzaro, Italy, Amministrazione Provinciale di Catanzaro, Museo Provinciale, 1972.

7753. Pujia, Carmello. **Fra Mattia Preti nel terzo suo centenario.** Napoli, Artigianelli, 1913.

7754. Refice Taschetta, Claudia. **Mattia Preti: contributi alla conoscenza del Cavalier Calabrese.** Brindisi, Italy, Abicca, [1959].

7755. Sergi, Antonino. **Mattia Preti, detto il Cavalier Calabrese: la vita, l'opera; catalogo delle opere.** Acireale, Italy, Tipografia XX Secolo, 1927.

PRIKKER, JOHAN THORN see THORN PRIKKER, JOHAN

PRIMATICCIO, FRANCESCO, 1504-1570

7756. Dimier, Louis. **Le Primatice, peintre, sculpteur et architecte des rois de France.** Paris, Leroux, 1900.

PROCACCINI, CAMILLO, 1555-1629

7757. Neilson, Nancy W. **Camillo Procaccini: paintings and drawings.** New York, Garland, 1979. (CR). (Garland Reference Library of the Humanities, 163).

PRUD'HON, PIERRE PAUL, 1758-1823

7758. Bricon, Etienne. **Prud'hon, biographie critique.** Paris, Laurens, [1907].

7759. Clément, Charles. **Prud'hon; sa vie, ses oeuvres et sa correspondance.** Paris, Didier, 1872.

7760. Forest, Alfred. **Pierre Paul Prud'hon, peintre français (1758-1823).** Paris, Leroux, 1913.

7761. Gauthiez, Pierre. **Prud'hon.** Paris, Rouam, 1886.

7762. Goncourt, Edmond de. **Catalogue raisonné de l'oeuvre peinte, dessiné et gravé de P. P. Prud'hon.** Paris, Rapilly, 1876. (CR).

7763. Grappe, Georges. **P.-P. Prud'hon.** Paris, Michel, 1958.

7764. Guiffrey, Jean. **L'oeuvre de P. P. Prud'hon.** Paris, Colin, 1924. (CR).

7765. Régamey, Raymond. **Prud'hon.** Paris, Rieder, 1928.

7766. Voïart, Elise. **Notice historique sur la vie et les oeuvres de P. P. Prud'hon, peintre.** Paris, Didot, 1824.

PUGET, PIERRE, 1620-1694

7767. Alibert, François P. **Pierre Puget.** Paris, Rieder, 1930.

7768. Arts et Livres de Provence. **Pierre Puget: pour le trois-cent cinquantième anniversaire de sa naissance à Marseille, le 16 octobre 1620.** Marseille, Arts et Livres de Provence, 1917. (Arts et livres de Provence, 78).

7769. Auquier, Philippe. **Pierre Puget, biographie critique.** Paris, Laurens, [1903].

7770. Baumann, Emile. **Pierre Puget, sculpteur.** Paris, Editions de l'Ecole, 1949.

7771. Brion, Marcel. **Pierre Puget.** Paris, Plon, 1930.

7772. Herding, Klaus. **Pierre Puget, das bildnerische Werk.** Berlin, Mann, 1970. (CR).

7773. Lagrange, Léon. **Pierre Puget; peintre, sculpteur, architecte, décorateur de vaisseaux.** Paris, Didier, 1868.

7774. Pons, Zenon. **Essai sur la vie et les ouvrages de Pierre Puget.** Paris, Delaunai, 1812.

7775. Provence Historique. **Puget et son temps: actes du colloque tenu à l'Université de Provence les 15, 16 et 17 octobre 1971.** Provence, Provence Historique, 1972.

7776. Vitzthum, Walter. **Pierre Puget.** Milano, Fabbri, 1966. (I maestri della scultura, 80).

PUGIN, AUGUSTUS CHARLES, 1768-1832

AUGUSTUS WELBY NORTHMORE, 1812-1852

7777. Ferrey, Benjamin. **Recollections of A. N. Welby Pugin and his father, Augustus Pugin.** With an appendix by E. Sheridan Purcell. London, Stanford, 1861. (Reprint: New York, Blom, 1972).

7778. Gwynn, Denis R. **Lord Shrewsbury, Pugin, and the Catholic revival.** London, Hollis & Carter, 1946.

7779. Harries, John G. **Pugin: an illustrated life of Augustus Welby Northmore Pugin, 1812-1852.** Aylesbury (England), Shire, 1973. (Lifelines, 17).

7780. Pugin, Augustus C., et al. **Examples of Gothic architecture; selected from various ancient edifices in England.** 3 v. London, [Pugin], 1831.

7781. Pugin, Augustus W. **An apology for the revival of Christian architecture in England.** London, Weale, 1843.

7782. _____. **Contrasts, or a parallel between the noble edifices of the Middle Ages and corresponding buildings of the present day, shewing the present decay of taste.** London, Dolmon, 1841. 2 ed. (Reprint, with an introduction by Henry Russell Hitchcock: Leicester, Leicester University Press, 1969).

7783. _____. **The true principles of pointed or Christian architecture.** London, Weale, 1841. (Reprint: New York, St. Martin's, 1973).

7784. Rope, Edward G. **Pugin.** Ditchling (England), Pepler & Sewell, 1935.

7785. Stanton, Phoebe. **Pugin.** Preface by Nikolaus Pevsner. London, Thames and Hudson, 1971.

7786. Trappes-Lomax, Michael. **Pugin: a medieval Victorian.** London, Sheed & Ward, 1932.

PURRMANN, HANS, 1880-1966

7787. Göpel, Barbara und Göpel, Erhard. **Leben und Meinungen des Malers Hans Purrmann; an Hand seiner Erzählungen, Schriften und Briefe.** Wiesbaden, Limes, 1961.

7788. Hausen, Edmund. **Der Maler Hans Purrmann.** Berlin, Lemmer, 1950.

7789. Pfalzgalerie Kaiserslautern. **Hans Purrmann zum 100. Geburtstag.** 8. Juni bis 6. Juli 1980. Mainz, Mittelrheinisches Landesmuseum, 1980.

7790. Steigelmann, Wilhelm. **Hans Purrmann und die Pfalz; erlebte Kunstgeschichte in Briefen.** Edenkoben (Germany), Edenkobener Rundschau, 1976.

7791. Villa Stuck (Munich). **Hans Purrmann, 1880-1966; Gemälde, Aquarelle, Zeichnungen, Druckgraphik.** 21. Oktober 1976-16. Januar 1977. München, Stuck-Jugendstil-Verein, 1976.

PUTZ, LEO, 1869-1940

7792. Kurhaus Meran. **Leo Putz, 1869-1940.** Gedächtnisausstellung zum 40. Todestag. 9. August-20. September 1980. Bozen, Germany, Athesia, 1980.

7793. Michel, Wilhelm. **Leo Putz, ein deutscher Künstler der Gegenwart.** Leipzig, Klinkhart & Biermann, [1909].

7794. Stein, Ruth. **Leo Putz.** Mit einem Verzeichnis der Gemälde und bildartigen Entwürfe. Wien, Tusch, 1974.

PUVIS DE CHAVANNES, PIERRE, 1824-1898

7795. Aynard, Edouard. **Les peintures décoratives de Puvis de Chavannes au Palais des Arts.** Lyon, Mougin-Rusand, 1884.

7796. Declairieux, A. **Puvis de Chavannes et ses oeuvres: trois conférences.** Lyon, Rey, 1928.

7797. Jean, René. **Puvis de Chavannes.** Paris, Alcan, 1914.

7798. Mauclair, Camille. **Puvis de Chavannes.** Paris, Plon, 1928.

7799. Michel, André. **Puvis de Chavannes, a biographical and critical study.** Notes by Jean Laran. Philadelphia, Lippincott/London, Heinemann, 1912.

7800. National Gallery of Canada (Ottawa). **Puvis de Chavannes, 1824-1898.** 25 March-8 May 1977. Ottawa, National Museums of Canada, 1977.

7801. Scheid, Gustave. **L'oeuvre de Puvis de Chavannes à Amiens.** [Paris], Office d'Edition des Musées et des Arts, 1907.

7802. Vachon, Marius. **Puvis de Chavannes.** Paris, Braun, 1895.

7803. Werth, Léon. **Puvis de Chavannes.** Paris, Crès, 1926.

PYLE, HOWARD, 1853-1911

7804. Abbott, Charles D. **Howard Pyle: a chronicle.** With an introduction by N. C. Wyeth. New York/London, Harper, 1925.

7805. Delaware Art Museum (Wilmington, Del.). **Howard Pyle: diversity in depth.** March 5-April 15, 1973. Wilmington, Wilmington Society of the Fine Arts, 1973.

7806. Morse, Willard S. and Brincklé, Gertrude. **Howard Pyle, a record of his illustrations and writings.** Wilmington, Del., Wilmington Society of the Fine Arts, 1921. (Reprint: Detroit, Singing Tree Press, 1969).

7807. Pitz, Henry C. **The Brandywine tradition.** Boston, Houghton Mifflin, 1969.

7808. _____. **Howard Pyle: writer, illustrator, founder of the Brandywine school.** New York, Clarkson Potter, 1975; distributed by Crown, New York.

QUARENGHI, GIACOMO, 1744-1817

7809. Colombo, Giuseppe. **Giacomo Quarenghi bergamasco, architetto alla corte imperiale di Petroburgo.** Torino, Artigianelli, 1879.

7810. Korshunova, Militsa F. **Dzhakomo Kvarengi.** Leningrad, Lenizdat, 1977.

7811. Palazzo della Ragione (Bergamo). **Disegni di Giacomo Quarenghi.** 30 aprile-30 giugno, 1967. Venezia, Pozza, 1967.

7812. Quarenghi, Giacomo. **Fabbriche e disegni di Giacomo Quarenghi, illustrate dal cav. Giulio suo figlio.** Milano, Tosi, 1821.

7813. Severin, Dante. **Giacomo Quarenghi, architetto in Russia.** Bergamo, Orobiche, 1953.

QUERCIA, JACOPO DELLA, 1372-1438

7814. Bacci, Pèleo. **Jacopo della Quercia; nuovi documenti e commenti.** Siena, Libreria Editrice Senese, 1929.

7815. Biagi, Luigi. **Jacopo della Quercia.** Firenze, Arnaud, 1946.

7816. Chelazzi Dini, Giulietta, ed. **Jacopo della Quercia fra gotico e Rinascimento: atti del convegno di studi.** [Università di] Siena, Facoltà di Lettere e Filosofia, 2-5 ottobre 1975. Firenze, Centro Di, 1977.

7817. Cornelius, Carl. **Jacopo della Quercia, eine kunsthistorische Studie.** Halle, Knapp, 1896.

7818. Gielly, Louis J. **Jacopo della Quercia.** Paris, Michel, 1930.

7819. Nicco, Giusta. **Jacopo della Quercia.** Firenze, Bemporad, 1934.

7820. Palazzo Pubblico (Siena). **Jacopo della Quercia nell'arte del suo tempo; mostra didattica.** 24 maggio-12 ottobre 1975. Firenze, Centro Di, 1975.

7821. Seymour, Charles. **Jacopo della Quercia, sculptor.** New Haven, Yale University Press, 1973. (Yale Publications in the History of Art, 23).

RACKHAM, ARTHUR, 1867-1939

7822. Gettings, Fred. **Arthur Rackham.** New York, Macmillan, 1976.

7823. Hudson, Derek. **Arthur Rackham, his life and work.** London, Heinemann, 1960.

7824. Latimore, Sarah B. and Haskell, Grace C. **Arthur Rackham, a bibliography.** Los Angeles, Suttonhouse, 1936.

RAEBURN, HENRY, 1756-1823

7825. Andrew, William R. **Life of Sir Henry Raeburn, by his great grandson.** London, Allen, 1894.

7826. Armstrong, Walter. **Sir Henry Raeburn.** With an introduction by R. A. M. Stevenson and a biographical and descriptive catalogue by J. L. Caw. London, Heinemann/ New York, Dodd, Mead, 1901.

7827. Dibdin, Edward R. **Raeburn.** London, Allen, 1925.

7828. Greig, James. **Sir Henry Raeburn, R. A.; his life and work.** London, Connoisseur, 1911.

RAFAËLLI, JEAN FRANÇOIS, 1850-1924

7829. Alexandre, Arsène. **Jean-Françoise Raffaelli; peintre, graveur et sculpteur.** Paris, Floury, 1909.

7830. Lecomte, Georges. **Raffaëlli.** Paris, Rieder, 1927.

7831. Raffaëlli, Jean F. **Mes promenades au Musée du Louvre.** Préface de Maurice Barres. Paris, Editions d'Art et de Littérature, 1913. 2 ed.

RAFFET, DENIS AUGUSTE MARIE, 1804-1860

7832. Béraldi, Henri. **Raffet, peintre national.** Paris, La
Librairie Illustrée, [1892].

7833. Bry, Auguste. **Raffet, sa vie et ses oeuvres.** Paris,
Bauer, 1874. 2 ed.

7834. Giacomelli, Hector. **Raffet: son oeuvre lithographique et
ses eaux-fortes, suivi de la bibliographie complète.**
Paris, Gazette des Beaux-Arts, 1862.

7835. Ladoué, Pierre. **Un peintre de l'Epopée française: Raffet.**
Paris, Michel, 1946.

7836. L'homme, François. **Raffet.** Paris, Librairie de L'Art,
[1892].

7837. Raffet, Denis. **Notes et croquis de Raffet.** Mis en ordre
et publiés par August Raffete. Paris, Goupil etc., 1878.

RAIBOLINI, FRANCESCO see FRANCIA

RAIMONDI, MARC ANTONIO, ca. 1480-1530

7838. Bartsch, Adam. **The works of Marcantonio Raimondi and of
his school.** Ed. by Konrad Oberhuber. 2 v. New York,
Abaris, 1978. (The illustrated Bartsch, 26/27; from his
Le peintre-graveur, Wien, Degen, 1803-1821).

7839. Delaborde, Henri. **Marc-Antoine Raimondi, étude historique
et critique suivie d'un catalogue raisonné des oeuvres du
maître.** Paris, Librairie de l'Art, 1888. (CR).

7840. Delessert, Benjamin. **Notice sur la vie de Marc-Antoine
Raimondi, graveur bolonais.** Paris, Goupil/Londres,
Colnaghi, 1853.

7841. Spencer Museum of Art, University of Kansas (Lawrence,
Kans.). **The engravings of Marcantonio Raimondi.**
February 10-March 28, 1982. Lawrence, Kan., Spencer
Museum of Art, University of Kansas, 1982.

7842. Witt, Antony de. **Marcantonio Raimondi, incisioni.** Scelte
e annotate di Antony de Witt. Firenze, La Nuova Italia,
1968.

RAINALDI, CARLO, 1611-1691

7843. Fasolo, Furio. **L'opera di Hieronimo e Carlo Rainaldi.**
Roma, Edizioni Ricerche, 1961.

7844. Hempel, Eberhard. **Carlo Rainaldi; ein Beitrag zur
Geschichte des römischen Barocks.** München, Wolf, 1919.

RAMAGE, JOHN, c. 1748-1802

7845. Morgan, John H. **A sketch of the life of John Ramage,
miniature painter.** New York, New York Historical
Society, 1930.

7846. Sherman, Frederic F. **John Ramage, a biographical sketch
and a list of his portrait miniatures.** New York,
[Sherman], 1929.

RAMSAY, ALLAN, 1713-1784

7847. National Gallery of Scotland (Edinburgh). **Allan Ramsay
(1713-1784); his masters and rivals.** 9 August-
15 September 1963. Edinburgh, National Galleries of
Scotland, 1963.

7848. Smart, Alastair. **The life and art of Allan Ramsay.**
London, Routledge & Kegan Paul, 1952.

RAPHAEL, 1483-1520

7849. Astolfi, Carlo. **Raffaello Sanzio, scultore.** Roma,
Palombi, 1935.

7850. Becherucci, Luisa, et al. **Rafaello; l'opera, le fonti, la
fortuna.** 2 v. Novara, Istituto Geografico de Agostini,
1968.

7851. Beck, James H. **Raphael.** New York, Abrams, 1976.

7852. Bellori, Giovanni P. **Descrizioni delle imagini dipinte da
Raffaelle d'Urbino nelle camere del palazzo apostolico
Vaticano.** Roma, Komarek, 1695.

7853. Bérence, Fred. **Raphaël ou la puissance de l'esprit.**
Paris, La Colombe, 1954.

7854. Berti, Luciano. **Raffaello.** Bergamo, Istituto Italiano
d'Arti Grafiche, 1961.

7855. Bricarelli, Carlo. **Il pensiero cristiano del Cinquecento
nell'arte di Raffaello.** Torino, Celanza, 1921.

7856. Brown, David A. **Raphael and America.** [Published in con-
junction with an exhibition at the National Gallery of
Art, Washington, D.C., Jan. 9-May 8, 1983]. Washington,
D.C., National Gallery of Art, 1983.

7857. Comolli, Angelo. **Vita inedita di Raffaello da Urbino,
illustrata con note.** Roma, Salvioni, 1790.

7858. Crowe, Joseph A. and Cavalcaselle, Giovanni B. **Raphael,
his life and works.** 2 v. London, Murray, 1882.

7859. Dacos, Nicole. **Le logge di Raffaello; maestro e bottega di
fronte all'antico.** Roma, Istituto Poligrafico dello
Stato, 1977.

7860. Dussler, Luitpold. **Raphael: a critical catalogue of his
pictures, wall-paintings and tapestries.** Trans. by
Sebastian Cruft. London/New York, Phaidon, 1971.
(CR).

7861. Euboeus, Tauriscus [pseud., W. Lepel]. **Catalogue des
estampes gravées d'après Raphael.** Francfort sur le Mein,
Hermann, 1819.

7862. Farabulini, David. **Saggio di nuovi studi su Raffaello
d'Urbino.** Roma, Agonale, 1875.

7863. Fischel, Oskar. **Raphael.** Trans. by Bernard Rackham. 2 v.
London, Kegan Paul, 1948.

7864. _____, ed. **Raphael Sanzio: Zeichnungen.** 9 v.
[Vol. 9 ed. by Konrad Oberhuber]. Berlin, Grote,
1913-1941/Berlin, Mann, 1972 [Vol. 9]. (CR).

7865. Fraprie, Frank R. **The Raphael book: an account of the life of Raphael Santi of Urbino and his place in the development of art.** Boston, Page, 1912.

7866. Fusero, Clemente. **Raffaello.** [Milano], dall'Oglio, 1963. (Reprint: 1983).

7867. Geymuller, Enrico de. **Raffaello Sanzio studiato come architetto con l'aiuto di nuovi documenti.** Milano, Hoepli, 1884.

7868. Gherardi, Pompeo. **Della vita e delle opere di Raffaello Sanzio da Urbino.** Urbino, Rocchetti, 1874.

7869. Golzio, Vincenzo. **Raffaello nei documenti nelle testimonianze dei contemporanei e nella letteratura del suo secolo.** Città del Vaticano, 1936. (Pontifica Insigne Accademia Artistica dei Virtuosi al Pantheon).

7870. Grand Palais (Paris). **Raphael et l'art français.** [November 15, 1983-February 13, 1984]. Paris, Galeries Nationales du Grand Palais, 1983.

7871. Grimm, Herman. **The life of Raphael.** Trans. by Sarah H. Adams. Boston, Cupples and Hurd, 1888.

7872. Gruyer, François A. **Essai sur les fresques de Raphaël au Vatican: chambres.** Paris, Gide, 1858.

7873. _____. **Essai sur les fresques de Raphaël au Vatican: loges.** Paris, Renouard, 1859.

7874. _____. **Raphaël et l'antiquité.** 2 v. Paris, Renouard, 1864.

7875. _____. **Raphaël, peintre de portraits; fragments d'histoire et d'iconographie.** 2 v. Paris, Renouard, 1881.

7876. _____. **Les vierges de Raphaël et l'iconographie de la vierge.** 3 v. Paris, Renouard, 1869.

7877. Hofmann, Theobald. **Raffael in seiner Bedeutung als Architekt.** 4 v. Zittau, Menzel, 1900-1911.

7878. Holmes, Charles. **Raphael and the modern use of the classical tradition.** New York, Dutton, 1933.

7879. Joannides, Paul. **The drawings of Raphael, with a complete catalogue.** Oxford, Phaidon, 1983. (CR).

7880. Jones, Roger and Penny, Nicholas. **Raphael.** New Haven/London, Yale University Press, 1983.

7881. Kelber, Wilhelm. **Raphael von Urbino, Leben und Werk.** Stuttgart, Urachhaus, 1979.

7882. Knab, Eckhart/Mitsch, Erwin [and] Oberhuber, Konrad. **Raphael; die Zeichnungen.** Stuttgart, Urachhaus, 1983.

7883. Knackfuss, Hermann. **Raphael.** Trans. by Campbell Dodgson. Bielefeld/Leipzig, Velhagen & Klasing, 1898. (Monographs on Artists, 1).

7884. Lohuizen-Mulder, Mab van. **Raphael's images of justice, humanity, friendship: a mirror of princes for Scipione Borghese.** Trans. by Patricia Wardle. Wassenaar (Holland), Mirananda, 1977.

7885. McCurdy, Edward. **Raphael Santi.** London/New York, Hodder and Stoughton, 1917.

7886. Middeldorf, Ulrich A. **Raphael's drawings.** New York, Bittner, 1945.

7887. Mulazzani, Germano. **Raffaello.** Milano, Rusconi, 1983.

7888. Muntz, Eugène. **Les historiens et critiques de Raphael; essai bibliographique.** Paris, Rouam, 1883.

7889. _____. **Raphael; his life, works, and times.** Edited by Walter Armstrong. London, Chapman and Hall/New York, Armstrong, 1882. (Reprint: Dover, N.H., Longwood, 1977).

7890. _____. **Les tapisseries de Raphael au Vatican et dans les principaux musées ou collections de l'Europe: étude historique et critique.** Paris, Rothschild, 1897.

7891. Nagler, Georg K. **Rafael als Mensch und Künstler.** München, Fleischmann, 1836.

7892. Oberhuber, Konrad. **Raffaello.** Milano, Mondadori, 1982.

7893. Oppé, Adolf A. **Raphael.** Edited with an introduction by Charles Mitchell. New York, Praeger, 1970. Revised ed.

7894. Palazzo Pitti (Florence). **Raffaello e l'architettura a Firenze nella prima metà del Cinquecento.** 11 gennaio-29 aprile 1984. Firenze, Palazzo Pitti, 1984.

7895. Passavant, Johann. **Rafael von Urbino und sein Vater Giovanni Santi.** 3 v. Leipzig, Brockhaus, 1839-1858. (English ed.: London/New York, Macmillan, 1872).

7896. Pedretti, Carlo. **Raffaello.** Bologna, Capitol, 1982.

7897. Poggiali, Pietro. **Raphael in Rome; a study of art and life in the XVI century.** Rome, Centenari, 1889.

7898. Ponente, Nello. **Who was Raphael?** Trans. by James Emmons. Geneva, Skira, 1967; distributed by World, Cleveland.

7899. Pope-Hennessy, John. **Raphael.** New York, New York University Press, 1970.

7900. Prisco, Michele [and] Vecchi, Pier L. de. **L'opera completa di Raffaello.** Milano, Rizzoli, 1966. (Classici dell'arte, 4).

7901. Putscher, Marielene. **Raphaels sixtinische Madonna, das Werk und seine Wirkung.** Tübingen, Hopfer, 1955.

7902. Quatremère de Quincy, Antoine C. **Histoire de la vie et des ouvrages de Raphael.** Paris, Le Clere, 1833. 2 ed. (English ed., trans. by William Hazlitt: London, Bogue, 1896; Reprint: New York/London, Garland, 1979).

7903. Ray, Stefano. **Raffaello architetto: linguaggio artistico e ideologia nel Rinascimento romano.** Prefazione di Bruno Zevi. Roma, Laterza, 1974.

7904. Redig de Campos, Deoclecio. **Raffaello nelle stanze.** Milano, Martello, 1965.

7905. Rosenberg, Adolf. **Raffael, des Meisters Gemälde.** Berlin/Leipzig, Deutsche Verlags-Anstalt, 1923. 5 ed. (Klassiker der Kunst, 1).

7906. Rumohr, Carl F. **Über Raphael und sein Verhältniss zu den Zeitgenossen.** Berlin/Stettin, Nicolai, 1831.

7907. Salmi, Mario, et al. **The complete work of Raphael.** New York, Harrison House, 1969.

7908. Serra, Luigi. **Raffaello.** Torino, Unione Tipografica/Editrice Torinese, 1945.

7909. Shearman, John. **Raphael's cartoons in the collection of Her Majesty the Queen and the tapestries for the Sistine Chapel.** London, Phaidon, 1972.

7910. Stein, Wilhelm. **Raphael.** Berlin, Bondi, 1923.

7911. Suida, Wilhelm. **Raphael.** London, Phaidon, 1948. 2 ed.

7912. Thompson, David. **Raphael, the life and the legacy.** London, British Broadcasting Corporation, 1983.

7913. Ullmann, Ernst. **Raffael.** Leipzig, Prisma, 1983.

7914. [Valentini, Agostino]. **I freschi delle loggie vaticane dipinti da Raffaele Sanzio.** Illustrati per cura d'Agostino Valentini. 2 v. Roma, Valentini, 1851.

7915. Vecchi, Pier L. de. **Raffaello, la pittura.** Prefazione di Anna M. Brizio. Firenze, Martello, 1981.

7916. Venturi, Adolfo. **Raffaello.** Testo aggiornato da Lionello Venturi. Milano, Mondadori, 1952. (Biblioteca moderna Mondadori, 310).

7917. Wagner, Hugo. **Raffael im Bildnis.** Bern, Benteli, 1969. (Berner Schriften zur Kunst, 11).

7918. Wanscher, Vilhelm. **Raffaello Santi da Urbino, his life and works.** London, Benn, 1926.

7919. Wolzogen, Alfred. **Raphael Santi, his life and his works.** Trans. by Fanny Bunnett. London, Smith, Elder, 1866.

RASTRELLI, BARTOLOMEO CARLO, 1675-1744

BARTOLOMEO FRANCESCO, 1700-1771

7920. Arkhipov, Nikolai I. [and] Raskin, A. G. **Bartolomeo Karlo Rastrelli, 1675-1744.** Leningrad, Iskusstvo, 1964.

7921. Koz'mian, Galina K. **F. B. Rastrelli.** Leningrad, Lenizdat, 1976.

RAUCH, CHRISTIAN DANIEL, 1777-1857

7922. Börsch-Supan, Helmut. **Die Werke Christian Daniel Rauchs im Schlossbezirk von Charlottenburg.** Berlin, Verwaltung der Staatlichen Schlösser und Gärten, 1977. (Aus Berliner Schlössern: Kleine Schriften, 3).

7923. Cheney, Ednah D. **Life of Christian Daniel Rauch of Berlin, Germany.** Boston, Lee and Shepard, 1893.

7924. Eggers, Friedrich und Eggers, Karl. **Christian Daniel Rauch.** 5 v. Berlin, Duncker, 1873-1886 [Vols. 1-4]; Berlin, Fontane, 1891 [Vol. 5].

7925. Rauch, Christian D. [and] Rietschel, Ernst. **Briefwechsel zwischen Rauch und Rietschel.** 2 v. Herausgegeben von Karl Eggers. Berlin, Fontane, 1890/1891.

7926. Weber, Helmut und Jedicke, Günter, eds. **Jubiläumsschrift zum 200. Geburtstag des Bildhauers Christian Daniel Rauch.** Arolsen, Stadt Arolsen, 1977.

RAUSCHENBERG, ROBERT, 1925-

7927. Adriani, Götz. **Robert Rauschenberg: Zeichnungen, Gouachen, Collagen, 1949 bis 1979.** München/Zürich, Piper, 1979.

7928. Forge, Andrew. **Rauschenberg.** New York, Abrams, 1969.

7929. National Collection of Fine Arts (Washington, D.C.). **Robert Rauschenberg.** October 30, 1976-January 2, 1977. Washington, D.C., National Collection of Fine Arts, Smithsonian Institution, 1976.

7930. Solomon, Alan R. **Robert Rauschenberg.** [Published in conjunction with an exhibition at the Jewish Museum, New York, March 31-May 12, 1963]. New York, Jewish Theological Seminary, 1963.

7931. Staatliche Kunsthalle, Berlin. **Robert Rauschenberg: Werke, 1950-1980.** 23. März bis 4. Mai 1980. Berlin, Staatliche Kunsthalle, 1980.

7932. Tomkins, Calvin. **Off the wall: Robert Rauschenberg and the art world of our time.** Garden City, N.Y., Doubleday, 1980.

RAY, MAN, 1890-1976

7933. Bramly, Serge. **Man Ray.** Paris, Belfond, 1980.

7934. Frankfurter Kunstverein (Frankfurt am Main). **Man Ray, Inventionen und Interpretationen.** [October 14-December 23, 1979]. Frankfurt a.M., Frankfurter Kunstverein, 1979.

7935. Janus [pseud.]. **Man Ray.** Milano, Fabbri, 1973.

7936. Palazzo delle Esposizioni (Rome). **Man Ray: l'occhio e il suo doppio; dipinti, collages, disegni, invenzioni, fotografiche, oggetti d'affezione, libri, cinema.** Luglio-settembre 1975. Roma, Assessorato Antichità Belle Arti e Problemi della Cultura, 1975.

7937. Penrose, Roland. **Man Ray.** London, Thames and Hudson, 1975.

7938. Perl, Jed. **Man Ray.** Millerton, N.Y., Aperture, 1979. (Aperture History of Photography, 15).

7939. Ray, Man. **Opera grafica.** Torino, Anselmino, 1973. (CR).

7940. _____. **Photographs.** Introduction by Jean-Herbert Martin. Trans. by Carolyn Breakspear. London, Thames and Hudson, 1982. (CR).

7941. _____. **Photographs, 1920-1934.** Edited by James Thrall
Soby. Paris, Cahiers d'Art/New York, Random House, 1934.
(New ed., with an introduction by A. D. Coleman: New
York, East River Press, 1975).

7942. _____. **Self portrait.** Boston, Little, Brown, 1963.

7943. Ribemont-Dessaignes, Georges. **Man Ray.** Paris, Gallimard,
1924.

7944. Schwartz, Arturo. **Man Ray; the rigour of imagination.** New
York, Rizzoli, 1977.

RAYSKI, FERDINAND VON, 1806-1890

7945. Goeritz, Mathias. **Ferdinand von Rayski und die Kunst des
neunzehnten Jahrhunderts.** Berlin, Hugo, 1942.

7946. Grautoff, Otto. **Ferdinand von Rayski.** Berlin, Grote, 1923.
(Grote'sche Sammlung von Monographien zur Kunstgeschichte,
4).

7947. Walter, Maräuschlein. **Ferdinand von Rayski, sein Leben und
sein Werk.** Bielefeld/Leipzig, Velhagen & Klasing,
1943. (CR).

REBEYROLLE, PAUL, 1926-

7948. Descargues, Pierre. **Rebeyrolle.** Paris, Maeght, 1970.

REDON, ODILON, 1840-1916

7949. Bacou, Roseline. **Odilon Redon.** 2 v. Genève, Cailler,
1956.

7950. Berger, Klaus. **Odilon Redon; fantasy and colour.** Trans.
by Michael Bullock. New York, McGraw-Hill, 1965.

7951. Destrée, Jules. **L'oeuvre lithographique de Odilon Redon,
catalogue descriptif.** Bruxelles, Deman, 1891.

7952. Fegdal, Charles. **Odilon Redon.** Paris, Rieder, 1929.

7953. Hobbs, Richard. **Odilon Redon.** Boston, New York Graphic
Society, 1977.

7954. Mellerio, André. **Odilon Redon.** Paris, Société pour
l'Étude de la Gravure Française, 1913. (Reprint: New
York, Da Capo. 1968).

7955. Redon, Ari, ed. **Lettres à Odilon Redon.** Textes et notes
par Roseline Bacou. Paris, Corti, 1960.

7956. Redon, Odilon. **Lettres d'Odilon Redon, 1878-1916.**
Publiées par sa famille, avec une préface de Marius-Ary
Leblond. Paris/Bruxelles, van Oest, 1923.

7957. Sandström, Sven. **Le monde imaginaire d'Odilon Redon; étude
iconologique.** Lund (Sweden), Gleerup/New York,
Wittenborn, 1955.

7958. Selz, Jean. **Odilon Redon.** Trans. by Eileen B. Hennessy.
New York, Crown, 1971.

7959. Werner, Alfred. **The graphic works of Odilon Redon.** New
York, Dover, 1969. (CR).

7960. Wilson, Michael. **Nature and imagination: the work of
Odilon Redon.** Oxford, Phaidon, 1978.

REGNAULT, HENRI, 1843-1871

7961. Baillière, Henri. **Henri Regnault, 1843-1871.** Paris,
Didier, 1872.

7962. Brey Mariño, Maria. **Viaje a España del pintor
Henri Regnault (1868-1870); España en la vida y en la
obra de un artista francés.** Madrid, Castalia, 1964.
2 ed.

7963. Cazalis, Henri. **Henri Regnault; sa vie et son oeuvre.**
Paris, Lemerre, 1872.

7964. Marx, Roger. **Henri Regnault, 1843-1871.** Paris, Rouam,
[1886].

7965. Regnault, Henri. **Correspondance.** Annotée et recueillie
par Arthur du Parc, suivi du catalogue complet de
l'oeuvre de H. Regnault. Paris, Charpentier, 1872.

REINHARDT, ADOLPH FREDERICK, 1913-1967

7966. Lippard, Lucy R. **Ad Reinhardt.** New York, Abrams, 1981.

7967. Reinhardt, Adolph F. **Art as art: the selected writings of
Ad Reinhardt.** Edited and with an introduction by Barbara
Rose. New York, Viking, 1975.

7968. Rowell, Margit. **Ad Reinhardt and color.** [Published in
conjunction with an exhibition at the Solomon R.
Guggenheim Museum, New York]. New York, Guggenheim
Foundation, 1980.

REJLANDER, OSCAR GUSTAV, 1813-1875

7969. Bunnell, Peter C., ed. **The photography of O. G. Rejlander:
two selections.** [On photographic composition, by O. G.
Rejlander; Rejlander's photographic studies, by A. H.
Wall]. New York, Arno, 1979.

7970. Jones, Edgar Y. **Father of art photography: O. G.
Rejlander, 1813-1875.** Newton Abbot (England), David &
Charles, 1973.

REMBRANDT HERMANSZOON VAN RIJN, 1606-1669

7971. Avermaete, Roger. **Rembrandt et son temps.** Paris, Payot,
1952.

7972. Bailey, Anthony. **Rembrandt's house.** Boston, Houghton
Mifflin, 1978.

7973. Bartsch, Adam. **Catalogue raisonné de toute les estampes
qui forment l'oeuvre de Rembrandt et ceux de ses
principaux imitateurs.** 2 v. Vienne, Blumauer, 1797.
(CR).

7974. Bauch, Kurt. Der frühe Rembrandt und seine Zeit; Studien zur geschichtlichen Bedeutung seines Frühstils. Berlin, Mann, 1960.

7975. _____. Die Kunst des jungen Rembrandt. Heidelberg, Winter, 1933. (Heidelberger kunstgeschichtliche Abhandlungen, 14).

7976. Benesch, Otto. The drawings of Rembrandt; complete edition in six volumes. Enlarged and edited by Eva Benesch. 6 v. London, Phaidon, 1973. 2 ed. (CR).

7977. _____. Rembrandt. Edited by Eva Benesch. London, Phaidon, 1970. (His Collected Writings, 1).

7978. _____. Rembrandt, biographical and critical study. Trans. by James Emmons. Geneva, Skira, 1957; distributed by Crown, New York. (The Taste of Our Time, 22).

7979. Bernhard, Marianne. Rembrandt: Druckgraphik, Handzeichnungen. 2 v. München, Südwest Verlag, 1976.

7980. Biörklund, George. Rembrandt's etchings: true and false; a summary catalogue. [Assisted by Osbert H. Barnard]. Stockholm, Biörklund, 1968. 2 ed.

7981. Blanc, Charles. L'oeuvre complet de Rembrandt, décrit et commenté. Catalogue raisonné. 2 v. Paris, Guerin, [1859/1861]. (CR).

7982. Bode, Wilhelm. The complete work of Rembrandt: history, description, and heliographic reproduction of all the master's pictures, with a study of his life and his art. Assisted by Cornelis Hofstede de Groot. Trans. by Florence Simmonds. 8 v. Paris, Sedelmeyer, 1897-1906. (CR).

7983. Bolton, Jaap and Bolten-Rempt, H. The hidden Rembrandt. Trans. by Danielle Adkinson. Chicago, Rand McNally, 1977.

7984. Borenius, Tancred. Rembrandt; selected paintings. London, Phaidon, 1942.

7985. Bredius, Abraham. Rembrandt, the complete edition of the paintings. Revised by Horst Gerson. London, Phaidon, 1969. 3 ed. (CR).

7986. Brion, Marcel. Rembrandt. Paris, Michel, 1946.

7987. Brown, G. Baldwin. Rembrandt, a study of his life and work. London, Duckworth/New York, Scribner, 1907.

7988. Bruijn, I. de en Bruijn-van der Leeuw, J. G. de. Catalogus van de verzameling etsen van Rembrandt in het bezit van I. de Bruijn en J. G. de Bruijn-van der Leeuw. 'S-Gravenhage, Nijhoff, 1932.

7989. Bruyn, Joshua. A corpus of Rembrandt paintings. Trans. by D. Cook-Radmore. [Work in progress]. The Hague, Nijhoff, 1982- ; distributed by Kluwer, Boston.

7990. Burnet, John. Rembrandt and his works, comprising a short account of his life; with a critical examination into his principles and practice of design, light, shade, and colour. London, Bogue, 1849.

7991. Clark, Kenneth M. Rembrandt and the Italian renaissance. London, Murray, 1966.

7992. Coppier, André-Charles. Les eaux-fortes authentiques de Rembrandt. 2 v. Paris, Didot, 1929. 2 ed.

7993. _____. Rembrandt. Paris, Alcan, 1920.

7994. Coquerel, Anthony. Rembrandt et l'individualisme dans l'art. Paris, Cherbuliez, 1869.

7995. Daulby, Daniel. A descriptive catalogue of the works of Rembrandt and of his scholars, Bol, Livens, and van Vliet. Compiled from the original etchings and from the catalogues of de Burgy, Gersaint, Helle and Glomy, Marcus, and Yver. Liverpool, M'Creery, 1796.

7996. Emmens, Jan A. Rembrandt en de regels van de kunst [with an English summary]. Utrecht, Dekker & Gumbert, 1968. (Orbis artium: Utrechtse kunsthistorische studiën, 10).

7997. Focillon, Henri and Goldscheider, Ludwig. Rembrandt; paintings, drawings, and etchings. New York, Phaidon, 1960.

7998. Gantner, Joseph. Rembrandt und die Verwandlung klassischer Formen. Bern/München, Francke, 1964.

7999. Gersaint, Edme F. Catalogue raisonné de toutes les pièces qui forment l'oeuvre de Rembrandt. Paris, Hochereau, 1751. (CR). (Supplément [par] Pieter Yver: Amsterdam, Yver, 1756; nouvelle édition, corrigée et considérablement augmentée par M. Claussin: Paris, Didot, 1824; supplément, 1828).

8000. Gerson, Horst. Rembrandt paintings. Trans. by Heinz Norden. New York, Reynal, 1968. (CR).

8001. Haak, Bob. Rembrandt: his life, his work, his time. Trans. by Elizabeth Willems-Treeman. New York, Abrams, 1969.

8002. Halewood, William H. Six subjects of Reformation art: a preface to Rembrandt. Toronto/Buffalo, University of Toronto Press, 1982.

8003. Hamann, Richard. Rembrandt. Neu herausgegeben von Richard Hamann-MacLean. Anmerkungen von Werner Sumowski. Berlin, Safari, 1969. 2 ed.

8004. _____. Rembrandts Radierungen. Berlin, Cassirer, 1913. 2 ed.

8005. Hanfstaengl, Eberhard. Rembrandt Harmensz van Rijn. München, Bruckmann, 1958. 3 ed.

8006. Hausenstein, Wilhelm. Rembrandt. Stuttgart, Deutsche Verlags-Anstalt, 1926.

8007. Heckscher, William S. Rembrandt's Anatomy of Dr. Nicolaas Tulp; an iconographical study. New York, New York University Press, 1958.

8008. Heiland, Susanne und Lüdecke, Heinz, eds. Rembrandt und die Nachwelt. Leipzig, Seemann, 1960.

8009. Held, Julius S. Rembrandt's Aristotle and other Rembrandt studies. Princeton, N.J., Princeton University Press, 1969.

8010. Hijmans, Willem, et al. Rembrandt's Nightwatch: the history of a painting. Trans. by Patricia Wardle. Alphen aan den Rijn, Sijthoff, 1978.

8011. Hind, Arthur M. **A catalogue of Rembrandt's etchings, chronologically arranged and completely illustrated.** 2 v. London, Methuen, 1923. 2 ed. (CR). (Reprint: New York, Da Capo, 1967).

8012. _____. **Rembrandt; being the substance of the Charles Eliot Norton lectures delivered before Harvard University, 1930-31.** Cambridge, Mass., Harvard University Press, 1932.

8013. Hofstede de Groot, Cornelis. **Die Urkunden über Rembrandt (1575-1721).** Haag, Nijhoff, 1906. (Quellenstudien zur holländischen Kunstgeschichte, 3).

8014. Holmes, Charles J. **Notes on the art of Rembrandt.** London, Chatto & Windus, 1911.

8015. Jahn, Johannes. **Rembrandt.** Leipzig, Seemann, 1956.

8016. Knackfuss, Hermann. **Rembrandt.** Bielefeld/Leipzig, Velhagen & Klasing, 1895. 2 ed. (Künstler-Monographien, 3).

8017. Knuttel, Gerhardus. **Rembrandt, de meester en zijn werk.** Amsterdam, Ploegsma, 1956.

8018. Landsberger, Franz. **Rembrandt, the Jews, and the Bible.** Trans. by Felix N. Gerson. Philadelphia, Jewish Publication Society of America, 1961. 2 ed.

8019. [Langbehn, Julius]. **Rembrandt als Erzieher, von einem Deutschen** [Julius Langbehn]. Leipzig, Hirschfeld, 1890. (New ed.: Stuttgart, Kohlhammer, 1936).

8020. Laurie, Arthur P. **The brush-work of Rembrandt and his school.** London, Oxford University Press, 1932.

8021. Lugt, Frits. **Met Rembrandt in en om Amsterdam.** Amsterdam, van Kampen & Zoon, 1915.

8022. Michel, Emile. **Rembrandt, his life, his work and his time.** Trans. Florence Simmonds. 2 v. London, Heinemann, 1894.

8023. Middleton, Charles H. **A descriptive catalogue of the etched work of Rembrandt van Rijn.** London, Murray, 1878.

8024. Muller, Joseph-Emile. **Rembrandt.** Paris, Somogy, 1968.

8025. Muller, M. **De etsen van Rembrandt.** Baarn, Hollandia, 1946.

8026. _____. **Zo leefde Rembrandt in de gouden eeuw.** Mit een voorwoord van A. van Schendel. Baarn, Hollandia, 1968.

8027. Münz, Ludwig. **The etchings of Rembrandt.** 2 v. London, Phaidon, 1952.

8028. _____. **Rembrandt.** Additional commentaries by Bob Haak. New York, Abrams, 1967. 2 ed.

8029. _____, ed. **Rembrandt, etchings.** 2 v. New York, Phaidon, 1952. (CR).

8030. Neumann, Carl. **Aus der Werkstatt Rembrandts.** Heidelberg, Winter, 1918. (Heidelberger kunstgeschichtliche Abhandlungen, 3).

8031. _____. **Rembrandt.** 2 v. München, Bruckmann, 1924. 4 ed.

8032. Rentsch, Eugen. **Der Humor bei Rembrandt.** Strassburg, Heitz, 1909. (Studien zur deutschen Kunstgeschichte, 110).

8033. Rijckevorsel, J. van. **Rembrandt en de traditie.** Rotterdam, Brusse, 1932.

8034. Roger-Marx, Claude. **Rembrandt.** [Paris], Tisné, 1960.

8035. Rosenberg, Adolf. **Rembrandt, des Meisters Gemälde.** Stuttgart/Berlin, Deutsche Verlags-Anstalt, [1908]. 3 ed.

8036. Rosenberg, Jakob. **Rembrandt, life and work.** New York, Phaidon, 1964. 2 ed.

8037. Rotermund, Hans-Martin. **Rembrandt's drawings and etchings for the Bible.** Trans. by Shierry M. Weber. Philadelphia/Boston, Pilgrim Press, 1969.

8038. Rovinski, Dmitri. **L'oeuvre gravé de Rembrandt, avec un catalogue raisonné.** 4 v. Saint-Pétersbourg, Imprimerie de l'Académie Impériale des Sciences, 1890. (CR). (Supplement, with text in French and Russian, by N. Tchétchouline: St.-Pétersbourg, Kotoff, 1914).

8039. Schmidt-Degener, Frederik. **Rembrandt.** Amsterdam, Meulenhoff, 1950.

8040. Seidlitz, Woldemar von. **Die Radierungen Rembrandts, mit einem kritischen Verzeichnis.** Leipzig, Seemann, 1922. (CR).

8041. Simmel, Georg. **Rembrandt, ein kunstphilosophischer Versuch.** München, Wolff, 1925. 2 ed.

8042. Singer, Hans W. **Rembrandt, des Meisters Radierungen.** Stuttgart/Leipzig, Deutsche Verlags-Anstalt, 1906. (Klassiker der Kunst, 8).

8043. Slive, Seymour. **Drawings of Rembrandt, with a selection of drawings by his pupils and followers.** 2 v. New York, Dover, 1965.

8044. _____. **Rembrandt and his critics, 1630-1730.** The Hague, Nijhoff, 1953.

8045. Strauss, Walter L. and Meulen, Marjon van der. **The Rembrandt documents.** [Prepared] with the assistance of S. A. C. Dudok van Heel and P. J. M. de Baar. New York, Abaris, 1979.

8046. Valentiner, Wilhelm R. **Rembrandt and Spinoza; a study of the spiritual conflicts in seventeenth-century Holland.** London, Phaidon, 1957.

8047. _____. **Rembrandt: des Meisters Handzeichnungen.** 2 v. Stuttgart/Berlin, Deutsche Verlags-Anstalt, 1925. (Klassiker der Kunst, 31/32).

8048. _____. **Rembrandt und seine Umgebung.** Strassburg, Heitz, 1905. (Zur Kunstgeschichte des Auslandes, 29).

8049. Van Dyke, John C. **Rembrandt and his school: a critical study of the master and his pupils with a new assignment of their pictures.** New York, Scribner, 1923.

8050. Verhaeren, Emile. **Rembrandt, biographie critique.** Paris, Laurens, [1907].

8051. Visser't Hooft, Willem A. **Rembrandt et la Bible.** Neuchâtel/Paris, Delachaux et Niestlé, 1947.

8052. Vogel-Köhn, Doris. **Rembrandts Kinderzeichnungen.** Köln, DuMont, 1981. (DuMont Taschenbücher, 102).

8053. Vosmaer, Carel. **Rembrandt, sa vie et ses oeuvres.** Seconde édition, entièrement refondue et augmentée. La Haye, Nijhoff, 1877.

8054. Vries, Ary B. de, et al. **Rembrandt in the Mauritshuis; an interdisciplinary study.** Trans. by James Brockway. Alphen aan de Rijn, Sitjhoff & Nordhoff, 1978.

8055. Waal, Henri van de. **Steps towards Rembrandt; collected articles, 1937-1972.** Trans. by Patricia Wardle and Alan Griffiths. Ed. by R. H. Fuchs. Amsterdam/London, North-Holland Publishing Co., 1974.

8056. Weisbach, Werner. **Rembrandt.** Berlin/Leipzig, de Gruyter, 1926.

8057. Wencelius, Léon. **Calvin et Rembrandt.** Paris, Les Belles Lettres, 1973.

8058. White, Christopher. **Rembrandt and his world.** New York, Viking, 1964.

8059. _____. **Rembrandt as an etcher; a study of the artist at work.** 2 v. London, Zwemmer, 1969.

8060. Wright, Christopher. **Rembrandt: self-portraits.** New York, Viking, 1982.

REMINGTON, FREDERIC, 1861-1909

8061. Hassrick, Peter H. **Frederic Remington: paintings, drawings and sculpture in the Amon Carter Museum and the Sid W. Richardson Foundation collections.** Foreword by Ruth Carter Johnson. New York, Abrams/ in association with the Amon Carter Museum of Western Art, Fort Worth, Texas, 1973.

8062. McCracken, Harold. **Frederic Remington, artist of the Old West.** Philadelphia, Lippincott, 1947.

8063. Remington, Frederic. **The collected writings of Frederic Remington.** Edited by Peggy and Harold Samuels. Illustrated by Frederic Remington. Garden City, N.Y., Doubleday, 1979.

8064. _____. **Frederic Remington's own West; written and illustrated by Frederic Remington.** Edited and with an introduction by Harold McCracken. New York, Dial, 1960.

8065. Samuels, Peggy and Samuels, Harold. **Frederic Remington, a biography.** Garden City, N.Y., Doubleday, 1982.

8066. Vorpahl, Ben M. **Frederic Remington and the West.** Austin/ London, University of Texas Press, 1972.

8067. Wear, Bruce. **The bronze world of Frederic Remington.** Tulsa, Oklahoma, Gaylord, 1966.

RENGER-PATZSCH, ALBERT, 1897-1966

8068. Heise, Carl G. **Albert Renger-Patzsch: der Photograph.** Berlin, Riemerschmidt, 1942.

8069. Renger-Patzsch, Albert. **Die Halligen.** Geleitwort von Johann Johannsen; unter Mitwirkung von Karl Häberlein. Berlin, Albertus, 1927.

8070. Rheinisches Landesmuseum, Bonn. **Industrielandschaft, Industriearchitektur, Industrieprodukt: Fotographien 1925-1960 von Albert Renger-Patzsch.** [Jan. 14-Feb. 13, 1977]. Köln, Rheinland-Verlag/Bonn, Habelt, 1977.

RENI, GUIDO, 1575-1642

8071. Albertina (Vienna). **Guido Reni: Zeichnungen.** 14. Mai-5. Juli 1981. Katalog und Ausstellung: Veronika Birke. Wien, Albertina, 1981.

8072. Bartsch, Adam. **Catalogue raisonné des estampes gravées à l'eau-forte par Guido Reni et de celles de ses disciples.** Vienne, Blumauer, 1795. (CR).

8073. Boehn, Max von. **Guido Reni.** Bielefeld/Leipzig, Velhagen & Klasing, 1910. (Künstler-Monographien, 100).

8074. Emiliani, Andrea. **Guido Reni.** Milano, Fabbri, 1964. (I maestri del colore, 35).

8075. Garboli, Cesare [and] Baccheschi, Edi. **L'opera completa di Guido Reni.** Milano, Rizzoli, 1971. (CR). (Classici dell'arte, 48).

8076. Malaguzzi Valeri, Francesco. **Guido Reni.** Firenze, Le Monnier, 1929.

8077. Malvasia, Carlo C. **The life of Guido Reni.** Trans. and with an introduction by Catherine Enggass and Robert Enggass. University Park, Penn./London, Pennsylvania State University Press, 1980.

8078. Palazzo dell'Archiginnasio (Bologna). **Mostra di Guido Reni.** Catalogo critico a cura di Gian Carlo Cavalli; saggio introduttivo di Cesare Gnudi. 1 settembre-31 ottobre, 1954. Bologna, Alfa, 1954.

8079. Sweetser, Moses F. **Guido Reni.** Boston, Houghton, Osgood, 1878.

RENOIR, PIERRE AUGUSTE, 1841-1919

8080. André, Albert [and] Elder, Marc. **L'atelier de Renoir.** 2 v. Paris, Bernheim-Jeune, 1931. (CR).

8081. Barnes, Albert C. and de Mazia, Violette. **The art of Renoir.** With a foreword by John Dewey. New York, Minton, Balch, 1935.

8082. Baudot, Jeanne. **Renoir: ses amis, ses modèles.** Paris, Editions Littéraires de France, 1949.

8083. Bünemann, Hermann. **Renoir.** Ettal, Buch-Kunstverlag, [1959].

8084. Callen, Anthea. **Renoir.** London, Oresko, 1978.

8085. Coquiot, Gustave. **Renoir.** Paris, Michel, 1925.

8086. Daulte, François. **Auguste Renoir, catalogue raisonné de l'oeuvre peint.** Avant-propos de Jean Renoir. Préface de Charles Durand-Ruel. I: **Figures, 1860-1890.** [No further volumes published]. Lausanne, Durand-Ruel, 1971. (CR).

8087. Drucker, Michel. **Renoir.** Paris, Tisné, 1944.

8088. Duret, Théodore. **Renoir.** Trans. by Madeleine Boyd. New York, Crown, 1937.

8089. Fezzi, Elda. **L'opera completa di Renoir nel periodo impressionista, 1869-1883.** Milano, Rizzoli, 1972. (CR). (Classici dell'arte, 59).

8090. Forthuny, Pascal, ed. **Renoir.** Préface d'Octave Mirbeau. Paris, Bernheim-Jeune, 1913.

8091. Fosca, François. **Renoir, l'homme et son oeuvre.** Paris, Somogy, 1961.

8092. Fouchet, Max-Pol. **Les nus de Renoir.** Lausanne, Guilde du Livre et Clairfontaine, 1974.

8093. Graber, Hans. **Auguste Renoir nach eigenen und fremden Zeugnissen.** Basel, Schwabe, 1943.

8094. Hanson, Lawrence. **Renoir: the man, the painter, and his world.** New York, Dodd, Mead, 1968.

8095. Meier-Graefe, Julius. **Renoir.** Leipzig, Klinkhardt & Biermann, 1929.

8096. Pach, Walter. **Pierre Auguste Renoir.** New York, Abrams, 1950.

8097. Perruchot, Henri. **La vie de Renoir.** Paris, Hachette, 1964.

8098. Renoir, Jean. **Renoir, my father.** Trans. by Randolph and Dorothy Weaver. Boston, Little, Brown, 1958.

8099. Rivière, Georges. **Renoir et ses amis.** Paris, Floury, 1921.

8100. Robida, Michel, et al. **Renoir.** Paris, Librairie Hachette, 1970. (Collection génies et réalités).

8101. Roger-Marx, Claude. **Renoir.** Paris, Floury, 1937.

8102. Rouart, Denis. **Renoir.** Trans. by James Emmons. Geneva, Skira, 1954. (The Taste of Our Time, 7).

8103. Stella, Joseph G. **The graphic work of Renoir, catalogue raisonné.** London, Humphries, [1975]. (CR).

8104. Vollard, Ambroise. **Renoir, an intimate record.** Trans. by Harold L. Van Doren and Randolph T. Weaver. New York, Knopf, 1925.

8105. _____. **Tableaux, pastels & dessins de Pierre-Auguste Renoir.** 2 v. Paris, Vollard, 1918. (CR). (Reprint: Paris, Mazo, 1954).

REPIN, IL'IA EFIMOVICH, 1844-1930

8106. Brodskii, Iosif A. **Repin, pedagog.** Moskva, Akademiia Khudozhestv SSSR, 1960.

8107. Chukovskii, Kornei I. **Il'ia Repin.** Moskva, Iskusstvo, 1969.

8108. Colliander, Tito. **Ilja Repin, en konstnär från Ukraina.** Helsingfors, Söderström, 1942. 2 ed.

8109. Ernst, Sergei R. **Il'ia Efimovich Repin.** Leningrad, Gosudarstvennyi Akademiia, 1927.

8110. Grabar, Igor E. **Repin, monografiia.** 2 v. Moskva, Izd-vo Akademiia Nauk, 1963-64. 2 ed.

8111. Liaskovskaia, Olga A. **Il'ia Efimovich Repin.** Moskva, Iskusstvo, 1962. 2 ed.

8112. Morgunova-Kudnitskaia, Natalia D. **Il'ia Repin, zhizn' i tvorchestvo.** Moskva, Iskusstvo, 1965.

8113. Parker, Fan and Parker, Stephen J. **Russia on canvas: Ilya Repin.** University Park, Penn./London, Pennsylvania State University Press, 1980.

8114. Prorokova, Sofia A. **Repin.** Moskva, Molodaia Gvardiia, 1960. 2 ed.

8115. Repin, Il'ia. **Dalekoe blizkoe.** [Ed. by Kornei Chukovskii]. Moskva, Iskusstvo, 1944. 2 ed.

8116. _____. **Izbrannye pis'ma, 1867-1930.** [Ed. by I. A. Brodskii]. 2 v. Moskva, Iskusstvo, 1969.

REPTON, HUMPHRY, 1752-1818

see also BROWN, LANCELOT

8117. Repton, Humphry. **Landscape gardening and landscape architecture.** A new edition with an introduction and biographical notice by J. C. Loudon. London, Longman, 1840.

8118. Stroud, Dorothy. **Humphry Repton.** London, Country Life, 1962.

RETHEL, ALFRED, 1816-1859

8119. Ponten, Josef. **Alfred Rethel.** Stuttgart/Leipzig, Deutsche Verlags-Anstalt, 1911. (Klassiker der Kunst, 17).

8120. Rethel, Alfred. **Briefe.** Herausgegeben von Josef Ponten. Berlin, Cassirer, 1912.

8121. Schmid, Max. **Rethel.** Bielefeld/Leipzig, Velhagen & Klasing, 1898. (Künstler-Monographien, 32).

8122. Schmidt, Heinrich. **Alfred Rethel, 1816-1859.** Neuss, Gesellschaft für Buchdruckerei, 1958. (Rheinischer Verein für Denkmalpflege und Heimatschutz, Jahrgang 1958).

REVERE, PAUL, 1735-1818

8123. Brigham, Clarence S. **Paul Revere's engravings.** Worcester, Mass., American Antiquarian Society, 1954. (New ed.: New York, Atheneum, 1969).

8124. Forbes, Esther. **Paul Revere and the world he lived in.** Boston, Houghton Mifflin, 1969.

8125. Museum of Fine Arts (Boston). **Paul Revere's Boston: 1735-1818.** April 18-October 12, 1975. Boston, Museum of Fine Arts, 1975; distributed by New York Graphic Society, Boston.

REYNOLDS, JOSHUA, 1723-1792

8126. Armstrong, Walter. **Sir Joshua Reynolds.** London, Heinemann, 1900.

8127. Boulton, William B. **Sir Joshua Reynolds.** New York, Dutton, 1905.

8128. Graves, Algernon and Cronin, William V. **A history of the works of Sir Joshua Reynolds.** 4 v. London, Graves, 1899-1901. (CR).

8129. Hamilton, Edward. **A catalogue raisonné of the engraved works of Sir Joshua Reynolds, P. R. A. from 1755 to 1822.** London, Colnaghi, 1884. 2 ed. (CR). (Reprinted, with the addition of plates and an index: Amsterdam, Hissink, 1973).

8130. Hilles, Frederick W. **The literary career of Sir Joshua Reynolds.** Cambridge, Cambridge University Press, 1936.

8131. Hudson, Derek. **Sir Joshua Reynolds, a personal study.** With Reynolds' *Journey from London to Brentford,* now first published. London, Bles, 1958.

8132. Leslie, Charles R. **Life and times of Sir Joshua Reynolds, with notices of some of his contemporaries.** Continued and concluded by Tom Taylor. 2 v. London, Murray, 1865.

8133. Molloy, Fitzgerald. **Sir Joshua and his circle.** 2 v. London, Hutchinson, 1906.

8134. Northcote, James. **Memoirs of Sir Joshua Reynolds.** London, Colburn, 1813. (New ed., revised and augmented: 2 v., 1819).

8135. Phillips, Claude. **Sir Joshua Reynolds.** New York, Scribner, 1894.

8136. Reynolds, Joshua. **Letters.** Ed. by Frederick W. Hilles. Cambridge, Cambridge University Press, 1929.

8137. _____. **Works.** [With] an account of the life and writings of the author by Edmond Malone. 2 v. London, Cadell and Davies, 1797.

8138. Waterhouse, Ellis K. **Reynolds.** New York, Phaidon, 1973; distributed by Praeger, New York. 2 ed.

RIBERA, JUSEPE, 1588?-1652

8139. Art Museum, Princeton University. **Jusepe de Ribera: prints and drawings.** October-November 1973. Princeton, N.J., Princeton University Press, 1973.

8140. Conte, Edouard. **Ribera.** Paris, Nilsson, 1924.

8141. Felton, Craig M. **Jusepe de Ribera: a catalogue raisonné.** Ann Arbor, Mich., University Microfilms, 1971. (CR).

8142. Kimball Art Museum (Fort Worth, Tex.). **Jusepe de Ribera, lo Spagnoletto, 1591-1652.** December 4, 1982-February 6, 1983. Edited by Craig Felton and William B. Jordan. Fort Worth, Tex., Kimball Art Museum, 1982; distributed by Washington University Press, Seattle and London.

8143. Lafond, Paul. **Ribera et Zurbaran, biographies critiques.** Paris, Laurens, [1909].

8144. Mayer, August L. **Jusepe de Ribera (lo Spagnoletto).** Leipzig, Hiersemann, 1908. (Kunstgeschichtliche Monographien, 10).

8145. Pérez Sánchez, Alfonso E. [and] Spinosa, Nicola. **L'opera completa del Ribera.** Milano, Rizzoli, 1978. (CR). (Classici dell'arte, 97).

8146. Pillement, Georges. **Ribera.** Paris, Rieder, 1929.

8147. Trapier, Elizabeth du Gué. **Ribera.** New York, Hispanic Society of America, 1952.

RICCI, MARCO, 1676-1730

SEBASTIANO, 1659/60-1734

8148. Daniels, Jeffrey. **L'opera completa di Sebastiano Ricci.** Milano, Rizzoli, 1976. (CR). (Classici dell'arte, 89).

8149. _____. **Sebastiano Ricci.** Hove, Eng., Wayland, 1976.

8150. Derschau, Joachim von. **Sebastiano Ricci, ein Beitrag zu den Anfängen der venezianischen Rokokomalerei.** Heidelberg, Winter, 1922.

8151. Palazzo Sturm (Bassano del Gruppa, Italy). **Marco Ricci: catalogo della mostra con un saggio di Rodolfo Palluchini.** Venezia, Alfieri, 1964.

8152. Pilo, Guiseppe M. **Sebastiano Ricci e la pittura veneziana del settecento.** Pordenone, Grafiche Editoriali Artistiche Pordenonesi, 1976.

RICCIO, ANDREA, 1470-1532

8153. Planiscig, Leo. **Andrea Riccio.** Wien, Schroll, 1927.

RICHARDSON, HENRY HOBSON, 1838-1886

8154. Eaton, Leonard K. **American architecture comes of age: European reaction to H. H. Richardson and Louis Sullivan.** Cambridge, Mass., MIT Press, 1972.

8155. Hitchcock, Henry R. **The architecture of H. H. Richardson and his times.** New York, Museum of Modern Art, 1936. (New ed.: Hamden, Conn., Archon, 1961).

8156. Ochsner, Jeffrey K. **H. H. Richardson, complete architectural works.** Cambridge, Mass./London, MIT Press, 1982. (CR).

8157. O'Gorman, James F. **H. H. Richardson and his office; selected drawings.** [Published in conjunction with an exhibition at the Fogg Art Museum, Harvard University, Cambridge, Mass., October 23-December 8, 1974]. Boston, Godine, 1974.

8158. Van Rensselaer, Mariana. **Henry Hobson Richardson and his works.** Boston/New York, Houghton Mifflin, 1888. (Reprint: New York, Dover, 1969).

RICHTER, ADRIAN LUDWIG, 1803-1884

8159. Bauer, Franz. **Ludwig Richter, ein deutscher Malerpoet.** Stuttgart, Schuler, 1960.

8160. Franke, Willibald. **Ludwig Richters Zeichnungen.** Leipzig/ Berlin, Grethlein, [1916]. 2 ed.

8161. Friedrich, Karl J. **Die Gemälde Ludwig Richters.** Berlin, Deutscher Verein für Kunstwissenschaft, 1937. (CR).

8162. _____. **Ludwig Richter und sein Schülerkreis.** Leipzig, Koehler & Amelang, 1956.

8163. Hoff, Johann F. **Adrian Ludwig Richter, Maler und Radierer.** Dresden, Richter, 1877.

8164. Kalkschmidt, Eugen. **Ludwig Richter, sein Leben und Schaffen.** Berlin, Grote, 1940.

8165. Kempe, Lothar. **Ludwig Richter, ein Maler des deutschen Volkes.** Dresden, Sachsenverlag, 1953.

8166. Koch, David. **Ludwig Richter, ein Künstler für das deutsche Volk.** Stuttgart, Steinkopf, 1903.

8167. Mohn, Victor P. **Ludwig Richter.** Bielefeld/Leipzig, Velhagen & Klasing, 1896. (Künstler-Monographien, 14).

8168. Richter, Ludwig. **Dein treuer Vater; Briefe Ludwig Richters aus vier Jahrzehnten an seinen Sohn Heinrich.** Herausgegeben von Karl J. Friedrich. Leipzig, Koehler & Amelang, 1953.

8169. _____. **Lebenserinnerungen eines deutschen Malers; Selbstbiographie.** Herausgegeben von Heinrich Richter. Frankfurt a.M., Ult, 1885.

8170. _____. **Richter-Album; eine Auswahl Holzschnitten nach Zeichnungen.** Leipzig, Wigand, 1848. (New ed., with notes by Otto Jahn: 2 v., 1861).

8171. Schmidt, Karl W. **Ludwig Richter, Leben und Werk.** Berlin, Deutsche Buchvertriebs- und Verlags-Gesellschaft, 1946.

8172. Stubbe, Wolf. **Das Ludwig Richter Hausbuch.** Auswahl: Aiga Matthes. München, Rogner & Bernhard, 1976.

RICHTER, DAVID (the elder), 1662-1735

DAVID (the younger), 1664-1741

8173. Holmquist, Bengt M. **Das Problem David Richter: Studien in der Kunstgeschichte des Spätbarocks.** Stockholm, Almqvist & Wiksell, 1968. (Acta Universitatis Stockholmiensis, 15).

RICHTER, HANS, 1888-1976

8174. Akademie Der Künste (Berlin). **Hans Richter, 1888-1976; Dadaist, Filmpionier, Maler, Theoretiker.** 31. Januar-7. März 1982. Berlin, Akademie der Künste, 1982.

8175. Richter, Hans. **Begegnungen von Dada bis heute: Briefe, Dokumente, Erinnerungen.** Köln, DuMont Schauberg, 1973.

8176. _____. **Dada: art and anti-art.** New York, McGraw-Hill, 1965. (The Modern Artist and His World, 1).

8177. _____. **Hans Richter.** Introd. by Sir Herbert Read. Autobiographical text by the artist. Neuchâtel, Editions du Griffon, 1965.

8178. _____. **Hans Richter by Hans Richter.** Ed. by Cleve Gray. London, Thames and Hudson, 1971.

RIDINGER, JOHANN ELIAS, 1698-1767

8179. Schwarz, Ignaz. **Katalog einer Ridinger-Sammlung.** 2 v. Wien, Verlag des Verfassers, 1918. (CR).

8180. Stubbe, Wolf. **Johann Elias Ridinger.** Hamburg/Berlin, Parey, 1966. (Die Jagd in der Kunst).

8181. Thienemann, Georg A. W. **Leben und Wirken des unvergleichlichen Thiermalers und Kupferstechers Johann Elias Ridinger.** Leipzig, Weigel, 1856.

RIEMENSCHNEIDER, TILMAN, 1460?-1531

8182. Becker, Carl. **Leben und Werke des Bildhauers Tilmann Riemenschneider.** Leipzig, Weigel, 1849.

8183. Bier, Justus. **Tilmann Riemenschneider, die frühen Werke.** Würzburg, Verlagsdruckerei Würzburg, 1925.

8184. _____. **Tilmann Riemenschneider, die reifen Werke.** Augsburg, Filser, 1930.

8185. _____. **Tilmann Riemenschneider, die späten Werke in Holz.** Wien, Schroll, 1978.

8186. _____. **Tilmann Riemenschneider, die späten Werke in Stein.** Wien, Schroll, 1973.

8187. _____. **Tilmann Riemenschneider, his life and work.** Lexington, Ky., University Press of Kentucky, 1982.

8188. Flesche, Herman. **Tilman Riemenschneider.** Bilder von Günther Beyer und Klaus Beyer. Hanau, Dausien, 1957.

8189. Freeden, Max H. von. **Tilman Riemenschneider, Leben und Werk.** Aufnamen von Walter Hege. [München], Deutscher

RIEMENSCHNEIDER

Kunstverlag, 1965. 3 ed.

8190. Gerstenberg, Kurt. **Tilman Riemenschneider.** München, Bruckmann, 1955. 5 ed.

8191. Hotz, Joachim. **Tilman Riemenschneider.** München, Schuler, 1977.

8192. Kirsch, Hans-Christian. **Tilman Riemenschneider, ein deutsches Schicksal.** München, Bertelsmann, 1981.

8193. Knapp, Fritz. **Riemenschneider.** Bielefeld/Leipzig, Velhagen & Klasing, 1935. (Künstler-Monographien, 119).

8194. Mainfränkisches Museum (Würzburg). **Tilman Riemenschneider, frühe Werke.** 5. September bis 1. November 1981. Regensburg, Pustet, 1981.

8195. Muth, Hanswernfried [and] Schneiders, Toni. **Tilman Riemenschneider und seine Werke.** Würzburg, Popp, 1980. 2 ed.

8196. Schrade, Hubert. **Tilman Riemenschneider.** 2 v. Heidelberg, Hain, 1927.

8197. Stein, Karl H. **Tilman Riemenschneider im deutschen Bauernkrieg; Geschichte einer geistigen Haltung.** Frankfurt a.M., Gutenberg, 1944.

8198. Streit, Carl. **Tylmann Riemenschneider, 1460-1531; Leben und Kunstwerke des fränkischen Bildschnitzers.** 2 v. Berlin, Wasmuth, 1888.

8199. Tönnies, Eduard. **Leben und Werke des Würzburger Bildschnitzers Tilmann Riemenschneider, 1468-1531.** Strassburg, Heitz, 1900. (Studien zur deutschen Kunstgeschichte, 22).

8200. Weber, Georg A. **Til Riemenschneider, sein Leben und Wirken.** Regensburg, Habbel, 1911.

RIETVELD, GERRIT THOMAS, 1888-1964

8201. Brown, Theodore M. **The world of G. Rietveld, architect.** Utrecht, Bruna & Zoon, 1958.

8202. Buffinga, A. **Gerrit Thomas Rietveld.** Amsterdam, Meulenhoff, 1971.

RIGAUD, HYACINTHE, 1659-1743

8203. Eudel, Paul. **Les livres de comptes de Hyacinthe Rigaud.** Paris, Le Soudier, 1910.

8204. Roman, Joseph. **Le livre de raison du peintre Hyacinthe Rigaud.** Paris, Laurens, 1919.

RIIS, JACOB AUGUST, 1849-1914

8205. Alland, Alexander, Sr. **Jacob A. Riis, photographer & citizen.** With a preface by Ansel Adams. Millerton, N.Y., Aperture, 1974.

8206. Hassner, Rune. **Jacob A. Riis, reporter med kamera i New Yorks slum.** Stockholm, Norstedt, 1970.

8207. Riis, Jacob A. **How the other half lives: studies among the tenements of New York.** New York, Scribner, 1890. (Reprint, with a preface by Charles A. Madison: New York, Dover, 1971).

8208. Ware, Louise. **Jacob A. Riis: police reporter, reformer, useful citizen.** Introduction by Allan Nevins. New York, Appleton-Century, 1938. (Reprint: Millwood, N.Y., Kraus, 1975).

RIMMER, WILLIAM, 1816-1879

8209. Bartlett, Truman H. **The art life of William Rimmer, sculptor, painter, and physician.** Boston/New York, Houghton Mifflin, 1882. (Reprinted from the 1890 ed., with a new preface by Leonard Baskin: New York, Da Capo/Kennedy Graphics, 1970).

8210. Whitney Museum of American Art (New York). **William Rimmer, 1816-1879.** November 5-27, 1946. [Text by Lincoln Kirstein]. [New York, Whitney Museum of American Art, 1946].

RIMŠA, PETRAS, 1881-1961

8211. Budrys, Stanislovas. **Piatras Rimsha.** Moskva, Sovetskii Khudozhnik, 1961.

8212. Rimantas, J. **Petras Rimša pasakoja.** Vilnius, USSR, Valstybine grožines literaturos leidykla, 1964.

RIPPL-RÓNAI, JÓZSEF, 1861-1927

8213. Genthon, István. **Rippl-Rónai, le Nabi hongrois.** [Translatd from the Hungarian by Imre Kelemen]. Budapest, Corvina, 1958.

8214. Petrovics, Elek. **Rippl-Rónai.** Budapest, Athenaeum, [n.d.].

8215. Pewny, Denise. **Rippl-Rónai József (1861-1927).** Budapest, Sárkány, 1940.

8216. Rippl-Rónai, József. **Rippl-Rónai, emlézezései.** Budapest, Nyugat, 1911.

RITZ, JOHANN, 1666-1729

8217. Steinmann, Othmar. **Der Bildhauer Johann Ritz (1666-1729) von Selkingen und seine Werkstatt.** Disentis, Switzerland, Benediktinerabtei Disentis, 1952.

RITZ, RAPHAEL, 1829-1894

8218. Ruppen, Walter. **Raphael Ritz, 1829-1894; Leben und Werk.** Bonn/Duisburg, Allitera, 1971.

244

RIVERA, DIEGO, 1886–1957

8219. [Anonymous]. **Das Werk des Malers Diego Rivera.** Berlin, Neuer Deutscher Verlag, 1928.

8220. Arquin, Florence. **Diego Rivera: the shaping of an artist, 1889–1921.** Norman, Okla., University of Oklahoma Press, 1971.

8221. Evans, Ernestine. **The frescos of Diego Rivera.** New York, Harcourt, Brace, 1929.

8222. Fondo Editorial de la Plástica Mexicana (Mexico City). **Diego Rivera: I. Pintura de caballete y dibujos.** [Work in progress]. [Mexico City], Fondo Editorial de la Plástica Mexicana, 1979– . (CR).

8223. Mittler, Max, ed. **Diego Rivera, Wort und Bekenntnis.** Zürich, Verlag der Arche, 1965.

8224. Museo Nacional de Artes Plásticas (Mexico City). **Diego Rivera: 50 años de su labor artistica; exposicion de homenaje nacional.** [Mexico City], Departamento de Artes Plásticas, Instituto Nacional de Bellas Artes, 1951.

8225. Museum of Modern Art (New York). **Diego Rivera.** December 23, 1931–January 27, 1932. New York, Museum of Modern Art, 1931.

8226. _____. **Frescos of Diego Rivera** [a portfolio]. New York, Museum of Modern Art, 1933.

8227. Ospovat, Lev S. **Diego Rivera.** Moskva, Molodaia Gvardiia, 1969.

8228. Ramos, Samuel. **Diego Rivera.** [Mexico City], Universidad Nacional Autónoma de México, Dirección General de Publicaciones, 1958. (Coleccion de arte, 4).

8229. Rivera, Diego. **My art, my life: an autobiography.** With Gladys March. New York, Citadel, 1960.

8230. _____. **Portrait of America.** With an explanatory text by Bertram D. Wolfe. New York, Covici, Friede, 1934.

8231. Rodriguez, Antonio. **Diego Rivera.** [Mexico City], Ediciones de Arte, 1950.

8232. Secker, Hans F. **Diego Rivera.** Dresden, Verlag der Kunst, 1957.

8233. Wolfe, Bertram D. **Diego Rivera; his life and times.** London, Hale, 1939.

8234. _____. **The fabulous world of Diego Rivera.** New York, Stein & Day, 1963.

RIVERS, LARRY, 1923–

8235. Hunter, Sam. **Larry Rivers.** With a memoir by Frank O'Hara. New York, Abrams, 1970.

8236. Kestner-Gesellschaft, Hannover. **Larry Rivers Retrospektive: Bilder und Skulpturen.** Herausgegeben von Carl Haenlein. 19. Dezember 1980 bis 15. Februar 1981. Hannover, Kestner-Gesellschaft, 1980. (Katalog 6/1980).

8237. _____. **Larry Rivers Retrospektive: Zeichnungen.** Herausgegeben von Carl Haenlein. 20. Dezember 1980 bis 25. Januar 1981. Hannover, Kestner-Gesellschaft, 1980. (Katalog 1/1981).

8238. Rivers, Larry. **Drawings and digressions.** By Larry Rivers with Carol Brightman. New York, Potter, 1979; distributed by Crown, New York.

8239. Rose Art Museum, Brandeis University (Waltham, Mass.). **Larry Rivers.** Introduction by Sam Hunter, with a memoir by Frank O'Hara and a statement by the artist. April 10–May 9, 1965. Waltham, Mass., Brandeis University, 1965.

RIZZO, ANTONIO, 1440–1500

8240. Schulz, Anne M. **Antonio Rizzo, sculptor and architect.** Princeton, N.J., Princeton University Press, 1982.

ROBBIA, ANDREA DELLA, 1435–1525

 GIOVANNI DELLA, 1469–1529

 LUCA DELLA, 1400–1482

8241. Barbet de Jouy, Henry. **Les Della Robbia, sculpteurs en terre émaillée; étude sur leurs travaux, suivie d'un catalogue de leur oeuvre fait en Italie en 1853.** Paris, Renouard, 1855.

8242. Bargellini, Piero. **I Della Robbia.** Milano, Arti Grafiche Ricordi, 1965.

8243. Burlamacchi, L. **Luca della Robbia.** London, Bell, 1900.

8244. Cavallucci, Camillo J. [and] Molinier, Emile. **Les Della Robbia, leur vie et leur oeuvre.** Paris, Rouam, 1884.

8245. Contrucci, Pietro. **Monumento Robbiano nella loggia dello Spedale di Pistoja.** Prato, Giachetti, 1835.

8246. Cruttwell, Maud. **Luca & Andrea Della Robbia and their successors.** London, Dent/New York, Dutton, 1902.

8247. Foville, Jean de. **Les Della Robbia, biographies critiques.** Paris, Laurens, 1910.

8248. Marquand, Allan. **Andrea Della Robbia and his atelier.** 2 v. Princeton, N.J., Princeton University Press, 1922. (CR). (Princeton Monographs in Art and Archeology, 11).

8249. _____. **The brothers of Giovanni Della Robbia: Fra Mattia, Luca, Girolamo, Ambrogio.** With an appendix and corrections for all the Della Robbia catalogues. Edited and extended by Frank J. Mather, Jr., and Charles R. Morey. Princeton, N.J., Princeton University Press, 1928.

8250. _____. **Della Robbias in America.** Princeton, N.J., Princeton University Press, 1912. (Princeton Monographs in Art and Archeology, 1).

8251. _____. **Giovanni Della Robbia.** Princeton, N.J., Princeton University Press, 1920. (CR). (Princeton Monographs on Art and Archeology, 8).

8252. _____. **Luca Della Robbia.** Princeton, N.J., Princeton University Press, 1914. (CR). (Princeton Monographs in Art and Archeology, 3).

8253. _____. **Robbia heraldry.** Princeton, N.J., Princeton University Press, 1919. (Princeton Monographs in Art and Archeology).

[Note: all of Marquand's Della Robbia volumes were reprinted by Hacker, New York, 1972].

8254. Planiscig, Leo. **Luca Della Robbia.** Wien, Schroll, 1940.

8255. Pope-Hennessy, John. **Luca Della Robbia.** Oxford, Phaidon, 1980. (CR).

8256. Reymond, Marcel. **Les Della Robbia.** Florence, Alinari, 1897.

8257. Schubring, Paul. **Luca Della Robbia und seine Familie.** Bielefeld/Leipzig, Velhagen & Klasing, 1905. (Künstler-Monographien, 74).

ROBERT, CHARLES, 1912-1948

8258. Comment, Jean-François, et al. **Charles Robert, dessins et peintures.** Moutier, Switzerland, Robert, 1956.

8259. Junod, Roger-Louis, et al. **Le peintre Charles Robert.** Préface de Claude Roger-Marx. Neuchâtel, Editions de la Baconnière, 1961.

8260. Roger-Marx, Claude. [Charles Robert:] **Espagne/Paris.** 2 v. Neuchâtel, Switzerland, Editions de l'Orée, 1962.

ROBERT, HUBERT, 1733-1808

see also FRAGONARD, JEAN HONORE

8261. Beau, Marguerite. **La collection des dessins d'Hubert Robert au Musée de Valence.** Lyon, Audin, 1968.

8262. Burda, Hubert. **Die Ruine in den Bildern Hubert Roberts.** München, Fink, 1967.

8263. Carlson, Victor. **Hubert Robert, drawings & watercolors.** [Published in conjunction with an exhibition at the National Gallery of Art, Washington, D.C., November 19, 1978-January 21, 1979]. Washington, D.C., National Gallery of Art, 1978.

8264. Gabillot, Claude. **Hubert Robert et son temps.** Paris, Librairie de L'Art, [1895].

8265. Leclère, Tristan. **Hubert Robert et les paysagistes français de XVIII siècle.** Paris, Laurens, 1913.

8266. Lévêque, Jean-Jacques. **L'univers d'Hubert Robert.** Paris, Screpel, 1979.

8267. Musée du Louvre (Paris). **Le Louvre d'Hubert Robert.** Catalogue rédigé par Marie-Catherine Sahut. 16 juin-29 octobre 1979. Paris, Editions de la Réunion des Musées Nationaux, 1979.

8268. Nolhac, Pierre de. **Hubert Robert, 1733-1808.** Paris, Goupil, 1910.

ROBERT, LOUIS LEOPOLD, 1794-1835

8269. Clément, Charles. **Léopold Robert d'après sa correspondance inédite.** Paris, Didier, 1875.

8270. Feuillet de Conches, Félix. **Léopold Robert; sa vie, ses oeuvres et sa correspondance.** Paris, Lévy, 1854.

ROBINSON, THEODORE, 1852-1896

8271. Baltimore Museum of Art. **Theodore Robinson, 1852-1896.** 1 May-10 June 1973. Baltimore, Baltimore Museum of Art, 1973.

8272. Baur, John I. H. **Theodore Robinson, 1852-1896.** [Published in conjunction with an exhibition at the Brooklyn Museum, New York, November 12, 1946-January 5, 1947]. New York, Brooklyn Museum, 1946.

ROBINSON, WILLIAM HEATH, 1872-1944

8273. Day, Langston. **The life and art of W. Heath Robinson.** London, Joseph, 1947.

8274. Lewis, John. **Heath Robinson, artist and comic genius.** Introd. by Nicolas Bentley. London, Constable, 1973.

8275. Robinson, Heath. **My line of life.** London/Glasgow, Blackie, 1938. (Reprint: East Ardsley, Eng., EP Publishing, 1974).

ROBUSTI, JACOPO see TINTORETTO, IL

ROCKWELL, NORMAN, 1894-1978

8276. Buechner, Thomas S. **Norman Rockwell, artist and illustrator.** New York, Abrams, 1970.

8277. Finch, Christopher. **Norman Rockwell's America.** New York, Abrams, 1975.

8278. Guptill, Arthur L. **Norman Rockwell, illustrator.** Preface by Dorothy Canfield Fisher; biographical introduction by Jack Alexander. New York, Watson-Guptill, 1946.

8279. Rockwell, Norman. **My adventures as an illustrator.** As told to Thomas Rockwell. Garden City, N.Y., Doubleday, 1960.

8280. _____. **The Norman Rockwell album.** Garden City, N.Y., Doubleday, 1961.

8281. Walton, Donald. **A Rockwell portrait: an intimate biography.** Kansas City, Kan., Sheed, Andrews & McMeel, 1978.

RODCHENKO, ALEKSANDR MIKHAILOVICH, 1891-1956

8282. Elliott, David, ed. **Rodchenko and the arts of revolutionary Russia.** New York, Pantheon, 1979.

8283. Gassner, Hubertus. **Rodčenko Fotographien.** Mit einem
Vorwort von Aleksander Lavrentjev. München,
Schirmer/Mosel, 1982. (English ed., without Gassner's
text, trans. by John W. Gabriel: New York, Rizzoli,
1982).

8284. Karginov, German. **Rodchenko.** Trans. by Elisabeth Hoch.
London, Thames and Hudson, 1979.

8285. Volkov-Lannit, Leonid F. **Aleksandr Rodchenko risuet,
fotografiruet, sporit.** Moskva, Iskusstvo, 1968.

8286. Weiss, Evelyn, ed. **Alexander Rodtschenko; Fotographien,
1920-1938.** Köln, Wienand, 1978.

RODIN, AUGUSTE, 1840-1917

8287. Bénédite, Léonce. **Rodin.** Paris, Rieder, 1926.

8288. Bourdelle, Antoine. **Rodin's later drawings.**
Interpretations by Antoine Bourdelle. Text and trans-
lations by Elisabeth C. Geissbuhler.

8289. _____. **La sculpture et Rodin.** Précédé de **Quatre pages de
journal** par Claude Aveline. Paris, Emile-Paul, 1937.

8290. Butler, Ruth, ed. **Rodin in perspective.** Englewood Cliffs,
N.J., Prentice-Hall, 1980.

8291. Champigneulle, Bernard. **Rodin.** Trans. and adapted by J.
Maxwell Brownjohn. New York, Abrams, 1967.

8292. Cladel, Judith. **Rodin; the man and his art.** Trans. by
S. K. Star. New York, Century, 1917.

8293. Coquiot, Gustave. **Rodin à l'Hôtel de Biron et à Meudon.**
Paris, Ollendorff, 1917.

8294. _____. **Le vrai Rodin.** Paris, Tallandier, 1913.

8295. De Caso, Jacques and Sanders, Patricia B. **Rodin's
sculpture: a critical study of the Spreckels Collection,
California Palace of the Legion of Honor.** San Francisco,
Fine Arts Museums of San Francisco/Rutland, Vt. and
Tokyo, Tuttle, 1977. (CR).

8296. Descharnes, Robert and Chabrun, Jean F. **August Rodin.**
Trans. by Haakon Chevalier. New York, Viking, 1967.

8297. Elsen, Albert E. **In Rodin's studio; a photographic record
of sculpture in the making.** Ithaca, N.Y., Cornell, 1980.

8298. _____. **Rodin.** New York, Museum of Modern Art, 1963;
distributed by Doubleday, Garden City, N.Y.

8299. _____. **Rodin's Gates of Hell.** Minneapolis, University of
Minnesota Press, 1960.

8300. _____, ed. **Auguste Rodin: readings on his life and work.**
Englewood Cliffs, N.J., Prentice-Hall, 1965.

8301. _____ and Varnedoe, J. Kirk T. **The drawings of Rodin.**
With additional contributions by Victoria Thorson
and Elsabeth C. Geissbuhler. New York, Praeger, 1971.

8302. Grappe, Georges. **Le Musée Rodin.** Paris, Taupin, 1944.

8303. Grautoff, Otto. **Auguste Rodin.** Bielefeld/Leipzig,
Velhagen & Klasing, 1908. (Künstler-Monographien, 93).

8304. Jianou, Ionel and Goldscheider, Cécile. **Rodin.** Paris,
Arted, 1967.

8305. Ludovici, Anthony M. **Personal reminiscences of Auguste
Rodin.** Philadelphia, Lippincott, 1926.

8306. Maillard, Léon. **Etudes sur quelques artistes originaux:
Auguste Rodin, statuaire.** Paris, Floury, 1899.

8307. Mauclair, Camille. **Auguste Rodin: the man, his ideas, his
works.** Trans. by Clementina Black. London, Duckworth,
1909.

8308. Musée Rodin (Paris). **Rodin et les écrivains de son temps:
sculptures, dessins, lettres et livres du fonds Rodin.**
23 juin-18 octobre 1976. Paris, Musée Rodin, 1976.

8309. National Gallery of Art (Washington, D.C.). **Rodin
rediscovered.** June 28, 1981-May 2, 1982. [Text edited
by Albert Elsen]. Washington, D.C., National Gallery of
Art, 1981.

8310. Nostitz, Helene von. **Dialogues with Rodin.** Trans. by
H. L. Ripperger. New York, Duffield & Green, 1931.

8311. Rilke, Rainer M. **Auguste Rodin.** Trans. by Jessie Lemont
and Hans Trausil. New York, Sunwise Turn, 1919.

8312. Rodin, Auguste. **Art.** Trans. from the French of Paul Gsell
by Romilly Fedden. Boston, Small, Maynard, 1912.

8313. _____. **Briefe an zwei deutsche Frauen.** Herausgegeben von
Helene von Nostitz. Mit einer Einführung von Rudolf
Alexander Schröder. Berlin, Holle, [n.d.].

8314. _____. **Les cathédrales de France.** Paris, Colin, 1914.
(English ed.: Trans. by Elisabeth C. Geissbuhler. With a
preface by Herbert Read. Boston, Beacon Press, 1965).

8315. Story, Sommerville. **Rodin.** New York, Phaidon, 1964.
3 ed.

8316. Sutton, Denys. **Triumphant satyr; the world of Auguste
Rodin.** New York, Hawthorn, 1966.

8317. Tancock, John L. **The sculpture of Auguste Rodin.** Special
photography by Murray Weiss. [Boston], Godine/
Philadelphia, Philadelphia Museum of Art, 1976. (CR).

8318. Thorson, Victoria. **Rodin graphics: a catalogue raisonné
of drypoints and book illustrations.** [Published in con-
junction with an exhibition at the California Palace of
the Legion of Honor, San Francisco, 14 June-10 August
1975]. San Francisco, Fine Arts Museums of San
Francisco, 1975. (CR).

8319. Tirel, Marcelle. **The last years of Rodin.** Trans. by R.
Francis. Preface by Judith Cladel. London, Philpot,
[1925].

8320. Waldmann, Emil. **Auguste Rodin.** Wien, Schroll, 1945.

ROEBLING, JOHN AUGUSTUS, 1806-1869

WASHINGTON AUGUSTUS, 1837-1926

8321. McCullough, David. **The Great Bridge.** New York, Simon & Schuster, 1972.

8322. Schuyler, Hamilton. **The Roeblings; a century of engineers, bridge-builders and industrialists.** Princeton, N.J., Princeton University Press, 1931.

8323. Steinman, David B. **The builders of the bridge: the story of John Roebling and his son.** New York, Harcourt Brace, 1945.

8324. Trachtenberg, Alan. **Brooklyn Bridge: fact and symbol.** New York, Oxford University Press, 1965.

ROERICH, NIKOLAI KONSTANTINOVICH, 1874-1947

8325. Kniazeva, Valentina P. **Nikolai Konstantinovich Rerikh, 1874-1947.** Moskva, Iskusstvo, 1963.

8326. Poliakova, Elena I. **Nikolai Rerikh.** Moskva, Iskusstvo, 1973.

8327. Roerich, Nikolai I. **Adamant.** New York, Corona Mundi, 1922.

8328. Selivanova, Nina. **The world of Roerich.** New York, Corona Mundi, 1922.

ROGERS, JOHN, 1829-1904

8329. Smith, Mr. and Mrs. Chetwood. **Rogers Groups: thought & wrought by John Rogers.** Introd. by Clarence S. Brigham. Boston, Goodspeed, 1934.

8330. Wallace, David H. **John Rogers, the people's sculptor.** Middletown, Conn., Wesleyan University Press, 1967. (CR).

ROGIER VAN DER WEYDEN see WEYDEN, ROGER VAN DER

ROHE, LUDWIG MIES VAN DER see MIES VAN DER ROHE, LUDWIG

ROHLFS, CHRISTIAN, 1849-1938

8331. Landesmuseum Münster. **Christian Rohlfs, 1849-1938; Aquarelle und Zeichnungen.** 15. Dezember 1974-26. Januar 1975. Münster, Landesmuseum Münster, 1975.

8332. Scheidig, Walther. **Christian Rohlfs.** Dresden, Verlag der Kunst, 1965.

8333. Uphoff, Carl E. **Christian Rohlfs.** Leipzig, Klinkhardt & Biermann, 1923. (Junge Kunst, 34).

8334. Vogt, Paul. **Christian Rohlfs.** Köln, DuMont Schauberg, 1967.

8335. _____. **Christian Rohlfs: Aquarelle und Zeichnungen.** Recklinghausen, Bongers, 1958.

8336. _____. **Christian Rohlfs: das graphische Werk.** Recklinghausen, Bongers, 1960. (CR).

8337. _____. **Christian Rohlfs: Oeuvre-Katalog der Gemälde.** Recklinghausen, Bongers, 1978. (CR).

ROMAKO, ANTON, 1832-1889

8338. Novotny, Fritz. **Der Maler Anton Romako, 1832-1889.** Wien, Schroll, 1954.

ROMANINO, GIROLAMO, 1485-1566

8339. Cassa Salvi, Elvira. **Romanino.** Milano, Fabbri, 1965. (I maestri del colore, 95).

8340. Comune di Brescia. **Mostra di Girolamo Romanino.** Catalogo a cura di Gaetano Panazza. Prefazione di G. A. dell'Acqua. Brescia, Comitato della Mostra, 1965.

8341. Ferrari, Maria L. **Il Romanino.** Milano, Bramante, 1961.

8342. Nicodemi, Giorgio. **Gerolamo Romanino.** [Brescia, La Poligrafica, 1925].

ROMANO, GIULIO see GIULIO ROMANO

ROMNEY, GEORGE, 1734-1802

8343. Chamberlain, Arthur B. **George Romney.** New York, Scribner, 1910.

8344. Davies, Randall. **Romney.** London, Black, 1913.

8345. Gamlin, Hilda. **George Romney and his art.** London, Sonnenschein, 1894.

8346. Gower, Ronald S. **George Romney.** London, Duckworth, 1904.

8347. Hayley, William. **The life of George Romney, Esq.** London, Payne, 1809.

8348. Jaffé, Patricia. **Drawings by George Romney [in the Fitzwilliam Museum, Cambridge].** Cambridge, Cambridge University Press for the Fitzwilliam Museum, 1977.

8349. Maxwell, Herbert E. **George Romney.** New York, Scribner, 1902.

8350. Romney, John. **Memoirs of the life and works of George Romney.** London, Baldwin and Cradock, 1830.

8351. Rump, Gerhard C. **George Romney (1734-1802); zur Bildform der bürgerlichen Mitte in der englischen Neoklassik.** 2 v. Hildesheim/New York, Olms, 1974.

8352. Ward, Thomas H., and Roberts, William. **Romney; a biographical and critical essay, with a catalogue raisonné of his work.** 2 v. New York, Scribner, 1904. (CR).

ROOT, JOHN WELLBORN, 1850-1891

8353. Hoffmann, Donald. **The architecture of John Wellborn Root.**
Baltimore/London, Johns Hopkins University Press, 1973.
(Johns Hopkins Studies in Nineteenth-Century
Architecture).

8354. Monroe, Harriet. **John Wellborn Root, a study of his life
and work.** Boston, Houghton Mifflin, 1896. (Reprint:
Park Forest, Ill., Prairie School Press, 1966).

8355. Root, John W. **The meaning of architecture: buildings and
writings by John Wellborn Root.** Ed. by Donald Hoffmann.
New York, Horizon, 1967.

ROPS, FELICIEN, 1833-1898

8356. Bory, Jean-François. **Félicien Rops: l'oeuvre graphique
complète.** Paris, Hubschmid, 1977. (CR).

8357. Boyer d'Agen, Jean et Roig, Jean de. **Ropsiana.** Paris,
Pellet, 1924.

8358. Brison, Charles. **Pornocrates: an introduction to the life
and work of Félicien Rops, 1833-1898.** London, Skilton,
1969.

8359. Dubray, Jean. **Félicien Rops.** Préface de Pierre MacOrlan.
[Paris], Seheur, 1928.

8360. Exsteens, Maurice. **L'oeuvre gravé et lithographié de
Félicien Rops.** 4 v. Paris, Pellet, 1928. (CR).

8361. Fontainas, André. **Rops.** Paris, Alcan, 1925.

8362. Lemonnier, Camille. **Félicien Rops, l'homme et l'artiste.**
Paris, Floury, 1908.

8363. Mascha, Ottokar. **Félicien Rops und sein Werk.** München,
Langen, 1910.

8364. Ramiro, Erastène. **Félicien Rops.** Paris, Pellet/Floury,
1905.

8365. _____. **L'oeuvre gravé de Félicien Rops, précédé d'une
notice biographique et critique.** Paris, Conquet, 1887.
Supplement: Paris, Floury, 1895. (CR).

8366. _____. **L'oeuvre lithographié de Félicien Rops.** Paris,
Conquet, 1891. (CR).

ROSA, SALVATOR, 1615-1673

8367. Cattaneo, Irene. **Salvatore Rosa.** Milano, Alpes, 1929.

8368. Limentani, Uberto. **Bibliografia della vita e delle opere
di Salvator Rosa.** Firenzi, Sansoni, 1955.

8369. Mahoney, Michael. **The drawings of Salvator Rosa.** 2 v.
New York/London, Garland, 1977. (CR).

8370. Morgan, Sydney. **The life and times of Salvator Rosa.** 2 v.
London, Colburn, 1824.

8371. Ozzola, Leandro. **Vita e opere di Salvator Rosa, pittore,
poeta, incisore.** Strassburg, Heitz, 1908. (Zur
Kunstgeschichte des Auslandes, 60).

8372. Rotili, Mario. **Salvator Rosa.** Napoli, Società Editrice
Napoletana, 1974. (CR).

8373. Roworth, Wendy W. **Pictor Succensor: a study of Salvator
Rosa as satirist, cynic, and painter.** New York/London,
Garland, 1978.

8374. Salerno, Luigi. **L'opera completa di Salvator Rosa.**
Milano, Rizzoli, 1975. (CR). (Classici dell'arte, 82).

8375. _____. **Salvator Rosa.** Firenze, Barbèra, 1963. (Collana
d'arte, 5).

8376. Wallace, Richard W. **The etchings of Salvator Rosa.**
Princeton, N.J., Princeton University Press, 1979. (CR).

ROSSELLINO, ANTONIO, 1427-1479

BERNARDO, 1409-1464

8377. Gottschalk, Heinz. **Antonio Rossellino.** Liegnitz,
Burmeister, 1930.

8378. Planiscig, Leo. **Bernardo und Antonio Rossellino.** Wien,
Schroll, 1942.

8379. Schulz, Anne M. **The sculpture of Bernardo Rossellino and
his workshop.** Princeton, N.J., Princeton University
Press, 1977.

8380. Tyszkiewiczowa, Maryla. **Bernardo Rossellino.** Florencja,
1928.

ROSSETTI, BIAGIO, 1447-1516

8381. Zevi, Bruno. **Saper vedere l'urbanistica: Ferrara di
Biagio Rossetti, la prima città moderna europea.** Torino,
Einaudi, 1971.

ROSSETTI, DANTE GABRIEL, 1828-1882

8382. Cary, Elisabeth L. **The Rossettis: Dante Gabriel and
Christina.** New York, Putnam, 1900.

8383. Dobbs, Brian and Dobbs, Judy. **Dante Gabriel Rossetti: an
alien Victorian.** London, Macdonald and Jane, 1977.

8384. Doughty, Oswald. **A Victorian romantic: Dante Gabriel
Rossetti.** London, Muller, 1949.

8385. Fleming, Gordon H. **Rossetti and the Pre-Raphaelite
Brotherhood.** London, Hart-Davis, 1967.

8386. Grieve, Alastair I. **The art of Dante Gabriel Rossetti.**
3 v. Hingham/Norwich, Real World, 1973.

8387. Henderson, Marina. **D. G. Rossetti.** Introd. by Susan
Miller. London, Academy/New York, St. Martin's, 1973.

8388. Hueffer, Ford M. **Rossetti, a critical essay on his art.** London, Duckworth, 1902.

8389. Knight, Joseph. **The life of Dante Gabriel Rossetti.** Bibliography and catalogue of pictures by John P. Anderson. London, Scott, 1887.

8390. Marillier, Henry C. **Dante Gabriel Rossetti.** London, Bell, 1899.

8391. Mourey, Gabriel. **D. G. Rossetti et les Préraphaélites anglais, biographies critiques.** Paris, Renouard, [1909].

8392. Nicoll, John. **Dante Gabriel Rossetti.** London, Studio Vista, 1975.

8393. Rossetti, Dante G. **Letters.** Ed. by Oswald Doughty and John R. Wall. 4 v. Oxford, Clarendon Press, 1965.

8394. Rossetti, William M. **Dante Gabriel Rossetti as designer and writer.** London, Cassell, 1889.

8395. Sharp, William. **Dante Gabriel Rossetti, a record and a study.** London, Macmillan, 1882.

8396. Surtees, Virginia. **The paintings and drawings of Dante Gabriel Rossetti (1828-1882); a catalogue raisonné.** 2 v. Oxford, Clarendon Press, 1971. (CR).

8397. Waugh, Evelyn. **Rossetti, his life and works.** London, Duckworth, 1928.

8398. Wood, Esther. **Dante Rossetti and the Pre-Raphaelite movement.** New York, Scribner, 1894.

ROSSI, DOMENICO EGIDIO, fl. 1697-1707

8399. Passavant, Günther. **Studien über Domenico Egidio Rossi und seine baukünstlerische Tätigkeit innerhalb des süddeutschen und österreichischen Barock.** Karlsruhe, Braun, 1967.

ROSSI, GIOVANNI ANTONIO, 1616-1695

8400. Spagnesi, Gianfranco. **Giovanni Antonio de Rossi, architetto romano.** Roma, Officina Edizioni, 1964.

ROSSI, KARL IVANOVICH, 1775-1849

8401. Piliavskii, V. I. **Zodchii Rossi.** Moskva, Gosudarstvennyi izd-vo Arkhitekturii i Gradostroitel'stva, 1951.

8402. Taranovskaia, Marianna Z. **Karl Rossi.** Leningrad, Lenizdat, 1978.

8403. Veinert, N. **Rossi.** Moskva, Iskusstvo, 1939.

ROSSO FIORENTINO, 1494-1540

8404. Barocchi, Paola. **Il Rosso Fiorentino.** Roma, Gismondi, [1950].

8405. Borea, Evelina. **Rosso Fiorentino.** Milano, Fabbri, 1965. (I maestri del colore, 106).

8406. Carroll, Eugene A. **The drawings of Rosso Fiorentino.** 2 v. New York/London, Garland, 1976. (CR).

8407. Kusenberg, Kurt. **Le Rosso.** Paris, Michel, 1931.

ROSSO, GIOVANNI BATTISTA see ROSSO FIORENTINO

ROSSO, MEDARDO, 1858-1928

8408. Barr, Margaret S. **Medardo Rosso.** New York, Museum of Modern Art, 1963; distributed by Doubleday, Garden City, N.Y.

8409. Borghi, Mino. **Medardo Rosso.** Milano, Edizioni del Milione, 1950. (Monografie di artisti italiani contemporanei, 4).

8410. Fles, Etha. **Medardo Rosso, der Mensch und der Künstler.** Freiburg i.Br., Heinrich, 1922.

8411. Soffici, Ardengo. **Medardo Rosso (1858-1928).** Firenze, Vallecchi, 1929.

ROT, DITER, 1930-

8412. Rot, Diter. **Gesammelte Werke.** [Work in progress]. Köln, Hansjörg, 1969- ; distributed by Wittenborn, New York. (CR). [Later imprints vary].

ROTHKO, MARK, 1903-1970

8413. Ashton, Dore. **About Rothko.** New York, Oxford University Press, 1983.

8414. Museum Boymans-van Beuningen (Rotterdam). **Mark Rothko.** 20 november 1971-2 januari 1972. [Rotterdam, Museum Boymans-van Beuningen, 1971].

8415. Seldes, Lee. **The legacy of Mark Rothko.** New York, Holt, Rinehart and Winston, 1978.

8416. Waldman, Diane. **Mark Rothko, 1903-1970; a retrospective.** [Published in conjunction with an exhibition at the Solomon R. Guggenheim Museum, New York]. New York, Abrams, 1978.

ROTTLUFF, KARL SCHMIDT see SCHMIDT-ROTTLUFF, KARL

ROUAULT, GEORGES, 1871-1958

8417. Bellini, Paolo. **Georges Rouault, uomo e artista.** Milano, Salamon e Agustoni, 1972.

8418. Chapon, François. **Rouault: oeuvre gravé.** Catalogue établi par Isabelle Rouault avec la collaboration d'Olivier Nouaille Rouault. 2 v. Monte Carlo, Sauret, 1978/1979. (CR).

8419. Charensol, Georges. **Georges Rouault, l'homme et l'oeuvre.** Paris, Editions des Quatre Chemins, 1926.

8420. Courthion, Pierre. **Georges Rouault.** Including a catalogue of works prepared with the collaboration of Isabelle Rouault. New York, Abrams, 1962. (CR).

8421. Getlein, Frank and Getlein, Dorothy. **Georges Rouault's Miserere.** Milwaukee, Bruce, 1964.

8422. Josef-Haubrich-Kunsthalle (Cologne). **Georges Rouault.** 11. März bis 8. Mai 1983. Köln, Josef-Haubrich-Kunsthalle, 1983.

8423. Musée National d'Art Moderne (Paris). **Georges Rouault; exposition du centenaire.** 27 mai-27 septembre 1971. Paris, Ministère des Affaires Culturelles, Réunion des Musées Nationaux, 1971.

8424. Rouault, Georges [and] Suarès, André. **Correspondance.** Introd. par Marcel Arland. Paris, Gallimard, 1960.

8425. Roulet, Claude. **Rouault: souvenirs.** Neuchâtel, Messeiller, 1961.

8426. Soby, James T. **Georges Rouault, paintings and prints.** New York, Museum of Modern Art, 1947.

8427. Venturi, Lionello. **Rouault, biographical and critical study.** Trans. by James Emmons. Paris, Skira, 1959; distributed by World, Cleveland. (The Taste of Our Time, 26).

8428. Wofsy, Alan. **Georges Rouault, the graphic work.** London, Secker & Warburg, 1976. (CR).

ROUBILIAC, LOUIS FRANÇOIS, 1695-1762

8429. Esdaile, Katherine A. **The life and works of Louis François Roubiliac.** London, Oxford University Press, 1928.

ROUBILLAC, LOUIS FRANÇOIS see ROUBILIAC, LOUIS FRANÇOIS

ROUSSEAU, HENRI JULIEN FELIX, 1844-1910

8430. Alley, Ronald. **Portrait of a primitive: the art of Henri Rousseau.** Oxford, Phaidon, 1978.

8431. Artieri, Giovanni [and] Vallier, Dora. **L'opera completa di Rousseau il doganiere.** Milano, Rizzoli, 1969. (CR). (Classici dell'arte, 29).

8432. Bouret, Jean. **Henri Rousseau.** Trans. by Martin Leake. Greenwich, Conn., New York Graphic Society, 1961.

8433. Certigny, Henry. **La vérité sur le douanier Rousseau.** Paris, Plon, 1961. (Supplemento: Paris, Plon, 1966; Lausanne, Bibliothèque des Arts, 1971).

8434. Courthion, Pierre. **Henri Rousseau, le douanier.** Genève, Skira, 1944.

8435. Grey, Roch. **Henri Rousseau.** Rome, Valori Plastici, 1922. (New ed., with a preface by André Salmon: Paris, Tel, 1943).

8436. Keay, Carolyn. **Henri Rousseau, le douanier.** New York, Rizzoli, 1976.

8437. Kolle, Helmud. **Henri Rousseau.** Leipzig, Klinkhardt & Biermann, 1922. (Junge Kunst, 27).

8438. Le Pichon, Yann. **Le monde du douanier Rousseau.** Paris, Laffont, 1981.

8439. Perruchot, Henri. **Le douanier Rousseau.** Paris, Editions Universitaires, 1957. (Témoins du XXe siècle, 9).

8440. Rich, Daniel C. **Henri Rousseau.** New York, Museum of Modern Art, 1942.

8441. Rousseau, Henri. **Dichtung und Zeugnis.** Mit Photos und Erinnerungen. Herausgegeben von Peter Schifferli. Übertragung von Sonja Bütler. Zürich, Verlag der Arche, 1958.

8442. Salmon, André. **Henri Rousseau.** Paris, Somogy, 1962.

8443. _____. **Henri Rousseau dit le douanier.** Paris, Crès, 1927.

8444. Soupault, Philippe. **Henri Rousseau, le douanier.** Paris, Editions des Quatre Chemins, 1927.

8445. Uhde, Wilhelm. **Henri Rousseau.** Paris, Figuière, 1911.

8446. Vallier, Dora. **Henri Rousseau.** Paris, Flammarion, 1979. (English ed.: New York, Crown, 1979).

8447. Zervos, Christian. **Rousseau.** Paris, Cahiers d'Art, 1927.

ROUSSEAU, PIERRE ETIENNE THEODORE, 1812-1867

see also MILLET, JEAN FRANÇOIS

8448. Dorbec, Prosper. **Théodore Rousseau, biographie critique.** Paris, Laurens, 1910.

8449. Musée du Louvre, Galerie Mollien (Paris). **Théodore Rousseau, 1812-1867.** 29 novembre 1967-12 février 1968. Paris, Ministère d'Etat Affaires Culturelles, Réunion des Musées Nationaux, 1967.

8450. Sensier, Alfred. **Souvenirs sur Théodore Rousseau.** Paris, Techener/Durand-Ruel, 1872.

ROUSSEL, KER XAVIER, 1867-1944

8451. Alain [pseud., Emile Chartier]. **Introduction à l'oeuvre gravé de K. X. Roussel.** Suivie d'un essai de catalogue par Jacques Salomon. Paris, Mercure de France, 1968. (CR).

8452. Cousturier, Lucie. **K. X. Roussel.** Paris, Bernheim-Jeune, 1927.

8453. Haus der Kunst (Munich). **Edouard Vuillard, Xavier Roussel.** 16. März-12. Mai 1968. München, Haus der Kunst, 1968.

8454. Kunsthalle Bremen. **Ker-Xavier Roussel, 1867-1944: Gemälde, Handzeichnungen, Druckgraphik.** 26. September bis 21. November 1965. Bremen, Kunsthalle Bremen, 1965.

ROUSSY, ANNE LOUIS GIRODET DE see GIRODET-TRIOSON, ANNE LOUIS

ROWLANDSON, THOMAS, 1756–1827

8455. Baskett, John and Snelgrove, Dudley. **The drawings of Thomas Rowlandson in the Paul Mellon Collection.** London, Barrie & Jenkins, 1977. (CR).

8456. Falk, Bernard. **Thomas Rowlandson; his life and art.** London, Hutchinson, 1949.

8457. Grego, Joseph. **Rowlandson the caricaturist; a selection from his works, with anecdotal descriptions and a sketch of his life.** 2 v. London, Chatto and Windus, 1880.

8458. Hayes, John. **Rowlandson, watercolours and drawings.** London, Phaidon, 1972.

8459. Oppé, Adolf P. **Thomas Rowlandson, his drawings and watercolours.** Edited by Geoffrey Holme. London, The Studio, 1923.

8460. Paulson, Ronald. **Rowlandson, a new interpretation.** London, Studio Vista/New York, Oxford University Press, 1972.

8461. Wark, Robert R. **Drawings by Thomas Rowlandson in the Huntington Collection.** San Marino, Calif., Huntington Library, 1975. (CR).

8462. Wolf, Edward C. **Rowlandson and his illustrations of eighteenth century English literature.** Copenhagen, Munksgaard, 1945.

RUBENS, PETER PAUL, 1577–1640

8463. Adler, Wolfgang. **Landscapes.** London, Miller/Oxford and New York, Oxford University Press, 1982. (Corpus Rubenianum Ludwig Burchard, 18).

8463a. Albertina (Vienna). **Die Rubenszeichnungen der Albertina.** Zum 400. Geburtstag, 30. März bis 12. Juni 1977. Wien, Jugend und Volk, 1977.

8464. Alpers, Svetlana L. **The decoration of the Torre de la Parada.** London/New York, Phaidon, 1971. (CR). (Corpus Rubenianum Ludwig Burchard, 9).

8465. Arents, Prosper. **Geschriften van en over Rubens.** Antwerpen, De Sikkel, 1940.

8466. _____. **Rubens-bibliografie: geschriften van en aan Rubens.** Brussel, De Lage Landen, 1943.

8467. Avermaete, Roger. **Rubens et son temps.** Bruxelles, Arcade, 1977.

8468. Baudouin, Frans. **Pietro Pauolo Rubens.** Anvers, Fonds Mercator, 1977.

8469. Belkin, Kristin L. **The costume book.** Brussels, Arcade, 1980. (CR). (Corpus Rubenianum Ludwig Burchard, 24).

8470. Bell Gallery, List Art Building, Brown University (Providence, R.I.). **Rubenism.** January 30–February 23, 1975. Providence, R.I., Department of Art, Brown University, 1975.

8471. Bernhard, Marianne. **Rubens Handzeichnungen.** München, Südwest Berlag, 1977.

8472. Boussard, Joseph F. **Les leçons de P. P. Rubens; ou, fragments épistolaires sur la religion, la peinture, et la politique.** Bruxelles, Lejeune, 1838.

8473. Burchard, Ludwig and Hulst, Roger A. d'. **Rubens drawings.** 2 v. Brussels, Arcade, 1963. (CR).

8474. Burckhardt, Jakob. **Erinnerungen aus Rubens.** Basel, Lendorff, 1898. (English ed., trans. by Mary Hottinger, R. H. Boothroyd and I. Graefe: New York, Phaidon, 1950; distributed by Oxford University Press).

8475. Cammaerts, Emile. **Rubens, painter and diplomat.** London, Faber, 1932.

8476. Chapin Library, Stetson Hall, Williams College (Williamstown, Mass.). **Rubens and the book: title pages by Peter Paul Rubens.** May 2–31, 1977. Williamstown, Mass., Williams College, 1977.

Corpus Rubenianum Ludwig Burchard: see under names of the authors of the individual volumes.

8477. Dillon, Edward. **Rubens.** London, Methuen, 1909.

8478. Druwé, Robert. **Peter Pauwel Rubens of Adam van Noort?: een inleiding tot het Rubensprobleem.** Tielt, Lannoo, [1951].

8479. Evers, Hans G. **Peter Paul Rubens.** München, Bruckmann, 1942.

8480. Freedberg, David. **Rubens: the Life of Christ after the Passion.** New York, Oxford University Press, 1983. (Corpus Rubenianum Ludwig Burchard, 7).

8481. Geffroy, Gustave. **Rubens, biographie critique.** Paris, Laurens, [1904].

8482. Génard, Pierre. **P. P. Rubens; aanteekeningen over den grooten meester en zijne bloedverwanten.** Antwerpen, Kockx, 1877.

8483. Gerrits, Gerrit E. **Petrus Paulus Rubens, zijn tijd en zijne tijdgenooten.** Amsterdam, Portielje, 1842.

8484. Glück, Gustave. **Rubens, Van Dyck und ihr Kreis.** Wien, Schroll, 1933.

8485. Goeler von Ravensburg, Friedrich. **Rubens und die Antike.** Jena, Costenoble, 1882.

8486. Goris, Jan A. and Held, Julius. **Rubens in America.** New York, Pantheon, 1947.

8487. Hairs, Marie-Louise. **Dans le sillage de Rubens: les peintres d'histoire anversois au XVIIe siècle.** Liège, Université de Liège, 1977. (Bibliothèque de la Faculté de Philosophie et Lettres de l'Université de Liège; Publications exceptionnelles, 4).

8488. Hasselt, André van. **Histoire de P. P. Rubens, suivie du catalogue général et raisonné de ses tableaux, esquisses, dessins et vignettes.** Bruxelles, Société des Beaux-Arts, 1840. (CR).

8489. Haverkamp Begemann, Egbert. **The Achilles series.** London, Phaidon, 1975. (CR). (Corpus Rubenianum Ludwig Burchard, 10).

8490. Held, Julius. **The oil sketches of Peter Paul Rubens.** 2 v. Princeton, N.J., Princeton University Press for the National Gallery of Art, 1980.

8491. _____. **Rubens and his circle; studies.** Princeton, N.J., Princeton University Press, 1982.

8492. _____. **Rubens, selected drawings.** 2 v. London, Phaidon, 1959.

8493. Hourticq, Louis. **Rubens.** Paris, Librairie de l'Art Ancien et Moderne, 1905.

8494. Hubala, Erich, ed. **Rubens; kunstgeschichtliche Beiträge.** Konstanz, Leonhardt, 1979.

8495. Huemer, Francis. **Portraits.** Brussels, Arcade, 1977; distributed by Phaidon, New York. (CR). (Corpus Rubenianum Ludwig Burchard, 19).

8496. Hymans, Henri S. **Histoire de la gravure dans l'école de Rubens.** Bruxelles, Olivier, 1879.

8497. Jaffe, Michael. **Rubens and Italy.** Ithaca, N.Y., Cornell University Press, 1977.

8498. Jamot, Paul. **Rubens.** Paris, Floury, 1936.

8499. Judson, Jay R. and Van de Velde, Carl. **Book illustrations and title-pages.** 2 v. London, Miller/Philadelphia, Heyden, 1978. (CR). (Corpus Rubenianum Ludwig Burchard, 21).

8500. Knackfuss, Hermann. **Rubens.** Trans. by Louise M. Richter. Bielefeld/Leipzig, Velhagen & Klasing/New York, Lemcke & Buechner, 1904. (Monographs on Artists, 9).

8501. Kunsthalle Köln. **Peter Paul Rubens, 1577-1640.** 2 v. 15. Oktober bis 15. Dezember 1977. Köln, Museen der Stadt Köln, 1977.

8502. Kunstsammlung der Universität Göttingen. **Rubens in der Grafik.** 13. Mai-19. Juni 1977. Göttingen, Kunstgeschichtliches Seminar Göttingen, 1977.

8503. Larsen, Erik. **P. P. Rubens.** With a complete catalogue of his works in America. Antwerp, De Sikkel, 1952.

8504. Lehmann, Friedrich R. **Rubens und seine Welt, ein Zeitgemälde des Barock.** Stuttgart, Günther, 1954.

8505. Liess, Reinhard. **Die Kunst des Rubens.** Braunschweig, Waisenhaus, 1977.

8506. Martin, John R. **The ceiling paintings for the Jesuit church in Antwerp.** London/New York, Phaidon, 1968. (CR). (Corpus Rubenianum Ludwig Burchard, 1).

8507. _____. **The decorations for the Pompa introitus Ferdinandi.** London/New York, Phaidon, 1972. (CR). (Corpus Rubenianum Ludwig Burchard, 16).

8508. _____, ed. **Rubens before 1620.** Princeton, N.J., Art Museum, Princeton University, 1972; distributed by Princeton University Press.

8509. Meulen, Marjon van der. **Petrus Paulus Rubens antiquarius: collector and copyist of antique gems.** Alphen aan den Rijn, Canaletto, 1975.

8510. Michel, Emile. **Rubens: his life, his work, and his time.** Trans. by Elizabeth Lee. 2 v. London, Heinemann/New York, Scribner, 1899.

8511. Michel, J. F. M. **Histoire de la vie de P. P. Rubens, chevalier, & seigneur de Steen.** Bruxelles, De Bel, 1771.

8512. Michiels, Alfred. **Rubens et l'école d'Anvers.** Paris, Delahays, 1854.

8513. Musée du Louvre (Paris). **Rubens: ses maîtres, ses élèves; dessins du Musée du Louvre.** 10 février-15 mai 1978. Paris, Ministère de la Culture et de l'Environment/Editions de la Réunion des Musées Nationaux, 1978.

8514. Musées Royaux des Beaux-Arts de Belgique (Brussels). **Le siècle de Rubens.** 15 octobre-12 décembre 1965. Bruxelles, Musées Royaux des Beaux-Arts de Belgique, 1965.

8515. Oldenbourg, Rudolf. **P. P. Rubens: des Meisters Gemälde.** Stuttgart, Deutsche Verlags-Anstalt, 1921. 4 ed.

8516. Palazzo Ducale (Genoa). **Rubens e Genova.** 18 dicembre 1977-12 febbraio 1978. Genova, Palazzo Ducale, 1977.

8517. Palazzo Pitti (Florence). **Rubens e la pittura fiamminga del Seicento nelle collezioni pubbliche fiorentine.** [July 22-October 9, 1977; text in Italian and French]. Firenze, Centro Di, 1977.

8518. Poorter, Nora de. **The Eucharist series.** 2 v. London, Miller/Philadelphia, Heyden, 1978. (CR). (Corpus Rubenianum Ludwig Burchard, 2).

8519. Puyvelde, Leo van. **Les esquisses de Rubens.** Bâle, Holbein, 1940.

8520. _____. **Rubens.** Bruxelles, Meddens, 1964. 2 ed. (Les peintres flamands du XVIIe siècle, 2).

8521. Rooses, Max. **L'oeuvre de P. P. Rubens, histoire et description de ses tableaux et dessins.** 5 v. Anvers, Maes, 1886-1892. (CR).

8522. _____. **Rubens.** Trans. by Harold Child. 2 v. London, Duckworth, 1904.

8523. Rosenberg, Adolf. **P. P. Rubens, des Meisters Gemälde.** Stuttgart/Leipzig, Deutsche Verlags-Anstalt, 1905. (Klassiker der Kunst, 5).

8524. Rowlands, John. **Rubens, drawings and sketches: catalogue of an exhibition at the Department of Prints and Drawings in the British Museum, 1977.** London, Trustees of the British Museum, 1977.

8525. Roy, Jean Joseph van. **Vie de Pierre-Paul Rubens.** Bruxelles, de Mat, 1840.

8526. Royal Museum of Fine Arts (Antwerp). **P. P. Rubens; paintings, oil-sketches, drawings.** 29th June-30th September 1977. Antwerp, Royal Museum of Fine Arts, 1977.

8527. Rubens, Peter P. **Correspondance et documents épistolaires concernant sa vie et ses oeuvres.** [Vol. 1: ed. by Charles Ruelens. Anvers, de Backer, 1887; Vol. 2-3: ed. by Max Rooses and Charles Ruelens. Anvers, Maes, 1898-1900; Vols. 4-6: ed. by Max Rooses and Charles Ruelens. Anvers, Buschmann, 1904-1909]. (Codex Diplomaticus

Rubenianus, 1-6; reprint: Soest (Holland), Davaco, 1973).

8528. _____. Letters. Trans. and ed. by Ruth S. Magurn. Cambridge, Mass., Harvard University Press, 1971. 2 ed.

8529. Sainsbury, William N., ed. Original unpublished papers illustrative of the life of Sir Peter Paul Rubens as an artist and a diplomat. London, Bradbury & Evans, 1859.

8530. Sauerländer, Willibald, et al. Peter Paul Rubens: Werk und Nachruhm. Herausgegeben vom Zentralinstitut für Kunstgeschichte und von den Bayerischen Staatsgemäldesammlungen. [München], Fink, 1981.

8531. Stechow, Wolfgang. Rubens and the classical tradition. Cambridge, Mass., Harvard University Press for Oberlin College, 1968. (Martin Classical Lectures, 22).

8532. Verachter, Frédéric. Généalogie de Pierre Paul Rubens et de sa famille. Anvers, Lacroix, 1840.

8533. Vergara, Lisa. Rubens and the poetics of landscape. New Haven/London, Yale University Press, 1982.

8534. Vlieghe, Hans. Saints. Trans. by P. S. Falla. London/New York, Phaidon, 1973. (CR). (Corpus Rubenianum Ludwig Burchard, 8).

8535. Waagen, Gustav F. Peter Paul Rubens, his life and genius. Trans. by Robert R. Noel. London, Saunders and Otley, 1840.

8536. White, Christopher. Rubens and his world. New York, Viking, 1968.

RUBLEV, ANDREI, 1360/70-1427/30

8537. Alpatov, Mikhail V. Andrei Rublev i ego epokha; sbornik statei. Moskva, Iskusstvo, 1971.

8538. _____. Andrei Rublev, okolo 1370-1430. Moskva, Izobrazitel'noe Iskusstvo, 1972.

8539. Demina, Natal'ia A. Andrei Rublev i khudozhniki ego kruga. Moskva, Nauka, 1972.

8540. Lazarev, Viktor N. Andrej Rublev. [Trans. from the Russian by Ettore Lo Gatto]. Milano, Club del Libro, 1966. (Collana d'arte del Club del Libro, 13).

8541. Lebedewa, Julia A. Andrei Rubljow und seine Zeitgenossen. [Trans. from the Russian by Gerhard Hallmann]. Dresden, Verlag der Kunst, 1962.

8542. Mainka, Rudolf M. Andrej Rublev's Dreifaltigskeitsikone: Geschichte, Kunst, und Sinngehalt des Bildes. Ettal, Buch-Kunstverlag Ettal, 1964.

8543. Pribytkov, Vladimir S. Andrei Rublev. Moskva, Molodaia Gvardiia, 1960.

RUDE, FRANÇOIS, 1784-1855

8544. Bertrand, Alexis. François Rude. Paris, Librairie de l'Art, [1888].

8545. Calmette, Joseph. François Rude. Paris, Floury, 1920.

8546. Fourcaud, Louis de. François Rude, sculpteur; ses oeuvres et son temps, 1784-1855. Paris, Librairie de l'Art Ancien et Moderne, 1904.

RUISDAEL, JACOB ISAACSZOON VAN, 1628-1682

8547. Levey, Michael. Ruisdael: Jacob van Ruisdael and other painters of his family. London, National Gallery, 1977. (Themes and Painters in the National Gallery, Series 2, No. 7).

8548. Michel, Emile. Jacob van Ruysdael et les paysagistes de l'école de Harlem. Paris, Librairie de l'Art, 1890.

8549. Riat, Georges. Ruysdael, biographie critique. Paris, Laurens, [1905].

8550. Rosenberg, Jakob. Jacob van Ruisdael. Berlin, Cassirer, 1928.

8551. Schmidt, Winfried. Studien zur Landschaftskunst Jacob van Ruisdaels: Frühwerke und Wanderjahre. Hildesheim/New York, Olms, 1981. (Studien zur Kunstgeschichte, 15).

8552. Slive, Seymour and Hoetink, H. R. Jacob van Ruisdael. [Published in conjunction with an exhibition at the Fogg Art Museum, Harvard University, Cambridge, Mass., 18 January-11 April 1982]. New York, Abbeville Press, 1981.

RUISDAEL, SALOMON VAN see RUYSDAEL, SALOMON VAN

RUNGE, PHILIPP OTTO, 1777-1810

8553. Aubert, Andreas. Runge und die Romantik. Berlin, Cassirer, 1909.

8554. Berefelt, Gunnar. Philipp Otto Runge: zwischen Aufbruch und Opposition, 1777-1802. Stockholm, Almqvist & Wiksell, 1961. (Stockholm Studies in History of Art, 7).

8555. Betthausen, Peter. Philipp Otto Runge. Leipzig, Seemann, 1980.

8556. Bisanz, Rudolf M. German romanticism and Philipp Otto Runge; a study in nineteenth century art theory and iconography. DeKalb, Ill., Northern Illinois University Press, 1970.

8557. Bohner, Theodor P. Philipp Otto Runge, ein Malerleben der Romantik. Berlin, Frundsberg, 1937.

8558. Böttcher, Otto. Philipp Otto Runge: sein Leben, Wirken und Schaffen. Hamburg, Friederichsen/de Gruyter, 1937.

8559. Grundy, John B. Tieck and Runge; a study in the relationship of literature and art in the Romantic period, with especial reference to "Franz Sternbald." Strassburg, Heitz, 1930. (Studien zur deutschen Kunstgeschichte, 270).

8560. Hamburger Kunsthalle. Runge in seiner Zeit. 21. Oktober 1977 bis 8. January 1978. München, Prestel/Hamburg, Hamburger Kunsthalle, 1977.

8561. Isermeyer, Christian A. **Philipp Otto Runge.** Berlin, Rembrandt, 1940. (Die Kunstbücher des Volkes, 32).

8562. Jensen, Jens C. **Philipp Otto Runge, Leben und Werk.** Köln, DuMont, 1977.

8563. Matile, Heinz. **Die Farbenlehre Philipp Otto Runges; ein Beitrag zur Geschichte der Künstlerfarbenlehre.** München/Mittenwald, Mäander, 1979. 2 ed. (Kunstwissenschaftliche Studientexte, 5).

8564. Richter, Cornelia. **Philipp Otto Runge: Ich weiss eine schöne Blume; Werkverzeichnis der Scherenschnitte.** München, Schirmer/Mosel, 1981. (CR).

8565. Roch, Wolfgang. **Philipp Otto Runges Kunstanschauung und ihr Verhältnis zur Frühromantik.** Strassburg, Heitz, 1909. (Studien zur deutschen Kunstgeschichte, 111).

8566. Runge, Philipp O. **Briefe und Schriften.** Herausgegeben und kommentiert von Peter Betthausen. München, Beck, 1982.

8567. _____. **Hinterlassene Schriften.** Herausgegeben von dessen ältestem Bruder. 2 v. Hamburg, Perthes, 1840-1841.

8568. Schmidt, Paul F. **Philipp Otto Runge, sein Leben und sein Werk.** Leipzig, Insel-Verlag, 1923.

8569. Traeger, Jörg. **Philipp Otto Runge, oder die Geburt einer neuen Kunst.** München, Prestel, 1977.

8570. _____. **Philipp Otto Runge und sein Werk; Monographie und kritischer Katalog.** München, Prestel, 1975. (CR).

RUSCHA, EDWARD, 1937-

8571. Auckland City Art Gallery (Auckland, New Zealand), **Graphic works of Edward Ruscha.** August to October 1978. Auckland, Auckland City Art Gallery, 1978.

8572. Ruscha, Edward. **Guacamole Airlines and other drawings.** New York, Abrams, 1980.

8573. San Francisco Museum of Modern Art. **The works of Edward Ruscha.** March 25-May 23, 1982. New York, Hudson Hills Press in association with the San Francisco Museum of Art, 1982; distributed by Viking, New York.

RUSH, WILLIAM, 1756-1833

8574. Marceau, Henri. **William Rush, 1756-1833, the first native American sculptor.** Philadelphia, Pennsylvania Museum of Art, 1937.

8575. Pennsylvania Academy of the Fine Arts (Philadelphia). **William Rush, American sculptor.** June 20-November 21, 1982. Philadelphia, Pennsylvania Academy of the Fine Arts, 1982.

RUSSOLO, LUIGI, 1885-1947

8576. Ca' Corner della Regina (Venice). **Russolo/L'arte dei rumori, 1913-1931.** 15 ottobre-20 novembre 1977. Venezia, Tipografia Emiliana, 1977. (La Biennale di Venezia, Archivio storico delle arti contemporanee, 3).

8577. Russolo, Luigi. **L'arte dei rumori: manifesto futurista.** Milano, Poesia, 1916.

RUYSCH, RACHEL, 1664-1750

8578. Grant, Maurice H. **Rachel Ruysch, 1664-1750.** Leigh-on-Sea, Lewis, 1956.

RUYSDAEL, SALOMON VAN, 1600-1670

8579. Stechow, Wolfgang. **Salomon van Ruysdael: eine Einführung in seine Kunst, mit kritischem Katalog der Gemälde.** Berlin, Mann, 1975. 2 ed. (CR).

RYDER, ALBERT PINKHAM, 1847-1917

8580. Goodrich, Lloyd. **Albert P. Ryder.** New York, Braziller, 1959.

8581. Price, Frederic N. **Ryder (1847-1917); a study of appreciation.** New York, Rudge, 1932.

8582. Sherman, Frederic F. **Albert Pinkham Ryder.** New York, Sherman, 1920.

8583. Whitney Museum of American Art (New York). **Albert P. Ryder, centenary exhibition.** October 18 to November 30, 1947. [Text by Lloyd Goodrich]. New York, Whitney Museum of American Art, 1947.

SAARINEN, EERO, 1910-1961

ELIEL, 1873-1950

8584. Christ-Janer, Albert. **Eliel Saarinen: Finnish-American architect and educator.** Foreword by Alvar Aalto. Chicago, University of Chicago Press, 1979. 2 ed.

8585. Saarinen, Aline B., ed. **Eero Saarinen on his work; a selection of buildings dating from 1947 to 1964, with statements by the architect.** New Haven, Yale University Press, 1968. 2 ed.

8586. Saarinen, Eliel. **The city: its growth, its decay, its future.** New York, Reinhold, 1943.

8587. _____. **Search for form, a fundamental approach to art.** New York, Reinhold, 1948.

8588. Spade, Rupert. **Eero Saarinen.** Photographs by Yukio Futagawa. New York, Simon & Schuster, 1971.

8589. Temko, Allan. **Eero Saarinen.** New York, Braziller, 1962.

SAFTLEVEN, CORNELIS, 1607-1681

HERMAN, 1609-1685

8590. Schultz, Wolfgang. **Cornelis Saftleven, 1607-1681; Leben und Werke.** Mit einem kritischen Katalog der Gemälde und Zeichnungen. Berlin/New York, de Gruyter, 1978. (CR). (Beiträge zur Kunstgeschichte, 14).

8591. _____. **Herman Saftleven, 1609-1685: Leben und Werke.**
Mit einem kritischen Katalog der Gemälde und Zeichnungen.
Berlin/New York, de Gruyter, 1982. (CR). (Beiträge zur
Kunstgeschichte, 18).

SAINT-AUBIN, AUGUSTIN DE, 1736-1807

GABRIEL JACQUES DE, 1724-1780

8592. Bocher, Emmanuel. **Augustin de Saint-Aubin.** Paris, Morgand
et Fatout, 1879. (CR). (Les gravures françaises du
XVIII^e siècle, 5).

8593. Dacier, Emile. **Gabriel de Saint-Aubin, peintre,
dessinateur et graveur (1724-1780); l'homme et l'oeuvre;
catalogue raisonné.** 2 v. Paris/Bruxelles, van Oest,
1929-1931. (CR).

8594. Davidson Art Center, Wesleyan University (Middletown,
Conn.). **Prints and drawings by Gabriel de Saint-Aubin,
1724-1780.** March 7-April 13, 1975. Middletown, Conn.,
Davidson Art Center, Wesleyan University, 1975.

8595. Moreau, Adrien. **Les Saint-Aubin.** Paris, Librairie de
l'Art, [1894].

SAINT-GAUDENS, AUGUSTUS, 1848-1907

8596. Cortissoz, Royal. **Augustus Saint-Gaudens.** Boston,
Houghton Mifflin, 1907.

8597. Dryfhout, John H. **The work of Augustus Saint-Gaudens.**
Hanover, N.H./London, University Presses of New England,
1982. (CR).

8598. Hind, Charles L. **Augustus Saint-Gaudens.** London, Lane,
1908.

8599. Saint-Gaudens, Augustus. **Reminiscences.** Edited and
amplified by Homer Saint-Gaudens. 2 v. New York,
Century, 1913. (Reprint: New York, Garland, 1976).

8600. Tharp, Louise H. **Saint-Gaudens and the Gilded Era.**
Boston, Little, Brown, 1969.

SAKONIDES, 6th c. B.C.

8601. Rumpf, Andreas. **Sakonides.** Leipzig, Keller, 1937.
(Bilder griechischer Vasen, 11).

SALIMBENI, JACOPO, d. ca. 1427

LORENZO, 1374-ca. 1419

8602. Rossi, Alberto. **I Salimbeni.** Milano, Electa, 1976.

8603. Zampetti, Pietro. **Gli affreschi di Lorenzo e Jacopo
Salimbeni nell'Oratorio di San Giovanni di Urbino.**
Urbino, Istituto Statale d'Arte di Urbino, 1956.
(Collana di studi archeologici ed artistici marchigiani,
6).

SALOMON, ERICH, 1866-1944

8604. Hunter-Salomon, Peter. **Erich Salomon.** Millerton, N.Y.,
Aperture, 1978. (Aperture History of Photography, 10).

8605. Salomon, Erich. **Berühmte Zeitgenossen in unbewachten
Augenblicken.** Stuttgart, Engelhorns, 1931. (New ed.:
München, Schirmer/Mosel, 1978).

8606. _____. **Portrait of an age.** Selected by Hans de Vries and
Peter Hunter-Salomon. Biography and notes by Peter
Hunter-Salomon. Trans. by Sheila Tobias. New York,
Macmillan, 1967.

SÁNCHEZ-COELLO, ALONSO, d. 1588

8607. Hispanic Society of America. **Sánchez Coello.** New York,
Trustees of the Hispanic Society, 1927.

8608. San Román y Fernandez, Francisco de. **Alonso Sánchez
Coello, ilustraciones a su biografia.** Lisboa, Amigos do
Museu Nacional de Arte Antiga, 1938.

SANDBERG, RAGNAR GÖSTA LEOPOLD, 1902-1972

8609. Linde, Ulf. **Ragnar Sandberg.** [Stockholm], Sveriges
Allmänna Konstförening, 1979. (Sveriges Allmänna
Konstförening, 88).

8610. Mörner, Stellan. **Ragnar Sandberg.** Stockholm, Forum, 1950.
(Forums små konstböcker).

8611. Sandberg, Ragnar. **Anteckningar.** Göteborg, Palettens
Skriftserie, 1953. (Palettens skriftserie, 4).

SANDBY, PAUL, 1725-1809

THOMAS, 1721-1798

8612. Faigen, Julian. **Paul Sandby drawings.** [Published in con-
junction with an exhibition at the City of Hamilton Art
Gallery, Hamilton, Australia, October 3-October 25, 1981,
and other places]. Sydney, Australian Gallery Directors'
Council, 1981.

8613. Oppé, Adolf P. **The drawings of Paul and Thomas Sandby in
the collection of His Majesty the King at Windsor Castle.**
Oxford/London, Phaidon, 1947.

8614. Sandby, William. **Thomas and Paul Sandby, Royal Academians;
some account of their lives and works.** London, Seeley,
1892.

SANDER, AUGUST, 1876-1964

8615. Newhall, Beaumont and Kramer, Robert. **August Sander:
photographs of an epoch, 1904-1959.** [Published in con-
junction with an exhibition at the Philadelphia Museum
of Art, March 1-April 27, 1980, and other places].
Millerton, N.Y., Aperture, 1980.

8616. Sander, August. **Antlitz der Zeit:** sechzig Aufnahmen
deutscher Menschen des 20. Jahrhunderts. Mit einer
Einleitung von Alfred Döblin. München, Transmare Verlag,
1929.

8617. _____. Rheinlandschaften: Photographien 1929-1946. Mit einem Text von Wolfgang Kemp. München, Schirmer/Mosel, 1975.

8618. Von Hartz, John. **August Sander.** Millerton, N.Y., Aperture, 1977. (Aperture History of Photography, 7).

SANDERS VAN HEMESSEN, JAN, 16th c.

8619. Graefe, Felix. **Jan Sanders von Hemessen und seine Identification mit dem Braunschweiger Monogrammisten.** Leipzig, Hiersemann, 1909. (Kunstgeschichtliche Monographien, 13).

SANDRART, JOACHIM VON, 1606-1688

8620. Kutter, Paul. **Joachim von Sandrart als Künstler, nebst Versuch eines Katalogs seiner noch vorhandenen Arbeiten.** Strassburg, Heitz, 1907. (Studien zur deutschen Kunstgeschichte, 83).

8621. Sandrart, Joachim von. **L'Academia todesca dell' architectura, scultura et pictura: oder Teutsche Academie der edlen Bau-, Bild-, und Mahlerey-Künste.** Nürnberg, Sandrart/Frankfurt, Merian, 1675.

8622. _____. **Der Teutschen Academie zweyter und letzter Haupt-Teil, von der edlen Bau-, Bild- und Mahlerey-Künste.** Nürnberg, Endtern/Frankfurt, Sandrart, 1679.

SANGALLO, ANTONIO DA, the elder, 1455-1535

ANTONIO DA, the younger, 1483-1546

GIULIANO DA, 1445-1516

8623. Clausse, Gustave. **Les San Gallo, architectes, peintres, sculpteurs, médailleurs, XV et XVI siècles.** 3 v. Paris, Leroux, 1900-1902.

8624. Fabriczy, Cornelius von. **Die Handzeichnungen Giulianos da San Gallo; kritisches Verzeichnis.** Stuttgart, Gerschel, 1902. (CR).

8625. Falb, Rodolfo. **Il taccuino senese di Giuliano da San Gallo.** Siena, Marzocchi, 1899.

8626. Giovannoni, Gustavo. **Antonio da Sangallo il giovane.** 2 v. Roma, Tipografia Regionale, 1959.

8627. Huelsen, Cristiano. **Il libro di Giuliano da Sangallo, con introduzione e note.** 2 v. Lipsia, Harrassowitz, 1910. (Codices e Vaticanis selecti, 11).

8628. Loukomski, Georgii K. **Les Sangallo.** Paris, Vincent, Fréal, 1934.

8629. Marchini, Giuseppe. **Giuliano da Sangallo.** Firenze, Sansoni, 1942. (Monographie e studi a cura dell' Istituto di Storia dell'Arte, Reale Università di Firenze, 3).

8630. Severini, Giancarlo. **Architetture militari di Giuliano da Sangallo.** Pisa, Istituto di Architettura e Urbanistica dell'Università di Pisa, 1970.

SANMICHELI, MICHELE, 1484-1559

8631. Fiocco, Giuseppe, et al. **Michele Sanmicheli: studi raccolti dall'Accademia di Agricoltura, Scienze e Lettere di Verona per la celebrazione del IV centenario della morte.** Verona, Valdonega, 1960.

8632. Langenskiöld, Eric. **Michel Sanmicheli, the architect of Verona; his life and works.** Uppsala (Sweden), Almqvist & Wiksell, 1938. (CR). (Uppsala studier i arkeologi och konsthistoria, 1).

8633. Palazzo Canossa (Verona). **Michel Sanmicheli.** Maggio-ottobre 1960. Catalogo a cura di Piero Gazzola. Venezia, Pozza, 1960.

8634. Pompei, Alessandro. **Li cinque ordini dell'architettura civile di Michel Sanmicheli rilevati dalle sue fabriche, e descritti e publicati con quelli di Vitruvio, Alberti, Palladio, Scamozzi, Serlio, e Vignola.** Verona, Vallarsi, 1735.

8635. Puppi, Lionello. **Michele Sanmicheli, architetto di Verona.** Padova, Marsilio, 1971.

8636. Ronzani, Francesco e Luciolli, Gerolamo. **Le fabbriche civile, ecclesiastiche e militari di Michele Sanmicheli.** Verona, Moroni, 1823. (New ed., with textual notes by Francesco Zanotto: Torino, Basadonna, 1862).

SANO DI PIETRO, 1406-1481

8637. Gaillard, Emile. **Un peintre siennois aux XV siècle, Sano di Pietro, 1406-1481.** Chambéry, Dardel, 1923.

8638. Trübner, Jörg. **Die stilistische Entwicklung der Tafelbilder des Sano di Pietro, 1405-1481.** Strassburg, Heitz, 1925. (Etudes sur l'art de tous les pays et de toutes les époques, 6).

SANSOVINO, ANDREA, 1460-1529

8639. Huntley, George H. **Andrea Sansovino, sculptor and architect of the Italian Renaissance.** Cambridge, Mass., Harvard University Press, 1935.

8640. Schönfeld, Paul. **Andrea Sansovino und seine Schule.** Stuttgart, Metzler, 1881.

SANSOVINO, JACOPO TATTI, 1486-1570

8641. Howard, Deborah. **Jacopo Sansovino: architecture and patronage in Renaissance Venice.** New Haven, Yale University Press, 1975.

8642. Lorenzetti, Giulia. **Itinerario Sansoviniano a Venezia.** Venezia, Comitato per le Onoranze Sansoviniane, 1929.

8643. Mariacher, Giovanni. **Il Sansovino.** Milano, Mondadori, 1962. (Biblioteca moderna Mondadori, 717).

8644. Pittoni, Laura. **Jacopo Sansovino, scultore.** Venezia, Istituto Veneto di Arti Grafiche, 1909.

8645. Sapori, Francesco. **Jacopo Tatti, detto il Sansovino.** Roma, Libreria dello Stato, 1928.

8646. Tafuri, Manfredo. **Jacopo Sansovino e l'architettura del '500 a Venezia.** Fotografie di Diego Birelli. Padova, Marsilio, 1972. 2 ed.

8647. Weihrauch, Hans R. **Studien zum bildernischen Werke des Jacopo Sansovino.** Strassburg, Heitz, 1935. (Zur Kunstgeschichte des Auslandes, 135).

SANTINI AICHL, JAN BLAŽEJ, 1677-1723

8648. Muzeum Knihy (Saar). **Průvodce expozici Jan Santini.** Ve Žd'áru nad Sázavou, Okr. památková správa, 1977.

SANZIO, GIOVANNI, 1435-1494

see also RAPHAEL

8649. Schmarsow, August. **Giovanni Santi, der Vater Raphaels.** Berlin, Haack, 1887.

SARGENT, JOHN SINGER, 1856-1925

8650. Charteris, Evan E. **John Sargent.** New York, Scribner, 1927.

8651. Coe Kerr Gallery (New York). **John Singer Sargent, his own work.** May 28-June 27, 1980. New York, Coe Kerr Gallery/Wittenborn, 1980.

8652. Corcoran Gallery of Art (Washington, D.C.). **John Singer Sargent: drawings from the Corcoran Gallery of Art.** [Text by Edward J. Nygren]. Washington, D.C., Smithsonian Institution and Corcoran Gallery of Art, 1983.

8653. Downes, William H. **John S. Sargent, his life and work.** Boston, Little Brown, 1925.

8654. Lomax, James and Ormond, Richard. **John Singer Sargent and the Edwardian age.** [Published in conjunction with an exhibition at the Leeds Art Galleries at Lotherton Hall, Leeds, 5 April to 10 June 1979, and other places]. Leeds, Leeds Art Galleries/London, National Portrait Gallery, 1979.

8655. McKibbin, David. **Sargent's Boston, with an essay & biographical summary & a complete checklist of Sargent's portraits.** [Published in conjunction with a centennial exhibition at the Museum of Fine Arts, Boston]. Boston, Museum of Fine Arts, 1956.

8656. Metropolitan Museum of Art (New York). **Memorial exhibition of the work of John Singer Sargent.** January 4-February 14, 1926. New York, Metropolitan Museum of Art, 1926.

8657. Meynell, Alice C. **The work of John S. Sargent, R. A.** London, Heinemann, 1903.

8658. Mount, Charles M. **John Singer Sargent, a biography.** New York, Norton, 1955.

8659. Ormond, Richard. **John Singer Sargent: paintings, drawings, watercolors.** New York, Harper & Row, 1970.

8660. Ratcliff, Carter. **John Singer Sargent.** New York, Abbeville Press, 1982.

SARTO, ANDREA DEL, 1486-1531

8661. Biadi, Luigi. **Notizie inedite della vita d'Andrea del Sarto raccolte da manoscritti e documenti autentici.** Firenze, Bonducciana, 1829.

8662. Comandè, Giovanni B. **Introduzione allo studio dell'arte di Andrea del Sarto.** Palermo, Palumbo, 1952.

8663. Fraenckel, Ingeborg. **Andrea del Sarto; Gemälde und Zeichnungen.** Strassburg, Heitz, 1935. (Zur Kunstgeschichte des Auslandes, 136).

8664. Freedberg, Sydney J. **Andrea del Sarto.** 2 v. Cambridge, Mass., Harvard University Press, 1963. (CR).

8665. Guinness, H. **Andrea del Sarto.** London, Bell, 1899.

8666. Knapp, Fritz. **Andrea del Sarto.** Bielefeld/Leipzig, Velhagen & Klasing, 1907. (Künstler-Monographien, 90).

8667. Monti, Raffaele. **Andrea del Sarto.** Milano, Edizioni di Comunità, 1965. (Studi e documenti di storia dell'arte, 8).

8668. Reumont, Alfred. **Andrea del Sarto.** Leipzig, Brockhaus, 1835.

8669. Shearman, John. **Andrea del Sarto.** 2 v. New York, Oxford University Press, 1965.

8670. Sricchia Santoro, Fiorella. **Andrea del Sarto.** Milano, Fabbri, 1964. (I maestri del colore, 53).

SASSETTA, 1392-1450

8671. Berenson, Bernard. **A Sienese painter of the Franciscan legend.** London, Dent, 1910.

8672. Carli, Enzo. **Sassetta e il Maestro dell'Osservanza.** Milano, Martello, 1957.

8673. Pope-Hennessy, John. **Sassetta.** London, Chatto & Windus, 1939.

SAVOLDO, GIOVANNI GIROLAMO, 1480-1548

8674. Boschetto, Antonio. **Giovanni Girolamo Savoldo.** Milano, Bramante, 1963.

8675. Gilbert, Creighton. **The works of Girolamo Savoldo.** 2 v. Ann Arbor, Mich., University Microfilms, 1962. (CR).

SCAMOZZI, VINCENZO, 1552-1616

8676. Barbieri, Franco. **Vincenzo Scamozzi.** Vicenza, Cassa di Risparmio di Verona e Vicenza, 1952.

8677. Donin, Richard K. **Vincenzo Scamozzi und der Einfluss Venedigs auf die Salzburger Architektur.** Innsbruck, Rohrer, 1948.

8678. Scamozzi, Vincenzo. **Discorsi sopra l'anticità di Roma.** Venezia, Ziletti, 1582.

8679. _____. L'idea della architettura universale. Venezia,
Valentino, 1615. (Reprint: Ridgewood, N.J., Gregg,
1964).

8680. _____. Taccuino di viaggio da Parigi a Venezia, 14 marzo-
11 maggio 1600. Edizioni e commento a cura di Franco
Barbieri. Venezia, Istituto per la Collaborazione
Culturale, 1959.

SCHADOW, JOHANN GOTTFRIED, 1764-1850

8681. Kaiser, Konrad. Gottfried Schadow als Karikaturist.
Dresden, Verlag der Kunst, 1955.

8682. Mackowsky, Hans. Johann Gottfried Schadow, Jugend und
Aufstieg, 1764 bis 1797. Berlin, Grote, 1927.

8683. _____. Schadows Graphik. Berlin, Deutscher Verein für
Kunstwissenschaft, 1936. (Forschungen zur deutschen
Kunstgeschichte, 19).

8684. Nemitz, Fritz. Gottfried Schadow der Zeichner. Berlin,
Mann, 1937.

8685. Schadow, Johann G. Aufsätze und Briefe. Nebst einem
Verzeichnis seiner Werke zur hundertjährigen Feier seiner
Geburt, 20. Mai 1764. Herausgegeben von Julius
Friedlaender. Stuttgart, Ebner & Seubert, 1890. 2 ed.
(See following for reprint).

8686. _____. Kunst-Werke und Kunst-Ansichten. Berlin, Decker,
1849. (Both reprinted in one vol.: Berlin, Seitz, 1980).

8687. Staatliche Museen zu Berlin, Nationalgalerie. Johann
Gottfried Schadow, 1764-1850: Bildwerke und Zeichnungen.
Oktober 1964 bis März 1965. Berlin, Staatliche Museen zu
Berlin, Nationalgalerie, 1964.

SCHAEUFELEIN, HANS LEONARD, 1490-1540

see also KULMBACH, HANS SUESS VON

8688. Oldenbourg, Consuelo. Die Buchholzschnitte des Hans
Schäufelein, ein bibliographisches Verzeichnis ihrer
Verwendungen. 2 v. Baden-Baden/Strasbourg, Heitz, 1964.
(CR). (Studien zur deutschen Kunstgeschichte, 340/341).

8689. Thieme, Ulrich. Hans Leonhard Schaeufeleins malerische
Thätigkeit. Leipzig, Seemann, 1892. (Beiträge zur
Kunstgeschichte, Neue Folge, 16).

SCHAFFNER, MARTIN, 16th c.

8690. Pückler-Limpurg, Siegfried G. Martin Schaffner.
Strassburg, Heitz, 1899. (Studien zur deutschen
Kunstgeschichte, 20).

8691. Ulmer Museum. Martin Schaffner, Maler zu Ulm.
20. September bis 15. November, 1959. Ulm, Ulmer
Museum, 1959. (Schriften des Ulmer Museums, Neue Folge,
2).

SCHAROUN, HANS, 1893-1972

8692. Akademie der Künste (Berlin). Hans Scharoun. 5. März-
30. April 1967. Berlin, Akademie der Künste, 1967.

8693. Pfankuch, Peter, ed. Hans Scharoun; Bauten, Entwürfe,
Texte. Berlin, Mann, [1974]. (Schriftenreihe der
Akademie der Künste, 10).

SCHEFFER, ARY, 1795-1858

8694. Grote, Harriet L. Memoir of the life of Ary Scheffer.
London, Murray, 1860.

8695. Institut Néerlandais (Paris). Ary Scheffer, 1795-1858:
dessins, aquarelles, esquisses à l'huile. 16 octobre-
30 novembre 1980. Paris, Institut Néerlandais, 1980.

8696. Kolb, Marthe. Ary Scheffer et son temps, 1795-1858.
Paris, Boivin, 1937.

8697. Wellicz, Léopold. Les amis romantiques: Ary Scheffer et
ses amis polonais. Paris, Trianon, 1933.

SCHIELE, EGON, 1890-1918

8698. Comini, Alessandra. Egon Schiele's portraits. Berkeley,
University of California Press, 1974.

8699. _____. Schiele in prison. Greenwich, Conn., New York
Graphic Society, 1973.

8700. Kallir, Otto. Egon Schiele, the graphic work. [Text in
German and English]. New York, Crown, 1970. (CR).

8701. _____. Egon Schiele, Oeuvre-Katalog der Gemälde. [Text
in German and English]. Wien, Zsolnay, 1966. (CR).

8702. Leopold, Rudolf. Egon Schiele: paintings, watercolors,
drawings. Trans. by Alexander Lieven. London, Phaidon,
1973. (CR).

8703. Malafarina, Gianfranco. L'opera di Schiele. Milano,
Rizzoli, 1982. (CR). (Classici dell'arte, 105).

8704. Mitsch, Erwin. The art of Egon Schiele. Trans. by W.
Keith Haughan. London, Phaidon, 1975.

8705. Nebehay, Christian M. Egon Schiele, 1890-1918: Leben,
Briefe, Gedichte. Salzburg/Wien, Residenz, 1979.

8706. Roessler, Arthur. Erinnerungen an Egon Schiele.
Wien/Leipzig, Konegen, 1922. (New ed.: Wien, Wiener
Volksbuchverlag, 1948).

8707. Sabarsky, Serge. Egon Schiele, watercolors and drawings.
New York, Abbeville Press, 1983.

8708. Schiele, Egon. Briefe und Prosa. Herausgegeben von Arthur
Roessler. Wien, Lányi, 1921.

8709. _____. A sketchbook. Commentary by Otto Kallir. 2 v.
New York, Johannes Press, 1967.

8710. Whitford, Frank. Egon Schiele. New York, Oxford
University Press, 1981.

8711. Wilson, Simon. Egon Schiele. Oxford, Phaidon, 1980.

SCHINDLER, EMIL JAKOB, 1842-1892

8712. Fuchs, Heinrich. **Emil Jakob Schindler: Zeugnisse eines ungewöhnlichen Kunstlebens; Werkkatalog.** Wien, Fuchs, 1970. (CR).

SCHINKEL, KARL FRIEDRICH, 1781-1841

8713. Brües, Eva. **Die Rheinlande.** Berlin, Deutscher Kunstverlag, 1968. (Karl Friedrich Schinkel. Das Lebenswerk).

8714. Forssman, Erik. **Karl Friedrich Schinkel: Bauwerke und Baugedanken.** München/Zürich, Schnell & Steiner, 1981.

8715. Grisebach, August. **Carl Friedrich Schinkel.** Leipzig, Insel-Verlag, 1924. (New ed.: München, Piper, 1981).

8716. Kania, Hans. **Mark Brandenburg.** Berlin, Deutscher Kunstverlag, 1960. (Karl Friedrich Schinkel. Das Lebenswerk).

8717. _____. **Potsdam, Staats- und Bürgerbauten.** Berlin, Deutscher Kunstverlag, 1939. (Karl Friedrich Schinkel. Das Lebenswerk).

8718. Kugler, Franz. **Karl Friedrich Schinkel: eine Charakteristik seiner künstlerischen Wirksamkeit.** Berlin, Gropius, 1842.

8719. Lorck, Carl von. **Karl Friedrich Schinkel.** Berlin, Rembrandt, 1939.

8720. Ohff, Heinz. **Karl Friedrich Schinkel.** Berlin, Stapp, 1981.

8721. Orangerie des Schlosses Charlottenburg. **Karl Friedrich Schinkel: Architektur, Malerei, Kunstgewerbe.** 13. März bis 13. September 1981. Charlottenburg, Verwaltung der Staatlichen Schlösser und Gärten, 1981.

8722. Peschken, Goerd. **Das architektonische Lehrbuch.** München/Berlin, Deutscher Kunstverlag, 1979. (Karl Friedrich Schinkel. Das Lebenswerk).

8723. Posener, Julius, ed. **Festreden: Schinkel zu Ehren, 1846-1980.** Berlin, Architekten- und Ingenieur-Verein zu Berlin, [1981].

8724. Pundt, Hermann G. **Schinkel's Berlin: a study in environmental planning.** Cambridge, Mass., Harvard University Press, 1972.

8725. Rave, Paul O. **Berlin.** 3 v. Berlin, Deutscher Kunstverlag, 1941-62. (CR). (Reprint, ed. by Margarete Kühn: München/Berlin, Deutscher Kunstverlag, 1981; Karl Friedrich Schinkel. Das Lebenswerk).

8726. Schinkel, Karl F. **Aus Schinkel's Nachlass: Reisetagebücher, Briefe und Aphorismen.** Mitgetheilt und mit einem Verzeichniss sämtlicher Werke Schinkel's versehen. 4 v. Berlin, Decker, 1862-1864.

8727. _____. **Reisen nach Italien: Tagebücher, Briefe, Zeichnungen, Aquarelle.** Herausgegeben von Gottfried Riemann. Berlin, Rütten & Loening, 1979.

8728. _____. **Sammlung architektonischer Entwürfe.** Berlin, Ernst & Korn, 1866. (Reprint: Chicago, Exedra, 1981).

8729. Schreiner, Ludwig. **Westfalen.** München/Berlin, Deutscher Kunstverlag, 1969. (Karl Friedrich Schinkel. Das Lebenswerk).

8730. Sievers, Johannes. **Die Arbeiten von Karl Friedrich Schinkel für Prinz Wilhelm, späteren König von Preussen.** Berlin, Deutscher Kunstverlag, 1955. (Karl Friedrich Schinkel. Das Lebenswerk).

8731. _____. **Bauten für die Prinzen August, Friedrich und Albrecht von Preussen; ein Beitrag zur Geschichte der Wilhelmstrasse in Berlin.** Berlin, Deutscher Kunstverlag, 1954. (Karl Friedrich Schinkel. Das Lebenswerk).

8732. _____. **Die Möbel.** Berlin, Deutscher Kunstverlag, 1950. (Karl Friedrich Schinkel. Das Lebenswerk).

8733. Springer, Peter. **Schinkels Schlossbrücke in Berlin: Zweckbau und Monument.** Wien, Propyläen, 1981.

8734. Vogel, Hans. **Pommern.** Berlin, Deutscher Kunstverlag, 1952. (Karl Friedrich Schinkel. Das Lebenswerk).

8735. Volk, Waltraud, ed. **Karl Friedrich Schinkel; sein Wirken als Architekt.** Ausgewählte Bauten in Berlin und Potsdam im 19. Jahrhundert. Berlin, Verlag für Bauwesen, 1981.

8736. Wolzogen, Alfred von. **Schinkel als Architekt, Maler und Kunstphilosoph; ein Vortrag.** Berlin, Ernst & Korn, 1864.

8737. Zadow, Mario. **Karl Friedrich Schinkel.** Berlin, Rembrandt, 1980.

8738. Ziller, Hermann. **Schinkel.** Bielefeld/Leipzig, Velhagen & Klasing, 1897. (Künstler-Monographien, 28).

SCHJERFBECK, HELENA SOFIA, 1862-1946

8739. Ahtela, H. [pseud., Einar Reuter]. **Helena Schjerfbeck.** Stockholm, Råben & Sjögren, 1953.

8740. Appelberg, Hanna och Appelberg, Eilif. **Helene Schjerfbeck, en biografisk konturteckning.** Helsingfors, Söderström, 1949.

SCHLAUN, JOHANN CONRAD, 1695-1773

8741. Hartmann, Heinrich. **Johann Conrad Schlaun; sein Leben und seine Bautätigkeit.** Münster, Coppenrath, 1910.

8742. Kunsthalle Bielefeld. **Johann Conrad Schlaun, 1695-1773; Baukunst des Barock.** 16. März-11. Mai 1975. Bielefeld, Kunsthalle Bielefeld, 1975.

8743. Landesmuseum Münster. **Johann Conrad Schlaun, 1695-1773: Ausstellung zu seinem 200. Todestag.** 2 v. 21. Oktober-30. Dezember 1973. Münster, Landesmuseum Münster, 1973.

8744. Rensing, Theodor. **Johann Conrad Schlaun, Leben und Werk des westfälischen Barockbaumeisters.** München/Berlin, Deutscher Kunstverlag, 1954.

SCHLEMMER, OSKAR, 1888-1943

8745. Grohmann, Will. **Oskar Schlemmer: Zeichnungen und Graphik; Oeuvrekatalog.** Stuttgart, Hatje, 1965. (CR).

8746. Herzogenrath, Wulf. **Oskar Schlemmer: die Wandgestaltung der neuen Architektur.** München, Prestel, 1973.

8747. Hildebrandt, Hans. **Oskar Schlemmer.** München, Prestel, 1952.

8748. Maur, Karin von. **Oskar Schlemmer.** 2 v. München, Prestel, 1979. (CR).

8749. Schlemmer, Oskar. **The letters and diaries of Oskar Schlemmer.** Selected and edited by Tut Schlemmer. Trans. by Krishna Winston. Middletown, Conn., Wesleyan University Press, 1972.

8750. _____. **Man: teaching notes from the Bauhaus.** Ed. by Heimo Kuchling. Trans. by Janet Seligman. Cambridge, Mass., MIT Press, 1971.

8751. Staatsgalerie Stuttgart. **Oskar Schlemmer.** 11. August bis 18. September 1977. Stuttgart, Württembergischer Kunstverein Stuttgart, 1977.

SCHLÜTER, ANDREAS, 1664-1714

8752. Benkard, Ernst. **Andreas Schlüter.** Frankfurt am Main, Iris, 1925.

8753. Gurlitt, Cornelius. **Andreas Schlüter.** Berlin, Wasmuth, 1891.

8754. Ladendorf, Heinz. **Andreas Schlüter.** Berlin, Rembrandt, 1937.

SCHMIDT-ROTTLUFF, KARL, 1884-1976

8755. Brix, Karl. **Karl Schmidt-Rottluff.** Wien/München, Schroll, 1972.

8756. Grohmann, Will. **Karl Schmidt-Rottluff.** Stuttgart, Kohlhammer, 1956.

8757. Kunstverein Braunschweig. **Karl Schmidt-Rottluff: Werke, 1905-1961.** 16. Dezember 1979-27. Januar 1980. Braunschweig, Kunstverein Braunschweig, 1979.

8758. Thiem, Gunther. **Karl Schmidt-Rottluff, Aquarelle und Zeichnungen.** München, Bruckmann, 1963.

8759. Valentiner, Wilhelm R. **Schmidt-Rottluff.** Leipzig, Klinkhardt & Biermann, 1920. (Junge Kunst, 16).

8760. Wietek, Gerhard. **Schmidt-Rottluff Graphik.** München, Thiemig, 1971.

SCHNORR VON CAROLSFELD, JULIUS, 1794-1872

8761. Nowald, Inken. **Die Nibelungenfresken von Julius Schnorr von Carolsfeld im Königsbau der Münchner Residenz, 1827-1867.** Kiel, Kunsthalle zu Kiel, 1978. (Schriften der Kunsthalle zu Kiel, 3).

8762. Schnorr von Carolsfeld, Julius. **Bible pictures.** With letter-press descriptions by John Tatlock. Boston, Carter & Karrick, 1888.

8763. _____. **Briefe aus Italien geschrieben in den Jahren 1817 bis 1827.** Gotha, Perthes, 1886.

8764. _____. **Das Nibelungen-Lied nach den Fresko-Gemälden.** Photographiert von Josef Albert. [Text by H. Holland]. München, Albert, [1868].

8765. Singer, Hans W. **Julius Schnorr von Carolsfeld.** Bielefeld/Leipzig, Velhagen & Klasing, 1911. (Künstler-Monographien, 103).

SCHONGAUER, MARTIN, 1430/50-1491

8766. Baum, Julius. **Martin Schongauer.** Wien, Schroll, 1948.

8767. Bernhard, Marianne. **Martin Schongauer und sein Kreis: Druckgraphik, Handzeichnungen.** München, Südwest, 1980.

8768. Buchner, Ernst. **Martin Schongauer als Maler.** Berlin, Deutscher Verein für Kunstwissenschaft, 1941.

8769. Champion, Claude. **Schongauer.** Paris, Alcan, 1925.

8770. Flechsig, Eduard. **Martin Schongauer.** Strasbourg, Heitz, 1951.

8771. Girodie, André. **Martin Schongauer et l'art du Haut-Rhin au XVe siècle.** Paris, Plon, [1911].

8772. Rosenberg, Jakob. **Martin Schongauer, Handzeichnungen.** München, Piper, 1923.

8773. Shestack, Alan. **The complete engravings of Martin Schongauer.** New York, Dover, 1969.

8774. Wendland, Hans. **Martin Schongauer als Kupferstecher.** Berlin, Meyer, 1907.

8775. Winzinger, Franz. **Die Zeichnungen Martin Schongauers.** Berlin, Deutscher Verein für Kunstwissenschaft, 1962. (CR).

8776. Wurzbach, Alfred von. **Martin Schongauer, eine kritische Untersuchung seines Lebens und seiner Werke.** Wien, Manz, 1880.

SCHULZE, ALFRED OTTO WOLFGANG see WOLS

SCHWANTHALER, LUDWIG MICHAEL, 1802-1848

 THOMAS, 1634-1707

8777. Augustinerchorherrenstift (Reichersberg, Austria). **Die Bildhauerfamilie Schwanthaler, 1633-1848: vom Barock zum Klassizismus.** 3. Mai bis 13. Oktober 1974. Linz, Landesverlag Linz, 1974.

8778. Oberes Belvedere in Wien. **Thomas Schwanthaler, 1634-1707.** 21. November 1974-16. Februar 1975. Wien, Österreichische Galerie, 1974.

8779. Otten, Frank. **Ludwig Michael Schwanthaler, 1802-1848: ein Bildhauer unter König Ludwig I von Bayern; Monographie und Werkverzeichnis.** München, Prestel, 1970. (CR). (Studien zur Kunst des neunzehnten Jahrhunderts, 12).

8780. Trautmann, Franz. **Ludwig Schwanthalers Reliquien.**
München, Fleischmann, 1858.

SCHWIND, MORITZ VON, 1804-1871

8781. Elster, Hanns M. **Moritz von Schwind, sein Leben und
Schaffen.** Berlin, Flemming und Wiskott, 1924.

8782. Führich, Lukas von. **Moritz von Schwind, eine Lebensskizze.**
Leipzig, Dürr, 1871.

8783. Haack, Friedrich. **Moritz von Schwind.** Bielefeld/
Leipzig, Velhagen & Klasing, 1898. (Künstler-
Monographien, 31).

8784. Holland, Hyazinth. **Moritz von Schwind, sein Leben und
seine Werke.** Stuttgart, Neff, 1873.

8785. Kalkschmidt, Eugen. **Moritz von Schwind, der Mann und das
Werk.** München, Bruckmann, 1943.

8786. Müller, August W. **Moritz von Schwind, sein Leben und
künstlerisches Schaffen.** Eisenbach, Baerecke, 1871.

8787. Pommeranz-Liedtke, Gerhard. **Moritz von Schwind, Maler und
Poet.** Wien/München, Schroll, 1974.

8788. Schwind, Moritz von. **Briefe.** Herausgegeben von Otto
Stoeffl. Leipzig, Bibliographisches Institut, [1924].

8789. Weigmann, Otto. **Schwind: des Meisters Werke.** Stuttgart/
Leipzig, Deutsche Verlags-Anstalt, 1904. (Klassiker
der Kunst, 9).

SCHWITTERS, KURT, 1887-1948

8790. Galerie Gmurzynska (Cologne). **Kurt Schwitters.**
Oktober-Dezember 1978. Köln, Galerie Gmurzynska, 1978.

8791. Nündel, Ernst, ed. **Kurt Schwitters in Selbstzeugnissen und
Bilddokumenten.** Reinbeck bei Hamburg, Rowohlt, 1981.
(Rowohlts Monographien).

8792. Schmalenbach, Werner. **Kurt Schwitters.** New York, Abrams,
1970. (CR).

8793. Schwitters, Kurt. **Wir spielen bis uns der Tod abholt;
Briefe aus fünf Jahrzehnten.** Gesammelt, ausgewählt und
kommentiert von Ernst Nündel. Frankfurt a.M., Ullstein,
1975.

8794. Steinitz, Kate T. **Kurt Schwitters; a portrait from life.**
With **Collision, a science fiction opera libretto in
banalities** by Kurt Schwitters and Kate T. Steinitz, and
other writings. Trans. by Robert B. Haas. Berkeley,
University of California Press, 1968.

SCOPAS, 395-350 B.C.

see also PRAXITELES

8795. Arias, Paolo E. **Skopas.** Roma, L'Erma, 1952.

8796. Lehmann, Phyllis W. **Skopas in Samothrace.** Northampton,
Mass., Smith College, 1975.

8797. Neugebauer, Karl A. **Studien über Skopas.** Leipzig,
Seemann, 1913. (Beiträge zur Kunstgeschichte, Neue
Folge, 39).

8798. Stewart, Andrew F. **Skopas of Paros.** Park Ridge, N.J.,
Noyes Press, 1977.

8799. Urlichs, Ludwig. **Skopas: Leben und Werke.** Greifswald,
Germany, Koch, 1863.

SCOREL, JAN VAN, 1495-1562

see also COECKE, PIETER

8800. Centraal Museum Utrecht. **Jan van Scorel in Utrecht.**
5 maart-1 mei 1977. Utrecht, Centraal Museum, 1977.

8801. Hoogewerff, Godefritus J. **Jan van Scorel, peintre de la
renaissance hollandaise.** La Haye, Nijhoff, 1923.

8802. Toman, Hugo. **Studien über Jan van Scorel, den Meister vom
Tode Mariä.** Leipzig, Seemann, 1889. (Beiträge zur
Kunstgeschichte, Neue Folge, 8).

SCOTT, GEORGE GILBERT, JR., 1811-1878

8803. Baylay, Stephen. **The Albert Memorial; the monument in its
social and architectural context.** London, Scolar Press,
1981.

8804. Cole, David. **The work of Sir Gilbert Scott.** London,
Architectural Press, 1980.

8805. Scott, George G. **An essay on the history of English church
architecture prior to the separation of England from
Roman obedience.** London, Simpkin, Marshall, 1881.

8806. _____. **Gleanings from Westminister Abbey.** Oxford/
London, Parker, 1863.

8807. _____. **Lectures on the rise and development of mediaeval
architecture delivered at the Royal Academy.** 2 v.
London, Murray, 1879.

8808. _____. **Personal and professional recollections.** Edited
by his son. London, Sampson Low, 1879. (Reprint: New
York, Da Capo, 1977).

8809. _____. **Remarks on secular & domestic architecture,
present and future.** London, Murray, 1857.

SCOTT, M. H. BAILLIE, 1865-1945

8810. Kornwolf, James D. **M. H. Baillie Scott and the Arts and
Crafts Movement: pioneers of modern design.** Baltimore/
London, Johns Hopkins Press, 1972. (Johns Hopkins
Studies in Nineteenth Century Architecture, 2).

8811. Medici-Mall, Katharina. **Das Landhaus Waldbühl von M. H.
Baillie Scott; ein Gesamtkunstwerk zwischen Neugotik und
Jugendstil.** Bern, Gesellschaft für Schweizerische
Kunstgeschichte, 1979. (Beiträge zur Kunstgeschichte der
Schweiz, 4).

8812. Scott, M. H. Baillie. **Houses and gardens.** London, Newnes,
1906.

SEGAL, GEORGE, 1924-

8813. Friedman, Martin and Beal, Graham W. J. **George Segal: sculptures.** With commentaries by George Segal. [Published in conjunction with an exhibition at the Walker Art Center, Minneapolis, 29 October 1978- 7 January 1979]. Minneapolis, Walker Art Center, 1978.

8814. Van der Marck, Jan. **George Segal.** New York, Abrams, 1975.

SEGALL, LASAR, 1891-1957

8815. Bardi, Pietro M. **Lasar Segall.** Trans. by John Drummond. Milano, Edizioni del Milione, 1959.

8816. Fierens, Paul. **Lasar Segall.** Paris, Chroniques du Jour, 1938.

8817. George, Waldemar. **Lasar Segall.** Paris, Le Triangle, 1932.

SEGANTINI, GIOVANNI, 1858-1899

8818. Arcangeli, Francesco [and] Gozzoli, Maria C. **L'opera completa di Segantini.** Milano, Rizzoli, 1973. (CR). (Classici dell'arte, 67).

8819. Budigna, Luciano. **Giovanni Segantini.** Milano, Bramante, 1962. (I grandi pittori italiani dell'ottocento).

8820. Lüthy, Hans A. [and] Maltese, Corrado. **Giovanni Segantini.** Zürich, Füssli, 1981.

8821. Montandon, Marcel. **Segantini.** Bielefeld/Leipzig, Velhagen & Klasing, 1904. (Künstler-Monographien, 72).

8822. Nicodemi, Giorgio. **Giovanni Segantini.** Milano, L'Arte, 1956.

8823. Quinsac, Annie-Paule. **Segantini, catalogo generale.** 2 v. Milano, Electa, 1982. (CR).

8824. Roedel, Reto. **Giovanni Segantini.** Roma, Bulzoni, 1978. (Biblioteca di cultura, 123).

8825. Segantini, Giovanni. **Scritti e lettere.** A cura di Bianca Segantini. Torino, Bocca, 1910.

8826. Servaes, Franz. **Giovanni Segantini, sein Leben und sein Werk.** Wien, Gerlach, 1902.

8827. Villari, Luigi. **Giovanni Segantini: the story of his life.** London, Unwin, 1901.

SEGHERS, HERCULES PIETERSZOON, ca. 1590-1645

8828. Collins, Leo C. **Hercules Seghers.** Chicago, University of Chicago Press, 1953.

8829. Fraenger, Wilhelm. **Die Radierungen des Hercules Seghers; ein physiognomischer Versuch.** Erlenbach/Zürich, Rentsch, 1922.

8830. Haverkamp Begemann, Egbert. **Hercules Segers, the complete etchings.** With an introduction by K. G. Boon. 2 v. Amsterdam, Scheltema & Holkema/The Hague, Nijhoff, 1973. (CR).

8831. Pfister, Kurt. **Herkules Segers.** München, Piper, 1921.

8832. Rowlands, John. **Hercules Segers.** New York, Braziller, 1979.

8833. Springer, Jaro. **Die Radierungen des Herkules Seghers.** 3 v. Berlin, Cassirer, 1910-1912. (CR). (Graphische Gesellschaft, 13/14/16).

SEGONZAC, ANDRE DUNOYER DE, 1884-1974

8834. Distel, Anne. **A. Dunoyer de Segonzac.** Paris, Flammarion, 1980.

8835. Fosca, François. **Segonzac Provence.** Trans. by Diana Imber. Lausanne, International Art Book, 1969. (Rhythm and Colour, Second series, 6).

8836. Hugault, Henry. **Dunoyer de Segonzac.** Paris, La Bibliothèque des Arts, 1973.

8837. Jamot, Paul. **Dunoyer de Segonzac.** Paris, Floury, 1929.

8838. Jean, René. **A. Dunoyer de Segonzac.** Paris, Nouvelle Revue Française, 1922. (Les peintres français nouveaux, 11).

8839. Kyriazi, Jean M. **André Dunoyer de Segonzac; sa vie, son oeuvre.** Lausanne, Harmonies et Couleurs, 1976.

8840. Lioré, Aimée et Cailler, Pierre. **Catalogue de l'oeuvre gravé de Dunoyer de Segonzac.** 8 v. Genève, Cailler, 1958-1970. (CR).

8841. Passeron, Roger. **Dunoyer de Segonzac, aquarelles.** Avec un texte inédit de l'artiste et une étude de son oeuvre d'aquarelliste. Neuchâtel, Ides et Calendes, 1976.

8842. _____. **Les gravures de Dunoyer de Segonzac.** Paris, La Bibliothèque des Arts, 1970.

8843. Roger-Marx, Claude. **Dunoyer de Segonzac.** Paris, Crès, 1925.

8844. _____. **Dunoyer de Segonzac.** Genève, Cailler, 1951.

8845. Segonzac, André D. de. **Dessins, 1900-1970.** Genève, Cailler, 1970.

SEITZ, GUSTAV, 1906-1969

8846. Busch, Günter. **Gustav Seitz: Bildhauer-Zeichnungen.** Frankfurt a.M., Societäts-Verlag, 1970.

8847. Flemming, Hans T. **Der Bildhauer Gustav Seitz.** Frankfurt a.M., Societäts-Verlag, 1963.

8848. Grohn, Ursel. **Gustav Seitz, das plastische Werk: Werkverzeichnis.** Mit einer Einführung von Alfred Hentzen. Hamburg, Hauswedell, 1980. (CR).

8849. Kunsthalle Bremen. **Gustav Seitz: Skulpturen und Handzeichnungen.** 15. August bis 10. Oktober 1976. Bremen, Kunsthalle Bremen, 1976.

SEMPER, GOTTFRIED, 1803-1879

8850. Börsch-Supan, Eva, ed. **Gottfried Semper und die Mitte des 19. Jahrhunderts: Symposion von 2. bis 6. Dezember 1974.** Basel/Stuttgart, Birkhäuser, 1976.

8851. Fröhlich, Martin. **Gottfried Semper: zeichnerischer Nachlass an der ETH Zürich, kritischer Katalog.** Basel/ Stuttgart, Birkhäuser, 1974. (CR).

8852. Herrmann, Wolfgang. **Gottfried Semper im Exil: Paris/ London, 1849-1855; zur Entstehung des Stil, 1840-1877.** Basel/Stuttgart, Birkhäuser, 1978. (Geschichte und Theorie der Architektur, 19).

8853. Quitzsch, Heinz. **Gottfried Semper: praktische Ästhetik und politischer Kampf.** Braunschweig, Vieweg, 1981. (Bauwelt Fundamente, 58).

8854. Semper, Gottfried. **Kleine Schriften.** Herausgegeben von Hans und Manfred Semper. Berlin/Stuttgart, Spemann, 1884. (Reprint: Mittenwald, Mäander Kunstverlag, 1979. Kunstwissenschaftliche Studientexte, 7).

8855. _____. **Der Stil in den technischen und tektonischen Künsten oder Praktische Aesthetik.** 2 v. München, Bruckmann, 1878/1879.

8856. _____. **Die vier Elemente der Baukunst.** Braunschweig, Vieweg, 1851. (Reprinted, in Quitzsch title above, 1981).

8857. Staatliche Kunstsammlungen Dresden, Institut für Denkmalpflege. **Gottfried Semper, 1803-1879; Baumeister zwischen Revolution und Historismus.** München, Callwey, 1979.

SENGAI, 1751-1837

8858. Suzuki, Daisetz T. **Sengai, the Zen master.** Edited by Eva von Hoboken. Preface by Sir Herbert Read. London, Faber, 1971.

SEQUEIRA, DOMINGOS ANTONIO DE, 1768-1837

8859. Correia, Vergílio. **Sequeira em Roma, duas épocas (1788-1795; 1826-1837).** Coimbra, Imprensa da Universidade, 1923. (Subsidios para a história da arte portuguesa, 6).

8860. Costa, Luiz X. da. **A obra litográfica de Domingos Antonio de Sequeira, com um embôço histórico dos inícios da litográfia em Portugal.** Lisboa, Tipografia do Comêrcio, 1925.

8861. Mourisca Beaumont, Maria A. **Domingos Antonio de Sequeira, desenhos.** Lisboa, Instituto de Alta Cultura, 1975. (CR).

SEREBRIAKOVA, ZINAIDA EVGEN'EVNA, 1884-1967

8862. Kniazeva, Valentina P. **Zinaida Evgen'evna Serebriakova.** Moskva, Izobrazitel'noe Iskusstvo, 1979.

SERGEL, JOHAN TOBIAS, 1740-1814

8863. Antonsson, Oscar. **Sergels ungdom och romtid.** Stockholm, Norstedt, 1942. (Sveriges allmänna konstförenings publikationer, 50).

8864. Brising, Harald. **Sergels konst.** Stockholm, Norstedt, 1914.

8865. Göthe, Georg. **Johan Tobias Sergel, hans lefnad och verksamhet.** Stockholm, Wahlström & Widstrand, 1898.

8866. _____. **Johan Tobias Sergels skulpturverk.** Stockholm, Norstedt, 1921.

8867. Hamburger Kunsthalle. **Johann Tobias Sergel, 1740-1814.** 22. Mai bis 21. September 1975. München, Prestel/ Hamburg, Hamburger Kunsthalle, 1975.

8868. Josephson, Ragnar. **Sergels fantasi.** 2 v. Stockholm, Natur och Kultur, 1956.

8869. Lange, Julius. **Sergel og Thorvaldsen; studier i den nordiske Klassicismes.** Kjøbenhavn, Høst, 1886.

8870. Looström, Ludwig. **Johan Tobias Sergel, en gustaviansk tidsbild.** Stockholm, Cederquist, 1914.

8871. Thorvaldsens Museum (Copenhagen). **Johan Tobias Sergel, 1740-1814.** 29. januar-1. april 1976. [Text in Danish and English]. København, Thorvaldsens Museum, 1976.

SERLIO, SEBASTIANO, 1475-ca. 1554

8872. Bolognini Amorini, Antonio. **Elogio di Sebastiano Serlio, architetto bolognese.** Bologna, Nobili, 1823.

8873. Charvet, Léon. **Sebastien Serlio, 1475-1554.** Lyon, Mondet, 1869.

8874. Rosci, Marco. **Il trattato di architettura di Sebastiano Serlio.** 2 v. Milano, ITEC, 1966.

8875. Rosenfeld, Myra N. **Sebastiano Serlio on domestic architecture: different dwellings from the meanest hovel to the most ornate palace.** Foreword by Adolf K. Placzek; introduction by James S. Ackerman. Cambridge, Mass., MIT Press, 1978.

8876. Serlio, Sebastiano. **Tutte l'opere d'architettura et prospetiva.** Venezia, Franceschi, 1584. (Reprint of 1619 ed.: Ridgewood, N.J., Gregg, 1964. English ed.: **The first book of architecture.** London, Peake, 1611; reprinted: New York, Blom, 1970).

SEROV, VALENTIN ALEKSANDROVICH, 1865-1911

8877. Efimova, Nina I. **Vospominaniia o Valentine Aleksandroviche Serove.** Leningrad, Khudozhnik RSFSR, 1964.

8878. Ernst, Sergei R. **V. A. Serov.** Peterburg, Rossiiskoi Akademeii Istorii Material'noi Kul'tury, 1921.

8879. Grabar, Igor E. **Valentin Aleksandrovich Serov; zhizn'i tvorchestvo, 1865-1911.** Moskva, Iskusstvo, 1980. 2 ed.

8880. Ivanova, Veneta K. **V. A. Serov, 1865-1911.** Sofiia, Nauka, 1960.

8881. Kopshitser, Mark I. **Valentin Serov.** Moskva, Iskusstvo, 1967.

8882. Leniashin, Vladimir A. **Portretnaia zhivopis V. A. Serova, 1900-kh godov: osnovnye problemy.** Leningrad, Khudozhnik RSFSR, 1980.

8883. Sarabyanov, Dmitry and Arbuzov, Grigory, eds. **Valentin Serov: paintings, graphic works, stage designs.** New York, Abrams/Leningrad, Aurora, 1982. (CR).

8884. Serov, Valentin A. **Perepiska, 1884-1911.** [Ed. by Natalii Sokolovoi]. Leningrad, Iskusstvo, 1937.

8885. Smirnova-Rakitina, Vera I. **Valentin Serov.** Moskva, Molodaia Gvardiia, 1961.

SERPOTTA, GIACOMO, 1656-1732

8886. Basile, Ernesto. **Le scolture e gli stucchi di Giacomo Serpotta.** Torino, Crudo, 1911.

8887. Carandente, Giovanni. **Giacomo Serpotta.** Torino, Edizioni Radiotelevisione Italiana, 1967.

8888. Fazio, Peppe. **Serpotta.** Palermo, Priulla, 1956.

8889. Società Siciliana per la Storia Patria (Palermo). **Secondo centenario della morte di Giacomo Serpotta (1732-1932).** 2 v. [Vol. 2: Meli, Filippo. Giacomo Serpotta, vita ed opere]. Palermo, Società Siciliana, 1934.

SERT, JOSÉ LUIS, 1902-1983

8890. Borràs, Maria L. **Sert: mediterranean architecture.** Boston, New York Graphic Society, 1975.

8891. Freixa, Jaume. **Josep L. Sert.** Barcelona, Gili, 1979.

8892. Ichinowatari, Katsuhiko, ed. **Josep Luis Sert: his work and ways.** [Text in Japanese and English]. Tokyo, Process Architecture, 1982; distributed by Van Nostrand Reinhold, New York.

8893. Sert, Jose L. **Architecture, city planning, urban design.** Ed. by Knud Bastlund. New York, Praeger, 1966.

8894. _____. **Can our cities survive?** Cambridge, Mass., Harvard University Press/London, Oxford University Press, 1942.

SERT Y BADIA, JOSÉ MARIÁ, 1876-1945

8895. Castillo, Alberto del. **José María Sert, su vida y su obra.** Barcelona/Buenos Aires, Argos, 1949. 2 ed.

SERUSIER, PAUL, 1864-1927

8896. Boyle-Turner, Caroline. **Paul Sérusier.** Ann Arbor, Mich., University Microfilms, 1983.

8897. Sérusier, Paul. **ABC de la peinture.** Suivie d'une correspondance inédite recueillie par Madame P. Sérusier. Paris, Floury, 1950.

8898. _____. **ABC de la peinture.** Suivie d'une étude sur la vie et l'oeuvre de Paul Sérusier par Maurice Denis. Paris, Floury, 1942.

SESSHU, 1420-1506

8899. Corell, Jon C. **Under the seal of Sesshu.** New York, De Pamphilis Press, 1941.

SETTIGNANO, DESIDERIO DA see DESIDERIO DA SETTIGNANO

SEURAT, GEORGES PIERRE, 1859-1891

8900. Alexandrian, Sarane. **Seurat.** Trans. by Alice Sachs. New York, Crown, 1980.

8901. Art Institute of Chicago. **Seurat, paintings and drawings.** January 16-March 7, 1958. Chicago, Art Institute of Chicago, 1958.

8902. Blunt, Anthony. **Seurat.** With an essay by Roger Fry. London, Phaidon, 1965; distributed by New York Graphic Society, Greenwich, Conn.

8903. Broude, Norma, ed. **Seurat in perspective.** Englewood Cliffs, N.J., Prentice-Hall, 1978.

8904. Chastel, André [and] Minervino, Fiorella. **L'opera completa di Seurat.** Milano, Rizzoli, 1972. (CR). (Classici dell'arte, 55).

8905. Coquiot, Gustave. **Georges Seurat.** Paris, Michel, 1924.

8906. Courthion, Pierre. **Georges Seurat.** Trans. by Norbert Guterman. New York, Abrams, 1968.

8907. Cousturier, Lucie. **Seurat.** Paris, Crès, 1926.

8908. Dorra, Henri et Rewald, John. **Seurat: l'oeuvre peint; biographie et catalogue critique.** Paris, Les Beaux-Arts, 1959. (CR).

8909. Hauke, César M. de. **Seurat et son oeuvre.** 2 v. Paris, Grund, 1961. (CR).

8910. Herbert, Robert L. **Seurat's drawings.** New York, Shorewood, 1962.

8911. Homer, William I. **Seurat and the science of painting.** Cambridge, Mass., MIT Press, 1964.

8912. Kahn, Gustave. **Les dessins de Georges Seurat, 1859-1891.** 2 v. Paris, Bernheim-Jeune, 1928.

8913. Perruchot, Henri. **La vie de Seurat.** Paris, Hachette, 1966.

8914. Rewald, John. **Georges Seurat.** Trans. by Lionel Abel. New York, Wittenborn, 1943.

8915. Rich, Daniel C. **Seurat and the evolution of La Grande Jatte.** Chicago, University of Chicago Press, 1935.

8916. Russell, John. **Seurat.** New York, Praeger, 1965.

8917. Seligman, Germain. **The drawings of Georges Seurat.** New York, Valentin, 1947.

8918. Terrasse, Antoine. **L'univers de Seurat.** Paris, Scrépel, 1976. (Les carnets de dessins).

SEVERINI, GINO, 1883-1966

8919. Quinti, Aldo e Quinti, Jolanda. **Severini e Cortona.** Roma, Officina Edizioni, 1976.

8920. Severini, Gino. **Dal cubismo al classicismo e altri saggi sulla divina proporzione e sul numero d'oro.** A cura di Piero Pacini. Firenze, Marchi & Bertolli, 1972.

8921. _____. **Témoignages: 50 ans de réflexion.** Avec un préface de Georges Borgeaud. Rome, Editions Art Moderne, 1963. (Témoignages, 1).

8922. _____. **La vita di un pittore.** Milano, Edizioni di Comunità, 1965.

8923. Venturi, Lionello. **Gino Severini.** Roma, de Luca, 1961.

SEYSSAUD, RENE, 1867-1952

8924. Humbourg, Pierre et Humbourg, Denise. **Seyssaud, avec une biographie, une bibliographie et une documentation complète sur le peintre et son oeuvre.** Genève, Cailler, 1967. (CR).

8925. Roger-Marx, Claude. **René Seyssaud, 1867-1952.** Paris, Braun, 1958.

8926. Silvestre, Yvonne. **Seyssaud, documents et souvenirs.** Paris, Braun, 1959.

SHAHN, BEN, 1898-1969

8927. Bentivoglio, Mirella. **Ben Shahn.** Roma, de Luca, [1963].

8928. McNulty, Kneeland. **The collected prints of Ben Shahn.** Essay and commentary by the artist. [Published in conjunction with an exhibition at the Philadelphia Museum of Art, November 15-December 31, 1967]. Philadelphia, Philadelphia Museum of Art, 1967.

8929. Morse, John D. **Ben Shahn.** New York, Praeger, 1972.

8930. Pratt, Davis, ed. **The photographic eye of Ben Shahn.** Cambridge, Mass., Harvard University Press, 1975.

8931. Prescott, Kenneth W. **The complete graphic works of Ben Shahn.** New York, Quadrangle, 1973. (CR).

8932. Rodman, Selden. **Portrait of the artist as an American: Ben Shahn.** New York, Harper, 1951.

8933. Shahn, Ben. **The shape of content.** Cambridge, Mass., Harvard University Press, 1957.

8934. Shahn, Bernarda B. **Ben Shahn.** New York, Abrams, 1972.

8935. Soby, James T. **Ben Shahn, his graphic art.** New York, Braziller, 1957.

8936. _____. **Ben Shahn, paintings.** New York, Braziller, 1963.

8937. Weiss, Margaret R., ed. **Ben Shahn, photographer: an album from the thirties.** New York, Da Capo, 1973.

SHARAKU, TOSHUSAI, ca. 1770-ca. 1825

8938. Henderson, Harold G. and Ledoux, Louis V. **The surviving works of Sharaku.** New York, Weyhe, 1939. (CR).

8939. Huguette Berès (Paris). **Sharaku; portraits d'acteurs, 1794-1795.** [Catalogue of an exhibition]. Paris, Huguette Berès, 1980.

8940. Kondo, Ichitaro. **Toshusai Sharaku.** English adaptation by Paul C. Blum. Rutland, Vt., Tuttle, 1955. (Kodansha Library of Japanese Art, 2).

8941. Kurth, Julius. **Sharaku.** München, Piper, 1922. 2 ed.

8942. Rumpf, Fritz. **Sharaku.** Berlin-Lankwitz, Würfel, 1932. 2 ed.

8943. Suzuki, Juzo. **Sharaku.** Trans. by John Bester. Tokyo/Palo Alto, Calif., Kodansha, 1968. (Masterworks of Ukiyo-e, 2).

SHAW, RICHARD NORMAN, 1831-1912

8944. Blomfield, Reginald. **Richard Norman Shaw, R. A., architect 1831-1912.** London, Batsford, 1940.

8945. Saint, Andrew. **Richard Norman Shaw.** New Haven/London, Yale University Press, 1976.

SHCHUSEV, ALEKSEI VIKTOROVICH, 1873-1949

8946. Afanas'ev, Kirill N. **A. V. Shchusev.** Moskva, Stroiizdat, 1978.

8947. Sokolov, N. B. **A. V. Shchusev.** Moskva, God. Izd'vo Lit'ry po Stroitelstvu i Arkhitekture, 1952.

SHEELER, CHARLES, 1883-1965

8948. Friedman, Martin. **Charles Sheeler.** New York, Watson-Guptill, 1975.

8949. Museum of Modern Art (New York). **Charles Sheeler: paintings, drawings, photographs.** With an introduction by William Carlos Willians. New York, Museum of Modern Art, 1939.

8950. National Collection of Fine Arts, Smithsonian Institution (Washington, D.C.). **Charles Sheeler.** 10 October-

24 November 1968. Washington, D.C., Smithsonian
Institution Press, 1968.

8951. Rourke, Constance M. **Charles Sheeler, artist in the
American tradition.** New York, Harcourt, 1938.

SHEN CHOU, 1427-1509

8952. Edwards, Richard. **The field of stones: a study of the art
of Shen Chou (1427-1509).** Washington, D.C., Smithsonian
Institution Press, 1962.

SHERIDAN, CLARE, 1885-1959

8953. Leslie, Anita. **Cousin Clare, the tempestuous career of
Clare Sheridan.** London, Hutchinson, 1976.

SHIH-TAO see TAO CHI

SHISHKIN, IVAN IVANOVICH, 1832-1898

8954. Savinov, Alexei and Fiodorov-Davydov, Alexei. **Shishkin.**
Selection and biographical outline by Irina Shuvalova.
Leningrad, Aurora, 1981.

8955. Shuvalova, Irina. **Ivan Ivanovich Shishkin: perepiska,
dnevnik, sovremenniki o khudoznike.** Leningrad, Iskusstvo
Leningradskoe Otd-nie, 1978.

8956. _____. **Shishkin.** [Text in English, French, German, and
Russian]. Leningrad, Aurora, 1971.

SHUBIN, FEDOT IVANOVICH, 1740-1805

8957. Lazareva, Ol'ga P. **Russkii skul'ptor Fedot Shubin.**
Moskva, Iskusstvo, 1965.

SHUBUN, early 15th c.

8958. Nakamura, Nihei. **Die Tuschmalerei des Shubun und das
Problem der unbemalten weissen Flächen.** Mit einem
Vorwort von Joseph Gantner. Konstanz, Leonhardt, 1981.

SHUNSHŌ, KATSUKAWA, 1726-1792

8959. Boller, Willy. **Japanische Farbholzschnitte von Katsukawa
Shunsho.** Bern, Hallwag, 1953.

8960. Succo, Friedrich. **Katsukawa Shunshō.** Plauen im Vogtland,
Schulz, 1922.

SICKERT, WALTER, 1860-1942

8961. Baron, Wendy. **Sickert.** London, Phaidon, 1973. (CR).

8962. Browse, Lillian. **Sickert.** London, Hart-Davis, 1960.

8963. Emmons, Robert. **The life and opinions of Walter Richard
Sickert.** London, Faber, 1941.

8964. Lilly, Marjorie. **Sickert: the painter and his circle.**
London, Elek, 1971.

8965. Sickert, Walter R. **A free house!, or the artist as
craftsman; being the writings of Walter Richard Sickert.**
Edited by Osbert Sitwell. London, Macmillan, 1947.

8966. Sutton, Denys. **Walter Sickert, a biography.** London,
Joseph, 1976.

8967. Troyen, Aimée. **Walter Sickert as printmaker.** [Published in
conjunction with an exhibition at the Yale Center for
British Art, New Haven, February 21-April 15, 1979].
New Haven, Yale Center for British Art, 1979.

SIGNAC, PAUL, 1863-1935

8968. Besson, George. **Signac, dessins.** Paris, Braun, 1950.

8969. Cachin, Françoise. **Paul Signac.** Paris, Bibliothèque des
Arts, 1971.

8970. Cousturier, Lucie. **Signac.** Paris, Crès, 1922.

8971. Kornfeld, E. W. and Wick, P. A. **Catalogue raisonné de
l'oeuvre gravé et lithographié de Paul Signac.** Berne,
Kornfeld et Klipstein, 1974. (CR).

8972. Mura, Anna M. **Signac.** Milano. Fabbri, 1967. (I maestri
del colore, 180).

8973. Musée du Louvre (Paris). **Signac.** Déc. 1963-fév. 1964.
Paris, Ministère d'Etat Affaires Culturelles, [1963].

8974. Signac, Paul. **D'Eugène Delacroix au neo-impressionisme.**
Introd. et notes par Françoise Cachin. Paris, Hermann,
1978.

SIGNORELLI, LUCA, 1441-1523

8975. Baldini, Umberto. **Luca Signorelli.** Milano, Fabbri, 1966.
(I maestri del colore, 176).

8976. Cruttwell, Maud. **Luca Signorelli.** London, Bell, 1899.

8977. Dussler, Luitpold. **Signorelli, des Meisters Gemälde.**
Stuttgart, Deutsche Verlags-Anstalt, 1927. (Klassiker
der Kunst, 34).

8978. Kury, Gloria. **The early work of Luca Signorelli: 1465-
1490.** New York/London, Garland, 1978.

8979. Mancini, Girolamo. **Vita di Luca Signorelli.** Firenze,
Carnesecchi, 1903.

8980. Moriondo, Margherita. **Mostra di Luca Signorelli, catalogo:
Cortona, maggio-agosto; Firenze, settembre-ottobre, 1953.**
Firenze, L'Arte della Stampa, 1953.

8981. Salmi, Mario. **Luca Signorelli.** Novara, Istituto
Geografico de Agostini, 1953.

8982. Scarpellini, Pietro. **Luca Signorelli.** Milano, Club del
Libro, 1964. (Collana d'arte del Club del Libro, 10).

8983. Venturi, Adolfo. **Luca Signorelli.** Firenze, Alinari, 1922.

8984. Vischer, Robert. **Luca Signorelli und die italienische Renaissance; eine kunsthistorische Monographie.** Leipzig, Viet, 1879.

SILOE, DIEGO DE, ca. 1495-1563

see also BERRUGUETE, ALONSO GONZALEZ

8985. Gomez-Moreno, Manuel. **Diego Siloe: homenaje en el IV centenario de su muerte.** Granada, Universidad de Granada, 1963.

SILVA, MARIA ELENA VIEIRA DA see VIEIRA DA SILVA, MARIA ELENA

SILVA Y VELAZQUEZ, DIEGO RODRIGUEZ DE

see VELAZQUEZ, DIEGO RODRIGUEZ DE SILVA Y

SINAN, KOCA, 1490-1588

8986. Egli, Ernst. **Sinan, der Baumeister osmanischer Glanzzeit.** Erlenbach-Zürich/Stuttgart, Rentsch, 1976. 2 ed.

8987. Stratton, Arthur. **Sinan.** New York, Scribner, 1971.

SINTENIS, RENEE, 1888-1965

8988. Crevel, René und Biermann, Georg. **Renée Sintenis.** Berlin, Klinkhardt & Biermann, 1930. (Junge Kunst, 57).

8989. Hagelstange, Rudolf, et al. **Renée Sintenis.** Berlin, Aufbau, 1947.

8990. Kiel, Hanna. **Renée Sintenis.** Berlin, Rembrandt, 1956. (Die Kunst unserer Zeit, 10).

SIQUEIROS, DAVID ALFARO, 1896-1974

8991. Azpeitia, Rafael C., ed. **Siqueiros.** México, D.F., Secretaría de Educación Pública, 1974.

8992. Orsanmichele/Palazzo Vecchio (Florence). **Siqueiros: David Alfaro Siqueiros e il muralismo messicano.** 10 novembre 1976-15 febbraio 1977. Firenze, Calenzano, 1976.

8993. Siqueiros, David A. **Como se pinta un mural.** México, D.F., Ediciones Mexicanas, 1951.

8994. _____. **Me llamaban el Coronelazo: memorias.** México, D.F., Grijalbo, 1977.

8995. Tibol, Raquel. **Siqueiros, introductor de realidades.** México, D.F., Universidad Nacional Autonoma de México, 1961.

SIRANI, ELISABETTA, 1638-1665

8996. Bianchini, Andrea. **Prove legali sull'avvelenamento della celebre pittrice bolognese Elisabetta Sirani.** Bologna, Guidi all'Ancora, 1854.

8997. Manaresi, Antonio. **Elisabetta Sirani; la vita, l'arte, la morte.** Bologna, Zanichelli, 1898.

8998. Mazzoni Toselli, Ottavio. **Di Elisabetta Sirani, pittrice bolognese e del supposto veneficio onde credesi morta nell'anno XXVII di sua età; racconto storico.** Bologna, Tipografia del Genio, 1833.

SISKIND, AARON, 1903-

8999. Chiarenza, Carl. **Aaron Siskind: pleasures and terrors.** Foreword by James L. Enyeart. Boston, Little, Brown, 1982.

9000. Lyons, Nathan, ed. **Aaron Siskind, photographer.** Rochester, N.Y., George Eastman House, 1965. (George Eastman House Monograph, 5).

9001. Siskind, Aaron. **Photographs.** Introduction by Harold Rosenberg. New York, Horizon Press, 1959.

SISLEY, ALFRED, 1839-1899

9002. Cogniat, Raymond. **Sisley.** Paris, Flammarion, 1978.

9003. Daulte, François. **Alfred Sisley; catalogue raisonné de l'oeuvre peint.** Lausanne, Durand-Ruel, 1959. (CR).

9004. Geffroy, Gustave. **Sisley.** Paris, Crès, 1923. (Les cahiers d'aujourd'hui).

SKIDMORE, OWINGS AND MERRILL, i.e.:

SKIDMORE, LOUIS, 1897-1962

MERRILL, JOHN O., 1896-1975

OWINGS, NATHANIEL A., 1903-1984

9005. Danz, Ernst. **The architecture of Skidmore, Owings & Merrill, 1950-1962.** Introduction by Henry R. Hitchcock. Trans. by Ernst van Haagen. New York, Praeger, 1963.

9006. Drexler, Arthur and Mengs, Axel. **The architecture of Skidmore, Owings & Merrill, 1963-1973.** New York, Architectural Book Publishing Co., 1974.

9007. Owings, Nathaniel A. **The spaces in between: an architect's journey.** Boston, Houghton Mifflin, 1973.

9008. Woodward, Christopher. **Skidmore, Owings & Merrill.** New York, Simon & Schuster, 1970.

SLEVOGT, MAX, 1868-1932

9009. Alten, Wilken von. **Max Slevogt.** Bielefeld/Leipzig, Velhagen & Klasing, 1926. (Künstler-Monographien, 116).

9010. Guthmann, Johannes. **Scherz und Laune: Max Slevogt und seine Gelegenheitsarbeiten.** Berlin, Cassirer, 1920.

9011. Imiela, Hans-Jürgen. **Max Slevogt, eine Monografie.** Karlsruhe, Braun, 1968.

9012. Kunsthalle Bremen. **Max Slevogt und seine Zeit: Gemälde, Handzeichnungen, Aquarelle, Druckgraphik.** 13. September bis 27. Oktober 1968. Bremen, Kunsthalle Bremen, 1968.

9013. Scheffler, Karl. **Max Slevogt.** Berlin, Rembrandt, 1940. (Die Kunstbücher des Volkes, 34).

9014. Sievers, Johannes [and] Waldmann, Emil. **Max Slevogt: das druckgraphische Werk, 1890-1914.** Herausgegeben von Hans-Jürgen Imiela. Heidelberg/Berlin, Impuls Verlag, 1962. (CR).

9015. Waldmann, Emil. **Max Slevogt.** Berlin, Cassirer, 1923.

SLOAN, JOHN, 1871-1951

9016. Brooks, Van Wyck. **John Sloan; a painter's life.** New York, Dutton, 1955.

9017. DuBois, Guy P. **John Sloan.** New York, Whitney Museum of Art, 1931.

9018. Goodrich, Lloyd. **John Sloan.** New York, Macmillan, 1952.

9019. Morse, Peter. **John Sloan's prints: a catalogue raisonné of the etchings, lithographs, and posters.** With a foreword by Jacob Kainen. New Haven/London, Yale University Press, 1969. (CR).

9020. National Gallery of Art (Washington, D.C.). **John Sloan, 1871-1951: his life and paintings, his graphics.** September 18, 1971-October 31, 1971. [Text by David W. Scott and E. John Bullard]. Washington, D.C., National Gallery of Art, 1971.

9021. Scott, David. **John Sloan.** New York, Watson-Guptill, 1975.

9022. Sloan, John. **Gist of art: principles and practise expounded in the classroom and studio.** Recorded with the assistance of Helen Farr. New York, American Artists Group, 1939.

9023. _____. **John Sloan's New York scene, from the diaries, notes, and correspondence, 1906-1913.** Edited by Bruce St. John; with an introduction by Helen Farr Sloan. New York, Harper & Row, 1965.

9024. St. John, Bruce. **John Sloan.** New York, Praeger, 1971.

SLUTER, CLAUS, ca. 1355-ca. 1406

9025. Arnoldi, Francesco N. **Sluter e la scultura borgognona.** Milano, Fabbri, 1966. (I maestri della scultura, 79).

9026. David, Henri. **Claus Sluter.** Paris, Tisné, 1951.

9027. Kleinclausz, Arthur J. **Claus Sluter et la sculpture bourguignonne au XV siècle.** Paris, Librairie de l'Art Ancien et Moderne, 1905.

9028. Liebreich, Aenne. **Claus Sluter.** Bruxelles, Dietrich, 1936.

9029. Troescher, Georg. **Claus Sluter und die burgundische Plastik um die Wende des XIV. Jahrhunderts.** Freiburg i.Br., Urban-Verlag, [1932].

SMIBERT, JOHN, 1688-1751

9030. Foote, Henry W. **John Smibert, painter.** Cambridge, Mass., Harvard University Press, 1950.

9031. Smibert, John. **The notebook of John Smibert.** With essays by Sir David Evans, John Kerslake and Andrew Oliver. Boston, Massachusetts Historical Society, 1969.

SMITH, DAVID, 1906-1965

9032. Carmean, E. A., Jr. **David Smith.** [Published in conjunction with an exhibition at the National Gallery of Art, Washington, D.C., November 7, 1982-April 24, 1983]. Washington, D.C., National Gallery of Art, 1982.

9033. Cummings, Paul. **David Smith, the drawings.** [Published in conjunction with an exhibition at the Whitney Museum of American Art, New York]. New York, Whitney Museum, 1979.

9034. Fogg Art Museum, Harvard University (Cambridge, Mass.). **David Smith, 1906-1965; a retrospective exhibition.** September 28-November 15, 1966. Cambridge, Mass., President and Fellows of Harvard College, 1966.

9035. Fry, Edward F. **David Smith.** [Published in conjunction with an exhibition at the Solomon R. Guggenheim Museum, New York]. New York, Guggenheim Foundation, 1969.

9036. Krauss, Rosalind E. **The sculpture of David Smith, a catalogue raisonné.** New York/London, Garland, 1977. (CR). (Garland Reference Library of the Humanities, 73).

9037. _____. **Terminal iron works: the sculpture of David Smith.** Cambridge, Mass., MIT Press, 1971.

9038. Marcus, Stanley E. **David Smith: the sculptor and his work.** Ithaca, N.Y., Cornell University Press, 1984.

9039. Smith, David. **David Smith.** Edited by Garnett McCoy. New York, Praeger, 1973.

9040. _____. **David Smith by David Smith.** Text and photographs by the author. Edited by Cleve Gray. New York, Holt, Rinehart and Winston, 1968.

SMITH, WILLIAM EUGENE, 1918-1978

9041. Johnson, William S. **W. Eugene Smith, master of the photographic essay.** Foreword by James L. Enyeart. Millerton, N.Y., Aperture, 1981.

9042. Smith, W. Eugene. **W. Eugene Smith: his photographs and notes.** Afterword by Lincoln Kirstein. New York, Aperture, 1969.

SMITHSON, ROBERT, 1938-1973

9043. Hobbs, Robert C., et al. **Robert Smithson, sculpture.** Ithaca, N.Y., Cornell University Press, 1981.

9044. Smithson, Robert. **The writings of Robert Smithson; essays with illustrations.** Edited by Nancy Holt. New York, New York University Press, 1979.

SMYTHSON, ROBERT, 1534/5-1614

9045. Girouard, Mark. **Robert Smythson & the Elizabethan country house.** New Haven, Yale University Press, 1983. 2 ed.

SOANE, JOHN, 1753-1837

9046. Bolton, Arthur T. **The portrait of John Soane (1753-1837) set forth in letters from his friends (1775-1837).** London, Butler, 1927.

9047. Du Prey, Pierre de la Ruffinière. **John Soane, the making of an architect.** Chicago, University of Chicago Press, 1982.

9048. Stroud, Dorothy. **The architecture of Sir John Soane.** With an introduction by Henry Russell Hitchcock. London, Studio, 1961.

9049. Summerson, John N. **Sir John Soane, 1753-1837.** London, Art and Technics, 1952.

SODOMA, IL, 1477-1549

9050. Cust, Robert H. **Giovanni Antonio Bazzi, hitherto usually styled Sodoma: the man and the painter, 1477-1549; a study.** New York, Dutton, 1909.

9051. Faccio, Cesare. **Giovan Antonio Bazzi (Il Sodoma), pittore vercellese del secolo XVI.** Vercelli, Gallardi & Ugo, 1902.

9052. Gielly, Louis. **Le Sodoma.** Paris, Plon, [1911].

9053. Hauvette, Henri. **Le Sodoma, biographie critique.** Paris, Laurens, 1911.

9054. Hayum, Andrée. **Giovanni Antonio Bazzi--Il Sodoma.** New York/London, Garland, 1976.

9055. Jacobsen, Emil. **Sodoma und das Cinquecento in Siena.** Strassburg, Heitz, 1910. (Zur Kunstgeschichte des Auslandes, 74).

9056. Jansen, Albert. **Leben und Werke des Malers Giovannantonio Bazzi von Vercelli, genannt Il Sodoma.** Stuttgart, Ebner & Seubert, 1870.

9057. Marciano-Agostinelli Tozzi, M. T. **Il Sodoma.** Messina, d'Amico, 1951.

9058. Priuli-Bon, Lilian. **Sodoma.** London, Bell, 1900.

9059. Segard, Achille. **Giov.-Antonio Bazzi detto Sodoma et la fin de l'école de Sienne aux XVI siècle.** Paris, Floury, 1910.

9060. Terrasse, Charles. **Sodoma.** Paris, Alcan, 1925.

SOEST, CONRAD VON, fl. 1402-1404

9061. Hölker, Carl. **Meister Conrad von Soest und seine Bedeutung für die norddeutsche Malerei in der ersten Hälfte des** 15. Jahrhunderts. Münster in Westfalen, Coppenrath, 1921. (Beiträge zur westfälischen Kunstgeschichte, 7).

9062. Meier, Paul J. **Werk und Wirkung des Meisters Konrad von Soest.** Münster in Westfalen, Coppenrath, 1921. (Westfalen, 1).

9063. Steinbart, Kurt. **Konrad von Soest.** Wien, Schroll, 1946.

SOLARIO, ANDREA, 1460-1524

9064. Badt, Kurt. **Andrea Solario, sein Leben und seine Werke; ein Beitrag zur Kunstgeschichte der Lombardei.** Leipzig, Klinkhardt & Biermann, 1914.

9065. Cogliati Arano, Luisa. **Andrea Solario.** Milano, Edizioni Tecnografico Italiano, 1965.

SOROLLA Y BASTIDA, JOAQUÍN, 1863-1923

9066. Anderson, Ruth M. **Costumes painted by Sorolla in his provinces of Spain.** New York, Hispanic Society of America, 1957.

9067. Beruete, Aureliano de, et al. **Eight essays on Joaquín Sorolla y Bastida.** 2 v. New York, Hispanic Society of America, 1909.

9068. Domènech, Rafael. **Sorolla, su vida y su arte.** Barcelona, Bayês, 1907.

9069. Manaut Viglietti, José. **Cronica del pintor Joaquín Sorolla.** Madrid, Editora Nacional, 1964.

9070. Pantorba, Bernardino de [pseud., Lopez Jiménez, José]. **La vida y la obra de Joaquín Sorolla, estudio biografico y critico.** Madrid, Gráficas Monteverde, 1970. 2 ed. (CR).

9071. Vehils, Rafael, et al. **Sorolla, 1863-1923.** Buenos Aires, Institución Cultural Española, 1942.

SOTATSU, TAWARAYA, 1576-1643

see also KOETSU and KORIN

9072. Grilli, Elise. **Tawaraya Sotatsu.** Edited by Ichimatsu Tanaka. Tokyo/Rutland, Vt., Tuttle, 1956. (Kodansha Library of Japanese Art, 6).

9073. Watson, William. **Sotatsu.** Based on the Japanese text of Yamane Yuzo. London, Faber, 1959.

SOUFFLOT, JACQUES-GABRIEL, 1713-1780

9074. Caisse Nationale des Monuments Historiques et des Sites (Paris). **Soufflot et son temps, 1780-1980.** 9 octobre 1980-25 janvier 1981. Paris, Caisse Nationale des Monuments Historiques et des Sites, 1980.

9075. Centre National de la Recherche Scientifique (Paris). **Soufflot et l'architecture des lumières.** [Published after a colloquium organized by l'Institut d'Histoire de l'Art de l'Université de Lyon II, 18-22 juin, 1980]. Paris, Centre National de la Recherche Scientifique, 1980.

9076. Mondain-Monval, Jean. **Soufflot: sa vie, son oeuvre, son esthétique (1713-1780).** Paris, Lemerre, 1918.

9077. _____, ed. **Correspondance de Soufflot avec les directeurs des batiments concernant la manufacture des Gobelins (1756-1780).** Paris, Lemerre, 1918.

9078. Petzet, Michael. **Soufflots Sainte-Geneviève und der französische Kirchenbau des 18. Jahrhunderts.** Berlin, de Gruyter, 1961. (Neue Münchner Beiträge zur Kunstgeschichte, 2).

9079. Université de Lyon II, Institut d'Histoire de l'Art. **L'oeuvre de Soufflot à Lyon: ètudes et documents.** Lyon, Presses Universitaires de Lyon, 1982.

SOUTHWORTH, ALBERT SANDS, 1811-1894

HAWES, JOSIAH JOHNSON, 1808-1901

9080. Homer, Rachel J. **The legacy of Josiah Johnson Hawes: 19th century photographs of Boston.** Barre, Mass., Barre Publishers, 1972.

9081. Sobieszak, Robert A. and Appel, Odette M. **The spirit of fact: the daguerreotypes of Southworth & Hawes, 1843-1862.** Boston, Godine, 1976.

SOULAGES, PIERRE, 1919-

9082. Ceysson, Bernard. **Soulages.** Trans. by Shirley Jennings. New York, Crown, 1980.

9083. Duby, Georges, et al. **Soulages: eaux-fortes, lithographies, 1952-1973.** Paris, Arts et Métiers Graphiques, 1974.

9084. Juin, Hubert. **Soulages.** Paris, Fall, 1958.

9085. Sweeney, James J. **Soulages.** London, Phaidon, 1972.

SOUTINE, CHAIM, 1894-1943

9086. Castaing, Marcellin and Leymarie, Jean. **Soutine.** Trans. by John Ross. New York, Abrams, 1964.

9087. Courthion, Pierre. **Soutine, peintre du déchirant.** Lausanne, Edita/Denoël, 1972. (CR).

9088. Szittya, Emil. **Soutine et son temps.** Paris, Bibliothèque des Arts, 1955.

9089. Werner, Alfred. **Chaim Soutine.** New York, Abrams, 1977.

9090. Westfälisches Landesmuseum für Kunst und Kulturgeschichte Münster. **C. Soutine, 1893-1943.** Edited by Ernst-Gerhard Güse; English version edited by Michael Raeborn. December 13, 1981-February 28, 1982. London, Arts Council of Great Britain, 1982.

9091. Wheeler, Monroe. **Soutine.** [Published in conjunction with an exhibition at the Museum of Modern Art, New York]. New York, Museum of Modern Art, 1950.

SPAGNOLETTO, LO see RIBERA, JUSEPE

SPENCER, STANLEY, 1891-1959

9092. Carline, Richard. **Stanley Spencer at war.** London, Faber, 1978.

9093. Collis, Louise. **A private view of Stanley Spencer.** London, Heinemann, 1972.

9094. Collis, Maurice. **Stanley Spencer, a biography.** London, Harvill Press, 1962.

9095. Robinson, Duncan. **Stanley Spencer: visions from a Berkshire village.** Oxford, Phaidon, 1979.

9096. Rothenstein, Elizabeth. **Stanley Spencer.** Oxford & London, Phaidon/New York, Oxford University Press, 1945.

9097. Rothenstein, John, ed. **Stanley Spencer, the man: correspondence and reminiscences.** London, Elek, 1979.

9098. Spencer, Gilbert. **Stanley Spencer.** London, Gollancz, 1961.

SPINELLI, SPINELLO DI LUCA see SPINELLO ARETINO

SPINELLO ARETINO, 1346-1410

9099. Gombosi, Georg. **Spinello Aretino, eine stilgeschichtliche Studie über die florentinische Malerei des ausgehenden XIV. Jahrhunderts.** Budapest, [Gombosi], 1926.

9100. Masetti, Anna R. **Spinello Aretino giovane.** Firenze, Centro Di, 1973. (Raccolta pisana di saggi e studi, 35).

SPITZWEG, CARL, 1808-1888

9101. Albrecht, Manuel. **Carl Spitzwegs Malerparadies.** Stuttgart, Schuler, 1968.

9102. Boehn, Max von. **Carl Spitzweg.** Bielefeld/Leipzig, Velhagen & Klasing, 1924. (Künstler Monographien, 110).

9103. Elsen, Alois. **Carl Spitzweg.** Wien, Schroll, 1948.

9104. Jensen, Jens C. **Carl Spitzweg.** Köln, DuMont, 1980.

9105. Kalkschmidt, Eugen. **Carl Spitzweg und seine Welt.** München, Bruckmann, 1945.

9106. Roennefahrt, Günther. **Carl Spitzweg: beschreibendes Verzeichnis seiner Gemälde, Ölstudien und Aquarelle.** München, Bruckmann, 1960. (CR).

9107. Spitzweg, Carl. **Carl Spitzweg, der Münchner Maler-Poet.** Gesammelt und mit einem Nachwort herausgegeben von Michael Dirrigl. München, Langen-Müller, 1969.

9108. Spitzweg, Wilhelm, ed. **Der unbekannte Spitzweg; ein Bild aus der Welt des Biedermeier: Dokumente, Briefe, Aufzeichnungen.** München, Braun & Schneider, 1958.

9109. Uhde-Bernays, Hermann. **Carl Spitzweg, des Meisters Werk und seine Bedeutung in der Geschichte der Münchner Kunst.** München, Delphin, 1913.

STAËL, NICOLAS DE, 1915-1955

9110. Chastel, André. **Nicolas de Staël.** Lettres annotées par Germain Viatte; catalogue raisonné des peintures établi par Jacques Dubourg et Françoise de Staël. Paris, Le Temps, 1968. (CR).

9111. Cooper, Douglas. **Nicolas de Staël.** New York, Norton, 1962.

9112. Dumur, Guy. **Staël.** Paris, Flammarion, 1975.

9113. Galeries Nationales du Grand Palais (Paris). **Nicolas de Staël.** 22 mai-24 août 1981. Paris, Musée National d'Art Moderne, Centre Georges Pompidou, 1981.

9114. Jouffroy, Jean P. **La mesure de Nicolas de Staël.** Neuchâtel, Editions Ides et Calendes, 1981.

9115. Sutton, Denys, ed. **Nicolas de Staël: notes on painting.** Trans. by Rita Barisse. New York, Grove, 1960.

9116. Tudal, Antoine. **Nicolas de Staël.** Paris, Fall, 1958.

STAUFFER-BERN, KARL, 1857-1891

9117. Arx, Bernhard von. **Der Fall Karl Stauffer, Chronik eines Skandals.** Bern/Stuttgart, Hallwag, 1969.

9118. Brahm, Otto. **Karl Stauffer-Bern; sein Leben, seine Briefe, seine Gedichte.** Stuttgart, Göschen, 1892.

9119. Stauffer-Bern, Karl. **Familienbriefe und Gedichte.** Herausgegeben von U. W. Züricher. Leipzig, Insel-Verlag/München, Verlag der Süddeutschen Monatshefte, 1914.

STEEN, JAN, 1626-1679

9120. Bredius, Abraham. **Jan Steen.** Amsterdam, Scheltema & Holkema, [1927].

9121. Groot, Cornelis W. de. **Jan Steen, beeld en woord.** Utrecht, Dekker & van de Vegt, 1952.

9122. Gudlaugsson, Sturla. **The comedians in the work of Jan Steen and his contemporaries.** Trans. by James Brockway. Soest, Netherlands, Davaco, 1974.

9123. Kirschenbaum, Baruch D. **The religious and historical paintings of Jan Steen.** New York/Montclair, N.J., Allanheld & Schram, 1977.

9124. Martin, Wilhelm. **Jan Steen.** Amsterdam, Meulenhoff, 1954.

9125. Rosenberg Adolf. **Terborch und Jan Steen.** Bielefeld/Leipzig, Velhagen & Klasing, 1897. (Künstler-Monographien, 19).

9126. Schmidt-Degener, Frederik. **Jan Steen.** Trans. by G. J. Renier. London, Lane, 1927.

9127. Vries, Lyckle de. **Jan Steen, de schilderende Uilenspiegel.** Amsterdam, Amsterdam Boek, 1976.

9128. Westrheene, Tobias van. **Jan Steen, étude sur l'art en Hollande.** La Haye, Nijhoff, 1856.

STEFANO DI GIOVANNI see SASSETTA

STEICHEN, EDWARD, 1879-1973

9129. Kelton, Ruth. **Edward Steichen.** Millerton, N.Y., Aperture, 1978. (Aperture History of Photography, 9).

9130. Longwell, Dennis. **Steichen; the master prints; 1895-1914: the symbolist period.** New York, Museum of Modern Art, 1978; distributed by New York Graphic Society, Boston.

9131. Phillips, Christopher. **Steichen at war.** New York, Abrams, 1981.

9132. Sandburg, Carl. **Steichen, the photographer.** New York, Harcourt, Brace, 1929.

9133. Steichen, Edward. **A life in photography.** London, Allen, 1963.

STEINBERG, SAUL, 1914-

9134. Butor, Michel et Rosenberg, Harold. **Steinberg: le masque.** Photographies d'Inge Morath. Paris, Maeght, 1966.

9135. Kölnischer Kunstverein. **Saul Steinberg: Zeichnungen, Aquarelle, Collagen, Gemälde, Reliefs, 1963-1974.** 14. November-31. Dezember 1974. Köln, Kölnischer Kunstverein, 1974.

9136. Rosenberg, Harold. **Saul Steinberg.** [Published in conjunction with an exhibition at the Whitney Museum of American Art, April 14-July 9, 1978]. New York, Knopf, 1978.

9137. Steinberg, Saul. **All in line.** New York, Duell, Sloan & Pearce, 1945.

9138. _____. **The art of living.** New York, Harper, 1949.

9139. _____. **The inspector.** New York, Viking, 1973.

9140. _____. **The labyrinth.** New York, Harper, 1960.

9141. _____. **The new world.** New York, Harper, 1965.

STEINLEN, THEOPHILE-ALEXANDRE, 1859-1923

9142. Cate, Phillip D. and Gill, Susan. **Théophile-Alexandre Steinlen.** [Published in conjunction with an exhibition at the Voorhees Art Museum, Rutgers University, New Brunswick, N.J.]. Salt Lake City, Smith, 1982.

9143. Crauzat, Ernest de. **L'oeuvre gravé et lithographié de Steinlen.** Préface de Roger Marx. Paris, Société de Propagation des Livres d'Art, 1913. (CR).

9144. Gute, Herbert. **A. Th. Steinlens Vermächtnis.** Berlin, Henschel, 1954.

9145. Jourdain, Francis. **Un grand imagier: Alexandre Steinlen.** Paris, Cercle d'Art, 1954.

9146. Staatliche Kunsthalle Berlin. **Théophile-Alexandre Steinlen, 1859-1923.** 15. Januar-15. Februar 1978. Berlin, Staatliche Kunsthalle, 1978.

STELLA, FRANK, 1936-

9147. Fort Worth Art Museum (Fort Worth, Tex.). **Stella since 1970.** March 19-April 30, 1978. Fort Worth, Tex., Fort Worth Art Museum, 1978.

9148. Kunsthalle Bielefeld. **Frank Stella: Werke 1958-1976.** 17. April bis 29. Mai 1977. Bielefeld, Kunsthalle Bielefeld, 1977.

9149. Rosenblum, Robert. **Frank Stella.** Harmondsworth, Eng., Penguin, 1971. (Penguin New Art, 1).

9150. Rubin, William S. **Frank Stella.** New York, Museum of Modern Art, 1970; distributed by New York Graphic Society, Greenwich, Conn.

STELLA, JOSEPH, 1879-1946

9151. Baur, John I. **Joseph Stella.** New York, Praeger, 1971.

9152. Gerdts, William H. **Drawings of Joseph Stella from the collection of Rabin & Krueger.** Newark, N.J., Rabin & Krueger Gallery, 1962.

9153. Jaffe, Irma B. **Joseph Stella.** Cambridge, Mass., Harvard University Press, 1970.

STETTHEIMER, FLORINE, 1871-1944

9154. McBride, Henry. **Florine Stettheimer.** New York, Museum of Modern Art, 1946; distributed by Simon & Schuster, New York.

9155. Tyler, Parker. **Florine Stettheimer; a life in art.** New York, Farrar, Straus, 1963.

STEVENS, ALFRED, 1817-1875

9156. Armstrong, Walter. **Alfred Stevens; a biographical study.** Paris, Librairie de L'Art, 1881.

9157. Beattie, Susan. **Alfred Stevens, 1817-75.** [Published in conjunction with an exhibition at the Victoria & Albert Museum]. London, HMSO, 1975.

9158. Physick, John. **The Wellington Monument.** London, HMSO, 1970.

9159. Stevens, Alfred G. **Drawings of Alfred Stevens.** New York, Scribner, 1908.

9160. Towndrow, Kenneth R. **Alfred Stevens, architectural sculptor, painter, and designer: a biography.** With a preface by D. S. MacColl. London, Constable, 1939.

9161. _____. **The works of Alfred Stevens in the Tate Gallery.** With an introduction and descriptive catalogue of classified works and a foreword by John Rothenstein. London, Tate Gallery, 1950.

STEVENS, ALFRED EMILE LEOPOLD, 1823-1906

 JOSEPH, 1819-1892

9162. Boucher, François. **Alfred Stevens.** Paris, Rieder, 1931.

9163. Coles, William A. **Alfred Stevens.** [Published in conjunction with an exhibition at the University of Michigan Museum of Art, Ann Arbor, Mich., September 10-October 16, 1977]. Ann Arbor, University of Michigan Museum of Art, 1977.

9164. Lemonnier, Camille. **Alfred Stevens et son oeuvre, suivi des impressions sur la peinture par Alfred Stevens.** Bruxelles, van Oest, 1906.

9165. Stevens, Alfred. **Impressions on painting.** Trans. by Charlotte Adams. New York, Coombes, 1886.

9166. Vanzype, Gustave. **Les frères Stevens.** Bruxelles, Nouvelle Société d'Editions, 1936.

STIEGLITZ, ALFRED, 1864-1946

9167. Frank, Waldo. **America & Alfred Stieglitz: a collective portrait.** New, revised edition. Millerton, N.Y., Aperture, 1979.

9168. Green, Jonathan, ed. **Camera Work: a critical anthology.** Millerton, N.Y., Aperture, 1973.

9169. Greenough, Sarah [and] Hamilton, Juan. **Alfred Stieglitz, photographs & writings.** [Published in conjunction with an exhibition at the National Gallery of Art, Washington, D.C.]. Washington, D.C., National Gallery of Art, 1982.

9170. Homer, William I. **Alfred Stieglitz and the American avant-garde.** Boston, New York Graphic Society, 1977.

9171. _____. **Alfred Stieglitz and the Photo-Secession.** Boston, New York Graphic Society, 1983.

9172. Lowe, Sue D. **Stieglitz, a memoir/biography.** New York, Farrar, Straus & Giroux, 1983.

9173. Norman, Dorothy. **Alfred Stieglitz.** Millerton, N.Y., Aperture, 1976. (Aperture History of Photography, 3).

9174. _____. **Alfred Stieglitz: an American seer.** New York, Random House, 1973. 2 ed.

9175. Seligmann, Herbert. **Alfred Stieglitz talking; notes on some of his conversations, 1925-1931.** New Haven, Yale University Library, 1966.

9176. Thomas, F. Richard. **Literary admirers of Alfred Stieglitz.** Carbondale, Ill., Southern Illinois University Press, 1983.

STONE, EDWARD DURELL, 1902-1978

9177. Stone, Edward D. **The evolution of an architect.** New York, Horizon Press, 1962.

9178. _____. **Recent and future architecture.** New York, Horizon Press, 1967.

STOSS, VEIT, 1440/50-1533

9179. Barthel, Gustav. **Die Ausstrahlungen der Kunst des Veit Stoss im Osten.** München, Bruckmann, 1944.

9180. Daun, Berthold. **Veit Stoss und seine Schule in Deutschland, Polen, Ungarn und Siebenbürgen.** Leipzig, Hiersemann, 1916. 2 ed. (Kunstgeschichtliche Monographien, 17).

9181. Dettloff, Szczesny. **Wit Stosz.** 2 v. Wrocław, Polskiej Akademii Nauk, 1961.

9182. Jaeger, Adolf. **Veit Stoss und sein Geschlecht.** Neustadt/Aisch, Degener, 1958.

9183. Kepiński, Zdzisław. **Wit Stwosz w starciu ideologii religijnych Odrodzenia Ołtarz Salwatora.** Wrocław, Polskiej Akademii Nauk, 1969.

9184. Lossnitzer, Max. **Veit Stoss, die Herkunft seiner Kunst, seine Werke und sein Leben.** Leipzig, Zeitler, 1912.

9185. Lutze, Eberhard. **Veit Stoss.** Berlin, Deutscher Kunstverlag, 1938.

9186. Skubiszewski, Piotr. **Rzeźba nagrobna Wita Stwosza.** Warszawa, Pánstwowym Instytucie Wydawniczym, 1957.

STOWASSER, FRIEDRICH see HUNDERTWASSER, FRIEDENSREICH

STRAND, PAUL, 1890-1976

9187. Hoffman, Michael E., ed. **Paul Strand: sixty years of photographs.** Profile by Calvin Tomkins. Millerton, N.Y., Aperture, 1976.

9188. Newhall, Nancy. **Paul Strand: photographs, 1915-1945.** [Published in conjunction with an exhibition at the Museum of Modern Art, New York]. New York, Museum of Modern Art, 1945.

9189. Strand, Paul. **Paul Strand: a retrospective monograph.** 2 v. Millerton, N.Y., Aperture, 1971.

STRETTON, LORD see LEIGHTON, FREDERICK

STRICKLAND, WILLIAM, 1788-1854

9190. Gilchrist, Agnes E. **William Strickland, architect and engineer, 1788-1854.** Philadelphia, University of Pennsylvania Press, 1950.

STRIGEL, BERNHARD, 1460/61-1528

9191. Otto, Gertrud. **Bernhard Strigel.** München/Berlin, Deutschen Kunstverlag, 1964.

STROZZI, BERNARDO, 1581-1644

9192. Fiocco, Giuseppe. **Bernardo Strozzi.** Roma, Biblioteca d'Arte Illustrata, 1921. (Biblioteca d'arte illustrata, 9).

9193. Matteucci, Anna M. **Bernardo Strozzi.** Milano, Fabbri, 1966. (I maestri del colore, 134).

9194. Mortari, Luisa. **Bernardo Strozzi.** Roma, de Luca, 1966.

STUART, GILBERT, 1755-1828

9195. Flexner, James T. **Gilbert Stuart.** New York, Knopf, 1955.

9196. Mason, George C. **The life and works of Gilbert Stuart.** New York, Scribner, 1879.

9197. Morgan, John H. **Gilbert Stuart and his pupils.** New York, New York Historical Society, 1939.

9198. Mount, Charles M. **Gilbert Stuart, a biography.** New York, Norton, 1964.

9199. Museum of Art, Rhode Island School of Design (Providence, R.I.). **Gilbert Stuart: portraitist of the new republic, 1755-1828.** Providence, Museum of Art, Rhode Island School of Design, 1967.

9200. Park, Lawrence. **Gilbert Stuart: an illustrated descriptive list of his works.** With an account of his life by John Hill Morgan and an appreciation by Royal Cortissoz. 4 v. New York, Rudge, 1926. (CR).

9201. Whitley, William T. **Gilbert Stuart.** Cambridge, Mass., Harvard University Press, 1932.

STUBBS, GEORGE, 1724-1806

9202. Doherty, Terence. **The anatomical works of George Stubbs.** Boston, Godine, 1975.

9203. Egerton, Judy. **George Stubbs, anatomist and animal painter.** [Published in conjunction with an exhibition at the Tate Gallery, London, 25 August-3 October 1976]. London, Tate Gallery, 1976.

9204. Gilbey, Walter. **Life of George Stubbs, R. A.** London, Vinton, 1898.

9205. Parker, Constance-Anne. **Mr. Stubbs, the horse painter.** London, Allen, 1971.

9206. Sparrow, Walter S. **George Stubbs and Ben Marshall.** London, Cassell/New York, Scribner, 1929.

9207. Tattersall, Bruce. **Stubbs & Wedgewood: unique alliance between artist and potter.** With an introduction by Basil Taylor. [Published in conjunction with an exhibi-

tion at the Tate Gallery, London, 19 June-18 August 1974]. London, Tate Gallery, 1974.

9208. Taylor, Basil. **Stubbs**. London, Phaidon, 1975. 2 ed.

STUCK, FRANZ VON, 1863-1928

9209. Bierbaum, Otto J. **Stuck**. Bielefeld/Leipzig, Velhagen & Klasing, 1899. (Künstler-Monographien, 42).

9210. Ostini, Fritz von. **Franz von Stuck: Gesamtwerk**. Muenchen, Hanfstaengl, [1909].

9211. Schmoll, J. August, ed. **Franz von Stuck**. München, Stuck-Jugendstil-Verein, 1968.

9212. _____. **Das Phänomen Franz von Stuck: Kritiken, Essays, Interviews, 1968-1972**. München, Stuck-Jugendstil-Verein, 1972.

9213. Singer, Hans W. **Zeichnungen von Franz von Stuck**. Leipzig, Schumann, 1912. (Meister der Zeichnung, 3).

9214. Voss, Heinrich. **Franz von Stuck, 1863-1928**. Werkkatalog der Gemälde mit einer Einführung in seinen Symbolismus. München, Prestel, 1973. (CR).

STWOSZ, WIT see STOSS, VEIT

SUDEK, JOSEF, 1896-1976

9215. Bulláty, Sonja. **Sudek**. Barre, Mass., Imprint Society, 1978; distributed by Crown, New York,

9216. Linharta, Lubomíra. **Josef Sudek, fotografie**. Praha, Státní Nakladatelství Krásné Literatury, 1956.

9217. Sudek, Josef. **Magic in stone**. Text by Martin S. Briggs. London, Lincolns-Prager, 1947.

9218. _____. **Praha panoramatická**. [Praha], Státní Nakladatelství Krásné Literatury, 1959.

SULLIVAN, LOUIS HENRY, 1856-1924

see also RICHARDSON, HENRY HOBSON

9219. Bush-Brown, Albert. **Louis Sullivan**. New York, Braziller, 1960.

9220. Connely, Willard. **Louis Sullivan as he lived: the shaping of American architecture**. New York, Horizon Press, 1960.

9221. Menocal, Narciso G. **Architecture as nature: the transcendentalist idea of Louis Sullivan**. Madison, Wis., University of Wisconsin Press, 1981.

9222. Morrison, Hugh. **Louis Sullivan, prophet of modern architecture**. New York, Museum of Modern Art/Norton, 1935.

9223. Paul, Sherman. **Louis Sullivan, an architect in American thought**. Englewood Cliffs, N.J., Prentice-Hall, 1962.

9224. Sprague, Paul E. **The drawings of Louis Henry Sullivan: a catalogue of the Frank Lloyd Wright Collection at the Avery Architectural Library**. Foreword by Adolf K. Placzek. Princeton, N.J., Princeton University Press, 1979.

9225. Sullivan, Louis H. **The autobiography of an idea**. New York, American Institute of Architects, 1926. (New ed., with a foreword by Claude Bragdon and an introduction by Ralph Marlowe Line: New York, Dover, 1956).

9226. _____. **Kindergarten chats and other writings**. Ed. by Isabella Athey. New York, Wittenborn, 1947.

9227. _____. **The testament of stone: themes of idealism and indignation from the writings of Louis Sullivan**. Ed. by Maurice English. Evanston, Ill., Northwestern University Press, 1963.

9228. Szarkowski, John. **The idea of Louis Sullivan**. Minneapolis, University of Minnesota Press, 1956.

SULLY, THOMAS, 1783-1872

9229. Biddle, Edward and Fielding, Mantle. **The life and work of Thomas Sully, 1783-1872**. Philadelphia, [privately printed], 1921. (CR).

9230. Hart, Charles H. **A register of portraits painted by Thomas Sully, 1801-1871**. Philadelphia, [Hart], 1909.

9231. Sully, Thomas. **Hints to young painters and the process of portrait painting**. Philadelphia, Stoddart, 1873. (Reprinted, with an introduction by Faber Birren: New York, Reinhold, 1965).

SURVAGE, LEOPOLD, 1879-1968

9232. Gauthier, Maximilien. **Survage**. Paris, Les Gémeaux, 1953.

9233. Putnam, Samuel. **The glistening bridge: Léopold Survage and the spatial problem in painting**. With an autobiographical sketch, an essay, and notes by M. Survage. New York, Covici-Friede, 1929.

SUTHERLAND, GRAHAM, 1903-1980

9234. Alley, Ronald. **Graham Sutherland**. [Published in conjunction with an exhibition at the Tate Gallery, London, 19 May-4 July, 1982]. London, Tate Gallery, 1982.

9235. Arcangeli, Francesco. **Graham Sutherland**. Trans. by Helen Barolini and H. Joseph Marks. New York, Abrams, 1975.

9236. Berthoud, Roger. **Graham Sutherland, a biography**. London, Faber, 1982.

9237. Cooper, Douglas. **The work of Graham Sutherland**. London, Lund Humphries, 1961.

9238. Hayes, John. **The art of Graham Sutherland**. Oxford, Phaidon, 1980.

9239. Sackville-West, Edward. **Graham Sutherland**. Harmondsworth, Eng., Penguin, 1943. (Penguin Modern Painters).

9240. Tassi, Roberto. **Graham Sutherland: complete graphic work.** New York, Rizzoli, 1978. (CR).

9241. _____. **Sutherland: disegni di guerra.** Milano, Electa, 1979.

SUTTERMANS, JUSTUS, 1597-1681

9242. Bautier, Pierre. **Juste Suttermans, peintre des Médicis.** Bruxelles, van Oest, 1912.

SZINYEI-MERSE, PÁL, 1845-1920

9243. Lázár, Béla. **Paul Merse von Szinyei, ein Vorläufer der Pleinairmalerei.** Leipzig, Klinkhardt & Biermann, [1911].

9244. Pataky, Dénes. **Pál Szinyei Merse.** Trans. by Edna Lenárt. Budapest, Corvina, 1965.

9245. Rajnai, Miklós. **Szinyei-Merse Pál, 1845-1920.** Budapest, Müvészeti Könyvek, 1953.

TADDEO DI BARTOLO, 1362-1422

9246. Symeonides, Sibilla. **Taddeo di Bartolo.** Siena, Accademia Senese degli Intronati, 1965. (Monografie d'arte senese, 7).

TAEUBER-ARP, SOPHIE HENRIETTE, 1889-1943

9247. Museum of Modern Art (New York). **Sophie Taeuber-Arp.** September 16-November 29, 1981. New York, Museum of Modern Art, 1981.

9248. Schmidt, Georg. **Sophie Taeuber-Arp.** Basel, Holbein-Verlag, 1948.

TAFT, LORADO, 1860-1936

9249. Taft, Ada B. **Lorado Taft, sculptor and citizen.** Greensboro, N.C., Smith, 1946.

9250. Taft, Lorado. **The history of American sculpture.** New edition, revised and with new matter. New York, Macmillan, 1925.

9251. _____. **Modern tendencies in sculpture.** Chicago, University of Chicago Press, 1921.

TALBOT, WILLIAM HENRY FOX, 1800-1877

9252. Arnold, Harry J. P. **William Henry Fox Talbot, pioneer of photography and man of science.** London, Hutchinson Benham, 1977.

9253. Booth, Arthur H. **William Henry Fox Talbot, father of photography.** London, Barker, 1965.

9254. Buckland, Gail. **Fox Talbot and the invention of photography.** Boston, Godine, 1980.

9255. Jammes, André. **William H. Fox Talbot, inventor of the negative-positive process.** New York, Macmillan, 1974.

9256. Lassam, Robert. **Fox Talbot, photographer.** Tisbury, Eng., Compton Press, 1979.

9257. Talbot, William H. F. **The pencil of nature.** London, Longman, 1844-1846. (Reprinted with a new introduction by Beaumont Newhall: New York, Da Capo, 1969).

9258. _____. **Some account of the art of photogenic drawing.** London, Taylor, 1839.

TAMAYO, RUFINO, 1900-

9259. Alba, Victor. **Coloquios de Coyoacan con Rufino Tamayo.** Mexico, D.F., Costa-Amic, [1956].

9260. Cogniat, Raymond. **Rufino Tamayo.** Paris, Presses Littéraires de France, 1951.

9261. Genauer, Emily. **Rufino Tamayo.** New York, Abrams, 1974.

9262. Goldwater, Robert. **Rufino Tamayo.** New York, Quadrangle, 1947.

9263. Museo Tamayo (Mexico City). **Rufino Tamayo: arte y proceso de la mixografia.** México, D.F., Museo Tamayo, 1983.

9264. Palazzo Strozzi (Florence). **Rufino Tamayo.** 1 marzo-30 aprile 1975. Firenze, Centro Di, 1975.

9265. Paz, Octavio. **Tamayo en la pintura mexicana.** México, D.F., Universidad Nacional Autonoma de México, 1959.

9266. _____ [and] Lassaigne, Jacques. **Rufino Tamayo.** Trans. by Kenneth Lyons. New York, Rizzoli, 1982.

9267. Solomon R. Guggenheim Museum (New York). **Rufino Tamayo, myth and magic.** New York, Guggenheim Foundation, 1979.

T'ANG-TAI, 1673?-1732

9268. Goepper, Roger. **T'ang-Tai, ein Hofmaler der Ch'ing Zeit.** München, Staatliche Museum für Völkerkunde, 1956.

TANGUY, YVES, 1900-1955

9269. Breton, André. **Yves Tanguy.** Trans. by Bravig Imbs. New York, Pierre Matisse Editions, 1946.

9270. Musée National d'Art Moderne, Centre Georges Pompidou (Paris). **Yves Tanguy, rétrospective, 1925-1955.** 17 juin-21 septembre 1982. Paris, Musée National d'Art Moderne, Centre Georges Pompidou, 1982.

9271. Soby, James T. **Yves Tanguy.** [Published in conjunction with an exhibition at the Museum of Modern Art, New York]. New York, Museum of Modern Art, 1955.

9272. Tanguy, Kay S., et al. **Yves Tanguy, a summary of his works.** [Text in French and English]. New York, Pierre Matisse, 1963. (CR).

9273. Wolfgang Wittrock Kunsthandel (Düsseldorf). **Yves Tanguy, das druckgraphische Werk: Ausstellung April-Mai 1976.** [Text in German, French, and English]. Düsseldorf, Wolfgang Wittrock Kunsthandel, 1976. (CR).

T'ANG YIN, 1470-1524

9274. Lai, T. C. **T'ang Yin, poet/painter, 1470-1524.** Hong Kong, Kelley and Walsh, 1971.

TANNER, HENRY OSSAWA, 1859-1937

9275. Mathews, Marcia M. **Henry Ossawa Tanner, American artist.** Chicago/London, University of Chicago Press, 1969.

9276. National Collection of Fine Arts, Smithsonian Institution, Washington, D.C. **The art of Henry O. Tanner (1859-1937).** 23 July through 7 September 1969. Washington, D.C., Frederick Douglass Institute in collaboration with the National Collection of Fine Arts, 1969.

9277. Simon, Walter A. **Henry O. Tanner: a study of the development of an American Negro artist, 1859-1937.** Ann Arbor, Mich., University Microfilms, 1960.

TAO CHI, 1630-1707

9278. Coleman, Earle J. **Philosophy of painting by Shih-T'ao: a translation and exposition of his Hua-P'u.** The Hague, Mouton, 1978.

9279. Fu, Marilyn and Fong, Wen. **The wilderness colors of Tao-Chi.** Introduction, commentary, and translations by Marilyn Fu and Wen Fong. New York, Metropolitan Museum of Art, 1973.

9280. Keim, Jean. **Che T'ao (1630-1707): paysages; album en huit feuilles.** 2 v. Paris, Euros, 1957.

9281. Museum of Art, University of Michigan (Ann Arbor, Mich.). **The painting of Tao-Chi, 1641-ca. 1720.** August 13-September 17, 1967. Ann Arbor, Mich., Museum of Art, University of Michigan, 1967.

TAPIE, MICHEL, 1909-

9282. Tapié, Michel. **Observations.** Edited by Paul and Esther Jenkins. New York, Wittenborn, 1956.

9283. Vicens, Francesc, ed. **Prolégomènes à une esthétique autre de Michel Tapié.** Barcelone, Centre International de Recherches Esthétiques, 1960.

TÀPIES, ANTONI, 1923-

9284. Albright-Knox Art Gallery (Buffalo, N.Y.). **Antoni Tàpies: thirty-three years of his work.** With an essay by José Luis Barrio-Garay. January 22-March 6, 1977. Buffalo, Buffalo Fine Arts Academy/Albright-Knox Art Gallery, 1977.

9285. Bonet, Blai. **Tàpies: selección, montaje, interpretación.** Barcelona, Polígrafa, 1964.

9286. Cirici, Alexandre. **Tàpies: testimonio del silencio.** Barcelona, Polígrafa, 1973.

9287. Cirlot, Juan-Eduardo. **Significacion de la pintura de Tàpies.** Barcelona, Seix Barral, 1962.

9288. Fernandez-Braso, Miguel. **Conversaciones con Tàpies.** Madrid, Rayuela, 1981.

9289. Gatt, Giuseppe. **Antoni Tàpies.** Prefazione di Giulio Carlo Argan. Bologna, Cappelli, 1967.

9290. Gimferrer, Pere. **Tàpies and the Catalan spirit.** Trans. by Kenneth Lyons. New York, Rizzoli, 1975.

9291. Kunsthalle Bremen. **Antoni Tàpies: Handzeichnungen, Aquarelle, Gouachen, Collagen, 1944-1976.** 4. September bis 23. Oktober 1977. Bremen, Kunsthalle Bremen, 1977.

9292. Penrose, Roland. **Tàpies.** New York, Rizzoli, 1978.

9293. Schmalenbach, Werner. **Antoni Tàpies: Zeichnungen.** Frankfurt a.M., Propyläen, 1974.

9294. Tapié, Michel. **Antoni Tàpies.** Barcelona, Editorial RM, 1959.

9295. Tàpies, Antoni. **Memòria personal: fragment per a una autobiografia.** Barcelona, Editorial Crítica, 1977.

9296. Teixidor, Joan. **Antoni Tàpies.** Barcelona, Sala Gaspar, 1964.

TASSI, AGOSTINO, 1565-1644

9297. Hess, Jacob. **Agostino Tassi, der Lehrer des Claude Lorrain; ein Beitrag zur Geschichte der Barockmalerei in Rom.** München, [Hess], 1935.

9298. Pugliatti, Teresa. **Agostino Tassi tra conformismo e libertà.** Roma, de Luca, 1977.

TATLIN, VLADIMIR YEVGRAFOVICH, 1885-1953

9299. Milner, John. **Vladimir Tatlin and the Russian avant-garde.** New Haven, Yale University Press, 1983.

9300. Moderna Museet (Stockholm). **Vladimir Tatlin.** Juli-september 1968. [Text in Swedish and English]. Stockholm, Moderna Museet, 1968.

9301. Nakov, Andrei B. **Tatlin's dream: Russian suprematist and constructivist art, 1910-1923.** [Published in conjunction with an exhibition at Fischer Fine Art, Ltd., London, November 1973-January 1974]. London, Fischer Fine Art, Ltd., 1974.

9302. Tatlin, Vladimir Y. **V. Y. Tatlin: katalog vystavki proizvedenii.** Moskva, Sovetskaia Khudozhnikov, 1977.

TATTI, JACOPO see SANSOVINO, JACOPO TATTI

TCHELITCHEW, PAVEL, 1898-1957

9303. Soby, James T. **Tchelitchew: paintings, drawings.**
[Published in conjunction with an exhibition at the
Museum of Modern Art, New York]. New York, Museum of
Modern Art, 1942.

9304. Tchelitchew, Pavel. **Drawings.** Edited by Lincoln Kirstein.
New York, Bittner, 1947.

9305. Tyler, Parker. **The divine comedy of Pavel Tchelitchew, a
biography.** New York, Fleet, 1967.

TENIERS, DAVID (the elder), 1582-1649

DAVID (the younger), 1610-1690

9306. Bocquet, Léon. **David Teniers.** Paris, Nilsson, 1924.

9307. Davidson, Jane P. **David Teniers the younger.** Boulder,
Colo., Westview Press, 1979.

9308. Duverger, Erik [and] Vlieghe, Hans. **David Teniers der
Altere; ein Vergessener flämischer Nachfolger Adam
Elsheimers.** Utrecht, Haentjens Dekker & Gumbert, 1971.

9309. Marillier, Henry C. **Handbook to the Teniers tapestries.**
London, Oxford University Press, 1932.

9310. Peyre, Roger R. **David Teniers, biographie critique.**
Paris, Laurens, 1910.

9311. Rosenberg, Adolf. **Teniers der Jüngere.** Bielefeld/Leipzig,
Velhagen & Klasing, 1895. (Künstler-Monographien, 8).

9312. Vermoelen, John. **Teniers le jeune; sa vie, ses oeuvres.**
Anvers, Donné, 1865.

TERBORCH, GERARD, 1617-1681

see also STEEN, JAN

9313. Gudlaugsson, Sturla J. **Geraert Ter Borch.** 2 v. Den Haag,
Nijhoff, 1959. (CR).

9314. Hellens, Franz. **Gérard Terborch.** Bruxelles, van Oest,
1911.

9315. Landesmuseum Münster. **Gerard ter Borch: Zwolle 1617-
Deventer 1681.** 12. Mai-23. Juni 1974. Münster,
Landesmuseum für Kunst und Kulturgeschichte, 1974.

9316. Michel, Emile. **Gérard Terburg (Ter Borch) et sa famille.**
Paris, Rouam, 1887.

9317. Plietzsch, Eduard. **Gerard ter Borch.** Wien, Schroll, 1944.

TERBRUGGHEN, HENDRICK, 1588-1629

9318. Nicholson, Benedict. **Hendrick Terbrugghen.** London, Lund,
Humphries, 1958. (CR).

TESSAI, TOMIOKA, 1836-1924

9319. Odakane, Taro. **Tessai, master of the literary style.**
Translation and adaptation by Money L. Hickman. Tokyo,
Kodansha, 1965; distributed by Japan Publications Trading
Co., Rutland, Vt.

9320. University of California Art Museum (Berkeley). **The works
of Tomioka Tessai, a travelling exhibition organized by
the International Exhibitions Foundation.** November
1968-November 1969. Takaruzuka (Japan), Kiyoshi Kojin
Seichoji, 1968.

TESSIN, NICODEMUS (the elder), 1615-1681

NICODEMUS (the younger), 1654-1728

9321. Josephson, Ragnar. **L'architecte de Charles XII: Nicodème
Tessin à la cour de Louis XIV.** Paris/Bruxelles, van
Oest, 1930.

9322. _____. **Nicodemus Tessin D. Y.: tiden, mannen, verket.**
Stockholm, Norstedt, 1931. (Sveriges allmänna
Konstförenings publikation, 39).

9323. Kommer, Björn R. **Nicodemus Tessin und das Stockholmer
Schloss.** Heidelberg, Winter, 1974. (Heidelberger
Kunstgeschichtliche Abhandlungen, Neue Folge, 11).

9324. Sirén, Osvald. **Nicodemus Tessin d.y:s, studieresor i
Danmark, Tyskland, Holland, Frankrike och Italien.**
Stockholm, Norstedt, 1914.

9325. Weigert, R. A. et Hernmarck, Carl, eds. **L'art en France
et en Suède, 1693-1718: extraits d'une correspondance
entre l'architecte Nicodème Tessin le jeune et Daniel
Cronström.** Stockholm, Egnellska Boktryckeriet, 1964.

THAYER, ABBOTT HANDERSON, 1849-1921

9326. Anderson, Ross. **Abbott Handerson Thayer.** [Published in
conjunction with an exhibition at the Everson Museum,
Syracuse, N.Y.]. Syracuse, Everson Museum, 1982.

9327. Thayer, Gerald H. **Concealing-coloration in the animal
kingdom: an exposition of the laws of disguise through
color and pattern, being a summary of Abbott Handerson
Thayer's discoveries.** New York, Macmillan, 1909.

9328. While, Nelson C. **Abbott H. Thayer, painter and
naturalist.** Hartford, Conn., Connecticut Printers, 1951.

THEOTOCOPOULOS, DOMENICOS see GRECO, EL

THEUS, JEREMIAH, 1716-1774

9329. Middleton, Margaret S. **Jeremiah Theus, colonial artist of
Charles Town.** Columbia, S.C., University of South
Carolina Press, 1953.

THIERSCH, FRIEDRICH, 1852-1921

9330. Marschall, Horst K. **Friedrich von Thiersch (1852-1921):
ein Münchner Architekt des Späthistorismus.** München,
Prestel, 1982.

9331. Münchner Stadtmuseum. **Friedrich von Thiersch, ein Münchner Architekt des Späthistorismus, 1852-1921.** München, Lipp, 1977.

9332. Thiersch, Hermann. **Friedrich von Thiersch der Architekt, 1852-1921; ein Lebensbild.** München, Bruckmann, 1925.

THOMA, HANS, 1839-1924

9333. Beringer, Joseph A. **Hans Thoma.** München, Bruckmann, 1922.

9334. Böhm, Heinrich. **Hans Thoma, sein Exlibris-Werk.** Berlin, Maximilian, 1959.

9335. Busse, Hermann E. **Hans Thoma, Leben und Werk.** Berlin, Rembrandt, 1935.

9336. Meissner, Franz. **Hans Thoma.** Berlin/Leipzig, Schuster & Loeffler, 1899. (Das Künstlerbuch, 4).

9337. Ostini, Fritz von. **Thoma.** Bielefeld/Leipzig, Velhagen & Klasing, 1900. (Künstler-Monographien, 46).

9338. Thode, Henry. **Thoma, des Meisters Gemälde.** Stuttgart/Leipzig, Deutsche Verlags-Anstalt, 1909. (Klassiker der Kunst, 15).

9339. Thoma, Hans. **Briefe an Frauen.** Herausgegeben von Joseph A. Beringer. Stuttgart, Strecker und Schröder, 1936.

9340. _____. **Gesammelte Schriften und Briefe.** Herausgegeben von Joseph A. Beringer. 2 v. Leipzig, Koehler & Amelang, 1927/1928.

9341. _____. **Im Herbst des Lebens.** München, Süddeutsche Monatshefte, 1908.

THORN PRIKKER, JOHAN, 1868-1932

9342. Hoff, August. **Johan Thorn Prikker.** Recklinghausen, Bongers, 1958. (Monographien zur rheinisch-westfälischen Kunst der Gegenwart, 12).

9343. Wember, Paul. **Johan Thorn Prikker: Glasfenster, Wandbilder, Ornamente, 1891-1932.** Bearbeitung des Werkverzeichnisses von Johannes Cladders. [Published in conjunction with an exhibition at the Kaiser Wilhelm Museum, Krefeld]. Krefeld, Scherpe, 1966. (CR).

THORNYCROFT, HAMO, 1850-1925

9344. Manning, Elfrida. **Marble & bronze: the art and life of Hamo Thornycroft.** Introduction by Benedict Read. London, Trefoil Books, 1982.

THORVALDSEN, BERTEL, 1770-1844

see also SERGEL, JOHANN TOBIAS

9345. Barnard, Mordaunt R. **The life of Thorvaldsen.** Collated from the Danish of J. M. Thiele. London, Chapman and Hall, 1865.

9346. Bott, Gerhard, et al. **Bertel Thorvaldsen: Untersuchungen zu seinem Werk und zur Kunst seiner Zeit.** [Published in conjunction with an exhibition at Kunsthalle Köln, February 5-April 3, 1977]. Köln, Museen der Stadt Köln, 1977.

9347. Hartmann, Jørgen B. **Antike Motive bei Thorvaldsen; Studien zur Antikenrezeption des Klassizismus.** Bearbeitet und herausgegeben von Klaus Parlasca. Tübingen, Wasmuth, 1979.

9348. _____. **Thorvaldsen a Roma.** Con prefazione di Antonio Muñoz. Roma, Palombi, 1959.

9349. Konrádsson, Helgi. **Bertel Thorvaldsen.** Reykjavík, Gunnarsson, 1944.

9350. Moltesen, Erik. **Bertel Thorvaldsen.** København, Navers, 1929.

9351. Müller, Sigurd. **Thorvaldsen, hans liv og hans vaerker.** Kjøbenhavn, Stockholm, 1893.

9352. Oppermann, Theodor. **Thorvaldsen.** 3 v. Kjøbenhavn, Gads, 1924-1930.

9353. Plon, Eugene. **Thorvaldsen, his life and works.** Trans. by I. M. Luyster. Boston, Roberts, 1873.

9354. Rave, Paul O. **Thorvaldsen.** Berlin, Rembrandt, 1947.

9355. Rosenberg, Adolf. **Thorwaldsen.** Bielefeld/Leipzig, Velhagen & Klasing, 1896. (Künstler-Monographien, 16).

9356. Sass, Else K. **Thorvaldsens portraetbuster.** 3 v. København, Gads, 1963/1965. (CR).

9357. Thiele, Just M. **Den danske billedhugger Bertel Thorvaldsen og hans vaerker.** 4 v. København, Forfatterens Forlag i Thieles Bogtrykkeri, 1831-1850.

9358. _____. **Thorvaldsens biographi.** 4 v. Kiøbenhavn, Reitzel, 1851-1856.

9359. Wallraf-Richartz-Museum/Kunsthalle Köln. **Bertel Thorvaldsen: Skulpturen, Modelle, Bozzetti, Handzeichnungen.** 5. Februar bis 3. April 1977. Köln, Museen der Stadt Köln, 1977.

TIBALDI, PELLEGRINO, 1527-1596

9360. Briganti, Giuliano. **Il manierismo e Pellegrino Tibaldi.** Roma, Cosmopolita, 1945.

9361. Hiersche, Waldemar. **Pellegrino dei Pellegrini als Architekt.** Parchim, Germany, Freise, 1913.

9362. Rocco, Giovanni. **Pellegrino Pellegrini, l'architetto di S. Carlo e le sue opere nel duomo di Milano.** Milano, Hoepli, 1939.

TIEPOLO, GIOVANNI BATTISTA, 1696-1770

GIOVANNI DOMENICO, 1726-1804

LORENZO, 1736-1776

9363. Büttner, Frank. **Giovanni Battista Tiepolo: die Fresken in der Residenz zu Würzburg.** Aufnahmen von Wolf-Christian von der Mülbe. Würzburg, Popp, 1980.

9364. Chennevières, Henry de. **Les Tiepolo.** Paris, Librairie de l'Art, 1898.

9365. Fogg Art Museum, Harvard University (Cambridge, Mass.). **Tiepolo: a bicentenary exhibition, 1770-1970.** March 14-May 3, 1970. Cambridge, Mass., Trustees of Harvard College, 1970.

9366. Freeden, Max H. von und Lamb, Carl. **Das Meisterwerk des Giovanni Battista Tiepolo: die Fresken der Würzburger Residenz.** München, Hirmer, 1956.

9367. Hadeln, Detlev von. **The drawings of G. B. Tiepolo.** 2 v. Paris, Pegasus, 1928.

9368. Hegemann, Hans W. **Giovanni Battista Tiepolo.** Berlin, Rembrandt, 1940.

9369. Knox, George. **Catalogue of the Tiepolo drawings in the Victoria and Albert Museum.** London, HMSO, 1975. (CR).

9370. _____. **Etchings by the Tiepolos.** [Published in conjunction with an exhibition at the National Gallery of Canada, Ottawa; text in English and French]. Ottawa, National Gallery of Canada, 1976.

9371. _____. **Giambattista and Domenico Tiepolo: a study and catalogue raisonné of the chalk drawings.** 2 v. Oxford, Clarendon Press, 1980. (CR).

9372. Leitschuh, Franz F. **Giovanni Battista Tiepolo, eine Studie zur Kunstgeschichte des 18. Jahrhunderts.** Würzburg, Bauer, 1896.

9373. Mariuz, Adriano. **Giandomenico Tiepolo.** Venezia, Alfieri, [1971]. (CR). (Profile e saggi di arte veneta, 9).

9374. Mazzariol, Giuseppe [and] Pignatti, Terisio. **Itinerario tiepolesco.** Venezia, Lombroso, 1951.

9375. Meissner, Franz H. **Tiepolo.** Bielefeld/Leipzig, Velhagen & Klasing, 1897. (Künstler-Monographien, 22).

9376. Molmenti, Pompeo G. **G. B. Tiepolo, la sua vita e le sue opere.** Milano, Hoepli, 1909.

9377. Morassi, Antonio. **A complete catalogue of the paintings of G. B. Tiepolo.** London, Phaidon, 1962. (CR).

9378. _____. **G. B. Tiepolo, his life and work.** London, Phaidon, 1955; distributed by Garden City Books, New York.

9379. Palazzo Ducale (Venice). **Tiepolo, tecnica e immaginazione.** Luglio-settembre 1979. Venezia, Alfieri, 1979.

9380. Pignatti, Terisio. **Tiepolo disegni.** Scelti e annotati da Terisio Pignatti. Firenze, La Nuova Italia, 1974.

9381. Piovene, Guido [and] Pallucchini, Anna. **L'opera completa di Giambattista Tiepolo.** Milano, Rizzoli, 1968. (CR). (Classici dell'arte, 25).

9382. Porcella, Antonio. **La giovinezza di Giambattista Tiepolo.** Roma, de Luca, 1973.

9383. Precerutti Garberi, Mercedes. **Giambattista Tiepolo, gli affreschi.** Torino, ERI, 1970.

9384. Sack, Eduard. **Giambattista und Domenico Tiepolo, ihr Leben und ihre Werke.** Hamburg, Clarmann, 1910.

9385. Semenzato, Camillo. **Giambattista Tiepolo.** Milano, Fabbri, 1964. (I maestri del colore, 37).

9386. Shaw, J. Byam. **The drawings of Domenico Tiepolo.** London, Faber, 1962.

9387. Urbani de Ghelthof, Giuseppe M. **Tiepolo e la sua famiglia.** Venezia, Kirchmayr e Scozzi, 1879.

9388. Vigni, Giorgio. **Disegni del Tiepolo; seconda edizione, riveduta e ampliata dall'autore.** Trieste, Editoriale Libraria, 1972. (CR).

9389. Villa Manin di Passariano. **Mostra del Tiepolo.** 2 v. 27 giugno-31 ottobre 1971. Milano, Electa, 1971.

TIMMERMANS, FELIX, 1886-1947

9390. Cordemans, Marcel. **Raymond de la Haye en Felix Timmermans, herinneringen.** Gent, Story-Scientia, 1967.

9391. Peeters, Denijs. **Felix Timmermans, tekenaar en schilder.** Leuven, Davidsfonds, [1956].

9392. Remoortere, Julien van. **Felix Timmermans; mens, schrijver, schilder, tekenaar.** Antwerpen, Mercatorfonds, 1972. (CR).

9393. Rutten, Th. **Felix Timmermans.** Groningen/Den Haag, Wolters, 1928.

9394. Timmermans, Lia. **Mijn Vader.** Amsterdam, De Brouwer, 1951.

9395. Vercammen, Louis. **Felix Timmermans: de mens--het Werk.** Hasselt, Heideland-Orbis, 1972.

9396. Veremans, Renaat. **Herinneringen aan Felix Timmermans.** Antwerpen, Vink, 1950.

TIMOTHEUS, 4th c. B.C.

9397. Schlörb, Barbara. **Timotheos.** Berlin, de Gruyter, 1965. (Jahrbuch des Archäologischen Instituts des Deutschen Reichs, Ergänzungsheft, 22).

TINGUELY, JEAN, 1925-

9398. Bezzola, Leonardo. **Jean Tinguely, 166 Fotos.** Zeichnungen, Texte, Gedichte, Briefe etc. von Eva Aeppli et al. Zürich, Arche, 1974.

9399. Monteil, Annemarie. **Der Tinguely-Brunnen in Basel.** Basel, Birkhaeuser, 1980.

9400. Wilhelm-Lehmbruck-Museum der Stadt Duisburg. **Jean Tinguely: Meta-Maschinen.** [December 17, 1978-February 4, 1979]. Duisburg, Wilhelm-Lehmbruck-Museum, 1978.

TINO DA CAMAINO, 1280-1337

9401. Carli, Enzo. **Tino di Camaino, scultore.** Firenze, Le Monnier, 1934.

9402. Morisani, Ottavio. **Tino di Camaino a Napoli.** Napoli, Libreria Scientifica Editrice, 1945.

9403. Valentiner, Wilhelm R. **Tino di Camaino, a Sienese sculptor of the fourteenth century.** Trans. by Josephine Walker. Paris, Pegasus, 1935.

TINTORETTO, IL, 1518-1594

9404. Bercken, Erich von der und Mayer, August L. **Jacopo Tintoretto.** 2 v. München, Piper, 1923.

9405. Bernari, Carlo [and] Vecchi, Pierluigi de. **L'opera completa del Tintoretto.** Milano, Rizzoli, 1970. (CR). (Classici dell'arte, 36).

9406. Bianchini, M. A. **Tintoretto.** Milano, Fabbri, 1964. (I maestri del colore, 17).

9407. Fosca, François [pseud., Georges de Traz]. **Tintoret.** Paris, Michel, 1929.

9408. Hadeln, Detlev von. **Zeichnungen des Giacomo Tintoretto.** Berlin, Cassirer, 1922.

9409. Holborn, John B. **Jacopo Robusti, called Tintoretto.** London, Bell, 1903.

9410. Loos, Viggo. **Tintoretto, motreformationens målare.** [Stockholm], Wahlström & Widstrand, 1940.

9411. Newton, Eric. **Tintoretto.** London, Longmans, Green, 1952.

9412. Osler, William R. **Tintoretto.** New York, Scribner and Welford/London, Sampson Low, 1879.

9413. Osmaston, Francis P. **The art and genius of Tintoret.** 2 v. London, Bell, 1915.

9414. Pallucchini, Rodolfo. **La giovinezza del Tintoretto.** Milano, Guarnati, 1950.

9415. _____. **Tintoretto a San Rocco.** Con note storiche di Mario Brunetti. Venezia, Le Tre Venezie, 1937.

9416. _____ [and] Rossi, Paola. **Tintoretto: le opere sacre e profane.** 2 v. Venezia, Alfieri/Milano, Electa, 1982.

9417. Phillips, Evelyn M. **Tintoretto.** London, Methuen, 1911.

9418. Pittaluga, Mary. **Il Tintoretto.** Bologna, Zanichelli, 1925.

9419. Ridolfi, Carlo. **Vita di Giacopo Robusti detto il Tintoretto, celebre pittore cittadino venetiano.** Venetia, Oddoni, 1642.

9420. Rossi, Paola. **I disegni di Jacopo Tintoretto.** Firenze, La Nuova Italia, 1975. (Corpus graphicum, 1).

9421. _____. **Jacopo Tintoretto: i ritratti.** Prefazione di Rodolfo Pallucchini. Venezia, Alfieri, 1974.

9422. Soulier, Gustave. **Le Tintoret, biographie critique.** Paris, Laurens, [1911].

9423. Stearns, Frank P. **Life and genius of Jacopo Robusti, called Tintoretto.** New York, Putnam, 1894.

9424. Thode, Henry. **Tintoretto.** Bielefeld/Leipzig, Velhagen & Klasing, 1901. (Künstler-Monographien, 49).

9425. Tietze, Hans. **Tintoretto: the paintings and drawings.** London, Phaidon, 1948.

9426. Villa alla Farnesina alla Lungara (Rome). **Immagini dal Tintoretto stampe dal XVI al XIX secolo nelle collezioni del Gabinetto delle Stampe.** 23 marzo-30 maggio 1982. Roma, de Luca, 1982.

9427. Waldmann, Emil. **Tintoretto.** Berlin, Cassirer, 1921.

TISCHBEIN, CHRISTIAN WILHELM, 1751-1824

JOHANN FRIEDRICH AUGUST, 1750-1812

JOHANN HEINRICH, 1722-1789

JOHANN HEINRICH WILHELM, 1751-1829

9428. Bahlmann, Hermann. **Johann Heinrich Tischbein.** Strassburg, Heitz, 1911. (Studien zur deutschen Kunstgeschichte, 142).

9429. Goethe, Johann W. **Wilhelm Tischbeins Idyllen.** München, Bruckmann, 1970.

9430. Landsberger, Franz. **Wilhelm Tischbein, ein Künstlerleben des 18. Jahrhunderts.** Leipzig, Klinkhardt & Biermann, 1908. (Bücher der Kunst, 3).

9431. Lenz, Christian. **Tischbein: Goethe in der Campagna di Roma.** [Published in conjunction with an exhibition at the Städelsches Kunstinstitut und Städtische Galerie, Frankfurt a.M.]. Frankfurt a.M., Städelsches Kunstinstitut und Städtische Galerie, 1970.

9432. Michel, Edmond. **Etude biographique sur les Tischbein, peintres allemands du XVIIIe siècle.** Lyon, Georg, 1881.

9433. Nonn, Konrad. **Christian Wilhelm Tischbein: Maler und Architekt, 1751-1824.** Strassburg, Heitz, 1912. (Studien zur deutschen Kunstgeschichte, 148).

9434. Stoll, Adolf. **Der Maler Johann Friedrich August Tischbein und seine Familie.** Stuttgart, Strecker und Schröder, 1923.

9435. Tischbein, Heinrich W. **Aus meinem Leben.** Herausgegeben von Kuno Mittelstädt. Berlin, Henschel, 1956.

TITIAN, 1488-1576

9436. Archivio General di Simancas (Simancas, Spain). **Tiziano e la corte di Spagna nei documenti dell'Archivio Generale di Simancas.** Madrid, Istituto Italiano di Cultura, 1975.

9437. Babelon, Jean. **Titien.** Paris, Plon, 1950.

9438. Barfoed, Christian. **Titian Vecellio, hans samtid, liv og kunst.** København, Lind, 1889.

9439. Basch, Victor. **Titien.** Paris, Librairie Français, 1920.

9440. Beltrame, Francesco. **Cenni illustrativi sul monumento a Tiziano Vecellio.** Venezia, Naratovich, 1852.

9441. Bergmann, Werner. **Tizian: Bilder aus seinem Leben und seiner Zeit.** 2 v. Hannover, Klindworth, 1865.

9442. Beroqui, Pedro. **Tiziano en el Museo del Prado.** Madrid, [Museo del Prado], 1946.

9443. Bettini, Sergio, et al. **Tiziano nel quarto centenario della sua morte, 1576-1976.** Venezia, Ateneo Veneto, 1977.

9444. Cadorin, Giuseppe. **Dello amore ai veneziani di Tiziano Vecellio delle sue case in Cadore e in Venezia e delle vite de' suoi figli.** Venezia, Hopfner, 1833.

9445. Cagli, Corrado [and] Valcanover, Francesco. **L'opera completa di Tiziano.** Milano, Rizzoli, 1969. (CR). (Classici dell'arte, 32).

9446. Caro-Delvaille, Henry. **Titien.** Paris, Alcan, 1913.

9447. Carpani, Giuseppe. **Le Majeriane ovvero lettere sul bello ideale, in riposta al libro Della Imitazione Pittorica del Andrea Majer.** Edizione terza, riveduta ed accrescuita dall'autore. Padova, Tipografia della Minerva, 1824.

9448. Christoffel, Ulrich. **Tizian.** Zürich/Wien, Europa, 1957. (Urban-Bücher, 25).

9449. Clausse, Gustav. **Les Farnèses peints par Titien.** Paris, Gazette des Beaux-Arts, 1905.

9450. Comitato promotore per le manifestazioni espositive Firenze e Prato. **Tiziano nelle gallerie fiorentine.** Firenze, Centro Di, 1978.

9451. Crowe, Joseph A. and Cavalcaselle, G. B. **Titian: his life and times.** 2 v. London, Murray, 1877.

9452. Fischel, Oskar. **Tizian, des Meisters Gemälde.** Stuttgart/Leipzig, Deutsche Verlags-Anstalt, 1904. (Klassiker der Kunst, 3).

9453. Fondazione Giorgio Cini (Venice). **Disegni di Tiziano e della sua cerchia.** Catalogo a cura di Konrad Oberhuber con l'assistenza di Hilliard Goldfarb. Presentazione di Rodolfo Pallucchini. Venezia, Pozza, 1976. (Cataloghi di mostre, 38).

9454. Galleria degli Uffizi (Florence). **Tiziano e il disegno veneziano del suo tempo.** Firenze, Olschki, 1976.

9455. Gentili, Augusto. **Da Tiziano a Tiziano: mito e allegoria nella cultura veneziana del cinquecento.** Milano, Feltrinelli, 1980.

9456. Gilbert, Josiah. **Cadore, or Titian's country.** London, Longmans, Green, 1869.

9457. Gronau, Georg. **Titian.** Trans. by Alice M. Todd. London, Duckworth/New York, Scribner, 1904.

9458. Hadeln, Detlev von. **Titian's drawings.** London, Macmillan, 1927.

9459. Hamel, Maurice. **Titien, biographie critique.** Paris, Laurens, [1904].

9460. Heath, Richard F. **Titian.** New York, Scribner and Welford, 1882.

9461. Hetzer, Theodor. **Tizian: Geschichte seiner Farbe.** Frankfurt a.M., Klostermann, 1935.

9462. Hope, Charles. **Titian.** New York, Harper & Row, 1980.

9463. Hourticq, Louis. **La jeunesse de Titien.** Paris, Hachette, 1919.

9464. Hume, Abraham. **Notice of the life and works of Titian.** London, Rodwell, 1829.

9465. Knackfuss, Hermann. **Tizian.** Bielefeld/Leipzig, Velhagen & Klasing, 1897. (Künstler-Monographien, 29).

9466. Lafenestre, Georges. **La vie et l'oeuvre de Titien.** Paris, May, 1886.

9467. Maier, Andrea. **Apologia del libro Della Imitazione Pittorica e delle eccellenza delle opere di Tiziano contro tre lettere di Giuseppe Carpani a Giuseppe Acerbi.** Ferrara, Pomatelli, 1820.

9468. _____. **Della imitazione pittorica [and] Della eccellenza delle opere di Tiziano e della Vita di Tiziano scritta da Stefano Ticozzi.** Venezia, Alvisopoli, 1818.

9469. Mauroner, Fabio. **Le incisioni di Tiziano.** Venezia, Le Tre Venezie, 1941.

9470. Morassi, Antonio. **Titian.** Greenwich, Conn., New York Graphic Society, 1965.

9471. Northcote, James. **The life of Titian.** 2 v. London, Colburn and Bentley, 1830.

9472. Palazzo Reale (Milan). **Omaggio a Tiziano: la cultura artistica milanese nell'età di Carlo V.** 27 aprile-20 luglio 1977. Milano, Electa, 1977.

9473. Pallucchini, Rodolfo. **Tiziano.** 2 v. Firenze, Sansoni, 1969.

9474. _____, ed. **Tiziano e il manierismo europeo.** Firenze, Olschki, 1978. (Civiltà veneziana, 24).

9475. Panofsky, Erwin. **Problems in Titian, mostly iconographic.** New York, New York University Press, 1969. (Wrightsman Lectures, 2).

9476. Phillips, Claude. **The earlier work of Titian.** London, Seeley, 1897. (Portfolio, 34).

9477. _____. **The later work of Titian.** London, Seeley, 1898. (Portfolio, 37).

9478. Pilla, Eugenio. **Tiziano: il pittore dell'Assunta.** Napoli, Treves, 1969.

9479. Pope, Arthur. **Titian's Rape of Europa: a study of the composition and the mode of representation in this and related paintings.** Cambridge, Mass., Harvard University Press, 1960.

9480. Ricketts, Charles. **Titian.** London, Methuen, 1910.

9481. Rosand, David. **Titian.** New York, Abrams, 1978.

9482. _____ ed. **Titian: his world and his legacy.** New York, Columbia University Press, 1982.

9483. _____ and Muraro, Michelangelo. **Titian and the Venetian woodcut.** [Published in conjunction with an exhibition at the National Gallery of Art, Washington, D.C., and other places]. Washington, D.C., National Gallery of Art, 1976.

9484. Suida, Wilhelm. **Tizian.** Zürich/Leipzig, Füssli, 1933.

9485. Sweetser, Moses F. **Titian.** Boston, Osgood, 1877.

9486. Ticozzi, Stefano. **Vite dei pittori Vecelli di Cadore.** Milano, Stella, 1817.

9487. Tietze, Hans. **Titian: paintings and drawings.** London, Phaidon, 1950. 2 ed.

9488. Tiziano Vecellio. **Le lettere.** Presentazioni di Giuseppe Vecellio. Introduzione di Ugo Fasolo. Prefazione di Clemente Gandini. Cadore, Magnifica Comunità di Cadore, 1977.

9489. Università degli Studi di Venezia. **Tiziano e Venezia: convegno internazionale di studi.** Vicenza, Pozza, 1980.

9490. Valcanover, Francesco. **All the paintings of Titian.** Trans. by Sylvia J. Tomalin. 4 v. New York, Hawthorn, 1960. (CR). (Complete Library of World Art, 29-32).

9491. Verdizzotti, Giovanni M. **Breve compendio della vita del famoso Tiziano Vecellio di Cadore.** Venetia, Appresso Santo Grillo, 1622.

9492. Villa della Farnesina alla Lungara (Rome). **Immagini da Tiziano: stampe dal secolo XVI al secolo XIX dalle collezioni del Gabinetto Nazionale delle Stampe.** 16 dicembre 1976-15 gennaio 1977. Roma, de Luca, 1976.

9493. Waldmann, Emil. **Tizian.** Berlin, Propyläen, 1922.

9494. Walther, Angelo. **Tizian.** Leipzig, Seemann, 1978.

9495. Wethey, Harold E. **The paintings of Titian, complete edition.** 3 v. London, Phaidon, 1969-1975. (CR).

9496. Wiel, Taddeo. **Tiziano a Venezia.** Venezia, Kirchmayr e Scozzi, 1880.

TIZIANO VECELLI see TITIAN

TOBEY, MARK, 1890-1976

9497. Heidenheim, Hanns H. **Mark Tobey: das graphische Werk.** Düsseldorf, Ursus, 1975. (CR).

9498. Musée des Arts Décoratifs (Paris). **Rétrospective Mark Tobey.** 18 octobre-1 décembre 1961. Paris, Musée des Arts Décoratifs, 1961.

9499. National Collection of Fine Arts, Smithsonian Institution (Washington, D.C.). **Tribute to Mark Tobey.** June 7-September 8, 1974. Washington, D.C., Smithsonian Institution Press, 1974.

9500. Rathbone, Eliza. **Mark Tobey, city paintings.** [Published in conjunction with an exhibition at the National Gallery of Art, Washington, D.C.]. Washington, D.C., National Gallery of Art, 1984.

9501. Roberts, Colette. **Tobey.** Paris, Fall, 1959.

9502. Seitz, William C. **Mark Tobey.** [Published in conjunction with an exhibition at the Museum of Modern Art, New York]. New York, Museum of Modern Art, 1962; distributed by Doubleday, Garden City, N.Y.

TOCQUE, LOUIS, 1696-1772

9503. Doria, Arnauld. **Louis Tocqué.** Paris, Beaux-Arts, 1929. (CR).

TOEPFFER, RODOLPHE, 1799-1846

9504. Blondel, Auguste [and] Mirabaud, Paul. **Rodolphe Töpffer: l'écrivain, l'artiste et l'homme.** Paris, Hachette, 1886.

9505. Chaponnière, Paul. **Notre Töpffer.** Lausanne, Payot, 1930.

9506. Courthion, Pierre. **Genève, ou le portrait de Töpffer.** Préface de Jean Cassou. Paris, Grasset, 1936.

9507. Gagnebin, Marianne. **Rodolphe Töpffer.** Neuchâtel, Editions du Griffon, 1947.

9508. Relave, Pierre M. **Rodolphe Töpffer, biographie et extraits.** Lyon, Vitte, 1899.

9509. Toepffer, Rodolphe. **Caricatures (oeuvres complètes).** 17 v. Genève, Skira, 1943-1945. (CR).

9510. Wiese, Ellen P. **Enter: the comics; Rodolphe Töpffer's Essay on Physiognomy and The True Story of Monsieur Crépin.** Trans. and edited, with an introduction, by E. Wiese. Lincoln, Nebr., University of Nebraska Press, 1965.

TOGORES, JOSEP DE, 1893-1970

9511. Fàbregas i Barri, Esteve. **Josep de Togores; l'obra, l'home, l'època (1893-1970).** Barcelona, Editorial Aedos, 1970. (Biblioteca biogràfica catalana, 46).

TOMASO DA MODENA, 1325/26-1379

9512. Coletti, Luigi. **Tomaso da Modena.** A cura di Clara R. Coletti; prefazione di Sergio Bettini. Venezia, Pozza, 1963. (Saggi e studi di storia dell'arte, 7).

9513. Santa Caterina, Capitolo dei Domenicani (Treviso). **Tomaso da Modena.** 5 luglio-5 novembre 1979. Treviso, Edizioni Canova, 1979.

9514. Zava Boccazzi, Franca. **Tommaso da Modena.** Milano, Fabbri, 1966. (I maestri del colore, 193).

TOMMASO DA MODENA see TOMASO DA MODENA

TOOROP, JAN THEODOOR, 1858-1928

9515. Institut Néerlandais (Paris). **Jan Toorop, 1858-1928; impressioniste, symboliste, pointilliste.** 19 octobre-4 décembre 1977. Paris, Institut Néerlandais, 1977.

9516. Knipping, John B. **Jan Toorop.** Amsterdam, Becht, [1947]. (Palet serie).

9517. Rijksmuseum Kröller-Müller (Otterlo, The Netherlands). **J. Th. Toorop, de jaren 1885 tot 1910.** 9 december 1978-11 februari 1979. Otterlo, Rijksmuseum Kröller-Müller, 1978.

TORII, KIYONAGA, 1752-1815

9518. Hirano, Chie. **Kiyonaga: a study of his life and works.** Boston, Museum of Fine Arts, 1969.

9519. Narazaki, Muneshige. **Kiyonaga.** Trans. by John Bester. Tokyo/Palo Alto, Calif., Kodansha, 1969. (Masterworks of Ukiyo-e).

9520. Noguchi, Yone. **Kiyonaga.** [Text in English and Japanese]. Tokyo, Seibundo, 1932.

9521. Takahashi, Seiichiro. **Torii Kiyonaga (1752-1815).** English adaptation by Thomas Kaasa. Tokyo/Rutland, Vt., Tuttle, 1956. (Kodansha Library of Japanese Art, 8).

TORRENTIUS, JOHANNES, 1589-1644

9522. Bredius, Abraham. **Johannes Torrentius, schilder, 1589-1644.** 's Gravenhage, Nijhoff, 1909.

9523. Rehorst, A. J. **Torrentius.** Rotterdam, Brusse, 1939.

TORRES-GARCÍA, JOAQUÍN, 1874-1949

9524. Biblioteca Nacional, Montevideo. **Joaquín Torres-García: centenario de su nacimiento, 1874-28 de Julio-1974; bibliografía.** Montevideo, Biblioteca Nacional, 1974.

9525. Jardí, Enric. **Torres García.** Trans. by Kenneth Lyons. Barcelona, Polígrafa, 1974. (CR).

9526. Robbins, Daniel. **Joaquín Torres-García, 1874-1949.** [Published in conjunction with an exhibition at the Museum of Art, Rhode Island School of Design, Providence R.I., and other places]. Providence, Museum of Art, Rhode Island School of Design, 1970.

9527. Schaefer, Claude. **Joaquín Torres-García.** Buenos Aires, Poseidón, 1945.

9528. Torres García, Joaquín. **Escritos.** Selección, analítica y prólogo: Juan Fló. Montevideo, Arca, 1974.

9529. _____. **Estructura.** Montevideo, Alfar, [1935].

9530. _____. **Historia de mi vida.** Montevideo, Talleres Graficos Sur, 1939.

9531. _____. **Universalismo constructivo.** Buenos Aires, Poseidón, 1944.

9532. University of Texas at Austin Art Museum. **Joaquín Torres-García, 1874-1949; chronology and catalogue of the family collection.** 13 October-24 November 1974. Austin, Tex., University of Texas at Austin, 1974.

TOSHUSAI SHARAKU see SHARAKU, TOSHUSAI

TOULOUSE-LAUTREC, HENRI DE, 1864-1901

9533. Adhémar, Jean. **Toulouse-Lautrec: his complete lithographs and drypoints.** New York, Abrams, 1965. (CR).

9534. Adriani, Götz. **Toulouse-Lautrec: das gesamte graphische Werk.** [Published in conjunction with an exhibition at Kunsthalle Tübingen, October-November 1976]. Köln, DuMont, 1976. (CR).

9535. _____. **Toulouse-Lautrec und das Paris um 1900.** Köln, DuMont, 1978.

9536. Astre, Achille. **H. de Toulouse-Lautrec.** Paris, Nillson, 1926.

9537. Beaute, Georges. **Il y a cent ans Henri de Toulouse-Lautrec.** Genève, Cailler, 1964.

9538. Bouret, Jean. **Toulouse-Lautrec.** Paris, Somogy, 1963. (Les plus grands, 6).

9539. Caproni, Giorgio [and] Sugana, Gabriele M. **L'opera completa di Toulouse-Lautrec.** Milano, Rizzoli, 1969. (CR). (Classici d'arte, 31).

9540. Cooper, Douglas. **Toulouse-Lautrec.** New York, Abrams, 1966.

9541. Coquiot, Gustave. **H. de Toulouse-Lautrec.** Paris, Blaizot, 1913. (New ed.: **Lautrec ou quinze ans de moeurs parisiennes.** Paris, Ollendorff, 1920).

9542. Dortu, M. G. **Toulouse-Lautrec et son oeuvre.** 6 v. New York, Collectors Editions, 1971. (CR).

9543. Duret, Théodore. **Lautrec.** Paris, Bernheim, 1920.

9544. Esswein, Hermann. **Henri de Toulouse-Lautrec.** München/Leipzig, Piper, [1916]. (Moderne Illustratoren, 3).

9545. Fermigier, André. **Toulouse-Lautrec.** Paris, Hazan, 1969.

9546. Gauzi, François. **Lautrec et son temps.** Paris, Perret, 1954.

9547. Hanson, Lawrence and Hanson, Elisabeth. **The tragic life of Toulouse-Lautrec.** New York, Random House, 1956.

9548. Huisman, Philippe and Dortu, M. G. **Lautrec by Lautrec.** Trans. by Corinne Bellow. London, Macmillan, 1964.

9549. Jedlicka, Gotthard. **Henri de Toulouse-Lautrec.** Zürich, Rentsch, 1943. 2 ed.

9550. Jourdain, Francis [and] Adhémar, Jean. **T.-Lautrec.** Paris, Tisné, 1952.

9551. Joyant, Maurice. **Henri de Toulouse-Lautrec, 1864-1901.** 2 v. Paris, Floury, 1926-1927.

9552. Julien, Edouard. **Les affiches de Toulouse-Lautrec.** Catalogue par Fernand Mourlot. Monte-Carlo, Sauret, 1967. 2 ed. (CR).

9553. Keller, Horst. **Toulouse-Lautrec: painter of Paris.** Trans. by Erika Bizzarri. New York, Abrams, 1969.

9554. Lapparent, P. de. **Toulouse-Lautrec.** Paris, Rieder, 1927.

9555. Lassaigne, Jacques. **Lautrec, biographical and critical studies.** Trans. by Stuart Gilbert. Geneva, Skira, 1953. (The Taste of Our Time, 3).

9556. Leclercq, Paul. **Autour de Toulouse-Lautrec.** Paris, Floury, 1920. (New ed.: Genève, Cailler, 1954).

9557. Mack, Gerstle. **Toulouse-Lautrec.** New York, Knopf, 1938.

9558. MacOrlan, Pierre. **Lautrec, peintre de la lumière froide.** Paris, Floury, 1934.

9559. Natanson, Thadée. **Un Henri de Toulouse-Lautrec.** Genève, Cailler, 1951. (Les grands artistes racontés par eux-mêmes et par leurs amis, 11).

9560. Novotny, Fritz. **Toulouse-Lautrec.** Trans. by Michael Glenney. London, Phaidon, 1969.

9561. Palais de la Berbie (Albi)/Petit Palais (Paris). **Centenaire de Toulouse-Lautrec.** [June-December 1964]. Paris, Ministère d'Etat Affaires Culturelles, 1964.

9562. Palais de la Berbie, Musée Toulouse-Lautrec (Albi). **Catalogue.** Albi, Palais de la Berbie, Musée Toulouse-Lautrec, 1973.

9563. Perruchot, Henri. **La vie de Toulouse-Lautrec.** Paris, Hachette, 1958.

9564. Polášek, Jan. **Toulouse-Lautrec: drawings.** New York, St. Martin's, 1976.

9565. Roger-Marx, Claude. **Toulouse-Lautrec.** Paris, Editions Universitaires, 1957. (Témoins du XXe siècle, 7).

9566. Schaub-Koch, Emile. **Psychoanalyse d'un peintre moderne: Henri de Toulouse-Lautrec.** Paris, Editions Littéraire Internationale, 1935.

9567. Stuckey, Charles F. **Toulouse-Lautrec: paintings.** [Publ. in conjunction with an exhibition at the Art Institute of Chicago]. Chicago, Art Institute of Chicago, 1979.

9568. Tapié de Céleyran, Mary. **Notre oncle Lautrec.** Genève, Cailler, 1953.

9569. Thomson, Richard. **Toulouse-Lautrec.** London, Oresko, 1977.

9570. Toulouse-Lautrec, Henri de. **Unpublished correspondence.** Edited by Lucien Goldschmidt and Herbert Schimmel, with an introduction and notes by Jean Adhémar and Theodore Reff. London, Phaidon, 1969.

TOURNACHON, FELIX, 1820-1910

9571. Barret, André. **Nadar: 50 photographies de ses illustres contemporains.** Paris, Trésors de la Photographie, 1975.

9572. Gosling, Nigel. **Nadar.** New York, Knopf, 1976.

9573. Greaves, Roger. **Nadar, ou le paradoxe vital.** Paris, Flammarion, 1980.

9574. Meyer, Catherine et Meyer, Bertrand. **Nadar: photographe, caricaturiste, journaliste.** Paris, Encre, 1979.

9575. Nadar [pseud., Felix Tournachon]. **Quand j'étais étudiant;** édition définitive. Paris, Dentu, 1881.

9576. _____. **Quand j'étais photographe.** Préface de Léon Daudet. Paris, Flammarion, 1899.

9577. Néagu, Philippe et Poulet-Allamagny, Jean-Jacques. **Nadar.** Préface de Jean-François Bory. 2 v. Paris, Hubschmid, 1979. 2 v. (CR).

9578. Prinet, Jean et Dilasser, Antoinette. **Nadar.** Paris, Colin, 1966. (Italian ed., with additional text by Lamberto Vitali and photographs by Nadar: Torino, Einaudi, 1973).

TOWN, ITHIEL, 1784-1844 see DAVIS, ALEXANDER JACKSON

TOWNE, FRANCIS, 1740-1816

9579. Bury, Adrian. **Francis Towne, lone star of water-colour painting.** London, Skilton, 1962.

TOYOKUNI, UTAGAWA ICHIYŌSAI, 1769-1825

9580. Strange, Edward F. **Japanese colour prints by Utagawa Toyokuni.** London, HMSO, 1908.

9581. Succo, Friedrich. **Utagawa Toyokuni und seine Zeit.** 2 v. München, Piper, 1913. (CR).

TRAINI, FRANCESCO, 14th c.

9582. Bonaini, Francesco. **Memorie inedite intorno alla vita e ai dipinti di Francesco Traini.** Pisa, Nistri, 1846.

9583. Meiss, Millard. **Francesco Traini.** Edited and with an introduction by Hayden B. J. Maginnis. Washington, D.C., Decatur House, 1983. (Art History Series, 6).

9584. Oertel, Robert. **Francesco Traini: der Triumph des Todes im Campo Santo zu Pisa.** Berlin, Mann, 1948.

TROOST, CORNELIS, 1697-1750

9585. Knoef, Jan. **Cornelis Troost.** Amsterdam, Becht, [1947]. (Palet serie).

9586. Museum Boymans-van Beuningen (Rotterdam). **Cornelis Troost en zijn tijd.** [July 27-September 15, 1946]. Rotterdam, van Waesberge, Hoogewerff & Richards, 1946.

9587. Niemeijer, J. W. **Cornelis Troost, 1696 [sic]-1750.** Assen, van Gorcum, 1973.

9588. Ver Huell, Alexander. **Cornelis Troost en zijn werken.** Arnhem, Gouda Quint, 1873.

TROVA, ERNEST TINO, 1927-

9589. Alloway, Lawrence. **Trova; selected works, 1953-1966.** New York, Pace Gallery, 1966.

9590. Bush, Martin H. **Ernest Trova.** [Published in conjunction with an exhibition at the Edwin A. Ulrich Museum of Art, Wichita State University, Wichita, Kan., March 21-April 8, 1979, and other places]. Wichita, Edwin A. Ulrich Museum of Art, 1977.

9591. Kultermann, Udo. **Trova.** New York, Abrams, 1978.

TROYON, CONSTANT, 1810-1865

see also COROT, JEAN-BAPTISTE CAMILLE

9592. Dumesnil, Henri. **Troyon; souvenirs intimes.** Paris, Laurens, 1888.

9593. Hustin, Arthur. **Constant Troyon.** Paris, Librairie de l'Art, 1895.

9594. Soullié, Louis. **Peintures, pastels, aquarelles, dessins de Constant Troyon relevés dans les catalogues de ventes de 1833 à 1900.** Paris, Soullié, 1900.

TRÜBNER, WILHELM, 1851-1917

9595. Beringer, Joseph A. **Trübner, des Meisters Gemälde.** Stuttgart/Berlin, Deutsche Verlags-Anstalt, 1917. (Klassiker der Kunst, 26).

9596. Fuchs, Georg. **Wilhelm Trübner und sein Werk.** München/Leipzig, Müller, 1908.

9597. Rosenhagen, Hans. **Wilhelm Trübner.** Bielefeld/Leipzig, Velhagen & Klasing, 1909. (Künstler-Monographien, 98).

9598. Trübner, Wilhelm. **Personalien und Prinzipien.** Eingeleitet von Emil Waldmann. Berlin, Cassirer, [1918]. 2 ed.

TRUMBULL, JOHN, 1756-1843

9599. Cooper, Helen A. **John Trumbull: the hand and spirit of a painter.** [Published in conjunction with an exhibition at the Yale University Art Gallery, New Haven, October 28, 1982-January 16, 1983]. New Haven, Yale University Art Gallery, 1982.

9600. Jaffe, Irma B. **John Trumbull, patriot-artist of the American Revolution.** Boston, New York Graphic Society, 1975.

9601. _____. **Trumbull: the Declaration of Independence.** New York, Viking, 1976.

9602. Sizer, Theodore. **The works of Colonel John Trumbull, artist of the American Revolution.** New Haven/London, Yale University Press, 1967. 2 ed. (CR).

9603. Trumbull, John. **The autobiography of Colonel John Trumbull, patriot-artist, 1756-1843.** Ed. by Theodore Sizer. New Haven, Yale University Press, 1953.

9604. Weir, John F. **John Trumbull, a brief sketch of his life to which is added a catalogue of his works.** New York, Scribner, 1901.

TURA, COSIMO, 1430-1495

see also COSSA, FRANCESCO DEL

9605. Cittadella, Luigi N. **Ricordi e documenti intorno alla vita di Cosimo Tura detto Cosmè, pittor ferrarese del secolo XV.** Ferrara, Taddei, 1866.

9606. Molajoli, Rosemarie. **L'opera completa di Cosmè Tura e i grandi pittori ferraresi del suo tempo: Francesco Cossa e Ercole de' Roberti.** Milano, Rizzoli, 1974. (CR). (Classici dell'arte, 73).

9607. Neppi, Alberto. **Cosmè Tura, saggio critico.** Milano, Gastaldi, 1952.

9608. Ruhmer, Eberhard. **Tura, paintings and drawings; complete edition.** London, Phaidon, 1958.

9609. Salmi, Mario. **Cosmè Tura.** Milano, Electa, 1957.

TURNER, JOSEPH MALLORD WILLIAM, 1775-1851

9610. Anderson, John. **The unknown Turner: revelations concerning the life and art of J. M. W. Turner.** New York, Privately printed for the author, 1926.

9611. Armstrong, Walter. **Turner.** London, Agnew/New York, Scribner, 1902.

9612. Bock, Henning und Prinz, Ursula. **J. M. W. Turner, der Maler des Lichts.** Berlin, Mann, 1972.

9613. British Museum (London). **Turner in the British Museum: drawings and watercolours.** [Catalogue by Andrew Wilton]. London, British Museum Publications, 1975.

9614. Brooke, Stopford. **Notes on the Liber Studiorum of J. M. W. Turner.** London, The Autotype Company, 1885.

9615. Burnet, John. **Turner and his works.** London, Bogue, 1852.

9616. Butlin, Martin and Joll, Evelyn. **The paintings of J. M. W. Turner.** 3 v. New Haven/London, Yale University Press, 1977. (CR).

9617. Centre Culturel du Marais (Paris). **Turner en France.** [October 7, 1981-January 10, 1982; text in French and English]. Paris, Centre Culturel du Marais, 1981.

9618. Clare, Charles. **J. M. W. Turner, his life and work.** London, Phoenix House, 1951.

9619. Dafforne, James. **The works of J. M. W. Turner.** London, Virtue, 1877.

9620. Finberg, Alexander J. **A complete inventory of the drawings of the Turner bequest** [to the National Gallery]. 2 v. London, HMSO, 1909.

9621. _____. **The history of Turner's Liber Studiorum with a new catalogue raisonné.** London, Benn, 1924. (CR).

9622. _____. **In Venice with Turner.** London, Cotswold Gallery, 1930.

9623. _____. **The life of J. M. W. Turner.** With a supplement by Hilda F. Finberg. Oxford, Clarendon Press, 1961. 2 ed.

9624. _____. **Turner's sketches and drawings.** London, Methuen, 1910. (New ed., with an introduction by Lawrence Gowing: New York, Schocken, 1968).

9625. Finley, Gerald. **Landscapes of memory: Turner as illustrator to Scott.** London, Scolar Press, 1980.

9626. Gage, John. **Color in Turner: poetry & truth.** New York, Praeger, 1969.

9627. _____. **Turner. Rain, steam & speed.** New York, Viking, 1972.

9628. Gaunt, William. **Turner.** Oxford, Phaidon, 1981. 2 ed.

9629. Gowing, Lawrence. **Turner: imagination and reality.** New York, Museum of Modern Art, 1966; distributed by Doubleday, Garden City, N.Y.

9630. Hamburger Kunsthalle. **William Turner und die Landschaft seiner Zeit.** 19. Mai bis 18. Juli 1976. München, Prestel, 1976.

9631. Hamerton, Philip G. **The life of J. M. W. Turner, R. A.** Boston, Roberts, 1879.

9632. Herrmann, Luke. **Ruskin and Turner.** London, Faber, 1968.

9633. _____. **Turner: paintings, watercolors, prints & drawings.** Boston, New York Graphic Society, 1975.

9634. Hind, C. Lewis. **Turner's golden visions.** London, Jack, 1910.

9635. Lindsay, Jack. **J. M. W. Turner; a critical biography.** Greenwich, Conn., New York Graphic Society, 1966.

9636. Mauclair, Camille. **Turner.** Trans. by E. B. Shaw. London, Heinemann, 1939.

9637. Monkhouse, W. Cosmo. **Turner.** New York, Scribner and Welford/London, Sampson Low, 1879.

9638. Rawlinson, William G. **The engraved work of J. M. W. Turner.** 2 v. London, Macmillan, 1908-1913. (CR).

9639. Reynolds, Graham. **Turner.** New York, Abrams, 1969.

9640. Rothenstein, John and Butlin, Martin. **Turner.** New York, Braziller, 1964.

9641. Ruskin, John. **Notes by Mr. Ruskin on his collection of drawings by the late J. M. W. Turner, R. A.** London, Fine Art Society, 1878.

9642. Russell, John. **Turner in Switzerland.** Survey and notes with a checklist of the finished Swiss watercolours by Andrew Wilton. Zurich, De Clivo Press, 1976.

9643. Shanes, Eric. **Turner's picturesque views in England and Wales, 1825-1838.** With an introduction by Andrew Wilton. London, Chatto & Windus, 1979.

9644. _____. **Turner's rivers, harbours and coasts.** London, Chatto & Windus, 1981.

9645. Swinburne, Charles A. **Life and work of J. M. W. Turner.** London, Bickers, 1902.

9646. Thornbury, Walter. **The life of J. M. W. Turner, R. A., founded on letters and papers furnished by his friends and fellow academians.** 2 v. London, Hurst and Blackett, 1862.

9647. Turner, J. M. W. **Collected correspondence.** With an early diary and a memoir by George Jones. Ed. by John Gage. Oxford, Clarendon Press, 1980.

9648. University Art Museum, University of California (Berkeley). **J. M. W. Turner: works on paper from American collections.** [September 30-November 23, 1975]. Berkeley, University Art Museum, 1975.

9649. Walker, John. **Joseph Mallord William Turner.** New York, Abrams, 1976.

9650. Wilkinson, Gerald. **Turner on landscape: the Liber Studiorum.** London, Barrie & Jenkins, 1982.

9651. _____. **Turner sketches, 1802-20: romantic genius.** London, Barrie & Jenkins, 1974.

9652. _____. **Turner's colour sketches, 1820-34.** London, Barrie & Jenkins, 1975.

9653. _____. **Turner's early sketchbooks: drawings in England, Wales, and Scotland from 1789 to 1802.** London, Barrie & Jenkins, 1972.

9654. Wilton, Andrew. **J. M. W. Turner.** New York, Rizzoli, 1979.

9655. _____. **Turner and the sublime.** [Published in conjunction with an exhibition at the Art Gallery of Ontario, Toronto, 1 November 1980-4 January 1981, and other places]. Toronto, Art Gallery of Ontario/New Haven, Yale Center for British Art, 1980.

9656. Winthrop, Grenville L. **A catalogue of the collection of prints from the Liber Studiorum of Joseph Mallord William**

Turner formed by the late Francis Bullard of Boston, Massachusetts. Boston, Merrymount Press, 1916.

9657. Wyllie, William L. **J. M. W. Turner.** London, Bell, 1905.

TZARA, TRISTAN, 1896-1963

9658. Tzara, Tristan. **Seven Dada manifestos and lampisteries.** Trans. by Barbara Wright. London, Calder, 1977.

UBERTINI, FRANCESCO, 1494-1557

9659. Merritt, Howard S. **Bachiacca studies: the uses of imitation.** Ann Arbor, Mich., University Microfilms, 1975.

9660. Nikolenko, Lada. **Francesco Ubertini called il Bacchiacca.** Locust Valley, N.Y., Augustin, 1966.

9661. Tinti, Mario. **Il Bacchiacca.** Firenze, Alinari, 1925. (Piccola collezione d'arte, 39).

UCCELLO, PAOLO, 1397-1475

9662. Boeck, Wilhelm. **Paolo Uccello, der Florentiner Meister und sein Werk.** Berlin, Grote, 1939.

9663. Carli, Enzo. **All the paintings of Paolo Uccello.** Trans. by Marion Fitzallan. New York, Hawthorn, 1963. (Complete Library of World Art, 22).

9664. Flaiano, Ennio [and] Tongiorgi Tomasi, Lucia. **L'opera completa di Paolo Uccello.** Milano, Rizzoli, 1971. (CR). (Classici dell'arte, 46).

9665. Parronchi, Alessandro. **Paolo Uccello.** Bologna, Boni, 1974.

9666. Pittaluga, Mary. **Paolo Uccello.** Roma, Tumminelli, 1946.

9667. Pope-Hennessy, John. **Paolo Uccello, complete edition.** London, Phaidon, 1969. 2 ed.

9668. Salmi, Mario. **Paolo Uccello, Andrea del Castagno, Domenico Veneziano.** Milano, Hoepli, 1938.

9669. Schefer, Jean L. **La déluge, la peste: Paolo Uccello.** Paris, Galilée, 1976.

9670. Soupault, Philippe. **Paolo Uccello.** Paris, Rieder, 1929.

UELSMANN, JERRY NORMAN, 1934-

9671. Enyeart, James L. **Jerry N. Uelsmann; twenty-five years: a retrospective.** Boston, New York Graphic Society, 1982.

9672. Uelsmann, Jerry. **Silver meditations.** Introd. by Peter C. Bunnell. Dobbs Ferry, N.Y., Morgan & Morgan, 1975.

9673. Ward, John L. **The criticism of photography as art: the photographs of Jerry Uelsmann.** Gainesville, University of Florida Press, 1970. (University of Florida Humanities Monographs, 32).

UGRIUMOV, GRIGORII IVANOVICH, 1764-1823

9674. Zonova, Zinaida T. **Grigorii Ivanovich Ugriumov, 1764-1823.** Moskva, Iskusstvo, 1966.

UHDE, FRITZ VON, 1848-1911

9675. Bierbaum, Otto J. **Fritz von Uhde.** München, Albert, 1893.

9676. Ostini, Fritz von. **Uhde.** Bielefeld/Leipzig, Velhagen & Klasing, 1902. (Künstler-Monographien, 61).

9677. Rosenhagen, Hans. **Uhde, des Meisters Gemälde.** Stuttgart/ Leipzig, Deutsche Verlags-Anstalt, 1908. (Klassiker der Kunst, 12).

UHLMANN, HANS, 1900-1975

9678. Akademie der Künste (Berlin). **Hans Uhlmann.** 17. März bis 15. April 1968. Berlin, Akademie der Künste, 1968.

9679. Baumgart, Fritz. **Uhlmann, Handzeichnungen.** Frankfurt a.M., Kiefer, 1960.

9680. Haftmann, Werner. **Hans Uhlmann, Leben und Werk.** Oeuvre-verzeichnis der Skulpturen von Ursula Lehmann-Brockhaus. Berlin, Mann, 1975. (CR). (Schriftenreihe der Akademie der Künste, 11).

UKHTOMSKII, DMITRI VASIL'EVICH, 1719-1774/5

9681. Mikhailov, Aleksei I. **Arkhitektor D. V. Ukhtomskii i ego shkola.** Moskva, Gosudarstvennyi Izd-vo Lit-ry po Stroitel'stvu i Arkhitekture, 1954.

UMLAUF, CHARLES, 1911-

9682. Goodall, Donald B. **Charles Umlauf, sculptor.** Foreword by Gibson A. Danes. Austin/London, University of Texas Press, 1967.

UNOLD, MAX, 1885-1964

9683. Hausenstein, Wilhelm. **Max Unold.** Leipzig, Klinkhart & Biermann, 1921. (Junge Kunst, 23).

9684. Unold, Max. **Über die Malerei.** Hamburg, Claassen & Goverts, 1948.

UPJOHN, RICHARD, 1802-1878

9685. Upjohn, Everard M. **Richard Upjohn, architect and churchman.** New York, Columbia University Press, 1939.

9686. Upjohn, Richard. **Upjohn's rural architecture: designs, working drawings and specifications for a wooden church and other rural structures.** New York, Putnam, 1852. (Reprint: New York, Da Capo, 1975).

URBANO DA CORTONA, fl. 1446

9687. Schubring, Paul. **Urbano da Cortona, ein Beitrag zur Kenntnis der Schule Donatellos und der sieneser Plastik im Quattrocento.** Strassburg, Heitz, 1903. (Zur Kunstgeschichte des Auslandes, 15).

URY, LESSER, 1861-1931

9688. Brieger, Lothar. **Lesser Ury.** Berlin, Verlag Neue Kunsthandlung, 1921.

9689. Donath, Adolph. **Lesser Ury, seine Stellung in der modernen deutschen Malerei.** Berlin, Perl, 1921.

9690. Galerie Pels-Leusden (Berlin). **Lesser Ury zum 50. Todestag.** 1. Juni 1981 bis 19. August 1981. Berlin, Galerie Pels-Leusden, 1981.

USHAKOV, SIMON FEDOROVICH, 1626-1686

9691. Anayeva, T. **Simon Ushakov.** [Text in English and Russian]. Leningrad, Aurora, 1971.

9692. Filimonov, Georgii D. **Simon Ushakov.** Moskva, Universitetskoi Tipografii, 1873.

UTAMARO KITIGAWA, 1754-1806

9693. Goncourt, Edmond. **Outamaro: le peintre des maison vertes.** Paris, Charpentier, 1904.

9694. Hillier, Jack R. **Utamaro, colour prints and paintings.** London, Phaidon, 1961.

9695. Kobayashi, Tadashi. **Utamaro.** Trans. by Mark A. Harbison. Tokyo/New York, Kodansha, 1982; distributed by Harper & Row, New York.

9696. Kondo, Ichitaro. **Kitagawa Utamaro (1753-1806).** English adaptation by Charles S. Terry. Tokyo/Rutland, Vt., Tuttle, 1956. (Kodansha Library of Japanese Art, 5).

9697. Kurth, Julius. **Utamaro.** Leipzig, Brockhaus, 1907.

9698. Narazaki, Muneshige and Kikuchi, Sadao. **Utamaro.** Trans. by John Bester. Tokyo/Palo Alto, Calif., Kodansha, 1968.

9699. Noguchi, Yone. **Utamaro.** London, Mathews, 1924.

9700. Trotter, Massey. **Catalogue of the work of Kitagawa Utamaro.** Introduction by Harold G. Henderson. New York, New York Public Library, 1950.

UTRILLO, MAURICE, 1883-1955

9701. Basler, Adolphe. **Maurice Utrillo.** Paris, Crès, 1931.

9702. Beachboard, Robert. **La trinité maudite: Valadon, Utrillo, Utter.** Paris, Amiot-Dumont, 1952.

9703. Carco, Francis. **Utrillo.** Paris, Grasset, 1956.

9704. Champigneulle, Bernard. **Utrillo.** Paris, Editions Universitaires, 1959. (Témoins du XXe siècle, 16).

9705. Crespello, Jean-Paul. **Utrillo: la bohème et l'ivresse à Montmartre.** Paris, Presses de la Cité, 1970.

9706. Fabris, Jean. **Utrillo: sa vie, son oeuvre.** [Paris], Birr, 1982. (CR).

9707. Gros, Gabriel J. **Maurice Utrillo.** Paris, Crès, 1927.

9708. Pétridès, Paul. **L'oeuvre complet de Maurice Utrillo.** Avant-propos d'Edmond Heuzé. Présentation de Florence G. Poisson. 5 v. Paris, Pétridès, 1959-1974. (CR).

9709. Tabarant, Adolphe. **Utrillo.** Paris, Bernheim, 1926.

9710. Valore, Lucie. **Maurice Utrillo, mon mari.** Paris, Foret, 1956.

9711. Werner, Alfred. **Maurice Utrillo.** New York, Abrams, 1981. 3 ed.

UYTEWAEL, JOACHIM ANTHONISZOON

see WTEWAEL, JOACHIM ANTHONISZOON

VALADIER, GIUSEPPE, 1762-1839

9712. Debenedetti, Elisa. **Valadier: diario architettonico.** Roma, Bulzoni, 1979.

9713. Marconi, Paolo. **Giuseppe Valadier.** [Roma], Officina Edizioni, 1964.

9714. Schulze-Battmann, Elfriede. **Giuseppe Valadier: ein klassizistischer Architekt Roms, 1762-1839.** Dresden, Zetzsche, 1939.

9715. Servi, Gaspare. **Notizie intorno alla vita del cav. Giuseppe Valadier, architetto romano.** Bologna, Tipi delle Muse alla Capra, 1840.

VALADON, SUZANNE, 1865-1938

see also UTRILLO, MAURICE

9716. Basler, Adolphe. **Suzanne Valadon.** Paris, Crès, 1929.

9717. Bonnat, Yves. **Valadon.** Paris, Club d'Art Bordas, 1968.

9718. Bouret, Jean. **Suzanne Valadon.** Paris, Pétridès, 1947.

9719. Jacometti, Nesto. **Suzanne Valadon.** Genève, Cailler, 1947.

9720. Musée National d'Art Moderne (Paris). **Suzanne Valadon.** 17 mars-30 avril 1967. Paris, Ministère des Affaires Culturelles/Réunion des Musées Nationaux, 1967.

9721. Pétridès, Paul. **L'oeuvre complet de Suzanne Valadon.** Paris, Compagnie Française des Arts Graphiques, 1971. (CR).

9722. Rey, Robert. **Suzanne Valadon.** Paris, Nouvelle Revue Française, 1922. (Les peintres français nouveaux, 14).

9723. Storm, John. **The Valadon drama; the life of Suzanne Valadon.** New York, Dutton, 1958.

VALDÉS LEAL, JUAN DE, 1622-1690

9724. Beruete y Moret, Aureliano de. **Valdés Leal, estudio critico.** Madrid, Suarez, 1911.

9725. Exposición Valdés Leal y de Art Retrospectivo (Seville). **Catálogo.** Mayo, 1922. Sevilla, Tipográfica Gironés, 1923.

9726. Gestoso y Pérez, José. **Biographía del pintor sevillano Juan de Valdés Leal.** Sevilla, Tipográfica Gironés, 1916.

9727. Lafond, Paul. **Juan de Valdés Leal; essai sur sa vie et son oeuvre.** Paris, Sansot, 1914.

9728. Lopez y Martinez, Celestino. **Valdés Leal y sus discipulos.** Sevilla, Diaz, 1907.

9729. Trapier, Elizabeth du Gué. **Valdés Leal, Spanish baroque painter.** New York, Hispanic Society of America, 1960.

VALLAYER-COSTER, ANNE, 1744-1818

9730. Roland-Michel, Marianne. **Anne Vallayer-Coster, 1744-1818.** Paris, Comptoir International du Livre, 1970. (CR).

VALLOTTON, FELIX, 1865-1925

9731. Bianconi, Piero. **Félix Vallotton.** Milano, Fabbri, 1966. (I maestri del colore, 126).

9732. Gourmont, Remy de. **Le livre des masques dessinés par Félix Vallotton.** Paris, Mercure de France, 1896-1898. 2 v. (Reprint: 1963).

9733. Guisan, Gilbert et Jakubec, Doris. **Félix Vallotton: documents pour une biographie et pour l'histoire d'une oeuvre.** 3 v. Lausanne/Paris, Bibliothèque des Arts, 1973-1975.

9734. Hahnloser-Bühler, Hedy. **Félix Vallotton et ses amis.** Paris, Sedrowski, 1936.

9735. Jourdain, Francis. **Félix Vallotton.** Avec une étude d'Edmond Jaloux de l'Académie Française. Genève, Cailler, 1953. (Peintres et sculpteurs d'hier et d'aujourd'hui, 29).

9736. Kunsthalle Bremen. **Félix Vallotton, das druckgraphische Werk.** 3. Mai bis 14. Juni 1981. Bremen, Kunsthalle Bremen, 1981.

9737. Kunstmuseum Winterthur. **Félix Vallotton: Bilder, Zeichnungen, Graphik.** 1. Oktober bis 12. November 1978. Winterthur, Kunstmuseum Winterthur, 1978.

9738. Meier-Graefe, Julius. **Félix Vallotton, biographie.** [Text in German and French]. Berlin, Stargardt/Paris, Sagot, 1898.

9739. Monnier, Jacques. **Félix Vallotton.** Lausanne, Rencontre, 1970.

9740. Vallotton, Maxime [and] Goerg, Charles. **Félix Vallotton, catalogue raisonné de l'oeuvre gravé et lithographié.** [Text in French and English]. Genève, Bonvent, 1972. (CR).

VALTAT, LOUIS, 1869-1952

9741. Cogniat, Raymond. **Louis Valtat.** Neuchâtel, Ides et Calendes, 1963.

9742. Valtat, Jean. **Louis Valtat: catalogue de l'oeuvre peint.** Neuchâtel, Ides et Calendes, 1977. (CR).

VANBRUGH, JOHN, 1664-1726

9743. Barman, Christian. **Sir John Vanbrugh.** New York, Scribner, 1924.

9744. Bingham, Madeleine. **Masks and façades; Sir John Vanbrugh: the man in his setting.** London, Allen & Unwin, 1974.

9745. Downes, Kerry. **Vanbrugh.** London, Zwemmer, 1977.

9746. Mavor, William F. **A new description of Blenheim.** London, Cadell, 1793. (Reprint: New York, Garland, 1982).

9747. Vanbrugh, John. **The complete works of Sir John Vanbrugh.** Edited by Bonamy Dobrée and Geoffrey Webb. 4 v. London, Nonesuch, 1927-1928.

9748. Whistler, Laurence. **The imagination of Vanbrugh and his fellow artists.** London, Batsford, 1954.

9749. _____. **Sir John Vanbrugh, architect and dramatist, 1664-1726.** New York, Macmillan, 1939.

VAN DER ROHE, LUDWIG MIES see MIES VAN DER ROHE, LUDWIG

VAN DER ZEE, JAMES, 1886-

9750. De Cock, Liliane and McGhee, Reginald, eds. **James van der Zee.** Introduction by Regina A. Perry. Dobbs Ferry, N.Y., Morgan & Morgan, 1973.

9751. McGhee, Reginald. **The world of James van der Zee: a visual record of Black Americans.** New York, Grove, 1969.

9752. Van Der Zee, James, et al. **The Harlem book of the dead.** Foreword by Toni Morrison. Dobbs Ferry, N.Y., Morgan & Morgan, 1978.

VAN DYCK, ANTHONY see DYCK, ANTHONY VAN

VAN GOGH, VINCENT see GOGH, VINCENT VAN

VANNUCCI, PIETRO DI CRISTOFORO see PERUGINO

VANTONGERLOO, GEORGES, 1886-1965

9753. Corcoran Gallery of Art (Washington, D.C.). **Georges Vantongerloo, a traveling retrospective exhibition.** April 22-June 17, 1980. [Brussels], Ministry of French Culture in Belgium, 1980.

9754. Vantongerloo, Georges. **Paintings, sculptures, reflections.** Trans. by Dollie P. Chareau and Ralph Manheim. New York, Wittenborn, Schultz, 1948. (Problems of Contemporary Art, 5).

VANVITELLI, GASPARE see WITTEL, GASPAR ADRIAENSZOON VAN

VANVITELLI, LUIGI, 1700-1773

9755. Carreras, Pietro. **Studi su Luigi Vanvitelli.** Firenze, La Nuova Italia, 1977.

9756. Chierici, Gino. **La reggia di Caserta.** Prefazione di Bruno Malojoli. Roma, Libreria dello Stato, 1969.

9757. Convegno Vanvitelliano (Ancona). **L'attivà architettonica di Luigi Vanvitelli nelle Marche e i suoi epigoni.** 27-28 aprile 1974. Ancona, Presso la Deputazione di Storia Patria per le Marche, 1975.

9758. Fichera, Francesco. **Luigi Vanvitelli.** Prefazione di Gustavo Giovannoni. Roma, Reale Accademia d'Italia, 1937.

9759. Fiengo, Giuseppe. **Gioffredo e Vanvitelli nei palazzi dei Casacalenda.** Napoli, Editoriale Scientifica, 1976.

9760. Fusco, Renato de, et al. **Luigi Vanvitelli.** [Napoli], Edizioni Scientifiche Italiane, 1973.

9761. Strazzullo, Franco, ed. **Le lettere di Luigi Vanvitelli della Biblioteca Palatina di Caserta.** Introduzione di Roberto Pane. Prefazione di Guerriera Guerrieri. 3 v. Galatina, Congedo, 1976/1977. (Biblioteca napoletana di storia e arte, 1-3).

9762. Vanvitelli, Luigi [Jr.]. **Vita dell'architetto Luigi Vanvitelli.** Napoli, Trani, 1823. (New ed., edited by Mario Rotili: Napoli, Società Editrice Napoletana, 1975).

VARIN, JEAN, 1604-1672

9763. Courajod, Louis. **Jean Warin et ses oeuvres de sculpture.** Paris, Champion, 1881.

9764. Mazerolle, F. **Jean Varin.** Paris, Bourgey et Schemit, 1932.

9765. Pény, Frédéric. **Jean Varin de Liège, 1607 [sic]-1672.** Liège, Imprimerie de L'Académie, 1947.

VASARELY, VICTOR, 1908-

9766. Dahhan, Bernard. **Victor Vasarely, ou la connaissance d'un art moléculaire.** Paris, Denoël/Gonthier, 1979.

9767. Ferrier, Jean-Louis. **Entretiens avec Victor Vasarely.** Paris, Belfond, 1969.

9768. Spies, Werner. **Victor Vasarely.** Trans. by Robert E. Wolf. New York, Abrams, 1971.

9769. Vasarely, Victor. **Notes brutes.** Introduction de Claude Desailly. Paris, Denoël/Gonthier, 1972.

9770. ———. **Plasticien.** Paris, Laffont, 1979.

9771. ———. **Vasarely.** Introductions by Marcel Joray. Texts and designs by Victor Vasarely. Trans. by Haakon Chevalier. 3 v. Neuchâtel, Editions du Griffon, 1969-1974.

VASARI, GIORGIO, 1511-1574

9772. Barocchi, Paola. **Vasari, pittore.** Milano, Il Club del Libro, 1964. (Collana d'arte del Club del Libro, 9).

9773. Boase, Thomas S. R. **Giorgio Vasari: the man and the book.** Princeton, N.J., Princeton University Press, 1979. (Bollingen Series XXXV, 20).

9774. Capriglione, Anna A. **Giorgio Vasari pittore e sua influenza sulla pittura napoletana.** [Napoli], Libreria Editrice Ferraro, 1970.

9775. Carden, Robert W. **The life of Giorgio Vasari, a study of the later Renaissance in Italy.** London, Warner, 1910.

9776. Churchill, Sydney J. **Bibliografia vasariana.** [Firenze], [n.p.], 1912.

9777. Hall, Marcia B. **Renovation and Counter-Reformation: Vasari and Duke Cosimo in Santa Maria Novella and Santa Croce, 1567-1577.** Oxford, Clarendon Press, 1979. (Oxford-Warburg Studies).

9778. Istituto Nazionale di Studi sul Rinascimento (Florence). **Il Vasari: storiografo e artista; atti del congresso internazionale nel IV centenario della morte, 2-8 settembre 1974.** Firenze, Istituto Nazionale di Studi sul Rinascimento, 1976.

9779. ———. **Studi vasariani: atti del convegno internazationale per il IV centenario della prima edizione delle Vite del Vasari.** 16-19 settembre, 1950. Firenze, Sansoni, 1952.

9780. Kallab, Wolfgang. **Vasaristudien.** Wien, Graeser, 1908.

9781. Ragghianti Collobi, Licia. **Il libro de disegni del Vasari.** 2 v. Firenze, Vallecchi, 1974.

9782. Rud, Einar. **Vasari's life and Lives: the first art historian.** Trans. by Reginald Spink. London, Thames and Hudson, 1963.

9783. Sottochiesa di San Francesco (Arezzo). **Giorgio Vasari: principi, letterati e artisti nelle carte di Giorgio Vasari.** 26 settembre-29 novembre 1981. Firenze, Edam, 1981.

9784. Vasari, Giorgio. **Il carteggio di Giorgio Vasari dal 1563 al 1565.** [Edited by Karl Frey; Italian edition by Alessandro del Vita]. Roma, Reale Istituto d'Archeologia e Storia dell'Arte, 1941.

9785. _____. **Il libro delle ricordanze di Giorgio Vasari.** A cura di Alessandro del Vita. Roma, Reale Istituto d'Archeologia e Storia dell'Arte, 1938.

9786. _____. **Ragionamenti del Signore Cavaliere Giorgio Vasari, pittore et architetto aretino.** Firenze, Giunti, 1588.

9787. _____. **Vasari on technique.** Trans. by Louisa S. Maclehose. Edited with an introduction and notes by G. Baldwin Brown. London, Dent, 1907. (Reprint: New York, Dover, 1960).

9788. _____. **Le vite de' piu eccellenti pittori, scultori e architettori.** Di nuovo dal medesimo riviste et ampliate. 3 v. Fiorenza, Giunti, 1568. (English ed., edited and annotated by E. H. and E. W. Blashfield and A. A. Hopkins: New York, Scribner, 1896. 4 v.).

9789. _____. **Lo zibaldone di Giorgio Vasari.** A cura di Alessandro del Vita. Roma, Reale Istituto d'Archeologia e Storia dell'Arte, 1938.

9790. Vita, Alessandro del. **Inventorio e regesto dei manoscritti dell'Archivio Vasariano.** Roma, Reale Istituto d'Archeologia e Storia dell'Arte, 1938.

VAUBAN, SEBASTIEN LE PRESTE DE, 1633-1707

9791. Blomfield, Reginald T. **Sebastien le Preste de Vauban, 1633-1707.** London, Methuen, 1938.

9792. Lazard, Pierre E. **Vauban, 1633-1707.** Paris, Alcan, 1934.

9793. Michel, Georges. **Histoire de Vauban.** Paris, Plon, 1879.

9794. Parent, Michel et Verroust, Jacques. **Vauban.** Paris, Fréal, 1971.

9795. Rochas d'Aiglun, Albert de, ed. **Vauban: sa famille et ses écrits, ses oisivetés et sa correspondance.** 2 v. Paris, Berger-Levrault, 1910.

9796. Vauban, Sebastien le Preste de. **Traité de l'attaque et de la défense des places.** Nouvelle édition. La Haye, de Hondt, 1742.

VÁZQUEZ-DÍAZ, DANIEL, 1882-1969

9797. Benito, Angel. **Vázquez-Díaz, vida y pintura.** Madrid, Direccion General de Bellas Artes/Ministerio de Educacion y Ciencia, 1971. (CR). (Arte de España, 1).

VECCHIO, PALMA see PALMA, GIACOMO

VECELLI, TIZIANO see TITIAN

VEDDER, ELIHU, 1836-1923

9798. National Collection of the Fine Arts, Smithsonian Institution (Washington, D.C.). **Perceptions and evocations: the art of Elihu Vedder.** October 13, 1978-February 4, 1979. Washington, D.C., Smithsonian Institution, 1979.

9799. Soria, Regina. **Elihu Vedder, American visionary artist in Rome (1836-1923).** Rutherford, N.J., Fairleigh Dickinson University Press, 1970.

9800. Vedder, Elihu. **The digressions of V., written for his own fun and that of his friends.** Boston, Houghton Mifflin, 1910.

VEEN, GERRIT JAN VAN DER, 1902-1944

9801. Helman, Albert [pseud., Lou Lichtveld]. **Gerrit Jan van der Veen, een doodgewone held.** Baarn, Het Wereldvenster, 1977. 2 ed.

VEIT, PHILIPP, 1793-1877

9802. Jungnitz, Ingobert. **Die Nazarener-Fresken im Mainzer Dom zum 100. Todestag von Philipp Veit.** Fotos von Winfried G. Popp. [Text in German and English]. Mainz, Krach, 1976.

9803. Spahn, Martin. **Philipp Veit.** Bielefeld/Leipzig, Velhagen & Klasing, 1901. (Künstler-Monographien, 51).

9804. Suhr, Norbert. **Philipp Veit: Porträts aus dem Mittelrheinischen Landesmuseum, Mainz und aus Privatbesitz.** Mainz, Mittelrheinisches Landesmuseum, 1978.

VELÁZQUEZ, DIEGO RODRIGUEZ DE SILVA Y, 1599-1660

see also MURILLO, BARTOLOMÉ ESTEBAN

9805. Alfaro, Juan de. **Memoria de las pinturas que la magestad catholica del Rey nuestro señor Don Philipe IV embia al Monasterio de San Laurencio el Real del Escurial este año de MDCLVI, descriptas y colocadas por Diego de Sylva Velázquez.** Roma, Grignano, 1658. (New ed., trans. into French and edited by Charles Davillier: Paris, Aubry, 1874).

9806. Allende-Salazar, Juan. **Velázquez, des Meisters Gemälde.** Einleitung von Walter Gensel. Stuttgart, Deutsche Verlags-Anstalt, 1925. 4 ed. (Klassiker der Kunst, 6).

9807. Aman-Jean, Edmond F. **Velázquez.** Paris, Alcan, 1913.

9808. Angulo Iñiguez, Diego. **Velázquez: cómo compuso sus principales cuadros.** Sevilla, Universidad de Sevilla, 1947.

9809. Armstrong, Walter. **The art of Velázquez.** London, Seeley, 1896. (Portfolio Artistic Monographs, 29).

9810. _____. **The life of Velázquez.** London, Seeley, 1896. (Portfolio Artistic Monographs, 28).

9811. Asturias, Miguel A. [and] Bardi, P. M. **L'opera completa di Velázquez.** Milano, Rizzoli, 1969. (CR). (Classici dell'arte, 26).

9812. Beruete, Aureliano de. **Velázquez.** Trans. by Hugh E. Poynter. London, Methuen, 1906.

9813. Brasil, Jaime. **Velázquez.** Lisboa, Portugália Editora, 1960.

9814. Brown, Dale. **The world of Velázquez, 1599-1660.** New York, Time-Life, 1969.

9815. Calvert, Albert F. and Hartley, C. Gasquoine. **Velázquez, an account of his life and works.** London, Lane, 1908.

9816. Camón Aznar, José. **Velázquez.** 2 v. Madrid, Espasa-Calpe, 1964.

9817. Campo y Francés, Angel del. **La magia de la meninas: une iconología velazqueña.** Madrid, Colegio de Ingenieros de Caminos, Canales, y Puertos, 1978.

9818. Casa de Velázquez (Madrid). **Velázquez; son temps, son influence: actes du colloque tenu à la Casa de Velázquez les 7, 9 et 10 décembre 1960.** Paris, Arts et Métiers Graphiques, 1963.

9819. Cruzada Villaamil, Gregorio. **Anales de la vida y de las obras de Diego de Silva Velázquez.** Madrid, Guijarro, 1885.

9820. Díez del Corral, Luis. **Velázquez, la monarquía, e italia.** Madrid, Espasa-Calpe, 1979.

9821. Dmitrienko, Mariia F. **Velaskes.** Moskva, Molodaia Gvardiia, 1965.

9822. Encina, Juan de la. **Sombra y enigma de Velázquez.** Buenos Aires, Espasa-Calpe, 1952.

9823. Faure, Elie. **Velázquez, biographie critique.** Paris, Laurens, [1903].

9824. Gállego, Julián. **Velázquez en Sevilla.** Sevilla, Diputación Provincial de Sevilla, 1974.

9825. Gaya Nuño, Juan A. **Bibliografia critica y antologia de Velázquez.** Madrid, Galdiano, 1963.

9826. _____. **Velázquez, biografía ilustrada.** Barcelona, Ediciones Destino, 1970.

9827. Gerstenberg, Kurt. **Diego Velázquez.** München, Deutscher Kunstverlag, 1957.

9828. Gudiol Ricart, Josep. **Velázquez, 1599-1660.** Trans. by Kenneth Lyons. New York, Viking, 1974.

9829. Harris, Enriqueta. **Velázquez.** Oxford, Phaidon, 1982.

9830. Hind, C. Lewis. **Days with Velázquez.** London, A & C Black, 1906.

9831. Instituto Diego Velázquez (Madrid). **Velázquez: homenaje en el tercer centenario de su muerte.** Madrid, Instituto Diego Velázquez, 1960.

9832. Justi, Carl. **Diego Velázquez and his times.** Trans. by A. H. Keane. London, Grevel, 1889.

9833. Kahr, Madlyn M. **Velázquez: the art of painting.** New York, Harper & Row, 1976.

9834. Kapterewa, Tatjana. **Velázquez und die spanische Porträtmalerei.** [Trans. from the Russian by Ulrich Kuhirt]. Leipzig, Seemann, 1961.

9835. Kehrer, Hugo. **Die Meninas des Velázquez.** München, Bruckmann, 1966.

9836. Kemenov, Vladimir. **Velázquez in Soviet museums.** Trans. by Roger Keys. Leningrad, Aurora, 1977.

9837. Knackfuss, Hermann. **Velázquez.** Bielefeld/Leipzig, Velhagen & Klasing, 1895. (Künstler-Monographien, 6).

9838. Lafuente Ferrari, Enrique. **Velázquez, biographical and critical study.** Trans. by James Emmons. Lausanne, Skira, 1960; distributed by World, Cleveland. (The Taste of Our Time, 33).

9839. Lefort, Paul. **Velázquez.** Paris, Librairie de l'Art, 1888.

9840. López-Rey, José. **Velázquez: the artist as a maker, with a catalogue raisonné of his extant works.** Lausanne/Paris, Bibliothèque des Arts, 1979. (CR).

9841. Maravall, José A. **Velázquez y el espiritu de la modernidad.** Madrid, Guadarrama, 1960.

9842. Mayer, August L. **Diego Velázquez.** Berlin, Propyläen, 1924.

9843. _____. **Velázquez: a catalogue raisonné of the pictures and drawings.** London, Faber, 1936. (CR).

9844. Mesonero Romanos, Manuel. **Velázquez fuera del Museo del Prado, apuntes para un catálogo de los cuadros que se le atribuyen en las principales galerías públicas y particulares de Europa.** Madrid, Hernández, 1899.

9845. Ministerio de Educacion Nacional (Madrid). **Varia velazqueña: homenaje a Velázquez en el III centenario de su muerte, 1660-1960.** 2 v. Madrid, Ministerio de Educacion Nacional, 1960.

9846. Muñoz, Antonio. **Velázquez.** Leipzig, Goldmann, 1941.

9847. Orozco Diaz, Emilio. **El barroquismo de Velázquez.** Madrid, Rialp, 1965.

9848. Ortega y Gasset, José. **Velásquez, Goya and the dehumanization of art.** Trans. by Alexis Brown. Intro. by Philip Troutman. New York, Norton, 1972.

9849. Pantorba, Bernardino de [pseud., José López Jiménez]. **La vida y la obra de Velázquez.** Madrid, Compañia Bibliografica Española, 1955.

9850. Pérez Sánchez, Alfonso E. **Velázquez.** Bologna, Capitol, 1980.

9851. Picon, Jacinto O. **Vida y obras de Don Diego Velázquez.** Madrid, Fé, 1899.

9852. Pompey, Francisco. **Velázquez, estudio biografico y critico.** Madrid, Offo, 1961.

9853. Saint-Paulien, J. [pseud., Maurice I. Sicard]. **Velázquez et son temps.** Paris, Fayard, 1961.

9854. Sérullaz, Maurice. **Velázquez.** Trans. by I. Mark Paris. New York, Abrams, 1981.

9855. Stirling, William. **Velázquez and his works.** London, Parker, 1855.

9856. Stowe, Edwin. **Velázquez.** New York, Scribner & Welford, 1881.

9857. Trapier, Elizabeth du Gué. **Velázquez.** New York, Hispanic Society of America, 1948.

9858. Znamerovskaia, Tat'iana P. **Velaskes.** Moskva, Izobrazitel'noe Iskusstvo, 1978.

VELDE, BRAM VAN, 1895-

9859. Beckett, Samuel, et al. **Bram van Velde.** Trans. by Olive Classe and Samuel Beckett. New York, Grove, 1960.

9860. Cabinet des Estampes, Musée d'Art et d'Histoire (Geneva). **Bram van Velde: les lithographies, 1923-1973.** Paris, Rivière, 1973.

9861. Gribaudo, Ezio, ed. **Bram van Velde.** [Text in English]. Torino, Pozzo, [1970]. (CR).

9862. Juliet, Charles. **Rencontres avec Bram van Velde.** Montpellier, Fata Morgana, 1978.

9863. Putnam, Jacques et Juliet, Charles. **Bram van Velde.** Paris, Maeght, 1975.

VELDE, HENRY VAN DE, 1863-1957

see also KIRCHNER, ERNST LUDWIG

9864. Hammacher, Abraham M. **Die Welt Henry van de Veldes.** Antwerpen, Mercator/Köln, DuMont Schauberg, 1967.

9865. Hüter, Karl-Heinz. **Henry van de Velde: sein Werk bis zum Ende seiner Tätigkeit in Deutschland.** Berlin, Akademie, 1967. (Schriften zur Kunstgeschichte, 9).

9866. Palais des Beaux-Arts (Brussels). **Henry van de Velde, 1863-1957.** 13 au 29 décembre 1963. Bruxelles, Palais des Beaux-Arts, 1963.

9867. Rességuier von Brixen, Clemens. **Die Schriften Henry van de Veldes.** New York, Delphic Press, 1955.

9868. Sharp, Dennis, ed. **Henri van de Velde: theatre designs 1904-1914.** [Text in English and French]. London, Architectural Association, 1974.

9869. Velde, Henry van de. **Die drei Sünden wider die Schönheit.** Deutsche berechtigte Uebersetzung mitsamt dem französischen Original. Zürich, Rascher, 1918. (Europäische Bibliothek, 5).

9870. _____. **Essays.** Leipzig, Insel-Verlag, 1910.

9871. _____. **Geschichte meines Lebens.** Herausgegeben und übertragen von Hans Curjel. München, Piper, 1962.

9872. _____. **Kunstgewerbliche Laienpredigten.** Leipzig, Seemann, 1902.

9873. _____. **Vom neuen Stil: der Laienpredigten, II Teil.** Leipzig, Insel-Verlag, 1907.

VELDE, JAN VAN DE, 1593-1641

9874. Franken, Daniel et Kellen, J. P. van der. **L'oeuvre de Jan van de Velde.** Amsterdam, Muller/Paris, Rapilly, 1883. (New ed., with additions and corrections in German by Simon Laschitzer: Amsterdam, Hissink, 1968).

9875. Gelder, Jan G. van. **Jan van de Velde, 1593-1641: teekenaar, schilder.** 's-Gravenhage, Nijhoff, 1933.

VELDE, WILLEM VAN DE, the elder, 1611-1693

WILLEM VAN DE, the younger, 1633-1707

9876. Baard, Henricus P. **Willem van de Velde de oude; Willem van de Velde de jonge.** Amsterdam, Becht, [1942]. (Palet serie, 25).

9877. Michel, Emile. **Les van de Velde.** Paris, Allison, [1892].

9878. Museum Boymans-van Beuningen (Rotterdam). **The Willem van de Velde drawings in the Boymans-van Beuningen Museum.** 3 v. Rotterdam, Museum Boymans-van Beuningen Foundation, 1979. (CR).

9879. National Maritime Museum (Greenwich). **Van de Velde Drawings.** 2 v. Cambridge, Cambridge University Press, 1958/1974.

9880. Zoege von Manteuffel, Kurt. **Die Künstlerfamilie van de Velde.** Bielefeld/Leipzig, Velhagen & Klasing, 1927. (Künstler-Monographien, 117).

VENETSIANOV, ALEKSEI GAVRILOVICH, 1780-1847

9881. Efros, Abram M. [and] Miuller, A. P., eds. **Venetsianov v pis'makh Khudozhnika i vospominaniiakh sovremennikov.** Moskva, Academia, 1931.

9882. Smirnov, G. **Venetsianov and his school.** [Text in English, French, German, and Russian]. Leningrad, Aurora, 1973.

VENEZIANO, DOMENICO, 1410-1461

9883. Bacci, Mina. **Domenico Veneziano.** Milano, Fabbri, 1965. (I maestri del colore, 60).

9884. Wohl, Hellmut. **The paintings of Domenico Veneziano, ca. 1410-1461: a study of Florentine art of the early Renaissance.** New York, New York University Press, 1980.

VERHULST, ROMBOUT, 1624-1698

9885. Van Notten, Marinus. **Rombout Verhulst, beeldhouwer, 1624-1698.** 's-Gravenhage, Nijhoff, 1907.

VERMEER, JAN, 1632-1675

see also FABRITIUS, CAREL

9886. Badt, Kurt. **Modell und Maler von Jan Vermeer.** Köln, DuMont Schauberg, 1961.

9887. Blankert, Albert. **Vermeer of Delft, complete edition of the paintings.** With contributions by Rob Ruurs and Willem L. van de Watering. Oxford, Phaidon, 1978.

9888. Blum, André. **Vermeer et Thoré-Bürger.** Genève, Editions du Mont-Blanc, 1945.

9889. Brion, Marcel. **Vermeer.** Paris, Somogy, 1963.

9890. Chantavoine, Jean. **Ver Meer de Delft, biographie critique.** Paris, Laurens, 1926.

9891. Descargues, Pierre. **Vermeer, biographical and critical study.** Trans. by James Emmons. Geneva, Skira, 1966. (The Taste of Our Time, 45).

9892. Goldscheider, Ludwig. **Jan Vermeer: the paintings, complete edition.** London, Phaidon, 1967. 2 ed.

9893. Gowing, Lawrence. **Vermeer.** London, Faber, 1952.

9894. Grimme, Ernst G. **Jan Vermeer van Delft.** Köln, DuMont Schauberg, 1974.

9895. Hale, Philip L. **Jan Vermeer of Delft.** Boston, Small, Maynard, 1913. (New ed., completed and prepared by Frederick W. Coburn and Ralph T. Hale: Boston, Hale, 1937.

9896. Jacob, John [and] Bianconi, Piero. **The complete paintings of Vermeer.** New York, Abrams, 1970. (CR).

9897. Malraux, André, ed. **Vermeer de Delft.** Paris, Gallimard, 1952.

9898. Martini, Alberto. **Johannes Vermeer.** Milano, Fabbri, 1965. (I maestri del colore, 54).

9899. Menzel, Gerhard W. **Vermeer.** Leipzig, Seemann, 1977.

9900. Mistler, Jean. **Vermeer.** Paris, Screpel, 1973.

9901. Plietzsch, Eduard. **Vermeer van Delft.** Leipzig, Hiersemann, 1911.

9902. Slatkes, Leonard J. **Vermeer and his contemporaries.** New York, Abbeville, 1981.

9903. Snow, Edward A. **A study of Vermeer.** Berkeley, University of California Press, 1979.

9904. Swillens, P. T. A. **Johannes Vermeer, painter of Delft, 1632-1675.** Trans. by C. M. Breuning-Williamson. Utrecht, Spectrum, 1950.

9905. Vanzype, Gustave. **Vermeer de Delft.** Bruxelles, van Oest, 1908.

9906. Vries, Ary B. de. **Jan Vermeer van Delft.** Trans. by Robert Allen. London, Batsford, 1948.

9907. Walicki, Michał. **Jan Vermeer van Delft.** [Trans. from the Polish by Peter Panomarow]. Dresden, Verlag der Kunst, [1970].

9908. Wheelock, Arthur, Jr. **Jan Vermeer.** New York, Abrams, 1981.

VERNET, ANTOINE CHARLES HORACE see VERNET, CARLE

VERNET, CARLE, 1758-1836

HORACE, 1789-1863

JOSEPH, 1714-1789

9909. Académie de France à Rome/Ecole Nationale Supérieure des Beaux-Arts, Paris. **Horace Vernet (1789-1863).** Mars-juillet 1980. Roma, de Luca, 1980.

9910. Arlaud, Pierre. **Catalogue raisonné des estampes gravées d'après Joseph Vernet.** Avignon, Rulliere-Libeccio, 1976. (CR).

9911. Blanc, Charles. **Une famille d'artistes; les trois Vernet: Joseph, Carle, Horace.** Paris, Laurens, [1898].

9912. [Buizard, L. M.]. **Catalogue de l'oeuvre lithographique de Mr. J. E. Horace Vernet.** Paris, Gratiot, 1826.

9913. Dayot, Armand. **Carle Vernet, étude sur l'artiste.** Paris, Le Goupy, 1925. (CR).

9914. _____. **Les Vernet: Joseph, Carle, Horace.** Paris, Magnier, 1898.

9915. Durande, Amédee, ed. **Joseph, Carle et Horace Vernet: correspondance et biographies.** Paris, Hetzel, [1864].

9916. Ingersoll-Smouse, Florence. **Joseph Vernet, peintre de marine, 1714-1789.** 2 v. Paris, Bignou, 1926. (CR).

9917. Lagrange, Léon. **Joseph Vernet et la peinture au XVIIIe siècle.** Paris, Didier, 1864.

9918. Mirecourt, Eugène de. **Horace Vernet.** Paris, Roret, 1855.

9919. Musée de la Marine, Palais de Chaillot (Paris). **Joseph Vernet, 1714-1789.** 15 octobre 1976-9 janvier 1977. Paris, Musée de la Marine, Palais de Chaillot, 1976.

VERNET, CLAUDE JOSEPH see VERNET, JOSEPH

VERNET, EMILE JEAN HORACE see VERNET, HORACE

VERONA, GIOVANNI DA see GIOVANNI DA VERONA

VERONESE, PAOLO, 1528-1588

9920. Badt, Kurt. **Paolo Veronese.** Köln, DuMont, 1981.

9921. Ca' Giustinian (Venice). **Mostra di Paolo Veronese.** Catalogo delle opere a cura di Rodolfo Pallucchini. 25 aprile-4 novembre 1939. Venezia, Libreria Serenissima, 1939.

9922. Caliari, Pietro. **Paolo Veronese: sua vita e sue opere; studi storico-estetici.** Roma, Forzani, 1888.

9923. Fiocco, Giuseppe. **Paolo Veronese, 1528-1588.** Bologna, Apollo, 1928.

9924. Gould, Cecil. **The Family of Darius before Alexander by Paolo Veronese; a resumé, some new deductions, and some new facts.** London, National Gallery, [1978].

9925. Loukomski, Georgii K. **Les fresques de Paul Véronèse et de ses disciples.** Préface de Paul Valéry. Paris, Seheur, 1928.

9926. Meissner, Franz H. **Veronese.** Bielefeld/Leipzig, Velhagen & Klasing, 1897. (Künstler-Monographien, 26).

9927. Osmond, Percy H. **Paolo Veronese, his career and work.** London, Sheldon Press, 1927.

9928. Pallucchini, Rodolfo. **Veronese.** Bergamo, Istituto Italiano d'Arti Grafiche, 1953. 3 ed.

9929. Pignatti, Teresio. **Veronese.** 2 v. Venezia, Alfieri, 1976. (CR).

9930. Piovene, Guido [and] Marini, Remigio. **L'opera completa del Veronese.** Milano, Rizzoli, 1968. (CR). (Classici dell'arte, 20).

9931. Venturi, Adolfo. **Paolo Veronese (per il IV centenario dalla nascità).** Milano, Hoepli, 1928.

9932. Villa della Farnesina alla Lungara (Rome). **Immagini dal Veronese: incisioni dal secolo XVI al XIX dalle collezioni del Gabinetto Nazionale delle Stampe.** 21 novembre 1978-31 gennaio 1979. Roma, de Luca, 1978.

9933. Yriarte, Charles. **Paul Véronèse.** Paris, Librairie de l'Art, [1888].

VERROCCHIO, ANDREA DEL, 1435-1488

9934. Busignani, Alberto. **Verrocchio.** Firenze, Sadea/Sansoni, 1966.

9935. Cruttwell, Maud. **Verrocchio.** London, Duckworth, 1904.

9936. Mackowsky, Hans. **Verrocchio.** Bielefeld/Leipzig, Velhagen & Klasing, 1901. (Künstler-Monographien, 52).

9937. Passavant, Günther. **Verrocchio: sculptures, paintings, and drawings; complete edition.** Trans. by Katherine Watson. London, Phaidon, 1969. (CR).

9938. Planiscig, Leo. **Andrea del Verrocchio.** Wien, Schroll, 1941.

9939. Reymond, Marcel. **Verrocchio.** Paris, Librairie de l'Art, 1906.

9940. Seymour, Charles, Jr. **The sculpture of Verrocchio.** Greenwich, Conn., New York Graphic Society, 1971.

VIEIRA DA SILVA, MARIA ELENA, 1908-

9941. Descargues, Pierre. **Vieira da Silva.** Paris, Presses Littéraires de France, 1950.

9942. França, José-Augusto. **Vieira da Silva.** Lisboa, Artis, 1958.

9943. Fundação Calouste Gulbenkian (Lisbon). **Vieira da Silva.** Junho-Julho 1970. [Text in Portuguese and French]. Lisboa, Fundação Caloute Gulbenkian, 1970.

9944. Lassaigne, Jacques and Weelen, Guy. **Vieira da Silva.** Trans. by John Shepley. New York, Rizzoli, 1979.

9945. Philipe, Anne, ed. **L'éclat de la lumière: entretiens avec Marie-Hélène Vieira da Silva et Arpad Szenes.** Paris, Gallimard, 1978.

9946. Solier, René de. **Vieira da Silva.** Paris, Fall, 1956.

9947. Vallier, Dora. **Vieira da Silva.** Paris, Weber, 1971.

9948. Weelen, Guy. **Vieira da Silva: les estampes, 1929-1976.** Paris, Rivière, 1977. (CR).

VIGEE-LE BRUN, ELISABETH LOUISE, 1755-1842

9949. Baillio, Joseph. **Elisabeth Louise Vigée Le Brun, 1755-1842.** [Published in conjunction with an exhibition at the Kimball Art Museum, Fort Worth, Tex., June 5-August 8, 1982]. Fort Worth, Kimball Art Museum, 1982.

9950. Blum, André. **Madame Vigée-Lebrun; peintre des grandes dames du XVIIIe siècle.** Paris, Piazza, 1919.

9951. Hautecoeur, Louis. **Madame Vigée-Le Brun; étude critique.** Paris, Laurens, 1917.

9952. Helm, William H. **Vigée-Lebrun, 1755-1842; her life, works, and friendships.** With a catalogue raisonné of the artist's pictures. Boston, Small, Maynard, 1915. (CR).

9953. Mycielski, Jerzy i Wasylewski, Stanisław. **Portrety polskie Elżbiety Vigée-Lebrun, 1755-1842.** Lwów, Wegner, 1928.

9954. Nolhac, Pierre de. **Madame Vigée-Le Brun, peintre de la reine Marie Antoinette, 1755-1842.** Paris, Goupil, 1908.

9955. Pillet, Charles. **Madame Vigée-Le Brun.** Paris, Librairie de l'Art, [1890].

9956. Vigée-LeBrun, Elisabeth L. **Memoirs.** Trans. by Gerald Shelley. New York, Doran, 1927.

VIGELAND, GUSTAV, 1869-1943

9957. Brenna, Arne. **Guide to Gustav Vigeland's sculpture park in Oslo.** Oslo, Enersen, 1960. 3 ed.

9958. Hale, Nathan C. **Embrace of life: the sculpture of Gustav Vigeland.** Photographs by David Finn. New York, Abrams, 1969.

9959. Romdahl, Axel L., et al. **Gustav Vigeland.** Oslo, Gyldendal, 1949.

9960. Stang, Ragna. **Gustav Vigeland, the sculptor and his works.** Trans. by Ardis Grosjean. Oslo, Tanum, 1965.

9961. Vigeland, Gustav. **Dagbok.** Utdrag av Harald Aars' etterlatte dagboknotater. [Edited with a foreword by Carl Just]. Oslo, Mortensen, 1955.

VIGNOLA, GIACINTO, 1540-1584

GIACOMO, 1507-1573

9962. Anzivino, Ciro L. **Jacopo Barozzi, il Vignola e gli architetti italiani del Cinquecento: repertorio bibliografico.** Vignola, Lions Club di Vignola, 1974.

9963. Barozzi, P. **Vita e opere di Jacopo Barozzi.** Modena, Arti Grafiche Modenesi, 1949.

9964. Cassa di Risparmio di Vignola, ed. **La vita e le opere di Jacopo Barozzi da Vignola, 1507-1573, nel quarto centenario della morte.** Vignola, Cassa di Risparmio di Vignola, 1975.

9965. Comitato Preposto alle Onoranze a Jacopo Barozzi, ed. **Memorie e studi intorno a Jacopo Barozzi pubblicati nel IV centenario dalla nascita.** Vignola, Monti, 1908.

9966. Domiani Almeyda, Giuseppe. **Giacomo Barozzi da Vignola ed il suo libro dei Cinque Ordini di Architettura.** Palermo, Giliberti, 1878.

9967. Lotz, Wolfgang. **Vignola-Studien.** Würzburg, Triltsch, 1939.

9968. Lukomskii, Georgii K. **Vignole (Jacopo Barozzi da Vignola).** Paris, Vincent, 1927.

9969. Spinelli, Alessandro G. **Bio-bibliografia dei due Vignola.** Roma, Società Multigrafica Editrice, 1968.

9970. Vignola, Giacomo. **Regola delle cinque ordini d'architettura.** Venetia, Ziletti, 1562. (English ed., trans. by Joseph Moxon: London, Moxon, 1655).

9971. Walcher Casotti, Maria. **Il Vignola.** 2 v. Trieste, Istituto di Storia dell'Arte Antica e Moderna, 1960. (Istituto di Storia dell'Arte, 11).

9972. Ware, William R. **The American Vignola.** 2 v. Boston, American Architect and Building News Co., 1902/Scranton, International Textbook Co., 1906. (New ed., with introductory notes by John Barrington Bayley and Henry Hope Reed: New York, Norton, 1977).

9973. Willich, Hans. **Giacomo Barozzi da Vignola.** Strassburg, Heitz, 1906. (Zur Kunstgeschichte des Auslandes, 46).

VILAR, MANUEL, 1812-1860

9974. Moreno, Salvador. **El escultor Manuel Vilar.** México, D. F., Instituto de Investigaciones Estéticas, Universidad Nacional Autónoma de México, 1969.

9975. Vilar, Manuel. **Copiador de cartas (1846-1860) y diario particular (1054-1060).** Palabras preliminares y notas de Salvador Moreno. México, D. F., Universidad Nacional Autónoma de México, 1979.

VILLARD DE HONNECOURT, 13th c.

9976. Barnes, Carl F., Jr. **Villard de Honnecourt: the artist and his drawings; a critical bibliography.** Boston, Hall, 1982.

9977. Bowie, Theodore R., ed. **The sketchbook of Villard de Honnecourt.** Bloomington, Indiana University Press, 1959.

9978. Hahnloser, Hans R. **Villard de Honnecourt.** Wien, Schroll, 1935.

VILLON, JACQUES, 1875-1963

see also DUCHAMP, MARCEL

9979. Auberty, Jacqueline, et Perussaux, Charles. **Jacques Villon: catalogue de son oeuvre gravé.** Paris, Prouté, 1950. (CR). (Les grands peintres graveurs français, 1).

9980. Eluard, Paul [and] René-Jean. **Jacques Villon, ou l'art glorieux.** Paris, Carré, 1948.

9981. Fogg Art Museum, Harvard University (Cambridge, Mass.). **Jacques Villon.** January 17-February 29, 1976. Cambridge, Mass., President and Fellows of Harvard College, 1976; distributed by Godine, Boston.

9982. Ginestet, Colette de et Pouillon, Catherine. **Jacques Villon: les estampes et les illustrations; catalogue raisonné.** Paris, Arts et Métiers Graphiques, 1979. (CR).

9983. Lassaigne, Jacques. **Jacques Villon.** Paris, Editions de Beaune, 1950.

9984. Vallier, Dora. **Jacques Villon: oeuvres de 1897 à 1956.** Paris, Cahiers d'Art, [1957].

VILLON, RAYMOND DUCHAMP see DUCHAMP-VILLON, RAYMOND

VINCI, LEONARDO DA see LEONARDO DA VINCI

VIOLLET-LE-DUC, EUGENE EMMANUEL, 1814-1879

9985. Abraham, Pol. **Viollet-le-Duc et le rationalisme médiéval.** Paris, Vincent, Fréal, 1934.

9986. Auzas, Pierre-Marie. **Eugène Viollet-le-Duc, 1814-1879.** Paris, Caisse Nationale des Monuments Historique et des Sites, 1979.

9987. Bekaert, Geert, ed. **À la recherche de Viollet-le-Duc.** Bruxelles, Mardaga, [1980].

9988. Ecole Nationale Supérieure des Beaux-Arts, Chapelle des Petits-Augustins (Paris). **Le voyage d'Italie d'Eugène Viollet-le-Duc, 1836-1837.** Janvier-mars 1980. Florence, Centro Di, 1980.

9989. Galeries Nationales du Grand Palais (Paris). **Viollet-le-Duc.** 19 février-5 mai 1980. Paris, Editions de la Réunion des Musées Nationaux, Ministère de la Culture et de la Communication, 1980.

9990. Gout, Paul. **Viollet-le-duc; sa vie, son oeuvre, sa doctrine.** Paris, Champion, 1914.

9991. Musée Historique de l'Ancien-Evêché (Lausanne). **Viollet-le-Duc: centenaire de la mort à Lausanne.** 22 juin-30 septembre 1979. Lausanne, Musée Historique de l'Ancien-Evêché, 1979.

9992. Saint-Paul, Anthyme. **Viollet-le-Duc, ses travaux d'art et son système archéologique.** Paris, Bureaux de l'Année Archéologique, 1881. 2 ed.

9993. Sauvageot, Claude. **Viollet-le-Duc et son oeuvre dessiné.** Paris, Morel, 1880.

9994. Tagliaventi, Ivo. **Viollet-le-Duc e la cultura architettonica dei revivals.** Bologna, Pàtron, 1976.

9995. Viollet-le-Duc, Eugène E. **Dictionnaire raisonné de l'architecture française du XIe au XVIe siècle.** 10 v. Paris, Bance/Morel, 1854-1868.

9996. _____. **Dictionnaire raisonné du mobilier français de l'époque carlovingienne à la Renaissance.** 6 v. Paris, Bance/Morel, 1858-1875.

9997. _____. **Entretiens sur l'architecture.** 2 v. Paris, Morel, 1863/1872. (English ed., trans. by Benjamin Bucknell: New York, Grove, 1959).

9998. _____. **Habitations modernes.** 2 v. Paris, Morel, 1875-1877. (Reprint: Bruxelles, Mardaga, 1976).

9999. _____. **Lettres d'Italie, 1836-1837.** Annotées par Geneviève Viollet-le-Duc. Paris, Laget, 1971.

VISCHER, PETER (the elder), 1460-1529

(the younger), 1487-1528

10000. Daun, Berthold. **P. Vischer und A. Krafft.** Bielefeld/ Leipzig, Velhagen & Klasing, 1905. (Künstler-Monographien, 75).

10001. Headlam, Cecil. **Peter Vischer.** London, Bell, 1901.

10002. Meller, Simon. **Peter Vischer der Ältere und seine Werkstatt.** Leipzig, Insel-Verlag, 1925.

10003. Pilz, Kurt. **Das Sebaldusgrabmal im Ostchor der St.-Sebaldus-Kirche in Nürnberg; ein Messingguss aus der Giesshütte der Vischer.** Nürnberg, Carl, 1970.

10004. Réau, Louis. **Peter Vischer et la sculpture franconienne du XIV au XVI siècle.** Paris, Plon, 1909.

10005. Reindel, Albert. **Die wichtigsten Bildwerke am Sebaldusgrabe zu Nürnberg von Peter Vischer.** 2 v. [Text in German, English, and French]. Nürnberg, Schrag, [1851/1856].

10006. Seeger, Georg. **Peter Vischer der Jüngere.** Leipzig, Seemann, 1897. (Beiträge zur Kunstgeschichte, Neue Folge, 23).

10007. Stafski, Heinz. **Der jüngere Peter Vischer.** Nürnberg, Carl, 1962.

10008. Stasiak, Ludwik. **Prawda o Piotrze Vischerze.** Kraków, [Stasiak], 1910.

VITALE DA BOLOGNA, fl. 1320-1359

10009. Gnudi, Cesare. **Vitale da Bologna and Bolognese painting in the fourteenth century.** Trans. by Olga Ragusa. New York, Abrams, 1964.

10010. Quintavalle, Carlo. **Vitale da Bologna.** Milano, Fabbri, 1966. (I maestri del colore, 157).

VITRUVIUS, ca. 90-ca. 20 B.C.

10011. Mikhailov, Boris P. **Vitruvii i Ellada; osnovy antichnoi teorii arkhitektury.** Moskva, Stroiizdat, 1967.

10012. Philandrier, Guillaume. **De architectura, annotationes.** Cum indicibus graeco & latino locupletissimis. Romae Dossena, 1544.

10013. Prestel, Jakob. **Des Marcus Vitruvius Pollio Basilika zu Fanum Fortunae.** Strassburg, Heitz, 1901. (Zur Kunstgeschichte des Auslandes, 4).

10014. Vagnetti, Luigi, ed. **2000 [i.e., due mille] anni di Vitruvio.** Firenze, Edizioni della Cattedra di Composizione Architettonica I A, 1978. (Studi e documenti di architettura, 8).

10015. Vitruvius. **De architectura.** [Roma, Herolt, 1486]. (English eds.: Vitruvius on architecture. Trans. by Frank Granger. 2 v. [Text in Latin and English]. Cambridge, Mass., Harvard University Press, 1931 . . . Loeb Classical Library . . . ; Vitruvius: the ten books of architecture. Trans. by Morris H. Morgan. Cambridge, Mass., Harvard University Press, 1914).

VITTONE, BERNARDO ANTONIO, 1702-1770

10016. Accademia delle Scienze di Torino. **Bernardo Vittone e la disputa fra classicismo e barocco nel settecento: atti del convegno internazionale.** 2 v. 21-24 settembre 1970. Torino, Accademia delle Scienze, 1972.

10017. Città di Vercelli. **Bernardo Vittone, architetto: mostra organizzata nella restaurata chiesa vittoniana di Santa Chiara.** 21 ottobre-26 novembre 1967. Vercelli, Città di Vercelli, 1967.

10018. Oechslin, Werner. **Bildungsgut und Antikenrezeption im frühen Settecento in Rom; Studien zum römischen Aufenthalt Bernardo Antonio Vittones.** Zürich, Atlantis, 1972.

10019. Olivero, Eugenio. **Le opere di Bernardo Antonio Vittone.** Torino, Collegio degli Artigianelli, 1920.

10020. Portoghesi, Paolo. **Bernardo Vittone, un architetto tra illuminismo e rococò.** Roma, Edizioni dell'Elefante, 1966.

VIVARINI, ALVISE, 1445-1505

ANTONIO, 1415-1484

BARTOLOMMEO, 1432-1499

10021. Flores d'Arcais, Francesca. **Antonio Vivarini.** Milano, Fabbri, 1966. (I maestri del colore, 151).

10022. Moschini, Vittorio. **I Vivarini.** Milano, Pizzi, 1946.

10023. Pallucchini, Rodolfo. **I Vivarini: Antonio, Bartolommeo, Alvise.** Venezia, Pozza, 1962.

10024. Sinigaglia, Giorgio. **De' Vivarini, pittori da Murano.** Bergamo, Istituto Italiano d'Arti Grafiche, 1905.

VLAMINCK, MAURICE DE, 1876-1958

see also DERAIN, ANDRE

10025. Carco, Francis. **M. de Vlaminck; trente et une reproductions précédées d'une étude critique.** Paris, Nouvelle Revue Française, 1920. (Les peintres français nouveaux, 7).

10026. Crespelle, Jean-Paul. **Vlaminck, fauve de la peinture.** Paris, Gallimard, 1958.

10027. Fels, Florent. **Vlaminck.** Paris, Seheur, 1928. (L'art et la vie, 8).

10028. Genevoix, Maurice. **Vlaminck.** Paris, Flammarion, 1954.

10029. Henry, Daniel [pseud., Daniel-Henry Kahnweiler]. **Maurice de Vlaminck.** Leipzig, Klinkhardt & Biermann, 1920. (Junge Kunst, 11).

10030. MacOrlan, Pierre. **Vlaminck.** Trans. by J. B. Sidgwick. New York, Universe, 1958.

10031. Mantaigne, André. **Maurice Vlaminck.** Paris, Crès, 1929.

10032. Perls, Klaus G. **Vlaminck.** New York, Hyperion Press, 1941.

10033. Sauvage, Marcel. **Vlaminck, sa vie et son message.** Genève, Cailler, 1956.

10034. Selz, Jean. **Vlaminck.** Paris, Flammarion, 1962.

10035. Vlaminck, Maurice de. **Paysages et personnages.** Paris, Flammarion, 1953.

10036. _____. **Tournant dangereux: souvenirs de ma vie.** Paris, Stock, 1929.

10037. Walterskirchen, Katalin von. **Maurice de Vlaminck: Verzeichnis des graphischen Werkes.** Bern, Benteli, 1974. (CR).

VOGELER, HEINRICH, 1872-1942

10038. Bonner Kunstverein (Bonn). **Heinrich Vogeler: vom Romantiker zum Revolutionär.** 23. Juni-1. August 1982. Bonn, Bonner Kunstverein, 1982.

10039. Erlay, David. **Vogeler: ein Maler und seine Zeit.** Bremen, Atelier im Bauernhaus, 1981.

10040. _____. **Worpswede-Bremen-Moskau: der Weg des Heinrich Vogeler.** Bremen, Schünemann, 1972.

10041. Hundt, Walter. **Bei Heinrich Vogeler in Worpswede, Erinnerungen.** Mit einem Nachwort von Berndt Stenzig. Worpswede, Worpsweder Verlag, 1981.

10042. Petzet, Heinrich W. **Von Worpswede nach Moskau: Heinrich Vogeler; ein Künstler zwischen den Zeiten.** Köln, DuMont Schauberg, 1972.

10043. Rief, Hans-Herman. **Heinrich Vogeler: das graphische Werk.** Bremen, Schmalfeldt, 1974. (CR).

10044. Schütze, Karl-Robert. **Heinrich Vogeler, Worpswede: Leben und architektonisches Werk.** Berlin, Frölich & Kaufmann, 1980.

10045. Staatliche Kunsthalle Berlin. **Heinrich Vogeler: Kunstwerke, Gebrauchsgegenstände, Dokumente.** 1.-6. Mai 1983. Berlin, Frölich & Kaufmann, 1983.

10046. Vogeler, Heinrich. **Erinnerungen.** Herausgegeben von Erich Weinert. Berlin, Rütten & Loening, 1952.

10047. _____. **Das neue Leben: ausgewählte Schriften zur proletarischen Revolution und Kunst.** Herausgegeben von Dietger Pforte. Darmstadt, Luchterhand, 1972.

VOLTERRA, DANIELE DA, 1509-1566

10048. Barolsky, Paul. **Daniele da Volterra, a catalogue raisonné.** New York/London, Garland, 1979. (CR). (Garland Reference Library of the Humanities, 130).

10049. Mez, Marie L. **Daniele da Volterra, saggio storico-artistico.** Volterra, Vanzi, 1935.

VOUET, AUBIN, 1595-1641

SIMON, 1590-1649

10050. Crelly, William R. **The painting of Simon Vouet.** New Haven/London, Yale University Press, 1962. (CR). (Yale Publications in the History of Art, 14).

10051. Picart, Yves. **La vie et l'oeuvre d'Aubin Vouet (1595-1641): un cadet bien oublié.** Paris, Quatre Chemins, 1982.

10052. _____. **La vie et l'oeuvre de Simon Vouet.** 2 v. Paris, Cahiers de Paris, 1958.

VOYSEY, CHARLES FRANCIS ANNESLEY, 1857-1941

10053. Gebhard, David. **Charles F. A. Voysey, architect.** Los Angeles, Hennessey & Ingalls, 1975.

10054. Simpson, Duncan. **C. F. A. Voysey: an architect of individuality.** London, Lund Humphries, 1979.

VRIES, ADRIAEN DE, 1545?-1626

10055. Böttinger, Johan. **Bronsarbeten of Adriaen de Vries I Sverige, Särskilt å Drottningholm.** Stockholm, Central, 1884.

VRIES

10056. Buchwald, Conrad. **Adriaen de Vries.** Leipzig, Seemann, 1899. (Beiträge zur Kunstgeschichte, Neue Folge, 25).

10057. Cahn, Erich B. **Adriaen de Vries und seine kirchlichen Bronzekunstwerke in Schaumberg.** Rinteln, Bösendahl, 1966.

10058. Larsson, Lars O. **Adrian de Vries: Adrianus Fries Hagiensis Batavus, 1545-1626.** Wien/München, Schroll, 1967.

VRIES, JAN VREDEMAN DE, 1527-1604

10059. Iwanoyko, Eugeniusz. **Gdański okres Hansa Vredemana de Vries.** Poznań, Uniwersytet im. Adama Mickiewicza, 1963.

10060. Mielke, Hans. **Hans Vredeman de Vries.** Berlin, Freien Universität, 1967.

10061. Vries, Jan V. de. **Perspective.** Leiden, Hondius, 1604. (New ed., with an introduction by Adolf K. Placzek: New York, Dover, 1968).

VROMAN, ADAM CLARK, 1856-1916

10062. Mahood, Ruth I. **Photographer of the Southwest: Adam Clark Vroman, 1856-1916.** Introduction by Beaumont Newhall. [Los Angeles], Ward Ritchie, 1961.

10063. Webb, William and Weinstein, Robert A. **Dwellers at the source: southwestern Indian photographs of A. C. Vroman, 1895-1904.** New York, Grossman, 1973.

VRUBEL', MIKHAIL ALEKSANDROVICH, 1856-1910

10064. Gavrilova, Evgeniia I. **Mikhail Vrubel'.** Moskva, Izobrazitel'noe Iskusstvo, 1973.

10065. Gomberg-Verzhbinskaia, Eleonora P., et al. **Vrubel': perepiska, vospominaniia o khudozhnike.** Leningrad, Iskusstvo, 1976.

10066. Iagodovskaia, Anna T. **Mikhail Aleksandrovich Vrubel'.** Leningrad, Khudizhnik RSFSR, 1966.

10067. Kogan, Dora Z. **M. A. Vrubel'.** Moskva, Iskusstvo, 1980.

10068. Rakitin, Vasilii I. **Mikhail Vrubel'.** Moskva, Iskusstvo, 1971.

10069. Suzdalev, Petr K. **Vrubel' i Lermontov.** Moskva, Izobrazitel'noe Iskusstvo, 1980.

10070. Tarabukin, Nikolai M. **Mikhail Aleksandrovich Vrubel'.** Moskva, Iskusstvo, 1974.

VUILLARD, EDOUARD, 1868-1940

see also ROUSSEL, KER XAVIER

10071. Chastel, André. **Vuillard, 1868-1940.** Paris, Floury, 1946.

10072. Preston, Stuart. **Edouard Vuillard.** New York, Abrams, 1974.

10073. Ritchie, Andrew C. **Edouard Vuillard.** [Published in conjunction with an exhibition at the Museum of Modern Art, New York]. New York, Museum of Modern Art, 1954.

10074. Roger-Marx, Claude. **L'oeuvre gravé de Vuillard.** Monte-Carlo, Sauret, 1948.

10075. _____. **Vuillard, his life and work.** Trans. by E. B. d'Auvergne. London, Elek, 1946.

10076. Russell, John, ed. **Vuillard.** Greenwich, Conn., New York Graphic Society, 1971.

10077. Salomon, Jacques. **Auprès de Vuillard.** Paris, La Palme, 1953.

10078. _____. **Vuillard.** Avant-propos de John Rewald. Paris, Gallimard, 1968. 2 ed.

10079. Schweicher, Curt. **Die Bildraumgestaltung, das Dekorative und das Ornamentale im Werke von Edouard Vuillard.** Trier, Paulinus, 1949.

VULCA, 6th c. B.C.

10080. Pallottino, Massimo. **La scuola di Vulca.** Roma, Danesi, 1945.

WAGNER, OTTO, 1841-1918

10081. Geretsegger, Heinz and Peintner, Max. **Otto Wagner, 1841-1918: the expanding city, the beginning of modern architecture.** Introduction by Richard Neutra. Trans. by Gerald Onn. New York, Rizzoli, 1979.

10082. Giusti Baculo, Adriana. **Otto Wagner: dall'architettura di stile allo stile utile.** Napoli, Edizioni Scientifiche Italiane, 1970.

10083. Hessisches Landesmuseum (Darmstadt). **Otto Wagner, das Werk des Wiener Architekten, 1841-1918.** 22. November 1963-2. Februar 1964. Darmstadt, Hessisches Landesmuseum, 1964.

10084. Lux, Joseph A. **Otto Wagner; eine Monographie.** München, Delphin, 1914.

10085. Ostwald, Hans. **Otto Wagner; ein Beitrag zum Verständnis seines baukünstlerischen Schaffens.** Baden-Baden, Verlag Buchdrucker, 1948.

10086. Tietze, Hans. **Otto Wagner.** Wien, Rikola, 1922.

10087. Wagner, Otto. **Die Baukunst unserer Zeit.** Wien, Schroll, 1914. (Reprint: Wien, Löcker, 1979).

10088. _____. **Einige Skizzen: Projecte und ausgeführte Bauwerke.** 4 v. Wien, Schroll, 1892.

300

WALDMÜLLER, FERDINAND GEORG, 1793-1865

10089. Altes Rathaus (Schweinfurt). **Ferdinand Georg Waldmüller: Gemälde aus der Sammlung Georg Schäfer, Schweinfurt.** 17. September bis 29. Oktober 1978. Schweinfurt, Sammlung Georg Schäfer, 1978.

10090. Eberlein, Kurt K. **Ferdinand Georg Waldmüller, das Werk des Malers.** Berlin, Juncker, 1938.

10091. Grimschitz, Bruno. **Ferdinand Georg Waldmüller.** Salzburg, Galerie Welz, 1957.

10092. Roessler, Arthur und Pisko, Gustav. **Ferdinand Georg Waldmüller, sein Leben, sein Werk und seine Schriften.** 2 v. Wien, Pisko, [1908].

10093. Waldmüller, Ferdinand G. **Andeutungen zur Belebung der vaterländischen bildenden Kunst.** Wien, Gerold, 1857.

10094. Wolf, Georg J. **Waldmüller: Bilder und Erlebnisse.** München, Delphin, [1916].

WALTHER, FRANZ ERHARD, 1939-

10095. Adriani, Götz, ed. **Franz Erhard Walther: Arbeiten 1955-1963; Material zum 1. Werksatz, 1963-1969.** Köln, DuMont Schauberg, 1972.

10096. Kunstraum München. **Diagramme zum 1. Werksatz.** [January 29-March 20, 1976]. München, Kunstraum München, 1976.

10097. Museum Ludwig (Cologne). **Franz Erhard Walther, 2. Werksatz: Skulpturen, Zeichnungen.** 6. Mai bis 26. Juni 1977. Köln, Museen der Stadt Köln, 1977.

WANG CHIEN, 1598-1677

HUI, 1632-1717

SHIH-MIN, 1592-1680

YÜAN-CHI, 1642-1715

10098. Chiang Fu-ts'ung. **Catalogue of Wang Hui's paintings.** [Text in Chinese and English]. Taipei, National Palace Museum, 1970.

10099. Contag, Victoria. **Die sechs berühmten Maler der Ch'ing Dynastie.** Leipzig, Seemann, 1940.

10100. Pang, Mae A. **Wang Yüan-Ch'i (1642-1715) and formal construction in Chinese landscape painting.** Ann Arbor, Mich., University Microfilms, 1976.

WANG WEI, 701-761

10101. Ch'eng Hsi. **An album of Wang Wei; pictures in illustration of his poems with translations by Ch'eng Hsi and Henry W. Wells.** [Text in English and Chinese]. Hong Kong, Ling-ch'ao-hsüan, 1974.

10102. Walmsley, Lewis C. and Walmsley, Dorothy B. **Wang Wei, the painter-poet.** Rutland, Vt., Tuttle, 1968.

WAPPERS, GUSTAV, 1803-1874

10103. Koninklijk Museum van Schone Kunsten (Antwerp). **Gustav Wappers en zijn school.** 26 juni tot 29 augustus 1976. Antwerpen, Ministerie van Nederlandse Cultuur, 1976.

WARD, JAMES, 1769-1859

WILLIAM, 1766-1826

10104. Frankau, Julia. **William Ward, James Ward; their lives and works.** 2 v. London, Macmillan, 1904.

10105. Fussell, George E. **James Ward, R. A., animal painter, 1769-1859, and his England.** London, Joseph, 1974.

10106. Grundy, C. Reginald. **James Ward, R. A.: his life and works.** London, Otto, 1909.

WARHOL, ANDY, 1928/31-

10107. Coplans, John. **Andy Warhol.** With contributions by Jonas Mekas and Calvin Tomkins. [Published in conjunction with an exhibition at the Pasadena Art Museum, Pasadena, Calif., May 12-June 21, 1970]. Greenwich, Conn., New York Graphic Society, 1970.

10108. Crone, Rainer. **Andy Warhol.** Trans. by John W. Gabriel. New York, Praeger, 1970.

10109. Gidal, Peter. **Andy Warhol, films and paintings.** New York, Dutton, 1971.

10110. Kestner-Gesellschaft, Hannover. **Andy Warhol, Bilder 1961 bis 1981.** 23. Oktober bis 13. Dezember 1981. Hannover, Kestner-Gesellschaft, 1981. (Katalog 7/1981).

10111. Kunsthaus Zürich. **Andy Warhol: ein Buch zur Ausstellung 1978.** 16. Mai-30. Juli 1978. Zürich, Kunsthaus Zürich, 1978.

10112. Ratcliff, Carter. **Andy Warhol.** New York, Abbeville, 1983. (Abbeville Modern Masters, 4).

10113. Warhol, Andy. **Andy Warhol's exposures: photographs by Andy Warhol.** Text by Andy Warhol with Bob Colacello. New York, Grosset & Dunlap, 1979.

10114. _____. **The philosophy of Andy Warhol (from A to B and back again).** New York, Harcourt, Brace, Jovanovich, 1975.

10115. _____ and Hackett, Pat. **Popism: the Warhol '60's.** New York, Harcourt Brace Jovanovich, 1980.

10116. Whitney Museum of American Art (New York). **Andy Warhol: portraits of the '70's.** November 20, 1979-January 27, 1980. New York, Whitney Museum of American Art, 1979.

10117. Württembergischer Kunstverein (Stuttgart). **Andy Warhol: das zeichnerische Werk, 1942-1975.** Stuttgart, Württembergischer Kunstverein, 1976.

10118. Wünsche, Hermann. **Andy Warhol, das graphische Werk, 1962-1980.** Köln, Bonner Universität Buchdruckerei, [1980]; distributed by Castelli Graphics, New York. (CR)

WASMANN, FRIEDRICH, 1805-1886

10119. Nathan, Peter. **Friedrich Wasmann, sein Leben und sein Werk.** München, Bruckmann, 1954. (CR).

10120. Wasmann, Friedrich. **Friedrich Wasmann, ein deutsches Künstlerleben.** Herausgegeben von Bernt Grönvold. Leipzig, Insel-Verlag, 1915.

WATERHOUSE, JOHN WILLIAM, 1849-1917

10121. Hobson, Anthony. **The art and life of J. W. Waterhouse, R. A., 1849-1917.** New York, Rizzoli, 1980.

WATKINS, CARLETON, 1829-1916

10122. Alinder, James, ed. **Carleton E. Watkins: photographs of the Columbia River and Oregon.** Essays by David Featherstone and Russ Anderson. Carmel, Calif., Friends of Photography, 1979.

10123. Johnson, J. W. **The early Pacific Coast photographs of Carleton E. Watkins.** [Berkeley], University of California Water Resources Center, 1960. (Archives Series Report, 8).

10124. Palinquist, Peter E. **Carleton E. Watkins: photographer of the American West.** Albuquerque, N.M., University of New Mexico Press, 1983.

10125. Ziebarth, Marilyn, ed. **Carleton E. Watkins.** San Francisco, California Historical Society, 1978.

WATKINS, FRANKLIN CHENAULT, 1894-1972

10126. Ritchie, Andrew C. **Franklin C. Watkins.** [Published in conjunction with an exhibition at the Museum of Modern Art, New York]. New York, Museum of Modern Art, 1950.

10127. Wolf, Ben. **Franklin C. Watkins: portrait of a painter.** Philadelphia, University of Pennsylvania Press, 1966.

WATTEAU, JEAN ANTOINE, 1684-1721

10128. Adhémar, Hélène. **Watteau, sa vie, son oeuvre.** Paris, Tisné, 1950.

10129. Banks, Oliver T. **Watteau and the North: studies in the Dutch and Flemish baroque influences on French rococo painting.** New York, Garland, 1977.

10130. Barker, Gilbert W. **Antoine Watteau.** London, Duckworth, 1939.

10131. Brinckmann, Albert E. **J. A. Watteau.** Wien, Schroll, 1943.

10132. Cellier, L. **Watteau; son enfance, ses contemporains.** Valenciennes, Henry, 1867.

10133. Champion, Pierre. **Notes critiques sur les vies anciennes d'Antoine Watteau.** Paris, Edouard Champion, 1921.

10134. Dacier, Emile et Vuaflart, Albert. **Jean de Jullienne et les graveurs de Watteau au XVIIIᵉ siècle.** 4 v. Paris, Société pour l'Etude de la Gravure Française, 1929-31.

10135. Dargenty, G. [pseud., Arthur A. M. du Cluseau d'Echerac]. **Antoine Watteau.** Paris, Librairie de l'Art, [1891].

10136. Eaubonne, Françoise d'. **Le coeur de Watteau.** [Monaco], Editions Littéraires de Monaco, 1944.

10137. Eidelberg, Martin P. **Watteau's drawings: their use and significance.** New York/London, Garland, 1977.

10138. Ferré, Jean, ed. **Watteau, critiques.** 4 v. Madrid, Athéna, 1972. (CR).

10139. Gillet, Louis. **Watteau, un grand maître du XVIII siècle.** Paris, Plon, 1943. 4 ed.

10140. Goncourt, Edmond de. **Catalogue raisonné de l'oeuvre peint, dessiné et gravé d'Antoine Watteau.** Paris, Rapilly, 1875. (CR).

10141. Guillaume, Georges. **Antoine Watteau; sa vie, son oeuvre, et les monuments élevés à sa mémoire.** Lille, Danel, 1884.

10142. Hildebrandt, Edmund. **Antoine Watteau.** Berlin, Propyläen, 1922.

10143. Hôtel de la Monnaie (Paris). **Pèlerinage à Watteau.** 4 v. [Catalogue of an exhibition]. Paris, Hôtel de la Monnaie, 1977.

10144. Huyghe, René. **L'univers de Watteau.** Paris, Scrépel, 1968.

10145. Josz, Virgile. **Antoine Watteau.** Paris, Piazza, [1904].

10146. Kunstler, Charles. **Watteau, l'enchanteur.** Paris, Floury, 1936.

10147. Lavallée, Pierre. **Antoine Watteau, 1684-1721; quatorze dessins.** Paris, Musées Nationaux, 1939.

10148. Macchia, Giovanni [and] Montagni, E. C. **L'opera completa di Watteau.** Milano, Rizzoli, 1968. (CR). (Classici dell'arte, 21).

10149. Mathey, Jacques. **Antoine Watteau: peintures réapparues, inconnues, ou négligées par les historiens.** Paris, de Nobele, 1959.

10150. Mauclair, Camille. **Antoine Watteau.** Trans. by Madame Simon Bussy. London, Duckworth, [1905].

10151. Maurel, André. **L'enseigne de Gersaint; étude sur le tableau de Watteau: son histoire, les controverses, solution du problème.** Paris, Hachette, 1913.

10152. Mollett, John W. **Watteau.** New York, Scribner & Welford/London, Sampson Low, 1883.

10153. Nemilova, Inna S. **Vatto i ego proizvedeniia v Ermitazhe.** Leningrad, Sovetskii Khudozhnik, 1964.

10154. Nordenfalk, Carl. **Antoine Watteau och andra franska sjutton hundratalsmästare i Nationalmuseum.** Stockholm, Ehlins, 1953.

10155. Parker, Karl T. **The drawings of Antoine Watteau.** London, Batsford, 1931.

10156. _____ et Mathey, Jacques. **Antoine Watteau, catalogue complet de son oeuvre dessiné.** 2 v. Paris, de Nobele, 1957. (CR).

10157. Phillips, Claude. **Antoine Watteau.** London, Seeley, 1895. (Portfolio, 18).

10158. Pilon, Edmond. **Watteau et son école.** Bruxelles/Paris, van Oest, 1912.

10159. Posner, Donald. **Watteau.** London, Weidenfeld and Nicolson, 1983.

10160. _____. **Watteau: A Lady at her Toilet.** New York, Viking, 1973. (Art in context).

10161. Rosenberg, Adolf. **Antoine Watteau.** Bielefeld/Leipzig, Velhagen & Klasing, 1896. (Künstler-Monographien, 15).

10162. Schneider, Pierre. **The world of Watteau, 1684-1721.** New York, Time, Inc., 1967.

10163. Séailles, Gabriel. **Watteau, biographie critique.** Paris, Laurens, 1907.

10164. Staley, Edgcumbe. **Watteau and his school.** London, Bell, 1902.

10165. Zimmermann, E. Heinrich. **Watteau, des Meisters Werke.** Stuttgart/Leipzig, Deutsche Verlags-Anstalt, 1912. (Klassiker der Kunst, 21).

WATTS, GEORGE FREDERICK, 1817-1904

10166. Barrington, Emilie I. **G. F. Watts, reminiscences.** New York, Macmillan, 1905.

10167. Blunt, Wilfrid. **England's Michelangelo: a biography of George Frederick Watts.** London, Hamilton, 1904.

10168. Chapman, Ronald. **The laurel and the thorn: a study of G. F. Watts.** London, Faber, 1945.

10169. Chesterton, Gilbert K. **G. F. Watts.** London, Duckworth, [1909].

10170. Macmillan, Hugh. **The life-work of George Frederick Watts.** London, Dent, 1903.

10171. National Portrait Gallery (London). **G. F. Watts: the Hall of Fame; portraits of his famous contemporaries.** London, HMSO, 1975.

10172. Schleinitz, Otto von. **George Frederick Watts.** Bielefeld/Leipzig, Velhagen & Klasing, 1904. (Künstler-Monographien, 73).

10173. Spielmann, Marion H. **The works of Mr. George F. Watts, R. A., with a complete catalogue of his pictures.** [London], Pall Mall Gazette, 1886. (Pall Mall Gazette Extra, 22).

10174. Watts, Mary S. **George Frederick Watts.** 3 v. London, Macmillan, 1912.

WAUGH, FREDERICK JUDD, 1861-1940

10175. Havens, George R. **Frederick J. Waugh, American marine painter.** Orono, Maine, University of Maine Press, 1969. (University of Maine Studies, 89).

WAYNE, JUNE, 1918-

10176. Baskett, Mary W. **The art of June Wayne.** New York, Abrams, 1969.

WEBER, ANDREAS PAUL, 1893-1981

10177. Reinhardt, Georg, ed. **A. Paul Weber: das graphische Werk, 1930-1978; Handzeichnungen, Lithographien.** [Based on an exhibition held at the Rheinisches Landesmuseum, Bonn, October 26-December 10, 1978]. München, Schirmer-Mosel, 1980. (CR).

10178. Schartel, Werner, ed. **A. Paul Weber: das anti-faschistische Werk.** Berlin/Hamburg, Elefanten Press, 1977.

10179. Wolandt, Gerd. **Bild und Wort: Überlegungen zum Werk A. Paul Webers.** Hamburg, Christian, 1977. (Schriften der A. Paul Weber-Gesellschaft, 1).

WEBER, MAX, 1881-1961

10180. Goodrich, Lloyd. **Max Weber.** New York, Macmillan, 1949.

10181. Rubenstein, Daryl R. **Max Weber: a catalogue raisonné of his graphic work.** Foreword by Alan Fern. Chicago, University of Chicago Press, 1980. (CR).

10182. Weber, Max. **Essays on art.** New York, Rudge, 1916.

10183. Werner, Alfred. **Max Weber.** New York, Abrams, 1975.

WEDGEWOOD, JOSIAH, 1730-1795

see also STUBBS, GEORGE

10184. Burton, Anthony. **Josiah Wedgwood, a biography.** New York, Stein and Day, 1976.

10185. Burton, William. **Josiah Wedgwood and his pottery.** London, Cassell, 1922.

10186. Church, Arthur H. **Josiah Wedgwood, master-potter.** London, Seeley, 1894. (Portfolio Artistic Monographs, 3).

10187. Jewitt, Llewellynn. **The Wedgwoods: being a life of Josiah Wedgwood with notices of his works and their productions.** London, Virtue, 1865.

10188. Meteyard, Eliza. **The life of Josiah Wedgwood, from his private correspondence and family papers.** With an introductory sketch of the art of pottery in England. 2 v. London, Hurst and Blackett, 1865.

10189. _____. **Wedgwood and his works: a selection of his plaques, cameos, medallions, vases, etc.** London, Bell and Daldy, 1873.

10190. National Portrait Gallery, Smithsonian Institution (Washington, D.C.). **Wedgwood portraits and the American Revolution.** Washington, D.C., Smithsonian Institution, 1976.

10191. Rathbone, Frederick. **Old Wedgwood: the decorative or artistic ceramic work in colour and relief.** London, Quaritch, 1898.

10192. Reilly, Robin and Savage, George. **Wedgwood: the portrait medallions.** London, Barrie & Jenkins, 1973. (CR).

10193. Science Museum (London). **Josiah Wedgwood: the arts and sciences united.** 21 March to 24 September 1978. Barlaston, England, Wedgwood, 1978.

10194. Smiles, Samuel. **Josiah Wedgwood, his personal history.** New York, Harper, 1895.

10195. Wedgwood, Josiah. **Selected letters.** Edited by Ann Finer and George Savage. New York, Born & Hawes, 1965.

10196. Wedgwood, Julia. **The personal life of Josiah Wedgwood, the potter.** Revised and edited by C. H. Herford. London, Macmillan, 1915.

WEIDITZ, HANS, 16th c.

see also MASTER OF PETRARCH

10197. Fraenger, Wilhelm. **Hans Weiditz und Sebastian Brandt.** Leipzig, Stubenrauch, 1930. (Denkmale der Volkskunst, 2).

10198. Röttinger, Heinrich. **Hans Weiditz, der Petrarkameister.** Strassburg, Heitz, 1904. (Studien zur deutschen Kunstgeschichte, 50).

10199. Scheidig, Walther. **Die Holzschnitte des Petrarca-meisters.** Berlin, Henschel, 1955.

WEINBRENNER, FRIEDRICH, 1766-1826

10200. Koebel, Max. **Friedrich Weinbrenner.** Berlin, Wasmuth, [1920].

10201. Lankheit, Klaus. **Friedrich Weinbrenner und der Denkmalskult um 1800.** Basel/Stuttgart, Birkhäuser, 1979. (Geschichte und Theorie der Architektur, 21).

10202. Staatliche Kunsthalle Karlsruhe. **Friedrich Weinbrenner, 1766-1826; eine Ausstellung des Instituts für Baugeschichte an der Universität Karlsruhe.** 29. Oktober 1977-15. Januar 1978. Karlsruhe, Institut für Baugeschichte an der Universität Karlsruhe, 1977.

10203. Valdenaire, Arthur. **Friedrich Weinbrenner, sein Leben und seine Bauten.** Karlsruhe, Druck, 1919. (New ed.: Karlsruhe, Müller, 1976).

10204. Weinbrenner, Friedrich. **Briefe und Aufsätze.** Herausgegeben von Arthur Valdenaire. Karlsruhe, Braun, 1926.

10205. _____. **Denkwürdigkeiten.** Herausgegeben und bearbeitet von Arthur von Schneider. Karlsruhe, Braun, 1958.

WEIR, JULIAN ALDEN, 1852-1919

10206. Flint, Janet A. **J. Alden Weir, an American printmaker, 1852-1919.** [Published in conjunction with an exhibition at the National Collection of Fine Arts, Smithsonian Institution, Washington, D.C., May 5-June 4, 1972, and other places]. Provo, Utah, Brigham Young University Press, 1972.

10207. Phillips, Duncan, et al. **Julian Alden Weir, an appreciation of his life and works.** New York, Century Club, 1921.

10208. Young, Dorothy W. **The life and letters of J. Alden Weir.** Edited with an introduction by Lawrence W. Chisholm. New Haven, Yale University Press, 1960.

10209. Zimmerman, Agnes. **An essay towards a catalogue raisonné of the etchings, dry-points, and lithographs of Julian Alden Weir.** New York, Metropolitan Museum of Art, 1923. (Metropolitan Museum of Art papers, I:2). (CR).

WELCH, LUCY ELIZABETH KEMP see KEMP-WELCH, LUCY ELIZABETH

WÊN CHÊNG-MING, 1470-1559

10210. Dubosc, Jean-Pierre. **Wen Tcheng-Ming et son école.** Lausanne, Bridel, 1961.

10211. University of Michigan Museum of Art (Ann Arbor, Mich.). **The art of Wen Cheng-Ming (1470-1559).** January 25-February 29, 1976. [Text by Richard Edwards, with an essay by Anne de Coursey Clapp]. Ann Arbor, Mich., University of Michigan Museum of Art, 1976.

WENGENROTH, STOW, 1906-1978

10212. McCord, David. **Stow Wengenroth's New England.** Barre, Mass., Barre Publishers, 1969.

10213. Stuckey, Ronald and Stuckey, Joan. **The lithographs of Stow Wengenroth, 1931-1972.** Barre, Mass., Barre Publishers, 1974. (CR).

10214. _____. **Stow Wengenroth's lithographs: a supplement.** With an essay by Albert Reese. Huntington, N.Y., Black Oaks Publishers, 1982. (CR).

10215. Wengenroth, Stow. **Making a lithograph.** London, The Studio, 1936.

WEREFKIN, MARIANNE, 1860-1938

10216. Hahl-Koch, Jelena. **Marianne Werefkin und der russische Symbolismus: Studien zur Ästhetik und Kunsttheorie.** München, Sagner, 1967. (Slavistische Beiträge, 24).

10217. Museum Wiesbaden. **Marianne Werefkin: Gemälde und Skizzen.** [September 28-November 23, 1980]. Wiesbaden, Museum Wiesbaden, 1980.

10218. Werefkin, Marianne. **Briefe an einen Unbekannten, 1901-1905.** Herausgegeben von Clemens Weiler. Köln, DuMont Schauberg, 1960.

WERNER, ANTON VON, 1843-1915

10219. Rosenberg, Adolf. **A. von Werner.** Bielefeld/Leipzig,
Velhagen & Klasing, 1895. (Künstler-Monographien, 9).

WEST, BENJAMIN, 1738-1820

RAPHAEL LAMAR, 1769-1850

10220. Alberts, Robert C. **Benjamin West, a biography.** Boston,
Houghton Mifflin, 1978.

10221. Allentown Art Museum (Allentown, Pa.). **The world of
Benjamin West.** [May 1-July 31, 1962]. Allentown,
Allentown Art Museum, 1962.

10222. Dillenberger, John. **Benjamin West: the context of his
life's work with particular attention to paintings with
religious subject matter.** San Antonio, Tex., Trinity
University Press, 1977.

10223. Evans, Grose. **Benjamin West and the taste of his times.**
Carbondale, Ill., Southern Illinois University Press,
1959.

10224. Galt, John. **The life and studies of Benjamin West.**
London, Cadell and Davies, 1816. (Reprinted with an
introduction by Nathalia Wright: Gainesville, Florida,
Scholar's Facsimiles & Reprints, 1960).

10225. Kraemer, Ruth S. **Drawings by Benjamin West and his son
Raphael Lamar West.** New York, Pierpont Morgan Library,
1975. (CR).

WESTON, BRETT, 1911-

EDWARD, 1886-1958

10226. Armitage, Merle. **Brett Weston, photographs.** New York,
Weyhe, 1956.

10227. Cravens, R. H. **Brett Weston, photographs from five
decades.** Millerton, N.Y., Aperture, 1980.

10228. Maddow, Ben. **Edward Weston, his life and photographs: the
definitive volume of his photographic work.** Millerton,
N.Y., Aperture, 1979. 2 ed.

10229. Weston, Brett. **Voyage of the eye.** Afterword by Beaumont
Newhall. Millerton, N.Y., Aperture, 1975.

10230. Weston, Charis W. and Weston, Edward. **California and
the West.** New York, Duell, Sloan, and Pearce, 1940.

10231. Weston, Edward. **The daybooks of Edward Weston.** Edited by
Nancy Newhall. 2 v. Millerton, N.Y., Aperture, 1973.

WEYDEN, ROGER VAN DER, 1400-1464

see also MASTER OF FLEMALLE

10232. Beenken, Hermann. **Rogier van der Weyden.** München,
Bruckmann, 1951.

10233. Burger, Willy. **Roger van der Weyden.** Leipzig,
Hiersemann, 1923.

10234. Campbell, Lorne. **Van der Weyden.** New York, Harper & Row,
1980.

10235. City Museum of Brussels. **Rogier van der Weyden: official
painter to the city of Brussels.** October 6-November 18,
1979. Brussels, City Museum of Brussels, 1979.

10236. Davies, Martin. **Rogier van der Weyden; an essay with a
critical catalogue of paintings assigned to him and to
Robert Campin.** London, Phaidon, 1972. (CR).

10237. Drestrée, Jules. **Roger de la Pasture van der Weyden.**
2 v. Paris/Bruxelles, van Oest, 1930.

10238. Hasse, Carl. **Roger van der Weyden und Roger van Brügge.**
Strassburg, Heitz, 1905. (Zur Kunstgeschichte des
Auslandes, 30).

10239. Koninklijke Academie voor Wetenschappen, Letteren en
Schone Kunsten van België. **Rogier van der Weyden en
zijn tijd: internationael colloquium, 11-12 juni 1964.**
[Text alternatingly in French or Dutch]. Brussel,
Paleis der Academiën, 1974.

10240. Lafond, Paul. **Roger van der Weyden.** Bruxelles, van Oest,
1912.

10241. Sonkes, Micheline. **Dessins du XVe siècle: groupe van der
Weyden; essai de catalogue des originaux du maître, des
copies, et des dessins anonymes inspirés par son style.**
Bruxelles, Centre National du Recherches Primitifs
Flamands, 1969. (Les primitifs flamands: contributions
à l'étude des primitifs flamands, 5).

WHISTLER, JAMES ABBOT McNEILL, 1834-1903

10242. Art Institute of Chicago. **James McNeill Whistler.**
January 13-February 25, 1968. Chicago, Art Institute of
Chicago, 1968.

10243. Arts Council Gallery (London). **James McNeill Whistler.**
September 1-24, 1960. London, Arts Council of Great
Britain, 1960.

10244. Bacher, Otto H. **With Whistler in Venice.** New York,
Century, 1908.

10245. Barbier, Carl P., ed. **Correspondance Mallarmé-Whistler.**
Paris, Nizet, 1964.

10246. Cary, Elisabeth L. **The works of James McNeill Whistler.**
New York, Moffat, 1907.

10247. Duret, Théodore. **Whistler.** Trans. by Frank Rutter.
Philadelphia, Lippincott, 1917.

10248. Eddy, Arthur J. **Recollections and impressions of James A.
McNeill Whistler.** Philadelphia/London, Lippincott,
1903.

10249. Fleming, Gordon H. **The young Whistler.** London, Allen &
Unwin, 1978.

10250. Gregory, Horace. **The world of James McNeill Whistler.**
New York, Nelson, 1959.

10251. Hartmann, Sadakichi. **The Whistler book: a monograph on
the life and position in art of James McNeill Whistler.**
Boston, Page, 1910.

10252. Holden, Donald. **Whistler landscapes and seascapes.** New York, Watson-Guptill, 1969.

10253. Kennedy, Edward G. **The etched work of Whistler.** 4 v. New York, Grolier Club, 1910. (CR).

10254. Laver, James. **Whistler.** London, Faber, 1930.

10255. Levy, Mervyn. **Whistler lithographs: an illustrated catalogue raisonné.** With an essay on Whistler the printmaker by Allen Staley. London, Jupiter, 1975. (CR).

10256. Mansfield, Howard. **A descriptive catalogue of the etchings and dry-points of James Abbott McNeill Whistler.** Chicago, Caxton Club, 1909. (CR).

10257. McMullen, Roy. **Victorian outsider: a biography of J. A. M. Whistler.** New York, Dutton, 1973.

10258. Menpes, Mortimer. **Whistler as I knew him.** London, Black, 1904.

10259. Pearson, Hesketh. **The man Whistler.** London, Methuen, 1952.

10260. Pennell, Elizabeth R. **Whistler the friend.** Philadelphia/London, Lippincott, 1930.

10261. Pennell, Elizabeth R. and Pennell, Joseph. **The life of James McNeill Whistler.** 2 v. Philadelphia, Lippincott, 1908.

10262. _____. **The Whistler journal.** Philadelphia, Lippincott, 1921.

10263. Pocock, Tom. **Chelsea Reach: the brutal friendship of Whistler and Walter Greaves.** London, Hodder and Stoughton, 1970.

10264. Prideaux, Tom. **The world of Whistler, 1834-1903.** New York, Time-Life, 1970.

10265. Rutter, Frank V. **James McNeill Whistler: an estimate & a biography.** New York, Kennerley, 1911.

10266. Salaman, Malcolm. **James McNeill Whistler.** 2 v. London, The Studio, 1927/1932. (Modern Masters of Etching, 13/32).

10267. Seitz, Don C. **Whistler stories.** New York, Harper, 1913.

10268. _____. **Writings by and about James Abbott McNeill Whistler, a bibliography.** Edinburgh, Schulze, 1910.

10269. Singer, Hans W. **James McNeill Whistler.** New York, Scribner, 1905. (Langham Series of Art Monographs, 12).

10270. Sutton, Denys. **James McNeill Whistler: paintings, etchings, pastels & watercolours.** London, Phaidon, 1966.

10271. _____. **Nocturne: the art of James McNeill Whistler.** London, Country Life, 1963.

10272. Taylor, Hilary. **James McNeill Whistler.** New York, Putnam, 1978.

10273. Way, Thomas R. **Memories of James McNeill Whistler, the artist.** London, Lane, 1912.

10274. _____. **Mr. Whistler's lithographs: the catalogue.** London, Bell, 1896. (CR). (Rev. ed.: 1905).

10275. _____ and Dennis, G. R. **The art of James McNeill Whistler, an appreciation.** London, Bell, 1903.

10276. Wedmore, Frederick. **Whistler's etchings: a study and a catalogue.** London, Thibadeau, 1886. (Rev. ed.: London, Colnaghi, 1899).

10277. Weintraub, Stanley. **Whistler, a biography.** New York, Weybright and Talley, 1974.

10278. Whistler, James A. **Eden versus Whistler: the baronet & the butterfly.** Paris, May, 1899.

10279. _____. **The gentle art of making enemies.** Edited by Sheridan Ford. Paris, Delabrosse, 1890.

10280. _____. **Mr. Whistler's Ten o'clock.** London, Chatto & Windus, 1888.

10281. _____. **Whistler v. Ruskin: art & art critics.** London, Chatto & Windus, 1878.

10282. Wildenstein Gallery (New York). **From Realism to Symbolism: Whistler and his world, an exhibition organized by the Department of Art History and Archaeology of Columbia University.** March 4-April 3, 1971. New York, Trustees of Columbia University, 1971.

10283. Young, Andrew M., et al. **The paintings of James McNeill Whistler.** 2 v. New Haven/London, Yale University Press, 1980. (CR).

WHITE, CHARLES WILBERT, 1918-1979

10284. Horowitz, Benjamin. **Images of dignity: the drawings of Charles White.** Foreword by Harry Belafonte; introduction by James Porter. Los Angeles, Ward Ritchie, 1967.

WHITE, CLARENCE H., 1871-1925

10285. Delaware Art Museum (Wilmington, Del.). **Symbolism of light: the photographs of Clarence H. White.** April 15-May 22, 1977. Wilmington, Delaware Art Museum, 1977.

10286. White, Maynard P. **Clarence H. White.** Millerton, N.Y., Aperture, 1979. (Aperture History of Photography, 11).

WHITE, MINOR, 1908-

10287. Hall, James B., ed. **Minor White: rites and passages; his photographs accompanied by excerpts from his diaries and letters.** Millerton, N.Y., Aperture, 1978.

10288. White, Minor. **Mirrors, messages, manifestations.** Millerton, N.Y., Aperture, 1969.

10289. _____. **Zone system manual.** Hastings-on-Hudson, Morgan & Morgan, 1968. (New ed., with additional material by Richard Zakia and Peter Lorenz: Dobbs Ferry, Morgan & Morgan, 1976).

WIERTZ, ANTOINE, 1806-1865

10290. Colleye, Hubert. **Antoine Wiertz.** Bruxelles, La Renaissance du Livre, 1957.

10291. Fierens-Gevaert, Hippolyte. **Antoine Wiertz.** Turnhout, Brepols, 1920.

10292. Sikes, Wert, et al. **Catalogue of the Wiertz-Museum.** Brussels, Weissenbruch, 1899.

10293. Terlinden, Charles. **La correspondance d'Antoine Wiertz, Prix de Rome, au cours de son voyage d'Italie.** Bruxelles/Rome, Academia Belgica, 1953. (Bibliothèque de l'Institut Historique Belge de Rome, 5).

WILIGELMUS, fl. 1099-1110

10294. Francovich, Géza de. **Wiligelmo da Modena e gli inizi della scultura romanica in Francia e in Spagna.** Roma, Istituto Poligrafico dello Stato Libreria, 1940.

10295. Salvini, Roberto. **Wiligelmo e le origini della scultura romanica.** Milano, Martello, 1956.

WILKIE, DAVID, 1785-1841

10296. [Anonymous]. **The Wilkie Gallery: a selection of the best pictures of the late Sir David Wilkie, R. A., with notices biographical and critical.** London/New York, Virtue, [1848].

10297. Cunningham, Allan. **The life of Sir David Wilkie.** 3 v. London, Murray, 1843.

10298. Gower, Ronald S. **Sir David Wilkie.** London, Bell, 1902.

10299. Heaton, Mrs. Charles. **The great works of Sir David Wilkie; twenty-six photographs with a descriptive account of the pictures and a memoir of the artist.** London, Bell and Daldy, 1868.

10300. Mollett, John W. **Sir David Wilkie.** New York, Scribner and Welford/London, Sampson Low, 1881.

10301. Pinnington, Edward. **Sir David Wilkie and the Scots school of painters.** Edinburgh/London, Oliphant, Anderson & Ferrier, [1900]. (Famous Scots).

WILLINK, ALBERT CAREL, 1900-

10302. Jaffé, Hans L. **Willink.** Amsterdam, Meulenhoff/Landshoff, 1979. (CR).

WILSON, RICHARD, 1714-1782

10303. Bury, Adrian. **Richard Wilson, the grand classic.** Leigh-on-Sea, Lewis, 1947.

10304. Constable, William G. **Richard Wilson.** Cambridge, Mass., Harvard University Press, 1953.

10305. Fletcher, Beaumont. **Richard Wilson, R. A.** London, Scott, 1908.

10306. Ford, Brinsley. **The drawings of Richard Wilson.** London, Faber, 1950.

10307. Sutton, Denys, ed. **An Italian sketchbook by Richard Wilson, R. A.** With a catalogue by Ann Clements. 2 v. London, Paul Mellon Foundation for British Art, 1968.

10308. Wright, Thomas. **Some account of the life of Richard Wilson, R. A.** London, Longmans, 1824.

WINTER, FRITZ, 1905-1976

10309. Buchner, Joachim. **Fritz Winter.** Recklinghausen, Bongers, 1963. (Monographien zur rheinisch-westfälischen Kunst der Gegenwart, 25).

10310. Keller, Horst. **Fritz Winter.** München, Bruckmann, 1976.

10311. Kunstverein Hannover. **Fritz Winter zum 60. Geburtstag.** 16. Januar-13. Februar 1966. Hannover, Kunstverein Hannover, 1966.

10312. Westfälisches Landesmuseum für Kunst und Kulturgeschichte (Münster). **Fritz Winter: Triebkräfte der Erde.** 8. November 1981-10. Januar 1982. Münster, Westfälisches Landesmuseum, [1981].

WITTEL, CASPAR ADRIAENSZOON VAN, 1653-1736

10313. Briganti, Giuliano. **Caspar van Wittel e l'origine della veduta settecentesca.** Roma, Bozzi, 1966.

10314. Lorenzetti, Constanza. **Gaspare Vanvitelli.** Milano, Treves, 1934.

10315. Vitzthum, Walter. **Drawings by Gaspar van Wittel (1652/53-1736) from Neapolitan collections.** Trans. and ed. by Catherine Johnston. [Text in English and French; published in conjunction with an exhibition at the National Gallery of Canada, Ottawa]. Ottawa, National Gallery of Canada, 1977.

WITTEN, HANS, fl. 1501-1512

10316. Fründt, Edith. **Der Bornaer Altar von Hans Witten.** Berlin, Union, 1975.

10317. Hentschel, Walter. **Hans Witten, der Meister H. W.** Leipzig, Seemann, 1938.

WITZ, KONRAD, 1400-1446

10318. Barrucand, Marianne. **Le retable du miroir du salut dans l'oeuvre de Konrad Witz.** Genève, Droz, 1972.

10319. Escherich, Mela. **Konrad Witz.** Strassburg, Heitz, 1916. (Studien zur deutschen Kunstgeschichte, 183).

10320. Feldges-Henning, Uta. **Werkstatt und Nachfolge des Konrad Witz: ein Beitrag zur Geschichte der Basler Malerei des 15. Jahrhunderts.** Basel, Werner & Bischoff, 1968.

10321. Gantner, Joseph. **Konrad Witz.** Wien, Schroll, 1942.

10322. Ganz, Paul L. **Meister Konrad Witz von Rottweil.** Bern, Urs Graf, 1947.

10323. Graber, Hans. **Konrad Witz.** Basel, Schwabe, 1922.

10324. Meng-Koehler, Mathilde. **Die Bilder des Konrad Witz und ihre Quellen.** Basel, Holbein, 1947.

10325. Ueberwasser, Walter. **Konrad Witz.** Basel, Cratander, [1938]. (Basel Kunstbücher, 1).

10326. Wendland, Hans. **Konrad Witz: Gemäldestudien.** Basel, Schwabe, 1924.

WOLS (Alfred Otto Wolfgang Schulze), 1913-1951

10327. Dorfles, Gillo. **Wols.** Milano, All'Insegna del Pesce d'Oro, 1958. (Nuova serie illustrata, 1).

10328. Frankfurter Kunstverein. **Wols: Gemälde, Aquarelle, Zeichnungen, Fotos.** 20. November 1965 bis 2. Januar 1966. Frankfurt a.M., Kunstverein, 1965.

10329. Glozer, Laszlo. **Wols: Photograph.** [Published in conjunction with an exhibition at the Kestner-Gesellschaft Hannover, June 30-August 14, 1978]. Hannover, Kestner-Gesellschaft, 1978. (Katalog 3/1978).

10330. Haftmann, Werner. **Wols Aufzeichnungen.** Köln, DuMont Schauberg, 1963.

10331. Nationalgalerie Berlin. **Wols, 1913-1951: Gemälde, Aquarelle, Zeichnungen.** 13. September-5. November 1973. Berlin, Nationalgalerie Berlin, 1973.

WOOD, GRANT, 1892-1942

see also BENTON, THOMAS HART and CURRY, JOHN STEUART

10332. Brown, Hazel E. **Grant Wood and Marvin Cone: artists of an era.** Ames, Iowa, Iowa State University Press, 1972.

10333. Corn, Wanda M. **Grant Wood: the regionalist vision.** [Published in conjunction with an exhibition at the Whitney Museum for American Art, New York, June 16-September 4, 1983, and other places]. New Haven/London, Yale University Press, 1983.

10334. Dennis, James M. **Grant Wood: a study in American art and culture.** New York, Viking, 1975.

10335. Garwood, Darrell. **Artist in Iowa: a life of Grant Wood.** New York, Norton, 1944.

10336. Liffring-Zug, Joan, ed. **This is Grant Wood country.** Davenport, Iowa, Davenport Municipal Art Gallery, 1977.

WOTRUBA, FRITZ, 1907-1975

10337. Akademie der Bildenden Künste in Wien. **Wotruba: Figur als Widerstand: Bilder und Schriften zu Leben und Werk.** [October 20-December 23, 1977]. Salzburg, Galerie Welz, 1977.

10338. Breicha, Otto, ed. **Um Wotruba: Schriften zum Werk.** Wien, Europa, 1967.

10339. Canetti, Elias. **Fritz Wotruba.** Wien, Rosenbaum, 1955.

10340. Heer, Friedrich. **Fritz Wotruba.** St. Gallen, Erker, 1977. (Künstler unserer Zeit, 19).

10341. Salis, Jean R. de. **Fritz Wotruba.** Zürich, Edition Graphis, 1948.

10342. Smithsonian Institution Traveling Exhibition Service (Washington, D.C.). **The human form: sculpture, prints and drawings [by] Fritz Wotruba.** Washington, D.C., Smithsonian Institution, 1977.

10343. Wotruba, Fritz. **Überlegungen: Gedanken zur Kunst.** Zürich, Oprecht, 1945.

WREN, CHRISTOPHER, 1632-1723

10344. Beard, Geoffrey W. **The work of Christopher Wren.** Edinburgh, Bartholomew, 1982.

10345. Bennett, J. A. **The mathematical science of Christopher Wren.** Cambridge, Cambridge University Press, 1982.

10346. Bolton, Arthur T. and Hendry, H. Duncan, eds. **The Wren Society.** 20 v. Oxford, Wren Society, 1924-1943. (CR).

10347. Briggs, Martin S. **Wren, the incomparable.** London, Allen & Unwin, 1953.

10348. Caröe, William D., ed. **Tom tower, Christ Church, Oxford: some letters of Sir Christopher Wren to John Fell.** [With chapters by Herbert H. Turner and Arthur Cochrane]. Oxford, Clarendon Press, 1923.

10349. Downes, Kerry. **The architecture of Wren.** London, Granada, 1982.

10350. Dutton, Ralph. **The age of Wren.** London, Batsford, 1951.

10351. Elmes, James. **Memoirs of the life and works of Sir Christopher Wren.** London, Priestley and Weale, 1823.

10352. Fürst, Viktor. **The architecture of Sir Christopher Wren.** London, Lund Humphries, 1956.

10353. Gray, Ronald D. **Christopher Wren and St. Paul's Cathedral.** Cambridge, Cambridge University Press, 1979.

10354. Hutchinson, Harold F. **Sir Christopher Wren: a biography.** London, Gollancz, 1976.

10355. Little, Bryan D. **Sir Christopher Wren: a historical biography.** London, Hale, 1975.

10356. Milman, Lena. **Sir Christopher Wren.** London, Duckworth, 1908.

10357. Pevsner, Nikolaus. **Christopher Wren, 1632-1723.** New York, Universe, 1960.

10358. Phillimore, Lucy. **Sir Christopher Wren: his family and his times.** London, Kegan Paul, 1881.

10359. Royal Institute of British Architects. **Sir Christopher Wren, A.D. 1632-1723: bicentenary memorial volume.** Ed. by Rudolf Dirks. London, Hodder & Stoughton, 1923.

10360. Sekler, Eduard F. **Wren and his place in European architecture.** New York, Macmillan, 1956.

10361. Summerson, John. **Sir Christopher Wren.** New York, Macmillan, 1953.

10362. Weaver, Lawrence. **Sir Christopher Wren; scientist, scholar, and architect.** London, Country Life, 1923.

10363. Webb, Geoffrey. **Wren.** London, Duckworth, 1937.

10364. Whinney, Margaret. **Wren.** London, Thames and Hudson, 1971.

10365. Whitaker-Wilson, Cecil. **Sir Christopher Wren, his life and times.** London, Methuen, 1932.

10366. Wren, Christopher, [Jr.]. **Parentalia, or memoirs of the family of the Wrens.** London, Osborn, 1750. (New ed., edited by E. J. Enthoven: London, Arnold, 1903).

WRIGHT, FRANK LLOYD, 1869-1959

10367. Bardeschi, Marco D. **Frank Lloyd Wright.** London, Hamlyn, 1972.

10368. Blake, Peter. **Frank Lloyd Wright, architecture and space.** Baltimore, Penguin, 1964.

10369. Brooks, Harold A. **The prairie school: Frank Lloyd Wright and his midwest contemporaries.** Toronto, University of Toronto Press, 1972.

10370. _____, ed. **Writings on Wright: selected comments.** Cambridge, Mass./London, MIT Press, 1981.

10371. Brownell, Baker and Wright, Frank L. **Architecture and modern life.** New York, Harper, 1937.

10372. Drexler, Arthur. **The drawings of Frank Lloyd Wright.** [Published in conjunction with an exhibition at the Museum of Modern Art, New York, March 14-May 6, 1962]. New York, Horizon/Museum of Modern Art, 1962.

10373. Eaton, Leonard K. **Two Chicago architects and their clients: Frank Lloyd Wright and Howard Van Doren Shaw.** Cambridge, Mass./London, MIT Press, 1969.

10374. Farr, Finis. **Frank Lloyd Wright, a biography.** New York, Scribner, 1961.

10375. Guggenheim, Harry T. and Wright, Frank L. **The Solomon R. Guggenheim Museum; architect: Frank Lloyd Wright.** New York, Horizon/Guggenheim Foundation, 1960.

10376. Hanks, David A. **The decorative designs of Frank Lloyd Wright.** New York, Dutton, 1979.

10377. Hanna, Paul R. and Hanna, Jean S. **Frank Lloyd Wright's Hanna House, the clients' report.** Cambridge, Mass./London, MIT Press, 1981. (Architectural History Foundation Series, 5).

10378. Heinz, Thomas A. **Frank Lloyd Wright.** New York, St. Martin's, 1982.

10379. Hitchcock, Henry-Russell. **In the nature of materials, 1887-1941: the buildings of Frank Lloyd Wright.** New York, Duell, 1942. (Reprinted, with a new foreword and bibliography by the author: New York, Da Capo, 1975).

10380. Hoffmann, Donald. **Frank Lloyd Wright's Fallingwater: the house and its history.** With an introduction by Edgar Kaufmann, Jr. New York, Dover, 1978.

10381. Jacobs, Herbert. **Building with Frank Lloyd Wright, an illustrated memoir.** With Katherine Jacobs. San Francisco, Chronicle Books, 1978.

10382. James, Cary. **The imperial hotel: Frank Lloyd Wright and the architecture of unity.** Rutland, Vt./Tokyo, Tuttle, 1968.

10383. Manson, Grant C. **Frank Lloyd Wright to 1910: the first golden age.** With a foreword by Henry-Russell Hitchcock. New York, Reinhold, 1958.

10384. Meehan, Patrick. **Frank Lloyd Wright: a research guide to archival sources.** With a foreword by Adolf K. Placzek. New York/London, Garland, 1983.

10385. Morton, Terry B., ed. **The Pope-Leighey house.** Washington, D.C., Presentation Press, 1983.

10386. Muschamp, Herbert. **Man about town: Frank Lloyd Wright in New York City.** Cambridge, Mass./London, MIT Press, 1983.

10387. Scully, Vincent. **Frank Lloyd Wright.** New York, Braziller, 1960.

10388. Sergeant, John. **Frank Lloyd Wright's usonian houses: the case for organic architecture.** New York, Watson-Guptill, 1976.

10389. Smith, Norris K. **Frank Lloyd Wright: a study in architectural content.** Englewood Cliffs, N.J., Prentice-Hall, 1966. (New ed.: Watkins Glen, N.Y., American Life Foundation, 1979). (CR).

10390. Storrer, William A. **The architecture of Frank Lloyd Wright, a complete catalog.** Cambridge, Mass./London, MIT Press, 1978.

10391. Sweeney, Robert L. **Frank Lloyd Wright: an annotated bibliography.** Los Angeles, Hennessey & Ingalls, 1978.

10392. Tafel, Edgar. **Apprentice to genius: years with Frank Lloyd Wright.** New York, McGraw-Hill, 1979.

10393. Twombly, Robert C. **Frank Lloyd Wright, his life and architecture.** New York, Wiley, 1979. 2 ed.

10394. Willard, Charlotte. **Frank Lloyd Wright: American architect.** New York, Macmillan, 1972.

10395. Wright, Frank Lloyd. **An American architecture.** Ed. by Edgar Kaufman. New York, Horizon, 1955.

10396. _____. **Ausgeführte Bauten und Entwürfe.** Berlin, Wasmuth, 1910. (English ed.: Studies and executed buildings. Palos Park, Ill., Prairie School Press, 1975).

10397. _____. An autobiography. New York, Duell, Sloan and Pearce, 1943. (New ed.: New York, Horizon, 1977).

10398. _____. Drawings for a living architecture. New York, Horizon, 1959.

10399. _____. The future of architecture. New York, Horizon, 1953.

10400. _____. Genius and Mobocracy. New York, Duell, Sloan and Pearce, 1949. (New ed.: New York, Horizon, 1971).

10401. _____. In the cause of architecture: essays by Frank Lloyd Wright for Architectural Record, 1908-1952. New York, Architectural Record, 1975.

10402. _____. Letters to apprentices. Selected and with commentary by Bruce B. Pfeiffer. Fresno, The Press at California State University, 1982.

10403. _____. Letters to architects. Selected and with commentary by Bruce B. Pfeiffer. Fresno, The Press at California State University, 1982.

10404. _____. The life-work of the American architect Frank Lloyd Wright. Santpoort, Holland, Mees, 1925. (New ed.: with an introduction by Mrs. Frank Lloyd Wright: New York, Horizon, 1965).

10405. _____. The living city. New York, Horizon, 1958.

10406. _____. The natural house. New York, Horizon, 1954.

10407. _____. On architecture: selected writings, 1894-1940. Ed. by Frederick Gutheim. New York, Duell, Sloan and Pearce, 1941.

10408. _____. Selected drawings proposal. Selected and arranged by A.D.A. Edita Tokyo Co., Ltd. 3 v. New York, Horizon, 1977-1982.

10409. _____. A testament. New York, Horizon, 1957.

10410. _____. Writings and buildings. Selected by Edgar Kaufmann and Ben Raeburn. Cleveland/New York, World, 1960.

10411. Wright, John L. My father who is on earth. New York, Putnam, 1946.

10412. Wright, Olgivanna L. Frank Lloyd Wright, his life, his work, his words. New York, Horzion, 1966.

10413. _____. Our house. New York, Horizon, 1959.

10414. Zevi, Bruno. Frank Lloyd Wright. Zürich, Artemis, 1980.

WRIGHT, JOSEPH, 1734-1797

10415. Bemrose, William. The life and works of Joseph Wright, A. R. A., commonly called Wright of Derby. With a preface by Cosmo Monkhouse. London, Bemrose, 1885.

10416. Nicholson, Benedict. Joseph Wright of Derby, painter of light. 2 v. London, Routledge and Kegan Paul, 1968. (CR).

10417. Smith, Solomon C. and Bemrose, H. Cheney. Wright of Derby. New York, Stokes, 1922.

WRIGHT OF DERBY, JOSEPH see WRIGHT, JOSEPH

WTEWAEL, JOACHIM ANTHONISZOON, 1566-1638

10418. Lindeman, Catherinus M. Joachim Anthonisz. Wtewael. Utrecht, Oosthoek, 1929.

WU CHÊN, 1280-1354

10419. Cahill, James F. Wu Chên, a Chinese landscapist and bamboo painter of the 14th century. Ann Arbor, Mich., University Microfilms, 1958.

WU LI, 1632-1718 see WANG FAMILY

WUNDERLICH, PAUL, 1927-

10420. Bense, Max, et al. Paul Wunderlich: Werkverzeichnis der Lithografien von 1949-1971. Berlin, Propyläen, [1977]. (CR).

10421. Jensen, Jens C. Paul Wunderlich: eine Werkmonographie. Mit Beiträgen von Max Bense und Philippe Roberts-Jones. Offenbach a.M., Huber, 1980. (CR).

10422. Raddatz, Fritz J. Paul Wunderlich: lithographies et peintures. Traduit de l'allemand par Cornélius Heim. Paris, Denoël, 1972.

10423. Wunderlich, Paul and Székessy, Karin. Correspondenzen. Herausgegeben von Fritz J. Raddatz. Stuttgart/Zürich, Belser, 1977.

WYATT, JAMES, 1746-1813

SAMUEL, 1737-1807

10424. Dale, Antony. James Wyatt. Oxford, Blackwell, 1956. 2 ed.

10425. Robinson, John M. The Wyatts, an architectural dynasty. With a foreword by Woodrow Wyatt. Oxford, Oxford University Press, 1979.

10426. Turnor, Reginald. James Wyatt, 1746-1813. London, Art and Technics, 1950.

WYATVILLE, JEFFRY, 1766-1840

see also WYATT, JAMES

10427. Linstrum, Derek. Sir Jeffry Wyatville, architect to the king. Oxford, Clarendon Press, 1972.

WYETH, ANDREW, 1911–

 JAMES, 1946–

 NEWELL CONVERS, 1882–1945

see also PYLE, HOWARD

10428. Allen, Douglas and Allen, Douglas Jr. N. C. Wyeth: the collected paintings, illustrations, and murals. New York, Crown, 1972.

10429. Corn, Wanda M. The art of Andrew Wyeth. [Published in conjunction with an exhibition at the De Young Memorial Museum, San Francisco, June 16–September 3, 1973]. Greenwich, Conn., New York Graphic Society, 1973.

10430. Duff, James H. The western world of N. C. Wyeth. [Published in conjunction with an exhibition at the Buffalo Bill Historical Center, Cody, Wyo., and other places]. Cody, Wyo., Buffalo Bill Historical Center, 1980.

10431. Fogg Art Museum, Harvard University (Cambridge, Mass.). Andrew Wyeth: dry brush and pencil drawings; a loan exhibition. Cambridge, Mass., President and Fellows of Harvard College, 1963.

10432. Logsdon, Gene. Wyeth people: a portrait of Andrew Wyeth as he is seen by his friends and neighbors. Garden City, N.Y., Doubleday, 1971.

10433. Meryman, Richard. Andrew Wyeth. Boston, Houghton Mifflin, 1968.

10434. Metropolitan Museum of Art (New York). Two worlds of Andrew Wyeth: Kuerners and Olsons. New York, Metropolitan Museum of Art, 1976. (Metropolitan Museum of Art Bulletin, XXXIV: 2).

10435. Museum of Fine Arts (Boston). Andrew Wyeth. Introduction by David McCord; selection by Frederick A. Sweet. Boston, Museum of Fine Arts, 1970; distributed by New York Graphic Society, Greenwich, Conn.

10436. Wyeth, Betsy J. Christina's World: paintings and pre-studies of Andrew Wyeth. Boston, Houghton Mifflin, 1982.

10437. _____. Wyeth at Kuerners. Boston, Houghton Mifflin, 1976.

10438. _____, ed. The Wyeths: the letters of N. C. Wyeth. Boston, Gambit, 1971.

10439. Wyeth, James. Jamie Wyeth. Boston, Houghton Mifflin, 1980.

WYSPIAŃSKI, STANISŁAW, 1869–1907

10440. Blum, Napisała H. Stanisław Wyspiański. Warszawa, Auriga, 1969.

10441. Makowiecki, Tadeusz. Poeta-malarz: studjum o Stanisławie Wyspiańskim. Warszawa, Mickiewicza, 1935.

10442. Przybyszewski, Stanisław i Żuk-Skarszewski, Tadeusz. Stanisław Wyspiański, dzieła malarskie. [Warszawa], Bibljoteka Polska, 1925.

10443. Skierkowska, Elżbieta. Wyspiański-artysta książki. Wrocław, Ossolineum, 1970. 2 ed.

10444. Stokowa, Maria. Stanisław Wyspiański: monografia bibliograficzna. 4 v. Kraków, Wydawnicka Literackie, 1967/1968.

YEATS, JACK BUTLER, 1871–1957

 JOHN BUTLER, 1839–1922

10445. MacGreevy, Thomas. Jack B. Yeats, an appreciation and an interpretation. Dublin, Waddington, 1945.

10446. Murphy, William M. Prodigal father: the life of John Butler Yeats (1839–1922). Ithaca/London, Cornell University Press, 1978.

10447. National Gallery of Ireland (Dublin). Jack B. Yeats, a centenary exhibition. September–December 1971. London, Secker & Warburg, 1971.

10448. Pyle, Hilary. Jack B. Yeats, a biography. London, Routledge, 1970.

10449. Yeats, Jack B. Sailing, swiftly. London, Putnam, 1933.

10450. Yeats, John B. Letters to his son W. B. Yeats and others, 1869–1922. Edited with a memoir by Joseph Hone, and a preface by Oliver Elton. London, Faber, 1944.

YEH SHIH, 1150–1223

10451. Lo, Winston W. The life and thought of Yeh Shih. Gainesville, Florida, University Presses of Florida/Hong Kong, Chinese University of Hong Kong, 1974.

YÜN SHOU-P'ING, 1633–1690 see WANG FAMILY

ZADKINE, OSSIP, 1890–1967

10452. Buchanan, Donald. The secret world of Zadkine. [Text by Zadkine; in French and English]. Paris, Arted, 1966.

10453. Czwiklitzer, Christophe. Ossip Zadkine, le sculpteur-graveur de 1919 à 1967. Préface de Jean Adhémar. Paris, Art-Christophe Czwiklitzer, 1967.

10454. Hammacher, Abraham M. Zadkine. Amsterdam, De Lange, 1954.

10455. Jianou, Ionel. Zadkine. Paris, Arted, 1979. 2 ed. (CR).

10456. Lichtenstern, Christa. Ossip Zadkine (1890–1967), der Bildhauer und seine Ikonographie. Berlin, Mann, 1980. (Frankfurter Forschungen zur Kunst, 8).

10457. Prax, Valentine. Avec Zadkine: souvenirs de notre vie. Lausanne/Paris, Bibliothèque des Arts, 1973.

10458. Raynal, Maurice. **Ossip Zadkine.** Rome, Valori Plastici, 1921.

10459. Zadkine, Ossip. **Lettres à André de Ridder.** Introduction de Jean Cassou. Anvers, Librairie des Arts, 1963.

10460. _____. **Le maillet et le ciseau: souvenirs de ma vie.** Paris, Michel, 1968.

10461. _____. **Voyage en Grèce/Trois Lumières.** [Amsterdam, Boeschoten, 1955].

ZAKHARIEV, VASIL, 1895-1971

10462. Svintila, Vladimir. **Vasil Zakhariev.** Sofia, Iskusstvo Bulgarski Khudozhnik, 1972.

10463. Tomov, Evtim. **Vassil Zachariev.** Sofia, Bulgarian Artist, 1954.

ZAMPIERI, DOMENICO see DOMENICHINO

ZANDOMENEGHI, FEDERICO, 1841-1917

10464. Cinotti, Mia. **Zandomeneghi.** Busto Arsizio, Bramante, 1960. (I grandi pittori italiani dell'ottocento, 3).

10465. Piceni, Enrico. **Zandomeneghi.** Milano, Bramante, 1967. (CR).

ZAO WOU-KI, 1920-

10466. Galeries Nationales du Grand Palais (Paris). **Zao Wou-Ki; peintures, encres de Chine.** 12 juin-10 août 1981. Paris, Ministère de la Culture et de la Communication, 1981.

10467. Jacometti, Nesto. **Zao Wou-Ki: catalogue raisonné de l'oeuvre gravée et lithographiée, 1949-1954.** Berne, Gutekunst et Klipstein, 1955. (CR).

10468. Laude, Jean. **Zao Wou-Ki.** Bruxelles, La Connaissance, 1974.

10469. Leymarie, Jean. **Zao Wou-Ki.** Trans. by Kenneth Lyons. New York, Rizzoli, 1979.

10470. Roy, Claude. **Zao Wou-Ki.** Paris, Fall, 1957.

10471. Zao Wou-Ki. **Les estampes, 1937-1974.** Paris, Arts et Métiers Graphiques, 1975. (CR).

ZAUFFELY, JOHANN see ZOFFANY, JOHN

ZEILLER, JOHANN JAKOB, 1708-1783

10472. Fischer, Pius. **Der Barockmaler Johann Jakob Zeiller und sein Ettaler Werk.** Vorwort von Norbert Lieb. München, Herold, 1964.

ZEVIO, ALTECHIERO DA see ALTECHIERI, ALTECHIERO

ZICHY, MIHÁLY, 1827-1906

10473. Aleshina, Liliia S. **Mikhai Zichi.** Moskva, Izobrazitel'noe Iskusstvo, 1975.

10474. Berkovits, Ilona. **Zichy Mihály, élete és munkássága (1827-1906).** Budapest, Akadémiai Kiado, 1964.

10475. Lázár, Béla. **Zichy Mihály, élete és müvészete.** Budapest, Atheneum, 1928.

ZIEM, FELIX, 1821-1911

10476. Fournier, Louis. **Un grand peintre, Félix Ziem; notes biographiques.** Beaune, Lambert, 1897.

10477. Roger-Milès, Léon. **Félix Ziem.** Paris, Librairie de l'Art Ancien et Moderne, 1903.

10478. Miquel, Pierre. **Félix Ziem, 1821-1911.** 2 v. Maurs-la-Jolie, Editions de la Martinelle, 1978. (CR).

10479. Musée de l'Annonciade (Saint-Tropez). **Ziem en marge.** 20 juin-15 septembre [1980]. Saint-Tropez, Musée de l'Annonciade, [1980].

ZILLE, HEINRICH, 1858-1929

10480. Flügge, Gerhard. **Heinrich Zille: Ernstes und Heiteres aus seinem Leben.** Rudolstadt, Greifenverlag, 1960.

10481. Köhler-Zille, Margarete. **Mein Vater, Heinrich Zille.** Erzählt von Gerhard Flügge. Berlin, Verlag Neues Leben, 1955.

10482. Luft, Friedrich. **Mein Photo-Milljöh: 100 X Alt-Berlin aufgenommen von Heinrich Zille.** Hannover, Fackelträger, 1967.

10483. Nagel, Otto. **H. Zille.** Berlin, Henschel, 1955.

10484. Oschilewski, Walther G. **Heinrich Zille Bibliographie; Veröffentlichungen von ihm und über ihn.** Herausgegeben von Gustav Schmidt-Küster. Hannover, Heinrich-Zille-Stiftung, 1979.

10485. Paust, Otto. **Vater Zille: der Meister in seinem Milljöh.** Berlin, Franke, 1941.

10486. Ranke, Winfried. **Vom Milljöh ins Milieu: Heinrich Zilles Aufstieg in der Berliner Gesellschaft.** Hannover, Fackelträger, 1979.

10487. Schumann, Werner. **Zille sein Milljöh.** Hannover, Fackelträger, 1952.

10488. Zille, Heinrich. **Das dicke Zillebuch.** Herausgegeben von Gerhard Flügge. Berlin, Eulenspiegel, 1972. 2 ed.

10489. _____. **Das grosse Zille-Album.** Einleitung von Werner Schumann. Hannover, Fackelträger, 1957.

ZIMMERMANN, DOMINIKUS, 1685-1766

 JOHANN BAPTIST, 1680-1758

10490. Hitchcock, Henry R. **German Rococo: the Zimmermann brothers.** London, Lane, 1968.

10491. Lamb, Carl. **Die Wies: das Meisterwerk von Dominikus Zimmermann.** Berlin, Rembrandt, 1937.

10492. Muchall-Viebrook, Thomas W. **Dominicus Zimmermann, ein Beitrag zur Geschichte der süddeutschen Kunst im 18. Jahrhundert.** Leipzig, Hiersemann, 1912.

10493. Thon, Christina. **Johann Baptist Zimmermann als Stukkator.** München/Zürich, Schnell & Steiner, 1977.

ZOFFANY, JOHN, 1733-1810

10494. Manners, Victoria and Williamson, George C. **John Zoffany, R. A.** London, Lane, 1920.

10495. Millar, Oliver. **Zoffany and his Tribuna.** London, Paul Mellon Foundation/Routledge & Kegan Paul, 1967.

10496. National Portrait Gallery (London). **Johann Zoffany, 1733-1810.** January 14-March 27, 1977. London, National Portrait Gallery, 1976.

10497. Webster, Mary. **Johann Zoffany.** Milano, Fabbri, 1966. (I maestri del colore, 237).

ZOLLER, ANTON, 1695-1768

 JOSEPH ANTON, 1730-1791

10498. Krall, Gertrud. **Anton und Joseph Anton Zoller: ein Beitrag zur Barockmalerei in Tirol.** Innsbruck, Universität Innsbruck, 1978. (Veröffentlichungen der Universität Innsbruck, 115; Kunstgeschichtliche Studien, 3).

ZORACH, WILLIAM, 1887-1966

10499. Bauer, John I. **William Zorach.** New York, Whitney Museum of American Art/Praeger, 1959.

10500. Brooklyn Museum (New York). **William Zorach; paintings, watercolors and drawings, 1911-1922.** November 26, 1968-January 19, 1969. New York, Brooklyn Museum, 1968.

10501. Wingert, Paul S. **The sculpture of William Zorach.** New York, Pitman, 1938.

10502. Zorach, William. **Art is my life.** Cleveland, World, 1967.

10503. _____. **Zorach explains sculpture: what it means and how it is made.** New York, American Artists Group, 1947.

ZORN, ANDERS LEONARD, 1860-1920

10504. Asplund, Karl. **Anders Zorn, his life and work.** Edited by Geoffrey Holme. Trans. by Henry Alexander. London, The Studio, 1921.

10505. _____. **Zorn's engraved work: a descriptive catalogue.** Trans. by Edward Adams-Ray. 2 v. Stockholm, Bukowski, 1920. (CR).

10506. Boëthius, Gerda. **Zorn: människan och konstnären.** Stockholm, Konst och Kultur, 1960.

10507. _____. **Zorn: Swedish painter and world traveller.** Trans. by Albert Read. Stockholm, Raben & Sjögren, 1959.

10508. _____. **Zorn: tecknaren, malaren, etsaren, skulptören.** Stockholm, Nordisk Rotogravyr, 1949.

10509. Broun, Elizabeth. **The prints of Anders Zorn.** [Published in conjunction with an exhibition at the Spencer Museum of Art, University of Kansas, Lawrence, Kansas]. Lawrence, Kan., Spencer Museum of Art, 1979.

10510. Brummer, Hans H. **Zorn, svensk målare i världen.** Stockholm, Bonniers, 1975.

10511. Engström, Albert. **Anders Zorn.** Stockholm, Bonniers, 1928.

10512. Hedberg, Tor. **Anders Zorn, ungdomstiden.** 2 v. Stockholm, Norstedt, 1923 1924. (Sveriges allmänna konstförenings publikation, 32/33).

10513. Hjert, Svenolof [and] Hjert, Bertil. **Zorn: engravings/ etsningar; a complete catalogue/en komplett katalog.** Preface by Hans H. Brummer. [Text in English and Swedish]. Uppsala, Hjert & Hjert, 1980. (CR).

10514. Servaes, Franz. **Anders Zorn.** Bielefeld/Leipzig, Velhagen & Klasing, 1910. (Künstler-Monographien, 102).

ZRZAVÝ, JAN, 1890-

10515. Lamač, Miroslav. **Jan Zrzavý.** Praha, Odeon, 1980.

10516. Plichta, Dalibor. **The modern symbolist: the painter Jan Zrzavý.** Trans. by Roberta F. Samsour. Prague, Artia, [1958].

10517. Šourek, Karel, ed. **Dílo Jana Zrzavého, 1906-1940.** Praze, Umělecka Beseda a Družstevní Práce, 1941.

ZUCCARI, FEDERIGO see ZUCCARO, FEDERIGO

ZUCCARI, TADDEO see ZUCCARO, TADDEO

ZUCCARO, FEDERIGO, 1530-1609

 TADDEO, 1529-1566

10518. Gere, John. **Taddeo Zuccaro: his development studied in his drawings.** London, Faber, 1969.

10519. Körte, Werner. **Der Palazzo Zuccari in Rom; sein Fresken-schmuck und seine Geschichte.** Leipzig, Keller, 1935. (Römische Forschungen der Bibliotheca Hertziana, 7).

10520. Zuccaro, Federico. **L'idea de' pittori, scultori ed architetti.** Torino, Disserolio, 1607. (Reprint included in: **Scritti d'arte di Federico Zuccaro.** A cura di Detlef Heikamp. Firenze, Olschki, 1961. Fonti per lo studio della storia dell'arte, 1).

ZULOAGA, IGNACIO, 1870-1945

10521. Arozamena, Jesus M. de. **Ignacio Zuloaga; el pintor, el hombre.** San Sebastián, Spain, Sociedad Guipuzcoana, 1970.

10522. Bénédite, Léonce. **Ignacio Zuloaga.** Paris, Librairie Artistique Internationale, [1912].

10523. Encina, Juan de la [pseud., Ricardo Gutierrez Abascal]. **El arte de Ignacio Zuloaga.** Madrid, Sociedad Española de Librería, [1916].

10524. Hispanic Society of America (New York). **Catalogue of paintings by Ignacio Zuloaga exhibited March 21 to April 11, 1909.** With introduction by Christian Brinton. New York, Hispanic Society of America, 1909.

10525. Inmaculada, Juan J. de la. **La incognita de Zuloaga.** Burgos, El Monte Carmelo, 1951.

10526. Lafuente Ferrari, Enrique. **La vida y el arte de Ignacio Zuloaga.** San Sebastián, Spain, Editora Internacional, 1950; distributed by Mayfe, Madrid. (New ed.: Madrid, Revista de Occidente, 1972).

10527. Milhou, Mayi. **Ignacio Zuloaga (1870-1945) et la France.** St. Loubes, Graphilux, 1981.

10528. Rodriguez del Castillo, Jesús. **Ignacio Zuloaga, el hombre.** Zarauz, Icharopena, 1970.

10529. Utrillo, Miguel, et al. **Five essays on the art of Ignacio Zuloaga.** [Text in either French or Spanish]. New York, Hispanic Society of America, 1909.

ZURBARÁN, FRANCISCO DE, 1598-1664

see also RIBERA, JUSEPE

10530. Brown, Jonathan. **Francisco de Zurbarán.** New York, Abrams, 1973.

10531. Calzada, Andrés M. y Santa Marina, Luys. **Estampas de Zurbarán.** Barcelona, Canosa, 1929.

10532. Carrascal Muñoz, José. **Francisco de Zurbarán.** Madrid, Giner, 1973.

10533. Cascales y Muñoz, José. **Francisco de Zurbarán; his epoch, his life and his works.** Trans. by Nellie S. Evans. New York, [privately printed], 1918.

10534. Cason del Buen Retiro (Madrid). **Exposicion Zurbarán en el III centenario de su muerte.** Noviembre 1964-Febrero 1965. Madrid, Ministerio de Educación Nacional/ Dirección General de Bellas Artes, 1964.

10535. Gállego, Julián [and] Gudiol, José. **Zurbarán, 1598-1664.** New York, Rizzoli, 1977. (CR).

10536. Gaya Nuño, Juan A. **Zurbarán.** Barcelona, Aedos, 1948.

10537. Gregori, Mina [and] Frati, Tiziana. **L'opera completa di Zurbarán.** Milano, Rizzoli, 1973. (CR). (Classici dell'arte, 69).

10538. Guinard, Paul. **Zurbarán et les peintres espagnols de la vie monastique.** Photographies de Roger Catherineau. Paris, Editions du Temps, 1960. (CR).

10539. Kehrer, Hugo. **Francisco de Zurbarán.** München, Schmidt, 1918.

10540. Pompey, Francisco. **Zurbarán, su vida y sus obras.** Madrid, Aguado, [1948].

10541. Sanchez de Palacios, Mariano. **Zurbarán, estudio biografico y critico.** Madrid, Offo, 1964.

10542. Soria, Martin S. **The paintings of Zurbarán, complete edition.** London, Phaidon, 1953; distributed by Garden City Books, New York.

10543. Torres Martín, Ramón. **Zurbarán, el pintor gótico del siglo XVII.** Sevilla, Gráficas del Sur, 1963.

AUTHOR INDEX

The numbers cited are entry numbers, not page numbers.

Baskett, John 8455
Baskett, Mary W. 10176
Basler, Adolphe 2262, 2263, 2287, 6203, 9701, 9716
Bassegoda Nonell, Juan 3276, 3281
Bassi, Elena 1317, 7217
Bastelaer, Rene van 1093
Bataille, Georges 5947
Bataille, Maria-Louis 6766
Battelli, Guido 1674
Battisti, Eugenio 1132, 1133, 1680, 3070, 3549
Bauch, Kurt 315, 7974, 7975
Baud-Bovy, Daniel 1798
Baudelaire, Charles 2050, 2195, 4096
Baudi di Vesme, Alessandro 438
Baudot, Jeanne 8082
Baudouin, Frans 8468
Bauer, Arnold 4977
Bauer, Franz 3134, 8159
Bauer, George C. 642
Bauer, Gerard 3028
Bauer, Walter 3645
Baum, Julius 4427, 8766
Baumann, Emile 4003, 7770
Baumgart, Fritz 1094, 1347, 9679
Baumgarten, Fritz 341
Baur, John I. 1094, 1172, 1173, 1347, 1640, 3986, 8272, 9151, 10499
Bautier, Pierre 790, 9242
Baxandall, David 7044
Baxandall, Michael 3550
Baxter, Lucy E. 433
Bayer, Herbert 471, 472
Bayerische Akademie der Schönen Künste (Munich) 5024
Bayerische Staatsgemäldesammlung (Munich) 119, 2305
Bayet, Charles 3551
Baylay, Stephen 8803
Bayley, Frank W. 1759, 2884
Bazalgette, Léon 3987, 6373
Bazin, Germain 163, 1799, 3032, 5690, 6287
Bazire, Edmond 5948
Beachboard, Robert 9702
Beal, Graham W. 2309, 8813
Beam, Philip C. 4447, 4448
Beard, Geoffrey W. 35, 10344
Beattie, Susan 9157
Beau, Marguerite 8261
Beaudin, André 502
Beaume, Georges 3171
Beaute, Georges 9537
Beazley, John D. 4890, 7283
Becatti, Giovanni 6260
Beccaria, Arnaldo 6728
Becherucci, Luisa 164, 7668, 7850
Bechtel, Edwin de T. 1230
Beck, Hans-Ulrich 3843
Beck, James H. 5408, 6395, 7851
Becker, Beril 3310
Becker, Carl 154, 8182
Becker, Hanna L. 120
Becker, Robert 6321
Beckett, Ronald B. 4334, 5380
Beckett, Samuel 9859
Beckmann, Max 518, 519
Beckmann, Peter 520
Beenken, Hermann 2782, 6167, 10232
Beer, François J. 846
Beerli, Conrad A. 6023
Beets, Nicholas 5783
Beguin, Sylvie M. 17
Behets, Armand 6374
Behling, Lottelisa 4013
Bekaert, Geert 9987
Béla, Lazar 2823
Beletskoi, E. A. 4766
Belkin, Kristin L. 8469
Bell Gallery, List Art Building, Brown University (Providence, R.I.) 8470
Bell, Charles F. 1914, 4646
Bell, Clive 7316
Bell, Malcolm 1181
Bell, Mrs. Arthur [Nancy] 6004
Bellinati, Claudio 3552
Bellini, Amedeo 95
Bellini, Paolo 801, 8417
Bellmer, Hans 569, 570, 571, 572
Bellochi, Ugo 18
Bellonci, Maria 6005
Bellori, Giovanni P. 1417, 7689, 7852

Bellosi, Luciano 3380, 5747, 6945
Bellows, George W. 591, 592
Belt, Elmer 5409
Beltrame, Francesco 9440
Beltrami, Giuseppe 5859
Beltrami, Luca 5410, 5528, 5791
Bemrose, H. Cheney 10417
Bemrose, William 10415
Bender, Ewald 4289, 4290
Benedictis, Cristina de 3578
Bénédite, Léonce 1617, 1875, 2837, 2838, 2839, 5348, 6268, 6535, 8287, 10522
Beneš Buchlovan, Bedrich 4739
Benesch, Otto 121, 3512, 6873, 7976, 7977, 7978
Benigni, Paola 1134
Benito, Angel 9797
Benjamin, Jean K. 4722
Benjamin, Ruth L. 963
Benkard, Ernst 643, 1348, 8752
Benkovitz, Miriam J. 492
Bennett, J. A. 10345
Benoit, François 4335, 4385
Bense, Max 10420
Benson, Emanuel M. 6062
Bentivoglio, Mirella 8927
Bentley, G. A., Jr. 2948
Bentley, Gerald E. 747
Benton, Thomas Hart 608, 609, 610
Benyovszky, Karl 7106
Benziger, Marieli 614
Béraldi, Henri [see also Draibel, Henri] 7832
Berckelaers, Ferdinand Louis see Seuphor, Michel
Bercken, Erich von der 9404
Berckenhagen, Eckhart 3861
Berefelt, Gunnar 8554
Bérence, Fred 5411, 6396, 7853
Berenson, Bernard 1349, 3071, 3552, 5756, 8671
Berge, Pierre 1157
Berger, Ernst 814
Berger, John 6979, 7415
Berger, Klaus 3397, 3398, 7950
Berger, Robert W. 5565
Bergh, Richard 617
Berghe, Gustaaf van den 4047
Bergmann, Werner 9441
Bergös, Joan 3277
Berhaut, Marie 1203
Beringer, Joseph A. 4933, 9333, 9595
Béritens, Germán 3876
Berjano Escobar, Daniel 6723
Berkovits, Ilona 10474
Berkson, William 4743
Berlage, Hendrick Petrus 625
Berlin Museum 3229
Bernales Ballestros, Jorge 1309
Bernard, Emile 629, 1510
Bernardi Ferrero, Daria de 4067
Bernardi, Marziano 2999, 3000
Bernardini, Giorgio 7539
Bernari, Carlo 9405
Bernasconi, Cesare 7575
Bernasconi, Ugo 6358
Bernath, Aurel 637
Bernhard, Marianne 342, 7979, 8471, 8767
Bernier, Georges 3598
Berninger, Herman 7683
Bernini, Domenico 644
Beroqui, Pedro 9442
Berr de Turique, Marcelle 2462
Berry, Erick [pseud., Allena Best] 4336
Berry-Hill, Henry 5218
Berry-Hill, Sidney 5218
Bertels, Kurt 2051
Berthold, Gertrude 1511
Berthoud, Roger 9236
Berti, Luciano 165, 1463, 5673, 6093, 6111, 7669, 7670, 7854
Bertini, Aldo 925
Berto, Giuseppe 1299, 1300
Bertoni, Giulio 1950
Bertotti Scamozzi, Ottavio 7218
Bertram, Anthony 6957
Bertrand, Alexis 8544
Beruete y Moret, Aureliano de 3770, 9067, 9724, 9812
Beschorner, Hans 7345
Besnard, Albert 683, 5172
Besset, Maurice 2662, 5255
Besson, George 8968
Best, Allena see Berry, Erick

Colliander, Tito 8108
Collignon, Maxime 5813, 7383, 7729
Collins, George R. 3280, 3281
Collins, Leo C. 8828
Collins, William 6774
Collis, Louise 9093
Collis, Maurice 9094
Colnaghi & Co., Ltd. (London) 5653
Colombier, Pierre du 5899, 6406
Colombo, Alfredo 5431
Colombo, Giuseppe 2902, 7809
Columbus Museum of Art (Columbus, Ohio) 595
Colvin, Sidney 2931, 2949
Comandé, Giovanni B. 8662
Combe, Jacques 891
Comini, Alessandra 4892, 8698, 8699
Comitato Nazionale per le Celebrazzioni Bramantesche 996
Comitato Nazionale per le Onoranze a Leonardo da Vinci nel Quinto
 Centenario della Nascita (1452-1952) 5432
Comitato Preposto alle Onoranze a Jacopo Barozzi 9965
Comitato Promotore per le Manifestazioni Espositive Firenze e
 Prato 9450
Comitato Vaticano per l'Anno Berniniano 652
Comment, Jean-François 8258
Comolli, Angelo 7857
Compin, Isabelle 1966
Comune di Brescia 8340
Comune di Sovicille, Assessorato alla Cultura (Sovicille, Italy)
 7373
Condivi, Ascanio 6407
Congresso Internazionale di Studi Bramanteschi 997
Connely, Willard 9220
Conrady, Charles 989
Consibee, Philip 1593
Constable, William G. 1279, 1280, 2950, 10304
Contag, Victoria 10099
Contaldi, Elena 3849
Conte, Edouard 8140
Contemporary Arts Museum (Houston) 6793
Conti, Angelo 3521
Contini, Gianfranco 6087
Contrucci, Pietro 8245
Convegno di Studi Borromino 878
Convegno di Studi Vinciani 5433
Convegno Internazionale di Studi sul Rinascimento VIII 2347
Convegno Vanvitelliano (Ancona) 9757
Conway, William M. 2506, 2786, 3522
Cook, Herbert F. 3523
Cook, Ruth V. 3962
Cook, Theodore A. 5434
Cook, Thomas 4342
Coope, Rosalys 1076
Cooper, Douglas 1028, 3656 3950, 3951, 5325, 7429, 9111, 9237,
 9540
Cooper, Helen A. 9599
Coopman, Henrik 4657
Coor, Gertrude 6981
Copertini, Giovanni 7297
Coplans, John 4777, 5613, 10107
Coppier, André Charles 684, 7992, 7993
Coquerel, Anthony 7994
Coquiot, Gustave 2156, 6692, 8085, 8293, 8294, 8905, 9541
Coquis, André 1801
Corbet, August 1730, 2970
Corcoran Gallery of Art (Washington, D.C.) 2618, 3120, 6794,
 8652, 9753
Cordemans, Marcel 9390
Cordey, Jean 7185
Cordier, Daniel 2409
Corell, Jon C. 8899
Coremans, Paul 2787, 2788
Corinth, Charlotte Berend 1772, 1773, 1774
Corn, Wanda M. 10333, 10429
Cornaggia, G. 7577
Cornelius, Carl 7817
Cornelius, Fidelis 4772
Cornell, Henrik 6528
Cornette, A. H. 2789
Cornu, Paul 1802
Corrard de Breban 3595
Corredor-Matheos, José 6564
Correia, Vergílio 8859
Cortesi Bosco, Francesca 5762
Corti, Maria 6288
Cortissoz, Royal 2127, 4162, 5074, 8596
Cossio, Manuel B. 3883
Costa, Luiz X. da 8860
Costantini, Constanzo 1634

Cottê, Sabine 1692
Coudenhove-Erthal, Eduard 2982
Coupin, P. A. 3599
Courajod, Louis 9763
Courières, Edouard des 2369, 4084, 7149
Courthier, Pierre 3400
Courthion, Pierre 849, 1693, 1886, 2059, 2197, 2467, 2468, 3657,
 4539, 5601, 5952, 5953, 6205, 6206, 7696, 8420, 8434, 8906,
 9087, 9506
Courtney, William Leonard 4233
Cousin, Jean (the elder) 1907
Cousin, Jean (the younger) 1908
Cousins, Frank 5838
Cousturier, Lucie 8452, 8907, 8970
Couturie, Marie A. 5326
Cowdrey, Bartlett 6845
Cox, E. M. 3474
Cox, Kenyon 4449
Cox, Trenchard 3034
Craig, Edward Gordon 1917
Cramer, Gérard 6699
Crastre, François 4216
Crastre, Victor 3884
Crauzat, Ernest de 9143
Cravens, R. H. 10227
Crawford, David A. E. L. (Lord Balcarres) 2348
Crelly, William R. 10050
Crespelle, Jean-Paul 1566, 9705, 10026
Cresson, Margaret French 3126, 3127
Cresti, Carlo 5280
Creutz, Max 6095, 7114
Crevel, René 8988
Crichton, E. R. 7597
Crichton, George H. 7597
Crichton, Michael 4628
Crippa, Roberto 1944
Crispolti, Enrico 2989, 2991, 4814
Cristinelli, Giuseppe 5716
Crone, Rainer 10108
Cronin, William V. 8128
Crook, J. Mordaunt 1176
Crow, Gerald H. 6801
Crowe, Joseph A. 7858, 9451
Cruttwell, Maud 6011, 7645, 8246, 8976, 9935
Cruzada Villaamil, D. G. 3776, 9819
Cugini, Davide 6789
Cuming, Edward D. 6776
Cummings, Paul 9033
Cunningham, Allan 10297
Cunningham, Peter 4639
Cuppers, Joachim 464
Curcin, Milan 6362
Curjel, Hans 344
Curtis, Atherton 843, 4571
Curtis, Charles B. 6919
Cust, Lionel H. 2584, 2585
Cust, Robert H. 1499, 9050
Cuypers, Firmin 2685
Czestochowski, Joseph H. 1987
Czwiklitzer, Christophe 7430, 10453
Çekalska-Zborowska, Halina 7153
D. Caz-Delbo Galleries (New York) 3013
Dacier, Emile 8593, 10134
Dacos, Nicole 7859
D'adda, Gerolamo 5435
Dafforne, James 5099, 6866, 9619
D'Agen, Boyer 4540
Daguerre, Louis J. M. 1997
Dahhan, Bernard 9766
Daingerfield, Elliott 4564
Daix, Pierre 7431, 7432, 7433
Dake, Carel L. 4576
Dal Poggetto, Paolo 6408
Dal-Gal, Niccolò 6788
Dale, Antony 10424
Dali, Ana Maria 2008
Dali, Salvador 6537
Dalisi, Riccardo 3282
Dalli Regoli, Gigetta 5746
Damase, Jacques 2686
Damerini, Gino 4052
Damon, Samuel Foster 756
Danforth Museum (Framingham, Mass.) 3014
Daniel, Howard 892, 1237
Daniel, Pete 4636
Daniels, Jeffrey 8148, 8149
Danielsson, Bengt 3318, 3319

Morgan, John H. 1764, 7845, 9197
Morgan, Sydney 8370
Morgunova-Kudnitskaia, Natalia D. 8112
Morice, Charles 1431, 3341
Moriondo, Margherita 8980
Morisani, Ottavio 2358, 6499, 6648, 6674, 9402
Mornard, Pierre 633
Mörner, Stellan 8610
Morosini, Duilio 4094
Morris, May 6811
Morrison, Hugh 9222
Morschel, Jürgen 5018
Morse, Albert Reynolds 2019, 2020
Morse, John D. 8929
Morse, Peter 9019
Morse, Willard S. 7806
Mortara, Antonio E. 7302
Mortari, Luisa 9194
Morton, Terry B. 10385
Morton, Thomas E. 2254
Mosby, Dewey F. 2147
Moschini, Vittorio 561, 562, 1289, 4058, 5718, 10022
Moss, Armand 2209
Mösser, Andeheinz 4862
Mostra Biennale d'Arte Antica (VII), Bologna 389
Mottini, Guido E. 1841
Mottram, Ralph H. 1963
Moulin, Raoul-Jean 3457
Mount, Charles M. 6675, 8658, 9198
Moureau, Adrien 1290
Mourey, Gabriel 686, 3250, 8391
Mourisca Beaumont, Maria A. 8861
Mourlot, Fernand 7469
Moxey, Keith P. F. 48
Mras, George P. 2210
Muccigrosso, Robert 1919
Mucha, Jiri 6850, 6851
Muchall-Viebrook, Thomas W. 10492
Mueller, Karl O. 7389
Muenier, Pierre-Alexis 4217
Mühlestein, Hans 4302, 4303
Mujica Gallo, Manuel 7470
Mulazzani, Germano 993, 7887
Müller, August W. 8786
Müller, Franz L. 2539
Müller, Hans 4757
Müller, Heinrich 1782
Müller, Josef 149
Muller, Joseph-Emile 2757, 8024
Muller, M. 8025, 8026
Müller, Sigurd 9351
Müller, Werner Y. 4290
Müller, Wolfgang J. 2959
Müller-Thalheim, Wolfgang K. 5038
Müller-Walde, Paul 5509
Muls, Jozef 6295
Münchner Stadtmuseum (Munich) 3261, 9331
Muñoz, Antonio 881, 1328, 2927, 2985, 5851, 5852, 6930, 9846
Munson-Williams-Proctor Institute (Utica, N.Y.) 294
Muntz, Eugène 5510, 7888, 7889, 7890
Münz, Ludwig 1120, 5732 8027, 8028, 8029
Mura, Anna M. 8972
Muraro, Maria T. 3273
Muratov, Pavel Pavlovich 170
Murken-Altrogge, Christa 6593
Murphy, Richard W. 1536
Murphy, William M. 10446
Murray, Linda 6452
Murray, Michelangelo 1395
Murray, Peter 7561
Murrell, William 2253
Murtha, Edwin 6001
Muschamp, Herbert 10386
Musée Cantini (Marseille) 2374
Musée Cantonal des Beaux Arts (Lausanne) 279
Musée Communal des Beaux Arts (Bruges) 2101, 6296
Musée d'Art Contemporain Montreal 871
Musée d'Art et d'Histoire (Geneva) 2737, 2847
Musée d'Art Moderne de la Ville de Paris 2869, 6607
Musée d'Ixelles (Bruxelles) 5138
Musée de l'Ain (Bourg-en-Bresse, France) 7142
Musée de l'Annonciade (Saint-Tropez) 10479
Musée de l'Art Wallon (Liège) 5711, 5712
Musée de l'Orangerie (Paris) 1432, 1541, 1592, 1621, 1813, 1843,
 2087, 2112, 2231, 3705, 5164, 5977, 6676
Musée de la Marine, Palais de Chaillot (Paris) 9919
Musée de Lyon 2375
Musée de Metz 5253

Musée de Montargis 3602
Musée de Peinture et de Sculpture (Grenoble) 3217
Musée de Vesoul 3416
Musée des Arts Décoratifs (Paris) 1579, 2418, 3057, 4812, 5340,
 9498
Musée des Beaux-Arts (Bordeaux) 743
Musée des Beaux-Arts de Dijon 2763
Musée des Beaux-Arts, Pau (France) 2298
Musée des Beaux-Arts (Rouen) 2453, 3407, 4509
Musée des Beaux-Arts (Troyes) 3597, 6968
Musée des Beaux-Arts, Valenciennes 1403
Musée du Louvre (Paris) 960, 961, 969, 1814, 1815, 1842, 2211,
 7715, 8267, 8513, 8973
Musée du Louvre, Galerie Mollien (Paris) 8449
Musée Gustave Courbet (Ornans) 1902
Musée Historique de l'Ancien-Evêché (Lausanne) 9991
Musée Ingres (Montauban) 2286
Musée Jules Chéret (Nice) 2477
Musée National d'Art Moderne (Paris) see Centre Georges Pompidou
Musée National du Château de Compiègne 6969
Musée Rath (Geneva) 1685
Musée Réattu (Arles) 6977
Musée Rodin (Paris) 636, 2291, 7150, 8308
Musée Royaux des Beaux-Arts de Belgique, Bruxelles 2779
Musée Toulouse-Lautrec (Albi) 5139
Musées Royaux des Beaux-Arts de Belgique (Brussels) 2238, 2242,
 8514
Musei Civici e Centro di Studi Preistorici e Archeologici Varese,
 Villa Mirabello (Varese) 6737
Musei di San Marco (Florence) 171
Museo Borgogna (Vercelli) 2905
Museo Civico (Bologna) 1713
Museo del Prado (Madrid) 3812, 6318
Museo dell'Accademia e Museo di San Marco (Florence) 3423
Museo di Castelvecchio (Verona) 368, 5610
Museo Espanol de Arte Contemporâneo (Madrid) 6575
Museo Nacional de Artes Plásticas (Mexico City) 8224
Museo National de Escultura (Valladolid, Spain) 4686
Museo Nazionale d'Arte Moderna, Tokyo 3004
Museo Nazionale del Bargello (Florence) 1145
Museo Regionale, Messina 203
Museo Tamayo (Mexico City) 9263
Museu Nacional de Bellas Artes (Rio de Janeiro) 7681
Museum Bellerive (Zurich) 3262
Museum Boymans-Van Beuningen (Rotterdam) 1200, 2021, 2243, 2372,
 2373, 3730, 3758, 4832, 4916, 5880, 8414, 9586, 9878
Museum der Stadt Aschaffenburg 4825
Museum des 20. Jahrhunderts (Wien) 810
Museum Folkwang (Essen) 9, 2479
Museum für Kunst und Gewerbe (Hamburg) 2877, 3946
Museum für Kunst und Geschichte (Freiburg i.Ue.) 4304
Museum Ludwig (Cologne) 10097
Museum of Art, Carnegie Institute (Pittsburgh) 6695
Museum of Art, Rhode Island School of Design (Providence, R.I.)
 9199
Museum of Art, University of Connecticut (Storrs, Conn.) 3731
Museum of Art, University of Michigan (Ann Arbor, Mich.) 9281
Museum of Fine Arts (Boston) 2540, 4529, 4648, 4826, 7133, 8125,
 10435
Museum of Fine Arts (Springfield, Mass.) 3020
Museum of Modern Art (New York) 10, 63, 854, 1056, 1537, 1859,
 2736, 2774, 2878, 3218, 3342, 3458, 3701, 3702, 3745, 3959,
 3973, 4331, 4484, 4806, 5019, 5071, 5117, 5597, 5665, 5881,
 6067, 6132, 6226, 6227, 6228, 6242, 6842, 6943, 7016, 7471,
 7472, 7653, 8225, 8226, 8949, 9247
Museum of Modern Art (Oxford, Eng.) 7162
Museum voor Schone Kunsten (Ghent) 6554
Museum Wiesbaden 10217
Musgrave, Clifford 41
Musper, Theodor 2541, 2542, 2543, 2544, 6169
Musso y Valiente 5854
Muth, Hanswernfried 8195
Muther, Richard 3813, 3862, 6545
Muzeum Knihy (Saar) 8648
Muzeum Narodowe (Warsaw) 7154
Mycielski, Jerzy 9953
Mynona [pseud., Salomon Friedländer] 3994
Nadeau, Maurice 2244
Naef, Hans 4552, 4554
Naegely, Henry 6546
Nagassé, Takeshiro 4378
Nagel, Otto 4996, 4997, 10483
Nagera, Humberto 3703
Nagler, Georg K. 7891
Nakamura, Nihei 8958
Nakov, Andrei B. 9301
Naquet, Félix 3058
Narazaki, Muneshige 4276, 4379, 4380, 9519, 9698

Petit, Jean 5302
Petitjean, Charles 6952
Petraccone, Enzo 3515
Pétridès, Paul 9708, 9721
Petrie, Brian 6677
Petrova, E. N. 7522
Petrovics, Elek 2899, 8214
Petrucci, Alfredo 1369
Pettenella, Plinia 134
Petzet, Heinrich W. 10042
Petzet, Michael 9078
Pevsner, Alexei 3219
Pevsner, Nikolaus 4036, 5836, 10357
Pewny, Denise 8215
Peyre, Roger R. 9310
Pfäfflin, Friedrich 3947
Pfalzgalerie Kaiserslautern 7789
Pfankuch, Peter 8693
Pfannstiel, Arthur 6608, 6609, 6610
Pfefferkorn, Rudolph 4876
Pfeiffer-Belli, Erich 4866, 6864
Pfister, Kurt 902, 2803, 3637, 3708, 8831
Pfister, Rudolf 7009
Pfister-Burkhalter, Margarete 6347
Philadelphia Museum of Art 774, 1817, 1904, 4155, 5104, 5980,
 6068, 6230
Philandrier, Guillaume 10012
Philip, Lotte Brand 2804
Philipe, Anne 9945
Philippe, Joseph 2805
Philipson, Morris 5524
Phillimore, Lucy 10358
Phillips Collection (Washington, D.C.) 1543
Phillips Memorial Art Gallery (Washington, D. C.) 2130
Phillips, Christopher 9131
Phillips, Claude 8135, 9476, 9477, 10157
Phillips, Duncan 3538, 10207
Phillips, Evelyn M. 7532, 9417
Photography Gallery (Philadelphia) 1342
Physick, John 3488, 3489, 9158
Phythian, J. Ernest 4581
Pia, Pascal 6135
Piantanida, Sandro 5525
Piatkowski, Henryk 159
Pica, Agnoldomenico 2995
Pica, Vittorio 7064
Picart, Yves 10051, 10052
Piccard, Gerhard 6839
Piccioni, Leone 6611
Piceni, Enrico 7065, 7066, 10465
Pichi, Giovanni F. 3086
Pickle, R. 7171
Pickvance, Ronald 3345
Picon, Gaëtan 2419, 4556, 6578
Picon, Jacinto O. 9851
Pierantoni, Amalia C. 5526
Piérard, Louis 3709, 5981
Pierre Matisse Gallery (New York) 374, 375, 3460
Pierre, José 4833, 6748
Pierron, Sander 6840
Piers, Harry 2925
Pietro, Filippo di 418
Pietsch, Ludwig 4237
Pieyre de Mandiargues, André 227, 577
Pigler, Andor 2379
Pignatti, Terisio 565, 1293, 1294, 1295, 1296, 1297, 3539, 4061,
 5719, 5720, 5721, 9374, 9380, 9929
Piliavskii, V. I. 8401
Pilla, Eugenio 9478
Pillement, Georges 8146
Pillet, Charles 9955
Pilo, Giuseppe Maria 1406, 8152
Pilon, Edmond 3940, 6250, 10158
Pilz, Kurt 10003
Pinder, Wilhelm 4414, 4972
Pinnington, Edward 10301
Pino, Domenico 5527
Piovene, Guido 9381, 9930
Pirchan, Emil 4899, 5913
Pires, Heliodoro 5695
Pisko, Gustav 10092
Pissarro, Ludovic R. 7620
Pittaluga, Mary 1202, 5680, 6103, 7066, 9418, 9666
Pittoni, Laura 8644
Pitz, Henry C. 7807, 7808
Place, Charles A. 1165
Placzek, Adolf K. 7565
Plan, Pierre Paul 1242

Planet, Louis de 2212
Planiscig, Leo 2281, 2360, 3425, 6946, 8153, 8254, 8378, 9938
Plant, Margaret 4867
Plate, Robert 1483
Pleasants, J. Hall 4638
Plettinck, Leopold 5932
Plichta, Dalibor 10516
Plietzsch, Eduard 9317, 9901
Plon, Eugène 1501, 9353
Pocock, Tom 10263
Podobedova, O. I. 5121
Poensgen, Georg 2977, 7379
Poeschel, Erwin 3461
Poeschke, Joachim 2361
Poggiali, Pietro 7897
Pogorilovschi, Ion 1009
Poillon, Louis 7716
Point Cardinal, Le (Paris) 2735
Point, Daniël 2818
Pointer, Andy 54
Pointon, Marcia R. 2582
Pois, Robert 7091
Poland, William C. 2886
Polásek, Jan 9564
Poley, Stefanie 255
Polfeldt, Ingegerd 4256
Poliakoff, Alexis 7639
Poliakova, Elena I. 8326
Pollock, Griselda 3710
Pomilio, Mario 5529
Pommeranz-Liedtke, Gerhard 6118, 8787
Pompei, Alessandro 8634
Pompey, Francisco 3025, 3819, 9852, 10540
Ponente, Nello 1544, 4868, 6182, 7898
Ponge, Francis 1043, 1044
Pons, Zenon 7774
Ponsonailhe, Charles 978
Ponte, Pietro da 6764
Ponten, Josef 8119
Pool, Phoebe 7417
Poore, Charles 3820
Poorter, Nora de 8518
Pope, Arthur 9479
Pope-Hennessy, John 173, 2341, 3594, 4265, 7899, 8255, 8673, 9667
Popham, Arthur E. 1845, 5530, 7303
Popp, Anny E. 6459
Popper, Frank 51
Porcella, Antonio 9382
Portalis, Roger 3061, 5068
Porter, Fairfield 2629
Porter, James A. 4649
Porteus, Hugh G. 5594
Portmann, Paul 6151
Portmas, Paul Ferdinand 681
Portoghesi, Paolo 883, 884, 885, 4071, 4487, 6497, 10020
Posener, Julius 8723
Posner, Donald 1423, 10159, 10160
Pospisil, Maria 5866
Posse, Hans 1932
Postan, Alexander 6964
Potocki, Antoni 3999
Potterton, Homan 1298
Pottier, Edmond 2578
Pouillon, Catherine 9982
Poulain, Gaston 479, 480
Poulet-Allamagny, Jean-Jacques 9577
Poulet-Malassis, Auguste 5350
Pound, Ezra 3303
Povoledo, Elena 3273
Powell, L. B. 2711
Powell, Nicolas 3208
Powers, Harry M. 6460
Pozza, Antonio M. dalla 7245
Pozza, Neri 6732
Pradel de Grandry, Marie 3746
Pradel, Pierre 1738
Prange, Christian F. 6319
Prasse, Leona E. 2880
Pratt, Davis 8930
Prause, Marianne 1445
Prax, Valentine 10457
Praz, Mario 1331
Precerutti Garberi, Mercedes 9383
Preibisz, Leon 4201
Prelinger, Elizabeth 6892
Prescott, Kenneth W. 8931
Pressly, Nancy L. 3209
Pressly, William L. 425

Riat, Georges 1905, 8549
Ribemont-Dessaignes, Georges 7943
Ricci, Corrado 566, 1847, 1848, 3088, 3274, 6284, 6464, 7533
Rice, Norman L. 6367
Rich, Daniel C. 2178, 7112, 8440, 8915
Richardson, Brenda 4513
Richardson, Edgar P. 102, 7323
Richardson, Joanna 2393
Richardson, John 1045
Richardson, Ralph 6780
Richet, Michèle 5336
Richman, Michael 3129
Richter, Cornelia 8564
Richter, George M. 1466, 3540
Richter, Gottfried 3154
Richter, Horst 5703, 6854
Richter, Jean Paul 5532
Richter, Julius Wilhelm 4415
Richter, Stanislav 4442
Ricketts, Charles 9480
Ridder, André de 1605, 2697, 5322, 6556, 7342
Ridolfi, Carlo 9419
Rief, Hans-Herman 10043
Riegel, Herman 1794, 1795
Riemer, Elke 4756
Rienaecker, Victor G. 1871
Rietdorf, Alfred 3502
Rieth, Adolf 6050
Rietschel, Ernst 7925
Riggenbach, Rudolf 4503
Rigollot, Marcel J. 5533
Rigon, Fernando 7251
Rijckevorsel, J. van 8033
Rijksmuseum Kröller-Müller (Otterlo, The Netherlands) 9517
Riley, Phil M. 5838
Rilke, Rainer Maria 8311
Rimantas, J. 8212
Rinaldis, Aldo de 3516, 5534, 6092
Rinder, Frank 1256
Ringbom, Sixten 4721
Rintelin, Friedrich 3574
Rio, Alexis F. 5535
Ripert, Pierre 6690
Ripley, Elizabeth 4469
Ritchie, Andrew C. 2255, 10073, 10126
Ritter, William 824
Rivers, John 3941
Rivière, Georges 8099
Rivière, Henri 2179
Rizzi, Aldo 1380, 1381
Rizzo, Giulio E. 7735
Robaut, Alfred 1818m 2213
Robbins, Daniel 9526
Robert, Guy 872, 872a
Roberts, Colette 7029, 9501
Roberts, William 4486, 8352
Roberts-Jones, Philippe 5886
Robertson, Bryan 7080, 7657
Robertson, David A. 2642
Robertson, Donald W. 3192
Robertson, Giles 567, 1477
Robida, Michel 8100
Robin, Michel 3711
Robinson, Basil W. 5053, 5054
Robinson, Duncan 9095
Robinson, Franklin W. 6372
Robinson, John M. 10425
Robinson, Susan Barnes 369
Robiquet, Jacques 3766
Rocco, Giovanni 9362
Roch, Wolfgang 8565
Rochas d'Aiglun, Albert de 9795
Roche, Denis 5585
Rocheblave, Samuel 7515
Roditi, Eduard 4800
Rodman, Selden 7548, 7549, 8932
Rodriguez del Castillo, Jesús 10528
Rodriguez, Antonio 8231
Rodriguez-Aguilera, Cesareo 7490
Roe, F. Gordon 2761
Roedel, Reto 8824
Roennefahrt, Günther 9106
Roessler, Arthur 1129, 8706, 10092
Roffler, Thomas 4305
Roger-Ballu 444
Roger-Marx, Claude 2091, 2292, 4654, 7312, 8034, 8101, 8260, 8843, 8844, 8925, 9565, 10074, 10075
Roger-Milès, Léon 839, 5536, 10477

Rogers, Ernesto N. 6990
Rogers, John J. 7137
Rogers, Meyric R. 6530
Rogge, Henning 539
Roggero, Mario F. 6307
Rogosz, Josef 4000
Roi, Pia 1849
Roig, Jean de 8357
Roland-Michel, Marianne 9730
Rolfs, Wilhelm 4038, 5194
Roli, Renato 387
Romagnoli, Fernanda 7103
Romain, Lothar 695
Romains, Jules 5323
Roman, Joseph 8204
Romanini, Angiola Maria 235
Romdahl, Axel L. 6465, 9959
Romney, John 8350
Römpler, Karl 5362
Ronchaud, Louis de 7391
Rondolino, Gianni 6630
Ronner, Heinz 4699
Ronzani, Francesco 8636
Roop, Guy 7252
Roosen-Runge, Heinz 6143
Rooses, Max 4664, 8521, 8522
Roosevelt, Blanche [pseud.] 2394
Rope, Edward G. 7784
Rosand, David 9481, 9482, 9483
Rosci, Marco 451, 3388, 5537, 8874
Roscoe, S. 705
Rose Art Museum, Brandeis University (Waltham, Mass.) 3123, 3193, 6243, 8239
Rose, Barbara 3122, 5611, 6579, 7129
Rose, Bernice 7658
Rose, Millicent 2395
Rosenauer, Artur 2362
Rosenbach, A. S. W. 1976
Rosenberg, Adolf 537, 2150, 3365, 4760, 5394, 5538, 7173, 7905, 8035, 8523, 9125, 9311, 9355, 10161, 10219
Rosenberg, Harold 2191, 3752, 7034, 9134, 9136
Rosenberg, Jakob 1922, 8036, 8550, 8772
Rosenberg, Marc 4604
Rosenberg, Pierre 1606, 1607, 5168
Rosenberger, Ludwig 5040
Rosenblum, Robert 4558, 9149
Rosenfeld, Myra N. 5133, 8875
Rosenhagen, Hans 3357, 5627, 9597, 9677
Rosenthal, Erwin 3575
Rosenthal, Léon 3410, 5985
Rosenthak, Mark 3961
Rosenthal, Michael 1749
Rosenthal, T. G. 4284
Rosenzweig, Phyllis D. 2630
Roserot, Alphonse 949
Rosito, Massimilian 3426
Rossel, André 2092
Rossetti, William M. 8394
Rossi Bortolatto, Luigina 2214, 6680
Rossi, Alberto 8602
Rossi, Giovanni G. de 4750
Rossi, Giuseppe I. 6466
Rossi, Paola 1260, 7307, 9416, 9420, 9421
Rössler, Arthur 116
Rostrup, Haavard 736
Rotermund, Hans-Martin 8037
Roth, Leland M. 5847
Rothe, Hans 3821
Röthel, Hans K. 1786, 4722
Rothenstein, Elizabeth 9096
Rothenstein, John 4627, 9097, 9640
Rothenstein, William 3822
Rothes, Walter 174
Röthlisberger, Marcel 568, 1052, 1053, 1706, 1707, 1708, 5659
Rothschild, Henri de 1608
Rothschild, Lincoln 6525
Rotili, Mario 8372
Rotonchamp, Jean de 3351
Rotondi, Pasquale 3008
Röttgen, Herwarth 1371
Röttger, Bernhard H. 6857
Röttinger, Heinrich 2969, 10198
Rotzler, Willy 4585
Rouart, Denis 2180, 2181, 2182, 5986, 6681, 6682, 6771, 8102
Rouart, Louis 6772
Rouchès, Gabriel 437, 1424, 5576, 7719
Roulet, Claude 8425
Rourke, Constance M. 296, 8951

Scheybal, Josef V. 4740
Scheyer, Ernst 2882, 6633
Schiaparelli, Attilio 5540
Schiavo, Armando 6471
Schick, Rudolf 825
Schiefler, Gustav 4827, 5629. 6895, 6896, 7093
Schiff, Gert 3210, 3211, 7498
Schifner, Kurt 7286
Schildt, Göran 14, 15
Schiller, Peter H. 6855
Schilling, Edmund 2975
Schinman, Barbara Ann 2712
Schinman, Edward P. 2712
Schlager, J. E. 2380
Schleinitz, Otto J. W. von 1941, 4522, 6819, 10172
Schlenoff, Norman 4559
Schleswig-Holsteinisches Landesmuseum (Schleswig, W.Germany) 4195
Schleswig-Holsteinischer Kunstverein (Kiel) 7094
Schliebler, Ralf 5887
Schlörb, Barbara 9397
Schlosser, Julius von 3427, 3428, 3833
Schlossmuseum Weimar 1934
Schlüter-Göttsche, Gertrud 7194
Schmalenbach, Werner 740, 741, 8792, 9293
Schmarsow, August 2811, 6105, 6105, 6285, 7534, 8649
Schmeckebier, Laurence E. 1988, 6368
Schmid, Heinrich Alfred 826, 827, 4418
Schmid, Max 4919, 8121
Schmidt, Georg 4303, 9248
Schmidt, Hans M. 6179
Schmidt, Harry 7195
Schmidt, Heinrich A. 4041, 6472, 8122
Schmidt, Justus 2945
Schmidt, Karl W. 8171
Schmidt, Paul F. 5041, 7095, 8568
Schmidt, Winfried 8551
Schmidt-Degener, Frederik 1082, 8039, 9126
Schmidt-Künsemüller, Friedrich A. 6820
Schmied, Wieland 3155, 4212, 4671, 5042, 7104
Schmit, Robert 970
Schmitz, Hermann 354
Schmoll gen. Eisenwerth, Josef Adolf 549
Schmoll, J. August 9211, 9212
Schmorl, Theodor A. 7008
Schmücking, Rolf 4149
Schnack, Jutta 6254
Schnackenburg, Bernhard 7175
Schnapper, Antoine 2114, 4681
Schneditz, Wolfgang 5043
Schneeberger, Pierre-Francis 3352
Schneede, Uwe M. 2742, 3996, 4998, 5888
Schneider, Arthur von 1373, 2978
Schneider, Hans 5633
Schneider, Laurie 3579
Schneider, Max F. 828
Schneider, Pierre 10162
Schneider, Reinhold 4947
Schneiders, Toni 8195
Schnütgen-Museum, Kunsthalle Köln (Cologne) 7294
Schöber, David G. 2553
Schoeller, André 1819, 1820, 1821
Schoenberger, Arno 4075
Schoenberger, Guido 4042
Schöne, Wolfgang 981
Schönfeld, Paul 8640
Schopenhauer, Johanna 2812
Schott, Rudolf 6473
Schottmüller, Frida 176, 2363
Schrade, Hubert 5708, 8196
Schram, Wilhelm 4751
Schreiber, Theodor 7666
Schreiner, Ludwig 8729
Schrenk, Klaus 2095
Schreyl, Karl Heinz 7120
Schröder, Bruno 6941
Schroeder, Thomas 1244
Schubert, Dietrich 2324, 5355
Schubring, Paul 135, 2364, 8257, 9687
Schuchardt, Christian 1935
Schuder, Rosemarie 905
Schudt, Ludwig 1374
Schüler, Irmgard 6165
Schult, Friedrich 405, 406, 407
Schultz, Wolfgang 8590, 8591
Schultze, Jürgen 4611
Schulz, Anne M. 1169, 7042, 8240, 8379
Schulze, Friedrich 7108
Schulze, Hanns 1069

Schulze-Battman, Elfriede 9714
Schumacher, Joachim 5541
Schumann, Werner 10487
Schurek, Paul 408, 409
Schürer, Oskar 7207, 7499
Schurmeyer, Walter 906
Schuster, Jean 6244
Schütze, Karl-Robert 10044
Schuurman, K. E. 2821
Schuyler, Hamilton 8322
Schvey, Henry I. 4964
Schwabacher, Ethel 3753
Schwabacher, Sascha 7649
Schwabik, Aurel 7208, 7209
Schwarz, Arturo 2456, 2457, 7944
Schwarz, Heinrich 4261
Schwarz, Herbert 1936
Schwarz, Ignaz 8179
Schwarz, Karl 1787, 4283
Schwarz, Michael 2381
Schweicher, Curt 10079
Schweizerisches Institut für Kunstwissenschaft (Zurich) 4306
Schwemmer, Wilhelm 4878, 5009
Sciascia, Leonardo 198
Science Museum (London) 10193
Sciolla, Gianni C. 6560
Scott, David 9021
Scott, Jonathan 7568
Scott, McDougall 5105
Scott, Temple 6821
Scottish Arts Council (Edinburgh) 1440
Scottish Arts Council Gallery (Edinburgh) 4262
Scully, Vincent, Jr. 4700, 10387
Scutenaire, Louis 5889
Séailles, Gabriel 1433, 5542, 10163
Secession (Berlin) 6055
Secker, Hans F. 8232
Secrest, Meryle 1075
Secrétain, Roger 3304
Sedelmeyer, Charles 6909
Sedlmaier, Richard 7009
Sedlmayr, Hans 886, 2946
Seeger, Georg 10006
Segard, Achille 1460, 3759, 9059
Segonzac, André D. de 2268
Seidlitz, Woldemar von 5543, 8040
Seitz, Don C. 10267, 10268
Seitz, William C. 3754, 6683, 9502
Sekler, Eduard F. 4325, 10360
Sekler, Mary P. 5303
Seldes, Lee 8415
Seldis, Henry J. 6716
Selevoy, Robert A. 682
Seligman, Germain 5087, 8917
Seligman, Janet 2039
Seligmann, Herbert 9175
Selinova, Nina 8328
Sellars, James 7281
Sellers, Charles C. 7324, 7325
Sello, Gottfried 3872
Selway, Neville C. 7650
Selz, Jean 6234, 6750, 6897, 7958, 10034
Selz, Peter H. 531, 2420, 3113, 4307, 7096
Sembat, Marcel 6235
Semenzato, Camillo 5717, 7254, 9385
Semler, Christian 7392
Semper, Hans 2365, 2366, 7210
Sensier, Alfred 6386, 6547, 8450
Sentenac, Paul 5908
Serenyi, Peter 5304
Serfinska, Stanislawa 6193
Sergeant, John 10388
Sergi, Antonino 7755
Serov, Valentin A. 8884
Serra, Luigi 2342, 7908
Serret, Georges 4087
Sert, José L. 3296
Sérullaz, Maurice 1822, 2113, 2216, 2217, 9854
Servaes, Franz 4920, 8826, 10514
Servi, Gaspare 9715
Servolini, Luigi 916
Settis, Salvatore 7393
Seuphor, Michel [pseud., Berckelaers, Ferdinand Louis] 194, 258, 5130, 6651
Severin, Dante 7813
Severini, Giancarlo 8630
Sevolini, Luigi 380
Sewell, Darrel 2632

Städtische Kunsthalle Düsseldorf 4150, 5022, 6843
Städtisches Kunstmuseum (Bonn) 4677, 5824
Städtisches Museum Leverkusen 6980
Stafski, Heinz 10007
Stahl, Fritz 6357
Staley, Edgcumbe 5374, 10164
Stampfle, Felice 7569
Standing, Percy Cross 111
Stang, Ragna T. 6898, 9960
Stange, Alfred 6148
Stanton, Phoebe 7785
Stanton, Theodore 841
Stapleton, Darwin H. 5191
Starczewski, Hanns Joachim 410
Starkweather, William E. B. 3836
Starodubova, Veronika Vasi'evna 976
Starzyński, Juliusz 6194
Stasiak, Ludwik 10008
Stasiv, V. 5017
State University of New York Art Gallery, Albany 482
Stearns, Frank P. 9423
Stearns, Raymond P. 1478
Stechow, Wolfgang 1122, 2555, 8531, 8579
Stedelijk Museum (Amsterdam) 2192, 2376, 2377, 3714
Stedelijk van Abbemuseum Eindhoven 2336, 5704
Steen, Marguerite 7049
Steevens, George 4358
Steigelmann, Wilhelm 7790
Stein, Gertrude 7502
Stein, Karl H. 8197
Stein, Ruth 7794
Stein, Wilhelm 4419, 7910
Steinbart, Kurt 1790, 1791, 5697, 6110, 9063
Steinberg, Leo 4630
Steinberg, Solomon David 4308
Steinitz, Kate T. 5546, 5547, 8794
Steinman, David B. 8323
Steinmann, Ernst 942, 943, 3437, 6477, 6478, 6479, 6480, 7535
Steinmann, Othmar 8217
Steinweg, Klara 7140
Steland-Stief, Anne Charlotte 264
Stella, Joseph G. 8103
Stelzer, Otto 6596
Stencuv graficky kabinet (Prague) 5943
Stenersen, Rolf 6899
Stenerud, Karl 6900
Stengel, Etienne 4938
Stephens, Frederick G. 110, 1978, 4523, 5106, 6868
Sterling, Charles 3043
Stern, Dorothea 5010
Stevenson, Enrico 7530
Stevenson, Sara 4263
Stewart, Andrew F. 8798
Stewart, Douglas A. 4929, 5652
Stich, Sidra 6584
Stift Melk (Austria) 7728
Stillman, Damie 43
Stirling, William 9855
Stites, Raymond S. 5548
Stokes, Hugh 3837
Stokowa, Maria 10444
Stoll, Adolf 9434
Stoll, Karlheinz 7102
Stoloff, Bernard 5312
Stone, Irving 3715
Stoppani, Leonard 6824
Storm, John 9723
Storrer, William A. 10390
Story, Alfred T. 5655
Story, Sommerville 8315
Stowe, Edwin 9856
Strachey, Constance 5233, 5234
Strajnić, Kosta 6369
Strange, Alfred 4411
Strange, Edward F. 4280, 4384, 9580
Stratton, Arthur 8987
Strauss, Gerhard 5001
Strauss, Walter L. 2556, 2557, 2558, 2559, 3733, 8045
Strazzullo, Franco 9761
Streicher, Elizabeth 4924
Streichhan, Annelise 4931
Streit, Carl 8198
Streitz, Robert 7256
Stridbeck, Carl Gustaf 1123
Strieder, Peter 2560, 2561
Strobl, Alice 4901
Strömberg, Martin 4682
Strong, Roy 4259, 4267, 4420, 4644

Stroud, Dorothy 1089, 8118, 9048
Strub, Marcel 3370
Strutt, Edward C. 5683
Stubbe, Wolf 411, 412, 6993, 8172, 8180
Stubblebine, James H. 2429, 4083
Stuchbury, Howard E. 1263
Stuck-Villa (Munich) 7739, 7791
Stuckey, Charles F. 9567
Stuckey, Joan 10213, 10214
Stuckey, Ronald 10213
Studentenstudio für Moderne Kunst (Tübingen) 3948
Studniczka, Franz 1206
Stumm, Lucie 6030
Stuttmann, Ferdinand 5630
Suarès, André 8424
Succo, Friedrich 8960, 9581
Sugana, Gabriele M. 3353, 9539
Sugranes, Jose M. a Guix 3295
Suhr, Norbert 9804
Suida Manning, Bertina 1250
Suida, Wilhelm 1000, 2562, 5549, 7911, 9484
Summers, David 6481
Summerson, John 4647, 6955, 9049, 10361
Sumowski, Werner 3157
Supino, Igino B. 1502, 3582, 5684, 5685
Surtees, Virginia 8396
Sutton, Denys 2277, 8316, 8966, 9115, 10270, 10271, 10307
Sutton, Peter C. 4476
Sutton, Thomas 2034
Suzdalev, Petr K. 5572, 10069
Suzuki, Daisetz T. 8858
Suzuki, Juzo 8943
Svenaeus, Gösta 6901, 6902
Svintila, Vladimir 10462
Swane, Leo 6236
Swanson, Vern G. 112
Swarbrick, John 44
Swarzenski, Georg 7602
Sweeney, James J. 1221, 1585, 2139, 3296, 6585, 6718, 9085
Sweeney, Robert L. 10391
Sweet, Frederick A. 1461
Sweetser, Moses F. 103, 1710, 2611, 5107, 5550, 8079, 9485
Swillens, P. T. A. 1264, 9904
Swinburne, Algernon Charles 777
Swinburne, Charles A. 9645
Swoboda, Karl M. 7295
Syamken, Georg G. 5867
Sydow, Eckart von 151
Sýkorová, Libuše 3354
Sylvester, David 329, 5890
Symeonides, Sibilla 9246
Symondo, Emily Morse see Paston, George
Symonds, John A. 6482
Symons, Arthur 778
Szarkowski, John 271, 1227, 9228
Székessy, Karin 10423
Szittya, Emil 9088
Szwykowski, Ignaz von 2612
Tabarant, Adolphe 5988, 5989, 7623, 9709
Táborský, Frantisek 4001, 4741
Tadgell, Christopher 3223
Taevernier, Aug 2699, 2700
Tafel, Edgar 10392
Taft, Ada B. 9249
Tafuri, Manfredo 8646
Tagliaventi, Ivo 9994
Taigny, Edmond 4575
Taillandier, Yvon 6506, 6684
Takahashi, Seiichiro 4157, 4281, 4765, 9521
Takeda, Tsuneo 4726
Tancock, John L. 8317
Tanguy, Kay S. 9272
Tannenbaum, Libby 2701
Tapié de Céleyran, Mary 9568
Tapié, Michel 1340, 2726, 2997, 9294
Tarabukin, Nikolai M. 10070
Taranovskaia, Marianna Z. 8402
Tarbé, Prosper 7516
Tarnowski, Stanislaw 6195
Tassi, Roberto 3158, 9240, 9241
Tatarinoff-Eggenschwiler, Adele 152
Tatarkiewicz, Wladyslaw 7155
Tate Gallery (London) 331, 377, 780, 1752, 1872, 2481, 3159, 3212, 3252, 3355, 4285, 5344, 6719, 6795, 6966, 7050, 7130
Tattersall, Bruce 9207
Tavel, Hans C. von 6031
Taylor, Basil 1753, 9208
Taylor, Hilary 10272